EVERYMAN,
I WILL GO WITH THEE,
AND BE THY GUIDE,
IN THY MOST NEED
TO GO BY THY SIDE

GIORGIO VASARI

Lives of the Painters, Sculptors and Architects

Translated by Gaston du C. de Vere
with an Introduction and Notes by
David Ekserdjian

VOLUME 2

EVERYMAN'S LIBRARY

129

First included in Everyman's Library, 1927
Translation by Gaston de Vere first published in 1912; first
published in Everyman's Library, 1996
Introduction, Notes, Bibliography and Chronology
© David Campbell Publishers Ltd., 1996
Typography by Peter B. Willberg

ISBN: Volume 1 1-85715-780-X
 Volume 2 1-85715-781-8
 Volumes 1 and 2 (boxed set) 1-85715-779-6

A CIP catalogue record for this book is available from the
British Library

Published by David Campbell Publishers Ltd., 79 Berwick Street,
London W1V 3PF

Distributed by Random House (UK) Ltd.,
20 Vauxhall Bridge Road, London SW1V 2SA

LIVES OF THE
PAINTERS, SCULPTORS
AND ARCHITECTS

———

10-01

CONTENTS OF
VOLUME TWO

VASARI'S LIVES

LIVES OF THE MOST EMINENT PAINTERS, SCULPTORS AND ARCHITECTS

BY GIORGIO VASARI

VOLUME TWO

(Part III – *Continued*)

LIVES OF THE MOST EMINENT PAINTERS, SCULPTORS AND ARCHITECTS

BY GIORGIO VASARI

VOLUME TWO

(Part II – Continued)

VASARI'S LIVES

FRA GIOCONDO, LIBERALE, AND OTHER CRAFTSMEN OF VERONA

If writers of history were to live a few years longer than the number commonly granted as the span of human life, I, for my part, have no manner of doubt that they would have something to add to the accounts of the past previously written by them, for the reason that, even as it is not possible for a single man, be he ever so diligent, to learn the exact truth in a flash, or to discover all the details of his subject in the little time at his command, so it is as clear as the light of day that Time, who is said to be the father of truth, is always revealing new things every day to the seeker after knowledge. If, many years ago, when I first wrote and also published these Lives of the Painters and other Craftsmen, I had possessed that full information which I have since received concerning Fra Giocondo of Verona, a man of rare parts and a master of all the most noble faculties, I would without a doubt have made that honourable record of him which I am now about to make for the benefit of craftsmen, or rather, of the world; and not of him only, but also of many other masters of Verona, who have been truly excellent. And let no one marvel that I place them all under the image of one only, because, not having been able to obtain portraits of them all, I am forced to do this; but, so far as in me lies, not one of them shall thereby have his excellence defrauded of its due.

Now, since the order of time and merit so demands, I shall speak first of Fra Giocondo. This man, when he assumed the habit of S. Dominic, was called not simply Fra Giocondo, but Fra Giovanni Giocondo. How the name Giovanni dropped from him I know not, but I do know that he was always called Fra Giocondo by everyone. And although his chief profession was that of letters, and he was not only a very good philosopher and theologian, but also an excellent Greek scholar (which was a rare thing at that time, when learning and letters were just beginning to revive in

Italy), nevertheless he was also a very fine architect, being a man
who always took supreme delight in that art, as Scaliger relates in
his epistle against Cardan, and the learned Budé in his book
'De Asse,' and in the observations that he wrote on the Pandects.

Fra Giocondo, then, who was a fine scholar, a capable archi-
tect, and an excellent master of perspective, spent many years
near the person of the Emperor Maximilian, and was master in
the Greek and Latin tongues to the learned Scaliger, who writes
that he heard him dispute with profound learning on matters of
the greatest subtlety before the same Maximilian. It is related by
persons still living, who remember the facts very clearly, that at
the time when Verona was under the power of that Emperor the
bridge which is called the Ponte della Pietra, in that city, was
being restored, and it was seen to be necessary to refound the
central pier, which had been destroyed many times in the past,
and Fra Giocondo gave the design for refounding it, and also for
safeguarding it in such a manner that it might never be destroyed
again. His method of safeguarding it was as follows: he gave
orders that the pier should be kept always bound together
with long and thick double piles fixed below the water on
every side, to the end that these might so protect it that the river
should not be able to undermine it; for the place where it is
built is in the main current of the river, the bed of which is
so soft that no solid ground can be found on which to lay its
foundations. And excellent, in truth, as is evident from the re-
sult, was the advice of Fra Giocondo, for the reason that the
pier has stood firm from that time to our own, as it still does,
without ever showing a crack; and there is hope that, by the
observation of the suggestions given by that good monk, it will
stand for ever.

In his youth Fra Giocondo spent many years in Rome, giving
his attention to the study of antiquities, and not of buildings only,
but also of the ancient inscriptions that are in the tombs, and the
other relics of antiquity, both in Rome itself and its neighbour-
hood, and in every part of Italy; and he collected all these inscrip-
tions and memorials into a most beautiful book, which he sent
as a present, according to the account of the citizens of Verona
mentioned above, to the elder Lorenzo de' Medici, the Magnifi-
cent, to whom, by reason of the great friendliness and favour that
he showed to all men of talent, both Fra Giocondo and Domizio
Calderino, his companion and compatriot, were always most

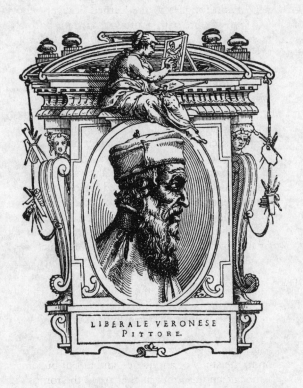

LIBERALE VERONESE
PITTORE.

deeply devoted. Of this book Poliziano makes mention in his Mugellane, in which he uses various parts of it as authorities, calling Fra Giocondo a profound master in antiquities.

The same Giocondo wrote some observations, which are in print, on the Commentaries of Cæsar; and he was the first who made a drawing of the bridge built by Cæsar over the River Rhone, and described by him in those same Commentaries, but misunderstood in the time of Fra Giocondo. Him the afore-said Budé confesses to have had as his master in the study of architecture, thanking God that he had been taught his Vitruvius by a teacher so learned and so diligent as was that monk, who corrected in that author a vast number of errors not recognized up to that time; and this he was able to do with ease, because he was a master of every kind of learning, and had a good know-ledge of both the Greek tongue and the Latin. This and other things declares Budé, extolling Fra Giocondo as an excellent architect, and adding that by the researches of the same monk there were discovered in an old library in Paris the greater part of the Epistles of Pliny, which, after having been so long out of the hands of mankind, were printed by Aldus Manutius, as may be read in a Latin letter written by him and printed with the same.

When living in Paris in the service of King Louis XII, Fra Giocondo built two superb bridges over the Seine, covered with shops – works truly worthy of that magnanimous King and of the marvellous intellect of Fra Giocondo. Wherefore that master, in addition to the inscription in his praise that may still be seen on those works, won the honour of being celebrated by Sannaz-zaro, a rare poet, in this most beautiful distich:

> Jocundus geminum imposuit tibi, Sequana, pontem;
> Hunc tu jure potes dicere pontificem.

Besides this, he executed a vast number of other works for that King throughout all his kingdom; but of these, after having made mention of those above, as being the greatest, I shall say no more.

Then, happening to be in Rome at the death of Bramante, he was placed, in company with Raffaello da Urbino and Giuliano da San Gallo, in charge of the Church of S. Pietro, to the end that the structure begun by Bramante might be carried forward. Now, from the circumstance that it had been erected in haste,

and for other reasons given in another place, it was threatening to fall in many parts, and by the advice of Fra Giocondo, Raffaello, and Giuliano, the foundations were in great measure renewed; in which work persons who were present and are still living declare that those masters adopted the following method. They excavated below the foundations many large pits after the manner of wells, but square, at a proper distance one from another, which they filled with masonry; and between every two of these piers, or rather pits filled with masonry, they threw very strong arches across the space below, insomuch that the whole building came to be placed on new foundations without suffering any shock, and was secured for ever from the danger of showing any more cracks.

But the work for which it seems to me that Fra Giocondo deserves the greatest praise is one on account of which an ever-lasting gratitude is due to him not only from the Venetians, but from the whole world as well. For he reflected that the life of the Republic of Venice depended in great measure on the preservation of its impregnable position on the lagoons on which that city, as it were by a miracle, is built; and that, whenever those lagoons silted up with earth, the air would become infected and pestilential, and the city consequently uninhabitable, or at the least exposed to all the dangers that threaten cities on the mainland. He set himself, therefore, to think in what way it might be possible to provide for the preservation of the lagoons and of the site on which the city had been built in the beginning. And having found a way, Fra Giocondo told the Signori that, if they did not quickly come to some resolution about preventing such an evil, in a few years, to judge by that which could be seen to have happened in part, they would become aware of their error, without being in time to be able to retrieve it. Roused by this warning, and hearing the powerful arguments of Fra Giocondo, the Signori summoned an assembly of the best engineers and architects that there were in Italy, at which many opinions were given and many designs made; but that of Fra Giocondo was held to be the best, and was put into execution. They made a beginning, therefore, with excavating a great canal, which was to divert two-thirds or at least one-half of the water brought down by the River Brenta, and to conduct that water by a long détour so as to debouch into the lagoons of Chioggia; and thus that river, no longer flowing into the lagoons at Venice, has not been able to fill them up by

bringing down earth, as it has done at Chioggia, where it has filled and banked up the lagoons in such a manner that, where there was formerly water, many tracts of land and villas have sprung up, to the great benefit of the city of Venice. Wherefore it is the opinion of many persons, and in particular of the Magnificent Messer Luigi Cornaro, a Venetian gentleman of ripe wisdom gained both by learning and by long experience, that, if it had not been for the warning of Fra Giocondo, all the silting up that took place in the lagoons of Chioggia would have happened, and perhaps on a greater scale, in those of Venice, inflicting incredible damage and almost ruin on that city. The same Messer Luigi, who was very much the friend of Fra Giocondo, as he is and always has been of all men of talent, declares that his native city of Venice owes an eternal debt of gratitude for this to the memory of Fra Giocondo, who on this account, he says, might reasonably be called the second founder of Venice; and that he almost deserves more praise for having preserved by that expedient the grandeur and nobility of that marvellous and puissant city, than do those who built it at the beginning in such a weak and ill-considered fashion, seeing that the benefit received from him will be to all eternity, as it has been hitherto, of incalculable utility and advantage to Venice.

Not many years after Fra Giocondo had executed this divine work, the Venetians suffered a great loss in the burning of the Rialto, the place in which are the magazines of their most precious merchandise – the treasure, as it were, of that city. This happened at the very time when that Republic had been reduced by long-continued wars and by the loss of the greater part, or rather almost the whole, of her dominions on the mainland to a desperate condition; and the Signori then governing were full of doubt and hesitation as to what they should do. However, the rebuilding of that place being a matter of the greatest importance, they resolved that it should be reconstructed at all costs. And wishing to give it all possible grandeur, in keeping with the greatness and magnificence of that Republic, and having already recognized the talent of Fra Giocondo and his great ability in architecture, they gave him the commission to make a design for that structure; whereupon he drew one in the following manner. He proposed to occupy all the space that lies between the Canale delle Beccherie,*

* Canal of the slaughter-houses.

in the Rialto, and the Rio del Fondaco delle Farine,* taking as
much ground between one canal and the other as would make a
perfect square – that is, the length of the sides of this fabric was
to be as great as the space which one covers at the present day
in walking from the debouchure of one of those canals into the
Grand Canal to that of the other. He intended, also, that the
same two canals should debouch on the other side into a com-
mon canal, which was to run from the one to the other, so that
the fabric might be left entirely surrounded by water, having the
Grand Canal on one side, the two smaller canals on two other
sides, and on the last the new canal that was to be made. Then
he desired that between the water and the buildings, right round
the square, there should be made, or rather should be left, a
beach or quay of some breadth, which might serve as a piazza
for the selling in duly appointed places of the vegetables, fruits,
fish, and other things, that come from many parts to the city. It
was also his opinion that right round the outer side of the build-
ings there should be erected shops looking out upon those same
quays, and that these shops should serve only for the sale of
eatables of every kind. And in these four sides the design of Fra
Giocondo had four principal gates – namely, one to each side,
placed in the centre, one directly opposite to another. But before
going into the central piazza, by whichever side one entered, one
would have found both on the right hand and on the left a street
which ran round the block of buildings and had shops on either
side, with handsome workshops above them and magazines for
the use of those shops, which were all to be devoted to the sale
of woven fabrics – that is, fine woollen cloth and silk, which are
the two chief products of that city. This street, in short, was to
contain all the shops that are called the Tuscan's and the silk-
merchant's.

From this double range of shops there was to be access by
way of the four gates into the centre of the whole block – that
is to say, into a vast piazza surrounded on every side by spacious
and beautiful loggie for the accommodation of the merchants and
for the use of the great number of people who flock together for
the purposes of their trade and commerce to that city, which is
the custom-house of all Italy, or rather of Europe. Under those
loggie, on every side, were to be the shops of the bankers,

* Small canal of the corn-magazines.

goldsmiths, and jewellers; and in the centre was to be built a most beautiful temple dedicated to S. Matthew, in which the people of quality might be able to hear the divine offices in the morning. With regard to this temple, however, some persons declare that Fra Giocondo changed his mind, and wished to build two under the loggie, so as not to obstruct the piazza. And, in addition, this superb structure was to have so many other conveniences, embellishments, and adornments, all in their proper places, that whoever sees at the present day the beautiful design that Fra Giocondo made for the whole, declares that nothing more lovely, more magnificent, or planned with better order, could be imagined or conceived by the most excellent of craftsmen, be his genius never so happy.

It was proposed, also, with the advice of the same master, and as a completion to this work, to build the Bridge of the Rialto of stone, covered with shops, which would have been a marvellous thing. But this enterprise was not carried into effect, for two reasons: first, because the Republic, on account of the extraordinary expenses incurred in the last war, happened to be drained dry of money; and, secondly, because a gentleman of great position and much authority at that time (of the family, so it is said, of Valereso), being a man of little judgment in such matters, and perchance influenced by some private interest, chose to favour one Maestro Zanfragnino,* who, so I am informed, is still alive, and who had worked for him on buildings of his own. This Zanfragnino – a fit and proper name for a master of his calibre – made the design for that medley of marble which was afterwards carried into execution, and which is still to be seen; and many who are still alive, and remember the circumstances very well, are even yet not done with lamenting that foolish choice.

Fra Giocondo, having seen that shapeless design preferred to his beautiful one, and having perceived how much more virtue there often is in favour than in merit with nobles and great persons, felt such disdain that he departed from Venice, nor would he ever return, although he was much entreated to do it. And the design, with others by the same monk, remained in the house of the Bragadini, opposite to S. Marina, in the possession of Frate Angelo, a member of that family and a friar of S. Dominic, who,

* Scarpagnino.

by reason of his many merits, afterwards became Bishop of Vicenza.

Fra Giocondo was very versatile, and delighted, in addition to the pursuits already mentioned, in simples and in agriculture. Thus Messer Donato Giannotti, the Florentine, who was very much his friend for many years in France, relates that once, when living in that country, the monk reared a peach-tree in an earthen pot, and that this little tree, when he saw it, was so laden with fruit that it was a marvellous sight. On one occasion, by the advice of some friends, he had set it in a place where the King was to pass and would be able to see it, when certain courtiers, who passed by first, plucked all the peaches off that little tree, as suchlike people were sure to do, and, playing about with one another, scattered what they could not eat along the whole length of the street, to the great displeasure of Fra Giocondo. The matter coming to the ears of the King, he first laughed over the jest with the courtiers, and then, after thanking the monk for what he had done to please him, gave him a present of such a kind that he was consoled.

Fra Giocondo was a man of saintly and most upright life, much beloved by all the great men of letters of his age, and in particular by Domizio Calderino, Matteo Bosso, and Paolo Emilio, the writer of the History of France, all three his compatriots. Very much his friends, likewise, were Sannazzaro, Budé, and Aldus Manutius, with all the Academy of Rome; and he had a disciple in Julius Cæsar Scaliger, one of the most learned men of our times. Finally, being very old, he died, but precisely at what time and in what place this happened, and consequently where he was buried, is not known.

Even as it is true that the city of Verona is very similar to Florence in situation, manners, and other respects, so it is also true that in the first as well as in the second there have always flourished men of the finest genius in all the noblest and most honourable professions. Saying nothing of the learned, for with them I have nothing to do here, and continuing to speak of the men of our arts, who have always had an honourable abode in that most noble city, I come to Liberale of Verona, a disciple of Vincenzio di Stefano, a native of the same city, already mentioned in another place, who executed for the Church of Ognissanti, belonging to the Monks of S. Benedict, at Mantua, in the year 1463, a Madonna that was a very praiseworthy example of

the work of those times. Liberale imitated the manner of Jacopo
Bellini, for when a young man, while the said Jacopo was painting
the Chapel of S. Niccolò at Verona, he gave his attention under
Bellini to the studies of design in such thorough fashion that,
forgetting all that he had learned from Vincenzio di Stefano, he
acquired the manner of Bellini and retained it ever after.

The first paintings of Liberale were in the Chapel of the
Monte della Pietà in S. Bernardino, in his native city; and there,
in the principal picture, he painted a Deposition from the Cross,
with certain Angels, some of whom have in their hands the Mys-
teries (for so they are called) of the Passion, and all with their
weeping faces show grief at the Death of the Saviour. Very natu-
ral, in truth, are these figures, as are other works of the same kind
by this master, who strove to show in many places that he was
able to paint weeping countenances. This may also be seen in
S. Anastasia, a church of Friars of S. Dominic, likewise in Vero-
na, where he painted a Dead Christ with the Maries mourning
for Him on the pediment of the Chapel of the Buonaveri; and
he executed many pictures in the same manner of painting as the
work mentioned above, which are dispersed among the houses
of various gentlemen in Verona.

In the same chapel he painted a God the Father surrounded
by many Angels who are playing instruments and singing, with
three figures on either side – S. Peter, S. Dominic, and S. Thomas
Aquinas on one side, and S. Lucia, S. Agnese, and another female
Saint on the other; but the first three are much the finer, being
executed in a better manner and with more relief. On the main
wall of that chapel he painted Our Lady, with the Infant Christ
marrying S. Catharine, the Virgin-Martyr; and in this work he
made a portrait of Messer Piero Buonaveri, the owner of the
chapel. Around this group are some Angels presenting flowers,
with some heads that are smiling, executed with such grace in
their gladness, that they prove that he was able to paint a smiling
face as well as he had painted tears in other figures. In the altar-
piece of the same chapel he painted S. Mary Magdalene in the air,
supported by some Angels, with S. Catharine below – a work
which was held to be very beautiful. On the altar of the Madonna
in the Church of S. Maria della Scala, belonging to the Servite
Friars, he executed the story of the Magi on two folding-doors
that enclose that Madonna, which is held in vast veneration
in that city; but the work did not long remain there, for it was

removed because it was being spoilt by the smoke of the candles, and placed in the sacristy, where it is much admired by the painters of Verona.

In the tramezzo* of the Church of S. Bernardino, above the Chapel of the Company of the Magdalene, he painted in fresco the story of the Purification, wherein is a figure of Simeon that is much extolled, as also is that of the Infant Christ, who with great affection is kissing that old man, who is holding Him in his arms; and very beautiful, likewise, is a priest standing there on one side, who, with his arms extended and his face uplifted towards Heaven, appears to be thanking God for the salvation of the world. Beside this chapel is a picture of the story of the Magi by the hand of the same Liberale; and in the pediment of the picture there is the Death of the Madonna, executed with little figures, which are highly extolled. Great, indeed, was his delight in painting works with little figures, with which he always took such pains that they seem to be the work rather of an illuminator than of a painter, as may be seen in the Duomo of the same city, where there is a picture by his hand of the story of the Magi, with a vast number of little figures, horses, dogs, and various other animals, and near them a group of rosy-coloured Cherubim, who serve as a support to the Mother of Jesus. In this picture the heads are so finished, and everything is executed with such diligence, that, as I have said, it appears to be the work of an illuminator.

He also painted stories of Our Lady on a small predella, likewise after the manner of miniatures, for the Chapel of the Madonna in the Duomo. But this was afterwards removed from that chapel by order of Monsignor Messer Giovan Matteo Giberti, Bishop of Verona, and placed in the Palace of the Vescovado, which is the residence of the Bishops, in that chapel wherein they hear Mass every morning. And there that predella stands in company with a most beautiful Crucifix in relief, executed by Giovanni Battista Veronese, a sculptor, who now lives in Mantua. Liberale also painted a panel-picture for the Chapel of the Allegni in S. Vitale, containing a figure of S. Mestro, the Confessor, a Veronese and a man of great sanctity, whom he placed between a S. Francis and a S. Dominic. For the Chapel of S. Girolamo in the Vittoria, a church and convent of certain Eremite Friars,

* See note on page 90, Vol. I.

he executed at the commission of the Scaltritegli family an altar-piece of S. Jerome in the habit of a Cardinal, with a S. Francis and a S. Paul, all much extolled. And in the tramezzo* of the Church of S. Giovanni in Monte he painted the Circumcision of Christ and other works, which were destroyed not long since, because it was considered that the tramezzo impaired the beauty of the church.

Being then summoned to Siena by the General of the Monks of Monte Oliveto, Liberale illuminated many books for that Order; and in these he succeeded so well, that he was commissioned in consequence to illuminate some that had been left unfinished – that is to say, only written – in the library of the Piccolomini. He also illuminated some books of plain-song for the Duomo of that city, where he would have remained longer, executing many works that he had in hand; but, being driven away by envy and persecution, he set off to return to Verona, with eight hundred crowns that he had earned, which he lent afterwards to the Monks of Monte Oliveto at S. Maria in Organo, from whom he drew interest to support him from day to day.

Having thus returned to Verona, he gave his attention for the rest of his life more to illumination than to any other kind of work. At Bardolino, a place on the Lake of Garda, he painted a panel-picture which is now in the Pieve; and another for the Church of S. Tommaso Apostolo. For the Chapel of S. Bernardo, likewise, in the Church of S. Fermo, a convent of Friars of S. Francis, he painted a panel-picture of the first-named Saint, with some scenes from his life in the predella. In the same place, also, and in others, he executed many nuptial pictures, one of which, containing the Madonna with the Child in her arms marrying S. Catharine, is in the house of Messer Vincenzio de' Medici at Verona.

On the corner of the house of the Cartai, on the way from the Ponte Nuovo to S. Maria in Organo, in Verona, he painted a Madonna and S. Joseph in fresco, a work which was much extolled. Liberale would have liked to paint the Chapel of the Riva family, which had been built in order to honour the memory of Giovanni Riva, a captain of men-at-arms at the battle of the Taro, in the Church of S. Eufemia; but he did not receive the commission, which was given to some strangers, and he was told

* See note on page 90, Vol. I.

that he was too old and that his sight was failing him. When this chapel was opened, a vast number of faults were perceived in it, and Liberale said that he who had given the commission had been much more blind than himself.

Finally, being eighty-four years of age, or even more, Liberale allowed himself to be ruled by his relatives, and particularly by a married daughter, who, like the rest, treated him very badly. At which, having grown angry both with her and with his other relatives, and happening to have under his charge one Francesco Turbido, called Il Moro, then a young man, who was a diligent painter and much affected towards him, he appointed him as heir to the house and garden that he had at S. Giovanni in Valle, a very pleasant part of the city; and with him he took up his quarters, saying that he would rather give the enjoyment of his property to one who loved virtue than to those who ill-treated their nearest of kin. But no long time passed before he died, which was on the day of S. Chiara in the year 1536, at the age of eighty-five; and he was buried in S. Giovanni in Valle.

His disciples were Giovan Francesco Caroto and Giovanni Caroto, Francesco Turbido, called Il Moro, and Paolo Cavazzuola, of whom, since they were truly excellent masters, I shall make mention in their due order.

Giovan Francesco Caroto was born at Verona in the year 1470, and after having learned the first rudiments of letters, being drawn to painting, he abandoned the studies of grammar and placed himself to learn painting under the Veronese Liberale, undertaking to recompense him for his pains. Young as he was, then, Giovan Francesco devoted himself with such love and diligence to design, that even in his earliest years he was a great assistance to Liberale both in that and in colouring. No long time after, when his judgment had increased with his years, he saw the works of Andrea Mantegna in Verona; and thinking, as indeed was the truth, that these were of another manner and better than those of his master, he so wrought upon his father that he was given leave, with the gracious consent of Liberale, to apprentice himself to Mantegna. Having gone to Mantua, therefore, and having placed himself under Mantegna, in a short time he made such proficience that Andrea sent out works by Caroto as works by his own hand. In short, before many years had passed by, he had become an able master. The first works that he executed after leaving the discipline of Mantegna were on the altar of the

three Magi in the Church of the Hospital of S. Cosimo at Verona, where he painted on the folding-doors that enclose that altar the Circumcision of Christ and the Flight into Egypt, with other figures. In the Church of the Frati Ingiesuati, called S. Girolamo, in two angles of a chapel, he painted the Madonna and the Angel of the Annunciation. And for the Prior of the Friars of S. Giorgio he executed a little panel-picture of the Manger, in which he may be seen to have greatly improved his manner, since the heads of the shepherds and of all the other figures have expressions so sweet and so beautiful, that this work was much extolled, and that rightly; and if it were not that the priming of gesso is peeling off through having been badly prepared, so that the picture is gradually perishing, it would be enough by itself to keep him alive for ever in the memory of his fellow-citizens.

Next, having been commissioned by the men who governed the Company of the Angel Raphael to paint their chapel in the Church of S. Eufemia, he executed therein two stories of the Angel Raphael in fresco, and in the altar-piece, in oils, three large Angels, Raphael in the centre, and Gabriel and Michael on either side, and all with good draughtsmanship and colouring. He was reproached, indeed, for having made the legs of those Angels too slender and wanting in softness; to which he made a pleasant and gracious answer, saying that even as Angels were represented with wings and with bodies, so to speak, celestial and ethereal, as if they were birds, so it was only right to make their legs lean and slender, to the end that they might fly and soar upwards with greater ease. For that altar of the Church of S. Giorgio where there is a Christ bearing His Cross, he painted S. Rocco and S. Sebastian, with some scenes in the predella executed with very beautiful little figures. And by order of the Company of the Madonna he painted on the predella of the altar of that Company, in S. Bernardino, the Nativity of the Madonna and the Massacre of the Innocents, with a great variety of attitudes in the murderers and in the groups of children whom their mothers are defending with all their might. This work is held in great veneration, and is kept covered, the better to preserve it; and it was the reason that the men of the Fraternity of S. Stefano commissioned him to paint three pictures with similar figures for their altar in the old Duomo of Verona, containing three little scenes from the life of Our Lady – her Marriage, the Nativity of Christ, and the story of the Magi.

After these works, thinking that he had gained enough credit in Verona, Giovan Francesco was minded to depart and make trial of other places; but his friends and relatives, pressing him much, persuaded him to take to wife a young woman of noble birth, the daughter of Messer Braliassarti Grandoni, whom he married in 1505. In a short time, however, after he had had a son by her, she died in child-birth; and Giovan Francesco, thus left free, departed from Verona and went off to Milan, where Signor Anton Maria Visconti received him into his house and caused him to execute many works for its adornment.

Meanwhile there was brought to Milan by a Fleming a head of a young man, taken from life and painted in oils, which was admired by everyone in that city; but Giovan Francesco, seeing it, laughed and said: 'I am confident that I can do a better.' At which the Fleming mocked him, but after many words the matter came to this, that Giovan Francesco was to try his hand, losing his own picture and twenty-five crowns if he lost, and winning the Fleming's head and likewise twenty-five crowns if he won. Setting to work, therefore, with all his powers, Giovan Francesco made a portrait of an aged gentleman with shaven face, with a falcon on his wrist; but, although this was a good likeness, the head of the Fleming was judged to be the better. Giovan Francesco did not make a good choice in executing his portrait, for he took a head that could not do him honour; whereas, if he had chosen a handsome young man, and had made as good a likeness of him as he did of the old man, he would at least have equalled his adversary's picture, even if he had not surpassed it. But for all this the head of Giovan Francesco did not fail to win praise, and the Fleming showed him courtesy, for he contented himself with the head of the shaven old man, and, being a noble and courteous person, would by no means accept the five-and-twenty crowns. This picture came after some time into the possession of Madonna Isabella d'Este, Marchioness of Mantua, who paid a very good price for it to the Fleming and placed it as a choice work in her study, in which she had a vast number of very beautiful coins, pictures, works in marble, and castings.

After completing his work for Visconti, Giovan Francesco, being invited by Guglielmo, Marquis of Montferrat, went willingly to serve him, as Visconti straitly besought him to do. On his arrival, a fine provision was assigned to him; and, setting to work, he painted for that noble at Casale, in a chapel where he heard

Mass, as many pictures as were necessary to fill it and adorn it on every side, with subjects from the Old Testament and the New, which were executed by him with supreme diligence, as was also the chief altar-piece. He then executed many works throughout the apartments of that Castle, which brought him very great fame. And in S. Domenico, by order of that Marquis, he painted the whole of the principal chapel for the adornment of the tomb wherein he was to be laid to rest; in which work Giovan Francesco acquitted himself so well, that he was rightly rewarded with honourable gifts by the liberality of his patron, who also favoured him by making him one of his own chamberlains, as may be seen from an instrument that is in the possession of his heirs at Verona. He made portraits of that lord and of his wife, with many pictures that they sent to France, and also the portrait of Guglielmo, their eldest child, who was then a boy, and likewise portraits of their daughters and of all the ladies who were in the service of the Marchioness.

On the death of the Marquis Guglielmo, Giovan Francesco departed from Casale, after first selling all the property that he had in those parts, and made his way to Verona, where he so arranged his affairs and those of his son, to whom he gave a wife, that in a short time he found himself in possession of more than seven thousand ducats. But he did not therefore abandon his painting; indeed, having a quiet mind, and not being obliged to rack his brain for a livelihood, he gave more attention to it than ever. It is true that either from envy or for some other reason he was accused of being a painter who could do nothing but little figures; wherefore, in executing the altar-piece of the Chapel of the Madonna in S. Fermo, a convent of Friars of S. Francis, wishing to show that the accusation was a calumny, he painted the figures larger than life, and so well, that they were the best that he had ever done. In the air is Our Lady seated in the lap of S. Anne, with some Angels standing upon clouds, and beneath are S. Peter, S. John the Baptist, S. Rocco, and S. Sebastian; and not far away, in a most beautiful landscape, is S. Francis receiving the Stigmata. This work, indeed, is held by craftsmen to be not otherwise than good.

For the Chapel of the Cross in S. Bernardino, a seat of the Frati Zoccolanti, he painted Christ kneeling on one knee and taking leave of His Mother. In this work, stirred to emulation by the many notable pictures by the hands of other masters that are

in that place, he strove to surpass them all; wherefore, in truth, he acquitted himself very well, and was praised by all who saw it, save only by the Guardian of that convent, who, like the boorish and solemn fool that he was, reproved Giovan Francesco with biting words, saying that he had made Christ show such little reverence to His Mother as to kneel only upon one knee. To which Giovan Francesco answered by saying: 'Father, first do me the favour of kneeling down and rising up again, and I will then tell you for what reason I have painted Christ so.' The Guardian, after much persuasion, knelt down, placing on the ground first his right knee and then his left; and in rising up he raised first the left and then the right. Which done, Giovan Francesco said: 'Did you observe, Father Guardian, that you neither knelt down nor rose up with both knees together? I tell you, therefore, that this Christ of mine is right, because one might say that He is either coming to His knees before His Mother, or beginning, after having knelt a while, to raise one leg in order to rise.' At which the Guardian had to appear a little appeased, although he went off muttering under his breath.

Giovan Francesco was very sharp in his answers; and it is also related of him that once, being told by a priest that his figures were too seductive for altar-pieces, he replied: 'A lusty fellow you must be, if painted figures so move you. Think how much you are to be trusted in places where there are living people for you to touch.' At Isola, a place on the Lake of Garda, he painted two panel-pictures for the Church of the Zoccolanti; and at Malsessino, a township above that same lake, he painted a very beautiful Madonna over the door of a church, and some Saints within the church, at the request of Fracastoro, a very famous poet, who was much his friend. For Count Giovan Francesco Giusti, executing a subject conceived by that nobleman, he painted a young man wholly naked except for the parts of shame, and in an attitude of indecision as to whether he shall rise up or not; and on one side he had a most beautiful young woman representing Minerva, who with one hand was pointing out to him a figure of Fame on high, and with the other was urging him to follow her; but Sloth and Idleness, who were behind the young man, were striving to detain him. Below these was a figure with an uncouth face, rather that of a slave and a plebeian than of one of noble blood, who had two great snails clinging to his elbows and was seated on a crab, and near him was another figure with the hands full of poppies.

This invention, in which are other beautiful details and fancies, was executed by Giovan Francesco with supreme diligence and love; and it serves as the head-board of a bedstead at that noble-man's lovely place near Verona, which is called S. Maria in Stella.

The same master painted the whole of a little chamber with various scenes in little figures, for Count Raimondo della Torre. And since he delighted to work in relief, he executed not only models for his own purposes and for the arrangement of draperies, but also other things of his own fancy, of which there are some to be seen in the house of his heirs, and in particular a scene in half-relief, which is not otherwise than passing good. He also executed portraits on medallions, and some are still to be seen, such as that of Guglielmo, Marquis of Montferrat, which has on the reverse a Hercules slaying . . . , with a motto that runs: 'Monstra domat.' He painted portraits of Count Raimondo della Torre, Messer Giulio his brother, and Messer Girolamo Fracastoro.

But when Giovan Francesco became old, he began gradually to lose his mastery over art, as may be seen from the organ-doors in S. Maria della Scala, from the panel-picture of the Movi family, wherein is a Deposition from the Cross, and from the Chapel of S. Martino in S. Anastasia. Giovan Francesco had always a great opinion of himself, and not for anything in the world would he have ever copied another man's work in his own. Now Bishop Giovan Matteo Giberti wished him to paint some stories of the Madonna in the great chapel of the Duomo, and had the designs for these drawn in Rome by Giulio Romano, who was very much his friend (for Giberti was Datary to Pope Clement VII). But, when the Bishop had returned to Verona, Giovan Francesco would never consent to execute these designs; at which the Bishop, in disdain, caused them to be put into execution by Francesco, called Il Moro.

Giovan Francesco held an opinion, in which he was not far from the truth, that varnishing pictures spoiled them, and made them become old sooner than they otherwise would; and for this reason he used varnish in the darks while painting, together with certain purified oils. He was also the first who executed land-scapes well in Verona; wherefore there are some by his hand to be seen in that city, which are very beautiful. Finally, when seventy-six years of age, Giovan Francesco died the death of a good Christian, leaving his grandchildren and his brother,

Giovanni Caroto, passing well provided. This Giovanni, after first applying himself to art under his brother, and then spending some time in Venice, had just returned to Verona when Giovan Francesco passed to the other life; and thus he took a hand with the grandchildren in inspecting the things of art that had been left to them. Among these they found a portrait of an old man in armour, very beautiful both in drawing and in colour, which was the best work by the hand of Giovan Francesco that was ever seen; and likewise a little picture containing a Deposition from the Cross, which was presented to Signor Spitech, a man of great authority with the King of Poland, who had come at that time to some baths that are in the territory of Verona. Giovan Francesco was buried in the Madonna dell' Organo, in the Chapel of S. Niccolò, which he himself had adorned with his paintings.

Giovanni Caroto, brother of Giovan Francesco, although he followed the manner of the latter, yet gained less reputation in the practice of painting. This master painted the altar-piece in the above-mentioned Chapel of S. Niccolò, wherein is the Madonna enthroned on clouds; and below this he placed a portrait of himself, taken from life, and that of his wife Placida. He also painted some little figures of female Saints for the altar of the Schioppi in the Church of S. Bartolommeo, together with a portrait of Madonna Laura degli Schioppi, who had caused that chapel to be built, and who was much celebrated by the writers of those times no less for her virtues than for her beauty. Giovanni likewise painted a S. Martin in a little altar-piece for S. Giovanni in Fonte, near the Duomo; and he made a portrait of Messer Marc' Antonio della Torre (who afterwards became a man of learning and gave public lectures at Padua and Pavia) as a young man, and also one of Messer Giulio; which heads are in the possession of their heirs at Verona. For the Prior of S. Giorgio he painted a picture of Our Lady, which, as a good painting, has been kept ever since, as it still is, in the chamber of the Priors. And he painted another picture, representing the transformation of Actaeon into a stag, for the organist Brunetto, who afterwards presented it to Girolamo Cicogna, an excellent embroiderer, and engineer to Bishop Giberti; and it now belongs to Messer Vincenzio Cicogna, his son.

Giovanni took ground-plans of all the ancient buildings of Verona, with the triumphal arches and the Colosseum. These were revised by the Veronese architect Falconetto, and they were

meant for the adornment of the book of the Antiquities of Verona, which had been written after his own original research by Messer Torello Saraina, who afterwards had the book printed. This book was sent to me by Giovanni Caroto when I was in Bologna (where I was executing the work of the Refectory of S. Michele in Bosco), together with the portrait of the reverend Father, Don Cipriano da Verona, who was twice General of the Monks of Monte Oliveto; and the portrait, which was sent to me by Giovanni to the end that I might make use of it, as I did, for one of those pictures, is now in my house at Florence, with other paintings by the hands of various masters.

Finally, having lived without children and without ambition, but with good means, Giovanni died at about the age of sixty, full of gladness because he saw some of his disciples, particularly Anselmo Canneri and Paolo Veronese, already in good repute. Paolo is now working in Venice, and is held to be a good master; and Anselmo has executed many works both in oils and in fresco, and in particular at the Villa Soranza on the Tesino, and in the Palace of the Soranzi at Castelfranco, and also in many other places, but more at Vicenza than anywhere else. But to return to Giovanni; he was buried in S. Maria dell' Organo, where he had painted a chapel with his own hand.

Francesco Turbido, called Il Moro, a painter of Verona, learned the first rudiments of art, when still quite young, from Giorgione da Castelfranco, whom he imitated ever afterwards in colouring and in softness of painting. But just when Il Moro was making progress, he came to words with I know not whom, and handled him so roughly, that he was forced to leave Venice and return to Verona. There, abandoning his painting, since he was somewhat ready with his hands and associated with the young noblemen, being a person of very good breeding, he lived for a time without doing any work. And associating in this way, in particular, with the Counts Sanbonifazi and the Counts Giusti, two illustrious families of Verona, he became so intimate with them that he lived in their houses as if he had been born in them; and, what is more, no long time passed before Count Zenovello Giusti gave him a natural daughter of his own for a wife, and granted him a commodious apartment in his own house for himself, his wife, and the children that were born to them.

It is said that Francesco, while living in the service of those noblemen, always carried a pencil in his pouch; and wherever he

went, if only he had time, he would draw a head or something else on the walls. Wherefore the same Count Zenovello, seeing him to be so much inclined to painting, relieved him of his other duties, like the generous nobleman that he was, and made him give his whole attention to art; and since Francesco had all but forgotten everything, he placed himself, through the good offices of that patron, under Liberale, a famous painter and illuminator of that time. And thus, practising under that master without ever ceasing, he went on making such progress from one day to another, that not only did all that he had forgotten awaken in his memory, but he also acquired in a short time as much more knowledge as sufficed to make him an able craftsman. It is true, however, that, although he always held to the manner of Liberale, he yet imitated the softness and well-blended colouring of Giorgione, his first instructor, believing that the works of Liberale, while good in other respects, suffered from a certain dryness.

Now Liberale, having recognized the beauty of Francesco's spirit, conceived such an affection for him, that he loved him ever afterwards as a son, and, when death came upon him, left him heir to all his possessions. And thus, after the death of Liberale, Francesco followed in his steps and executed many works, which are dispersed among various private houses. Of those in Verona which deserve to be extolled above all others, the first is the great chapel of the Duomo, on the vaulting of which are four large pictures painted in fresco, wherein are the Nativity of the Madonna and the Presentation in the Temple, and, in the picture in the centre, which appears to recede inwards, three Angels in the air, who are seen foreshortened from below, and are holding a crown of stars wherewith to crown the Madonna, who is in the recess, in the act of ascending into Heaven, accompanied by many Angels, while the Apostles are gazing upwards in attitudes of great variety; and these Apostles are figures twice the size of life. All these pictures were executed by Il Moro after the designs of Giulio Romano, according to the wish of Bishop Giovan Matteo Giberti, who gave the commission for the work, and who, as has been said, was very much the friend of that same Giulio.

After this Il Moro painted the façade of the house of the Manuelli, which stands on the abutment of the Ponte Nuovo, and a façade for Torello Saraina, the doctor, who wrote the above-mentioned book of the Antiquities of Verona. In Friuli, likewise, he painted in fresco the principal chapel of the Abbey

of Rosazzo, for Bishop Giovan Matteo, who held it 'in commendam,' and, being a noble and truly religious dignitary, rebuilt it; for it had been allowed to fall completely into ruin, as such buildings are generally found to be, by those who had held it 'in commendam' before him, attending only to the drawing of the revenues and spending not a farthing in the service of God and of the Church.

Il Moro afterwards painted many works in oils at Verona and in Venice. On the outer wall (of a chapel) in S. Maria in Organo he executed in fresco the figures that are still there, with the exception of the Angel Michael and the Angel Raphael, which are by the hand of Paolo Cavazzuola. For the same chapel he painted an altar-piece in oils, wherein he made a portrait of Messer Jacopo Fontani, who gave the commission for the work, in a figure of S. James, in addition to the Madonna and other very beautiful figures. And in a large semicircle above that altar-piece, occupying the whole width of the chapel, he painted the Transfiguration of Our Lord, and the Apostles beneath, which were held to be among the best figures that he ever executed. For the Chapel of the Bombardieri, in S. Eufemia, he painted an altar-piece with S. Barbara in the heavens, in the centre, and a S. Anthony below, with his hand on his beard, which is a most beautiful head, and on the other side a S. Rocco, which is also held to be a very good figure; whence this work is rightly looked upon as one executed with supreme diligence and unity of colouring. In a picture on the altar of the Santificazione, in the Madonna della Scala, he painted a S. Sebastian, in competition with Paolo Cavazzuola, who executed a S. Rocco in another picture; and he afterwards painted an altar-piece that was taken to Bagolino, a place in the mountains of Brescia.

Il Moro executed many portraits, and his heads are in truth beautiful to a marvel, and very good likenesses of those whom they were meant to represent. At Verona he executed a portrait of Count Francesco Sanbonifazio, who, on account of the length of his body, was called the Long Count; with that of one of the Franchi, which was an amazing head. He also painted the portrait of Messer Girolamo Verità, which remained unfinished, because Il Moro was inclined to be dilatory in his work; and this, still unfinished, is in the possession of the sons of that good nobleman. Among many other portraits, likewise, he executed one of the Venetian, Monsignor de' Martini, a knight of Rhodes, and to

the same man he sold a head of marvellous beauty and excellence, which he had painted many years before as the portrait of a Venetian gentleman, the son of one who was then Captain in Verona. This head, through the avarice of the Venetian, who never paid him, was left in the hands of Francesco, and he disposed of it to Monsignor de' Martini, who had the Venetian dress changed into that of a shepherd or herdsman. It is as rare a portrait as ever issued from the hand of any craftsman, and it is now in the house of the heirs of the same Monsignor de' Martini, where it is rightly held in vast veneration. In Venice he painted a portrait of Messer Alessandro Contarini, Procurator of S. Mark and Proveditor of the forces, and one of Messer Michele San Michele for one of Messer Michele's dearest friends, who took the portrait to Orvieto; and it is said that he executed another of the same architect, Messer Michele, which is now in the possession of Messer Paolo Ramusio, the son of Messer Giovan Battista. He also painted a portrait of Fracastoro, a very famous poet, at the instance of Monsignor Giberti, by whom it was sent to Giovio, who placed it in his museum.

Il Moro executed many other works, of which there is no need to make mention, although they are all well worthy of remembrance, because he was as diligent a colourist as any master that lived in his day, and because he bestowed much time and labour on his work. So great, indeed, was his diligence, that it brought upon him more blame than praise, as may also be seen at times to happen to others, for the reason that he accepted any commission and took the earnest-money from every patron, and trusted to the will of God to finish the work; and if he did this in his youth, everyone may imagine what he must have done in his last years, when to his natural slowness there was added that which old age brings in its train. By this method of procedure he brought upon himself more entanglements and annoyances than he cared for; and Messer Michele San Michele, therefore, moved by compassion for him, took him into his house in Venice and treated him like a friend and man of talent.

Finally, having been invited back to Verona by his former patrons, the Counts Giusti, Il Moro died among them in their beautiful Palace of S. Maria in Stella, and was buried in the church of that villa, being accompanied to his tomb by all those loving noblemen, and even laid to rest with extraordinary affection by their own hands; for they loved him as a father, since they

had all been born and brought up while he was living in their house. In his youth Il Moro was very courageous and agile in body, and handled all kinds of arms with great skill. He was most faithful to his friends and patrons, and he showed spirit in all his actions. His most intimate friends were the architect, Messer Michele San Michele, Danese da Carrara, an excellent sculptor, and the very reverend and most learned Fra Marco de' Medici, who often went after his studies to sit with him, watching him at work, and discoursing lovingly with him, in order to refresh his mind when he was weary with labour.

A disciple and son-in-law of Il Moro, who had two daughters, was Battista d' Agnolo, who was afterwards called Battista del Moro. This master, although he had his hands full for a time with the complications of the inheritance that Il Moro bequeathed to him, has yet executed many works which are not otherwise than passing good. In Verona he has painted a S. John the Baptist in the Church of the Nuns of S. Giuseppe, and in the tramezzo* of S. Eufemia, above the altar of S. Paolo, a scene in fresco showing the latter Saint presenting himself to Ananias after being converted by Christ; which work, although he executed it when still a lad, is much extolled. For the noble Counts Canossi he painted two apartments, and in a hall two friezes with battle-pieces, which are very beautiful and praised by everyone. In Venice he painted the façade of a house near the Carmine, a work of no great size, but much extolled, in which he executed a figure of Venice crowned and seated upon a lion, the device of that Republic. For Camillo Trevisano he painted the façade of his house at Murano, and in company with his son Marco he decorated the inner court with very beautiful scenes in chiaroscuro. And in competition with Paolo Veronese he painted a large chamber in the same house, which proved to be so beautiful that it brought him much honour and profit.

The same master has also executed many works in miniature, of which the most recent is a very beautiful drawing of S. Eustachio adoring Christ, who has appeared to him between the horns of a deer, with two dogs near him, which could not be more excellent, and a landscape full of trees, receding and fading away little by little into the distance, which is an exquisite thing. This drawing has been very highly praised by the many persons who

* See note on page 90, Vol. I.

have seen it, and particularly by Danese da Carrara, who saw it when he was in Verona, carrying out the work of the Chapel of the Signori Fregosi, which is one of rare distinction among all the number that there are in Italy at the present day. Danese, I say, having seen this drawing, was lost in astonishment at its beauty, and exhorted the above-mentioned Fra Marco de' Medici, his old and particular friend, not for anything in the world to let it slip through his hands, but to contrive to place it among the other choice examples of all the arts in his possession. Whereupon Battista, having heard that Fra Marco desired it, and knowing of his friendship with his father-in-law, gave it to him, almost forcing him to accept it, in the presence of Danese; nor was that good Father ungrateful to him for so much courtesy. However, since that same Battista and his son Marco are alive and still at work, I shall say nothing more of them for the present.

Il Moro had another disciple, called Orlando Fiacco, who has become a good master and a very able painter of portraits, as may be seen from the many that he has painted, all very beautiful and most lifelike. He made a portrait of Cardinal Caraffa when he was returning from Germany, which he took secretly by torch-light while the Cardinal was at supper in the Vescovado of Verona; and this was such a faithful likeness that it could not have been improved. He also painted a very lifelike portrait of the Cardinal of Lorraine, when, coming from the Council of Trent, he passed through Verona on his return to Rome; and likewise portraits of the two Bishops Lippomani of Verona, Luigi the uncle and Agostino the nephew, which Count Giovan Battista della Torre now has in a little apartment. Other portraits that he painted were those of Messer Adamo Fumani, a Canon and a very learned gentleman of Verona, of Messer Vincenzio de' Medici of Verona, and of his consort, Madonna Isotta, in the guise of S. Helen, and of their grandson, Messer Niccolò. He has likewise executed portraits of Count Antonio della Torre, of Count Girolamo Canossi, and his brothers, Count Lodovico and Count Paolo, of Signor Astorre Baglioni, Captain-General of all the light cavalry of Venice and Governor of Verona, the latter clad in white armour and most beautiful in aspect, and of his consort, Signora Ginevra Salviati. In like manner, he has portrayed the eminent architect Palladio and many others; and he still continues at work, wishing to become in the art of painting as true an Orlando as once was that great Paladin of France.

In Verona, where an extraordinary degree of attention has been given to design ever since the death of Fra Giocondo, there have flourished at all times men excellent in painting and architecture, as will now be seen, in addition to what has been observed hitherto, in the Lives of Francesco Monsignori, of Domenico Morone and his son Francesco, of Paolo Cavazzuola, of the architect Falconetto, and, lastly, of the miniaturists Francesco and Girolamo.

Francesco Monsignori, the son of Alberto, was born at Verona in the year 1455; and when he was well grown he was advised by his father, who had always delighted in painting, although he had not practised it save for his own pleasure, to give his attention to design. Having, therefore, gone to Mantua to seek out Mantegna, who was then working in that city, he exerted himself in such a manner, being fired by the fame of his instructor, that no long time passed before Francesco II, Marquis of Mantua, who found an extraordinary delight in painting, took him into his own service; and in the year 1487 he gave him a house for his habitation in Mantua, and assigned him an honourable provision. For these benefits Francesco was not ungrateful, for he always served that lord with supreme fidelity and lovingness; whence the Marquis came to love and favour him more and more every day, insomuch that he could not leave the city without having Francesco in his train, and was once heard to say that Francesco was as dear to him as the State itself.

Francesco painted many works for that lord in his Palace of S. Sebastiano at Mantua, and also in the Castello di Gonzaga and in the beautiful Palace of Marmirolo without the city. In the latter Francesco had finished painting in the year 1499, after a vast number of other pictures, some triumphs and many portraits of gentlemen of the Court; and on Christmas Eve, on which day he had finished those works, the Marquis presented to him an estate of a hundred fields in the territory of Mantua, at a place called La Marzotta, with a mansion, garden, meadows, and other things of great beauty and convenience. He was most excellent at taking portraits from life, and the Marquis caused him to paint many portraits, of himself, of his sons, and of many other lords of the house of Gonzaga, which were sent to France and Germany as presents for various Princes. And many of these portraits are still in Mantua, such as those of the Emperor Frederick Barbarossa; of Doge Barbarigo of Venice; of Francesco Sforza,

Duke of Milan; of Massimiliano, also Duke of Milan, who died in France; of the Emperor Maximilian; of Signor Ercole Gonzaga, who afterwards became a Cardinal; of his brother, Duke Federigo (then a young man); of Signor Giovan Francesco Gonzaga; of Messer Andrea Mantegna, the painter; and of many others; of all which Francesco preserved copies drawn on paper in chiaroscuro, which are now in the possession of his heirs at Mantua.

Above the pulpit of S. Francesco de' Zoccolanti, in the same city, is a picture that he painted of S. Louis and S. Bernardino holding a large circle that contains the name of Jesus; and in the refectory of those friars there is a picture on canvas as large as the whole of the head-wall, of the Saviour in the midst of the twelve Apostles, painted in perspective and all very beautiful, and executed with many proofs of consideration. Among them is the traitor Judas, with a face wholly different from those of the others, and in a strange attitude; and the others are all gazing intently at Jesus, who is speaking to them, being near His Passion. On the right hand of this work is a S. Francis of the size of life, a very beautiful figure, the countenance of which is the very presentment of that sanctity which was peculiar to that most saintly man; and he is presenting to Christ the Marquis Francesco, who is kneeling at his feet, portrayed from life in a long coat pleated and worked with a curly pattern, according to the fashion of those times, and embroidered with white crosses, perchance because he may have been at that time Captain of the Venetians. And in front of the Marquis is a portrait, with the hands clasped, of his eldest son, who was then a very beautiful boy, and afterwards became Duke Federigo. On the other side is painted a S. Bernardino, equal in excellence to the figure of S. Francis, and likewise presenting to Christ the brother of the Marquis, Cardinal Sigismondo Gonzaga, a very beautiful kneeling figure, robed in the habit of a Cardinal, with the rochet, which is also a portrait from life; and in front of that Cardinal is a portrait of Signora Leonora, the daughter of the same Marquis, who was then a girl, and afterwards became Duchess of Urbino. This whole work is held by the most excellent painters to be a marvellous thing.

The same master painted a picture of S. Sebastian, which was afterwards placed in the Madonna delle Grazie, without the city of Mantua; and to this he devoted extraordinary pains, copying many things in it from the life. It is related that the Marquis, going one day, while Francesco was executing this picture, to see

him at work, as he used often to do, said to him: 'Francesco, you must take some fine figure as your model in painting this Saint.' To which Francesco answered: 'I am using as my model a porter with a very handsome figure, whom I bind in a fashion of my own in order to make the work natural.' 'But the limbs of this Saint of yours,' rejoined the Marquis, 'are not true to life, for they have not the appearance of being strained by force or by that fear which one would expect in a man bound and shot with arrows; and by your leave I will undertake to show you what you ought to do in order to make this figure perfect.' 'Nay, but I beg you to do it, my lord,' said Francesco; and the Marquis added: 'When you have your porter bound here, send for me, and I will show you what you must do.' The next day, therefore, when Francesco had the porter bound in the manner that he wished, he sent a secret summons to the Marquis, but without knowing what he intended to do. And the Marquis, bursting out of a neighbouring room in a great fury, with a loaded cross-bow in his hand, rushed towards the porter, crying out at the top of his voice, 'Traitor, prepare to die! At last I have caught thee as I would have thee,' and other suchlike words; which hearing, the wretched porter, thinking himself as good as dead, struggled in a frenzy of terror with the ropes wherewith he was bound, and made frantic efforts to break them, thus truly representing one about to be shot with arrows, and revealing fear in his face and the horror of death in his strained and distorted limbs, as he sought to escape from his peril. This done, the Marquis said to Francesco, 'There he is in the state that he ought to be: the rest is for you to do'; which the painter having well considered, made his figure as perfect as could be imagined.

Francesco painted in the Gonzaga Palace, besides many other things, the Election of the first Lords of Mantua, with the jousts that were held on the Piazza di S. Piero, which is seen there in perspective. When the Grand Turk sent one of his men with a most beautiful dog, a bow, and a quiver, as presents for the Marquis, the latter caused the dog, the Turk who had brought it, and the other things, to be painted in the same Gonzaga Palace; and, this done, wishing to see whether the painted dog were truly lifelike, he had one of his own dogs, of a breed very hostile to the Turkish dog, brought to the place where the other one stood on a pedestal painted in imitation of stone. The living dog, then, arriving there, had no sooner seen the painted one than, precisely as if it had been a living animal and the very one for whom he

had a mortal hatred, he broke loose from his keeper and rushed at it with such vehemence, in order to bite it, that he struck his head full against the wall and dashed it all to pieces.

Another story is told by persons who were present at the scene, of a little picture by the hand of Francesco, little more than two span in height, and belonging to his nephew Benedetto Baroni, in which is a Madonna painted in oils, from the breast upwards, and almost life-size, and, lower down, in the corner of the picture, the Child, seen from the shoulders upwards, with one arm uplifted and in the act of caressing His Mother. It is related, I say, that, when the Emperor was master of Verona, Don Alfonso of Castille and Alarcon, a very famous Captain, happened to be in that city on behalf of His Majesty and the Catholic King; and that these lords, being in the house of the Veronese Count Lodovico da Sesso, said that they had a great desire to see that picture. Whereupon it was sent for; and one evening they were standing contemplating it in a good light, and admiring its masterly workmanship, when Signora Caterina, the wife of the Count, entered into the room where those noblemen were, together with one of her sons, who had on his wrist one of those green birds – called in Verona 'terrazzani,'* because they make their nests on the ground – which learn to perch on the wrist, like hawks. It happened, then, that, while she stood with the others contemplating the picture, the bird, seeing the extended arm and wrist of the painted Child, flew to perch upon it; but, not having been able to find a hold on the surface of the painting, and having therefore fallen to the ground, it twice returned to settle on the wrist of that painted Child, precisely as if it had been one of those living children who were always holding it on their wrists. At which those noblemen, being amazed, offered to pay a great price to Benedetto for the picture, if only he would give it to them; but it was not possible by any means to wrest it from him. Not long afterwards the same persons planned to have it stolen from him on the day of the festival of S. Biagio in S. Nazzaro; but the owner was informed of this, and their design did not succeed.

For S. Paolo, in Verona, Francesco painted a panel-picture in gouache, which is very beautiful, and another, also most beautiful, for the Chapel of the Bandi in S. Bernardino. In Mantua he executed for Verona a picture with two most lovely nudes, a

* From 'terra', earth.

Madonna in the sky, with the Child in her arms, and some Angels, all marvellous figures, which is in the chapel where S. Biagio is buried, in the Black Friars Church of S. Nazzaro.

Francesco was a man of saintly life, and the enemy of every vice, insomuch that he would never on any account paint licentious works, although he was very often entreated to do so by the Marquis; and equal to him in goodness were his brothers, as will be related in the proper place. Finally, being old, and suffering in the bladder, Francesco, with the leave of the Marquis and by the advice of the physicians, went with his wife and many servants to the Baths of Caldero, in the territory of Verona, to take the waters. There, one day, after he had drunk the water, he allowed himself to be overcome by drowsiness, and slept a little, being indulged in this by his wife out of compassion; whereupon, a violent fever having come upon him in consequence of his sleeping, which is a deadly thing for one who has just taken that water, he finished the course of his life on the second day of July, 1519; which having been reported to the Marquis, he straightway sent orders by a courier that the body of Francesco should be brought to Mantua. This was done, although it gave little pleasure to the people of Verona; and he was laid to rest with great honour in the burial-place of the Compagnia Segreta in S. Francesco at Mantua. Francesco lived to the age of sixty-four, and the portrait of him which belongs to Messer Fermo was executed when he was fifty. Many compositions were written in his praise, and he was mourned by all who knew him as a virtuous and saintly man, which he was. He had for wife Madonna Francesca Gioacchini of Verona, but he had no children.

The eldest of his three brothers was called Monsignore; and he, being a person of culture and learning, received offices with good salaries in Mantua from the Marquis, on account of that nobleman's love of Francesco. He lived to the age of eighty, and left children, who keep the family of the Monsignori alive in Mantua. Another brother of Francesco had the name of Girolamo when in the world, and of Fra Cherubino among the Frati Zoccolanti di San Francesco; and he was a very beautiful calligrapher and illuminator. The third, who was a Friar of S. Dominic and an Observantine, and was called Fra Girolamo, chose out of humility to become a lay-brother. He was not only a man of good and holy life, but also a passing good painter, as may be seen in the Convent of S. Domenico in Mantua, where,

besides other works, he executed a most beautiful Last Supper in the refectory, with a Passion of Christ, which remained unfinished on account of his death. The same friar painted the beautiful Last Supper that is in the refectory of the very rich abbey which the Monks of S. Benedict possess in the territory of Mantua. In S. Domenico he painted the altar of the Rosary; and in the Convent of S. Anastasia, in Verona, he painted in fresco the Madonna, S. Remigio the Bishop, and S. Anastasia; with a Madonna, S. Dominic, and S. Thomas Aquinas, all executed with mastery, on a little arch over the second door of entrance in the second cloister.

Fra Girolamo was a person of great simplicity, wholly indifferent to the things of the world. He lived in the country, at a farm belonging to his convent, in order to avoid all noise and disturbance, and the money sent to him in return for his works, which he used for buying colours and suchlike things, he kept in a box without a cover, hung from the ceiling in the middle of his chamber, so that all who wished could take some; and in order not to have the trouble of thinking every day what he was to eat, he used to cook a pot of beans every Monday to last him the whole week.

When the plague came to Mantua and the sick were abandoned by all, as happens in such cases, Fra Girolamo, with no other motive but the purest love, would never desert the poor plague-stricken monks, and even tended them all day long with his own hands. And thus, careless of his life for the love of God, he became infected with that malady and died at the age of sixty, to the great grief of all who knew him.

But to return to Francesco Monsignori: he painted a life-size portrait, which I forgot to mention above, of Count Ercole Giusti of Verona, in a robe of cloth of gold, such as he was wont to wear; and this is a very beautiful likeness, as may be seen in the house of his son, Count Giusto.

Domenico Morone, who was born at Verona about the year 1430, learned the art of painting from some masters who were disciples of Stefano, and from works by the same Stefano, by Jacopo Bellini, by Pisano, and by others, which he saw and copied. Saying nothing of the many pictures that he executed after the manner of those times, which are now in monasteries and private houses, I begin by recording that he painted in chiaroscuro, with 'terretta verde,' the façade of a house belonging to

the city of Verona, on the square called the Piazza de' Signori; and in this may be seen many ornamental friezes and scenes from ancient history, with a very beautiful arrangement of figures and costumes of bygone days. But the best work to be seen by the hand of this master is the Leading of Christ to the Cross, with a multitude of figures and horses, which is in S. Bernardino, on the wall above the Chapel of the Monte di Pietà, for which Liberale painted the picture of the Deposition with the weeping Angels. The same Domenico received a commission to paint the chapel that is next to that one, both within and without, at great expense and with a lavish use of gold, from the Chevalier, Messer Niccolò de' Medici, who was considered to be the richest man of his day in Verona, and who spent great sums of money on other pious works, being a man who was inclined to this by nature. This gentleman, after he had built many monasteries and churches, and had left scarcely any place in that city where he had not executed some noble and costly work to the honour of God, chose as his burial-place the chapel mentioned above, for the ornamentation of which he availed himself of Domenico, at that time more famous than any other painter in that city, Liberale being in Siena.

Domenico, then, painted in the interior of this chapel the Miracles of S. Anthony of Padua, to whom it is dedicated, and portrayed the Chevalier in an old man with shaven face and white hair, without any cap, and wearing a long gown of cloth of gold, such as Chevaliers used to wear in those times. All this, for a work in fresco, is very well designed and executed. Then, in certain medallions in the outer vaulting, which is all overlaid with gold, he painted the four Evangelists; and on the pilasters both within and without he executed figures of Saints, among which are S. Elizabeth of the Third Order of S. Francis, S. Helen, and S. Catharine, which are very beautiful figures, and much extolled for the draughtsmanship, colouring, and grace. This work, then, can bear witness to the talent of Domenico and to the magnificent liberality of that Chevalier.

Domenico died very old, and was buried in S. Bernardino, wherein are the works by his hand described above, leaving his son, Francesco Morone, heir to his property and his talents. This Francesco, who learned the first principles of art from his father, afterwards exerted himself in such a manner that in a short time he became a much better master than his father had been, as the

works that he executed in emulation of those of his father clearly demonstrate. Below his father's work on the altar of the Monte, in the aforesaid Church of S. Bernardino, Francesco painted in oils the folding-doors that enclose the altar-piece of Liberale; on the inner side of which he depicted in one the Virgin, and in the other S. John the Evangelist, both life-size figures, with great beauty in the faces, which are weeping, in the draperies, and in every other part. In the same chapel, at the foot of the face of that wall which serves as head-wall to the tramezzo,* he painted the Miracle that Our Lord performed with the five loaves and two fishes, which satisfied the multitude; and in this are many beautiful figures and many portraits from life, but most of all is praise given to a S. John the Evangelist, who is very slender, and has his back partly turned towards the spectator. He then executed in the same place, beside the altar-piece, in the vacant spaces on the wall against which it rests, a S. Louis, Bishop and Friar of S. Francis, and another figure; with some heads in foreshortening in a sunk medallion on the vaulting. All these works are much extolled by the painters of Verona. And for the altar of the Cross, on which are so many painted pictures, between that chapel and the Chapel of the Medici, in the same church, he executed a picture which is in the centre above all the others, containing Christ on the Cross, the Madonna, and S. John, and very beautiful. In another picture, which is above that of Caroto, on the left-hand side of the same altar, he painted Our Lord washing the feet of the Apostles, who are seen in various attitudes; in which work, so men say, this painter made a portrait of himself in the figure of one who is serving Christ by bringing water.

For the Chapel of the Emilii, in the Duomo, Francesco executed a S. James and a S. John, one on either side of Christ, who is bearing His Cross; and the beauty and excellence of these two figures leave nothing to be desired. The same master executed many works at Lonico, in an abbey of Monks of Monte Oliveto, whither great multitudes flock together to adore a figure of the Madonna which performs many miracles in that place. Afterwards, Francesco being very much the friend, and, as it were, the brother of Girolamo dai Libri, the painter and illuminator, they undertook to paint in company the organ-doors of S. Maria in Organo, a church of Monks of Monte Oliveto. In one of these,

* See note on page 90, Vol. I.

on the outer side, Francesco painted a S. Benedict clothed in white, and S. John the Evangelist, and on the inner side the Prophets Daniel and Isaiah, with two little Angels in the air, and a ground all full of very beautiful landscapes. And then he executed the great altar-piece of the altar of the Muletta, painting therein a S. Peter and a S. John, which are little more than one braccio in height, but wrought so well and with such diligence, that they have the appearance of miniatures. The carvings of this work were executed by Fra Giovanni da Verona, a master of tarsia and carving.

In the same place, on the wall of the choir, Francesco painted two scenes in fresco – one of Our Lord riding on an ass into Jerusalem, and the other of His Prayer in the Garden, wherein, on one side, is the armed multitude coming to take Him, guided by Judas. But more beautiful than all the rest is the vaulted sacristy, which is all painted by the same master, excepting only the S. Anthony being scourged by Demons, which is said to be by the hand of his father, Domenico. In this sacristy, then, besides the Christ and some little Angels that are seen in foreshortening on the vaulting, he painted in the lunettes, two in each niche, and robed in their pontifical vestments, the various Popes who have been exalted to the Pontificate from the Order of S. Benedict. Round the sacristy, below the lunettes of the vaulting, is drawn a frieze four feet high, and divided into compartments, wherein are painted in the monastic habit various Emperors, Kings, Dukes, and other Princes, who have abandoned the States and Principalities that they ruled, and have become monks. In these figures Francesco made portraits from life of many of the monks who had their habitation or a temporary abode in that monastery, the while that he was working there; and among them are portraits of many novices and other monks of every kind, which are heads of great beauty, and executed with much diligence. In truth, by reason of these ornaments, that was then the most beautiful sacristy that there was in all Italy, since, in addition to the beauty of the room, which is of considerable size and well proportioned, and the pictures described above, which are also very beautiful, there is at the foot of the walls a range of panelled seats adorned with fine perspective-views, so well executed in tarsia and carving, that there is no work to be seen of those times, and perchance even of our own, that is much better. For Fra Giovanni da Verona, who executed this work, was most excellent in that art, as was said in the Life of Raffaello da Urbino, and as is

demonstrated not only by his many other works in houses of his Order, but also by those that are in the Papal Palace at Rome, in Monte Oliveto di Chiusuri in the territory of Siena, and in other places. But those of this sacristy are the best of all the works that Fra Giovanni ever executed, for the reason that it may be said that in them he surpassed himself by as much as he excelled in the rest every other master. Among other things, Fra Giovanni carved for this place a candelabrum more than fourteen feet in height to hold the Paschal candle, all made of walnut-wood, and wrought with such extraordinary patience that I do not believe that there is a better work of the same kind to be seen.

But to return to Francesco: he painted for the same church the panel-picture which is in the Chapel of the Counts Giusti, in which he depicted the Madonna, with S. Augustine and S. Martin in pontifical robes. And in the cloister he executed a Deposition from the Cross, with the Maries and other Saints, works in fresco which are much extolled in Verona. In the Church of the Vittoria he painted the Chapel of the Fumanelli, which is below the wall that supports the choir which was built by the Chevalier Messer Niccolò de' Medici; and a Madonna in fresco in the cloister. And afterwards he painted a portrait from life of Messer Antonio Fumanelli, a physician very famous for the works written by him in connection with his profession. He painted in fresco, also, on a house which is seen on the left hand as one crosses the Ponte delle Navi on the way to S. Paolo, a Madonna with many Saints, which is held to be a very beautiful work, both in design and in colouring; and on the house of the Sparvieri, in the Brà, opposite to the garden of the Friars of S. Fermo, he painted another like it. Francesco painted a number of other works, of which there is no need to make mention, since the best have been described; let it suffice to say that he gave grace, unity, and good design to his pictures, with a colouring as vivid and pleasing as that of any other painter. Francesco lived fifty-five years, and died on May 16, 1529. He chose to be carried to his tomb in the habit of a Friar of S. Francis, and he was buried in S. Domenico, beside his father. He was so good a man, so religious, and so exemplary, that there was never heard to issue from his mouth any word that was otherwise than seemly.

A disciple of Francesco, and much more able than his master, was the Veronese Paolo Cavazzuola, who executed many works in Verona; I say in Verona, because it is not known that he ever

worked in any other place. In S. Nazzaro, a seat of Black Friars
at Verona, he painted many works in fresco near those of his
master Francesco; but these were all thrown to the ground when
that church was rebuilt by the pious munificence of the reverend
Father, Don Mauro Lonichi, a nobleman of Verona and Abbot
of that Monastery. On the old house of the Fumanelli, in the Via
del Paradiso, Paolo painted, likewise in fresco, the Sibyl showing
to Augustus Our Lord in the heavens, in the arms of His Mother;
which work is beautiful enough for one of the first that he ex-
ecuted. On the outer side of the Chapel of the Fontani, in
S. Maria in Organo, he painted, also in fresco, two Angels –
namely, S. Michael and S. Raphael. In the street into which there
opens the Chapel of the Angel Raphael, in S. Eufemia, over a
window that gives light to a recess in the staircase of that chapel,
he painted the Angel Raphael, and with him Tobias, whom he
guided on his journey; which was a very beautiful little work. And
in S. Bernardino, in a round picture over the door where there is
the bell, he painted a S. Bernardino in fresco, and in another
round picture on the same wall, but lower down, and above the
entrance to a confessional, a S. Francis, which is beautiful and
well executed, as is also the S. Bernardino. These are all the works
that Paolo is known to have painted in fresco.

As for his works in oils, he painted a picture of S. Rocco for
the altar of the Santificazione in the Church of the Madonna della
Scala, in emulation of the S. Sebastian which Il Moro painted for
the other side of the same place; which S. Rocco is a very beau-
tiful figure. But the best figures that this painter ever executed are
in S. Bernardino, where all the large pictures that are on the altar
of the Cross, round the principal altar-piece, are by his hand,
excepting that with the Christ Crucified, the Madonna, and
S. John, which is above all the others, and is by the hand of his
master Francesco. Beside it, in the upper part, are two large pic-
tures by the hand of Paolo, in one of which is Christ being
scourged at the Column, and in the other His Coronation,
painted with many figures somewhat more than life-size. In the
principal picture, which is lower down, in the first range, he
painted a Deposition from the Cross, with the Madonna, the
Magdalene, S. John, Nicodemus, and Joseph; and he made a
portrait of himself, so good that it has the appearance of life, in
one of these figures, a young man with a red beard, who is near
the Tree of the Cross, with a coif on his head, such as it was the

custom to wear at that time. On the right-hand side is a picture by Paolo of Our Lord in the Garden, with the three Disciples near Him; and on the left-hand side is another of Christ with the Cross on His shoulder, being led to Mount Calvary. The excellence of these works, which stand out strongly in comparison with those by the hand of his master that are in the same place, will always give Paolo a place among the best craftsmen.

On the base he painted some Saints from the breast upwards, which are all portraits from life. The first figure, wearing the habit of S. Francis, and representing a Beato, is a portrait of Fra Girolamo Rechalchi, a noble Veronese; the figure beside the first, painted to represent S. Bonaventura, is the portrait of Fra Bonaventura Rechalchi, brother of the aforesaid Fra Girolamo; and the head of S. Joseph is the portrait of a steward of the Marchesi Malespini, who had been charged at that time by the Company of the Cross to see to the execution of this work. All these heads are very beautiful.

For the same church Paolo painted the altar-piece of the Chapel of S. Francesco, in which work, the last that he executed, he surpassed himself. There are in it six figures larger than life; one being S. Elizabeth, of the Third Order of S. Francis, who is a most beautiful figure, with a smiling air and a gracious countenance, and with her lap full of roses; and she seems to be rejoicing at the sight of the bread that she, great lady as she was, had been carrying to the poor, turned by a miracle of God into roses, in token that her humble charity in thus ministering to the poor with her own hands was acceptable to God. This figure is a portrait of a widowed lady of the Sacchi family. Among the other figures are S. Bonaventura the Cardinal and S. Louis the Bishop, both Friars of S. Francis. Near these are S. Louis, King of France, S. Eleazar in a grey habit, and S. Ivo in the habit of a priest. Then there is the Madonna on a cloud above them all, with S. Francis and other figures round her; but it is said that these are not by the hand of Paolo, but by that of a friend who helped him to execute the picture; and it is evident, indeed, that these figures are not equal in excellence to those beneath. And in this picture is a portrait from life of Madonna Caterina de' Sacchi, who gave the commission for the work.

Now Paolo, having set his heart on becoming great and famous, made to this end such immoderate exertions that he fell ill and died at the early age of thirty-one, at the very moment when

he was beginning to give proofs of what might be expected from him at a riper age. It is certain that Paolo, if Fortune had not crossed him at the height of his activity, would without a doubt have attained to the highest, best, and greatest honours that could be desired by a painter. His loss, therefore, grieved not only his friends, but all men of talent and everyone who knew him, and all the more because he had been a young man of excellent character, untainted by a single vice. He was buried in S. Paolo, after making himself immortal by the beautiful works that he left behind him.

Stefano Veronese, a very rare painter in his day, as has been related, had a brother-german, called Giovanni Antonio, who, although he learned to paint from that same Stefano, nevertheless did not become anything more than a mediocre painter, as may be seen from his works, of which there is no need to make mention. To this Giovanni Antonio was born a son, called Jacopo, who likewise became a painter of commonplace works; and to Jacopo, were born Giovan Maria, called Falconetto, whose Life we are about to write, and Giovanni Antonio. The latter, devoting himself to painting, executed many works at Rovereto, a very famous township in the Trentino, and many pictures at Verona, which are dispersed among the houses of private citizens. He also painted many works in the valley of the Adige, above Verona, and a panel-picture of S. Nicholas, with many animals, at Sacco, opposite to Rovereto, with many others; after which he finally died at Rovereto, where he had gone to live. This master was particularly excellent in making animals and fruits, of which many very beautiful drawings, executed in miniature, were taken to France by the Veronese Mondella; and many of them were given by Agnolo, the son of Giovanni Antonio, to Messer Girolamo Lioni, a Venetian gentleman of noble spirit.

But to come at last to Giovan Maria, the brother of Giovanni Antonio. He learned the rudiments of painting from his father, whose manner he rendered no little better and grander, although even he was not a painter of much reputation, as is evident from the Chapels of the Maffei and of the Emilii in the Duomo of Verona, from the upper part of the cupola of S. Nazzaro, and from works in other places. This master, recognizing the little value of his work in painting, and delighting beyond measure in architecture, set himself with great diligence to study and draw all the antiquities in his native city of Verona. He then resolved to

visit Rome, and to learn architecture from its marvellous remains, which are the true masters; and he made his way to that city, and stayed there twelve whole years. That time he spent, for the most part, in examining and drawing all those marvellous antiquities, searching out in every place all the ground-plans that he could see and all the measurements that he could find. Nor did he leave anything in Rome, either buildings or their members, such as cornices, capitals, and columns, of whatsoever Order, that he did not draw with his own hand, with all the measurements; and he also drew all the sculptures which were discovered in those times, insomuch that when he returned to his own country, after those twelve years, he was rich in all the treasures of his art. And, not content with the things in the city of Rome itself, he drew all that was good and beautiful in the whole of the Roman Campagna, going even as far as the Kingdom of Naples, the Duchy of Spoleto, and other parts. It is said that Giovan Maria, being poor, and therefore having little wherewith to live or to maintain himself in Rome, used to spend two or three days every week in assisting some painter with his work; and with his earnings, since at that time masters were well paid and living was cheap, he was able to live the other days of the week, pursuing the studies of architecture. Thus, then, he drew all those antiquities as if they were complete, reconstructing them in his drawings from the parts and members that he saw, from which he imagined all the other parts of the buildings in all their perfection and integrity, and all with such true measurements and proportions, that he could not make an error in a single detail.

Having returned to Verona, and finding no opportunity of exercising himself in architecture, since his native city was in the throes of a change of government, Giovan Maria gave his attention for the time to painting, and executed many works. On the house of the Della Torre family he painted a large escutcheon crowned by some trophies; and for two German noblemen, counsellors of the Emperor Maximilian, he executed in fresco some scenes from the Scriptures on a wall of the little Church of S. Giorgio, and painted there life-size portraits of those two Germans, one kneeling on one side and one on the other. He executed a number of works at Mantua, for Signor Luigi Gonzaga; and some others at Osimo, in the March of Ancona. And while the city of Verona was under the Emperor, he painted the imperial arms on all the public buildings, and received for this from

the Emperor a good salary and a patent of privilege, from which it may be seen that many favours and exemptions were granted to him, both on account of his good service in matters of art, and because he was a man of great spirit, brave and formidable in the use of arms, with which he might likewise be expected to give valiant and faithful service: and all the more because he drew after him, on account of the great credit that he had with his neighbours, the whole mass of the people who lived in the Borgo di San Zeno, a very populous part of the city, in which he had been born and had taken a wife from the family of the Provali. For these reasons, then, he had all the inhabitants of his district as his following, and was called throughout the city by no other name but that of the 'Red-head of San Zeno.'

Now, when the city again changed its government and returned to the rule of its ancient masters the Venetians, Giovan Maria, being known as one who had served the party of the Emperor, was forced to seek safety in flight; and he went, therefore, to Trento, where he passed some time painting certain pictures. Finally, however, when matters had mended, he made his way to Padua, where he was first received in audience and then much favoured by the very reverend Monsignor Bembo, who presented him not long afterwards to the illustrious Messer Luigi Cornaro, a Venetian gentleman of lofty spirit and truly regal mind, as is proved by his many magnificent enterprises. This gentleman, who, in addition to his other truly noble qualities, delighted in the study of architecture, the knowledge of which is worthy of no matter how great a Prince, had therefore read the works of Vitruvius, Leon Batista Alberti, and others who have written on this subject, and he wished to put what he had learned into practice. And when he saw the designs of Falconetto, and perceived with what profound knowledge he spoke of these matters, and rendered clear all the difficulties that can arise through the variety of the Orders of architecture, he conceived such a love for him that he took him into his own house and kept him there as an honoured guest for twenty-one years, which was the whole of the rest of Giovan Maria's life.

During this time Falconetto executed many works with the help of the same Messer Luigi. The latter, desiring to see the antiquities of Rome on the spot, even as he had seen them in the drawings of Giovan Maria, went to Rome, taking him with him; and there he devoted himself to examining everything minutely,

having him always in his company. After they had returned to
Padua, a beginning was made with building from the design and
model of Falconetto that most beautiful and ornate loggia which
is in the house of the Cornari, near the Santo; and the palace was
to be erected next, after the model made by Messer Luigi himself.
In this loggia the name of Giovan Maria is carved on a pilaster.

The same architect built a very large and magnificent Doric
portal for the Palace of the Captain of that place; and this portal is
much praised by everyone as a work of great purity. He also erected
two very beautiful gates for the city, one of which, called the Porta
di S. Giovanni, and leading to Vicenza, is very fine, and commo-
dious for the soldiers who guard it; and the other, which is very well
designed, was called the Porta Savonarola. He made, likewise, for
the Friars of S. Dominic, the design and model of the Church of
S. Maria delle Grazie, and laid the foundations; and this work, as
may be seen from the model, is so beautiful and well designed, that
one of equal size to rival it has perhaps never been seen up to our
own day in any other place. And by the same master was made the
model of a most superb palace for Signor Girolamo Savorgnano, at
his well fortified stronghold of Usopo in Friuli; for which all the
foundations were then laid, and it had begun to rise above the
ground, when, by reason of the death of that nobleman, it was left
in that condition without being carried further; but if this building
had been finished, it would have been a marvel.

About the same time Falconetto went to Pola, in Istria, for
the sole purpose of seeing and drawing the theatre, amphitheatre,
and arch that are in that most ancient city. He was the first who
made drawings of theatres and amphitheatres and traced their
ground-plans, and those that are to be seen, particularly in the
case of Verona, came from him, and were printed at the instance
of others after his designs. Giovan Maria was a man of exalted
mind, and, being one who had never done anything else but draw
the great works of antiquity, he desired nothing save that there
should be presented to him opportunities of executing works
similar to those in greatness. He would sometimes make ground-
plans and designs for them, with the very same pains that he
would have taken if he had been commissioned to put them into
execution at once; and in this he lost himself so much, so to
speak, that he would not deign to make designs for the private
houses of gentlemen, either in the country or in the city, although
he was much besought to do so.

Giovan Maria was in Rome on many occasions besides those described above; whence that journey was so familiar to him, that when he was young and vigorous he would undertake it on the slightest opportunity. Persons who are still alive relate that, falling one day into a discussion with a foreign architect, who happened to be in Verona, about the measurements of I know not what ancient cornice in Rome, after many words Giovan Maria said, 'I will soon make myself certain in this matter,' and then went straight to his house and set out on his way to Rome.

This master made for the Cornaro family two very beautiful designs of tombs, which were to be erected in S. Salvatore, at Venice – one for the Queen of Cyprus, a lady of that family, and the other for Cardinal Marco Cornaro, who was the first of that house to be honoured with that dignity. And in order that these designs might be carried out, a great quantity of marble was quarried at Carrara and taken to Venice, where the rough blocks still are, in the house of the same Cornari.

Giovan Maria was the first who brought the true methods of building and of good architecture to Verona, Venice, and all those parts, where before him there had not been one who knew how to make even a cornice or a capital, or understood either the measurements or the proportions of a column or of any Order of architecture, as is evident from the buildings that were erected before his day. This knowledge was afterwards much increased by Fra Giocondo, who lived about the same time, and it received its final perfection from Messer Michele San Michele, insomuch that those parts are therefore under an everlasting obligation to the people of Verona, in which city were born and lived at one and the same time these three most excellent architects. To them there then succeeded Sansovino, who, not resting content with architecture, which he found already grounded and established by the three masters mentioned above, also brought thither sculpture, to the end that by its means their buildings might have all the adornments that were proper to them. And for this a debt of gratitude – if one may use such a word – is due to the ruin of Rome, by reason of which the masters were dispersed over many places and the beauties of these arts communicated throughout all Europe.

Giovan Maria caused some works in stucco to be carried out in Venice, and taught the method of executing them. Some declare that when he was a young man he had the vaulting of the

Chapel of the Santo, at Padua, decorated with stucco by Tiziano da Padova and many others, and also had similar works executed in the house of the Cornari, which are very beautiful. He taught his work to two of his sons, Ottaviano, who was, like himself, also a painter, and Provolo. Alessandro, his third son, worked in his youth at making armour, and afterwards adopted the calling of a soldier; he was three times victor in the lists, and finally, when a captain of infantry, died fighting valiantly before Turin in Piedmont, having been wounded by a harquebus-ball.

Giovan Maria, on his part, after being crippled by gout, finished the course of his life at Padua, in the house of the aforesaid Messer Luigi Cornaro, who always loved him like a brother, or rather, like his own self. And to the end that there might be no separation in death between the bodies of those whose minds had been united together in the world by friendship and love of art, Messer Luigi had intended that Giovan Maria should be laid to rest beside himself in the tomb that was to be erected for his own burial, together with that most humorous poet, Ruzzante, his very familiar friend, who lived and died in his house; but I do not know whether this design of the illustrious Cornaro was ever carried into effect. Giovan Maria was a fine talker, pleasant and agreeable in conversation, and very acute in repartee, insomuch that Cornaro used to declare that a whole book could have been made with his sayings. And since, although he was crippled by gout, he lived cheerfully, he preserved his life to the age of seventy-six, dying in 1534.

He had six daughters, five of whom he gave in marriage himself, and the sixth was married by her brothers, after his death, to Bartolommeo Ridolfi of Verona, who executed many works in stucco in company with them, and was a much better master than they were. This may be seen from his works in many places, and in particular at Verona, in the house of Fiorio della Seta on the Ponte Nuovo, in which he decorated some apartments in a very beautiful manner. There are others in the house of the noble Counts Canossi, which are amazing; and such, also, are those that he executed in the house of the Murati, near S. Nazzaro; and for Signor Giovan Battista della Torre, for Cosimo Moneta, the Veronese banker, at his beautiful villa, and for many others in various places, all works of great beauty. Palladio, most excellent of architects, declares that he knows no person more marvellous in invention or better able to adorn apartments with beautiful

designs in stucco, than this Bartolommeo Ridolfi. Not many years since, Spitech Giordan, a nobleman of great authority with the King of Poland, took Bartolommeo with him to that King; and there, enjoying an honourable salary, he has executed, as he still does, many works in stucco, large portraits, medallions, and many designs for palaces and other buildings, with the assistance of a son of his own, who is in no way inferior to his father.

The elder Francesco dai Libri of Verona lived some time before Liberale, although it is not known exactly at what date he was born; and he was called 'Dai Libri'* because he practised the art of illuminating books, his life extending from the time when printing had not yet been invented to the very moment when it was beginning to come into use. Since, therefore, there came to him from every quarter books to illuminate – a work in which he was most excellent – he was known by no other surname than that of 'Dai Libri'; and he executed great numbers of them, for the reason that whoever went to the expense of having them written, which was very great, wished also to have them adorned as much as was possible with illuminations.

This master illuminated many choral books, all beautiful, which are at Verona, in S. Giorgio, in S. Maria in Organo, and in S. Nazzaro; but the most beautiful is a little book, or rather, two little pictures that fold together after the manner of a book, on one side of which is a S. Jerome, a figure executed with much diligence and very minute workmanship, and on the other a S. John in the Isle of Patmos, depicted in the act of beginning to write his Book of the Apocalypse. This work, which was bequeathed to Count Agostino Giusti by his father, is now in S. Leonardo, a convent of Canons Regular, of which Don Timoteo Giusti, the son of that Count, is a member. Finally, after having executed innumerable works for various noblemen, Francesco died, content and happy for the reason that, in addition to the serenity of mind that his goodness brought him, he left behind him a son, called Girolamo, who was so excellent in art that before his death he saw him already a much greater master than himself.

This Girolamo, then, was born at Verona in the year 1472, and at the age of sixteen he painted for the Chapel of the Lischi, in S. Maria in Organo, an altar-piece which caused such marvel

* *I.e.*, 'of the books.'

to everyone when it was uncovered and set in its place, that the whole city ran to embrace and congratulate his father Francesco. In this picture is a Deposition from the Cross, with many figures, and among the many beautiful weeping heads the best of all are a Madonna and a S. Benedict, which are much commended by all craftsmen; and he also made therein a landscape, with a part of the city of Verona, drawn passing well from the reality. Then, encouraged by the praises that he heard given to his work, Girolamo painted the altar of the Madonna in S. Paolo in a masterly manner, and also the picture of the Madonna with S. Anne, which is placed between the S. Sebastian of Il Moro and the S. Rocco of Cavazzuola in the Church of the Scala. For the family of the Zoccoli he painted the great altar-piece of the high-altar in the Church of the Vittoria, and for the family of the Cipolli the picture of S. Onofrio, which is near the other, and is held to be both in design and in colouring the best work that he ever executed.

For S. Leonardo nel Monte, also, near Verona, he painted at the commission of the Cartieri family the altar-piece of the high-altar, which is a large work with many figures, and much esteemed by everyone, above all for its very beautiful landscape. Now a thing that has happened very often in our own day has caused this work to be held to be a marvel. There is a tree painted by Girolamo in the picture, and against it seems to rest the great chair on which the Madonna is seated. This tree, which has the appearance of a laurel, projects considerably with its branches over the chair, and between the branches, which are not very thick, may be seen a sky so clear and beautiful, that the tree seems to be truly a living one, graceful and most natural. Very often, therefore, birds that have entered the church by various openings have been seen to fly to this tree in order to perch upon it, and particularly swallows, which had their nests among the beams of the roof, and likewise their little ones. Many persons well worthy of credence declare that they have seen this, among them Don Giuseppe Mangiuoli of Verona, a person of saintly life, who has twice been General of his Order and would not for anything in the world assert a thing that was not absolutely true, and also Don Girolamo Volpini, likewise a Veronese, and many others.

In S. Maria in Organo, where was the first work executed by Girolamo, he also painted two Saints on the outer side of one of the folding doors of the organ – the other being painted by Francesco Morone, his companion – and on the inner side a

Manger. And afterwards he painted the picture that is opposite to his first work, containing the Nativity of Our Lord, with shepherds, landscapes, and very beautiful trees; but most lifelike and natural of all are two rabbits, which are executed with such diligence that each separate hair may actually be seen in them. He painted another altar-piece for the Chapel of the Buonalivi, with a Madonna seated in the centre, two other figures, and some Angels below, who are singing. Then, in the ornamental work made by Fra Giovanni da Verona for the altar of the Sacrament, the same Girolamo painted three little pictures after the manner of miniatures. In the central picture is a Deposition from the Cross, with two little Angels, and in those at the sides are painted six Martyrs, kneeling towards the Sacrament, three in each picture, these being saints whose bodies are deposited in that very altar. The first three are Cantius, Cantianus, and Cantianilla, who were nephews of the Emperor Diocletian, and the others are Protus, Chrysogonus, and Anastasius, who suffered martyrdom at Aquæ Gradatæ, near Aquileia; and all these figures are in miniature, and very beautiful, for Girolamo was more able in that field of art than any other master of his time in Lombardy and in the State of Venice.

Girolamo illuminated many books for the Monks of Montescaglioso in the Kingdom of Naples, some for S. Giustina at Padua, and many others for the Abbey of Praia in the territory of Padua; and also some at Candiana, a very rich monastery of the Canons Regular of S. Salvatore, to which place he went in person to work, although he would never go to any other place. While he was living there, Don Giulio Clovio, who was a friar in that place, learned the first rudiments of illumination; and he has since become the greatest master of that art that is now alive in Italy. Girolamo illuminated at Candiana a sheet with a Kyrie, which is an exquisite work, and for the same monks the first leaf of a psalter for the choir; with many things for S. Maria in Organo and for the Friars of S. Giorgio, in Verona. He executed, likewise, some other very beautiful illuminations for the Black Friars of S. Nazzaro at Verona. But that which surpassed all the other works of this master, which were all divine, was a sheet on which was depicted in miniature the Earthly Paradise, with Adam and Eve driven forth by the Angel, who is behind them with a sword in his hand. One would not be able to express how great and how beautiful is the variety of the trees, fruits, flowers, animals, birds, and all the other things that are in this amazing work,

which was executed at the commission of Don Giorgio Caccia-
male of Bergamo, then Prior of S. Giorgio in Verona, who, in
addition to the many other courtesies that he showed to Girolamo,
gave him sixty crowns of gold. This work was afterwards
presented by that Father to a Roman Cardinal, at that time Pro-
tector of his Order, who showed it to many noblemen in Rome,
and they all declared it to be the best example of illumination that
had ever been seen up to that day.

Girolamo painted flowers with such diligence, and made them
so true, so beautiful, and so natural, that they appeared to all who
beheld them to be real; and he counterfeited little cameos and
other engraved stones and jewels in such a manner, that there
was nothing more faithfully imitated or more diminutive to be
seen. Among his little figures there are seen some, as in his imita-
tions of cameos and other stones, that are no larger than little
ants, and yet all the limbs and all the muscles can be perceived
so clearly that one who has not seen them could scarcely believe
it. Girolamo used to say in his old age that he knew more in his
art then than he had ever known, and saw where every stroke
ought to go, but that when he came to handle the brushes, they
went the wrong way, because neither his eye nor his hand would
serve him any longer. He died on the 2nd of July in the year 1555,
at the age of eighty-three, and was laid to rest in the burial-place
of the Company of S. Biagio in S. Nazzaro.

He was a good and upright man, who never had a quarrel or
dispute with anyone, and his life was very pure. He had, besides
other children, a son called Francesco, who learned his art from
him, and executed miracles of illumination when still a mere lad,
so that Girolamo declared that he had not known as much at that
age as his son knew. But this young man was led away from him
by a brother of his mother, who, being passing rich, and having
no children, took him with him to Vicenza and placed him in
charge of a glass-furnace that he was setting up. When Francesco
had spent his best years in this, his uncle's wife dying, he fell
from his high hopes, and found that he had wasted his time, for
the uncle took another wife, and had children by her, and thus
Francesco did not become his uncle's heir, as he had thought to
be. Thereupon he returned to his art after an absence of six years,
and, after acquiring some knowledge, set himself to work. Among
other things, he made a large globe, four feet in diameter, hollow
within, and covered on the outer side, which was of wood, with

a glue made of bullock's sinews, which was of a very strong ad-
mixture, so that there should be no danger of cracks or other
damage in any part. This sphere, which was to serve as a terrestrial
globe, was then carefully measured and divided under the personal
supervision of Fracastoro and Beroldi, both eminent physicians,
cosmographers, and astrologers; and it was to be painted by
Francesco for Messer Andrea Navagiero, a Venetian gentleman,
and a most learned poet and orator, who wished to make a present
of it to King Francis of France, to whom he was about to go as
Ambassador from his Republic. But Navagiero had scarcely ar-
rived in France after a hurried journey, when he died, and this
work remained unfinished. A truly rare work it would have been,
thus executed by Francesco with the advice and guidance of two
men of such distinction; but it was left unfinished, as we have said,
and, what was worse, in its incomplete condition it received some
injury, I know not what, in the absence of Francesco. However,
spoiled as it was, it was bought by Messer Bartolommeo Lonichi,
who has never consented to give it up to anyone, although he has
been much besought and offered vast prices.

Before this, Francesco had made two smaller globes, one of
which is in the possession of Mazzanti, Archpriest of the Duomo
of Verona, and the other belonged to Count Raimondo della
Torre, and is now in the hands of his son, Count Giovan Batista,
who holds it very dear, because this one, also, was made with the
measurements and personal assistance of Fracastoro, who was a
very familiar friend of Count Raimondo.

Finally, growing weary of the extraordinary labour that mini-
atures demand, Francesco devoted himself to painting and to
architecture, in which he became very skilful, executing many
works in Venice and in Padua. About that time the Bishop of
Tournai, a very rich and noble Fleming, had come to Italy in
order to study letters, to see the country, and to learn our man-
ners and ways of living. This man, delighting much in architec-
ture, and happening to be in Padua, became so enamoured of the
Italian method of building that he resolved to take the modes of
our architecture with him to his own country; and in order to
facilitate this purpose, he drew Francesco, whose ability he had
recognized, into his service with an honourable salary, meaning
to take him to Flanders, where he intended to carry out many
magnificent works. But when the time came to depart, poor
Francesco, who had caused designs to be made of all the best

and greatest and most famous buildings in Italy, was overtaken by death, while still young and the object of the highest expectations, leaving his patron much grieved by his loss.

Francesco left an only brother, in whom, being a priest, the Dai Libri family became extinct, after producing in succession three men most excellent in their field of art. Nor have any disciples survived them to keep this art alive, excepting the above-mentioned churchman, Don Giulio, who, as we have related, learned it from Girolamo when he was working at Candiana, where the former was a friar; and this Don Giulio has since raised it to a height of excellence which very few have reached and no one has ever surpassed.

I knew for myself some of the facts about the excellent and noble craftsmen mentioned above, but I would never have been able to learn the whole of what I have related of them if the great goodness and diligence of the reverend and most learned Fra Marco de' Medici of Verona, a man profoundly conversant with all the most noble arts and sciences, and with him Danese Cattaneo of Carrara, a sculptor of great excellence, both being very much my friends, had not given me that complete and perfect information which I have just written down, to the best of my ability, for the convenience and advantage of all who may read these our Lives, in which the courtesy of many friends, who have taken pains with the investigation of these matters in order to please me and to benefit the world, has been, as it still is, of great assistance to me. And let this be the end of the Lives of these craftsmen of Verona, the portraits of each of whom I have not been able to obtain, because this full notice did not reach my hands until I found myself almost at the close of my work.

FRANCESCO GRANACCI (IL GRANACCIO), Painter of Florence

GREAT, indeed, is the good fortune of those craftsmen who are brought into contact, either by their birth or by the associations that are formed in childhood, with those men whom Heaven has chosen out to be distinguished and exalted above all others in our arts, for the reason that a good and beautiful manner can be acquired with the greatest facility by seeing the methods and

works of men of excellence, not to mention that rivalry and emulation, as we have said elsewhere, have great power over our minds.

Francesco Granacci, of whom we have already spoken, was one of those who were placed by the Magnificent Lorenzo de' Medici to learn in his garden; whence it happened that, recognizing, boy as he was, the great genius of Michelagnolo, and what extraordinary fruits he was likely to produce when full grown, he could never tear himself away from his side, and even strove with incredible attention and humility to be always following that great brain, insomuch that Michelagnolo was constrained to love him more than all his other friends, and to confide so much in him, that there was no one with whom he was more willing to confer touching his works or to share all that he knew of art at that time, than with Granacci. Then, after they had been companions together in the workshop of Domenico Ghirlandajo, it came to pass that Granacci, because he was held to be the best of Ghirlandajo's young men, the strongest draughtsman, and the one who had most grace in painting in distemper, assisted David and Benedetto Ghirlandajo, the brothers of Domenico, to finish the altar-piece of the high-altar in S. Maria Novella, which had been left unfinished at the death of the same Domenico. By this work Granacci gained much experience, and afterwards he executed in the same manner as that altar-piece many pictures that are in the houses of citizens, and others which were sent abroad.

And since he was very gracious, and made himself very useful in certain ceremonies that were performed in the city during the festivals of the Carnival, he was constantly employed by the Magnificent Lorenzo de' Medici in many similar works, and in particular for the masquerade that represented the Triumph of Paulus Emilius, which was held in honour of the victory that he gained over certain foreign nations. In this masquerade, which was full of most beautiful inventions, Granacci acquitted himself so well, although he was a mere lad, that he won the highest praise. And here I will not omit to tell that the same Lorenzo de' Medici, as I have said in another place, was the first inventor of those masquerades that represent some particular subject, and are called in Florence 'Canti';* for it is not known that any were performed in earlier times.

* From the 'canti', or 'songs', that were sung in them.

In like manner Granacci was employed in the sumptuous and magnificent preparations that were made in the year 1513 for the entry of Pope Leo X, one of the Medici, by Jacopo Nardi, a man of great learning and most beautiful intellect, who, having been commanded by the Tribunal of Eight to prepare a splendid masquerade, executed a representation of the Triumph of Camillus. This masquerade, in so far as it lay in the province of the painter, was so beautifully arranged and adorned by Granacci that no man could imagine anything better; and the words of the song, which Jacopo composed, began thus:

> Contempla in quanta gloria sei salita,
> Felice alma Fiorenza,
> Poichè dal Ciel discesa,

with what follows. For the same spectacle Granacci executed a great quantity of theatrical scenery, as he did both before and afterwards. And while working with Ghirlandajo he painted standards for ships, and also banners and devices for certain Knights of the Golden Spur, for their public entry into Florence, all at the expense of the Captains of the Guelph Party, as was the custom at that time, and as has been done in our own day, not long since.

In like manner he made many beautiful embellishments and decorations of his own invention for the Potenze* and their tournaments. These festivals were of a kind which is peculiar to the Florentines, and very pleasing, and in them were seen men standing almost upright on horseback, with very short stirrups, and breaking a lance with the same facility as do the warriors firmly seated on their saddles; and all this was done for the abovementioned visit of Leo to Florence. Granacci also made, besides other things, a most beautiful triumphal arch opposite to the door of the Badia, covered with scenes in chiaroscuro and very lovely things of fancy. This arch was much extolled, and particularly for the invention of the architecture, and because he had made an imitation of that same door of the Badia for the entrance of the Via del Palagio, executed in perspective with the steps and every other thing, so that the painted and supposititious door was in no way different from the real and true one. To adorn the same arch

* The 'Potenze' were merry companies composed of the men of the various quarters in costume. Each quarter had its own, representing an Emperor, King, or Prince, and his Court.

he executed with his own hand some very beautiful figures of clay in relief, and on the summit of the arch he placed a great inscription with these words: LEONI X PONT. MAX. FIDEI CULTORI.

But to come at length to some works by Granacci that are in existence, let me relate that, having studied the cartoon of Michelagnolo Buonarroti while the latter was executing it for the Great Hall of the Palace, he found it so instructive and made such proficience, that, when Michelagnolo was summoned to Rome by Pope Julius II to the end that he might paint the vaulting of the Chapel in his Palace, Granacci was one of the first to be sent for by Buonarroti to help him to paint that work in fresco after the cartoons that he himself had prepared. It is true that Michelagnolo, being dissatisfied with the manner and method of every one of his assistants, afterwards found means to make them all return to Florence without dismissing them, by closing the door on them all and not allowing himself to be seen.

In Florence Granacci painted for Pier Francesco Borgherini a scene in oils on the head-board of a couch which stood in an apartment wherein Jacopo da Pontormo, Andrea del Sarto, and Francesco Ubertini had painted many stories from the life of Joseph, in Pier Francesco's house in Borgo Sant' Apostolo; and in this scene were little figures representing a story of the same Joseph, executed with extraordinary finish and with great charm and beauty of colouring, and a building in perspective, wherein he depicted Joseph ministering to Pharaoh, which could not be more beautiful in any part. For the same man, also, he painted a round picture, likewise in oils, of the Trinity, or rather, God the Father supporting a Christ Crucified. And in the Church of S. Piero Maggiore there is a picture of the Assumption by his hand, with many Angels and a S. Thomas, to whom the Madonna is giving the Girdle. The figure of S. Thomas is very graceful, turning to one side in a beautiful attitude worthy of the hand of Michelagnolo, and such, also, is that of Our Lady. The drawing for these two figures by the hand of Granacci is in our book, together with others likewise by him. On either side of this picture are figures of S. Paul, S. Laurence, S. James, and S. John, which are all so beautiful that the work is held to be the best that Francesco ever painted; and in truth this work alone, even if he had never executed another, would ensure his being considered to be, as indeed he was, an excellent painter.

For the Church of S. Gallo, without the Gate of the same

name, and formerly a seat of the Eremite Friars of S. Augustine, he painted an altar-piece with the Madonna and two children, S. Zanobi, Bishop of Florence, and S. Francis. This altar-piece, which was in the Chapel of the Girolami, to which family that S. Zanobi belonged, is now in S. Jacopo tra Fossi at Florence.

Michelagnolo Buonarroti, having a niece who was a nun in S. Apollonia at Florence, had therefore executed an ornament for the high-altar of that church, and a design for the altar-piece; and Granacci painted there some scenes in oils with figures large and small, which gave much satisfaction to the nuns at that time, and also to the other painters. For the same place he painted another altar-piece, which stood lower down, but this was burned one night, together with some draperies of great value, through some lights being inadvertently left on the altar; which was certainly a great loss, seeing that the work was much extolled by craftsmen. And for the Nuns of S. Giorgio in sulla Costa he executed the altar-piece of their high-altar, painting in it the Madonna, S. Catharine, S. Giovanni Gualberto, S. Bernardo Uberti the Cardinal, and S. Fedele.

Granacci also executed many pictures, both square and round, which are dispersed among the houses of gentlemen in the city; and he made many cartoons for glass-windows, which were afterwards put into execution by the Frati Ingiesuati of Florence. He delighted much in painting on cloth, either alone or in company with others; wherefore, in addition to the works mentioned above, he painted many church-banners. And since he practised art more to pass the time than from necessity, he worked at his ease, always consulting his own convenience, and avoiding discomforts as much as he was able, more than any other man; and yet, without being covetous of the goods of others, he always preserved his own. Allowing but few cares to oppress him, he was a merry fellow, and took his pleasures with a glad heart. He lived sixty-seven years, at the end of which he finished the course of his life after an ordinary malady, a kind of fever; and he was buried in the Church of S. Ambrogio at Florence, on the day of S. Andrew the Apostle, in 1544.

BACCIO D'AGNOLO, Architect of Florence

GREAT is the pleasure that I take in studying at times the beginnings of our craftsmen, for one sees some rising from the lowest

depth to the greatest height, and especially in architecture, a science which has not been practised for several years past save by carvers and cunning impostors who profess to understand perspective without knowing even its terms or its first principles. The truth, indeed, is that architecture can never be practised to perfection save by those who have an excellent judgment and a good mastery of design, or have laboured much in painting, sculpture, or works in wood, for the reason that in it have to be executed with true measurements the dimensions of their figures, which are columns, cornices, and bases, and all the ornaments, which are made for the adornment of the figures, and for no other reason. And thus the workers in wood, by continually handling such things, in course of time become architects; and sculptors likewise, by having to find positions for their statues and by making ornaments for tombs and other works in the round, come in time to a knowledge of architecture; and painters, on account of their perspectives, the variety of their inventions, and the buildings that they draw, are compelled to take the ground-plans of edifices, seeing that they cannot plant houses or flights of steps on the planes where their figures stand, without in the first place grasping the order of the architecture.

Working in his youth excellently well at wood-inlaying, Baccio executed the backs of the stalls in the choir of S. Maria Novella, in the principal chapel, wherein are most beautiful figures of S. John the Baptist and S. Laurence. In carving, he executed the ornaments of that same chapel, those of the high-altar in the Nunziata, the decorations of the organ in S. Maria Novella, and a vast number of other works, both public and private, in his native city of Florence. Departing from that city, he went to Rome, where he applied himself with great zeal to the study of architecture; and on his return he made triumphal arches of wood in various places for the visit of Pope Leo X. But for all this he never gave up his workshop, where there were often gathered round him, in addition to many citizens, the best and most eminent masters of our arts, so that most beautiful conversations and discussions of importance took place there, particularly in winter. The first of these masters was Raffaello da Urbino, then a young man, and next came Andrea Sansovino, Filippino, Maiano, Cronaca, Antonio da San Gallo and Giuliano da San Gallo, Granaccio, and sometimes, but not often, Michelagnolo, with many young Florentines and strangers.

Having thus given his attention to architecture in so thorough a manner, and having made some trial of his powers, Baccio began to be held in such credit in Florence, that the most magnificent buildings that were erected in his time were entrusted to him and were put under his direction. When Piero Soderini was Gonfalonier, Baccio took part, with Cronaca and others, as has been related above, in the deliberations that were held with regard to the great Hall of the Palace; and with his own hand he executed in wood the ornament for the large panel-picture which was begun by Fra Bartolommeo, after the design by Filippino. In company with the same masters he made the staircase that leads to that Hall, with a very beautiful ornamentation of stone, and also the columns of variegated marble and the doors of marble in the hall that is now called the Sala de' Dugento.

He built a palace for Giovanni Bartolini, which is very ornate within, on the Piazza di S. Trinita; and he made many designs for the garden of the same man in Gualfonda. And since that palace was the first edifice that was built with ornaments in the form of square windows with pediments, and a portal with columns supporting architrave, frieze, and cornice, these things were much censured by the Florentines with spoken words and sonnets, and festoons of boughs were hung upon them, as is done in churches for festivals, men saying that the façade was more like that of a temple than of a palace; so that Baccio was like to go out of his mind. However, knowing that he had imitated good examples, and that his work was sound, he regained his peace of mind. It is true that the cornice of the whole palace proved, as has been said in another place, to be too large; but in every other respect the work has always been much extolled.

For Lanfredino Lanfredini he erected a house on the bank of the Arno, between the Ponte a S. Trinita and the Ponte alla Carraja; and on the Piazza de' Mozzi he began the house of the Nasi, which looks out upon the sandy shore of the Arno, but did not finish it. For Taddeo, of the Taddei family, he built a house that was held to be very beautiful and commodious. For Pier Francesco Borgherini he made the designs of the house that he built in Borgo S. Apostolo, in which he caused ornaments for the doors and most beautiful chimney-pieces to be executed at great expense, and made for the adornment of one chamber, in particular, coffers of walnut-wood covered with little boys carved

BACCIO DAGNOLO
ARCHITETTORE.

with supreme diligence. Such a work it would now be impossible
to execute with such perfection as he gave to it. He also prepared
the design for the villa that Borgherini caused to be built on the
hill of Bellosguardo, which was very beautiful and commodious,
and erected at vast expense. For Giovan Maria Benintendi he
executed an ante-chamber, with an ornamental frame for some
scenes painted by excellent masters, which was a rare thing. The
same Baccio made the model of the Church of S. Giuseppe near
S. Nofri, and directed the construction of the door, which was
his last work. He also caused to be built of masonry the cam-
panile of S. Spirito in Florence, which was left unfinished, and is
now being completed by order of Duke Cosimo after the original
design of Baccio; and he likewise erected the campanile of
S. Miniato sul Monte, which was battered by the artillery of the
camp, but never destroyed, on which account it gained no less
fame for the affront that it offered to the enemy than for the
beauty and excellence with which Baccio had caused it to be built
and carried to completion.

Next, having been appointed on account of his abilities, and
because he was much beloved by the citizens, as architect to
S. Maria del Fiore, Baccio gave the design for constructing the
gallery that encircles the cupola. This part of the work Filippo
Brunelleschi, being overtaken by death, had not been able to
execute; and although he had made designs even for this, they
had been lost or destroyed through the negligence of those in
charge of the building. Baccio, then, having made the design and
model for this gallery, carried into execution all the part that is
to be seen facing the Canto de' Bischeri. But Michelagnolo Buon-
arroti, on his return from Rome, perceiving that in carrying out
this work they were cutting away the toothings that Filippo Brun-
elleschi, not without a purpose, had left projecting, made such a
clamour that the work was stopped; saying that it seemed to him
that Baccio had made a cage for crickets, that a pile so vast
required something grander and executed with more design, art,
and grace than appeared to him to be displayed by Baccio's de-
sign, and that he himself would show how it should be done.
Michelagnolo having therefore made a model, the matter was
disputed at great length before Cardinal Giulio de' Medici by
many craftsmen and competent citizens; and in the end neither
the one model nor the other was carried into execution. Baccio's
design was censured in many respects, not that it was not a

well-proportioned work of its kind, but because it was too insignificant in comparison with the size of the structure; and for these reasons that gallery has never been brought to completion.

Baccio afterwards gave his attention to executing the pavement of S. Maria del Fiore, and to his other buildings, which were not a few, for he had under his particular charge all the principal monasteries and convents of Florence, and many houses of citizens, both within and without the city. Finally, when near the age of eighty-three, but still of good and sound judgment, he passed to a better life in 1543, leaving three sons, Giuliano, Filippo, and Domenico, who had him buried in S. Lorenzo.

Of these sons, who all gave their attention after the death of Baccio to the art of carving and working in wood, Giuliano, who was the second, was the one who applied himself with the greatest zeal to architecture both during his father's lifetime and afterwards; wherefore, by favour of Duke Cosimo, he succeeded to his father's place as architect to S. Maria del Fiore, and continued not only all that Baccio had begun in that temple, but also all the other buildings that had remained unfinished at his death. At that time Messer Baldassarre Turini da Pescia was intending to place a panel-picture by the hand of Raffaello da Urbino in the principal church of Pescia, of which he was Provost, and to erect an ornament of stone, or rather, an entire chapel, around it, and also a tomb; and Giuliano executed all this after his own designs and models, and also restored for the same patron his house at Pescia, making in it many beautiful and useful improvements. For Messer Francesco Campana, formerly First Secretary to Duke Alessandro, and afterwards to Duke Cosimo de' Medici, the same Giuliano built at Montughi, without Florence, beside the church, a house which is small but very ornate, and so well situated, that it commands from its slight elevation a view of the whole city of Florence and the surrounding plain. And a most beautiful and commodious house was built at Colle, the native place of that same Campana, from the design of Giuliano, who shortly afterwards began for Messer Ugolino Grifoni, Lord of Altopascio, a palace at San Miniato al Tedesco, which was a magnificent work.

For Ser Giovanni Conti, one of the secretaries of the Lord Duke Cosimo, he made many useful and beautiful improvements in his house at Florence; although it is true that in the two ground-floor windows, supported by knee-shaped brackets, which open out upon the street, Giuliano departed from his usual

method, and so cut them up with projections, little brackets, and off-sets, that they inclined rather to the German manner than to the true and good manner of ancient or modern times. Works of architecture, without a doubt, must first be massive, solid, and simple, and then enriched by grace of design and by variety of subject in the composition, without, however, disturbing by poverty or by excess of ornamentation the order of the architecture or the impression produced on a competent judge.

Meanwhile Baccio Bandinelli, having returned from Rome, where he had finished the tombs of Leo and Clement, persuaded the Lord Duke Cosimo, then a young man, to make at the head of the Great Hall of the Ducal Palace a façade full of columns and niches, with a range of fine marble statues; and this façade was to have windows of marble and grey-stone looking out upon the Piazza. The Duke having resolved to have this done, Bandinelli set his hand to making the design; but finding that the hall, as has been related in the Life of Cronaca, was out of square, and having never given attention to architecture, which he considered an art of little value, marvelling and even laughing at those who gave their attention to it, he was forced, on recognizing the difficulty of this work, to confer with Giuliano with regard to his model, and to beseech him that he, as an architect, should direct the work. And so all the stone-cutters and carvers of S. Maria del Fiore were set to work, and a beginning was made with the structure. Bandinelli had resolved, with the advice of Giuliano, to let the work remain out of square, following in part the course of the wall. It came to pass, therefore, that he was forced to make all the stones irregular in shape, preparing them with great labour by means of the pifferello, which is the instrument otherwise called the bevel-square; and this made the work so clumsy, that, as will be related in the Life of Bandinelli, it has been difficult to bring it to such a form as might be in harmony with the rest. Such a thing would not have happened if Bandinelli had possessed as much knowledge in architecture as he did in sculpture; not to mention that the great niches in the side-walls at each end proved to be squat, and that the one in the centre was not without defect, as will be told in the Life of that same Bandinelli. This work, after having been pursued for ten years, was abandoned, and so it remained for some time. It is true that the profiled stones as well as the columns, both of Fossato stone and of marble, were wrought with the greatest diligence by the

stone-cutters and carvers under the care of Giuliano, and were afterwards so well built in that it would not be possible to find any masonry better put together, all the stones being accurately measured. In this respect Giuliano may be celebrated as most excellent; and the work, as will be related in the proper place, was finished in five months, with an addition, by Giorgio Vasari of Arezzo.

Giuliano, meanwhile, not neglecting his workshop, was giving his attention, together with his brothers, to the execution of many carvings and works in wood, and also to pressing on the making of the pavement of S. Maria del Fiore; and since he was superintendent and architect of that building, he was requested by the same Bandinelli to make designs and models of wood, after some fantasies of figures and other ornaments of his own, for the high-altar of that same S. Maria del Fiore, which was to be constructed of marble; which Giuliano did most willingly, being a good and kindly person and one who delighted in architecture as much as Bandinelli despised it, and being also won over by the lavish promises of profit and honour that Bandinelli made him. Setting to work, therefore, on that model, Giuliano made it much after the simple pattern formerly designed by Brunelleschi, save that he enriched it by doubling both the columns and the arch above. And when he had brought it to completion, and the model, together with many designs, had been carried by Bandinelli to Duke Cosimo, his most illustrious Excellency resolved in his regal mind to execute not only the altar, but also the ornament of marble that surrounds the choir, following its original octagonal shape, with all those rich adornments with which it has since been carried out, in keeping with the grandeur and magnificence of that temple. Giuliano, therefore, with the assistance of Bandinelli, made a beginning with that choir, without altering anything save the principal entrance, which is opposite to the above-mentioned altar; for which reason he wished that it should be exactly similar to that altar, with the same arch and decorations. He also made two other similar arches, which unite with the entrance and the altar in forming a cross; and these were for two pulpits, which the old choir also had, serving for music and other ceremonies of the choir and of the altar. In this choir, around the eight faces, Giuliano made an ornament of the Ionic Order, and placed at every corner a pilaster bent in the middle, and one on every face; and since each pilaster so narrowed that the extension-lines of its side-faces met

in the centre of the choir, from inside it looked narrow and bent in, and from outside broad and pointed. This invention was not much extolled, nor can it be commended as beautiful by any man of judgment; and for a work of such cost, in a place so celebrated, Bandinelli, if he despised architecture, or had no knowledge of it, should have availed himself of someone living at that time with the knowledge and ability to do better. Giuliano deserves to be excused in the matter, because he did all that he could, which was not a little; but it is very certain that one who has not strong powers of design and invention in himself, will always be too poor in grace and judgment to bring to perfection great works of architecture.

Giuliano made for Filippo Strozzi a couch of walnut-wood, which is now at Città di Castello, in the house of the heirs of Signor Alessandro Vitelli. For an altar-piece which Giorgio Vasari painted for the high-altar of the Abbey of Camaldoli in the Casentino, he made a very rich and beautiful frame, after the design of Giorgio; and he carved another ornamental frame for a large altar-piece that the same Giorgio executed for the Church of S. Agostino in Monte Sansovino. The same Giuliano made another beautiful frame for another altar-piece by the hand of Vasari, which is in the Abbey of Classi, a seat of the Monks of Camaldoli, at Ravenna. He also executed the frames for the pictures by the hand of the same Giorgio of Arezzo that are in the refectory of the Monks of the Abbey of S. Fiore at Arezzo; and in the Vescovado in the same city, behind the high-altar, he made a most beautiful choir of walnut-wood, after the design of Giorgio, which provided for the bringing forward of the altar. And, finally, a short time before his death, he made the rich and beautiful Ciborium of the most Holy Sacrament for the high-altar of the Nunziata, with the two Angels of wood, in full-relief, which are on either side of it. This was the last work that he executed, and he passed to a better life in the year 1555.

Nor was Domenico, the brother of that Giuliano, inferior to him in judgment, seeing that, besides carving much better in wood, he was also very ingenious in matters of architecture, as may be seen from the house that was built for Bastiano da Montaguto in the Via de' Servi after his design, wherein there are also many works in wood by Domenico's own hand. The same master executed for Agostino del Nero, in the Piazza de' Mozzi, the buildings that form the street-corner and a very beautiful terrace for that house of the Nasi formerly begun by his father Baccio.

And it is the common belief that, if he had not died so young, he would have surpassed by a great measure both his father and his brother Giuliano.

VALERIO VICENTINO, GIOVANNI DA CASTEL BOLOGNESE, MATTEO DAL NASSARO OF VERONA, AND OTHER EXCELLENT ENGRAVERS OF CAMEOS AND GEMS

SINCE the Greeks were such divine masters in the engraving of Oriental stones and so perfect in the cutting of cameos, it seems to me certain that I should commit no slight error were I to pass over in silence those of our own age who have imitated those marvellous intellects; although among our moderns, so it is said, there have been none who in this present and happy age have surpassed the ancients in delicacy and design, save perchance those of whom we are about to give an account. But before making a beginning, it is proper for me to discourse briefly on this art of engraving hard stones and gems, which was lost, together with the other arts of design, after the ruin of Greece and Rome. Of this work, whether engraved in intaglio or in relief, we have seen examples discovered daily among the ruins of Rome, such as cameos, cornelians, sardonyxes, and other most excellent intagli; but for many and many a year the art remained lost, there being no one who gave attention to it, and even if any work was done, it was not in such a manner as to be worthy to be taken into account. So far as is known, it is not found that anyone began to do good work or to attain to excellence until the time of Pope Martin V and Pope Paul II; after which the art continued to grow little by little down to the time of Lorenzo de' Medici, the Magnificent, who greatly delighted in the engraved cameos of the ancients. Lorenzo and his son Piero collected a great quantity of these, particularly chalcedonies, cornelians, and other kinds of the choicest engraved stones, which contained various fanciful designs; and in consequence of this, wishing to establish the art in their own city, they summoned thither masters from various countries, who, besides restoring those stones, brought to them other works which were at that time rare.

By these masters, at the instance of the Magnificent Lorenzo, this art of engraving in intaglio was taught to a young Florentine called Giovanni delle Corniole,* who received that surname because he engraved them excellently well, of which we have testimony in the great numbers of them by his hand that are to be seen, both great and small, but particularly in a large one, which was a very choice intaglio, wherein he made the portrait of Fra Girolamo Savonarola, who was adored in Florence in his day on account of his preaching. A rival of Giovanni was Domenico de' Cammei,† a Milanese, who, living at the same time as Duke Lodovico, Il Moro, made a portrait of him in intaglio on a balasruby greater than a giulio, which was an exquisite thing and one of the best works in intaglio that had been seen executed by a modern master. This art afterwards rose to even greater excellence in the pontificate of Pope Leo X, through the talents and labours of Pier Maria da Pescia, who was a most faithful imitator of the works of the ancients; and he had a rival in Michelino, who was no less able than Pier Maria in works both great and small, and was held to be a graceful master.

These men opened the way in this art, which is so difficult, for engraving in intaglio is truly working in the dark, since the craftsman can use nothing but impressions of wax, as spectacles, as it were, wherewith to see from time to time what he is doing. And finally they brought it to such a condition that Giovanni da Castel Bolognese, Valerio Vicentino, Matteo dal Nassaro, and others, were able to execute the many beautiful works of which we are about to make mention.

Let me begin, then, by saying that Giovanni Bernardi of Castel Bolognese, who worked in his youth in the service of Duke Alfonso of Ferrara, made for him, in the three years of honourable service that he gave him, many little works, of which there is no need to give any description. Of his larger works the first was an intaglio on a piece of crystal, in which he represented the whole of the action of Bastia, which was very beautiful; and then he executed the portrait of that Duke in a steel die for the purpose of making medals, with the Taking of Jesus Christ by the Multitude on the reverse. Afterwards, urged by Giovio, he went to Rome, and obtained by favour of Cardinal Ippolito de' Medici and Cardinal Giovanni Salviati the privilege of taking a portrait

* Giovanni of the Cornelians.
† Domenico of the Cameos.

of Clement VII, from which he made a die for medals, which was very beautiful, with Joseph revealing himself to his brethren on the reverse; and for this he was rewarded by His Holiness with the gift of a Mazza, an office which he afterwards sold in the time of Paul III, receiving two hundred crowns for it. For the same Clement he executed figures of the four Evangelists on four round crystals, which were much extolled, and gained for him the favour and friendship of many prelates, and in particular the good-will of Salviati and of the above-mentioned Cardinal Ippolito de' Medici, that sole refuge for men of talent, whose portrait he made on steel medals, besides executing for him on crystal the Presentation of the Daughter of Darius to Alexander the Great.

After this, when Charles V went to Bologna to be crowned, Giovanni made a portrait of him in steel, from which he struck a medal of gold. This he carried straightway to the Emperor, who gave him a hundred pistoles of gold, and sent to inquire whether he would go with him to Spain; but Giovanni refused, saying that he could not leave the service of Clement and of Cardinal Ippolito, for whom he had begun some work that was still unfinished.

Having returned to Rome, Giovanni executed for the same Cardinal de' Medici a Rape of the Sabines, which was very beautiful. And the Cardinal, knowing himself to be much indebted to him for all these things, rewarded him with a vast number of gifts and courtesies; but the greatest of all was this, that the Cardinal, when departing for France in the midst of a company of many lords and gentlemen, turned to Giovanni, who was there among the rest, and, taking from his own neck a little chain to which was attached a cameo worth more than six hundred crowns, he gave it to him, telling him that he should keep it until his return, and intending to bestow upon him afterwards such a recompense as he knew to be due to the talent of Giovanni.

On the death of the Cardinal, that cameo fell into the hands of Cardinal Farnese, for whom Giovanni afterwards executed many works in crystal, and in particular a Christ Crucified for a Cross, with a God the Father above, Our Lady and S. John at the sides, and the Magdalene at the foot; and in a triangle at the base of the Cross he made three scenes of the Passion of Christ, one in each angle. For two candelabra of silver he engraved six round crystals. In the first is the Centurion praying Christ that He should heal his son, in the second the Pool of Bethesda, in the third the Transfiguration on Mount Tabor, in the fourth the

VALERIO VICENTINO
INTAGLIATORE.

Miracle of the five loaves and two fishes, in the fifth the scene of Christ driving the traders from the Temple, and in the last the Raising of Lazarus; and all were exquisite. The same Cardinal Farnese afterwards desired to have a very rich casket made of silver, and had the work executed by Manno, a Florentine gold-smith, of whom there will be an account in another place; but he entrusted all the compartments of crystal to Giovanni, who made them all full of scenes, with marble in half-relief; and he made figures of silver and ornaments in the round, and all with such diligence, that no other work of that kind was ever carried to such perfection. On the body of this casket are the following scenes, engraved in ovals with marvellous art by the hand of Giovanni: The Chase of Meleager after the Calydonian Boar, the Followers of Bacchus, a naval battle, Hercules in combat with the Amazons, and other most beautiful fantasies of the Cardinal, who caused finished designs of them to be executed by Perino del Vaga and other masters. Giovanni then executed on a crystal the triumph of the taking of Goletta, and the War of Tunis on an-other. For the same Cardinal he engraved, likewise on crystal, the Birth of Christ and the scenes when He prays in the Garden; when He is taken by the Jews; when He is led before Annas, Herod, and Pilate; when He is scourged and then crowned with thorns; when He carries the Cross; when He is nailed upon it and raised on high; and, finally, His divine and glorious Resurrection. All these works were not only very beautiful, but also executed with such rapidity, that every man was struck with astonishment.

Michelagnolo had made for the above-mentioned Cardinal de' Medici a drawing, which I forgot to mention before, of a Tityus whose heart was being devoured by a vulture; and Giovanni en-graved this beautifully on crystal. And he did the same with an-other drawing by Buonarroti, in which Phaethon, not being able to manage the chariot of the Sun, has fallen into the Po, and his weeping sisters are transformed into trees.

Giovanni executed a portrait of Madama Margherita of Aus-tria, daughter of the Emperor Charles V, who had been the wife of Duke Alessandro de' Medici, and was then the consort of Duke Ottavio Farnese; and this he did in competition with Val-erio Vicentino. For these works executed for Cardinal Farnese, he received from that lord a reward in the form of the office of Giannizzero, from which he drew a good sum of money; and, in addition, he was so beloved by that Cardinal that he obtained a

great number of other favours from him, nor did the Cardinal
ever pass through Faenza, where Giovanni had built a most com-
modious house, without going to take up his quarters with him.
Having thus settled at Faenza, in order to rest after a life of much
labour in the world, Giovanni remained there ever afterwards;
and his first wife, by whom he had not had children, being dead,
he took a second. By her he had two sons and a daughter; and
with them he lived in contentment, being well provided with
landed property and other revenues, which yielded him more
than four hundred crowns, until he came to the age of sixty,
when he rendered up his soul to God on the day of Pentecost,
in the year 1555.

Matteo dal Nassaro, who was born in Verona, and was the
son of Jacopo dal Nassaro, a shoemaker, gave much attention in
his early childhood not only to design, but also to music, in which
he became excellent, having had as his masters in that study
Marco Carrà and Il Tromboncino, both Veronese, who were then
in the service of the Marquis of Mantua. In matters of intaglio he
was much assisted by two Veronese of honourable family, with
whom he was continually associated. One of these was Niccolò
Avanzi, who, working privately in Rome, executed cameos, cor-
nelians, and other stones, which were taken to various Princes;
and there are persons who remember to have seen a lapis-lazuli
by his hand, three fingers in breadth, containing the Nativity of
Christ, with many figures, which was sold as a choice work to the
Duchess of Urbino. The other was Galeazzo Mondella, who,
besides engraving gems, drew very beautifully.

After Matteo had learned from these two masters all that they
knew, it chanced that there fell into his hands a beautiful piece
of green jasper, marked with red spots, as the good pieces are;
and he engraved in it a Deposition from the Cross with such
diligence, that he made the wounds come in those parts of the
jasper that were spotted with the colour of blood, which caused
that work to be a very rare one, and brought him much commen-
dation. That jasper was sold by Matteo to the Marchioness Isa-
bella d' Este.

He then went to France, taking with him many works by his
own hand which might serve to introduce him to the Court of
King Francis I; and when he had been presented to that Sover-
eign, who always held in estimation every manner of man of
talent, the King, after taking many of the stones engraved by him,

received him into his service and ordained him a good salary; and he held Matteo dear no less because he was an excellent musician and could play very well upon the lute, than for his profession of engraving stones. Of a truth, there is nothing that does more to kindle men's minds with love for the arts than to see them appreciated and rewarded by Princes and noblemen, as has always been done in the past, and is done more than ever at the present day, by the illustrious House of Medici, and as was also done by that truly magnanimous Sovereign, King Francis.

Matteo, thus employed in the service of that King, executed many rare works, not only for His Majesty, but also for almost all the most noble lords and barons of the Court, of whom there was scarcely one who did not have some work by his hand, since it was much the custom at that time to wear cameos and other suchlike gems on the neck and in the cap. For the King he made an altar-piece for the altar of the chapel which His Majesty always took with him on his journeys; and this was full of figures of gold, partly in the round and partly in half-relief, with many engraved gems distributed over the limbs of those figures. He also engraved many pieces of crystal in intaglio, impressions of which in sulphur and gesso are to be seen in many places, and particularly in Verona, where there are marvellous representations of all the planets, and a Venus with a Cupid that has the back turned, which could not be more beautiful. In a very fine chalcedony, found in a river, Matteo engraved divinely well the head of a Deianira almost in full-relief, wearing the lion's skin, the surface being tawny in colour; and he turned to such good advantage a vein of red that was in that stone, representing with it the inner side of the lion's skin at its junction with the head, that the skin had the appearance of one newly flayed. Another spot of colour he used for the hair, and the white for the face and breast, and all with admirable mastery. This head came into the possession of King Francis, together with the other things; and there is an impression of it at the present day in Verona, which belongs to the goldsmith Zoppo, who was Matteo's disciple.

Matteo was a man of great spirit and generosity, insomuch that he would rather have given his works away than sold them for a paltry price. Wherefore when a baron, for whom he had made a cameo of some value, wished to pay him a wretched sum for it, Matteo besought him straitly that he should accept it as a present. To this the other would not consent, and yet wished to

have it for the same miserable price; whereupon Matteo, flying into a rage, crushed it to powder with a hammer in his presence. For the same King Matteo executed many cartoons for tapestries, and with these, to please His Majesty, he was obliged to go to Flanders, and to stay there until they had been woven in silk and gold; which being finished and taken to France, they were held to be very beautiful. Finally, Matteo returned to his own country, as almost all men do, taking with him many rare things from those foreign parts, and in particular some landscapes on canvas painted in Flanders in oils and in gouache, and executed by very able hands, which are still preserved and treasured in Verona, in memory of him, by Signor Luigi and Signor Girolamo Stoppi. Having returned to Verona, Matteo took up his abode in a cave hollowed out under a rocky cliff, above which is the garden of the Frati Ingiesuati – a place which, besides being very warm in winter and very cool in summer, commands a most beautiful view. But he was not able to enjoy that habitation, thus contrived after his own fancy, as long as he would have liked, for King Francis, as soon as he had been released from his captivity, sent a special messenger to recall Matteo to France, and to pay him his salary even for all the time that he had been in Verona; and when he had arrived there, the King made him master of dies for the Mint. Taking a wife in France, therefore, Matteo settled down to live in those parts, since such was the pleasure of the King his master. By that wife he had some children, but all so unlike himself that he had little satisfaction from them.

Matteo was so gentle and courteous, that he welcomed with extraordinary warmth anyone who arrived in France, not only from his own city of Verona, but from every part of Lombardy. His dearest friend in those regions was Paolo Emilio of Verona, who wrote the history of France in the Latin tongue. Matteo taught many disciples, among them a fellow-Veronese, the brother of Domenico Brusciasorzi, two of his nephews, who went to Flanders, and many other Italians and Frenchmen, of whom there is no need to make mention. And finally he died, not long after the death of King Francis of France.

But to come at length to the marvellous art of Valerio Vicentino, of whom we have now to speak: this master executed so many works, both great and small, either in intaglio or in relief, and all with such a finish and such facility, that it is a thing incredible. If Nature had made Valerio a good master of design,

even as she made him most excellent in engraving, in which he executed his works with extraordinary patience, diligence, and rapidity, he would not merely have equalled the ancients, as he did, but would have surpassed them by a great measure; and even so he had such judgment, that he always availed himself in his works of the designs of others or of the intagli of the ancients.

Valerio fashioned for Pope Clement VII a casket entirely of crystal, wrought with admirable mastery, for which he received two thousand crowns of gold from that Pontiff in return for his labour. In those crystals Valerio engraved the whole Passion of Jesus Christ, after the designs of others; and that casket was afterwards presented by Pope Clement to King Francis at Nice, at the time when his niece went to be married to the Duke of Orleans, who afterwards became King Henry. For the same Pope Valerio made some most beautiful paxes, and a divine cross of crystal, and likewise dies for striking medals, containing the portrait of Pope Clement, with very beautiful reverses; and through him that art produced in his day many masters, both from Milan and from other parts, who had grown to such a number before the sack of Rome, that it was a marvel. He made the medals of the twelve Emperors, with their reverses, copying the most beautiful antiques, with a great number of Greek medals; and he engraved so many other works in crystal, that the shops of the goldsmiths, or rather, the whole world, may be seen to be full of impressions taken in gesso, sulphur, or other compositions, from the intagli in which he made scenes, figures, or heads. He had, indeed, a skill of hand so extraordinary, that there was never anyone in his profession who executed more works than Valerio.

He also fashioned many vases of crystal for Pope Clement, who presented some to various Princes, and others were placed in the Church of S. Lorenzo at Florence, together with many vases that were formerly in the Palace of the Medici and had belonged to the elder Lorenzo, the Magnificent, and to other members of that most illustrious family, that they might serve to contain the relics of many Saints, which that Pontiff presented to that church in memory of himself. It would not be possible to find anything more varied than the curves of those vases, some of which are of sardonyx, agate, amethyst, and lapis-lazuli, and some of plasma, heliotrope, jasper, crystal, and cornelian, so that in point of value or beauty nothing more could be desired.

For Pope Paul III he made a cross and two candelabra, likewise of crystal, engraved with scenes of the Passion of Jesus Christ in various compartments; with a vast number of stones, both great and small, of which it would take too long to make mention. And in the collection of Cardinal Farnese may be seen many things by the hand of Valerio, who left no fewer finished works than did the above-named Giovanni. At the age of seventy-eight he performed miracles, so sure were his eye and hand; and he taught his art to a daughter of his own, who works very well. He so delighted to lay his hands on antiquities in marble, impressions in gesso of works both ancient and modern, and drawings and pictures by rare masters, that he shrank from no expense; wherefore his house at Vicenza is adorned by such an abundance of various things, that it is a marvel. It is clearly evident that when a man bears love to art, it never leaves him until he is in the grave; whence he gains praise and his reward during his lifetime, and makes himself immortal after death. Valerio was well remunerated for his labours, and received offices and many benefits from those Princes whom he served; and thus those who survived him are able, thanks to him, to maintain an honourable state. And in the year 1546, when, by reason of the infirmities that old age brings in its train, he could no longer attend to his art, or even live, he rendered up his soul to God.

At Parma, in times past, lived Marmita, who gave his attention for a period to painting, and then turned to intaglio, in which he imitated the ancients very closely. Many most beautiful works by his hand are to be seen, and he taught the art to a son of his own, called Lodovico, who lived for a long time in Rome with Cardinal Giovanni de' Salviati. Lodovico executed for that Cardinal four ovals of crystal engraved with figures of great excellence, which were placed on a very beautiful casket of silver that was afterwards presented to the most illustrious Signora Leonora of Toledo, Duchess of Florence. He made, among many other works, a cameo with a most beautiful head of Socrates, and he was a great master at counterfeiting ancient medals, from which he gained extraordinary advantage.

There followed, in Florence, Domenico di Polo, a Florentine and an excellent master of intaglio, who was the disciple of Giovanni delle Corniole, of whom we have spoken. In our own day this Domenico executed a divine portrait of Duke Alessandro de' Medici, from which he made dies in steel and most beautiful

medals, with a reverse containing a Florence. He also made a portrait of Duke Cosimo in the first year after his election to the government of Florence, with the sign of Capricorn on the reverse; and many other little works in intaglio, of which there is no need to make record. He died at the age of sixty-five.

Domenico, Valerio, Marmita, and Giovanni da Castel Bolognese being dead, there remained many who have surpassed them by a great measure; one in Venice, for example, being Luigi Anichini of Ferrara, who, with the delicacy of his engraving and the sharpness of his finish, has produced works that are marvellous. But far beyond all others in grace, excellence, perfection, and versatility, has soared Alessandro Cesati, surnamed Il Greco, who has executed cameos in relief and gems in intaglio in so beautiful a manner, as well as dies of steel in incavo, and has used the burin with such supreme diligence and with such mastery over the most delicate refinements of his art, that nothing better could be imagined. Whoever wishes to be amazed by his miraculous powers, should study a medal that he made for Pope Paul III, with his portrait on one side, which has all the appearance of life, and on the reverse Alexander the Great, who has thrown himself at the feet of the High-Priest of Jerusalem, and is doing him homage – figures which are so marvellous that it would not be possible to do anything better. And Michelagnolo Buonarroti himself, looking at them in the presence of Giorgio Vasari, said that the hour of death had come upon the art, for nothing better could ever be seen. This Alessandro made the medal of Pope Julius III for the holy year of 1550, with a reverse showing the prisoners that were released in the days of the ancients at times of jubilee, which was a rare and truly beautiful medal; with many other dies and portraits for the Mint of Rome, which he kept busily employed for many years. He executed portraits of Pier Luigi Farnese, Duke of Castro, and his son, Duke Ottavio; and he made a portrait of Cardinal Farnese in a medal, a very choice work, the head being of gold and the ground of silver. The same master engraved for Cardinal Farnese in intaglio, on a cornelian larger than a giulio, a head of King Henry of France, which has been considered in point of design, grace, excellence, and perfection of finish, one of the best modern intagli that have ever been seen. There may also be seen many other stones engraved by his hand, in the form of cameos; truly perfect is a nude woman wrought with great art, and another in which is a lion, and likewise one of a boy, with

many small ones, of which there is no need to speak; but that which surpassed all the others was the head of the Athenian Phocion, which is marvellous, and the most beautiful cameo that is to be seen.

A master who gives his attention to cameos at the present day is Giovanni Antonio de' Rossi, an excellent craftsman of Milan, who, in addition to the various beautiful works that he has engraved in relief and in intaglio, has executed for the most illustrious Duke Cosimo de' Medici a very large cameo, one-third of a braccio in height and the same in width, in which he has cut two figures from the waist upwards – namely, His Excellency and the most illustrious Duchess Leonora, his consort, who are both holding with their hands a medallion containing a Florence, and beside them are portraits from life of the Prince Don Francesco, Don Giovanni the Cardinal, Don Garzia, Don Ernando, and Don Pietro, together with Donna Isabella and Donna Lucrezia, all their children. It would not be possible to find a more amazing or a larger work in cameo than this; and since it surpasses all the other cameos and smaller works that he has made, I shall make no further mention of them, for they are all to be seen.

Cosimo da Trezzo, also, has executed many works worthy of praise in this profession, and has won much favour on account of his rare gifts from Philip, the great Catholic King of Spain, who retains him about his person, honouring and rewarding him in return for his ability in his vocation of engraving in intaglio and in relief. He has no equal in making portraits from life; and in other kinds of work, as well as in that, his talent is extraordinary.

Of the Milanese Filippo Negrolo, who worked at chasing arms of iron with foliage and figures, I shall say nothing, since copper-engravings of his works, which have given him very great fame, may be seen about. By Gasparo and Girolamo Misuroni, engravers of Milan, have been seen most beautiful vases and tazze of crystal. For Duke Cosimo, in particular, they have executed two that are marvellous; besides which, they have made out of a piece of heliotrope a vase extraordinary in size and admirable for its engraving, and also a large vase of lapis-lazuli, which deserves infinite praise. Jacopo da Trezzo practises the same profession in Milan; and these men, in truth, have brought great beauty and facility to this art. Many masters could I mention who, in executing in incavo heads and reverses for medals, have equalled and even surpassed the ancients; as, for example, Benvenuto Cellini,

who, during the time when he exercised the goldsmith's art in Rome under Pope Clement, made two medals with a head of Pope Clement that is a living likeness, and on the reverse of one a figure of Peace that has bound Fury and is burning her arms, and on the other Moses striking the rock and causing water to flow to quench the thirst of his people: beyond which it is not possible to go in that art. And the same might be said of the coins and medals that Benvenuto afterwards made for Duke Alessandro in Florence.

Of the Chevalier, Leone Aretino, who has done equally well in the same art, and of the works that he has made and still continues to make, there will be an account in another place.

The Roman Pietro Paolo Galeotto, also, has executed for Duke Cosimo, as he still does, medals with portraits of that lord, dies for coins, and works in tarsia, imitating the methods of Maestro Salvestro, a most excellent master, who produced marvellous works in that profession at Rome.

Pastorino da Siena, likewise, has executed so many heads from life, that he may be said to have made portraits of every kind of person in the whole world, great nobles, followers of the arts, and many people of low degree. He discovered a kind of hard stucco for making portraits, wherewith he gave them the colouring of nature, with the tints of the beard, hair, and flesh, so that they had the appearance of life itself; but he deserves much more praise for his work in steel, in which he has made excellent dies for medals.

It would take too long if I were to speak of all those who execute portrait-medals of wax, seeing that every goldsmith at the present day makes them, and a number of gentlemen have given their attention to this, and still do so; such as Giovan Battista Sozzini at Siena, Rosso de' Giugni at Florence, and very many others, of whom I shall not now say more. And, to bring this account to conclusion, I return to the steel-engravers, of whom one is Girolamo Fagiuoli of Bologna, a master of chasing and of copper-engraving, and another, at Florence, is Domenico Poggini, who has made, as he still does, dies for the Mint, with medals of Duke Cosimo, and who also executes statues of marble, imitating, in so far as he is able, the rarest and most excellent masters who have ever produced choice works in these professions.

MARC' ANTONIO BOLOGNESE AND OTHER ENGRAVERS OF PRINTS

SEEING that in the Treatise on the Technique of Painting there was little said of copper-plate engraving, since it was enough at that time to describe the method of engraving silver with the burin, which is a square tool of iron, cut on the slant, with a sharp point, I shall use the occasion of this Life to say as much on that subject as I may consider to be sufficient. The beginning of print-engraving, then, came from the Florentine Maso Finiguerra, about the year of our salvation 1460; for of all the works which that master engraved in silver with designs to be filled up with niello, he took impressions in clay, over which he poured melted sulphur, which reproduced the lines of the design; and these, when filled with smoke-black mixed with oil, produced the same effect as the silver. He also did the same with damped paper and with the same tint, going over the whole with a round and smooth roller, which not only gave the designs the appearance of prints, but they also came out as if drawn with the pen. This master was followed by Baccio Baldini, a goldsmith of Florence, who, not having much power of design, took all that he did from the invention and design of Sandro Botticelli. And this method, coming to the knowledge of Andrea Mantegna in Rome, was the reason that he made a beginning with engraving many of his works, as was said in his Life.

This invention having afterwards passed into Flanders, a certain Martin, who was held to be an excellent painter in Antwerp at that time, executed many works, and sent to Italy a great number of printed designs, which were all signed in the following manner: 'M.C.' The first of these were the Five Foolish Virgins with their lamps extinguished, the Five Wise Virgins with their lamps burning, and a Christ Crucified, with S. John and the Madonna at the foot of the Cross, which was so good an engraving, that Gherardo, the Florentine illuminator, set himself to copy it with the burin, and succeeded very well; but he went no further with this, for he did not live long. Martin then published four round engravings of the four Evangelists, and Jesus Christ with the twelve Apostles, in small sheets, Veronica with six Saints, of the same size, and some coats of arms of German noblemen, supported by men, both naked and clothed, and also

by women. He published, likewise, a S. George slaying the Dragon, a Christ standing before Pilate, who is washing his hands, and a Passing of Our Lady, with all the Apostles, a work of some size, which was one of the best designs that this master ever engraved. In another he represented S. Anthony beaten by Devils, and carried through the air by a vast number of them in the most varied and bizarre forms that could possibly be imagined; which sheet so pleased Michelagnolo, when he was a mere lad, that he set himself to colour it.

After this Martin, Albrecht Dürer began to give attention to prints of the same kind at Antwerp, but with more design and better judgment, and with more beautiful invention, seeking to imitate the life and to draw near to the Italian manners, which he always held in much account. And thus, while still quite young, he executed many works which were considered as beautiful as those of Martin; and he engraved them with his own hand, signing them with his name. In the year 1503 he published a little Madonna, in which he surpassed both Martin and his own self; and afterwards many other sheets with horses, two in each sheet, taken from nature and very beautiful. In another he depicted the Prodigal Son, in the guise of a peasant, kneeling with his hands clasped and gazing up to Heaven, while some swine are eating from a trough; and in this work are some most beautiful huts after the manner of German cottages. He engraved a little S. Sebastian, bound, with the arms upraised; and a Madonna seated with the Child in her arms, with the light from a window falling upon her, a small work, than which there is nothing better to be seen. He also made a Flemish woman on horseback, with a groom at her feet; and on a larger copper-plate he engraved a nymph being carried away by a sea-monster, while some other nymphs are bathing. On a plate of the same size he engraved with supreme delicacy of workmanship, attaining to the final perfection of this art, a Diana beating a nymph, who has fled for protection to the bosom of a satyr; in which sheet Albrecht sought to prove that he was able to make nudes.

But although those masters were extolled at that time in those countries, in ours their works are commended only for the diligent execution of the engraving. I am willing, indeed, to believe that Albrecht was perhaps not able to do better because, not having any better models, he drew, when he had to make nudes,

from one or other of his assistants, who must have had bad figures, as Germans generally have when naked, although one sees many from those parts who are fine men when in their clothes. In various little printed sheets he executed figures of peasant men and women in different Flemish costumes, some playing on the bagpipes and dancing, some selling fowls and suchlike things, and others in many other attitudes. He also drew a man sleeping in a bathroom who has Venus near him, leading him into temptation in a dream, while Love is diverting himself by mounting on stilts, and the Devil blows into his ears with a pair of bellows. And he engraved two different figures of S. Christopher carrying the Infant Christ, both very beautiful, and executed with much diligence in the close detail of the hair and in every other respect.

After these works, perceiving how much time he consumed in engraving on copper, and happening to have in his possession a great abundance of subjects drawn in various ways, he set himself to making woodcuts, a method of working in which those who have the greatest powers of design find the widest field wherein to display their ability in its perfection. And in the year 1510 he published two little prints in this manner, in one of which is the Beheading of S. John, and in the other the scene of the head of the same S. John being presented in a charger to Herod, who is seated at table; with other sheets of S. Christopher, S. Sixtus the Pope, S. Stephen, and S. Laurence. Then, having seen that this method of working was much easier than engraving on copper, he pursued it and executed a S. Gregory chanting the Mass, accompanied by the deacon and sub-deacon. And, growing in courage, in the year 1510 he represented on a sheet of royal folio part of the Passion of Christ – that is, he executed four pieces, with the intention of afterwards finishing the whole, these four being the Last Supper, the Taking of Christ by Night in the Garden, His Descent into the Limbo of Hell in order to deliver the Holy Fathers, and His glorious Resurrection. That second piece he also painted in a very beautiful little picture in oils, which is now at Florence, in the possession of Signor Bernardetto de' Medici. As for the eight other parts, although they were afterwards executed and printed with the signature of Albrecht, to us it does not seem probable that they are the work of his hand, seeing that they are poor stuff, and bear no resemblance to his manner, either in the heads, or in the draperies, or in any other respect. Wherefore it

is believed that they were executed after his death, for the sake of gain, by other persons, who did not scruple to father them on Albrecht. That this is true is also proved by the circumstance that in the year 1511 he represented the whole life of Our Lady in twenty sheets of the same size, executing it so well that it would not be possible, whether in invention, in the composition of the perspective-views, in the buildings, in the costumes, or in the heads of old and young, to do better. Of a truth, if this man, so able, so diligent, and so versatile, had had Tuscany instead of Flanders for his country, and had been able to study the treasures of Rome, as we ourselves have done, he would have been the best painter of our land, even as he was the rarest and most celebrated that has ever appeared among the Flemings. In the same year, continuing to give expression to his fantasies, Albrecht resolved to execute fifteen woodcuts of the same size, representing the terrible vision that S. John the Evangelist described in his Apocalypse on the Isle of Patmos. And so, setting his hand to the work, with his extravagant imagination, so well suited to such a subject, he depicted all those things both of heaven and of earth so beautifully, that it was a marvel, and with such a variety of forms in those animals and monsters, that it was a great light to many of our craftsmen, who have since availed themselves of the vast abundance of his beautiful fantasies and inventions. By the hand of the same master, also, is a woodcut that is to be seen of a nude Christ, who has round Him the Mysteries of His Passion, and is weeping for our sins, with His hands to His face; and this, for a small work, is not otherwise than worthy of praise.

Then, having grown both in power and in courage, as he saw that his works were prized, Albrecht executed some copper-plates that astonished the world. He also set himself to make an engraving, for printing on a sheet of half-folio, of a figure of Melancholy, with all the instruments that reduce those who use them, or rather, all mankind, to a melancholy humour; and in this he succeeded so well, that it would not be possible to do more delicate engraving with the burin. He executed three small plates of Our Lady, all different one from another, and most subtle in engraving. But it would take too long if I were to try to enumerate all the works that issued from Albrecht's hand; let it be enough for the present to tell that, having drawn a Passion of Christ in thirty-six parts, and having engraved these, he made an

agreement with Marc' Antonio Bolognese that they should publish the sheets in company; and thus, arriving in Venice, this work was the reason that marvellous prints of the same kind were afterwards executed in Italy, as will be related below.

While Francesco Francia was working at his painting in Bologna, there was among his many disciples a young man called Marc' Antonio, who, being more gifted than the others, was much brought forward by him, and, from having been many years with Francia and greatly beloved by him, acquired the surname of De' Franci. This Marc' Antonio, who was more able in design than his master, handled the burin with facility and grace, and executed in niello girdles and many other things much in favour at that time, which were very beautiful, for the reason that he was indeed most excellent in that profession. Having then been seized, as happens to many, with a desire to go about the world and see new things and the methods of other craftsmen, with the gracious leave of Francia he went off to Venice, where he was well received by the craftsmen of that city. About the same time there arrived in Venice some Flemings with many copper-plate engravings and woodcuts by Albrecht Dürer, which were seen by Marc' Antonio on the Piazza di S. Marco; and he was so amazed at the manner and method of the work of Albrecht, that he spent on those sheets almost all the money that he had brought from Bologna. Among other things, he bought the Passion of Jesus Christ, which had been engraved on thirty-six wood-blocks and printed not long before on sheets of quarter-folio by the same Albrecht. This work began with the Sin of Adam and the scene of the Angel expelling him from Paradise, and continued down to the Descent of the Holy Spirit.

Marc' Antonio, having considered what honour and profit might be acquired by one who should apply himself to that art in Italy, formed the determination to give his attention to it with all possible assiduity and diligence. He thus began to copy those engravings by Albrecht Dürer, studying the manner of each stroke and every other detail of the prints that he had bought, which were held in such estimation on account of their novelty and their beauty, that everyone sought to have some. Having then counterfeited on copper, with engraving as strong as that of the woodcuts that Albrecht had executed, the whole of the said Life and Passion of Christ in thirty-six parts, he added to these the signature that Albrecht used for all his works, which was

'A.D.,' and they proved to be so similar in manner, that, no one knowing that they had been executed by Marc' Antonio, they were ascribed to Albrecht, and were bought and sold as works by his hand. News of this was sent in writing to Albrecht, who was in Flanders, together with one of the counterfeit Passions executed by Marc' Antonio; at which he flew into such a rage that he left Flanders and went to Venice, where he appeared before the Signoria and laid a complaint against Marc' Antonio. But he could obtain no other satisfaction but this, that Marc' Antonio should no longer use the name or the above-mentioned signature of Albrecht on his works.

After this affair, Marc' Antonio went off to Rome, where he gave his whole attention to design; and Albrecht returned to Flanders, where he found that another rival had already begun to execute many most delicate engravings in competition with him. This was Lucas of Holland,* who, although he was not as fine a master of design as Albrecht, was yet in many respects his equal with the burin. Among the many large and beautiful works that Lucas executed, the first were two in 1509, round in shape, in one of which is Christ bearing the Cross, and in the other His Crucifixion. Afterwards he published a Samson, a David on horseback, and a S. Peter Martyr, with his tormentors; and then he made a copper-plate engraving of Saul seated with the young David playing in his presence. And not long after, having made a great advance, he executed a very large plate with the most delicate engraving, of Virgil suspended from the window in the basket, with some heads and figures so marvellous, that they were the reason that Albrecht, growing more subtle in power through this competition, produced some printed sheets of such excellence, that nothing better could be done. In these, wishing to display his ability, Albrecht made an armed man on horseback, representing Human Strength, which is so well finished, that one can see the lustre of the arms and of the black horse's coat, which is a difficult thing to reproduce in design. This stalwart horseman had Death, hour-glass in hand, beside him, and the Devil behind. There was also a long-haired dog, executed with the most subtle delicacy that can possibly be achieved in engraving. In the year 1512 there issued from the hand of the same master sixteen little scenes of the Passion of Jesus Christ, engraved so well on copper,

* Luca di Leyden.

that there are no little figures to be seen that are more beautiful, sweet, and graceful, nor any that are stronger in relief.

Spurred likewise by rivalry, the same Lucas of Holland executed twelve similar plates, very beautiful, and yet not so perfect in engraving and design; and, in addition to these, a S. George who is comforting the Maiden, who is weeping because she is destined to be devoured by the Dragon; and also a Solomon, who is worshipping idols; the Baptism of Christ; Pyramus and Thisbe, and Ahasuerus with Queen Esther kneeling before him. Albrecht, on his part, not wishing to be surpassed by Lucas either in the number or in the excellence of his works, engraved a nude figure on some clouds, and a Temperance with marvellous wings, holding a cup of gold and a bridle, with a most delicate little landscape; and then a S. Eustachio kneeling before the stag, which has the Crucifix between its horns, a sheet which is amazing, and particularly for the beauty of some dogs in various attitudes, which could not be more perfect. Among the many children of various kinds that he made for the decoration of arms and devices, he engraved some who are holding a shield, wherein is a Death with a cock for crest, the feathers of which are rendered in such detail, that it would be impossible to execute anything more delicate with the burin.

Finally, he published the sheet with S. Jerome in the habit of a Cardinal, writing, with the Lion sleeping at his feet. In this work Albrecht represented a room with windows of glass, through which stream the rays of the sun, falling on the place where the Saint sits writing, with an effect so natural, that it is a marvel; besides which, there are books, timepieces, writings, and so many other things, that nothing more and nothing better could be done in this field of art. Not long afterwards, in the year 1523, he executed a Christ with the twelve Apostles, in little figures, which was almost the last of his works. There may also be seen prints of many heads taken from life by him, such as that of Erasmus of Rotterdam, that of Cardinal Albrecht of Brandenburg, Elector of the Empire, and also his own. Nor, with all the engravings that he produced, did he ever abandon painting; nay, he was always executing panels, canvases, and other paintings, all excellent, and, what is more, he left many writings on matters connected with engraving, painting, perspective, and architecture.

But to return to the subject of engraving: the works of Albrecht Dürer induced Lucas of Holland to follow in his steps to

the best of his power. After the works already mentioned, Lucas engraved on copper four scenes from the life of Joseph, and also the four Evangelists, the three Angels who appeared to Abraham in the Valley of Mamre, Susannah in the Bath, David praying, Mordecai riding in Triumph on Horseback, Lot made drunk by his Daughters, the Creation of Adam and Eve, God commanding them that they shall not eat of the Fruit from the Tree that He points out to them, and Cain killing his brother Abel; all which sheets were published in the year 1529. But that which did more than anything else to bring renown and fame to Lucas, was a large sheet in which he represented the Crucifixion of Jesus Christ; with another wherein Pilate is showing Him to the people, saying, 'Ecce Homo!' These sheets, which are large, and contain a great number of figures, are held to be excellent; as are, likewise, one with a Conversion of S. Paul, and another showing him being led, blind, into Damascus. And let these works suffice to prove that Lucas may be numbered among those who have handled the burin with ability.

The scenes of Lucas are very happy in composition, being executed with such clearness and so free from confusion, that it seems certain that the action represented could not have taken place in any other way; and they are arranged more in accordance with the rules of art than those of Albrecht. Besides this, it is evident that he used a wise discretion in the engraving of his works, for the reason that all those parts which recede little by little into the distance are less strongly defined in proportion as they are lost to view, even as natural objects become less clear to the eye when seen from afar. Indeed, he executed them with such thoughtful care, and made them so soft and well blended, that they would not be better in colour; and his judicious methods have opened the eyes of many painters. The same master engraved many little plates: various figures of Our Lady, the twelve Apostles with Christ, many Saints, both male and female; arms and helmet-crests, and other suchlike things. Very beautiful is a peasant who is having a tooth drawn, and is feeling such pain, that he does not notice that meanwhile a woman is robbing his purse. All these works of Albrecht and Lucas have brought it about that many other Flemings and Germans after them have printed similar sheets of great beauty.

But returning to Marc' Antonio: having arrived in Rome, he engraved on copper a most lovely drawing by Raffaello da

Urbino, wherein was the Roman Lucretia killing herself, which he executed with such diligence and in so beautiful a manner, that Raffaello, to whom it was straightway carried by some friends, began to think of publishing in engravings some designs of works by his hand, and then a drawing that he had formerly made of the Judgment of Paris, wherein, to please himself, he had drawn the Chariot of the Sun, the nymphs of the woods, those of the fountains, and those of the rivers, with vases, the helms of ships, and other beautiful things of fancy all around; and when he had made up his mind, these were engraved by Marc' Antonio in such a manner as amazed all Rome. After them was engraved the drawing of the Massacre of the Innocents, with most beautiful nudes, women and children, which was a rare work; and then the Neptune, with little stories of Æneas around it, the beautiful Rape of Helen, also after a drawing by Raffaello, and another design in which may be seen the death of S. Felicita, who is being boiled in oil, while her sons are beheaded. These works acquired such fame for Marc' Antonio, that his engravings were held in much higher estimation, on account of their good design, than those of the Flemings; and the merchants made very large profits out of them.

Raffaello had kept an assistant called Baviera for many years to grind his colours; and since this Baviera had a certain ability, Raffaello ordained that he should attend to the printing of the engravings executed by Marc' Antonio, to the end that all his compositions might thus be finished, and then sold in gross and in detail to all who desired them. And so, having set to work, they printed a vast number, which brought very great profit to Raffaello; and all the plates were signed by Marc' Antonio with the following signatures, 'R.S.' for the name of Raffaello Sanzio of Urbino, and 'M.F.' for that of Marc' Antonio. Among these works were a Venus embraced by Love, after a drawing by Raffaello, and a scene in which God the Father is blessing the seed of Abraham, with the handmaiden and two children. Next were engraved all the round pictures that Raffaello had painted in the apartments of the Papal Palace, such as the Universal Knowledge, Calliope with the musical instrument in her hand, Foresight, and Justice; and then, after a small drawing, the scene which Raffaello had painted in the same apartment, of Mount Parnassus, with Apollo, the Muses, and the Poets; and also that of Æneas carrying Anchises on his back while Troy is burning, of which

Raffaello had made the drawing in order to paint a little picture. After this they engraved and printed another work of Raffaello, Galatea in a car drawn over the sea by Dolphins, with some Tritons who are carrying off a Nymph.

These works finished, Marc' Antonio engraved many separate figures, likewise on copper, and after drawings by Raffaello; an Apollo with a lyre in his hand; a figure of Peace, to whom Love is offering an olive-branch; the three Theological and the four Moral Virtues, and a Jesus Christ with the twelve Apostles, of the same size; a half-folio plate of the Madonna that Raffaello had painted in the altar-piece of the Araceli, and likewise one of that which went to S. Domenico in Naples, with Our Lady, S. Jerome, the Angel Raphael, and Tobias; and a little plate of Our Lady seated on a chair and embracing the Infant Christ, who is half clothed, with many other figures of the Madonna copied from the pictures which Raffaello had painted for various persons. After these he engraved a young S. John the Baptist, seated in the desert, and then the picture which Raffaello executed for S. Giovanni in Monte, of S. Cecilia with other Saints, which was held to be a most beautiful sheet. When Raffaello had finished all the cartoons of the tapestries for the Papal Chapel, which were afterwards woven in silk and gold, with stories of S. Paul, S. Peter, and S. Stephen, Marc' Antonio engraved the Preaching of S. Paul, the Stoning of S. Stephen, and the Blind Man receiving his Sight; which plates, what with the invention of Raffaello, the grace of the design, and the diligent engraving of Marc' Antonio, were so beautiful, that there was nothing better to be seen. He then engraved, after the invention of the same Raffaello, a most beautiful Deposition from the Cross, with a Madonna in a swoon, who is marvellous; and not long afterwards a plate, which is very beautiful, of that picture by Raffaello which went to Palermo, of a Christ who is bearing the Cross, and also one of a drawing that Raffaello had executed of a Christ in the air, with Our Lady, S. John the Baptist, and S. Catharine kneeling on the ground, and S. Paul the Apostle standing, which was a large and very lovely engraving. This and the others, after becoming spoiled and almost worn out through being too much used, were carried away by Germans and others in the sack of Rome.

The same Marc' Antonio engraved the portrait of Pope Clement VII in profile, with the face shaved, in the form of a

medallion; one of the Emperor Charles V at the time when he was a young man, and another of him at a riper age; and also one of Ferdinand, King of the Romans, who afterwards succeeded Charles V as Emperor. He also made in Rome a portrait from life of Messer Pietro Aretino, a very famous poet, which was the most beautiful that Marc' Antonio ever executed; and, not long afterwards, portraits of the twelve ancient Emperors in medallions. Of these sheets Raffaello sent some into Flanders to Albrecht Dürer, who praised Marc' Antonio highly, and sent in return to Raffaello, in addition to many other sheets, his own portrait, which was held to be a miracle of beauty.

Now, the fame of Marc' Antonio having grown very great, and the art of engraving having come into credit and repute, many disciples had placed themselves under him in order to learn it. And of their number, two who made great proficience were Marco da Ravenna, who signed his plates with the signature of Raffaello, 'R.S.,' and Agostino Viniziano, who signed his works in the following manner: 'A.V.' These two engraved and printed many designs by Raffaello, such as one of Our Lady with Christ lying dead at full length, and at His feet S. John, the Magdalene, Nicodemus, and the other Maries; and they engraved another plate of greater size, in which is a Madonna, with the arms outstretched and the eyes raised towards Heaven, in an attitude of supreme pity and sorrow, with Christ, in like manner, lying dead at full length.

Agostino afterwards engraved a large plate of the Nativity, with the Shepherds and Angels about the hut, and God the Father above; and he executed many vases, both ancient and modern, and also a censer, or rather, two women with a vase perforated at the top. He engraved a plate with a man transformed into a wolf, who is stealing towards a bed in order to kill one who is sleeping in it. And he also executed one of Alexander with Roxana, to whom that Prince is presenting a royal crown, while some Loves are hovering about her and adorning her head, and others are playing with the arms of Alexander.

The same masters together engraved the Last Supper of Christ with the twelve Apostles, on a plate of some size, and an Annunciation, all after the designs of Raffaello; and then two stories of the Marriage of Psyche, which had been painted by Raffaello not long before. In the end, Agostino and the above-mentioned Marco between them engraved almost all the works that Raffaello

ever drew or painted, and made prints of them; and also many of the pictures painted by Giulio Romano, after copies drawn for that purpose. And to the end that there might remain scarcely a single work of Raffaello that had not been engraved by them, they finally made engravings of the scenes that Giulio had painted in the Loggie after the designs of Raffaello.

There may still be seen some of the first plates, with the signature 'M.R.' for Marco Ravignano, and others with the signature 'A.V.' for Agostino Viniziano, re-engraved by others after them, such as the Creation of the World, and God forming the Animals; the Sacrifices of Cain and Abel, and the Death of Abel; Abraham sacrificing Isaac; Noah's Ark, the Deluge, and the Animals afterwards issuing from the Ark; the Passage of the Red Sea; the Delivery of the Laws from Mount Sinai through Moses, and the Manna; David slaying Goliath, already engraved by Marc' Antonio; Solomon building the Temple; the Judgment of the same Solomon between the two women, and the Visit of the Queen of Sheba; and, from the New Testament, the Nativity and the Resurrection of Christ, and the Descent of the Holy Spirit. All these were engraved and printed during the lifetime of Raffaello.

After the death of Raffaello, Marco and Agostino separated, and Agostino was retained by Baccio Bandinelli, the Florentine sculptor, who caused him to engrave after his design an anatomical figure that he had formed out of lean bodies and dead men's bones; and then a Cleopatra. Both these were held to be very good plates. Whereupon, growing in courage, Baccio drew, and caused Agostino to engrave, a large plate – one of the largest, indeed, that had ever been engraved up to that time – full of women clothed, and of naked men who are slaughtering the little innocents by command of King Herod.

Marc' Antonio, meanwhile, continuing to work at engraving, executed some plates with small figures of the twelve Apostles, in various manners, and many Saints, both male and female, to the end that the poor painters who were weak in design might be able to avail themselves of these in their need. He also engraved a nude young man, who has a lion at his feet, and is seeking to furl a large banner, which is swollen out by the wind in a direction contrary to his purpose; another who is carrying a pedestal on his back; and a little S. Jerome who is meditating on death, placing a finger in the hollow of a skull that he has in his

hand, the invention and design of which were by Raffaello. Then he executed a figure of Justice, which he copied from the tapestries of the Chapel; and afterwards an Aurora, drawn by two horses, on which the Hours are placing bridles. He also copied the Three Graces from the antique; and he engraved a scene of Our Lady ascending the steps of the Temple.

After these things, Giulio Romano, who in his modesty would never have any of his works engraved during the lifetime of his master Raffaello, lest he should seem to wish to compete with him, caused Marc' Antonio, after the death of Raffaello, to engrave two most beautiful battles of horsemen on plates of some size, and all the stories of Venus, Apollo, and Hyacinthus, which he had painted in the bathroom that is at the villa of Messer Baldassarre Turini da Pescia. And he did the same with the four stories of the Magdalene and the four Evangelists that are in the vaulting of the chapel of the Trinità, which were executed for a courtezan, although the chapel now belongs to Messer Agnolo Massimi. By the same master was drawn and reproduced in engraving a very beautiful ancient sarcophagus containing a lion-hunt, which was formerly at Maiano, and is now in the court of S. Pietro; as well as one of the ancient scenes in marble that are under the Arch of Constantine; and, finally, many scenes that Raffaello had designed for the corridor and Loggie of the Palace, which have since been engraved once more by Tommaso Barlacchi, together with those of the tapestries that Raffaello executed for the public Consistory.

After this, Giulio Romano caused Marc' Antonio to engrave twenty plates showing all the various ways, attitudes, and positions in which licentious men have intercourse with women; and, what was worse, for each plate Messer Pietro Aretino wrote a most indecent sonnet, insomuch that I know not which was the greater, the offence to the eye from the drawings of Giulio, or the outrage to the ear from the words of Aretino. This work was much censured by Pope Clement; and if, when it was published, Giulio had not already left for Mantua, he would have been sharply punished for it by the anger of the Pope. And since some of these sheets were found in places where they were least expected, not only were they prohibited, but Marc' Antonio was taken and thrown into prison; and he would have fared very badly if Cardinal de' Medici and Baccio Bandinelli, who was then at Rome in the service of the Pope, had not obtained his release.

Of a truth, the gifts of God should not be employed, as they very often are, in things wholly abominable, which are an outrage to the world.

Released from prison, Marc' Antonio finished engraving for Baccio Bandinelli a large plate that he had previously begun, with a great number of nude figures engaged in roasting S. Laurence on the gridiron, which was held to be truly beautiful, and was indeed engraved with incredible diligence, although Bandinelli, complaining unjustly of Marc' Antonio to the Pope while that master was executing it, said that he was committing many errors. But for this sort of gratitude Bandinelli received the reward that his lack of courtesy deserved, for Marc' Antonio, having heard the whole story, and having finished the plate, went, without Baccio being aware of it, to the Pope, who took infinite delight in the arts of design; and he showed him first the original drawing by Bandinelli, and then the printed engraving, from which the Pope recognized that Marc' Antonio not only had committed no errors, but had even corrected with great judgment many committed by Bandinelli, which were of no small importance, and had shown more knowledge and craftsmanship in his engraving than had Baccio in his drawing. Wherefore the Pope commended him greatly and ever afterwards received him with favour; and it is believed that he might have done much for him, but the sack of Rome supervening, Marc' Antonio became little less than a beggar, seeing that, besides losing all his property, he was forced to disburse a good ransom in order to escape from the hands of the Spaniards. Which done, he departed from Rome, never to return; and there are few works to be seen which were executed by him after that time. Our arts are much indebted to Marc' Antonio, in that he made a beginning with engraving in Italy, to the advantage and profit of art and to the convenience of her followers, in consequence of which others have since executed the works that will be described hereafter.

Now Agostino Viniziano, of whom we have already spoken, came to Florence, after the circumstances described above, with the intention of attaching himself to Andrea del Sarto, who was held to be about the best painter in Italy after Raffaello. And so Andrea, persuaded by this Agostino to have his works engraved, made a drawing of a Dead Christ supported by three Angels; but since the attempt did not succeed exactly according to his fancy, he would never again allow any work of his to be engraved. After

his death, however, certain persons published engravings of the Visitation of S. Elizabeth and of the Baptism of the people by S. John, taken from the work in chiaroscuro that Andrea painted in the Scalzo at Florence. Marco da Ravenna, likewise, in addition to the works already mentioned, which he executed in company with Agostino, also engraved many others by himself, which are all good and worthy of praise, and are known by his signature, which has been described above. Many others, also, have there been after these, who have worked very well at engraving, and have brought it about that every country has been able to see and enjoy the honoured labours of the most excellent masters.

Nor has there been wanting one who has had the enterprise to execute with wood-blocks prints that possess the appearance of having been made with the brush after the manner of chiaroscuro, which is an ingenious and difficult thing. This was Ugo da Carpi, who, although he was a mediocre painter, was nevertheless a man of most subtle wit in strange and fanciful inventions. He it was, as has been related in the thirtieth chapter of the Treatise on Technique, who first attempted, and that with the happiest result, to work with two blocks, one of which he used for hatching the shadows, in the manner of a copper-plate, and with the other he made the tint of colour, cutting deeply with the strokes of the engraving, and leaving the lights so bright, that when the impression was pulled off they appeared to have been heightened with lead-white. Ugo executed in this manner, after a design drawn by Raffaello in chiaroscuro, a woodcut in which is a Sibyl seated who is reading, with a clothed child giving her light with a torch. Having succeeded in this, Ugo took heart and attempted to make prints with wood-blocks of three tints. The first gave the shadow; the second, which was lighter in tone, made the middle tint, and the third, cut deeply, gave the higher lights of the ground and left the white of the paper. And the result of this, also, was so good, that he executed a woodcut of Æneas carrying Anchises on his back, while Troy is burning. He then made a Deposition from the Cross, and the story of Simon Magus, which had been used by Raffaello for the tapestries of the above-mentioned Chapel; and likewise David slaying Goliath, and the Flight of the Philistines, of which Raffaello had prepared the design in order to paint it in the Papal Loggie. And after many other works in chiaroscuro, he executed in the same manner a Venus, with many Loves playing about her.

Now since, as I have said, he was a painter, I must not omit to tell that he painted in oils, without using a brush, but with his fingers, and partly, also, with other bizarre instruments of his own, an altar-piece which is on the altar of the Volto Santo in Rome. Upon this altar-piece, being one morning with Michelagnolo at that altar to hear Mass, I saw an inscription saying that Ugo da Carpi had painted it without a brush; and I laughed and showed the inscription to Michelagnolo, who answered, also with a laugh, that it would have been better if he had used a brush, for then he might have done it in a better manner.

The method of executing these two kinds of woodcuts, in imitation of chiaroscuro, thus invented by Ugo da Carpi, was the reason that, many following in his steps, a great number of most beautiful prints were produced by others. For after him Baldassarre Peruzzi, the painter of Siena, made a similar woodcut in chiaroscuro, which was very beautiful, of Hercules driving Avarice, a figure laden with vases of gold and silver, from Mount Parnassus, on which are the Muses in various lovely attitudes. And Francesco Parmigiano engraved a Diogenes for a sheet of royal folio laid open, which was a finer print than any that Ugo ever produced. The same Parmigiano, having shown the method of making prints from three blocks to Antonio da Trento, caused him to execute a large sheet in chiaroscuro of the Beheading of S. Peter and S. Paul. And afterwards he executed another, but with two blocks only, of the Tiburtine Sibyl showing the Infant Christ in the lap of the Virgin to the Emperor Octavian; a nude man seated, who has his back turned in a beautiful attitude; and likewise an oval print of the Madonna lying down, with many others by his hand that may be seen in various places, printed after his death by Joannicolo Vicentino. But the most beautiful were executed later by Domenico Beccafumi of Siena, after the death of Parmigiano, as will be related at greater length in the Life of Domenico.

Not otherwise than worthy of praise, also, is the method that has been invented of making engravings more easily than with the burin, although they do not come out so clear – that is, with aquafortis, first laying on the copper a coat of wax, varnish, or oil-colour, and then drawing the design with an iron instrument that has a sharp point to cut through the wax, varnish, or colour, whichever it may be, after which one pours over it the aquafortis, which eats into the copper in such a manner that it

leaves the lines of the design hollow, and impressions can be taken from it. With this method Francesco Parmigiano executed many little things, which are full of grace, such as the Nativity of Christ, a Dead Christ with the Maries weeping over Him, and one of the tapestries executed for the Chapel after the designs of Raffaello, with many other works.

After these masters, fifty sheets with varied and beautiful landscapes were produced by Battista, a painter of Vicenza, and Battista del Moro of Verona. In Flanders, Hieronymus Cock has executed engravings of the liberal arts; and in Rome, engravings have been done of the Visitation in the Pace, painted by Fra Sebastiano Viniziano, of that by Francesco Salviati in the Misericordia, and of the Feast of Testaccio; besides many works that have been engraved in Venice by the painter Battista Franco, and by many other masters.

But to return to the simple copper-plate engravings; after Marc' Antonio had executed the many works that have been mentioned above, Rosso arrived in Rome, and Baviera persuaded him that he should have some of his works engraved; wherefore he commissioned Gian Jacopo Caraglio of Verona, who was one of the most skilful craftsmen of that day, and who sought with all diligence to imitate Marc' Antonio, to engrave a lean anatomical figure of his own, which holds a death's head in the hand, and is seated on a serpent, while a swan is singing. This plate succeeded so well, that the same Rosso afterwards caused engravings to be made, on plates of considerable size, of some of the Labours of Hercules: the Slaying of the Hydra, the Combat with Cerberus, the Killing of Cacus, the Breaking of the Bull's Horns, the Battle with the Centaurs, and the Centaur Nessus carrying off Deianira. And these plates proved to be so beautiful and so well engraved, that the same Jacopo executed, likewise after the design of Rosso, the story of the daughters of Pierus, who, for seeking to contend with the Muses and to sing in competition with them, were transformed into crows.

Baviera having then caused Rosso to draw twenty Gods in niches, with their attributes, for a book, these were engraved by Gian Jacopo Caraglio in a very beautiful and graceful manner; and also, not long afterwards, their Transformations; but of these Rosso did not make the drawings, save only of two, for he had a difference with Baviera, and Baviera had ten of them executed by Perino del Vaga. The two by Rosso were the Rape of

Proserpine and the Transformation of Philyra into a horse; and all were engraved with such diligence by Caraglio, that they have always been prized. Caraglio afterwards began for Rosso the Rape of the Sabines, which would have been a very rare work, but, the sack of Rome supervening, it could not be finished, for Rosso went away, and the plates were all lost. And although this work has since come into the hands of the printers, it has proved a miserable failure, for the engraving has been done by one who had no knowledge of the art, and thought only of making money.

After this, Caraglio engraved for Francesco Parmigiano a plate of the Marriage of Our Lady, and other works by the same master; and then another plate for Tiziano Vecelli, which was very beautiful, of a Nativity that Tiziano had formerly painted. This Gian Jacopo Caraglio, after having executed many copper-plates, being an ingenious spirit, gave his attention to engraving cameos and crystals, in which he became no less excellent than he had been in the engraving of copper-plates. And since then, having entered the service of the King of Poland, he has occupied himself no longer with engraving on copper, now in his opinion a mean art, but with the cutting of gems, with working in incavo, and with architecture; for which having been richly rewarded by the liberality of that King, he has spent large sums in investments in the territory of Parma, in order to be able to retire in his old age to the enjoyment of his native country among his friends and disciples, after the labours of so many years.

After these masters came another excellent copper-plate engraver, Lamberto Suave,* by whose hand are thirteen plates of Christ and the twelve Apostles, in which the execution of the engraving is perfect in its delicacy. If Lamberto had possessed a more thorough mastery of design in addition to the industry, patience, and diligence that he showed in all other points, he would have been marvellous in every respect; as may be perceived clearly from a little sheet of S. Paul writing, and from a larger sheet with the story of the Raising of Lazarus, in which there are most beautiful things to be seen. Worthy of note, in particular, are the hollow rock in the cavern which he represented as the burial-place of Lazarus, and the light that falls upon some figures, all of which is executed with beautiful and fanciful invention.

* Lambert Zutmann.

No little ability, likewise, has been shown in this profession by Giovan Battista Mantovano, a disciple of Giulio Romano; among other works, in a Madonna who has the Child in her arms and the moon under her feet, and in some very beautiful heads with helmet-crests after the antique; in two sheets, in which are a captain of mercenaries on foot and one on horseback, and also in a sheet wherein is a Mars in armour, who is seated upon a bed, while Venus gazes on a Cupid whom she is suckling, which has in it much that is good. Very fanciful, also, are two large sheets by the hand of the same master, in which is the Burning of Troy, executed with extraordinary invention, design, and grace. These and many other sheets by the same hand are signed with the letters 'J.B.M.'

And no less excellent than any of those mentioned above has been Enea Vico of Parma, who engraved the well-known copper-plate of the Rape of Helen by Rosso, and also another plate after the design of the same painter, of Vulcan with some Loves, who are fashioning arrows at his forge, while the Cyclopes are also at work, which was truly a most beautiful engraving. He executed the Leda of Michelagnolo on another, and also an Annunciation after the design of Tiziano, the story of Judith that Michelagnolo painted in the Chapel, the portrait of Duke Cosimo de' Medici as a young man, in full armour, after the drawing by Bandinelli, and likewise the portrait of Bandinelli himself; and then the Contest of Cupid and Apollo in the presence of all the Gods. And if Enea had been maintained and rewarded for his labours by Bandinelli, he would have engraved many other beautiful plates for him. Afterwards, Francesco, a protégé of the Salviati, and an excellent painter, being in Florence, and assisted by the liberality of Duke Cosimo, commissioned Enea to engrave the large plate of the Conversion of S. Paul, full of horses and soldiers, which was held to be very beautiful, and gave Enea a great name. The same Enea then executed the portrait of Signor Giovanni de' Medici, father of Duke Cosimo, with an ornament full of figures. He engraved, also, the portrait of the Emperor Charles V, with an ornament covered with appropriate Victories and trophies, for which he was rewarded by His Majesty and praised by all; and on another plate, very well engraved, he represented the victory that the Emperor gained on the Elbe. For Doni he executed some heads from nature in the manner of medallions, with beautiful ornaments: King Henry of France, Cardinal Bembo, Messer

Lodovico Ariosto, the Florentine Gello, Messer Lodovico Domenichi, Signora Laura Terracina, Messer Cipriano Morosino, and Doni himself. He also engraved for Don Giulio Clovio, a most excellent illuminator, a plate of a S. George on horseback who is slaying the Dragon, in which, although it was, one might say, one of the first works that he engraved, he acquitted himself very well.

Afterwards, being a man of lofty genius, and desiring to pass on to greater and more honourable undertakings, Enea applied himself to the study of antiquities, and in particular of ancient medals, of which he has published several books in engraving, wherein are the true effigies of many Emperors and their wives, with every kind of inscription and reverse that could bring all who delight in them to a clear understanding of their stories; for which he has rightly won great praise, as he still does. And those who have found fault with him for his books of medals have been in the wrong, for whoever shall consider the labours that he has performed, and how useful and beautiful these are, must perforce excuse him, even though he may have erred in a few matters of little importance; and such errors, which are not committed save from faulty information, from a too ready credulity, or from having opinions differing from others with some show of reason, are worthy to be excused, seeing that Aristotle, Pliny, and many others have been guilty of the like.

Enea also designed to the common satisfaction and benefit of all mankind fifty costumes of different nations, such as were worn by men and women, peasants and citizens, in Italy, in France, in Spain, in Portugal, in England, in Flanders, and in other parts of the world; which was an ingenious work, both fanciful and beautiful. He executed, also, a genealogical tree of all the Emperors, which was a thing of great beauty. And finally, after much toil and travailing, he now lives in repose under the shadow of Alfonso II, Duke of Ferrara, for whom he has made a genealogical tree of all the Marquises and Dukes of the House of Este. For all these works and many others that he has executed, as he still continues to do, I have thought it right to make this honourable record of him among so many other men of the arts.

Many others have occupied themselves with copper-plate engraving, who, although they have not attained to such perfection, have none the less benefited the world with their labours, by bringing many scenes and other works of excellent masters into

the light of day, and by thus giving the means of seeing the
various inventions and manners of the painters to those who are
not able to go to the places where the principal works are, and
conveying to the ultramontanes a knowledge of many things that
they did not know. And although many plates have been badly
executed through the avarice of the printers, eager more for gain
than for honour, yet in certain others, besides those that have
been mentioned, there may be seen something of the good; as in
the large design of the Last Judgment of Michelagnolo Buonar-
roti on the front wall of the Papal Chapel, engraved by Giorgio
Mantovano, and in the engravings by Giovan Battista de' Cava-
lieri of the Crucifixion of S. Peter and the Conversion of S. Paul
painted in the Pauline Chapel at Rome. This Giovan Battista has
also executed copper-plate engravings, besides other designs, of
the Meditation of S. John the Baptist, of the Deposition from the
Cross that Daniello Ricciarelli of Volterra painted in a chapel in
the Trinità at Rome, of a Madonna with many Angels, and of a
vast number of other works. Moreover, many things taken from
Michelagnolo have been engraved by others at the commission
of Antonio Lanferri, who has employed printers for the same
purpose. These have published books of all the kinds of fishes,
and also the Phaethon, the Tityus, the Ganymede, the Archers,
the Bacchanalia, the Dream, the Pietà, and the Crucifix, all done
by Michelagnolo for the Marchioness of Pescara; and, in addition,
the four Prophets of the Chapel and other scenes and drawings
have been engraved and published, but executed so badly, that I
think it well to be silent as to the names of those engravers and
printers.

But I must not be silent about the above-mentioned Antonio
Lanferri and Tommaso Barlacchi, for they, as well as others, have
employed many young men to engrave plates after original draw-
ings by the hands of a vast number of masters, insomuch that it
is better to say nothing of these works, lest it should become
wearisome. And in this manner have been published, among
other plates, grotesques, ancient temples, cornices, bases, capitals,
and many other suchlike things, with all their measurements.

Seeing everything reduced to a miserable manner, and moved
by compassion, Sebastiano Serlio, an architect of Bologna, has
engraved on wood and copper two books of architecture, in
which, among other things, are thirty doors of the Rustic Order,
and twenty in a more delicate style; which book is dedicated to

King Henry of France. Antonio L'Abacco, likewise, has published plates in a beautiful manner of all the notable antiquities of Rome, with their measurements, executed with great mastery and with very subtle engraving by Perugino. Nor has less been accomplished in this field by the architect Jacopo Barozzo of Vignola, who in a book of copper-plate engravings has shown with simple rules how to enlarge or to diminish in due proportion every part of the five Orders of Architecture, a work most useful in that art, for which we are much indebted to him; even as we are to Giovanni Cugini* of Paris for his engravings and writings on architecture.

In Rome, besides the masters named above, Niccolò Beatricio† of Lorraine has given so much attention to engraving with the burin, that he has executed many plates worthy of praise; such as two pieces of sarcophagi with battles of horsemen, engraved on copper, and other plates full of various animals very well executed, and a scene showing the Widow's Daughter being restored to life by Jesus Christ, engraved in a bold manner from the design of Girolamo Mosciano, a painter of Brescia. The same master has engraved an Annunciation from a drawing by the hand of Michelagnolo, and has also executed prints of the Navicella of mosaic that Giotto made in the portico of S. Pietro.

From Venice, likewise, have come many most beautiful engravings on wood and on copper; on wood, after Tiziano, many landscapes, a Nativity of Christ, a S. Jerome, and a S. Francis; and on copper the Tantalus, the Adonis, and many other plates, which have been engraved by Giulio Bonasone of Bologna, together with some others by Raffaello, by Giulio Romano, by Parmigiano, and by all the other masters whose drawings he has been able to obtain. And Battista Franco, a painter of Venice, has engraved, partly with the burin and partly with aquafortis, many works by the hands of various masters, such as the Nativity of Christ, the Adoration of the Magi, the Preaching of S. Peter, some plates from the Acts of the Apostles, and many stories from the Old Testament. So far, indeed, has this practice of making prints been carried, that those who make a profession of it keep draughtsmen continually employed in copying every beautiful work as it appears, and put it into prints. Wherefore there

* Jean Cousin.
† Nicolas Beautrizet.

came from France, after the death of Rosso, engravings of all the work by his hand that could be found, such as Clelia with the Sabine women passing the river; some masks after the manner of the Fates, executed for King Francis; a bizarre Annunciation; a Dance of ten women; and King Francis advancing alone into the Temple of Jupiter, leaving behind him Ignorance and other similar figures, which were executed during the lifetime of Rosso by the copper-plate engraver Renato.* And many more have been drawn and engraved since Rosso's death; among many other works, all the stories of Ulysses, and, to say nothing of the rest, vases, chandeliers, candelabra, salt-cellars, and a vast number of other suchlike things made in silver after designs of Rosso.

Luca Penni, also, has published engravings of two Satyrs giving drink to a Bacchus, a Leda taking the arrows from the quiver of a Cupid, Susannah in the Bath, and many other plates copied from the designs of the same Rosso and of Francesco Primaticcio of Bologna, now Abbot of S. Martin in France. And among these engravings are the Judgment of Paris, Abraham sacrificing Isaac, a Madonna, Christ marrying S. Catharine, Jove changing Callisto into a bear, the Council of the Gods, Penelope weaving with her women, and other things without number, engraved on wood, and executed for the most part with the burin; by reason of which the wits of the craftsmen have become very subtle, insomuch that little figures have been engraved so well, that it would not be possible to give them greater delicacy. And who can see without marvelling the works of Francesco Marcolini of Forlì? Who, besides other things, printed the book of the Garden of Thoughts from wood-blocks, placing at the beginning an astrologer's sphere and a head of himself after the design of Giuseppe Porta of Castelnuovo della Garfagnana; in which book are various fanciful figures, such as Fate, Envy, Calamity, Timidity, Praise, and many others of the same kind, which were held to be most beautiful. Not otherwise than praiseworthy, also, were the figures that Gabriele Giolito, a printer of books, placed in the Orlando Furioso, for they were executed in a beautiful manner of engraving. And even such, likewise, were the eleven large anatomical plates that were done by Andrea Vessalio after the drawings of Johann of Calcar, a most excellent Flemish painter, which

* René Boyvin.

were afterwards copied on smaller sheets and engraved on copper by Valverde, who wrote on anatomy after Vessalio.

Next, among the many plates that have issued from the hands of Flemings within the last ten years, very beautiful are some drawn by one Michele,* a painter, who worked for many years in two chapels that are in the Church of the Germans at Rome. These plates contain the story of Moses and the Serpents, and thirty-two stories of Psyche and Love, which are held to be most beautiful. Hieronymus Cock, also a Fleming, has engraved a large plate after the invention and design of Martin Heemskerk, of Delilah cutting off the locks of Samson; and not far away is the Temple of the Philistines, in which, the towers having fallen, one sees ruin and destruction in the dead, and terror in the living, who are taking to flight. The same master has executed in three smaller plates the Creation of Adam and Eve, the Eating of the Fruit, and the Angel driving them out of Paradise; and in four other plates of the same size, in the first the Devil imprinting avarice and ambition into the heart of man, and in the others all the passions that result from those two. There may also be seen twenty-seven plates of the same size by his hand, with stories from the Old Testament after the expulsion of Adam from Paradise, drawn by Martin in a bold, well-practised, and most resolute manner, which is very similar to the Italian. Hieronymus afterwards engraved six round plates with the history of Susannah, and twenty-three other stories from the Old Testament, similar to those of Abraham already mentioned – namely, six plates with the story of David, eight plates with that of Solomon, four with that of Balaam, and five with those of Judith and Susannah. And from the New Testament he engraved twenty-nine plates, beginning with the Annunciation of the Virgin, and continuing down to the whole Passion and Death of Jesus Christ. He also engraved, after the drawings of the same Martin, the seven Works of Mercy, and the story of the rich Lazarus and the poor Lazarus, and four plates with the Parable of the Samaritan wounded by thieves, with four other plates of the Parable of the Talents, written by S. Matthew in his eighteenth chapter.

At the time when Hans Liefrinck executed in competition with him ten plates of the Life and Death of S. John the Baptist,

* Michael Coxie.

he engraved the Twelve Tribes on an equal number of plates; Reuben upon a hog, representing Sensuality; Simeon with a sword as a symbol of Homicide; and in like manner the other heads of Tribes with attributes appropriate to the nature of each. He then executed ten plates, engraved with greater delicacy, with the stories and acts of David, from the time of his being anointed by Samuel to his going before Saul; and he engraved six other plates with the story of how Amnon became enamoured of his sister Tamar and ravished her, and the death of that same Amnon. And not long afterwards he executed ten plates of similar size with the history of Job; and from thirteen chapters of the Proverbs of Solomon he drew subjects for five plates of the same kind. He also engraved the story of the Magi; and then, on six plates, the Parable that is in the twelfth chapter of S. Matthew, of those who for various reasons refused to go to the King's Feast, and of him who went without having a wedding-garment; and six plates of equal size with some of the acts of the Apostles. And in eight similar plates he engraved figures of women of perfect excellence, in various costumes: six from the Old Testament – Jael, Ruth, Abigail, Judith, Esther, and Susannah; and two from the New – Mary the Virgin, Mother of Jesus Christ, and Mary Magdalene.

After these works he carried out the engraving of the Triumphs of Patience in six plates, with various things of fancy. In the first, in a chariot, is Patience, who has in her hand a standard, on which is a rose among thorns. In the second may be seen a burning heart, beaten by three hammers, upon an anvil; and the chariot of this second plate is drawn by two figures – namely, by Desire, who has wings upon the shoulders, and by Hope, who has an anchor in the hand, and behind them Fortune, with her wheel broken, is led as a prisoner. In the next plate is Christ on a chariot, with the standard of the Cross and of His Passion, with the Evangelists at the corners in the form of animals; and this chariot is drawn by two lambs, and has behind it four prisoners – the Devil, the World, or rather, the Flesh, Sin, and Death. In another Triumph is Isaac, nude, upon a camel; on the banner that he holds in his hand are a pair of prisoner's irons; and behind him is drawn the altar with the ram, the knife, and the fire. In the next plate he made Joseph riding in triumph on an ox crowned with ears of corn and fruits, with a standard on which is a bee-hive; and the prisoners that are led behind him are

Anger and Envy, who are devouring a heart. He engraved in another Triumph David on a lion, with the harp, and with a standard in his hand, on which is a bit; and behind him is Saul as a prisoner, and Shimei, with his tongue protruding. In another plate is Tobias riding in triumph on an ass, and holding in his hand a banner, on which is a fountain; and behind him Poverty and Blindness, bound, are led as prisoners. And in the last of the six Triumphs is S. Stephen the Protomartyr, who is riding in triumph on an elephant, and has a standard with a figure of Charity; and the prisoners behind him are his persecutors. All these were inventions full of fancy, and very ingenious; and they were all engraved by Hieronymus Cock, whose hand is very bold, sure, and resolute.

The same master engraved a plate of Fraud and Avarice, fantastic and beautiful, and another very lovely plate of a Feast of Bacchanals, with children dancing. On another he represented Moses passing across the Red Sea, according as it had been painted by Agnolo Bronzino, a painter of Florence, in the upper chapel in the Palace of the Duke of Florence; and in competition with him, also after the design of Bronzino, Giorgio Mantovano engraved a Nativity of Jesus Christ, which was very beautiful. After these works, Hieronymus engraved twelve plates of the victories, battles, and deeds of arms of Charles V, for him who was the inventor of the subjects; and for Verese, a painter and a great master of perspective in those parts, twenty plates with various buildings. For Hieronymus Bosch he executed a plate of S. Martin, with a barque full of Devils in the most bizarre forms. And he made another of an alchemist who loses all his possessions, distilling away his brains and consuming all that he has in various ways, insomuch that in the end he takes refuge in the hospital with his wife and children; which plate was designed for him by a painter, who caused him to engrave the Seven Mortal Sins, with Demons of various forms, which was a fantastic and laughable work. He also engraved a Last Judgment; an old man who is seeking with a lantern for peace among the wares of the world, and finds it not; likewise a great fish that is devouring some little fishes; a figure of Carnival enjoying the pleasures of the table with many others, and driving Lent away, and another of Lent driving away Carnival; and so many other whimsical and fantastic inventions, that it would be wearisome to attempt to speak of them all.

Many other Flemings have imitated the manner of Albrecht Dürer with the greatest care and subtlety, as may be seen from their engravings, and in particular from those of * who has engraved in little figures four stories of the Creation of Adam, four of the lives of Abraham and of Lot, and four others of Susannah, which are very beautiful. In like manner, G ... P ... † has engraved the Seven Works of Mercy in seven small round plates, eight stories taken from the Books of Kings, Regulus placed in the barrel filled with nails, and an Artemisia, which is a plate of great beauty. J ... B ... ‡ has executed figures of the four Evangelists, which are so small that it seems scarcely possible that he could have done them; and also five other very fine plates, in the first of which is a Virgin drawn into the grave by Death in all the freshness of her youth, and in the second is Adam, in the third a peasant, in the fourth a Bishop, and in the fifth a Cardinal, each, like the Virgin, called by Death to his last account. And in some others are many Germans going on parties of pleasure with their wives, and some beautiful and fantastic Satyrs. By ... are plates of the four Evangelists, engraved with great care, and no less beautiful than are twelve stories of the Prodigal Son executed with much diligence by the hand of M ... And, finally, Franz Floris, a painter famous in those parts, has produced a great number of works and drawings which have since been engraved, for the most part by Hieronymus Cock, such as ten plates of the Labours of Hercules, a large plate with all the activities of the life of man, another with the Horatii and Curiatii engaged in combat in the lists, the Judgment of Solomon, and the Battle between Hercules and the Pygmies. The same master, also, has engraved a Cain who has killed Abel, over whose body Adam and Eve are weeping; an Abraham who is about to sacrifice Isaac on the altar, and a vast number of other plates, so full of variety and invention, that it is indeed marvellous to think of all that has been done in engravings on copper and wood. Lastly, it is enough to draw attention to the engravings of the portraits of the Painters, Sculptors, and Architects in this our book, which were drawn by Giorgio Vasari and his pupils, and engraved by Maestro Cristofano ... ,** who has executed in Venice, as he still continues to do, a vast number of works worthy of record.

* Albrecht Aldegrever. † Georg Pencz.
‡ Hans Beham. ** Cristofano Coriolano.

In conclusion, for all the assistance that the ultramontanes have received from seeing the various Italian manners by means of engravings, and that the Italians have received from having seen those of the ultramontanes and foreigners, thanks should be rendered, for the most part, to Marc' Antonio Bolognese, in that, besides the circumstance that he played a great part in the beginning of this profession, as has been related, there has not as yet been one who has much surpassed him, although some few have equalled him in certain points. This Marc' Antonio died at Bologna, not long after his departure from Rome. In our book are some drawings of Angels by his hand, done with the pen, and some other very beautiful sheets drawn from the apartments that Raffaello da Urbino painted. In one of these apartments Marc' Antonio, as a young man, was portrayed by Raffaello in one of those grooms who are carrying Pope Julius II, in that part where the High-Priest Onias is praying.

And let this be the end of the Lives of Marc' Antonio Bolognese and of all the other engravers of prints mentioned above, of whom I have thought it right to give this long but necessary account, in order to satisfy not only the students of our arts, but also all those who delight in works of that kind.

ANTONIO DA SAN GALLO (THE YOUNGER), Architect of Florence

How many great and illustrious Princes, abounding with infinite wealth, would leave behind them a name renowned and glorious, if they possessed, together with their store of the goods of Fortune, a mind filled with grandeur and inclined to those things that not only embellish the world, but also confer vast benefit and advantage on the whole race of men! And what works can or should Princes and great persons undertake more readily than noble and magnificent buildings and edifices, both on account of the many kinds of men that are employed upon them in the making, and because, when made, they endure almost to eternity? For of all the costly enterprises that the ancient Romans executed at the time when they were at the supreme height of their greatness, what else is there left to us save those remains of buildings, the everlasting glory of the Roman name, which we revere as

sacred things and strive to imitate as the sole patterns of the highest beauty? And how much these considerations occupied the minds of certain Princes who lived in the time of the Florentine architect, Antonio da San Gallo, will now be seen clearly in the Life of him that we are about to write.

Antonio, then, was the son of Bartolommeo Picconi of Mugello, a maker of casks; and after having learned the joiner's craft in his boyhood, hearing that his uncle, Giuliano da San Gallo, was working at Rome in company with his brother Antonio, he set out from Florence for that city. And there, having devoted himself to the matters of the art of architecture with the greatest possible zeal, and pursuing that art, he gave promise of those achievements that we see in such abundance throughout all Italy, in the vast number of works executed by him at a more mature age. Now it happened that Giuliano was forced by the torment that he suffered from the stone to return to Florence; and Antonio, having become known to the architect Bramante of Castel Durante, began to give assistance to that master, who, being old and crippled in the hands by palsy, was not able to work as before in the preparation of his designs. And these Antonio executed with such accuracy and precision that Bramante, finding that they were correct and true in all their measurements, was constrained to leave to him the charge of a great number of works that he had on his hands, only giving him the order that he desired and all the inventions and compositions that were to be used in each work. In these he found himself served by Antonio with so much judgment, diligence, and expedition, that in the year 1512 he gave him the charge of the corridor that was to lead to the ditches of the Castello di S. Angelo; for which he began to receive a salary of ten crowns a month; but the death of Julius II then took place, and the work was left unfinished. However, the circumstance that Antonio had already acquired a name as a person of ability in architecture, and one who had a very good manner in matters of building, was the reason that Alessandro, who was first Cardinal Farnese, and afterwards Pope Paul III, conceived the idea of commissioning him to restore the old palace in the Campo di Fiore, in which he lived with his family; and for that work Antonio, desiring to grow in reputation, made several designs in different manners. Among which, one that was arranged with two apartments was that which pleased his very reverend Highness, who, having two sons, Signor Pier Luigi and

Signor Ranuccio, thought that he would leave them well accommodated by such a building. And, a beginning having been made with that work, a certain portion was constructed regularly every year.

At this time a church dedicated to S. Maria di Loreto was being built at the Macello de' Corbi, near the Column of Trajan, in Rome, and it was brought to perfection by Antonio, with decorations of great beauty. After this, Messer Marchionne Baldassini caused a palace to be erected from the model and under the direction of Antonio, near S. Agostino, which is arranged in such a manner that, small though it may be, it is held to be, as indeed it is, the finest and most convenient dwelling in Rome; and in it the staircases, the court, the loggie, the doors, and the chimney-pieces, are all executed with consummate grace. With which Messer Marchionne being very well satisfied, he determined that Perino del Vaga, the Florentine painter, should decorate one of the halls in colour, with scenes and other figures, as will be related in his Life; which decorations have given it infinite grace and beauty. And near the Torre di Nona Antonio directed and finished the building of the house of the Centelli, which is small, but very convenient.

No long time passed before he went to Gradoli, a place in the dominions of the very reverend Cardinal Farnese, where he caused a most beautiful and commodious palace to be erected for that Cardinal. On that journey he did a work of great utility in restoring the fortress of Capo di Monte, which he surrounded with low and well-shaped walls; and at the same time he made the design of the fortress of Caprarola. And the very reverend Monsignor Farnese, finding himself served by Antonio in all these works in a manner so satisfactory, was constrained to wish him well, and, coming to love him more and more, he showed him favour in his every enterprise whenever he was able. After this, Cardinal Alborense, wishing to leave a memorial of himself in the church of his nation, caused a chapel of marble, with a tomb for himself, to be erected and brought to completion by Antonio in S. Jacopo degli Spagnuoli; which chapel, as has been related, was all painted in the spaces between the pilasters by Pellegrino da Modena, and on the altar stood a most beautiful S. James of marble executed by Jacopo Sansovino. This is a work of architecture that is held to be truly worthy of the highest praise, since the marble ceiling is divided very beautifully into

octagonal compartments. Nor was it long before M. Bartolom-
meo Ferratino, for his own convenience and for the benefit of
his friends, and also in order to leave an honourable and enduring
memorial of himself, commissioned Antonio to build a palace on
the Piazza d' Amelia, which is a beautiful and most imposing
work; whereby Antonio acquired no little fame and profit. During
this time Antonio di Monte, Cardinal of Santa Prassedia, was in
Rome, and he desired that the same architect should build for
him the palace that he afterwards occupied, looking out upon the
Agone, where there is the statue of Maestro Pasquino; and in the
centre, which looks over the Piazza, he wished to erect a tower.
This was planned and brought to completion for him by Antonio
with a most beautiful composition of pilasters and windows from
the first floor to the third – a good and graceful design; and it
was adorned both within and without by Francesco dell' Indaco
with figures and scenes in terretta. And Antonio having mean-
while become the devoted servant of the Cardinal of Arimini,
that lord caused him to erect a palace at Tolentino in the March,
for which, in addition to the rewards that Antonio received, the
Cardinal ever afterwards held himself indebted to him.

While these matters were in progress, and the fame of Anto-
nio was growing and spreading abroad, it happened that old age
and various infirmities made Bramante a citizen of the other
world; at which three architects were appointed straightway by
Pope Leo for the building of S. Pietro – Raffaello da Urbino,
Giuliano da San Gallo, the uncle of Antonio, and Fra Giocondo
of Verona. But no long time passed before Fra Giocondo de-
parted from Rome, and Giuliano, being old, received leave to
return to Florence. Whereupon Antonio, who was in the service
of the very reverend Cardinal Farnese, besought him very straitly
that he should make supplication to Pope Leo, to the end that
he might grant the place of his uncle Giuliano to him, which
proved to be a thing very easy to obtain, first because of the
abilities of Antonio, which were worthy of that place, and then
by reason of the cordial relations between the Pope and the very
reverend Cardinal Farnese. And thus, in company with Raffaello
da Urbino, he continued that building, but coldly enough.

The Pope then went to Città Vecchia, in order to fortify it,
and in his company were many lords; among others, Giovan
Paolo Baglioni and Signor Vitello, and such persons of ability
as Pietro Navarra and Antonio Marchissi, the architect for

fortifications at that time, who had come from Naples at the command of the Pope. Discussions arising as to the fortification of that place, many and various were the opinions about this, one man making one design, and another a different one; but among so many, Antonio displayed before them a plan which was approved by the Pope and by those lords and architects as superior to all the others in strength and beauty and in the handsome and useful character of its arrangements; wherefore Antonio came into very great credit with the Court. After this, the genius of Antonio repaired a great mischief brought about in the following manner: Raffaello da Urbino, in executing the Papal Loggie and the apartments that are over the foundations, had left many empty spaces in the masonry in order to oblige some friends, to the serious damage of the whole building, by reason of the great weight that had to be supported above them; and the edifice was already beginning to show signs of falling, on account of the weight being too great for the walls. And it would certainly have fallen down but for the genius of Antonio, who filled up those little chambers with the aid of props and beams, and refounded the whole fabric, thus making it as firm and solid as it had ever been in the beginning.

Meanwhile the Florentine colony had begun their church in the Strada Giulia, behind the Banchi, from the design of Jacopo Sansovino. But they had chosen a site that extended too far into the river, so that, compelled by necessity, they spent twelve thousand crowns on foundations in the water, which were executed in a very secure and beautiful manner by Antonio, who found the way after Jacopo had failed to discover it; and several braccia of the edifice were built over the water. Antonio made a model so excellent, that, if the work had been carried to completion, it would have been something stupendous. Nevertheless, it was a great error, giving proof of little judgment, on the part of those who were at that time the heads of that colony in Rome, for they should never have allowed the architects to found so large a church in so terrible a river, for the sake of gaining twenty braccia of length, and to throw away so many thousands of crowns on foundations, only to be compelled to contend with that river for ever; particularly because, by bringing that church forward and giving it another form, they might have built it on solid ground, and, what is more, might have carried the whole to completion with almost the same expense. And if they trusted in the riches

of the merchants of that colony, it was seen afterwards how fallacious such a hope was, for in all the years that the pontificate was held by Leo and Clement of the Medici family, by Julius III, and by Marcellus, who all came from Florentine territory, although the last-named lived but a short time, and for all the greatness of so many Cardinals and the riches of so many merchants, it remained, as it still does, in the same condition in which it was left by our San Gallo. It is clear, therefore, that architects and those who cause buildings to be erected should look well to the end and to every matter, before setting their hands to works of importance.

But to return to Antonio: the fortress of Monte Fiascone had been formerly built by Pope Urban, and he restored it at the commission of the Pope, who took him to those parts one summer in his train. And at the request of Cardinal Farnese he built two little temples on the island of Visentina in the Lake of Bolsena, one of which was constructed as an octagon without and round within, and the other was square on the outer side and octagonal on the inner, with four niches in the walls at the corners, one to each; which two little temples, executed in so beautiful a manner, bore testimony to the skill with which Antonio was able to give variety to the details of architecture. While these temples were building, Antonio returned to Rome, where he made a beginning with the Palace of the Bishop of Cervia, which was afterwards left unfinished, on the Canto di S. Lucia, where the new Mint stands. He built the Church of S. Maria di Monferrato, which is held to be very beautiful, near the Corte Savella, and likewise the house of one Marrano, which is behind the Cibo Palace, near the houses of the Massimi.

Meanwhile Leo died, and with him all the fine and noble arts, which had been restored to life by him and by his predecessor, Julius II; and his successor was Adrian VI, in whose pontificate all arts and talents were so crushed down, that, if the government of the Apostolic Seat had remained long in his hands, that fate would have come upon Rome under his rule which fell upon her on another occasion, when all the statues saved from the destruction of the Goths, both the good and the bad, were condemned to be burned. Adrian, perhaps in imitation of the Pontiffs of those former times, had already begun to speak of intending to throw to the ground the Chapel of the divine Michelagnolo, saying that it was a bagnio of nudes; and he despised all good

pictures and statues, calling them vanities of the world, and shameful and abominable things, which circumstance was the reason that not only Antonio, but all the other beautiful intellects were kept idle, insomuch that, not to mention other works, scarcely anything was done in the time of that Pontiff on the building of S. Pietro, to which at least he should have been friendly, since he wished to prove himself so much the enemy of worldly things.

For that reason, therefore, attending under that Pontiff to works of no great importance, Antonio restored the aisles of the Church of S. Jacopo degli Spagnuoli, and furnished the façade with most beautiful windows. He also caused a tabernacle of travertine to be constructed for the Imagine di Ponte, which, although small, is yet very graceful; and in it Perino del Vaga afterwards executed a beautiful little work in fresco.

The poor arts had already come to an evil pass through the life of Adrian, when Heaven, moved to pity for them, resolved by the death of one to give new life to thousands; wherefore it removed him from the world and caused him to surrender his place to one who would fill that position more worthily and would govern the affairs of the world in a different spirit. And thus a new Pope was elected in Clement VII, who, being a man of generous mind, and desiring to follow in the steps of Leo and of the other members of his illustrious family who had preceded him, bethought himself that, even as he had created beautiful memorials of himself as Cardinal, so as Pope he should surpass all others in restoring and adorning buildings. That election, then, brought consolation to many men of talent, and infused a potent and heaven-sent breath of life in those ingenious but timid spirits who had sunk into abasement; and they, thus revived, afterwards executed the beautiful works that we see at the present day. And first, having been set to work at the commission of His Holiness, Antonio straightway reconstructed a court in front of the Loggie, which had been painted previously under the direction of Raffaello, in the Palace; which court was a vast improvement in beauty and convenience, for it was formerly necessary to pass through certain narrow and tortuous ways, and Antonio, widening these and giving them better form, made them spacious and beautiful. But this part is not now in the condition in which Antonio left it, for Pope Julius III took away the columns of granite that were there, in order to adorn his villa with them, and altered everything.

Antonio also executed the façade of the old Mint of Rome, a
work of great beauty and grace, in the Banchi, making a rounded
corner, which is held to be a difficult and even miraculous thing;
and in that work he placed the arms of the Pope. And he re-
founded the unfinished part of the Papal Loggie, which had re-
mained incomplete at the death of Pope Leo, and had not been
continued, or even touched, through the negligence of Adrian.
And thus, at the desire of Clement, they were carried to their final
completion.

His Holiness then resolving to fortify Parma and Piacenza,
after many designs and models had been made by various crafts-
men, Antonio was sent to those places, and with him Giuliano
Leno, the supervisor of those fortifications. When they had ar-
rived there, Antonio having with him his pupil L'Abacco, Pier
Francesco da Viterbo, a very able engineer, and the architect
Michele San Michele of Verona, all of them together carried the
designs of those fortifications into execution. Which done, the
others remaining, Antonio returned to Rome, where Pope Cle-
ment, since the Palace was poorly supplied in the matter of apart-
ments, ordained that Antonio should begin those in which the
public consistories are held, above the Ferraria, which were ex-
ecuted in such a manner, that the Pontiff was well satisfied with
them, and caused other apartments to be constructed above them
for the Chamberlains of His Holiness. Over the ceilings of those
apartments, likewise, Antonio made others which were very com-
modious – a work which was most dangerous, because it necessi-
tated so much refounding. In this kind of work Antonio was in
truth very able, seeing that his buildings never showed a crack;
nor was there ever among the moderns any architect more cau-
tious or more skilful in joining walls.

In the time of Pope Paul II, the Church of the Madonna of
Loreto, which was small, and had its roof immediately over brick
piers of rustic work, had been refounded and brought to that size
in which it may be seen at the present day, by means of the skill
and genius of Giuliano da Maiano; and it had been continued
from the outer string-course upwards by Sixtus IV and by others,
as has been related; but finally, in the time of Clement, in the year
1526, without having previously shown the slightest sign of fall-
ing, it cracked in such a manner, that not only the arches of the
tribune were in danger, but the whole church in many places, for
the reason that the foundations were weak and wanting in depth.

Wherefore Antonio was sent by the said Pope Clement to put right so great a mischief; and when he had arrived at Loreto, propping up the arches and fortifying the whole, like the resolute and judicious architect that he was, he refounded all the building, and, making the walls and pilasters thicker both within and without, he gave it a beautiful form, both as a whole and in its well-proportioned parts, and made it strong enough to be able to support any weight, however great. He adhered to one and the same order in the transepts and in the aisles of the church, making superb mouldings on the architraves, friezes, and cornices above the arches, and he rendered beautiful and well constructed in no common way the socles of the four great piers around the eight sides of the tribune which support the four arches – namely, three in the transepts, where the chapels are, and the larger one in the central nave. This work certainly deserves to be celebrated as the best that Antonio ever executed, and that not without sufficient reason, seeing that those who erect some new building, or raise one from the foundations, have the power to make it high or low, and to carry it to such perfection as they desire or are able to achieve, without being hindered by anything; which does not fall to the lot of him who has to rectify or restore works begun by others and brought to a sorry state either by the craftsman or by the circumstances of Fortune; whence it may be said that Antonio restored a dead thing to life, and did that which was scarcely possible. Having finished all this, he arranged that the church should be covered with lead, and gave directions for the execution of all that still remained to do; and thus, by his means, that famous temple received a better form and more grace than it had possessed before, and the hope of a long-enduring life.

He then returned to Rome, just after that city had been given over to sack; and the Pope was at Orvieto, where the Court was suffering very greatly from want of water. Thereupon, at the wish of the Pontiff, Antonio built in that city a well all of stone, twenty-five braccia wide, with two spiral staircases cut in the tufa, one above the other, following the curve of the well. By these two spiral staircases it is possible to descend to the bottom of the well, insomuch that the animals that go there for water, entering by one door, go down by one of the two staircases, and when they have come to the platform where they receive their load of water, they pass, without turning round, into the other branch of the spiral staircase, which winds above that of the descent, and

emerge from the well by a different door, opposite to the other. This work, which was an ingenious, useful, and marvellously beautiful thing, was carried almost to completion before the death of Clement; and the mouth of the well, which alone remained to be executed, was finished by order of Pope Paul III, but not according to the directions drawn up by Clement with the advice of Antonio, who was much commended for so beautiful a work. Certain it is that the ancients never built a structure equal to this in workmanship or ingenuity, seeing, above all, that the central shaft is made in such a way that even down to the bottom it gives light by means of certain windows to the two staircases mentioned above.

While this work was in progress, the same Antonio directed the construction of the fortress of Ancona, which in time was carried to completion. Afterwards, Pope Clement resolving, at the time when his nephew Alessandro de' Medici was Duke of Florence, to erect an impregnable fortress in that city, Signor Alessandro Vitelli, Pier Francesco da Viterbo, and Antonio laid out that castle, or rather, fortress, which is between the Porta al Prato and the Porta a S. Gallo, and caused it to be built with such rapidity, that no similar structure, whether ancient or modern, was ever completed so quickly. In a great tower, which was the first to be founded, and was called the Toso, were placed many inscriptions and medals, with the most solemn pomp and ceremony; and this work is now celebrated over all the world, and is held to be impregnable.

By order of Antonio were summoned to Loreto the sculptor Tribolo, Raffaello da Montelupo, Francesco da San Gallo, then a young man, and Simone Cioli, who finished the scenes of marble begun by Andrea Sansovino. To the same place Antonio summoned the Florentine Mosca, a most excellent carver of marble, who was then occupied, as will be related in his Life, with a chimney-piece of stone for the heirs of Pellegrino da Fossombrone, which proved to be a divine work of carving. This master, I say, at the entreaty of Antonio, made his way to Loreto, where he executed festoons that are absolutely divine. Thus, with rapidity and diligence, the ornamentation of that Chamber of Our Lady was completely finished, although Antonio had five works of importance on his hands at one and the same time, to all of which, notwithstanding that they were in different places, distant one from another, he gave his attention in such a manner that he

never neglected any of them; for, when at any time he could not conveniently be there in person, he availed himself of the assistance of his brother Battista. These five works were the above-mentioned Fortress of Florence, that of Ancona, the work at Loreto, the Apostolic Palace, and the well at Orvieto.

After the death of Clement, when Cardinal Farnese was elected supreme Pontiff under the title of Paul III, Antonio, having been the friend of the Pope while he was a Cardinal, came into even greater credit; and His Holiness, having created his son, Signor Pier Luigi, Duke of Castro, sent Antonio to make the designs of the fortress which that Duke caused to be founded in that place; of the palace, called the Osteria, that is on the Piazza; and of the Mint, built of travertine after the manner of that in Rome, which is in the same place. Nor were these the only designs that Antonio made in that city, for he prepared many others of palaces and other buildings for various persons, both natives and strangers, who erected edifices of such cost that it would seem incredible to one who has not seen them, so ornate are they all, so commodious, and built with so little regard for expense; which was done by many, without a doubt, in order to please the Pope, seeing that even by such means do many contrive to procure favours for themselves, flattering the humour of Princes; and this is a thing not otherwise than worthy of praise, for it contributes to the convenience, advantage, and pleasure of the whole world.

Next, in the year in which the Emperor Charles V returned victorious from Tunis, most magnificent triumphal arches were erected to him in Messina, in Apulia, and in Naples, in honour of so great a victory; and since he was to come to Rome, Antonio, at the commission of the Pope, made a triumphal arch of wood at the Palace of S. Marco, of such a shape that it might serve for two streets, and so beautiful that a more superb or better proportioned work in wood has never been seen. And if in such a work splendid and costly marbles had been added to the industry, art, and diligence bestowed on its design and execution, it might have been deservedly numbered, on account of its statues, painted scenes, and other ornaments, among the Seven Wonders of the world. This arch, which was placed at the end of the corner turning into the principal Piazza, was of the Corinthian Order, with four round columns overlaid with silver on each side, and capitals carved in most beautiful foliage, completely

overlaid with gold. There were very beautiful architraves, friezes, and cornices placed with projections over every column; and between each two columns were two painted scenes, insomuch that there were four scenes distributed over each side, which, with the two sides, made eight scenes altogether, containing, as will be described elsewhere in speaking of those who painted them, the deeds of the Emperor. In order to enhance this splendour, also, and to complete the pediment above that arch on each side, there were two figures in relief, each four braccia and a half in height, representing Rome, with two Emperors of the House of Austria on either side, those on the front part being Albrecht and Maximilian, and those on the other side Frederick and Rudolph. And upon the corners, likewise, were four prisoners, two on each side, with a great number of trophies, also in relief, and the arms of His Holiness and of His Majesty; which were all executed under the direction of Antonio by excellent sculptors and by the best painters that there were in Rome at that time. And not only this arch was executed under the direction of Antonio, but also all the preparations for the festival that was held for the reception of so great and so invincible an Emperor.

The same Antonio then set to work on the Fortress of Nepi for the aforesaid Duke of Castro, and on the fortification of the whole city, which is both beautiful and impregnable. He laid out many streets in the same city, and made for its citizens the designs of many houses and palaces. His Holiness then causing the bastions of Rome to be constructed, which are very strong, and the Porta di S. Spirito being included among those works, the latter was built with the direction and design of Antonio, with rustic decorations of travertine, in a very solid and beautiful manner, and so magnificent, that it equals the works of the ancients. After the death of Antonio, there were some who sought, moved more by envy than by any reasonable motive, and employing extraordinary means, to have this structure pulled down; but this was not allowed by those in power.

Under the direction of the same architect was refounded almost the whole of the Apostolic Palace, which was in danger of ruin in many other parts besides those that have been mentioned; in particular, on one side, the Sistine Chapel, in which are the works of Michelagnolo, and likewise the façade, which he did in such a way that not the slightest crack appeared – a work richer in danger than in honour. He enlarged the Great Hall of that

same Sistine Chapel, making in two lunettes at the head of it
those immense windows with their marvellous lights, and with
compartments pushed up into the vaulting and wrought in stucco;
all executed at great cost, and so well, that this hall may be
considered the richest and the most beautiful that there had been
in the world up to that time. And he added to it a staircase, by
which it might be possible to go into S. Pietro, so commodious
and so well built that nothing better, whether ancient or modern,
has yet been seen; and likewise the Pauline Chapel, where the
Sacrament has to be placed, which is a work of extraordinary
charm, so beautiful and so well proportioned and distributed, that
through the grace that may be seen therein it appears to present
itself to the eye with a festive smile.

Antonio built the Fortress of Perugia, at the time when there
was discord between the people of that city and the Pope; and
that work, for which the houses of the Baglioni were thrown to
the ground, was finished with marvellous rapidity, and proved
to be very beautiful. He also built the Fortress of Ascoli, bringing
it in a few days to such a condition that it could be held by a
garrison, although the people of Ascoli and others did not think
that it could be carried so far in many years; wherefore it hap-
pened that, when the garrison was placed in it so quickly, those
people were struck with astonishment, and could scarce believe
it. He also refounded his own house in the Strada Giulia at
Rome, in order to protect himself from the floods that rise when
the Tiber is swollen; and he not only began, but in great part
completed, the palace that he occupied near S. Biagio, which now
belongs to Cardinal Riccio of Montepulciano, who has finished
it, adding most ornate apartments, and spending upon it vast
sums in addition to what had been spent by Antonio, which was
some thousands of crowns.

But all that Antonio did to the benefit and advantage of the
world is as nothing in comparison with the model of the vener-
able and stupendous fabric of S. Pietro at Rome, which, planned
in the beginning by Bramante, he enlarged and rearranged with a
new plan and in an extraordinary manner, giving it dignity and a
well-proportioned composition, both as a whole and in its separ-
ate parts, as may be seen from the model made of wood by the
hand of his disciple, Antonio L'Abacco, who carried it to abso-
lute perfection. This model, which gave Antonio a very great
name, was published in engraving after the death of Antonio da

San Gallo, together with the ground-plan of the whole edifice, by
the said Antonio L'Abacco, who wished to show in this way how
great was the genius of San Gallo, and to make known to all men
the opinion of that architect; for new plans had been proposed
in opposition by Michelagnolo Buonarroti, and out of this change
of plans many contentions afterwards arose, as will be related in
the proper place. It appeared to Michelagnolo, and also to many
others who saw the model of San Gallo, and such parts as were
carried into execution by him, that Antonio's composition was
too much cut up by projections and by members which are too
small, as are also the columns, the arches upon arches, and the
cornices upon cornices. Besides this, it seems not to be approved
that the two bell-towers in his plan, the four little tribunes, and
the principal cupola, should have that ornament, or rather, gar-
land of columns, many and small. In like manner, men did not
much approve, nor do they now, of those innumerable pinnacles
that are in it as a finish to the work; and it appears that in that
model he imitated the style and manner of the Germans rather
than the good manner of the ancients, which is now followed by
the best architects. The above-mentioned model of S. Pietro was
finished by L'Abacco a short time after the death of Antonio; and
it was found that, in so far as appertained merely to the wood-
work and the labour of the carpenters, it had cost four thousand
one hundred and eighty-four crowns. In executing it, Antonio
L'Abacco, who had charge of the work, acquitted himself very
well, having a good knowledge of the matters of architecture, as
is proved by the book of the buildings of Rome that he printed,
which is very beautiful. This model, which is now to be found in
the principal chapel of S. Pietro, is thirty-five palme* in length,
twenty-six in breadth, and twenty palme and a half in height;
wherefore, according to the model, the work would have been
one thousand and forty palme in length, or one hundred and four
canne,† and three hundred and sixty palme in breadth, or thirty-
six canne, for the reason that the canna which is used in Rome,
according to the measure of the masons, is equal to ten palme.

For the making of this model and of many designs, there were
assigned to Antonio by the Wardens of the building of S. Pietro
fifteen hundred crowns, of which he received one thousand in

* The 'palma' as used here is equal to about nine inches.
† The 'canna' is equal to four braccia.

cash; but the rest he never drew, for a short time after that work he passed to the other life. He strengthened the piers of the same Church of S. Pietro, to the end that the weight of the tribune might be supported securely; and he filled all the scattered parts of the foundations with solid material, and made them so strong, that there is no reason to fear that the building may show any more cracks or threaten to fall, as it did in the time of Bramante. This masterly work, if it were above the ground instead of being hidden below, would amaze the boldest intellect. And for these reasons the name and fame of this admirable craftsman should always have a place among the rarest masters.

We find that ever since the time of the ancient Romans the men of Terni and those of Narni have been deadly enemies with one another, as they still are, for the reason that the lake of the Marmora, becoming choked up at times, would do injury to one of those communities; and thus, when the people of Narni wished to release the waters, those of Terni would by no means consent to it. On that account there has always been a difference between them, whether the Pontiffs were governing Rome, or whether it was subject to the Emperors; and in the time of Cicero that orator was sent by the Senate to compose that difference, but it remained unsettled. Wherefore, after envoys had been sent to Pope Paul III in the year 1546 for the same purpose, he despatched Antonio to them to settle that dispute; and so, by his good judgment, it was resolved that the lake should have an outlet on the side where the wall is, and Antonio had it cut, although with the greatest difficulty. But it came to pass by reason of the heat, which was great, and other hardships, that Antonio, being now old and feeble, fell sick of a fever at Terni, and rendered up his spirit not long after; at which his friends and relatives felt infinite sorrow, and many buildings suffered, particularly the Palace of the Farnese family, near the Campo di Fiore.

Pope Paul III, when he was Cardinal Alessandro Farnese, had carried that palace a considerable way towards completion, and had finished part of the first range of windows in the façade and the inner hall, and had begun one side of the courtyard; but the building was yet not so far advanced that it could be seen in its perfection, when the Cardinal was elected Pontiff, and Antonio altered the whole of the original design, considering that he had to make a palace no longer for a Cardinal, but for a Pope. Having therefore pulled down some houses that were round it, and the

old staircase, he rebuilt it with a more gentle ascent, and increased the courtyard on every side and also the whole palace, making the halls greater in extent and the rooms more numerous and more magnificent, with very beautiful carved ceilings and many other ornaments. And he had already brought the façade, with the second range of windows, to completion, and had only to add the great cornice that was to go right round the whole, when the Pope, who was a man of exalted mind and excellent judgment, desiring to have a cornice richer and more beautiful than any that there had ever been in any other palace whatsoever, resolved that, in addition to the designs that Antonio had made, all the best architects of Rome should each make one, after which he would choose the finest, but would nevertheless have it carried into execution by Antonio. And so one morning, while he was at table at the Belvedere, all those designs were brought before him in the presence of Antonio, the masters who had made them being Perino del Vaga, Fra Sebastiano del Piombo, Michelagnolo Buonarroti, and Giorgio Vasari, who was then a young man and in the service of Cardinal Farnese, at the commission of whom and of the Pope he had prepared for that cornice not one only, but two different designs. It is true that Buonarroti did not bring his own himself, but sent it by the same Giorgio Vasari, who had gone to show him his designs, to the end that he might express his opinion on them as a friend; whereupon Michelagnolo gave him his own design, asking that he should take it to the Pope and make his excuses for not going in person, on the ground that he was indisposed. And when all the designs had been presented to the Pope, his Holiness examined them for a long time, and praised them all as ingenious and very beautiful, but that of the divine Michelagnolo above all.

Now all this did not happen without causing vexation to Antonio, who was not much pleased with this method of procedure on the part of the Pope, and who would have liked to do everything by himself. But even more was he displeased to see that the Pope held in great account one Jacomo Melighino of Ferrara, and made use of him as architect in the building of S. Pietro, although he showed neither power of design nor much judgment in his works, giving him the same salary as he paid to Antonio, on whom fell all the labour. And this happened because this Melighino had been the faithful servant of the Pope for many years without any reward, and it pleased His Holiness to

recompense him in that way; not to mention that he had charge of the Belvedere and of some other buildings belonging to the Pope.

After the Pope, therefore, had seen all the designs mentioned above, he said, perchance to try Antonio: 'These are all beautiful, but it would not be amiss for us to see another that our Melighino has made.' At which Antonio, feeling some resentment, and believing that the Pope was making fun of him, replied: 'Holy Father, Melighino is but an architect in jest.' Which hearing, the Pope, who was seated, turned towards Antonio, and, bowing his head almost to the ground, answered: 'Antonio, it is our wish that Melighino should be an architect in earnest, as you may see from his salary.' Having said this, he dismissed the company and went away; and by these words he meant to show that it is very often by Princes rather than by their own merits that men are brought to the greatness that they desire. The cornice was afterwards executed by Michelagnolo, who reconstructed the whole of that palace almost in another form, as will be related in his Life.

After the death of Antonio there remained alive his brother Battista Gobbo, a person of ability, who spent all his time on the buildings of Antonio, although the latter did not behave very well towards him. This Battista did not live many years after Antonio, and at his death he left all his possessions to the Florentine Company of the Misericordia in Rome, on the condition that the men of that Company should cause to be printed a book of Observations on Vitruvius that he had written. That book has never come into the light of day, but it is believed to be a good work, for he had a very fine knowledge of the matters of his art, and was a man of excellent judgment, and he was also upright and true.

But returning to Antonio: having died at Terni, he was taken to Rome and carried to the grave with the greatest pomp, followed by all the craftsmen of design and by many others; and then, at the instance of the Wardens of S. Pietro, his body was placed in a tomb near the Chapel of Pope Sixtus in S. Pietro, with the following epitaph:

ANTONIO SANCTI GALLI FLORENTINO, URBE MUNIENDA AC PUB. OPERIBUS, PRÆCIPUEQUE D. PETRI TEMPLO ORNAN. ARCHITECTORUM FACILE PRINCIPI, DUM VELINI LACUS EMISSIONEM PARAT, PAULO PONT. MAX. AUCTORE, INTERAMNÆ INTEMPESTIVE EXTINCTO, ISABELLA DETA UXOR MŒSTISS. POSUIT 1546, III. CALEND. OCTOBRIS.

And in truth Antonio, who was a most excellent architect, deserves to be celebrated and extolled, as his works clearly demonstrate, no less than any other architect, whether ancient or modern.

GIULIO ROMANO, Painter

AMONG his many, or rather innumerable, disciples, the greater number of whom became able masters, Raffaello da Urbino had not one who imitated him more closely in manner, invention, design, and colouring, than did Giulio Romano, nor one who was better grounded, more bold, resolute, prolific, and versatile, or more fanciful and varied than Giulio; not to mention for the present that he was very pleasant in his conversation, gay, amiable, gracious, and supremely excellent in character. These qualities were the reason that he was so beloved by Raffaello, that, if he had been his son, he could not have loved him more; wherefore it came to pass that Raffaello always made use of him in his most important works, and, in particular, in executing the Papal Loggie for Leo X; for after Raffaello had made the designs for the architecture, the decorations, and the scenes, he caused Giulio to paint many of the pictures there, among which are the Creation of Adam and Eve, that of the animals, the Building of Noah's Ark, his Sacrifice, and many other works, which are known by the manner, such as the one in which the daughter of Pharaoh, with her ladies, finds Moses in the little ark, which had been cast adrift on the river by the Hebrews – a work that is marvellous on account of a very well executed landscape. Giulio also assisted Raffaello in painting many things in that apartment of the Borgia Tower which contains the Burning of the Borgo, more particularly the base, which is painted in the colour of bronze, with the Countess Matilda, King Pepin, Charlemagne, Godfrey de Bouillon, King of Jerusalem, and other benefactors of the Church – all excellent figures; and prints of a part of this scene, taken from a drawing by the hand of Giulio, were published not long since. The same Giulio also executed the greater part of the scenes in fresco that are in the Loggia of Agostino Chigi; and he worked in oils on a very beautiful picture of S. Elizabeth, which was painted by Raffaello and sent to King Francis of

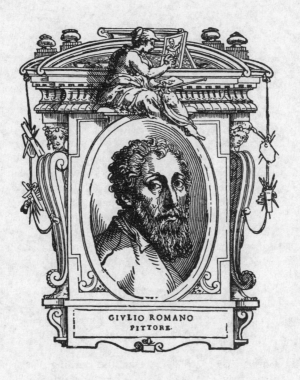

GIVLIO ROMANO
PITTORE.

France, together with another picture, of S. Margaret, painted almost entirely by Giulio after the design of Raffaello, who sent to the same King the portrait of the Vice-Queen of Naples, wherein Raffaello did nothing but the likeness of the head from life, and the rest was finished by Giulio. These works, which were very dear to that King, are still in the King's Chapel at Fontaine-bleau in France.

Working in this manner in the service of his master Raffaello, and learning the most difficult secrets of art, which were taught to him by Raffaello himself with extraordinary lovingness, before a long time had passed Giulio knew very well how to draw in perspective, take the measurements of buildings, and execute ground-plans; and Raffaello, designing and sketching at times in-ventions after his own fancy, would afterwards have them drawn on a larger scale, with the proper measurements, by Giulio, in order to make use of them in his works of architecture. And Giulio, beginning to delight in that art, gave his attention to it in such a manner, that he afterwards practised it and became a most excellent master. At his death, Raffaello left as his heirs Giulio and Giovan Francesco, called Il Fattore, on the condition that they should finish the works begun by him; and they carried the greater part of these to completion with honour.

Now Cardinal Giulio de' Medici, who afterwards became Pope Clement VII, took a site under Monte Mario at Rome, in which, besides a beautiful view, there were running waters, with some woods on the banks and a lovely plain which, running along the Tiber as far as the Ponte Molle, formed on either side a wide expanse of meadowland that extended almost to the Porta di S. Pietro; and on the highest point of the bank, where there was a level space, he proposed to build a palace with all the best and most beautiful conveniences and adornments that could be desired in the form of apartments, loggie, gardens, fountains, groves, and other things. Of all this he gave the charge to Giulio, who, undertaking it willingly, and setting his hand to the work, brought that palace, which was then called the Vigna de' Medici, and is now known as the Villa Madama, to that condition which will be described below. Accommodating himself, then, to the nature of the site and the wishes of the Cardinal, he made the façade in the form of a semicircle, after the manner of a theatre, with a design of niches and windows of the Ionic Order; which was so excellent, that many believe that Raffaello made the first

sketch for it, and that the work was afterwards pursued and carried to completion by Giulio. The same Giulio painted many pictures in the chambers and elsewhere; in particular, in a very beautiful loggia beyond the first entrance vestibule, which is adorned all around with niches large and small, wherein are great numbers of ancient statues; and among these was a Jupiter, a rare work, which was afterwards sent by the Farnese family to King Francis of France, with many other most beautiful statues. In addition to those niches, the said loggia is all wrought in stucco and has the walls and ceilings all painted with grotesques by the hand of Giovanni da Udine. At the head of this loggia Giulio painted in fresco an immense Polyphemus with a vast number of children and little satyrs playing about him, for which he gained much praise, even as he did for all the designs and works that he executed for that place, which he adorned with fish-ponds, pavements, rustic fountains, groves, and other suchlike things, all most beautiful and carried out with fine order and judgment.

It is true that, the death of Leo supervening, for a time this work was carried no further, for when a new Pontiff had been elected in Adrian, and Cardinal de' Medici had returned to Florence, it was abandoned, together with all the public works begun by Adrian's predecessor. During this time Giulio and Giovan Francesco brought to completion many things that had been left unfinished by Raffaello, and they were preparing to carry into execution some of the cartoons that he had made for the pictures of the Great Hall of the Palace – in which he had begun to paint four stories from the life of the Emperor Constantine, and had, when he died, covered one wall with the proper mixture for painting in oils – when they saw that Adrian, being a man who took no delight in pictures, sculptures, or in any other good thing, had no wish that the Hall should be finished. Driven to despair, therefore, Giulio and Giovan Francesco, and with them Perino del Vaga, Giovanni da Udine, Sebastiano Viniziano, and all the other excellent craftsmen, were almost like to die of hunger during the lifetime of Adrian. But by the will of God, while the Court, accustomed to the magnificence of Leo, was all in dismay, and all the best craftsmen, perceiving that no art was prized any longer, were beginning to consider where they might take refuge, Adrian died, and Cardinal Giulio de' Medici was elected Supreme Pontiff under the name of Clement VII; and with him all the arts of design, together with the other arts, were restored to life in

one day. Giulio and Giovan Francesco, full of joy, set themselves straightway by order of the Pope to finish the above-mentioned Hall of Constantine, and threw to the ground the preparation that had been laid on one wall for painting in oils; but they left untouched two figures that they had painted previously in oils, which serve as adornments to certain Popes; and these were a Justice and another similar figure.

The distribution of this Hall, which is low, had been designed with much judgment by Raffaello, who had placed at the corners, over all the doors, large niches with ornaments in the form of little boys holding various devices of Leo, such as lilies, diamonds, plumes, and other emblems of the House of Medici. In the niches were seated some Popes in pontificals, each with a canopy in his niche; and round those Popes were some little boys in the form of little angels, holding books and other appropriate things in their hands. And each Pope had on either side of him a Virtue, chosen according to his merits; thus, the Apostle Peter had Religion on one side and Charity, or rather Piety, on the other, and so all the others had similar Virtues; and the said Popes were Damasus I, Alexander I, Leo III, Gregory, Sylvester, and some others. All these figures were so well placed in position and executed by Giulio, who painted all the best parts of this work in fresco, that it is clear that he endured much labour and took great pains with them; as may also be seen from a drawing of S. Sylvester, which was designed very well by his own hand, and is perhaps a much more graceful work than the painted figure. It may be affirmed, indeed, that Giulio always expressed his conceptions better in drawings than in finished work or in paintings, for in the former may be seen more vivacity, boldness, and feeling; and this may have happened because he made a drawing in an hour, in all the heat and glow of working, whereas on paintings he spent months, and even years, so that, growing weary of them, and losing that keen and ardent love that one has at the beginning of a work, it is no marvel that he did not give them that absolute perfection that is to be seen in his drawings.

But to return to the stories: Giulio painted on one of the walls Constantine making an address to his soldiers; while in the air, in a splendour of light, appears the Sign of the Cross, with some little boys, and letters that run thus: 'In hoc signo vinces.' And there is a dwarf at the feet of Constantine, placing a helmet on his head, who is executed with great art. Next, on the largest wall,

there is the battle of horsemen which took place at the Ponte Molle, in which Constantine routed Maxentius. This work is worthy of the highest praise, on account of the dead and wounded that may be seen in it, and the various extravagant attitudes of the foot-soldiers and horsemen who are fighting in groups, all painted with great spirit; not to mention that there are many portraits from life. And if this scene were not too much darkened and loaded with blacks, which Giulio always delighted to use in colouring, it would be altogether perfect; but this takes away much of its grace and beauty. In the same scene he painted the whole landscape of Monte Mario, and the River Tiber, in which Maxentius, who is on horseback, proud and terrible, is drowning. In short, Giulio acquitted himself in such a manner in this work, that it has been a great light to all who have painted battle-pieces of that kind since his day. He himself learned so much from the ancient columns of Trajan and Antoninus that are in Rome, that he made much use of this knowledge for the costumes of soldiers, armour, ensigns, bastions, palisades, battering-rams, and all the other instruments of war that are painted throughout the whole of that Hall. And beneath these scenes, right round, he painted many things in the colour of bronze, which are all beautiful and worthy of praise.

On another wall he painted S. Sylvester the Pope baptizing Constantine, representing there the very bath made by Constantine himself, which is at S. Giovanni Laterano at the present day; and he made a portrait from life of Pope Clement in the S. Sylvester who is baptizing, with some assistants in their vestments, and a crowd of people. Among the many attendants of the Pope of whom he painted portraits there, also from life, was the Cavalierino, who was very influential with His Holiness at that time, and Messer Niccolò Vespucci, a Knight of Rhodes. And below this, on the base, he painted a scene with figures in imitation of bronze, of Constantine causing the Church of S. Pietro to be built at Rome, in allusion to Pope Clement. There he made portraits of the architect Bramante and of Giuliano Lemi,* holding the design of the ground-plan of the said church, and this scene is very beautiful.

On the fourth wall, above the chimney-piece of that Hall, he depicted in perspective the Church of S. Pietro at Rome, with the

* Giuliano Leno.

Pope's throne exactly as it appears when His Holiness chants the Pontifical Mass; the body of Cardinals and all the other prelates of the Court; the chapel of singers and musicians; and the Pope seated, represented as S. Sylvester, with Constantine kneeling at his feet and presenting to him a figure of Rome made of gold in the manner of those that are on the ancient medals, by which Giulio intended to signify the dowry which that Constantine gave to the Roman Church. In this scene Giulio painted many women kneeling there to see that ceremony, who are very beautiful; a beggar asking for alms; a little boy amusing himself by riding on a dog; and the Lancers of the Papal Guard, who are making the people give way and stand back, as is the custom. And among many portraits that are in this work may be seen portraits from life of Giulio himself, the painter; of Count Baldassarre Castiglioni, the author of the 'Cortigiano,' and very much his friend; of Pontano and Marullo; and of many other men of letters and courtiers. Right round the Hall and between the windows Giulio painted many devices and poetical compositions, which were pleasing and fanciful; and everything was much to the satisfaction of the Pope, who rewarded him liberally for his labours.

While this Hall was being painted, Giulio and Giovan Francesco, although they could not meet the demands of their friends even in part, executed an altar-piece with the Assumption of Our Lady, a very beautiful work, which was sent to Perugia and placed in the Convent of the Nuns of Monteluci. Then, having withdrawn to work by himself, Giulio painted a picture of Our Lady, with a cat that was so natural that it appeared to be truly alive; whence that picture was called the Picture of the Cat. In another picture, of great size, he painted a Christ being scourged at the Column, which was placed on the altar of the Church of S. Prassedia at Rome. And not long after this, M. Giovan Matteo Giberti, who was then Datary to Pope Clement, and afterwards became Bishop of Verona, commissioned Giulio, who was his very familiar friend, to make the design for some rooms that were built of brick near the gate of the Papal Palace, looking out upon the Piazza of S. Pietro, and serving for the accommodation of the trumpeters who blow their trumpets when the Cardinals go to the Consistory, with a most commodious flight of steps, which can be ascended on horseback as well as on foot. For the same M. Giovan Matteo he painted an altar-piece of the Stoning of S. Stephen, which M. Giovan Matteo sent to a benefice of his

own, called S. Stefano, in Genoa. In this altar-piece, which is most beautiful in invention, grace, and composition, the young Saul may be seen seated on the garments of S. Stephen while the Jews are stoning him; and, in a word, Giulio never painted a more beautiful work than this, so fierce are the attitudes of the persecutors and so well expressed the patience of Stephen, who appears to be truly seeing Jesus Christ on the right hand of the Father in the Heaven, which is painted divinely well. This work, together with the benefice, M. Giovan Matteo gave to the Monks of Monte Oliveto, who have turned the place into a monastery.

The same Giulio executed at the commission of the German Jacob Fugger, for a chapel that is in S. Maria de Anima at Rome, a most lovely altar-piece in oils, in which are the Madonna, S. Anne, S. Joseph, S. James, S. John as a little boy kneeling, and S. Mark the Evangelist with a lion at his feet, which is lying down with a book, its hair curving in accordance with its position, which was a beautiful consideration, and difficult to execute; not to mention that the same lion has short wings on its shoulders, with feathers so soft and plumy, that it seems almost incredible that the hand of a craftsman could have been able to imitate nature so closely. Besides this, he painted there a building that curves in a circular form after the manner of a theatre, with some statues so beautiful and so well placed that there is nothing better to be seen. Among other figures there is a woman who is spinning and gazing at a hen with some chickens, than which nothing could be more natural; and above Our Lady are some little boys, very graceful and well painted, who are upholding a canopy. And if this picture, also, had not been so heavily loaded with black, by reason of which it has become very dark, it would certainly have been much better; but this blackness has brought it about that the greater part of the work that is in it is lost or destroyed, and that because black, even when fortified with varnish, is the ruin of all that is good, always having in it a certain desiccative quality, whether it be made from charcoal, burnt ivory, smoke-black, or burnt paper.

Among the many disciples that Giulio had while he was executing these works, such as Bartolommeo da Castiglione, Tommaso Papacello of Cortona, and Benedetto Pagni of Pescia, those of whom he made the most particular use were Giovanni da Lione and Raffaello dal Colle of Borgo a San Sepolcro, both of whom assisted him in the execution of many things in the Hall

of Constantine and in the other works of which we have spoken. Wherefore I do not think it right to refrain from mentioning that these two, who were very dexterous in painting, and followed the manner of Giulio closely in carrying into execution the works that he designed for them, painted in colours after his design, near the old Mint in the Banchi, the escutcheon of Pope Clement VII, each of them doing one-half, with two terminal figures, one on either side of that escutcheon. And the same Raffaello, not long after, painted in fresco from a cartoon drawn by Giulio, in a lunette within the door of the Palace of Cardinal della Valle, a Madonna who is covering the Child, who is sleeping, with a piece of drapery, with S. Andrew the Apostle on one side and S. Nicholas on the other, which was held, with justice, to be an excellent picture.

Giulio, meanwhile, being very intimate with Messer Baldassarre Turini da Pescia, built for him on Mount Janiculum, where there are some villas that have a most beautiful view, after making the design and model, a palace so graceful and so well appointed, from its having all the conveniences that could be desired in such a place, that it defies description. Moreover, the apartments were adorned not only with stucco, but also with paintings, for he himself painted there some stories of Numa Pompilius, who was buried on that spot; and in the bathroom of this palace, with the help of his young men, Giulio painted some stories of Venus, Love, Apollo, and Hyacinthus, which are all to be seen in engraving.

After having separated himself completely from Giovan Francesco, he executed various architectural works in Rome, such as the design of the house of the Alberini in the Banchi (although some believe that the plan of this work came from Raffaello), and likewise a palace that may be seen at the present day on the Piazza della Dogana in Rome, which, being beautiful in design, has been reproduced in engraving. And for himself, on a corner of the Macello de' Corbi, where stood his own house, in which he was born, he made a beginning with a beautiful range of windows, which is a small thing, but very graceful.

By reason of all these excellent qualities, Giulio, after the death of Raffaello, was celebrated as the best craftsman in Italy. And Count Baldassarre Castiglioni, who was then in Rome as ambassador from Federigo Gonzaga, Marquis of Mantua, and was much the friend, as has been related, of Giulio, having been

commanded by his master the Marquis to send him an architect
of whom he might avail himself for the necessities of his palace
and of the city, the Marquis adding that he would particularly like
to have Giulio – the Count, I say, so wrought upon him with
entreaties and promises, that Giulio said that he would go, pro-
vided that he could do this with the leave of Pope Clement;
which leave having been obtained, the Count, setting out for
Mantua, from which he was then to go on behalf of the Pope to
the Emperor, took Giulio with him; and having arrived there, he
presented him to the Marquis, who, after welcoming him warmly,
caused an honourably appointed house to be given to him,
together with a salary and also a good table for himself, for his
disciple Benedetto Pagni, and for another young man who was
in his service; and, what is more, the Marquis sent him several
canne of velvet, satin, and other kinds of silk and cloth wherewith
to clothe himself. Then, hearing that he had no horse to ride, he
sent for a favourite horse of his own, called Luggieri, and
presented it to him; and when Giulio had mounted upon it, they
rode to a spot a bow-shot beyond the Porta di S. Bastiano, where
His Excellency had a place with some stables, called the Te,
standing in the middle of a meadow, in which he kept his stud
of horses and mares. Arriving there, the Marquis said that he
would like, without destroying the old walls, to have some sort
of place arranged to which he might resort at times for dinner or
supper, as a recreation.

Giulio, having heard the will of the Marquis, and having
examined the whole place, took a ground-plan of that site and set
his hand to the work. Availing himself of the old walls, he made
in the principal part the first hall that is to be seen at the present
day as one enters, with the suite of rooms that are about it. And
since the place has no living rock, and no quarries from which to
excavate material for hewn and carved stone, such as are used in
building by those who can obtain them, he made use of brick and
baked stone, which he afterwards worked over with stucco; and
with this material he made columns, bases, capitals, cornices,
doors, windows, and other things, all with most beautiful propor-
tions. And he executed the decorations of the vaults in a new and
fantastic manner, with very handsome compartments, and with
richly adorned recesses, which was the reason that the Marquis,
after a beginning so humble, then resolved to have the whole of
that building reconstructed in the form of a great palace.

Thereupon Giulio made a very beautiful model, all of rustic work both without and within the courtyard, which pleased that lord so much, that he assigned a good sum of money for the building; and after Giulio had engaged many masters, the work was quickly carried to completion. The form of the palace is as follows: The building is quadrangular, and has in the centre an open courtyard after the manner of a meadow, or rather, of a piazza, into which open four entrances in the form of a cross. The first of these traverses straightway, or rather, passes, into a very large loggia, which opens by another into the garden, and two others lead into various apartments; and these are all adorned with stucco-work and paintings. In the hall to which the first entrance gives access the vaulting is wrought in various compartments and painted in fresco, and on the walls are portraits from life of all the favourite and most beautiful horses from the stud of the Marquis, together with the dogs of the same coat or marking as the horses, with their names; which were all designed by Giulio, and painted in fresco on the plaster by the painters Benedetto Pagni and Rinaldo Mantovano, his disciples, and so well, in truth, that they seem to be alive.

From this hall one passes into a room which is at one corner of the palace, and has the vaulting most beautifully wrought with compartments in stucco-work and varied mouldings, touched in certain places with gold. These mouldings divide the surface into four octagons, which enclose a picture in the highest part of the vaulting, in which is Cupid marrying Psyche in the sight of Jove, who is on high, illumined by a dazzling celestial light, and in the presence of all the Gods. It would not be possible to find anything executed with more grace or better draughtsmanship than this scene, for Giulio foreshortened the figures so well, with a view to their being seen from below, that some of them, although they are scarcely one braccio in length, appear when seen from the ground to be three braccia high; and, in truth, they are wrought with marvellous art and ingenuity, Giulio having succeeded in so contriving them, that, besides seeming to be alive (so strong is the relief), they deceive the human eye with a most pleasing illusion. In the octagons are all the earlier stories of Psyche, showing the adversities that came upon her through the wrath of Venus, and all executed with the same beauty and perfection; in other angles are many Loves, as likewise in the windows, producing various effects in accordance with the spaces

where they are; and the whole of the vaulting is painted in oils by the hands of the above-mentioned Benedetto and Rinaldo. The rest of the stories of Psyche are on the walls below, and these are the largest. In one in fresco is Psyche in the bath; and the Loves are bathing her, and then wiping her dry with most beautiful gestures. In another part is Mercury preparing the banquet, while Psyche is bathing, with the Bacchantes sounding instruments; and there are the Graces adorning the table with flowers in a beautiful manner. There is also Silenus supported by Satyrs, with his ass, and a goat lying down, which has two children sucking at its udder; and in that company is Bacchus, who has two tigers at his feet, and stands leaning with one arm on the credence, on one side of which is a camel, and on the other an elephant. This credence, which is barrel-shaped, is adorned with festoons of verdure and flowers, and all covered with vines laden with bunches of grapes and leaves, under which are three rows of bizarre vases, basins, drinking-cups, tazze, goblets, and other things of that kind in various forms and fantastic shapes, and so lustrous, that they seem to be of real silver and gold, being counterfeited with a simple yellow and other colours, and that so well, that they bear witness to the extraordinary genius and art of Giulio, who proved in this part of the work that he was rich, versatile, and abundant in invention and craftsmanship. Not far away may be seen Psyche, who, surrounded by many women who are serving and attiring her, sees Phœbus appearing in the distance among the hills in the chariot of the sun, which is drawn by four horses; while Zephyr is lying nude upon some clouds, and is blowing gentle breezes through a horn that he has in his mouth, which make the air round Psyche balmy and soft. These stories were engraved not many years since after the designs of Battista Franco of Venice, who copied them exactly as they were painted from the great cartoons of Giulio by Benedetto of Pescia and Rinaldo Mantovano, who carried into execution all the stories except the Bacchus, the Silenus, and the two children suckled by the goat; although it is true that the work was afterwards retouched almost all over by Giulio, so that it is very much as if it had been all painted by him. This method, which he learned from Raffaello, his instructor, is very useful to young men, who in this way obtain practice and thereby generally become excellent masters. And although some persuade themselves that they are greater than those who keep them at work,

such fellows, if their guide fails them before they are at the end, or if they are deprived of the design and directions for the work, learn that through having lost or abandoned that guidance too early they are wandering like blind men in an infinite sea of errors.

But to return to the apartments of the Te; from that room of Psyche one passes into another full of double friezes with figures in low-relief, executed in stucco after the designs of Giulio by Francesco Primaticcio of Bologna, then a young man, and by Giovan Battista Mantovano, in which friezes are all the soldiers that are on Trajan's Column at Rome, wrought in a beautiful manner. And on the ceiling, or rather soffit, of an antechamber is painted in oils the scene when Icarus, having been taught by his father Dædalus, seeks to rise too high in his flight, and, after seeing the Sign of Cancer and the chariot of the sun, which is drawn by four horses in foreshortening, near the Sign of Leo, is left without his wings, the wax being consumed by the heat of the sun; and near this the same Icarus may be seen hurtling through the air, and almost falling upon those who gaze at him, his face dark with the shadow of death. This invention was so well conceived and imagined by Giulio, that it seems to be real and true, for in it one sees the fierce heat of the sun burning the wretched youth's wings, the flaming fire gives out smoke, and one almost hears the crackling of the burning plumes, while death may be seen carved in the face of Icarus, and in that of Dædalus the most bitter sorrow and agony. In our book of drawings by various painters is the original design of this very beautiful scene, by the hand of Giulio himself, who executed in the same place the stories of the twelve months of the year, showing all that is done in each of them in the arts most practised by mankind – paintings which are notable no less for their fantastic and delightful character and their beauty of invention than for the judgment and diligence with which they were executed.

After passing the great loggia, which is adorned with stuccowork and with many arms and various other bizarre ornaments, one comes to some rooms filled with such a variety of fantasies, that the brain reels at the thought of them. For Giulio, who was very fanciful and ingenious, wishing to demonstrate his worth, resolved to make, at an angle of the palace which formed a corner similar to that of the room of Psyche described above, an apartment the masonry of which should be in keeping with the

painting, in order to deceive as much as possible all who might
see it. He therefore had double foundations of great depth sunk
at that corner, which was in a marshy place, and over that angle
he constructed a large round room, with very thick walls, to the
end that the four external angles of the masonry might be strong
enough to be able to support a double vault, round after the
manner of an oven. This done, he caused to be built at the
corners right round the room, in the proper places, the doors,
windows, and fireplace, all of rustic stones rough-hewn as if by
chance, and, as it were, disjointed and awry, insomuch that they
appeared to be really hanging over to one side and falling down.
Having built this room in such strange fashion, he set himself to
paint in it the most fantastic composition that he was able to
invent – namely, Jove hurling his thunderbolts against the Giants.
And so, depicting Heaven on the highest part of the vaulting, he
placed there the throne of Jove, representing it as seen in fore-
shortening from below and from the front, within a round
temple, supported by open columns of the Ionic Order, with his
canopy over the centre of the throne, and with his eagle; and all
was poised upon the clouds. Lower down he painted Jove in
anger, slaying the proud Giants with his thunderbolts, and below
him is Juno, assisting him; and around them are the Winds, with
strange countenances, blowing towards the earth, while the God-
dess Ops turns with her lions at the terrible noise of the thunder,
as also do the other Gods and Goddesses, and Venus in particu-
lar, who is at the side of Mars; and Momus, with his arms out-
stretched, appears to fear that Heaven may be falling headlong
down, and yet he stands motionless. The Graces, likewise, are
standing filled with dread, and beside them, in like manner, the
Hours. All the Deities, in short, are taking to flight with their
chariots. The Moon, Saturn, and Janus are going towards the
lightest of the clouds, in order to withdraw from that terrible
uproar and turmoil, and the same does Neptune, who, with his
dolphins, appears to be seeking to support himself on his trident.
Pallas, with the nine Muses, stands wondering what horrible thing
this may be, and Pan, embracing a Nymph who is trembling with
fear, seems to wish to save her from the glowing fires and the
lightning-flashes with which the heavens are filled. Apollo stands
in the chariot of the sun, and some of the Hours seem to be
seeking to restrain the course of his horses. Bacchus and Silenus,
with Satyrs and Nymphs, betray the greatest terror, and Vulcan,

with his ponderous hammer on one shoulder, gazes towards Hercules, who is speaking of this event with Mercury, beside whom is Pomona all in dismay, as are also Vertumnus and all the other Gods dispersed throughout that Heaven, in which all the effects of fear are so well expressed, both in those who are standing and in those who are flying, that it is not possible, I do not say to see, but even to imagine a more beautiful fantasy in painting than this one.

In the parts below, that is, on the walls that stand upright, underneath the end of the curve of the vaulting, are the Giants, some of whom, those below Jove, have upon their backs mountains and immense rocks which they support with their stout shoulders, in order to pile them up and thus ascend to Heaven, while their ruin is preparing, for Jove is thundering and the whole Heaven burning with anger against them; and it appears not only that the Gods are dismayed by the presumptuous boldness of the Giants, upon whom they are hurling mountains, but that the whole world is upside down and, as it were, come to its last day. In this part Giulio painted Briareus in a dark cavern, almost covered with vast fragments of mountains, and the other Giants all crushed and some dead beneath the ruins of the mountains. Besides this, through an opening in the darkness of a grotto, which reveals a distant landscape painted with beautiful judgment, may be seen many Giants flying, all smitten by the thunderbolts of Jove, and, as it were, on the point of being overwhelmed at that moment by the fragments of the mountains, like the others. In another part Giulio depicted other Giants, upon whom are falling temples, columns, and other pieces of buildings, making a vast slaughter and havoc of those proud beings. And in this part, among those falling fragments of buildings, stands the fireplace of the room, which, when there is a fire in it, makes it appear as if the Giants are burning, for Pluto is painted there, flying towards the centre with his chariot drawn by lean horses, and accompanied by the Furies of Hell; and thus Giulio, not departing from the subject of the story with this invention of the fire, made a most beautiful adornment for the fireplace.

In this work, moreover, in order to render it the more fearsome and terrible, Giulio represented the Giants, huge and fantastic in aspect, falling to the earth, smitten in various ways by the lightnings and thunderbolts; some in the foreground and others in the background, some dead, others wounded, and

others again covered by mountains and the ruins of buildings. Wherefore let no one ever think to see any work of the brush more horrible and terrifying, or more natural than this one; and whoever enters that room and sees the windows, doors, and other suchlike things all awry and, as it were, on the point of falling, and the mountains and buildings hurtling down, cannot but fear that everything will fall upon him, and, above all, as he sees the Gods in the Heaven rushing, some here, some there, and all in flight. And what is most marvellous in the work is to see that the whole of the painting has neither beginning nor end, but is so well joined and connected together, without any divisions or ornamental partitions, that the things which are near the buildings appear very large, and those in the distance, where the landscapes are, go on receding into infinity; whence that room, which is not more than fifteen braccia in length, has the appearance of open country. Moreover, the pavement being of small round stones set on edge, and the lower part of the upright walls being painted with similar stones, there is no sharp angle to be seen, and that level surface has the effect of a vast expanse, which was executed with much judgment and beautiful art by Giulio, to whom our craftsmen are much indebted for such inventions.

In this work the above-mentioned Rinaldo Mantovano became a perfect colourist, for he carried the whole of it into execution after the cartoons of Giulio, as well as the other rooms. And if this painter had not been snatched from the world so young, even as he did honour to Giulio during his lifetime, so he would have done honour (to himself) after Giulio's death.

In addition to this palace, in which Giulio executed many other works worthy to be praised, of which, in order to avoid prolixity, I shall say nothing, he reconstructed with masonry many rooms in the castle where the Duke lives at Mantua, and made two very large spiral staircases, with very rich apartments adorned all over with stucco. In one hall he caused the whole of the story of Troy and the Trojan War to be painted, and likewise twelve scenes in oils in an antechamber, below the heads of the twelve Emperors previously painted there by Tiziano Vecelli, which are all held to be excellent. In like manner, at Marmirolo, a place five miles distant from Mantua, a most commodious building was erected after the design of Giulio and under his direction, with large paintings no less beautiful than those of the castle and of the palace of the Te. The same master

painted an altar-piece in oils for the Chapel of Signora Isabella
Buschetta in S. Andrea at Mantua, of Our Lady in the act of
adoring the Infant Jesus, who is lying on the ground, with
S. Joseph, the ass and the ox near a manger, and on one side
S. John the Evangelist, and S. Longinus on the other, figures of
the size of life. Next, on the walls of the same chapel, he caused
Rinaldo to paint two very beautiful scenes after his own designs;
on one, the Crucifixion of Jesus Christ, with the Thieves, some
Angels in the air, and on the ground the ministers of the Cruci-
fixion and the Maries, with many horses, in which he always
delighted, making them beautiful to a marvel, and many soldiers
in various attitudes; and, on the other, the scene when the Blood
of Christ was discovered in the time of the Countess Matilda,
which was a most beautiful work.

Giulio then painted with his own hand for Duke Federigo a
picture of Our Lady washing the little Jesus Christ, who is stand-
ing in a basin, while a little S. John is pouring out the water from
a vase. Both of these figures, which are of the size of life, are
very beautiful; and in the distance are small figures, from the
waist upwards, of some ladies who are coming to visit the Ma-
donna. This picture was afterwards presented by the Duke to
Signora Isabella Buschetta, of which lady Giulio subsequently
made a most beautiful portrait in a little picture of the Nativity
of Christ, one braccio in height, which is now in the possession
of Signor Vespasiano Gonzaga, together with another picture
presented to him by Duke Federigo, and likewise by the hand of
Giulio, in which are a young man and a young woman embracing
each other on a bed, in the act of caressing one another, while
an old woman peeps at them secretly from behind a door –
figures which are little less than life-size, and very graceful. In the
house of the same person is another very excellent picture of a
most beautiful S. Jerome, also by the hand of Giulio. And in the
possession of Count Niccola Maffei is a picture of Alexander the
Great, of the size of life, with a Victory in his hand, copied from
an ancient medal, which is a work of great beauty.

After these works, Giulio painted in fresco over a chimney-
piece, for M. Girolamo, the organist of the Duomo at Mantua,
who was very much his friend, a Vulcan who is working his
bellows with one hand and holding with the other, with a pair of
tongs, the iron head of an arrow that he is forging, while Venus
is tempering in a vase some already made and placing them in

Cupid's quiver. This is one of the most beautiful works that Giulio ever executed; and there is little else in fresco by his hand to be seen. For S. Domenico, at the commission of M. Lodovico da Fermo, he painted an altar-piece of the Dead Christ, whom Joseph and Nicodemus are preparing to lay in the sepulchre, and near them are His Mother, the other Maries, and S. John the Evangelist. And a little picture, in which he also painted a Dead Christ, is in the house of the Florentine Tommaso da Empoli at Venice.

At the same time when he was executing these and other pictures, it happened that Signor Giovanni de' Medici, having been wounded by a musket-ball, was carried to Mantua, where he died. Whereupon M. Pietro Aretino, who was the devoted servant of that lord, and very much the friend of Giulio, desired that Giulio should mould a likeness of him with his own hand as he lay dead; and he, therefore, having taken a cast from the face of the dead man, executed a portrait from it, which remained for many years afterwards in the possession of the same Aretino.

For the entry of the Emperor Charles V into Mantua, Giulio, by order of the Duke, made many most beautiful festive preparations in the form of arches, scenery for dramas, and a number of other things; in which inventions Giulio had no equal, nor was there ever any man more fanciful in preparing masquerades and in designing extravagant costumes for jousts, festivals, and tournaments, as was seen at that time with amazement and marvel by the Emperor Charles and by all who were present. Besides this, at different times he gave so many designs for chapels, houses, gardens, and façades throughout the whole of Mantua, and he so delighted to embellish and adorn the city, that, whereas it was formerly buried in mud and at times full of stinking water and almost uninhabitable, he brought it to such a condition that at the present day, thanks to his industry, it is dry, healthy, and altogether pleasing and delightful.

While Giulio was in the service of that Duke, one year the Po, bursting its banks, inundated Mantua in such a manner, that in certain low-lying parts of the city the water rose to the height of nearly four braccia, insomuch that for a long time frogs lived in them almost all the year round. Giulio, therefore, after pondering in what way he might put this right, so went to work that for the time being the city was restored to its former condition; and to the end that the same might not happen another time, he

contrived to have the streets on that side raised so much, by command of the Duke, that they came above the level of the water, and the buildings stood in safety. In that part of the city the houses were small, slightly built, and of no great importance, and he gave orders that they should be pulled down, in order to raise the streets and bring that quarter to a better state, and that new houses, larger and more beautiful, should be built there, to the advantage and improvement of the city. To this measure many opposed themselves, saying to the Duke that Giulio was doing too much havoc; but he would not hear any of them – nay, he made Giulio superintendent of the streets at that very time, and decreed that no one should build in that city save under Giulio's direction. On which account many complaining and some even threatening Giulio, this came to the ears of the Duke, who used such words in his favour as made it known that if they did anything to the despite or injury of Giulio, he would count it as done to himself, and would make an example of them.

The Duke was so enamoured of the excellence of Giulio, that he could not live without him; and Giulio, on his part, bore to that lord the greatest reverence that it is possible to imagine. Wherefore he never asked a favour for himself or for others without obtaining it, and when he died it was found that with all that he had received from the Duke he had an income of more than a thousand ducats.

Giulio built a house for himself in Mantua, opposite to S. Barnaba, on the outer side of which he made a fantastic façade, all wrought with coloured stucco, and the interior he caused to be all painted and wrought likewise with stucco; and he found place in it for many antiquities brought from Rome and others received from the Duke, to whom he gave many of his own. He made so many designs both for Mantua and for places in its neighbourhood, that it was a thing incredible; for, as has been told, no palaces or other buildings of importance could be erected, particularly in the city, save after his design. He rebuilt upon the old walls the Church of S. Benedetto, a rich and vast seat of Black Friars at Mantua, near the Po; and the whole church was embellished with most beautiful paintings and altar-pieces from designs by his hand. And since his works were very highly prized throughout Lombardy, it pleased Gian Matteo Giberti, Bishop of Verona, to have the tribune of the Duomo of that city all painted, as has been related in another place, by Il Moro the

Veronese, after designs by Giulio. For the Duke of Ferrara, also, he executed many designs for tapestries, which were afterwards woven in silk and gold by Maestro Niccolò and Giovan Battista Rosso, both Flemings; and of these there are engravings to be seen, executed by Giovan Battista Mantovano, who engraved a vast number of things drawn by Giulio, and in particular, besides three drawings of battles engraved by others, a physician who is applying cupping-glasses to the shoulders of a woman, and the Flight of Our Lady into Egypt, with Joseph holding the ass by the halter, and some Angels bending down a date-palm in order that Christ may pluck the fruit. The same master engraved, also after the designs of Giulio, the Wolf on the Tiber suckling Romulus and Remus, and four stories of Pluto, Jove and Neptune, who are dividing the heavens, the earth, and the sea among them by lot; and likewise the goat Amaltheia, which, held by Melissa, is giving suck to Jove, and a large plate of many men in a prison, tortured in various ways. There were also printed, after the inventions of Giulio, Scipio and Hannibal holding a parley with their armies on the banks of the river; the Nativity of S. John the Baptist, which was engraved by Sebastiano da Reggio, and many other works engraved and printed in Italy. In Flanders and in France, likewise, have been printed innumerable sheets from designs by Giulio, of which, although they are very beautiful, there is no need to make mention, nor of all his drawings, seeing that he made them, so to speak, in loads. Let it be enough to say that he was so facile in every field of art, and particularly in drawing, that we have no record of any one who has produced more than he did.

Giulio, who was very versatile, was able to discourse on every subject, but above all on medals, upon which he spent large sums of money and much time, in order to gain knowledge of them. And although he was employed almost always in great works, this did not mean that he would not set his hand at times to the most trifling matters in order to oblige his patron and his friends; and no sooner had one opened his mouth to explain to him his conception than he had understood it and drawn it. Among the many rare things that he had in his house was the portrait from life of Albrecht Dürer on a piece of fine Rheims cloth, by the hand of Albrecht himself, who sent it, as has been related in another place, as a present to Raffaello da Urbino. This portrait was an exquisite thing, for it had been coloured in gouache with

much diligence with water-colours, and Albrecht had executed it without using lead-white, availing himself in its stead of the white of the cloth, with the delicate threads of which he had so well rendered the hairs of the beard, that it was a thing scarcely possible to imagine, much less to do; and when held up to the light it showed through on either side. This portrait, which was very dear to Giulio, he showed to me himself as a miracle, when I went during his lifetime to Mantua on some affairs of my own.

At the death of Duke Federigo, by whom Giulio had been beloved beyond belief, he was so overcome with sorrow, that he would have left Mantua, if the Cardinal, the brother of the Duke, on whom the government of the State had descended because the sons of Federigo were very young, had not detained him in that city, where he had a wife and children, houses, villas, and all the other possessions that are proper to a gentleman of means. And this the Cardinal did (aided by those reasons) from a wish to avail himself of the advice and assistance of Giulio in renovating, or rather building almost entirely anew, the Duomo of that city; to which work Giulio set his hand, and carried it well on in a very beautiful form.

At this time Giorgio Vasari, who was much the friend of Giulio, although they did not know one another save only by reputation and by letters, in going to Venice, took the road by Mantua, in order to see Giulio and his works. And so, having arrived in that city, and going to find his friend, when they met, although they had never seen each other, they knew one another no less surely than if they had been together in person a thousand times. At which Giulio was so filled with joy and contentment, that for four days he never left him, showing him all his works, and in particular all the ground-plans of the ancient edifices in Rome, Naples, Pozzuolo, and Campania, and of all the other fine antiquities of which anything is known, drawn partly by him and partly by others. Then, opening a very large press, he showed to Giorgio the ground-plans of all the buildings that had been erected after his designs and under his direction, not only in Mantua and in Rome, but throughout all Lombardy, which were so beautiful, that I, for my part, do not believe that there are to be seen any architectural inventions more original, more lovely, or better composed. After this, the Cardinal asking Giorgio what he thought of the works of Giulio, Giorgio answered in the presence of Giulio that they were such that he deserved to have

a statue of himself placed at every corner of the city, and that, since he had given that city a new life, the half of the State would not be a sufficient reward for the labours and abilities of Giulio; to which the Cardinal answered that Giulio was more the master of that State than he was himself. And since Giulio was very loving, especially towards his friends, there was no mark of love and affection that Giorgio did not receive from him. The same Vasari, having left Mantua and gone to Venice, returned to Rome at the very time when Michelagnolo had just uncovered his Last Judgment in the Chapel; and he sent to Giulio by M. Nino Nini of Cortona, the secretary of the aforesaid Cardinal of Mantua, three sheets containing the Seven Mortal Sins, copied from that Last Judgment of Michelagnolo, which were welcome in no ordinary manner to Giulio, both as being what they were, and because he had at that time to paint a chapel in the palace for the Cardinal, and they served to inspire him to greater things than those that he had in mind. Putting forward all possible effort, therefore, to make a most beautiful cartoon, he drew in it with fine fancy the scene of Peter and Andrew leaving their nets at the call of Christ, in order to follow Him, and to be thenceforward, not fishers of fishes, but fishers of men. And this cartoon, which proved to be the most beautiful that Giulio had ever made, was afterwards carried into execution by the painter Fermo Ghisoni, a pupil of Giulio, and now an excellent master.

Not long afterwards the superintendents of the building of S. Petronio at Bologna, being desirous to make a beginning with the façade of that church, succeeded after great difficulty in inducing Giulio to go there, in company with a Milanese architect called Tofano Lombardino, a man in great repute at that time in Lombardy for the many buildings by his hand that were to be seen in that country. These masters, then, made many designs, those of Baldassarre Peruzzi of Siena having been lost; and one that Giulio made, among others, was so beautiful and so well ordered, that he rightly received very great praise for it from that people, and was rewarded with most liberal gifts on his return to Mantua.

Meanwhile, Antonio da San Gallo having died at Rome about that time, the superintendents of the building of S. Pietro had been thereby left in no little embarrassment, not knowing to whom to turn or on whom to lay the charge of carrying that great fabric to completion after the plan already begun; but they thought that no one could be more fitted for this than Giulio

Romano, for they all knew how great were his worth and excellence. And so, surmising that he would accept such a charge more than willingly in order to repatriate himself in an honourable manner and with a good salary, they caused some of his friends to approach him, but in vain, for the reason that, although he would have gone with the greatest willingness, two things prevented him – the Cardinal would in no way consent to his departure, and his wife, with her relatives and friends, used every possible means to dissuade him. Neither of these two reasons, perchance, would have prevailed with him, if he had not happened to be in somewhat feeble health at that time; for, having considered how much honour and profit he might secure for himself and his children by accepting so handsome a proposal, he was already fully disposed to make every effort not to be hindered in the matter by the Cardinal, when his malady began to grow worse. However, since it had been ordained on high that he should go no more to Rome, and that this should be the end and conclusion of his life, in a few days, what with his vexation and his malady, he died at Mantua, which city might well have allowed him, even as he had embellished her, so also to honour and adorn his native city of Rome.

Giulio died at the age of fifty-four, leaving only one male child, to whom he had given the name of Raffaello out of regard for the memory of his master. This young Raffaello had scarcely learned the first rudiments of art, showing signs of being destined to become an able master, when he also died, not many years after, together with his mother, Giulio's wife; wherefore there remained no descendant of Giulio save a daughter called Virginia, who still lives in Mantua, married to Ercole Malatesta. Giulio, whose death was an infinite grief to all who knew him, was given burial in S. Barnaba, where it was proposed that some honourable memorial should be erected to him; but his wife and children, postponing the matter from one day to another, themselves died for the most part without doing anything. It is indeed a sad thing that there has been no one who has treasured in any way the memory of a man who did so much to adorn that city, save only those who availed themselves of his services, who have often remembered him in their necessities. But his own talent, which did him so much honour in his lifetime, has secured for him after death, in the form of his own works, an everlasting monument which time, with all its years, can never destroy.

Giulio was neither tall nor short of stature, and rather stout than slight in build. He had black hair, beautiful features, and eyes dark and merry, and he was very loving, regular in all his actions, and frugal in eating, but fond of dressing and living in honourable fashion. He had disciples in plenty, but the best were Giovanni da Lione, Raffaello dal Colle of Borgo, Benedetto Pagni of Pescia, Figurino da Faenza, Rinaldo Mantovano, Giovan Battista Mantovano, and Fermo Ghisoni, who still lives in Mantua and does him honour, being an excellent painter. And the same may be said for Benedetto, who has executed many works in his native city of Pescia, and an altar-piece for the Duomo of Pisa, which is in the Office of Works, and also a picture of Our Lady in which, with a poetical invention full of grace and beauty, he painted a figure of Florence presenting to her the dignities of the House of Medici; which picture is now in the possession of Signor Mondragone, a Spaniard much in favour with that most illustrious lord the Prince of Florence.

Giulio died on the day of All Saints in the year 1546, and over his tomb was placed the following epitaph:

ROMANUS MORIENS SECUM TRES JULIUS ARTES
ABSTULIT, HAUD MIRUM, QUATUOR UNUS ERAT.

FRA SEBASTIANO VINIZIANO DEL PIOMBO, Painter

THE first profession of Sebastiano, so many declare, was not painting, but music, since, besides being a singer, he much delighted to play various kinds of instruments, and particularly the lute, because on that instrument all the parts can be played, without any accompaniment. This art made him for a time very dear to the gentlemen of Venice, with whom, as a man of talent, he always associated on intimate terms. Then, having been seized while still young with a desire to give his attention to painting, he learned the first rudiments from Giovanni Bellini, at that time an old man. And afterwards, when Giorgione da Castelfranco had established in that city the methods of the modern manner, with its superior harmony and its brilliancy of colouring, Sebastiano left Giovanni and placed himself under Giorgione, with

whom he stayed so long that in great measure he acquired his manner. He thus executed in Venice some portraits from life that were very like; among others, that of the Frenchman Verdelotto, a most excellent musician, who was then chapel-master in S. Marco, and in the same picture that of his companion Uberto, a singer, which picture Verdelotto took with him to Florence when he became chapel-master in S. Giovanni; and at the present day the sculptor Francesco da San Gallo has it in his house. About that time he also painted for S. Giovanni Crisostomo at Venice an altar-piece with some figures which incline so much to the manner of Giorgione, that they have been sometimes held by people without much knowledge of the matters of art to be by the hand of Giorgione himself. This altar-piece is very beautiful, and executed with such a manner of colouring that it has great relief.

The fame of the abilities of Sebastiano thus spreading abroad, Agostino Chigi of Siena, a very rich merchant, who had many affairs in Venice, hearing him much praised in Rome, sought to draw him to that city, being attracted towards him because, besides his painting, he knew so well how to play on the lute, and was sweet and pleasant in his conversation. Nor was it very difficult to draw Sebastiano to Rome, since he knew how much that place had always been the benefactress and common mother-city of all beautiful intellects, and he went thither with no ordinary willingness. Having therefore gone to Rome, Agostino set him to work, and the first thing that he caused him to do was to paint the little arches that are over the loggia which looks into the garden of Agostino's palace in the Trastevere, where Baldassarre of Siena had painted all the vaulting, on which little arches Sebastiano painted some poetical compositions in the manner that he had brought from Venice, which was very different from that which was followed in Rome by the able painters of that day. After this work, Raffaello having executed a story of Galatea in the same place, Sebastiano, at the desire of Agostino, painted beside it a Polyphemus in fresco, in which, spurred by rivalry with Baldassarre of Siena and then with Raffaello, he strove his utmost to surpass himself, whatever may have been the result. He likewise painted some works in oils, for which, from his having learned from Giorgione a method of colouring of no little softness, he was held in vast account at Rome.

While Sebastiano was executing these works in Rome, Raffaello da Urbino had risen into such credit as a painter, that his

friends and adherents said that his pictures were more in accord with the rules of painting than those of Michelagnolo, being pleasing in colour, beautiful in invention, and charming in the expressions, with design in keeping with the rest; and that those of Buonarroti had none of those qualities, with the exception of the design. And for such reasons these admirers judged that in the whole field of painting Raffaello was, if not more excellent than Michelagnolo, at least his equal; but in colouring they would have it that he surpassed Buonarroti without a doubt. These humours, having spread among a number of craftsmen who preferred the grace of Raffaello to the profundity of Michelagnolo, had so increased that many, for various reasons of interest, were more favourable in their judgments to Raffaello than to Michelagnolo. But Sebastiano was in no way a follower of that faction, since, being a man of exquisite judgment, he knew the value of each of the two to perfection. The mind of Michelagnolo, therefore, drew towards Sebastiano, whose colouring and grace pleased him much, and he took him under his protection, thinking that, if he were to assist Sebastiano in design, he would be able by this means, without working himself, to confound those who held such an opinion, remaining under cover of a third person as judge to decide which of them was the best.

While the matter stood thus, and some works that Sebastiano had executed were being much extolled, and even exalted to infinite heights on account of the praise that Michelagnolo bestowed on them, besides the fact that they were in themselves beautiful and worthy of praise, a certain person from Viterbo, I know not who, much in favour with the Pope, commissioned Sebastiano to paint a Dead Christ, with a Madonna who is weeping over Him, for a chapel that he had caused to be built in S. Francesco at Viterbo. That work was held by all who saw it to be truly most beautiful, for the invention and the cartoon were by Michelagnolo, although it was finished with great diligence by Sebastiano, who painted in it a dark landscape that was much extolled, and thereby Sebastiano acquired very great credit, and confirmed the opinions of those who favoured him. Wherefore Pier Francesco Borgherini, a Florentine merchant, who had taken over a chapel in S. Pietro in Montorio, which is on the right as one enters the church, allotted it at the suggestion of Michelagnolo to Sebastiano, because Borgherini thought that Michelagnolo would execute the design of the whole work, as indeed he did. Sebastiano, therefore,

having set to work, executed it with such zeal and diligence, that it was held to be, as it is, a very beautiful piece of painting. From the small design by Michelagnolo he made some larger ones for his own convenience, and one of these, a very beautiful thing, which he drew with his own hand, is in our book. Thinking that he had discovered the true method of painting in oils on walls, Sebastiano covered the rough-cast of that chapel with an incrustation which seemed to him likely to be suitable for this purpose; and the whole of that part in which is Christ being scourged at the Column he executed in oils on the wall. Nor must I omit to tell that many believe not only that Michelagnolo made the small design for this work, but also that the above-mentioned Christ who is being scourged at the Column was outlined by him, for there is a vast difference between the excellence of this figure and that of the others. Even if Sebastiano had executed no other work but this, for it alone he would deserve to be praised to all eternity, seeing that, in addition to the heads, which are very well painted, there are in the work some hands and feet of great beauty; and although his manner was a little hard, on account of the labour that he endured in the things that he counterfeited, nevertheless he can be numbered among the good and praiseworthy craftsmen. Above this scene he painted two Prophets in fresco, and on the vaulting the Transfiguration; and the two Saints, S. Peter and S. Francis, who are on either side of the scene below, are very bold and animated figures. It is true that he laboured for six years over this little work, but when works are executed to perfection, one should not consider whether they have been finished quickly or slowly, although more praise is due to him who carries his labours to completion both quickly and well; and he who pleads haste as an excuse when his works do not give satisfaction, unless he has been forced to it, is accusing rather than excusing himself. When this work was uncovered, it was seen that Sebastiano had done well, although he had toiled much over painting it, so that the evil tongues were silenced and there were few who found fault with him.

After this, when Raffaello painted for Cardinal de' Medici, for sending to France, that altar-piece containing the Transfiguration of Christ which was placed after his death on the principal altar of S. Pietro a Montorio, Sebastiano also executed at the same time another altar-piece of the same size, as it were in competition with Raffaello, of Lazarus being raised from the dead four

days after death, which was counterfeited and painted with supreme diligence under the direction of Michelagnolo, and in some parts from his design. These altar-pieces, when finished, were publicly exhibited together in the Consistory, and were vastly extolled, both the one and the other; and although the works of Raffaello had no equals in their perfect grace and beauty, nevertheless the labours of Sebastiano were also praised by all without exception. One of these pictures was sent by Cardinal Giulio de' Medici to his episcopal palace at Narbonne in France, and the other was placed in the Cancelleria, where it remained until it was taken to S. Pietro a Montorio, together with the ornamental frame that Giovan Barile executed for it. By means of this work Sebastiano became closely connected with the Cardinal, and was therefore honourably rewarded during his pontificate.

Not long afterwards, Raffaello having passed away, the first place in the art of painting was unanimously granted by all, thanks to the favour of Michelagnolo, to Sebastiano, and Giulio Romano, Giovan Francesco of Florence, Perino del Vaga, Polidoro, Maturino, Baldassarre of Siena, and all the others had to give way. Wherefore Agostino Chigi, who had been having a chapel and tomb built for himself under the direction of Raffaello in S. Maria del Popolo, came to an agreement with Sebastiano that he should paint it all; whereupon the screen was made, but the chapel remained covered, without ever being seen by anyone, until the year 1554, at which time Luigi, the son of Agostino, resolved that, although his father had not been able to see it finished, he at least would do so. And so, the chapel and the altar-piece being entrusted to Francesco Salviati, he carried the work in a short time to that perfection which it had not received from the dilatory and irresolute Sebastiano, who, so far as one can see, did little work there, although we find that he obtained from the liberality of Agostino and his heirs much more than would have been due to him even if he had finished it completely, which he did not do, either because he was weary of the labours of art, or because he was too much wrapped up in comforts and pleasures. And he did the same to M. Filippo da Siena, Clerk of the Chamber, for whom he began a scene in oils on the wall above the high-altar of the Pace at Rome, and never finished it; wherefore the friars, in despair about it, were obliged to take away the staging, which obstructed their church, to cover the

work with a cloth, and to have patience for as long as the life of Sebastiano lasted. After his death, the friars uncovered the work, and it was found that what he had done was most beautiful painting, for the reason that in the part where he represented Our Lady visiting S. Elizabeth, there are many women portrayed from life that are very beautiful, and painted with consummate grace. But it may be seen here that this man endured extraordinary labour in all the works that he produced, and that he was not able to execute them with that facility which nature and study are wont at times to give to him who delights in working and exercises his hand continually. And of the truth of this there is also a proof in the same Pace, in the Chapel of Agostino Chigi, where Raffaello had executed the Sibyls and Prophets; for Sebastiano, wishing to paint some things on the stone in the niche that remained to be painted below, in order to surpass Raffaello, caused it to be incrusted with peperino-stone, the joinings being filled in with fired stucco; but he spent so much time on cogitations that he left the wall bare, for, after it had remained thus for ten years, he died.

It is true that a few portraits from life could be obtained with ease from Sebastiano, because he could finish these with more facility and promptitude; but it was quite otherwise with stories and other figures. To tell the truth, the painting of portraits from life was his proper vocation, as may be seen from the portrait of Marc' Antonio Colonna, which is so well executed that it seems to be alive, and also from those of Ferdinando, Marquis of Pescara, and of Signora Vittoria Colonna, which are very beautiful. He likewise made a portrait of Adrian VI when he first arrived in Rome, and one of Cardinal Hincfort. That Cardinal desired that Sebastiano should paint for him a chapel in S. Maria de Anima at Rome; but he kept putting him off from one day to another, and the Cardinal finally had it painted by the Fleming Michael, his compatriot, who painted there in fresco stories from the life of S. Barbara, imitating our Italian manner very well; and in the altar-piece he made a portrait of the same Cardinal.

But returning to Sebastiano: he also took a portrait of Signor Federigo da Bozzolo, and one of a captain in armour, I know not who, which is in the possession of Giulio de' Nobili at Florence. He painted a woman in Roman dress, which is in the house of Luca Torrigiani; and Giovan Battista Cavalcanti has a head by the same master's hand, which is not completely finished. He

executed a picture of Our Lady covering the Child with a piece of drapery, which was a rare work; and Cardinal Farnese now has it in his guardaroba. And he sketched, but did not carry to completion, a very beautiful altar-piece of S. Michael standing over a large figure of the Devil, which was to be sent to the King of France, who had previously received a picture by the hand of the same master.

Then, after Cardinal Giulio de' Medici had been elected Supreme Pontiff and had taken the name of Clement VII, he gave Sebastiano to understand through the Bishop of Vasona that the time to show him favour had come, and that he would become aware of this when the occasion arose. And in the meantime, while living in these high hopes, Sebastiano, who had no equal in portrait-painting, executed many from life, and among others one of Pope Clement, who was not then wearing a beard, or rather, two of him, one of which came into the possession of the Bishop of Vasona, and the other, which is much larger, showing a seated figure from the knees upwards, is in the house of Sebastiano at Rome. He also painted a portrait of the Florentine Anton Francesco degli Albizzi, who happened to be then in Rome on some business, and he made it such that it appeared to be not painted but really alive; wherefore Anton Francesco sent it to Florence as a pearl of great price. The head and hands of this portrait were things truly marvellous, to say nothing of the beautiful execution of the velvets, the linings, the satins, and all the other parts of the picture; and since Sebastiano was indeed superior to all other men in the perfect delicacy and excellence of his portrait-painting, all Florence was amazed at this portrait of Anton Francesco.

At this same time he also executed a portrait of Messer Pietro Aretino, and made it such that, besides being a good likeness, it is an astounding piece of painting, for there may be seen in it five or six different kinds of black in the clothes that he is wearing – velvet, satin, ormuzine, damask, and cloth – and, over and above those blacks, a beard of the deepest black, painted in such beautiful detail, that the real beard could not be more natural. This figure holds in the hand a branch of laurel and a scroll, on which is written the name of Clement VII; and in front are two masks, one of Virtue, which is beautiful, and another of Vice, which is hideous. This picture M. Pietro presented to his native city, and the people of Arezzo have placed it in their public Council Chamber, thus doing honour to the memory of their talented

fellow-citizen, and also receiving no less from him. After this, Sebastiano made a portrait of Andrea Doria, which was in like manner an admirable work, and a head of the Florentine Baccio Valori, which was also beautiful beyond belief.

In the meantime Fra Mariano Fetti, Friar of the Piombo, died, and Sebastiano, remembering the promises made to him by the above-mentioned Bishop of Vasona, master of the household to His Holiness, asked for the office of the Piombo; whereupon, although Giovanni da Udine, who had also done much in the service of His Holiness 'in minoribus,' and still continued to serve him, asked for the same office, the Pope, moved by the prayers of the Bishop, and also thinking that the talents of Sebastiano deserved it, ordained that Sebastiano should have the office, but should pay out of it to Giovanni da Udine an allowance of three hundred crowns. Thus Sebastiano assumed the friar's habit, and straightway felt his soul changed thereby, for, perceiving that he now had the means to satisfy his desires, he spent his time in repose without touching a brush, and recompensed himself with his comforts and his revenues for many misspent nights and laborious days; and whenever he happened to have something to do, he would drag himself to the work with such reluctance, that he might have been going to his death. From which one may learn how much our reason and the little wisdom of men are deceived, in that very often, nay, almost always, we covet the very opposite to that which we really need, and, as the Tuscan proverb has it, in thinking to cross ourselves with a finger, poke it into our own eyes. It is the common opinion of men that rewards and honours spur the minds of mortals to the studies of those arts which they see to be the best remunerated, and that, on the contrary, to see that those who labour at these arts are not recompensed by such men as have the means, causes the same students to grow negligent and to abandon them. And for this reason both ancients and moderns censure as strongly as they are able those Princes who do not support every kind of man of talent, and who do not give due honour and reward to all who labour valiantly in the arts. But, although this rule is for the most part a good one, it may be seen, nevertheless, that at times the liberality of just and magnanimous Princes produces the contrary effect, for the reason that many are more useful and helpful to the world in a low or mediocre condition than they are when raised to greatness and to an abundance of all good things. And

here we have an example, for the magnificent liberality of Clement VII, bestowing too rich a reward on Sebastiano Viniziano, who had done excellent work as a painter in his service, was the reason that he changed from a zealous and industrious craftsman into one most idle and negligent, and that, whereas he laboured continually while he was living in poor circumstances and the rivalry between him and Raffaello da Urbino lasted, he did quite the opposite when he had enough for his contentment.

Be this as it may, let us leave it to the judgment of wise Princes to consider how, when, towards whom, in what manner, and by what rule, they should exercise their liberality in the case of craftsmen and men of talent, and let us return to Sebastiano. After he had been made Friar of the Piombo, he executed for the Patriarch of Aquileia, with great labour, Christ bearing the Cross, a half-length figure painted on stone – a work which was much extolled, particularly for the head and the hands, parts in which Sebastiano was truly most excellent. Not long afterwards the niece of the Pope, who in time became Queen of France, as she still is, having arrived in Rome, Fra Sebastiano began a portrait of her; but this remained unfinished in the guardaroba of the Pope. And a short time after this, Cardinal Ippolito de' Medici having become enamoured of Signora Giulia Gonzaga, who was then living at Fondi, that Cardinal sent Sebastiano to that place, accompanied by four light horsemen, to take her portrait; and within a month he finished that portrait, which, being taken from the celestial beauty of that lady by a hand so masterly, proved to be a divine picture. Wherefore, after it had been carried to Rome, the labours of that craftsman were richly rewarded by the Cardinal, who declared that this portrait surpassed by a great measure all those that Sebastiano had ever executed up to that day, as indeed it did; and the work was afterwards sent to King Francis of France, who had it placed in his Palace of Fontainebleau.

This painter then introduced a new method of painting on stone, which pleased people greatly, for it appeared that by this means pictures could be made eternal, and such that neither fire nor worms could harm them. Wherefore he began to paint many pictures on stone in this manner, surrounding them with ornaments of variegated kinds of stone, which, being polished, formed a very beautiful setting; although it is true that these pictures, with their ornaments, when finished, could not be transported or even moved, on account of their great weight, save

with the greatest difficulty. Many persons, then, attracted by the novelty of the work and by the beauty of his art, gave him earnest-money, in order that he might execute some for them; but he, delighting more to talk about such pictures than to work at them, always kept delaying everything. Nevertheless he executed on stone a Dead Christ with the Madonna, with an ornament also of stone, for Don Ferrante Gonzaga, who sent it to Spain. The whole work together was held to be very beautiful, and Sebastiano was paid five hundred crowns for the painting by Messer Niccolò da Cortona, agent in Rome for the Cardinal of Mantua. In this kind of painting Sebastiano was truly worthy of praise, for the reason that whereas Domenico, his compatriot, who was the first to paint in oils on walls, and after him Andrea dal Castagno, Antonio Pollaiuolo, and Piero Pollaiuolo, failed to find the means of preventing the figures executed by them in this manner from becoming black and fading away very quickly, Sebastiano did find it; wherefore the Christ at the Column, which he painted in S. Pietro in Montorio, has never changed down to our own time, and has the same freshness of colouring as on the first day. For he went about the work with such diligence that he used to make the coarse rough-cast of lime with a mixture of mastic and colophony, which, after melting it all together over the fire and applying it to the wall, he would then cause to be smoothed over with a mason's trowel made red-hot, or rather white-hot, in the fire; and his works have therefore been able to resist the damp and to preserve their colour very well without suffering any change. With the same mixture he worked on peperino-stone, white and variegated marble, porphyry, and slabs of other very hard kinds of stone, materials on which paintings can last a very long time; not to mention that this has shown how one may paint on silver, copper, tin, and other metals.

This man found so much pleasure in cogitating and discoursing, that he would spend whole days without working; and when he did force himself to work, it was evident that he was suffering greatly in his mind, which was the chief reason that he was of the opinion that no price was large enough to pay for his works. For Cardinal Rangoni he painted a picture of a nude and very beautiful S. Agatha being tortured in the breasts, which was an exquisite work, and this picture is now in the guardaroba of Signor Guidobaldo, Duke of Urbino, and is in no way inferior to the many other most beautiful pictures that are there, by the hands

of Raffaello da Urbino, Tiziano, and others. He also made a portrait from life of Signor Piero Gonzaga, painted in oils on stone, which was a very fine work; but he toiled for three years over finishing it.

Now, when Michelagnolo was in Florence in the time of Pope Clement, engaged in the work of the new Sacristy of S. Lorenzo, Giuliano Bugiardini wished to paint for Baccio Valori a picture with the head of Pope Clement and that of Baccio himself, and another for Messer Ottaviano de' Medici of the same Pontiff and the Archbishop of Capua. Michelagnolo therefore sent to Sebastiano to ask him to despatch from Rome a head of the Pope painted in oils with his own hand; and Sebastiano painted one, which proved to be very beautiful, and sent it to him. After Giuliano had made use of the head and had finished his pictures, Michelagnolo, who was a close companion of the said Messer Ottaviano, made him a present of it; and of a truth, among the many heads that Fra Sebastiano executed, this is the most beautiful of all and the best likeness, as may be seen in the house of the heirs of Messer Ottaviano. The same master also took the portrait of Pope Paul Farnese, as soon as he was elected Supreme Pontiff; and he began one of the Duke of Castro, his son, but left it unfinished, as he did with many other works with which he had made a beginning.

Fra Sebastiano had a passing good house which he had built for himself near the Popolo, and there he lived in the greatest contentment, without troubling to paint or work any more. He used often to say that it was a great fatigue to have to restrain in old age those ardours which in youth craftsmen are wont to welcome out of emulation and a desire for profit and honour, and that it was no less wise for a man to live in peace than to spend his days in restless labour in order to leave a name behind him after death, for all his works and labours had also in the end, sooner or later, to die. And even as he said these things, so he carried them into practice as well as he was able, for he always sought to have for his table all the best wines and the rarest luxuries that could be found, holding life in more account than art. Being much the friend of all men of talent, he often had Molza and Messer Gandolfo to supper, making right good cheer. He was also the intimate friend of Messer Francesco Berni, the Florentine, who wrote a poem to him; to which Fra Sebastiano answered with another, passing well, for, being very versatile, he was even able to set his hand to writing humorous Tuscan verse.

Having been reproached by certain persons, who said that it was shameful that he would no longer work now that he had the means to live, Fra Sebastiano replied in this manner: 'Why will I not work now that I have the means to live? Because there are now in the world men of genius who do in two months what I used to do in two years; and I believe that if I live long enough, and not so long, either, I shall find that everything has been painted. And since these stalwarts can do so much, it is well that there should also be one who does nothing, to the end that they may have the more to do.' With these and similar pleasantries Fra Sebastiano was always diverting himself, being a man who was never anything but humorous and amusing; and, in truth, a better companion never lived.

Sebastiano, as has been related, was much beloved by Michelagnolo. But it is also true that when the front wall of the Papal Chapel, where there is now the Last Judgment by the same Buonarroti, was to be painted, there did arise some disdain between them, for Fra Sebastiano had persuaded the Pope that he should make Michelagnolo paint it in oils, whereas the latter would only do it in fresco. Now, Michelagnolo saying neither yea nor nay, the wall was prepared after the fashion of Fra Sebastiano, and Michelagnolo stood thus for some months without setting his hand to the work. But at last, after being pressed, he said that he would only do it in fresco, and that painting in oils was an art for women and for leisurely and idle people like Fra Sebastiano. And so, after the incrustation laid on by order of the friar had been stripped off, and the whole surface had been covered with rough-cast in a manner suitable for working in fresco, Michelagnolo set his hand to the work; but he never forgot the affront that he considered himself to have received from Fra Sebastiano, against whom he felt hatred almost to the day of the friar's death.

Finally, after Fra Sebastiano had come to such a state that he would not work or do any other thing but attend to the duties of his office as Friar of the Piombo, and enjoy the pleasures of life, at the age of sixty-two he fell sick of a most acute fever, which, being a ruddy person and of a full habit of body, threw him into such a heat that he rendered up his soul to God in a few days, after making a will and directing that his body should be carried to the tomb without any ceremony of priests or friars, or expenditure on lights, and that all that would have been spent thus should be distributed to poor persons, for the love of God;

and so it was done. He was buried in the Church of the Popolo, in the month of June of the year 1547. Art suffered no great loss in his death, seeing that, as soon as he assumed the habit of Friar of the Piombo, he might have been numbered among those lost to her; although it is true that he was regretted for his pleasant conversation by many friends as well as craftsmen.

Many young men worked under Sebastiano at various times in order to learn art, but they made little proficience, for from his example they learned little but the art of good living, excepting only Tommaso Laureti, a Sicilian, who, besides many other works, has executed a picture full of grace at Bologna, of a very beautiful Venus, with Love embracing and kissing her, which picture is in the house of M. Francesco Bolognetti. He has also painted a portrait of Signor Bernardino Savelli, which is much extolled, and some other works of which there is no need to make mention.

PERINO DEL VAGA, Painter of Florence

A TRULY great gift is art, who, paying no regard to abundance of riches, to high estate, or to nobility of blood, embraces, protects, and uplifts from the ground a child of poverty much more often than one wrapped in the ease of wealth. And this Heaven does in order to show how much power the influences of its stars and constellations have over us, distributing more of its favours to one, and to another less; which influences are for the most part the reason that we mortals come to be born with dispositions more or less fiery or sluggish, weak or strong, fierce or gentle, fortunate or unfortunate, and richer or poorer in talent. And whoever has any doubt of this, will be enlightened in this present Life of Perino del Vaga, a painter of great excellence and genius.

This Perino, the son of a poor father, having been left an orphan as a little child and abandoned by his relatives, was guided and governed by art, whom he always acknowledged as his true mother and honoured without ceasing. And the studies of the art of painting were pursued by him with such zeal and diligence, that he was enabled in due time to execute those noble and famous decorations which have brought so much glory to Genoa

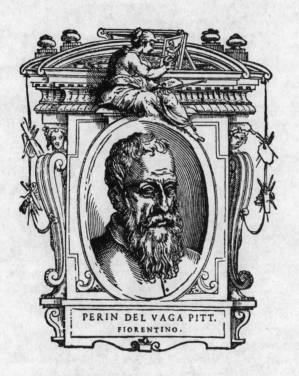

PERIN DEL VAGA PITT.
FIORENTINO.

and to Prince Doria. Wherefore we may believe without a doubt that it is Heaven that raises men from those infinite depths in which they were born, to that summit of greatness to which they ascend, when they prove by labouring valiantly at their works that they are true followers of the sciences that they have chosen to learn; even as Perino chose and pursued as his vocation the art of design, in which he proved himself full of grace and most excellent, or rather, absolutely perfect. And he not only equalled the ancients in stucco-work, but also equalled the best modern craftsmen in the whole field of painting, displaying all the excellence that could possibly be desired in a human intellect that seeks, in solving the difficulties of that art, to achieve beauty, grace, charm, and delicacy with colouring and with every other kind of ornament.

But let us speak more particularly of his origin. There lived in the city of Florence one Giovanni Buonaccorsi, who entered the service of Charles VIII, King of France, and fought in his wars, and, being a spirited and open-handed young man, spent all that he possessed in that service and in gaming, and finally lost his life therein. To him was born a son, who received the name of Piero; and this son, after being left as an infant of two months old without his mother, who died of plague, was reared in the greatest misery at a farm, being suckled by a goat, until his father, having gone to Bologna, took as his second wife a woman whose husband and children had died of plague; and she, with her plague-infected milk, finished nursing Piero, who was now called Pierino* (a pet name such as it is a general custom to give to little children), and retained that name ever afterwards. He was then taken to Florence by his father, who, on returning to France, left him with some relatives; and they, either because they had not the means, or because they would not accept the burdensome charge of maintaining him and having him taught some ingenious vocation, placed him with the apothecary of the Pinadoro, to the end that he might learn that calling. But, not liking that profession, he was taken as shop-boy by the painter Andrea de' Ceri, who was pleased with the air and the ways of Perino, and thought that he saw in him a certain lively spirit of intelligence from which it might be hoped that in time some good fruits would issue from him. Andrea was no great painter; quite

* Or Perino.

commonplace, indeed, and one of those who stand openly and publicly in their workshops, executing any kind of work, however mean; and he was wont to paint every year for the festival of S. John certain wax tapers which were carried as offerings, as they still are, together with the other tributes of the city; for which reason he was called Andrea de' Ceri, and from that name Perino was afterwards called for some time Perino de' Ceri.

Andrea, then, took care of Perino for some years, teaching him the rudiments of art as well as he could; but when the boy had reached the age of eleven, he was forced to seek for him some master better than himself. And so, having a straight friendship with Ridolfo, the son of Domenico Ghirlandajo, who, as will be related, was held to be able and well practised in painting, Andrea de' Ceri placed Perino with him, to the end that he might give his attention to design, and strive with all the zeal and love at his command to make in that art the proficience of which his great genius gave promise. Whereupon, pursuing his studies, among the many young men whom Ridolfo had in his workshop, all engaged in learning art, in a short time Perino came to surpass all the rest, so great were his ardour and his eagerness. Among them was one named Toto del Nunziata, who was to him as a spur to urge him on continually; which Toto, likewise attaining in time to equality with the finest intellects, departed from Florence and made his way with some Florentine merchants to England, where he executed all his works, and was very richly rewarded by the King of that country, whom he also served in architecture, erecting, in particular, his principal palace. He and Perino, then, working in emulation of one another, and pursuing the studies of art with supreme diligence, after no long time became very excellent. And Perino, drawing from the cartoon of Michelagnolo Buonarroti in company with other young men, both Florentines and strangers, won and held the first place among them all, insomuch that he was regarded with that expectation which was afterwards fulfilled in the beautiful works that he executed with so much excellence and art.

There came to Florence at that time the Florentine painter Vaga, a master of no great excellence, who was executing commonplace works at Toscanella in the province of Rome. Having a superabundance of work, he was in need of assistance, and he desired to take back with him a companion and also a young man who might help him in design, in which he was wanting, and in

the other matters of art. Now this painter, having seen Perino drawing in the workshop of Ridolfo together with the other young men, found him so superior to them all, that he was astonished; and, what is more, he was pleased with his appearance and his ways, for Perino was a very beautiful youth, most courteous, modest, and gentle, and every part of his body was in keeping with the nobility of his mind; wherefore Vaga was so charmed with him, that he asked him whether he would go with him to Rome, saying that he would not fail to assist him in his studies, and promising him such benefits and conditions as he might demand. So great was the desire that Perino had to attain to excellence in his profession, that, when he heard Rome mentioned, through his eagerness to see that city, he was deeply moved; but he told him that he must speak to Andrea de' Ceri, who had supported him up to that time, so that he was loth to abandon him. And so Vaga, having persuaded Ridolfo, Perino's master, and Andrea, who maintained him, so contrived that in the end he took Perino, with the companion, to Toscanella. There Perino began to work and to assist them, and they finished not only the work that Vaga had undertaken, but also many that they undertook afterwards. But Perino complained that the promise of seeing Rome, by which he had been brought from Florence, was not being fulfilled, in consequence of the profit and advantage that Vaga was drawing from his services, and he resolved to go thither by himself; which was the reason that Vaga, leaving all his works, took him to Rome. And there, through the love that he bore to art, Perino returned to his former work of drawing and continued at it many weeks, growing more ardent every day. But Vaga wished to return to Toscanella, and therefore made him known, as one belonging to himself, to many commonplace painters, and also recommended him to all the friends that he had there, to the end that they might assist and favour him in his absence; from which circumstance he was always called from that day onward Perino del Vaga.

Thus left in Rome, and seeing the ancient works of sculpture and the marvellous masses of buildings, reduced for the most part to ruins, Perino stood lost in admiration at the greatness of the many renowned and illustrious men who had executed those works. And so, becoming ever more and more aflame with love of art, he burned unceasingly to attain to a height not too far distant from those masters, in order to win fame and profit for

himself with his works, even as had been done by those at whom he marvelled as he beheld their beautiful creations. And while he contemplated their greatness and the depths of his own lowliness and poverty, reflecting that he possessed nothing save the desire to rise to their height, and that, having no one who might maintain him and provide him with the means to live, he was forced, if he wished to remain alive, to labour at work for those ordinary shops, now with one painter and now with another, after the manner of the day-labourers in the fields, a mode of life which so hindered his studies, he felt infinite grief and pain in his heart at not being able to make as soon as he would have liked that proficience to which his mind, his will, and his necessities were urging him. He made the resolve, therefore, to divide his time equally, working half the week at day work, and during the other half devoting his attention to design; and to this second half he added all the feast-days, together with a great part of the nights, thus stealing time from time itself, in order to become famous and to escape from the hands of others so far as it might be possible.

Having carried this intention into execution, he began to draw in the Chapel of Pope Julius, where the vaulting had been painted by Michelagnolo Buonarroti, following both his methods and the manner of Raffaello da Urbino. And then, going on to the ancient works in marble and also to the grotesque in the grottoes under the ground, which pleased him through their novelty, he learned the methods of working in stucco, gaining his bread meanwhile by grievous labour, and enduring every hardship in order to become excellent in his profession. Nor had any long time passed before he became the best and most finished draughtsman that there was among all who were drawing in Rome, for the reason that he had, perhaps, a better knowledge of muscles and of the difficult art of depicting the nude than many others who were held to be among the best masters at that time; which was the reason that he became known not only to the men of his profession, but also to many lords and prelates. And, in particular, Giulio Romano and Giovan Francesco, called Il Fattore, disciples of Raffaello da Urbino, having praised him not a little to their master, roused in him a desire to know Perino and to see his works in drawing; which having pleased him, and together with his work his manner, his spirit, and his ways of life, he declared that among all the young men that he had known, Perino would attain to the highest perfection in that art.

Meanwhile Raffaello da Urbino had built the Papal Loggie, by the command of Leo X; and the same Pope ordered that Raffaello should also have them adorned with stucco, painted, and gilded, according as it should seem best to him. Thereupon Raffaello placed at the head of that enterprise, for the stucco-work and the grotesques, Giovanni da Udine, who was very excellent and without an equal in such works, but mostly in executing animals, fruits, and other little things. And since he had chosen in Rome and summoned from other parts a great number of masters, he had assembled together a company of men each very able at his own work, one in stucco, another in grotesques, a third in foliage, a fourth in festoons, another in scenes, and others in other things; and according as they improved they were brought forward and paid higher salaries, so that by competing in that work many young men attained to great perfection, who were afterwards held to be excellent in their various fields of art. Among that company Perino was assigned to Giovanni da Udine by Raffaello, to the end that he might execute grotesques and scenes together with the others; and he was told that according as he should acquit himself, so he would be employed by Giovanni. And thus, labouring out of emulation and in order to prove his powers and make proficience, before many months had passed Perino was held to be the first among all those who were working there, both in drawing and in colouring; the best, I say, the most perfect in grace and finish, and he who could execute both figures and grotesques in the most delicate and beautiful manner; to which clear testimony and witness are borne by the grotesques, festoons, and scenes by his hand that are in that work, which, besides surpassing the others, are executed in much more faithful accord with the designs and sketches that Raffaello made for them. This may be seen from a part of those scenes in the centre of the loggia, on the vaulting, where the Hebrews are depicted crossing over the Jordan with the sacred Ark, and also marching round the walls of Jericho, which fall into ruin; and the other scenes that follow, such as that of Joshua causing the sun to stand still during the combat with the Amorites. Among those painted in imitation of bronze on the base the best are likewise those by the hand of Perino – namely, Abraham sacrificing his son, Jacob wrestling with the Angel, Joseph receiving his twelve brethren, the fire descending from Heaven and consuming the sons of Levi, and many others which there is no need to name,

for their number is very great, and they can be distinguished from the rest. At the beginning of the loggia, also, where one enters, he painted scenes from the New Testament, the Nativity and the Baptism of Christ, and His Last Supper with the Apostles, which are very beautiful; besides which, below the windows, as has been said, are the best scenes painted in the colour of bronze that there are in the whole work. These labours cause every man to marvel, both the paintings and the many works in stucco that he executed there with his own hand; and his colouring, moreover, is much more pleasing and more highly finished than that of any of the others.

This work was the reason that he became famous beyond all belief, yet this great praise did not send him to sleep, but rather, since genius grows with praise, inspired him with even more zeal, and made him almost certain that by persisting he would come to win those fruits and honours that he saw every day in the possession of Raffaello da Urbino and Michelagnolo Buonarroti. And he laboured all the more willingly, because he saw that he was held in estimation by Giovanni da Udine and by Raffaello, and was employed in works of importance. He always showed extraordinary deference and obedience towards Raffaello, honouring him in such a manner that he was beloved by Raffaello as a son.

There was executed at this time, by order of Pope Leo, the vaulting of the Hall of the Pontiffs, which is that through which one passes by way of the Loggie into the apartments of Pope Alexander VI, formerly painted by Pinturicchio; and that vaulting was painted by Giovanni da Udine and Perino. They executed in company the stucco-work and all those ornaments, grotesques, and animals that are to be seen there, in addition to the varied and beautiful inventions that were depicted by them in the compartments of the ceiling, which they had divided into certain circles and ovals to contain the seven Planets of Heaven drawn by their appropriate animals, such as Jupiter drawn by Eagles, Venus by Doves, the Moon by Women, Mars by Wolves, Mercury by Cocks, the Sun by Horses, and Saturn by Serpents; besides the twelve Signs of the Zodiac, and some figures from the forty-eight Constellations of Heaven, such as the Great Bear, the Dog Star, and many others, which, by reason of their number, we must pass over in silence, without recounting them all in their order, since anyone may see the work; which figures are almost

all by the hand of Perino. In the centre of the vaulting is a circle with four figures representing Victories, seen foreshortened from below upwards, who are holding the Pope's Crown and the Keys; and these are very well conceived and wrought with masterly art, to say nothing of the delicacy with which he painted their vestments, veiling the nude with certain light draperies that partly reveal the naked legs and arms, a truly graceful and beautiful effect. This work was justly held, as it still is at the present day, to be very magnificent and rich in craftsmanship, and also cheerful and pleasing; worthy, in short, of that Pontiff, who did not fail to reward their labours, which truly deserved some signal remuneration.

Perino decorated a façade in chiaroscuro – a method brought into use at that time by the example of Polidoro and Maturino – which is opposite to the house of the Marchioness of Massa, near Maestro Pasquino, executing it with great boldness of design and with supreme diligence.

In the third year of his pontificate Pope Leo paid a visit to Florence, for which many triumphal preparations were made in that city, and Perino went thither before the Court, partly in order to see the pomps of the city, and partly from a wish to revisit his native country; and on a triumphal arch at S. Trinità he made a large and very beautiful figure, seven braccia high, while another was executed in competition with him by Toto del Nunziata, who had already been his rival in boyhood. But to Perino every hour seemed a thousand years until he could return to Rome, for he perceived that the rules and methods of the Florentine craftsmen were very different from those that were customary in Rome; wherefore he departed from Florence and returned to Rome, where he resumed his usual course of work. And in S. Eustachio dalla Dogana he painted a S. Peter in fresco, which is a figure that has very strong relief, executed with a simple flow of folds, and yet wrought with much design and judgment.

There was in Rome at this time the Archbishop of Cyprus, a man who was a great lover of the arts, and particularly of painting; and he, having a house near the Chiavica, where he had laid out a little garden with some statues and other antiquities of truly noble beauty, and desiring to enhance their effect with some fine decorations, sent for Perino, who was very much his friend, and they came to the decision that he should paint round the walls

of that garden many stories of Bacchantes, Satyrs, Fauns, and other wild things, in reference to an ancient statue of Bacchus, seated beside a tiger, which the Archbishop had there. And so Perino adorned that place with a variety of poetical fancies; and, among other things, he painted there a little loggia with small figures, various grotesques, and many landscapes, coloured with supreme grace and diligence. This work has been held by craftsmen, as it always will be, to be worthy of the highest praise; and it was the reason that he became known to the Fugger family, merchants of Germany, who, having built a house near the Banchi, on the way to the Church of the Florentines, and having seen Perino's work and liked it, caused him to paint there a courtyard and a loggia, with many figures, all worthy of the same praise as the other works by his hand, for in them may be seen much delicacy and grace and great beauty of manner.

At this same time M. Marchionne Baldassini, having caused a house to be built for him near S. Agostino, as has been related, by Antonio da San Gallo, who designed it very well, desired that a hall which Antonio had constructed there should be painted all over; and after passing in review many of the young painters, to the end that it might be well and beautifully done, he finally resolved to give it to Perino. Having agreed about the price, Perino set his hand to it, nor did he turn his attention from that work to any other until he had brought it to a very happy conclusion in fresco. In that hall he made compartments by means of pilasters which have between them niches great and small; in the larger niches are various figures of philosophers, two in each niche, and in some one only, and in the smaller niches are little boys, partly naked and partly draped in veiling, while above those small niches are some heads of women, painted in imitation of marble. Above the cornice that crowns the pilasters there follows a second series of pictures, separated from the first series below, with scenes in figures of no great size from the history of the Romans, beginning with Romulus and ending with Numa Pompilius. There are likewise various ornaments in imitation of different kinds of marble, and over the beautiful chimney-piece of stone is a figure of Peace burning arms and trophies, which is very lifelike. This work was held in much estimation during the lifetime of M. Marchionne, as it has been ever since by all those who work in painting, and also by many others not of the profession, who give it extraordinary praise.

In the Convent of the Nuns of S. Anna, Perino painted a chapel in fresco with many figures, which was executed by him with his usual diligence. And on an altar in S. Stefano del Cacco he painted in fresco, for a Roman lady, a Pietà with the Dead Christ in the lap of Our Lady, with a portrait from life of that lady, which still has the appearance of a living figure; and the whole work is very beautiful, and executed with great mastery and facility.

In those days Antonio da San Gallo had built at the corner of a house in Rome, which is known as the Imagine di Ponte, a tabernacle finely adorned with travertine and very handsome, in which something beautiful in the way of painting was to be executed; and he received a commission from the owner of that house to give the work to one whom he should consider capable of painting some noble picture there. Wherefore Antonio, who knew Perino to be the best of the young men who were in Rome, allotted it to him. And he, setting his hand to the work, painted there a Christ in the act of crowning the Madonna, and in the background he made a Glory, with a choir of Seraphim and Angels clothed in light and delicate draperies, who are scattering flowers, and other children of great beauty and variety; and on the sides of the tabernacle he painted Saints, S. Sebastian on one side and S. Anthony on the other. This work was executed truly well, and was equal to the others by his hand, which were always full of grace and charm.

A certain protonotary had erected a chapel of marble on four columns in the Minerva, and, desiring to leave an altar-piece there in memory of himself, even if it were but a small one, he came to an agreement with Perino, whose fame he had heard, and commissioned him to paint it in oils. And he chose that the subject should be the Deposition of Christ from the Cross, which Perino set himself to execute with the greatest possible zeal and diligence. In this picture he represented Him as already laid upon the ground, surrounded by the Maries weeping over Him, in whose gestures and attitudes he portrayed a melting pity and sorrow; besides which there are the Nicodemuses* and other figures that are much admired, all woeful and afflicted at seeing the sinless Christ lying dead. But the figures that he painted most

* Vasari sometimes groups under this name all the male figures that appear in a picture of the Deposition from the Cross.

divinely were those of the two Thieves, left fixed upon the crosses, which, besides appearing to be real dead bodies, reveal a very good mastery over muscles and nerves, which this occasion enabled him to display; wherefore, to the eyes of him who beholds them, their limbs present themselves all drawn in that violent death by the nerves, and the muscles by the nails and cords. There is, in addition, a landscape wrapped in darkness, counterfeited with much judgment and art. And if the inundation which came upon Rome after the sack had not done damage to this work, covering more than half of it, its excellence would be clearly seen; but the water so softened the gesso, and caused the wood to swell in such sort, that all the lower part that was soaked has peeled off too much for the picture to give any pleasure; nay, it is a grief and a truly heartrending sorrow to behold it, for it would certainly have been one of the most precious things in all Rome.

There was being rebuilt at this time, under the direction of Jacopo Sansovino, the Church of S. Marcello in Rome, a convent of Servite Friars, which still remains unfinished; and when they had carried the walls of some chapels to completion, and had roofed them, those friars commissioned Perino to paint in one of these, as ornaments for a Madonna that is worshipped in that church, two figures in separate niches, S. Joseph and S. Filippo, a Servite friar and the founder of that Order, one on either side of the Madonna. These finished, he painted above them some little boys that are perfect, and in the centre of the wall he placed another standing upon a dado, who has upon his shoulders the ends of two festoons, which he directs towards the corners of the chapel, where there are two other little boys who support them, being seated upon them, with their legs in most beautiful attitudes. All this he executed with such art, such grace, and so beautiful a manner, and gave to the flesh a tint of colour so fresh and soft, that one might say that it was real flesh rather than painted. And certainly these figures may be held to be the most beautiful that ever any craftsman painted in fresco, for the reason that there is life in their eyes and movement in their attitudes, and with the mouth they make as if to break into speech and say that art has conquered Nature, and that even art declares that nothing more than this can be done in her. This work was so excellent in the sight of all good judges of art, that he acquired a great name thereby, although he had executed many works and

what was known of his great genius in his profession was well known; and he was therefore held in much more account and greater estimation than ever before.

For this reason Lorenzo Pucci, Cardinal Santiquattro, who had taken over a chapel on the left hand beside the principal chapel in the Trinità, a convent of Calabrian and French Friars who wear the habit of S. Francis of Paola, allotted it to Perino, to the end that he might paint there in fresco the life of Our Lady. Which having begun, Perino finished all the vaulting and a wall under an arch; and on the outer side, also, over an arch of the chapel, he painted two Prophets four braccia and a half in height, representing Isaiah and Daniel, who in their great proportions reveal all the art, excellence of design, and beauty of colouring that can be seen in their perfection only in a picture executed by a great craftsman. This will be clearly evident to one who shall consider the Isaiah, in whom, as he reads, may be perceived the thoughtfulness that study infuses in him, and his eagerness in reading new things, for he has his gaze fixed upon a book, with one hand to his head, exactly as a man often is when he is studying; and Daniel, likewise, is motionless, with his head upraised in celestial contemplation, in order to resolve the doubts of his people. Between these figures are two little boys who are upholding the escutcheon of the Cardinal, a shield of beautiful shape: and these boys, besides being so painted as to seem to be of flesh, also have the appearance of being in relief. The vaulting is divided into four scenes, separated one from another by the cross – that is, by the ribs of the vaulting. In the first is the Conception of Our Lady, in the second her Nativity, in the third the scene when she ascends the steps of the Temple, and in the fourth S. Joseph marrying her. On a wall-space equal in extent to the arch of the vaulting is her Visitation, in which are many figures that are very beautiful, but above all some who have climbed on certain socles and are standing in very spirited and natural attitudes, the better to see the ceremonious meeting of those women; besides which, there is something of the good and of the beautiful in the buildings and in every gesture of the other figures. He pursued this work no further, illness coming upon him; and when he was well, there began the plague of the year 1523, which raged so violently in Rome, that, if he wished to save his life, it became expedient for him to make up his mind to depart.

There was in the city of Rome at that time the goldsmith Piloto, who was much the friend and intimate companion of Perino, and he was desirous of departing; and so one morning, as they were breakfasting together, he persuaded Perino to take himself off and go to Florence, on the ground that it was many years since he had been there, and that it could not but bring him great honour to make himself known there and to leave some example of his excellence in that city; saying also that, although Andrea de' Ceri and his wife, who had brought him up, were dead, nevertheless, as a native of that country, if he had no possessions there, he had his love for it. Wherefore, after no long time, one morning Perino and Piloto departed and set out on the way to Florence. And when they had arrived there, Perino took the greatest pleasure in seeing once again the old works painted by the masters of the past, which had been as a school to him in the days of his boyhood, and likewise those of the masters then living who were the most celebrated and held to be the best in that city, in which, through the interest of friends, a work was allotted to him, as will be related below. It happened one day that many craftsmen having assembled in his presence to do him honour, painters, sculptors, architects, goldsmiths, and carvers in wood and marble, who had gathered together according to the ancient custom, some to see Perino, to keep him company, and to hear what he had to say, many to learn what difference in practice there might be between the craftsmen of Rome and those of Florence, but most of them to hear the praise and censure that craftsmen are wont often to give to one another; it happened, I say, that thus discoursing together of one thing and another, and examining the works, both ancient and modern, in the various churches, they came to that of the Carmine, in order to see the chapel of Masaccio. There everyone gazed attentively at the paintings, and many various opinions were uttered in praise of that master, all declaring that they marvelled that he should have possessed so much judgment as to be able in those days, without seeing anything but the work of Giotto, to work with so much of the modern manner in the design, in the colouring, and in the imitation of Nature, and that he should have solved the difficulties of his art in a manner so facile; not to mention that among all those who had worked at painting, there had not as yet been one who had equalled him in strength of relief, in resoluteness, and in mastery of execution.

This kind of discourse much pleased Perino, and to all those craftsmen who spoke thus he answered in these words: 'I do not deny that what you say, and even more, may be true; but that there is no one among us who can equal this manner, that I will deny with my last breath. Nay, I will declare, if I may say it with the permission of the company, not in contempt, but from a desire for the truth, that I know many both more resolute and richer in grace, whose works are no less lifelike in the painting than these, and even much more beautiful. And I, by your leave, I who am not the first in this art, am grieved that there is no space near these works wherein I might be able to paint a figure; for before departing from Florence I would make a trial beside one of these figures, likewise in fresco, to the end that you might see by comparison whether there be not among the moderns one who has equalled him.' Among their number was a master who was held to be the first painter in Florence; and he, being curious to see the work of Perino, and perhaps wishing to lower his pride, put forward an idea of his own, which was this: 'Although,' said he, 'all the space here is full, yet, since you have such a fancy, which is certainly a good one and worthy of praise, there, on the opposite side, where there is the S. Paul by his hand, a figure no less good and beautiful than any other in the chapel, is a space in which you may easily prove what you say by making another Apostle, either beside that S. Peter by Masolino or beside the S. Paul of Masaccio, whichever you may prefer.' The S. Peter was nearer the window, and the space beside it was greater and the light better; besides which, it was a figure no less beautiful than the S. Paul. Everyone, therefore, urged Perino to do it, because they had a great desire to see that Roman manner; besides which, many said that he would be the means of taking out of their heads the fancy that they had nursed in their minds for so many decades, and that if his figure should prove to be the best all would run after modern works. Wherefore, persuaded by that master, who told him at last that he ought not to disappoint the entreaties and expectations of so many lofty intellects, particularly since it would not take longer than two weeks to execute a figure in fresco, and they would not fail to spend years in praising his labours, Perino resolved to do it, although he who spoke thus had an intention quite contrary to his words, being persuaded that Perino would by no means execute anything much better than the work of those craftsmen who were considered to be the

most excellent at that time. Perino, then, undertook to make this attempt; and having summoned by common consent M. Giovanni da Pisa, the Prior of the convent, they asked him for the space for the execution of the work, which he granted to them with truly gracious courtesy; and thus they took measurements of the space, with the height and breadth, and went away.

An Apostle was then drawn by Perino in a cartoon, in the person of S. Andrew, and finished with the greatest diligence; whereupon Perino, having first caused the staging to be erected, was prepared to begin to paint it. But before this, on his arrival in Florence, his many friends, who had seen most excellent works by his hand in Rome, had contrived to obtain for him the commission for that work in fresco which I mentioned, to the end that he might leave some example of his handiwork in Florence, which might demonstrate how spirited and how beautiful was his genius for painting, and also to the end that he might become known and perchance be set to work on some labour of importance by those who were then governing. There were at that time certain craftsmen who used to assemble in a company called the Company of the Martyrs, in the Camaldoli at Florence; and they had proposed many times to have a wall that was in that place painted with the story of the Martyrs being condemned to death before two Roman Emperors, who, after they had been taken in battle, caused them to be crucified in the wood and hanged on trees. This story was suggested to Perino, and, although the place was out of the way, and the price small, so much was he attracted by the possibilities of invention in the story and by the size of the wall, that he was disposed to undertake it; besides which, he was urged not a little by those who were his friends, on the ground that the work would establish him in that reputation which his talent deserved among the citizens, who did not know him, and among his fellow-craftsmen in Florence, where he was not known save by report. Having then determined to do the work, he accepted the undertaking and made a small design, which was held to be a thing divine; and having set his hand to making a cartoon as large as the whole work, he never left off labouring at it, and carried it so far that all the principal figures were completely finished. And so the Apostle was abandoned, without anything more being done.

Perino drew this cartoon on white paper, well shaded and hatched, leaving the paper itself for the lights, and executing the

whole with admirable diligence. In it were the two Emperors on the seat of judgment, condemning to the cross all the prisoners, who were turned towards the tribunal, some kneeling, some standing, and others bowed, but all naked and bound in different ways, and writhing with piteous gestures in various attitudes, revealing the trembling of the limbs at the prospect of the severing of the soul from the body in the agony and torment of crucifixion; besides which, there were depicted in those heads the constancy of faith in the old, the fear of death in the young, and in others the torture that they suffer from the strain of the cords on their bodies and arms. And there could also be seen the swelling of the muscles and even the cold sweat of death, all depicted in that design. Then in the soldiers who were leading them there was revealed a terrible fury, most impious and cruel, as they presented them at the tribunal for condemnation and led them to the cross. The Emperors and the soldiers were wearing cuirasses after the ancient manner and garments very ornate and bizarre, with buskins, shoes, helmets, shields, and other pieces of armour wrought with all that wealth of the most beautiful ornamentation to which a craftsman can attain in imitating and reproducing the antique, and drawn with the greatest lovingness, subtlety, and delicacy that the perfection of art can display. When this cartoon was seen by the craftsmen and by other judges of discernment, they declared that they had never seen such beauty and excellence in design since the cartoon drawn by Michelagnolo Buonarroti in Florence for the Council Chamber; wherefore Perino acquired the greatest fame that he could have gained in art. And while he was engaged in finishing that cartoon, he amused himself by causing oil-colours to be prepared and ground in order to paint for his dearest friend, the goldsmith Piloto, a little picture of no great size, containing a Madonna, which he carried something more than half-way towards completion.

For many years past Perino had been intimately acquainted with a certain lame priest, Ser Raffaello di Sandro, a chaplain of S. Lorenzo, who always bore love to the craftsmen of design. This priest, then, persuaded Perino to take up his quarters with him, seeing that he had no one to cook for him or to keep house for him, and that during the time that he had been in Florence he had stayed now with one friend and now with another; wherefore Perino went to lodge with him, and stayed there many weeks. Meanwhile the plague began to appear in certain parts of

Florence, and filled Perino with fear lest he should catch the infection; on which account he determined to go away, but wished first to recompense Ser Raffaello for all the days that he had eaten at his table. But Ser Raffaello would never consent to take anything, only saying: 'I would be fully paid by having a scrap of paper from your hand.' Seeing him to be determined, Perino took about four braccia of coarse canvas, and, after having it fixed to the wall between two doors in the priest's little room, painted on it in a day and a night a scene coloured in imitation of bronze. On this canvas, which was to serve as a screen for the wall, he painted the story of Moses passing the Red Sea and Pharaoh being submerged with his horses and his chariots; and Perino painted therein figures in most beautiful attitudes, some swimming in armour and some naked, others swimming while clasping the horses round the neck, with their beards and hair all soaked, crying out in the fear of death and struggling with all their power to escape. On the other side of the sea are Moses, Aaron, and all the other Hebrews, male and female, who are thanking God, and a number of vases that he counterfeited, carried off by them from Egypt, varied and beautiful in form and shape, and women with head-dresses of great variety. Which finished, he left it as a mark of lovingness to Ser Raffaello, to whom it was as dear as the Priorate of S. Lorenzo would have been. This canvas was afterwards much extolled and held in estimation, and after the death of Ser Raffaello it passed, together with his other possessions, to his brother Domenico di Sandro, the cheesemonger.

Departing, then, from Florence, Perino abandoned the work of the Martyrs, which caused him great regret; and certainly, if it had been in any other place but the Camaldoli, he would have finished it; but, considering that the officials of health had taken that very Convent of Camaldoli for those infected with the plague, he thought it better to save himself than to leave fame behind him in Florence, being satisfied that he had proved how much he was worth in the design. The cartoon, with his other things, remained in the possession of the goldsmith Giovanni di Goro, his friend, who died in the plague; and after that it fell into the hands of Piloto, who kept it spread out in his house for many years, showing it readily as a very rare work to every person of intelligence; but I do not know what became of it after the death of Piloto.

Perino stayed for many months in various places, seeking to
avoid the plague, but for all this he never spent his time in vain,
for he was continually drawing and studying the secrets of art;
and when the plague had ceased, he returned to Rome and gave
his attention to executing little works of which I shall say nothing
more. In the year 1523 came the election of Pope Clement VII,
which was the greatest of blessings for the arts of painting
and sculpture, which had been so kept down by Adrian VI
during his lifetime, that not only had nothing been executed for
him, but, as has been related in other places, not delighting in
them, or rather, holding them in detestation, he had brought it
about that no other person delighted in them, or spent money
upon them, or employed a single craftsman. Then, therefore,
after the election of the new Pontiff, Perino executed many
works.

Afterwards it was proposed that Giulio Romano and Giovan
Francesco, called Il Fattore, should be made heads of the world
of art in place of Raffaello, who was dead, to the end that they
might distribute the various works to the others, according to
the previous custom. But Perino, in executing an escutcheon
of the Pope in fresco over the door of Cardinal Cesarino, after
the cartoon of Giulio Romano, acquitted himself so excellently
well, that they doubted whether he would not be preferred to
themselves, because, although they were known as the disciples
of Raffaello and as the heirs to his possessions, they had not
inherited the whole of the art and grace that he used to give to
his figures with colours. Giulio and Giovan Francesco therefore
made up their minds to attach Perino to themselves; and so in
the holy year of Jubilee, 1525, they gave him Caterina, the sister
of Giovan Francesco, for wife, to the end that the perfect friend-
ship which had been maintained between them for so long might
be converted into kinship. Thereupon, continuing the works that
he had in hand, no long time had passed when, on account of
the praises bestowed upon him for the first work executed by
him in S. Marcello, it was resolved by the Prior of that convent
and by certain heads of the Company of the Crocifisso, which
has a chapel there built by its members as a place of assembly,
that the chapel should be painted; and so they allotted this work
to Perino, in the hope of having some excellent painting by his
hand. Perino, having caused the staging to be erected, began the
work; and in the centre of the barrel-shaped vaulting he painted

the scene when God, after creating Adam, takes his wife Eve
from his side. In this scene Adam, a most beautiful naked figure
painted with perfect art, is seen lying overcome by sleep, while
Eve, with great vivacity, rises to her feet with the hands clasped
and receives the benediction of her Maker, the figure of whom
is depicted grave in aspect and sublime in majesty, standing with
many draperies about Him, which curve round His nude form
with their borders. On one side, on the right hand, are two Evan-
gelists, S. Mark and S. John, the first of whom Perino finished
entirely, and also the second with the exception of the head and
a naked arm. Between these two Evangelists, by way of orna-
ment, he made two little boys embracing a candelabrum, which
are truly of living flesh; and the Evangelists, likewise, in the
heads, the draperies, the arms, and all that he painted in them
with his own hand, are very beautiful.

While he was executing this work, he suffered many interrup-
tions from illness and from other misfortunes, such as happen
every day to all who live in this world; besides which, it is said
that the men of the Company also ran short of money. And so
long did this business drag on, that in the year 1527 there came
upon them the ruin of Rome, when that city was given over to
sack, many craftsmen were killed, and many works destroyed or
carried away. Whereupon Perino, caught in that turmoil, and hav-
ing a wife and a baby girl, ran from place to place in Rome with
the child in his arms, seeking to save her, and finally, poor
wretch, was taken prisoner and reduced to paying a ransom,
which hit him so hard that he was like to go out of his mind.
When the fury of the sack had abated, he was so crushed down
by the fear that still possessed him, that all thought of art was
worlds away from him, but nevertheless he painted canvases in
gouache and other fantasies for certain Spanish soldiers; and after
regaining his composure, he lived like the rest in some poor
fashion. Alone among so many, Baviera, who had the engravings
of Raffaello, had not lost much; wherefore, moved by the friend-
ship that he had with Perino, and wishing to employ him, he
commissioned him to draw some of the stories of the Gods
transforming themselves in order to achieve the consummation
of their loves. These were engraved on copper by Jacopo Cara-
glio, an excellent engraver of prints, who acquitted himself so
well in the matter of these designs, that, preserving the outlines
and manner of Perino, and hatching the work with beautiful

facility, he sought also to impart to the engravings that grace and that delicacy which Perino had given to the drawings.

While the havoc of the sack had destroyed Rome and driven away the inhabitants and the Pope himself, who was living at Orvieto, not many remaining in the city, and no business of any kind being done there, there arrived in Rome one Niccola Viniziano, a rare and even unrivalled master of embroidery, the servant of Prince Doria. He, moved by his long-standing friendship with Perino, and being a man who always favoured and wished well to the men of our arts, persuaded him to leave that misery and set out for Genoa, promising that he would so go to work with that Prince, who was a lover of art and delighted in painting, that he would commission Perino to execute some big works, and saying, moreover, that His Excellency had often told him that he would like to have a suite of rooms adorned with handsome decorations. It did not take much to persuade Perino, for he was oppressed by want and burning with desire to leave Rome; and he determined to depart with Niccola. Having therefore made arrangements for leaving his wife and daughter well cared for by relatives in Rome, and having put all his affairs in order, he set off for Genoa. Arriving there, and making himself known to that Prince by means of Niccola, his coming was as welcome to His Excellency as any agreeable experience that he had ever had in all his life. He was received, therefore, with the greatest possible warmth and gladness, and after many conversations and discussions they finally arranged that he should begin the work; and they decided that he should execute a palace adorned with stucco-work and with pictures in fresco, in oils, and of every kind, which I will strive to describe as briefly as I am able, with all the rooms, pictures, and general arrangement, saying nothing as to where Perino first began to labour, to the end that I may not obscure this work, which is the best of all those by his hand, with words.

I begin, then, by saying that at the entrance of the Prince's Palace there is a marble portal composed in the Doric Order, and built after designs and models by the hand of Perino, with all its appurtenances of pedestals, socles, shafts, capitals, architrave, frieze, cornice and pediment, and with some most beautiful seated figures of women, who are supporting an escutcheon. The masonry and carving of this work were executed by Maestro Giovanni da Fiesole, and the figures were finished to perfection

by Silvio, the sculptor of Fiesole, a bold and resolute master.
Entering within the portal, one finds over the vestibule a vault
covered with stucco-work, varied scenes, and grotesques, and
little arches in each of which are scenes of war and various kinds
of battles, some fighting on foot and others on horseback, and
all wrought with truly extraordinary diligence and art. On the left
one finds the staircase, which has decorations of little grotesques
after the antique that could not be richer or more beautiful, with
various scenes and little figures, masks, children, animals, and
other things of fancy, executed with that invention and judgment
that always marked his work, insomuch that of their kind they
may well be called divine. Having ascended the staircase, one
comes into a most beautiful loggia, which has at each end a very
handsome door of stone; and over each of these doors, in the
pediment, are painted two figures, one male and the other female,
represented in directly opposite attitudes, one showing the front
view and the other the back. The vaulting has five arches, and is
wrought superbly in stucco, and it is also divided by pictures in
certain ovals, containing scenes executed with the most perfect
beauty that could be achieved; and the walls are painted down to
the floor with many seated figures of captains in armour, some
drawn from life and some from imagination, and representing all
the ancient and modern captains of the house of Doria, and
above them are large letters of gold, which run thus – 'Magni viri,
maximi duces, optima fecere pro patria.' In the first hall, which
opens into the loggia and is entered by one of the two doors,
that on the left hand, there are most beautiful ornaments of
stucco on the corners of the vaulting, and in the centre there is
a large scene of the Shipwreck of Æneas in the sea, in which are
nude figures, living and dead, in attitudes of infinite variety,
besides a good number of ships and galleys, some sound and
some shattered by the fury of the tempest; not without beautiful
considerations in the figures of the living, who are striving to save
themselves, and expressions of terror that are produced in their
features by the struggle with the waves, the danger of death, and
all the emotions aroused by the perils of the sea. This was the
first scene and the first work that Perino began for the Prince. It
is said that when he arrived in Genoa, Girolamo da Treviso had
already appeared there in advance of him in order to execute
certain pictures, and was painting a wall that faced towards the
garden. And after Perino had begun to draw the cartoon for the

scene of the Shipwreck that has been described above, while he was taking his time about it, amusing himself and seeing Genoa, and labouring only at intervals at the cartoon, although a great part was finished in various ways and those nudes were drawn, some in chiaroscuro, some in charcoal, and others in black chalk, some being drawn in imitation of gradine-work, others shaded, and others again only outlined; while, I say, Perino was going on in this way, without beginning to paint, Girolamo da Treviso murmured against him, saying, 'Cartoons, and nothing but cartoons! I have my art at the tip of my brush.' Decrying him very often in this or some other similar manner, it came to the ears of Perino, who, taking offence, straightway caused his cartoon to be fixed to the vaulting where the scene was to be painted, and the boards of his staging to be removed in many places, to the end that the work might be seen from below; and then he threw open the hall. Which hearing, all Genoa ran to see it, and, amazed by Perino's grand design, they praised him to the skies. Thither, among others, went Girolamo da Treviso, who saw what he had never thought to see from the hand of Perino; whereupon, dumbfoundered by the beauty of the work, he departed from Genoa without asking leave of Prince Doria, and returned to Bologna, where he lived. Perino was thus left alone in the service of the Prince, and finished that hall, painting it in oils on the surface of the walls; and it was held to be, as indeed it is, a thing unrivalled in its beauty, with its lovely work in stucco in the centre of the vaulting and all around, even below the lunettes, as I have described. In the other hall, into which one enters by the right-hand door in the loggia, he executed on the vaulting works in stucco almost similar in design to those of the other, and painted pictures in fresco of Jove slaying the Giants with his thunderbolts, in which are many very beautiful nudes, larger than life. In the Heaven, likewise, are all the Gods, who are making gestures of great vivacity and truly appropriate to their natures, amid the terrible uproar of the thunder; besides which, the stucco-work is executed with supreme diligence, and the fresco-colouring could not be more beautiful, seeing that Perino was very able – indeed, a perfect master – in that field. Near this he adorned four chambers, the ceilings of which are all wrought in stucco, and distributed among them, in fresco, are the most beautiful fables from Ovid, which have all the appearance of reality, nor could any one imagine the beauty, the abundance,

the variety, and the great numbers of the little figures, animals, foliage, and grotesques that are in them, all executed with lively invention. Beside the other hall, likewise, he adorned four more chambers, but only directing the work, which was carried out by his assistants, although he gave them the designs both of the stucco-decorations and of the scenes, figures, and grotesques, upon which a vast number of them worked, some little and some much; such as Luzio Romano, who did much work in stucco there and many grotesques, and a number of Lombards. Let it suffice to say that there is no room there that has not something by his hand and is not full of ornaments, even to the space below the vaulting, with various compositions full of children, bizarre masks, and animals, which all defies description; not to mention that the little studies, the antechambers, the closets, and all other parts of the palace, are painted and made beautiful. From the palace one passes into the garden and into a low building, which has the most ornate decorations in all the rooms, even below the ceilings, and so also the halls, chambers, and anterooms, all adorned by the same hand. In this work Pordenone also took a part, as I said in his Life, and likewise Domenico Beccafumi of Siena, a very rare painter, who showed that he was not inferior to any of the others, although the works by his hand that are in Siena are the most excellent among the vast number that he painted.

But to return to the works that Perino executed after those that he did in the Palace of the Prince; he executed a frieze in a room in the house of Giannetin Doria, containing most beautiful women, and he did many works for various gentlemen throughout the city, both in fresco and in oil-colours. He painted a most beautiful altar-piece, very finely designed, for S. Francesco, and another for a church called S. Maria 'de Consolatione,' at the commission of a gentleman of the house of Baciadonne: in which picture he painted the Nativity of Christ, a work that is much extolled, but it was placed in a position so dark, that, by reason of the light not being good enough, one is not able to recognize its perfection, and all the more because Perino strove to paint it in a dark manner, so that it has need of a strong light. He also made drawings of the greater part of the Æneid, with the stories of Dido, from which tapestries were woven; and he likewise drew beautiful ornaments for the poops of galleys, which were carved and finished to perfection by Carota and Tasso, wood-carvers of Florence, who proved excellently well how able

they were in that art. And in addition to all these things he also executed a vast number of works on cloth for the galleys of the Prince, and the largest standards that could be made for their adornment and embellishment. Wherefore he was so beloved by that Prince for his fine qualities, that, if he had continued to serve him, the Prince would have richly rewarded his abilities.

But while he was working in Genoa, the fancy came to him to fetch his wife from Rome, and so he bought a house in Pisa, being pleased with that city and half thinking of choosing it as his place of habitation when old age should come upon him. Now at that time the Warden of the Duomo at Pisa was M. Antonio di Urbano, who had a very great desire to embellish that temple, and had already caused a beginning to be made with some very beautiful ornaments of marble for the chapels of the church, which had been executed by the hand of Stagio da Pietrasanta, a very able and well practised carver of marble: removing some old, clumsy, and badly proportioned chapels that were there. Having thus made a beginning, the Warden proposed to fill up those ornaments in the interior with altar-pieces in oils, and on the outer side with a series of scenes in fresco and decorations in stucco, by the hands of the best and most excellent masters that he could find, without grudging any expense that might be incurred. He had already set to work on the sacristy, which he had placed in the great recess behind the high-altar, and there the ornamentation of marble was already finished, and many pictures had been painted by the Florentine painter Giovanni Antonio Sogliani, the rest of which, together with the altar-pieces and the chapels that were wanting, were finished many years afterwards by order of M. Sebastiano della Seta, the Warden of the Duomo in those days.

At that time Perino returned from Genoa to Pisa, and, having seen that beginning, at the instance of Battista del Cervelliera, a person well conversant with art and a most ingenious master of wood-carving, perspective, and inlaying, he was presented to the Warden. After they had discoursed together on the subject of the works of the Duomo, Perino was asked to paint an altar-piece for an ornament immediately within the ordinary door of entrance, the ornamental frame being already finished, and above that a scene of S. George slaying the Dragon and delivering the King's Daughter. Perino therefore made a most beautiful design, which included a row of children and other ornaments in fresco

between one chapel and the other, and niches with Prophets and scenes of various kinds; and this design pleased the Warden. And so, having made the cartoon for one of them, the first one, that opposite to the door mentioned above, he began to execute it in colour, and finished six children, which are very well painted. He was to have continued this right round, which would have made a very rich and very beautiful decoration; and the whole work together would have proved to be something very handsome. But he was seized with a desire to return to Genoa, where he had involved himself in love affairs and other pleasures, to which he was inclined at certain times: and on his departure he gave to the Nuns of S. Maffeo a little altar-piece that he had painted for them in oils, which is now in their possession in the convent. Then, having arrived in Genoa, he stayed there many months, executing other works for the Prince.

His departure from Pisa displeased the Warden greatly, and even more the circumstance that the work remained unfinished; wherefore he did not cease to write to him every day that he should return, or to make inquiries from Perino's wife, whom he had left in Pisa. But finally, perceiving that the matter would never end, Perino neither answering nor returning, he allotted the altar-piece of that chapel to Giovanni Antonio Sogliani, who finished it and set it into its place. Not long after this Perino returned to Pisa, and, seeing the work of Sogliani, flew into a rage, and would on no account continue what he had begun, saying that he did not choose that his pictures should serve as ornaments for those of other masters; wherefore, so far as concerned him, that work remained unfinished. Giovanni Antonio carried it on to such purpose that he painted four altar-pieces: but these, at a later date, appeared to Sebastiano della Seta, the new Warden, to be all in the same manner, and somewhat less beautiful than the first, and he allotted to Domenico Beccafumi of Siena – after proving his worth from some pictures that he painted round the sacristy, which are very beautiful – an altar-piece which he executed in Pisa. This not giving as much satisfaction as the first pictures, he caused the two last that were wanting to be painted by Giorgio Vasari of Arezzo; and they were placed at the two doors beside the corner-walls of the main façade of the church. Of these, as well as of many other works, both large and small, that are dispersed throughout Italy and various places abroad, it does not become me to say more, and

I will leave the right of free judgment about them to all who have seen or may see them. The loss of this work caused real vexation to Perino, he having already made the designs for it, which gave promise that it would prove to be something worthy of him, and likely to give that temple great fame over and above that of its antiquities, and also to make Perino immortal.

During the many years of his sojourn in Genoa, although he drew both profit and pleasure from that city, Perino had grown weary of it, as he remembered Rome in the happy days of Leo. But although, during the lifetime of Cardinal Ippolito de' Medici, he had received letters inviting him into his service, and he had been disposed to enter it, the death of that lord brought it about that he hesitated to repatriate himself. While matters stood thus, with his many friends urging his return, himself desiring it infinitely more than any of them, and several letters being exchanged, one morning, in the end, the fancy took him, and without saying a word he set off from Pisa and made his way to Rome. There, after making himself known to the most reverend Cardinal Farnese, and then to Pope Paul, he stayed many months without doing anything; first, because he was put off from one day to another, and then because he was attacked by some infirmity in one of his arms, on account of which he spent several hundreds of crowns, to say nothing of the discomfort, before he could be cured of it. Wherefore, having no one to maintain him, and being vexed by his cold welcome from the Court, he was tempted many times to go away; but Molza and many other friends exhorted him to have patience, telling him that Rome was no longer what she had been, and that now she expected that a man should be exhausted and weary of her before she would choose and cherish him as her own, and particularly if he were pursuing the path of some fine art.

At this time M. Pietro de' Massimi bought a chapel in the Trinità, with the vaulting and the lunettes painted and adorned with stucco, and the altar-piece painted in oils, all by Giulio Romano and Perino's brother-in-law, Giovan Francesco; and that gentleman was desirous to have it finished. In the lunettes were four stories of S. Mary Magdalene in fresco, and in the altar-piece in oils was Christ appearing to Mary Magdalene in the form of a gardener; and M. Pietro first caused a gilt frame of wood to be made for the altar-piece, which had a miserable one of stucco, and then allotted the walls to Perino, who, having caused the

staging and the screen to be erected, set his hand to the work, and after many months brought it to completion. He made a design of bizarre and beautiful grotesques, partly in low-relief and partly painted; and he executed two little scenes of no great size, one on each wall, surrounding them with an ornament in stucco of great variety. In one scene was the Pool of Bethesda, with all the cripples and sick persons, and the Angel who comes to move the waters, the porticoes seen most beautifully foreshortened in perspective, and the movements and vestments of the priests, all painted with great grace and vivacity, although the figures are not very large. In the other, he painted the Raising of Lazarus after he had been dead four days, wherein he is seen newly restored to life, and still marked by the pallor and fear of death: and round him are many who are unswathing him, and not a few who are marvelling, and others struck with awe, besides which the scene is adorned with some little temples that recede into the distance, executed with supreme lovingness, as are also the works in stucco all around. There are likewise four very small scenes, two to each wall, and one on either side of the larger scene; in one of which is the Centurion beseeching Christ that He should heal with a word his son who is dying, in another Christ driving the traders from the Temple, in a third the Transfiguration, and in the last a similar scene. And on the projections of the pilasters within the chapel he painted four figures in the guise of Prophets, which, in their proportions, their excellence, and their beauty, are as well executed and finished as they could well be. In a word, the whole work was carried out with such diligence, and is so delicate, that it resembles miniature rather than painting. In it may be seen much charm and vivacity of colouring, and signs of great patience in its execution, revealing that true love which should be felt for art; and he painted this whole work with his own hand, although he had a great part of the stucco-work executed after his designs by Guglielmo Milanese, whom he had formerly had with him at Genoa, loving him much, and once even offering to give him his daughter in marriage. This Guglielmo, in reward for restoring the antiquities of the house of Farnese, has now been made Friar of the Piombo, in the place of Fra Sebastiano Viniziano.

I must not omit to tell that against one wall of this chapel was a most beautiful tomb of marble, with a dead woman of marble, beautifully carved by the sculptor Bologna, on the sarcophagus, and two little naked boys at the sides. The countenance of that

woman was a lifelike portrait of a very famous courtezan of Rome, who left that memorial of herself, which was removed by the friars because they felt scruples that such a woman should have been laid to rest there with so much honour.

This work, with many designs that he made, was the reason that the very reverend Cardinal Farnese began to give him an allowance and to make use of him in many works. By order of Pope Paul, a chimney-piece that was in the Chamber of the Burning of the Borgo was placed in that of the Segnatura, where there were the panellings with perspective views in wood executed by the hand of the carver Fra Giovanni for Pope Julius. Raffaello had painted both of those chambers; but it became necessary to repaint all the base to the scenes in the Chamber of the Segnatura, which is that in which is the picture of Mount Parnassus. On which account a decorative design in imitation of marble was painted by Perino, with various terminal figures, festoons, masks, and other ornaments; and, in certain spaces, scenes painted to look like bronze, which are very beautiful for works in fresco. In these scenes, even as above them were Philosophers discoursing on Philosophy, Theologians on Theology, and Poets on Poetry, were all the actions of those who have been eminent in those professions. And although he did not execute them all with his own hand, he retouched them so much 'a secco,' besides making perfectly finished cartoons, that they may almost be said to be entirely by his hand; which method he employed because, being troubled by a catarrh, he was not fit for so much labour. Whereupon the Pope, recognizing that he deserved something both on account of his age and for all his work, and hearing him much recommended, gave him an allowance of twenty-five ducats a month, which lasted up to his death, on the condition that he should have charge of the Palace and of the house of the Farnese family.

By this time Michelagnolo Buonarroti had uncovered the wall with the Last Judgment in the Papal Chapel, and there remained still unpainted the base below, where there was to be fixed a screen of arras woven in silk and gold, like the tapestries that adorn the Chapel. Wherefore, the Pope having ordained that the weaving should be done in Flanders, it was arranged with the consent of Michelagnolo that Perino should begin to paint a canvas of the same size, which he did, executing in it women, children and terminal figures, holding festoons, and all very

lifelike, with the most bizarre things of fancy; but this work, which was truly worthy of him and of the divine picture that it was to adorn, remained unfinished after his death in some apartments of the Belvedere.

After this, Antonio da San Gallo having finished the building of the Great Hall of Kings in front of the Chapel of Sixtus IV in the Papal Palace, Perino divided the ceiling into a large pattern of octagonal compartments, crosses, and ovals, both sunk and in relief; which done, Perino was also commissioned to adorn it with stucco-work, with the richest and most beautiful ornaments that could be produced by all the resources of that art. He thus began it, and in the octagons, in place of rosettes, he made four little boys in full relief, who, with their feet pointing to the centre and their arms forming a circle, make a most beautiful rosette, and in the rest of the compartments are all the devices of the house of Farnese, with the arms of the Pope in the centre of the vaulting. And this work in stucco may be said with truth to have surpassed in mastery of execution, in beauty, and in delicacy, all those that have ever been done by ancients or moderns, and to be truly worthy of the head of the Christian religion. After the designs of the same man, likewise, the glass windows were executed by Pastorino da Siena, an able master of that craft; and Perino caused the walls below to be prepared with very beautiful ornaments in stucco, intending to paint scenes there with his own hand, which were afterwards continued by the painter Daniello Ricciarelli of Volterra, who, if death had not cut short the noble aspirations that he had, would have proved how the moderns have the courage not only to equal the ancients with their works, but perhaps even to surpass them by a great measure.

While the stucco-work of this vaulting was in progress, and Perino was considering the designs for his scenes, the old walls of the Church of S. Pietro at Rome were being pulled down to make way for those of the new building, and the masons came to a wall where there was a Madonna, with other pictures, by the hand of Giotto; which being seen by Perino, who was in the company of Messer Niccolò Acciaiuoli, a Florentine doctor and much his friend, both of them were moved to pity for that picture and would not allow it to be destroyed; nay, having caused the wall to be cut away around it, they had it well braced with beams and bars of iron and deposited below the organ of S. Pietro, in a place where there was neither altar nor any other

consecrated object. And before the wall that had been round the Madonna was pulled down, Perino copied the figure of Orso dell' Anguillara, the Roman Senator who had crowned M. Francesco Petrarca on the Campidoglio, and who was at the feet of that Madonna. Round the picture of the Madonna were to be made some ornaments in stucco and painting, and together with them a memorial to a certain Niccolò Acciaiuoli, who had formerly been a Roman Senator; and Perino, having made the designs, straightway set his hand to the work, and, assisted by his young men and by Marcello Mantovano, his disciple, carried it out with great diligence.

In the same S. Pietro the Sacrament did not occupy, with regard to masonry, a very honourable position; wherefore certain deputies were appointed from the Company of the Sacrament, who ordained that a chapel should be built in the centre of the old church by Antonio da San Gallo, partly with remains in the form of ancient marble columns, and partly with other ornaments of marble, bronze, and stucco, placing in the centre a tabernacle by the hand of Donatello, by way of further adornment; and Perino executed there a very beautiful ceiling with many minute scenes full of figures from the Old Testament, symbolical of the Sacrament. In the middle of it, also, he painted a somewhat larger scene, containing the Last Supper of Christ with the Apostles, and below it two Prophets, one on either side of the body of Christ.

The same master, likewise, caused his young men to paint in the Church of S. Giuseppe, near the Ripetta, the chapel of that church, which was afterwards retouched and finished by himself; and he also had a chapel painted after his designs in the Church of S. Bartolommeo in Isola, which he retouched in like manner, and caused some scenes to be painted at the high-altar of S. Salvatore del Lauro, with some grotesques on the vaulting, and likewise an Annunciation on the façade outside, which was executed by his pupil, Girolamo Sermoneta. Thus, then, partly because he was not able, and partly because the labour wearied him, liking to design his works rather than to execute them, he pursued the same course that Raffaello da Urbino had formerly followed at the end of his life. How harmful and how blameworthy is this practice, is proved by the Chigi works and by all those carried out by other hands, and is also shown by those that Perino caused to be executed in the same way; besides which,

those works of Giulio Romano's that he did not paint with his own hand have not done him much honour. And although this method pleases Princes, giving them their works quickly, and perhaps benefits the craftsmen who labour upon them, yet, if they were the ablest men in the world, they could never feel that love for the works of others which a man feels for his own. Nor, however well drawn the cartoons may be, can they be imitated as exactly and as thoroughly as by the hand of their author, who, seeing the work going to ruin, in despair leaves it to fall into complete destruction. He, then, who thirsts for honour, should do his own painting. This I can say from experience, for after I had laboured with the greatest possible pains on the cartoons for the Hall of the Cancelleria in the Palace of S. Giorgio in Rome, the work having to be executed with great haste in a hundred days, a vast number of painters were employed to paint it, who departed so far from their outlines and their true form, that I made a resolution, to which I have adhered, that from that time onward no one should lay a hand on any works of mine. Whoever, therefore, wishes to ensure long life for his name and his works, should undertake fewer and do them all with his own hand, if he desires to obtain that full meed of honour that a man of exalted genius seeks to acquire.

I say, then, that Perino, by reason of the number of the labours committed to his care, was forced to employ many persons; and he thirsted rather for gain than for glory, considering that he had thrown away his life and had saved nothing in his youth. And it vexed him so much to see young men coming forward to undertake work, that he sought to enroll them all under his own command, to the end that they might not encroach on his position. Now in the year 1546 there came to Rome the Venetian Tiziano da Cadore, a painter highly celebrated for his portraits, who, having formerly taken a portrait of Pope Paul at the time when His Holiness went to Busseto, without exacting any remuneration either for that or for some others that he had executed for Cardinal Farnese and Santa Fiore, was received by those prelates with the greatest honour in the Belvedere; at which a rumour arose in the Court, and then spread throughout Rome, to the effect that he had come in order to paint scenes with his own hand in the Hall of Kings in the Palace, where Perino was to paint them and the stucco-work was already in progress. This arrival caused much vexation to Perino, and he

complained of it to many of his friends, not because he believed that Tiziano was likely to surpass him at painting historical scenes in fresco, but because he desired to occupy himself with that work peacefully and honourably until his death, and, if he was to do it, he wished to do it without competition, the wall and the vaulting by Michelagnolo in the Chapel close by being more than enough for him by way of comparison. That suspicion was the reason that while Tiziano stayed in Rome, Perino always avoided him, and remained in an ill-humour until his departure.

The Castellan of the Castello di S. Angelo, Tiberio Crispo, who was afterwards made a Cardinal, being a person who delighted in our arts, made up his mind to beautify the Castle, and rebuilt loggie, chambers, halls, and apartments in a very handsome manner, in order to be able to receive His Holiness more worthily when he went there. Many rooms and other ornaments were executed from the designs and under the direction of Raffaello da Montelupo, and then in the end by Antonio da San Gallo, and a loggia was wrought in stucco under the supervision of Raffaello, who also made the Angel of marble, a figure six braccia high, which was placed on the summit of the highest tower in the Castle. Tiberio then caused the said loggia, which is the one facing the meadows, to be painted by Girolamo Sermoneta; which finished, the rest of the rooms were entrusted in part to Luzio Romano, and finally the halls and other important apartments were finished partly by Perino with his own hand, and partly by others after his cartoons. The principal hall is very pleasing and beautiful, being wrought in stucco and all filled with scenes from Roman history, executed for the most part by Perino's young men, and not a few by the hand of Marco da Siena, the disciple of Domenico Beccafumi; and in certain rooms there are most beautiful friezes.

Perino, when he could find young men of ability, was wont to make use of them willingly in his works; but for all that he never ceased to execute any commonplace commission. He very often painted pennons for trumpets, banners for the Castle, and those of the fleet of the Militant Order; and he executed hangings, tabards, door-curtains, and the most insignificant works of art. He began some canvases from which tapestries were to be woven for Prince Doria, and he painted a chapel for the very reverend Cardinal Farnese, and a writing-study for the most illustrious Madama Margherita of Austria. He caused an ornamental frame to

be made round the Madonna in S. Maria del Pianto, and also
another ornamental frame round the Madonna in Piazza Giudea;
and he executed many other works, of which, by reason of their
number, I will not now make any further mention, particularly
because he was accustomed to accept any sort of work that came
to his hand. This disposition of Perino's, which was well known
to the officials of the Palace, was the reason that he always had
something to do for one or another of them, and he did it will-
ingly, in order to bind them to himself, so that they might be
obliged to serve him in the payment of his allowances and in his
other requirements. In addition to this, Perino had acquired such
authority that all the work in Rome was allotted to him, for the
reason that, besides the circumstance that it appeared to be in a
certain sense his due, he would sometimes execute commissions
for the most paltry prices; whereby he did little good, nay rather,
much harm, to himself and to art. That these words are true is
proved by this, that if he had undertaken to paint the Hall of
Kings in the Palace on his own account, and had worked at it
together with his own assistants, he would have saved several
hundreds of crowns, which all went to the overseers who had
charge of the work and paid the daily wages to those who worked
there.

Thus, having undertaken a burden so heavy and so laborious,
and being infirm and enfeebled by catarrh, he was not able
to endure such discomforts, having to draw day and night
and to meet the demands of the Palace, and, among other
things, to make the designs of embroideries, of engravings for
banner-makers, and of innumerable ornaments required by the
caprice of Farnese and other Cardinals and noblemen. In short,
having his mind incessantly occupied, and being always sur-
rounded by sculptors, masters in stucco, wood-carvers, seamsters,
embroiderers, painters, gilders, and other suchlike craftsmen, he
had never an hour of repose; and the only happiness and con-
tentment that he knew in this life was to find himself at times
with some of his friends at a tavern, which was his favourite
haunt in all the places where it fell to his lot to live, considering
that this was the true blessedness and peace of this world, and
the only repose from his labours. And thus, having ruined his
constitution by the fatigues of his art and by his excesses in eating
and in love, he was attacked by asthma, which, sapping his
strength little by little, finally caused him to sink into consump-

tion; and one evening, while talking with a friend near his house, he fell dead of an apoplectic seizure in his forty-seventh year. At this many craftsmen felt infinite sorrow, it being a truly great loss that art suffered; and he received honourable burial from his son-in-law, M. Gioseffo Cincio, the physician of Madama, and from his wife, in the Chapel of S. Giuseppe in the Ritonda at Rome, with the following epitaph:

PERINO BONACCURSIO VAGÆ FLORENTINO, QUI INGENIO ET ARTE SINGULARI EGREGIOS CUM PICTORES PERMULTOS, TUM PLASTAS OMNES FACILE SUPERAVIT, CATHERINA PERINI CONJUGI, LAVINIA BONACCURSIA PARENTI, JOSEPHUS CIN-CIUS SOCERO CARISSIMO ET OPTIMO FECERE. VIXIT ANN. 46, MEN. 3, DIES 21. MORTUUS EST 14 CALEND. NOVEMB. ANN. CHRIST. 1547.

The place of Perino was filled by Daniello of Volterra, who had worked much with him, and who finished the two other Prophets that are in the Chapel of the Crocifisso in S. Marcello. Daniello has also adorned a chapel in S. Trinità most beautifully with stucco-work and painting, for Signora Elena Orsina; with many other works, of which mention will be made in the proper place.

Perino, then, as may be seen from the works described and from many others that might be mentioned, was one of the most versatile painters of our times, in that he assisted the craftsmen to work excellently in stucco, and executed grotesques, land-scapes, animals, and all the other things of which a painter can have knowledge, using colours in fresco, in oils, and in distemper. Whence it may be said that he was the father of these most noble arts, seeing that his talents live in those who are continually imi-tating him in every honourable field of art. After Perino's death were published many prints taken from his drawings, such as the Slaying of the Giants that he executed in Genoa, eight stories of S. Peter taken from the Acts of the Apostles, of which he made designs for the embroidering of a cope for Pope Paul III, and many other things, which are known by the manner.

Perino made use of many young men, and taught the secrets of art to many disciples; but the best of them all, and the one of whom he availed himself more than of any other, was Girolamo Siciolante of Sermoneta, of whom there will be an account in the proper place. His disciple, likewise, was Marcello Mantovano,

who executed on a wall at the entrance of the Castello di S. Angelo, after the design and under the direction of Perino, a Madonna with many Saints in fresco, which was a very beautiful thing; but of his works as well there will be an account elsewhere.

Perino left many designs at his death, some by his hand and some by others; among the latter, one of the whole Chapel of Michelagnolo Buonarroti, drawn by the hand of Leonardo Cungi of Borgo a San Sepolcro, which was an excellent work. All these designs, with other things, were sold by his heirs; and in our book are many drawings done by him with the pen, which are very beautiful.

To the Craftsmen in Design – GIORGIO VASARI

EXCELLENT AND WELL-BELOVED BROTHER-CRAFTSMEN –

So great has always been the delight, to say nothing of the profit and honour, that I have derived from practising my hand to the best of my ability in this most noble art of ours, that I have not only had a burning desire to exalt and to celebrate her, and to honour her in every manner open to me, but have also been full of affection for all those who have taken the same pleasure in her and have succeeded in practising her more happily than I, perhaps, have been able to do. And from this my good will, so full of the most sincere affection, it appears to me that I have gathered hitherto fruits that are an ample reward, for I have been always loved and honoured by you all, and we have been united in the most perfect intimacy or brotherhood, I know not which to call it; mutually showing our works to one another, I to you and you to me, and helping one another with counsel and assistance whenever the occasion has presented itself. Wherefore I have always felt myself deeply bound by this loving fellowship, and much more by your excellent abilities, and no less, also, by this my inclination, by nature, and by a most powerful attraction, to assist and serve you in every way and every matter wherein I have considered myself able to bring you pleasure or advantage. To this end I published in the year 1550 the Lives of our best and most famous Craftsmen, moved by a cause that has been mentioned in another place, and also, to tell the truth, by a

generous indignation that so much talent should have been for so long a time, and should still remain, buried in oblivion. And this my labour appears not to have been in any way unwelcome; on the contrary, so acceptable, that, not to mention what has been said and written to me from many quarters, out of the vast number that were printed at that time, there is not one single volume to be found at the booksellers.

Thus, therefore, receiving every day requests from many friends, and understanding no less clearly the unexpressed desires of many others, once more, although in the midst of most important undertakings, I have applied myself to the same labour, with the intention not only of adding those masters who have passed to a better world between that time and the present, thus giving me the opportunity of writing their Lives in full, but also of supplying that which may have been wanting to the perfection of my first work. For since then I have had leisure to come to a better knowledge of many matters, and to re-examine others, not only by the favour of these my most illustrious Lords, whom I serve, the true refuge and protection of all the arts, but also through the facilities that they have given me to search the whole of Italy once again and to see and understand many things which had not before come under my notice. I have been able, therefore, not merely to make corrections, but also to add so many things, that many of the Lives may be said to have been almost written anew; while some, indeed, even of the old masters, which were not there before, have been added. Nor, the better to revive the memory of those whom I so greatly honour, have I grudged the great labour, pains and expense of seeking out their portraits, which I have placed at the head of their Lives. And for the greater satisfaction of many friends not of our profession, who are yet devoted lovers of art, I have included in a compendium the greater part of the works of those who are still living and are worthy to be for ever renowned on account of their abilities; for that scruple which formerly restrained me can have no place here in the opinion of any thoughtful reader, since I deal with no works save those that are excellent and worthy of praise. And this may perchance serve as a spur to make every craftsman continue to labour worthily and advance unceasingly from good to better; insomuch that he who shall write the rest of this history, may be able to give it more grandeur and majesty, having occasion to describe those rarer and more perfect works which, begun from

time to time through the desire of immortality, and finished by the loving care of intellects so divine, the world in days to come shall see issuing from your hands. And the young men who follow with their studies, incited by hope of glory (if hope of gain has not enough force), may perchance be inspired by such an example to attain to excellence.

And to the end that this work may prove to be in every way complete, and that there may be no need to seek anything outside its pages, I have added a great part of the works of the most celebrated craftsmen of antiquity, both Greek and of other nations, whose memory has been preserved down to our own day by Pliny and other writers, without whose pens they would have been buried, like many others, in eternal oblivion. And this consideration, also, may perchance increase the willingness of men in general to labour valiantly, and may impel and inspire us all, as we behold the nobility and greatness of our art, and how she has always been prized and rewarded by all nations, and particularly by the most lofty minds and the most powerful Princes, to leave the world adorned by works infinite in number and unsurpassed in excellence; whence, rendered beautiful by us, it may give to us that rank which it has given to those ever marvellous and celebrated spirits.

Accept, then, with a friendly mind, these my labours, which, whatever they may be, have been lovingly carried to conclusion by me for the glory of art and for the honour of her craftsmen, and take them as a sure token and pledge of my heart, which is desirous of nothing more ardently than of your greatness and glory, in which, seeing that I also have been received by you into your company (for which I render my thanks to you, and congratulate myself not a little on my own account), I shall always consider myself in a certain sense a participator.

DOMENICO BECCAFUMI OF SIENA, Painter and Master of Casting

THAT same quality, the pure gift of nature, which has been seen in Giotto and in some others among those painters of whom we have spoken hitherto, has been revealed most recently in Domenico Beccafumi, the painter of Siena, in that he, while guarding

some sheep for his father Pacio, the labourer of the Sienese citizen Lorenzo Beccafumi, was observed to practise his hand by himself, child as he was, in drawing sometimes on stones and sometimes in other ways. It happened that the said Lorenzo saw him one day drawing various things with a pointed stick on the sand of a small stream, where he was watching his little charges, and he asked for the child from his father, meaning to employ him as his servant, and at the same time to have him taught. The boy, therefore, who was then called Mecherino, having been given up by his father Pacio to Lorenzo, was taken to Siena, where Lorenzo caused him for a while to spend all the spare time that he had after his household duties in the workshop of a painter who was his neighbour. This painter, who was no great craftsman, caused Mecherino to learn all that he could not himself teach him from designs by eminent painters that he had in his possession, of which he availed himself for his own purposes, as those masters are wont to do who are not very able in design. Exercising his hand, therefore, in this manner, Mecherino gave promise of being destined to become an excellent painter.

During this time Pietro Perugino, then a famous painter, came to Siena, where, as has been related, he painted two altar-pieces; and his manner pleased Domenico greatly, so that he set himself to study it and to copy those altar-pieces, and no long time passed before he had caught that manner. Then, after the Chapel of Michelagnolo and the works of Raffaello da Urbino had been thrown open in Rome, Domenico, who desired nothing so much as to learn, and knew that he was losing his time in Siena, took leave of Lorenzo Beccafumi, from whom he acquired the family name of Beccafumi, and made his way to Rome. There he placed himself under a painter, who gave him board and lodging, and executed many works in company with him, giving his attention at the same time to studying the works of Michelagnolo, Raffaello, and other eminent masters, and the marvellous statues and sarcophagi of antiquity. No long time passed, therefore, before he became a bold draughtsman, fertile in invention, and a very pleasing colourist; but during this period, which did not exceed two years, he did nothing worthy of record save a façade in the Borgo with an escutcheon of Pope Julius II in colour.

Meanwhile, there had been brought to Siena by a merchant of the Spannocchi family, as will be related in the proper place, the painter Giovanni Antonio of Vercelli, a young man of passing

good ability, who was much employed, particularly in making portraits from life, by the gentlemen of that city, which has always been the friend and patron of all men of talent. Domenico, who was very desirous of returning to his own country, having heard this news, made his way back to Siena; and when he saw that Giovanni Antonio was very well grounded in drawing, which he knew to be the essence of the excellence of a craftsman, not resting content with what he had done in Rome, he set himself with the utmost zeal to follow him, devoting himself much to anatomy and to drawing nudes; which helped him so much, that in a short time he began to be greatly esteemed in that most noble city. Nor was he beloved less for his goodness and his character than for his art, for the reason that, whereas Giovanni Antonio was coarse, licentious, and eccentric, being called Il Sodoma because he always mixed and lived with beardless boys, and answering willingly enough to that name, Domenico, on the other hand, was a pattern of good conduct and uprightness, living like a Christian and keeping very much to himself. But such persons as are called merry fellows and good companions are very often more esteemed by men than the virtuous and orderly, and most of the young men of Siena followed Sodoma, extolling him as a man of originality. And this Sodoma, being an eccentric, and wishing to please the common herd, always kept at his house parrots, apes, dwarf donkeys, little Elba horses, a talking raven, barbs for running races, and other suchlike creatures; from which he had won such a name among the vulgar, that they spoke of nothing but his follies.

Sodoma, then, had painted with colours in fresco the façade of the house of M. Agostino Bardi, and Domenico at the same time, in competition with him, painted the façade of a house of the Borghese, close to the Postierla column, near the Duomo, with which he took very great pains. Below the roof, in a frieze in chiaroscuro, he executed some little figures that were much extolled; and in the spaces between the three ranges of windows of travertine that adorn that palace, he painted many ancient gods and other figures in imitation of bronze, in chiaroscuro and in colour, which were more than passing good, although the work of Sodoma was more extolled. Both these façades were executed in the year 1512.

Domenico afterwards painted for S. Benedetto, a seat of Monks of Monte Oliveto, without the Porta a Tufi, an altar-piece

of S. Catharine of Siena in a building receiving the Stigmata, with a S. Benedict standing on her right hand, and on her left a S. Jerome in the habit of a Cardinal; which altar-piece, being very soft in colouring and strong in relief, was much praised, as it still is. In the predella of this picture, likewise, he painted some little scenes in distemper with incredible boldness and vivacity, and with such facility of design, that they could not be more graceful, and yet they have the appearance of having been executed without the slightest effort in the world. In one of these little scenes is the Angel placing in the mouth of that same S. Catharine part of the Host consecrated by the priest; in another is Jesus Christ marrying her, in a third she is receiving the habit from S. Dominic, and there are other stories.

For the Church of S. Martino the same master painted a large altar-piece with Christ born and being adored by the Virgin, by Joseph, and by the Shepherds; and above the hut is a most beautiful choir of Angels dancing. In this work, which is much extolled by craftsmen, Domenico began to show to those who had some understanding that his works were painted with a different foundation from those of Sodoma. He then painted in fresco, in the Great Hospital, the Madonna visiting S. Elizabeth, in a manner very pleasing and very natural. And for the Church of S. Spirito he executed an altar-piece of the Madonna holding in her arms the Child, who is marrying the above-mentioned S. Catharine of Siena, and at the sides S. Bernardino, S. Francis, S. Jerome, and S. Catharine the Virgin-Martyr, with S. Peter and S. Paul upon some marble steps in front, on the polished surface of which he counterfeited with great art some reflections of the colour of their draperies. This work, which was executed with fine judgment and design, brought him much honour, as did also some little figures painted on the predella of the picture, in which is S. John baptizing Christ, a King causing the wife and children of S. Gismondo to be thrown into a well, S. Dominic burning the books of the heretics, Christ presenting to S. Catharine of Siena two crowns, one of roses and the other of thorns, and S. Bernardino of Siena preaching on the Piazza of Siena to a vast multitude.

Next, by reason of the fame of these works, there was allotted to Domenico an altar-piece that was to be placed in the Carmine, in which he had to paint a S. Michael doing vengeance on Lucifer; and he, being full of fancy, set himself to think out a new

invention, in order to display his talent and the beautiful concep-
tions of his brain. And so, seeking to represent Lucifer and his
followers driven for their pride from Heaven to the lowest
depths of Hell, he began a shower of nude figures raining down,
which is very beautiful, although, from his having taken too great
pains with it, it appears if anything rather confused. This altar-
piece, which remained unfinished, was taken after the death of
Domenico to the Great Hospital and placed at the top of some
steps near the high-altar, where it is still regarded with marvel on
account of some very beautiful foreshortenings in the nudes. In
the Carmine, where this picture was to have been set up, was
placed another, in the upper part of which is counterfeited a God
the Father above the clouds with many Angels round Him,
painted with marvellous grace; and in the centre of the picture is
the Angel Michael in armour, flying, and pointing to Lucifer,
whom he has driven to the centre of the earth, where there are
burning buildings, rugged caverns, and a lake of fire, with Angels
in various attitudes, and nude figures of lost souls, who are
swimming with different gestures of agony in that fire. All this is
painted with such beauty and grace of manner, that it appears
that this marvellous work, in its thick darkness, is illuminated by
the fire; wherefore it is held to be a rare picture. Baldassarre
Peruzzi of Siena, an excellent painter, could never have his fill of
praising it, and I myself, one day that I saw it uncovered in his
company, while passing through Siena, was struck with
astonishment by it, as I also was by the five little scenes that are
in the predella, painted with distemper in a judicious and beautiful
manner. For the Nuns of Ognissanti in the same city Domenico
painted another altar-piece, in which is Christ on high in the
heavens, crowning the Glorified Virgin, and below them are
S. Gregory, S. Anthony, S. Mary Magdalene, and S. Catharine the
Virgin-Martyr; and in the predella, likewise, are some very beau-
tiful little figures executed in distemper.

In the house of Signor Marcello Agostini Domenico painted
some very lovely works in fresco on the ceiling of an apartment,
which has three lunettes on each main side and two at each end,
with a series of friezes that go right round. The centre of the
ceiling is divided into two quadrangular compartments; in the
first, where a silken arras is counterfeited as upheld by the orna-
ment, there may be seen, as if woven upon it, Scipio Africanus
restoring the young woman untouched to her husband, and in

the other the celebrated painter Zeuxis, who is copying several nude women in order to paint his picture, which was to be placed in the Temple of Juno. In one of the lunettes, painted with little figures only about half a braccio high, but very beautiful, are the two Roman Brothers who, having been enemies, became friends for the public good and for the sake of their country. In that which follows is Torquatus,* who, in order to observe the laws, when his son has been condemned to lose his eyes, causes one of his son's and one of his own to be put out. In the next is the Petition of . . .,† who, after hearing the recital of his crimes against his country and the Roman people, is put to death. In the lunette beside that one is the Roman people deliberating on the expedition of Scipio to Africa; and next to this, in another lunette, is an ancient sacrifice crowded with a variety of most beautiful figures, with a temple drawn in perspective, which has no little relief, for in that field Domenico was a truly excellent master. In the last is Cato killing himself after being overtaken by some horsemen that are most beautifully painted there. And in the recesses of the lunettes, also, are some little scenes very well finished.

The excellence of this work was the reason that Domenico was recognized as a rare painter by those who were then governing, and was commissioned to paint the vaulting of a hall in the Palace of the Signori, to which he devoted all the diligence, study, and effort of which any man is capable, in order to prove his worth and to adorn that celebrated building of his native city, which was honouring him so much. This hall, which is two squares long and one square wide, has the ceiling made not with lunettes, but after the manner of a groined vaulting; wherefore Domenico executed the compartments in painting, thinking that this would give the best result, with friezes and cornices overlaid with gold, and all so beautifully, that, without any stucco-work or other ornaments, they are so well painted and so graceful that they appear to be really in relief. On each of the two ends of this hall there is a large picture with an historical scene, and on each main wall there are two, one on either side of an octagon; and thus the pictures are six and the octagons two, and in each of the latter is a scene. At each corner of the vaulting, where the rib is, there is drawn a round compartment, which extends half on one

* Zaleucus. † Here there is a blank in the text.

wall and half on the other, so that these compartments, being divided by the ribs of the vaulting, form eight spaces, in each of which are large seated figures, representing distinguished men who have defended their Republic and have observed her laws. The highest part of the surface of the vaulting is divided into three parts, in such a manner as to form a circular compartment in the centre, immediately above the octagons, and two square compartments over those on the walls.

In one of the octagons, then, is a woman with some children round her, who holds a heart in her hand, representing the love that men owe to their country. In the other octagon is another woman, with an equal number of children, as a symbol of civic concord. And these are one on either side of a Justice that is in the circle, with the sword and scales in her hands, and seen from below in such bold foreshortening that it is a marvel, for at the feet she is dark both in drawing and in colour, and about the knees she becomes lighter, and so continues little by little towards the torso, the shoulders, and the arms, until she rises into a celestial splendour at the head, which makes it appear as if that figure dissolves gradually in a mist: wherefore it is not possible to imagine, much less to see, a more beautiful figure than this one, or one executed with greater judgment and art, among all that were ever painted to be seen in foreshortening from below.

As for the stories, in the first, at the end of the hall and on the left hand as one enters, are M. Lepidus and Fulvius Flaccus the Censors, who, after being at enmity with one another, as soon as they became colleagues in the office of the Censorship, laid aside their private hatred for the good of their country, and acted in that office like the closest friends. And Domenico painted them on their knees, embracing each other, with many figures round them, and with a most beautiful prospect of buildings and temples drawn in perspective so ingeniously and so well, that one may see in them what a master of perspective was Domenico. On the next wall there follows a picture with the story of the Dictator Postumius Tiburtius, who, having left his only son at the head of his army in place of himself, commanding him that he should do nothing else but guard the camp, put him to death for having been disobedient and having with a fair occasion attacked the enemy and gained a victory. In this scene Domenico painted Postumius as an old man with shaven face, with the right hand on his axe, and with the left showing to the army his son lying

dead upon the ground, and depicted very well in foreshortening; and below this picture, which is most beautiful, is an inscription very well composed. In the octagon that follows, in the centre of the wall, is the story of Spurius Cassius, whom the Roman Senate, suspecting that he was plotting to become King, caused to be beheaded, and his house to be pulled down; and in this scene the head, which is beside the executioner, and the body, which is on the ground in foreshortening, are very beautiful. In the next picture is the Tribune Publius Mucius, who caused all his fellow-tribunes, who were conspiring with Spurius to become tyrants of their country, to be burned; and here the fire that is consuming their bodies is painted very well and with great art.

At the other end of the hall, in another picture, is the Athenian Codrus, who, having heard from the oracle that the victory would fall to that side whose King should be killed by the enemy, laid aside his robes, entered unknown among the enemy, and let himself be slain, thus giving the victory to his people by his own death. Domenico painted him seated, with his nobles round him as he puts off his robes, near a most beautiful round temple; and in the distant background of the picture he is seen dead, with his name in an epitaph below. Then, as one turns to the other long wall, opposite to the two pictures with the octagon in the centre between them, in the first scene one finds Prince Zaleucus, who, in order not to break the law, caused one of his own eyes to be put out, and one of his son's; and here many are standing round him, praying him that he should not do that cruelty to himself and his son, and in the distance is his son offering violence to a maiden, and below is his name in an inscription. In the octagon that is beside that picture is the story of Marcus Manilius being hurled down from the Capitol; and the figure of the young Marcus, who is being thrown down from a kind of balcony, is painted so well in foreshortening, with the head downwards, that it seems to be alive, as also seem some figures that are below. In the next picture is Spurius Melius, who belonged to the Equestrian Order, and was killed by the Tribune Servilius because the people suspected that he was conspiring to become tyrant of his country; which Servilius is seated with many round him, and one who is in the centre points to Spurius lying dead upon the ground, a figure painted with great art.

Then, in the circles at the corners, where there are the eight figures mentioned above, are many men who have been

distinguished for their defence of their country. In the first part is the famous Fabius Maximus, seated and in armour; and on the other side is Speusippus, Prince of the Tegeatæ, who, being exhorted by a friend that he should rid himself of his rival and adversary, answered that he did not wish, at the bidding of his own private interest, to deprive his country of such a citizen. In the circle that is at the next corner, in one part, there is the Prætor Celius, who, for having fought against the advice and wish of the soothsayers, although he had won and had gained a victory, was punished by the Senate; and beside him sits Thrasybulus, who with the aid of some friends valorously slew thirty tyrants, in order to free his country. Thrasybulus is an old man, shaven, with white locks, and has his name written beneath him, as have also all the others. In a circle at one corner of the lower end of the hall is the Prætor Genutius Cippus, who having had a bird with wings in the form of horns miraculously alight on his head, was told by the oracle that he would become King of his country, whereupon, although already an old man, he chose to go into exile, in order not to take away her liberty; and Domenico therefore painted a bird upon his head. Beside him sits Charondas, who, having returned from the country, and having gone straightway into the Senate without disarming himself, in violation of a law which ordained that one who entered the Senate with arms should be put to death, killed himself on perceiving his error. In the second circle on the other side are Damon and Phintias, whose unexampled friendship is so well known, and with them is Dionysius, Tyrant of Sicily; and beside these figures sits Brutus, who from love of his country condemned his two sons to death, because they were conspiring to bring the Tarquins back to their country.

This work, then, so truly extraordinary, made known to the people of Siena the ability and worth of Domenico, who showed most beautiful art, judgment, and genius in all that he did.

The first time that the Emperor Charles V came to Italy, it was expected that he would go to Siena, for he had declared such an intention to the Ambassadors of that Republic; and among other vast and magnificent preparations that were made for the reception of so great an Emperor, Domenico fashioned a horse eight braccia high and in full relief, all of paste-board and hollow within. The weight of that horse was supported by an armature of iron, and upon it was the statue of the Emperor, armed in the ancient fashion, with a sword in his hand. And below it were

three large figures – vanquished by him, as it were – which also supported part of the weight, the horse being in the act of leaping with the front legs high in the air; which three figures represented three provinces conquered and subdued by the Emperor. In that work Domenico showed that he was a master no less of sculpture than of painting; to which it must be added that he had placed the whole work upon a wooden structure four braccia high, with a number of wheels below it, which, being set in motion by men concealed within, caused the whole to move forward; and the design of Domenico was that at the entry of His Majesty this horse, having been set in motion as has been described, should accompany him from the gate as far as the Palace of the Signori, and should then come to rest in the middle of the Piazza. This horse, after being carried by Domenico so near completion that there only remained to gild it, was left in that condition, because His Majesty after all did not at that time go to Siena, but left Italy after being crowned at Bologna; and the work remained unfinished. But none the less the art and ingenuity of Domenico were recognized, and all men greatly praised the grandeur and excellence of that great structure, which stood in the Office of Works of the Duomo from that time until His Majesty, returning from his victorious enterprise in Africa, passed through Messina and then Naples, Rome, and finally Siena; at which time Domenico's work was placed on the Piazza del Duomo, to his great honour.

The fame of the ability of Domenico being thus spread abroad, Prince Doria, who was with the Court, after seeing all the works by his hand that were in Siena, besought him that he should go to Genoa to work in his palace, where Perino del Vaga, Giovanni Antonio of Pordenone, and Girolamo da Treviso had worked. But Domenico could not promise that lord that he would go to serve him at that time, although he engaged himself for another time, for in those days he had set his hand to finishing a part of the marble pavement in the Duomo, which Duccio, the painter of Siena, had formerly begun in a new manner of work. The figures and scenes were already in great part designed on the marble, the outlines being hollowed out with the chisel and filled with a black mixture, with ornaments of coloured marble all around, and likewise the grounds for the figures. But Domenico, with fine judgment, saw that this work could be much improved, and he therefore took grey marbles, to the end that these, profiled with the chisel and placed beside the brilliancy of

the white marble, might give the middle shades; and he found
that in this way, with white and grey marble, pictures of stone
could be made with great perfection after the manner of chiaro-
scuro. Having then made a trial, the work succeeded so well in
invention, in solidity of design, and in abundance of figures, that
he made a beginning after this fashion with the grandest, the
most beautiful, and the most magnificent pavement that had ever
been made; and in the course of his life, little by little, he ex-
ecuted a great part of it. Round the high-altar he made a border
of pictures, in which, in order to follow the order of the stories
begun by Duccio, he executed scenes from Genesis; namely,
Adam and Eve expelled from Paradise and tilling the earth, the
Sacrifice of Abel, and that of Melchizedek. In front of the altar
is a large scene with Abraham about to sacrifice Isaac, and this
has round it a border of half-length figures, carrying various ani-
mals which they seem to be going to sacrifice. Descending the
steps, one finds another large picture, which serves to accompany
that above, and in it Domenico represented Moses receiving the
Laws from God on Mount Sinai; and below this is the scene
when, having found the people worshipping the Golden Calf, he
is seized with anger and breaks the Tables on which those Laws
were written. Below this scene, opposite to the pulpit, and right
across the church, is a frieze with a great number of figures,
which is composed with so much grace and such design that it
defies description; and in this is Moses, who, striking the rock in
the desert, causes water to gush out and gives drink to his thirsty
people. Here, along the whole length of the frieze, Domenico
represented the stream of water, from which the people are
drinking in various ways with a vivacity so pleasing, that it is
almost impossible to imagine any effect more lovely, or figures in
more graceful and beautiful attitudes than are those in this scene
– some stooping to the ground to drink, some kneeling before
the rock that is spouting with water, some drawing it in vases and
others in cups, and others, finally, drinking with their hands.
There are, moreover, some who are leading animals to drink,
amid the great rejoicing of that people; and, among other things,
most marvellous is a little boy who has taken a little dog by the
head and neck and plunges its muzzle into the water, in order to
make it drink, after which the dog, having drunk, and not wishing
to drink any more, shakes its head so naturally that it seems to
be alive. In short, this frieze is so beautiful, that for a work of

that kind it could not be executed with greater art, seeing that the various kinds of shadows that may be seen in these figures are not merely beautiful, but miraculous; and although the whole work, on account of the fantastic nature of its craftsmanship, is one of great beauty, this part is held to be the most beautiful and the best. Below the cupola, moreover, there is a hexagonal compartment, which is divided into seven hexagons and six rhombs, of which hexagons Domenico finished four before he died, representing in them the stories and sacrifices of Elijah, and doing all this much at his leisure, because this work was as a school and a pastime to Domenico, nor did he ever abandon it altogether for his other works.

While he was thus labouring now at this work and now elsewhere, he painted a large altar-piece in oils which is in S. Francesco on the right hand as one enters into the church, containing Christ descending in Glory to the Limbo of Hell in order to deliver the Holy Fathers; wherein, among many nudes, is a very beautiful Eve, and a Thief who is behind Christ with the cross is a very well-executed figure, while the cavern of Limbo and the demons and fires of that place are fantastic to a marvel. And since Domenico was of the opinion that pictures painted in distemper preserved their freshness better than those painted in oils, saying that it seemed to him that the works of Luca da Cortona, of the Pollaiuoli, and of the other masters who painted in oils in those days, had suffered from age more than those of Fra Giovanni, Fra Filippo, Benozzo, and the others before their time who painted in distemper – for this reason, I say, having to paint an altar-piece for the Company of S. Bernardino on the Piazza di S. Francesco, he resolved to do it in distemper; and in this way he executed it excellently well, painting in it Our Lady with many Saints. In the predella, which is very beautiful, and painted by him likewise in distemper, he depicted S. Francis receiving the Stigmata; S. Anthony of Padua, who, in order to convert some heretics, performs the miracle of the Ass, which makes obeisance before the sacred Host; and S. Bernardino of Siena, who is preaching to the people of his city on the Piazza de' Signori. And on the walls of this Company, also, he painted two stories of Our Lady in fresco, in competition with some others that Sodoma had executed in the same place. In one he represented the Visitation of S. Elizabeth, and in the other the Passing of Our Lady, with the Apostles all around; and both of these are much extolled.

Finally, after having been long expected in Genoa by Prince Doria, Domenico made his way there, but with great reluctance, being a man who was accustomed to a life of peace and contented with that which his wants required, and nothing more; besides which, he was not much used to making journeys, for the reason that, having built himself a little house in Siena, and having also a vineyard a mile beyond the Porta a Camollia, which he cultivated with his own hand as a recreation, going there often, it was a long time since he had gone far from Siena. Having then arrived in Genoa, he painted a scene there, beside that of Pordenone, in which he succeeded very well, and yet not in such a manner that it could be counted among his best works. But, since the ways of the Court did not please him, being used to a life of freedom, he did not stay very willingly in that place, and, indeed, appeared as if he were stupefied. Wherefore, having come to the end of that work, he sought leave of the Prince and set out to return home; and passing by Pisa, in order to see that city, he met with Battista del Cervelliera and was shown all the most noteworthy things in the city, and in particular the altar-pieces of Sogliani and the pictures that are in the recess behind the high-altar of the Duomo.

Meanwhile Sebastiano della Seta, the Warden of Works of the Duomo, having heard from Cervelliera of the qualities and abilities of Domenico, and being desirous to finish the work so long delayed by Giovanni Antonio Sogliani, allotted two of the pictures for that recess to Domenico, to the end that he might execute them at Siena and send them finished to Pisa; and so it was done. In one is Moses, who, having found that the people had sacrificed to the Golden Calf, is breaking the Tables; and in this Domenico painted some nudes that are figures of great beauty. In the other is the same Moses, with the earth opening and swallowing up a part of the people; and in this, also, are some nudes killed by flaming thunderbolts, which are marvellous. These pictures, when taken to Pisa, led to Domenico painting four pictures for the front of that recess – namely, two on each side – of the four Evangelists, which were four very beautiful figures. Whereupon Sebastiano della Seta, who saw that he had been served quickly and well, commissioned Domenico, after these pictures, to paint the altar-piece of one of the chapels in the Duomo, Sogliani having by that time painted four. Settling in Pisa, therefore, Domenico painted in that altar-piece Our

Lady in the sky with the Child in her arms, upon some clouds supported by some little Angels, with many Saints both male and female below, all executed passing well, but yet not with that perfection which marked the pictures described above. But he, excusing himself for this to many of his friends, and particularly on one occasion to Giorgio Vasari, said that since he was away from the air of Siena and from certain comforts of his own, he did not seem to be able to do anything.

Having therefore returned home, determined that he would never again go away to work elsewhere, he painted for the Nuns of S. Paolo, near S. Marco, an altar-piece in oils of the Nativity of Our Lady, with some nurses, and S. Anne in a bed that is foreshortened and represented as standing within a door; and in a dark shadow is a woman who is drying clothes, without any other light but that which comes from the blaze of the fire. In the predella, which is full of charm, are three scenes in distemper – the Presentation of the Virgin at the Temple, her Marriage, and the Adoration of the Magi. In the Mercanzia, a tribunal in that city, the officials have a little altar-piece which they say was painted by Domenico when he was young; it is very beautiful, and it contains in the centre a S. Paul seated, and on one side his Conversion, in little figures, and on the other the scene of his Beheading.

Finally, Domenico was commissioned to paint the great recess of the Duomo, which is at the end behind the high-altar. In this he first made a decoration of stucco with foliage and figures, all with his own hand, and two Victories in the vacant spaces in the semicircle; which decoration was in truth a very rich and beautiful work. Then in the centre he painted in fresco the Ascension of Christ into Heaven; and from the cornice downwards he painted three pictures divided by columns in relief, and executed in perspective. In the middle picture, which has above it an arch in perspective, are Our Lady, S. Peter, and S. John; and in the spaces at the sides are ten Apostles, five on each side, all in various attitudes and gazing at Christ, who is ascending into Heaven; and above each of the two pictures of the Apostles is an Angel in foreshortening, the two together representing those two Angels who, after the Ascension, declared that He had risen into Heaven. This work is certainly admirable, but it would have been even more so if Domenico had given beautiful expressions to the heads; as it is, they have something in the expressions that is not

very pleasing, and it appears that in his old age he adopted for his countenances an expression of terror by no means agreeable. This work, I say, if there had been any beauty in the heads, would have been so beautiful that there would have been nothing better to be seen. But in this matter of the expressions of the heads, in the opinion of the people of Siena, Sodoma was superior to Domenico, for the reason that Sodoma made them much more beautiful, although those of Domenico had more design and greater force. And, in truth, the manner of the heads in these our arts is of no little importance, and by painting them with graceful and beautiful expressions many masters have escaped the censure that they might have incurred for the rest of their work.

This was the last work in painting executed by Domenico, who, having taken it into his head in the end to work in relief, began to give his attention to casting in bronze, and went so far with this that he executed, although with extraordinary labour, six Angels of bronze in the round, little less than life-size, for the six columns nearest the high-altar of the Duomo. These Angels, which are very beautiful, are holding tazze, or rather little basins, which support candelabra containing lights, and in the last of them he acquitted himself so well, that he was very highly praised for them. Whereupon, growing in courage, he made a beginning with figures of the twelve Apostles, which were to be placed on the columns lower down, where there are now some of marble, old and in a bad manner; but he did not continue them, for he did not live long after that. And since he was a man of infinite ingenuity, and succeeded well in everything, he engraved wood-blocks by himself in order to make prints in chiaroscuro, and there are to be seen prints of two Apostles engraved by him excellently well, of which we have one in our book of drawings, together with some sheets drawn divinely by his hand. He also engraved copper-plates with the burin, and he executed with aquafortis some very fanciful little stories of alchemy, in which Jove and the other Gods, wishing to congeal Mercury, place him bound in a crucible, and Vulcan and Pluto make fire around him; but when they think that he must be fixed, Mercury flies away and goes off in smoke.

Domenico, in addition to the works described above, executed many others of no great importance, pictures of the Madonna and other suchlike chamber-pictures, such as a Madonna that is in the house of the Chevalier Donati, and a picture in distemper

in which Jove changes himself into a shower of gold and rains into the lap of Danaë. Piero Catanei, likewise, has a round picture in oils of a very beautiful Virgin by the hand of the same master. He also painted a most beautiful bier for the Confraternity of S. Lucia, and likewise another for that of S. Antonio; nor should anyone be astonished that I make mention of such works, for the reason that they are beautiful to a marvel, as all know who have seen them.

Finally, having come to the age of sixty-five, he hastened the end of his life by toiling all by himself day and night at his castings in metal, polishing them himself without calling in any assistance. He died, then, on the 18th of May, 1549, and was given burial by his dearest friend, the goldsmith Giuliano, in the Duomo, where he had executed so many rare works. And he was carried to the tomb by all the craftsmen of his city, which recognized even then the great loss that she had suffered in the death of Domenico, and now, as she admires his works, recognizes it more than ever.

Domenico was an orderly and upright person, fearing God and studious in his art, although solitary beyond measure; wherefore he well deserved to be honourably celebrated by his fellow-citizens of Siena, who have always won great praise by their attention to noble studies and to poetry, with verses both in Latin and in the vulgar tongue.

GIOVANNI ANTONIO LAPPOLI,
Painter of Arezzo

RARELY does it happen that from an old stock there fails to sprout some good shoot, which, growing with time, revives and reclothes with its leaves that desolate stem, and reveals with its fruits to those who taste them the same savour that was once known in the ancient tree. And that this is true is proved in this present Life of Giovanni Antonio, who, at the death of his father Matteo, who was a painter of passing good repute in his day, was left with a good income under the guardianship of his mother, and lived thus up to the age of twelve. Having come to that period of his life, and not caring to choose any other pursuit than that of painting, to which he was drawn, besides other reasons,

by a wish to follow the footsteps of his father in that art, Giovanni Antonio began to learn the first rudiments of design under Domenico Pecori, a painter of Arezzo, who had been, together with his father Matteo, a disciple of Clemente,* and who was his first master. Then, after having been some time with him, desiring to make greater proficience than he was making under the discipline of that master and in that place, where he was not able to learn by himself, although he had a strong natural inclination, he turned his thoughts towards the idea of settling in Florence. To this intention, not to mention that he was left alone by the death of his mother, Fortune was favourable enough, for a young sister that he had was married to Leonardo Ricoveri, one of the first and richest citizens that there were at that time in Arezzo; and so he went off to Florence.

There, among the works of many that he saw, the manner of Andrea del Sarto and of Jacopo da Pontormo pleased him more than that of all the others who had worked at painting in that city. Wherefore he resolved to place himself under one of those two, and was hesitating as to which of them he should choose as his master, when there were uncovered the Faith and Charity painted by Pontormo over the portico of the Nunziata in Florence, and he became fully determined to go to work under Pontormo, thinking that his manner was so beautiful that it might be expected that Jacopo, who was still a young man, was destined to surpass all the young painters of his own age, as, indeed, was the firm belief of everyone at that time. Lappoli, then, although he might have gone to work under Andrea, for the said reasons attached himself to Pontormo, under whose discipline he was for ever drawing, spurred to incredible exertions, out of emulation, by two motives. One of these was the presence of Giovan Maria dal Borgo a San Sepolcro, who was studying design and painting under the same master, and who, always advising him for his own good, brought it about that he changed his manner and adopted the good manner of Pontormo. The other – and this spurred him more strongly – was the sight of Agnolo, who was called Bronzino, being much brought forward by Jacopo on account of his loving submissiveness and goodness and the untiring diligence that he showed in imitating his master's works, not to mention that he drew very well and acquitted himself in colouring in

* Don Bartolommeo della Gatta, Abbot of S. Clemente.

such a manner, that he aroused hopes that he was destined to attain to that excellence and perfection which have been seen in him, and still are seen, in our own day.

Giovanni Antonio, then, being desirous to learn, and impelled by the reasons mentioned above, spent many months in making drawings and copies of the works of Jacopo da Pontormo, which were so well executed, so good, and so beautiful, that it is certain that if he had persevered, what with the assistance that he had from Nature, his wish to become eminent, the force of competition, and the good manner of his master, he would have become most excellent; and to this some drawings in red chalk by his hand, which may be seen in our book, can bear witness. But pleasure, as may often be seen to happen, is in young men generally the enemy of excellence, and brings it about that their intellects are led astray; wherefore he who is engaged in the studies of any faculty, science, or art whatsoever should have no relations save with those who are of the same profession, and good and orderly besides. Giovanni Antonio, then, in order that he might be looked after, had gone to live in the house of one Ser Raffaello di Sandro, a lame chaplain, in S. Lorenzo, to whom he paid so much a year, and he abandoned in great measure the study of painting, for the reason that the priest was a man of the world, delighting in pictures, music, and other diversions, and many persons of talent frequented the rooms that he had at S. Lorenzo; among others, M. Antonio da Lucca, a most excellent musician and performer on the lute, at that time a very young man, from whom Giovanni learned to play the lute. And although the painter Rosso and some others of the profession also frequented the same place, Lappoli attached himself rather to the others than to the men of his art, from whom he might have learned much, while at the same time amusing himself. Through these distractions, therefore, the love of painting of which Giovanni Antonio had given proof cooled off in great measure; but none the less, being the friend of Pier Francesco di Jacopo di Sandro, who was a disciple of Andrea del Sarto, he went sometimes with him to the Scalzo to draw the pictures and nudes from life. And no long time passed before he applied himself to colouring and executed pictures of Jacopo's, and then by himself some Madonnas and portraits from life, among which were that of the above-mentioned M. Antonio da Lucca and that of Ser Raffaello, which are very good.

In the year 1523, the plague being in Rome, Perino del Vaga came to Florence, and he also settled down to lodge with Ser Raffaello del Zoppo; wherefore Giovanni Antonio having formed a strait friendship with him and having recognized the ability of Perino, there was reawakened in his mind the desire to attend to painting, abandoning all other pleasures, and he resolved when the plague had ceased to go with Perino to Rome. But this design was never fulfilled, for the plague having come to Florence, at the very moment when Perino had finished the scene of the Submersion of Pharaoh in the Red Sea, painted in the colour of bronze in chiaroscuro for Ser Raffaello, during the execution of which Lappoli was always present, they were forced both the one and the other to fly from Florence, in order not to lose their lives there.

Thereupon Giovanni Antonio returned to Arezzo, and set himself, in order to pass the time, to paint on canvas the scene of the death of Orpheus, killed by the Bacchantes: he set himself, I say, to paint this scene in chiaroscuro of the colour of bronze, after the manner in which he had seen Perino paint the picture mentioned above, and when the work was finished it brought him no little praise. He then set to work to finish an altar-piece that his former master Domenico Pecori had begun for the Nuns of S. Margherita: in which altar-piece, now to be seen in their convent, he painted an Annunciation. And he made two cartoons for two portraits from life from the waist upwards, both very beautiful; one was Lorenzo d' Antonio di Giorgio, at that time a pupil and a very handsome youth, and the other was Ser Piero Guazzesi, who was a convivial person.

The plague having finally somewhat abated, Cipriano d' Anghiari, a rich man of Arezzo, who in those days had caused a chapel with ornaments and columns of grey-stone to be built in the Abbey of S. Fiore at Arezzo, allotted the altar-piece to Giovanni Antonio at the price of one hundred crowns. Meanwhile, Rosso passed through Arezzo on his way to Rome, and lodged with Giovanni Antonio, who was very much his friend; and, hearing of the work that he had undertaken to do, he made at the request of Lappoli a very beautiful little sketch full of nudes. Whereupon Giovanni Antonio, setting his hand to the work and imitating the design of Rosso, painted in that altar-piece the Visitation of S. Elizabeth, and in the lunette above it a God the Father and some children, copying the draperies and all the rest from life. And when he had brought it to completion, he was

much praised and commended for it, and above all for some heads copied from life, painted in a good manner and with much profit to himself.

Then, recognizing that if he wished to make greater proficience in his art he must take his leave of Arezzo, he determined, after the plague had ceased entirely in Rome, to go to that city, where he knew that Perino, Rosso, and many others of his friends had already returned and were employed in a number of important works. While of this mind, a convenient occasion of going there presented itself to him, for there arrived in Arezzo M. Paolo Valdambrini, the Secretary of Pope Clement VII, who, in returning from France in great haste, passed through Arezzo in order to see his brothers and nephews; and when Giovanni Antonio had gone to visit him, M. Paolo, who was desirous that there should be in his native city of Arezzo men distinguished in all the arts, who might demonstrate the genius which that air and that sky give to those who are born there, exhorted him, although there was not much need for exhortation, that he should go in his company to Rome, where he would obtain for him every convenience to enable him to attend to the studies of his art. Having therefore gone with M. Paolo to Rome, he found there Perino, Rosso, and others of his friends; and besides this he was able by means of M. Paolo to make the acquaintance of Giulio Romano, Sebastiano Viniziano, and Francesco Mazzuoli of Parma, who arrived in Rome about that time. This Francesco, delighting to play the lute, and therefore conceiving a very great affection for Giovanni Antonio and consorting continually with him, brought it about that Lappoli set himself with great zeal to draw and paint and to profit by the good fortune that he enjoyed in being the friend of the best painters that there were in Rome at that time. And he had already carried almost to completion a picture containing a Madonna of the size of life, which M. Paolo wished to present to Pope Clement in order to make Lappoli known to him, when, as Fortune would have it, who often sets herself in opposition to the designs of mankind, there took place on the 6th of May, in the year 1527, the accursed sack of Rome. On that miserable day M. Paolo galloped on horseback, and Giovanni Antonio with him, to the Porta di S. Spirito in the Trastevere, in order to prevent the soldiers of Bourbon for a time from entering by that gate; and there M. Paolo was killed and Lappoli was taken prisoner by the Spaniards. And in a short time,

everything being given over to sack, the picture was lost, together with the designs executed in the chapel and all that poor Giovanni Antonio possessed. He, after having been much tormented by the Spaniards to induce him to pay a ransom, escaped in his shirt one night with some other prisoners, and, after suffering desperate hardships and running in great danger of his life, because the roads were not safe, finally made his way to Arezzo, where he was received by M. Giovanni Pollastra, a man of great learning, who was his uncle; but he had all that he could do to recover himself, so broken was he by terror and suffering.

Then in the same year there came upon Arezzo the great plague in which four hundred persons died every day, and Giovanni Antonio was forced once more to fly, all in despair and very loth to go, and to stay for some months out of the city. But finally, when that pestilence had abated to such an extent that people could begin to mix together, a certain Fra Guasparri, a Conventual Friar of S. Francis, who was then Guardian of their convent in that city, commissioned Giovanni Antonio to paint the altar-piece of the high-altar in that church for one hundred crowns, stipulating that he should represent in it the Adoration of the Magi. Whereupon Lappoli, hearing that Rosso, having also fled from Rome, was at Borgo a San Sepolcro, and was there executing an altar-piece for the Company of S. Croce, went to visit him; and after showing him many courtesies and causing some things to be brought for him from Arezzo, of which he knew him to stand in need, since he had lost everything in the sack of Rome, he obtained for himself from Rosso a very beautiful design of the above-mentioned altar-piece that he had to paint for Fra Guasparri. And when he had returned to Arezzo he set his hand to the work, and finished it within a year from the day of the commission, according to the agreement, and that so well, that he was very highly praised for it. That design of Rosso's passed afterwards into the hands of Giorgio Vasari, and from him to the very reverend Don Vincenzio Borghini, Director of the Hospital of the Innocenti in Florence, who has it in his book of drawings by various painters.

Not long afterwards, having become surety for Rosso to the amount of three hundred crowns, in the matter of some pictures that the said Rosso was to paint in the Madonna delle Lagrime, Giovanni Antonio found himself in a very evil pass, for Rosso went away without finishing the work, as has been related in his

Life, and Lappoli was constrained to restore the money; and if his friends had not helped him, and particularly Giorgio Vasari, who valued at three hundred crowns the part that Rosso had left finished, Giovanni Antonio would have been little less than ruined in his effort to do honour and benefit to his native city. These difficulties over, Lappoli painted an altar-piece in oils containing the Madonna, S. Bartholomew, and S. Matthew at the commission of Abbot Camaiani of Bibbiena, for a chapel in the lower church at S. Maria del Sasso, a seat of the Preaching Friars in the Casentino; and he acquitted himself very well, counterfeiting the manner of Rosso. And this was the reason that a Confraternity at Bibbiena afterwards caused him to paint on a banner for carrying in processions a nude Christ with the Cross on His shoulder, who is shedding blood into the Chalice, and on the other side an Annunciation, which was one of the best things that he ever did.

In the year 1534, Duke Alessandro de' Medici being expected in Arezzo, the Aretines, with Luigi Guicciardini, the commissary in that city, wishing to honour the Duke, ordained that two comedies should be performed. The charge of arranging one of those festivals was in the hands of a Company of the most noble young men in the city, who called themselves the Umidi; and the preparations and scenery for this comedy, which had for its subject the Intronati of Siena, were made by Niccolò Soggi, who was much extolled for them, and the comedy was performed very well and with infinite satisfaction to all who saw it. The festive preparations for the other were executed in competition by another Company of young men, likewise noble, who called themselves the Company of the Infiammati. And they, in order to be praised no less than the Umidi, performed a comedy by M. Giovanni Pollastra, a poet of Arezzo, under his management, and entrusted the making of the scenery to Giovanni Antonio, who acquitted himself consummately well; and thus their comedy was performed with great honour to that Company and to the whole city. Nor must I pass over a lovely notion of that poet's, who was certainly a man of beautiful ingenuity. While the preparations for these and other festivals were in progress, on many occasions the young men of the two Companies, out of rivalry and for various other reasons, had come to blows, and several disputes had arisen; wherefore Pollastra arranged a surprise (keeping the matter absolutely secret), which was as follows. When all the people, with the gentlemen and their ladies, had assembled in the place

where the comedy was to be performed, four of those young men who had come to blows with one another in the city on other occasions, dashing out with naked swords and cloaks wound round their arms, began to shout on the stage and to pretend to kill one another: and the first of them to be seen rushed out with one temple as it were smeared with blood, crying out: 'Come forth, traitors!' At which uproar all the people rose to their feet, men began to lay hands on their weapons, and the kinsmen of the young men, who appeared to be giving each other fearful thrusts, ran towards the stage; when he who had come out first, turning towards the other young men, said: 'Hold your hands, gentlemen, and sheathe your swords, for I have taken no harm; and although we are at daggers drawn and you believe that the play will not be performed, yet it will take place, and I, wounded as I am, will now begin the Prologue.' And so after this jest, by which all the spectators and the actors themselves, only excepting the four mentioned above, were taken in, the comedy was begun and played so well, that afterwards, in the year 1540, when the Lord Duke Cosimo and the Lady Duchess Leonora were in Arezzo, Giovanni Antonio had to prepare the scenery anew on the Piazza del Vescovado and have it performed before their Excellencies. And even as the performers had given satisfaction on the first occasion, so at that time they gave so much satisfaction to the Lord Duke, that they were afterwards invited to Florence to perform at the next Carnival. In these two scenic preparations, then, Lappoli acquitted himself very well, and he was very highly praised.

He then made an ornament after the manner of a triumphal arch, with scenes in the colour of bronze, which was placed about the altar of the Madonna delle Chiavi. After a time Giovanni Antonio settled in Arezzo, fully determined, now that he had a wife and children, to go roaming no more, and living on his income and on the offices that the citizens of that city enjoy; and so he continued without working much. Not long, indeed, after these events, he sought to obtain the commissions for two altarpieces that were to be painted in Arezzo, one for the Church and Company of S. Rocco, and the other for the high-altar of S. Domenico; but he did not succeed, for the reason that both those pictures were allotted to Giorgio Vasari, whose designs, among the many that were made, gave more satisfaction than any of the others. For the Company of the Ascension in that city Giovanni Antonio painted on a banner for carrying in proces-

sions Christ in the act of Resurrection, with many soldiers round the Sepulchre, and His Ascension into Heaven, with the Madonna surrounded by the twelve Apostles, which was all executed very well and with diligence. At Castello della Pieve he painted an altar-piece in oils of the Visitation of Our Lady, with some Saints about her, and in an altar-piece that was painted for the Pieve a San Stefano he depicted the Madonna and other Saints; which two works Lappoli executed much better than the others that he had painted up to that time, because he had been able to see at his leisure many works in relief and casts taken in gesso from the statues of Michelagnolo and from other ancient works, and brought by Giorgio Vasari to his house at Arezzo. The same master painted some pictures of Our Lady, which are dispersed throughout Arezzo and other places, and a Judith who is placing the head of Holofernes in a basket held by her serving-woman, which now belongs to Mons. M. Bernardetto Minerbetti, Bishop of Arezzo, who loved Giovanni Antonio much, as he loves all other men of talent, and received from him, besides other things, a young S. John the Baptist in the desert, almost wholly naked, which is held dear by him, since it is an excellent figure.

Finally, recognizing that perfection in this art consists in nothing else but seeking in good time to become rich in invention and to study the nude continually, and thus to render facile the difficulties of execution, Giovanni Antonio repented that he had not spent in the study of art the time that he had given to his pleasures, perceiving that what can be done easily in youth cannot be done well in old age. But although he was always conscious of his error, yet he did not recognize it fully until, having set himself to study when already an old man, he saw a picture in oils, fourteen braccia long and six braccia and a half high, executed in forty-two days by Giorgio Vasari, who painted it for the Refectory of the Monks of the Abbey of S. Fiore at Arezzo; in which work are painted the Nuptials of Esther and King Ahasuerus, and there are in it more than sixty figures larger than life. Going therefore at times to see Giorgio at work, and staying to discourse with him, Giovanni Antonio said: 'Now I see that continual study and work is what lifts men out of laborious effort, and that our art does not come down upon us like the Holy Ghost.'

Giovanni Antonio did not work much in fresco, for the reason that the colours changed too much to please him; nevertheless, there may be seen over the Church of Murello a Pietà

with two little naked Angels by his hand, executed passing well. Finally, after having lived like a man of good judgment and one not unpractised in the ways of the world, he fell sick of a most violent fever at the age of sixty, in the year 1552, and died.

A disciple of Giovanni Antonio was Bartolommeo Torri, the scion of a not ignoble family in Arezzo, who, making his way to Rome, and placing himself under Don Giulio Clovio, a most excellent miniaturist, devoted himself in so thorough a manner to design and to the study of the nude, but most of all to anatomy, that he became an able master, and was held to be the best draughtsman in Rome. And it is not long since Don Silvano Razzi related to me that Don Giulio Clovio had told him in Rome, after having praised this young man highly, the very thing that he has often declared to me – namely, that he had turned him out of his house for no other reason but his filthy anatomy, for he kept so many limbs and pieces of men under his bed and all over his rooms, that they poisoned the whole house. Besides this, by neglecting himself and thinking that living like an unwashed philosopher, accepting no rule of life, and avoiding the society of other men, was the way to become great and immortal, he ruined himself completely; for nature will not tolerate the unreasonable outrages that some men at times do to her. Having therefore fallen ill at the age of twenty-five, Bartolommeo returned to Arezzo, in order to regain his health and to seek to build himself up again; but he did not succeed, for he continued his usual studies and the same irregularities, and in four months, a little after the death of Giovanni Antonio, he died and went to join him.

The loss of this young man was an infinite grief to the whole city, for if he had lived, to judge from the great promise of his works, he was like to do extraordinary honour to his native place and to all Tuscany; and whoever sees any of the drawings that he made when still a mere lad, stands marvelling at them and full of compassion for his untimely death.

NICCOLÒ SOGGI, Painter

AMONG the many who were disciples of Pietro Perugino, there was not one, after Raffaello da Urbino, who was more studious or more diligent than Niccolò Soggi, whose Life we are now

about to write. This master was born in Florence, the son of
Jacopo Soggi, a worthy person, but not very rich; and in time he
entered the service of M. Antonio dal Monte in Rome, because
Jacopo had a farm at Marciano in Valdichiana, and, passing most
of his time there, associated not a little with that same M. Anto-
nio dal Monte, their properties being near together.

Jacopo, then, perceiving that this son of his was much inclined
to painting, placed him with Pietro Perugino; and in a short time,
by means of continual study, he learned so much that it was not
long before Pietro began to make use of him in his works, to the
great advantage of Niccolò, who devoted himself in such a man-
ner to drawing in perspective and copying from nature, that he
afterwards became very excellent in both the one field and the
other. Niccolò also gave much attention to making models of
clay and wax, over which he laid draperies and soaked parch-
ment: which was the reason that he rendered his manner so dry,
that he always held to the same as long as he lived, nor could he
ever get rid of it for all the pains that he took.

The first work that this Niccolò executed after the death of
his master Pietro was an altar-piece in oils in the Hospital for
Women, founded by Bonifazio Lupi, in the Via San Gallo at
Florence – that is, the side behind the altar, wherein is the Angel
saluting Our Lady, with a building drawn in perspective, in which
there are arches and a groined vaulting rising above pilasters after
the manner of Pietro. Then, in the year 1512, after having ex-
ecuted many pictures of Our Lady for the houses of citizens, and
other little works such as are painted every day, hearing that great
things were being done in Rome, he departed from Florence,
thinking to make proficience in art and also to save some money,
and went off to Rome. There, having paid a visit to the aforesaid
M. Antonio dal Monte, who was then a Cardinal, he was not only
welcomed warmly, but also straightway set to work to paint, in
those early days of the pontificate of Leo, on the façade of the
palace where there is the statue of Maestro Pasquino, a great
escutcheon of Pope Leo in fresco, between that of the Roman
People and that of the Cardinal. In that work Niccolò did not
acquit himself very well, for in painting some nude figures and
others clothed that he placed there as ornaments for those escut-
cheons, he recognized that the study of models is bad for him
who wishes to acquire a good manner. Thereupon, after the un-
covering of that work, which did not prove to be of that

excellence which many expected, Niccolò set himself to execute a picture in oils, in which he painted the Martyr S. Prassedia squeezing a sponge full of blood into a vessel; and he finished it with such diligence that he recovered in part the honour that he considered himself to have lost in painting the escutcheons described above. This picture, which was executed for the abovementioned Cardinal dal Monte, who was titular of S. Prassedia, was placed in the centre of that church, over an altar beneath which is a well of the blood of Holy Martyrs – a beautiful idea, the picture alluding to the place where there was the blood of those Martyrs. After this Niccolò painted for his patron the Cardinal another picture in oils, three-quarters of a braccio in height, of Our Lady with the Child in her arms, S. John as a little boy, and some landscapes, all executed so well and with such diligence, that the whole work appears to be done in miniature, and not painted; which picture, one of the best works that Niccolò ever produced, was for many years in the apartment of that prelate. Afterwards, when the Cardinal arrived in Arezzo and lodged in the Abbey of S. Fiore, a seat of the Black Friars of S. Benedict, in return for the many courtesies that were shown to him, he presented that picture to the sacristy of that place, in which it has been treasured ever since, both as a good painting and in memory of the Cardinal.

Niccolò himself went with the Cardinal to Arezzo, where he lived almost ever afterwards. At the time he formed a friendship with the painter Domenico Pecori, who was then painting an altar-piece with the Circumcision of Christ for the Company of the Trinità; and such was the intimacy between them that Niccolò painted for Domenico in that altar-piece a building in perspective with columns and arches supporting a ceiling full of rosettes, according to the custom of those days, which was held at that time to be very beautiful. Niccolò also painted for the same Domenico a round picture of the Madonna with a multitude below, in oils and on cloth, for the baldachin of the Confraternity of Arezzo, which was burned, as has been related in the Life of Domenico Pecori,* during a festival that was held in S. Francesco. Then, having received the commission for a chapel in that same S. Francesco, the second on the right hand as one enters the church, he painted there in distemper Our Lady, S. John the Baptist, S. Bernard, S. Anthony, S. Francis, and three Angels in

* See p. 512, Vol. I.

the air who are singing, with God the Father in a pediment; which were executed by Niccolò almost entirely in distemper, with the point of the brush. But since the work has almost all peeled off on account of the strength of the distemper, it was labour thrown away. Niccolò did this in order to try new methods; and when he had recognized that the true method was working in fresco, he seized the first opportunity, and undertook to paint in fresco a chapel in S. Agostino in that city, beside the door on the left hand as one enters the church. In this chapel, which was allotted to him by one Scamarra, a master of furnaces, he painted a Madonna in the sky with a multitude beneath, and S. Donatus and S. Francis kneeling; but the best thing that he did in this work was a S. Rocco at the head of the chapel.

This work giving great pleasure to Domenico Ricciardi of Arezzo, who had a chapel in the Church of the Madonna delle Lagrime, he entrusted the painting of the altar-piece of that chapel to Niccolò, who, setting his hand to the work, painted in it with much care and diligence the Nativity of Jesus Christ. And although he toiled a long time over finishing it, he executed it so well that he deserves to be excused for this, or rather, merits infinite praise, for the reason that it is a most beautiful work; nor would anyone believe with what extraordinary consideration he painted every least thing in it, and a ruined building, near the hut wherein are the Infant Christ and the Virgin, is drawn very well in perspective. In the S. Joseph and some Shepherds are many heads portrayed from life, such as Stagio Sassoli, a painter and the friend of Niccolò, and Papino della Pieve, his disciple, who, if he had not died when still young, would have done very great honour both to himself and to his country; and three Angels in the air who are singing are so well executed that they would be enough by themselves to demonstrate the talent of Niccolò and the patience with which he laboured at this work up to the very last. And no sooner had he finished it than he was requested by the men of the Company of S. Maria della Neve, at Monte Sansovino, to paint for that Company an altar-piece wherein was to be the story of the Snow, which, falling on the site of S. Maria Maggiore at Rome on the 5th of August, was the reason of the building of that temple. Niccolò, then, executed that altar-piece for the above-mentioned Company with much diligence; and afterwards he executed at Marciano a work in fresco that won no little praise.

Now in the year 1524, after M. Baldo Magini had caused
Antonio, the brother of Giuliano da San Gallo, to build in the
Madonna delle Carceri, in the town of Prato, a tabernacle of
marble with two columns, architrave, cornice, and a quarter-
round arch, Antonio resolved to bring it about that M. Baldo
should give the commission for the picture which was to adorn
that tabernacle to Niccolò, with whom he had formed a friend-
ship when he was working in the Palace of the above-mentioned
Cardinal dal Monte at Monte Sansovino. He presented him,
therefore, to M. Baldo, who, although he had been minded to
have it painted by Andrea del Sarto, as has been related in an-
other place, resolved, at the entreaties and advice of Antonio, to
allot it to Niccolò. And he, having set his hand to it, strove with
all his power to make a beautiful work, but he did not succeed;
for, apart from diligence, there is no excellence of design to be
seen in it, nor any other quality worthy of much praise, because
his hard manner, with his labours over his models of clay and
wax, almost always gave a laborious and displeasing effect to his
work. And yet, with regard to the labours of art, that man could
not have done more than he did or shown more lovingness; and
since he knew that none . . .* for many years he could never bring
himself to believe that others surpassed him in excellence. In this
work, then, there is a God the Father who is sending down the
crown of virginity and humility upon the Madonna by the hands
of some Angels who are round her, some of whom are playing
various instruments. Niccolò made in the picture a portrait from
life of M. Baldo, kneeling at the feet of S. Ubaldo the Bishop,
and on the other side he painted S. Joseph; and those two figures
are one on either side of the image of the Madonna, which
worked miracles in that place. Niccolò afterwards painted a pic-
ture three braccia in height of the same M. Baldo Magini from
life, standing with the Church of S. Fabiano di Prato in his hand,
which he presented to the Chapter of the Canons of the Pieve;
and this Niccolò executed for that Chapter, which, in memory of
the benefit received, caused the picture to be placed in the sacri-
sty, an honour well deserved by that remarkable man, who with
excellent judgment conferred benefits on that church, the princi-
pal church of his native city, and so renowned for the Girdle of
the Madonna, which is preserved there. This portrait was one of

* These words are missing in the text.

the best works that Niccolò ever executed in painting. It is also the belief of some that a little altar-piece that is in the Company of S. Pier Martire on the Piazza di S. Domenico, at Prato, in which are many portraits from life, is by the hand of the same Niccolò; but in my opinion, even if this be true, it was painted by him before any of the other pictures mentioned above.

After these works, Niccolò – under whose discipline Domenico Giuntalodi, a young man of excellent ability belonging to Prato, had learned the rudiments of the art of painting, although, in consequence of having acquired the manner of Niccolò, he never became a great master in painting, as will be related – departed from Prato and came to work in Florence; but, having seen that the most important works in art were given to better and more eminent men than himself, and that his manner was not up to the standard of Andrea del Sarto, Pontormo, Rosso, and the others, he made up his mind to return to Arezzo, in which city he had more friends, greater credit, and less competition. Which having done, no sooner had he arrived than he made known to M. Giuliano Bacci, one of the chief citizens of that place, a desire that he had in his heart, which was this, that he wished that Arezzo should become his country, and that therefore he would gladly undertake to execute some work which might maintain him for a time in the practice of his art, whereby he hoped to demonstrate to that city the nature of his talents. Whereupon Messer Giuliano, an ingenious man who desired that his native city should be embellished and should contain persons engaged in the arts, so went to work with the men then governing the Company of the Nunziata, who in those days had caused a great vaulting to be built in their church, with the intention of having it painted, that one arch of the wall-surface of that vaulting was allotted to Niccolò; and it was proposed that he should be commissioned to paint the rest, if the first part, which he had to do then, should please the men of the aforesaid Company. Having therefore set his hand to this work with great diligence, in two years Niccolò finished the half, but not more, of one arch, on which he painted in fresco the Tiburtine Sibyl showing to the Emperor Octavian the Virgin in Heaven with the Infant Jesus Christ in her arms, and Octavian in reverent adoration. In the figure of Octavian he portrayed the above-mentioned M. Giuliano Bacci, and his pupil Domenico in a tall young man draped in red, and others of his friends in other heads; and, in a word,

he acquitted himself in this work in such a manner that it did not displease the men of that Company and the other men of that city. It is true, indeed, that everyone grew weary of seeing him take so long and toil so much over executing his works; but notwithstanding all this the rest would have been given to him to finish, if that had not been prevented by the arrival in Arezzo of the Florentine Rosso, a rare painter, to whom, after he had been put forward by the Aretine painter Giovanni Antonio Lappoli and M. Giovanni Pollastra, as has been related in another place, much favour was shown and the rest of that work allotted. At which Niccolò felt such disdain, that, if he had not taken a wife the year before and had a son by her, so that he was settled in Arezzo, he would have departed straightway. However, having finally become pacified, he executed an altar-piece for the Church of Sargiano, a place two miles distant from Arezzo, where there are Frati Zoccolanti; in which he painted the Assumption of Our Lady into Heaven, with many little Angels supporting her, and S. Thomas below receiving the Girdle, while all around are S. Francis, S. Louis, S. John the Baptist, and S. Elizabeth, Queen of Hungary. In some of these figures, and particularly in some of the little Angels, he acquitted himself very well; and so also in the predella he painted some scenes with little figures, which are passing good. He executed, likewise, in the Convent of the Nuns of the Murate, who belong to the same Order, in that city, a Dead Christ with the Maries, which is wrought with a high finish for a picture in fresco. In the Abbey of S. Fiore, a seat of Black Friars, behind the Crucifix that is placed on the high-altar, he painted in oils, on a canvas, Christ praying in the Garden and the Angel showing to Him the Chalice of the Passion and comforting Him, which was certainly a work of no little beauty and excellence. And for the Nuns of S. Benedetto, of the Order of Camaldoli, at Arezzo, on an arch above a door by which one enters the convent, he painted the Madonna, S. Benedict, and S. Catharine, a work which was afterwards thrown to the ground in order to enlarge the church.

In the township of Marciano in Valdichiana, where he passed much of his time, living partly on the revenues that he had in that place and partly on what he could earn there, Niccolò began an altar-piece of the Dead Christ and many other works, with which he occupied himself for a time. And meanwhile, having with him the above-mentioned Domenico Giuntalodi of Prato, whom he

loved as a son and kept in his house, he strove to make him excellent in the matters of art, teaching him so well how to draw in perspective, to copy from nature, and to make designs, that he was already becoming very able in all these respects, showing a good and beautiful genius. And this Niccolò did, besides being moved by the love and affection that he bore to that young man, in the hope of having one who might help him now that he was nearing old age, and might give him some return in his last years for so much labour and lovingness. Niccolò was in truth most loving with every man, true by nature, and much the friend of those who laboured in order to attain to something in the world of art; and what he knew he taught to them with extraordinary willingness.

No long time after this, when Niccolò had returned from Marciano to Arezzo and Domenico had left him, the men of the Company of the Corpo di Cristo, in that city, had a commission to give for the painting of an altar-piece for the high-altar of the Church of S. Domenico. Now, Niccolò desiring to paint it, and likewise Giorgio Vasari, then a mere lad, the former did something which probably not many of the men of our art would do at the present day, which was as follows: Niccolò, who was one of the members of the above-mentioned Company, perceiving that many were disposed to have it painted by Giorgio, in order to bring him forward, and that the young man had a very great desire for it, resolved, after remarking Giorgio's zeal, to lay aside his own desire and need and to have the picture allotted by his companions to Giorgio, thinking more of the advantage that the young man might gain from the work than of his own profit and interest; and even as he wished, so exactly did the men of that Company decide.

In the meantime Domenico Giuntalodi, having gone to Rome, found Fortune so propitious that he became known to Don Martino, the Ambassador of the King of Portugal, and went to live with him; and he painted for him a canvas with some twenty portraits from life, all of his followers and friends, with himself in the midst of them, engaged in conversation; which work so pleased Don Martino, that he looked upon Domenico as the first painter in the world. Afterwards Don Ferrante Gonzaga, having been made Viceroy of Sicily, and desiring to fortify the towns of that kingdom, wished to have about his person a man who might draw and put down on paper for him all that he thought of from

day to day; and he wrote to Don Martino that he should find for him a young man who might be both able and willing to serve him in this way, and should send him off as soon as possible. Don Martino, therefore, first sent to Don Ferrante some designs by the hand of Domenico, among which was a Colosseum, engraved on copper by Girolamo Fagiuoli of Bologna for Antonio Salamanca, but drawn in perspective by Domenico; an old man in a child's go-cart, drawn by the same hand and published in engraving, with letters that ran thus, 'Ancora imparo'; and a little picture with the portrait of Don Martino himself. And shortly afterwards he sent Domenico, at the wish of the aforesaid lord, Don Ferrante, who had been much pleased with that young man's works. Having then arrived in Sicily, there were assigned to Domenico an honourable salary, a horse, and a servant, all at the expense of Don Ferrante; and not long afterwards he was set to work on the walls and fortresses of Sicily. Whereupon, abandoning his painting little by little, he devoted himself to something else which for a time was more profitable to him; for, being an ingenious person, he made use of men who were well adapted to heavy labour, kept beasts of burden in the charge of others, and caused sand and lime to be collected and furnaces to be set up; and no long time had passed before he found that he had saved so much that he was able to buy offices in Rome to the extent of two thousand crowns, and shortly afterwards some others. Then, after he had been made keeper of the wardrobe to Don Ferrante, it happened that his master was removed from the government of Sicily and sent to that of Milan; whereupon Domenico went with him, and, working on the fortifications of that State, contrived, what with being industrious and with being something of a miser, to become very rich; and what is more, he came into such credit that he managed almost everything in that government.

Hearing of this, Niccolò, who was at Arezzo, now an old man, needy, and without any work to do, went to find Domenico in Milan, thinking that even as he had not failed Domenico when he was a young man, so Domenico should not fail him now, but should avail himself of his services, since he had many in his employ, and should be both able and willing to assist him in his poverty-stricken old age. But he found to his cost that the judgments of men, in expecting too much from others, are often deceived, and that the men who change their condition also change more often than not their nature and their will. For after

arriving in Milan, where he found Domenico raised to such greatness that he had no little difficulty in getting speech of him, Niccolò related to him all his troubles, and then besought him that he should help him by making use of his services; but Domenico, not remembering or not choosing to remember with what lovingness he had been brought up by Niccolò as if he had been his own son, gave him a miserably small sum of money and got rid of him as soon as he was able. And so Niccolò returned to Arezzo very sore at heart, having recognized that with the labour and expense with which, as he thought, he had reared a son, he had formed one who was little less than an enemy.

In order to earn his bread, therefore, he went about executing all the work that came to his hand, as he had done many years before, and he painted among other things a canvas for the Commune of Monte Sansovino, containing the said town of Monte Sansovino and a Madonna in the sky, with two Saints at the sides; which picture was set up on an altar in the Madonna di Vertigli, a church belonging to the Monks of the Order of Camaldoli, not far distant from the Monte, where it has pleased and still pleases Our Lord daily to perform many miracles and to grant favours to those who recommend themselves to the Queen of Heaven. Afterwards, Julius III having been created Supreme Pontiff, Niccolò, who had been much connected with the house of Monte, made his way to Rome, although he was an old man of eighty, and, having kissed the foot of His Holiness, besought him that he should deign to make use of him in the buildings which were to be erected, so men said, at the Monte, a place which the Lord Duke of Florence had given in fief to the Pontiff. The Pope, then, having received him warmly, ordained that the means to live in Rome should be given to him without exacting any sort of exertion from him; and in this manner Niccolò spent several months in Rome, drawing many antiquities to pass the time.

Meanwhile the Pope resolved to increase his native town of Monte Sansovino, and to make there, besides many ornamental works, an aqueduct, because that place suffered much from want of water; and Giorgio Vasari, who had orders from the Pope to cause those buildings to be begun, recommended Niccolò Soggi strongly to His Holiness, entreating him that Niccolò should be given the office of superintendent over those works. Whereupon Niccolò went to Arezzo filled with these hopes, but he had not been there many days when, worn out by the fatigues and

hardships of this world and by the knowledge that he had been abandoned by him who should have been the last to forsake him, he finished the course of his life and was buried in S. Domenico in that city.

Not long afterwards Domenico Giuntalodi, Don Ferrante Gonzaga having died, departed from Milan with the intention of returning to Prato and of passing the rest of his life there in repose. However, finding there neither relatives nor friends, and recognizing that Prato was no abiding place for him, he repented too late that he had behaved ungratefully to Niccolò, and returned to Lombardy to serve the sons of Don Ferrante. But no long time passed before he fell sick unto death; whereupon he made a will leaving ten thousand crowns to his fellow-citizens of Prato, to the end that they might buy property to that amount and form a fund wherewith to maintain continually at their studies a certain number of students from Prato, in the manner in which they maintained certain others, as they still do, according to the terms of another bequest. And this has been carried out by the men of that town of Prato, who, grateful for such a benefit, which in truth has been a very great one and worthy of eternal remembrance, have placed in their Council Chamber the image of Domenico, as that of one who has deserved well of his country.

NICCOLÒ, CALLED TRIBOLO,
Sculptor and Architect

RAFFAELLO the carpenter, surnamed Il Riccio de' Pericoli, who lived near the Canto a Monteloro in Florence, had born to him in the year 1500, as he used to tell me himself, a male child, whom he was pleased to call at baptism, like his own father, Niccolò; and having perceived that the boy had a quick and ready intelligence and a lofty spirit, he determined, although he was but a poor artisan, that he should begin straightway by learning to read and write well and cast accounts. Sending him to school, therefore, it came about, since the child was very vivacious and so high-spirited in his every action, that he was always cramped for room and was a very devil both among the other boys at school and everywhere else, always teasing and tormenting both himself and others, that he lost his own name of Niccolò and

acquired that of Tribolo* to such purpose, that he was called that ever afterwards by everyone.

Now, Tribolo growing, his father, in order both to make use of him and to curb the boy's exuberance, took him into his workshop and taught him his own trade; but having seen in a few months that he was ill suited for such a calling, being somewhat delicate, thin, and feeble in health, he came to the conclusion that if he wished to keep him alive, he must release him from the heavier labours of his craft and set him to wood-carving. Having heard that without design, the father of all the arts, the boy could not become an excellent master therein, Raffaello resolved that he should begin by devoting all his time to design, and therefore made him draw now cornices, foliage, and grotesques, and now other things necessary to such a profession. And having seen that in doing this the boy was well served both by his head and by his hand, and reflecting, like a man of judgment, that with him Niccolò could at best learn nothing else but to work by the square, Raffaello first spoke of this with the carpenter Ciappino, who was the very familiar friend of Nanni Unghero; and with his advice and assistance, he placed Niccolò for three years with the said Nanni, in whose workshop, where both joiner's work and carving were done, there were constantly to be found the sculptor Jacopo Sansovino, the painter Andrea del Sarto, and others, who afterwards became such able masters. Now Nanni, who had in those days a passing good reputation for excellence, was executing many works both in joinery and in carving for the villa of Zanobi Bartolini at Rovezzano, without the Porta alla Croce, for the palace of the Bartolini, which Giovanni, the brother of that Zanobi, was having built at that time on the Piazza di S. Trinita, and for the house and garden of the same man in Gualfonda; and Tribolo, who was made to work by Nanni without discretion, always having to handle saws, planes, and other common tools, and not being capable, by reason of the feebleness of his body, of such exertions, began to feel dissatisfied and to say to Riccio, when he asked for the cause of his discontent, that he did not think that he could remain with Nanni in that craft, and that therefore Raffaello should see to placing him with Andrea del Sarto or Jacopo Sansovino, whom he had come to know in Unghero's workshop, for the reason that with one or the other of

* Teasel.

them he hoped to do better and to be sounder in health. Moved by these reasons, then, and again with the advice and assistance of Ciappino, Riccio placed Tribolo with Jacopo Sansovino, who took him willingly, because he had known him in the workshop of Nanni Unghero, and had seen that he worked well in design and even better in relief.

Jacopo Sansovino, when Tribolo, now restored to health, went to work under him, was executing in the Office of Works of S. Maria del Fiore, in competition with Benedetto da Rovezzano, Andrea da Fiesole, and Baccio Bandinelli, the marble statue of S. James the Apostle which is still to be seen at the present day at that place together with the others. And thus Tribolo, with these opportunities of learning, by working in clay and drawing with great diligence, contrived to make such proficience in that art, for which he felt a natural inclination, that Jacopo, growing to love him more and more every day, began to encourage him and to bring him forward by making him execute now one thing and now another. Whereupon, although Sansovino had in his workshop at that time Solosmeo da Settignano and Pippo del Fabro, young men of great promise, seeing that Tribolo, having added skill in the use of chisels to his good knowledge of working in clay and in wax, not only equalled them but surpassed them by a great measure, he began to make much use of him in his works. And after finishing the Apostle and a Bacchus that he made for the house of Giovanni Bartolini in Gualfonda, and undertaking to make for M. Giovanni Gaddi, his intimate friend, a chimney-piece and a water-basin of hard sandstone for his house on the Piazza di Madonna, he caused some large figures of boys in clay, which were to go above the great cornice, to be made by Tribolo, who executed them so extraordinarily well, that M. Giovanni, having seen the beautiful manner and the genius of the young man, commissioned him to execute two medallions of marble, which, finished with great excellence, were afterwards placed over certain doors in the same house.

Meanwhile there was a commission to be given for a tomb, a work of great magnitude, for the King of Portugal; and since Jacopo had been the disciple of Andrea Contucci of Monte Sansovino, and had the reputation not only of having equalled his master, a man of great renown, but of having a manner even more beautiful, that work, through the good offices of the Bartolini, was allotted to him. Whereupon Jacopo made a most

NICCOLO DETTO IL TRIBOLO
SCVLTORE, ET ARCHI.

superb model of wood, all covered with scenes and figures of
wax, which were executed for the most part by Tribolo; and these
proving to be very beautiful, the young man's fame so increased
that Matteo di Lorenzo Strozzi – Tribolo having now left Sanso-
vino, thinking that he was by that time able to work by himself
– commissioned him to make some children of stone, and shortly
afterwards, being much pleased with them, two of marble that
are holding a dolphin which pours water into a fish-pond, a work
that is now to be seen at San Casciano, a place eight miles distant
from Florence, in the villa of that M. Matteo.

While these works were being executed by Tribolo in
Florence, M. Bartolommeo Barbazzi, a Bolognese gentleman who
had gone there on some business, remembered that a search was
being made in Bologna for a young man who could work well,
to the end that he might be set to making figures and scenes of
marble for the façade of S. Petronio, the principal church of that
city. Wherefore he spoke to Tribolo, and having seen some of his
works, which pleased him, as also did the young man's ways and
other qualities, he took him to Bologna, where Tribolo, with
great diligence and with much credit to himself, in a short time
made the two Sibyls of marble that were afterwards placed in the
ornament of that door of S. Petronio which leads to the Della
Morte Hospital. These works finished, arrangements were being
made to give him greater things to do, and he was receiving many
proofs of love and affection from M. Bartolommeo, when the
plague of the year 1525 began in Bologna and throughout all
Lombardy; whereupon Tribolo, in order to avoid that plague,
made his way to Florence. After living there during all the time
that this contagious and pestilential sickness lasted, he departed
as soon as it had ceased, and returned, in obedience to a sum-
mons, to Bologna, where M. Bartolommeo, not allowing him to
set his hand to any work for the façade, resolved, seeing that
many of his friends and relatives had died, to have a tomb made
for himself and for them. And so Tribolo, after finishing the
model, which M. Bartolommeo insisted on seeing completed be-
fore he did anything else, went in person to Carrara to have the
marbles excavated, intending to rough-hew them on the spot and
to lighten them in such a manner, that they might not only be
easier to transport, as indeed they were, but also that the figures
might come out larger. In that place, in order not to waste his
time, he blocked out two large children of marble, which were

taken to Bologna with beasts of burden, unfinished as they were, together with the rest of the work; and after the death of M. Bartolommeo, which caused such grief to Tribolo that he returned to Tuscany, they were placed, with the other marbles, in a chapel in S. Petronio, where they still are.

Having thus departed from Carrara, Tribolo, on his way back to Florence, stayed in Pisa to visit the sculptor Maestro Stagio da Pietrasanta, his very dear friend, who was executing in the Office of Works of the Duomo in that city two columns with capitals of marble all in open work, which were to stand one on either side of the high-altar and the Tabernacle of the Sacrament; and each of these was to have upon the capital an Angel of marble one braccio and three quarters in height, with a candelabrum in the hand. At the invitation of the said Stagio, having nothing else to do at that time, he undertook to make one of those Angels: which being finished with all the perfection that could be given to a delicate work of that size in marble, proved to be such that nothing more could have been desired, for the reason that the Angel, with the movement of his person, has the appearance of having stayed his flight in order to uphold that light, and the nude form has about it some delicate draperies which are so graceful in their effect, and look so well on every side and from every point of view, that words could not express their beauty. But, having consumed much time in executing this work, since he cared for nothing but his delight in art, and not having received for it from the Warden the payment that he expected, he resolved that he would not make the other Angel, and returned to Florence. There he met with Giovan Battista della Palla, who at that time was not only causing all the sculptures and pictures that he could to be executed for sending to King Francis I in France, but was also buying antiques of all sorts and pictures of every kind, provided only that they were by the hands of good masters; and every day he was packing them up and sending them off. Now, at the very moment when Tribolo returned, Giovan Battista had an ancient vase of granite, of a very beautiful shape, which he wished to arrange in such a manner that it might serve for a fountain for that King. He therefore declared his mind to Tribolo, and what he proposed to have done; and he, setting to work, made him a Goddess of Nature, who, raising one arm, holds that vase, the foot of which she has upon her head, with the hands, the first row of breasts being adorned with some boys standing

out entirely detached from the marble, who are in various most beautiful attitudes, holding certain festoons in their hands, while the next range of breasts is covered with quadrupeds, and at her feet are many different kinds of fishes. That figure was finished with such diligence and such perfection, that it well deserved, after being sent to France together with other works, to be held very dear by the King, and to be placed, as a rare thing, in Fontainebleau.

Afterwards, in the year 1529, when preparations were being made for the war against Florence and the siege, Pope Clement VII, wishing to study the exact site of the city and to consider in what manner and in what places his forces could be distributed to the best advantage, ordained that a plan of the city should be made secretly, with all the country for a mile around it – the hills, mountains, rivers, rocks, houses, churches, and other things, and also the squares and streets within, together with the walls and bastions surrounding it, and the other defences. The charge of all this was given to Benvenuto di Lorenzo della Volpaia, an able maker of clocks and quadrants and a very fine astrologer, but above all a most excellent master in taking ground-plans. This Benvenuto chose Tribolo as his companion, and that with great judgment, for the reason that it was Tribolo who suggested that this plan, for the better consideration of the height of the mountains, the depth of the low-lying parts, and all other particulars, should be made in relief; the doing of which was not without much labour and danger, in that, staying out all night to measure the roads and to mark the number of braccia between one place and another, and also to measure the height of the summits of the belfries and towers, drawing intersecting lines in every direction by means of the compass, and going beyond the walls to compare the height of the hills with that of the cupola, which they had marked as their centre, they did not execute such a work save after many months; but they used great diligence, for they made it of cork, for the sake of lightness, and limited the whole plan to the space of four braccia, and measured everything to scale. Having then been finished in this manner, and being made in pieces, that plan was packed up secretly and smuggled out of Florence in some bales of wool that were going to Perugia, being consigned to one who had orders to send it to the Pope, who made use of it continually during the siege of Florence, keeping it in his chamber, and seeing from one day to another, from

letters and despatches, where and how the army was quartered, where skirmishes took place, and, in short, all the incidents, arguments, and discussions that occurred during that siege; all greatly to his satisfaction, for it was in truth a rare and marvellous work.

The war finished – during the progress of which Tribolo executed some works in clay for his friends, and for Andrea del Sarto, his dearest friend, three figures of wax in the round, of which Andrea availed himself in painting in fresco, on the Piazza, near the Condotta, portraits from nature of three captains who had fled with the pay-chests, depicted as hanging by one foot – Benvenuto, summoned by the Pope, went to Rome to kiss the feet of his Holiness, and was placed by him in charge of the Belvedere, with an honourable salary. In that office, having often conversations with the Pope, Benvenuto, when the occasion arose, did not fail to extol Tribolo as an excellent sculptor and to recommend him warmly; insomuch that, the siege finished, Clement made use of him. For, designing to give completion to the Chapel of Our Lady at Loreto, which had been begun by Leo and then abandoned on account of the death of Andrea Contucci of Monte Sansovino, he ordained that Antonio da San Gallo, who had the charge of executing that fabric, should summon Tribolo and set him to complete some of those scenes that Maestro Andrea had left unfinished. Tribolo, then, thus summoned by San Gallo by order of Clement, went with all his family to Loreto, whither there likewise went Simone, called Mosca, a very rare carver of marble, Raffaello da Montelupo, Francesco da San Gallo the younger, Girolamo Ferrarese the sculptor, a disciple of Maestro Andrea, Simone Cioli, Ranieri da Pietrasanta, and Francesco del Tadda, all invited in order to finish that work. And to Tribolo, in the distribution of the labours, there fell, as the work of the greatest importance, a scene in which Maestro Andrea had represented the Marriage of Our Lady.

Thereupon Tribolo made an addition to that scene, and had the notion of placing among the many figures that are standing watching the Marriage of the Virgin, one who in great fury is breaking his rod, because it had not blossomed; and in this he succeeded so well, that the suitor could not display with greater animation the rage that he feels at not having had the good fortune that he desired. Which work finished, and also that of the others, with great perfection, Tribolo had already made many

models of wax with a view to executing some of those Prophets that were to go in the niches of that chapel, which was now built and completely finished, when Pope Clement, after seeing those works and praising them much, and particularly that of Tribolo, determined that they should all return without loss of time to Florence, in order to finish under the discipline of Michelagnolo Buonarroti all those figures that were wanting in the sacristy and library of S. Lorenzo, and the rest of the work, after the models of Michelagnolo and with his assistance, with the greatest possible speed, to the end that, having finished the sacristy, they might all together be able, thanks to the proficience made under the discipline of so great a man, also to finish the façade of S. Lorenzo. And in order that there might be no manner of delay in doing this, the Pope sent Michelagnolo back to Florence, and with him Fra Giovanni Angelo de' Servi, who had executed some works in the Belvedere, to the end that he might assist him in carving the marbles and might make some statues, according as he should receive orders from Michelagnolo, who caused him to make a S. Cosimo, which was to stand on one side of the Madonna, with a S. Damiano, allotted to Montelupo, on the other.

These commissions given, Michelagnolo desired that Tribolo should make two nude statues, which were to be one on either side of that of Duke Giuliano, which he himself had already made; one was to be a figure of Earth crowned with cypress, weeping with bowed head and with the arms outstretched, and lamenting the death of Duke Giuliano, and the other a figure of Heaven with the arms uplifted, all smiling and joyful, and show-ing her gladness at the adornment and splendour that the soul and spirit of that lord conferred upon her. But Tribolo's evil fortune crossed him at the very moment when he was about to begin to work on the statue of Earth; for, whether it was the change of air, or his feeble constitution, or because he had been irregular in his way of living, he fell ill of a grievous sickness, which, ending in a quartan fever, hung about him many months, to his infinite vexation, since he was tormented no less by his grief at having had to abandon the work, and at seeing that the friar and Raffaello had taken possession of the field, than by the illness itself. However, wishing to conquer that illness, in order not to be left behind by his rivals, whose name he heard cel-ebrated more and more every day, feeble as he was, he made a large model of clay for the statue of Earth, and, when he had

finished it, began to execute the work in marble, with such diligence and assiduity, that the statue could be seen already all cut out in front, when Fortune, who is always ready to oppose herself to any fair beginning, by the death of Clement at a moment when nothing seemed less likely, cut short the aspirations of all those excellent masters who were hoping to acquire under Michelagnolo, besides boundless profits, immortal renown and everlasting fame.

Stupefied by this misfortune and robbed of all his spirit, and being also ill, Tribolo was living in utter despair, seeming not to be able either in Florence or abroad to hit upon anything that might be to his advantage; but Giorgio Vasari, who was always his friend and loved him from his heart, and helped him all that he could, consoled him, saying that he should not lose heart, because he would so contrive that Duke Alessandro would give him something to do, by means of the favour of the Magnificent Ottaviano de' Medici, into whose service Giorgio had introduced him on terms of no little intimacy. Wherefore Tribolo, having regained a little courage, occupied himself, while measures were being taken to assist him, with copying in clay all the figures of marble in the Sacristy of S. Lorenzo which Michelagnolo had executed – namely, Dawn, Twilight, Day, and Night. And he succeeded in doing them so well, that M. Giovan Battista Figiovanni, the Prior of S. Lorenzo, to whom he presented the Night in return for having the sacristy opened for him, judging it to be a rare work, presented it to Duke Alessandro, who afterwards gave it to Giorgio Vasari, who was living with his Excellency, knowing that Giorgio gave his attention to such studies; which figure is now in his house at Arezzo, with other works of art. Having afterwards copied, likewise in clay, the Madonna made by Michelagnolo for the same sacristy, Tribolo presented it to the above-named M. Ottaviano de' Medici, who had a most beautiful ornament in squared work made for it by Battista del Cinque, with columns, cornices, brackets, and other carvings very well executed.

Meanwhile, by the favour of him who was Treasurer to his Excellency, and at the commission of Bertoldo Corsini, the proveditor for the fortress which was being built at that time, out of three escutcheons that were to be made by order of the Duke for placing on the bastions, one on each, one four braccia in height was given to Tribolo to execute, with two nude figures representing Victories; which escutcheon, finished by him with

great diligence and promptitude, with the addition of three great masks that support the escutcheon and the figures, so pleased the Duke, that he conceived a very great love for Tribolo. Now shortly afterwards the Duke went to Naples to defend himself before the Emperor Charles V, who had just returned from Tunis, against many calumnies that had been laid upon him by some of his citizens; and, having not only defended himself, but also obtained from his Majesty his daughter Signora Margherita of Austria for wife, he wrote to Florence that four men should be appointed who might cause vast and splendid decorations to be prepared throughout the city, in order to receive the Emperor, who was coming to Florence, with proper magnificence. And I, having to distribute the various works at the commission of his Excellency – who ordained that I should act in company with the said four men, who were Giovanni Corsi, Luigi Guicciardini, Palla Rucellai, and Alessandro Corsini – gave the greatest and most difficult labours for that festival to Tribolo to execute, which were four large statues. The first was a Hercules that has just killed the Hydra, six braccia in height, in the round and overlaid with silver, which was placed at that corner of the Piazza di S. Felice that is at the end of the Via Maggio, with the following inscription in letters of silver on the base: UT HERCULES LABORE ET ÆRUMNIS MONSTRA EDOMUIT, ITA CÆSAR VIR-TUTE ET CLEMENTIA, HOSTIBUS VICTIS SEU PLACATIS, PACEM ORBI TERRARUM ET QUIETEM RESTITUIT. Two others were colossal figures eight braccia high, one representing the River Bagrada, which was resting upon the skin of the serpent that was brought to Rome, and the other representing the Ebro, with the horn of Amaltheia in one hand and in the other the helm of a ship; both coloured in imitation of bronze, with in-scriptions on the bases; below the Ebro, HIBERUS EX HISPANIA, and below the other, BAGRADAS EX AFRICA. The fourth was a statue five braccia in height, on the Canto de' Medici, repres-enting Peace, who had in one hand an olive branch and in the other a lighted torch, with which she was setting fire to a pile of arms heaped up on the base on which she was placed; with the following words: FIAT PAX IN VIRTUTE TUA. He did not finish, as he had hoped to do, the horse seven braccia in length that was set up on the Piazza di S. Trinita, upon which was to be placed the statue of the Emperor in armour, because Tasso the wood-carver, who was much his friend, did not show any promptitude

in executing the base and the other things in the way of wood-
carving that were to be included in the work, being a man who
let time slip through his fingers in arguing and jesting; and there
was only just time to cover the horse alone with tin-foil laid upon
the still fresh clay. On the base were to be read the following
words:

IMPERATORI CAROLO AUGUSTO VICTORIOSISSIMO, POST
DEVICTOS HOSTES, ITALIÆ PACE RESTITUTA ET SALUTATO
FERDIN. FRATRE, EXPULSIS ITERUM TURCIS AFRICAQUE
PERDOMITA, ALEXANDER MED. DUX FLORENTIÆ, D.D.

His Majesty having departed from Florence, a beginning was
made with the preparations for the nuptials, in expectation of his
daughter, and to the end that she and the Vice-Queen of Naples,
who was in her company, might be commodiously lodged ac-
cording to the orders of his Excellency in the house of M. Otta-
viano de' Medici, an addition was made to his old house in four
weeks, to the astonishment of everyone; and Tribolo, the painter
Andrea di Cosimo, and I, in ten days, with the help of about
ninety sculptors and painters of the city, what with masters and
assistants, completed the preparations for the wedding in so far
as appertained to the house and its decorations, painting the
loggie, courtyards, and other spaces in a manner suitable for nup-
tials of such importance. Among these decorations, Tribolo
made, besides other things, two Victories in half-relief that were
one on either side of the principal door, supported by two large
terminal figures, which also upheld the escutcheon of the Em-
peror, pendent from the neck of a very beautiful eagle in the
round. The same master also made certain boys, likewise in
the round, and large in size, which were placed on either side of
some heads over the pediments of various doors; and these were
much extolled.

Meanwhile, as the nuptials were in progress, Tribolo received
letters from Bologna, in which Messer Pietro del Magno, his
devoted friend, besought him that he should consent to go to
Bologna, in order to make for the Madonna di Galliera, where a
most beautiful ornament of marble was already prepared, a scene
likewise of marble three braccia and a half in extent. Whereupon
Tribolo, happening to have nothing else to do at that time, went
thither, and after making a model of a Madonna ascending into
Heaven, with the Apostles below in various attitudes, which,

being very beautiful, gave great satisfaction, he set his hand to executing it; but with little pleasure for himself, since the marble that he was carving was that Milanese marble, saline, full of emery, and bad in quality; and it seemed to him that he was wasting his time, without feeling a particle of that delight that men find in working those marbles which are a pleasure to carve, and which in the end, when brought to completion, show a surface that has the appearance of the living flesh itself. However, he did so much that it was already almost finished, when I, having persuaded Duke Alessandro to recall Michelagnolo from Rome, and also the other masters, in order to finish the work of the sacristy begun by Clement, was arranging to give him something to do in Florence; and I would have succeeded, but in the meantime, by reason of the death of Alessandro, who was murdered by Lorenzo di Pier Francesco de' Medici, not only was this design frustrated, but the greatness and prosperity of art were thrown into utter ruin.

Having heard of the Duke's death, Tribolo condoled with me in his letters, beseeching me, after he had exhorted me to bear with resignation the death of that great Prince, my gracious master, that if I went to Rome, as he had heard that I, being wholly determined to abandon Courts and to pursue my studies, was intending to do, I should obtain some commission for him, for the reason that, if assisted by my friends, he would do whatever I told him. But it so chanced that it became in no way necessary for him to seek commissions in Rome. For Signor Cosimo de' Medici, having been created Duke of Florence, as soon as he had freed himself from the troubles that he had in the first year of his rule by routing his enemies at Monte Murlo, began to take some diversion, and in particular to frequent not a little the villa of Castello, which is little more than two miles distant from Florence. There he began to do some building, in order that he might be able to live there comfortably with his Court, and little by little – being encouraged in this by Maestro Pietro da San Casciano, who was held to be a passing good master in those days, and was much in the service of Signora Maria, the mother of the Duke, and had also always been the master-builder and the former servant of Signor Giovanni – he resolved to conduct to that place certain waters that he had desired long before to bring thither. Whereupon a beginning was made with building an aqueduct that was to receive all the waters from the hill of Castellina,

which was at a distance of a quarter of a mile or more from Castello; and the work was pursued vigorously with a good number of men. But the Duke recognizing that Maestro Pietro had neither invention nor power of design enough to make in that place a beginning that might afterwards in time receive that ornamentation which the site and the waters required, one day that his Excellency was on the spot, speaking of this with such men as Messer Ottaviano de' Medici and Cristofano Rinieri, the friend of Tribolo and the old servant of Signora Maria and of the Duke, they extolled Tribolo in such a manner, as a man endowed with all those parts that were requisite in the head of such a fabric, that the Duke gave Cristofano a commission to make him come from Bologna. Which having been straightway done by Rinieri, Tribolo, who could not have received any better news than that he was to serve Duke Cosimo, set out immediately for Florence, and, arriving there, was taken to Castello, where his most illustrious Excellency, having heard from him what he thought should be done in the way of decorative fountains, gave him a commission to make the models. Whereupon he set his hand to these, and was engaged upon them, while Maestro Pietro da San Casciano was executing the aqueduct and bringing the waters to the place, when the Duke, who meanwhile had begun, for the security of the city, to surround with a very strong wall the bastions erected on the hill of San Miniato at the time of the siege after the designs of Michelagnolo, ordained that Tribolo should make an escutcheon of hard stone, with two Victories, for an angle of the summit of a bastion that faces Florence. But Tribolo had scarcely finished the escutcheon, which was very large, and one of those Victories, a figure four braccia high, which was held to be a very beautiful thing, when he was obliged to leave that work incomplete, for the reason that, Maestro Pietro having carried well on the making of the aqueduct and the bringing of the waters, to the full satisfaction of the Duke, his Excellency wished that Tribolo should begin to put into execution, for the adornment of that place, the designs and models that he had already shown to him, ordaining him for the time being a salary of eight crowns a month, the same that was paid to San Casciano.

Now, in order that I may not become confused in describing the intricacies of the aqueducts and of the ornaments of the fountains, it may be well to say briefly some few words about the site and position of Castello. The villa of Castello stands

at the roots of Monte Morello, below the Villa della Topaia, which is halfway up the slope; it has before it a plain that descends little by little, for the space of a mile and a half, down to the River Arno, and exactly where the ascent of the mountain begins stands the palace, which was built in past times by Pier Francesco de' Medici, after a very good design. The principal front faces straight towards the south, overlooking a vast lawn with two very large fish-ponds full of running water, which comes from an ancient aqueduct made by the Romans in order to conduct water from Valdimarina to Florence, and provided with a vaulted cistern under the ground; and so it has a very beautiful and very pleasing view. The fish-ponds in front are divided in the middle by a bridge twelve braccia wide, which leads to an avenue of the same width, bounded at the sides and covered above by an unbroken vault of mulberry-trees, ten braccia in height, thus making a covered avenue three hundred braccia in length, delightful for its shade, which opens on to the high road to Prato by a gate placed between two fountains that serve to give water to travellers and animals. On the eastern side the same palace has a very beautiful pile of stable-buildings, and on the western side a private garden into which one goes from the courtyard of the stables, passing straight through the ground-floor of the palace by way of the loggie, halls, and chambers on the level of the ground; from which private garden one can enter by a door on the west side into another garden, very large and all filled with fruit-trees, and bounded by a forest of fir-trees that conceals the houses of the labourers and others who live there, engaged in the service of the palace and of the gardens. Next, that part of the palace which faces north, towards the mountain, has in front of it a lawn as long as the palace, the stables, and the private garden altogether, and from this lawn one climbs by steps to the principal garden, a place enclosed by ordinary walls, which, rising in a gentle slope, stretches so well clear of the palace as it rises, that the mid-day sun searches it out and bathes it all with its rays, as if there were no palace in front; and at the upper end it stands so high that it commands a view not only of the whole palace, but also of the plain that is in front and around it, and likewise about the city. In the middle of this garden is a forest of very tall and thickly-planted cypresses, laurels, and myrtles, which, laid out in a circular shape, have the form of a labyrinth, all surrounded by box-hedges two braccia and a half in height, so

even and grown with such beautiful order that they have the appearance of a painting done with the brush; in the centre of which labyrinth, at the desire of the Duke, Tribolo, as will be described below, made a very beautiful fountain of marble. At the principal entrance, where there is the first-mentioned lawn with the two fish-ponds and the avenue covered with mulberry-trees, Tribolo wished that the avenue should be so extended that it might stretch for a distance of more than a mile, covered and shaped in like manner, and might reach as far as the River Arno, and that the waters which ran away from all the fountains, flowing gently in pleasant channels at the sides of the avenue, and filled with various kinds of fishes and crayfish, might accompany it down to that river.

As for the palace – to describe what has still to be done as well as that which has been finished – he wished to make a loggia in front of it, which, passing by an open courtyard, was to have on the side where the stables are another palace as large as the old one, with the same proportion of apartments, loggie, private garden, and the rest; which addition would have made it a vast palace, with a most beautiful façade. After passing the court from which one enters into the large garden of the labyrinth, at the main entrance, where there is a vast lawn, after climbing the steps that lead to that labyrinth, there came a level space thirty braccia square, on which there was to be – and has since been made – a very large fountain of white marble, which was to spout upwards above ornaments fourteen braccia in height, while from the mouth of a statue at the highest point was to issue a jet of water rising to the height of six braccia. At either end of the lawn was to be a loggia, one opposite to the other, each thirty braccia in length and fifteen in breadth; and in the middle of each loggia was to be placed a marble table twelve braccia in length, and on the outside a basin of eight braccia, which was to receive the water from a vase held by two figures. In the middle of the above-mentioned labyrinth Tribolo had thought to achieve the most decorative effect with water by means of jets and a very beautiful seat round the fountain, the marble basin of which was to be, even as it was afterwards made, much smaller than that of the large principal fountain; and at the summit it was to have a figure of bronze spouting water. At the end of this garden, in the centre, there was to be a gate with some children of marble on both sides spouting water, with a fountain on either

side, and in the corners double niches in which statues were to be placed, as in the others that are in the walls at the sides, at the opposite ends of the avenues that cross the garden, which are all covered with greenery distributed in various ways.

Through the above-mentioned gate, which is at the upper end of this garden, above some steps, one enters into another garden, as wide as the first, but of no great depth in the direct line, in comparison with the mountain beyond. In this garden were to be two other loggie, one on either side, and in the wall opposite to the gate, which supports the soil of the mountain, there was to be in the centre a grotto with three basins, with water playing into them in imitation of rain. The grotto was to be between two fountains placed in the same wall, and opposite to these, in the lower wall of the garden, were to be two others, one on either side of the gate; so that the fountains of this garden would have been equal in number to those of the other, which is below it, and receives its water from the first, which is higher. And this garden was to be all full of orange-trees, which would have had – and will have, whenever that may be – a most favourable situation, being defended by the walls and by the mountain from the north wind and other harmful winds.

From this garden one climbs by two staircases of flint, one on either side, to a forest of cypresses, fir-trees, holm-oaks, laurels, and other evergreen trees, distributed with beautiful order, in the middle of which, according to Tribolo's design, there was to be a most lovely fish-pond, which has since been made. And because this part, gradually narrowing, forms an angle, that angle, to the end that it might be made flat, was to be blunted by the breadth of a loggia, from which, after climbing some steps, might be seen in front the palace, the gardens, the fountains, and all the plain below and about them, as far as the Ducal Villa of Poggio a Caiano, Florence, Prato, Siena, and all that is around for many miles.

Now the above-named Maestro Pietro da San Casciano, having carried his work of the aqueduct as far as Castello, and having turned into it all the waters of Castellina, was overtaken by a violent fever, and died in a few days. Whereupon Tribolo, undertaking the charge of directing all the building by himself, perceived that, although the waters brought to Castello were in great abundance, nevertheless they were not sufficient for all that he had made up his mind to do; not to mention that, coming from

Castellina, they did not rise to the height that he required for his purposes. Having therefore obtained from the Lord Duke a commission to conduct thither the waters of Petraia, a place more than one hundred and fifty braccia above Castello, which are good and very abundant, he caused a conduit to be made, similar to the other, and so high that one can enter into it, to the end that thus those waters of Petraia might come to the fish-pond through another aqueduct with enough fall for the fish-pond and the great fountain.

This done, Tribolo began to build the above-mentioned grotto, proposing to make it with three niches, in a beautiful architectural design, and likewise the two fountains that were one on either side of it. In one of these there was to be a large statue of stone, representing Monte Asinaio, which, pressing its beard, was to pour water from its mouth into a basin that was to be in front of it; from which basin the water, issuing by a hidden channel, and passing under the wall, was to flow to the fountain that there is at the present day behind the wall, at the end of the slope of the garden of the labyrinth, pouring into the vase on the shoulder of the figure of the River Mugnone, which is in a large niche of grey-stone decorated with most beautiful ornaments, and all covered with sponge-stone. This work, if it had been finished in all its perfection, even as it is in part, would have had great similarity to the reality, since the Mugnone rises from Monte Asinaio.

For the Mugnone, then, to describe that which has been done, Tribolo made a figure of grey-stone, four braccia in length, and reclining in a very beautiful attitude, which has upon one shoulder a vase that pours water into a basin, and rests the other on the ground, leaning upon it, with the left leg crossed over the right. And behind this river is a woman representing Fiesole, wholly naked, issuing from among the sponge-stones and rocks in the middle of the niche, and holding in the hand a moon which is the ancient emblem of the people of Fiesole. Below this niche is a very large basin supported by two great Capricorns, which are one of the devices of the Duke; from which Capricorns hang some festoons and masks of great beauty, and from their lips issues the water from that basin, which is convex in the middle, and has outlets at the sides; and all the water that overflows pours away from the sides through the mouths of the Capricorns, and then, after falling into the hollow base of the

vase, flows through the herb-beds that are round the walls of the garden of the labyrinth, where there are fountains between the niches, and between the fountains espaliers of oranges and pomegranates.

In the second garden described above, where Tribolo had intended that there should be made the Monte Asinaio that was to supply water to the Mugnone, there was to be on the other side, beyond the gate, a similar figure of the Monte della Falterona; and even as this mountain is the source of the River Arno, so the statue representing that river in the garden of the labyrinth, opposite to the Mugnone, was to receive the water from the Falterona. But since neither the figure of that mountain nor its fountain has ever been finished, let us speak of the fountain and figure of the River Arno, which were completed by Tribolo to perfection. This river, then, holds its vase upon one thigh, lying down and leaning with one arm on a lion, which holds a lily in its paw, and the vase receives its water through the perforated wall, behind which there was to be the Falterona, exactly in the manner in which, as has been described, the statue of the River Mugnone also receives its water; and since the long basin is in every way similar to that of the Mugnone, I shall say no more about it, save this, that it is a pity that the art and excellence of these works, which are truly most beautiful, are not embodied in marble.

Then, continuing the work of the conduit, Tribolo caused the water from the grotto to pass under the orange-garden and then under the next garden, and thus brought it into the labyrinth, where, forming a circle round all the middle of the labyrinth, in a good circumference round the centre, he laid down the central pipe, through which the fountain was to spout water. After which, taking the waters from the Arno and the Mugnone, and bringing them together under the level of the labyrinth by means of certain bronze pipes that were distributed in beautiful order throughout that space, he filled that whole pavement with very fine jets, in such a manner that it was possible by turning a key to drench all those who came near to see the fountain. Nor is one able to escape either quickly or with ease, because Tribolo made round the fountain and the pavement, in which are the jets, a seat of grey-stone supported by lion's paws, between which are sea monsters in low-relief; which was a difficult thing to do, because he chose, since the place was sloping and the square lay on the slant, to make it level, and the same with the seat.

Having then set his hand to the fountain of the labyrinth, he made on the shaft, in marble, an interwoven design of sea monsters cut out in full relief, with tails intertwined so well, that nothing better of that kind could be done. And this finished, he executed the tazza with a piece of marble brought long before to Castello, together with a large table, also of marble, from the Villa dell' Antella, which M. Ottaviano de' Medici formerly bought from Giuliano Salviati. By reason of this opportunity, then, Tribolo made that tazza sooner than he might otherwise have done, fashioning round it a dance of little children attached to the moulding which is beside the lip of the tazza; which children are holding festoons of products of the sea, cut out of the marble with beautiful art. And so also the shaft which he made over the tazza, he executed with much grace, with some very beautiful children and masks to spout water. Upon that shaft it was the intention of Tribolo to place a bronze statue three braccia high, representing Florence, in order to signify that from the above-named Mounts Asinaio and Falterona the waters of the Arno and Mugnone come to Florence; of which figure he had made a most beautiful model which, pressing the hair with the hands, caused water to pour forth. Then, having brought the water as far as the space thirty braccia square, below the labyrinth, he made a beginning with the great fountain, which, made with eight sides, was to receive all the above-mentioned waters into its lowest basin – namely, those from the water-works of the labyrinth, and likewise those of the great conduit. Each of these eight sides, then, rises above a step one-fifth of a braccio in height, and each angle of the eight sides has a projection, as have also the steps, which, thus projecting, rise at each angle in a great step of two-fifths of a braccio, in such a way that the central face of the steps withdraws into the projections, and their straight line is thus broken, which produces a bizarre effect, and makes the ascent very easy. The edges of the fountain have the shape of a vase, and the body of the fountain – that is, the inner part where the water is – curves in the form of a circle. The shaft begins with eight sides, and continues with eight seats almost up to the base of the tazza, upon which are seated eight children of the size of life, all in the round and in various attitudes, who, linked together with the legs and arms, make a rich adornment and a most beautiful effect. And since the tazza, which is round, projects to the extent of six braccia, the water of the whole fountain, pouring equally over the

edge on every side, sends a very beautiful rain, like the drippings from a roof, into the octagonal basin mentioned above, and those children that are on the shaft of the tazza are not wetted, and they appear to be there in order not to be wetted by the rain, almost like real children, full of delight and playing as they shelter under the lip of the tazza, which could not be equalled in its simplicity and beauty. Opposite to the four paths that intersect the garden are four children of bronze lying at play in various attitudes, which are after the designs of Tribolo, although they were executed afterwards by others. Above this tazza begins another shaft, which has at the foot, on some projections, four children of marble in the round, who are pressing the necks of some geese that spout water from their mouths; and this water is that of the principal conduit coming from the labyrinth, and rises exactly to this height. Above these children is the rest of the shaft of this pedestal, which is made with certain cartouches which spurt forth water in a most bizarre manner; and then, regaining a quadrangular form, it rises over some masks that are very well made. Above this, then, is a smaller tazza, on the lip of which, on all four sides, are fixed by the horns four heads of Capricorns, making a square, which spout water through their mouths into the large tazza, together with the children, in order to make the rain which falls, as has been told, into the first basin, which has eight sides. Still higher there follows another shaft, adorned with other ornaments and with some children in half-relief, who, projecting outwards, form at the top a round space that serves as base to the figure of a Hercules who is crushing Antæus, which was designed by Tribolo and executed afterwards by others, as will be related in the proper place. From the mouth of this Antæus he intended that, instead of his spirit, there should gush out through a pipe water in great abundance, as indeed it does; which water is that of the great conduit of Petraia, which comes with much force, and rises sixteen braccia above the level where the steps are, and makes a marvellous effect in falling back into the greater tazza. In that same aqueduct, then, come not only those waters from Petraia, but also those that go to the fish-pond and the grotto, and these, uniting with those from Castellina, go to the fountains of the Falterona and Monte Asinaio, and thence to the fountains of the Arno and Mugnone, as has been related; after which, being reunited at the fountain of the labyrinth, they go to the centre of the great fountain, where are the children with

the geese. From there, according to the design of Tribolo, they were to flow through two distinct and separate conduits into the basins of the loggie, where the tables are, and then each into a separate private garden. The first of these gardens – that towards the west – is all filled with rare and medicinal plants; wherefore at the highest level of that water, in that garden of simples, in the niche of the fountain, and behind a basin of marble, there was to be a statue of Æsculapius.

The principal fountain described above, then, was completely finished in marble by Tribolo, and carried to the finest and greatest perfection that could be desired in a work of this kind. Wherefore I believe that it may be said with truth that it is the most beautiful fountain, the richest, the best proportioned, and the most pleasing that has ever been made, for the reason that in the figures, in the vases, in the tazze, and, in short, throughout the whole work, are proofs of extraordinary diligence and industry. After this, having made the model of the above-mentioned statue of Æsculapius, Tribolo began to execute it in marble, but, being hindered by other things, he did not finish that figure, which was completed afterwards by the sculptor Antonio di Gino, his disciple.

On the side towards the east, in a little lawn without the garden, Tribolo arranged an oak in a most ingenious manner, for, besides the circumstance that it is so thickly covered both above and all around with ivy intertwined among the branches, that it has the appearance of a very dense grove, one can climb up it by a convenient staircase of wood similarly covered with ivy, at the top of which, in the middle of the oak, there is a square chamber surrounded by seats, the backs of which are all of living verdure, and in the centre is a little table of marble with a vase of variegated marble in the middle, from which, through a pipe, there flows and spurts into the air a strong jet of water, which, after falling, runs away through another pipe. These pipes mount upwards from the foot of the oak so well hidden by the ivy, that nothing is seen of them, and the water can be turned on or off at pleasure by means of certain keys; nor is it possible to describe in full in how many ways that water of the oak can be turned on, in order to drench anyone at pleasure with various instruments of copper, not to mention that with the same instruments one can cause the water to produce various sounds and whistlings.

Finally, all these waters, after having served so many different purposes, and supplied so many fountains, are collected together, and flow into the two fish-ponds that are without the palace, at the beginning of the avenue, and thence to other uses of the villa.

Nor will I omit to tell what was the intention of Tribolo with regard to the statues that were to be as ornaments in the great garden of the labyrinth, in the niches that may be seen regularly distributed there in various spaces. He proposed, then – acting in this on the judicious advice of M. Benedetto Varchi, who has been in our times most excellent as poet, orator, and philosopher – that at the upper and lower ends there should be placed the four Seasons of the year – Spring, Summer, Autumn, and Winter – and that each should be set up in that part where its particular season is most felt. At the entrance, on the right hand, beside the Winter, and in that part of the wall which stretches upwards, were to go six figures that were to demonstrate the greatness and goodness of the house of Medici, and to denote that all the virtues are to be found in Duke Cosimo; and these were Justice, Compassion, Valour, Nobility, Wisdom, and Liberality, which have always dwelt in the house of Medici, and are all united together at the present day in the most excellent Lord Duke, in that he is just, compassionate, valorous, noble, wise, and liberal. And because these qualities have made the city of Florence, as they still do, strong in laws, peace, arms, science, wisdom, tongues, and arts, and also because the said Lord Duke is just in the laws, compassionate in peace, valorous in arms, noble through the sciences, wise in his encouragement of tongues and other culture, and liberal to the arts, Tribolo wished that on the other side from the Justice, Compassion, Valour, Nobility, Wisdom, and Liberality, on the left hand, as will be seen below, there should be these other figures: Laws, Peace, Arms, Sciences, Tongues, and Arts. And it was most appropriately arranged that in this manner these statues and images should be placed, as they would have been, above the Arno and Mugnone, in order to signify that they do honour to Florence. It was also proposed that in the pediments there should be placed portrait-busts of men of the house of Medici, one in each – over Justice, for example, the portrait of his Excellency, that being his particular virtue, over Compassion that of the Magnificent Giuliano, over Valour Signor Giovanni, over Nobility the elder Lorenzo, over Wisdom the elder Cosimo or Clement VII, and over Liberality Pope Leo. And

in the pediments on the other side it was suggested that there might be placed other heads from the house of Medici, or of persons of the city connected with that house. But since these names make the matter somewhat confused, they have been placed here in the following order:

SUMMER. THE MUGNONE. GATE. THE ARNO. SPRING.

ARTS.				LIBERALITY.
TONGUES.				WISDOM.
SCIENCES.	LOGGIA.		LOGGIA.	NOBILITY.
ARMS.				VALOUR.
PEACE.				COMPASSION.
LAWS.				JUSTICE.

AUTUMN. GATE. LOGGIA. GATE. WINTER.

All these ornaments would have made this in truth the richest, the most magnificent, and the most ornate garden in Europe; but these works were not carried to completion, for the reason that Tribolo was not able to take measures to have them finished while the Duke was in the mind to continue them, as he might have done in a short time, having men in abundance and the Duke ready to spend money, and not suffering from those hindrances that afterwards stopped him. The Duke, indeed, not being contented at that time with the great quantity of water that is to be seen there, was thinking of trying to obtain the water of Valcenni, which is very abundant, in order to join it with the rest, and then to conduct it from Castello by an aqueduct similar to the one which he had made to the Piazza in front of his Palace in Florence. And of a truth, if this work had been pressed forward by a man with greater energy and more desire of glory, it would have been carried at least well on; but since Tribolo, besides that he was much occupied with various affairs of the Duke's, had not much energy, nothing more was done. And in all the time that he worked at Castello, he did not execute with his own hand anything save the two fountains, with the two rivers, the Arno and the Mugnone, and the statue of Fiesole; this arising from no other cause, so far as one can see, but his being too much occupied, as has been related, with the many affairs of the Duke.

Among other things, the Duke caused him to make a bridge over the River Mugnone on the high road that goes to Bologna,

without the Porta a S. Gallo. This bridge, since the river crosses the road obliquely, Tribolo caused to be built with an arch like-wise oblique, in accordance with its oblique line across the river, which was a new thing, and much extolled, above all because he had the arch put together of stones cut on the slant on every side in such a manner that it proved to be very strong and very graceful; in short, this bridge was a very beautiful work.

Not long before, the Duke had been seized with a desire to make a tomb for Signor Giovanni de' Medici, his father, and Tribolo, being eager to have the commission, made a very beau-tiful model for it, in competition with one that had been executed by Raffaello da Montelupo, who had the favour of Francesco di Sandro, the master of arms to his Excellency. And then, the Duke having resolved that the one to be put into execution should be Tribolo's, he went off to have the marble quarried at Carrara, where he also caused to be quarried the two basins for the loggie at Castello, a table, and many other blocks of marble. Meanwhile, Messer Giovan Battista da Ricasoli, now Bishop of Pistoia, being in Rome on business of the Lord Duke's, he was sought out by Baccio Bandinelli, who had just finished the tombs of Pope Leo X and Clement VII in the Minerva; and he was asked by Baccio to recommend him to his Excellency. Where-upon Messer Giovan Battista wrote to the Duke that Bandinelli desired to serve him, and his Excellency wrote in reply that on his return he should bring him in his company. And Bandinelli, having therefore arrived in Florence, so haunted the Duke in his audacity, making promises and showing him designs and models, that the tomb of the above-named Signor Giovanni, which was to have been made by Tribolo, was allotted to him; and so, taking some pieces of marble of Michelagnolo's, which were in the Via Mozza in Florence, he hacked them about without scruple and began the work. Wherefore Tribolo, on returning from Carrara, found that in consequence of his being too leisurely and good-natured, the commission had been taken away from him.

In the year when bonds of kinship were formed between the Lord Duke Cosimo and the Lord Don Pedro di Toledo, Marquis of Villafranca, at that time Viceroy of Naples, the Lord Duke taking Don Pedro's daughter, Signora Leonora, to wife, prepara-tions were made in Florence for the nuptials, and Tribolo was given the charge of constructing a triumphal arch at the Porta al Prato, through which the bride, coming from Poggio, was to

enter; which arch he made a thing of beauty, very ornate with columns, pilasters, architraves, great cornices, and pediments. That arch was to be all covered with figures and scenes, in addition to the statues by the hand of Tribolo; and all those paintings were executed by Battista Franco of Venice, Ridolfo Ghirlandajo, and Michele, his disciple. Now the principal figure that Tribolo made for this work, which was placed at the highest point in the centre of the pediment, on a dado wrought in relief, was a woman five braccia high, representing Fecundity, with five little boys, three clinging to her legs, one on her lap, and another in her arms; and beside her, where the pediment sloped away, were two figures of the same size, one on either side. Of these figures, which were lying down, one was Security, leaning on a column with a light wand in her hand, and the other was Eternity, with a globe in her arms, and below her feet a white-haired old man representing Time, and holding in his arms the Sun and Moon. I shall say nothing as to the works of painting that were on that arch, because everyone may read about them for himself in the description of the festive preparations for those nuptials. And since Tribolo had particular charge of all decorations for the Palace of the Medici, he caused many devices to be executed in the lunettes of the vaulting of the court, with mottoes appropriate to the nuptials, and all those of the most illustrious members of the house of Medici. Besides this, he had a most sumptuous decoration made in the great open court, all full of stories; on one side of the Greeks and Romans, and on the other sides of deeds done by illustrious men of that house of Medici, which were all executed under the direction of Tribolo by the most excellent young painters that there were in Florence at that time – Bronzino, Pier Francesco di Sandro, Francesco Il Bacchiacca, Domenico Conti, Antonio di Domenico, and Battista Franco of Venice.

On the Piazza di S. Marco, also, upon a vast pedestal ten braccia in height (in which Bronzino had painted two very beautiful scenes of the colour of bronze on the socle that was above the cornices), Tribolo erected a horse of twelve braccia, with the fore-legs in the air, and upon it an armed figure, large in proportion; and this figure, which had below it men dead and wounded, represented the most valorous Signor Giovanni de' Medici, the father of his Excellency. This work was executed by Tribolo with so much art and judgment, that it was admired by all who saw it,

and what caused even greater marvel was the speed with which he finished it; among his assistants being the sculptor Santi Buglioni, who was crippled for ever in one leg by a fall, and came very near dying.

Under the direction of Tribolo, likewise, for the comedy that was performed, Aristotile da San Gallo executed marvellous scenery, being truly most excellent in such things, as will be told in his Life; and for the costumes in the interludes, which were the work of Giovan Battista Strozzi, who had charge of the whole comedy, Tribolo himself made the most pleasing and beautiful inventions that it is possible to imagine in the way of vestments, buskins, head-dresses, and other wearing apparel. These things were the reason that the Duke afterwards availed himself of Tribolo's ingenuity in many fantastic masquerades, as in that of the bears, in a race of buffaloes, in the masquerade of the ravens, and in others.

In like manner, in the year when there was born to the said Lord Duke his eldest son, the Lord Don Francesco, there was to be made in the Temple of S. Giovanni in Florence a very magnificent decoration which was to be marvellous in its grandeur, and capable of accommodating one hundred most noble young maidens, who were to accompany the Prince from the Palace as far as the said temple, where he was to receive baptism. The charge of this was given to Tribolo, who, in company with Tasso, adapting himself to the place, brought it about that the temple, which in itself is ancient and very beautiful, had the appearance of a new temple designed very well in the modern manner, with seats all round it richly adorned with pictures and gilding. In the centre, beneath the lantern, he made a great vase of carved wood-work with eight sides, the base of which rested on four steps, and at the corners of the eight sides were some large caulicoles, which, springing from the ground, where there were some lions' paws, had at the top of them certain children of large size in various attitudes, who were holding with their hands the lip of the vase, and supporting with their shoulders some festoons which hung like a garland right round the space in the middle. Besides this, Tribolo had made in the middle of the vase a pedestal of wood with beautiful things of fancy round it, upon which, to crown the work, he placed the S. John the Baptist of marble, three braccia high, by the hand of Donatello, which was left by him in the house of Gismondo Martelli, as has been related in

the Life of Donatello himself. In short, this temple was adorned both within and without as well as could possibly be imagined, and the only part neglected was the principal chapel, where there is an old tabernacle with those figures in relief that Andrea Pisano made long ago; by reason of which it appeared that, every other part being made new, that old chapel spoilt all the grace that the other things together displayed. Wherefore the Duke, going one day to see those decorations, after praising everything like a man of judgment, and recognizing how well Tribolo had adapted himself to the situation and to every other feature of the place, censured one thing only, but that severely – that no thought had been given to the principal chapel. And then he ordained on the spot, like a person of resolute character and beautiful judgment, that all that part should be covered with a vast canvas painted in chiaroscuro, with S. John the Baptist baptizing Christ, and the people standing all around to see them or to be baptized, some taking off their clothes, and others putting them on again, in various attitudes; and above this was to be a God the Father sending down the Holy Spirit, with two fountains in the guise of river-gods, representing the Jor and the Dan, which, pouring forth water, were to form the Jordan. Jacopo da Pontormo was requested to execute this work by Messer Pier Francesco Riccio, at that time major-domo to the Duke, and by Tribolo, but he would not do it, on the ground that he did not think that the time given, which was only six days, would be enough for him; and the same refusal was made by Ridolfo Ghirlandajo, Bronzino, and many others. Now at this time Giorgio Vasari, having returned from Bologna, was executing for Messer Bindo Altoviti the altar-piece of his chapel in S. Apostolo at Florence, but he was not held in much consideration, although he had friendship with Tribolo and Tasso, because certain persons had formed a faction under the protection of the above-named Messer Pier Francesco Riccio, and whoever was not of that faction had no share in the favours of the Court, although he might be able and deserving. This was the reason that many who, with the aid of so great a Prince, would have become excellent, found themselves neglected, none being employed save those chosen by Tasso, who, being a gay person, got Riccio so well under his thumb with his jokes, that in certain affairs he neither proposed nor did anything save what was suggested by Tasso, who was architect to the Palace and did all the work. These men, then, having a sort of

suspicion of Giorgio, who laughed at their vanities and follies, and sought to make a position for himself rather by means of the studies of art than by favour, gave no thought to his claims; but he was commissioned by the Lord Duke to execute that canvas, with the subject described above. This work he executed in chiaroscuro, in six days, and delivered it finished in the manner known to those who saw what grace and adornment it conferred on the whole decoration, and how much it enlivened that part of the temple that stood most in need of it, amid the magnificence of that festival. Tribolo, then (to return to the point whence, I know not how, I digressed), acquitted himself so well, that he rightly won the highest praise; and the Duke commanded that a great part of the ornaments that he placed between the columns should be left there, where they still are, and deservedly.

For the Villa of Cristofano Rinieri at Castello, while he was occupied with the fountains of the Duke, Tribolo made for a niche over a fish-pond which is at the head of a fowling-place, a river-god of grey-stone, of the size of life, which pours water into a very large basin of the same stone; which figure is made of pieces, and put together with such diligence and art, that it appears to be all of one block. Tribolo then set his hand, at the command of his Excellency, to attempting to finish the staircase of the library of S. Lorenzo – that, namely, which is in the vestibule before the door; but after he had placed four steps in position, not finding either the plan or the measurements of Michelagnolo, by order of the Duke he went to Rome, not only to hear the opinion of Michelagnolo with regard to that staircase, but also to make an effort to bring him to Florence. But he did not succeed either in the one object or in the other, for Michelagnolo, not wishing to leave Rome, excused himself in a handsome manner, and as for the staircase he declared that he remembered neither the measurements nor anything else. Tribolo, therefore, having returned to Florence, and not being able to continue the work of that staircase, set himself to make the pavement of the said library with white and red bricks, after the manner of some pavements that he had seen in Rome; but he added a filling of red clay to the white clay mixed with bole, in order to produce various effects of carving in those bricks; and thus he made in that pavement a copy of the ceiling and coffered work above – a notion that was highly extolled. He then began, but did not finish, a work that was to be placed on the main

tower of the defences of the Porta a Faenza, for Don Giovanni di Luna, the castellan at that time – namely, an escutcheon of grey-stone, and a large eagle in full relief with two heads, which he made in wax to the end that it might be cast in bronze, but nothing more was done with it, and of the escutcheon only the shield was finished.

Now it was the custom in the city of Florence to have almost every year on the principal piazza, on the evening of the festival of S. John the Baptist, towards nightfall, a girandola – that is, a contrivance full of fire-trumpets, rockets, and other fireworks; which girandola had the form now of a temple, now of a ship, sometimes of rocks, and at times of a city or of an inferno, according as it pleased the designer; and one year the charge of making one was given to Tribolo, who, as will be described below, made it very beautifully. Of the various manners of these fireworks, and particularly of set pieces, Vannoccio of Siena and others give an account, and on this subject I shall enlarge no further; but I must say something as to the nature of these girandole. The whole structure, then, is of wood, with broad compartments radiating outwards from the foot, to the end that the rockets, when they have been lighted, may not set fire to the other fireworks, but may rise in due order from their separate places, one after another, filling the heavens in proper succession with the fire that blazes in the girandola both above and below. They are distributed, I say, at wide intervals, to the end that they may not burn all at once, and may produce a beautiful effect; and the same do the mortars, which are bound to the firm parts of the girandola, and make the most beautiful and joyous noises. The fire-trumpets, likewise, are fitted in among the ornaments, and are generally contrived so as to discharge through the mouths of masks and other suchlike things. But the most important point is to arrange the girandola in such a manner that the lights that burn in certain vases may last the whole night, and illuminate the piazza; wherefore the whole work is connected together by a simple match of tow steeped in a mixture of powder full of sulphur and aquavitæ, which creeps little by little with its fire to every part which it has to set alight, one after another, until it has kindled the whole. Now, as I have said, the things represented are various, but all must have something to do with fire, and must be subject to its action; and long before this there had been counterfeited the city of Sodom, with Lot and his daughters

flying from it, at another time Geryon, with Virgil and Dante on his back, according as Dante himself relates in the *Inferno*, and even earlier Orpheus bringing Eurydice with him from those infernal regions, with many other inventions. And his Excellency ordained that the work should not be given to any of the puppet-painters, who for many years past had made a thousand absurdities in the girandole, but that an excellent master should produce a work that might have in it something of the good; wherefore the charge of this was given to Tribolo, who, with the ingenuity and art wherewith he had executed all his other works, made one in the form of a very beautiful octagonal temple, rising with its ornaments to the total height of twenty braccia. This temple he represented as the Temple of Peace, placing on the summit an image of Peace, who was setting fire to a great pile of arms which she had at her feet; and these arms, the statue of Peace, and all the other figures that made this structure one of great beauty, were made of paste-board, clay, and cloth steeped in glue, put together with extraordinary art. They were, I say, of these materials, to the end that the whole work might be the lighter, since it was to be suspended at a great height from the ground by a double rope that crossed the piazza high in the air. It is true, indeed, that the fireworks having been placed in it too thickly, and the fuses of tow being too near one to another, when they were set alight, such was the fury of the conflagration, and so great and so violent the blaze, that everything caught fire all at once, and was burned in a flash, whereas it should have continued to burn for an hour at least; and what was worse, the fire seizing on the woodwork and on all that should have been preserved, the ropes and every other thing were consumed in a moment, which was no small loss, and gave little pleasure to the people. But with regard to workmanship, it was more beautiful than any other girandola that had ever been made up to that time.

The Duke, then, resolving to erect the Loggia of the Mercato Nuovo for the convenience of his citizens and merchants, did not wish to lay a greater burden than he could bear on Tribolo, who, as chief engineer to the Capitani di Parte and the commissioners of the rivers and the sewers of the city, was always riding through the Florentine dominions, engaged in bringing back to their proper beds many rivers that did damage by breaking away from them, in repairing bridges, and in other suchlike works; and he gave the charge of this enterprise to Tasso, at the advice of the

above-mentioned Messer Pier Francesco, his major-domo, in order to change that Tasso from a carpenter into an architect. This was certainly against the wishes of Tribolo, although he did not show it, and even acted as the close friend of Tasso; and a proof that this is true is that Tribolo perceived many errors in Tasso's model, but, so it is believed, would by no means tell him of them. Such an error, for example, was that of the capitals of the columns that are beside the pilasters, whereby, the columns not leaving enough space, when everything had been drawn up, and the capitals had to be set into position, the corona above those capitals would not go in, so that it was found necessary to cut away so much that the order of the architecture was ruined; besides many other errors, of which there is no need to speak. For the above-named Messer Pier Francesco the same Tasso executed the door of the Church of S. Romolo, and a window with knee-shaped brackets on the Piazza del Duca, in an order of his own, substituting capitals for bases, and doing so many other things without measure or order, that it might have been said that the German Order had begun to return to life in Tuscany by means of this man; to say nothing of the works that he did in the Palace in the way of staircases and apartments, which the Duke has been obliged to have destroyed, because they had no sort of order, measure, or proportion, and were, on the contrary, all shapeless, out of square, and without the least convenience or grace. All these things were not done without some responsibility falling on Tribolo, who, having considerable knowledge in such matters, should not, so it seemed, have allowed his Prince to throw away his money and to do him such an affront to his face; and, what was even more serious, he should not have permitted such things to Tasso, who was his friend. Well did men of judgment recognize the presumption and madness of the one in seeking to exercise an art of which he knew nothing, and the dissimulation of the other, who declared that he was pleased with that which he certainly knew to be bad; and of this a proof may be found in the works that Giorgio Vasari has had to pull down in the Palace, to the loss of the Duke and the great shame of those men.

But the same thing happened to Tribolo as to Tasso, in that, even as Tasso abandoned wood-carving, a craft in which he had no equal, but never became a good architect, and thus won little honour by deserting an art in which he was very able, and

applying himself to another of which he knew not one scrap, so Tribolo, abandoning sculpture, in which it may be said with truth that he was most excellent and caused everyone to marvel, and setting himself to attempt to straighten out rivers, ceased to win honour by pursuing the one, while the other brought him blame and loss rather than honour and profit. For he did not succeed in his tinkering with rivers, and he made many enemies, particularly in the district of Prato, on account of the Bisenzio, and in many places in the Val di Nievole.

Duke Cosimo having then bought the Palace of the Pitti, of which there has been an account in another place, and his Excellency desiring to adorn it with gardens, groves, fountains, fishponds, and other suchlike things, Tribolo executed all the distribution of the hill in the manner in which it still remains, accommodating everything in its proper place with beautiful judgment, although various things in many parts of the garden have since been changed. Of this Pitti Palace, which is the most beautiful in Europe, mention will be made in another place with a more suitable occasion.

After these things, Tribolo was sent by his Excellency to the island of Elba, not only that he might see the city and port that the Duke had caused to be built there, but also that he might make arrangements for the transport of a round piece of granite, twelve braccia in diameter, from which was to be made a tazza for the great lawn of the Pitti Palace, which might receive the water of the principal fountain. Tribolo, therefore, went thither and caused a boat to be made on purpose for transporting the tazza, and then, after giving the stone-cutters directions for the transportation, he returned to Florence; where he had no sooner arrived, than he found the whole country full of murmurings and maledictions against him, since about that time floods and inundations had done infinite havoc in the neighbourhood of those rivers that he had patched up, although it was, perhaps, not altogether through his fault that this had happened. However that may have been, whether it was the malignity of some of his assistants, or perchance envy, or that the accusation was indeed true, the blame for all that damage was laid on Tribolo, who, being a man of no great spirit, and rather wanting in resolution than otherwise, and doubting that the malice of some enemy might make him lose the favour of the Duke, was in a state of great despondency, when, being of a feeble habit of body, on the

20th of August in the year 1550, there came upon him a most
violent fever. At that time Giorgio Vasari was in Florence, for
the purpose of having sent to Rome the marbles for the tombs
that Pope Julius III caused to be erected in S. Pietro a Montorio;
and he, as one who sincerely esteemed the talents of Tribolo,
visited and comforted him, beseeching him that he should think
of nothing save his health, and that, when cured, he should return
to finish the work of Castello, letting the rivers go their own way,
for they were more likely to drown his fame than to bring him
any profit or honour. This, which he promised to attempt to do,
he would, I believe, have done at all costs, if he had not been
prevented by death, which closed his eyes on the 7th of Septem-
ber in the same year. And so the works of Castello, begun and
carried well forward by him, remained unfinished; for although
some work has been done there since his day, now in one part
and now in another, nevertheless they have never been pursued
with the diligence and resolution that were shown when Tribolo
was alive and when the Lord Duke was hot in the undertaking.
Of a truth, he who does not press great works forward while
those who are having them done are spending money willingly
and devoting their best attention to them, brings it about that
those works are put on one side and left unfinished, which zeal
and solicitude could have carried to perfection. And thus, by the
negligence of the workers, the world is left without its adorn-
ment, and they without their honour and fame, for the reason
that it rarely happens, as it did to this work of Castello, that on
the death of the first master he who succeeds to his place is
willing to finish it according to his design and model with that
modesty with which Giorgio Vasari, at the commission of the
Duke, has caused the great fish-pond of Castello to be finished
after the directions of Tribolo, even as he will do with the other
things according as his Excellency may desire from time to time
to have them done.

Tribolo lived sixty-five years, and was interred by the Com-
pany of the Scalzo in their place of burial. He left behind him a
son called Raffaello, who has not taken up art, and two daughters,
one of whom is the wife of David, Tribolo's assistant in building
all the works at Castello, who, being a man of judgment and
capable in such matters, is now employed on the aqueducts of
Florence, Pisa, and all the other places in the dominion, accord-
ing as it may please his Excellency.

PIERINO (PIERO) DA VINCI, Sculptor

Although those men are generally the most celebrated who have executed some work excellently well, nevertheless, if the works already accomplished by any man foreshadow those that he did not achieve as likely to have been numerous and much more rare, if some accident, unforeseen and out of the common use, had not happened to interrupt him, it is certain that such a man, wherever there may be one willing to be just in his appreciation of the talent of another, will be rightly extolled and celebrated both on the one count and on the other, and as much for what he would have done as for what he did. The sculptor Vinci, therefore, should not suffer on account of the short duration of his life, or be robbed thereby of the praise due to him from the judgment of those who shall come after us, considering that he was only in the first bloom both of his life and of his studies at the time when he produced and gave to the world that which everyone admires, and was like to bring forth fruits in greater abundance, if a hostile tempest had not destroyed both the fruits and the tree.

I remember having said in another place that in the township of Vinci, in the lower Valdarno, there lived Ser Piero, the father of Leonardo da Vinci, most famous of painters. To this Ser Piero, after Leonardo, there was born, as his youngest son, Bartolommeo, who, living at Vinci and attaining to manhood, took for his wife one of the first maidens of that township. Bartolommeo was desirous of having a male child, and spoke very often to his wife of the greatness of the genius with which his brother Leonardo had been endowed, praying God that He should make her worthy that from her there might be born in his house another Leonardo, the first being now dead. In a short time, therefore, according to his desire, there was born to him a gracious boy, to whom he wished to give the name of Leonardo; but, being advised by his relatives to revive the memory of his father, he gave him the name of Piero. Having come to the age of three years, the boy had a most beautiful countenance, with curly locks, and showed great grace in every movement, with a quickness of intelligence that was marvellous; insomuch that Maestro Giuliano del Carmine, an excellent astrologer, and with him a priest devoted to chiromancy, who were both close friends of Bartolommeo,

having arrived in Vinci and lodged in Bartolommeo's house, looking at the forehead and hand of the boy, revealed to the father, both the astrologer and the chiromancer together, the greatness of his genius, and predicted that in a short time he would make extraordinary proficience in the mercurial arts, but that his life would also be very short. And only too true was their prophecy, for both in the one part and in the other (when one would have sufficed), in his life as well as in his art, it needs must be fulfilled.

Then, continuing to grow, Piero had his father as his master in letters, but of himself, without any master, giving his attention to drawing and to making various little puppets in clay, he showed that the divine inclination of his nature recognized by the astrologer and the chiromancer was already awakening and beginning to work in him. By reason of which Bartolommeo judged that his prayer had been heard by God; and, believing that his brother had been restored to him in his son, he began to think of removing Piero from Vinci and taking him to Florence. Having then done this without delay, he placed Piero, who was now twelve years of age, with Bandinelli in Florence, flattering himself that Baccio, having been once the friend of Leonardo, would take notice of the boy and teach him with diligence; besides which, it seemed to him that Piero delighted more in sculpture than in painting. But afterwards, coming very often to Florence, he recognized that Bandinelli was not answering with deeds to his expectations, and was not taking pains with the boy or showing interest in him, although he saw him to be willing to learn. For which reason Bartolommeo took him away from Bandinelli, and entrusted him to Tribolo, who appeared to him to make more effort to help those who were seeking to learn, besides giving more attention to the studies of art and bearing even greater affection to the memory of Leonardo.

Tribolo was executing some fountains at Castello, the villa of his Excellency; and thereupon Piero, beginning once more his customary drawing, through having there the competition of the other young men whom Tribolo kept about him, set himself with great ardour of spirit to study day and night, being spurred by his nature, which was desirous of excellence and honour, and being even more kindled by the example of the others like himself whom he saw constantly around him. Wherefore in a few months he made such progress, that it was a marvel to everyone; and,

having begun to gain some experience with the chisels, he sought to see whether his hand and his tools would obey in practice the thoughts within him and the designs formed in his brain. Tribolo, perceiving his readiness, and having had a water-basin of stone made at that very time for Cristofano Rinieri, gave to Piero a small piece of marble, from which he was to make for that water-basin a boy that should spurt forth water from the private part. Piero, taking the marble with great gladness, first made a little model of clay, and then executed the work with so much grace, that Tribolo and the others ventured the opinion that he would become one of those who are counted as rare in that art. Tribolo then gave him a Ducal Mazzocchio* to make in stone, to be placed over an escutcheon with the Medici balls, for Messer Pier Francesco Riccio, the major-domo of the Duke; and he made it with two children with their legs intertwined together, who are holding the Mazzocchio in their hands and placing it upon the escutcheon, which is fixed over the door of a house that the major-domo then occupied, opposite to S. Giuliano, near the Priests of S. Antonio. When this work was seen, all the craftsmen of Florence formed the same judgment that Tribolo had pronounced before.

After this, he carved a boy squeezing a fish that is pouring water from its mouth, for the fountains of Castello. And then, Tribolo having given him a larger piece of marble, Piero made from it two children who are embracing each other and squeezing fishes, causing water to spout from their mouths. These children were so graceful in the heads and in their whole persons, and executed with so beautiful a manner in the legs, arms, and hair, that already it could be seen that he would have been able to execute the most difficult work to perfection. Taking heart, there-fore, and buying a piece of grey-stone, two braccia and a half in length, which he took to his house on the Canto alla Briga, Piero began to work at it in the evenings, after returning from his labours, at night, and on feast-days, insomuch that little by little he brought it to completion. This was a figure of Bacchus, who had a Satyr at his feet, and with one hand was holding a cup, while in the other he had a bunch of grapes, and his head was girt with a crown of grapes; all after a model made by himself in clay. In this and in his other early works Piero showed a marvel-lous facility, which never offends the eye, nor is it in any respect

* See note on p. 282, Vol. I.

disturbing to him who beholds it. This Bacchus, when finished, was bought by Bongianni Capponi, and his nephew Lodovico Capponi now has it in a courtyard in his house.

The while that Piero was executing these works, few persons as yet knew that he was the nephew of Leonardo da Vinci; but his labours making him well known and renowned, by this means his parentage and his birth were likewise revealed. Wherefore ever afterwards, both from his connection with his uncle and from his own happy genius, wherein he resembled that great man, he was called by everyone not Piero, but Vinci.

Now Vinci, while occupied in this manner, had often heard various persons speaking of the things connected with the arts to be seen in Rome, and extolling them, as is always done by everyone; wherefore a great desire had been kindled in him to see them, hoping to be able to derive profit by beholding not only the works of the ancients, but also those of Michelagnolo, and even the master himself, who was then alive and residing in Rome. He went thither, therefore, in company with some friends; but after seeing Rome and all that he wished, he returned to Florence, having reflected judiciously that the things of Rome were as yet too profound for him, and should be studied and imitated not so early in his career, but after a greater acquaintance with art.

At that time Tribolo had finished a model for the shaft of the fountain in the labyrinth, in which are some Satyrs in low-relief, four masks in half-relief, and four little boys in the round, who are seated upon certain caulicoles. Vinci having then returned, Tribolo gave him this shaft to do, and he executed and finished it, making in it some delicate designs not employed by any other but himself, which greatly pleased all who saw them. Then, having had the whole marble tazza of that fountain finished, Tribolo thought of placing on the edge of it four children in the round, lying down and playing with their arms and legs in the water, in various attitudes; and these he intended to cast in bronze. Vinci, at the commission of Tribolo, made them of clay, and they were afterwards cast in bronze by Zanobi Lastricati, a sculptor and a man very experienced in matters of casting; and they were placed not long since around the fountain, where they make a most beautiful effect.

There was in daily intercourse with Tribolo one Luca Martini, the proveditor at that time for the building of the Mercato Nuovo, who, praising highly the excellence in art and the fine

character of Vinci, and desiring to help him, provided him with a piece of marble two-thirds of a braccio in height and one and a quarter in length. Vinci, taking the marble, made with it a Christ being scourged at the Column, in which the rules of low-relief and of design may be seen to have been well observed; and in truth it made everyone marvel, considering that he had not yet reached the age of seventeen, and had made in five years of study that proficience in art which others do not achieve save after length of life and great experience of many things.

At this time Tribolo, having undertaken the office of superintendent of the drains in the city of Florence, ordained in that capacity that the drain in the old Piazza di S. Maria Novella should be raised from the ground, in such a way that, becoming more capacious, it might be better able to receive all the waters that ran into it from various quarters. For this work, then, he commissioned Vinci to make the model of a great mask of three braccia, which with its open mouth might swallow all the rainwater. Afterwards, by order of the Ufficiali della Torre, the work was allotted to Vinci, who, in order to execute it more quickly, summoned to his aid the sculptor Lorenzo Marignolli. In company with this master he finished it, making it from a block of hard-stone; and the work is such that it adorns the whole Piazza, with no small advantage to the city.

It now appeared to Vinci that he had made such proficience in art, that it would be a great benefit to him to see the principal works in Rome, and to associate with the most excellent craftsmen living there; wherefore, an occasion to go there presenting itself, he seized it readily. There had arrived from Rome an intimate friend of Michelagnolo Buonarroti, Francesco Bandini, who, having come to know Vinci by means of Luca Martini, and having praised him highly, caused him to make a model of wax for a tomb of marble that he wished to erect in his chapel in S. Croce; and shortly afterwards, on returning to Rome, Vinci having spoken his mind to Luca Martini, Bandini took him in his company. There Vinci remained a year, studying all the time, and executed some works worthy of remembrance. The first was a Christ on the Cross in low-relief, rendering up His spirit to His Father, which was copied from a design done by Michelagnolo. For Cardinal Ridolfi he added to an antique head a breast in bronze, and made a Venus of marble in low-relief, which was much extolled. For Francesco Bandini he restored an ancient

horse, of which many pieces were wanting, and made it complete. And in order to give some proof of gratitude, where he could, to Luca Martini, who was writing to him by every courier, and continually recommending him to Bandini, it seemed good to Vinci to make a copy in wax, in the round and two-thirds (of a braccio) in height, of the Moses of Michelagnolo that is on the tomb of Pope Julius II in S. Pietro in Vincula, than which there is no more beautiful work to be seen; and so, having made the Moses of wax, he sent it as a present to Luca Martini.

At the time when Vinci was living in Rome and executing the works mentioned above, Luca Martini was made by the Duke of Florence proveditor of Pisa, and in his office he did not forget his friend, and therefore wrote to him that he was preparing a room for him and was providing a block of marble of three braccia, so that he might return from Rome at his pleasure, seeing that while with him he should want for nothing. Vinci, attracted by this prospect and by the love that he bore to Luca, resolved to depart from Rome and to take up his abode for some time in Pisa, where he looked to find opportunities of practising his hand and making trial of his ability. Having therefore gone to Pisa, he found that the marble was already in his room, prepared according to the orders of Luca; but, on proceeding to begin to carve from it an upright figure, he perceived that the marble had in it a crack that diminished it by a braccio. Wherefore, having resolved to change it into a recumbent figure, he made a young River God holding a vase that is pouring out water, the vase being upheld by three children, who are assisting the River God to pour the water forth; and beneath his feet runs a copious stream of water, in which may be seen fishes darting about and water-fowl flying in various parts. This River God finished, Vinci made a present of it to Luca, who presented it to the Duchess, to whom it was very dear; and then, her brother Don Garzia di Toledo being at that time in Pisa, whither he had gone by galley, she gave it to that brother, who accepted it with much pleasure for the fountains of his garden in the Chiaia at Naples.

In those days Luca Martini was writing some observations on the Commedia of Dante, and he pointed out to Vinci the cruelty described by Dante, which the Pisans and Archbishop Ruggieri showed towards Count Ugolino della Gherardesca, causing him to die of hunger with his four sons in the tower that is therefore called the Tower of Hunger; whereby he offered to Vinci the

occasion for a new work and the idea of a new design. Wherefore, while he was still working at the River God described above, he set his hand to making a scene in wax more than a braccio in height and three-quarters in breadth, to be cast in bronze, in which he represented two of the Count's sons already dead, one in the act of expiring, and the fourth overcome by hunger and near his end, but not yet reduced to the last breath; with the father in a pitiful and miserable attitude, blind and heavy with grief, and groping over the wretched bodies of his sons stretched upon the ground. In this work Vinci displayed the excellence of design no less than did Dante the perfection of poetry in his verses, for no less compassion is stirred by the attitudes shaped in wax by the sculptor in him who beholds them, than is roused in him who listens to the words and accents imprinted on the living page by the poet. And in order to mark the place where the event happened, he made at the foot of the scene the River Arno, which occupies its whole width, for the above-named tower is not far distant from the river in Pisa; while upon that tower he placed an old woman, naked, withered, and fearsome, representing Hunger, much after the manner wherein Ovid describes her. The wax model finished, he cast the scene in bronze, and it gave consummate satisfaction, being held by the Court and by everyone to be no ordinary work.

Duke Cosimo was then intent on enriching and beautifying the city of Pisa, and he had already caused the Piazza del Mercato to be built anew, with a great number of shops around it, and had placed in the centre a column ten braccia high, upon which, according to the design of Luca, was to stand a statue representing Abundance. Martini, therefore, having spoken to the Duke and presented Vinci to his notice, easily obtained for him from his Excellency the commission for that statue, the Duke being always eager to assist men of talent and to bring fine intellects forward. Vinci executed a statue of travertine, three braccia and a half in height, which was much extolled by everyone; for at the feet of the figure he placed a little child, who assists her to support the Cornucopia, carved with much softness and facility, although the stone is rough and difficult to work.

Luca afterwards sent to Carrara to have a block of marble quarried five braccia in height and three in breadth, from which Vinci, who had once seen some sketches by Michelagnolo of

Samson slaying a Philistine with the jawbone of an ass, proposed to make two figures of five braccia from his own fancy, after that subject. Whereupon, while the marble was on its way, he set himself to make several models, all varying one from another, and then fixed on one of them; and after the block had arrived he began to carve it, and carried it well on, imitating Michelagnolo in cutting his conception and design little by little out of the stone, without spoiling it or making any sort of error. He executed all the perforation in this work, whether undercut or at an easy angle, with great facility, laborious as it was, and the manner of the whole work was very delicate. But since the labour was very fatiguing, he sought to distract himself with other studies and works of less importance; and thus he executed during the same time a little tablet of marble in low-relief, in which he represented Our Lady with Christ, S. John, and S. Elizabeth, which was held, as it still is, to be a rare work. This came into the hands of the most illustrious Duchess, and it is now among the choice things in the study of the Duke.

He then set his hand to a scene of marble, one braccio high and one and a half wide, partly in half-relief and partly in low-relief, in which he represented the restoration of Pisa by the Duke, who is in the work present in person at the restoration of that city, which is being pressed forward by his presence. Round the Duke are figures of his virtues; in particular a Minerva representing his wisdom and also the arts revived by him in that city of Pisa, who is surrounded by many evils and natural defects of the site, which besiege her on every side, and afflict her in the manner of enemies; but from all these that city has since been delivered by the above-mentioned virtues of the Duke. All these virtues round the Duke, with all the evils round Pisa, were portrayed by Vinci in his scene with most beautiful gestures and attitudes; but he left it unfinished, to the great regret of those who saw it, on account of the perfection of the things in it that were completed.

The fame of Vinci having grown and spread abroad by reason of these works, the heirs of Messer Baldassarre Turini da Pescia besought him that he should make a model of a marble tomb for Messer Baldassarre; which finished, it pleased them, whereupon they made an agreement that the tomb should be executed, and Vinci sent Francesco del Tadda, an able master of marble-carving, to have the marble quarried at Carrara. And when that

master had sent him a block of marble, Vinci began a statue, and carved out of the stone a figure blocked out in such a manner that one who knew not the circumstances would have said that it was certainly blocked out by Michelagnolo.

The name of Vinci was now very great, and his genius was admired by all, being much more perfect than could have been expected in one so young, and it was likely to grow even more and to become greater, and to equal that of any other man in his art, as his own works bear witness, without any other testimony; when the term prescribed for him by Heaven, being now close at hand, interrupted all his plans, and caused his rapid progress to cease at one blow, not suffering that he should climb any higher, and depriving the world of many excellent works of art with which, had Vinci lived, it would have been adorned. It happened at this time, while Vinci was intent on the tomb of another, not knowing that his own was preparing, that the Duke had to send Luca Martini to Genoa on affairs of importance; and Luca, both because he loved Vinci and wished to have him in his company, and also in order to give him some diversion and recreation, and to enable him to see Genoa, took him with him on his journey. There, while Martini was transacting his business, at his suggestion Messer Adamo Centurioni commissioned Vinci to execute a figure of S. John the Baptist, of which he made the model. But soon he was attacked by fever, and, to increase his distress, at the same time his friend was also taken away from him; perchance to provide a way in which fate might be fulfilled in the life of Vinci. For it became necessary that Luca, in the interests of the business entrusted to him, should go to Florence to find the Duke; wherefore he parted from his sick friend, to the great grief of both the one and the other, leaving him in the house of the Abate Nero, to whom he straitly recommended him, although Piero was very unwilling to remain in Genoa. But Vinci, feeling himself growing worse every day, resolved to have himself removed from Genoa; and, having caused an assistant of his own, called Tiberio Cavalieri, to come from Pisa, with his help he had himself carried to Livorno by water, and from Livorno to Pisa in a litter. Arriving in Pisa at the twenty-second hour in the evening, all exhausted and broken by the journey, the sea-voyage, and the fever, during the night he had no repose, and the next morning, at the break of day, he passed to the other life, not having yet reached the age of twenty-three.

The death of Vinci was a great grief to all his friends, and to Luca Martini beyond measure; and it grieved all those who had hoped to see from his hands such works as are not often seen. And Messer Benedetto Varchi, who was much the friend of his abilities and of those of every master, afterwards wrote the following sonnet in memory of his fame:

Come potrò da me, se tu non presti
O forza, o tregua al mio gran duolo interno,
Soffrirlo in pace mai, Signor superno,
Che fin quì nuova ognor pena mi desti?
Dunque de' miei più cari or quegli, or questi,
Verde sen voli all' alto Asilo eterno,
Ed io canuto in questo basso inferno
A pianger sempre e lamentarmi resti?
Sciolgami almen tua gran bontade quinci,
Or che reo fato nostro, o sua ventura,
Ch' era ben degno d' altra vita, e gente,
Per far più ricco il cielo, e la scultura
Men bella, e me col buon Martin dolente,
N' ha privi, o pietà, del secondo Vinci.

BACCIO BANDINELLI, Sculptor of Florence

In the days when the arts of design flourished in Florence by the favour and assistance of the elder Lorenzo de' Medici the Magnificent, there lived in the city a goldsmith called Michelagnolo di Viviano of Gaiuole, who worked excellently well at chasing and incavo for enamels and niello, and was very skilful in every sort of work in gold and silver plate. This Michelagnolo had a great knowledge of jewels, and set them very well; and on account of his talents and his versatility all the foreign masters of his art used to have recourse to him, and he gave them hospitality, as well as to the young men of the city, insomuch that his workshop was held to be, as it was, the first in Florence. Of him the Magnificent Lorenzo and all the house of Medici availed themselves; and for the tourney that Giuliano, the brother of that Magnificent Lorenzo, held on the Piazza di S. Croce, he executed with subtle craftsmanship all the ornaments of helmets, crests, and devices. Wherefore he acquired a great name and much

intimacy with the sons of the Magnificent Lorenzo, to whom his work was ever afterwards very dear, and no less useful to him their acquaintance and friendship, by reason of which, and also by the many works that he executed throughout the whole city and dominion, he became a man of substance as well as one of much repute in his art. To this Michelagnolo the Medici, on their departure from Florence in the year 1494, entrusted much plate in silver and gold, which was all kept in safe hiding by him and faithfully preserved until their return, when he was much extolled by them for his fidelity, and afterwards recompensed with rewards.

In the year 1487 there was born to Michelagnolo a son, whom he called Bartolommeo, but afterwards, according to the Florentine custom, he was called by everyone Baccio. Michelagnolo, desiring to leave his son heir to his art and connection, took him into his own workshop in company with other young men who were learning to draw; for that was the custom in those times, and no one was held to be a good goldsmith who was not a good draughtsman and able to work well in relief. Baccio, then, in his first years, gave his attention to design according to the teaching of his father, being assisted no less to make proficience by the competition of the other lads, among whom he chose as his particular companion one called Piloto, who afterwards became an able goldsmith; and with him he often went about the churches drawing the works of the good painters, but also mingling work in relief with his drawing, and counterfeiting in wax certain sculptures of Donato and Verrocchio, besides executing some works in clay, in the round.

While still a boy in age, Baccio frequented at times the workshop of Girolamo del Buda, a common-place painter, on the Piazza di S. Pulinari. There, at one time during the winter, a great quantity of snow had fallen, which had been thrown afterwards by the people into a heap in that piazza; and Girolamo, turning to Baccio, said to him jestingly: 'Baccio, if this snow were marble, could we not carve a fine giant out of it, such as a Marforio lying down?' 'We could so,' answered Baccio, 'and I suggest that we should act as if it were marble.' And immediately, throwing off his cloak, he set his hands to the snow, and, assisted by other boys, taking away the snow where there was too much, and adding some in other places, he made a rough figure of Marforio lying down, eight braccia in length. Whereupon the painter and

all the others stood marvelling, not so much at what he had done as at the spirit with which he had set his hand to a work so vast, and he so young and so small.

Baccio, indeed, having more love for sculpture than for goldsmith's work, gave many proofs of this; and when he went to Pinzirimonte, a villa bought by his father, he would often plant himself before the naked labourers and draw them with great eagerness, and he did the same with the cattle on the farm. At this time he continued for many days to go in the morning to Prato, which was near the villa, where he stayed the whole day drawing in the Chapel of the Pieve from the work of Fra Filippo Lippi, and he did not cease until he had drawn it all, imitating the draperies of that master, who did them very well. And already he handled with great skill the style and the pen, and also chalk both red and black, which last is a soft stone that comes from the mountains of France, and with it, when cut to a point, drawings can be executed with great delicacy.

These things making clear to Michelagnolo the mind and inclination of his son, he also changed his intention, like the boy himself, and, being likewise advised by his friends, placed him under the care of Giovan Francesco Rustici, one of the best sculptors in the city, whose workshop was still constantly frequented by Leonardo da Vinci. Leonardo, seeing the drawings of Baccio and being pleased with them, exhorted him to persevere and to take to working in relief; and he recommended strongly to him the works of Donato, saying also that he should execute something in marble, such as a head or a low-relief. Baccio, encouraged by the comforting advice of Leonardo, set himself to copy in marble an antique head of a woman, of which he had shaped a model from one that is in the house of the Medici. This, for his first work, he executed passing well, and it was held very dear by Andrea Carnesecchi, who received it as a present from Baccio's father and placed it in his house in the Via Larga, over that door in the centre of the court which leads into the garden. Now, Baccio continuing to make other models of figures in clay in the round, his father, wishing not to fail in his duty towards the praiseworthy zeal of his son, sent for some blocks of marble from Carrara, and caused to be built for him, at the end of his house at Pinti, a room with lights arranged for working, which looked out upon the Via Fiesolana. Whereupon he set himself to block out various figures in those marbles, and one, among

others, he carried well on from a piece of marble of two braccia and a half, which was a Hercules that is holding the dead Cacus beneath him, between his legs. These sketches were left in the same place in memory of him.

At this time was thrown open to view the cartoon of Michelagnolo Buonarroti, full of nude figures, which Michelagnolo had executed at the commission of Piero Soderini for the Great Council Chamber, and, as has been related in another place, all the craftsmen flocked together to draw it on account of its excellence. Among these came Baccio, and no long time passed before he outstripped them all, for the reason that he understood nudes, and outlined, shaded, and finished them, better than any of the other draughtsmen, among whom were Jacopo Sansovino, Andrea del Sarto, Il Rosso, who was then very young, and Alfonso Berughetta the Spaniard, together with many other famous craftsmen. Baccio frequented the place more than any of the others, and had a counterfeit key; and it happened that, Piero Soderini having been deposed from the government about this time, in the year 1512, and the house of Medici having been restored to power, during the confusion caused in the Palace by the change of government, Baccio entered in secret, all by himself, and tore the cartoon into many pieces. Of which not knowing the reason, some said that Baccio had torn it up in order to have some pieces of the cartoon in his possession for his own convenience, some declared that he wished to deprive the other young men of that advantage, so that they might not be able to profit by it and make themselves a name in art, others said that he was moved to do this by his affection for Leonardo da Vinci, from whom Michelagnolo's cartoon had taken much of his reputation, and others, again, perhaps interpreting his action better, attributed it to the hatred which he felt against Michelagnolo and afterwards demonstrated as long as he lived. The loss of the cartoon was no light one for the city, and very heavy the blame that was rightly laid upon Baccio by everyone, as an envious and malicious person.

Baccio then executed some pieces of cartoon with lead-white and charcoal, among which was a very beautiful one of a nude Cleopatra, which he presented to the goldsmith Piloto. Having already acquired a name as a great draughtsman, he was desirous of learning to paint in colours, having a firm belief that he would not only equal Buonarroti, but even greatly surpass him in both fields of art. Now he had executed a cartoon of a Leda, in which

Castor and Pollux were issuing from the egg of the swan em-
braced by her, and he wished to colour it in oils, in such a way
as to make it appear that the methods of handling the colours
and mixing them together in order to make the various tints, with
the lights and shades, had not been taught to him by others, but
that he had found them by himself, and, after pondering how he
could do this, he thought of the following expedient. He be-
sought Andrea del Sarto, who was much his friend, that he
should paint a portrait of him in oils, flattering himself that he
would thereby gain two advantages in accordance with his pur-
pose; one was that he would see the method of mixing the col-
ours, and the other was that the painted picture would remain in
his hands, which, having seen it executed and understanding it,
would assist him and serve him as a pattern. But Andrea per-
ceived Baccio's intention as he made his request, and was angry
at his want of confidence and astuteness, for he would have been
willing to show him what he desired, if Baccio had asked him as
a friend; wherefore, without making any sign that he had found
him out, and refraining from mixing the colours into tints, he
placed every sort of colour on his palette and mingled them
together with the brush, and, taking some now from one and
now from another with great dexterity of hand, counterfeited in
this way the vivid colouring of Baccio's face. The latter, both
through the artfulness of Andrea and because he had to sit still
where he was if he wished to be painted, was never able to see
or learn anything that he wished: and it was a fine notion of
Andrea's, thus at the same time to punish the deceitfulness of his
friend and to display with this method of painting, like a well-
practised master, even greater ability and experience in art.

For all this, however, Baccio did not abandon his determina-
tion, in which he was assisted by the painter Rosso, whom he
afterwards asked more openly for the help that he desired. Hav-
ing thus learned the methods of colouring, he painted a picture
in oils of the Holy Fathers delivered from the Limbo of Hell by
the Saviour, and also a larger picture of Noah drunk with wine
and revealing his nakedness in the presence of his sons. He tried
his hand at painting on the wall, on fresh plaster, and executed
on the walls of his house heads, arms, legs, and torsi, coloured in
various ways; but, perceiving that this involved him in greater
difficulties than he had expected, through the drying of the plas-
ter, he returned to his former study of working in relief. He made

a figure of marble, three braccia in height, of a young Mercury with a flute in his hand, with which he took great pains, and it was extolled and held to be a rare work; and afterwards, in the year 1530, it was bought by Giovan Battista della Palla and sent to France to King Francis, who held it in great estimation.

Baccio devoted himself with great study and solicitude to examining and reproducing the most minute details of anatomy, persevering in this for many months and even years. And certainly one can praise highly in this man his desire for honour and excellence in art, and for working well therein; spurred by which desire, and by the most fiery ardour, with which, rather than with aptitude or dexterity in art, he had been endowed by nature from his earliest years, Baccio spared himself no fatigue, never relaxed his efforts for a moment, was always intent either on preparing for work or on working, always occupied, and never to be found idle, thinking that by continual work he would surpass all others who had ever practised his art, and promising this result to himself as the reward of his incessant study and endless labour. Continuing, therefore, his zealous study, he not only produced a great number of sheets drawn in various ways with his own hand, but also contrived to get Agostino Viniziano, the engraver of prints, to engrave for him a nude Cleopatra and a larger plate filled with various anatomical studies, in order to see whether this would be successful; and the latter plate brought him great praise.

He then set himself to make in wax, in full-relief, a figure one braccio and a half in height of S. Jerome in Penitence, lean beyond belief, which showed on the bones the muscles all withered, a great part of the nerves, and the skin dry and wrinkled; and with such diligence was this work executed by him, that all the craftsmen, and particularly Leonardo da Vinci, pronounced the opinion that there had never been seen a better thing of its kind, nor one wrought with greater art. This figure Baccio carried to Cardinal Giovanni de' Medici and to his brother the Magnificent Giuliano, and by its means he made himself known to them as the son of the goldsmith Michelagnolo; and they, besides praising the work, showed him many other favours. This was in the year 1512, when they had returned to their house and their government. At this same time there were being executed in the Office of Works of S. Maria del Fiore certain Apostles of marble, which were to be set up within the marble tabernacles in those very places in that church where there are the Apostles painted by the

painter Lorenzo di Bicci. At the instance of the Magnificent Giuliano there was allotted to Baccio a S. Peter, four braccia and a half in height, which after a long time he brought to completion; and, although it has not the highest perfection of sculpture, nevertheless good design may be seen in it. This Apostle remained in the Office of Works from the year 1513 down to 1565, in which year Duke Cosimo, in honour of the marriage of Queen Joanna of Austria, his daughter-in-law, was pleased to have the interior of S. Maria del Fiore whitewashed, which church had never been touched from the time of its erection down to that day, and to have four Apostles set up in their places, among which was the S. Peter mentioned above.

Now in the year 1515, Pope Leo X passing through Florence on his way to Bologna, the city, in order to do him honour, ordained, among many other ornaments and festive preparations, that there should be made a colossal figure of nine braccia and a half, which was to be placed under an arch of the Loggia in the Piazza near the Palace; and this was given to Baccio. This colossal figure was a Hercules, and from the premature words of Baccio men expected that it would surpass the David of Buonarroti, which stood there near it; but the act did not correspond to the word, nor the work to the boast, and it robbed Baccio of much of the estimation in which he had previously been held by the craftsmen and by the whole city.

Pope Leo had allotted the work of the ornamentation in marble that surrounds the Chamber of Our Lady at Loreto, with the statues and scenes, to Maestro Andrea Contucci of Monte Sansovino, who had already executed some of these with great credit to himself, and was then engaged on others. Now at this time Baccio took to Rome, for the Pope, a very beautiful model of a nude David who was holding Goliath under him and was cutting off his head; which model he intended to execute in bronze or in marble for that very spot in the court of the house of the Medici in Florence where there once stood the David of Donato, which, at the spoiling of the Medici Palace, was taken to the Palace that then belonged to the Signori. The Pope, having praised Baccio, but not thinking that the time had come to execute the David, sent him to Loreto to Maestro Andrea, to the end that Andrea might give him one of those scenes to do. Having arrived in Loreto, he was received lovingly by Maestro Andrea and shown much kindness, both on account of his fame

and because the Pope had recommended him, and a piece of marble was assigned to him from which he should carve the Nativity of Our Lady. Baccio, after making the model, began the work; but, being a person who was not able to endure a colleague or an equal, and had little praise for·the works of others, he also began to speak hardly before the other sculptors who were there of the works of Maestro Andrea, saying that he had no design, and he said the same of the others, insomuch that in a short time he made himself disliked by them all. Whereupon, all that Baccio had said of Maestro Andrea having come to his ears, he, like a wise man, answered him lovingly, saying that works are done with the hands and not with the tongue, that good design is to be looked for not in drawings but in the perfection of the work finished in stone, and, finally, that in future Baccio should speak of him in a different tone. But Baccio answering him arrogantly with many abusive words, Maestro Andrea could endure no more, and rushed upon him in order to kill him; but Bandinelli was torn away from him by some who intervened between them. Being therefore forced to depart from Loreto, Baccio had his scene carried to Ancona; but he grew weary of it, although it was near completion, and he went away leaving it unfinished. This work was finished afterwards by Raffaello da Montelupo, and placed together with the others of Maestro Andrea; but it is by no means equal to them in excellence, although even so it is worthy of praise.

Baccio, having returned to Rome, obtained a promise from the Pope, through the favour of Cardinal Giulio de' Medici, always ready to assist the arts and their followers, that he should be commissioned to execute some statue for the court of the Medici Palace in Florence. Having therefore come to Florence, he made an Orpheus of marble, who with his playing and his singing is charming Cerberus, and moving Hell itself to compassion. He imitated in this work the Apollo of the Belvedere at Rome, and it was very highly praised, and rightly, because, although the Orpheus of Baccio is not in the attitude of the Apollo Belvedere, nevertheless it reproduces very successfully the manner of the torso and of all the members. The statue, when finished, was carried by order of Cardinal Giulio, while he was governing Florence, into the above-mentioned court, and placed on a carved base executed by the sculptor Benedetto da Rovezzano. But since Baccio never paid any attention to the art of

architecture, he took no heed of the genius of Donatello, who had made for the David that was there before a simple column on which rested a cleft base in open-work, to the end that one entering from without might see from the street-door the inner door, that of the other court, opposite to him; and, not having such foresight, he caused his statue to be placed on a broad and wholly solid base, of such a kind that it blocks the view of him who enters and covers the opening of the inner door, so that in passing through the first door one does not see whether the palace extends farther inwards or finishes in the first court.

Cardinal Giulio had caused a most beautiful villa to be erected below Monte Mario at Rome, and wished to set up two giants in this villa; and he had them executed in stucco by Baccio, who was always delighted to make giants. These figures, eight braccia in height, stand one on either side of the gate that leads into the wood, and they were held to be reasonably beautiful. While Baccio was engaged on these works, never abandoning his practice of drawing, he caused Marco da Ravenna and Agostino Viniziano, the engravers of prints, to engrave a scene drawn by him on a very large sheet, in which was the Slaughter of the Innocents, so cruelly done to death by Herod. This scene, which was filled by him with a quantity of nudes, both male and female, children living and dead, and women and soldiers in various attitudes, made known the fine draughtsmanship that he showed in figures and his knowledge of muscles and of all the members, and it won him great fame over all Europe. He also made a most beautiful model of wood, with the figures in wax, of a tomb for the King of England, which in the end was not carried out by Baccio, but was given to the sculptor Benedetto da Rovezzano, who executed it in metal.

There had recently returned from France Cardinal Bernardo Divizio of Bibbiena, who, perceiving that King Francis possessed not a single work in marble, whether ancient or modern, although he much delighted in such things, had promised his Majesty that he would prevail on the Pope to send him some beautiful work. After this Cardinal there came to the Pope two Ambassadors from King Francis, and they, having seen the statues of the Belvedere, lavished all the praise at their command on the Laocoon. Cardinals de' Medici and Bibbiena, who were with them, asked them whether the King would be glad to have a work of that kind; and they answered that it would be too great a gift. Then

the Cardinal said to them: 'There shall be sent to his Majesty either this one or one so like it that there shall be no difference.' And, having resolved to have another made in imitation of it, he remembered Baccio, whom he sent for and asked whether he had the courage to make a Laocoon equal to the original. Baccio answered that he was confident that he could make one not merely equal to it, but even surpassing it in perfection. The Cardinal then resolved that the work should be begun, and Baccio, while waiting for the marble to come, made one in wax, which was much extolled, and also executed a cartoon in lead-white and charcoal of the same size as the one in marble. After the marble had come and Baccio had caused an enclosure with a roof for working in to be erected for himself in the Belvedere, he made a beginning with one of the boys of the Laocoon, the larger one, and executed this in such a manner that the Pope and all those who were good judges were satisfied, because between his work and the ancient there was scarcely any difference to be seen. But after setting his hand to the other boy and to the statue of the father, which is in the middle, he had not gone far when the Pope died. Adrian VI being then elected, he returned with the Cardinal to Florence, where he occupied himself with his studies in design. After the death of Adrian and the election of Clement VII, Baccio went post-haste to Rome in order to be in time for his coronation, for which he made statues and scenes in half-relief by order of his Holiness. Then, having been provided by the Pope with rooms and an allowance, he returned to his Laocoon, a work which was executed by him in the space of two years with the greatest excellence that he ever achieved. He also restored the right arm of the ancient Laocoon, which had been broken off and never found, and Baccio made one of the full size in wax, which so resembled the ancient work in the muscles, in force, and in manner, and harmonized with it so well, that it showed how Baccio understood his art; and this model served him as a pattern for making the whole arm of his own Laocoon. This work seemed to his Holiness to be so good, that he changed his mind and resolved to send other ancient statues to the King, and this one to Florence; and to Cardinal Silvio Passerino of Cortona, his Legate in Florence, who was then governing the city, he sent orders that he should place the Laocoon at the head of the second court in the Palace of the Medici. This was in the year 1525.

This work brought great fame to Baccio, who, after finishing the Laocoon, set himself to draw a scene on a sheet of royal folio laid open, in order to carry out a design of the Pope, who wished to have the Martyrdom of S. Cosimo and S. Damiano painted on one wall of the principal chapel of S. Lorenzo in Florence, and on the other that of S. Laurence, when he was put to death by Decius on the gridiron. Baccio then drew with great subtlety the story of S. Laurence, in which he counterfeited with much judgment and art figures both clothed and nude, different attitudes and gestures in the bodies and limbs, and various movements in those who are standing about S. Laurence, engaged in their dreadful office, and in particular the cruel Decius, who with threatening brow is urging on the fiery death of the innocent Martyr, who, raising one arm to Heaven, recommends his spirit to God. With this scene Baccio so satisfied the Pope, that he took steps to have it engraved on copper by Marc' Antonio Bolognese, which was done by Marc' Antonio with great diligence; and his Holiness created Baccio, in order to do honour to his talents, a Chevalier of S. Pietro.

After these things Baccio returned to Florence, where he found that Giovan Francesco Rustici, his first master, was painting a scene of the Conversion of S. Paul; for which reason he undertook to make in a cartoon, in competition with his master, a nude figure of a young S. John in the desert, who is holding a lamb with the left arm and raising the right to Heaven. Then, having caused a panel to be prepared, he set himself to colour it, and when it was finished he exposed it to view in the workshop of his father Michelagnolo, opposite to the descent that leads from Orsanmichele to the Mercato Nuovo. The design was praised by the craftsmen, but not so much the colouring, because it was somewhat crude and painted in no beautiful manner. But Baccio sent it as a present to Pope Clement, who had it placed in his guardaroba, where it may still be found.

As far back as the time of Leo X there had been quarried at Carrara, together with the marbles for the façade of S. Lorenzo in Florence, another block of marble nine braccia and a half high and five braccia wide at the foot. With this block of marble Michelagnolo Buonarroti had thought of making a giant in the person of Hercules slaying Cacus, intending to place it in the Piazza beside the colossal figure of David formerly made by him, since both the one and the other, David and Hercules, were

emblems of the Palace. He had made several designs and various models for it, and had sought to gain the favour of Pope Leo and of Cardinal Giulio de' Medici, saying that the David had many defects caused by the sculptor Maestro Andrea, who had first blocked it out and spoiled it. But by reason of the death of Leo the façade of S. Lorenzo was for a time abandoned, and also this block of marble. Now afterwards, Pope Clement having conceived a desire to avail himself of Michelagnolo for the tombs of the heroes of the house of Medici, which he wished to have constructed in the Sacristy of S. Lorenzo, it became once more necessary to quarry marbles; and the head of these works, keeping the accounts of the expenses, was Domenico Buoninsegni. This man tried to tempt Michelagnolo to make a secret partnership with him in the matter of the stone-work for the façade of S. Lorenzo; but Michelagnolo refused, not consenting that his genius should be employed in defrauding the Pope, and Domenico conceived such hatred against him that he went about ever afterwards opposing his undertakings, in order to annoy and humiliate him, but this he did covertly. He thus contrived to have the façade discontinued and the sacristy pushed forward, which two works, he said, were enough to keep Michelagnolo occupied for many years. And as for the marble for the making of the giant, he urged the Pope that it should be given to Baccio, who at that time had nothing to do; saying that through the emulation of two men so eminent his Holiness would be served better and with more diligence and promptitude, rivalry stimulating both the one and the other in his work. The counsel of Domenico pleased the Pope, and he acted in accordance with it. Baccio, having obtained the marble, made a great model in wax, which was a Hercules who, having fixed the head of Cacus between two stones with one knee, was constraining him with great force with the left arm, holding him crouching under his legs in a distorted attitude, wherein Cacus revealed his suffering and the strain of the weight of Hercules upon him, which was rending asunder every least muscle in his whole body. Hercules, likewise, with his head bent down close against his enemy, grinding and gnashing his teeth, was raising the right arm and with great vehemence giving him another blow with his club, in order to dash his head to pieces.

Michelagnolo, as soon as he had heard that the marble had been given to Baccio, was very much displeased; but, for all the

efforts that he made in this matter, he was never able to turn the Pope from his purpose, so completely had he been satisfied by Baccio's model; to which reason were added his promises and boasts, for he boasted that he would surpass the David of Michelagnolo, and he was also assisted by Buoninsegni, who said that Michelagnolo desired everything for himself. Thus was the city deprived of a rare ornament, such as that marble would undoubtedly have been when shaped by the hand of Buonarroti. The above-mentioned model of Baccio is now to be found in the guardaroba of Duke Cosimo, by whom it is held very dear, and by the craftsmen as a rare work.

Baccio was sent to Carrara to see this marble, and the Overseers of the Works of S. Maria del Fiore were commissioned to transport it by water, along the River Arno, as far as Signa. The marble having been conveyed there, within a distance of eight miles from Florence, when they set about removing it from the river in order to transport it by land, the river being too low from Signa to Florence, it fell into the water, and on account of its great size sank so deep into the sand, that the Overseers, with all the contrivances that they used, were not able to drag it out. For which reason, the Pope wishing that the marble should be recovered at all costs, by order of the Wardens of Works Pietro Rosselli, an old builder of great ingenuity, went to work in such a manner that, having diverted the course of the water into another channel and cut away the bank of the river, with levers and windlasses he moved it, dragged it out of the Arno, and brought it to solid ground, for which he was greatly extolled. Tempted by this accident to the marble, certain persons wrote verses, both Tuscan and Latin, ingeniously ridiculing Baccio, who was detested for his loquacity and his evil-speaking against Michelagnolo and all the other craftsmen. One among them took for his verses the following subject, saying that the marble, after having been approved by the genius of Michelagnolo, learning that it was to be mangled by the hands of Baccio, had thrown itself into the river out of despair at such an evil fate.

While the marble was being drawn out of the water, a difficult process which took time, Baccio found, on measuring it, that it was neither high enough nor wide enough to enable him to carve the figures of his first model. Whereupon he went to Rome, taking the measurements with him, and made known to the Pope how he was constrained by necessity to abandon his first design

and make another. He then made several models, and out of their number the Pope was most pleased with one in which Hercules had Cacus between his legs, and, grasping his hair, was holding him down after the manner of a prisoner; and this one they resolved to adopt and to carry into execution. On returning to Florence, Baccio found that the marble had been conveyed into the Office of Works of S. Maria del Fiore by Pietro Rosselli, who had first placed on the ground some planks of walnut-wood planed square, and laid lengthways, which he kept changing according as the marble moved forward, under which and upon those planks he placed some round rollers well shod with iron, so that by pulling the marble with three windlasses, to which he had attached it, little by little he brought it with ease into the Office of Works. The block having been set up there, Baccio began a model in clay as large as the marble and shaped according to the last one which he had made previously in Rome; and he finished it, working with great diligence, in a few months. But with all this it appeared to many craftsmen that there was not in this model that spirited vivacity that the action required, nor that which he had given to his first model. Afterwards, beginning to work at the marble, Baccio cut it away all round as far as the navel, laying bare the limbs in front, and taking care all the time to carve the figures in such a way that they might be exactly like those of the large model in clay.

At this same time Baccio had undertaken to execute in painting an altar-piece of considerable size for the Church of Cestello, and for this he had made a very beautiful cartoon containing a Dead Christ surrounded by the Maries, with Nicodemus and other figures; but, for a reason that we shall give below, he did not paint the altar-piece. He also made at this time, in order to paint a picture, a cartoon in which was Christ taken down from the Cross and held in the arms of Nicodemus, with His Mother, who was standing, weeping for Him, and an Angel who was holding in his hands the Nails and the Crown of Thorns. Setting himself straightway to colour it, he finished it quickly and placed it on exhibition in the workshop of his friend Giovanni di Goro, the goldsmith, in the Mercato Nuovo, in order to hear the opinions of men and particularly what Michelagnolo said of it. Michelagnolo was taken by the goldsmith Piloto to see it, and, after he had examined every part, he said that he marvelled that so good a draughtsman as Baccio should allow a picture so crude

and wanting in grace to leave his hands, that he had seen the most feeble painters executing their works in a better manner, and that this was no art for Baccio. Piloto reported Michelagnolo's judgment to Baccio, who, for all the hatred that he felt against him, recognized that he spoke the truth. Certainly Baccio's drawings were very beautiful, but in colours he executed them badly and without grace, and he therefore resolved to paint no more with his own hand; but he took into his service one who handled colours passing well, a young man called Agnolo, the brother of the excellent painter Franciabigio, who had died a few years before. To this Agnolo he desired to entrust the execution of the altar-piece for Cestello, but it remained unfinished, the reason of which was the change of government in Florence, which took place in the year 1527, when the Medici left Florence after the sack of Rome. For Baccio did not think himself safe, having a private feud with a neighbour at his villa of Pinzirimonte, who was of the popular party; and after he had buried at that villa some cameos and little antique figures of bronze, which belonged to the Medici, he went off to live in Lucca. There he remained until the time when the Emperor Charles V came to receive his crown at Bologna; whereupon he presented himself before the Pope and then went with him to Rome, where he was given rooms in the Belvedere, as before.

While Baccio was living there, his Holiness resolved to fulfil a vow that he had made when he was shut up in the Castello di S. Angelo; which vow was that he would place on the summit of the great round tower of marble, which is in front of the Ponte di Castello, seven large figures of bronze, each six braccia in length, and all lying down in different attitudes, as it were vanquished by an Angel that he wished to have set up on the centre of the tower, upon a column of variegated marble, the Angel being of bronze with a sword in the hand. By this figure of the Angel he wished to represent the Angel Michael, the guardian and protector of the Castle, whose favour and assistance had delivered him and brought him out of that prison; and the seven recumbent figures were to personify the seven Mortal Sins, demonstrating that with the help of the victorious Angel he had conquered and thrown to the ground his enemies, evil and impious men, who were represented by those seven figures of the seven Mortal Sins. For this work his Holiness caused a model to be made; which having pleased him, he ordained that Baccio

should begin to make the figures in clay of the size that they were to be, in order to have them cast afterwards in bronze. Baccio began the work, and finished in one of the apartments in the Belvedere one of those figures in clay, which was much extolled. At the same time, also, in order to divert himself, and wishing to see how he would succeed in casting, he made many little figures in the round, two-thirds of a braccio in height, as of Hercules, Venus, Apollo, Leda, and other fantasies of his own, which he caused to be cast in bronze by Maestro Jacopo della Barba of Florence; and they succeeded excellently well. He presented them afterwards to his Holiness and to many lords; and some of them are now in the study of Duke Cosimo, among a collection of more than a hundred antique figures, all very choice, and others that are modern.

At this same time Baccio had made a scene of the Deposition from the Cross with little figures in low-relief and half-relief, which was a rare work; and he had it cast with great diligence in bronze. When finished, he presented it in Genoa to Charles V, who held it very dear; and a sign of this was that his Majesty gave Baccio a Commandery of S. Jago, and made him a Chevalier. From Prince Doria, also, he received many courtesies; and from the Republic of Genoa he had the commission for a statue of marble six braccia high, which was to be a Neptune in the likeness of Prince Doria, to be set up on the Piazza in memory of the virtues of that Prince and of the extraordinary benefits that his native country of Genoa had received from him. This statue was allotted to Baccio at the price of a thousand florins, of which he received five hundred at that time; and he went straightway to Carrara to block it out at the quarry of Polvaccio.

While the popular government was ruling Florence, after the departure of the Medici, Michelagnolo Buonarroti was employed on the fortifications of the city; and there was shown to him the marble that Baccio had blocked out, together with the model of the Hercules and Cacus, the intention being that if the marble had not been cut away too much Michelagnolo should take it and carve from it two figures after his own design. Michelagnolo, having examined the block, thought of a different subject; and, abandoning the Hercules and Cacus, he chose the subject of Samson holding beneath him two Philistines whom he had cast down, one being already dead, and the other still alive, against

whom he was aiming a blow with the jaw-bone of an ass, seeking to kill him. But even as it often happens that the minds of men promise themselves at times certain things the opposite of which is determined by the wisdom of God, so it came to pass then, for, war having arisen against the city of Florence, Michelagnolo had other things to think about than polishing marble, and was obliged from fear of the citizens to withdraw from the city. Afterwards, the war being finished and peace made, Pope Clement caused Michelagnolo to return to Florence in order to finish the Sacristy of S. Lorenzo, and sent Baccio to see to the completion of the giant. Baccio, while engaged in this, took up his abode in the Palace of the Medici; and, writing almost every week to his Holiness in order to make a show of devotion, he entered, besides dealing with matters of art, into particulars relating to the citizens and those who were administering the government, with an odious officiousness likely to bring upon him even more ill-will than he had awakened before. Whereupon, when Duke Alessandro returned from the Court of his Majesty to Florence, the citizens made known to him the sinister policy that Baccio was pursuing against them; from which it followed that his work of the giant was hindered and retarded by the citizens by every means in their power.

At this time, after the war of Hungary, Pope Clement and the Emperor Charles held a conference at Bologna, whither there went Cardinal Ippolito de' Medici and Duke Alessandro; and it occurred to Baccio to go and kiss the feet of his Holiness. He took with him a panel, one braccio high and one and a half wide, of Christ being scourged at the Column by two nude figures, which was in half-relief and very well executed; and he gave this panel to the Pope, together with a portrait-medal of his Holiness, which he had caused to be made by Francesco dal Prato, his familiar friend, the reverse of the medal being the Flagellation of Christ. This gift was very acceptable to his Holiness, to whom Baccio described the annoyances and impediments that he had experienced in the execution of his Hercules, praying him that he should prevail upon the Duke to give him the means to carry it to completion. He added that he was envied and hated in that city; and, being a very devil with his wit and his tongue, he persuaded the Pope to induce the Duke to see that his work should be brought to completion and set up in its place in the Piazza.

Death had now snatched away the goldsmith Michelagnolo, the father of Baccio, who during his lifetime had undertaken to make for the Wardens of Works of S. Maria del Fiore, by order of the Pope, a very large cross of silver, all covered with scenes in low-relief of the Passion of Christ. This cross, for which Baccio had made the figures and scenes in wax, to be afterwards cast in silver, Michelagnolo had left unfinished at his death; and Baccio, having the work in his hands, together with many libbre of silver, sought to persuade his Holiness to have it finished by Francesco dal Prato, who had gone with him to Bologna. But the Pope, perceiving that Baccio wished not only to withdraw from his father's engagements, but also to make something out of the labours of Francesco, gave Baccio orders that the silver and the scenes, those merely begun as well as those finished, should be given to the Wardens of Works, that the account should be settled, and that the Wardens should melt all the silver of that cross, in order to make use of it for the necessities of the church, which had been stripped of its ornaments at the time of the siege; and to Baccio he caused one hundred florins of gold and letters of recommendation to be given, to the end that he might return to Florence and finish the work of the giant.

While Baccio was at Bologna, Cardinal Doria, having heard that he was about to depart, went to the pains of seeking him out, and threatened him with many reproaches and abusive words, for the reason that he had broken his pledge and failed in his duty by neglecting to finish the statue of Prince Doria and leaving it only blocked out at Carrara, after taking five hundred crowns in payment; on which account, said the Cardinal, if Andrea could get Baccio into his hands, he would make him pay for it at the galleys. Baccio defended himself humbly and with soft words, saying that he had been delayed by a sufficient hindrance, but that he had in Florence a block of marble of the same height, from which he had intended to carve that figure, and that when he had carved and finished it he would send it to Genoa. And so well did he contrive to speak and to excuse himself that he succeeded in escaping from the presence of the Cardinal. After this he returned to Florence, and caused the base for the giant to be taken in hand; and, himself working continuously at the figure, in the year 1534 he finished it completely. But Duke Alessandro, on account of the hostile reports of the citizens, did not take steps to have it set up in the Piazza.

The Pope had returned to Rome many months before this, and desired to erect two tombs of marble in the Minerva, one for Pope Leo and one for himself; and Baccio, seizing this occasion, went to Rome. Thereupon the Pope resolved that Baccio should make those tombs after he had succeeded in setting up the giant on the Piazza; and his Holiness wrote to the Duke that he should give Baccio every convenience for placing his Hercules in position there. Whereupon, after an enclosure of planks had been made all round, the base was built of marble, and at the foot of it they placed a stone with letters in memory of Pope Clement VII, and a good number of medals with the heads of his Holiness and of Duke Alessandro. The giant was then taken from the Office of Works, where it had been executed; and in order to convey it with greater ease, without damaging it, they made round it a scaffolding of wood, with ropes passing under the legs and cords supporting it under the arms and at every other part; and thus, suspended in the air between the beams in such a way that it did not touch the wood, little by little, by means of compound pulleys and windlasses and ten pairs of oxen, it was drawn as far as the Piazza. Great assistance was rendered by two thick, semi- cylindrical beams, which were fixed lengthways along the foot of the scaffolding, in the manner of a base, and rested on other similar beams smeared with soap, which were withdrawn and replaced by workmen in succession, according as the structure moved forward; and with these ingenious contrivances the giant was conveyed safely and without much labour to the Piazza. The charge of all this was given to Baccio d'Agnolo and the elder Antonio da San Gallo, the architects to the Office of Works, who afterwards with other beams and a double system of compound pulleys set the statue securely on its base.

It would not be easy to describe the concourse and multitude that for two days occupied the whole Piazza, flocking to see the giant as soon as it was uncovered; and various judgments and opinions were heard from all kinds of men, every one censuring the work and the master. There were also attached round the base many verses, both Latin and Tuscan, in which it was pleasing to see the wit, the ingenious conceits, and the sharp sayings of the writers; but they overstepped all decent limits with their evil-speaking and their biting and satirical compositions, and Duke Alessandro, considering that, the work being a public one, the indignity was his, was forced to put in prison some who went

so far as to attach sonnets openly and without scruple to the statue; which proceeding soon stopped the mouths of the critics.

When Baccio examined his work in position, it seemed to him that the open air was little favourable to it, making the muscles appear too delicate. Having therefore caused a new enclosure of planks to be made around it, he attacked it again with his chisels, and, strengthening the muscles in many places, gave the figures stronger relief than they had before. Finally, the work was uncovered for good; and by everyone able to judge it has always been held to be not only a triumph over difficulties, but also very well studied, with every part carefully considered, and the figure of Cacus excellently adapted to its position. It is true that the David of Michelagnolo, which is beside Baccio's Hercules, takes away not a little of its glory, being the most beautiful colossal figure that has ever been made; for in it is all grace and excellence, whereas the manner of Baccio is entirely different. But in truth, considering Baccio's Hercules by itself, one cannot but praise it highly, and all the more because it is known that many sculptors have since tried to make colossal statues, and not one has attained to the standard of Baccio, who, if he had received as much grace and facility from nature as he took pains and trouble by himself, would have been absolutely perfect in the art of sculpture.

Desiring to know what was being said of his work, he sent to the Piazza a pedagogue whom he kept in his house, telling him that he should not fail to report to him the truth of what he might hear said. The pedagogue, hearing nothing but censure, returned sadly to the house, and, when questioned by Baccio, answered that all with one voice were abusing the giants, and that they pleased no one. 'And you,' asked Baccio, 'what do you say of them?' 'I speak well of them,' he replied, 'and say, may it please you, that they please me.' 'I will not have them please you,' said Baccio, 'and you, also, must speak ill of them, for, as you may remember, I never speak well of anyone; and so we are quits.' Thus Baccio concealed his vexation, and it was always his custom to act thus, pretending not to care for the censure that any man laid on his works. Nevertheless, it is likely enough that his resentment was considerable, because when a man labours for honour, and then obtains nothing but censure, one cannot but believe, although that censure may be unjust and undeserved, that it afflicts him secretly in his heart and torments him continually. He

was consoled in his displeasure by an estate, which was given to him in addition to his payment, by order of Pope Clement. This gift was doubly dear to him, first because it was useful for its revenue and was near his villa of Pinzirimonte, and then because it had previously belonged to Rignadori, his mortal enemy, who had just been declared an outlaw, and with whom he had always been at strife on account of the boundary of this property.

At this time a letter was written to Duke Alessandro by Prince Doria, asking that he should prevail upon Baccio to finish his statue, now that the giant was completely finished, and saying that he was ready to revenge himself on Baccio if he did not do his duty; at which Baccio was so frightened that he would not trust himself to go to Carrara. However, having been reassured by Cardinal Cibo and Duke Alessandro, he went there, and, working with some assistants, proceeded to carry the statue forward. The Prince had himself informed every day as to how much Baccio was doing; wherefore, receiving a report that the statue was not of that excellence which had been promised, he gave Baccio to understand that, if he did not serve him well, he would make him smart for it. Baccio, hearing this, spoke very ill of the Prince; which having come to the Prince's ears, he determined to get him into his hands at all costs, and to take vengeance upon him by putting him in wholesome fear of the galleys. Whereupon Baccio, seeing certain persons spying and keeping a watch upon him, became suspicious, and, being a shrewd and resolute man, left the work as it was and returned to Florence.

About this time a son was born to Baccio from a woman whom he kept in his house, and to this son, Pope Clement having died in those days, he gave the name of Clemente, in memory of that Pontiff, who had always loved and favoured him. After the death of Pope Clement, he heard that Cardinal Ippolito de' Medici, Cardinal Innocenzio Cibo, Cardinal Giovanni Salviati, and Cardinal Niccolò Ridolfi, together with Messer Baldassarre Turini da Pescia, being the executors of the Pope's will, had commissions to give for the two marble tombs of Leo and Clement, which were to be placed in the Minerva. For these tombs Baccio in the past had already made the models; but the work had been promised recently to the Ferrarese sculptor Alfonso Lombardi through the favour of Cardinal de' Medici, whose

servant he was. This Alfonso, by the advice of Michelagnolo, had changed the design of the tombs, and he had already made the models for them, but without any contract for the commission, relying wholly on promises, and expecting every day to have to go to Carrara to quarry the marble. While the time was slipping away in this manner, it happened that Cardinal Ippolito died of poison on his way to meet Charles V. Baccio, hearing this, went without wasting any time to Rome, where he was first received by the sister of Pope Leo, Madonna Lucrezia Salviati de' Medici, to whom he strove to prove that no one could do greater honour to the remains of those great Pontiffs than himself, with his ability in art, adding that Alfonso was a sculptor without power of design and without skill and judgment in the handling of marble, and that he was not able to execute so honourable an undertaking save only with the help of others. He also used many other devices, and so went to work in various ways and by various means that he succeeded in changing the purpose of those lords, who finally entrusted to Cardinal Salviati the charge of making an agreement with Baccio.

At this time the Emperor Charles V had arrived in Naples, and in Rome Filippo Strozzi, Anton Francesco degli Albizzi, and the other exiles were seeking to arrange with Cardinal Salviati to go and set his Majesty against Duke Alessandro; and they were with the Cardinal at all hours. Baccio was also all day long in Salviati's halls and apartments, waiting to have the contract made for the tombs, but not able to bring matters to a head, because of the Cardinal's preoccupation with the affairs of the exiles; and they, seeing Baccio in those rooms morning and evening, grew suspicious of this, and, fearing lest he might be there to spy upon their movements and give information to the Duke, some of the young men among them agreed to follow him secretly one evening and put him out of the way. But Fortune, coming to his aid in time, brought it about that the two other Cardinals, with Messer Baldassarre da Pescia, undertook to finish Baccio's business. Knowing that Baccio was worth little as an architect, they had caused a design to be made by Antonio da San Gallo, which pleased them, and had ordained that all the mason's work to be done in marble should be executed under the direction of the sculptor Lorenzetto, and that the marble statues and scenes should be allotted to Baccio. Having arranged the matter in this way, they finally made the contract with Baccio, who therefore

appeared no more about the house of Cardinal Salviati, with-drawing himself just in time; and the exiles, the occasion having passed by, thought nothing more about him.

After these things Baccio made two models of wood, with the statues and scenes in wax. These models had the bases solid, without projections, and on each base were four fluted Ionic columns, which divided the space into three compartments, a large one in the middle, where in each there was a Pope in full pontificals seated upon a pedestal, who was giving the benedic-tion, and smaller spaces, each with a niche containing a figure in the round and standing upright, four braccia high; which figures, representing Saints, stood on either side of those Popes. The order of the composition had the form of a triumphal arch, and above the columns that supported the cornice was a marble tablet three braccia in height and four braccia and a half in width, in which was a scene in half-relief. In the scene above the statue of Pope Leo, which statue had on either side of it in the niches S. Peter and S. Paul, was his Conference with King Francis at Bologna, and this story of Leo in the middle, above the columns, was accompanied by two smaller scenes, in one of which, that above S. Peter, was the Saint restoring a dead man to life, and in the other, that above S. Paul, that Saint preaching to the people. In the scene above Pope Clement, which corresponded to that mentioned above, was that Pontiff crowning the Emperor Charles at Bologna, and on either side of it are two smaller scenes, in one of which is S. John the Baptist preaching to the people, and in the other S. John the Evangelist raising Drusiana from the dead; and these have below them in the niches the same Saints, four braccia high, standing on either side of the statue of Pope Clement, as with that of Leo.

In this structure Baccio showed either too little religion or too much adulation, or both together, in that he thought fit that the first founders – after Christ – of our religion, men deified and most dear to God, should give way to our Popes, and placed them in positions unworthy of them and inferior to those of Leo and Clement. Certain it is that this design of his, even as it was displeasing to God and to the Saints, so likewise gave no pleasure to the Popes or to any other man, for the reason, it appears to me, that religion – and I mean our own, the true religion – should be placed by mankind before all other interests and consider-ations. And, on the other hand, he who wishes to exalt and

honour any other person, should, I think, be temperate and re-
strained, and confine himself within certain limits, so that his
praise and honour may not become another thing – I mean
senseless adulation, which first disgraces the praiser, and also
gives no pleasure to the person praised, if he has any proper
feeling, but does quite the contrary. Baccio, in doing what I have
described, made known to everyone that he had much good-will
and affection indeed towards the Popes, but little judgment in
exalting and honouring them in their sepulchres.

The models described above were taken by Baccio to the
garden of Cardinal Ridolfi at S. Agata on Monte Cavallo, where
his lordship was entertaining Cibo, Salviati, and Messer Baldas-
sarre da Pescia to dinner, they having assembled together there
in order to settle all that was necessary in the matter of the
tombs. While they were at table, then, there arrived the sculptor
Solosmeo, an amusing and outspoken person, who was always
ready to speak ill of anyone, and little the friend of Baccio. When
the message was brought to those lords that Solosmeo was seek-
ing admittance, Ridolfi ordered that he should be ushered in, and
then, turning to Baccio, said to him: 'I wish that we should hear
what Solosmeo says of our bestowal of these tombs. Raise that
door-curtain, Baccio, and stand behind it.' Baccio immediately
obeyed, and, when Solosmeo had entered and had been invited
to drink, they then turned to the subject of the tombs allotted to
Baccio; whereupon Solosmeo reproached the Cardinals for hav-
ing made a bad choice, and went on to speak all manner of evil
against Baccio, taxing him with ignorance of art, avarice, and
arrogance, and going into many particulars in his criticisms. Bac-
cio, who stood hidden behind the door-curtain, was not able to
contain himself until Solosmeo should have finished, and, burst-
ing out scowling and full of rage, said to Solosmeo: 'What have
I done to you, that you should speak of me with such scant
respect?' Dumbfoundered at the appearance of Baccio, Solosmeo
turned to Ridolfi and said: 'What tricks are these, my lord? I want
nothing more to do with priests!' and took himself off. The
Cardinals had a hearty laugh both at the one and at the other;
and Salviati said to Baccio: 'You hear the opinion of your broth-
ers in art. Go and give them the lie with your work.'

Baccio then began the work of the statues and scenes, but his
performances by no means corresponded to his promises and his
duty towards those Pontiffs, for he used little diligence in the

figures and scenes, and left them badly finished and full of defects, being more solicitous about drawing his money than about working at the marble. Now his patrons became aware of Baccio's procedure, and repented of what they had done; but the two largest pieces of marble remained, those for the two statues that were still to be executed, one of Leo seated and the other of Clement, and these they ordered him to finish, beseeching him that he should do better in them. But Baccio, having already drawn all the money, entered into negotiations with Messer Giovan Battista da Ricasoli, Bishop of Cortona, who was in Rome on business of Duke Cosimo's, to depart from Rome and go to Florence in order to serve Cosimo in the matter of the fountains of his villa of Castello and the tomb of his father, Signor Giovanni. The Duke having answered that Baccio should come, he set off for Florence without a word, leaving the work of the tombs unfinished and the statues in the hands of two assistants. The Cardinals, hearing of this, allotted those two statues of the Popes, which still remained to be finished, to two sculptors, one of whom was Raffaello da Montelupo, who received the statue of Pope Leo, and the other Giovanni di Baccio, to whom was given the statue of Clement. They then gave orders that the masonry and all that was prepared should be put together, and the work was erected; but the statues and scenes were in many parts neither pumiced nor polished, so that they brought Baccio more discredit than fame.

Arriving in Florence, Baccio found that the Duke had sent the sculptor Tribolo to Carrara to quarry the marble for the fountains of Castello and the tomb of Signor Giovanni; and he so wrought upon the Duke that he wrested the tomb of Signor Giovanni from the hands of Tribolo, demonstrating to his Excellency that the marbles for such a work were already in great measure in Florence. Thus, little by little, he penetrated into the confidence of the Duke, insomuch that both for this reason and for his arrogance everyone was afraid of him. He then proposed to the Duke that the tomb of Signor Giovanni should be erected in the Chapel of the Neroni, a narrow, confined, and mean place, in S. Lorenzo, being too ignorant or not wishing to suggest that for so great a Prince it was proper that a new chapel should be built on purpose. He also prevailed on the Duke to demand from Michelagnolo, on Baccio's behalf, many pieces of marble that he had in Florence; and when the Duke had obtained them from

Michelagnolo, and Baccio from the Duke, among those marbles
being some blocked out figures and a statue carried well on to-
wards completion by Michelagnolo, Bandinelli, taking them all
over, hacked and broke to pieces everything that he could find,
thinking that by so doing he was avenging himself on Michel-
agnolo and causing him displeasure. He found, moreover, in the
same room in S. Lorenzo wherein Michelagnolo worked, two
statues in one block of marble, representing Hercules crushing
Antæus, which the Duke was having executed by the sculptor Fra
Giovanni Agnolo. These were well advanced; but Baccio, saying
to the Duke that the friar had spoilt that marble, broke it into
many pieces.

In the end, he constructed all the base of the tomb, which
is an isolated pedestal about four braccia on every side, and has
at the foot a socle with a moulding in the manner of a base,
which goes right round, and with a fillet at the top, such as is
generally made for pedestals; and above this a cyma three-quar-
ters of a braccio in height, which goes inwards in a concave
curve, inverted, after the manner of a frieze, on which are carved
some horses' skulls bound one to another with draperies; and
above the whole was to be a smaller pedestal, with a seated statue
of four braccia and a half, armed in the ancient fashion, and
holding in the hand the baton of a condottiere captain of armies,
which was to represent the person of the invincible Signor Gio-
vanni de' Medici. This statue was begun by him from a block of
marble, and carried well on, but never finished or placed on the
base built for it. It is true that on the front of that base he
finished entirely a scene of marble in half-relief, with figures
about two braccia high, in which he represented Signor Giovanni
seated, to whom are being brought many prisoners, soldiers,
women with dishevelled hair, and nude figures, but all without
invention and without revealing any feeling. At the end of the
scene, indeed, there is a figure with a pig on the shoulder, which
is said to have been made by Baccio to represent Messer Baldas-
sarre da Pescia, in derision; for Baccio looked upon him as his
enemy, since about this time Messer Baldassarre, as has been
related above, had allotted the two statues of Leo and Clement
to other sculptors, and, moreover, had so gone to work in Rome
that Baccio had perforce to restore at great inconvenience the
money that he had received beyond his due for those statues and
figures.

During this time Baccio had given his attention to nothing else but demonstrating to Duke Cosimo how much the glory of the ancients had lived through their statues and buildings, saying that his Excellency should seek to obtain in the same way immortality for himself and his actions in the ages to come. Then, after he had brought the tomb of Signor Giovanni near completion, he set about planning to make the Duke begin some great and costly work, which might take a very long time. Duke Cosimo had ceased to inhabit the Palace of the Medici, and had returned with his Court to live in the Palace in the Piazza, which was formerly occupied by the Signoria; and this he was daily rearranging and adorning. Now he had said to Baccio that he had a desire to make a public audience-chamber, both for the foreign Ambassadors and for his citizens and the subjects of the State; and Baccio, with Giuliano di Baccio d'Agnolo, went about thinking how to suggest to him that he should erect an ornamental work of Fossato stone and marble, thirty-eight braccia in width and eighteen in height. This ornamental work, they proposed, should serve as the audience-chamber, and should be in the Great Hall of the Palace, at that end which looks towards the north. The audience-chamber was to have a space of fourteen braccia in depth, the ascent to which was to be by seven great steps; and it was to be closed in front by a balustrade, excepting the entrance in the middle. At the end of the hall were to be three great arches, two of which were to serve for windows, being divided up by columns, four to each, two of Fossato stone and two of marble; and above this was to curve a round arch with a frieze of brackets, which were to form on the outer side the ornament of the façade of the Palace, and on the inner side to adorn in the same manner the façade of the hall. The arch in the middle, forming not a window, but a niche, was to be accompanied by two other similar niches, which were to be at the ends of the audience-chamber, one on the east and the other on the west, and adorned with four round Corinthian columns, which were to be ten braccia high and to form a projection at the ends. In the central façade were to be four pilasters, which were to serve as supports between one arch and another to the architrave, frieze, and cornice running right round both above the arches and above the columns. These pilasters were to have between one and another a space of about three braccia, and in each of these spaces was to be a niche four braccia and a half in height, to contain statues,

by way of accompaniment to the great niche in the middle of the façade and the two at the sides; in each of which niches Baccio wished to place three statues.

Baccio and Giuliano had in mind, in addition to the ornament of the inner façade, another larger ornament of extraordinary cost and grandeur for the outer façade. The hall being awry and out of square, this ornament was to reduce that outer side to a square form; and there was to be a projection of six braccia right round the walls of the Palazzo Vecchio, with a range of columns fourteen braccia high supporting other columns, between which were to be arches, forming a loggia below, right round the Palace, where there are the Ringhiera and the Giants. Above this, again, was to be another range of pilasters, with arches between them in the same manner, running all the way round the windows of the Palazzo Vecchio, so as to make a façade right round the Palace; and above these pilasters was to be yet another range of arches and pilasters, after the manner of a theatre, with the battlements of that Palace, finally, forming a cornice to the whole structure.

Knowing that this was a work of vast expense, Baccio and Giuliano consulted together that they should not reveal their conception to the Duke, save only with regard to the ornament of the audience-chamber within the hall, and that of the façade of Fossato stone on the side towards the Piazza, stretching to the length of twenty-four braccia, which is the breadth of the hall. Designs and plans of this work were made by Giuliano, and with these in his hand Baccio spoke to the Duke, to whom he pointed out that in the large niches at the sides he wished to place statues of marble four braccia high, seated on pedestals – namely, Leo X in the act of restoring peace to Italy, and Clement VII crowning Charles V, with two statues in smaller niches within the large ones, on either side of the Popes, which should represent the virtues practised and put into action by them. For the niches four braccia high between the pilasters, in the central façade, he wished to make upright statues of Signor Giovanni, Duke Alessandro, and Duke Cosimo, together with many decorations of various fantasies in carving, and a pavement all of variegated marbles of different colours.

This ornament much pleased the Duke, thinking that with this opportunity it should be possible in time to bring to completion, as has since been done, the body of that hall, with the rest of the decorations and the ceiling, in order to make it the most beautiful

hall in Italy. And so great was his Excellency's desire that this work should be done, that he assigned for its execution such a sum of money as Baccio wished and demanded every week. A beginning was made with the quarrying and cutting of the Fossato stone, in order to make the ornamentation in the form of the base, columns, and cornices; and Baccio required that all should be done and carried to completion by the stone-cutters of the Office of Works of S. Maria del Fiore. This work was certainly executed by those masters with great diligence; and if Baccio and Giuliano had urged it on, they would have finished and built in all the ornaments of stone very quickly. But Baccio gave his attention to nothing save to having the statues blocked out, finishing few of them entirely, and to drawing his salary, which the Duke gave him every month, besides paying for his assistants and meeting every sort of expense that he incurred in the work, and giving him five hundred crowns for one of the statues finished by him in marble; wherefore the end of this work was never in sight.

Even so, if Baccio and Giuliano, being engaged on a work of such importance, had brought the head of that hall into square, as they could have done, instead of putting right only half of the eight braccia by which it was awry, and leaving several parts badly proportioned, such as the central niche and the two large ones at the sides, which are squat, and the members of the cornices, which are too slight for so great a body; if, as they might have done, they had gone higher with the columns, thus giving greater grandeur, a better manner, and more invention to that work; and if, also, they had brought the uppermost cornice into touch with the level of the original old ceiling above, they would have shown more art and judgment, nor would all that labour have been spent in vain and wasted so thoughtlessly, as has since been evident to those to whom, as will be related, it has fallen to put it right and finish it. For, in spite of all the pains and thought afterwards devoted to it, there are many defects and errors in the door of entrance and in the relation of the niches in the side-walls, in which it has since been seen to be necessary to change the form of many parts, although it has never yet been found possible, without demolishing the whole, to correct the divergence from the square or to prevent this from being revealed in the pavement and the ceiling. It is true that in the manner in which they arranged it, even as it now stands, there is proof of great

craftsmanship and pains, and it deserves no little praise for the many stones worked with the bevel-square, which slant away obliquely by reason of the hall being awry; and as for diligence and excellence in the working, laying, and joining together of the stones, nothing better could be seen or done. But the whole work would have succeeded much better if Baccio, who never held architecture in any account, had availed himself of some judgment more able than that of Giuliano, who, although he was a good master in wood and had some knowledge of architecture, was yet not the sort of man to be suitable for such a work as that was, as experience has proved. For this reason the work was pursued over a period of many years, without much more than half being built. Baccio finished and placed in the smaller niches the statue of Signor Giovanni and that of Duke Alessandro, both in the principal façade, and on a pedestal of bricks in the great niche the statue of Pope Clement; and he also brought to completion the statue of Duke Cosimo. In the last he took no little pains with the head, but for all this the Duke and the gentlemen of the Court said that it did not resemble him in the least. Wherefore Baccio, having already made one of marble, which is now in one of the upper apartments in the same Palace, and which looked very well and was the best head that he ever made, defended himself and sought to cover up the defects and worthlessness of the new head with the excellence of the old. However, hearing that head censured by everyone, one day in a rage he knocked it off, with the intention of making another and fixing it in its place; but in the end he never made it at all. It was a custom of Baccio's to add pieces of marble both small and large to the statues that he executed, feeling no annoyance in doing this, and making light of it. He did this with one of the heads of Cerberus in the group of Orpheus; in the S. Peter that is in S. Maria del Fiore he let in a piece of drapery; in the case of the Giant of the Piazza, as may be seen, he joined two pieces – a shoulder and a leg – to the Cacus, and in many other works he did the same, holding to such ways as generally damn a sculptor completely.

Having finished these statues, he set his hand to the statue of Pope Leo for this work, and carried it well forward. Then, perceiving that the work was proving very long, that he was now never likely to attain to the completion of his original design for the façades right round the Palace, that a great sum of money had been spent and much time consumed, and that for all this the

work was not half finished and gained little approval from the people, he set about thinking of some new fantasy, and began to attempt to remove from the Duke's mind the thought of the Palace, believing that his Excellency also was weary of that work. Thus, then, having made enemies of the proveditors and of all the stone-cutters in the Office of Works of S. Maria del Fiore, which was under his authority, while the statues that were destined for the audience-chamber were, after his fashion, some only blocked out and others finished and placed in position, and the ornamentation in great part built up, wishing to conceal the many defects that were in the work and little by little to abandon it, he suggested to the Duke that the Wardens of Works of S. Maria del Fiore were throwing away his money and no longer doing anything of any importance. He said that he had therefore thought that his Excellency would do well to divert all that useless expenditure of the Office of Works into making the octagonal choir of the church and the ornaments of the altar, the steps, the daïses of the Duke and the magistrates, and the stalls in the choir for the canons, chaplains, and clerks, according as was proper for so honourable a church. Of this choir Filippo di Ser Brunellesco had left the model in that simple framework of wood which previously served as the choir in the church, intending in time to have it executed in marble, in the same form, but more ornate. Baccio reflected, besides the considerations mentioned above, that in this choir he would have occasion to make many statues and scenes in marble and in bronze for the high-altar and all around the choir, and also for two pulpits of marble that were to be in the choir, and that the base of the outer side of the eight faces might be adorned with many scenes in bronze let into the marble ornamentation. Above this he thought to place a range of columns and pilasters to support the cornice right round, and four arches distributed according to the cross of the church; of which arches one was to form the principal entrance, opposite to another rising above the high-altar, and the two others were to be at the sides, one on the right hand and another on the left, and below these last two were to be placed the pulpits. Over the cornice was to be a range of balusters, curving right round above the eight sides, and over the balusters a garland of candelabra, in order, as it were, to crown the choir with lights according to the seasons, as had always been the custom while the wooden model of Brunelleschi was there.

Pointing out all this to the Duke, Baccio said that his Excellency, with the revenues of the Office of Works – namely, of S. Maria del Fiore and of its Wardens – and with that which his liberality might add, in a short time could adorn that temple and give great grandeur and magnificence to the same, and consequently to the whole city, of which it was the principal temple, and would leave an everlasting and honourable memorial of himself in such a structure; and besides all this, he said, his Excellency would be giving him an opportunity of exerting his powers and of making many good and beautiful works, and also, by displaying his ability, of acquiring for himself name and fame with posterity, which should be pleasing to his Excellency, since he was his servant and had been brought up by the house of the Medici. With these designs and these words Baccio so moved the Duke, that, consenting that such a structure should be erected, his Excellency commissioned him to make a model of the whole choir. Departing from the Duke, then, Baccio went to his architect, Giuliano di Baccio d'Agnolo, and discussed the whole matter with him; and, after they had gone to the place and examined everything with diligence, they resolved not to depart from the form of Filippo's model, but to follow it, adding only other ornaments in the shape of columns and projections, and enriching it as much as they could while preserving the original design and form. But it is not the number of parts and ornaments that renders a fabric rich and beautiful, but their excellence, however few they may be, provided also that they are set in their proper places and arranged together with due proportion; it is these that give pleasure and are admired, and, having been executed with judgment by the craftsman, afterwards receive praise from all others. This Giuliano and Baccio do not seem to have considered or observed, for they chose a subject involving much labour and endless pains, but wanting in grace, as experience has proved.

The design of Giuliano, as may be seen, was to place at the corners of all the eight sides pilasters bent round the angles, the whole work being composed in the Ionic Order; and these pilasters, since in the ground-plan they were made, with all the rest of the work, to diminish towards the centre of the choir and were not even, necessarily had to be broad on the outer side and narrow on the inner, which is a breach of proportionate measurement. And since each pilaster was bent according to the inner angles of the eight sides, the extension-lines towards the centre

so diminished it that the two columns that were one on either side of the pilaster at the corner caused it to appear too slender, and produced an ungraceful effect both in it and in the whole work, both on the outer side and likewise on the inner, although the measurements there are correct. Giuliano also made the model of the whole altar, which stood at a distance of one braccio and a half from the ornament of the choir. For the upper part of this Baccio afterwards made in wax a Christ lying dead, with two Angels, one of whom was holding His right arm and supporting His head on one knee, and the other was holding the Mysteries of the Passion; which statue of Christ occupied almost the whole altar, so that there would scarcely have been room to celebrate Mass, and Baccio proposed to make this statue about four braccia and a half in length. He made, also, a projection in the form of a pedestal behind the altar, attached to it in the centre, with a seat upon which he afterwards placed a seated figure of God the Father, six braccia high and giving the benediction, and accompanied by two other Angels, each four braccia high, kneeling at the extreme corners of the predella of the altar, on the level on which rested the feet of God the Father. This predella was more than a braccio in height, and on it were many stories of the Passion of Jesus Christ, which were all to be in bronze, and on the corners of the predella were the Angels mentioned above, both kneeling and each holding in the hands a candelabrum; which candelabra of the Angels served to accompany eight large candelabra placed between the Angels, and three braccia and a half in height, which adorned that altar; and God the Father was in the midst of them all. Behind God the Father was left a space of half a braccio, in order that there might be room to ascend to kindle the lights.

Under the arch that stood opposite to the principal entrance of the choir, on the base that ran right round, on the outer side, Baccio had placed, directly under the centre of that arch, the Tree of the Fall, round the trunk of which was wound the Ancient Serpent with a human face, and two nude figures were about the Tree, one being Adam and the other Eve. On the outer side of the choir, to which those figures had their faces turned, there ran lengthways along the base a space about three braccia long, which was to contain the story of their Creation, either in marble or in bronze; and this was to be pursued along the faces of the base of the whole work, to the number of twenty-one stories, all from

the Old Testament. And for the further enrichment of this base he had made for each of the socles upon which stood the columns and pilasters, a figure of some Prophet, either draped or nude, to be afterwards executed in marble – a great work, truly, and a marvellous opportunity, likely to reveal all the art and genius of a perfect master, whose memory should never be extinguished by any lapse of time. This model was shown to the Duke, and also a double series of designs made by Baccio, which, both from their variety and their number, and likewise from their beauty – for the reason that Baccio worked boldly in wax and drew very well – pleased his Excellency, and he ordained that the masonry-work should be straightway taken in hand, devoting to it all the expenditure administered by the Office of Works, and giving orders that a great quantity of marble should be brought from Carrara.

Baccio, on his part, also set to work to make a beginning with the statues; and among the first was an Adam who was raising one arm, and was about four braccia in height. This figure was finished by Baccio, but, since it proved to be narrow in the flanks and somewhat defective in other parts, he changed it into a Bacchus, and afterwards gave it to the Duke, who kept it in his Palace many years, in his chamber; and not long ago it was placed in a niche in the ground-floor apartments which his Excellency occupies in summer. He had also made a seated figure of Eve of the same size, which he had half finished: but it was abandoned on account of the Adam, which it was to have accompanied. For, having made a beginning with another Adam, in a different form and attitude, it became necessary for him to change also the Eve, and the original seated figure was converted by him into a Ceres, which he gave to the most illustrious Duchess Leonora, together with an Apollo, which was another nude that he had executed; and her Excellency had them placed in the ornament in front of the fish-pond, the design and architecture of which are by Giorgio Vasari, in the gardens of the Pitti Palace. Baccio worked at these two figures with very great zeal, thinking to satisfy the craftsmen and all the world as well as he had satisfied himself; and he finished and polished them with all the diligence and lovingness that were in him. He then set up these figures of Adam and Eve in their place, but, when uncovered, they experienced the same fate as his other works, and were torn to pieces with savage bitterness in sonnets and Latin verses, one going to

the length of suggesting that even as Adam and Eve, having defiled Paradise by their disobedience, deserved to be driven out, so these figures, defiling the earth, deserved to be expelled from the church. Nevertheless the statues are well-proportioned, and beautiful in many parts; and although there is not in them that grace which has been spoken of in other places, and which he was not able to give to his works, yet they display so much art and design, that they deserve no little praise. A lady who had set herself to examine these statues, being asked by some gentlemen what she thought of these naked bodies, answered, 'About the man I can give no judgment;' and, being pressed to give her opinion of the woman, she replied that in the Eve there were two good points, worthy of considerable praise, in that she was white and firm; whereby she contrived ingeniously, while seeming to praise, covertly to deal a shrewd blow to the craftsman and his art, giving to the statue the praise proper to the female body, which it is also necessary to apply to the marble, the material, and which is true of it, but not of the work or of the craftsmanship, for by such praise the craftsmanship is not praised. Thus, then, that shrewd lady hinted that in her opinion nothing could be praised in that statue save the marble.

Baccio afterwards set his hand to the statue of the Dead Christ, which likewise not succeeding as he had expected, he abandoned it when it was already well advanced, and, taking another block of marble, began another Christ in an attitude different from the first, and together with that the Angel who supports the head of Christ on one leg and with one hand His arm; and he did not rest until he had finished entirely both the one figure and the other. When arrangements were made to set it up on the altar, it proved to be so large that it occupied too much space, and there was no room left for the ministrations of the priest; and although this statue was passing good, and even one of Baccio's best, nevertheless the people – the ordinary citizens no less than the priests – could never have their fill of speaking ill of it and picking it to pieces. Recognizing that to uncover unfinished works injures the reputation of a craftsman in the eyes of all those who are not of the profession, or have no knowledge of art, or have not seen the models, Baccio resolved, in order to accompany the statue of Christ and to complete the altar, to make the statue of God the Father, for which a very beautiful block of marble had come from Carrara. And he had already

carried it well forward, making it half nude after the manner of a Jove, when, since it did not please the Duke and appeared to Baccio himself to have certain defects, he left it as it was, and even so it is still to be found in the Office of Works.

Baccio cared nothing for the words of others, but gave his attention to making himself rich and buying property. He bought a most beautiful farm, called Lo Spinello, on the heights of Fiesole, and another with a very beautiful house called Il Cantone, in the plain above San Salvi, on the River Affrico, and a great house in the Via de' Ginori, which he was enabled to acquire by the moneys and favours of the Duke. Having thus secured his own position, Baccio thenceforward cared little to work or to exert himself; and although the tomb of Signor Giovanni was unfinished, the audience-chamber of the Great Hall only begun, and the choir and altar behindhand, he paid little attention to the words of others or to the censure that was laid upon him on that account. However, having erected the altar and set into position the marble base upon which was to stand the statue of God the Father, he made a model for this and finally began it, and, employing stone-cutters, proceeded to carry it slowly forward.

There came from France in those days Benvenuto Cellini, who had served King Francis in the matter of goldsmith's work, of which he was the most famous master of his day; and he had also executed some castings in bronze for that King. Benvenuto was introduced to Duke Cosimo, who, desiring to adorn the city, showed also to him much favour and affection, and commissioned him to make a statue of bronze about five braccia high, of a nude Perseus standing over a nude woman representing Medusa, whose head he had cut off; which work was to be placed under one of the arches of the Loggia in the Piazza. While he was executing the Perseus, Benvenuto also did other things for the Duke. Now, even as it happens that the potter is always the jealous enemy of the potter, and the sculptor of the sculptor, Baccio was not able to endure the various favours shown to Benvenuto. It appeared to him a strange thing, also, that Benvenuto should have thus changed in a moment from a goldsmith into a sculptor, nor was he able to grasp in his mind how a man who was used to making medals and little things, could now execute colossal figures and giants. Baccio could not conceal his thoughts, but expressed them freely, and he found a man able to answer him; for, Baccio saying many of his biting words to

Benvenuto in the presence of the Duke, Benvenuto, who was no less proud than himself, took pains to be even with him. And thus, arguing often on the matters of art and their own works, and pointing out each other's defects, they would utter the most slanderous words of one another in the presence of the Duke, who, because he took pleasure in this and recognized true genius and acuteness in their biting phrases, had given them full liberty and licence to say whatever they pleased about one another before him, provided that they did not remember their quarrel elsewhere.

This rivalry, or rather, enmity, was the reason that Baccio pressed forward his statue of God the Father; but he was no longer receiving from the Duke those favours to which he had been accustomed, and he consoled himself for this by paying court and doing service to the Duchess. One day, among others, that they were railing at one another as usual and laying bare many of each other's actions, Benvenuto, glaring at Baccio and threatening him, said: 'Prepare yourself for another world, Baccio, for I mean to send you out of this one.' And Baccio answered: 'Let me know a day beforehand, so that I may confess and make my will, and may not die like the sort of beast that you are.' By reason of which the Duke, who for many months had found amusement in their quarrels, bade them be silent, fearing some evil ending, and caused them to make a portrait-bust of himself from the girdle upwards, both to be cast in bronze, to the end that he who should succeed best should carry off the honours.

Amid this rivalry and contention Baccio finished his figure of God the Father, which he arranged to have placed in the church on the base beside the altar. This figure was clothed and six braccia high, and he erected and completely finished it. But, in order not to leave it unaccompanied, he summoned from Rome the sculptor Vincenzio de' Rossi, his pupil, wishing to execute in clay for the altar all that remained to be done in marble; and he caused Vincenzio to assist him in finishing the two Angels who are holding the candelabra at the corners, and the greater part of the scenes on the predella and the base. Having then set everything upon the altar, in order to see how his work, when finished, was to stand, he strove to prevail on the Duke to come and see it, before he should uncover it. But the Duke would never go, and, although entreated by the Duchess, who favoured Baccio in this matter, he would never let himself be shaken, and did not go

to see it, being angered because among so many works Baccio had never finished one, even after his Excellency had made him rich and had won odium among the citizens by honouring him highly and doing him many favours. For all this his Excellency was disposed to assist Clemente, the natural son of Baccio – a young man of ability, who had made considerable proficience in design – because it was likely to fall to him in time to finish his father's works.

At this same time, which was in the year 1554, there came from Rome, where he had been working for Pope Julius III, Giorgio Vasari of Arezzo, in order to serve his Excellency in many works that he was intending to execute, and in particular to decorate the Palace on the Piazza, and to renovate it with new constructions, and to finish the Great Hall, as he was afterwards seen to do. In the following year Giorgio Vasari summoned from Rome and engaged in the Duke's service the sculptor Bartolommeo Ammanati, to the end that he might execute the other façade in the above-named Hall, opposite to the audience-chamber begun by Baccio, and a fountain in the centre of that façade; and a beginning was straightway made with executing a part of the statues that were to go into that work. Baccio, perceiving that the Duke was employing others, recognized that he did not wish to use his services any longer; at which, feeling great displeasure and vexation, he had become so strange and so irritable that no one could have any dealings with him either in his house or out of it, and to his son Clemente he behaved very strangely, keeping him in want of everything. For this reason Clemente, who had made a large head of his Excellency in clay, in order to execute it in marble for the statue of the audience-chamber, sought leave of the Duke to depart and go to Rome, on account of his father's strangeness; and the Duke said that he would not fail him. Baccio, at the departure of Clemente, who had asked leave of him, would not give him anything, although the young man had been a great help to him in Florence, and, indeed, Baccio's right hand in every matter; nevertheless, he thought nothing of getting rid of him. The young man, having arrived in Rome at an unfavourable season, died in the same year both from over-study and from wild living, leaving in Florence an example of his handiwork in an almost finished head of Duke Cosimo in marble, which is very beautiful, and was afterwards placed by Baccio over the principal door of his house in the Via de' Ginori. Clemente also left well

advanced a Dead Christ who is supported by Nicodemus, which Nicodemus is a portrait from life of Baccio; and these statues, which are passing good, Baccio set up in the Church of the Servites, as we shall relate in the proper place. The death of Clemente was a very great loss to Baccio and to art, and Bandinelli recognized this after he was dead.

Baccio uncovered the altar of S. Maria del Fiore, and the statue of God the Father was criticized. The altar has remained as was described above, nor has anything more been done to it since; but the work of the choir has been continued.

Many years before, there had been quarried at Carrara a great block of marble ten braccia and a half in height and five braccia in width, of which having received notice, Baccio rode to Carrara and made a contract for it with him to whom it belonged, giving him fifty crowns as earnest-money. He then returned to Florence and so pestered the Duke, that, by the favour of the Duchess, he obtained the commission to make from it a giant, which was to be placed in the Piazza, at the corner where the Lion was; on which spot was to be made a great fountain to spout water, in the middle of which was to be a Neptune in his chariot, drawn by sea-horses, and this figure was to be carved out of the above-mentioned block of marble. For this figure Baccio made more than one model, and showed them to his Excellency; but the matter stood thus, without anything more being done, until the year 1559, at which time the owner of the marble, having come from Carrara, asked to be paid the rest of the money, saying that otherwise he would give back the fifty crowns and break it into several pieces, in order to sell it, since he had received many offers. Orders were given by the Duke to Giorgio Vasari that he should have the marble paid for; which having been heard throughout the world of art, and also that the Duke had not yet made a free gift of the marble to Baccio, Benvenuto, and likewise Ammanati, bestirring themselves, each besought the Duke that he should be allowed to make a model in competition with Baccio, and that his Excellency should deign to give the marble to him who had shown the greatest ability in his model. The Duke did not deny to either of them the right to make a model, or deprive them of the hope that he who should acquit himself the best might be chosen to execute the statue. His Excellency knew that in ability, judgment, and design Baccio was still better than any of the sculptors who were in his service, if only he would

consent to take pains, and he welcomed this competition, in order to incite Baccio to acquit himself better and to do the most that he could. Bandinelli, having seen this competition on his shoulders, was greatly troubled by it, fearing the loss of the Duke's favour more than any other thing, and once more he set himself to making models. He was most assiduous in waiting on the Duchess, and so wrought upon her, that he obtained leave to go to Carrara in order to make arrangements for having the marble brought to Florence. Having arrived in Carrara, he had the marble so reduced in size – as he had planned to do – that he made it a sorry thing, and robbed both himself and the others of a noble opportunity and of the hope of ever making from it a beautiful and magnificent work. On returning to Florence, there was a long contention between Benvenuto and him, Benvenuto saying to the Duke that Baccio had spoilt the marble before it had been assigned to him. Finally the Duchess so went to work that the marble became Baccio's; and orders were given that it should be taken from Carrara to the sea-shore, and a boat was made ready with the proper appliances, which was to convey it up the Arno as far as Signa. Baccio also caused a room to be built up in the Loggia of the Piazza, wherein to work at the marble.

In the meantime he had set his hand to executing cartoons, in order to have some pictures painted which were to adorn the apartments of the Pitti Palace. These pictures were painted by a young man called Andrea del Minga, who handled colour passing well. The stories painted in the pictures were the Creation of Adam and Eve, and their Expulsion from Paradise by the Angel, a Noah, and a Moses with the Tables; which finished, he then presented them to the Duchess, seeking to obtain her favour in his difficulties and contentions. And, in truth, if it had not been for that lady, who loved him for his abilities and held him on his feet, Baccio would have fallen headlong down and would have lost completely the favour of the Duke. The Duchess also made much use of Baccio in the Pitti garden, where she had caused to be constructed a grotto full of tufa and sponge-stone formed by the action of water, and containing a fountain; and for this Baccio had caused his pupil, Giovanni Fancelli, to execute in marble a large basin and some goats of the size of life, which spout forth water, and likewise, for a fish-pond, after a model made by himself, a countryman who is emptying a barrel full of water. For these reasons the Duchess was constantly helping and

favouring Baccio with the Duke, who finally gave him leave to begin the great model of the Neptune; on which account he once more sent to Rome for Vincenzio de' Rossi, who had previously departed from Florence, with the intention of making him help to execute it.

While these preparations were in progress, Baccio was seized with a desire to finish the statue of the Dead Christ supported by Nicodemus, which his son Clemente had carried well forward; for he had heard that Buonarroti was finishing one in Rome that he had begun to carve from a large block of marble, containing five figures, which was to be placed on his tomb in S. Maria Maggiore. Out of emulation with him Baccio set to work on his group with the greatest assiduity, with assistants, until he had finished it. And meanwhile he was going about among the principal churches of Florence, seeking for a place where he might set up that work and also make a tomb for himself; but for long he found no place for the tomb that could content him, until he resolved on a chapel in the Church of the Servites which belongs to the family of the Pazzi. The owners of this chapel, at the request of the Duchess, granted the place to Baccio, without divesting themselves of the rights of ownership and of the devices of their house that were there; and they granted him only this, that he should erect an altar of marble and place upon it the statues mentioned above, and make his tomb at the foot of it. Afterwards, also, he came to an agreement with the friars of that convent with regard to the other matters appertaining to the celebration of Mass. During this time, then, Baccio was causing the altar and the marble base to be built, in order to place upon it the above-named statues; and, when he had finished it, he proposed to lay in that tomb, in which he wished to be laid himself together with his wife, the bones of his father Michelagnolo, which, at his death, he had caused to be placed in a vault in the same church. These bones of his father he chose to lay piously in that tomb with his own hands; whereupon it happened that either because he felt sorrow and a shock to his mind in handling his father's bones, or because he exerted himself too much in transferring those bones with his own hands and in rearranging the marbles, or from both reasons together, he was so overcome that he felt ill and had to go home, and, his malady growing daily worse, in eight days he died, at the age of seventy-two, having been up to that time robust and vigorous, and

without having ever suffered much illness during the whole of his life. He was buried with honourable obsequies, and laid beside his father's bones in the above-mentioned tomb constructed by himself, on which is this epitaph: –

D. O. M.
BACCIUS BANDINELL. DIVI JACOBI EQUES
SUB HAC SERVATORIS IMAGINE,
A SE EXPRESSA, CUM JACOBA DONIA
UXORE QUIESCIT, AN. S. MDLIX.

He left behind him both sons and daughters, who were the heirs to his many possessions in lands, houses, and money, which he bequeathed to them; and to the world he left the works in sculpture described by us, and designs in great numbers, which are in the possession of his family, and in our book there are some executed with the pen and with chalk, than which it is certain that nothing better could be done.

The marble for the giant was left more in dispute than ever, because Benvenuto was always about the Duke, and wished, in virtue of a little model that he had made, that the Duke should give it to him. On the other hand, Ammanati, being a sculptor of marbles and more experienced in such works than Benvenuto, considered for many reasons that this work belonged to him. Now it happened that Giorgio Vasari had to go to Rome with the Cardinal, the son of the Duke, when he went to receive his hat, and Ammanati gave to Vasari a little model of wax showing the shape in which he desired to carve that figure from the marble, and a piece of wood reproducing the exact proportions – the length, breadth, thickness, and inclination from the straight – of the marble, to the end that Giorgio might show them in Rome to Michelagnolo Buonarroti and persuade him to declare his opinion in the matter, and so move the Duke to give him the marble. All this Giorgio did most willingly, and it was the reason that the Duke gave orders that an arch should be partitioned off in the Loggia of the Piazza, and that Ammanati should make a great model as large as the giant was to be. Having heard this, Benvenuto rode in a great fury to Pisa, where the Duke was, and said to him that he could not suffer that his genius should be trampled underfoot by one who was inferior to himself, and that he desired to make a great model in competition with Ammanati, in the same place; and the Duke, wishing to pacify him, granted

him leave to have another arch of the Loggia partitioned off, and caused to be given to him materials for making, as he desired, a large model in competition with Ammanati.

While these masters were engaged in making their models, after having made fast their enclosures in such a manner that neither the one nor the other could see what his rival was doing, although these enclosures were attached to each other, there rose up the Flemish sculptor Maestro Giovan Bologna, a young man not inferior in ability or in spirit to either of the others. This master, being in the service of the Lord Don Francesco, Prince of Florence, asked his Excellency to enable him to make a giant which might serve as a model, of the same size as the marble; and the Prince granted him this favour. Maestro Giovan Bologna had as yet no thought of having the giant to execute in marble, but he wished at least to display his ability and to make himself known for what he was worth; and, having received permission from the Prince, he, also, began a model in the Convent of S. Croce. Nor was Vincenzio Danti, the sculptor of Perugia, a younger man than any of the others, willing to fail to compete with these three masters, not in the hope of obtaining the marble, but in order to demonstrate his spirit and genius. And so, having set to work on his own account in the house of Messer Alessandro, the son of M. Ottaviano de' Medici, he executed a model good in many parts and as large as the others.

The models finished, the Duke went to see those of Ammanati and of Benvenuto; and, being more pleased with that of Ammanati than with that of Benvenuto, he resolved that Ammanati should have the marble and make the giant, because he was younger than Benvenuto and more practised in marble. The disposition of the Duke was strengthened by Giorgio Vasari, who did many good offices with his Excellency for Ammanati, having perceived that, in addition to his knowledge, he was ready to endure any labour, and hoping that from his hands there would issue an excellent work finished in a short time. The Duke would not at that time see the model of Maestro Giovan Bologna, because, not having seen any work by him in marble, it did not seem to him that he could entrust to that master, as his first work, so great an undertaking, although he heard from many craftsmen and other men of judgment that Giovan Bologna's model was in many parts better than the others. But if Baccio had been alive, there would not have been all that contention

among those masters, because without a doubt it would have fallen to him to make the model of clay and the giant of marble. This work, then, was snatched from Baccio by death, but the same circumstance brought him no little glory, in that it revealed by means of those four models – the reason of the making of which was that Baccio was not alive – how much better were the design, judgment and ability of him who placed on the Piazza the Hercules and Cacus, as it were living in the marble; the excellence of which work has been made evident and brought to light even more by the works that have been executed since Baccio's death by those others, who, although they have acquitted themselves in a manner worthy of praise, have yet not been able to attain to the beauty and excellence that he placed in his work.

Afterwards Duke Cosimo, for the marriage of Queen Joanna of Austria, his daughter-in-law, seven years after the death of Baccio, caused the audience-chamber in the Great Hall, begun by Baccio, of which we have spoken above, to be finished; and he chose that the head of this work of completion should be Giorgio Vasari, who has sought with all diligence to put right the many defects that would have been in it if it had been continued and finished after the original design followed in the beginning by Baccio. Thus that imperfect work has now been carried with the help of God to completion, and is enriched on its side faces by the addition of niches and pilasters, and statues set in their places. Moreover, since it was laid out awry and out of square, we have taken pains to make it even in so far as has been possible, and have raised it considerably with a corridor of Tuscan columns at the top; and as for the statue of Leo begun by Baccio, his pupil Vincenzio de' Rossi has finished it. Besides this, that work has been adorned with friezes full of stucco-work, with many figures large and small, and with devices and other ornaments of various kinds, and under the niches and in the partitions of the vaulting have been made many and various designs in stucco and many beautiful inventions in carving; all which things have enriched the work in such a manner, that it has changed its form and has gained not a little in beauty and grace. For whereas, according to the first design, the ceiling of the Hall being twenty-one braccia above the floor, the audience-chamber did not rise higher than eighteen braccia, so that between it and the old ceiling there was a space of only three braccia; now, after our design, the ceiling of the Hall has been raised so much that it has risen

twelve braccia above the old ceiling and fifteen above the audi-
ence-chamber of Baccio and Giuliano, so that the ceiling is now
thirty-three braccia above the floor of the Hall. And it certainly
showed great spirit in his Excellency, that he should resolve to
cause to be finished in the space of five months for the above-
named nuptials the whole of a work of which more than a third
still remained to do, although it had taken more than fifteen years
to arrive at the condition in which it was at that time; so eager
was he to carry it to completion. But it was not only Baccio's
work that his Excellency caused to be completely finished, but
also all the rest of what Giorgio Vasari had designed; beginning
again from the base that runs over the whole of that work, with
a border of balusters in the open spaces, which forms a corridor
that passes above the work in the Hall, and commands a view on
the outer side of the Piazza and on the inner side of the whole
Hall. Thus the Princes and other lords will be able to see, without
being seen, all the festivals that may be held there, with much
pleasure and convenience for themselves, and then to retire to
their apartments, passing by the private and public staircases
through all the rooms in the Palace. Nevertheless, to many it has
caused dissatisfaction that in a work of such beauty and grandeur
that structure was not made square, and many would have liked
to have it pulled down and then rebuilt true to square. But it has
been judged to be better to continue the work in that way, in
order not to appear presumptuous and malign towards Baccio,
and also because otherwise we would have seemed not to have
the power to correct the errors and defects found by us but
committed by others.

But, returning to Baccio, we must say that his abilities were
always recognized during his lifetime, yet will be recognized and
regretted much more now that he is dead. And even more would
he have been acknowledged for what he was, when alive, and
beloved, if he had been so favoured by nature as to be more
amiable and more courteous, because his being the contrary, and
very rough with his tongue, robbed him of the goodwill of other
persons, obscured his talents, and brought it about that his works
were regarded with ill will and a prejudiced eye, and therefore
could never please anyone. And although he served one noble-
man after another, and was enabled by his talent to serve them
well, nevertheless he rendered his services with such bad grace,
that there was no one who felt grateful to him for them.

Moreover, his always decrying and maligning the works of others brought it about that no one could endure him, and, whenever another was able to pay him back in his own coin, it was returned to him with interest; and before the magistrates he spoke all manner of evil without scruple about the other citizens, and received from them as good as he gave. He brought suits and went to law about everything with the greatest readiness, living in one long succession of law-suits, and appearing to triumph in them. But since his drawing, to which it is evident that he gave his attention more than to any other thing, was of such a kind and of such excellence that it atones for his every natural defect and makes him known as a rare master of our art, we therefore not only count him among the greatest craftsmen, but also have always paid respect to his works, and have sought not to destroy but to finish them and do them honour, for the reason that it appears to us that Baccio was in truth one of those who deserve honourable praise and everlasting fame.

We have deferred to the end the mention of his family name, because it was not always the same, but varied, Baccio having himself called now De' Brandini, and now De' Bandinelli. In his early prints the name De' Brandini may be seen engraved after that of Baccio; but afterwards he preferred the name De' Bandinelli, which he retained to the end and still retains, and he used to say that his ancestors were of the Bandinelli of Siena, who once removed to Gaiuole, and from Gaiuole to Florence.

GIULIANO BUGIARDINI, Painter of Florence

BEFORE the siege of Florence the population had multiplied in such great numbers that the widespread suburbs which lay without every gate, together with the churches, monasteries, and hospitals, formed as it were another city, inhabited by many honourable persons and by good craftsmen of every kind, although for the most part they were less wealthy than those of the city, and lived there with less expense in the way of customs-dues and the like. In one of these suburbs, then, without the Porta a Faenza, was born Giuliano Bugiardini, who lived there, even as his ancestors had done, until the year 1529, when all the suburbs were pulled down. But before that, when still a mere lad, he

began his studies in the garden of the Medici on the Piazza di
S. Marco, in which, attending to the study of art under the sculp-
tor Bertoldo, he formed such strait friendship and intimacy
with Michelagnolo Buonarroti, that he was much beloved by
Buonarroti ever afterwards; which Michelagnolo did not so
much because of any depth that he saw in Giuliano's manner of
drawing, as on account of the extraordinary diligence and
love that he showed towards art. There was in Giuliano, besides
this, a certain natural goodness and a sort of simplicity in his
mode of living, free from all envy and malice, which vastly
pleased Buonarroti; nor was there any notable defect in him save
this, that he loved too well the works of his own hand. For,
although all men are wont to err in this respect, Giuliano in truth
passed all due bounds, whatever may have been the reason –
either the great pains and diligence that he put into executing
them, or some other cause. Wherefore Michelagnolo used to
call him blessed, since he appeared to be content with what he
knew, and himself unhappy, in that no work of his ever fully
satisfied him.

After Giuliano had studied design for some time in the above-
named garden, he worked, together with Buonarroti and
Granacci, under Domenico Ghirlandajo, at the time when he was
painting the chapel in S. Maria Novella. Then, having made his
growth and become a passing good master, he betook himself to
work in company with Mariotto Albertinelli in Gualfonda; in
which place he finished a panel-picture that is now at the door of
entrance of S. Maria Maggiore in Florence, containing S. Alberto,
a Carmelite friar, who has under his feet the Devil in the form
of a woman, a work that was much extolled.

It was the custom in Florence before the siege of 1530, at the
burial of dead persons of good family and noble blood, to carry
in front of the bier a string of pennons fixed round a panel that
a porter bore on his head; which pennons were afterwards left in
the church in memory of the deceased and of his family. Now,
when the elder Cosimo Rucellai died, Bernardo and Palla, his
sons, in order to have something new, thought of having not
pennons, but in place of them a quadrangular banner four braccia
wide and five braccia high, with some pennons at the foot con-
taining the arms of the Rucellai. These men therefore giving
this work to Giuliano to execute, he painted on the body of
the said banner four great figures, executed very well – namely,

S. Cosimo, S. Damiano, S. Peter, and S. Paul, which were truly most beautiful paintings, and done with more diligence than had ever been shown in any other work on cloth.

These and other works of Giuliano's having been seen by Mariotto Albertinelli, he recognized how careful Giuliano was in following the designs that were put before him, without departing from them by a hair's breadth, and, since he was preparing in those days to abandon art, he gave him to finish a panel-picture that Fra Bartolommeo di San Marco, his friend and companion, had formerly left only designed and shaded with water-colours on the gesso of the panel, as was his custom. Giuliano, then, setting his hand to this work, executed it with supreme diligence and labour, and it was placed at that time in the Church of S. Gallo, without the gate of that name. The church and convent were afterwards pulled down on account of the siege, and the picture was carried into the city and placed in the Priests' Hospital in the Via di S. Gallo, and then from there into the Convent of S. Marco, and finally into S. Jacopo tra Fossi on the Canto degli Alberti, where it stands at the present day on the high-altar. In this picture is the Dead Christ, with the Magdalene, who is embracing His feet, and S. John the Evangelist, who is holding His head and supporting it on one knee. There, likewise, are S. Peter, who is weeping, and S. Paul, who, stretching out his arms, is contemplating his Dead Master; and, to tell the truth, Giuliano executed this picture with so much lovingness and so much consideration and judgment, that he will be always very highly extolled for it, even as he was at that time, and that rightly. And after this he finished for Cristofano Rinieri a picture with the Rape of Dina that had been likewise left incomplete by the same Fra Bartolommeo; and he painted another picture like it, which was sent to France.

Not long afterwards, having been drawn to Bologna by certain friends, he executed some portraits from life, and, for a chapel in the new choir of S. Francesco, an altar-piece in oils containing Our Lady and two Saints, which was held at that time in Bologna, from there not being many masters there, to be a good work and worthy of praise. Then, having returned to Florence, he painted for I know not what person five pictures of the life of Our Lady, which are now in the house of Maestro Andrea Pasquali, physician to his Excellency and a man of great distinction.

Messer Palla Rucellai having commissioned him to execute an altar-piece that was to be placed on his altar in S. Maria Novella, Giuliano began to paint in it the Martyrdom of S. Catharine the Virgin. Mountains in labour! He had it in hand for twelve years, but never carried it to completion after all that time, because he had no invention and knew not how to paint the many various things that had a part in that martyrdom; and, although he was always racking his brain as to how those wheels should be made, and how he should paint the lightning and the fire that consumed them, constantly changing one day what he had done the day before, in all that time he was never able to finish it. It is true that in the meantime he executed many works, and among others, for Messer Francesco Guicciardini – who had returned from Bologna and was then living in his villa at Montici, writing his history – a portrait of him, which was a passing good likeness and pleased him much. He took the portrait, likewise, of Signora Angela de' Rossi, the sister of the Count of Sansecondo, for Signor Alessandro Vitelli, her husband, who was then on garrison-duty in Florence. For Messer Ottaviano de' Medici he painted in a large picture, copied from one by Fra Sebastiano del Piombo, two full-length portraits, Pope Clement seated and Fra Niccolò della Magna standing; and in another picture, likewise, with incredible pains and patience, he portrayed Pope Clement seated, and before him Bartolommeo Valori, who is kneeling and speaking to him.

Next, the above-named Messer Ottaviano de' Medici having besought Giuliano privately that he should take for him the portrait of Michelagnolo Buonarroti, he set his hand to it; and, after he had kept Michelagnolo, who used to take pleasure in his conversation, sitting for two hours, Giuliano said to him: 'Michelagnolo, if you wish to see yourself, get up and look, for I have now fixed the expression of the face.' Michelagnolo, having risen and looked at the portrait, said to Giuliano, laughing: 'What the devil have you been doing? You have painted me with one of my eyes up in the temple. Give a little thought to what you are doing.' Hearing this, Giuliano, after standing pensive for a while and looking many times from the portrait to the living model, answered in serious earnest: 'To me it does not seem so, but sit you down again, and I shall see a little better from the life whether it be true.' Buonarroti, who knew whence the defect arose and how small was the judgment of Bugiardini, straightway

resumed his seat, grinning. And Giuliano looked many times now at Michelagnolo and now at the picture, and then finally, rising to his feet, declared: 'To me it seems that the thing is just as I have drawn it, and that the life is in no way different.' 'Well, then,' answered Buonarroti, 'it is a natural deformity. Go on, and spare neither brush nor art.' And so Giuliano finished the picture and gave it to Messer Ottaviano, together with the portrait of Pope Clement by the hand of Fra Sebastiano, as Buonarroti desired, who had sent to Rome for it.

Giuliano afterwards made for Cardinal Innocenzio Cibo a copy of the picture in which Raffaello da Urbino had formerly painted portraits of Pope Leo, Cardinal Giulio de' Medici, and Cardinal de' Rossi; but in place of Cardinal de' Rossi he painted the head of Cardinal Cibo, in which he acquitted himself very well, and he executed the whole picture with great diligence and labour. At that time, likewise, he took the portrait of Cencio Guasconi, who was then a very beautiful youth. And after this he painted at the villa of Baccio Valori, at Olmo a Castello, a tabernacle in fresco, which, although it had not much design, was well and very carefully executed.

Meanwhile Palla Rucellai was pressing him to finish his altarpiece, of which mention has been made above, and Giuliano resolved to take Michelagnolo one day to see it. And so, after he had brought him to the place where he kept it, and had described to him with what pains he had executed the lightning-flash, which, coming down from Heaven, shivers the wheels and kills those who are turning them, and also a sun, which, bursting from a cloud, delivers S. Catharine from death, he frankly besought Michelagnolo, who could not keep from laughing as he heard poor Bugiardini's lamentations, that he should tell him how to make eight or ten principal figures of soldiers in the foreground of this altar-piece, drawn up in line after the manner of a guard, and in the act of flight, some being prostrate, some wounded, and others dead; for, said Giuliano, he did not know for himself how to foreshorten them in such a manner that there might be room for them all in so narrow a space, in the fashion that he had imagined, in line. Buonarroti, then, having compassion on the poor man and wishing to oblige him, went up to the picture with a piece of charcoal and outlined with a few strokes, lightly sketched in, a line of marvellous nude figures, which, foreshortened in different attitudes, were falling in various ways, some

backward and others forward, with some wounded or dead, and all executed with that judgment and excellence that were peculiar to Michelagnolo. This done, he went away with the thanks of Giuliano, who not long afterwards took Tribolo, his dearest friend, to see what Buonarroti had done, telling him the whole story. But since, as has been related, Buonarroti had drawn his figures only in outline, Bugiardini was not able to put them into execution, because there were neither shadows in them nor any other help; whereupon Tribolo resolved to assist him, and thus made some sketch-models in clay, which he executed excellently well, giving them that boldness of manner that Michelagnolo had put into the drawing, and working them over with the gradine, which is a toothed instrument of iron, to the end that they might be somewhat rough and might have greater force; and, thus finished, he gave them to Giuliano. However, since that manner did not please the smooth fancy of Bugiardini, no sooner had Tribolo departed than he took a brush and, dipping it from time to time in water, so smoothed them that he took away the gradine-marks and polished them all over, insomuch that, whereas the lights should have served as contrasts to make the shadows stronger, he contrived to destroy all the excellence that made the work perfect. Which having afterwards heard from Giuliano himself, Tribolo laughed at the foolish simplicity of the man; and Giuliano finally delivered the work finished in such a manner that there is nothing in it to show that Michelagnolo ever looked at it.

In the end, being old and poor, and having very few works to do, Giuliano applied himself with extraordinary and even incredible pains to make a Pietà in a tabernacle that was to go to Spain, with figures of no great size, and executed it with such diligence, that it seems a strange thing to think of an old man of his age having the patience to do such a work for the love that he bore to art. On the doors of that tabernacle, in order to depict the darkness that fell at the death of the Saviour, he painted a Night on a black ground, copied from the one by the hand of Michelagnolo which is in the Sacristy of S. Lorenzo. But since that statue has no other sign than an owl, Giuliano, amusing himself over his picture of Night by giving rein to his fancy, painted there a net for catching thrushes by night, with the lantern, and one of those little vessels holding a candle, or rather, a candle-end, that are carried about at night, with other suchlike things that have something to do with darkness and gloom, such

as night-caps, coifs, pillows, and bats; wherefore Buonarroti was like to dislocate his jaw with laughing when he saw this work and considered with what strange caprices Bugiardini had enriched his Night.

Finally, after having always been that kind of man, Giuliano died at the age of seventy-five, and was buried in the Church of S. Marco at Florence, in the year 1556.

Giuliano once relating to Bronzino how he had seen a very beautiful woman, after he had praised her to the skies, Bronzino said, 'Do you know her?' 'No,' answered Giuliano, 'but she is a miracle of beauty. Just imagine that she is a picture by my hand, and there you have her.'

CRISTOFANO GHERARDI [CALLED DOCENO] OF BORGO SAN SEPOLCRO, Painter

WHILE Raffaello dal Colle of Borgo San Sepolcro, who was a disciple of Giulio Romano and helped him to paint in fresco the Hall of Constantine in the Papal Palace at Rome, and the apartments of the Te in Mantua, was painting, after his return to the Borgo, the altar-piece of the Chapel of SS. Gilio e Arcanio (in which, imitating Giulio and Raffaello da Urbino, he depicted the Resurrection of Christ, a work that was much extolled), with another altar-piece of the Assumption for the Frati de' Zoccoli without the Borgo, and some other works for the Servite Friars at Città di Castello; while, I say, Raffaello was executing these and other works in the Borgo, his native place, acquiring riches and fame, a young man sixteen years of age, called Cristofano, and by way of by-name, Doceno, the son of Guido Gherardi, a man of honourable family in that city, was attending from a natural inclination and with much profit to painting, drawing and colouring so well and with such grace, that it was a marvel. Wherefore the above-named Raffaello, having seen some animals by the hand of this Cristofano, such as dogs, wolves, hares, and various kinds of birds and fishes, executed very well, and perceiving that he was most agreeable in his conversation and very witty and amusing, although he lived a life apart, almost like a philosopher, was well pleased to form a friendship with him and to have him frequent his workshop in order to learn.

Now, after Cristofano had spent some time drawing under the discipline of Raffaello, there arrived in the Borgo the painter Rosso, with whom he contracted a friendship, and received some of his drawings; and these Doceno studied with great diligence, considering, as one who had seen no others but those by the hand of Raffaello, that they were very beautiful, as indeed they were. But these studies were broken off by him, for, when Giovanni de' Turrini of the Borgo, at that time Captain of the Florentines, went with a band of soldiers from the Borgo and from Città di Castello to the defence of Florence, which was besieged by the armies of the Emperor and of Pope Clement, Cristofano went thither among the other soldiers, having been led away by his many friends. It is true that he did this no less in the hope of having some occasion to study the works in Florence than with the intention of fighting; but in this he failed, for his captain, Giovanni, had to guard not a place within the city, but the bastions on the hill without. That war finished, and the guard of Florence being commanded not long afterwards by Signor Alessandro Vitelli of Città di Castello, Cristofano, drawn by his friends and by his desire to see the pictures and sculptures of the city, enlisted as a soldier in that guard. And while he was in that service, Signor Alessandro, having heard from Battista della Bilia, a painter and soldier from Città di Castello, that Cristofano gave his attention to painting, and having obtained a beautiful picture by his hand, determined to send him with that same Battista della Bilia and with another Battista, likewise of Città di Castello, to decorate with sgraffiti and paintings a garden and loggia that he had begun at Città di Castello. But the one Battista having died while that garden was being built up, and the other Battista having taken his place, for the time being, whatever may have been the reason, nothing more was done.

Meanwhile Giorgio Vasari had returned from Rome, and was passing his time with Duke Alessandro in Florence, until his patron Cardinal Ippolito should return from Hungary; and he had received rooms in the Convent of the Servites, that he might make a beginning with the execution of certain scenes in fresco from the life of Cæsar in the chamber at the corner of the Medici Palace, where Giovanni da Udine had decorated the ceiling with stucco-work and pictures. Now Cristofano, having made Giorgio's acquaintance at the Borgo in the year 1528, when he went to see Rosso in that place, where he had shown him much

kindness, resolved that he would attach himself to Vasari and thus find much more opportunity for giving attention to art than he had done in the past. Giorgio, then, after a year's intercourse with him as his companion, finding that he was likely to make an able master, and that he was pleasant and gentle in manners and a man after his own heart, conceived an extraordinary affection for him. Wherefore, having to go not long afterwards, at the commission of Duke Alessandro, to Città di Castello, in company with Antonio da San Gallo and Pier Francesco da Viterbo (who had been in Florence to build the castle, or rather, citadel, and on their return were taking the road by Città di Castello), in order to repair the walls of the above-mentioned garden of Vitelli, which were threatening to fall, he took Cristofano with him, to the end that after Vasari himself had designed and distributed in their due order the friezes that were to be executed in certain apartments, and likewise the scenes and compartments of a bath-room, and other sketches for the walls of the loggia, Gherardi and the above-named Battista might carry the whole to completion. All this they did so well and with such grace, and particularly Cristofano, that a past master in art, well practised in his work, could not have done so much; and, what is more, experimenting in that work, he became facile and able to a marvel in drawing and colouring.

Then, in the year 1536, the Emperor Charles V coming to Italy and to Florence, as has been related in other places, the most magnificent festive preparations were ordained, among which Vasari, by order of Duke Alessandro, received the charge of the decorations of the Porta a S. Piero Gattolini, of the façade at S. Felice in Piazza, at the head of the Via Maggio, and of the pediment that was erected over the door of S. Maria del Fiore; and, in addition, of a standard of cloth for the castle, fifteen braccia in depth and forty in length, into the gilding of which there went fifty thousand leaves of gold. Now the Florentine painters and others who were employed in these preparations, thinking that Vasari was too much in favour with Duke Alessandro, and wishing to leave him disgraced in that part of the decorations – a part truly great and laborious – which had fallen to him, so went to work that he was not able to enlist the services of any master of architectural painting, whether young or old, among all those that were in the city, to assist him in any single thing. Of which having become aware, Vasari sent for Cristofano,

Raffaello dal Colle, and Stefano Veltroni of Monte Sansovino, his kinsman; and with their assistance and that of other painters from Arezzo and other places, he executed the works mentioned above, in which Cristofano acquitted himself in such a manner, that he caused everyone to marvel, doing honour to himself and also to Vasari, who was much extolled for those works. After they were finished, Cristofano remained many days in Florence, assisting the same Vasari in the preparations that were made in the Palace of Messer Ottaviano de' Medici for the nuptials of Duke Alessandro; wherein, among other things, Cristofano executed the coat of arms of the Duchess Margherita of Austria, with the balls, upheld by a most beautiful eagle, with some boys, very well done.

Not long afterwards, when Duke Alessandro had been assassinated, a compact was made in the Borgo to hand over one of the gates of the city to Piero Strozzi, when he came to Sestino, and letters were therefore written to Cristofano by some soldiers exiled from the Borgo, entreating him that he should consent to help them in this: which letters received, although Cristofano did not grant their request, yet, in order not to do a mischief to the soldiers, he chose rather to tear them up, as he did, than to lay them, as according to the laws and edicts he should have done, before Gherardo Gherardi, who was then Commissioner for the Lord Duke Cosimo in the Borgo. When the troubles were over and the matter became known, many citizens of the Borgo were exiled as rebels, and among them Doceno; and Signor Alessandro Vitelli, who knew the truth of this affair and could have helped him, did not do so, to the end that Cristofano might be as it were forced to serve him in the work of his garden at Città di Castello, of which we have spoken above.

After having consumed much time in this service, without any profit or advantage, Cristofano finally took refuge, almost in despair, with other exiles, in the village of S. Giustino in the States of the Church, a mile and a half distant from the Borgo and very near the Florentine frontier. In that place, although he stayed there at his peril, he painted for Abbot Bufolini of Città di Castello, who has most beautiful and commodious apartments there, a chamber in a tower, with a pattern of little boys and figures very well foreshortened to be seen from below, and with grotesques, festoons, and masks, the most lovely and the most bizarre that could be imagined. This chamber, when finished, so pleased

the Abbot that he caused him to do another, in which, desiring
to make some ornaments of stucco, and not having marble to
grind into powder for mixing it, for this purpose he found a very
good substitute in some stones from a river-bed, veined with
white, the powder from which took a good and very firm hold.
And within these ornaments of stucco Cristofano then painted
some scenes from Roman history, executing them so well in
fresco that it was a marvel.

At that time Giorgio Vasari was painting in fresco the upper
part of the tramezzo* of the Abbey of Camaldoli, and two
panel-pictures for the lower part; and, wishing to make about
these last an ornament in fresco full of scenes, he would
have liked to have Cristofano with him, no less to restore him to
the favour of the Duke than to make use of him. But, although
Messer Ottaviano de' Medici pleaded strongly with the Duke,
it proved impossible to bend him, so ugly was the information
that had been given to him about the behaviour of Cristofano.
Not having succeeded in this, therefore, Vasari, as one who
loved Cristofano, set himself to contrive to remove him at least
from S. Giustino, where he, with other exiles, was living in the
greatest peril. In the year 1539, then, having to execute for the
Monks of Monte Oliveto, for the head of a great refectory in
the Monastery of S. Michele in Bosco without Bologna, three
panel-pictures in oils with three scenes each four braccia in
length, and a frieze in fresco three braccia high all round with
twenty stories of the Apocalypse in little figures, and all the mon-
asteries of that Order copied from the reality, with partitions of
grotesques, and round each window fourteen braccia of festoons
with fruits copied from nature, Giorgio wrote straightway to Cris-
tofano that he should go from S. Giustino to Bologna, together
with Battista Cungi of the Borgo, his compatriot, who had also
served Vasari for seven years. These men, therefore, having gone
to Bologna, where Giorgio had not yet arrived – for he was still
at Camaldoli, where, having finished the tramezzo, he was draw-
ing the cartoon for a Deposition from the Cross, which was
afterwards executed by him and set up on the high-altar in that
same place – set themselves to prime the said three panels with
gesso and to lay on the ground, until such time as Giorgio should
arrive.

* See note on p. 90, Vol. I.

Now Vasari had given a commission to Dattero, a Jew, the friend of Messer Ottaviano de' Medici, who was then a banker in Bologna, that he should provide Cristofano and Battista with everything that they required. And since this Dattero was very obliging and most courteous, he did them a thousand favours and courtesies; wherefore those two at times went about Bologna in his company in very familiar fashion, and, Battista having prominent eyes and Cristofano a great speck in one of his, they were thus taken for Jews, as Dattero was in fact. One morning, therefore, a shoemaker, who had to bring a pair of new shoes at the commission of the above-named Jew to Cristofano, arriving at the monastery, said to Cristofano himself, who was standing at the gate looking on at the distribution of alms, 'Sir, could you show me the rooms of those two Jew painters who are working in there?' 'Jews or no Jews,' said Cristofano, 'what have you to do with them?' 'I have to give these shoes,' he answered, 'to one of them called Cristofano.' 'I am he,' replied Cristofano, 'an honest man and a better Christian than you are.' 'You may be what you please,' answered the shoemaker. 'I called you Jews, because, besides that you are held and known as Jews by everyone, that look of yours, which is not of our country, convinced me of it.' 'Enough,' said Cristofano, 'you shall see that we do the work of Christians.'

But to return to the work: Vasari having arrived in Bologna, not a month had passed before, Giorgio designing, and Cristofano and Battista laying in the panels in colour, all three were completely laid in, with great credit to Cristofano, who acquitted himself in this excellently well. The laying in of the panels being finished, work was begun on the frieze, in which Cristofano had a companion, although he was to have executed it all by himself; for there came from Camaldoli to Bologna the cousin of Vasari, Stefano Veltroni of Monte Sansovino, who had laid in the panel-picture of the Deposition, and the two executed that work together, and that so well, that it proved a marvel. Cristofano painted grotesques so well, that there was nothing better to be seen, but he did not give them that particular finish that would have made them perfect; and Stefano, on the contrary, was wanting in resolution and grace, for the reason that his brush-strokes did not fix his subjects in their places at one sweep, but, since he was very patient, in the end, although he endured greater labour, he used to execute his grotesques with more neatness and delicacy. Labouring in competition, then, at the work of this frieze,

these two took such pains, both the one and the other, that Cristofano learned to finish from Stefano, and Stefano learned from Cristofano to be more resolute and to work like a master.

Work being then begun on the broad festoons that were to run in clusters round the windows, Vasari made one with his own hand, keeping real fruits in front of him, that he might copy them from nature. This done, he ordained that Cristofano and Stefano should go on with the rest, holding to the same design, one on one side of the window, and the other on the other side, and should thus, one by one, proceed to finish them all; promising to him who might prove at the end of the work to have acquitted himself best a pair of scarlet hose. And so, competing lovingly for both honour and profit, they set themselves to copy everything, from the large things down to the most minute, such as millet-seed, hemp-seed, bunches of fennel, and the like, in such a manner that those festoons proved to be very beautiful; and both of them received from Vasari the prize of the scarlet hose.

Giorgio took great pains to persuade Cristofano to execute by himself part of the designs for the scenes that were to go into the frieze, but he would never do it. Wherefore, the while that Giorgio was drawing them himself, Gherardi executed the buildings in two of the panel-pictures, with much grace and beauty of manner, and such perfection, that a master of great judgment, even if he had had the cartoons before him, could not have done what Cristofano did. And, in truth, there never was a painter who could do by himself, and without study, the things that he contrived to do. After having finished the execution of the buildings in the two panel-pictures, the while that Vasari was carrying to completion the twenty stories from the Apocalypse for the above-mentioned frieze, Cristofano, taking in hand the panel-picture in which S. Gregory (whose head is a portrait of Pope Clement VII) is eating with his twelve poor men, executed the whole service of the table, all very lifelike and most natural. Then, a beginning having been made with the third panel-picture, while Stefano was occupied with the gilding of the ornamental frames of the other two, a staging was erected upon two trestles of wood, from which, while Vasari was painting on one side, in a glory of sunlight, the three Angels that appeared to Abraham in the Valley of Mamre, Cristofano painted some buildings on the other side. But he was always making some contraption with stools and tables, and at times with basins and pans upside down,

on which he would climb, like the casual creature that he was; and once it happened that, seeking to draw back in order to look at what he had done, one of his feet gave way under him, the whole contraption turned topsy-turvy, and he fell from a height of five braccia, bruising himself so grievously that he had to be bled and properly nursed, or he would have died. And, what was worse, being the sort of careless fellow that he was, one night there slipped off the bandages that were on the arm from which the blood had been drawn, to the great danger of his life, so that, if Stefano, who was sleeping with him, had not noticed this, it would have been all up with him; and even so Stefano had something to do to revive him, for the bed was a lake of blood, and he himself was reduced almost to his last gasp. Vasari, therefore, taking him under his own particular charge, as if he had been his brother, had him tended with the greatest possible care, than which, indeed, nothing less would have sufficed; and with all this he was not restored until that work was completely finished. After that, returning to S. Giustino, Cristofano completed some of the apartments of the Abbot there, which had been left unfinished, and then executed at Città di Castello, all with his own hand, an altar-piece that had been allotted to Battista, his dearest friend, and a lunette that is over the side-door of S. Fiorido, containing three figures in fresco.

Giorgio being afterwards summoned to Venice at the instance of Messer Pietro Aretino, in order to arrange and execute for the nobles and gentlemen of the Company of the Calza the setting for a most sumptuous and magnificent festival, and the scenery of a comedy written by that same Messer Pietro Aretino for those gentlemen, Giorgio, I say, knowing that he was not able to carry out so great a work by himself alone, sent for Cristofano and the above-mentioned Battista Cungi. And they, having finally arrived in Venice after being carried by the chances of the sea to Sclavonia, found that Vasari not only had arrived there before them, but had already designed everything, so that there was nothing for them to do but to set hand to painting. Now the said gentlemen of the Calza had taken at the end of the Canareio a large house which was not finished – it had nothing, indeed, save the main walls and the roof – and in a space forming an apartment seventy braccia long and sixteen braccia wide, Giorgio caused to be made two ranges of wooden steps, four braccia in height from the floor, on which the ladies were to be seated. The

walls at the sides he divided each into four square spaces of ten braccia, separated by niches each four braccia in breadth, within which were figures, and these niches had each on either side a terminal figure in relief, nine braccia high; insomuch that the niches on either side were five and the terminal figures ten, and in the whole apartment there were altogether ten niches, twenty terminal figures, and eight square pictures with scenes. In the first of these pictures (which were all in chiaroscuro), that on the right hand, next the stage, there was, representing Venice, a most beautiful figure of Adria depicted as seated upon a rock in the midst of the sea, with a branch of coral in the hand. Around her stood Neptune, Thetis, Proteus, Nereus, Glaucus, Palæmon, and other sea gods and nymphs, who were presenting to her jewels, pearls, gold, and other riches of the sea; and besides this there were some Loves that were shooting arrows, and others that were flying through the air and scattering flowers, and the rest of the field of the picture was all most beautiful palms. In the second picture were the Rivers Drava and Sava naked, with their vases. In the third was the Po, conceived as large and corpulent, with seven sons, representing the seven branches which, issuing from the Po, pour into the sea as if each of them were a kingly river. In the fourth was the Brenta, with other rivers of Friuli. On the other wall, opposite to the Adria, was the Island of Candia, wherein was to be seen Jove being suckled by the Goat, with many Nymphs around. Beside this, and opposite to the Drava, were the River Tagliamento and the Mountains of Cadore. Beyond this, opposite to the Po, were Lake Benacus and the Mincio, which were pouring their waters into the Po; and beside them, opposite to the Brenta, were the Adige and the Tesino, falling into the sea. The pictures on the right-hand side were divided by these Virtues, placed in the niches – Liberality, Concord, Compassion, Peace, and Religion; and opposite to these, on the other wall, were Fortitude, Civic Wisdom, Justice, a Victory with War beneath her, and, lastly, a Charity. Above all, then, were a large cornice and architrave, and a frieze full of lights and of glass globes filled with distilled waters, to the end that these, having lights behind them, might illuminate the whole apartment. Next, the ceiling was divided into four quadrangular compartments, each ten braccia wide in one direction and eight braccia in the other; and, with a width equal to that of the niches of four braccia, there was a frieze which ran right round the cornice,

while in a line with the niches there came in the middle of all the spaces a compartment three braccia square. These compartments were in all twenty-three, without counting one of double size that was above the stage, which brought the number up to twenty-four; and in them were the Hours, twelve of the night, namely, and twelve of the day. In the first of the compartments ten braccia in length, which was above the stage, was Time, who was arranging the Hours in their places, accompanied by Æolus, God of the Winds, by Juno, and by Iris. In another compartment, at the door of entrance, was the Car of Aurora, who, rising from the arms of Tithonus, was scattering roses, while the Car itself was being drawn by some Cocks. In the third was the Chariot of the Sun; and in the fourth was the Chariot of Night, drawn by Owls, and Night had the Moon upon her head, some Bats in front of her, and all around her darkness.

Of these pictures Cristofano executed the greater part, and he acquitted himself so well, that everyone stood marvelling at them: particularly in the Chariot of Night, wherein he did in the way of oil-sketches that which was, in a manner of speaking, not possible. And in the picture of Adria, likewise, he painted those monsters of the sea with such beauty and variety, that whoever looked at them was struck with astonishment that a craftsman of his rank should have shown such knowledge. In short, in all this work he bore himself beyond all expectation like an able and well-practised painter, and particularly in the foliage and grotesques.

After finishing the preparations for that festival, Vasari and Cristofano stayed some months in Venice, painting for the Magnificent Messer Giovanni Cornaro the ceiling, or rather, soffit, of an apartment, into which there went nine large pictures in oils. Vasari being then entreated by the Veronese architect, Michele San Michele, to stay in Venice, he might perhaps have consented to remain there for a year or two; but Cristofano always dissuaded him from it, saying that it was not a good thing to stay in Venice, where no account was taken of design, nor did the painters in that city make any use of it, not to mention that those painters themselves were the reason that no attention was paid there to the labours of the arts; and he declared that it would be better to return to Rome, the true school of noble arts, where ability was recognized much more than in Venice. The dissuasions of Cristofano being thus added to the little desire that

Vasari had to stay there, they went off together. But, since Cristofano, being an exile from the State of Florence, was not able to follow Giorgio, he returned to S. Giustino, where he did not remain long, doing some work all the time for the above-mentioned Abbot, before he went to Perugia on the first occasion when Pope Paul III went there after the war waged with the people of that city. There, in the festive preparations that were made to receive his Holiness, he acquitted himself very well in several works, and particularly in the portal called after Frate Rinieri, where, at the wish of Monsignore della Barba, who was then governor there, Cristofano executed a large Jove in Anger and another Pacified, which are two most beautiful figures, and on the other side he painted an Atlas with the world on his back, between two women, one of whom had a sword and the other a pair of scales. These works, with many others that Cristofano executed for those festivities, were the reason that afterwards, when the citadel had been built in Perugia by order of the same Pontiff, Messer Tiberio Crispo, who was governor and castellan at that time, when causing many of the rooms to be painted, desired that Cristofano, in addition to that which Lattanzio, a painter of the March, had executed in them up to that time, should also work there. Whereupon Cristofano not only assisted the above-named Lattanzio, but afterwards executed with his own hand the greater part of the best works that are painted in the apartments of that fortress, in which there also worked Raffaello dal Colle and Adone Doni of Assisi, an able and well-practised painter, who has executed many things in his native city and in other places. Tomasso Papacello also worked there; but the best that there was among them, and the one who gained most praise there, was Cristofano, on which account he was recommended by Lattanzio to the favour of the said Crispo, and was ever afterwards much employed by him.

Meanwhile, that same Crispo having built in Perugia a new little church known as S. Maria del Popolo, but first called Del Mercato, Lattanzio had begun for it an altar-piece in oils, and in this Cristofano painted with his own hand all the upper part, which is indeed most beautiful and worthy of great praise. Then, Lattanzio having been changed from a painter into the Constable of Perugia, Cristofano returned to S. Giustino, where he stayed many months, again working for the above-named Lord Abbot Bufolini.

After this, in the year 1543, Giorgio Vasari, having to execute a panel-picture in oils for the Great Cancelleria by order of the most illustrious Cardinal Farnese, and another for the Church of S. Agostino at the commission of Galeotto da Girone, sent for Cristofano, who went very willingly, as one who had a desire to see Rome. There he stayed many months, doing little else but go about seeing everything; but nevertheless he thus gained so much, that, after returning once more to S. Giustino, he painted in a hall some figures after his own fancy which were so beautiful, that it appeared that he must have studied at them twenty years. Then, in the year 1545, Vasari had to go to Naples to paint for the Monks of Monte Oliveto a refectory involving much more work than that of S. Michele in Bosco at Bologna, and he sent for Cristofano, Raffaello dal Colle, and Stefano, already mentioned as his friends and pupils; and they all came together at the appointed time in Naples, excepting Cristofano, who remained behind because he was ill. However, being pressed by Vasari, he made his way to Rome on his journey to Naples; but he was detained by his brother Borgognone, who was likewise an exile, and who wished to take him to France to enter the service of the Colonel Giovanni da Turrino, and so that occasion was lost. But when Vasari returned from Naples to Rome in the year 1546, in order to execute twenty-four pictures that were afterwards sent to Naples and placed in the Sacristy of S. Giovanni Carbonaro, in which he painted stories from the Old Testament, and also from the life of S. John the Baptist, with figures of one braccio or little more, and also in order to paint the doors of the organ of the Piscopio, which were six braccia in height, he availed himself of Cristofano, who was of great assistance to him and executed figures and landscapes in those works excellently well. Giorgio had also proposed to make use of him in the Hall of the Cancelleria, which was painted after cartoons by his hand, and entirely finished in a hundred days, for Cardinal Farnese, but in this he did not succeed, for Cristofano fell ill and returned to S. Giustino as soon as he had begun to mend. And Vasari finished the Hall without him, assisted by Raffaello dal Colle, the Bolognese Giovan Battista Bagnacavallo, the Spaniards Roviale and Bizzerra, and many others of his friends and pupils.

After returning from Rome to Florence and setting out from that city to go to Rimini, to paint a chapel in fresco and an altar-piece in the Church of the Monks of Monte Oliveto for

Abbot Gian Matteo Faettani, Giorgio passed through S. Giustino, in order to take Cristofano with him: but Abbot Bufolini, for whom he was painting a hall, would not let him go for the time being, although he promised Giorgio that he should send Cristofano to him soon all the way to Romagna. But, notwithstanding such a promise, the Abbot delayed so long to send him, that Cristofano, when he did go, found that Vasari had not only finished all the work for the other Abbot, but had also executed an altar-piece for the high-altar of S. Francesco at Rimini, for Messer Niccolò Marcheselli, and another altar-piece in the Church of Classi, belonging to the Monks of Camaldoli, at Ravenna, for Don Romualdo da Verona, the Abbot of that abbey.

In the year 1550, not long before this, Giorgio had just executed the story of the Marriage of Esther in the Black Friars' Abbey of S. Fiore, that is, in the refectory, at Arezzo, and also, at Florence, for the Chapel of the Martelli in the Church of S. Lorenzo, the altar-piece of S. Gismondo, when, Julius III having been elected Pope, he was summoned to Rome to enter the service of his Holiness. Thereupon he thought for certain that by means of Cardinal Farnese, who went at that time to stay in Florence, he would be able to reinstate Cristofano in his country and restore him to the favour of Duke Cosimo. But this proved to be impossible, so that poor Cristofano had to stay as he was until 1554, at which time, Vasari having been invited into the service of Duke Cosimo, there came to him an opportunity of delivering Cristofano. Bishop de' Ricasoli, who knew that he would be doing a thing pleasing to his Excellency, had set to work to have the three façades of his palace, which stands on the abutment of the Ponte alla Carraja, painted in chiaroscuro, when Messer Sforza Almeni, Cup-bearer as well as first and favourite Chamberlain to the Duke, resolved that he also would have his house in the Via de' Servi painted in chiaroscuro, in emulation of the Bishop. But, not having found in Florence any painters according to his fancy, he wrote to Giorgio Vasari, who had not then arrived in Florence, that he should think out the inventions and send him designs of all that it might seem to him best to paint on that façade of his. Whereupon Giorgio, who was much his friend, for they had known each other from the time when they were both in the service of Duke Alessandro, having thought out the whole according to the measurements of the

façade, sent him a design of most beautiful invention, which embellished the windows and joined them together with a well-varied decoration in a straight line from top to bottom, and filled all the spaces in the façade with rich scenes. This design, I say, which contained, to put it briefly, the whole life of man from birth to death, was sent by Vasari to Messer Sforza; and it so pleased him, and likewise the Duke, that, in order that it might have all its perfection, they resolved that they would not have it taken in hand until such time as Vasari himself should have arrived in Florence. Which Vasari having at last come and having been received by his most illustrious Excellency and by the above-named Messer Sforza with great friendliness, they began to discuss who might be the right man to execute that façade. Whereupon Giorgio, not allowing the occasion to slip by, said to Messer Sforza that no one was better able to carry out that work than Cristofano, and that neither in that nor in the works that were to be executed in the Palace, could he do without Cristofano's aid. And so, Messer Sforza having spoken of this to the Duke, after many inquiries it was found that Cristofano's crime was not so black as it had been painted, and the poor fellow was at last pardoned by his Excellency. Which news having been received by Vasari, who was at Arezzo, revisiting his native place and his friends, he sent a messenger expressly to Cristofano, who knew nothing of the matter, to give him that good news; and when he heard it, he was like to faint with joy. All rejoicing, therefore, and confessing that no one had ever been a better friend to him than Vasari, he went off next morning from Città di Castello to the Borgo, where, after presenting his letters of deliverance to the Commissioner, he made his way to his father's house, where his mother and also his brother, who had been recalled from exile long before, were struck with astonishment. Then, after passing two days there, he went off to Arezzo, where he was received by Giorgio with more rejoicing than if he had been his own brother, and recognized that he was so beloved by Vasari that he resolved that he would spend the rest of his life with him.

They then went from Arezzo to Florence together, and Cristofano went to kiss the hands of the Duke, who received him readily and was struck with amazement, for the reason that, whereas he had thought to see some great bravo, he saw the best little man in the world. Cristofano was likewise made much of by

Messer Sforza, who conceived a very great affection for him; and he then set his hand to the above-mentioned façade. In that work, Giorgio, because it was not yet possible to work in the Palace, assisted him, at his own request, to execute some designs for the scenes in the façade, also designing at times during the progress of the work, on the plaster, some of the figures that are there. But, although there are in it many things retouched by Vasari, nevertheless the whole façade, with the greater part of the figures and all the ornaments, festoons, and large ovals, is by the hand of Cristofano, who in truth, as may be seen, was so able in handling colours in fresco, that it may be said – and Vasari confesses it – that he knew more about it than Giorgio himself. And if Cristofano, when he was a lad, had exercised himself continuously in the studies of art – for he never did a drawing save when he had afterwards to carry it into execution – and had pursued the practice of art with spirit, he would have had no equal, seeing that his facility, judgment and memory enabled him to execute his works in such a way, without any further study, that he used to surpass many who in fact knew more than he. Nor could anyone believe with what facility and resolution he executed his labours, for, when he set himself to work, no matter how long a time it might take, he so delighted in it that he would never lift his eyes off his painting; wherefore his friends might well expect the greatest things from him. Besides this, he was so gracious in his conversation and his jesting as he worked, that Vasari would at times stay working in his company from morning till night, without ever growing weary.

Cristofano executed this façade in a few months, not to mention that he sometimes stayed away some weeks without working there, going to the Borgo to see and enjoy his home. Now I do not wish to grudge the labour of describing the distribution and the figures of this work, which, from its being in the open air and much exposed to the vagaries of the weather, may not have a very long life; scarcely, indeed, was it finished, when it was much injured by a terrible rain and a very heavy hail-storm, and in some places the wall was stripped of plaster. In this façade, then, there are three compartments. The first, to begin at the foot, is where the principal door and the two windows are; the second is from the sill of those windows to that of the second range of windows; and the third is from those last windows to the cornice of the roof. There are, besides this, six windows in each range, which

give seven spaces; and the whole work was divided according to
this plan in straight lines from the cornice of the roof down to
the ground. Next to the cornice of the roof, then, there is in
perspective a great cornice, with brackets that project over a
frieze of little boys, six of whom stand upright along the breadth
of the façade – namely, one above the centre of the arch of each
window; and these support with their shoulders most beautiful
festoons of fruits, leaves, and flowers, which run from one to
another. Those fruits and flowers are arranged in due succession
according to the seasons, symbolizing the periods of our life,
which is there depicted; and on the middle of the festoons, like-
wise, where they hang down, are other little boys in various atti-
tudes. This frieze finished, between the upper windows, in the
spaces that are there, there were painted the seven Planets, with
the seven celestial Signs above them as a crown and an ornament.
Beneath the sill of these windows, on the parapet, is a frieze of
Virtues, who, two by two, are holding seven great ovals; in which
ovals are seven distinct stories representing the Seven Ages of
Man, and each Age is accompanied by two Virtues appropriate
to her, and beneath the ovals in the spaces between the lower
windows there are the three Theological and the four Moral Vir-
tues. Below this, in the frieze that is above the door and the
windows supported by knee-shaped brackets, are the seven Libe-
ral Arts, each of which is in a line with the oval in which is the
particular story of the Life of Man appropriate to it; and in the
same straight lines, continued upwards, are the Moral Virtues,
Planets, Signs, and other corresponding symbols. Next, between
the windows with knee-shaped brackets, there is Life, both the
active and the contemplative, with scenes and statues, continued
down to Death, Hell, and our final Resurrection.

In brief, Cristofano executed almost all by himself the whole
cornice, the festoons, the little boys, and the seven Signs of the
Planets. Then, beginning on one side, he painted first the Moon,
and represented her by a Diana who has her lap full of flowers,
after the manner of Proserpine, with a moon upon her head and
the Sign of Cancer above her. Below, in the oval wherein is the
story of Infancy, there are present at the Birth of Man some
nurses who are suckling infants, and newly-delivered women in
bed, executed by Cristofano with much grace; and this oval
is supported by Will alone, who is a half-nude young woman,
fair and beautiful, and she is sustained by Charity, who is also

suckling infants. And beneath the oval, on the parapet, is Grammar, who is teaching some little boys to read.

Beginning over again, there follows Mercury with the Caduceus and with his Sign, who has below him in the oval some little boys, some of whom are going to school and some playing. This oval is supported by Truth, who is a nude little girl all pure and simple, who has on one side a male figure representing Falsehood, with a variety of girt-up garments and a most beautiful countenance, but with the eyes much sunken. Beneath the oval of the windows is Faith, who with the right hand is baptizing a child in a conch full of water, and with the left hand is holding a cross; and below her, on the parapet, is Logic covered by a veil, with a serpent.

Next follows the Sun, represented by an Apollo who has the lyre in his hand, with his Sign in the ornament above. In the oval is Adolescence, represented by two boys of equal age, one of whom, holding a branch of olive, is ascending a mountain illumined by the sun, and the other, halting half-way up to admire the beauties that Fraud displays from the middle upwards, without perceiving that her hideous countenance is concealed behind a smooth and beautiful mask, is caused by her and her wiles to fall over a precipice. This oval is supported by Sloth, a gross and corpulent man, who stands all sleepy and nude in the guise of a Silenus; and also by Toil, in the person of a robust and hardworking peasant, who has around him the implements for tilling the earth. These are supported by that part of the ornament that is between the windows, where Hope is, who has the anchors at her feet; and on the parapet below is Music, with various musical instruments about her.

There follows in due order Venus, who has clasped Love to her bosom, and is kissing him; and she, also, has her Sign above her. In the oval that she has beneath her is the story of Youth; that is, in the centre a young man seated, with books, instruments for measuring, and other things appertaining to design, and in addition maps of the world and cosmographical globes and spheres; and behind him is a loggia, in which are young men who are merrily passing the time away with singing, dancing, and playing, and also a banquet of young people all given over to enjoyment. On one side this oval is supported by Self-knowledge, who has about her compasses, armillary spheres, quadrants, and books, and is gazing at herself in a mirror; and, on the other side,

by Fraud, a hideous old hag, lean and toothless, who is mocking at Self-knowledge, and in the act of covering her face with a smooth and beautiful mask. Below the oval is Temperance, with a horse's bridle in her hand, and beneath her, on the parapet, is Rhetoric, who is in a line with the other similar figures.

Next to these comes Mars in armour, with many trophies about him, and with the Sign of the Lion above him. In his oval, which is below him, is Virility, represented by a full-grown man, standing between Memory and Will, who are holding before him a basin of gold containing a pair of wings, and are pointing out to him the path of deliverance in the direction of a mountain; and this oval is supported by Innocence, who is a maiden with a lamb at her side, and by Hilarity, who, all smiling and merry, reveals herself as what she really is. Beneath the oval, between the windows, is Prudence, who is making herself beautiful before a mirror; and she has below her, on the parapet, a figure of Philosophy.

Next there follows Jove, with his thunderbolt and his bird, the Eagle, and with his Sign above him. In the oval is Old Age, who is represented by an old man clothed as a priest and kneeling before an altar, upon which he is placing the basin of gold with the two wings; and this oval is supported by Compassion, who is covering some naked little boys, and by Religion, enveloped in sacerdotal vestments. Below these is a Fortitude in armour, who, planting one of her legs in a spirited attitude on a fragment of a column, is placing some balls in the mouth of a lion; and beneath her, on the parapet, she has a figure of Astrology.

The last of the seven Planets is Saturn, depicted as an old man heavy with melancholy, who is devouring his own children, with a great serpent that is seizing its own tail with its teeth; which Saturn has above him the Sign of Capricorn. In the oval is Decrepitude, and here is depicted Jove in Heaven receiving a naked and decrepit old man, kneeling, who is watched over by Felicity and Immortality, who are casting his garments into the world. This oval is supported by Beatitude, who is upheld by a figure of Justice in the ornament below, who is seated and has in her hand the sceptre and upon her shoulders the stork, with arms and laws around her; and on the parapet below is Geometry.

In the lowest part at the foot, which is about the windows with knee-shaped brackets and the door, is Leah in a niche, representing the Active Life, and on the other side of the same place

is Industry, who has a Cornucopia and two goads in her hands. Near the door is a scene in which many masters in wood and stone, architects, and stone-cutters have before them the gate of Cosmopolis, a city built by the Lord Duke Cosimo in the island of Elba, with a representation of Porto-Ferrajo. Between this scene and the frieze in which are the Liberal Arts, is Lake Trasimene, round which are Nymphs who are issuing from the water with tench, pike, eels, and roach, and beside the lake is Perugia, a nude figure holding with her hands a dog, which she is showing to a figure of Florence corresponding to her, who stands on the other side, with a figure of Arno beside her who is embracing and fondling her. And below this is the Contemplative Life in another scene, in which many philosophers and astrologers are measuring the heavens, appearing to be casting the horoscope of the Duke; and beside this, in the niche corresponding to that of Leah, is her sister Rachel, the daughter of Laban, representing the Contemplative Life. The last scene, which is likewise between two niches and forms the conclusion of the whole invention, is Death, who, mounted on a lean horse and holding the scythe, and accompanied by War, Pestilence, and Famine, is riding over persons of every kind. In one niche is the God Pluto, and beneath him Cerberus, the Hound of Hell; and in the other is a large figure rising again from a sepulchre on the last day. After all these things Cristofano executed on the pediments of the windows with knee-shaped brackets some nude figures that are holding the devices of his Excellency, and over the door a Ducal coat of arms, the six balls of which are upheld by some naked little boys, who twine in and out between each other as they fly through the air. And last of all, in the bases at the foot, beneath all the scenes, the some Cristofano painted the device of M. Sforza; that is, some obelisks, or rather triangular pyramids, which rest upon three balls, with a motto around that reads – Immobilis.

This work, when finished, was vastly extolled by his Excellency and by Messer Sforza himself, who, like the courteous gentleman that he was, wished to reward with a considerable present the art and industry of Cristofano; but he would have none of it, being contented and fully repaid by the goodwill of that lord, who loved him ever afterwards more than I could say. While the work was being executed, Vasari had Cristofano with him, as he had always done in the past, in the house of Signor

Bernardetto de' Medici, who much delighted in painting; which having perceived, Cristofano painted two scenes in chiaroscuro in a corner of his garden. One was the Rape of Proserpine, and in the other were Vertumnus and Pomona, the deities of agriculture; and besides this Cristofano painted in this work some ornaments of terminal figures and children of such variety and beauty, that there is nothing better to be seen.

Meanwhile arrangements had been made for beginning to paint in the Palace, and the first thing that was taken in hand was a hall in the new apartments, which, being twenty braccia wide, and having a height, according as Tasso had constructed it, of not more than nine braccia, was raised three braccia with beautiful ingenuity by Vasari, that is, to a total height of twelve braccia, without moving the roof, which was half a pavilion roof.

But because in doing this, before it could become possible to paint, much time had to be devoted to reconstructing the ceilings and to other works in that apartment and in others, Vasari himself obtained leave to go to Arezzo to spend two months there together with Cristofano. However, he did not succeed in being able to rest during that time, for the reason that he could not refuse to go in those days to Cortona, where he painted in fresco the vaulting and the walls of the Company of Jesus with the assistance of Cristofano, who acquitted himself very well, and particularly in the twelve different sacrifices from the Old Testament which they executed in the lunettes between the spandrels of the vaulting. Indeed, to speak more exactly, almost the whole of this work was by the hand of Cristofano, Vasari having done nothing therein beyond making certain sketches, designing some parts on the plaster, and then retouching it at times in various places, according as it was necessary.

This work finished, which is not otherwise than grand, worthy of praise, and very well executed, by reason of the great variety of things that are in it, they both returned to Florence in the month of January of the year 1555. There, having taken in hand the Hall of the Elements, while Vasari was painting the pictures of the ceiling, Cristofano executed some devices that bind together the friezes of the beams in perpendicular lines, in which are heads of capricorns and tortoises with the sail, devices of his Excellency. But the works in which he showed himself most marvellous were some festoons of fruits that are in the friezes of the beams on the under side, which are so beautiful that there is

nothing better coloured or more natural to be seen, particularly because they are separated one from another by certain masks, that hold in their mouths the ligatures of the festoons, than which one would not be able to find any more varied or more bizarre; in which manner of work it may be said that Cristofano was superior to any other who has ever made it his principal and particular profession. This done, he painted some large figures on that part of the walls where there is the Birth of Venus, but after the cartoons of Vasari, and many little figures in a landscape, which were executed very well. In like manner, on the wall where there are the Loves as tiny little children, fashioning the arrows of Cupid, he painted the three Cyclopes forging thunderbolts for Jove. Over six doors he executed in fresco six large ovals with ornaments in chiaroscuro and containing scenes in the colour of bronze, which were very beautiful; and in the same hall, between the windows, he painted in colours a Mercury and a Pluto, which are likewise very beautiful.

Work being then begun in the Chamber of the Goddess Ops, which is next to that described above, he painted the four Seasons in fresco on the ceiling, and, in addition to the figures, some festoons that were marvellous in their variety and beauty, for the reason that, even as those of Spring were filled with a thousand kinds of flowers, so those of Summer were painted with an infinite number of fruits and cereals, those of Autumn were of leaves and bunches of the grape, and those of Winter were of onions, turnips, radishes, carrots, parsnips, and dried leaves, not to mention that in the central picture, in which is the Car of Ops, he coloured so beautifully in oils four lions that are drawing the Car, that nothing better could be done; and, in truth, in painting animals he had no equal.

Then in the Chamber of Ceres, which is beside the last-named, he executed in certain angles some little boys and festoons that are beautiful to a marvel. And in the central picture, where Vasari had painted Ceres seeking for Proserpine with a lighted pine torch, upon a car drawn by two serpents, Cristofano carried many things to completion with his own hand, because Vasari was ill at that time and had left that picture, among other things, unfinished.

Finally, when it came to decorating a terrace that is beyond the Chamber of Jove and beside that of Ops, it was decided that all the history of Juno should be painted there; and so, after all

the ornamentation in stucco had been finished, with very rich carvings and various compositions of figures, wrought after the cartoons of Vasari, the same Vasari ordained that Cristofano should execute that work by himself in fresco, desiring, since it was a work to be seen from near, and of figures not higher than one braccio, that Gherardi should do something beautiful in this, which was his peculiar profession. Cristofano, then, executed in an oval on the vaulting a Marriage with Juno in the sky, and in a picture on one side Hebe, Goddess of Youth, and on the other Iris, who is pointing to the rainbow in the heavens. On the same vaulting he painted three other quadrangular pictures, two to match the others, and a larger one in a line with the oval in which is the Marriage, and in the last-named picture is Juno seated in a car drawn by peacocks. In one of the other two, which are on either side of that one, is the Goddess of Power, and in the other Abundance with the Cornucopia at her feet. And in two other pictures on the walls below, over the openings of two doors, are two other stories of Juno – the Transformation of Io, the daughter of the River Inachus, into a Cow, and of Callisto into a Bear.

During the execution of that work his Excellency conceived a very great affection for Cristofano, seeing him zealous and diligent in no ordinary manner at his work; for the morning had scarcely broken into day when Cristofano would appear at his labour, of which he had such a love, and it so delighted him, that very often he would not finish dressing before setting out. And at times, nay, frequently, it happened that in his haste he put on a pair of shoes – all such things he kept under his bed – that were not fellows, but of two kinds; and more often than not he had his cloak wrong side out, with the hood on the inside. One morning, therefore, appearing at an early hour at his work, where the Lord Duke and the Lady Duchess were standing looking at it, while preparations were being made to set out for the chase, and the ladies and others of the Court were making themselves ready, they noticed that Cristofano had as usual his cloak wrong side out and the hood inside. At which both laughing, the Duke said: 'What is your idea in always wearing your cloak inside out?' 'I know not, my Lord,' answered Cristofano, 'but I mean to find some day a kind of cloak that shall have neither right side nor wrong side, and shall be the same on both sides, for I have not the patience to think of wearing it in any other way, since in the

morning I generally dress and go out of the house in the dark, besides that I have one eye so feeble that I can see nothing with it. But let your Excellency look at what I paint, and not at my manner of dressing.' The Duke said nothing in answer, but within a few days he caused to be made for him a cloak of the finest cloth, with the pieces sewn and drawn together in such a manner that there was no difference to be seen between outside and inside, and the collar worked with braid in the same manner both inside and out, and so also the trimming that it had round the edges. This being finished, he sent it to Cristofano by a lackey, commanding the man that he should give it to him on the part of the Duke. Having therefore received the cloak very early one morning, Cristofano, without making any further ceremony, tried it on and then said to the lackey: 'The Duke is a man of sense. Tell him that it suits me well.'

Now, since Cristofano was thus careless of his person and hated nothing more than to have to put on new clothes or to go about too tightly constrained and confined in them, Vasari, who knew this humour of his, whenever he observed that he was in need of any new clothes, used to have them made for him in secret, and then, early one morning, used to place these in his chamber and take away the old ones; and so Cristofano was forced to put on those that he found. But it was marvellous sport to stand and hear him raging with fury as he dressed himself in the new clothes. 'Look here,' he would say, 'what devilments are these? Devil take it, can a man not live in his own way in this world, without the enemies of comfort giving themselves all this trouble?' One morning among others, Cristofano having put on a pair of white hose, the painter Domenico Benci, who was also working in the Palace with Vasari, contrived to persuade him to go with himself, in company with other young men, to the Madonna dell' Impruneta. There they walked, danced, and enjoyed themselves all day, and in the evening, after supper, they returned home. Then Cristofano, who was tired, went off straightway to his room to sleep; but, when he set himself to take off his hose, what with their being new and his having sweated, he was not able to pull off more than one of them. Now Vasari, having gone in the evening to see how he was, found that he had fallen asleep with one leg covered and the other bare; whereupon, one servant holding his leg and the other pulling at the stocking, they contrived to draw it off, while he lay cursing clothes,

Giorgio, and him who invented such fashions as – so he said – kept men bound in chains like slaves. Nay, he grumbled that he would take leave of them all and by hook or by crook return to S. Giustino, where he was allowed to live in his own way and had not all these restraints; and it was the devil's own business to pacify him.

It pleased him to talk seldom, and he loved that others also should be brief in speaking, insomuch that he would have gone so far as to have men's proper names very short, like that of a slave belonging to M. Sforza, who was called 'M.' 'These,' said Cristofano, 'are fine names, and not your Giovan Francesco and Giovanni Antonio, which take an hour's work to pronounce;' and since he was a good fellow at heart, and said these things in his own jargon of the Borgo, it would have made the Doleful Knight himself laugh. He delighted to go on feast-days to the places where legends and printed pictures were sold, and he would stay there the whole day; and if he bought some, more often than not, while he went about looking at the others, he would leave them at some place where he had been leaning. And never, unless he was forced, would he go on horseback, although he was born from a noble family in his native place and was rich enough.

Finally, his brother Borgognone having died, he had to go to the Borgo; and Vasari, who had drawn much of the money of his salary and had kept it for him, said to him: 'See, I have all this money of yours, it is right that you should take it with you and make use of it in your requirements.' 'I want no money,' answered Cristofano, 'take it for yourself. For me it is enough to have the luck to stay with you and to live and die in your company.' 'It is not my custom,' replied Vasari, 'to profit by the labour of others. If you will not have it, I shall send it to your father Guido.' 'That you must not do,' said Cristofano, 'for he would only waste it, as he always does.' In the end, he took the money and went off to the Borgo, but in poor health and with little contentment of mind; and after arriving there, what with his sorrow at the death of his brother, whom he had loved very dearly, and a cruel flux of the reins, he died in a few days, after receiving the full sacraments of the Church and distributing to his family and to many poor persons the money that he had brought. He declared a little before his death that it grieved him for no other reason save that he was leaving Vasari too much embarrassed by the great labours to which he had set his hand in

the Palace of the Duke. Not long afterwards, his Excellency having heard of the death of Cristofano, and that with true regret, he caused a head of him to be made in marble and sent it with the under-written epitaph from Florence to the Borgo, where it was placed in S. Francesco:

D. O. M.

CHRISTOPHORO GHERARDO BURGENSI
PINGENDI ARTE PRÆSTANTISS.
QUOD GEORGIUS VASARIUS ARETINUS HUJUS
ARTIS FACILE PRINCEPS
IN EXORNANDO
COSMI FLORENTIN. DUCIS PALATIO
ILLIUS OPERAM QUAM MAXIME
PROBAVERIT,
PICTORES HETRUSCI POSUERE.
OBIIT A.D. MDLVI.
VIXIT AN. LVI, M. III, D. VI.

JACOPO DA PONTORMO, Painter of Florence

THE ancestors – or rather, the elders of Bartolommeo di Jacopo di Martino, the father of Jacopo da Pontormo, whose Life we are now about to write – had their origin, so some declare, in Ancisa, a township in the Upper Valdarno, famous enough because from it the ancestors of Messer Francesco Petrarca likewise derived their origin. But, whether it was from there or from some other place that his elders came, the above-named Bartolommeo, who was a Florentine, and, so I have been told, of the family of the Carrucci, is said to have been a disciple of Domenico Ghirlandajo, and, after executing many works in the Valdarno, as a painter passing able for those times, to have finally made his way to Empoli to carry out certain labours, living there and in the neighbouring places, and taking to wife at Pontormo a most virtuous girl of good condition, called Alessandra, the daughter of Pasquale di Zanobi and of his wife Monna Brigida. To this Bartolommeo, then, there was born in the year 1493 our Jacopo. But the father having died in the year 1499, the mother in the year 1504, and the grandfather in the year 1506, Jacopo was left to the care of his grandmother, Monna Brigida, who kept him for several years at Pontormo, and had him taught reading, writing,

and the first rudiments of Latin grammar; and finally, at the age of thirteen, he was taken by the same guardian to Florence, and placed with the Pupilli, to the end that his small property might be safeguarded and preserved by that board, as is the custom. And after settling the boy himself in the house of one Battista, a shoemaker distantly related to him, Monna Brigida returned to Pontormo, taking with her a sister of Jacopo's. But not long after that, Monna Brigida herself having died, Jacopo was forced to bring that sister to Florence, and to place her in the house of a kinsman called Niccolaio, who lived in the Via de' Servi; and the girl, also, following the rest of her family, died in the year 1512, before ever she was married.

But to return to Jacopo; he had not been many months in Florence when he was placed by Bernardo Vettori with Leonardo da Vinci, and shortly afterwards with Mariotto Albertinelli, then with Piero di Cosimo, and finally, in the year 1512, with Andrea del Sarto, with whom, likewise, he did not stay long, for the reason that, after Jacopo had executed the cartoons of the little arch for the Servites, of which there will be an account below, it appears that Andrea never again looked favourably upon him, whatever may have been the reason. The first work, then, that Jacopo executed at that time was a little Annunciation for one his friend, a tailor; but the tailor having died before the work was finished, it remained in the hands of Jacopo, who was at that time with Mariotto, and Mariotto took pride in it, and showed it as a rare work to all who entered his workshop. Now Raffaello da Urbino, coming in those days to Florence, saw with infinite marvel the work and the lad who had done it, and prophesied of Jacopo that which was afterwards seen to come true. Not long afterwards, Mariotto having departed from Florence and gone to Viterbo to execute the panel-picture that Fra Bartolommeo had begun there, Jacopo, who was young, solitary, and melancholy, being thus left without a master, went by himself to work under Andrea del Sarto, at the very moment when Andrea had finished the stories of S. Filippo in the court of the Servites, which pleased Jacopo vastly, as did all his other works and his whole manner and design. Jacopo having then set himself to make every effort to imitate him, no long time passed before it was seen that he had made marvellous progress in drawing and colouring, insomuch that from his facility it seemed as if he had been many years in art.

IACOPO DA PVNTORMO PIT.
FIORENTINO.

Now Andrea had finished in those days a panel-picture of the Annunciation for the Church of the Friars of S. Gallo, which is now destroyed, as has been related in his Life; and he gave the predella of that panel-picture to Jacopo to execute in oils. Jacopo painted in it a Dead Christ, with two little Angels who are weeping over Him and illuminating Him with two torches, and, in two round pictures at the sides, two Prophets, which were executed by him so ably, that they have the appearance of having been painted not by a mere lad but by a practised master; but it may also be, as Bronzino says, that he remembers having heard from Jacopo da Pontormo himself that Rosso likewise worked on this predella. And even as Andrea was assisted by Jacopo in executing the predella, so also was he aided by him in finishing the many pictures and works that Andrea continually had in hand.

In the meantime, Cardinal Giovanni de' Medici having been elected Supreme Pontiff under the title of Leo X, there were being made all over Florence by the friends and adherents of that house many escutcheons of the Pontiff, in stone, in marble, on canvas, and in fresco. Wherefore the Servite Friars, wishing to give some sign of their service and devotion to that house and Pontiff, caused the arms of Leo to be made in stone, and placed in the centre of the arch in the first portico of the Nunziata, which is on the piazza; and shortly afterwards they arranged that it should be overlaid with gold by the painter Andrea di Cosimo, and adorned with grotesques, of which he was an excellent master, and with the devices of the house of Medici, and that, in addition, on either side of it there should be painted a Faith and a Charity. But Andrea di Cosimo, knowing that he was not able to execute all these things by himself, thought of giving the two figures to some other to do; and so, having sent for Jacopo, who was then not more than nineteen years of age, he gave him those two figures to execute, although he had no little trouble to persuade him to undertake to do it, seeing that, being a mere lad, he did not wish to expose himself at the outset to such a risk, or to work in a place of so much importance. However, having taken heart, although he was not as well practised in fresco as in oil-painting, Jacopo undertook to paint those two figures. And, withdrawing – for he was still working with Andrea del Sarto – to draw the cartoons at S. Antonio by the Porta a Faenza, where he lived, in a short time he carried them to completion; which done, one day he took his master Andrea to see them. Andrea, after

seeing them with infinite marvel and amazement, praised them vastly; but afterwards, as has been related, whether it was from envy or from some other reason, he never again looked with a kindly eye on Jacopo; nay, Jacopo going several times to his workshop, either the door was not opened to him or he was mocked at by the assistants, insomuch that he retired altogether by himself, beginning to live on the least that he could, for he was very poor, and to study with the greatest assiduity.

When Andrea di Cosimo, then, had finished gilding the escutcheon and all the eaves, Jacopo set to work all by himself to finish the rest; and being carried away by the desire to make a name, by his joy in working, and by nature, which had endowed him with extraordinary grace and fertility of genius, he executed that work with incredible rapidity and with such perfection as could not have been surpassed by an old, well-practised, and excellent master. Wherefore, growing in courage through this experience, and thinking that he could do a much better work, he took it into his head that he would throw to the ground all that he had done, without saying a word to anyone, and paint it all over again after another design that he had in his brain. But in the meantime the friars, having seen that the work was finished and that Jacopo came no more to his labour, sought out Andrea, and so pestered him that he resolved to uncover it. Having therefore looked for Jacopo, in order to ask him whether he wished to do any more to the work, and not finding him, for the reason that he stayed shut up over his new design and would not answer to anyone, Andrea had the screen and scaffolding removed and the work uncovered. The same evening Jacopo, having issued from his house in order to go to the Servite convent, and, when it should be night, to throw to the ground the work that he had done, and to put into execution the new design, found the scaffolding taken away and everything uncovered, and a multitude of people all around gazing at the work. Whereupon, full of fury, he sought out Andrea, and complained of his having uncovered it without his consent, going on to describe what he had in mind to do. To which Andrea answered, laughing: 'You are wrong to complain, because the work that you have done is so good that, if you had it to do again, you may take my word for it that you would not be able to do it better. You will not want for work, so keep these designs for another occasion.' That work, as may be seen, was of such a kind and so beautiful, what with the

novelty of the manner, the sweetness in the heads of those two women, and the loveliness of the graceful and lifelike children, that it was the most beautiful work in fresco that had ever been seen up to that time; and, besides the children with the Charity, there are two others in the air holding a piece of drapery over the escutcheon of the Pope, who are so beautiful that nothing better could be done, not to mention that all the figures have very strong relief and are so executed in colouring and in every other respect that one is not able to praise them enough. And Michelagnolo Buonarroti, seeing the work one day, and reflecting that a youth of nineteen had done it, said: 'This young man, judging from what may be seen here, will become such that, if he lives and perseveres, he will exalt this art to the heavens.' This renown and fame being heard by the men of Pontormo, they sent for Jacopo, and commissioned him to execute in their stronghold, over a gate placed on the main road, an escutcheon of Pope Leo with two little boys, which was very beautiful; but already it has been little less than ruined by rain.

At the Carnival in the same year, all Florence being gay and full of rejoicing at the election of the above-named Leo X, many festive spectacles were ordained, and among them two of great beauty and extraordinary cost, which were given by two companies of noblemen and gentlemen of the city. One of these, which was called the Diamante,* had for its head the brother of the Pope, Signor Giuliano de' Medici, who had given it that name because the diamond had been a device of his father, the elder Lorenzo; and the head of the other, which had as name and device the Broncone,† was Signor Lorenzo, the son of Piero de' Medici, who had for his device a Broncone – that is, a dried trunk of laurel growing green again with leaves, as it were to signify that he was reviving and restoring the name of his grandfather.

By the Company of the Diamante, then, a commission was given to M. Andrea Dazzi, who was then lecturing on Greek and Latin Letters at the Studio in Florence, to look to the invention of a triumphal procession; whereupon he arranged one similar to those that the Romans used to have for their triumphs, with three very beautiful cars wrought in wood, and painted with rich and beautiful art. In the first was Boyhood, with a most beautiful array of boys. In the second was Manhood, with many persons

* Diamond. † Trunk or branch.

who had done great things in their manly prime. And in the third
was Old Age, with many famous men who had performed great
achievements in their last years. All these persons were very richly
apparelled, insomuch that it was thought that nothing better
could be done. The architects of these cars were Raffaello delle
Vivole, Il Carota the wood-carver, the painter Andrea di Cosimo,
and Andrea del Sarto; those who arranged and prepared the
dresses of the figures were Ser Piero da Vinci, the father of
Leonardo, and Bernardino di Giordano, both men of beautiful
ingenuity; and to Jacopo da Pontormo alone it fell to paint all the
three cars, wherein he executed various scenes in chiaroscuro of
the Transformations of the Gods into different forms, which are
now in the possession of Pietro Paolo Galeotto, an excellent
goldsmith. The first car bore, written in very clear characters, the
word 'Erimus,' the second 'Sumus,' and the third 'Fuimus' – that
is, 'We shall be,' 'We are,' and 'We have been.' The song began,
'The years fly on. . . .'

Having seen these triumphal cars, Signor Lorenzo, the head
of the Company of the Broncone, desiring that they should be
surpassed, gave the charge of the whole work to Jacopo Nardi, a
noble and most learned gentleman, to whom, for what he after-
wards became, his native city of Florence is much indebted. This
Jacopo prepared six triumphal cars, in order to double the num-
ber of those executed by the Diamante. The first, drawn by a pair
of oxen decked with herbage, represented the Age of Saturn and
Janus, called the Age of Gold; and on the summit of the car were
Saturn with the Scythe, and Janus with the two heads and with
the key of the Temple of Peace in the hand, and at his feet a
figure of Fury bound, with a vast number of things around ap-
pertaining to Saturn, all executed most beautifully in different
colours by the genius of Pontormo. Accompanying this car were
six couples of Shepherds, naked but for certain parts covered by
skins of marten and sable, with footwear of various kinds after
the ancient manner, and with their wallets, and on their heads
garlands of many kinds of leaves. The horses on which these
Shepherds sat were without saddles, but covered with skins of
lions, tigers, and lynxes, the paws of which, overlaid with gold,
hung at their sides with much grace and beauty. The ornaments
of their croups and of the grooms were of gold cord, the stirrups
were heads of rams, dogs, and other suchlike animals, and the
bridles and reins made with silver cord and various kinds of

verdure. Each Shepherd had four grooms in the garb of shepherd-boys, dressed more simply in other skins, with torches fashioned in the form of dry trunks and branches of pine, which made a most beautiful sight.

Upon the second car, drawn by two pairs of oxen draped in the richest cloth, with garlands on their heads and great paternosters hanging from their gilded horns, was Numa Pompilius, the second King of Rome, with the books of religion and all the sacerdotal instruments and the things appertaining to sacrifices, for the reason that he was the originator and first founder of religion and sacrifices among the Romans. This car was accompanied by six priests on most beautiful she-mules, their heads covered with hoods of linen embroidered with silver and gold in a masterly pattern of ivy-leaves; and on their bodies they had sacerdotal vestments in the ancient fashion, with borders and fringes of gold all round, and in the hands one had a thurible, another a vase of gold, and the rest other similar things. At their stirrups they had attendants in the guise of Levites, and the torches that these had in their hands were after the manner of ancient candelabra, and wrought with beautiful artistry.

The third car represented the Consulate of Titus Manlius Torquatus, who was Consul after the end of the first Carthaginian war, and governed in such a manner, that in his time there flourished in Rome every virtue and every blessing. That car, upon which was Titus himself, with many ornaments executed by Pontormo, was drawn by eight most beautiful horses, and before it went six couples of Senators clad in the toga, on horses covered with cloth of gold, accompanied by a great number of grooms representing Lictors, with the fasces, axes, and other things appertaining to the administration of justice.

The fourth car, drawn by four buffaloes disguised as elephants, represented Julius Cæsar in Triumph for the victory gained over Cleopatra, the car being all painted by Pontormo with his most famous deeds. That car was accompanied by six couples of men-at-arms clad in rich and brightly shining armour all bordered with gold, with their lances on their hips; and the torches that the half-armed grooms carried had the form of trophies, designed in various ways.

The fifth car, drawn by winged horses that had the form of gryphons, bore upon it Cæsar Augustus, the Lord of the Universe, accompanied by six couples of Poets on horseback, all

crowned, as was also Cæsar, with laurel, and dressed in costumes varying according to their provinces; and these were there because poets were always much favoured by Cæsar Augustus, whom they exalted with their works to the heavens. And to the end that they might be recognized, each of them had across his forehead a scroll after the manner of a fillet, on which was his name.

On the sixth car, drawn by four pairs of heifers richly draped, was Trajan, that just Emperor, before whom, as he sat on the car, which was painted very well by Pontormo, there rode upon beautiful and finely caparisoned horses six couples of Doctors of Law, with togas reaching to their feet and with capes of miniver, such as it was the ancient custom for Doctors to wear. The grooms who carried their torches, a great number, were scriveners, copyists, and notaries, with books and writings in their hands.

After these six came the car, or rather, triumphal chariot, of the Age or Era of Gold, wrought with the richest and most beautiful artistry, with many figures in relief executed by Baccio Bandinelli, and very beautiful paintings by the hand of Pontormo; among those in relief the four Cardinal Virtues being highly extolled. From the centre of the car rose a great sphere in the form of a globe of the world, upon which there lay prostrate on his face, as if dead, a man clad in armour all eaten with rust, who had the back open and cleft, and from the fissure there issued a child all naked and gilded, who represented the new birth of the age of gold and the end of the age of iron, from which he was coming forth into that new birth by reason of the election of that Pontiff; and this same significance had the dry trunk putting forth new leaves, although some said that the matter of that dry trunk was an allusion to the Lorenzo de' Medici who became Duke of Urbino. I should mention that the gilded boy, who was the son of a baker, died shortly afterwards through the sufferings that he endured in order to gain ten crowns.

The chant that was sung in that masquerade, as is the custom, was composed by the above-named Jacopo Nardi, and the first stanza ran thus:

> Colui che da le leggi alla Natura
> E i varii stati e secoli dispone,
> D' ogni bene è cagione;
> E il mal, quanto permette, al Mondo dura;

Onde questa figura
Contemplando si vede,
Come con certo piede
L' un secol dopo l' altro al Mondo viene
E muta il bene in male, e 'l male in bene.

From the works that he executed for this festival Pontormo
gained, besides the profit, so much praise, that probably few
young men of his age ever gained as much in that city; wherefore,
Pope Leo himself afterwards coming to Florence, he was much
employed in the festive preparations that were made, for he had
attached himself to Baccio da Montelupo, a sculptor advanced in
years, who made an arch of wood at the head of the Via del
Palagio, at the steps of the Badia, and Pontormo painted it all
with very beautiful scenes, which afterwards came to an evil end
through the scant diligence of those who had charge of them.
Only one remained, that in which Pallas is tuning an instrument
into accord with the lyre of Apollo, with great grace and beauty;
from which scene one is able to judge what excellence and per-
fection were in the other works and figures. For the same festiv-
ities Ridolfo Ghirlandajo had received the task of fitting up and
embellishing the Sala del Papa, which is attached to the Convent
of S. Maria Novella, and was formerly the residence of the Pon-
tiffs in the city of Florence; but being pressed for time, he was
forced to avail himself in some things of the work of others, and
thus, after having adorned all the other rooms, he laid on Jacopo
da Pontormo the charge of executing some pictures in fresco in
the chapel where his Holiness was to hear Mass every morning.
Whereupon, setting his hand to the work, Jacopo painted there a
God the Father with many little Angels, and a Veronica who had
the Sudarium with the image of Jesus Christ; which work, thus
executed by Jacopo in so short a time, was much extolled.

He then painted in fresco, in a chapel of the Church of
S. Ruffillo, behind the Archbishop's Palace in Florence, Our Lady
with her Son in her arms between S. Michelagnolo and S. Lucia,
and two other Saints kneeling; and, in the lunette of the chapel,
a God the Father with some Seraphim about Him. Next, having
been commissioned by Maestro Jacopo, a Servite friar, as he had
greatly desired, to paint a part of the court of the Servites, be-
cause Andrea del Sarto had gone off to France and left the work
of that court unfinished, he set himself with much study to make

the cartoons. But since he was poorly provided with the things of this world, and was obliged, while studying in order to win honour, to have something to live upon, he executed over the door of the Hospital for Women – behind the Church of the Priest's Hospital, between the Piazza di S. Marco and the Via di S. Gallo, and exactly opposite to the wall of the Sisters of S. Catharine of Siena – two most beautiful figures in chiaroscuro, with Christ in the guise of a pilgrim awaiting certain women in order to give them hospitality and lodging; which work was deservedly much extolled in those days, as it still is, by all good judges. At this same time he painted some pictures and little scenes in oils for the Masters of the Mint, on the Carro della Moneta, which goes every year in the procession of S. John; the workmanship of which car was by the hand of Marco del Tasso. And over the door of the Company of Cecilia, on the heights of Fiesole, he painted a S. Cecilia with some roses in her hand, coloured in fresco, and so beautiful and so well suited to that place, that, for a work of that kind, it is one of the best paintings in fresco that there are to be seen.

These works having been seen by the above-named Servite friar, Maestro Jacopo, he became even more ardent in his desire, and he determined at all costs to cause Jacopo to finish the work in that court of the Servites, thinking that in emulation of the other masters who had worked there he would execute something of extraordinary beauty in the part that remained to be painted. Having therefore set his hand to it, from a desire no less of glory and honour than of gain, Jacopo painted the scene of the Visitation of the Madonna, in a manner a little freer and more lively than had been his wont up to that time; which circumstance gave an infinite excellence to the work, in addition to its other extraordinary beauties, in that the women, little boys, youths, and old men are executed in fresco with such softness and such harmony of colouring, that it is a thing to marvel at, and the flesh-colours of a little boy who is seated on some steps, and, indeed, those likewise of all the other figures, are such that they could not be done better or with more softness in fresco. This work, then, after the others that Jacopo had executed, gave a sure earnest of his future perfection to the craftsmen, comparing them with those of Andrea del Sarto and Franciabigio. Jacopo delivered the work finished in the year 1516, and received in payment sixteen crowns and no more.

Having then been allotted by Francesco Pucci, if I remember rightly, the altar-piece of a chapel that he had caused to be built in S. Michele Bisdomini in the Via de' Servi, Jacopo executed the work in so beautiful a manner, and with a colouring so vivid, that it seems almost impossible to credit it. In this altar-piece Our Lady, who is seated, is handing the Infant Jesus to S. Joseph, in whose countenance there is a smile so animated and so lifelike that it is a marvel; and very beautiful, likewise, is a little boy painted to represent S. John the Baptist, and also two other little children, naked, who are upholding a canopy. There may be seen also a S. John the Evangelist, a most beautiful old man, and a S. Francis kneeling, who is absolutely alive, for, with the fingers of one hand interlocked with those of the other, and wholly intent in contemplating fixedly with his eyes and his mind the Virgin and her Son, he appears really to be breathing. And no less beautiful is the S. James who may be seen beside the others. Wherefore it is no marvel that this is the most beautiful altar-piece that was ever executed by this truly rare painter.

I used to believe that it was after this work, and not before, that the same Jacopo had painted in fresco the two most lovely and graceful little boys who are supporting a coat of arms over a door within a passage on the Lungarno, between the Ponte S. Trinita and the Ponte alla Carraja, for Bartolommeo Lanfredini; but since Bronzino, who may be supposed to know the truth about these matters, declares that they were among the first works that Jacopo executed, we must believe that this is so without a doubt, and praise Pontormo for them all the more, seeing that they are so beautiful that they cannot be matched, and yet were among the earliest works that he did.

But to resume the order of our story: after these works, Jacopo executed for the men of Pontormo an altar-piece wherein are S. Michelagnolo and S. John the Evangelist, which was placed in the Chapel of the Madonna in S. Agnolo, their principal church. At this time one of two young men who were working under Jacopo – that is, Giovan Maria Pichi of Borgo a S. Sepolcro, who was acquitting himself passing well, and who afterwards became a Servite friar, and executed some works in the Borgo and in the Pieve a S. Stefano – while still working, I say, under Jacopo, painted in a large picture a nude S. Quentin in martyrdom, in order to send it to the Borgo. But since Jacopo, like a loving master to his disciple, desired that Giovan Maria should win

honour and praise, he set himself to retouch it, and so, not being able to take his hands off it, and retouching one day the head, the next day the arms, and the day after the body, the retouching became such that it may almost be said that the work is entirely by his hand. Wherefore it is no marvel that this picture, which is now in the Church of the Observantine Friars of S. Francis in the Borgo, is most beautiful.

The second of the two young men, who was Giovanni Antonio Lappoli of Arezzo, of whom there has been an account in another place, like a vain fellow had taken a portrait of himself with a mirror, also while he was working under Jacopo. But his master, thinking that the portrait was a poor likeness, took it in hand himself, and executed a portrait that is so good that it has the appearance of life; which portrait is now at Arezzo, in the house of the heirs of that Giovanni Antonio.

Pontormo also portrayed in one and the same picture two of his dearest friends – one the son-in-law of Beccuccio Bicchieraio, and another, whose name likewise I do not know; it is enough that the portraits are by the hand of Pontormo. He then executed for Bartolommeo Ginori, in anticipation of his death, a string of pennons, according to the custom of the Florentines; and in the upper part of all these, on the white taffeta, he painted a Madonna with the Child, and on the coloured fringe below he painted the arms of that family, as is the custom. For the centre of the string, which was of twenty-four pennons, he made two all of white taffeta without any fringe, on which he painted two figures of S. Bartholomew, each two braccia high. The size of all these pennons and their almost novel manner caused all the others that had been made up to that time to appear poor and mean; and this was the reason that they began to be made of the size that they are at the present day, with great grace and much less expense for gold.

At the head of the garden and vineyard of the Friars of S. Gallo, without the gate that is called after that Saint, in a chapel that is in a line with the central entrance, he painted a Dead Christ, a Madonna weeping, and two little Angels in the air, one of whom was holding the Chalice of the Passion in his hands, and the other was supporting the fallen head of Christ. On one side was S. John the Evangelist, all tearful, with the arms stretched out, and on the other S. Augustine in episcopal robes, who, leaning with the left hand on the pastoral staff, stood in an

attitude truly full of sorrow, contemplating the Dead Saviour. And for Messer Spina, the familiar friend of Giovanni Salviati, he executed in a courtyard, opposite to the principal door of his house, the coat of arms of that Giovanni (who had been made a Cardinal in those days by Pope Leo), with the red hat above and two little boys standing – works in fresco which are very beautiful, and much esteemed by Messer Filippo Spina, as being by the hand of Pontormo.

Jacopo also worked, in competition with other masters, on the ornamentation in wood that was formerly executed in a magnificent manner, as has been related elsewhere, in some apartments of Pier Francesco Borgherini; and, in particular, he painted there with his own hand on two coffers some stories from the life of Joseph in little figures, which were truly most beautiful. And whoever wishes to see the best work that he ever did in all his life, in order to consider how able and masterly was Jacopo in giving liveliness to heads, in grouping figures, in varying attitudes, and in beauty of invention, let him look at a scene of some size, likewise in little figures, in the corner on the left hand as one enters through the door, in the chamber of Borgherini, who was a nobleman of Florence; in which scene is Joseph in Egypt, as it were a Prince or a King, in the act of receiving his father Jacob with all his brethren, the sons of that Jacob, with extraordinary affection. Among these figures he portrayed at the foot of the scene, seated upon some steps, Il Bronzino, who was then a boy and his disciple – a figure with a basket, which is lifelike and beautiful to a marvel. And if this scene were on a greater scale, on a large panel or a wall, instead of being small, I would venture to say that it would not be possible to find another picture executed with the grace, excellence, and even perfection wherewith this one was painted by Jacopo; wherefore it was rightly regarded by all craftsmen as the most beautiful picture that Pontormo ever executed. Nor is it to be wondered at that Borgherini should have prized it as he did, and should have been besought to sell it by great persons as a present for mighty lords and princes.

On account of the siege of Florence Pier Francesco retired to Lucca, and Giovan Battista della Palla, who desired to obtain, together with other things that he was transporting into France, the decorations of this chamber, so that they might be presented to King Francis in the name of the Signoria, received such favours, and went to work so effectively with both words and

deeds, that the Gonfalonier granted a commission that they should be taken away after payment to the wife of Pier Francesco. Whereupon some others went with Giovan Battista to execute the will of the Signori; but, when they arrived at the house of Pier Francesco, his wife, who was in the house, poured on Giovan Battista the greatest abuse that was ever spoken to any man. 'So you make bold, Giovan Battista,' said she, 'you vile slop-dealer, you little two-penny pedlar, to strip the ornaments from the chambers of noblemen and despoil our city of her richest and most honoured treasures, as you have done and are always doing, in order to embellish with them the countries of foreigners, our enemies! At you I do not marvel, you, a base plebeian and the enemy of your country, but at the magistrates of this city, who aid and abet you in these shameful rascalities. This bed, which you would seize for your own private interest and for greed of gain, although you keep your evil purpose cloaked with a veil of righteousness, this is the bed of my nuptials, in honour of which my husband's father, Salvi, made all these magnificent and regal decorations, which I revere in memory of him and from love for my husband, and mean to defend with my very blood and with life itself. Out of this house with these your cut-throats, Giovan Battista, and go to those who sent you with orders that these things should be removed from their places, for I am not the woman to suffer a single thing to be moved from here. If they who believe in you, a vile creature of no account, wish to make presents to King Francis of France, let them go and strip their own houses, and take the ornaments and beds from their own chambers, and send them to him. And you, if you are ever again so bold as to come to this house on such an errand, I will make you smart sorely for it, and teach you what respect should be paid by such as you to the houses of noblemen.' Thus spoke Madonna Margherita, the wife of Pier Francesco Borgherini, and the daughter of Ruberto Acciaiuoli, a most noble and wise citizen; and she, a truly courageous woman and a worthy daughter of such a father, with her noble ardour and spirit, was the reason that those gems are still preserved in that house.

Giovan Maria Benintendi, about this same time, had adorned an antechamber in his house with many pictures by the hands of various able men; and after the work executed for Borgherini, incited by hearing Jacopo da Pontormo very highly praised, he

caused a picture to be painted by him with the Adoration of the
Magi, who went to Bethlehem to see Christ; which work, since
Jacopo devoted to it much study and diligence, proved to be well
varied and beautiful in the heads and in every other part, and to
be truly worthy of all praise. Afterwards he executed for Messer
Goro da Pistoia, then Secretary to the Medici, a picture with the
portrait of the Magnificent Cosimo de' Medici, the elder, from
the knees upwards, which is indeed worthy to be extolled; and
this portrait is now in the house of Messer Ottaviano de' Medici,
in the possession of his son, Messer Alessandro, a young man –
besides the distinction and nobility of his blood – of most up-
right character, well lettered, and the worthy son of the Magnifi-
cent Ottaviano and of Madonna Francesca, the daughter of
Jacopo Salviati and the maternal aunt of the Lord Duke Cosimo.

By means of this work, and particularly this head of Cosimo,
Pontormo became the friend of Messer Ottaviano; and the Great
Hall at Poggio a Caiano having then to be painted, there were
given to him to paint the two ends where the round openings are
that give light – that is, the windows – from the vaulting down
to the floor. Whereupon, desiring to do himself honour even
beyond his wont, both from regard for the place and from emu-
lation of the other painters who were working there, he set him-
self to study with such diligence, that he overshot the mark, for
the reason that, destroying and doing over again every day what
he had done the day before, he racked his brains in such a man-
ner that it was a tragedy; but all the time he was always making
new discoveries, which brought credit to himself and beauty to
the work. Thus, having to execute a Vertumnus with his hus-
bandmen, he painted a peasant seated with a vine-pruner in his
hand, which is so beautiful and so well done that it is a very rare
thing, even as certain children that are there are lifelike and natu-
ral beyond all belief. On the other side he painted Pomona and
Diana, with other Goddesses, enveloping them perhaps too
abundantly with draperies. However, the work as a whole is beau-
tiful and much extolled; but while it was being executed Leo was
overtaken by death, and so it remained unfinished, like many
other similar works at Rome, Florence, Loreto, and other places;
nay, the whole world was left poor, being robbed of the true
Mæcenas of men of talent.

Having returned to Florence, Jacopo painted in a picture a
seated figure of S. Augustine as a Bishop, who is giving the

benediction, with two little nude Angels flying through the air, who are very beautiful; which picture is over an altar in the little Church of the Sisters of S. Clemente in the Via di S. Gallo. He carried to completion, likewise, a picture of a Pietà with certain nude Angels, which was a very beautiful work, and held very dear by certain merchants of Ragusa, for whom he painted it; but most beautiful of all in this picture was a landscape taken for the most part from an engraving by Albrecht Dürer. He also painted a picture of Our Lady with the Child in her arms, and some little Angels about her, which is now in the house of Alessandro Neroni; and for certain Spaniards he executed another like it – that is, of the Madonna – but different from the one described above and in another manner, which picture, being for sale in a second-hand dealer's shop many years after, was bought by Bartolommeo Panciatichi at the suggestion of Bronzino.

Then, in the year 1522, there being a slight outbreak of plague in Florence, and many persons therefore departing in order to avoid that most infectious sickness and to save themselves, an occasion presented itself to Jacopo of flying the city and removing himself to some distance, for a certain Prior of the Certosa, a place built by the Acciaiuoli three miles away from Florence, had to have some pictures painted in fresco at the corners of a very large and beautiful cloister that surrounds a lawn, and Jacopo was brought to his notice; whereupon the Prior had him sought out, and he, having accepted the work very willingly at such a time, went off to Certosa, taking with him only Bronzino. There, after a trial of that mode of life, that quiet, that silence, and that solitude – all things after the taste and nature of Jacopo – he thought with such an occasion to make a special effort in the matters of art, and to show to the world that he had acquired greater perfection and a different manner since those works that he had executed before. Now not long before there had come from Germany to Florence many sheets printed from engravings done with great subtlety with the burin by Albrecht Dürer, a most excellent German painter and a rare engraver of plates on copper and on wood; and, among others, many scenes, both large and small, of the Passion of Jesus Christ, in which was all the perfection and excellence of engraving with the burin that could ever be achieved, what with the beauty and variety of the vestments and the invention. Jacopo, having to paint at the corners of those cloisters scenes from the Passion of the Saviour, thought

to avail himself of the above-named inventions of Albrecht
Dürer, in the firm belief that he would satisfy not only himself
but also the greater part of the craftsmen of Florence, who were
all proclaiming with one voice and with common consent and
agreement the beauty of those engravings and the excellence of
Albrecht. Setting himself therefore to imitate that manner, and
seeking to give to the expressions of the heads of his figures that
liveliness and variety which Albrecht had given to his, he caught
it so thoroughly, that the charm of his own early manner, which
had been given to him by nature, all full of sweetness and grace,
suffered a great change from that new study and labour, and was
so impaired through his stumbling on that German manner, that
in all these works, although they are all beautiful, there is but a
sorry remnant to be seen of that excellence and grace that he had
given up to that time to all his figures.

At the entrance to the cloister, then, in one corner, he painted
Christ in the Garden, counterfeiting so well the darkness of night
illumined by the light of the moon, that it appears almost like
daylight; and while Christ is praying, not far distant are Peter,
James, and John sleeping, executed in a manner so similar to that
of Dürer, that it is a marvel. Not far away is Judas leading the
Jews, likewise with a countenance so strange, even as the features
of all those soldiers are depicted in the German manner with
bizarre expressions, that it moves him who beholds it to pity for
the simplicity of the man, who sought with such patience to learn
that which others avoid and seek to lose, and all to lose the
manner that surpassed all others in excellence and gave infinite
pleasure to everyone. Did not Pontormo know, then, that the
Germans and Flemings came to these parts to learn the Italian
manner, which he with such effort sought to abandon as if it
were bad?

Beside this scene is one in which is Christ led by the Jews
before Pilate, and in the Saviour he painted all the humility that
could possibly be imagined in the Person of Innocence betrayed
by the sins of men, and in the wife of Pilate that pity and dread
for themselves which those have who fear the divine judgment;
which woman, while she pleads the cause of Christ before her
husband, gazes into His countenance with pitying wonder.
Round Pilate are some soldiers so characteristic in the expres-
sions of the faces and in the German garments, that one who
knew not by whose hand was that work would believe it to have

been executed in reality by ultramontanes. It is true, indeed, that in the distance in this scene there is a cup-bearer of Pilate's that is descending some steps with a basin and a ewer in his hands, carrying to his master the means to wash the hands, who is lifelike and very beautiful, having in him something of the old manner of Jacopo.

Having next to paint the Resurrection of Christ in one of the other corners, the fancy came to Jacopo, as to one who had no steadfastness in his brain and was always cogitating new things, to change his colouring; and so he executed that work with a colouring in fresco so soft and so good, that, if he had done the work in another manner than that same German, it would certainly have been very beautiful, for in the heads of those soldiers, who are in various attitudes, heavy with sleep, and as it were dead, there may be seen such excellence, that one cannot believe that it is possible to do better.

Then, continuing the stories of the Passion in another of the corners, he painted Christ going with the Cross upon His shoulder to Mount Calvary, and behind Him the people of Jerusalem, accompanying Him; and in front are the two Thieves, naked, between the ministers of justice, who are partly on foot and partly on horseback, with the ladders, the inscription for the Cross, hammers, nails, cords, and other suchlike instruments. And in the highest part, behind a little hill, is the Madonna with the Maries, who, weeping, are awaiting Christ, who has fallen to the ground in the middle of the scene, and has about Him many Jews that are smiting Him, while Veronica is offering to Him the Sudarium, accompanied by some women both young and old, all weeping at the outrage that they see being done to the Saviour. This scene, either because he was warned by his friends, or perhaps because Jacopo himself at last became aware, although tardily, of the harm that had been done to his own sweet manner by the study of the German, proved to be much better than the others executed in the same place, for the reason that certain naked Jews and some heads of old men are so well painted in fresco, that it would not be possible to do more, although the same German manner may be seen constantly maintained in the work as a whole.

After these he was to have gone on with the Crucifixion and the Deposition from the Cross in the other corners; but, putting them aside for a time, with the intention of executing them last,

he painted in their stead Christ taken down from the Cross, keeping to the same manner, but with great harmony of colouring. In this scene, besides that the Magdalene, who is kissing the feet of Christ, is most beautiful, there are two old men, representing Joseph of Arimathæa and Nicodemus, who, although they are in the German manner, have the most beautiful expressions and heads of old men, with beards feathery and coloured with marvellous softness, that there are to be seen.

Now Jacopo, besides being generally slow over his works, was pleased with the solitude of the Certosa, and he therefore spent several years on these labours; and, after the plague had finished and he had returned to Florence, he did not for that reason cease to frequent that place constantly, and was always going and coming between the Certosa and the city. Proceeding thus, he satisfied those fathers in many things, and, among others, he painted in their church, over one of the doors that lead into the chapels, in a figure from the waist upwards, the portrait of a lay-brother of that monastery, who was alive at that time and one hundred and twenty years old, executing it so well and with such finish, such vivacity, and such animation, that through it alone Pontormo deserves to be excused for the strange and fantastic new manner with which he was saddled by that solitude and by living far from the commerce of men.

Besides this, he painted for the Prior of that place a picture of the Nativity of Christ, representing Joseph as giving light to Jesus Christ in the darkness of the night with a lantern, and this in pursuit of the same notions and caprices which the German engravings put into his head. Now let no one believe that Jacopo is to blame because he imitated Albrecht Dürer in his inventions, for the reason that this is no error, and many painters have done it and are continually doing it; but only because he adopted the unmixed German manner in everything, in the draperies, in the expressions of the heads, and in the attitudes, which he should have avoided, availing himself only of the inventions, since he had the modern manner in all the fullness of its beauty and grace. For the Stranger's Apartment of the same monks he painted a large picture on canvas and in oil-colours, without straining himself at all or forcing his natural powers, of Christ at table with Cleophas and Luke, figures of the size of life; and since in this work he followed the bent of his own genius, it proved to be truly marvellous, particularly because he portrayed among those

who are serving at that table some lay-brothers of the convent, whom I myself have known, in such a manner that they could not be either more lifelike or more animated than they are.

Bronzino, meanwhile (that is, while his master was executing the works described above in the Certosa), pursuing with great spirit the studies of painting, and encouraged all the time by Pontormo, who was very loving with his disciples, executed on the inner side over an arch above the door of the cloister that leads into the church, without having ever seen the process of painting in oil-colours on the wall, a nude S. Laurence on the gridiron, which was so beautiful that there began to be seen some indication of that excellence to which he has since attained, as will be related in the proper place; which circumstance gave infinite satisfaction to Jacopo, who already saw whither that genius would arrive.

Not long afterwards there returned from Rome Lodovico di Gino Capponi, who had bought that chapel in S. Felicita, on the right hand of the entrance into the church, which the Barbadori had formerly caused to be built by Filippo di Ser Brunellesco; and he resolved to have all the vaulting painted, and then to have an altar-piece executed for it, with a rich ornament. Having therefore consulted in the matter with M. Niccolò Vespucci, knight of Rhodes, who was much his friend, the knight, who was also much the friend of Jacopo, and knew, into the bargain, the talent and worth of that able man, did and said so much that Lodovico allotted that work to Pontormo. And so, having erected an enclosure, which kept that chapel closed for three years, he set his hand to the work. On the vaulted ceiling he painted a God the Father, who has about Him four very beautiful Patriarchs; and in the four medallions at the angles he depicted the four Evangelists, or rather, he executed three of them with his own hand, and Bronzino one all by himself. And with this occasion I must mention that Pontormo used scarcely ever to allow himself to be helped by his assistants, or to suffer them to lay a hand on that which he intended to execute with his own hand; and when he did wish to avail himself of one of them, chiefly in order that they might learn, he allowed them to do the whole work by themselves, as he allowed Bronzino to do here.

In the works that Jacopo executed in the said chapel up to this point, it seemed almost as if he had returned to his first manner; but he did not follow the same method in painting the

altar-piece, for, thinking always of new things, he executed it without shadows, and with a colouring so bright and so uniform, that one can scarcely distinguish the lights from the middle tints, and the middle tints from the darks. In this altar-piece is a Dead Christ taken down from the Cross and being carried to the Sepulchre. There is the Madonna who is swooning, and the Maries, all executed in a fashion so different from his first work, that it is clearly evident that his brain was always busy investigating new conceptions and fantastic methods of painting, not being content with, and not fixing on, any single method. In a word, the composition of this altar-piece is altogether different from the figures on the vaulting, and likewise the colouring; and the four Evangelists, which are in the medallions on the spandrels of the vaulting, are much better and in a different manner.

On the wall where the window is are two figures in fresco, on one side the Virgin, and on the other the Angel, who is bringing her the Annunciation, but so distorted, both the one and the other, that it is evident that, as I have said, that bizarre and fantastic brain was never content with anything. And in order to be able to do as he pleased in this, and to avoid having his attention distracted by anyone, all the time that he was executing this work he would never allow even the owner of the chapel himself to see it, insomuch that, having painted it after his own fancy, without any of his friends having been able to give him a single hint, when it was finally uncovered and seen, it amazed all Florence. For the same Lodovico he executed a picture of Our Lady in that same manner for his chamber, and in the head of a S. Mary Magdalene he made the portrait of a daughter of Lodovico, who was a very beautiful young woman.

Near the Monastery of Boldrone, on the road that goes from there to Castello, and at the corner of another that climbs the hill and goes to Cercina (that is, at a distance of two miles from Florence), he painted in fresco in a shrine Christ Crucified, Our Lady weeping, S. John the Evangelist, S. Augustine, and S. Giuliano; all which figures, his caprice not being yet satisfied, and the German manner still pleasing him, are not very different from those that he executed at the Certosa. He did the same, also, in an altar-piece that he painted for the Nuns of S. Anna, at the Porta a S. Friano, in which altar-piece is Our Lady with the Child in her arms, and S. Anne behind her, with S. Peter, S. Benedict, and other Saints, and in the predella is a small scene

with little figures, which represent the Signoria of Florence as it used to go in procession with trumpeters, pipers, mace-bearers, messengers, and ushers, with the rest of the household; and this he did because the commission for that altar-piece was given to him by the Captain and the household of the Palace.

The while that Jacopo was executing this work, Alessandro and Ippolito de' Medici, who were both very young, having been sent to Florence by Pope Clement VII under the care of the Legate, Silvio Passerini, Bishop of Cortona, the Magnificent Ottaviano, to whom the Pope had straitly recommended them, had the portraits of both of them taken by Pontormo, who served him very well, and made them very good likenesses, although he did not much depart from the manner that he had learned from the Germans. In the portrait of Ippolito he also painted a favourite dog of that lord, called Rodon, and made it so characteristic and so natural, that it might be alive. He took the portrait, likewise, of Bishop Ardinghelli, who afterwards became a Cardinal; and for Filippo del Migliore, who was much his friend, he painted in fresco in his house on the Via Larga, in a niche opposite to the principal door, a woman representing Pomona, from which it appeared that he was beginning to seek to abandon in part his German manner.

Now Giovan Battista della Palla perceived that by reason of many works the name of Jacopo was becoming every day more celebrated; and, since he had not succeeded in sending to King Francis the pictures executed by that same master and by others for Borgherini, he resolved, knowing that the King had a desire for them, at all costs to send him something by the hand of Pontormo. Whereupon he so went to work that he persuaded Jacopo to execute a most beautiful picture of the Raising of Lazarus, which proved to be one of the best works that he ever painted and that was ever sent by Giovan Battista, among the vast number that he sent, to King Francis of France. For, besides that the heads were most beautiful, the figure of Lazarus, whose spirit as he returned to life was re-entering his dead flesh, could not have been more marvellous, for about the eyes he still had the hue of corruption, and the flesh cold and dead at the extremities of the hands and feet, where the spirit had not yet come.

In a picture of one braccio and a half he painted for the Sisters of the Hospital of the Innocenti, with an infinite number of little figures, the story of the eleven thousand Martyrs who were

condemned to death by Diocletian and all crucified in a wood. In this Jacopo represented a battle of horsemen and nude figures, very beautiful, and some most lovely little Angels flying through the air, who are shooting arrows at the ministers of the crucifixion; and in like manner, about the Emperor, who is pronouncing the condemnation, are some most beautiful nude figures who are going to their death. This picture, which in every part is worthy to be praised, is now held in great price by Don Vincenzio Borghini, the Director of that Hospital, who once was much the friend of Jacopo. Another picture similar to that described above he painted for Carlo Neroni, but only with the Battle of the Martyrs and the Angel baptizing them; and then the portrait of Carlo himself. He also executed a portrait, at the time of the siege of Florence, of Francesco Guardi in the habit of a soldier, which was a very beautiful work; and on the cover of this picture Bronzino afterwards painted Pygmalion praying to Venus that his statue, receiving breath, might spring to life and become – as, according to the fables of the poets, it did – flesh and blood. At this time, after much labour, there came to Jacopo the fulfilment of a desire that he had long had, in that, having always felt a wish to have a house that might be his own, so that he should no longer live in the house of another, but might occupy his own and live as pleased himself, finally he bought one in the Via della Colonna, opposite to the Nuns of S. Maria degli Angeli.

The siege finished, Pope Clement commanded Messer Ottaviano de' Medici that he should cause the hall of Poggio a Caiano to be finished. Whereupon, Franciabigio and Andrea del Sarto being dead, the whole charge of this was given to Pontormo, who, after having the staging and the screens made, began to execute the cartoons; but, for the reason that he went off into fantasies and cogitations, beyond that he never set a hand to the work. This, perchance, would not have happened if Bronzino had been in those parts, who was then working at the Imperiale, a place belonging to the Duke of Urbino, near Pesaro; which Bronzino, although he was sent for every day by Jacopo, nevertheless was not able to depart at his own pleasure, for the reason that, after he had executed a very beautiful naked Cupid on the spandrel of a vault in the Imperiale, and the cartoons for the others, Prince Guidobaldo, having recognized the young man's genius, ordained that his own portrait should be taken by him, and, seeing that he wished to be portrayed in some armour that he

was expecting from Lombardy, Bronzino was forced to stay with that Prince longer than he could have wished. During that time he painted the case of a harpsichord, which much pleased the Prince, and finally Bronzino executed his portrait, which was very beautiful, and the Prince was well satisfied with it.

Jacopo, then, wrote so many times, and employed so many means, that in the end he brought Bronzino back; but for all that the man could never be induced to do any other part of this work than the cartoons, although he was urged to it by the Magnificent Ottaviano and by Duke Alessandro. In one of these cartoons, which are now for the most part in the house of Lodovico Capponi, is a Hercules who is crushing Antæus, in another a Venus and Adonis, and in yet another drawing a scene of nude figures playing football.

In the meantime Signor Alfonso Davalos, Marchese del Vasto, having obtained from Michelagnolo Buonarroti by means of Fra Niccolò della Magna a cartoon of Christ appearing to the Magdalene in the garden, moved heaven and earth to have it executed for him in painting by Pontormo, Buonarroti having told him that no one could serve him better than that master. Jacopo then executed that work to perfection, and it was accounted a rare painting by reason both of the grandeur of Michelagnolo's design and of Jacopo's colouring. Wherefore Signor Alessandro Vitelli, who was at that time Captain of the garrison of soldiers in Florence, having seen it, had a picture painted for himself from the same cartoon by Jacopo, which he sent to Città di Castello and caused to be placed in his house. It thus became evident in what estimation Michelagnolo held Pontormo, and with what diligence Pontormo carried to completion and executed excellently well the designs and cartoons of Michelagnolo, and Bartolommeo Bettini so went to work that Buonarroti, who was much his friend, made for him a cartoon of a nude Venus with a Cupid who is kissing her, in order that he might have it executed in painting by Pontormo and place it in the centre of a chamber of his own, in the lunettes of which he had begun to have painted by Bronzino figures of Dante, Petrarca, and Boccaccio, with the intention of having there all the other poets who have sung of love in Tuscan prose and verse. Jacopo, then, having received this cartoon, executed it to perfection at his leisure, as will be related, in the manner that all the world knows without my saying another word in praise of it. These designs of Michelagnolo's were

the reason that Pontormo, considering the manner of that most noble craftsman, took heart of grace, and resolved that by hook or by crook he would imitate and follow it to the best of his ability. And then it was that Jacopo recognized how ill he had done to allow the work of Poggio a Caiano to slip through his hands, although he put the blame in great measure on a long and very troublesome illness that he had suffered, and finally on the death of Pope Clement, which brought that undertaking completely to an end.

Jacopo having executed after the works described above a picture with the portrait from life of Amerigo Antinori, a young man much beloved in Florence at that time, and that portrait being much extolled by everyone, Duke Alessandro had him informed that he wished to have his portrait taken by him in a large picture. And Jacopo, for the sake of convenience, executed his portrait for the time being in a little picture of the size of a sheet of half-folio, and with such diligence and care, that the works of the miniaturists do not in any way come up to it; for the reason that, besides its being a very good likeness, there is in that head all that could be desired in the rarest of paintings. From that little picture, which is now in the guardaroba of Duke Cosimo, Jacopo afterwards made a portrait of the same Duke in a large picture, with a style in the hand, drawing the head of a woman; which larger portrait Duke Alessandro afterwards presented to Signora Taddea Malespina, the sister of the Marchesa di Massa. Desiring at all costs to reward liberally the genius of Jacopo for these works, the Duke sent him a message by Niccolò da Montaguto, his servant, that he should ask whatever he wished, and it would be granted to him. But such was the poor spirit or the excessive respect and modesty of the man, I know not which to call it, that he asked for nothing save as much money as would suffice him to redeem a cloak that he had pledged; which having heard, the Duke, not without laughing at the character of the man, commanded that fifty gold crowns should be given and a salary offered to him; and even then Niccolò had much ado to make him accept it.

Meanwhile Jacopo had finished painting the Venus from the cartoon belonging to Bettini, which proved to be a marvellous thing, but it was not given to Bettini at the price for which Jacopo had promised it to him, for certain tuft-hunters, in order to do Bettini an injury, took it almost by force from the hands

of Jacopo and gave it to Duke Alessandro, restoring the cartoon
to Bettini. Which having heard, Michelagnolo felt much displea-
sure for love of the friend for whom he had drawn the cartoon,
and he bore a grudge against Jacopo, who, although he received
fifty crowns for it from the Duke, nevertheless cannot be said to
have defrauded Bettini, seeing that he gave up the Venus at the
command of him who was his lord. But of all this some say that
Bettini himself was in great measure the cause, from his asking
too much.

The occasion having thus presented itself to Pontormo, by
means of these moneys, to set his hand to the fitting up of his
house, he made a beginning with his building, but did nothing of
much importance. Indeed, although some persons declare that he
had it in mind to spend largely, according to his position, and to
make a commodious dwelling and one that might have some
design, it is nevertheless evident that what he did, whether this
came from his not having the means to spend or from some
other reason, has rather the appearance of a building erected by
an eccentric and solitary creature than of a well-ordered habita-
tion, for the reason that to the room where he used to sleep and
at times to work, he had to climb by a wooden ladder, which,
after he had gone in, he would draw up with a pulley, to the end
that no one might go up to him without his wish or knowledge.
But that which most displeased other men in him was that he
would not work save when and for whom he pleased, and after
his own fancy; wherefore on many occasions, being sought out
by noblemen who desired to have some of his work, and once
in particular by the Magnificent Ottaviano de' Medici, he would
not serve them; and then he would set himself to do anything in
the world for some low and common fellow, at a miserable price.
Thus the mason Rossino, a person of no small ingenuity consid-
ering his calling, by playing the simpleton, received from him in
payment for having paved certain rooms with bricks, and for
having done other mason's work, a most beautiful picture of Our
Lady, in executing which Jacopo toiled and laboured as much as
the mason did in his building. And so well did the good Rossino
contrive to manage his business, that, in addition to the above-
named picture, he got from the hands of Jacopo a most beautiful
portrait of Cardinal Giulio de' Medici, copied from one by the
hand of Raffaello, and, into the bargain, a very beautiful little
picture of a Christ Crucified, which, although the above-

mentioned Magnificent Ottaviano bought it from the mason Rossino as a work by the hand of Jacopo, nevertheless is known for certain to be by the hand of Bronzino, who executed it all by himself while he was working with Jacopo at the Certosa, although it afterwards remained, I know not why, in the possession of Pontormo. All these three pictures, won by the industry of the mason from the hands of Jacopo, are now in the house of M. Alessandro de' Medici, the son of the above-named Ottaviano.

Now, although this procedure of Jacopo's and his living solitary and after his own fashion were not much commended, that does not mean that if anyone wished to excuse him he would not be able, for the reason that for those works that he did we should acknowledge our obligation to him, and for those that he did not choose to do we should not blame or censure him. No craftsman is obliged to work save when and for whom he pleases; and, if he suffered thereby, the loss was his. As for solitude, I have always heard say that it is the greatest friend of study; and, even if it were not so, I do not believe that much blame is due to him who lives in his own fashion without offence to God or to his neighbour, dwelling and employing his time as best suits his nature.

But to return, leaving these matters on one side, to the works of Jacopo: Duke Alessandro had caused to be restored in some parts the Villa of Careggi, formerly built by the elder Cosimo de' Medici, at a distance of two miles from Florence, and had carried out the ornamentation of the fountain and the labyrinth, which wound through the centre of an open court, into which there opened two loggie, and his Excellency ordained that those loggie should be painted by Jacopo, but that company should be given him, to the end that he might finish them the quicker, and that conversation with others, keeping him cheerful, might be a means of making him work without straying so much into vagaries and distilling away his brains. Nay, the Duke himself sent for Jacopo and besought him that he should strive to deliver that work completely finished as soon as possible. Jacopo, therefore, having summoned Bronzino, caused him to paint a figure on each of five spandrels of the vaulting, these being Fortune, Justice, Victory, Peace, and Fame; and on the other spandrel, for they are in all six, Jacopo with his own hand painted a Love. Then, having made the design for some little boys that were going in the oval space of the vaulting, with various animals in their hands, and all

foreshortened to be seen from below, he caused them all, with the exception of one, to be executed in colour by Bronzino, who acquitted himself very well. And since, while Jacopo and Bronzino were painting these figures, the ornaments all around were executed by Jacone, Pier Francesco di Jacopo, and others, the whole of that work was finished in a short time, to the great satisfaction of the Lord Duke. His Excellency wished to have the other loggia painted, but he was not in time, for the reason that the above-named work having been finished on the 13th of December in the year 1536, on the 6th of the January following that most illustrious lord was assassinated by his kinsman Lorenzino; and so this work and others remained without their completion.

The Lord Duke Cosimo having then been elected, and the affair of Montemurlo having passed off happily, a beginning was made with the works of Castello, according as has been related in the Life of Tribolo, and his most illustrious Excellency, in order to gratify Signora Donna Maria, his mother, ordained that Jacopo should paint the first loggia, which one finds on the left hand in entering the Palace of Castello. Whereupon, setting to work, Jacopo first designed all the ornaments that were to be painted there, and had them executed for the most part by Bronzino and the masters who had executed those of Careggi. Then, shutting himself up alone, he proceeded with that work after his own fancy and wholly at his leisure, studying with all diligence, to the end that it might be much better than that of Careggi, which he had not executed entirely with his own hand. This he was able to do very conveniently, having eight crowns a month for it from his Excellency, whom he portrayed, young as he was, in the beginning of that work, and likewise Signora Donna Maria, his mother. Finally, after that loggia had been closed for five years, no one being able to have even a glance at what Jacopo had done, one day the above-named lady became enraged against him, and commanded that the staging and the screen should be thrown to the ground. But Jacopo, having begged for grace and having obtained leave to keep it covered for a few days more, first retouched it where it seemed to him to be necessary, and then caused a cloth of his own contriving to be made, which should keep that loggia covered when those lords were not there, to the end that the weather might not, as it had done at Careggi, eat away those pictures, which were executed in oils on the dry plaster; and at last he uncovered it, amid the lively expectation of

everyone, all thinking that in that work Jacopo must have surpassed himself and done something altogether stupendous. But the effect did not correspond completely to the expectations, for the reason that, although many parts of the work are good, the general proportion of the figures appears very poor in form, and certain distorted attitudes that are there seem to be wanting in measure and very strange. But Jacopo excused himself by saying that he had never worked very willingly in that place, for the reason that, being without the city, it seemed much exposed to the fury of the soldiery and to other suchlike dangers; but there was no need for him to be afraid of that, seeing that time and the weather, from the work having been executed in the manner already described, are eating it away little by little.

In the centre of the vaulting, then, he painted a Saturn with the Sign of Capricorn, and a Hermaphrodite Mars in the Sign of the Lion and of the Virgin, and some little Angels who are flying through the air, like those of Careggi. He then painted in certain gigantic women, almost entirely nude, Philosophy, Astrology, Geometry, Music, Arithmetic, and a Ceres; with some little scenes in medallions, executed with various tints of colour and appropriate to the figures. Although this work, so fatiguing and so laboured, did not give much satisfaction, or, if a certain measure of satisfaction, much less than was expected, yet his Excellency declared that it pleased him, and availed himself of Jacopo on every occasion, chiefly because that painter was held in great veneration by the people on account of the very good and beautiful works that he had executed in the past.

The Lord Duke then brought to Florence the Flemings, Maestro Giovanni Rosso and Maestro Niccolò, excellent masters in arras-tapestries, to the end that the art might be learned and practised by the Florentines, and he ordained that tapestries in silk and gold should be executed for the Council Hall of the Two Hundred at a cost of 60,000 crowns, and that Jacopo and Bronzino should make the cartoons with the stories of Joseph. But, when Jacopo had made two of them, in one of which is the scene when the death of Joseph is announced to Jacob and the bloody garments are shown to him, and in the other the Flight of Joseph from the wife of Potiphar, leaving his garment behind, they did not please either the Duke or those masters who had to put them into execution, for they appeared to them to be strange things and not likely to be successful when executed in woven

tapestries. And so Jacopo did not go on to make any more car-
toons, but returned to his usual labours and painted a picture of
Our Lady, which was presented by the Duke to Signor Don . . .,
who took it to Spain.

Now his Excellency, following in the footsteps of his ances-
tors, has always sought to embellish and adorn his city; and he
resolved, the necessity having come to his notice, to cause to be
painted all the principal chapel of the magnificent Temple of
S. Lorenzo, formerly built by the great Cosimo de' Medici, the
elder. Whereupon he gave the charge of this to Jacopo da Pon-
tormo, either of his own accord, or, as was said, at the instance
of Messer Pier Francesco Ricci, his major-domo; and Jacopo was
very glad of that favour, for the reason that, although the great-
ness of the work, he being well advanced in years, gave him food
for thought and perhaps dismayed him, on the other hand he
reflected how, in a work of such magnitude, he had a fair field
to show his ability and worth. Some say that Jacopo, finding that
the work had been allotted to him notwithstanding that Fran-
cesco Salviati, a painter of great fame, was in Florence and had
brought to a happy conclusion the painting of that hall in the
Palace which was once the audience-chamber of the Signoria,
must needs declare that he would show the world how to draw
and paint, and how to work in fresco, and, besides this, that the
other painters were but ordinary hacks, with other words equally
insolent and overbearing. But I myself always knew Jacopo as a
modest person, who spoke of everyone honourably and in a
manner proper to an orderly and virtuous craftsman, such as he
was, and I believe that these words were imputed to him falsely,
and that he never let slip from his mouth any such boastings,
which are for the most part the marks of vain men who presume
too much upon their merits, in which manner of men there is no
place for virtue or good breeding. And, although I might have
kept silent about these matters, I have not chosen to do so,
because to proceed as I have done appears to me the office of a
faithful and veracious historian; it is enough that, although these
rumours went around, and particularly among our craftsmen,
nevertheless I have a firm belief that they were the words of
malicious persons, Jacopo having always been in the experience
of everyone modest and well-behaved in his every action.

Having then closed up that chapel with walls, screens of
planks, and curtains, and having given himself over to complete

solitude, he kept it for a period of eleven years so well sealed up, that excepting himself not a living soul entered it, neither friend nor any other. It is true, indeed, that certain lads who were drawing in the sacristy of Michelagnolo, as young men will do, climbed by its spiral staircase on to the roof of the church, and, removing some tiles and the plank of one of the gilded rosettes that are there, saw everything. Of which having heard, Jacopo took it very ill, but took no further notice beyond closing up everything with greater care; although some say that he persecuted those young men sorely, and sought to make them regret it.

Imagining, then, that in this work he would surpass all other painters, and perchance, so it was said, even Michelagnolo, he painted in the upper part, in a number of scenes, the Creation of Adam and Eve, the Eating of the Forbidden Fruit, their Expulsion from Paradise, the Tilling of the Earth, the Sacrifice of Abel, the Death of Cain, the Blessing of the Seed of Noah, and the same Noah designing the plan and the measurements of the Ark. Next, on one of the lower walls, each of which is fifteen braccia in each direction, he painted the inundation of the Deluge, in which is a mass of dead and drowned bodies, and Noah speaking with God. On the other wall is painted the Universal Resurrection of the Dead, which has to take place on the last and final day; with such variety and confusion, that the real resurrection will perhaps not be more confused, or more full of movement, in a manner of speaking, than Pontormo painted it. Opposite to the altar and between the windows – that is, on the central wall – there is on either side a row of nude figures, who, clinging to each other's bodies with hands and legs, form a ladder wherewith to ascend to Paradise, rising from the earth, where there are many dead in company with them, and at the end, on either side, are two dead bodies clothed with the exception of the legs and also the arms, with which they are holding two lighted torches. At the top, in the centre of the wall, above the windows, he painted in the middle Christ on high in His Majesty, who, surrounded by many Angels all nude, is raising those dead in order to judge them.

But I have never been able to understand the significance of this scene, although I know that Jacopo had wit enough for himself, and also associated with learned and lettered persons; I mean, what he could have intended to signify in that part where there is Christ on high, raising the dead, and below His feet is

God the Father, who is creating Adam and Eve. Besides this, in one of the corners, where are the four Evangelists, nude, with books in their hands, it does not seem to me that in a single place did he give a thought to any order of composition, or measurement, or time, or variety in the heads, or diversity in the flesh-colours, or, in a word, to any rule, proportion, or law of perspective; for the whole work is full of nude figures with an order, design, invention, composition, colouring, and painting contrived after his own fashion, and with such melancholy and so little satisfaction for him who beholds the work, that I am determined, since I myself do not understand it, although I am a painter, to leave all who may see it to form their own judgment, for the reason that I believe that I would drive myself mad with it and would bury myself alive, even as it appears to me that Jacopo in the period of eleven years that he spent upon it sought to bury himself and all who might see the painting, among all those extraordinary figures. And although there may be seen in this work some bit of a torso with the back turned or facing to the front and some attachments of flanks, executed with marvellous care and great labour by Jacopo, who made finished models of clay in the round for almost all the figures, nevertheless the work as a whole is foreign to his manner, and, as it appears to almost every man, without proportion, the torsi for the most part being large and the legs and arms small, to say nothing of the heads, in which there is not a trace to be seen of that singular excellence and grace that he used to give to them, so greatly to the satisfaction of those who examine his other pictures. Wherefore it appears that in this work he paid no attention to anything save certain parts, and of the other more important parts he took no account whatever. In a word, whereas he had thought in this work to surpass all the paintings in the world of art, he failed by a great measure to equal his own works that he had executed in the past; whence it is evident that he who seeks to strive beyond his strength and, as it were, to force nature, ruins the good qualities with which he may have been liberally endowed by her. But what can we or ought we to do save have compassion upon him, seeing that the men of our arts are as much liable to error as others? And the good Homer, so it is said, even he sometimes nods; nor shall it ever be said that there is a single work of Jacopo's, however he may have striven to force his nature, in which there is not something good and worthy of praise.

He died shortly before finishing the work, and some therefore declare that he died of grief, ending his life very much dissatisfied with himself; but the truth is that, being old and much exhausted by making portraits and models in clay and labouring so much in fresco, he sank into a dropsy, which finally killed him at the age of sixty-five. After his death there were found in his house many designs, cartoons, and models in clay, all very beautiful, and a picture of Our Lady executed by him excellently well and in a lovely manner, to all appearance many years before, which was sold by his heirs to Piero Salviati. Jacopo was buried in the first cloister of the Church of the Servite Friars, beneath the scene of the Visitation that he had formerly painted there; and he was followed to the grave by an honourable company of the painters, sculptors, and architects.

Jacopo was a frugal and sober man, and in his dress and manner of life he was rather miserly than moderate; and he lived almost always by himself, without desiring that anyone should serve him or cook for him. In his last years, indeed, he kept in his house, as it were to bring him up, Battista Naldini, a young man of fine spirit, who took such care of Jacopo's life as Jacopo would allow him to take; and under his master's discipline he made no little proficiency in design, and became such, indeed, that a very happy result is looked for from him. Among Pontormo's friends, particularly in this last period of his life, were Pier Francesco Vernacci and Don Vincenzio Borghini, with whom he took his recreation, sometimes eating with them, but rarely. But above all others, and always supremely beloved by him, was Bronzino, who loved him as dearly, being grateful and thankful for the benefits that he had received from him.

Pontormo had very beautiful manners, and he was so afraid of death, that he would not even hear it spoken of, and avoided having to meet dead bodies. He never went to festivals or to any other places where people gathered together, so as not to be caught in the press; and he was solitary beyond all belief. At times, going out to work, he set himself to think so profoundly on what he was to do, that he went away without having done any other thing all day but stand thinking. And that this happened to him times without number in the work of S. Lorenzo may readily be believed, for the reason that when he was determined, like an able and well-practised craftsman, he had no difficulty in doing what he desired and had resolved to put into execution.

SIMONE MOSCA, Sculptor and Architect

FROM the times of the ancient Greek and Roman sculptors to our own, no modern carver has equalled the beautiful and difficult works that they executed in their bases, capitals, friezes, cornices, festoons, trophies, masks, candelabra, birds, grotesques, or other carved cornice-work, save only Simone Mosca of Settignano, who in our own days has worked in such a manner in those kinds of labour, that he has made it evident by his genius and art that all the diligence and study of the modern carvers who had come before him had not enabled them up to that time to imitate the best work of those ancients or to adopt the good method in their carvings, for the reason that their works incline to dryness, and the turn of their foliage to spikiness and crudeness. He, on the other hand, has executed foliage with great boldness, rich and abundant in new curves, the leaves being carved in various manners with beautiful indentations and with the most lovely flowers, seeds and creepers that there are to be seen, not to speak of the birds that he has contrived to carve so gracefully in various forms among his foliage and festoons, insomuch that it may be affirmed that Simone alone – be it said without offence to the others – has been able to remove from the marble that hardness which craftsmen are wont very often to leave in their sculptures, and has brought his works by his handling of the chisel to such a point that they have the appearance of things real to the touch, and the same may be said of the cornices and other such-like labours, executed by him with most beautiful grace and judgment.

This Simone, having given his attention to design in his childhood with much profit, and having then become well-practised in carving, was taken by Maestro Antonio da San Gallo, who recognized his genius and noble spirit, to Rome, where he caused him to execute, as his first works, some capitals and bases and several friezes of foliage for the Church of S. Giovanni de' Fiorentini, and some works for the Palace of Alessandro, the first Cardinal Farnese. Simone meanwhile devoting himself, particularly on feast-days, and whenever he could snatch the time, to drawing the antiquities of that city, no long time passed before he was drawing and tracing ground-plans with more grace and neatness than did Antonio himself, insomuch that, having applied himself

heart and soul to the study of designing foliage in the ancient manner, of giving a bold turn to the leaves, and of perforating his works in such a way as to make them perfect, taking the best from the best examples, one thing from one and one from another, in a few years he formed a manner of composition so beautiful and so catholic, that afterwards he did everything well, whether in company or by himself. This may be seen in some coats of arms that were to be placed in the above-named Church of S. Giovanni in the Strada Giulia; in one of which coats of arms, making a great lily, the ancient emblem of the Commune of Florence, he carved upon it some curves of foliage with creepers and seeds executed so well that they made everyone gasp with wonder. Nor had any long time passed when Antonio da San Gallo – who was directing for Messer Agnolo Cesis the execution of the marble ornaments of a chapel and tomb for himself and his family, which were afterwards erected in the year 1550 in the Church of S. Maria della Pace – caused part of certain pilasters and socles covered with friezes, which were going into that work, to be wrought by Simone, who executed them so well and with such beauty, that they make themselves known among the others, without my saying which they are, by their grace and perfection; nor is it possible to see any altars for the offering of sacrifices after the ancient use more beautiful and fanciful than those that he made on the base of that work. Afterwards the same San Gallo, who was superintending the execution of the mouth of the well in the cloister of S. Pietro in Vincula, caused Mosca to make the borders with some large masks of great beauty.

Not long afterwards he returned one summer to Florence, having a good name among craftsmen, and Baccio Bandinelli, who was making the Orpheus of marble that was placed in the court of the Medici Palace, after having the base for that work carried out by Benedetto da Rovezzano, caused Simone to execute the festoons and other carvings therein, which are very beautiful, although one festoon is unfinished and only worked over with the gradine. Having then done many works in grey sandstone, of which there is no need to make record, he was planning to return to Rome, when in the meantime the sack took place, and he did not go after all. But, having taken a wife, he was living in Florence with little to do: wherefore, being obliged to support his family, and having no income, he was occupying

himself with any work that he could obtain. Now in those days
there arrived in Florence one Pietro di Subisso, a master-mason
of Arezzo, who always had under him a good number of work-
men, for the reason that all the building in Arezzo passed
through his hands; and he took Simone, with many others, to
Arezzo. There he set Simone to making a chimney-piece of grey
sandstone and a water-basin of no great cost, for a hall in the
house of the heirs of Pellegrino da Fossombrone, a citizen of
Arezzo; which house had been formerly erected by M. Piero
Geri, an excellent astrologer, after the design of Andrea Sansovi-
no, and had been sold by his nephews. Setting to work, therefore,
and beginning with the chimney-piece, Simone placed it upon
two pilasters, making two niches in the thickness of the wall, in
the direction of the fire, and laying upon those pilasters archi-
trave, frieze, and great cornice, and over all a pediment with
festoons and with the arms of that family. And thus, proceeding
with it, he executed it with carvings of such a kind and so well
varied, and with such subtle craftsmanship, that, although that
work was of grey sandstone, under his hands it became more
beautiful than if it had been of marble, and more astounding;
which, indeed, came to pass the more readily because that stone
is not as hard as marble and, if anything, rather sandy. Putting
extraordinary diligence, therefore, into the work, he executed on
the pilasters trophies in half-relief and low-relief, than which
nothing more bizarre or more beautiful could be done, with hel-
mets, buskins, shields, quivers, and various other arms; and he
likewise made there masks, sea monsters, and other graceful fan-
tasies, all so well figured and cut out that they have the appear-
ance of silver. The frieze that is between the architrave and the
great cornice, he made with a most beautiful turn of foliage, all
pierced through and full of birds that are executed so well, that
they seem to be flying through the air; and it is a marvellous thing
to see their little legs, no larger than life, and yet completely in
the round and detached from the stone in such a way as one
cannot believe to be possible; and, in truth, the work seems
rather a miracle than a product of human art. Besides all this, he
made there in a festoon some leaves and fruits so well cut out,
and wrought with such delicacy and care, that in a certain sense
they surpass the reality. Lastly, the work is finished off by some
great masks and candelabra, which are truly most beautiful. Al-
though Simone need not have given such care to a work of that

kind, for which he was to be but poorly paid by those patrons, who could not afford much, yet, drawn by the love that he bore to art and by the pleasure that a man feels in working well, he chose to do so; but he did not do the same with the water-basin for the same patrons, for he made it beautiful enough, but simple.

At the same time he assisted Pietro di Subisso, who did not know much, to make many designs of buildings and plans of houses, doors, windows, and other things appertaining to that profession. On the Canto degli Albergotti, below the school and university of the Commune, there is a window of considerable beauty constructed after his design; and there are two of them in the house of Ser Bernardino Serragli in the Pelliceria. On the corner of the Palazzo de' Priori there is a large escutcheon of Pope Clement VII in grey sandstone, by the hand of the same master; and under his direction, and partly by his hand, was executed for Bernardino di Cristofano da Giuovi a chapel of grey sandstone in the Corinthian Order, which was erected in the Abbey of S. Fiore, a passing handsome monastery of Black Friars in Arezzo. For this chapel the patron wished to have the altarpiece painted by Andrea del Sarto, and then by Rosso, but in this he never succeeded, seeing that, being hindered now by one thing and now by another, they were not able to serve him. Finally Bernardino turned to Giorgio Vasari, but with him also he had difficulties, and there was much trouble in finding a way of arranging the matter, for the reason that, the chapel being dedicated to S. James and S. Christopher, he wished to have in the picture Our Lady with the Child in her arms, and also the giant S. Christopher with another little Christ on his shoulder; which composition, besides that it appeared monstrous, could not be accommodated, nor was it possible to paint a giant of six braccia in an altar-piece of four braccia. Giorgio, then, being desirous to serve Bernardino, made him a design in this manner: he placed Our Lady upon some clouds, with a sun behind her back, and on the ground he painted S. Christopher kneeling on one side of the picture, with one leg in the water, and with the other in the act of moving in order to rise, while Our Lady is placing upon his shoulders the Infant Christ with the globe of the world in His hands. In the rest of the altar-piece, also, were to be S. James and the other Saints, accommodated in such a manner that they would not have been in the way; and this design, pleasing Bernardino, would have been put into execution, but Bernardino in

the meantime died, and the chapel was left in that condition to his heirs, who have not done anything more.

Now, while Simone was labouring at that chapel, there passed through Arezzo Antonio da San Gallo, who was returning from the work of fortifying Parma and was going to Loreto to finish the work of the Chapel of the Madonna, to which he had sent Tribolo, Raffaello da Montelupo, the young Francesco da San Gallo, Girolamo da Ferrara, Simone Cioli, and other carvers, masons, and stone-cutters, in order to finish that which Andrea Sansovino at his death had left incomplete; and he contrived to take Simone to work there. He ordained that Simone should have charge not only of the carvings, but also of the architecture and of the other ornaments of that work; in which commissions Mosca acquitted himself very well, and, what is more, executed many things perfectly with his own hands, particularly some little boys of marble in the round, which are on the pediments of the doors; and although there are also some by the hand of Simone Cioli, the best – and rare indeed they are – are all by Mosca. He made, likewise, all the festoons of marble that are around all that work, with most beautiful artistry and carvings full of grace and worthy of all praise; wherefore it is no marvel that these works are so esteemed and admired, that many craftsmen from distant parts have set off in order to go to see them.

Antonio da San Gallo, then, recognizing how much Mosca was worth, made use of him in any undertaking of importance, with the intention of remunerating him some day when the occasion might present itself, and of giving him to know how much he loved him for his abilities. When, therefore, after the death of Pope Clement, a new Supreme Pontiff had been elected in Paul III of the Farnese family, who ordained that, the mouth of the well at Orvieto having remained unfinished, Antonio should have charge of it, Antonio took Mosca thither, to the end that he might carry that work to completion, which presented some difficulties, and particularly in the ornamentation of the doors, for the reason that, the curve of the mouth being round, convex without and concave within, those two circles conflicted with each other and caused a difficulty in accommodating the squared doors with the ornaments of stone. But the virtue of that singular genius of Simone's solved every difficulty, and executed the whole work with such grace and perfection, that no one could see that there had ever been any difficulty. He finished off the

mouth and border of the well in grey sandstone, filled in with bricks, together with some very beautiful inscriptions on white stone and other ornaments, making the doors correspond with one another. He also made there in marble the arms of the above-named Pope Paul Farnese, or rather, where they had previously been made of balls for Pope Clement, who had carried out that work, Mosca was forced – and he succeeded excellently well – to make lilies out of the balls in relief, and thus to change the arms of the Medici into those of the house of Farnese; notwithstanding, as I have said (for so do things go in this world), that the author of that vast, regal, and magnificent work was Pope Clement VII, of whom in this last and most imposing part no mention whatever was made.

While Simone was engaged in finishing this well, the Wardens of Works of S. Maria, the Duomo of Orvieto, desiring to give completion to the chapel of marble that had been carried as far as the socle under the direction of Michele San Michele of Verona, with some carvings, besought Simone, whom they had come to know as a master of true excellence, that he should attend to it. Whereupon they came to terms, and Simone, liking the society of the people of Orvieto, brought his family thither, in order to live in greater comfort; and then he set himself to work with a quiet and composed mind, being greatly honoured by everyone in that place. When, therefore, as it were by way of sample, he had made a beginning with some pilasters and friezes, the excellence and ability of Simone were recognized by those men, and there was assigned to him a salary of two hundred crowns of gold a year, and with this, continuing to labour, he carried that work well forward. Now in the centre, to fill up the ornaments, there was to go a scene of marble in half-relief, representing the Adoration of the Magi; and there was summoned at the suggestion of Simone his very dear friend Raffaello da Montelupo, the Florentine sculptor, who, as has been related, executed half of that scene in a very beautiful manner. In the ornamentation of this chapel, then, are certain socles, each two and a half braccia in breadth, which are on either side of the altar, and upon these are pilasters five braccia high, two on either side, between which is the story of the Magi; and on the pilasters next to the story, of which two of the faces are seen, are carved some candelabra, with friezes of grotesques, masks, little figures, and foliage, which are things divine. In the predella at the foot, which runs right over

the altar from pilaster to pilaster, is a little half-length Angel who
is holding an inscription with his hands, with festoons over all,
between the capitals of the pilasters, where the architrave, frieze
and great cornice project to the extent of the depth of the pilas-
ters. Above those in the centre, in a space equal to their breadth,
curves an arch that serves as an ornament to the above-named
story of the Magi, and in this, namely, in the lunette, are many
Angels; and above the arch is a cornice, which runs from one
pilaster to another, that is, from those on the outside, which form
a frontispiece to the whole work. In this part is a God the Father
in half-relief; and at the sides, where the arch rises over the
pilasters, are two Victories in half-relief. All this work, then, is so
well composed, and executed with such a wealth of carvings, that
one cannot have enough of examining the minute details of the
perforations and the excellence of all the things that are in the
capitals, cornices, masks, festoons, and candelabra in the round,
which form the completion of a work truly worthy to be admired
as something rare.

Simone Mosca thus dwelling in Orvieto, a son of his called
Francesco, and as a by-name Il Moschino, a boy fifteen years of
age, who had been produced by nature with chisels in his hand,
as it were, and with so beautiful a genius, that he did with su-
preme grace whatsoever thing he desired to do, executed in this
work under the discipline of his father, miraculously, so to speak,
the Angels that are holding the inscriptions between the pilasters,
then the God the Father in the pediment, as well as the Angels
that are in the lunette of that work, above the Adoration of the
Magi executed by Raffaello da Montelupo, and finally the Vic-
tories at the sides of the lunette; by which works he caused
everyone to wonder and marvel. All this was the reason that,
when the chapel was finished, Simone was commissioned by the
Wardens of Works of the Duomo to make another similar to it,
on the other side, to the end that the space of the Chapel of the
High-Altar might be suitably set off, on the understanding that
the figures should be varied without varying the architecture, and
that in the centre there should be the Visitation of Our Lady,
which was allotted to the above-named Moschino. Then, having
made an agreement about every matter, the father and son set
their hands to the work; and, while they were engaged upon it,
Mosca was very helpful and useful to that city, making for many
citizens architectural designs of houses and many other edifices.

Among other things, he executed in that city the ground-plan and façade of the house of Messer Raffaello Gualtieri, father of the Bishop of Viterbo, and of Messer Felice, both noblemen and lords of great excellence and reputation; and likewise the ground-plans of some houses for the honourable Counts della Cervara. He did the same in many places near Orvieto, and made, in particular, the models of many structures and buildings for Signor Pirro Colonna da Stripicciano.

The Pope then causing the fortress to be built in Perugia where there had stood the houses of the Baglioni, Antonio da San Gallo, having sent for Mosca, gave him the charge of making the ornaments; where there were executed after his designs all the doors, windows, chimney-pieces, and other suchlike things, and in particular two large and very beautiful escutcheons of his Holiness. In that work Simone formed a connection with M. Tiberio Crispo, who was Castellan there; and he was sent by M. Tiberio to Bolsena, where, on the highest point of that stronghold, overlooking the lake, he arranged a large and beautiful habitation, partly on the old structure and partly founding anew, with a very handsome flight of steps and many ornaments of stone. Nor did any long time pass before Messer Tiberio, having been made Castellan of the Castello di S. Angelo, caused Mosca to go to Rome, where he made use of him in many matters in renovating the apartments of that castle; and, among other things, he caused him to make over the arches that rise over the new loggia, which faces towards the meadows, two escutcheons of the above-named Pope in marble, which are so well wrought and perforated in the mitre, or rather, triple crown, in the keys, and in certain festoons and little masks, that they are marvellous.

Having then returned to Orvieto in order to finish the work of the chapel, he laboured there continuously all the time that Pope Paul was alive, executing it in such a manner that it proved to be, as may be seen, no less excellent than the first, and perhaps even better. For Mosca, as has been said, bore such love to art, and took such pleasure in working, that he could never have enough of it, almost striving after the impossible, and that rather from a desire for glory than from any wish to accumulate gold, for he was more pleased to work well at his profession than to acquire property.

Finally, Julius III having been elected Pope in the year 1550, and all men thinking that work would be begun in earnest on the

building of S. Pietro, Mosca went off to Rome and sought to obtain at a fixed price from the superintendents of that building the commission for some capitals of marble, but more to accommodate Gian Domenico, his son-in-law, than for any other reason. Now Giorgio Vasari, who always bore love to Mosca, found him in Rome, whither he also had been summoned to the service of the Pope, and he thought that without fail he would have some work to offer him, for the reason that the old Cardinal dal Monte, when he died, had left directions with his heirs that a tomb of marble should be built for him in S. Pietro a Montorio, and the above-named Pope Julius, his nephew and heir, had ordained that this should be done, and had given the charge of the matter to Vasari; and Giorgio wished that in that tomb Mosca should execute some extraordinary work in carving. But, after Giorgio had made some models for that tomb, the Pope discussed the whole matter with Michelagnolo Buonarroti before he would make up his mind; whereupon Michelagnolo told his Holiness that he should not involve himself with carvings, saying that, although they enrich a work, they confuse the figures, whereas squared work, when it is well done, is much more beautiful than carving and is a better accompaniment for the figures, for the reason that figures do not brook other carvings about them: and even so did his Holiness order the work to be done. Wherefore Vasari was not able to give Mosca anything to do in that work, and he was dismissed; and the tomb was finished without any carvings, which made it much better than it would have been with them.

Simone having then returned to Orvieto, arrangements were made to erect after his designs, in the cross at the head of the church, two great tabernacles of marble, works truly graceful, beautiful, and well-proportioned, for one of which Raffaello da Montelupo made in marble a nude Christ with the Cross on His shoulder in a niche, and for the other Moschino made a S. Sebastian, likewise nude. Work being then continued on the execution of the Apostles for the church, Moschino made a S. Peter and a S. Paul of the same size, which were held to be creditable statues. Meanwhile the work of the above-mentioned Chapel of the Visitation was not abandoned, and it was carried so far forward during the lifetime of Mosca, that there was nothing left to do save two birds, and even these would not have been wanting, had not M. Bastiano Gualtieri, Bishop of Viterbo, as has

been related, kept Simone occupied with an ornament of marble in four pieces, which, when finished, he sent to France to the Cardinal of Lorraine, who held it very dear, for it was beautiful to a marvel, all full of foliage and wrought with such diligence, that it is believed to have been one of the best that Simone ever executed.

Not long after he had finished that work, in the year 1554, Simone died, at the age of fifty-eight, to the no small loss of that church of Orvieto, in which he was buried with honour.

Francesco Moschino was then elected to his father's place by the Wardens of Works of that same Duomo, but, thinking nothing of it, he left it to Raffaello da Montelupo, and went to Rome, where he finished for M. Ruberto Strozzi two very graceful figures in marble, the Mars and Venus, namely, which are in the court of his house in the Banchi. Afterwards he executed a scene with little figures, almost in full-relief, in which is Diana bathing with her Nymphs, who changes Actæon into a stag, and he is devoured by his own hounds; and then Francesco came to Florence, and gave the work to the Lord Duke Cosimo, whom he much desired to serve. Whereupon his Excellency, having accepted and much commended it, did not disappoint the desire of Moschino, even as he has never disappointed anyone who has sought to work valiantly in any calling. For he was attached to the Works of the Duomo at Pisa, and has laboured up to the present day with great credit to himself in the Chapel of the Nunziata, formerly built by Stagio da Pietrasanta, executing the Angel and the Madonna in figures of four braccia, together with the carvings and every other thing; in the centre, Adam and Eve, who have the apple-tree between them; and a large God the Father with certain little boys on the vaulting of that chapel, which is all of marble, as are also the two statues, which have gained for Moschino no little fame and honour. And since that chapel is little less than finished, his Excellency has given orders that the chapel opposite to it should be taken in hand, which is called the Chapel of the Incoronata and stands immediately at the entrance of the church, on the left hand. The same Moschino, in connection with the nuptial festivities of her most serene Majesty Queen Joanna and the most illustrious Prince of Florence, has acquitted himself very well in those works that were given him to do.

GIROLAMO AND BARTOLOMMEO GENGA, AND GIOVAN BATTISTA SAN MARINO, SON-IN-LAW OF GIROLAMO

GIROLAMO GENGA, who was of Urbino, was apprenticed by his father at the age of ten to the wool trade, but he followed it with the greatest ill-will, and, according as he could find time and place, he was for ever drawing in secret with charcoal or an ordinary pen. Which circumstance being observed by some friends of his father, they exhorted him to remove the boy from that trade and to set him to painting; wherefore he placed Girolamo with certain masters of little reputation in Urbino. But, having seen his beautiful manner, and that he was like to make proficience, when the boy was fifteen years of age the father apprenticed him to Maestro Luca Signorelli of Cortona, an excellent master in painting of that time; with whom he stayed many years, following him to the March of Ancona, to Cortona, and to many other places where he executed works, and in particular to Orvieto, in the Duomo of which city, as has been related, Luca painted a chapel of Our Lady with an infinite number of figures. At this our Girolamo worked continually, and he was always one of the best disciples that Luca had.

Then, having parted from Signorelli, he placed himself with Pietro Perugino, a much esteemed painter, with whom he stayed about three years, giving considerable attention to perspective, which was so well grasped and understood by him, that it may be said that he became very excellent therein, even as is evident from his works in painting and architecture. This was at the same time that there was with Pietro the divine Raffaello da Urbino, who was much the friend of Girolamo.

After leaving Pietro, he went off to live in Florence, where he studied for some considerable time. Then, having gone to Siena, he stayed there for months and even years with Pandolfo Petrucci, in whose house he painted many rooms, which, from their being very well designed and coloured in a pleasing manner, were rightly admired and praised by all the people of Siena, and particularly by the above-named Pandolfo, by whom he was always looked upon with great favour and cherished most dearly. Pandolfo having died, he then returned to Urbino, where Guidobaldo, the second Duke, retained him for a considerable

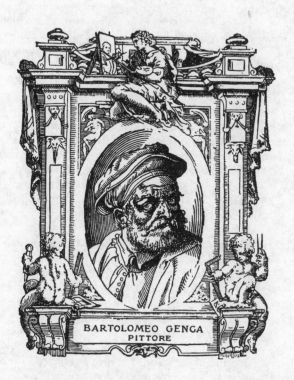

BARTOLOMEO GENGA
PITTORE

time, causing him to paint horses' caparisons, such as were used in those times, in company with Timoteo da Urbino, a painter of passing good name and much experience, together with whom he painted a chapel of S. Martino in the Vescovado for Messer Giovan Piero Arrivabene of Mantua, then Bishop of Urbino. In this, both the one and the other of them gave proof of very beautiful genius, as the work itself demonstrates, in which is a portrait of the above-named Bishop, which has all the appearance of life. Genga was also particularly employed by the same Duke to execute scenery and settings for comedies, which, since he had a very good understanding of perspective and was well-grounded in architecture, he made marvellously beautiful.

He then departed from Urbino and went to Rome, where he executed in painting, in S. Caterina da Siena on the Strada Giulia, a Resurrection of Christ, wherein he made himself known as a rare and excellent master, having done it with good design and with figures foreshortened in beautiful attitudes and well coloured, to which those who are of the profession and have seen it are able to bear ample testimony. While living in Rome, he gave much attention to measuring the antiquities there, as is proved by writings in the possession of his heirs.

At this time, Duke Guido having died, and having been succeeded by Francesco Maria, third Duke of Urbino, Girolamo was recalled from Rome by Francesco Maria, and constrained to return to Urbino at the time when the above-named Duke took to wife and brought into his dominions Leonora Gonzaga, the daughter of the Marquis of Mantua; and he was employed by his Excellency in making triumphal arches, festive preparations, and scenery for comedies, which were all so well arranged and carried into execution by him, that Urbino could be likened to a Rome in triumph; from which he gained very great fame and honour. Afterwards, in due course, the Duke was expelled from his state for the last time, when he went to Mantua, and Girolamo followed him, even as he had already done in his other periods of exile, always sharing one and the same fortune with him; and he retired with his family to Cesena. There he painted for the high-altar of S. Agostino an altar-piece in oils, at the top of which is an Annunciation, and below that a God the Father, and still lower down a Madonna with the Child in her arms, between the four Doctors of the Church – a work truly beautiful and worthy to be esteemed. He then painted in fresco a chapel on the right

hand in S. Francesco at Forlì, containing the Assumption of the Madonna, with many Angels and other figures – Prophets, namely, and Apostles – around; in this, also, it is evident how admirable was his genius, and the work was judged to be very beautiful. He also painted there the story of the Holy Spirit, which he finished in the year 1512, for Messer Francesco Lombardi, a physician; and other works throughout Romagna, for all which he gained honour and rewards.

The Duke having then returned to his state, Girolamo also returned, and was retained by him and employed as architect in restoring an old palace on the Monte dell' Imperiale, above Pesaro, and adding to it another tower. That palace was adorned with scenes in painting from the actions of the Duke, after the directions and designs of Girolamo, by Francesco da Forlì and Raffaello dal Borgo, painters of good repute, and by Camillo Mantovano, a very rare master in painting landscapes and verdure; and the young Florentine Bronzino also worked there, among others, as has been related in the Life of Pontormo. Thither, likewise, were summoned the Dossi of Ferrara, and a room was assigned to them to paint; but since, when they had finished that room, it did not please the Duke, he had it thrown down and repainted by the masters mentioned above. Girolamo then erected the tower there, one hundred and twenty feet in height, with thirteen flights of wooden steps whereby to ascend to the top, so well fitted and concealed in the walls, that they can be withdrawn with ease from story to story, which renders that tower very strong and marvellous. A desire afterwards came to the Duke to fortify Pesaro, and he caused Pier Francesco da Viterbo, a most excellent architect, to be sent for; and Girolamo always taking part in the discussions that arose about the fortifications, his discourse and his opinions were held to be good and full of judgment. Wherefore, if I may be allowed to say it, the design of that fortress came rather from Girolamo than from any other, although that sort of architecture was always little esteemed by him, appearing to him to be of small value and dignity.

The Duke, then, perceiving how rare a genius he had at his command, determined to build on the above-named Monte dell' Imperiale, near the old palace, a new palace; and so he built that to be seen there at the present day, which being a very beautiful and well-planned fabric, and full of apartments, colonnades,

courts, loggie, fountains, and most delightful gardens, there is no Prince passes that way that does not go to see it. Wherefore it was right fitting that Pope Paul III, on his way to Bologna with all his Court, should go to see it and find it entirely to his satisfaction. From the design of this same master, the Duke caused the Palace at Pesaro to be restored, and also the little park, making within it a house representing a ruin, which is a very beautiful thing to see. Among other things there, is a staircase similar to that of the Belvedere in Rome, which is very handsome. By means of him the Duke had the fortress of Gradara restored, and likewise the Palace at Castel Durante, insomuch that all that is good in those works came from that admirable genius. Girolamo also built the corridor of the Palace at Urbino, above the garden, and he enclosed a courtyard on one side with perforated stone-work executed with great diligence.

From the design of the same master, likewise, were begun the Convent of the Frati Zoccolanti at Monte Baroccio and S. Maria delle Grazie at Sinigaglia, which in the end remained unfinished by reason of the death of the Duke. And about the same time was begun after his directions and design the Vescovado of Sinigaglia, of which the model, made by him, is still to be seen. He also executed some works in sculpture and figures of clay and wax in the round, beautiful enough, which are in the house of his family at Urbino. For the Imperiale he made some Angels in clay, which he afterwards caused to be cast in bronze and placed over the doors of the rooms decorated with stucco-work in the new palace; and these are very beautiful. For the Bishop of Sinigaglia he executed some fantasies in wax in the form of drinking-cups, which were afterwards to be made in silver; and with greater diligence he made some others, most beautiful, for the Duke's credence. He showed fine invention in masquerades and costumes, as was seen in the time of the above-named Duke, by whom he was passing well rewarded, as he deserved, for his rare parts and good qualities.

His son, Guidobaldo, who reigns at the present day, having then succeeded him as Duke, caused a beginning to be made by the above-named Genga with the Church of S. Giovan Battista at Pesaro, which, having been carried out according to the model of Girolamo by his son Bartolommeo, is of very beautiful architecture in every part, for he imitated the antique considerably, and made it in such a manner that it is the most beautiful temple that

there is in those parts, as the work itself clearly demonstrates, being able to challenge comparison with the most famous buildings in Rome. After his designs and directions, likewise, there was executed in S. Chiara at Urbino by the Florentine sculptor Bartolommeo Ammanati, who was then very young, the tomb of Duke Francesco Maria, which, for a simple work of little cost, proved to be very beautiful. In like manner, the Venetian painter Battista Franco was summoned by him to paint the great chapel of the Duomo at Urbino, at the time when there was being made after his design the ornament of the organ of that Duomo, which is not yet finished.

Shortly afterwards, the Cardinal of Mantua having written to the Duke that he should send him Girolamo, because he wished to restore the Vescovado of that city, Girolamo went thither and fitted it up very well with lights and with all that the above-named lord desired. Besides this, the Cardinal, wishing to make a beautiful façade for the Duomo, caused him to prepare a model for it, which was executed by him in such a manner, that it may be said that it surpassed all the architectural works of his time, for the reason that in it may be seen grandeur, proportion, grace, and great beauty of composition.

Having then returned from Mantua, now an old man, he went to live at a villa of his own, called Le Valle, in the territory of Urbino, in order to rest and enjoy the fruits of his labours; in which place, not wishing to remain idle, he executed in chalk a Conversion of S. Paul with figures and horses of considerable size and in very beautiful attitudes, which was finished by him with such patience and diligence, that no greater could be either described or seen, as is evident from the work itself, now in the possession of his heirs, by whom it is treasured as a very dear and precious thing. There, while living with a tranquil mind, he was attacked by a terrible fever, and, after he had received all the Sacraments of the Church, finished the course of his life, to the infinite grief of his wife and children, on the 11th of July in the year 1551, at the age of about seventy-five. Having been carried from that place to Urbino, he was buried with honour in the Vescovado, in front of the Chapel of S. Martino formerly painted by him; and his death caused extraordinary sorrow to his relatives and to all the citizens.

Girolamo was always an excellent man, insomuch that nothing was ever heard of any bad action committed by him. He was not

only a painter, sculptor, and architect, but also a good musician and a fine talker, and his society was very agreeable. He was full of courtesy and lovingness towards his relatives and friends; and, what entitles him to no little praise, he laid the foundation of the house of Genga at Urbino with his good name and property. He left two sons, one of whom followed in his footsteps and gave his attention to architecture, in which, if he had not been hindered by death, he was like to become most excellent, as his beginnings demonstrate; and the other, who devoted himself to the cares of the family, is still alive at the present day.

A disciple of Girolamo, as has been related, was Francesco Menzochi of Forlì, who first began to draw by himself when still a child, imitating and copying an altar-piece in the Duomo of Forlì, by the hand of Marco Parmigiano* of Forlì, containing a Madonna, S. Jerome, and other Saints, and held at that time to be the best of the modern pictures; and he occupied himself likewise with imitating the works of Rondinino† da Ravenna, a painter more excellent than Marco, who a little time before had placed on the high-altar of the above-named Duomo a most beautiful altar-piece, in which was painted Christ giving the Communion to the Apostles, and in a lunette above it a Dead Christ, and in the predella of that altar-piece very graceful scenes with little figures from the life of S. Helen. These works brought him forward in such a manner, that, when Girolamo Genga went, as we have said, to paint the chapel in S. Francesco at Forlì for M. Bartolommeo Lombardino, Francesco at that time went to live with Genga, seizing that opportunity of learning, and did not cease to serve him as long as he lived. There, and also at Urbino and in the work of the Imperiale at Pesaro, he laboured continually, as has been related, esteemed and beloved by Genga, because he acquitted himself very well, as many altar-pieces by his hand bear witness that are dispersed throughout the city of Forlì, and particularly three of them which are in S. Francesco, besides that there are some scenes of his in fresco in the hall of the Palace.

He painted many works throughout Romagna; and at Venice, also, for the very reverend Patriarch Grimani, he executed four large pictures in oils that were placed in the ceiling of a little hall in his house, round an octagon that Francesco Salviati painted;

* Palmezzani. † Rondinello.

in which pictures are the stories of Psyche, held to be very beautiful. But the place where he strove to do his utmost and to put forth all his powers, was the Chapel of the most holy Sacrament in the Church of Loreto, in which he painted some Angels round a tabernacle of marble wherein rests the Body of Christ, and two scenes on the walls of that chapel, one of Melchizedek and the other of the Manna raining down, both executed in fresco; and over the vaulting he distributed fifteen little scenes of the Passion of Jesus Christ, nine of which he executed in painting, and six in half-relief. This was a rich work and well conceived, and he won for it such honour, that he was not suffered to depart until he had decorated another chapel of equal size in the same place, opposite to the first, and called the Chapel of the Conception, with the vaulting all wrought with rich and very beautiful stucco-work; in which he taught the art of stucco-work to his son Pietro Paolo, who has since done him honour and has become a well-practised master in that field. Francesco, then, painted in fresco on the walls the Nativity and the Presentation of Our Lady, and over the altar he painted S. Anne and the Virgin with the Child in her arms, and two Angels that are crowning her. And, in truth, his works are much extolled by the craftsmen, and likewise his ways and his life, which was that of a true Christian; and he lived in peace, enjoying that which he had gained with his labours.

A pupil of Genga, also, was Baldassarre Lancia of Urbino, who, having given his attention to many ingenious matters, has since practised his hand in fortifications, at which he worked on a salary for the Signoria of Lucca, in which place he stayed for some time. He then attached himself to the most illustrious Duke Cosimo de' Medici, whom he came to serve in the fortifications of the states of Florence and Siena; and the Duke has employed and still employs him in many ingenious works, in which Baldassarre has laboured valiantly and with honour, winning remunerations from that grateful lord.

Many others also served Girolamo Genga, of whom, from their not having attained to any great excellence, there is no need to speak.

To the above-named Girolamo, at Cesena, in the year 1518, the while that he was accompanying the Duke his master in exile, there was born a son called Bartolommeo, who was brought up by him very decently, and then, when he was well grown, placed to learn grammar, in which he made more than ordinary

proficience. Afterwards, when he was eighteen years of age, the father, perceiving that he was inclined more to design than to letters, caused him to study design under his own discipline for about two years: which finished, he sent him to study design and painting in Florence, where he knew that the true study of that art was to be found, on account of the innumerable works by excellent masters that are there, both ancient and modern. Living in that place, and attending to design and to architecture, Bartolommeo formed a friendship with Giorgio Vasari, the painter and architect of Arezzo, and with the sculptor Bartolommeo Ammanati, from whom he learned many things appertaining to art. Finally, after having been three years in Florence, he returned to his father, who was then attending to the building of S. Giovanni Battista at Pesaro. Whereupon, the father having seen the designs of Bartolommeo, it appeared to him that he acquitted himself much better in architecture, for which he had a very good inclination, than in painting; wherefore, keeping him under his own care some months, he taught him the methods of perspective. And afterwards he sent him to Rome, to the end that he might see the marvellous buildings, both ancient and modern, that are there, of which, in the four years that he stayed there, he took the measurements, and made therein very great proficience. Then, on his way back to Urbino, passing through Florence in order to see Francesco* San Marino, his brother-in-law, who was living there as engineer to the Lord Duke Cosimo, Signor Stefano Colonna da Palestrina, at that time general to that lord, having heard of his ability, sought to engage him with himself, with a good salary. But he, being much indebted to the Duke of Urbino, would not attach himself to others, and returned to Urbino, where he was received by that Duke into his service, and ever afterwards held very dear.

Not long afterwards, the Duke taking to wife Signora Vittoria Farnese, Bartolommeo received from the Duke the charge of executing the festive preparations for those nuptials, which he did in a truly honourable and magnificent manner. Among other things, he made a triumphal arch in the Borgo di Valbuona, so beautiful and so well wrought, that there is none larger or more beautiful to be seen; whence it became evident how much knowledge of architecture he had acquired at Rome. Then the Duke,

* Giovan Battista.

having to go into Lombardy, as General to the Signoria of
Venice, to inspect the fortresses of that dominion, took with him
Bartolommeo, of whom he availed himself much in preparing
designs and sites of fortresses, and in particular at the Porta
S. Felice in Verona. Now, while Bartolommeo was in Lombardy,
the King of Bohemia, who was returning from Spain to his king-
dom, passed through that province and was received with honour
by the Duke at Verona; and he saw those fortresses. And, since
they pleased him, after he had become acquainted with Bartolom-
meo, he wished to take him to his kingdom, in order to make use
of him in fortifying his territories, with a good salary; but the
Duke would not give him leave, and the matter went no further.

When they had returned to Urbino, no long time passed be-
fore Girolamo, the father, came to his death; whereupon Bar-
tolommeo was set by the Duke in the place of his father over
all the buildings of the state, and sent to Pesaro, where he con-
tinued the building of S. Giovanni Battista, after the model of
Girolamo. During that time he built in the Palace of Pesaro, over
the Strada de' Mercanti, a suite of rooms which the Duke now
occupies; a fine work, with most beautiful ornaments in the form
of doors, staircases, and chimney-pieces, of which things he was
an excellent architect. Which having seen, the Duke desired that
in the Palace of Urbino as well he should make another suite of
apartments, almost entirely on the façade that faces towards
S. Domenico; and this, when finished, proved to be the most
beautiful suite in that court, or rather, palace, and the most ornate
that is there. Not long afterwards, the Signori of Bologna having
asked for him for some days from the Duke, his Excellency
granted him to them very readily; and he, having gone, served
them in what they desired in such a manner, that they remained
very well satisfied and showed him innumerable courtesies.

He then made for the Duke, who desired to construct a sea-
port at Pesaro, a very beautiful model; and this was taken to
Venice, to the house of Count Giovan Giacomo Leonardi, at that
time the Duke's Ambassador in that place, to the end that it
might be seen by many of the profession who often assembled,
with other choice spirits, to hold discussions and disputations on
various matters in the house of the above-named Count, who
was a truly remarkable man. There, then, after that model had
been seen and the fine discourse of Genga had been heard, the
model was held by all without exception to be masterly and

beautiful, and the master who had made it a man of the rarest genius. But, when he had returned to Pesaro, the model after all was not carried into execution, because new circumstances of great importance drove that project out of the Duke's mind.

About that time Genga made the design of the Church of Monte L'Abbate, and also that of the Church of S. Piero in Mondavio, which was carried into execution by Don Pier Antonio Genga in such a manner, that, for a small work, I do not believe that there is anything better to be seen.

These works finished, no long time passed before, Pope Julius III having been elected, and the Duke of Urbino having been created by him Captain General of Holy Church, his Excellency went to Rome, and Genga with him. There, his Holiness wishing to fortify the Borgo, at the request of the Duke Genga made some very beautiful designs, which, with a number of others, are in the collection of his Excellency at Urbino. For these reasons the fame of Bartolommeo spread abroad, and the Genoese, while he was living with the Duke in Rome, asked for him from his Excellency, in order to make use of him in some fortifications of their own; but the Duke would not grant him to them, either at that time or on another occasion when they again asked for him, after his return to Urbino.

In the end, when he was near the close of his life, there were sent to Pesaro by the Grand Master of Rhodes two knights of that Order of Jerusalem, to beseech his Excellency that he should deign to lend them Bartolommeo, to the end that they might take him to the Island of Malta, in which they wished to construct not only very large fortifications wherewith to defend themselves against the Turks, but also two cities, so as to unite many villages that were there into one or two places. Whereupon the Duke, whom the above-named knights in two months had not been able to induce to grant them Bartolommeo, although they had availed themselves of the good services of the Duchess and others, finally complied with their request for a fixed period, at the entreaty of a good Capuchin father, to whom his Excellency bore a very great affection, and refused nothing that he asked; and the artifice that was used by that holy man, who made it a matter of conscience with the Duke, saying that it was in the interest of the Christian Republic, was not otherwise than highly commendable and worthy of praise. And thus Bartolommeo, who had never received any favour greater than this, departed

with the above-named knights from Pesaro on the 20th of January, 1558; but they lingered in Sicily, being delayed by the fortune of the sea, and they did not reach Malta, where they were received with rejoicing by the Grand Master, until the 11th of March. Having then been shown what he was to do, he acquitted himself so well in those fortifications, that it could not be expressed in words; insomuch that to the Grand Master and all those noble knights it appeared that they had found another Archimedes, and this they proved by making him most honourable presents and holding him, as a rare master, in supreme veneration. Then, after having made the models of a city, of some churches, and of the palace and residence of the same Grand Master, with most beautiful invention and design, he fell sick of his last illness, for, having set himself one day in the month of July, the heat in that island being very great, between two doors to refresh himself, he had not been there long when he was assailed by insufferable pains of the body and by a cruel flux, which killed him in seventeen days, to the infinite sorrow of the Grand Master and all those most honourable and valiant knights, to whom it appeared that they had found a man after their own hearts, when he was snatched from them by death. The Lord Duke of Urbino, having been advised of this sad news, felt indescribable sorrow, and bewailed the death of poor Genga; and then, having resolved to demonstrate to the five children whom he had left behind him the love that he bore to him, he took them under his particular and loving protection.

Bartolommeo showed beautiful invention in masquerades, and was a rare master in making scenic settings for comedies. He delighted to write sonnets and other compositions in verse and prose, and in none was he better than in the ottava rima, in which manner of writing he was an author of passing good renown. He died at the age of forty, in the year 1558.

Giovan Battista Bellucci of San Marino having been the son-in-law of Girolamo Genga, I have judged that it would not be well to withhold what I have to say of him, after the Lives of Girolamo and Bartolommeo Genga, and particularly in order to show that men of fine intellect, if only they be willing, succeed in everything, even if they set themselves late in life to difficult and honourable enterprises; for study, when added to natural inclination, has often been seen to accomplish marvellous things. Giovan Battista, then, was born in San Marino on the 27th of

September, 1506, to Bartolommeo Bellucci, a person of passing good family in that place; and after he had learned the first rudiments of the humanities, when eighteen years of age, he was sent by that same Bartolommeo, his father, to Bologna, to attend to the pursuit of commerce under Bastiano di Ronco, a merchant of the Guild of Wool. Having been there about two years, he returned to San Marino sick of a quartan fever, which hung upon him two years; of which being finally cured, he set up a wool business of his own, with which he continued up to the year 1535, at which time his father, perceiving that Giovan Battista was in good circumstances, gave him for a wife in Cagli a daughter of Guido Peruzzi, a person of considerable standing in that city. But she died not long afterwards, and Giovan Battista went to Rome to seek out Domenico Peruzzi, his brother-in-law, who was equerry to Signor Ascanio Colonna; and by means of him Giovan Battista lived for two years with that lord as a gentleman. He then returned home; and it came about that, as he frequented Pesaro, Girolamo Genga, having come to know him as an excellent and well-behaved young man, gave him a daughter of his own for wife and took him into his house. Whereupon Giovan Battista, being much inclined to architecture, and giving his attention with much diligence to the architectural works that his wife's father was executing, began to gain a very good grasp of the various manners of building, and to study Vitruvius; and thus, what with that which he acquired by himself and that which Genga taught him, he became a good architect, and particularly in the matter of fortifications and other things relating to war.

Then, in the year 1541, his wife died, leaving him two boys; and he remained until 1543 without coming to any further resolution about his life. At that time, in the month of September, there appeared in San Marino one Signor Gustamante, a Spaniard, sent by his Imperial Majesty to that Republic on some affairs. Giovan Battista was recognized by him as an excellent architect, and at his instance he entered not long afterwards into the service of the most illustrious Lord Duke Cosimo, as engineer. And thus, having arrived in Florence, his Excellency made use of him for all the fortifications of his dominion, according to the necessities that arose every day; and, among other things, the fortress of the city of Pistoia having been begun many years before, San Marino, by the desire of the Duke, completely finished it, with great credit to himself, although it is no great work. Then, under the direction

of the same architect, a very strong bastion was built at Pisa. Wherefore, his method of work pleasing the Duke, his Excellency caused him to construct – where, as has been related, there had been built on the hill of S. Miniato, without Florence, the wall that curves from the Porta S. Niccolò to the Porta S. Miniato – the fortification that encloses a gate by means of two bastions, and guards the Church and Monastery of S. Miniato; making on the summit of that hill a fortress that dominates the whole city and looks on the outer side towards the east and the south, a work that was vastly extolled. The same Giovan Battista made many designs and ground-plans of various fortifications for places in the states of his Excellency, and also various rough models in clay, which are in the possession of the Lord Duke. And since San Marino was a man of fine genius and very studious, he wrote a little book on the methods of fortifications; which work, a beautiful and useful one, is now in the possession of Messer Bernardo Puccini, a gentleman of Florence, who learned many things with regard to the matters of architecture and fortification from San Marino, who was much his friend.

Giovan Battista, after having designed in the year 1554 many bastions that were to be built round the walls of the city of Florence, some of which were begun in earth, went with the most illustrious lord, Don Garzia di Toledo, to Monte Alcino, where, having made some trenches, he mined under a bastion and so shattered it, that he threw down the breastwork; but as it was falling to the ground a harquebus-ball struck San Marino in the thigh. Not long afterwards, his wound being healed, he went secretly to Siena and took the ground-plan of that city, and of the earthworks that the people of Siena had made at the Porta Camollia; which plan of fortifications he then showed to the Lord Duke and to the Marchese di Marignano, making it clear to them that the work was not difficult to capture or to secure afterwards on the side towards Siena. That this was true was proved by the fact, the night that it was taken by the above-named Marquis, with whom Giovan Battista had gone by order and commission of the Duke. On that account, then, the Marquis, having conceived an affection for him and knowing that he had need of his judgment and ability in the field (that is, in the war against Siena), so went to work with the Duke, that his Excellency sent Giovan Battista off as captain of a strong company of foot-soldiers; whereupon he served from that day onward in the field, as a

valiant soldier and an ingenious architect. Finally, having been
sent by the Marquis to Aiuola, a fortress in the Chianti, while
disposing the artillery he was wounded in the head by a harque-
bus-ball; wherefore he was taken by his soldiers to the Pieve di
S. Paolo, which belongs to Bishop da Ricasoli, and died in a few
days, and was carried to San Marino, where he received honour-
able burial from his children.

Giovan Battista deserves to be highly extolled, for the reason
that, besides having been excellent in his profession, it is a mar-
vellous thing that, having set himself to give attention to it late
in life, at the age of thirty-five, he should have made in it the
proficience that he did make; and it may be believed that if he
had begun younger, he would have become a very rare master.
Giovan Battista was something obstinate, so that it was a serious
undertaking to move him from any opinion. He took extraordi-
nary pleasure in reading stories, and turned them to very great
advantage, writing down with great pains the most notable
things in them. His death much grieved the Duke and his in-
numerable friends; wherefore his son Gian Andrea, coming to
kiss his Excellency's hands, was received kindly by him and wel-
comed most warmly with very generous offers, on account of the
ability and fidelity of the father, who died at the age of forty-
eight.

MICHELE SAN MICHELE, Architect of Verona

MICHELE SAN MICHELE, who was born at Verona in the year
1484, and learned the first principles of architecture from his
father Giovanni and his uncle Bartolommeo, both excellent
architects, went off at sixteen years of age to Rome, leaving his
father and two brothers of fine parts, one of whom, called
Jacopo, devoted himself to letters, and the other, named Don
Camillo, was a Canon Regular and General of that Order. Having
arrived there, he studied the ancient remains of architecture in
such a manner, and with such diligence, observing and measuring
everything minutely, that in a short time he became renowned
and famous not only in Rome, but throughout all the places that
are around that city. Moved by his fame, the people of Orvieto
summoned him as architect to their celebrated temple, with an

honourable salary; and while he was employed in their service, he was summoned for the same reason to Monte Fiascone, as architect for the building of their principal temple; and thus, serving both the one and the other of these places, he executed all that there is to be seen in these two cities in the way of good architecture. Among other works, a most beautiful tomb was built after his design in S. Domenico at Monte Fiascone – I believe, for one of the Petrucci, a nobleman of Siena – which cost a great sum of money, and proved to be marvellous. Besides all this, he made an infinite number of designs for private houses in those places, and made himself known as a man of great judgment and excellence.

Thereupon Pope Clement VII, proposing to make use of him in the most important operations of the wars that were stirring at that time throughout all Italy, gave him as a companion to Antonio da San Gallo, with a very good salary, to the end that they might go together to inspect all the places of greatest importance in the States of the Church, and, wherever necessary, might see to the construction of fortifications; above all, at Parma and Piacenza, because those two cities were most distant from Rome, and nearest and most exposed to the perils of war. Which duty having been executed by Michele and Antonio to the full satisfaction of the Pontiff, there came to Michele a desire, after all those years, to revisit his native city and his relatives and friends, and even more to see the fortresses of the Venetians. Wherefore, after he had been a few days in Verona, he went to Treviso to see the fortress there, and then to Padua for the same purpose; but the Signori of Venice, having been warned of this, became suspicious that San Michele might be going about inspecting those fortresses with a hostile intent. Having therefore been arrested at Padua at their command and thrown into prison, he was examined at great length; but, when it was found that he was an honest man, he was not only liberated by them, but also entreated that he should consent to enter the service of those same Signori of Venice, with honourable rank and salary. He excused himself by saying that he was not able to do that for the present, being engaged to his Holiness; but he gave them fair promises, and then took his leave of them. Now he had not been away long, when he was forced to depart from Rome – to such purpose did those Signori go to work in order to secure him – and to go, with the gracious leave of the Pope, whom he first

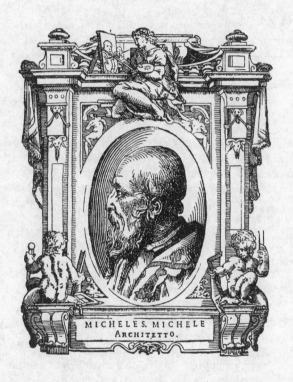

MICHELE S. MICHELE
ARCHITETTO.

satisfied in full, to serve those most illustrious noblemen, his natural lords. Abiding with them, he gave soon enough a proof of his judgment and knowledge by making at Verona (after many difficulties which the work appeared to present) a very strong and beautiful bastion, which gave infinite satisfaction to those Signori and to the Lord Duke of Urbino, their Captain General. After these things, the same Signori, having determined to fortify Legnago and Porto, places most important to their dominion, and situated upon the River Adige, one on one side and the other on the opposite side, but joined by a bridge, commissioned San Michele to show them by means of a model how it appeared to him that those places could and should be fortified. Which having been done by him, his design gave infinite satisfaction to the Signori and to the Duke of Urbino. Whereupon, arrangements having been made for all that had to be done, San Michele executed the fortifications of those two places in such a manner, that among works of that kind there is nothing better to be seen, or more beautiful, or more carefully considered, or stronger, as whoever has seen them well knows.

This done, he fortified in the Bresciano, almost from the foundations, Orzinuovo, a fortress and port similar to Legnago. San Michele being then sought for with great insistence by Signor Francesco Sforza, last Duke of Milan, the Signori consented to grant him leave, but for three months only. Having therefore gone to Milan, he inspected all the fortresses of that State, and gave directions in every place for all that it seemed to him necessary to do, and that with such credit and so much to the satisfaction of the Duke, that his Excellency, besides thanking the Signori of Venice, presented five hundred crowns to San Michele. And with this occasion, before returning to Venice, Michele went to Casale di Monferrato, in order to see that very strong and beautiful fortress and city, the architecture of which was the work of Matteo San Michele, an excellent architect, his cousin; and also an honoured and very beautiful tomb of marble erected in S. Francesco in the same city, likewise under the direction of Matteo.

Having then returned home, he had no sooner arrived than he was sent with the above-named Duke of Urbino to inspect La Chiusa, a fortress and pass of much importance, above Verona, and then all the places in Friuli, Bergamo, Vicenza, Peschiera, and others, of all which, and of what seemed to him to be required, he gave minute information in writing to the Signori. Having next

been sent by the same Signori to Dalmatia, to fortify the cities and other places of that province, he inspected everything, and carried out restorations with great diligence wherever he saw the necessity to be greatest; and, since he could not himself despatch all the work, he left there Gian Girolamo, his kinsman, who, after fortifying Zara excellently well, erected from the foundations the marvellous fortress of S. Niccolò, over the mouth of the harbour of Sebenico.

Meanwhile Michele was sent in great haste to Corfu, and restored the fortress there in many parts; and he did the same in all the places in Cyprus and Candia. Even so, not long afterwards – on account of a fear that the island might be lost, by reason of the war with the Turks, which was imminent – he was forced to return there, after having inspected the fortresses of the Venetian dominion in Italy, to fortify, with incredible rapidity, Canea, Candia, Retimo, and Settia, but particularly Canea and Candia, which he rebuilt from the foundations and made impregnable. Napoli di Romania being then besieged by the Turks, what with the diligence of S. Michele in fortifying it and furnishing it with bastions, and the valour of Agostino Chisoni of Verona, a very valiant captain, in defending it with arms, it was not after all taken by the enemy or forced to surrender.

These wars finished, San Michele went with the Magnificent M. Tommaso Mozzenigo, Captain General of the Fleet, to fortify Corfu once again; and they then returned to Sebenico, where the diligence of Gian Girolamo, shown by him in constructing the above-mentioned fortress of S. Niccolò, was much commended. San Michele having then returned to Venice, where he was much extolled for the works executed in the Levant in the service of that Republic, the Signori resolved to build a fortress on the Lido, at the mouth of the port of Venice. Wherefore, giving the charge of this to San Michele, they said to him that, if he had done such great things far away from Venice, he should think how much it was his duty to do in a work of such importance, which was to lie for ever under the eyes of the Senate and of so many great lords; and that in addition, besides beauty and strength in the work, there was expected of him particular industry in founding truly and well in a marshy spot, which was surrounded on all sides by the sea and exposed to the ebb and flow of the tide, a pile of such importance. San Michele having therefore not only made a very beautiful and solid model, but also considered the

method of laying the foundations and carrying it into effect, orders were given to him that he should set his hand to the work without delay. Whereupon, after receiving from those Signori all that was required, he prepared the materials for filling in the foundations, and, besides this, caused great numbers of piles to be sunk in double rows, and then, with a vast number of persons well acquainted with those waters, he set himself to make the excavations, and to contrive by means of pumps and other instruments to keep the water pumped out, which was seen continually rising from below, because the site was in the sea. One morning, finally, resolving to make a supreme effort to begin the foundations, and assembling as many men fit for the purpose as could be obtained, with all the porters of Venice, and many of the Signori being present, in a moment, with incredible assiduity and promptitude, the waters were mastered for a little to such purpose, that the first stones of the foundations were thrown instantly upon the piles already driven in; which stones, being very large, took up much space and made an excellent foundation. And so, continuing to keep the water pumped out without losing any time, almost in a flash those foundations were laid, contrary to the expectation of many who had looked upon that work as absolutely impossible. The foundations, when finished, were allowed sufficient time to settle, and then Michele erected upon them a mighty and marvellous fortress, building it on the outer side all in rustic work, with very large stones from Istria, which are of an extreme hardness and able to withstand wind, frost, and the worst of weather. Wherefore that fortress, besides being marvellous with regard to the site on which it is built, is also, from the beauty of the masonry and from its incredible cost, one of the most stupendous that there are in Europe at the present day, rivalling the grandeur and majesty of the most famous edifices erected by the greatness of the Romans; for, besides other things, it appears as if made all from one block, and as though a mountain of living rock had been carved and given that form, so large are the blocks of which it is built, and so well joined and united together, not to speak of the ornaments and other things that are there, seeing that one would never be able to say enough to do them justice. Within it Michele afterwards made a piazza, divided by pilasters and arches of the Rustic Order, which would have proved to be a very rare work, if it had not been left unfinished.

This vast pile having been carried to the condition that has been described, some malign and envious persons said to the Signoria that, although it was very beautiful and built with every possible consideration, nevertheless it would be useless for any purpose, and perhaps even dangerous, for the reason that on discharging the artillery – on account of the great quantity and weight of artillery that the place required – it was almost inevitable that the edifice should split open and fall to the ground. It therefore appeared to those prudent Signori that it would be well to make certain of this, the matter being one of great importance; and they caused to be taken there a vast quantity of artillery, the heaviest that could be found in the Arsenal. Then, all the embrasures both above and below having been filled with cannon, and the cannon charged more heavily than was usual, they were all fired off together; whereupon such were the noise, the thunder, and the earthquake that resulted, that it seemed as if the world had burst to pieces, and the fortress, with all those flaming cannon, had the appearance of a volcano and of Hell itself. But for all that the building stood firm in its former strength and solidity, whereby the Senate was convinced of the great worth of San Michele, and the evil-speakers were put to scorn as men of little judgment, although they had put such terror into everyone, that the ladies then pregnant, fearing some great disaster, had withdrawn from Venice.

Not long afterwards a place of no little importance on the coast near Venice, called Marano, having returned under the dominion of the Venetians, was restored and fortified with promptitude and diligence under the direction of San Michele. And about the same time, the fame of Michele and of his kinsman, Gian Girolamo, spreading ever more widely, they were requested many times, both the one and the other, to go to live with the Emperor Charles V and with King Francis of France; but, although they were invited under most honourable conditions, they would not leave their own masters to enter into the service of foreigners. Indeed, continuing in their offices, they went about inspecting and restoring every year, wherever it was necessary, all the cities and fortresses of the State of Venice.

But more than all the rest did Michele fortify and adorn his native city of Verona, making there, besides other things, those most beautiful gates of the city, which have no equal in any other place. One was the Porta Nuova, all in the Dorico-rustic Order,

which in its solidity and massive firmness corresponds to the strength of the site, being all built of tufa and pietra viva,* and having within it rooms for the soldiers who mount guard there, and many other conveniences, never before added to that kind of building. That edifice, which is quadrangular and open above, serving with its embrasures as a cavalier, defends two great bastions, or rather, towers, which stand one on either side of the gate at proper distances; and all is done with so much judgment, cost, and magnificence, that no one thought that for the future there could be executed any work of greater grandeur or better design, even as none such had been seen in the past. But a few years afterwards the same San Michele founded and carried upwards the gate commonly called the Porta dal Palio, which is in no way inferior to that described above, but equally beautiful, grand, and magnificent, or even more so, and designed excellently well. And, in truth, in these two gates the Signori of Venice may be seen to have equalled, by means of the genius of this architect, the edifices and fabrics of the ancient Romans.

This last gate, then, is on the outer side of the Doric Order, with immense projecting columns, all fluted according to the manner of that Order; and these columns, which are eight in all, are placed in pairs. Four serve to enclose the gate, with the arms of the Rectors of the city, between one and another, on either side, and the other four, likewise in pairs, make a finish to the angles of the gate, the façade of which is very wide and all of bosses, or rather, blocks, not rough, but made smooth, with very beautiful ornamentation; and the opening, or rather passage, through the gate, is left quadrangular, but of an architecture that is new, bizarre, and most beautiful. Above it is a great and very rich Doric cornice, with all its appurtenances, over which, as may be seen from the model, was to go a fronton with all its ornaments, forming a parapet for the artillery, since this gate, like the other, was to serve as a cavalier. Within the gate are very large rooms for the soldiers, with other apartments and conveniences. On the front that faces towards the city, San Michele made a most beautiful loggia, all of the Dorico-rustic Order on the outer side, and on the inner all in rustic work, with very large piers that have as ornaments columns round on the outside and on the inside square and projecting to the half of their thickness, and all

* Any kind of stone that is easily split.

made of pieces in rustic masonry, with Doric capitals without bases; and at the top is a great cornice, likewise Doric, and carved, passing along the whole loggia, which is of great length, both within and without. In a word, this work is marvellous; wherefore it was well and truly spoken by the most illustrious Signor Sforza Pallavicino, Captain General of the Venetian forces, when he said that there was not to be found in all Europe any structure that could in any way compare with it. This was the last of Michele's marvels, for the reason that he had scarcely erected the whole of the first range described above, when he finished the course of his life. Wherefore the work remained unfinished, nor will it ever be finished at all, for there are not wanting certain malignant persons – as always happens with great works – who censure it, striving to diminish the glory of others by their malignity and evil-speaking, since they fail by a great measure to achieve similar things with their own powers.

The same master built another gate at Verona, called the Porta di S. Zeno, which is very beautiful; in any other place, indeed, it would be marvellous, but in Verona its beauty and artistry are obscured by the two others described above. A work of Michele's, likewise, is the bastion, or rather rampart, that is near this gate, and also another that is lower down, opposite to S. Bernardino, and another between them, called Dell' Acquaio, which is opposite to the Campo Marzio; and also that surpassing all the others in size, which is placed by the Chain, where the Adige enters the city.

At Padua he built the bastion called the Cornaro, and likewise that of S. Croce, which are both of marvellous size, and constructed in the modern manner, according to the order invented by Michele himself. For the method of making bastions with angles was the invention of Michele, and before his day they were made round; and whereas that kind of bastion was very difficult to defend, at the present day, having an obtuse angle on the outer side, they can be defended with ease, either from the cavalier erected between the two bastions and near to them, or, indeed, from the other bastion, provided that it be near the one attacked and the ditch wide. His invention, also, was the method of making bastions with three platforms, whereby the two at the sides guard and defend the ditch and the curtains, with their open embrasures, and the merlon in the centre defends itself and attacks the enemy in front. This method of fortification has since

been imitated by everyone, causing the abandonment of the ancient fashion of subterranean embrasures, called casemates, in which, on account of the smoke and other impediments, the artillery could not be well handled; not to mention that they often weakened the foundations of the towers and walls.

The same Michele built two very beautiful gates at Legnago. He directed at Peschiera the work of the first foundation of that fortress, and likewise many works at Brescia; and he always did everything with such diligence and such good foundations, that not one of his buildings ever showed a crack. Finally, he restored the fortress of La Chiusa above Verona, making it possible for persons to pass by without entering the fortress, but yet in such a manner that, on the raising of a bridge by those who are within, no one can pass by against their will, or even show himself on the road, which is very narrow and cut out of the rock. He also built at Verona, just after he had returned from Rome, the very beautiful bridge over the Adige, called the Ponte Nuovo, doing this at the commission of Messer Giovanni Emo, at that time Podestà of that city; which bridge was on account of its strength, as it still is, a marvellous thing.

Michele was excellent not only in fortifications, but also in private buildings and in temples, churches, and monasteries, as may be seen from many buildings at Verona and other places, and particularly from the most ornate and beautiful Chapel of the Guareschi in S. Bernardino, which is round after the manner of a temple, and in the Corinthian Order, with all the ornaments which that manner admits. That chapel, I say, he built all of that white pietra viva, which, from the sound that it makes when it is being worked, is called in that city 'Bronzo'; and, in truth, that kind of stone, after fine marble, is the most beautiful that has been found down to our own times, being absolutely solid and without holes or spots that might spoil it. Since that chapel, then, is built on the inside all of that most beautiful stone, and wrought by excellent masters of carving, and put together very well, it is considered that among works of that kind there is at the present day no other more beautiful in all Italy. For Michele made the whole work curve in a circle in such a manner, that three altars which are in it, with their pediments and cornices, and likewise the space of the door, all turn in a perfect round, almost after the likeness of the entrances that Filippo Brunelleschi made in the Chapels of the Temple of the Angeli in Florence; which is a very

difficult thing to do. Michele then made therein a gallery over the first range of columns, which circles right round the chapel, and there are to be seen most beautiful carvings in the form of columns, capitals, foliage, grotesques, little pilasters, and other things, carved with incredible diligence. The door of that chapel he made quadrangular on the outer side, of the Corinthian Order and very beautiful, and similar to an ancient door that he saw, so he used to say, in some place at Rome. It is true, indeed, that this work, after having been left unfinished by Michele, I know not for what reason, was given, either from avarice or from lack of judgment, to certain others to be finished, who spoiled it, to the infinite vexation of Michele, who in his lifetime saw it ruined before his very eyes, without being able to prevent it; wherefore he used to complain at times to his friends, but only on this account, that he had not thousands of ducats wherewith to buy it from the avaricious hands of a woman who, by spending less than she was able, was shamefully spoiling it.

A work of Michele's was the design of the round Temple of the Madonna di Campagna, near Verona, which was very beautiful, although the parsimony, weakness, and little judgment of the Wardens of that building have since disfigured it in many parts; and even worse would they have done, if Bernardino Brugnuoli, a kinsman of Michele, had not had charge of it and made a complete model, after which the building of that temple, as well as of many others, is now being carried forward. For the Friars of S. Maria in Organo, or rather, the Monks of Monte Oliveto in Verona, he made a design of the Corinthian Order, which was most beautiful, for the façade of their church. This façade, after being carried to a certain height by Paolo San Michele, was left not long since in that condition, on account of many expenses that were incurred by those monks in other matters, but even more by reason of the death of him who had begun it, Don Cipriano of Verona, a man of saintly life and of much authority in that Order, of which he was twice General. At S. Giorgio in Verona, a convent of the Regular Priests of S. Giorgio in Alega, the same Michele directed the building of the cupola of that church, which was a very beautiful work, and succeeded against the expectations of many who did not think that the structure would ever remain standing, on account of the weakness of its supports; but these were then so strengthened by Michele, that there is no longer anything to fear. In the same convent he made

the design and laid the foundations of a very beautiful campanile of hewn stone, partly tufa and partly pietra viva, which was carried well forward by him, and is now being continued by the above-mentioned Bernardino, his nephew, who is employed in carrying it to completion.

Monsignor Luigi Lippomani, Bishop of Verona, having resolved to carry to completion the campanile of his church, which had been begun a hundred years before, caused a design for this to be made by Michele, who did it very beautifully, taking into consideration the preserving of the old part and the expense that the Bishop was able to incur. But a certain Messer Domenico Porzio, a Roman, and his vicar, a person with little knowledge of building, although otherwise a worthy man, allowed himself to be imposed upon by one who also knew little about it, and gave him the charge of carrying on that fabric. Whereupon that person built it of unprepared stone from the mountains, and made the stairs in the thickness of the walls, doing all this in such a manner, that everyone who was even slightly conversant with architecture foretold that which afterwards happened – namely, that the structure would not remain standing. And, among others, the very reverend Fra Marco de' Medici of Verona, who, in addition to his other more serious studies, has always delighted in architecture, as he still does, predicted what would happen to such a building; but he was answered thus: 'Fra Marco counts for much in his own profession of letters, philosophy, and theology, wherein he is public lecturer, but in architecture he does not fish so deeply as to command belief.' Finally, that campanile, having risen to the level where the bells were to be, opened out in four parts in such a manner, that, after having spent many thousands of crowns in building it, they had to give three hundred crowns to the builders to throw it to the ground, lest it should fall by itself, as it would have done in a few days, and destroy everything all around. And it is only right that this should happen to those who desert good and eminent masters, and mix themselves up with bunglers. The above-named Monsignor Luigi having afterwards been chosen Bishop of Bergamo, Monsignor Agostino Lippomani was made Bishop of Verona in his place, and he commissioned Michele to reconstruct almost anew the model of that campanile, and to set to work. And after him, according to the same model, Monsignor Girolamo Trivisani, a friar of S. Dominic, who succeeded the last-named Lippomani in the

bishopric, has caused that work to be continued, which is now progressing passing slowly. The model is very beautiful, and the stairs are being accommodated within the tower in such a manner, that the fabric remains stable and very strong.

For the noble Counts della Torre of Verona, Michele built a very beautiful chapel in the manner of a round temple, with the altar in the centre, at their villa of Fumane. And in the Church of the Santo, at Padua, a very handsome tomb was built under his direction for Messer Alessandro Contarini, Procurator of S. Mark, who had been Proveditor to the Venetian forces; in which tomb it would seem that Michele sought to show in what manner such works should be done, departing from a kind of commonplace method which, in his opinion, had in it more of the altar or chapel than of the tomb. This work, which is very rich in ornamentation, solid in composition, and warlike in character, has as ornaments a Thetis and two prisoners by the hand of Alessandro Vittoria, which are held to be good figures, and a head, or rather, effigy from life of the above-named lord, with armour on the breast, executed in marble by Danese da Carrara. There are, in addition, other ornaments in abundance; prisoners, trophies, spoils of war, and others, of which there is no need to make mention.

In Venice he made the model of the Convent of the Nuns of S. Biagio Catoldo, which was much extolled. It was then resolved at Verona to rebuild the Lazzaretto, a dwelling, or rather, hospital, which serves for the sick in times of plague, the old one having been destroyed together with other edifices that had been in the suburbs; and Michele was commissioned to make a design for this (which proved to be beautiful beyond all expectations), to the end that it might be put into execution on a spot near the river, at some distance from the city and beyond the esplanade. But this design, truly most beautiful and excellently well considered in every part, which is now in the possession of the heirs of Luigi Brugnuoli, Michele's nephew, was not carried completely into execution by certain persons, by reason of their little judgment and poverty of spirit, but much restricted, curtailed, and reduced to mean proportions by those persons, who used the authority that they had received in the matter from the public in disfiguring the work, in consequence of the untimely death of some gentlemen who were in charge of it at the beginning, and who had a greatness of spirit equal to their nobility of blood.

A work of Michele's, likewise, was the very beautiful palace that the noble Counts of Canossa have at Verona, which was built at the commission of the very reverend Monsignor di Bajus, who once was Count Lodovico Canossa, a man so much celebrated by all the writers of his time. For the same Monsignor Michele built another magnificent palace in the Villa of Grezzano, in the Veronese territory. Under the direction of the same architect the façade of the Counts Bevilacqua was reconstructed, and all the apartments were restored in the castle of those lords, called La Bevilacqua. And at Verona, likewise, he built the house and façade of the Lavezzoli, which were much extolled.

In Venice he built from the foundations the very rich and magnificent palace of the Cornaro family, near S. Polo, and restored another palace, also of the Cornaro family, which is by S. Benedetto all' Albore, for M. Giovanni Cornaro, of whom Michele was much the friend; and this led to Giorgio Vasari painting nine pictures in oils for the ceiling of a magnificent apartment, all adorned with woodwork carved and richly overlaid with gold, in that palace. In like manner, he restored the house of the Bragadini, opposite to S. Marina, and made it very commodious and ornate. And in the same city he founded and raised above the ground after a model of his own, at incredible cost, the marvellous palace of the most noble M. Girolamo Grimani, near S. Luca, on the Grand Canal; but Michele, being overtaken by death, was not able to carry it to completion himself, and the other architects chosen in his stead by that nobleman altered his design and model in many parts.

Near Castelfranco, on the borders of the territories of Padua and Treviso, there was built under the direction of the same Michele the most famous Palace of the Soranzi, called by that family La Soranza; which palace is held to be, for a country residence, the most beautiful and the most commodious that had been built in those parts up to that time. He also built the Casa Cornara at Piombino, in that territory, and so many other private houses, that it would make too long a story to attempt to speak of them all; let it be enough to have made mention of the most important. I will not, indeed, refrain from recording that he made most beautiful gates for two palaces, one of which was that of the Rectors and of the Captain, and the other that of the Palazzo del Podestà, both in Verona and worthy of the highest praise, although the latter, which is in the Ionic Order, with double

columns and very ornate intercolumniations, and some Victories at the angles, has a somewhat dwarfed appearance by reason of the lowness of the site where it stands, particularly because it is without pedestals and very wide on account of the double columns; but such was the wish of Messer Giovanni Delfini, who had it made.

While Michele was enjoying a tranquil ease in his native place, and the reputation and renown that his honourable labours had brought him, there came to him a piece of news that so afflicted him, that it finished the course of his life. But to the end that the whole may be better understood, and that all the beautiful works of the San Michele family may be made known in this Life, I shall say something of Gian Girolamo, the kinsman of Michele.

This Gian Girolamo, then, was the son of Paolo, the cousin of Michele, and, being a young man of very beautiful genius, was instructed with such diligence by Michele in the matters of architecture, and so beloved by him, that he would always have the young man with him in all undertakings of importance, and particularly in fortifications. Having therefore become in a short time so excellent, with the help of such a master, that the most difficult work of fortification could be entrusted to him, in which manner of architecture he took particular delight, his ability was recognized by the Signori of Venice, and he was placed with a good salary among the number of their architects, although he was very young, and then sent now to one place and now to another, to inspect and restore the fortresses of their dominion, and at times to carry into execution the designs of his kinsman Michele. And, among other places, he took part with much judgment and labour in the fortification of Zara, and in the marvellous fortress of S. Niccolò at Sebenico, placed, as has been mentioned, at the mouth of the port; which fortress, erected by him from the very foundations, is held to be, for a private fortress, one of the strongest and best designed that there are to be seen. He also reconstructed after his own designs, with the advice of his kinsman, the great fortress of Corfù, which is considered the key of Italy on that side. In this fortress, I say, Gian Girolamo rebuilt the two great towers that face towards the land, making them much larger and stronger than they were before, with open embrasures and platforms that flank the ditch in the modern manner, after the invention of his kinsman. He then caused the ditches to be made much wider than they were before, and had

a hill levelled, which, being near the fortress, appeared to command it. But, besides the many other works that he did there with great consideration, what gave most satisfaction was that in one corner of the fortress he made a place of great size and strength, in which in time of siege the people of that island can stay in safety without any danger of being captured by the enemy.

On account of these works Gian Girolamo came into such credit with the above-named Signori, that they ordained him a salary equal to that of his kinsman, judging him to be not inferior to Michele, and even superior in that work of fortification: which gave the greatest contentment to San Michele, who saw his own art advancing in the person of his relative in proportion as old age was taking away from himself the power to go further. Gian Girolamo, besides his great judgment in recognizing the nature of different sites, showed much industry in having them represented by designs and models in relief, insomuch that he enabled his patrons to see even the most minute details of his fortifications in very beautiful models of wood that he would cause to be made; which diligence pleased them vastly, for without leaving Venice they saw every day how matters were proceeding in the most distant parts of their State. In order that they might be the more readily seen by everyone, these models were kept in the Palazzo del Principe, in a place where the Signori could examine them at their convenience; and to the end that Gian Girolamo might continue to pursue that course, they not only reimbursed him the expenses that he incurred in making the above-mentioned models, but also showed him many other courtesies.

Gian Girolamo could have gone to serve many lords, with large salaries, but he would never leave his Venetian Signori; nay, at the advice of his father and his kinsman Michele, he took a wife in Verona, a noble young woman of the Fracastoro family, with the intention of always living in those parts. But he had been not more than a few days with his beloved bride, who was called Madonna Ortensia, when he was summoned by his patrons to Venice, and thence sent in great haste to Cyprus to inspect every place in that island, orders having been given to all the officials that they should provide him with all that he might require for any purpose. Having then arrived in that island, in three months Gian Girolamo went all round it and diligently inspected everything, putting every detail into writing and drawing, in order to be able to give an account of the whole to his masters. But, while

he was attending with too much care and solicitude to his office, paying little regard to his own life, in the burning heat which prevailed at that time in the island he fell sick of a pestilential fever, which robbed him of life in six days; although some said that he had been poisoned. However that may have been, he died content in being in the service of his masters and employed by them in works of importance, knowing that they had trusted more in his fidelity and his skill in fortification than in those of any other man. The moment that he fell sick, knowing that he was dying, he gave all the drawings and writings that he had prepared on the works in that island into the hands of the architect Luigi Brugnuoli, his kinsman by marriage (who was then engaged in the fortification of Famagosta, which is the key of that kingdom), to the end that he might carry them to his masters.

When the news of Gian Girolamo's death arrived in Venice, there was not one of the Senate who did not feel indescribable sorrow at the loss of such a man, who had been so devoted to that Republic. Gian Girolamo died at the age of forty-five, and received honourable burial from his above-named kinsman in S. Niccolò at Famagosta. Then, having returned to Venice, Brugnuoli presented Gian Girolamo's drawings and writings; which done, he was sent to give completion to the fortifications of Legnago, where he had spent many years in executing the designs and models of his uncle. But he had not been long in that place when he died, leaving two sons, who are men of passing good ability in design and in the practice of architecture. Bernardino, the elder, has now many undertakings on his hands, such as the building of the campanile of the Duomo, that of S. Giorgio, and that of the church called the Madonna di Campagna, in which and other works that he is directing at Verona and other places, he is succeeding excellently well; and particularly in the ornamental work of the principal chapel of S. Giorgio at Verona, which is of the composite order, and such that in size, design, and workmanship, the people of Verona declare that they do not believe that there is one equal to it to be found in Italy. This work, which follows the curve of the recess, is of the Corinthian Order, with composite capitals and double columns in full relief, and pilasters behind. In like manner, the frontispiece which surmounts the whole also curves in very masterly fashion according to the shape of the recess, and has all the ornaments which that Order embraces. Wherefore Monsignor Barbaro,

Patriarch-elect of Aquileia, a man with a great knowledge of the profession, who has written of it, on his return from the Council of Trent saw not without marvel all that had been done in that work, and that which was being done every day; and, after considering it several times, he had to say that he had never seen the like, and that nothing better could be done. And let this suffice as a proof of what may be expected from the genius of Bernardino, who was born on the mother's side from the San Michele family.

But let us return to Michele, from whom we digressed, not without reason, some little time back. He was struck by such grief at the death of Gian Girolamo, in whom he saw the house of San Michele become extinct, since his kinsman left no children, that, although he strove to conquer or conceal it, in a few days he was overcome by a malignant fever, to the inconsolable sorrow of his country and of his most illustrious patrons. Michele died in the year 1559, and was buried in S. Tommaso, a church of Carmelite Friars, where there is the ancient burial-place of his forefathers; and at the present day Messer Niccolò San Michele, a physician, has set his hand to erecting him an honourable tomb, which is even now being carried into execution.

Michele was a man of most upright life, and most honourable in his every action. He was a cheerful person, yet with an admixture of seriousness. He feared God, and was very religious, insomuch that he would never set himself to do anything in the morning without having first heard Mass devoutly and said his prayers; and at the beginning of any undertaking of importance, in the morning, before doing any other thing, he would always have the Mass of the Holy Spirit or of the Madonna solemnly chanted. He was very liberal, and so courteous with his friends, that they were as much masters of his possessions as he was himself. And I will not withhold a proof of his great loyalty and goodness, which I believe few others know besides myself. When Giorgio Vasari, of whom, as has been told, he was much the friend, parted from him for the last time in Venice, Michele said to him: 'I would have you know, Messer Giorgio, that, when I was in my youth at Monte Fiascone, I became enamoured, as fortune would have it, of the wife of a stone-cutter, and received from her complaisance all that I desired; but no one ever heard of it from me. Now, having heard that the poor woman has been left a widow, with a daughter ready for a husband, whom she says

she conceived by me, I wish – although it may well be that this is not true, and such is my belief – that you should take to her these fifty crowns of gold and give them to her on my part, for the love of God, to the end that she may use them for her advantage and settle her daughter according to her station.' Giorgio, therefore, going to Rome, and arriving at Monte Fiascone, although the good woman freely confessed to him that the girl was not the daughter of Michele, insisted, in obedience to Michele's command, on paying her the fifty crowns, which were as welcome to that poor woman as five hundred would have been to another.

Michele, then, was courteous beyond the courtesy of any other man, insomuch that he no sooner heard of the needs and desires of his friends, than he sought to gratify them, even to the spending of his life; nor did any person ever do him a service that was not repaid many times over. Giorgio Vasari once made for him in Venice, with the greatest diligence at his command, a large drawing in which the proud Lucifer and his followers, vanquished by the Angel Michael, could be seen raining headlong down from Heaven into the horrible depths of Hell; and at that time Michele did not do anything but thank Giorgio for it when he took leave of him. But not many days after, returning to Arezzo, Giorgio found that San Michele had sent long before to his mother, who lived at Arezzo, a quantity of presents beautiful and honourable enough to be the gifts of a very rich nobleman, with a letter in which he did her great honour for love of her son.

Many times the Signori of Venice offered to increase his salary, but he refused, always praying that they should increase his kinsmen's salaries instead of his own. In short, Michele was in his every action so gentle, courteous, and loving, that he made himself rightly beloved by innumerable lords; by Cardinal de' Medici, who became Pope Clement VII, while he was in Rome; by Cardinal Alessandro Farnese, who became Paul III; by the divine Michelagnolo Buonarroti; by Signor Francesco Maria, Duke of Urbino; and by a vast number of noblemen and senators of Venice. At Verona he was much the friend of Fra Marco de' Medici, a man of great learning and infinite goodness, and of many others of whom there is no need at present to make mention.

Now, in order not to have to turn back in a short time to speak of the Veronese, taking the opportunity presented by the masters mentioned above, I shall make mention in this place of

some painters from that country, who are still alive and worthy to be named, and by no means to be passed over in silence. The first of these is Domenico del Riccio, who has painted in fresco, mostly in chiaroscuro and partly in colour, three façades of the house of Fiorio della Seta at Verona, on the Ponte Nuovo – that is, the three that do not look out upon the bridge, the house standing by itself. In one, over the river, are battles of sea-monsters, in another the battles of the Centaurs and many rivers, and in the third two pictures in colour. In the first of these, which is over the door, is the Table of the Gods, and in the other, over the river, is the fable of the nuptials between the Benacus, called the Lake of Garda, and the Nymph Caris, in the person of Garda, from whom is born the River Mincio, which in fact issues from that lake. In the same house is a large frieze wherein are some Triumphs in colour, executed in a beautiful and masterly manner. In the house of Messer Pellegrino Ridolfi, also at Verona, the same master painted the Coronation of the Emperor Charles V, and the scene when, after being crowned in Bologna, he rides with the Pope through the city in great pomp. In oils he has painted the principal altar-piece of the church that the Duke of Mantua has built recently near the Castello, in which is the Be-heading and Martyrdom of S. Barbara, painted with much diligence and judgment. And what moved the Duke to have that altar-piece executed by Domenico was his having seen and much liked his manner in an altar-piece that Domenico had painted long before for the Chapel of S. Margherita in the Duomo of Mantua, in competition with Paolino,* who painted that of S. Antonio, with Paolo Farinato, who executed that of S. Mar-tino, and with Battista del Moro, who painted that of the Magdalene; all which four Veronese had been summoned thither by Cardinal Ercole of Mantua, in order to adorn that church, which had been reconstructed by him after the design of Giulio Romano. Other works has Domenico executed in Verona, Vicen-za, and Venice, but it must suffice to have spoken of those named. He is an honest and excellent craftsman, and, in addition to his painting, he is a very fine musician, and one of the first in the most noble Philharmonic Academy of Verona.

Not inferior to him will be his son Felice, who, although still young, has proved himself a painter out of the ordinary in an

* Paolo Caliari or Veronese.

altar-piece that he has executed for the Church of the Trinità, in which are the Madonna and six other Saints, all of the size of life. Nor is this any marvel, for the young man learned his art in Florence, living in the house of Bernardo Canigiani, a Florentine gentleman and a crony of his father Domenico.

In the same Verona, also, lives Bernardino, called L'India, who, besides many other works, has painted the Fable of Psyche in most beautiful figures on the ceiling of a chamber in the house of Count Marc' Antonio del Tiene. And he has painted another chamber, with beautiful inventions and a lovely manner of painting, for Count Girolamo of Canossa.

A much extolled painter, also, is Eliodoro Forbicini, a young man of most beautiful genius and of considerable skill in every manner of painting, but particularly in making grotesques, as may be seen in the two chambers mentioned above and in other places where he has worked.

In like manner Battista da Verona, who is called thus, and not otherwise, out of his own country, after having learned the first rudiments of painting from an uncle at Verona, placed himself with the excellent Tiziano in Venice, under whom he has become a very good painter. When a young man, this Battista painted in company with Paolino a hall in the Palace of the Paymaster and Assessor Portesco at Tiene in the territory of Vicenza; where they executed a vast number of figures, which acquired credit and repute for both the one and the other. With the same Paolino he executed many works in fresco in the Palace of the Soranza at Castelfranco, both having been sent to work there by Michele San Michele, who loved them as his sons. And with him, also, he painted the façade of the house of M. Antonio Cappello, which is on the Grand Canal in Venice; and then, still together, they painted the ceiling, or rather, soffit in the Hall of the Council of Ten, dividing the pictures between them. Not long afterwards, having been summoned to Vicenza, Battista executed many works there, both within and around the city; and recently he has painted the façade of the Monte della Pietà, wherein he has executed an infinite number of nude figures in various attitudes, larger than life, with very good design, and all in so few months, that it has been a marvel. And if he has done so much at so early an age (for he is not yet past thirty), everyone may imagine what may be expected of him in the course of his life.

A Veronese, likewise, is one Paolino, a painter who is in very

good repute in Venice at the present day, in that, although he is not yet more than thirty years of age, he has executed many works worthy of praise. This master, who was born at Verona to a stone-cutter, or, as they say in those parts, a stone-hewer, after having learned the rudiments of painting from Giovanni Caroto of Verona, painted in fresco, in company with the above-named Battista, the hall of the Paymaster and Assessor Portesco at Tiene, in the Vicentino; and afterwards at the Soranza, with the same companion, many works executed with good design and judgment and a beautiful manner. At Masiera, near Asolo in the Trevisano, he has painted the very beautiful house of Signor Daniello Barbaro, Patriarch-elect of Aquileia. At Verona, for the Refectory of S. Nazzaro, a monastery of Black Friars, he has painted in a large picture on canvas the supper that Simon the Leper gave to Our Lord, when the woman of sin threw herself at His feet, with many figures, portraits from life, and very rare perspective-views; and under the table are two dogs so beautiful that they appear real and alive, and further away certain cripples executed excellently well.

By the hand of Paolino, in the Hall of the Council of Ten at Venice, in an oval that is larger than certain others that are there, placed, as the principal one, in the centre of the ceiling, is Jove who is driving away the Vices, in order to signify that that supreme and absolute tribunal drives away vice and chastises wicked and vicious men. The same master painted the soffit, or rather, ceiling of the Church of S. Sebastiano, which is a very rare work, and the altar-piece of the principal chapel, together with some pictures that serve to adorn it, and likewise the doors of the organ; which are all pictures truly worthy of the highest praise. In the Hall of the Grand Council he painted a large picture of Frederick Barbarossa presenting himself to the Pope, with a good number of figures varied in their costumes and vestments, all most beautiful and representing worthily the Court of a Pope and an Emperor, and also a Venetian Senate, with many noblemen and Senators of that Republic, portrayed from life. In short, this work is such in its grandeur and design, and in the beauty and variety of the attitudes, that it is rightly extolled by everyone. After this scene, Paolino painted the ceilings of certain chambers, which are used by that Council of Ten, with figures in oils, which are much foreshortened and very rare.

In like manner, he painted in fresco the façade of the house of a merchant, which was a very beautiful work, on the road from S. Maurizio to S. Moisè; but the wind from the sea is little by little destroying it. For Camillo Trevisani, at Murano, he painted a loggia and an apartment in fresco, which were much extolled. And in S. Giorgio Maggiore at Venice, at the head of a large apartment, he painted in oils the Marriage of Cana in Galilee, which was a marvellous work for its grandeur, the number of figures, the variety of costumes, and the invention; and, if I remember right, there are to be seen in it more than one hundred and fifty heads, all varied and executed with great diligence.

The same Paolino was commissioned by the Procurators of S. Mark to paint certain angular medallions that are in the ceiling of the Nicene Library, which was left to the Signoria by Cardinal Bessarion, with a vast treasure of Greek books. Now the above-named lords, when they had the painting of that library begun, promised a prize of honour, in addition to the ordinary payment, to him who should acquit himself best in painting it; and the pictures were divided among the best painters that there were at that time in Venice. When the work was finished and the pictures painted had been very well considered, a chain of gold was placed round the neck of Paolino, he being the man who was judged to have done better than all the others. The picture that gave him the victory and the prize of honour was that wherein he painted Music, in which are depicted three very beautiful young women, one of whom, the most beautiful, is playing a great bass-viol, looking down at the fingerboard of the instrument, the attitude of her person showing that her ear and her voice are fixed intently on the sound; and of the other two, one is playing a lute, and the other singing from a book. Near these women is a Cupid without wings, who is playing a harpsichord, signifying that Love is born from Music, or rather, that Love is always in company with Music; and, because he never parts from her, Paolino made him without wings. In the same picture he painted Pan, the God, according to the poets, of shepherds, with certain pipes made of the bark of trees, as it were consecrated to him as votive offerings by shepherds who have been victorious in playing them. Two other pictures Paolino painted in the same place; in one is Arithmetic, with certain Philosophers dressed in the ancient manner, and in the other is Honour, seated on a throne, to whom sacrifices are being offered and royal crowns presented. But,

seeing that this young man is at this very moment at the height of his activity and not yet in his thirty-second year, I shall say nothing more of him for the present.

Likewise a Veronese is Paolo Farinato, an able painter, who, after having been a disciple of Niccolò Ursino,* has executed many works at Verona. The most important are a hall in the house of the Fumanelli, which he filled with various scenes in fresco-colours at the desire of Messer Antonio, a gentleman of that family, most famous as physician over all Europe, and two very large pictures in the principal chapel of S. Maria in Organo. In one of these is the story of the Innocents, and in the other is the scene when the Emperor Constantine causes a number of children to be brought before him, intending to kill them and to bathe in their blood, in order to cure himself of his leprosy. Then in the recess of that chapel are two pictures, large, but smaller than the others, in one of which is Christ receiving S. Peter, who is walking towards Him on the water, and in the other the dinner that S. Gregory gives to certain poor men. In all these works, which are much to be extolled, is a vast number of figures, executed with good design, study, and diligence. By the hand of the same master is an altar-picture of S. Martino that was placed in the Duomo of Mantua, which he executed in competition with others his compatriots, as has just been related.

And let this be the end of the Lives of the excellent Michele San Michele and of those other able men of Verona, so truly worthy of all praise on account of their excellence in the arts and their great talents.

GIOVANNI ANTONIO BAZZI, CALLED IL SODOMA, Painter of Vercelli

IF men were to recognize their position when Fortune presents to them the opportunity to become rich, obtaining for them the favour of great persons, and were to exert themselves in their youth to make their merit equal to their good fortune, marvellous results would be seen to issue from their actions; whereas very often the contrary is seen to happen, for the reason that, even as

* Giolfino.

it is true that he who trusts only in Fortune generally finds himself deceived, so it is very clear, as experience teaches us every day, that merit alone, likewise, if not accompanied by Fortune, does not do great things. If Giovanni Antonio of Vercelli, even as he had good fortune, had possessed an equal dower of merit, as he could have done if he had studied, he would not have been reduced to madness and miserable want in old age at the end of his life, which was always eccentric and beastly.

Now Giovanni Antonio was taken to Siena by some merchants, agents of the Spannocchi family, and his good fortune, or perhaps his bad fortune, would have it that, not finding any competition for a time in that city, he should work there alone; which, although it was some advantage to him, was in the end injurious, for the reason that he went to sleep, as it were, and never studied, but did most of his work by rule of thumb. And, if he did study a little, it was only in drawing the works of Jacopo della Fonte, which were much esteemed, and in little else. In the beginning he executed many portraits from life with that glowing manner of colouring which he had brought from Lombardy, and he thus made many friendships in Siena, more because that people is very kindly disposed towards strangers than because he was a good painter; and, besides this, he was a gay and licentious man, keeping others entertained and amused with his manner of living, which was far from creditable. In which life, since he always had about him boys and beardless youths, whom he loved more than was decent, he acquired the by-name of Sodoma; and in this name, far from taking umbrage or offence, he used to glory, writing about it songs and verses in terza rima, and singing them to the lute with no little facility. He delighted, in addition, to have about the house many kinds of extraordinary animals; badgers, squirrels, apes, marmosets, dwarf asses, horses, barbs for running races, little horses from Elba, jays, dwarf fowls, Indian turtle-doves, and other suchlike animals, as many as he could lay his hands on. But, besides all these beasts, he had a raven, which had learned from him to speak so well, that in some things it imitated exactly the voice of Giovanni Antonio, and particularly in answering to anyone who knocked at the door, doing this so excellently that it seemed like Giovanni Antonio himself, as all the people of Siena know very well. In like manner, the other animals were so tame that they always flocked round anybody in the house, playing the strangest pranks and the maddest tricks in

the world, insomuch that the man's house looked like a real Noah's Ark.

Now this manner of living and his eccentric ways, with his works and pictures, wherein he did indeed achieve something of the good, caused him to have such a name among the people of Siena – that is, among the populace and the common herd, for the people of quality knew him better – that he was held by many to be a great man. Whereupon, Fra Domenico da Lecco, a Lombard, having been made General of the Monks of Monte Oliveto, Sodoma went to visit him at Monte Oliveto di Chiusuri, the principal seat of that Order, distant fifteen miles from Siena; and he so contrived with his persuasive words, that he was commissioned to finish the stories of the life of S. Benedict, part of which had been executed on a wall by Luca Signorelli of Cortona. This work he finished for a small enough price, besides the expenses that he incurred, and those of certain lads and colour-grinders who assisted him; nor would it be possible to describe the amusement that he gave while he was labouring at that place to those fathers, who called him Il Mattaccio,* in the mad pranks that he played.

But to return to the work. Having executed there certain scenes, which he hurried over mechanically and without diligence, and the General complaining of this, Mattaccio said that he worked as he felt inclined, and that his brush danced to the tune of money, so that, if the General consented to spend more, he was confident that he could do much better. The General having therefore promised that he would pay him better for the future, Giovanni Antonio painted three scenes, which still remained to be executed in the corners, with so much more study and diligence than he had shown in the others, that they proved to be much finer. In one of these is S. Benedict departing from Norcia and from his father and mother, in order to go to study in Rome; in the second, S. Mauro and S. Placido as children, presented to him and offered to God by their fathers; and in the third, the Goths burning Monte Cassino. For the last, in order to do despite to the General and the Monks, he painted the story of the priest Fiorenzo, the enemy of S. Benedict, bringing many loose women to dance and sing around the monastery of that holy man, in order to tempt the purity of those fathers. In this scene

* Madcap or buffoon.

Sodoma, who was as shameless in his painting as in his other actions, painted a dance of nude women, altogether lewd and shameful; and, since he would not have been allowed to do it, as long as he was at work he would never let any of the monks see it. Wherefore, when the scene was uncovered, the General wished by hook or by crook to throw it to the ground and utterly destroy it; but Mattaccio, after much foolish talk, seeing that father in anger, clothed all the naked women in that work, which is one of the best that are there. Under each of these scenes he painted two medallions, and in each medallion a friar, to represent all the Generals who had ruled that congregation. And, since he had not their portraits from life, Mattaccio did most of the heads from fancy, and in some he portrayed old friars who were in the monastery at that time, and in the end he came to paint the head of the above-named Fra Domenico da Lecco, who was their General in those days, as has been related, and was causing him to execute that work. But, after some of those heads had lost the eyes, and others had been damaged, Fra Antonio Bentivogli, the Bolognese, caused them all to be removed, for good reasons.

Now, while Mattaccio was executing these scenes, there had gone thither, to assume the habit of a monk, a Milanese nobleman, who had a yellow cloak trimmed with black cords, such as was worn at that time; and, after he had put on the monk's habit, the General gave that cloak to Mattaccio, who, by means of a mirror, painted a portrait of himself with it on his back in one of the scenes, wherein S. Benedict, still almost a child, miraculously puts together and mends the corn-measure, or rather, tub, of his nurse, which she had broken. At the feet of the portrait he painted a raven, an ape, and others of his animals. This work finished, he painted the story of the five loaves and two fishes, with other figures, in the Refectory of the Monastery of S. Anna, a seat of the same Order, distant five miles from Monte Oliveto; which work completed, he returned to Siena. There, at the Postierla, he painted in fresco the façade of the house of M. Agostino de' Bardi of Siena, in which were some things worthy of praise, but for the most part they have been consumed by time and the weather.

During this time there arrived in Siena Agostino Chigi, a very rich and famous merchant of that city, and he became acquainted with Giovanni Antonio, both on account of his follies and because he had the name of a good painter. Wherefore he took him

in his company to Rome, where Pope Julius II was then causing the Papal apartments in the Palace of the Vatican, which Pope Nicholas V had formerly erected, to be painted; and Chigi so went to work with the Pope, that some painting was given also to Sodoma. Now Pietro Perugino, who was painting the ceiling of an apartment that is beside the Borgia Tower, was working at his ease, like the old man that he was, and was not able to set his hand to anything else, as he had been at first commanded to do: and there was given to Giovanni Antonio to paint another apartment, which is beside the one that Perugino was painting. Having therefore set his hand to it, he made the ornamentation of that ceiling with cornices, foliage, and friezes; and then, in some large medallions, he executed certain passing good scenes in fresco. But this animal, devoting his attention to his beasts and his follies, would not press the work forward; and therefore, after Raffaello da Urbino had been brought to Rome by the architect Bramante, and it had become known to the Pope how much he surpassed the others, his Holiness ordained that neither Perugino nor Giovanni Antonio should work any more in the above-named apartments; indeed, that everything should be thrown to the ground. But Raffaello, who was goodness and modesty in person, left standing all that had been done by Perugino, who had once been his master; and of Mattaccio's he destroyed nothing save the inner work and the figures of the medallions and scenes, leaving the friezes and the other ornaments, which are still round the figures that Raffaello painted there, which were Justice, Universal Knowledge, Poetry, and Theology.

But Agostino, who was a gentleman, without paying any attention to the affront that Giovanni Antonio had received, commissioned him to paint in one of his principal apartments, which opens into the great hall in his Palace in the Trastevere, the story of Alexander going to sleep with Roxana. In that work, besides other figures, he painted a good number of Loves, some of whom are unfastening Alexander's cuirass, some are drawing off his boots, or rather, buskins, some are removing his helmet and dress, and putting them away; others scattering flowers over the bed, and others, again, doing other suchlike offices. Near the chimney-piece he painted a Vulcan forging arrows, which was held at that time to be a passing good and praiseworthy work; and if Mattaccio, who had beautiful gifts and was much assisted by Nature, had given his attention, after that reversal of fortune,

to his studies, as any other man would have done, he would have made very great proficience. But he had his mind always set on his amusements, and he worked by caprice, caring for nothing so earnestly as for dressing in pompous fashion, wearing doublets of brocade, cloaks all adorned with cloth of gold, the richest caps, necklaces, and other suchlike fripperies only fit for clowns and charlatans; in which things Agostino, who liked the man's humour, found the greatest amusement in the world.

Julius II having then come to his death, and Leo X having been elected, who took pleasure in eccentric and light-headed figures of fun such as our painter was, Mattaccio felt the greatest possible joy, particularly because he had an ill-will against Julius, who had done him that affront, wherefore, having set to work in order to make himself known to the new Pontiff, he painted in a picture the Roman Lucrece, nude, who was stabbing herself with a dagger; and, since Fortune takes care of madmen and sometimes aids the thoughtless, he succeeded in executing a most beautiful female body, and a head that was breathing. Which work finished, at the instance of Agostino Chigi, who was on terms of strait service with the Pope, he presented it to his Holiness, by whom he was made a Chevalier and rewarded for so beautiful a picture. Whereupon Giovanni Antonio, believing that he had become a great man, began to be disinclined to work any more, save when he was driven by necessity. But, after Agostino had gone on some business to Siena, taking Giovanni Antonio with him, while staying there he was forced, being a Chevalier without an income, to set himself to painting; and so he painted an altar-piece containing a Christ taken down from the Cross, on the ground Our Lady in a swoon, and a man in armour who, having his back turned, shows his front reflected in a helmet that is on the ground, bright as a mirror. This work, which was held to be, as it is, one of the best that he ever executed, was placed in S. Francesco, on the right hand as one enters the church. Then in the cloister that is beside the above-named church, he painted in fresco Christ scourged at the Column, with many Jews around Pilate, and with a range of columns drawn in perspective after the manner of wing-walls; in which work Giovanni Antonio made a portrait of himself without any beard – that is, shaven – and with the hair long, as it was worn at that time.

Not long afterwards he executed some pictures for Signor

Jacopo VI of Piombino, and, while living with him at that place, some other works on canvas. Wherefore by his means, besides many courtesies and presents that he received from him, Giovanni Antonio obtained from his island of Elba many little animals such as that island produces, all of which he took to Siena.

Arriving next in Florence, a monk of the Brandolini family, Abbot of the Monastery of Monte Oliveto, which is without the Porta a S. Friano, caused him to paint some pictures in fresco on the wall of the refectory; but since, like a careless fellow, he did them without study, they proved to be such that he was derided and mocked at for his follies by those who were expecting that he would do some extraordinary work. Now, while he was engaged on that work, having taken a Barbary horse with him to Florence, he set it to run in the race of S. Barnaba; and, as fortune would have it, the horse ran so much better than the others, that it won. Whereupon, the boys having, as is the custom, to call out the name or by-name of the owner of the horse that had won, after the running of the race and the fanfare of trumpets, Giovanni Antonio was asked what name they were to call out; and, after he had replied, 'Sodoma, Sodoma,' the boys called out that name. But some honest old men, having heard that filthy name, began to protest against it and to say, 'What filthy thing is this, and what ribaldry, that so vile a name should be cried through our city?' Insomuch that, a clamour arising, poor Sodoma came within an ace of being stoned by the boys and the populace, with his horse and the ape that he had with him on the crupper. Having in the space of many years got together many prizes, won in the same way by his horses, he took the greatest pride in the world in them, and showed them to all who came into his house; and very often he made a show of them at his windows.

But to return to his works: he painted for the Company of S. Bastiano in Camollia, beyond the Church of the Umiliati, on a banner of cloth which is carried in processions, in oils, a nude S. Sebastian, bound to a tree, who is standing on the right leg, with the left in foreshortening, and raises the head towards an Angel who is placing a crown upon it. This work is truly beautiful, and much to be praised. On the reverse side is Our Lady with the Child in her arms, and below her are S. Gismondo, S. Rocco, and some Flagellants kneeling on the ground. It is said that some merchants of Lucca offered to give three hundred crowns of gold

to the men of that Company for that picture, but did not obtain it, because the others did not wish to deprive their Company and the city of so rare a painting. And, in truth, in certain works – whether it was study, or good fortune, or chance – Sodoma acquitted himself very well; but of such he did very few. In the Sacristy of the Friars of the Carmine is a picture by the hand of the same master, wherein is a very beautiful Nativity of Our Lady, with some nurses; and on the corner near the Piazza de' Tolomei he painted in fresco, for the Guild of Shoemakers, a Madonna with the Child in her arms, S. John, S. Francis, S. Rocco, and S. Crispino, the Patron Saint of the men of that Guild, who has a shoe in his hand. In the heads of these figures, and in all the rest, Giovanni Antonio acquitted himself very well.

In the Company of S. Bernardino of Siena, beside the Church of S. Francesco, he executed some scenes in fresco in competition with Girolamo del Pacchia, a Sienese painter, and Domenico Beccafumi – namely, the Presentation of Our Lady in the Temple, when she goes to visit S. Elizabeth, her Assumption, and when she is crowned in Heaven. In the angles of the same Company he painted a Saint in episcopal robes, S. Louis, and S. Anthony of Padua; but the best figure of all is a S. Francis, who, standing on his feet and raising his head, is gazing at a little Angel, who appears to be in the act of speaking to him; the head of which S. Francis is truly marvellous. In the Palazzo de' Signori at Siena, likewise, in a hall, he painted some little tabernacles full of columns and little children, with other ornaments; and within these tabernacles are various figures. In one is S. Vittorio armed in the ancient fashion, with the sword in his hand; near him, in the same manner, is S. Ansano, who is baptizing certain persons; in another is S. Benedict; and all are very beautiful. In the lower part of that Palace, where salt is sold, he painted a Christ who is returning to life, with some soldiers about the Sepulchre, and two little Angels, held to be passing beautiful in the heads. Farther on, over a door, is a Madonna with the Child in her arms, painted by him in fresco, and two Saints.

In S. Spirito he painted the Chapel of S. Jacopo, which he did at the commission of the men of the Spanish colony, who have their place of burial there; depicting there an image of the Madonna after the ancient manner, with S. Nicholas of Tolentino on the right hand, and, on the left, the Archangel S. Michael, who is slaying Lucifer. Above these, in a lunette, he painted Our Lady

placing the sacerdotal habit upon a Saint, with some Angels around. Over all these figures, which are in oils on panel, there is painted in fresco, in the semicircle of the vaulting, a S. James in armour on a galloping horse, who has grasped his sword with a fiery gesture, and below him are many Turks, dead and wounded. Below all this, on the sides of the altar, are painted in fresco S. Anthony the Abbot and a nude S. Sebastian at the Column, which are held to be passing good works.

In the Duomo of the same city, on the right hand as one enters the church, there is upon an altar a picture in oils by his hand, in which there are Our Lady with the Child on her knee, S. Joseph on one side, and S. Calixtus on the other; which work is likewise held to be very beautiful, because it is evident that in colouring it Sodoma showed much more diligence than he used to devote to his works. He also painted for the Company of the Trinity a bier for carrying the dead to burial, which was very beautiful; and he executed another for the Company of Death, which is held to be the most beautiful in Siena; and I believe that the latter is the finest that there is to be seen, for, besides that it is indeed much to be extolled, it is very seldom that such works are executed at much cost or with much diligence. In the Church of S. Domenico, in the Chapel of S. Caterina da Siena, where there is in a tabernacle the head of that Saint, enclosed in one of silver, Giovanni Antonio painted two scenes, which are one on either side of that tabernacle. In one, on the right hand, is that Saint when, having received the Stigmata from Jesus Christ, who is in the air, she lies half-dead in the arms of two of her sisters, who are supporting her; of which work Baldassarre Peruzzi, the painter of Siena, after considering it, said that he had never seen anyone represent better the expression of persons fainting and half-dead, or with more similitude to the reality, than Giovanni Antonio had contrived to do. And in truth it is so, as may be seen, apart from the work itself, from the design by Sodoma's own hand which I have in my book of drawings. On the left hand, in the other picture, is the scene when the Angel of God carries to the same Saint the Host of the most Holy Communion, and she, raising her head to Heaven, sees Jesus Christ and Mary the Virgin, while two of her sisters, her companions, stand behind her. In another scene, which is on the wall on the right hand, is painted the story of a criminal, who, going to be beheaded, would not be converted or commend himself to God,

despairing of His mercy; when, the above-named Saint praying for him on her knees, her prayers were so acceptable to the goodness of God, that, when the felon's head was cut off, his soul was seen ascending to Heaven; such power with the mercy of God have the prayers of those saintly persons who are in His grace. In this scene is a very great number of figures, as to which no one should marvel if they are not of the highest perfection, for the reason that I have heard as a fact that Giovanni Antonio had sunk to such a pitch in his negligence and slothfulness, that he would make neither designs nor cartoons when he had any work of that kind to execute, but would attack the work by designing it with the brush directly on the plaster, which was a strange thing; in which method it is evident that this scene was executed by him. The same master also painted the arch in front of that chapel, making therein a God the Father. The other scenes in that chapel were not finished by him, partly from his own fault, he not choosing to work save by caprice, and partly because he had not been paid by him who was having the chapel painted. Below this is a God the Father, who has beneath Him a Virgin in the ancient manner, on panel, with S. Dominic, S. Gismondo, S. Sebastian, and S. Catharine.

For S. Agostino, in an altar-piece that is on the right hand at the entrance into the church, he painted the Adoration of the Magi, which was held to be, and is, a good work, for the reason that, besides the Madonna, which is much extolled, the first of the three Magi, and certain horses, there is a head of a shepherd between two trees which has all the appearance of life. Over a gate of the city, called the Porta di S. Viene, he painted in fresco, in a large tabernacle, the Nativity of Jesus Christ, with some Angels in the air; and on the arch of that gate a child in foreshortening, very beautiful and in strong relief, which is intended to signify that the Word has been made Flesh. In this work Sodoma made a portrait of himself, with a beard, being now old, and with a brush in his hand, which is pointing to a scroll that says 'Feci.'

He painted likewise in fresco the Chapel of the Commune at the foot of the Palace, in the Piazza, representing there Our Lady with the Child in her arms, upheld by some little Angels, S. Ansano, S. Vittorio, S. Augustine, and S. James; and above this, in a triangular lunette, he painted a God the Father with some Angels about Him. From this work it is evident that when he executed it he was beginning, as it were, to have no more love

for art, having lost that certain quality of excellence that he used to have in his better days, by means of which he gave a certain air of beauty to his heads, which made them graceful and lovely. And this is manifestly true, for some works that he executed long before this one have quite another grace and another manner, as may be seen above the Postierla, from a wall in fresco over the door of the Captain Lorenzo Mariscotti, where there is a Dead Christ in the lap of His Mother, who has a marvellous divinity and grace. In like manner, a picture in oils of Our Lady, which he painted for Messer Enea Savini della Costerella, is much extolled, and also a canvas that he executed for Assuero Rettori of S. Martino, in which is the Roman Lucrece stabbing herself, while she is held by her father and her husband, all painted with much beauty of attitude and marvellous grace in the heads.

Finally, perceiving that the devotion of the people of Siena was all turned to the talents and excellent works of Domenico Beccafumi, and possessing neither house nor revenues in Siena, and having by that time consumed almost all his property and become old and poor, Giovanni Antonio departed from Siena almost in despair and went off to Volterra. And there, as his good fortune would have it, chancing upon Messer Lorenzo di Galeotto de' Medici, a rich and honoured nobleman, he proceeded to live under his protection, with the intention of staying there a long time. And so, dwelling in the house of that nobleman, he painted for him on a canvas the Chariot of the Sun, which, having been badly guided by Phaëthon, is falling into the Po; but it is easy to see that he did that work to pass the time, and hurried through it by rule of thumb, without giving any thought to it, so entirely commonplace is it and so ill-considered. Then, having grown weary of living at Volterra and in the house of that nobleman, as one who was accustomed to being free, he departed and went off to Pisa, where, at the instance of Battista del Cervelliera, he executed two pictures for Messer Bastiano della Seta, the Warden of Works of the Duomo, which were placed in the recess behind the high-altar of that Duomo, beside those of Sogliani and Beccafumi. In one is the Dead Christ with Our Lady and the other Maries, and in the other Abraham sacrificing his son Isaac; but since these pictures did not succeed very well, the Warden, who had intended to make him paint some altar-pieces for the church, dismissed him, knowing that men who do not study, once they have lost in old age the quality of excellence that they had in their

youth from nature, are left with a kind of facility of manner that is generally little to be praised. At that same time Giovanni Antonio finished an altar-piece that he had previously begun in oils for S. Maria della Spina, painting in it Our Lady with the Child in her arms, with S. Mary Magdalene and S. Catharine kneeling before her, and S. John, S. Sebastian, and S. Joseph standing at the sides; in all which figures he acquitted himself much better than in the two pictures for the Duomo.

Then, having nothing more to do at Pisa, he made his way to Lucca, where, at S. Ponziano, a seat of the Monks of Monte Oliveto, an Abbot of his acquaintance caused him to paint a Madonna on the ascent of a staircase that leads to the dormitory. That work finished, he returned weary, old, and poor to Siena, where he did not live much longer; for he fell ill, through not having anyone to look after him or any means of sustenance, and went off to the Great Hospital, and there in a few weeks he finished the course of his life.

Giovanni Antonio, when young and in good repute, took for his wife in Siena a girl born of a very good family, and had by her in the first year a daughter. But after that, having grown weary of her, because he was a beast, he would never see her more; and she, therefore, withdrawing by herself, lived always on her own earnings and on the interest of her dowry, bearing with great and endless patience the beastliness and the follies of that husband of hers, who was truly worthy of the name of Mattaccio which, as has been related, the Monks of Monte Oliveto gave him.

Riccio of Siena, the disciple of Giovanni Antonio, a passing able and well-practised painter, having taken as his wife his master's daughter, who had been very well and decently brought up by her mother, became the heir to all the possessions connected with art of his wife's father. This Riccio, I say, has executed many beautiful and praiseworthy works at Siena and elsewhere, and has decorated with stucco and pictures in fresco a chapel in the Duomo of the above-named city, on the left hand as one enters the church; and he now lives at Lucca, where he has done, as he still continues to do, many beautiful works worthy to be extolled.

A pupil of Giovanni Antonio, likewise, was a young man who was called Giomo del Sodoma; but, since he died young, and was not able to give more than a small proof of his genius and knowledge, there is no need to say more about him.

Sodoma lived seventy-five years, and died in the year 1554.

BASTIANO DA SAN GALLO, CALLED ARISTOTILE, Painter and Sculptor of Florence

WHEN Pietro Perugino, by that time an old man, was painting the altar-piece of the high-altar of the Servites at Florence, a nephew of Giuliano and Antonio da San Gallo, called Bastiano, was placed with him to learn the art of painting. But the boy had not been long with Perugino, when he saw the manner of Michelagnolo in the cartoon for the Hall, of which we have already spoken so many times, in the house of the Medici, and was so struck with admiration, that he would not return any more to Pietro's workshop, considering that his manner, beside that of Buonarroti, was dry, petty, and by no means worthy to be imitated. And since, among those who used to go to paint that cartoon, which was for a time the school of all who wished to attend to painting, the most able of all was held to be Ridolfo Ghirlandajo, Bastiano chose him as his companion, in order to learn colouring from him, and so they became fast friends. But not ceasing therefore to give his attention to that cartoon and to work at those nudes, Bastiano copied all together in a little cartoon the whole composition of that mass of figures, which not one of all those who had worked at it had ever drawn as a whole. And since he applied himself to it with all the earnestness that was in him, it proved that he was afterwards able on any occasion to render an account of the attitudes, muscles, and movements of those figures, and of the reasons that had caused Buonarroti to depict certain difficult postures; in doing which he would speak slowly and sententiously, with great gravity, so that a company of able craftsmen gave him the name of Aristotile, which, moreover, sat upon him all the better because it appeared that according to an ancient portrait of that supreme philosopher and confidant of Nature, Bastiano much resembled him.

But to return to the little cartoon drawn by Aristotile; he held it always so dear, that, after Buonarroti's original had perished, he would never let it go either at a price or on any other terms, or allow it to be copied; indeed, he would not show it, save only as a man shows precious things to his dearest friends, as a favour. Afterwards, in the year 1542, this drawing was copied in oils by Aristotile, at the persuasion of Giorgio Vasari, who was much his friend, in a picture in chiaroscuro, which was sent through

Monsignor Giovio to King Francis of France, who held it very dear, and gave a handsome reward to San Gallo. This Vasari did in order that the memory of that work might be preserved, seeing that drawings perish very readily.

In his youth, then, Aristotile delighted, as the others of his house have done, in the matters of architecture, and he therefore gave his attention to measuring the ground-plans of buildings and with great diligence to the study of perspective; in doing which he was much assisted by a brother of his, called Giovan Francesco, who was employed as architect in the building of S. Pietro, under Giuliano Leno, the proveditor. Giovan Francesco, having drawn Aristotile to Rome, employed him to keep the accounts in a great business that he had of furnaces for lime and works in pozzolana and tufa, which brought him very large profits; and in this way Bastiano lived for a time, without doing anything but draw in the Chapel of Michelagnolo, and resort, by means of M. Giannozzo Pandolfini, Bishop of Troia, to the house of Raffaello da Urbino. After a time, Raffaello having made for that Bishop the design of a palace which he wished to erect in the Via di S. Gallo at Florence, the above-named Giovan Francesco was sent to put it into execution, which he did with all the diligence wherewith it is possible for such a work to be carried out. But in the year 1530, Giovan Francesco being dead, and the siege of Florence in progress, that work, as we shall relate, was left unfinished. Its completion was afterwards entrusted to his brother Aristotile, who, as will be told, had returned to Florence many and many a year before, after having amassed a large sum of money under the above-named Giuliano Leno, in the business that his brother had left him in Rome; with a part of which money Aristotile bought, at the persuasion of Luigi Alamanni and Zanobi Buondelmonte, who were much his friends, a site for a house behind the Convent of the Servites, near Andrea del Sarto, where, with the intention of taking a wife and living at leisure, he afterwards built a very commodious little house.

After returning to Florence, then, Aristotile, being much inclined to perspective, to which he had given his attention under Bramante in Rome, appeared to delight in scarcely any other thing; but nevertheless, besides executing a portrait or two from the life, he painted in oils, on two large canvases, the Eating of the Fruit by Adam and Eve and their Expulsion from Paradise,

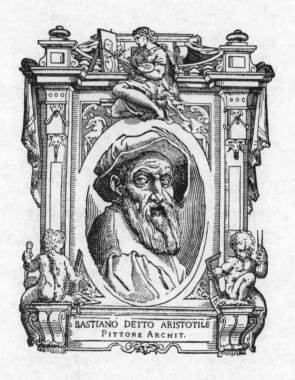

BASTIANO DETTO ARISTOTILE
Pittore Archit.

which he did after copies that he had made from the works painted by Michelagnolo on the vaulting of the Chapel in Rome. These two canvases of Aristotile's, because of his having taken them bodily from that place, were little extolled; but, on the other hand, he was well praised for all that he did in Florence for the entry of Pope Leo, making, in company with Francesco Granacci, a triumphal arch opposite to the door of the Badia, with many scenes, which was very beautiful. In like manner, at the nuptials of Duke Lorenzo de' Medici, he was of great assistance in all the festive preparations, and particularly in some prospect-views for comedies, to Franciabigio and Ridolfo Ghirlandajo, who had charge of everything.

He afterwards executed many pictures of Our Lady in oils, partly from his own fancy, and partly copied from the works of others; and among them he painted one similar to that which Raffaello executed for S. Maria del Popolo in Rome, with the Madonna covering the Child with a veil, which now belongs to Filippo dell' Antella. And another is in the possession of the heirs of Messer Ottaviano de' Medici, together with the portrait of the above-named Lorenzo, which Aristotile copied from that which Raffaello had executed. Many other pictures he painted about the same time, which were sent to England. But, recognizing that he had no invention, and how much study and good grounding in design painting required, and that for lack of these qualities he would not be able to achieve any great excellence, Aristotile resolved that his profession should be architecture and perspective, executing scenery for comedies, to which he was much inclined, on every occasion that might present itself to him. And so, the above-mentioned Bishop of Troia having once more set his hand to his palace in the Via di S. Gallo, the charge of this was given to Aristotile, who in time carried it with much credit to himself to the condition in which it is now to be seen.

Meanwhile Aristotile had formed a great friendship with Andrea del Sarto, his neighbour, from whom he learned to do many things to perfection, attending with much study to perspective; wherefore he was afterwards employed in many festivals that were held by certain companies of gentlemen who were living at Florence in those peaceful times. Thus, when the Mandragola, a most amusing comedy, was to be performed by the Company of the Cazzuola in the house of Bernardino di Giordano, on the Canto a Monteloro, Andrea del Sarto and Aristotile executed the

scenery, which was very beautiful; and not long afterwards Aristotile executed the scenery for another comedy by the same author, in the house of the furnace-master Jacopo at the Porta S. Friano. From that kind of scenery and prospect-views, which much pleased the citizens in general, and in particular Signor Alessandro and Signor Ippolito de' Medici (who were in Florence at that time, under the care of Silvio Passerini, Cardinal of Cortona), Aristotile acquired so great a name, that it was ever afterwards his principal profession; indeed, so some will have it, his name of Aristotile was given him because he appeared in truth to be in perspective what Aristotle was in philosophy.

But, as it often happens that from the height of peace and tranquillity one falls into wars and discords, with the year 1527 all peace and gladness in Florence were changed into sorrow and distress, for by that time the Medici had been driven out, and then came the plague and the siege, and for many years life was anything but gay; wherefore no good could be done then by craftsmen, and Aristotile lived in those days always in his own house, attending to his studies and fantasies. Afterwards, however, when Duke Alessandro had assumed the government of Florence, and matters were beginning to clear up a little, the young men of the Company of the Children of the Purification, which is opposite to S. Marco, arranged to perform a tragicomedy taken from the Book of Kings, of the tribulations that ensued from the violation of Tamar, which had been composed by Giovan Maria Primerani. Thereupon the charge of the scenery and prospect-views was given to Aristotile, and he prepared the most beautiful scenery, considering the capacity of the place, that had ever been made. And since, besides the beauty of the setting, the tragi-comedy was beautiful in itself and well performed, and very pleasing to Duke Alessandro and his sister, who heard it, their Excellencies caused the author, who was in prison, to be liberated, on the condition that he should write another comedy, but after his own fancy. Which having been done by him, Aristotile made in the loggia of the garden of the Medici, on the Piazza di S. Marco, a very beautiful scene and prospect-view, full of colonnades, niches, tabernacles, statues, and many other fanciful things that had not been used up to that time in festive settings of that kind; which all gave infinite satisfaction, and greatly enriched that sort of painting. The subject of the piece was Joseph falsely accused of having sought to violate his

mistress, and therefore imprisoned, and then liberated after his interpretation of the King's dream.

This scenery having also much pleased the Duke, he ordained, when the time came, that for his nuptials with Madama Margherita of Austria another comedy should be performed, with scenery by Aristotile, in the Company of Weavers, which is joined to the house of the Magnificent Ottaviano de' Medici, in the Via di S. Gallo. To which having set his hand with all the study, diligence, and labour of which he was capable, Aristotile executed all those preparations to perfection. Now Lorenzo di Pier Francesco de' Medici, having himself written the piece that was to be performed, had charge of the whole representation and the music; and, being such a man that he was always thinking in what way he might be able to kill the Duke, by whom he was so much favoured and beloved, he thought to find a way of bringing him to his end in the preparations for the play. And so, where the steps of the prospect-view and the floor of the stage ended, he caused the wing-walls on either side to be thrown down to the height of eighteen braccia, intending to build up in that space a room in the form of a purse-shaped recess, which was to be of considerable size, and a stage on a level with the stage proper, which might serve for the choral music. Above this first stage he wished to make another for harpsichords, organs, and other suchlike instruments that cannot be moved or changed about with ease; and the space where he had pulled down the walls, in front, he wished to have covered with curtains painted with prospect-views and buildings. All which pleased Aristotile, because it enriched the proscenium, and left the stage free of musicians, but he was by no means pleased that the rafters upholding the roof, which had been left without the walls below to support them, should be arranged otherwise than with a great double arch, which should be very strong; whereas Lorenzo wished that it should be sustained by some props, and by nothing else that could in any way interfere with the music. Aristotile, knowing that this was a trap certain to fall headlong down on a multitude of people, would not on any account agree in the matter with Lorenzo, who in truth had no other intention but to kill the Duke in that catastrophe. Wherefore, perceiving that he could not drive his excellent reasons into Lorenzo's head, he had determined that he would withdraw from the whole affair, when Giorgio Vasari, who was the protégé of Ottaviano de' Medici, and was

at that time, although a mere lad, working in the service of Duke Alessandro, hearing, while he was painting on that scenery, the disputes and differences of opinion that there were between Lorenzo and Aristotile, set himself dexterously between them, and, after hearing both the one and the other and perceiving the danger that Lorenzo's method involved, showed that without making any arch or interfering in any other way with the stage for the music, those rafters of the roof could be arranged easily enough. Two double beams of wood, he said, each of fifteen braccia, should be placed along the wall, and fastened firmly with clamps of iron beside the other rafters, and upon them the central rafter could be securely placed, for in that way it would lie as safely as upon an arch, neither more nor less. But Lorenzo, refusing to believe either Giorgio, who proposed the plan, or Aristotile, who approved it, did nothing but oppose them with his cavillings, which made his evil intention known to everyone. Whereupon Giorgio, having seen what a terrible disaster might result from this, and that it was nothing less than an attempt to kill three hundred persons, said that come what might he would speak of it to the Duke, to the end that he might send to examine and render safe the whole fabric. Hearing this, and fearing to betray himself, Lorenzo, after many words, gave leave to Aristotile that he should follow the advice of Giorgio; and so it was done. This scenery, then, was the most beautiful not only of all that Aristotile had executed up to that time, but also of all that had ever been made by others, for he made in it many corner-pieces in relief, and also, in the opening of the stage, a representation of a most beautiful triumphal arch in imitation of marble, covered with scenes and statues, not to mention the streets receding into the distance, and many other things wrought with marvellous invention and incredible diligence and study.

After Duke Alessandro had been killed by the above-named Lorenzo, and Cosimo had been elected Duke, in 1536, there came to be married to him Signora Leonora di Toledo, a lady in truth most rare, and of such great and incomparable worth, that she may be likened without question, and perchance preferred, to the most celebrated and renowned woman in ancient history. And for the nuptials, which took place on the 27th of June in the year 1539, Aristotile made in the great court of the Medici Palace, where the fountain is, another scenic setting that represented Pisa, in which he surpassed himself, ever improving and

achieving variety; wherefore it will never be possible to put together a more varied arrangement of doors and windows, or façades of palaces more fantastic and bizarre, or streets and distant views that recede more beautifully and comply more perfectly with the rules of perspective. And he depicted there, besides all this, the Leaning Tower of the Duomo, the Cupola, and the round Temple of S. Giovanni, with other features of that city. Of the flights of steps that he made in the work, and how everyone was deceived by them, I shall say nothing, lest I should appear to be saying the same that has been said at other times; save only this, that the flight of steps which appeared to rise from the ground to the stage was octagonal in the centre and quadrangular at the sides – an artifice extraordinary in its simplicity, which gave such grace to the prospect-view above, that it would not be possible to find anything better of that kind. He then arranged with much ingenuity a lantern of wood in the manner of an arch, behind all the buildings, with a sun one braccio high, in the form of a ball of crystal filled with distilled water, behind which were two lighted torches, which rendered the sky of the scenery and prospect-view so luminous, that it had the appearance of the real and natural sun. This sun, which had around it an ornament of golden rays that covered the curtain, was drawn little by little by means of a small windlass that was there, in such a manner that at the beginning of the performance the sun appeared to be rising, and then, having climbed to the centre of the arch, it so descended that at the end of the piece it was setting and sinking below the horizon.

The author of the piece was Antonio Landi, a gentleman of Florence, and the interludes and music were in the hands of Giovan Battista Strozzi, a man of very beautiful genius, who was then very young. But since enough was written at that time about the other things that adorned the performance, such as the interludes and music, I shall do no more than mention who they were who executed certain pictures, and it must suffice for the present to know that all the other things were carried out by the above-named Giovan Battista Strozzi, Tribolo, and Aristotile. Below the scenery of the comedy, the walls at the sides were divided into six painted pictures, each eight braccia in height and five in breadth, and each having around it an ornamental border one braccio and two-thirds in width, which formed a frieze about it and was moulded on the side next the picture, containing four

medallions in the form of a cross, with two Latin mottoes for each scene, and in the rest were suitable devices. Over all, right round, ran a frieze of blue baize, save where the scene was, above which was a canopy, likewise of baize, which covered the whole court. On that frieze of baize, above every painted story, were the arms of some of the most illustrious families with which the house of Medici had kinship.

Beginning with the eastern side, then, next to the stage, in the first picture, which was by the hand of Francesco Ubertini, called Il Bacchiacca, was the Return from Exile of the Magnificent Cosimo de' Medici; the device consisted of two Doves on a Golden Bough, and the arms in the frieze were those of Duke Cosimo. In the second, which was by the same hand, was the Journey of the Magnificent Lorenzo to Naples; the device a Pelican, and the arms those of Duke Lorenzo – namely, Medici and Savoy. In the third picture, painted by Pier Francesco di Jacopo di Sandro, was Pope Leo X on his visit to Florence, being carried by his fellow-citizens under the baldachin; the device was an Upright Arm, and the arms those of Duke Giuliano – Medici and Savoy. In the fourth picture, by the same hand, was Biegrassa taken by Signor Giovanni, who was to be seen issuing victorious from that city; the device was Jove's Thunderbolt, and the arms in the frieze were those of Duke Alessandro – Austria and Medici. In the fifth, Pope Clement was crowning Charles V at Bologna; the device was a Serpent that was biting its own tail, and the arms were those of France and Medici. That picture was by the hand of Domenico Conti, the disciple of Andrea del Sarto, who proved that he had no great ability, being deprived of the assistance of certain young men whose services he had thought to use, since all, both good and bad, were employed; wherefore he was laughed at, who, much presuming, at other times with little discretion had laughed at others. In the sixth scene, the last on that side, by the hand of Bronzino, was the Dispute that took place at Naples, before the Emperor, between Duke Alessandro and the Florentine exiles, with the River Sebeto and many figures, and this was a most beautiful picture, and better than any of the others; the device was a Palm, and the arms those of Spain.

Opposite to the Return of Cosimo the Magnificent (that is, on the other side), was the happy day of the birth of Duke Cosimo; the device was a Phœnix, and the arms those of the city of Florence – namely, a Red Lily. Beside this was the Creation, or

rather, Election of the same Cosimo to the dignity of Duke; the device was the Caduceus of Mercury, and in the frieze were the arms of the Castellan of the Fortress; and this scene, which was designed by Francesco Salviati, who had to depart in those days from Florence, was finished excellently well by Carlo Portelli of Loro. In the third were the three proud Campanian envoys, driven out of the Roman Senate for their presumptuous demand, as Titus Livius relates in the twentieth book of his history; and in that place they represented three Cardinals who had come to Duke Cosimo, but in vain, with the intention of removing him from the government; the device was a Winged Horse, and the arms those of the Salviati and the Medici. In the fourth was the Taking of Monte Murlo; the device an Egyptian Horn-owl over the head of Pyrrhus, and the arms those of the houses of Sforza and Medici; in which scene, painted by Antonio di Donnino, a bold painter of things in motion, might be seen in the distance a skirmish of horsemen, which was so beautiful that this picture, by the hand of a person reputed to be feeble, proved to be much better than the works of some others who were able men only by report. In the fifth could be seen Duke Alessandro being invested by his Imperial Majesty with all the devices and insignia of a Duke; the device was a Magpie, with leaves of laurel in its beak, and in the frieze were the arms of the Medici and of Toledo; and that picture was by the hand of Battista Franco the Venetian. In the last of all those pictures were the Espousals of the same Duke Alessandro, which took place at Naples; the devices were two Crows, the ancient symbols of marriage, and in the frieze were the arms of Don Pedro di Toledo, Viceroy of Naples; and that picture, which was by the hand of Bronzino, was executed with such grace, that, like the first-named, it surpassed the scenes of all the others.

By the same Aristotile, likewise, there was executed over the loggia a frieze with other little scenes and arms, which was much extolled, and which pleased his Excellency, who rewarded him liberally for the whole work. Afterwards, almost every year, he executed scenery and prospect-views for the comedies that were performed at Carnival time; and he had in that manner of painting such assistance from nature and such practice, that he had determined that he would write of it and teach others; but this he abandoned, because the undertaking proved to be more difficult than he had expected, but particularly because afterwards

commissions to execute prospect-views were given by new men in authority at the Palace to Bronzino and Francesco Salviati, as will be related in the proper place. Aristotile, therefore, perceiving that many years had passed during which he had not been employed, went off to Rome to find Antonio da San Gallo, his cousin, who, immediately after his arrival, having received and welcomed him very warmly, set him to press on certain buildings, with a salary of ten crowns a month, and then sent him to Castro, where he stayed some months, being commissioned by Pope Paul III to execute a great part of the buildings there after the designs and directions of Antonio. But, because Aristotile, having been brought up with Antonio from childhood, had become accustomed to treat him too familiarly, it is said that Antonio kept him at a distance, since Aristotile had never been able to accustom himself to calling him 'you,' insomuch that he gave him the 'thou' even if they were before the Pope, to say nothing of a circle of nobles and gentlemen, even as is still done by Florentines used to the ancient fashions and to giving the 'thou' to everyone, as if they were from Norcia, without being able to accommodate themselves to modern ways of life as others do, who march step by step with the times. And how strange this circumstance appeared to Antonio, accustomed as he was to be honoured by Cardinals and other great men, everyone may imagine for himself. Having therefore grown weary of his stay at Castro, Aristotile besought Antonio that he should enable him to return to Rome; in which Antonio obliged him very readily, but said to him that he must behave towards him in a different manner and with better breeding, particularly whenever they were in the presence of great persons.

One year, at the time of the Carnival, when Ruberto Strozzi was giving a banquet at Rome to certain lords, his friends, and a comedy was to be performed at his house, Aristotile made for him in the great hall a prospect-scene, which, considering the little space at his disposal, was so pleasing, so graceful, and so beautiful, that Cardinal Farnese, among others, not only was struck with astonishment at it, but caused him to make one in his Palace of S. Giorgio, where is the Cancelleria, in one of those mezzanine halls that look out on the garden; but in such a way that it might remain there permanently, so that he might be able to make use of it whenever he so wished or required. This work, then, was carried out by Aristotile with all the study in his power

and knowledge, and in such a manner, that it gave the Cardinal and the men of the arts infinite satisfaction. Now the Cardinal commissioned Messer Curzio Frangipane to remunerate Aristotile; and he, as a man of prudence, wishing to do what was right by him, but also not to overpay him, asked Perino del Vaga and Giorgio Vasari to value the work. This was very agreeable to Perino, because, feeling hatred for Aristotile, and taking it ill that he had executed that prospect-scene, which he thought should have fallen to him as the servant of the Cardinal, he was living in apprehension and jealousy, and all the more because the Cardinal had made use in those days not only of Aristotile but also of Vasari, and had given him a thousand crowns for having painted in fresco, in a hundred days, the Hall of 'Parco Majori' in the Cancelleria. For these reasons, therefore, Perino intended to value that prospect-view of Aristotile's at so little, that he would have to repent of having done it. But Aristotile, having heard who were the men who had to value his prospect-view, went to seek out Perino, and at the first word, according to his custom, began to give him the 'thou' to his face, for he had been his friend in youth; whereupon Perino, who had already an ill-will against him, flew into a rage and all but revealed, without noticing, the malicious thing that he had it in his mind to do. Aristotile having therefore told the whole story to Vasari, Giorgio told him that he should have no anxiety and should be of good cheer, for no wrong would be done to him.

Afterwards, Perino and Giorgio coming together to settle that affair, Perino, as the older man, began to speak, and set himself to censure that prospect-scene and to say that it was a work of a few halfpence, and that Aristotile, having received money on account and having been paid for those who had assisted him, had been overpaid, adding: 'If I had been commissioned to do it, I would have done it in another manner, and with different scenes and ornaments from those used by that fellow; but the Cardinal always chooses to favour some person who does him little honour.' From these words and others Giorgio recognized that Perino wished rather to avenge himself on Aristotile for the grievance that he had against the Cardinal than to ensure with friendly affection the remuneration of the talents and labours of a good craftsman; and he spoke these soft words to Perino: 'Although I have not as much knowledge of such works as I might have, nevertheless, having seen some by the hands of those

who know how to do them, it appears to me that this one is very well executed, and worthy to be valued at many crowns, and not, as you say, at a few halfpence. And it does not seem to me right that he who sits in his work-room drawing cartoons, in order afterwards to reproduce in great works such a variety of things in perspective, should be paid for the labour of his nights – and perhaps for the work of many weeks into the bargain – on the same scale as are paid the days of those who have to undergo no fatigue of the mind and hand, and little of the body, it being enough for them to imitate, without in any way racking their brains, as Aristotile has done. And if you, Perino, had executed it, as you say, with more scenes and ornaments, perhaps you might not have done it with that grace which has been achieved by Aristotile, who in that kind of painting has been esteemed with much judgment by the Cardinal to be a better master than you. Remember that in the end, by giving a wrong and unjust estimate, you do harm not so much to Aristotile as to art and excellence in general, and even more to your own soul, if you depart from what is right for the sake of some private grievance; not to mention that all who recognize the work as a good one, will censure not it but our weak judgment, and may even put it down to envy and malice in our natures. And whoever seeks to ingratiate himself with another, to glorify his own works, or to avenge himself for any injury by censuring or estimating at less than their true value the good works of others, is finally recognized by God and man as what he is, namely, as malignant, ignorant, and wicked. Consider, you who do all the work in Rome, how it would appear to you if others were to value your labours as you do theirs? Put yourself, I beg you, in the shoes of this poor old man, and you will see how far you are from reason and justice.'

Of such force were these and other words that Giorgio spoke lovingly to Perino, that they arrived at a just estimate, and satisfaction was given to Aristotile, who, with that money, with the payment for the picture sent, as was related at the beginning, to France, and with the savings from his salaries, returned joyously to Florence, notwithstanding that Michelagnolo, who was his friend, had intended to make use of him in the building that the Romans were proposing to erect on the Campidoglio. Having thus returned to Florence in the year 1547, Aristotile went to kiss the hands of the Lord Duke Cosimo, and besought

his Excellency, since he had set his hand to many buildings, that he should assist him and make use of his services. And that lord, having received him graciously, as he has always received men of excellence, ordained that an allowance of ten crowns a month should be given to him, and said to him that he would be employed according as occasion might arise. With that allowance Aristotile lived peacefully for some years, without doing anything more, and then died at the age of seventy, on the last day of May in the year 1551, and was buried in the Church of the Servites. In our book are some drawings by the hand of Aristotile, and there are some in the possession of Antonio Particini; among which are some very beautiful sheets drawn in perspective.

There lived in the same times as Aristotile, and were his friends, two painters of whom I shall make brief mention here, because they were such that they deserve to have a place among these rare intellects, on account of some works executed by them that were truly worthy to be extolled. One was Jacone, and the other Francesco Ubertini, called Il Bacchiacca. Jacone, then, did not execute many works, being one who lost himself in talking and jesting, and contented himself with the little that his fortune and his idleness allowed him, which was much less than what he required. But, since he was closely associated with Andrea del Sarto, he drew very well and with great boldness; and he was very fantastic and bizarre in the posing of his figures, distorting them and seeking to make them varied and different from those of others in all his compositions. In truth, he had no little design, and when he chose he could imitate the good. In Florence, when still young, he executed many pictures of Our Lady, many of which were sent by Florentine merchants into France. For S. Lucia, in the Via de' Bardi, he painted in an altar-piece God the Father, Christ, and Our Lady, with other figures, and at Montici, about a tabernacle on the corner of the house of Lodovico Capponi, he executed two figures in chiaroscuro. For S. Romeo, in an altar-piece, he painted Our Lady and two Saints.

Then, hearing once much praise spoken of the façades executed by Polidoro and Maturino at Rome, without anyone knowing about it he went off to that city, where he stayed some months and made some copies, gaining such proficience in matters of art, that he afterwards proved himself in many works a passing good painter. Wherefore the Chevalier Buondelmonte commissioned him to paint in chiaroscuro a house that he had

built opposite to S. Trinita, at the beginning of the Borgo S. Apostolo; wherein Jacone painted stories from the life of Alexander the Great, very beautiful in certain parts, and executed with so much grace and design, that many believe that the designs for the whole work were made for him by Andrea del Sarto. To tell the truth, from the proof of his powers that Jacone gave in that work, it was thought that he was likely to produce some great fruits. But, since he always had his mind set more on giving himself a good time and every possible amusement, living in a round of suppers and feastings with his friends, than on studying and working, he was for ever forgetting rather than learning. And that which was a thing to laugh at or to pity, I know not which, was that he belonged to a company, or rather, gang, of friends who, under the pretence of living like philosophers, lived like swine and brute-beasts; they never washed their hands, or face, or head, or beard; they did not sweep their houses, and never made their beds save only once every two months; they laid their tables with the cartoons for their pictures, and they drank only from the flask or the jug; and this miserable existence of theirs, living, as the saying goes, from hand to mouth, was held by them to be the finest life in the world. But, since the outer man is wont to be a guide to the inner, and to reveal what our minds are, I believe, as has been said before, that they were as filthy and brutish in mind as their outward appearance suggested.

For the festival of S. Felice in Piazza – that is, the representation of the Annunciation of the Madonna, of which there has been an account in another place – which was held by the Company of the Orciuolo in the year 1525, Jacone made among the outer decorations, according to the custom of those times, a most beautiful triumphal arch standing by itself, large, double, and very high, with eight columns, pilasters, and pediments; all of which he caused to be carried to completion by Piero da Sesto, a well-practised master in wood-work. On this arch, then, were painted nine scenes, part of which, the best, he executed himself, and the rest Francesco Ubertini, Il Bacchiacca; and these scenes were all from the Old Testament, and for the greater part from the life of Moses. Having then been summoned by a Scopetine friar, his kinsman, to Cortona, Jacone painted two altar-pieces in oils for the Church of the Madonna, which is without the city. In one of these is Our Lady with S. Rocco, S. Augustine, and other Saints, and in the other a God the Father who is crowning

Our Lady, with two Saints at the foot, and in the centre is S. Francis, who is receiving the Stigmata; which two works were very beautiful. Then, having returned to Florence, he decorated for Bongianni Capponi a vaulted chamber in that city; and he executed certain others for the same man in his villa at Montici. And finally, when Jacopo da Pontormo painted for Duke Alessandro, in his villa at Careggi, that loggia of which there has been an account in his Life, Jacone helped to execute the greater part of the ornaments, such as grotesques, and other things. After this he occupied himself with certain insignificant works, of which there is no need to make mention.

The sum of the matter is that Jacone spent the best part of his life in jesting, in going off into cogitations, and in speaking evil of all and sundry. For in those days the art of design in Florence had fallen into the hands of a company of persons who paid more attention to playing jokes and to enjoyment than to working, and whose occupation was to assemble in shops and other places, and there to spend their time in criticizing maliciously, in their own jargon, the works of others who were persons of excellence and lived decently and like men of honour. The heads of this company were Jacone, the goldsmith Piloto, and the wood-carver Tasso; but the worst of them all was Jacone, for the reason that, among his other fine qualities, his every word was always a foul slander against somebody. Wherefore it was no marvel that from such a company there should have sprung in time, as will be related, many evil happenings, or that Piloto, on account of his slanderous tongue, was killed by a young man. And since their habits and proceedings were displeasing to honest men, they were generally to be found – I do not say all of them, but some at least – like wool-carders and other fellows of that kidney, playing at chuck-stones at the foot of a wall, or making merry in a tavern.

One day that Giorgio Vasari was returning from Monte Oliveto, a place without Florence, after a visit to the reverend and most cultured Don Miniato Pitti, who was then Abbot of that monastery, he found Jacone, with a great part of his crew, at the Canto de' Medici; and Jacone thought to attempt, as I heard afterwards, with some of his idle talk, speaking half in jest and half in earnest, to hit on some phrase insulting to Giorgio. And so, when Vasari rode into their midst on his horse, Jacone said to him: 'Well, Giorgio, how goes it with you?' 'Finely, my Jacone,'

answered Giorgio. 'Once I was poor like all of you, and now I find myself with three thousand crowns or more. You thought me a fool, and the priests and friars think me an able master. I used to be your servant, and here is a servant of my own, who serves me and looks after my horse. I used to dress in the clothes that beggarly painters wear, and here am I dressed in velvet. Once I went on foot, and now I go on horseback. So you see, my Jacone, it goes exceeding well with me. May God be with you.'

When poor Jacone had heard all this recital in one breath, he lost all his presence of mind and stood confused, without saying another word, as if reflecting how miserable he was, and how often the engineer is hoist with his own petard. Finally, having become much reduced by an infirmity, and being poor, neglected, and paralysed in the legs, so that he could do nothing to better himself, Jacone died in misery in a little hovel that he had on a mean street, or rather, alley, called Codarimessa, in the year 1553.

Francesco Ubertini, called Il Bacchiacca, was a diligent painter, and, although he was the friend of Jacone, he always lived decently enough and like an honest man. He was likewise a friend of Andrea del Sarto, and much assisted and favoured by him in matters of art. Francesco, I say, was a diligent painter, and particularly in painting little figures, which he executed to perfection, with much patience, as may be seen from a predella with the story of the Martyrs, below the altar-piece of Giovanni Antonio Sogliani, in S. Lorenzo at Florence, and from another predella, executed very well, in the Chapel of the Crocifisso. For the chamber of Pier Francesco Borgherini, of which mention has already been made so many times, Il Bacchiacca, in company with the others, executed many little figures on the coffers and the panelling, which are known by the manner, being different from the others. For the antechamber of Giovan Maria Benintendi, which likewise has been already mentioned, he painted two very beautiful pictures with little figures, in one of which, the most beautiful and the most abundant in figures, is the Baptist baptizing Jesus Christ in the Jordan. He also executed many others for various persons, which were sent to France and England. Finally, having entered the service of Duke Cosimo, since he was an excellent painter in counterfeiting all the kinds of animals, Il Bacchiacca painted for his Excellency a cabinet all full of birds of various kinds, and rare plants, all of which he

executed divinely well in oils. He then made, with a vast number of little figures, cartoons of all the months of the year, which were woven into most beautiful tapestries in silk and gold, with such industry and diligence that there is nothing better of that kind to be seen, by Marco, the son of Maestro Giovanni Rosto the Fleming. After these works, Il Bacchiacca decorated in fresco the grotto of a water-fountain that is at the Pitti Palace. Lastly, he made the designs for a bed that was executed in embroidery, all full of scenes and little figures. This is the most ornate work in the form of a bed, in such a kind of workmanship, that there is to be seen, the embroidering having been made rich with pearls and other things of price by Antonio Bacchiacca, the brother of Francesco, who is an excellent embroiderer; and, since Francesco died before the completion of the bed, which has served for the happy nuptials of the most illustrious Lord Prince of Florence, Don Francesco de' Medici, and of her serene Highness Queen Joanna of Austria, it was finished in the end after the directions and designs of Giorgio Vasari.

Francesco died at Florence in the year 1557.

BENVENUTO GAROFALO AND GIROLAMO DA CARPI, PAINTERS OF FERRARA, AND OTHER LOMBARDS

In this part of the Lives that we are about to write we shall give a brief account of the best and most eminent painters, sculptors, and architects who have lived in Lombardy in our time, after Mantegna, Costa, Boccaccino of Cremona, and Francia of Bologna; for I am not able to write the life of each in detail, and it seems to me enough to enumerate their works. And even this I would not have set myself to do, nor to give a judgment on those works, if I had not first seen them; but since, from the year 1542 down to this present year of 1566, I had not travelled, as I did before, over almost the whole of Italy, nor seen the above-mentioned works and the others that had appeared in great numbers during that period of four-and-twenty years, I resolved, before writing of them, being almost at the end of this my labour, to see them and judge of them with my own eyes. Wherefore, after the conclusion of the above-mentioned nuptials of the most illustrious

Lord Don Francesco de' Medici, Prince of Florence and Siena, my master, and of her serene Highness Queen Joanna of Austria, on account of which I had been much occupied for two years on the ceiling of the principal hall of their Palace, I resolved, without sparing any expense or fatigue, to revisit Rome, Tuscany, part of the March, Umbria, Romagna, Lombardy, and Venice with all her domain, in order to re-examine the old works and to see the many that have been executed from the year 1542 onward. And so, having made a record of the works that were most notable and most worthy to be put down in writing, in order not to do wrong to the talents of many craftsmen or depart from that sincere truthfulness which is expected from those who write history of any kind, I shall proceed without bias of mind to write down all that is wanting in any part of what has been already written, without disturbing the order of the story, and then to give an account of the works of some who are still living, and have worked or are still working excellently well; for it appears to me that so much is demanded by the merits of many rare and noble craftsmen.

Let me begin, then, with the men of Ferrara. Benvenuto Garofalo was born at Ferrara in the year 1481, to Piero Tisi, whose elders had their origin in Padua. He was born, I say, so inclined to painting, that, when still but a little boy, while going to school to learn reading, he would do nothing but draw; from which exercise his father, who looked on painting as a folly, sought to divert him, but was never able. Wherefore that father, having seen that he must second the inclination of that son of his, who would never do anything day and night but draw, finally placed him with Domenico Panetti, a painter of some repute at that time, although his manner was dry and laboured, in Ferrara. With that Domenico Benvenuto had been some little time, when, going once to Cremona, he happened to see in the principal chapel of the Duomo in that city, among other works by the hand of Boccaccio Boccaccino, a painter of Cremona, who had painted the tribune there in fresco, a Christ seated on a throne surrounded by four Saints, and giving the Benediction. Whereupon, that work having pleased him, he placed himself by means of some friends under Boccaccino, who was at that time executing in the same church, likewise in fresco, some stories of the Madonna, as has been said in his Life, in competition with the painter Altobello, who was painting in the same church, opposite

to Boccaccino, some stories of Jesus Christ, which are very beau-
tiful and truly worthy to be praised.

Now, after Benvenuto had been two years in Cremona, and
had made much progress under the discipline of Boccaccino, he
went off in the year 1500, at the age of nineteen, to Rome, where,
having placed himself with Giovanni Baldini, a Florentine painter
of passing good skill, who possessed many very beautiful draw-
ings by various excellent masters, he was constantly practising his
hand on those drawings whenever he had time, and particularly
at night. Then, after he had been fifteen months with that master
and had seen to his great delight the works of Rome, he travelled
for a time over various parts of Italy, and finally made his way to
Mantua. There he stayed two years with the painter Lorenzo
Costa, serving him with such lovingness, that Lorenzo, after that
period of two years, in order to reward him, placed him in the
service of Francesco Gonzaga, Marquis of Mantua, for whom
Costa himself was working. But Benvenuto had not been long
with the Marquis, when, his father Piero falling ill in Ferrara, he
was forced to return to that city, where he stayed afterwards for
four years together, executing many works by himself alone, and
some in company with the Dossi.

Then, in the year 1505, being sent for by Messer Geronimo
Sagrato, a gentleman of Ferrara, who was living in Rome, Benve-
nuto returned there with the greatest willingness, and particularly
from a desire to see the miracles that were being related of
Raffaello da Urbino and of the Chapel of Julius painted by Buon-
arroti. But when Benvenuto had arrived in Rome, he was struck
with amazement, and almost with despair, by seeing the grace and
vivacity that the pictures of Raffaello revealed, and the depth in
the design of Michelagnolo. Wherefore he cursed the manners of
Lombardy, and that which he had learned with so much study
and effort at Mantua, and right willingly, if he had been able,
would he have purged himself of all that knowledge; but he
resolved, since there was no help for it, that he would unlearn it
all, and, after the loss of so many years, change from a master
into a disciple. And so he began to draw from such works as were
the best and the most difficult, and to study with all possible
diligence those greatly celebrated manners, and gave his attention
to scarcely any other thing for a period of two whole years; by
reason of which he so changed his method, transforming his bad
manner into a good one, that notice was taken of him by the

craftsmen. And, what was more, he so went to work with humility and every kind of loving service, that he became the friend of Raffaello da Urbino, who, being very courteous and not ungrateful, taught Benvenuto many things, and always assisted and favoured him.

If Benvenuto had pursued his studies in Rome, without a doubt he would have done things worthy of his beautiful genius; but he was constrained, I know not by what cause, to return to his own country. In taking leave of Raffaello, he promised that he would, as that master advised him, return to Rome, where Raffaello assured him that he would give him more than enough in the way of work, and that in honourable undertakings. Having then arrived in Ferrara, Benvenuto settled the affairs and despatched the business that had caused him to return; and he was preparing himself to make his way back to Rome, when the Lord Duke Alfonso of Ferrara set him to decorate a little chapel in the Castle, in company with other Ferrarese painters. That work finished, his departure was again delayed by the great courtesy of M. Antonio Costabili, a Ferrarese gentleman of much authority, who gave him an altar-piece to paint in oils for the high-altar of the Church of S. Andrea; which finished, he was forced to execute another for S. Bartolo, a convent of Cistercian Monks, wherein he painted the Adoration of the Magi, which was beautiful and much extolled. He then painted another for the Duomo, full of figures many and various, and two others that were placed in the Church of S. Spirito, in one of which is the Virgin in the air with the Child in her arms, and some other figures below, and in the other the Nativity of Jesus Christ.

In executing those works, remembering at times how he had turned his back on Rome, he felt the bitterest regret; and he had resolved at all costs to return thither, when, his father Piero's death taking place, all his plans were broken off; for, finding himself burdened with a sister ready for a husband and a brother fourteen years of age, and his affairs in disorder, he was forced to compose his mind and resign himself to live in his native place. And so, after parting company with the Dossi, who had worked with him up to that time, he painted by himself in the Church of S. Francesco, in a little chapel, the Raising of Lazarus, a work filled with a variety of good figures, and pleasant in colouring, with attitudes spirited and vivacious, which brought him much commendation. In another chapel in the same church he

painted the Massacre of the Innocents, cruelly done to death by Herod, so well and with such spirited movements in the soldiers and other figures, that it was a marvel. Very well depicted, in addition, are different expressions in the great variety of heads, such as terror in the mothers and nurses, death in the infants, and cruelty in the slayers, and many other things, which gave infinite satisfaction. It is worthy of remark that in executing that work Benvenuto did a thing that up to that time had never been done in Lombardy – namely, he made models of clay, the better to see the shadows and lights, and availed himself of a figure-model made of wood, jointed in such a way that the limbs moved in every direction, which he arranged as he wished, in various attitudes, with draperies over it. But what is most important is that he copied every least detail from life and nature, as one who knew that the true way is to observe and imitate the reality. For the same church he executed the altar-piece of a chapel; and on a wall he painted in fresco Christ taken by the multitude in the Garden.

For S. Domenico, in the same city, he painted two altar-pieces in oils; in one is the Miracle of the Cross and S. Helen, and in the other is S. Peter Martyr with a good number of very beautiful figures, wherein it is evident that Benvenuto departed considerably from his first manner, making it bolder and less laboured. For the Nuns of S. Salvestro he painted an altar-picture of Christ praying to His Father on the Mount, while the three Apostles are lower down, sleeping. For the Nuns of S. Gabriello he executed an Annunciation, and for those of S. Antonio, in the altar-piece of the high-altar, the Resurrection of Christ. For the high-altar of the Frati Ingesuati, in the Church of S. Girolamo, he painted Jesus Christ in the Manger, with a choir of Angels on a cloud, held to be very beautiful. In S. Maria del Vado, in an altar-piece by the same hand, very well conceived and coloured, is Christ ascending into Heaven, with the Apostles standing in contemplation of Him. For the Church of S. Giorgio, a seat of the Monks of Monte Oliveto, without the city, he painted an altar-piece in oils of the Magi adoring Christ and offering to Him myrrh, incense, and gold; and this is one of the best works that Benvenuto ever executed in all his life.

All these works much pleased the people of Ferrara, by reason of which he executed pictures almost without number for their houses, and many others for monasteries and for the townships

and villas round about the city; and, among others, he painted the Resurrection of Christ in an altar-piece for Bondeno. And, finally, he executed in fresco with beautiful and fantastic invention, in the Refectory of S. Andrea, many figures that are bringing the Old Testament into accord with the New. But, since the works of this master are numberless, let it be enough to have spoken of those that are the best.

Girolamo da Carpi having received his first instructions in painting from Benvenuto, as will be related in his Life, they painted in company the façade of the house of the Muzzarelli, in the Borgo Nuovo, partly in chiaroscuro and partly in colours, with some things done in imitation of bronze. They painted together, likewise, both within and without, the Palace of Coppara, a place of recreation belonging to the Duke of Ferrara; for which lord Benvenuto executed many other works, both by himself and in company with other painters.

Then, having lived a long time in the determination that he would not take a wife, in the end, after separating from his brother and growing weary of living alone, at the age of forty-eight he took one; but he had scarcely had her a year, when, falling grievously ill, he lost the sight of his right eye, and was in fear and peril of the other. However, having recommended himself to God and made a vow that he would always dress in grey, as he afterwards did, by the grace of God he preserved the sight of the other eye, insomuch that the works executed by him at the age of sixty-five were so well done, and with such diligence and finish, that it was a marvel. Wherefore on one occasion, when the Duke of Ferrara showed to Pope Paul III a Triumph of Bacchus in oils, five braccia in length, and the Calumny of Apelles, painted by Benvenuto at that age after the designs of Raffaello da Urbino, which pictures are now over certain chimney-pieces belonging to his Excellency, that Pontiff was struck with astonishment that an old man of such an age, with only one eye, should have executed works so large and so beautiful.

On every feast-day for twenty whole years Benvenuto worked for the love of God in the Convent of the Nuns of S. Bernardino, where he executed many works of importance in oils, in distemper, and in fresco; which was certainly a marvellous thing, and a great proof of his true and good nature, for in that place he had no competition, and nevertheless put no less study and diligence into his labour than he would have done at any other more

frequented place. Those works are passing good in composition, with beautiful expressions in the heads, not confused, and executed in a truly sweet and good manner.

For all the disciples that Benvenuto had, although he taught them everything that he knew with no ordinary willingness, in order to make some of them excellent masters, he never had any success with a single one of them, and, in place of being rewarded by them for his lovingness at least with gratitude of heart, he never received anything from them save vexations; wherefore he used to say that he had never had any enemies but his own disciples and assistants. In the year 1550, being now old, and the malady returning to his eye, he became wholly blind, and he lived thus for nine years; which misfortune he bore with a patient mind, resigning himself completely to the will of God. Finally, when he had come to the age of seventy-eight, thinking at last that he had lived too long in that darkness, and rejoicing in death, in the hope of going to enjoy eternal light, he finished the course of his life on the 6th of September in the year 1559, leaving a son called Girolamo, who is a very gentle person, and a daughter.

Benvenuto was a very honest creature, fond of a jest, pleasant in his conversation, patient and calm in all his adversities. As a young man he delighted in fencing and playing the lute, and in his friendships he was loving beyond measure and prodigal with his services. He was the friend of the painter Giorgione da Castelfranco, Tiziano da Cadore, and Giulio Romano, and most affectionate towards all the men of art in general; and to this I can bear witness, for on the two occasions when I was at Ferrara in his time I received from him innumerable favours and courtesies. He was buried with honour in the Church of S. Maria del Vado, and was celebrated in verse and prose by many choice spirits no less than his talents deserved. But it has not been possible to obtain Benvenuto's portrait, and therefore there has been placed at the head of these Lives of the Lombard painters that of Girolamo da Carpi, whose Life we are now about to write.

Girolamo, then, called Da Carpi, who was a Ferrarese and a disciple of Benvenuto, was employed at first by his father Tommaso, who was a kind of house-painter, in his workshop, to paint strong-boxes, stools, mouldings, and other suchlike commonplace things. After Girolamo had made some proficience under the discipline of Benvenuto, he began to think that he should be removed by his father from those base labours; but Tommaso,

as one who had need of money, would do nothing of the kind, and Girolamo resolved at all costs to leave him. And so he went to Bologna, where he received no little favour from the gentlemen of that city; wherefore, having made some portraits, which were passing good likenesses, he acquired so much credit that he earned much money and assisted his father more while living at Bologna than he had done when staying in Ferrara. At that time there was brought to the house of the noble Counts Ercolani at Bologna a picture by the hand of Antonio da Correggio, in which Christ is appearing to Mary Magdalene in the form of a gardener, executed with incredible softness and excellence; and that manner so took possession of Girolamo's heart, that, not content with having copied that picture, he went to Modena to see the other works by the hand of Correggio. Having arrived there, besides being filled with marvel at the sight of them, one among them in particular struck him with amazement, and that was the great picture, a divine work, in which is the Madonna, with the Child in her arms marrying S. Catharine, a S. Sebastian, and other figures, with an air of such beauty in the heads, that they appear as if made in Paradise; nor is it possible to find more beautiful hair, more lovely hands, or any colouring more pleasing and natural. Having then received permission to copy it from the owner of the picture, Messer Francesco Grillenzoni, a doctor, who was much the friend of Correggio, Girolamo copied it with the greatest diligence that it is possible to imagine. After that he did the same with the altar-picture of S. Peter Martyr, which Correggio had painted for a Company of Secular Priests, who hold it in very great price, as it deserves, there being in it, in particular, besides other figures, an Infant Christ in the lap of His Mother, who appears as if breathing, and a most beautiful S. Peter Martyr; and another little altar-piece by the same hand, painted for the Company of S. Bastiano, and no less beautiful than the other. All these works, thus copied by Girolamo, were the reason that he so improved his manner, that it did not appear like his original manner, or in any way the same thing.

From Modena Girolamo went to Parma, where he had heard that there were some works by the same Correggio, and he copied some of the pictures in the tribune of the Duomo, considering them extraordinary works, particularly the beautiful foreshortening of the Madonna, who is ascending into Heaven, surrounded by a multitude of Angels, with the Apostles, who are

standing gazing on her as she ascends, and four Saints, Protectors of that city, who are in the niches – S. John the Baptist, who is holding a lamb; S. Joseph, the husband of Our Lady; S. Bernardo degli Uberti the Florentine, a Cardinal and Bishop of Florence; and another Bishop. Girolamo likewise studied the figures by the hand of the same Correggio in the recess of the principal chapel in S. Giovanni Evangelista – namely, the Coronation of the Madonna, with S. John the Evangelist, the Baptist, S. Benedict, S. Placido, and a multitude of Angels who are about them; and the marvellous figures that are in the Chapel of S. Gioseffo in the Church of S. Sepolcro – a divine example of panel-painting.

Now, since it is inevitable that those who are pleased to follow some particular manner, and who study it with lovingness, should acquire it – at least, in some degree (whence it also happens that many become more excellent than their masters) – Girolamo caught not a little of Correggio's manner; wherefore, after returning to Bologna, he imitated him always, not studying any other thing but that manner and that altar-piece by the hand of Raffaello da Urbino which we mentioned as being in that city. And all these particulars I heard from Girolamo da Carpi, who was much my friend, at Rome in the year 1550; and he lamented very often to me that he had consumed his youth and his best years in Ferrara and Bologna, and not in Rome or some other place, where, without a doubt, he would have made much greater proficience. No little harm, also, did Girolamo suffer in matters of art from his having given too much attention to amorous delights and to playing the lute at the time when he might have been making progress in painting.

Having returned, then, to Bologna, he made a portrait, among others, of Messer Onofrio Bartolini, a Florentine, who was then in that city for his studies, and afterwards became Archbishop of Pisa; and that head, which is now in the possession of the heirs of that Messer Noferi, is very beautiful and in a manner full of grace. There was working in Bologna at this time a certain Maestro Biagio, a painter, who, perceiving that Girolamo was coming into good repute, began to be afraid lest he might outstrip him and deprive him of all his profits. Wherefore, seizing a good occasion, he established a friendship with Girolamo, with the intention of hindering him in his work, and became his intimate companion to such purpose, that they began to work in company; and so they continued for a while. This friendship was

harmful to Girolamo, not only in the matter of his earnings, but likewise with respect to art, for the reason that he followed in the footsteps of Maestro Biagio (who worked by rule of thumb, and took everything from the designs of one master or another), and he, also, put no more diligence into his pictures.

Now in the monastery of S. Michele in Bosco, without Bologna, a certain Fra Antonio, a monk of that convent, had painted a S. Sebastian of the size of life, besides executing an altar-piece in oils for a convent of the same Order of Monte Oliveto at Scaricalasino, and some figures in fresco in the Chapel of S. Scholastica, in the garden of Monte Oliveto Maggiore, and Abbot Ghiaccino, who had compelled him to stay that year in Bologna, desired that he should paint the new sacristy of his church there. But Fra Antonio, who did not feel it in him to do so great a work, and perchance was not very willing to undergo such fatigue, as is often the case with that kind of man, so contrived that the work was allotted to Girolamo and Maestro Biagio, who painted it all in fresco. In the compartments of the vaulting they executed some little boys and Angels, and at the head, in large figures, the story of the Transfiguration of Christ, availing themselves of the design of that which Raffaello da Urbino painted for S. Pietro in Montorio at Rome; and on the other walls they painted some Saints, in which, to be sure, there is something of the good. But Girolamo, having recognized that to stay in company with Maestro Biagio was not the course for him, and, indeed, that it was his certain ruin, broke up the partnership when that work was finished, and began to work for himself.

The first work that he executed on his own account was an altar-piece for the Chapel of S. Bastiano in the Church of S. Salvadore, in which he acquitted himself very well. But then, having heard of the death of his father, he returned to Ferrara, where for a time he did nothing save some portraits and works of little importance. Meanwhile, Tiziano Vecelli went to Ferrara to execute certain things for Duke Alfonso, as will be related in his Life, in a little closet, or rather, study, where Giovanni Bellini had already painted some pictures, and Dosso a Bacchanal rout of men which was so good, that, even if he had never done any other thing, for that alone he would deserve praise and the name of an excellent painter; and Girolamo, by means of Tiziano and others, began to have dealings with the Court of the Duke. And so, as it were to give a proof of his powers before he should do

anything else, he copied the head of Duke Ercole of Ferrara from one by the hand of Tiziano, and counterfeited it so well, that it seemed the same as the original; wherefore it was sent, as a work worthy of praise, into France. Afterwards, having taken a wife and had children by her, sooner, perchance, than he should have done, Girolamo painted in S. Francesco at Ferrara, in the angles of the vaulting, the four Evangelists in fresco, which were passing good figures. In the same place he executed a frieze right round the church, which was a very large and abundant work, being full of half-length figures and little boys linked together in a very pleasing manner; and for that church, also, he painted an altar-picture of S. Anthony of Padua, with other figures, and another altar-piece of Our Lady in the air with two Angels, which was placed on the altar of Signora Giulia Muzzarelli, whose portrait was executed very well therein by Girolamo.

At Rovigo, in the Church of S. Francesco, the same master painted the Holy Spirit appearing in Tongues of Fire, which was a work worthy of praise for the composition and for the beauty of the heads. At Bologna, for the Church of S. Martino, he painted an altar-piece of the three Magi, with most beautiful heads and figures; and at Ferrara, in company with Benvenuto Garofalo, as has been related, the façade of the house of Signor Battista Muzzarelli, and also the Palace of Coppara, a villa of the Duke's, distant twelve miles from Ferrara; and, again, in Ferrara, the façade of Piero Soncini in the Piazza near the Fishmarket, painting there the Taking of Goletta by the Emperor Charles V. The same Girolamo painted for S. Polo, a church of the Carmelite Friars in the same city, a little altar-piece in oils of S. Jerome with two other Saints, of the size of life; and for the Duke's Palace a great picture with a figure large as life, representing Opportunity, and executed with beautiful vivacity, movement and grace, and fine relief. He also painted a nude Venus, life-size and recumbent, with Love beside her, which was sent to Paris for King Francis of France; and I, who saw it at Ferrara in the year 1540, can with truth affirm that it was very beautiful. He also made a beginning with the decorations in the Refectory of S. Giorgio, a seat of the Monks of Monte Oliveto at Ferrara, and executed a great part of them; but he left the work unfinished, and it has been completed in our own day by Pellegrino Pellegrini, a painter of Bologna.

Now, if we were to seek to make particular mention of the

pictures that Girolamo executed for many lords and gentlemen, the story would be longer than is our desire, and I shall speak of two only, which are most beautiful. From a picture by the hand of Correggio that the Chevalier Baiardo has at Parma, beautiful to a marvel, in which Our Lady is putting a shirt on the Infant Christ, Girolamo made a copy so like it that it seems the very same picture, and he made another copy from one by the hand of Parmigiano, which is in the cell of the Vicar in the Certosa at Pavia, doing this so well and with such diligence, that there is no miniature to be seen that is wrought with more subtlety; and he executed innumerable others with great care. And since Girolamo delighted in architecture, and also gave his attention to it, in addition to many designs of buildings that he made for private persons, he served in that art, in particular, Cardinal Ippolito of Ferrara, who, having bought the garden at Monte Cavallo in Rome which had formerly belonged to the Cardinal of Naples, with many vineyards belonging to individuals around it, took Girolamo to Rome, to the end that he might serve him not only in the buildings, but also in the truly regal ornaments of wood-work in that garden. In this he acquitted himself so well, that everyone was struck with astonishment; and, indeed, I know not what other man could have done better than he did in executing in woodwork – which has since been covered with most beautiful verdure – works so fine and so pleasingly designed in various forms and in different kinds of temples, in which there may now be seen arranged the richest and most beautiful ancient statues that there are in Rome, some whole and some restored by Valerio Cioli, a Florentine sculptor, and by others.

By these works Girolamo came into very great credit in Rome, and in the year 1550 he was introduced by the above-named Cardinal, his lord, who loved him dearly, into the service of Pope Julius III, who made him architect over the works of the Belvedere, giving him rooms in that place and a good salary. But, since that Pontiff could never be satisfied in such matters, and, to make it worse, was hindered by understanding very little of design, and would not have in the evening a thing that had pleased him in the morning, and also because Girolamo had to be always contending with certain old architects, to whom it seemed strange to see a new man of little reputation preferred to themselves, he resolved, having perceived their envy and possible malignity, and also being rather cold by nature than otherwise, to

retire. And so he chose, as the better course, to return to the service of the Cardinal at Monte Cavallo; for which action Girolamo was much commended, for it is too wretched a life to have to be always contending all day long and on every least detail with one person or another, and, as he used to say, it is at times better to enjoy peace of mind on bread and water than to sweat and strive amid grandeur and honours. Wherefore, after Girolamo had executed for his lord the Cardinal a very beautiful picture, which, when I saw it, pleased me very much, being now weary, he returned with him to Ferrara, to enjoy the peace of his home with his wife and children, leaving the hopes and rewards of fortune in the possession of his adversaries, who received from that Pope the same as he had done, neither more nor less.

While he was living thus at Ferrara, a part of the Castle was burned, I know not by what mischance, and Duke Ercole gave the charge of restoring it to Girolamo, who did it very well, adorning it as much as is possible in that district, which suffers from a great dearth of stone wherewith to make carvings and ornaments; for which he well deserved to be always held dear by that lord, who rewarded him liberally for his labours. Finally, after having executed these and many other works, Girolamo died in the year 1556, at the age of fifty-five, and was buried in the Church of the Angeli, beside his wife. He left two daughters, and also three sons, Giulio, Annibale, and another.

Girolamo was a blithe spirit, very sweet and pleasing in his conversation, and in his work somewhat slow and dilatory. He was of middle stature, and he delighted beyond measure in music, and more in the pleasures of love than was perhaps expedient. The buildings of his patrons have been carried on since his death by the Ferrarese architect Galasso, a man of the most beautiful genius, and of such judgment in matters of architecture, that, in so far as may be seen from the ordering of his designs, he would have demonstrated his worth much more than he has done, if he had been employed in works of importance.

An excellent sculptor, and likewise a Ferrarese, has been Maestro Girolamo, who, living at Recanati, has executed many works in marble at Loreto after his master, Andrea Contucci, and has made many of the ornaments round that Chapel or House of the Madonna. This master – since the departure from that place of Tribolo, who was the last there, after he had finished the largest scene in marble, which is at the back of the chapel,

wherein are the Angels carrying that house from Sclavonia into
the forest of Loreto – has laboured there continually from 1534
to the year 1560, executing many works. The first of these was a
seated figure of a Prophet of three braccia and a half, which,
being good and beautiful, was placed in a niche that is turned
towards the west; which statue, having given satisfaction, was the
reason that he afterwards made all the other Prophets, with the
exception of one, that facing towards the east on the outer side,
over against the altar, which is by the hand of Simone Cioli of
Settignano, likewise a disciple of Andrea Sansovino. The rest of
those Prophets, I say, are by the hand of Maestro Girolamo, and
are executed with much diligence and study and good skill of
hand. For the Chapel of the Sacrament the same master has made
the candelabra of bronze about three braccia in height, covered
with foliage and figures cast in the round, which are so well
wrought that they are things to marvel at. And a brother of
Maestro Girolamo's, who is an able master in similar works of
casting, has executed many things in company with him at Rome,
and in particular a very large tabernacle of bronze for Pope Paul
III, which was to be placed in the chapel that is called the Pauline
in the Palace of the Vatican.

Among the Modenese, also, there have been at all times crafts-
men excellent in our arts, as has been said in other places, and as
may be seen from four panel-pictures, of which no mention was
made in the proper place because the master was not known;
which pictures were executed in distemper a hundred years ago
in that city, and, for those times, they are painted with diligence
and very beautiful. The first is on the high-altar of S. Domenico,
and the others in the chapels that are in the tramezzo* of that
church. And there is living in the same country at the present day
a painter called Niccolò, who in his youth painted many works
in fresco about the Beccherie, which have no little beauty, and
for the high-altar of S. Piero, a seat of the Black Friars, in an
altar-piece, the Beheading of S. Peter and S. Paul, imitating in the
soldier who is cutting off their heads a similar figure by the hand
of Antonio da Correggio, much renowned, which is in S. Gio-
vanni Evangelista at Parma. Niccolò has been more excellent in
fresco-painting than in the other fields of painting, and, in addi-
tion to many works that he has executed at Modena and Bologna,

* See note on p. 90, Vol. I.

I understand that he has painted some very choice pictures in France, where he still lives, under Messer Francesco Primaticcio, Abbot of S. Martin, after whose designs Niccolò has painted many works in those parts, as will be related in the Life of Primaticcio.

Giovan Battista, also, a rival of that Niccolò, has executed many works in Rome and elsewhere, and in particular he has painted at Perugia, in the Chapel of Signor Ascanio della Cornia, in S. Francesco, many pictures of the life of S. Andrew the Apostle, in which he has acquitted himself very well. In competition with the above-named Niccolò, the Fleming Arrigo, a master of glass windows, has painted in the same place an altar-piece in oils, containing the story of the Magi, which would be beautiful enough if it were not somewhat confused and overloaded with colours, which conflict with one another and destroy all the gradation; but he has acquitted himself better in a window of glass designed and painted by himself, and executed for the Chapel of S. Bernardino in S. Lorenzo, in the same city. But to return to Giovan Battista; having gone back after the above-named works to Modena, he has executed in the same S. Piero, for which Niccolò painted the altar-piece, two great scenes at the sides, of the actions of S. Peter and S. Paul, in which he has acquitted himself with no ordinary excellence.

In the same city of Modena there have also been some sculptors worthy to be numbered among the good craftsmen, for, in addition to Modanino, of whom mention has been made in another place, there has been a master called Il Modena, who has executed most beautiful works in figures of terra-cotta, of the size of life and even larger; among others, those of a chapel in S. Domenico at Modena, and for the centre of the dormitory of S. Piero (a monastery of Black Friars, likewise in Modena), a Madonna, S. Benedict, S. Giustina, and another Saint. To all these figures he has given so well the colour of marble, that they appear as if truly of that stone; not to mention that they all have beautiful expressions of countenance, lovely draperies, and admirable proportions. The same master has executed similar figures for the dormitory of S. Giovanni Evangelista at Parma; and he has made a good number of figures in the round and of the size of life for many niches on the outer side of S. Benedetto at Mantua, in the façade and under the portico, which are so fine that they have the appearance of marble.

In like manner Prospero Clemente, a sculptor of Modena, has been, and still is, an able man in his profession, as is evident from the tomb of Bishop Rangone, by his hand, in the Duomo of Reggio, wherein is a seated statue of that prelate, as large as life, with two little boys, all very well executed; which tomb he made at the commission of Signor Ercole Rangone. In the Duomo of Parma, likewise, in the vaults below, there is by the hand of Prospero the tomb of the Blessed Bernardo degli Uberti, the Florentine, Cardinal and Bishop of that city, which was finished in the year 1548, and much extolled.

Parma, also, has had at various times many excellent craftsmen and men of fine genius, as has been said above, for, besides one Cristofano Castelli, who painted a very beautiful altar-piece for the Duomo in the year 1499, and Francesco Mazzuoli, whose Life has been written, there have been many other able men in that city. Mazzuoli, as has been related, executed certain works in the Madonna della Steccata, but left that undertaking unfinished at his death, and Giulio Romano, having made a coloured design on paper, which may be seen in that place by everyone, directed that a certain Michelagnolo Anselmi, a Sienese by origin, but a citizen of Parma by adoption, being a good painter, should carry that cartoon into execution, wherein is the Coronation of Our Lady. This he did excellently well, in truth, so that he well deserved that there should be allotted to him a great niche – one of four very large niches that are in that temple – opposite to that in which he had executed the above-mentioned work after the design of Giulio. Whereupon, setting his hand to this, he carried well on towards completion there the Adoration of the Magi, with a good number of beautiful figures, making on the flat arch, as was related before in the Life of Mazzuoli, the Wise Virgins and the design of copper rosettes; but, when about a third of that work remained for him to do, he died, and so it was finished by Bernardo Soiaro of Cremona, as we shall relate in a short time. By the hand of that Michelagnolo is the Chapel of the Conception in S. Francesco, in the same city; and a Celestial Glory in the Chapel of the Cross in S. Pier Martire.

Girolamo Mazzuoli, the cousin of Francesco, as has been told, continuing the work in that Church of the Madonna, left unfinished by his kinsman, painted an arch with the Wise Virgins and adorned it with rosettes. Then, in the recess at the end, opposite to the principal door, he painted the Holy Spirit descending in

Tongues of Fire on the Apostles, and in the last of the flat arches the Nativity of Jesus Christ, which, although not yet uncovered, he has shown to us this year of 1566, to our great pleasure, since it is a truly beautiful example of work in fresco. The great central tribune of the same Madonna della Steccata, which is being painted by Bernardo Soiaro, the painter of Cremona, will also be, when finished, a rare work, and able to compare with the others that are in that place. But of all these it cannot be said that the cause has been any other than Francesco Mazzuoli, who was the first who with beautiful judgment began the magnificent ornamentation of that church, which, so it is said, was built after the designs and directions of Bramante.

As for the masters of our arts in Mantua, besides what has been said of them up to the time of Giulio Romano, I must say that he sowed the seeds of his art in Mantua and throughout all Lombardy in such a manner that there have been able men there ever since, and his own works are every day more clearly recognized as good and worthy of praise. And although Giovan Battista Bertano, the principal architect for the buildings of the Duke of Mantua, has constructed in the Castle, over the part where there are the waters and the corridor, many apartments that are magnificent and richly adorned with stucco-work and pictures, executed for the most part by Fermo Ghisoni, the disciple of Giulio, and by others, as will be related, nevertheless he has not equalled those made by Giulio himself. The same Giovan Battista has caused Domenico Brusciasorzi to execute after his design for S. Barbara, the church of the Duke's Castle, an altar-piece in oils truly worthy to be praised, in which is the Martyrdom of that Saint. And, in addition, having studied Vitruvius, he has written and published a work on the Ionic volute, showing how it should be turned, after that author; and at the principal door of his house at Mantua he has placed a complete column of stone, and the flat module of another, with all the measurements of that Ionic Order marked, and also the palm, inch, foot, and braccio of the ancients, to the end that whoever so desires may be able to see whether those measurements are correct or not. In the Church of S. Piero, the Duomo of Mantua, which was the work and architecture of the above-named Giulio Romano, since in renovating it he gave it a new and modern form, the same Bertano has caused an altar-piece to be executed for each chapel by the hands of various painters; and two of these he has had

painted after his own designs by the above-mentioned Fermo Ghisoni, one for the Chapel of S. Lucia, containing that Saint and two children, and the other for that of S. Giovanni Evangelista. Another similar picture he caused to be executed by Ippolito Costa of Mantua, in which is S. Agata with the hands bound and between two soldiers, who are cutting and tearing away her breasts. Battista d' Agnolo del Moro of Verona painted for the same Duomo, as has been told, the altar-piece that is on the altar of S. Maria Maddalena, and Girolamo Parmigiano that of S. Tecla. Paolo Farinato of Verona Bertano commissioned to execute the altar-piece of S. Martino, and the above-named Domenico Brusciasorzi that of S. Margherita; and Giulio Campo of Cremona painted that of S. Gieronimo. And one that was better than any other, although all are very beautiful, in which is S. Anthony the Abbot beaten by the Devil in the form of a woman, who tempts him, is by the hand of Paolo Veronese. But of all the craftsmen of Mantua, that city has never had a more able master in painting than Rinaldo, who was a disciple of Giulio. By his hand is an altar-piece in S. Agnese in that city, wherein is Our Lady in the air, with S. Augustine and S. Jerome, which are very good figures; but him death snatched from the world before his time.

In a very beautiful antiquarium and study made by Signor Cesare Gonzaga, which is full of ancient statues and heads of marble, that lord has had the genealogical tree of the House of Gonzaga painted, in order to adorn it, by Fermo Ghisoni, who has acquitted himself very well in everything, and especially in the expressions of the heads. The same Signor Cesare has placed there, in addition, some pictures that are certainly very rare, such as that of the Madonna with the Cat which Raffaello da Urbino painted, and another wherein Our Lady with marvellous grace is washing the Infant Jesus. In another little cabinet made for medals, which has been beautifully wrought in ebony and ivory by one Francesco da Volterra, who has no equal in such works, he has some little antique figures in bronze, which could not be more beautiful than they are.

In short, between the last time that I saw Mantua and this year of 1566, when I have revisited that city, it has become so much more beautiful and ornate, that, if I had not seen it for myself, I would not believe it; and, what is more, the craftsmen have multiplied there, and they still continue to multiply. Thus, to that

Giovan Battista Mantovano, an excellent sculptor and engraver of prints, of whom we have spoken in the Life of Giulio Romano and in that of Marc' Antonio Bolognese, have been born two sons, who engrave copper-plates divinely well, and, what is even more astonishing, a daughter, called Diana, who also engraves so well that it is a thing to marvel at; and I who saw her, a very gentle and gracious girl, and her works, which are most beautiful, was struck with amazement.

Nor will I omit to say that in S. Benedetto, a very celebrated monastery of Black Friars at Mantua, renovated by Giulio Romano after a most beautiful design, are many works executed by the above-named craftsmen of Mantua and other Lombards, in addition to those described in the Life of the same Giulio. There are, then, works by Fermo Ghisoni, such as a Nativity of Christ, two altar-pieces by Girolamo Mazzuoli, three by Lattanzio Gambara of Brescia, and three others by Paolo Veronese, which are the best. In the same place, at the head of the refectory, by the hand of a certain Fra Girolamo, a lay-brother of S. Dominic, as has been related elsewhere, is a picture in oils which is a copy of the very beautiful Last Supper that Leonardo painted in S. Maria delle Grazie at Milan, and copied so well, that I was amazed by it. Of which circumstance I make mention again very willingly, having seen Leonardo's original in Milan, this year of 1566, reduced to such a condition, that there is nothing to be seen but a mass of confusion; wherefore the piety of that good father will always bear testimony in that respect to the genius of Leonardo da Vinci. By the hand of the same monk I have seen in the above-named house of the Mint, at Milan, a picture copied from one by Leonardo, in which are a woman that is smiling and S. John the Baptist as a boy, counterfeited very well.

Cremona, as was said in the Life of Lorenzo di Credi and in other places, has had at various times men who have executed in painting works worthy of the highest praise. And we have already related that when Boccaccio Boccaccino was painting the great recess of the Duomo at Cremona and the stories of Our Lady throughout the church, Bonifazio Bembi was also a good painter, and Altobello executed in fresco many stories of Jesus Christ with much more design than have those of Boccaccino. After these works Altobello painted in fresco a chapel in S. Agostino of the same city, in a manner full of beauty and grace, as may be seen by everyone. At Milan, in the Corte Vecchia – that is, the

courtyard, or rather, piazza of the Palace – he painted a standing figure armed in the ancient fashion, much better than any of the others that were executed there by many painters about the same time. After the death of Bonifazio, who left unfinished the above-mentioned stories of Christ in the Duomo of Cremona, Giovanni Antonio Licinio of Pordenone, called in Cremona De' Sacchi, finished those stories begun by Bonifazio, painting there in fresco five scenes of the Passion of Christ with a grand manner in the figures, bold colouring, and foreshortenings that have vivacity and force; all which things taught the good method of painting to the Cremonese, and not in fresco only, but likewise in oils, for the reason that in the same Duomo, placed against a pilaster in the centre of the church, is an altar-piece by the hand of Pordenone that is very beautiful. Camillo, the son of Boccaccino, afterwards imitated that manner in painting in fresco the principal chapel of S. Gismondo, without the city, and in other works, and so succeeded much better than his father had done. That Camillo, however, being slow and even dilatory in his work, did not paint much save small things and works of little importance.

But he who imitated most the good manners, and who profited most by the competition of the above-named masters, was Bernardo de' Gatti, called Il Soiaro, of whom mention has been made in speaking of Parma. Some say that he was of Verzelli, and others of Cremona; but, wherever he may have come from, he painted a very beautiful altar-piece for the high-altar of S. Piero, a church of the Canons Regular, and in their refectory the story of the miracle that Jesus Christ performed with the five loaves and two fishes, satisfying an infinite multitude, although he retouched it so much 'a secco,' that it has since lost all its beauty. That master also executed under a vault in S. Gismondo, without Cremona, the Ascension of Jesus Christ into Heaven, which was a pleasing work and very beautiful in colouring. In the Church of S. Maria di Campagna at Piacenza, in competition with Pordenone and opposite to the S. Augustine that has been mentioned, he painted in fresco a S. George in armour and on horseback, who is killing the Serpent, with spirit, movement, and excellent relief. That done, he was commissioned to finish the tribune of that church, which Pordenone had left unfinished, wherein he painted in fresco all the life of the Madonna; and although the Prophets and Sibyls that Pordenone executed there,

with some children, are beautiful to a marvel, nevertheless Soiaro acquitted himself so well, that the whole of that work appears as if all by one and the same hand. In like manner, some little altar-pieces that he has executed at Vigevano are worthy of considerable praise for their excellence. Finally, after he had betaken himself to Parma to work in the Madonna della Steccata, the great niche and the arch that were left incomplete through the death of Michelagnolo of Siena were finished by the hands of Soiaro. And to him, from his having acquitted himself well, the people of Parma have since given the charge of painting the great tribune that is in the centre of that church, where he is now constantly occupied in executing in fresco the Assumption of Our Lady, which, it is hoped, is to prove a most admirable work.

While Boccaccino was still alive, but old, Cremona had another painter, called Galeazzo Campo, who painted the Rosary of the Madonna in a large chapel in the Church of S. Domenico, and the façade at the back of S. Francesco, with other works and altar-pieces by his hand that are in Cremona, all passing good. To him were born three sons, Giulio, Antonio, and Vincenzio; but Giulio, although he learned the first rudiments of art fron his father Galeazzo, nevertheless afterwards followed the manner of Soiaro, as being better, and studied much from some canvases executed in colours at Rome by the hand of Francesco Salviati, which were painted for the weaving of tapestries, and sent to Piacenza to Duke Pier Luigi Farnese. The first works that this Giulio executed in his youth at Cremona were four large scenes in the choir of the Church of S. Agata, containing the martyrdom of that virgin, which proved to be such, that a well-practised master might perhaps not have done them so well. Then, after executing some works in S. Margherita, he painted many façades of palaces in chiaroscuro, with good design. For the Church of S. Gismondo, without the city, he painted in oils the altar-piece of the high-altar, which was very beautiful on account of the diversity and multitude of the figures that he executed in it, in competition with the many painters who had worked in that place before him. After the altar-piece he painted there many things in fresco on the vaulting, and in particular the Descent of the Holy Spirit on the Apostles, who are foreshortened to be seen from below, with beautiful grace and great artistry. At Milan, for the Church of the Passione, a convent of Canons Regular, he painted a Christ Crucified on a panel in oils, with some Angels,

the Madonna, S. John the Evangelist, and the other Maries. In the Nunnery of S. Paolo, a convent also in Milan, he executed four scenes, with the Conversion and other acts of that Saint. In that work he was assisted by Antonio Campo, his brother, who also painted for the Nunnery of S. Caterina at the Porta Ticinese, likewise in Milan, for a chapel in the new church, the architecture of which is by Lombardino, a picture in oils of S. Helen directing the search for the Cross of Christ, which is a passing good work. And Vincenzio, likewise, the third of those three brothers, having learned much from Giulio, as Antonio has also done, is a young man of excellent promise.

To the same Giulio Campo have been disciples not only his two above-named brothers, but also Lattanzio Gambara and others; but most excellent in painting, doing him more honour than any of the rest, has been Sofonisba Anguisciuola of Cremona, with her three sisters, which most gifted maidens are the daughters of Signor Amilcare Anguisciuola and Signora Bianca Punzona, both of whom belong to the most noble families in Cremona. Speaking, then, of Signora Sofonisba, of whom we said but little in the Life of Properzia of Bologna, because at that time we knew no more, I must relate that I saw this year in the house of her father at Cremona, in a picture executed with great diligence by her hand, portraits of her three sisters in the act of playing chess, and with them an old woman of the household, all done with such care and such spirit, that they have all the appearance of life, and are wanting in nothing save speech. In another picture may be seen, portrayed by the same Sofonisba, her father Signor Amilcare, who has on one side one of his daughters, her sister, called Minerva, who was distinguished in painting and in letters, and on the other side Asdrubale, their brother, the son of the same man; and these, also, are executed so well, that they appear to be breathing and absolutely alive. At Piacenza, in the house of the reverend Archdeacon of the principal church, are two very beautiful pictures by the same hand: in one is the portrait of the Archdeacon, and in the other that of Sofonisba herself, and each of those figures lacks nothing save speech. That lady, having been brought afterwards by the Duke of Alva, as was related above, into the service of the Queen of Spain, in which she still remains at the present day with a handsome salary and much honour, has executed a number of portraits and pictures that are things to marvel at. Moved by the fame of which works,

Pope Pius IV had Sofonisba informed that he desired to have from her hand the portrait of her serene Highness the Queen of Spain; wherefore, having executed it with all the diligence in her power, she sent it to Rome to be presented to him, writing to his Holiness a letter in the precise form given below:

'HOLY FATHER,

'From the very reverend Nuncio of your Holiness I understood that you desired to have a portrait by my hand of her Majesty the Queen, my Liege-lady. And since I accepted this commission as a singular grace and favour, having thus to serve your Holiness, I asked leave of her Majesty, who granted it very willingly, recognizing therein the fatherly affection that your Holiness bears to her. Taking the opportunity presented by this Chevalier, I send it to you, and, if I shall have satisfied therein the desire of your Holiness, I shall receive infinite compensation; but I must not omit to tell you that if it were possible in the same way to present with the brush to the eyes of your Holiness the beauties of the mind of this most gracious Queen, you would see the most marvellous thing in all the world. But in those parts which can be portrayed by art, I have not failed to use all the diligence in my power and knowledge, in order to present the truth to your Holiness. And with this conclusion, in all reverence and humility, I kiss your most holy feet.

'From the most humble servant of your Holiness,
 'SOFONISBA ANGUISCIUOLA.

'At Madrid, on the 16th of September, 1561.'

To that letter his Holiness answered with that given below, which, having thought the portrait marvellously beautiful, he accompanied with gifts worthy of the great talents of Sofonisba:

'PIUS PAPA IV DILECTA IN CHRISTO FILIA.

'We have received the portrait of the most gracious Queen of Spain, our dearest daughter, which you have sent to us; and it has been most acceptable to us, both on account of the person therein represented, whom we love with the love of a father by reason of her true piety and her other most beautiful qualities of mind, to say nothing of other reasons, and also because it has been very

well and diligently executed by your hand. We thank you for it, assuring you that we shall hold it among our dearest possessions, and commending this your art, whish, although it is marvellous, we understand to be the least of the many gifts that are in you. And with this conclusion we send you once again our benediction. May our Lord God preserve you.

'Dat. Romæ, die 15 Octob., 1561.'

And let this testimony suffice to prove how great is the talent of Sofonisba.

A sister of hers, called Lucia, left at her death fame no less than that of Sofonisba, by means of some pictures by her hand that are no less beautiful and precious than those of her sister described above, as may be seen at Cremona from a portrait that she executed of Signor Pietro Maria, an eminent physician, but even more from another portrait, painted by that gifted maiden, of the Duke of Sessa, which was counterfeited by her so well, that it would seem impossible to do better or to make a portrait with a more animated likeness.

The third of the sisters Anguisciuola, called Europa, is still a child in age. To her, a girl all grace and talent, I have spoken this very year; and, in so far as one can see from her works and drawings, she will be in no way inferior to Sofonisba and Lucia, her sisters. This Europa has executed many portraits of gentlemen at Cremona, which are altogether beautiful and natural, and one of her mother, Signora Bianca, she sent to Spain, which vastly pleased Sofonisba and everyone of that Court who saw it. Anna, the fourth sister, although but a little girl, is also giving her attention with much profit to design: so that I know not what to say save that it is necessary to have by nature an inclination for art, and then to add to that study and practice, as has been done by those four noble and gifted sisters, so much enamoured of every rare art, and in particular of the matters of design, insomuch that the house of Signor Amilcare Anguisciuola, most happy father of a fair and honourable family, appeared to me the home of painting, or rather, of all the arts. But, if women know so well how to produce living men, what marvel is it that those who wish are also so well able to create them in painting?

But to return to Giulio Campo, of whom I have said that those young women are the disciples; besides other works, a

painting on cloth that he has made as a cover for the organ in
the Cathedral Church, is executed with much study in distemper,
with a great number of figures representing the stories of Esther
and Ahasuerus and the Crucifixion of Haman. And in the same
church there is a graceful altar-piece by his hand on the altar of
S. Michael; but since Giulio is still alive, I shall say no more for
the present about his works. Of Cremona, likewise, were the
sculptor Geremia, who was mentioned by us in the Life of
Filarete,* and who has executed a large work in marble in
S. Lorenzo, a seat of the Monks of Monte Oliveto; and Giovanni
Pedoni, who has done many works at Cremona and Brescia, and
in particular many things in the house of Signor Eliseo Raimon-
do, which are beautiful and worthy of praise.

In Brescia, also, there have been, and still are, persons most
excellent in the arts of design, and, among others, Girolamo Ro-
manino has executed innumerable works in that city. The altar-
piece on the high-altar of S. Francesco, which is a passing good
picture, is by his hand, and so also the little shutters that enclose
it, which are painted in distemper both within and without; and
his work, likewise, is another altar-piece executed in oils that is
very beautiful, wherein may be seen masterly imitations of natural
objects. But more able than that Girolamo was Alessandro
Moretto, who painted in fresco, under the arch of the Porta
Brusciata, the Translation of the bodies of SS. Faustino and Jovi-
ta, with some groups of figures that are accompanying those
bodies, all very well done. For S. Nazzaro, also in Brescia, he
executed certain works, and others for S. Celso, which are passing
good, and an altar-piece for S. Piero in Oliveto, which is full of
charm. At Milan, in the house of the Mint, there is a picture by
the hand of that same Alessandro with the Conversion of S. Paul,
and other heads that are very natural, with beautiful adornments
of draperies and vestments, for the reason that he much delighted
to counterfeit cloth of gold and of silver, velvets, damasks, and
other draperies of every kind, which he used to place on the
figures with great diligence. The heads by the hand of that master
are very lifelike, and hold to the manner of Raffaello da Urbino,
and even more would they hold to it if he had not lived so far
from Raffaello.

The son-in-law of Alessandro was Lattanzio Gambara, a

* Really in the Life of Filippo Brunelleschi.

painter of Brescia, who, having learned his art, as has been related, under Giulio Campo of Verona,* is now the best painter that there is in Brescia. By his hand, in the Black Friars Church of S. Faustino, are the altar-piece of the high-altar, and the vaulting and walls painted in fresco, with other pictures that are in the same church. In the Church of S. Lorenzo, also, the altar-piece of the high-altar is by his hand, with two scenes that are on the walls, and the vaulting, all painted in fresco almost in the same manner. He has also painted, besides many other façades, that of his own house, with most beautiful inventions, and likewise the interior; in which house, situated between S. Benedetto and the Vescovado, I saw, when I was last in Brescia, two very beautiful portraits by his hand, that of Alessandro Moretto, his father-in-law, which is a very lovely head of an old man, and that of the same Alessandro's daughter, his wife. And if the other works of Lattanzio were equal to those portraits, he would be able to compare with the greatest men of his art. But, since his works are without number, and he himself besides is still living, it must suffice for the present to have made mention of those named.

By the hand of Gian Girolamo Bresciano are many works to be seen in Venice and Milan, and in the above-mentioned house of the Mint there are four pictures of Night and of Fire, which are very beautiful. In the house of Tommaso da Empoli at Venice is a Nativity of Christ, a very lovely effect of night, and there are some other similar works of fantasy, in which he was a master. But, since he occupied himself only with things of that kind, and executed no large works, there is nothing more to be said of him save that he was a man of fanciful and inquiring mind, and that what he did deserves to be much commended.

Girolamo Mosciano of Brescia, after spending his youth in Rome, has executed many beautiful works in figures and landscapes, and at Orvieto, in the principal Church of S. Maria, he has painted two altar-pieces in oils and some Prophets in fresco, which are good works; and the drawings by his hand that are published in engraving, are executed with good design. But, since he also is alive, serving Cardinal Ippolito d'Este in the buildings and restorations that he is carrying out in Rome, in Tivoli, and in other places, I shall say no more about him at present.

* Rather, of Cremona.

There has returned recently from Germany Francesco
Ricchino, likewise a painter of Brescia, who, besides many
other pictures that he has painted in various places, has executed
some works of painting in oils in the above-named S. Piero in
Oliveto at Brescia, which are done with much study and di-
ligence.

The brothers Cristofano and Stefano, painters of Brescia, have
a great name among craftsmen for their facility in drawing in
perspective; and, among other works in Venice, they have
counterfeited in painting on the flat ceiling of S. Maria dell' Orto
a corridor of double twisted columns, similar to those of the
Porta Santa in S. Pietro at Rome, which, resting on certain great
consoles that project outwards, form a superb corridor with
groined vaulting right round that church. This work, when seen
from the centre of the church, displays most beautiful fore-
shortenings, which fill with astonishment everyone who sees
them, and make the ceiling, which is flat, appear to be vaulted;
besides that it is accompanied by a beautiful variety of mouldings,
masks, festoons, and some figures, which make a very rich adorn-
ment to the work, which deserves to be vastly extolled by
everyone, both for its novelty and for its having been carried to
completion excellently well and with great diligence. And, since
this method gave much satisfaction to that most illustrious Sen-
ate, there was entrusted to the same masters another ceiling, simi-
lar, but small, in the Library of S. Marco, which, for a work of
that kind, was very highly extolled. Finally, those brothers have
been summoned to their native city of Brescia to do the same
with a magnificent hall which was begun on the Piazza many
years ago, at vast expense, and erected over a theatre of large
columns, under which is a promenade. This hall is sixty-two full
paces long, thirty-five broad, and likewise thirty-five in height at
the highest point of its elevation; although it appears much larger,
being isolated on every side, and without any apartment or other
building about it. On the ceiling of this magnificent and most
honourable hall, then, those two brothers have been much em-
ployed, with very great credit to themselves; having made a roof-
truss for the roof (which is covered with lead) of beams of wood
that are very large, composed of pieces well secured with clamps
of iron, and having turned the ceiling with beautiful artistry in the
manner of a basin-shaped vault, so that it is a rich work. It is true
that in that great space there are included only three pictures

painted in oils, each of ten braccia, which were painted by the old Tiziano; whereas many more could have gone there, with a richer, more beautiful, and better proportioned arrangement of compartments, which would have made that hall more cheerful, handsome, and ornate; but in every other part it has been made with much judgment.

Now, having spoken in this part of our book, up to the present, of the craftsmen of design in the cities of Lombardy, it cannot but be well to say something about those of the city of Milan, the capital of that province, of whom no mention has been made here, although of some of them we have spoken in many other places in this our work. To begin, then, with Bramantino, of whom mention has been made in the Life of Piero della Francesca of the Borgo, I find that he executed many more works than I have enumerated above; and, in truth, it did not then appear to me possible that a craftsman so renowned, who introduced good design into Milan, should have executed works so few as those that had come to my notice. Now, after he had painted in Rome, as has been related, some apartments for Pope Nicholas V, and had finished over the door of S. Sepolcro, in Milan, the Christ in foreshortening, the Madonna who has Him on her lap, the Magdalene, and S. John, which was a very rare work, he painted in fresco, on a façade in the court of the Mint in Milan, the Nativity of Christ our Saviour, and, in the Church of S. Maria di Brera, in the tramezzo,* the Nativity of Our Lady, with some Prophets on the doors of the organ, which are foreshortened very well to be seen from below, and a perspective-view which recedes with a beautiful gradation excellently contrived; at which I do not marvel, he having always much delighted in the studies of architecture, and having had a very good knowledge of them. Thus I remember to have seen once in the hands of Valerio Vicentino a very beautiful book of antiquities, drawn with all the measurements by the hand of Bramantino, wherein were those of Lombardy and the ground-plans of many well-known edifices, which I drew from that book, being then a lad. In it was the Temple of S. Ambrogio in Milan, built by the Lombards, and all full of sculptures and pictures in the Greek manner, with a round tribune of considerable size, but not well conceived in the matter of architecture; which temple was

* See note on p. 90, Vol. I.

rebuilt in the time of Bramantino, after his design, with a portico
of stone on one side, and with columns in the manner of
trunks of trees that have been lopped, which have in them some-
thing of novelty and variety. There, likewise, was drawn the
ancient portico of the Church of S. Lorenzo in the same city,
built by the Romans, which is a great work, beautiful and well
worthy of note; but the temple there, or rather, the church, is in
the manner of the Goths. In the same book was drawn the
Temple of S. Aquilino, which is very ancient, and covered
with incrustations of marble and stucco, very well preserved, with
some large tombs of granite. In like manner, there was the
Temple of S. Piero in Ciel d' Oro at Pavia, in which place is the
body of S. Augustine, in a tomb that is in the sacristy, covered
with little figures, which, according to my belief, is by the hands
of Agostino and Agnolo, the sculptors of Siena. There, also, was
drawn the tower of brick built by the Goths, which is a beautiful
work, for there may be seen in it, besides other things, some
figures fashioned of terra-cotta after the antique, each six braccia
high, which have remained in passing good preservation down to
the present day. In that tower, so it is said, died Boetius, who was
buried in the above-named S. Piero in Ciel d' Oro, now called
S. Agostino, where there may be seen, even at the present day,
the tomb of that holy man, with the inscription placed there by
Aliprando, who restored and rebuilt the church in the year 1222.
And, besides all these, there was in that book, drawn by the hand
of Bramantino himself, the very ancient Temple of S. Maria in
Pertica, round in shape, and built with fragments by the Lom-
bards; in which place now lie the bones from the slaughter of the
Frenchmen and others who were routed and slain before Pavia,
when King Francis I of France was taken prisoner there by the
Emperor Charles V.

But let us now leave drawings on one side: Bramantino
painted in Milan the façade of the house of Signor Giovan Bat-
tista Latuate, with a most beautiful Madonna, and on either side
of her a Prophet. On the façade of Signor Bernardo Scacalarozzo
he painted four Giants in imitation of bronze, which are reason-
ably good; with other works that are in Milan, which brought him
credit, from his having been the first light of a good manner of
painting that was seen in Milan, and the reason that after him
Bramante became, on account of the good form that he gave to
his buildings and perspective-views, an excellent master in the

matters of architecture; for the first things that Bramante studied were the works of Bramantino. Under the direction of Bramante was built the Temple of S. Satiro, which pleases me exceedingly, for it is a very rich work, adorned both within and without with columns, double corridors, and other ornaments, with the accompaniment of a most beautiful sacristy all full of statues. But above all does the central tribune of that place merit praise, the beauty of which, as has been related in the Life of Bramante, was the reason that Bernardino da Trevio followed that method in the Duomo of Milan, and gave his attention to architecture, although his first and principal art was painting; having executed, as has been related, in a cloister of the Monastery of S. Maria delle Grazie, four scenes of the Passion in fresco, and some others in chiaroscuro.

By that Bernardino was brought forward and much assisted the sculptor Agostino Busto, called Il Bambaja, of whom there has been an account in the Life of Baccio da Montelupo. Agostino executed some works in S. Marta, a convent of nuns in Milan, among which, although it is difficult to obtain leave to enter that place, I have seen the tomb of Monsignor De Foix, who died at Pavia,* in the form of many pieces of marble, wherein are about ten scenes with little figures, carved with much diligence, of the deeds, battles, victories, and triumphant assaults on strongholds of that lord, and finally his death and burial. To put it briefly, that work is such that I, gazing at it in amazement, stood for a while marvelling that it was possible for works so delicate and so extraordinary to be done with the hand and with tools of iron; for there may be seen in that tomb, executed with the most marvellous carving, decorations of trophies, arms of every kind, chariots, artillery, and many other engines of war, and, finally, the body of that lord in armour, large as life, and almost seeming to be full of gladness, as he lies dead, at the victories that he had gained. And certainly it is a pity that this work, which is well worthy to be numbered among the most stupendous examples of the art, should be unfinished and left to lie on the ground in pieces, and not built up in some place; wherefore I do not marvel that some figures have been stolen from it, and then sold and set up in other places. The truth is that there is so little humanity, or rather, piety, to be found among men

* Ravenna.

at the present day, that of all those who were benefited and beloved by De Foix not one has ever felt a pang for his memory or for the beauty and excellence of the work. By the hand of the same Agostino Busto are some works in the Duomo, and, as has been related, the tomb of the Biraghi in S. Francesco, with many others that are very beautiful in the Certosa of Pavia.

A rival of Agostino was one Cristofano Gobbo, who also executed many works in the façade of the above-named Certosa and in the church, and that so well, that he can be numbered among the best sculptors that there were in Lombardy at that time. And the Adam and Eve that are in the east front of the Duomo of Milan, which are by his hand, are held to be rare works, and such as can stand in comparison with any that have been executed by other masters in those parts.

Almost at the same time there lived at Milan another sculptor called Angelo, and by way of surname Ciciliano, who executed on the same side (of the Duomo), and of equal size, a S. Mary Magdalene raised on high by four little Angels, which is a very beautiful work, and by no means inferior to those of Cristofano. That sculptor also gave his attention to architecture, and executed, among other works, the portico of S. Celso in Milan, which was finished after his death by Tofano, called Lombardino, who, as was said in the Life of Giulio Romano, built many churches and palaces throughout all Milan, and, in particular, the convent, church, and façade of the Nuns of S. Caterina at the Porta Ticinese, with many other buildings similar to these.

Silvio da Fiesole, labouring at the instance of Tofano in the works of that Duomo, executed in the ornament of a door that faces between the west and the north, wherein are several scenes from the life of Our Lady, the scene containing her Espousal, which is very beautiful; and that of equal size opposite to it, in which is the Marriage of Cana in Galilee, is by the hand of Marco da Grà, a passing well-practised sculptor. The work of these scenes is now being continued by a very studious young man called Francesco Brambilari, who has carried one of them almost to completion, a very beautiful work, in which are the Apostles receiving the Holy Spirit. He has made, also, a drop-shaped console of marble, all in open-work, with foliage and a group of children that are marvellous; and over that work, which is to be placed in the Duomo, there is to go a statue in marble of Pope Pius IV, one of the Medici, and a citizen of Milan.

If there had been in that place the study of those arts that there is in Rome and in Florence, those able masters would have done, and would still be doing, astonishing things. And, in truth, they are greatly indebted at the present day to the Chevalier Leone Lioni of Arezzo, who, as will be told, has spent much time and money in bringing to Milan casts of many ancient works, taken in gesso, for his own use and that of the other craftsmen.

But to return to the Milanese painters; after Leonardo da Vinci had executed there the Last Supper already described, many sought to imitate him, and these were Marco Oggioni and others, of whom mention has been made in Leonardo's Life. In addition to them, Cesare da Sesto, likewise a Milanese, imitated him very well; and, besides what has been mentioned in the Life of Dosso, he painted a large picture that is in the house of the Mint in Milan, a truly abundant and beautiful work, in which is Christ being baptized by John. By the same hand, also, in that place, is a head of Herodias, with that of S. John the Baptist in a charger, executed with most beautiful artistry. And finally he painted for S. Rocco, without the Porta Romana, an altar-piece containing that Saint as a very young man; with other pictures that are much extolled.

Gaudenzio, a Milanese painter, who in his lifetime was held to be an able master, painted the altar-piece of the high-altar in S. Celso. In a chapel of S. Maria delle Grazie he executed in fresco the Passion of Jesus Christ, with figures of the size of life in strange attitudes; and then, in competition with Tiziano, he painted an altar-piece for a place below that chapel, in which, although he was very confident, he did not surpass the works of the others who had laboured in that place.

Bernardino del Lupino, of whom some mention was made not very far back, painted in Milan, near S. Sepolcro, the house of Signor Gian Francesco Rabbia – that is, the façade, loggie, halls, and apartments – depicting there many of the Metamorphoses of Ovid and other fables, with good and beautiful figures, executed with much delicacy. And in the Monastero Maggiore he painted all the great altar-wall with different stories, and likewise, in a chapel, Christ scourged at the Column, with many other works, which are all passing good.

And let this be the end of the above-written Lives of various Lombard craftsmen.

RIDOLFO, DAVID, AND BENEDETTO
GHIRLANDAJO, Painters of Florence

ALTHOUGH it appears in a certain sense impossible that one who imitates some man excellent in our arts, and follows in his footsteps, should not become in great measure like him, nevertheless it may be seen that very often the brothers and sons of persons of singular ability do not follow their kinsmen in this respect, but fall away strangely from their standard. Which comes to pass, I think, not because there are not in them, through their blood, the same fiery spirit and the same genius, but rather from another reason — that is, from overmuch ease and comfort and from an over-abundance of means, which often prevent men from becoming industrious and assiduous in their studies. Yet this rule is not so fixed that the contrary does not sometimes happen.

David and Benedetto Ghirlandajo, although they had very good parts and could have followed their brother Domenico in the matters of art, yet did not do so, for the reason that after the death of that same brother they strayed away from the path of good work, one of them, Benedetto, spending a long time as a wanderer, and the other distilling his brains away vainly in the study of mosaic. David, who had been much beloved by Domenico, and who loved him equally, both living and dead, finished after his death, in company with his brother Benedetto, many works begun by Domenico, and in particular the altar-piece of the high-altar in S. Maria Novella, that is, the part at the back, which now faces the choir; and some pupils of the same Domenico finished the predella in little figures, Niccolaio painting with great diligence, below the figure of S. Stephen, a disputation of that Saint, while Francesco Granacci, Jacopo del Tedesco, and Benedetto executed the figures of S. Antonino, Archbishop of Florence, and S. Catharine of Siena. And they painted an altarpicture of S. Lucia that is in that place, with the head of a friar, near the centre of the church; and many other paintings and pictures that are in the houses of various individuals.

After having been several years in France, where he worked and earned not a little, Benedetto returned to Florence with many privileges and presents that he had received from that King in testimony of his talents. And finally, after having given his

attention not only to painting but also to miniatures, he died at the age of fifty.

David, although he drew and worked much, yet did not greatly surpass Benedetto: and this may have come about from his being too prosperous, and from not keeping his thoughts fixed on art, who is never found save by him who seeks her, and, when found, must not be abandoned, or she flies away. By the hand of David, in the garden of the Monks of the Angeli in Florence, at the head of a path that is opposite to a door that leads into that garden, are two figures in fresco at the foot of a Crucifix – namely, S. Benedict and S. Romualdo – with some other similar works, little worthy to have any record made of them. But, while David himself would not give attention to art, it was not a little to his credit that he caused his nephew Ridolfo, the son of Domenico, to devote himself to it with all diligence, and set him on the right way; for that Ridolfo, who was under the care of David, being a lad of beautiful genius, was placed by him to practise painting, and provided with all facilities for study by his uncle, who repented too late that he had not studied that art, and had spent all his time on mosaic. David executed on a thick panel of walnut-wood, which was to be sent to the King of France, a Madonna in mosaic, with some Angels about her, which was much extolled. And, living at Montaione, a township in Valdelsa, where he had furnaces, glass, and wood at his command, he executed there many works in glass and mosaic, and in particular some vases, which were presented to the Magnificent Lorenzo de' Medici, the elder, and three heads, that of S. Peter, that of S. Laurence, and that of Giuliano de' Medici, on a dish of copper, which are now in the guardaroba of the Duke.

Meanwhile Ridolfo, drawing from the cartoon of Michelagnolo, was held to be one of the best draughtsmen thus employed, and was therefore much beloved by everyone, and particularly by Raffaello Sanzio of Urbino, who at that time, also being a young man of great reputation, was living in Florence, as has been related, in order to learn art. After Ridolfo had studied from that cartoon, and had become well-practised in painting under Fra Bartolommeo di San Marco, he already knew so much, according to the judgment of the best masters, that Raffaello, when about to go to Rome at the summons of Pope Julius II, left him to finish the blue drapery and other little things that were wanting in the picture of a Madonna that he had painted for some

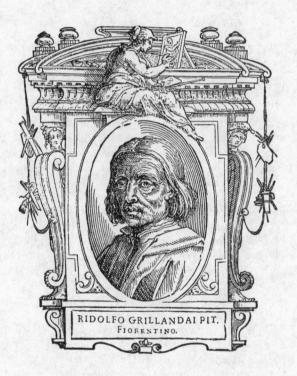

RIDOLFO GRILLANDAI PIT.
FIORENTINO.

gentlemen of Siena; which picture Ridolfo, after he had finished it with much diligence, sent to Siena. And Raffaello had not been long in Rome before he sought in many ways to attract Ridolfo to that city, but he, having never been out of sight of the Cupola, as the saying goes, and not being able to reconcile himself to living out of Florence, never accepted any proposal made to him that would interfere with his living in that city.

For the Convent of the Nuns of Ripoli Ridolfo painted two altar-pieces in oils: in one the Coronation of Our Lady, and in the other a Madonna surrounded by certain Saints. For the Church of S. Gallo he painted in an altar-piece Christ bearing the Cross, with a good number of soldiers, and the Madonna and the other Maries, who are weeping in company with John, while Veronica is offering the Sudarium to Christ; all showing force and animation. That work, in which are many very beautiful heads, taken from life and executed with lovingness, acquired a great name for Ridolfo; and in it are portrayed his father and some lads who were working with him, and, of his friends, Poggino, Scheggia, and Nunziata, the head of the last-named being very lifelike. That Nunziata, although he was a puppet-painter, was in some things a person of distinction, and above all in preparing fireworks and the girandole that were made every year for the festival of S. John; and, since he was an amusing and facetious person, everyone took great pleasure in conversing with him. A citizen once saying to him that he was displeased with certain painters who could paint nothing but lewd things, and that he therefore wished him to paint a picture of a Madonna that might be seemly, well advanced in years and not likely to provoke lascivious thoughts, Nunziata painted him one with a beard. Another meaning to ask from him a Christ on the Cross for a ground-floor room where he lived in summer, and not being able to say anything but 'I want a Christ on the Cross for summer,' Nunziata, who saw him to be a simpleton, painted him one in breeches.

But to return to Ridolfo. Having been commissioned to paint the Nativity of Christ in an altar-piece for the Monastery of Cestello, he exerted himself much, in order to surpass his rivals, and executed that work with the greatest diligence and labour at his command, painting therein the Madonna, who is adoring the Infant Christ, S. Joseph, and two figures, S. Francis and S. Jerome, kneeling. He also made there a most beautiful landscape, very like the Sasso della Vernia, where S. Francis received the Stigmata,

and above the hut some Angels that are singing; and the whole work was very beautiful in colouring, and passing good in relief. About the same time, after executing an altar-piece that went to Pistoia, he set his hand to two others for the Company of S. Zanobi, which is beside the canonical buildings of S. Maria del Fiore; which altar-pieces were to stand on either side of the Annunciation that Mariotto Albertinelli had formerly painted there, as was related in his Life. Ridolfo, then, carried the two pictures to completion with great satisfaction to the men of that Company, painting in one S. Zanobi restoring a boy to life in the Borgo degli Albizzi in Florence, which is a very lively and spirited scene, for there are in it many heads portrayed from life, and some women who show very vividly their joy and astonishment at seeing the boy reviving and the spirit returning to him. In the other is the scene of the same S. Zanobi being carried dead by six Bishops from S. Lorenzo, where he was first buried, to S. Maria del Fiore, when, passing through the Piazza di S. Giovanni, an elm that was there, all withered, on the spot where there is now a column of marble, with a cross upon it in memory of the miracle, was no sooner touched (through the will of God) by the coffin wherein was the holy corpse, than it put forth leaves again and burst into bloom; which picture was no less beautiful than the others by Ridolfo mentioned above.

Now those works were executed by that painter while his uncle David was still alive, and that good old man took the greatest pleasure in them, thanking God that he had lived so long as to see the art of Domenico come to life again, as it were, in Ridolfo. But finally, being seventy-four years of age, while he was preparing, old as he was, to go to Rome to take part in the holy Jubilee, he fell ill and died in the year 1525, and received burial from Ridolfo in S. Maria Novella, where the others of the Ghirlandajo family lie.

Ridolfo had a brother called Don Bartolommeo in the Angeli, a seat of the Monks of Camaldoli in Florence, who was a truly religious, upright, and worthy man; and Ridolfo, who loved him much, painted for him in the cloister that opens into the garden – that is, in the loggia where there are the stories of S. Benedict painted in verdaccio by the hand of Paolo Uccello, on the right hand as one enters by the door of the garden – a scene in which that same Saint, seated at table with two Angels beside him, is waiting for bread to be sent for him into the grotto by Romanus,

but the Devil has cut the cord with stones; and the same Saint investing a young man with the habit. But the best figure of all those that are on that little arch, is the portrait of a dwarf who stood at the door of the monastery at that time. In the same place, over the holy-water font at the entrance into the church, he painted in fresco-colours a Madonna with the Child in her arms, and some Angels about her, all very beautiful. And in the cloister that is in front of the chapter-house, in a lunette over the door of a little chapel, he painted in fresco S. Romualdo with the Church of the Hermitage of Camaldoli in his hand: and not long afterwards a very beautiful Last Supper that is at the head of the refectory of the same monks, which he did at the commission of Don Andrea Doffi the Abbot, who had been a monk of that monastery, and who had his own portrait painted in a corner at the foot.

Ridolfo also executed three very beautiful stories of the Madonna, which have the appearance of miniatures, on a predella in the little Church of the Misericordia, in the Piazza di S. Giovanni. And for Matteo Cini, in a little tabernacle on the corner of his house, near the Piazza di S. Maria Novella, he painted Our Lady, S. Matthew the Apostle, and S. Dominic, with two little sons of that Matteo on their knees, portrayed from life; which work, although small, is very beautiful and full of grace. For the Nuns of S. Girolamo, of the Order of S. Francesco de' Zoccoli, on the heights of S. Giorgio, he painted two altar-pieces; in one is S. Jerome in Penitence, very beautiful, with a Nativity of Jesus Christ in the lunette above, and in the other, which is opposite to the first, is an Annunciation, and in the lunette above S. Mary Magdalene partaking of the Communion. In the Palace that is now the Duke's he painted the chapel where the Signori used to hear Mass, executing in the centre of the vaulting the most Holy Trinity, and in the other compartments some little Angels who are holding the Mysteries of the Passion, with some heads representing the twelve Apostles. In the four corners he painted the four Evangelists in whole-length figures, and at the head the Angel Gabriel bringing the Annunciation to the Virgin, depicting in a kind of landscape the Piazza della Nunziata in Florence as far as the Church of S. Marco; and all this work is executed excellently well, with many beautiful ornaments. When it was finished, he painted in an altar-piece, which was placed in the Pieve of Prato, Our Lady presenting the Girdle to S. Thomas,

who is with the other Apostles. For Ognissanti, at the commission of Monsignor de' Bonafè, Director of the Hospital of S. Maria Nuova, and Bishop of Cortona, he executed an altarpiece with Our Lady, S. John the Baptist, and S. Romualdo; and for the same patron, having served him well, he painted some other works, of which there is no need to make mention. He then copied the three Labours of Hercules (which Antonio del Pollaiuolo had formerly painted in the Palace of the Medici), for Giovan Battista della Palla, who sent them to France.

After he had executed these and many other pictures, Ridolfo, happening to have in his house all the appliances for working in mosaic which had belonged to his uncle David and his father Domenico, and having also learned something of that work from the uncle, determined that he would try to do some work in mosaic with his own hand. Which having done, and finding that he was successful, he undertook to decorate the arch that is over the door of the Nunziata, wherein he made the Angel bringing the Annunciation to Our Lady. But, since he had not the patience for putting together all those little pieces, he never again did any work in that field of art.

For a little church of the Company of Woolcarders at the head of the Campaccio, he painted in an altar-piece the Assumption of the Madonna, with a choir of Angels, and the Apostles about the Sepulchre. But by misadventure, the room in which the picture was having been filled in the year of the siege with green broom for making fascines, the damp so softened the gesso that it all peeled away; wherefore Ridolfo had to repaint it, and made in it his own portrait. At the Pieve of Giogoli, in a tabernacle that is on the high road, he painted Our Lady with two Angels; and in another tabernacle opposite to a mill of the Eremite Fathers of Camaldoli, which is on the Ema, beyond the Certosa, he painted many figures in fresco. By reason of all which works, Ridolfo, finding himself sufficiently employed, and living comfortably with a good income, would by no means rack his brains to do all that he could have done in painting, but rather became disposed to live like a gentleman and take life as it came.

For the visit of Pope Leo to Florence, he executed in company with his young men and assistants all the festive preparations in the house of the Medici, and decorated the Sala del Papa and the adjoining rooms, causing the chapel to be painted by Pontormo, as has been related. In like manner, for the nuptials

of Duke Giuliano and Duke Lorenzo he executed the decorations and some scenery for comedies; and, since he was much beloved by those lords for his excellence, he received many offices by their means, and was elected to the Collegio as an honoured citizen. Ridolfo did not disdain also to make pennons, standards, and other suchlike things in plenty, and I remember having heard him say that three times he had painted the banners of the Potenze,* which used every year to hold tournaments and keep the city festive. In short, all sorts of works used to be executed in his shop, so that many young men frequented it, each learning that which pleased him best.

Thus Antonio del Ceraiolo, having been with Lorenzo di Credi, was then with Ridolfo, and afterwards, having withdrawn by himself, executed many works and portraits from life. In S. Jacopo tra Fossi there is by the hand of this Antonio an altar-piece, with S. Francis and S. Mary Magdalene at the foot of a Crucifix; and in the Church of the Servites, behind the high-altar, a S. Michelagnolo copied from that by Ghirlandajo in the Ossa of S. Maria Nuova.

Another disciple of Ridolfo, who acquitted himself very well, was Mariano da Pescia, by whose hand is a picture of Our Lady, with the Infant Christ, S. Elizabeth, and S. John, executed very well, in the above-mentioned chapel of the Palace, which Ridolfo had previously painted for the Signoria. The same Mariano painted in chiaroscuro the whole house of Carlo Ginori, in the street which takes its name from that family, executing there stories from the life of Samson, in a very beautiful manner. And if this painter had enjoyed a longer life than he did, he would have become an excellent master.

A disciple of Ridolfo, likewise, was Toto del Nunziata, who painted for S. Piero Scheraggio, in company with his master, an altar-piece of Our Lady, with the Child in her arms, and two Saints.

But dear beyond all the others to Ridolfo was a disciple of Lorenzo di Credi, who was also with Andrea del Ceraiolo, called Michele, a young man of an excellent nature, who executed his works with boldness and without effort. This Michele, then, following the manner of Ridolfo, approached him so closely that, whereas at the beginning he received from his master a third of

* See note on p. 52, Vol. II.

his earnings, they came to execute their works in company, and shared the profits. Michele looked upon Ridolfo always as a father, and loved him, and also was so beloved by him, that, as one belonging to Ridolfo, he has ever been and still is known by no other name but Michele di Ridolfo. These two, I say, loving each other like father and son, executed innumerable works in company. First, for the Church of S. Felice in Piazza, a place then belonging to the Monks of Camaldoli, they painted in an altar-piece Christ and Our Lady in the air, who are praying to God the Father for the people below, where some Saints are kneeling. In S. Felicita they painted two chapels in fresco, despatching them in an able manner; in one is the Dead Christ with the Maries, and in the other the Assumption of Our Lady, with some Saints. For the Church of the Nuns of S. Jacopo delle Murate they executed an altar-piece at the commission of Bishop de' Bonafè of Corto-na: and for the Convent of the Nuns of Ripoli another altar-piece with Our Lady and some Saints. For the Chapel of the Segni, below the organ in the Church of S. Spirito, they painted, likewise in an altar-piece, Our Lady, S. Anne, and many other Saints; for the Company of the Neri a picture of the Beheading of S. John the Baptist; and for the Monachine in Borgo S. Friano an altar-piece of the Annunciation. In another altar-piece, for S. Rocco at Prato, they painted S. Rocco, S. Sebastian, and between them Our Lady; and likewise, for the Company of S. Bastiano, beside S. Jacopo sopra Arno, they executed an altar-piece containing Our Lady, S. Sebastian, and S. James; with another for S. Martino alla Palma. And, finally, they painted for S. Alessandro Vitelli a S. Anne in a picture that was sent to Città di Castello, and placed in the chapel of that lord in S. Fiorido.

But, since the works and pictures that issued from Ridolfo's shop were without number, and even more so the portraits from life, I shall say only that a portrait was made by him of Signor Cosimo de' Medici when he was very young, which was a most beautiful work, and very true to life; which picture is still preserved in the guardaroba of his Excellency. Ridolfo was a rapid and resolute painter in certain kinds of work, and particu-larly in festive decorations; and thus, for the entry of the Emperor Charles V into Florence, he executed in ten days an arch at the Canto alla Cuculia, and another arch in a very short time at the Porta al Prato for the coming of the most illustrious Lady, Duchess Leonora, as will be related in the Life of Battista

Franco. At the Madonna di Vertigli, a seat of the Monks of Camaldoli, without the township of Monte Sansovino, Ridolfo, having with him the above-named Battista Franco and Michele, executed in chiaroscuro, in a little cloister, all the stories of the life of Joseph; in the church, the altar-pieces of the high-altar, and a Visitation of Our Lady in fresco, which is as beautiful as any work in fresco that Ridolfo ever painted. But lovely beyond all others, in the venerable aspect of the countenance, is the figure of S. Romualdo, which is on that high-altar. They also executed other pictures there, but it must suffice to have spoken of these. Ridolfo painted grotesques on the vaulting of the Green Chamber in the Palace of Duke Cosimo, and some landscapes on the walls, which much pleased the Duke.

Finally, having grown old, Ridolfo lived a very happy life, having his daughters married, and seeing his sons well started in the affairs of commerce in France and at Ferrara. And, although afterwards he found himself so oppressed by the gout that he stayed always in the house or had to be carried in a chair, nevertheless he bore that infirmity with great patience, and also some misfortunes suffered by his sons. Old as he was, he felt a great love for the world of art, and insisted on being told of, and at times on seeing, those works that he heard much praised, such as buildings, pictures, and other suchlike things that were being executed every day; and one day that the Lord Duke was out of Florence, having had himself carried in his chair into the Palace, he dined there and stayed the whole day, gazing at that Palace, which was so changed and transformed from what it was before, that he did not recognize it; and in the evening, when going away, he said: 'I die happy, because I shall be able to carry to our craftsmen in the next world the news that I have seen the dead restored to life, the ugly rendered beautiful, and the old made young.' Ridolfo lived seventy-five years, and died in the year 1560; and he was buried with his forefathers in S. Maria Novella.

His disciple Michele, who, as I have said, is called by no other name than Michele di Ridolfo, has painted in fresco, since Ridolfo left the world of art, three great arches over certain gates of the city of Florence; at S. Gallo, Our Lady, S. John the Baptist, and S. Cosimo, which are executed with very beautiful mastery; at the Porta al Prato, other similar figures; and, at the Porta alla Croce, Our Lady, S. John the Baptist, and S. Ambrogio; with

altar-pieces and pictures without number, painted with good mastery. And I, on account of his goodness and capacity, have employed him several times, together with others, in the works of the Palace, with much satisfaction to myself and everyone besides. But that which pleases me most in him, in addition to his being a truly honest, orderly, and God-fearing man, is that he has always in his workshop a good number of young men, whom he teaches with incredible lovingness.

A disciple of Ridolfo, also, was Carlo Portelli of Loro in the Valdarno di Sopra, by whose hand are some altar-pieces and innumerable pictures in Florence; as in S. Maria Maggiore, in S. Felicita, in the Nunnery of Monticelli, and, at Cestello, the altar-piece of the Chapel of the Baldesi on the right hand of the entrance into the church, wherein is the Martyrdom of S. Romolo, Bishop of Fiesole.

GIOVANNI DA UDINE, Painter

In Udine, a city of Friuli, lived a citizen called Giovanni, of the family of the Nanni, who was the first of that family to give attention to the practice of embroidery, in which his descendants afterwards followed him with such excellence, that their house was called no longer De' Nanni but De' Ricamatori.* Among them, then, one Francesco, who lived always like an honourable citizen, devoted to the chase and to other suchlike exercises, had in the year 1494 a son, to whom he gave the name Giovanni; and this son, while still a child, showed such inclination to design that it was a thing to marvel at, for, following behind his father in his hunting and fowling, whenever he had time he was for ever drawing dogs, hares, bucks, and, in short, all the kinds of birds and beasts that came into his hands; which he did in such a fashion that everyone was astonished. Perceiving this inclination, his father Francesco took him to Venice, and placed him to learn the art of design with Giorgione da Castelfranco; but, while working under him, the boy heard the works of Michelagnolo and Raffaello so extolled, that he resolved at all costs to go to Rome. And so, having obtained from Domenico Grimani, who

* Embroiderers.

was much his father's friend, letters of introduction to Baldassarre Castiglioni, the Secretary of the Duke of Mantua and a close friend of Raffaello da Urbino, he went off to that city. There, having been placed by that Castiglioni in the school of the young men of Raffaello, he learned excellently well the principles of art, a thing which is of great importance, for the reason that when a man begins by adopting a bad manner, it rarely happens that he can abandon it without great difficulty, in order to learn a better.

Giovanni, then, having been only a very short time under the discipline of Giorgione in Venice, when he had once seen the sweet, graceful, and beautiful manner of Raffaello, determined, like a young man of fine intelligence, that he would at all costs attach himself to that manner. And so, his brain and hand being equal to his noble intention, he made so much proficience, that in a short time he was able to draw very well and to work in colour with facility and grace, insomuch that, to put it in a few words, he succeeded in counterfeiting excellently well every natural object – animals, draperies, instruments, vases, landscapes, buildings, and verdure; in which not one of the young men of that school surpassed him. But, above all, he took supreme delight in depicting birds of every kind, insomuch that in a short time he filled a book with them, which was so well varied and so beautiful, that it was a recreation and a delight to Raffaello. Living with Raffaello was a Fleming called Giovanni, who was an excellent master in depicting fruits, leaves, and flowers with a very faithful and pleasing likeness to nature, although in a manner a little dry and laboured; and from him Giovanni da Udine learned to make them as beautiful as his master, and, what is more, with a certain soft and pastose manner that enabled him to become, as will be related, supremely excellent in some fields of art. He also learned to execute landscapes with ruined buildings and fragments of antiquities, and likewise to paint landscapes and verdure in colours on cloth, in the manner that has been followed after him not only by the Flemings, but also by all the Italian painters.

Raffaello, who much loved the genius of Giovanni, in executing the altar-picture of S. Cecilia that is in Bologna, caused him to paint the organ which that Saint has in her hand; and he counterfeited it so well from the reality, that it appears as if in relief, and also all the musical instruments that are at the feet of the Saint. But what was of much greater import was that he made

his painting so similar to that of Raffaello, that the whole appears as if by one and the same hand. Not long afterwards, excavations being made at S. Pietro in Vincula, among the ruins and remains of the Palace of Titus, in the hope of finding figures, certain rooms were discovered, completely buried under the ground, which were full of little grotesques, small figures, and scenes, with other ornaments of stucco in low-relief. Whereupon, Giovanni going with Raffaello, who was taken to see them, they were struck with amazement, both the one and the other, at the freshness, beauty, and excellence of those works, for it appeared to them an extraordinary thing that they had been preserved for so long a time; but it was no great marvel, for they had not been open or exposed to the air, which is wont in time, through the changes of the seasons, to consume all things. These grotesques – which were called grotesques from their having been discovered in the underground grottoes – executed with so much design, with fantasies so varied and so bizarre, with their delicate ornaments of stucco divided by various fields of colour, and with their little scenes so pleasing and beautiful, entered so deeply into the heart and mind of Giovanni, that, having devoted himself to the study of them, he was not content to draw and copy them merely once or twice; and he succeeded in executing them with facility and grace, lacking nothing save a knowledge of the method of making the stucco on which the grotesques were wrought. Now many before him, as has been related, had exercised their wits on this, but had discovered nothing save the method of making the stucco, by means of fire, with gypsum, lime, colophony, wax, and pounded brick, and of overlaying it with gold; and they had not found the true method of making stucco similar to that which had been discovered in those ancient chambers and grottoes. But at that time works were being executed in lime and pozzolana, as was related in the Life of Bramante, for the arches and the tribune at the back in S. Pietro, all the ornaments of foliage, with the ovoli and other members, being cast in moulds of clay, and Giovanni, after considering that method of working with lime and pozzolana, began to try if he could succeed in making figures in low-relief; and so, pursuing his experiments, he contrived to make them as he desired in every part, save that the outer surface did not come out with the delicacy and finish that the ancient works possessed, nor yet so white. On which account he began to think that it might be necessary to mix with the white lime of

travertine, in place of pozzolana, some substance white in colour; whereupon, after making trial of various materials, he caused chips of travertine to be pounded, and found that it answered passing well, but that still the work was of a livid rather than a pure white, and also rough and granular. But finally, having caused chips of the whitest marble that could be found to be pounded and reduced to a fine powder, and then sifted, he mixed it with white lime of travertine, and discovered that thus he had succeeded without any doubt in making the true stucco of the ancients, with all the properties that he had desired therein. At which rejoicing greatly, he showed to Raffaello what he had done; wherefore he, who was then executing by order of Pope Leo X, as has been related, the Loggie of the Papal Palace, caused Giovanni to decorate all the vaulting there in stucco, with most beautiful ornaments bordered by grotesques similar to the antique, and with very lovely and fantastic inventions, all full of the most varied and extravagant things that could possibly be imagined. Having executed the whole of that ornamentation in half-relief and low-relief, he then divided it up with little scenes, landscapes, foliage, and various friezes, in which he touched the highest level, as it were, that art can reach in that field.

In all this he not only equalled the ancients, but also, in so far as one can judge from the remains that we have seen, surpassed them, for the reason that these works of Giovanni's, in beauty of design, in the invention of figures, and in colouring, whether executed in stucco or painted, are beyond all comparison superior to those of the ancients that are to be seen in the Colosseum, and to the paintings in the Baths of Diocletian and in other places. In what other place are there to be seen birds painted that are more lifelike and natural, so to speak, in colouring, in the plumage, and in all other respects, than those that are in the friezes and pilasters of the Loggie? And they are there in as many varieties as Nature herself has been able to create, some in one manner and some in another; and many are perched on bunches, ears, and panicles, not only of corn, millet, and buckwheat, but of all the kinds of cereals, vegetables, and fruits that earth has produced from the beginning of time for the sustenance and nourishment of birds. As for the fishes, likewise, the sea-monsters, and all the other creatures of the water that Giovanni depicted in the same place, since the most that one could say would be too little, it is better to pass them over in

silence rather than seek to attempt the impossible. And what should I say of the various kinds of fruits and flowers without number that are there, in all the forms, varieties, and colours that Nature contrives to produce in all parts of the world and in all the seasons of the year? What, likewise, of the various musical instruments that are there, all as real as the reality? And who does not know as a matter of common knowledge that – Giovanni having painted at the head of the Loggia, where the Pope had not yet determined what should be done in the way of masonry, some balusters to accompany the real ones of the Loggia, and over them a carpet – who, I say, does not know that one day, a carpet being urgently required for the Pope, who was going to the Belvedere, a groom, who knew not the truth of the matter, ran from a distance to take one of those painted carpets, being completely deceived? In short, it may be said, without offence to other craftsmen, that of all works of the kind this is the most beautiful, the most rare, and the most excellent painting that has ever been seen by mortal eye. And, in addition, I will make bold to say that this work has been the reason that not Rome only but also all the other parts of the world have been filled with this kind of painting, for, besides that Giovanni was the restorer and almost the inventor of grotesques in stucco and of other kinds, from this his work, which is most beautiful, whoever has wished to execute such things has taken his exemplar; not to mention that the young men that assisted Giovanni, who were many, and even, what with one time and another, innumerable, learned from the true master and filled every province with them.

Then, proceeding to execute the first range below those Loggie, Giovanni used another and quite different method in the distribution of the stucco-work and paintings on the walls and vaultings of the other Loggie; but nevertheless those also were very beautiful, by reason of the pleasing invention of the pergole of canes counterfeited in various compartments, all covered with vines laden with grapes, and with clematis, jasmine, roses, and various kinds of birds and beasts. Next, Pope Leo, wishing to have painted the hall where the guard of halberdiers have their quarters, on the level of the above-named Loggie, Giovanni, in addition to the friezes of children, lions, Papal arms, and grotesques that are round that hall, made some divisions on the walls with imitations of variegated marbles of different kinds, similar to the incrustations that the ancient Romans used to make on their

baths, temples, and other buildings, such as may be seen in the
Ritonda and in the portico of S. Pietro. In another hall beside
that one, which was used by the Chamberlains, Raffaello da Ur-
bino painted in certain tabernacles some Apostles in chiaroscuro,
large as life and very beautiful; and over the cornices of that work
Giovanni portrayed from life many parrots of various colours
which his Holiness had at that time, and also baboons, marmo-
sets, civet-cats, and other strange creatures. But this work had a
short life, for the reason that Pope Paul IV destroyed that apart-
ment in order to make certain small closets and little places of
retirement, and thus deprived the Palace of a very rare work;
which that holy man would not have done if he had possessed
any taste for the arts of design. Giovanni painted the cartoons
for those hangings and chamber-tapestries that were afterwards
woven in silk and gold in Flanders, in which are certain little boys
that are sporting around various festoons, and as ornaments the
devices of Pope Leo and various animals copied from life. These
tapestries, which are very rare works, are still in the Palace at the
present day. He also executed the cartoons for some tapestries
full of grotesques, which are in the first rooms of the Consistory.

While Giovanni was labouring at those works, the Palace of
M. Giovan Battista dall' Aquila, which had been erected at the
head of the Borgo Nuovo, near the Piazza di S. Pietro, had
the greater part of the façade decorated in stucco by the hand
of the same master, which was held to be a remarkable work.
The same Giovanni executed the paintings and all the stucco-
work in the loggia of the villa that Cardinal Giulio de' Medici
caused to be built under Monte Mario, wherein are animals, grot-
esques, festoons, and friezes of such beauty, that it appears as if
in that work Giovanni had sought to outstrip and surpass his
own self. Wherefore he won from that Cardinal, who much loved
his genius, in addition to many benefits that he received for his
relatives, the gift of a canonicate for himself at Civitale in Friuli,
which was afterwards given by Giovanni to a brother of his own.
Then, having to make for the same Cardinal, likewise at that villa,
a fountain with the water spouting through the trunk of an ele-
phant's head in marble, he imitated in the whole work and in
every detail the Temple of Neptune, which had been discovered
a short time before among the ancient ruins of the Palazzo Mag-
giore, all adorned with lifelike products of the sea, and wrought
excellently well with various ornaments in stucco; and he even

surpassed by a great measure the artistry of that ancient hall by giving great beauty to those animals, shells, and other suchlike things without number, and arranging them very well. After this he made another fountain, but in a rustic manner, in the hollow of a torrent-bed surrounded by a wood; causing water to flow in drops and fine jets from sponge-stones and stalactites, with beautiful artifice, so that it had all the appearance of a work of nature. On the highest point of those hollow rocks and sponge-stones he fashioned a large lion's head, which had around it a garland formed of maidenhair and other plants, trained there with great artistry; and no one could believe what grace these gave to that wild place, which was most beautiful in every part and beyond all conception pleasing.

That work finished, after the Cardinal had made Giovanni a Chevalier of S. Pietro, he sent him to Florence, to the end that, when a certain chamber had been made in the Palace of the Medici (at that corner, namely, where the elder Cosimo, the builder of that edifice, had made a loggia for the convenience and assemblage of the citizens, as it was the custom at that time for the most noble families to do), he might paint and adorn it all with grotesques and stucco. That loggia having then been enclosed after the design of Michelagnolo Buonarroti, and given the form of a chamber, with two knee-shaped windows, which were the first to be made in that manner, with iron gratings, for the exterior of a palace, Giovanni adorned all the vaulting with stucco-work and painting, making in a medallion the six balls, the arms of the House of Medici, supported by three little boys executed in relief in attitudes of great beauty and grace. Besides this, he made there many most beautiful animals, and also many most lovely devices of gentlemen and lords of that illustrious house, together with some scenes in half-relief, executed in stucco; and on the field of the vaulting he did the rest of the work in pictures, counterfeiting them after the manner of cameos in black and white, and so well, that nothing better could be imagined. There remained four arches beneath the vaulting, each twelve braccia in breadth and six in height, which were not painted at that time, but many years afterwards by Giorgio Vasari, as a young man of eighteen years, when he was in the service of Duke Alessandro de' Medici, his first lord, in the year 1535; which Giorgio executed there stories from the life of Julius Cæsar, in allusion to the above-named Cardinal Giulio, who had caused the work to

be done. Giovanni then executed on a little barrel-shaped vault, beside that chamber, some works in stucco in the lowest of low-relief, and likewise some pictures, which are exquisite; but, although these pleased the painters that were in Florence at that time, being wrought with boldness and marvellous mastery, and filled with spirited and fantastic inventions, yet, since they were accustomed to a laboured manner of their own and to doing everything that they carried into execution with copies taken from life, they did not praise them without reserve, not being altogether decided in their minds, nor did they set themselves to imitate them, perhaps because they had not the courage.

Having then returned to Rome, Giovanni executed in the loggia of Agostino Chigi, which Raffaello had painted and was still engaged in carrying to completion, a border of large festoons right round the groins and squares of the vaulting, making there all the kinds of fruits, flowers, and leaves, season by season, and fashioning them with such artistry, that everything may be seen there living and standing out from the wall, and as natural as the reality; and so many are the various kinds of fruits and plants that are to be seen in that work, that, in order not to enumerate them one by one, I will say only this, that there are there all those that Nature has ever produced in our parts. Above the figure of a Mercury who is flying, he made, to represent Priapus, a pumpkin entwined in bind-weed, which has for testicles two egg-plants, and near the flower of the pumpkin he depicted a cluster of large purple figs, within one of which, over-ripe and bursting open, the point of the pumpkin with the flower is entering; which conceit is rendered with such grace, that no one could imagine anything better. But why say more? To sum the matter up, I venture to declare that in that kind of painting Giovanni surpassed all those who have best imitated Nature in such works, for the reason that, besides all the other things, even the flowers of the elder, of the fennel, and of the other lesser plants are there in truly astonishing perfection. There, likewise, may be seen a great abundance of animals in the lunettes, which are encircled by those festoons, and certain little boys that are holding in their hands the attributes of the Gods; and, among other things, a lion and a sea-horse, being most beautifully foreshortened, are held to be divine.

Having finished that truly extraordinary work, Giovanni executed a very beautiful bath-room in the Castello di S. Angelo,

and in the Papal Palace, besides those mentioned above, many other small works, which for the sake of brevity are passed over. Raffaello having then died, whose loss much grieved Giovanni, and Pope Leo having also left this world, there was no more place in Rome for the arts of design or for any other art, and Giovanni occupied himself for many months on some works of little importance at the villa of the above-named Cardinal de' Medici. And for the arrival of Pope Adrian in Rome he did nothing but the small banners of the Castle, which he had renewed twice in the time of Pope Leo, together with the great standard that flies on the summit of the highest tower. He also executed four square banners when the Blessed Antonino, Archbishop of Florence, and S. Hubert, once Bishop of I know not what city of Flanders, were canonized as Saints by the abovementioned Pope Adrian; of which banners, one, wherein is the figure of that S. Antonino, was given to the Church of S. Marco in Florence, where the body of the Saint lies, another, wherein is the figure of S. Hubert, was placed in S. Maria de Anima, the church of the Germans in Rome, and the other two were sent to Flanders.

Clement VII having then been elected Supreme Pontiff, with whom Giovanni had a strait bond of service, he returned immediately from Udine, whither he had gone to avoid the plague, to Rome; where having arrived, he was commissioned to make a rich and beautiful decoration over the steps of S. Pietro for the coronation of that Pope. And afterwards it was ordained that he and Perino del Vaga should paint some pictures on the vaulting of the old hall opposite to the lower apartments, which lead from the Loggie, which he had painted before, to the apartments of the Borgia Tower; whereupon Giovanni executed there a most beautiful design in stucco-work, with many grotesques and various animals, and Perino the cars of the seven planets. They had also to paint the walls of that same hall, on which Giotto, according as is written by Platina in the Lives of the Pontiffs, had formerly painted some Popes who had been put to death for the faith of Christ, on which account that hall was called for a time the Hall of the Martyrs. But the vaulting was scarcely finished, when there took place that most unhappy sack of Rome, and the work could not be pursued any further. Thereupon Giovanni, having suffered not a little both in person and in property, returned again to Udine, intending to stay there a long time; but in

that he did not succeed, for the reason that Pope Clement, after returning from Bologna, where he had crowned Charles V, to Rome, caused Giovanni also to return to that city, where he commissioned him first to make anew the standards of the Castello di S. Angelo, and then to paint the ceiling of the great chapel, the principal one in S. Pietro, where the altar of that Saint is. Meanwhile, Fra Mariano having died, who had the office of the Piombo, his place was given to Sebastiano Viniziano, a painter of great repute, and to Giovanni a pension on the same of eighty chamber-ducats.

Then, after the troubles of the Pontiff had in great measure ceased and affairs in Rome had grown quiet, Giovanni was sent by his Holiness with many promises to Florence, to execute in the new sacristy of S. Lorenzo, which had been adorned with most excellent sculptures by Michelagnolo, the ornaments of the tribune, which is full of sunk squares that diminish little by little towards the central point. Setting his hand to this, then, Giovanni carried it excellently well to completion with the aid of many assistants, with most beautiful foliage, rosettes, and other ornaments of stucco and gold; but in one thing he failed in judgment, for the reason that on the flat friezes that form the ribs of the vaulting, and on those that run crossways, so as to enclose the squares, he made foliage, birds, masks, and figures that cannot be seen at all from the ground, although they are very beautiful, by reason of the distance, and also because they are divided up by other colours, whereas, if he had painted them in colours without any other elaboration, they would have been visible, and the whole work would have been brighter and richer. There remained no more of the work to be executed than he would have been able to finish in a fortnight, going over it again in certain places, when there came the news of the death of Pope Clement, and Giovanni was robbed of all his hopes, particularly of that which he expected from that Pontiff as the reward and guerdon of this work. Wherefore, having recognized, although too late, how fallacious in most cases are the hopes based on the favour of Courts, and how often those who put their trust in the lives of particular Princes are left disappointed, he returned to Rome; but, although he would have been able to live there on his offices and revenues, serving also Cardinal Ippolito de' Medici and the new Pontiff, Paul III, he resolved to repatriate himself and to return to Udine.

Carrying that intention into effect, therefore, he went back to live in his native place with that brother to whom he had given the canonicate, determined that he would never more handle a brush. But in this also he was disappointed, for the reason that, having taken a wife and had children by her, he was in a manner forced by the instinct that a man naturally feels to bring up his children and to leave them in good circumstances, to set himself once more to work. He painted, then, at the entreaty of the father of the Chevalier Giovan Francesco di Spilimbergo, a frieze in a hall, filling it with children, festoons, fruits, and other things of fancy. After that, he adorned with lovely paintings and works in stucco the Chapel of S. Maria at Civitale; and for the Canons of the Duomo of that place he executed two most beautiful standards. And for the Confraternity of S. Maria di Castello, at Udine, he painted on a rich banner Our Lady with the Child in her arms, and an Angel full of grace who is offering to her that Castello, which stands on a hill in the centre of the city. At Venice, in the Palace of Grimani, the Patriarch of Aquileia, he decorated with stucco-work and paintings a very beautiful chamber in which are some lovely little scenes by the hand of Francesco Salviati.

Finally, in the year 1550, Giovanni went to Rome to take part in the most holy Jubilee, on foot and dressed poorly as a pilgrim, and in the company of humble folk; and he stayed there many days without being known by anyone. But one day, while going to S. Paolo, he was recognized by Giorgio Vasari, who was riding in a coach to the same Pardon in company with Messer Bindo Altoviti, who was much his friend. At first Giovanni denied that it was he, but finally he was forced to reveal himself and to confess that he had great need of Giorgio's assistance with the Pope in the matter of the pension that he had from the Piombo, which was being denied to him by one Fra Guglielmo, a Genoese sculptor, who had received that office after the death of Fra Sebastiano. Giorgio spoke of this matter to the Pope, which was the reason that the bond was renewed, and afterwards it was proposed to exchange it for a canonicate at Udine for Giovanni's son. But afterwards, being again defrauded by that Fra Guglielmo, Giovanni went from Udine to Florence, after Pope Pius had been elected, in the hope of being assisted and favoured by his Excellency with that Pontiff, by means of Vasari. Having arrived in Florence, then, he was presented by Giorgio to his most

illustrious Excellency, with whom he went to Siena, and then from there to Rome, whither there also went the Lady Duchess Leonora; and in such wise was he assisted by the kindness of the Duke, that he was not only granted all that he desired, but also set to work by the Pope with a good salary to give the final completion to the last Loggia, which is the one over that which Pope Leo had formerly caused him to decorate. That finished, the same Pope commissioned him to retouch all that first Loggia, which was an error and a thing very ill considered, for the reason that retouching it 'a secco' caused it to lose all those masterly strokes that had been drawn by Giovanni's brush in all the excellence of his best days, and also the boldness and freshness that had made it in its original condition so rare a work.

After finishing that work, Giovanni, being seventy years of age, finished also the course of his life, in the year 1564, rendering up his spirit to God in that most noble city which had enabled him for many years to live with so much success and so great a name. Giovanni was always, but much more in his last years, a God-fearing man and a good Christian. In his youth he took pleasure in scarcely any other thing but hunting and fowling; and his custom when he was young was to go hunting on feast-days with his servant, at times roaming over the Campagna to a distance of ten miles from Rome. He could shoot very well with the fusil and the crossbow, and therefore rarely returned home without his servant being laden with wild geese, ringdoves, wild ducks, and other creatures such as are to be found in those marshy places. Giovanni, so many declare, was the inventor of the ox painted on canvas that is made for using in that pursuit, so as to fire off the fusil without being seen by the wild creatures; and on account of those exercises of hunting and fowling he always delighted to keep dogs and to train them by himself.

Giovanni, who deserves to be extolled among the greatest masters of his profession, chose to be buried in the Ritonda, near his master Raffaello da Urbino, in order not to be divided in death from him to whom in life his spirit was always attached; and since, as has been told, each of them was an excellent Christian, it may be believed that they are still together in eternal blessedness.

BATTISTA FRANCO, Painter of Venice

BATTISTA FRANCO of Venice, having given his attention in his early childhood to design, went off at the age of twenty, as one who aimed at perfection in that art, to Rome, where, after he had devoted himself for some time with much study to design, and had seen the manner of various masters, he resolved that he would not study or seek to imitate any other works but the drawings, paintings, and sculptures of Michelagnolo; wherefore, having set himself to make research, there remained no sketch, study, or even any thing copied by Michelagnolo that he had not drawn. Wherefore no long time passed before he became one of the first draughtsmen who frequented the Chapel of Michelagnolo; and, what was more, he would not for a time set himself to paint or to do any other thing but draw. But in the year 1536, festive preparations of a grand and sumptuous kind being arranged by Antonio da San Gallo for the coming of the Emperor Charles V, in which, as has been related in another place, all the craftsmen, good and bad, were employed, Raffaello da Montelupo, who had to execute the decorations of the Ponte S. Angelo with the ten statues that were placed upon it, having seen that Battista was a young man of good parts and a finished draughtsman, resolved to bring it about that he also should be employed, and by hook or by crook to have some work given to him to do. And so, having spoken of this to San Gallo, he so contrived that Battista was commissioned to execute in fresco four large scenes in chiaroscuro on the front of the Porta Capena, now called the Porta di S. Bastiano, through which the Emperor was to enter.

In that work Battista, without having hitherto touched colours, executed over the gate the arms of Pope Paul III and those of the Emperor Charles, with a Romulus who was placing on the arms of the Pontiff a Papal crown, and on those of the Emperor an Imperial crown; which Romulus, a figure of five braccia, dressed in the ancient manner, with a crown on the head, had on the right hand Numa Pompilius, and on the left Tullus Hostilius, and above him these words – Quirinus Pater. In one of the scenes that were on the faces of the towers standing on either side of the gate, was the elder Scipio triumphing over Carthage, which he had made tributary to the Roman people; and in the other, on the right hand, was the triumph of the younger Scipio,

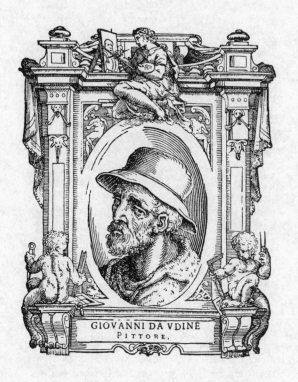

GIOVANNI DA VDINE
PITTORE.

who had ruined and destroyed that same city. In one of the two pictures that were on the exterior of the towers, on the front side, could be seen Hannibal under the walls of Rome, driven back by the tempest, and in the other, on the left, Flaccus entering by that gate to succour Rome against that same Hannibal. All these scenes and pictures, being Battista's first paintings, and in comparison with those of the others, were passing good and much extolled. And, if Battista had begun from the first to paint and from time to time to practise using colours and handling brushes, there is no doubt that he would have surpassed many craftsmen; but his obstinate adherence to a certain opinion that many others hold, who persuade themselves that draughtsmanship is enough for him who wishes to paint, did him no little harm. For all that, however, he acquitted himself much better than did some of those who executed the scenes on the arch of S. Marco, on which there were eight scenes, four on each side, the best of which were painted partly by Francesco Salviati, and partly by a certain Martino* and other young Germans, who had come to Rome at that very time in order to learn. Nor will I omit to tell, in this connection, that the above-named Martino, who was very able in works in chiaroscuro, executed some battle scenes with such boldness and such beautiful inventions in certain encounters and deeds of arms between Christians and Turks, that nothing better could have been done. And the marvellous thing was that Martino and his assistants executed those canvases with such assiduity and rapidity, in order that the work might be finished in time, that they never quitted their labour; and since drink, and that good Greco, was continually being brought to them, what with their being constantly drunk and inflamed with the heat of the wine, and their facility in execution, they achieved wonders. Wherefore, when Salviati, Battista, and Calavrese saw the work of these men, they confessed that for him who wishes to be a painter it is necessary to begin to handle brushes in good time; which matter having afterwards considered more carefully in his own mind, Battista began not to give so much study to finishing his drawings, and at times to use colour.

Montelupo then going to Florence, where, in like manner, very great preparations were being made for the reception of the above-named Emperor, Battista went with him, and when they

* Martin Heemskerk.

arrived they found those preparations well on the way to completion; but Battista, being set to work, made a base all covered with figures and trophies for the statue on the Canto de' Carnesecchi that Fra Giovanni Agnolo Montorsoli had executed. Having therefore become known among the craftsmen as a young man of good parts and ability, he was much employed afterwards at the coming of Madama Margherita of Austria, the wife of Duke Alessandro, and particularly in the festive preparations that Giorgio Vasari made in the Palace of Messer Ottaviano de' Medici, where that lady was to reside.

These festivities finished, Battista set himself to draw with the greatest industry the statues of Michelagnolo that are in the new Sacristy of S. Lorenzo, to which at that time all the painters and sculptors of Florence had flocked to draw and to work in relief; and among these Battista made no little proficience, but, nevertheless, it was recognized that he had committed an error in never consenting to draw from the life and to use colours, or to do anything but imitate statues and little else besides, which had given his manner a hardness and dryness that he was not able to shake off, nor could he prevent his works from having a hard and angular quality, as may be seen from a canvas in which he depicted with much pains and labour the Roman Lucretia violated by Tarquinius. Consorting thus with the others and frequenting that sacristy, Battista formed a friendship with the sculptor Bartolommeo Ammanati, who was studying the works of Buonarroti there in company with many others. And of such a kind was that friendship, that Ammanati took Battista into his house, as well as Genga of Urbino, and they lived thus in company for some time, attending with much profit to the studies of art.

Duke Alessandro having then been done to death in the year 1536, and Signor Cosimo de' Medici elected in his place, many of the servants of the dead Duke remained in the service of the new, but others did not, and among those who went away was the above-named Giorgio Vasari, who returned to Arezzo, with the intention of having nothing more to do with Courts, having lost Cardinal Ippolito de' Medici, his first lord, and then Duke Alessandro; but he brought it about that Battista was invited to serve Duke Cosimo and to work in his guardaroba, where he painted in a large picture Pope Clement and Cardinal Ippolito, copying them from a work by Fra Sebastiano and from one by Tiziano, and Duke Alessandro from a picture by Pontormo. This picture

was not of that perfection that was expected; but, having seen in the same guardaroba the cartoon of the 'Noli me tangere' by Michelagnolo, which Pontormo had previously executed in colours, he set himself to make a cartoon like it, but with larger figures; which done, he painted a picture from it wherein he acquitted himself much better in the colouring. And the cartoon, which he copied exactly after that of Michelagnolo, was executed with great patience and very beautiful.

The affair of Monte Murlo having then taken place, in which the exiles and rebels hostile to the Duke were routed and captured, Battista depicted with beautiful invention a scene of the battle fought there, mingled with poetic fantasies of his own, which was much extolled, although there were recognized in the armed encounter and in the taking of the prisoners many things copied bodily from the works and drawings of Buonarroti. For the battle was in the distance, and in the foreground were the huntsmen of Ganymede, who were standing there gazing at Jove's Eagle carrying the young man away into Heaven; which part Battista took from the design of Michelagnolo, in order to use it to signify that the young Duke had risen by the grace of God from the midst of his friends into Heaven, or some such thing. This scene, I say, was first drawn by Battista in a cartoon, and then painted with supreme diligence in a picture; and it is now, together with his other works mentioned above, in the upper apartments of the Pitti Palace, which his most illustrious Excellency has just caused to be completely finished.

Having thus been engaged on these and some other works in the service of the Duke, until the time when he took to wife the Lady Donna Leonora of Toledo, Battista was next employed in the festive preparations for those nuptials, on the triumphal arch at the Porta al Prato, where Ridolfo Ghirlandajo caused him to execute some scenes of the actions of Signor Giovanni, father of Duke Cosimo. In one of these that lord could be seen passing the Rivers Po and Adda, in the presence of Cardinal Giulio de' Medici, who became Pope Clement VII, Signor Prospero Colonna, and other lords; and in another was the scene of the delivering of San Secondo. On the other side Battista painted in another scene the city of Milan, and around it the Camp of the League, which, on departing, the above-named Signor Giovanni leaves there. On the right flank of the arch he painted on one side a picture of Opportunity, who, having her tresses all unbound, was

offering them with one hand to Signor Giovanni, and on the other side Mars, who was likewise offering him his sword. In another scene under the arch, by the hand of Battista, was Signor Giovanni fighting between the Tesino and Biegrassa upon the Ponte Rozzo, defending it, as it were like another Horatius, with incredible bravery. Opposite to this was the Taking of Caravaggio, and in the centre of the battle Signor Giovanni, who was passing fearlessly through fire and sword in the midst of the hostile army. Between the columns, on the right hand, there was in an oval Garlasso, taken by the same lord with a single company of soldiers, and on the left hand, between the two other columns, the bastion of Milan, likewise taken from the enemy. On the fronton, which was at the back of anyone entering, was the same Signor Giovanni on horseback under the walls of Milan, when, tilting in single combat with a knight, he ran him through from side to side with his lance. Above the great cornice, which reached out to the other cornice, on which the pediment rested, in another large scene executed by Battista with much diligence, there was in the centre the Emperor Charles V, who, crowned with laurel, was seated on a rock, with the sceptre in his hand; at his feet lay the River Betis with a vase that poured water from two mouths, and beside that figure was the River Danube, which, with seven mouths, was pouring its waters into the sea. I shall not make mention here of the vast number of statues that accompanied the above-named pictures and others on that arch, for the reason that it is enough for me at the present moment to describe that which concerns Battista Franco, and it is not my office to give an account of all that was done by others in the festive preparations for those nuptials and described at great length; besides which, having spoken of the masters of those statues where the necessity arose, it would be superfluous for me to say anything about them here, and particularly because the statues are not now standing, so that they cannot be seen and considered. But to return to Battista: the best thing that he did for those nuptials was one of the ten above-mentioned pictures which were in the decorations in the great court of the Medici Palace, wherein he painted in chiaroscuro Duke Cosimo invested with all the Ducal insignia. But, for all the diligence that he used there, he was surpassed by Bronzino, and by others who had less design than himself, in invention, in boldness, and in the treatment of the chiaroscuro. For, as has been said before, pictures must be

executed with facility, and the parts set in their places with judgment, and without that effort and that labour which make things appear hard and crude; besides which, overmuch study often makes them come out heavy and dark, and spoils them, while lingering over them so long takes away the grace, boldness and excellence that facility is wont to give them. And these qualities, although they come in great measure as gifts from nature, can also in part be acquired by study and art.

Having then been taken by Ridolfo Ghirlandajo to the Madonna di Vertigli in Valdichiana (which place was once attached to the Monastery of the Angeli, of the Order of Camaldoli, in Florence, and is now an independent body in place of the Monastery of S. Benedetto, which, being without the Porta a Pinti, was destroyed on account of the siege of Florence), Battista painted there the scenes in the cloister already mentioned, while Ridolfo was executing the altar-piece and the ornaments of the high-altar. These finished, as has been related in the Life of Ridolfo, they adorned with other pictures that holy place, which is very celebrated and renowned for the many miracles that are wrought there by the Virgin Mother of the Son of God.

Battista then returned to Rome, at the very time when the Judgment of Michelagnolo had just been uncovered; and, being a zealous student of the manner and works of that master, he gazed at it very gladly, and in infinite admiration made drawings of it all. And then, having resolved to remain in Rome, at the commission of Cardinal Francesco Cornaro – who had rebuilt the palace that he occupied beside S. Pietro, which looks out on the portico in the direction of the Camposanto – he painted over the stucco a loggia that looks towards the Piazza, making there a kind of grotesques all full of little scenes and figures; which work, executed with much labour and diligence, was held to be very beautiful.

About the same time, which was the year 1538, Francesco Salviati, having painted a scene in fresco in the Company of the Misericordia, was to give it the final completion and to set his hand to others, which many private citizens desired to have painted; but, by reason of the rivalry that there was between him and Jacopo del Conte, nothing more was done; which hearing, Battista sought to obtain by this means an opportunity to prove himself superior to Francesco and the best master in Rome; and he so went to work, employing his friends and other means, that

Monsignor della Casa, after seeing a design by his hand, allotted
the work to him. Thereupon, setting his hand to it, he painted
there in fresco S. John the Baptist taken at the command of
Herod and cast into prison. But, although this picture was ex-
ecuted with much labour, it was not held to be equal by a great
measure to that of Salviati, from its having been painted with
very great effort and in a manner crude and melancholy, while it
had no order in the composition, nor in a single part any of that
grace and charm of colouring which Francesco's work possessed.
And from this it may be concluded that those men are deceived
who, in pursuing this art, give all their attention to executing well
and with a good knowledge of muscles a torso, an arm, a leg, or
other member, believing that a good grasp of that part is the
whole secret; for the reason that the part of a work is not the
whole, and only he carries it to perfect completion, in a good and
beautiful manner, who, after executing the parts well, knows how
to make them fit in due proportion into the whole, and who,
moreover, so contrives that the composition of the figures ex-
presses and produces well and without confusion the effect that
it should produce. And, above all, care must be taken to make
the heads vivacious, spirited, gracious, and beautiful in the ex-
pressions, the manner not crude, and the nudes so tinted with
black that they may have relief, melting gradually into the distance
according as may be required; to say nothing of the perspective-
views, landscapes, and other parts that good pictures demand,
nor that in making use of the works of others a man should
proceed in such a manner that this may not be too easily recog-
nized. Battista thus became aware too late that he had wasted
time beyond all reason over the minutiæ of muscles and over
drawing with too great diligence, while paying no attention to the
other fields of art.

Having finished that work, which brought him little praise,
Battista transferred himself by means of Bartolommeo Genga to
the service of the Duke of Urbino, to paint a very large vaulting
in the church and chapel attached to the Palace of Urbino. Hav-
ing arrived there, he set himself straightway to make the designs
according as the invention presented itself in the work, without
giving it any further thought and without making any compart-
ments. And so in imitation of the Judgment of Buonarroti, he
depicted in a Heaven the Glory of the Saints, who are dispersed
over that vaulting on certain clouds, with all the choirs of the

Angels about a Madonna, who, having ascended into Heaven, is received by Christ, who is in the act of crowning her, while in various separate groups stand the Patriarchs, the Prophets, the Sibyls, the Apostles, the Martyrs, the Confessors, and the Virgins; which figures, in their different attitudes, reveal their rejoicing at the advent of that Glorious Virgin. This invention would certainly have given Battista a great opportunity to prove himself an able master, if he had chosen a better way, not only making himself well-practised in fresco-colours, but also proceeding with better order and judgment than he displayed in all his labour. But he used in this work the same methods as in all his others, for he made always the same figures, the same countenances, the same members, and the same draperies; besides which, the colouring was without any charm, and everything laboured and executed with difficulty. When all was finished, therefore, it gave little satisfaction to Duke Guidobaldo, Genga, and all the others who were expecting great things from that master, equal to the beautiful design that he had shown to them in the beginning; for, in truth, in making beautiful designs Battista had no peer and could be called an able man. Which recognizing, the Duke thought that his designs would succeed very well if carried into execution by those who were fashioning vases of clay so excellently at Castel Durante, for which they had availed themselves much of the prints of Raffaello da Urbino and other able masters; and he caused Battista to draw innumerable designs, which, when put into execution in that sort of clay, the most kindly of all that there are in Italy, produced a rare result. Wherefore vases were made in such numbers and of as many kinds as would have sufficed to do honour to the credence of a King; and the pictures that were painted on them would not have been better if they had been executed in oils by the most excellent masters. Of these vases, which in the quality of the clay much resemble the kind that was wrought at Arezzo in ancient times, in the days of Porsenna, King of Tuscany, the above-named Duke Guidobaldo sent enough for a double credence to the Emperor Charles V, and a set to Cardinal Farnese, the brother of Signora Vittoria, his consort. And it is right that it should be known that of this kind of paintings on vases, in so far as we can judge, the Romans had none, for the vases of those times, filled with the ashes of their dead or used for other purposes, are covered with figures hatched and grounded with only one colour, either black, or red, or white;

nor have they ever that lustrous glazing or that charm and variety of paintings which have been seen and still are seen in our own times. Nor can it be said that, if perchance they did have such things, the paintings have been consumed by time and by their having been buried, for the reason that we see our own resisting the assaults of time and every other danger, insomuch that it may even be said that they might remain four thousand years under the ground without the paintings being spoilt. Now, although vases and paintings of that kind are made throughout all Italy, yet the best and most beautiful works in clay are those that are wrought, as I have said, at Castel Durante, a place in the State of Urbino, and those of Faenza, the best of which are for the most part of a very pure white, with few paintings, and those in the centre or on the edges, but delicate and pleasing enough.

But to return to Battista: for the nuptials of the above-mentioned Lord Duke and Signora Vittoria Farnese, which took place afterwards at Urbino, he, assisted by his young men, executed on the arches erected by Genga, who was the head of the festive preparations, all the historical pictures that were painted upon them. Now, since the Duke doubted that Battista would not finish in time, the undertaking being very great, he sent for Giorgio Vasari – who at that time was painting at Rimini, for the White Friars of Scolca, of the Order of Monte Oliveto, a large chapel in fresco and an altar-piece in oils for their high-altar – to the end that he might go to the aid of Genga and Battista in those preparations. But Vasari, feeling indisposed, made his excuses to his Excellency and wrote to him that he should have no doubt, for the reason that the talents and knowledge of Battista were such that he would have everything finished in time, as indeed, in the end, he did. Giorgio then going, after finishing his works at Rimini, to visit that Duke and to make his excuses in person, his Excellency caused him to examine, to the end that he might value it, the above-mentioned chapel that had been painted by Battista, which Vasari much extolled, recommending the ability of that master, who was largely rewarded by the great liberality of that lord.

It is true, however, that Battista was not at that time in Urbino, but in Rome, where he was engaged in drawing not only the statues but all the antiquities of that city, and in making, as he did, a great book of them, which was a praiseworthy work. Now,

while Battista was giving his attention to drawing in Rome, Messer Giovanni Andrea dell' Anguillara, a man truly distinguished in certain forms of poetry, having got together a company of various choice spirits, was causing very rich scenery and decorations to be prepared in the large hall of S. Apostolo, in order to perform comedies by various authors before gentlemen, lords, and great persons. He had caused seats to be made for the spectators of different ranks, and for the Cardinals and other great prelates he had prepared certain rooms from which, through jalousies, they could see and hear without being seen. And since in that company there were painters, sculptors, architects, and men who were to perform the dramas and to fulfil other offices, Battista and Ammanati, having been chosen of the company, were given the charge of preparing the scenery, with some stories and ornaments in painting, which Battista executed so well (together with some statues that Ammanati made), that he was very highly extolled for them. But the great expenses of that place exceeded the means available, so that M. Giovanni Andrea and the others were forced to remove the prospect-scene and the other ornaments from S. Apostolo and to convey them into the new Temple of S. Biagio, in the Strada Giulia. There, Battista having once more arranged everything, many comedies were performed with extraordinary satisfaction to the people and courtiers of Rome; and from this origin there sprang in time the players who travel around, called the Zanni.

After these things, having come to the year 1550, Battista executed in company with Girolamo Siciolante of Sermoneta, for Cardinal di Cesis, on the façade of his palace, the coat of arms of Pope Julius III, who had been newly elected Pontiff, with three figures and some little boys, which were much extolled. That finished, he painted in the Minerva, in a chapel built by a Canon of S. Pietro and all adorned with stucco, some stories of the Madonna and of Jesus Christ in the compartments of the vaulting, which were the best works that he had ever executed up to that time. On one of the two walls he painted the Nativity of Jesus Christ, with some Shepherds, and Angels that are singing over the hut, and on the other the Resurrection of Christ, with many soldiers in various attitudes about the Sepulchre; and above each of those scenes, in certain lunettes, he executed some large Prophets. And finally, on the altar-wall, he painted Christ Crucified, Our Lady, S. John, S. Dominic, and some other Saints in

the niches; in all which he acquitted himself very well and like an excellent master.

But since his earnings were scanty and the expenses of Rome very great, after having executed some works on cloth, which had not much success, he returned to his native country of Venice, thinking by a change of country to change also his fortune. There, by reason of his fine manner of drawing, he was judged to be an able man, and a few days afterwards he was commissioned to execute an altar-piece in oils for the Chapel of Mons. Barbaro, Patriarch-elect of Aquileia, in the Church of S. Francesco della Vigna; in which he painted S. John baptizing Christ in the Jordan, in the air God the Father, at the foot two little boys who are holding the vestments of Christ, in the angles the Annunciation, and below these figures the semblance of a canvas superimposed, with a good number of little nude figures of Angels, Demons, and Souls in Purgatory, and with an inscription that runs – 'In nomine Jesu omne genuflectatur.' That work, which was certainly held to be very good, won him much credit and fame; indeed, it was the reason that the Frati de' Zoccoli, who have their seat in that place, and who have charge of the Church of S. Giobbe in Canareio, caused him to paint in the Chapel of the Foscari, in that Church of S. Giobbe, a Madonna who is seated with the Child in her arms, with a S. Mark on one side and a female Saint on the other, and in the air some Angels who are scattering flowers. In S. Bartolommeo, at the tomb of Cristofano Fuccheri, a German merchant, he executed a picture of Abundance, Mercury, and Fame. For M. Antonio della Vecchia, a Venetian, he painted in a picture with figures of the size of life and very beautiful Christ crowned with Thorns, and about them some Pharisees, who are mocking Him.

Meanwhile there had been built of masonry in the Palace of S. Marco, after the design of Jacopo Sansovino, as will be related in the proper place, the staircase that leads from the first floor upwards, and it had been adorned with various designs in stucco by the sculptor Alessandro, a disciple of Sansovino; and Battista painted very minute grotesques over it all, and in certain larger spaces a good number of figures in fresco, which have been extolled not a little by the craftsmen, and he then decorated the ceiling of the vestibule of that staircase. Not long afterwards, when, as has been related above, three pictures were given to each of the best and most renowned painters of Venice to paint

for the Library of S. Marco, on the condition that he who should acquit himself best in the judgment of those Magnificent Senators was to receive, in addition to the usual payment, a chain of gold, Battista executed in that place three scenes, with two Philosophers between the windows, and acquitted himself very well, although he did not win the prize of honour, as we said above.

After these works, having received from the Patriarch Grimani the commission for a chapel in S. Francesco della Vigna, which is the first on the left hand entering into the church, Battista set his hand to it and began to make very rich designs in stucco over the whole vaulting, with scenes of figures in fresco, labouring there with incredible diligence. But – whether it was his own carelessness, or that he had executed some works, perchance on very fresh walls, as I have heard say, at the villas of certain gentlemen – before he had that chapel finished, he died, and it remained incomplete. It was finished afterwards by Federigo Zucchero of S. Agnolo in Vado, a young and excellent painter, held to be among the best in Rome, who painted in fresco on the walls at the sides Mary Magdalene being converted by the Preaching of Christ and the Raising of her brother Lazarus, which are pictures full of grace. And, when the walls were finished, the same Federigo painted in the altar-piece the Adoration of the Magi, which was much extolled.

Extraordinary credit and fame have come to Battista, who died in the year 1561, from his many printed designs, which are truly worthy to be praised.

In the same city of Venice and about the same time there lived, as he still does, a painter called Jacopo Tintoretto, who has delighted in all the arts, and particularly in playing various musical instruments, besides being agreeable in his every action, but in the matter of painting swift, resolute, fantastic, and extravagant, and the most extraordinary brain that the art of painting has ever produced, as may be seen from all his works and from the fantastic compositions of his scenes, executed by him in a fashion of his own and contrary to the use of other painters. Indeed, he has surpassed even the limits of extravagance with the new and fanciful inventions and the strange vagaries of his intellect, working at haphazard and without design, as if to prove that art is but a jest. This master at times has left as finished works sketches still so rough that the brush-strokes may be seen, done more by chance and vehemence than with judgment and design. He has

painted almost every kind of picture in fresco and in oils, with portraits from life, and at every price, insomuch that with these methods he has executed, as he still does, the greater part of the pictures painted in Venice. And since in his youth he proved himself by many beautiful works a man of great judgment, if only he had recognized how great an advantage he had from nature, and had improved it by reasonable study, as has been done by those who have followed the beautiful manners of his predecessors, and had not dashed his work off by mere skill of hand, he would have been one of the greatest painters that Venice has ever had. Not that this prevents him from being a bold and able painter, and delicate, fanciful, and alert in spirit.

Now, when it had been ordained by the Senate that Jacopo Tintoretto and Paolo Veronese, at that time young men of great promise, should each execute a scene in the Hall of the Great Council, and Orazio, the son of Tiziano, another, Tintoretto painted in his scene Frederick Barbarossa being crowned by the Pope, depicting there a most beautiful building, and about the Pontiff a great number of Cardinals and Venetian gentlemen, all portrayed from life, and at the foot the Pope's chapel of music. In all this he acquitted himself in such a manner, that the picture can bear comparison with those of the others, not excepting that of the above-named Orazio, in which is a battle that was fought at Rome between the Germans of that Frederick and the Romans, near the Castello di S. Angelo and the Tiber. In this picture, among other things, is a horse in foreshortening, leaping over a soldier in armour, which is most beautiful; but some declare that Orazio was assisted in the work by his father Tiziano. Beside these Paolo Veronese, of whom there has been an account in the Life of Michele San Michele, painted in his scene the same Frederick Barbarossa presenting himself at Court and kissing the hand of Pope Ottaviano, to the despite of Pope Alexander III; and, in addition to that scene, which was very beautiful, Paolo painted over a window four large figures: Time, Union, with a bundle of rods, Patience, and Faith, in which he acquitted himself better than I could express in words.

Not long afterwards, another scene being required in that hall, Tintoretto so went to work with the aid of friends and other means, that it was given to him to paint; whereupon he executed it in such a manner that it was a marvel, and that it deserves to be numbered among the best things that he ever did, so powerful

in him was his determination that he would equal, if not vanquish and surpass, his rivals who had worked in that place. And the scene that he painted there – to the end that it may be known also by those who are not of the art – was Pope Alexander excommunicating and interdicting Barbarossa, and that Frederick therefore forbidding his subjects to render obedience any longer to the Pontiff. And among other fanciful things that are in this scene, that part is most beautiful in which the Pope and the Cardinals are throwing down torches and candles from a high place, as is done when some person is excommunicated, and below is a rabble of nude figures that are struggling for those torches and candles – the most lovely and pleasing effect in the world. Besides all this, certain bases, antiquities, and portraits of gentlemen that are dispersed throughout the scene, are executed very well, and won him favour and fame with everyone. He therefore painted, for places below the work of Pordenone in the principal chapel of S. Rocco, two pictures in oils as broad as the width of the whole chapel – namely, about twelve braccia each. In one he depicted a view in perspective as of a hospital filled with beds and sick persons in various attitudes who are being healed by S. Rocco; and among these are some nude figures very well conceived, and a dead body in foreshortening that is very beautiful. In the other is a story likewise of S. Rocco, full of most graceful and beautiful figures, and such, in short, that it is held to be one of the best works that this painter has executed. In a scene of the same size, in the centre of the church, he painted Jesus Christ healing the impotent man at the Pool of Bethesda, which is also a work held to be passing good.

In the Church of S. Maria dell' Orto, where, as has been told above, Cristofano and his brother, painters of Brescia, painted the ceiling, Tintoretto has painted – that is, on canvas and in oils – the two walls of the principal chapel, which are twenty-two braccia in height from the vaulting to the cornice at the foot. In that which is on the right hand he has depicted Moses returning from the Mount, where he had received the Laws from God, and finding the people worshipping the Golden Calf; and opposite to that, in the other, is the Universal Judgment of the last day, painted with an extravagant invention that truly has in it something awesome and terrible, by reason of the diversity of figures of either sex and all ages that are there, with vistas and distant views of the souls of the blessed and the damned. There, also,

may be seen the boat of Charon, but in a manner so different from that of others, that it is a thing beautiful and strange. If this fantastic invention had been executed with correct and well-ordered drawing, and if the painter had given diligent attention to the parts and to each particular detail, as he has done to the whole in expressing the confusion, turmoil, and terror of that day, it would have been a most stupendous picture. And whoever glances at it for a moment, is struck with astonishment; but, considering it afterwards minutely, it appears as if painted as a jest. The same master has painted in oils in that church, on the doors of the organ, Our Lady ascending the steps of the Temple, which is a highly-finished work, and the best-executed and most gladsome picture that there is in that place. In S. Maria Zebenigo, likewise on the doors of the organ, he has painted the Conversion of S. Paul, but not with much care. In the Carità is an altar-piece by his hand, of Christ taken down from the Cross; and in the Sacristy of S. Sebastiano, in competition with Paolo Veronese, who executed many pictures on the ceiling and the walls of that place, he painted over the presses Moses in the Desert and other scenes, which were continued afterwards by Natalino, a Venetian painter, and by others. The same Tintoretto then painted for the altar of the Pietà, in S. Giobbe, three Maries, S. Francis, S. Sebastian, and S. John, with a piece of landscape; and, on the organ-doors in the Church of the Servites, S. Augustine and S. Philip, and beneath them Cain killing his brother Abel. At the altar of the Sacrament in S. Felice, or rather, on the ceiling of the tribune, he painted the four Evangelists; and in the lunette above the altar an Annunciation, in the other lunette Christ praying on the Mount of Olives, and on the wall the Last Supper that He had with His Apostles. And in S. Francesco della Vigna, on the altar of the Deposition from the Cross, there is by the same hand the Madonna in a swoon, with the other Maries and some Prophets.

In the Scuola of S. Marco, near SS. Giovanni e Polo, are four large scenes by his hand. In one of these is S. Mark, who, appearing in the air, is delivering one who is his votary from many torments that may be seen prepared for him with various instruments of torture, which being broken, the executioner was never able to employ them against that devout man; and in that scene is a great abundance of figures, foreshortenings, pieces of armour, buildings, portraits, and other suchlike things, which render the

work very ornate. In the second is a tempest of the sea, and S. Mark, likewise in the air, delivering another of his votaries; but that scene is by no means executed with the same diligence as that already described. In the third is a storm of rain, with the dead body of another of S. Mark's votaries, and his soul ascending into Heaven; and there, also, is a composition of passing good figures. In the fourth, wherein an evil spirit is being exorcised, he counterfeited in perspective a great loggia, and at the end of it a fire that illumines it with many reflections. And in addition to those scenes there is on the altar a S. Mark by the same hand, which is a passing good picture.

These works, then, and many others that are here passed over, it being enough to have made mention of the best, have been executed by Tintoretto with such rapidity, that, when it was thought that he had scarcely begun, he had finished. And it is a notable thing that with the most extravagant ways in the world, he has always work to do, for the reason that when his friendships and other means are not enough to obtain for him any particular work, even if he had to do it, I do not say at a low price, but without payment or by force, in one way or another, do it he would. And it is not long since, Tintoretto having executed the Passion of Christ in a large picture in oils and on canvas for the Scuola of S. Rocco, the men of that Company resolved to have some honourable and magnificent work painted on the ceiling above it, and therefore to allot that commission to that one among the painters that there were in Venice who should make the best and most beautiful design. Having therefore summoned Joseffo Salviati, Federigo Zucchero, who was in Venice at that time, Paolo Veronese, and Jacopo Tintoretto, they ordained that each of them should make a design, promising the work to him who should acquit himself best in this. While the others, then, were engaged with all possible diligence in making their designs, Tintoretto, having taken measurements of the size that the work was to be, sketched a great canvas and painted it with his usual rapidity, without anyone knowing about it, and then placed it where it was to stand. Whereupon, the men of the Company having assembled one morning to see the designs and to make their award, they found that Tintoretto had completely finished the work and had placed it in position. At which being angered against him, they said that they had called for designs and had not commissioned him to execute the work; but he answered

them that this was his method of making designs, that he did not
know how to proceed in any other manner, and that designs and
models of works should always be after that fashion, so as to
deceive no one, and that, finally, if they would not pay him for
the work and for his labour, he would make them a present of
it. And after these words, although he had many contradictions,
he so contrived that the work is still in the same place. In this
canvas, then, there is painted a Heaven with God the Father
descending with many Angels to embrace S. Rocco, and in the
lowest part are many figures that signify, or rather, represent the
other principal Scuole of Venice, such as the Carità, S. Giovanni
Evangelista, the Misericordia, S. Marco, and S. Teodoro, all ex-
ecuted after his usual manner. But since it would be too long a
task to enumerate all the pictures of Tintoretto, let it be enough
to have spoken of the above-named works of that master, who
is a truly able man and a painter worthy to be praised.

There was in Venice about this same time a painter called
Brazzacco, a protégé of the house of Grimani, who had been
many years in Rome; and he was commissioned by favour to
paint the ceiling in the Great Hall of the Chiefs of the Council
of Ten. But this master, knowing that he was not able to do it
by himself and that he had need of assistance, took as compan-
ions Paolo Veronese and Battista Farinato, dividing between him-
self and them nine pictures in oils that were destined for that
place – namely, four ovals at the corners, four oblong pictures,
and a larger oval in the centre. Giving the last-named oval, with
three of the oblong pictures, to Paolo Veronese, who painted
therein a Jove who is hurling his thunderbolts against the Vices,
and other figures, he took for himself two of the smaller ovals,
with one of the oblong pictures, and gave two ovals to Battista.
In one of these pictures is Neptune, the God of the Sea, and in
each of the others two figures demonstrating the greatness and
the tranquil and peaceful condition of Venice. Now, although all
three of them acquitted themselves well, Paolo Veronese suc-
ceeded better than the others, and well deserved, therefore, that
those Signori should afterwards allot to him the other ceiling
that is beside the above-named hall, wherein he painted in oils,
in company with Battista Farinato, a S. Mark supported in the air
by some Angels, and lower down a Venice surrounded by Faith,
Hope, and Charity; which work, although it was beautiful, was
not equal in excellence to the first. Paolo afterwards executed by

himself in the Umiltà, in a large oval of the ceiling, an Assumption of Our Lady with other figures, which was a gladsome, beautiful, and well-conceived picture.

Likewise a good painter in our own day, in that city, has been Andrea Schiavone; I say good, because at times, for all his misfortunes, he has produced some good work, and because he has always imitated as well as he has been able the manners of the good masters. But, since the greater part of his works have been pictures that are dispersed among the houses of gentlemen, I shall speak only of some that are in public places. In the Chapel of the family of Pellegrini, in the Church of S. Sebastiano at Venice, he has painted a S. James with two Pilgrims. In the Church of the Carmine, on the ceiling of the choir, he has executed an Assumption with many Angels and Saints; and in the Chapel of the Presentation, in the same church, he has painted the Infant Christ presented by His Mother in the Temple, with many portraits from life, but the best figure that is there is a woman suckling a child and wearing a yellow garment, who is executed in a certain manner that is used in Venice – dashed off, or rather, sketched, without being in any respect finished. Him Giorgio Vasari caused in the year 1540 to paint on a large canvas in oils the battle that had been fought a short time before between Charles V and Barbarossa; and that work, which is one of the best that Andrea Schiavone ever executed, and truly very beautiful, is now in Florence, in the house of the heirs of the Magnificent M. Ottaviano de' Medici, to whom it was sent as a present by Vasari.

GIOVAN FRANCESCO RUSTICI,
Sculptor and Architect of Florence

IT is in every way a notable thing that all those who were of the school in the garden of the Medici, and were favoured by the Magnificent Lorenzo the Elder, became without exception supremely excellent; which circumstance cannot have come from any other cause but the great, nay, infinite judgment of that most noble lord, the true Mæcenas of men of talent, who, even as he was able to recognize men of lofty spirit and genius, was also both willing and able to recompense and reward them. Thus

Giovan Francesco Rustici, a Florentine citizen, acquitting himself
very well in drawing and working in clay in his boyhood, was
placed by that Magnificent Lorenzo, who recognized him as a
boy of spirit and of good and beautiful genius, to learn under
Andrea del Verrocchio, with whom there was also working Leo-
nardo da Vinci, a rare youth and gifted with infinite parts. Where-
upon Rustici, being pleased by the beautiful manner and ways of
Leonardo, and considering that the expressions of his heads and
the movements of his figures were more graceful and more
spirited than those of any other works that he had ever seen,
attached himself to him, after he had learned to cast in bronze,
to draw in perspective, and to work in marble, and after Andrea
had gone to work in Venice. Rustici thus living with Leonardo
and serving him with the most loving submission, Leonardo con-
ceived such an affection for him, recognizing him to be a young
man of good, true, and liberal mind, patient and diligent in the
labours of art, that he did nothing, either great or small, save
what was pleasing to Giovan Francesco, who, besides being of a
noble family, had the means to live honourably, and therefore
practised art more for his own delight and from desire of glory
than for gain. And, to tell the truth of the matter, those craftsmen
who have as their ultimate and principal end gain and profit, and
not honour and glory, rarely become very excellent, even al-
though they may have good and beautiful genius; besides which,
labouring for a livelihood, as very many do who are weighed
down by poverty and their families, and working not by inclina-
tion, when the mind and the will are drawn to it, but by necessity
from morning till night, is a life not for men who have honour
and glory as their aim, but for hacks, as they are called, and
manual labourers, for the reason that good works do not get
done without first having been well considered for a long time.
And it was on that account that Rustici used to say in his more
mature years that you must first think, then make your sketches,
and after that your designs; which done, you must put them aside
for weeks and even months without looking at them, and then,
choosing the best, put them into execution; but that method
cannot be followed by everyone, nor do those use it who labour
only for gain. And he used to say, also, that works should not be
shown readily to anyone before they are finished, so that a man
may change them as many times and in as many ways as he
wishes, without any scruple.

Giovan Francesco learned many things from Leonardo, but particularly how to represent horses, in which he so delighted that he fashioned them of clay and of wax, in the round or in low-relief, and in as many manners as could be imagined; and of these there are some to be seen in our book which are so well drawn, that they bear witness to the knowledge and art of Giovan Francesco. He knew also how to handle colours, and executed some passing good pictures, although his principal profession was sculpture. And since he lived for a time in the Via de' Martelli, he became much the friend of all the men of that family, which has always had men of the highest ability and worth, and particularly of Piero, for whom, being the nearest to his heart, he made some little figures in full-relief, and, among others, a Madonna with the Child in her arms seated upon some clouds that are covered with Cherubim. Similar to that is another that he painted after some time in a large picture in oils, with a garland of Cherubim that form a diadem around the head of Our Lady.

The Medici family having then returned to Florence, Rustici made himself known to Cardinal Giovanni as the protégé of his father Lorenzo, and was received with much lovingness. But, since the ways of the Court did not please him and were distasteful to his nature, which was altogether simple and peaceful, and not full of envy and ambition, he would always keep to himself and live the life as it were of a philosopher, enjoying tranquil peace and repose. And although he did at times choose to take some recreation, and found himself among his friends in art or some citizens who were his intimate companions, he did not therefore cease to work when the desire came to him or the occasion presented itself. Wherefore, for the visit of Pope Leo to Florence in the year 1515, at the request of Andrea del Sarto, who was much his friend, he executed some statues that were held to be very beautiful; which statues, since they pleased Cardinal Giulio de' Medici, were the reason that the Cardinal caused him to make, for the summit of the fountain that is in the great court of the Palace of the Medici, the nude Mercury of bronze about one braccio in height, standing on a ball in the act of taking flight. In the hands of that figure Rustici placed an instrument that is made to revolve by the water that it pours down from above, in the following manner: one leg being perforated, a pipe passes through it and through the torso, and the water, having risen to the mouth of the figure, falls upon that instrument, which is

balanced with four thin plates fixed after the manner of a butter-
fly, and causes it to revolve. That figure, I say, for a small work,
was much extolled. Not long afterwards, Giovan Francesco made
for the same Cardinal the model for a David to be cast in bronze
(similar to that executed by Donato, as has been related, for the
elder Cosimo, the Magnificent), for placing in the first court,
whence the other had been taken away. That model gave much
satisfaction, but, by reason of a certain dilatoriness in Giovan
Francesco, it was never cast in bronze; wherefore the Orpheus in
marble of Bandinelli was placed there, and the David of clay
made by Rustici, which was a very rare work, came to an evil end,
which was a very great loss. Giovan Francesco made an Annun-
ciation in half-relief in a large medallion, with a most beautiful
perspective-view, in which he was assisted by the painter Raffaello
Bello and by Niccolò Soggi. This, when cast in bronze, proved
to be a work of such rare beauty, that there was nothing more
beautiful to be seen; and it was sent to the King of Spain. And
then he executed in marble, in another similar medallion, a Ma-
donna with the Child in her arms and S. John the Baptist as a
little boy, which was placed in the first hall in the residence of
the Consuls of the Guild of Por Santa Maria.

By these works Giovan Francesco came into great credit, and
the Consuls of the Guild of Merchants, who had caused to be
removed certain clumsy figures of marble that were over the
three doors of the Temple of S. Giovanni (made, as has been
related, in the year 1240), after allotting to Contucci of Sansovino
those that were to be set up in place of the old ones over the
door that faces towards the Misericordia, allotted to Rustici those
that were to be placed over the door that faces towards the
canonical buildings of that temple, on the condition that he
should make three figures of bronze of four braccia each, repre-
senting the same persons as the old ones – namely, S. John in
the act of preaching, standing between a Pharisee and a Levite.
That work was much after the heart of Giovan Francesco, be-
cause it was to be set up in a place so celebrated and of such
importance, and, besides this, by reason of the competition with
Andrea Contucci. Having therefore straightway set his hand to it
and made a little model, which he surpassed in the excellence of
the work itself, he showed all the consideration and diligence that
such a labour required. When finished, the work was held to be
in all its parts the best composed and best conceived of its kind

that had been made up to that time, the figures being wholly perfect and wrought with great grace of aspect and also extra-ordinary force. In like manner, the nude arms and legs are very well conceived, and attached at the joints so excellently, that it would not be possible to do better; and, to say nothing of the hands and feet, what graceful attitudes and what heroic gravity have those heads!

Giovan Francesco, while he was fashioning that work in clay, would have no one about him but Leonardo da Vinci, who, during the making of the moulds, the securing them with irons, and, in short, until the statues were cast, never left his side; wherefore some believe, but without knowing more than this, that Leonardo worked at them with his own hand, or at least assisted Giovan Francesco with his advice and good judgment. These statues, which are the most perfect and the best conceived that have ever been executed in bronze by a modern master, were cast in three parts and polished in the above-mentioned house in the Via de' Martelli where Giovan Francesco lived; and so, also, the ornaments of marble that are about the S. John, with the two columns, the mouldings, and the emblem of the Guild of Mer-chants. In addition to the S. John, which is a spirited and lively figure, there is a bald man inclined to fatness, beautifully wrought, who, having rested the right arm on one flank, with part of a shoulder naked, and with the left hand holding a scroll before his eyes, has the left leg crossed over the right, and stands in an attitude of deep contemplation, about to answer S. John; and he is clothed in two kinds of drapery, one delicate, which floats over the nude parts of the figure, and over that a mantle of thicker texture, executed with a flow of folds full of mastery and artistry. Equal to him is the Pharisee, who, having laid his right hand on his beard, with a grave gesture, is drawing back a little, revealing astonishment at the words of John.

While Rustici was executing that work, growing weary at last of having to ask for money every day from those Consuls or their agents, who were not always the same (and such persons are generally men who hold art or any work of value in little ac-count), he sold, in order to be able to finish the work, a farm out of his patrimony that he possessed at San Marco Vecchio, at a short distance from Florence. And yet, notwithstanding such la-bours, expenses, and pains, he was poorly remunerated for it by the Consuls and by his fellow-citizens, for the reason that one of

the Ridolfi, the head of that Guild, out of some private spite, and perchance also because Rustici had not paid him enough honour or allowed him to see the figures at his convenience, was always opposed to him in everything. And so that which should have resulted in honour for Giovan Francesco did the very opposite, for, whereas he deserved to be esteemed not only as a nobleman and a citizen but also as a master of art, his being a most excellent craftsman robbed him, with the ignorant and foolish, of all that was due to his noble blood. Thus, when Giovan Francesco's work was to be valued, and he had chosen on his side Michelagnolo Buonarroti, the body of Consuls, at the persuasion of Ridolfi, chose Baccio d'Agnolo; at which Rustici complained, saying to the men of that body, at the audience, that it was indeed something too strange that a worker in wood should have to value the labours of a statuary, and he as good as declared that they were a herd of oxen, but Ridolfi answered that, on the contrary, it was a good choice, and that Giovan Francesco was a swollen bladder of pride and arrogance. And, what was worse, that work, which deserved not less than two thousand crowns, was valued by the Consuls at five hundred, and even those were not paid to him in full, but only four hundred, and that only with the help of Cardinal Giulio de' Medici.

Having met with such malignity, Giovan Francesco withdrew almost in despair, determined that he would never again do work for public bodies, or in any undertaking where he might have to depend on more than one citizen or any other single person. And so, keeping to himself and leading a solitary life in his rooms at the Sapienza, near the Servite Friars, he continued to work at various things, in order to pass the time and not to live in idleness; but also consuming his life and his money in seeking to congeal mercury, in company with a man of like brain called Raffaello Baglioni. Giovan Francesco painted a picture in oils three braccia in breadth and two in height, of the Conversion of S. Paul, full of different kinds of horses ridden by the soldiers of that Saint, with various beautiful attitudes and foreshortenings; which painting, together with many other works by the hand of the same master, is in the possession of the heirs of the above-named Piero Martelli, to whom he gave it. In a little picture he painted a hunting-scene full of various animals, which is a very bizarre and pleasing work; and it now belongs to Lorenzo Borghini, who holds it dear, as one who much delights in the

treasures of our arts. For the Nuns of S. Luca, in the Via di S. Gallo, he executed in clay, in half-relief, a Christ in the Garden who is appearing to Mary Magdalene, which was afterwards glazed by Giovanni della Robbia and placed on an altar in the church of those sisters, within an ornament of grey sandstone. For Jacopo Salviati the elder, of whom he was much the friend, he made a most beautiful medallion of marble, containing a Madonna, for the chapel in his palace above the Ponte alla Badia, and, round the courtyard, many medallions filled with figures of terra-cotta, together with other very beautiful ornaments, which were for the most part, nay, almost all, destroyed by the soldiers in the year of the siege, when the palace was set on fire by the party hostile to the Medici. And since Giovan Francesco had a great affection for that place, he would set out at times from Florence to go there just as he was, in his lucco;* and once out of the city he would throw it over his shoulder and slowly wander all by himself, lost in contemplation, until he was there. One day among others, being on that road, and the day being hot, he hid the lucco in a thicket of thorn-bushes, and, having reached the palace, had been there two days before he remembered it. In the end, sending his man to look for it, when he saw that he had found it he said: 'The world is too good to last long.'

Giovan Francesco was a man of surpassing goodness, and very loving to the poor, insomuch that he would never let anyone leave him uncomforted; nay, keeping his money, whether he had much or little, in a basket, he would give some according to his ability to anyone who asked of him. Wherefore a poor man who often went to him for alms, seeing him go always to that basket, said, not thinking that he could be heard: 'Ah! God! if I had in my own room all that is in that basket, I would soon settle all my troubles.' Giovan Francesco, hearing him, said, after gazing at him fixedly a while: 'Come here, I will satisfy you.' And then, emptying the basket into a fold of his cloak, he said to him: 'Go, and may God bless you.' And shortly afterwards he sent to Niccolò Buoni, his dearest friend, who managed all his affairs, for more money; which Niccolò, who kept an account of his crops and of his money in the Monte, and sold his produce at the proper seasons, made a practice, according to Rustici's own wish, of

* A long gown worn by the Florentine citizens, particularly on occasions of ceremony.

giving him so much money every week, which Giovan Francesco then kept in the drawer of his desk, without a key, and from time to time anyone who wished would take some to spend on the requirements of the household, according as might be necessary.

But to return to his works: Giovan Francesco made a most beautiful Crucifix of wood, as large as life, for sending to France, but it was left with Niccolò Buoni, together with other things in low-relief and drawings, which are now in his possession, at the time when Rustici resolved to leave Florence, believing that it was no place for him and thinking by a change of country to obtain a change of fortune. For Duke Giuliano, by whom he was always much favoured, he made a profile of his head in half-relief, and cast it in bronze; and this, which was held to be a remarkable work, is now in the house of M. Alessandro, the son of M. Ottaviano de' Medici. To the painter Ruberto di Filippo Lippi, who was his disciple, Giovan Francesco gave many works by his own hand, such as low-reliefs, models, and designs; and, among other things, several pictures – a Leda, a Europa, a Neptune, a very beautiful Vulcan, and another little panel in low-relief wherein is a nude man on horseback of great beauty, which panel is now in the study of Don Silvano Razzi, at the Angeli. The same Giovan Francesco made a very beautiful woman in bronze, two braccia in height, representing one of the Graces, who was pressing one of her breasts; but it is not known what became of it, nor in whose possession it is to be found. Of his horses in clay with men on their backs or under them, similar to those already mentioned, there are many in the houses of citizens, which were presented by him to his various friends, for he was very courteous, and not, like most men of his class, mean and discourteous. And Dionigi da Diacceto, an excellent and honourable gentleman, who also kept the accounts of Giovan Francesco, like Niccolò Buoni, and was his friend, had from him many low-reliefs.

There never was a man more amusing or fanciful than Giovan Francesco, nor one that delighted more in animals. He had made a porcupine so tame, that it stayed under the table like a dog, and at times it rubbed against people's legs in such a manner, that they drew them in very quickly. He had an eagle, and also a raven that said a great number of things so clearly, that it was just like a human being. He also gave his attention to the study of necromancy, and by means of that I am told that he gave strange frights to his servants and assistants; and thus he lived without

a care. Having built a room almost in the manner of a fish-pond, and keeping in it many serpents, or rather, grass-snakes, which could not escape, he used to take the greatest pleasure in standing, particularly in summer, to observe the mad pranks that they played, and their fury.

There used to assemble in his rooms at the Sapienza a company of good fellows who called themselves the Company of the Paiuolo;* and these, whose numbers were limited to twelve, were our Giovan Francesco, Andrea del Sarto, the painter Spillo, Domenico Puligo, the goldsmith Robetta, Aristotile da San Gallo, Francesco di Pellegrino, Niccolò Buoni, Domenico Baccelli, who played and sang divinely, the sculptor Solosmeo, Lorenzo called Guazzetto, and the painter Ruberto di Filippo Lippi, who was their proveditor. Each of these twelve could bring to certain suppers and entertainments of theirs four friends and no more. The manner of the suppers, which I am very willing to describe because these companies have fallen almost entirely out of fashion, was that each man should bring some dish for supper, prepared with some beautiful invention, which, on arriving at the proper place, he presented to the master of the feast, who was always one of their number, and who then gave it to whomsoever he pleased, each man thus exchanging his dish for that of another. When they were at table, they all offered each other something from their dishes, and every man partook of everything; and whoever had hit on the same invention for his dish as another, and had produced the same thing, was condemned to pay a penalty.

One evening, then, when Giovan Francesco gave a supper to that Company of the Paiuolo, he arranged that there should serve as a table an immense cauldron made with a vat, within which they all sat, and it appeared as if they were in the water of the cauldron, in the centre of which came the viands arranged in a circle; and the handle of the cauldron, which curved like a crescent above them, gave out a most beautiful light from the centre, so that, looking round, they all saw each other face to face. Now, when they were all seated at table in the cauldron, which was most beautifully contrived, there issued from the centre a tree with many branches, which set before them the supper, that is, the first course of viands, two to each plate. This done, it

* Cooking-pot or cauldron.

descended once more below, where there were persons who played music, and in a short time came up again and presented the second course, and then the third, and so on in due order, while all around were servants who poured out the choicest wines. The invention of the cauldron, which was beautifully adorned with hangings and pictures, was much extolled by the men of that company. For that evening the contribution of Rustici was a cauldron in the form of a pie, in which was Ulysses dipping his father in order to make him young again; which two figures were boiled capons that had the form of men, so well were the limbs arranged, and all with various things good to eat. Andrea del Sarto presented an octagonal temple, similar to that of S. Giovanni, but raised upon columns. The pavement was a vast plate of jelly, with a pattern of mosaic in various colours; the columns, which had the appearance of porphyry, were sausages, long and thick; the socles and capitals were of Parmesan cheese; the cornices of sugar, and the tribune was made of sections of marchpane. In the centre was a choir-desk made of cold veal, with a book of lasagne* that had the letters and notes of the music made of pepper-corns; and the singers at the desk were cooked thrushes standing with their beaks open, and with certain little shirts after the manner of surplices, made of fine cauls of pigs, and behind them, for the basses, were two fat young pigeons, with six ortolans that sang the soprano. Spillo presented as his dish a smith, which he had made from a great goose or some such bird, with all the instruments wherewith to mend the cauldron in case of need. Domenico Puligo represented by means of a cooked sucking-pig a serving-girl with a distaff at her side, who was watching a brood of chickens, and was there to scour the cauldron. Robetta made out of a calf's head, with appurtenances formed of other fat meats, an anvil for the maintenance of the cauldron, which was very fine and very beautiful, as were also all the other contributions; not to enumerate one by one all the dishes of that supper and of many others that they gave.

The Company of the Cazzuola,† which was similar to the other, and to which Giovan Francesco belonged, had its origin in the following manner. One evening in the year 1512 there were at supper in the garden that Feo d'Agnolo the hunchback, a fifeplayer and a very merry fellow, had in the Campaccio, with Feo

* Broad, flat strips of maccheroni. † Mason's trowel.

himself, Ser Bastiano Sagginati, Ser Raffaello del Beccaio, Ser Cecchino de' Profumi, Girolamo del Giocondo, and Il Baia, and, while they were eating their ricotta,* the eyes of Baia fell on a heap of lime with the trowel sticking in it, just as the mason had left it the day before, by the side of the table in a corner of the garden. Whereupon, taking some of the lime with that trowel, or rather, mason's trowel, he dropped it all into the mouth of Feo, who was waiting with gaping jaws for a great mouthful of ricotta from another of the company. Which seeing, they all began to shout: 'A Trowel, a Trowel!' That Company being then formed by reason of that incident, it was ordained that its members should be in all twenty-four, twelve of those who, as the phrase was in those times, were 'going for the Great,'† and twelve of those who were 'going for the Less'; and that its emblem should be a trowel, to which they added afterwards those little black tadpoles that have a large head and a tail, which are called in Tuscany Cazzuole. Their Patron Saint was S. Andrew, whose festal day they used to celebrate with much solemnity, giving a most beautiful supper and banquet according to their rules. The first members of that Company, those 'going for the Great,' were Jacopo Bottegai, Francesco Rucellai, Domenico his brother, Giovan Battista Ginori, Girolamo del Giocondo, Giovanni Miniati, Niccolò del Barbigia, Mezzabotte his brother, Cosimo da Panzano, Matteo his brother, Marco Jacopi, and Pieraccino Bartoli; and those 'going for the Less,' Ser Bastiano Sagginati, Ser Raffaello del Beccaio, Ser Cecchino de' Profumi, Giuliano Bugiardini the painter, Francesco Granacci the painter, Giovan Francesco Rustici, Feo the hunchback, his companion Il Talina the musician, Pierino the fifer, Giovanni the trombone-player, and Il Baia the bombardier. The associates were Bernardino di Giordano, Il Talano, Il Caiano, Maestro Jacopo del Bientina and M. Giovan Battista di Cristofano Ottonaio, both heralds of the Signoria, Buon Pocci, and Domenico Barlacchi. And not many years passed (so much did they increase in reputation as they held their feasts and merrymakings), before there were elected to that Company of the Cazzuola Signor Giuliano de' Medici, Ottangolo Benvenuti, Giovanni Canigiani, Giovanni Serristori, Giovanni Gaddi, Giovanni

* A sort of curd.
† The phrase, 'To go for the Great,' was originally applied to those Florentine families that belonged to the seven chief Guilds. It afterwards came to be used simply as a mark of superiority.

Bandini, Luigi Martelli, Paolo da Romena, and Filippo Pandolfini
the hunchback; and together with these, at one and the same
time, as associates, Andrea del Sarto the painter, Bartolommeo
Trombone the musician, Ser Bernardo Pisanello, Piero the cloth-
shearer, Gemma the mercer, and lastly Maestro Manente da San
Giovanni the physician.

The feasts that these men held at various times were innumer-
able, and I shall describe only a few of them for the sake of those
who do not know the customs of these Companies, which, as has
been related, have now fallen almost entirely out of fashion. The
first given by the Cazzuola, which was arranged by Giuliano Bu-
giardini, was held at a place called the Aia,* at S. Maria Nuova,
where, as we have already said, the gates of S. Giovanni were cast
in bronze. There, I say, the master of the Company having com-
manded that every man should present himself dressed in what-
ever costume he pleased, on condition that those who might
resemble one another in their manner of dress by being clothed
in the same fashion, should pay a penalty, at the appointed hour
there appeared the most beautiful, bizarre, and extravagant cos-
tumes that could be imagined. Then, the hour of supper having
come, they were placed at table according to the quality of their
clothes – those who were dressed as Princes in the first places,
the rich and noble after them, and those dressed as poor persons
in the last and lowest places. And whether they had games and
merrymaking after supper, it is better to leave that to everyone
to imagine for himself than to say anything about it.

At another repast, which was arranged by the same Bugiardini
and by Giovan Francesco Rustici, the men of the Company ap-
peared, as the master had commanded, all in the dress of masons
and their labourers; that is, those who were 'going for the Great'
had the trowel with the cutting edge and hammer in their girdles,
and those 'going for the Less' were dressed as labourers with the
hod, the levers for moving weights, and in their girdles the ordi-
nary trowel. When all had arrived in the first room, the lord of
the feast showed them the ground-plan of an edifice that had to
be built by the company, and placed the master-masons at table
around it; and then the labourers began to carry up the materials
for making the foundations – hods full of cooked lasagne and
ricotta prepared with sugar for mortar, sand made of cheese,

* Threshing-floor.

spices, and pepper mixed together, and for gravel large sweet-meats and pieces of berlingozzo.* The wall-bricks, paving-bricks, and tiles, which were brought in baskets and hand-barrows, were loaves of bread and flat cakes. A basement having then come up, it appeared to the stone-cutters that it had not been executed and put together well enough, and they judged that it would be a good thing to break it and take it to pieces; whereupon, having set upon it and found it all composed of pastry, pieces of liver, and other suchlike things, they feasted on these, which were placed before them by the labourers. Next, the same labourers having come on the scene with a great column swathed with the cooked tripe of calves, it was taken to pieces, and after distribut-ing the boiled veal, capons, and other things of which it was composed, they eat the base of Parmesan cheese and the capital, which was made in a marvellous manner of pieces carved from roasted capons and slices of veal, with a crown of tongues. But why do I dally over describing all the details? After the column, there was brought up on a car a very ingenious piece of architrave with frieze and cornice, composed in like manner so well and of so many different viands, that to attempt to describe them all would make too long a story. Enough that when the time came to break up, after many peals of thunder an artificial rain began to fall, and all left the work and fled, each one going to his own house.

Another time, when the master of the same Company was Matteo da Panzano, the banquet was arranged in the following manner. Ceres, seeking Proserpine her daughter, who had been carried off by Pluto, entered the room where the men of the Cazzuola were assembled, and, coming before their master, be-sought him that they should accompany her to the infernal re-gions. To which request consenting after much discussion, they went after her, and so, entering into a somewhat darkened room, they saw in place of a door a vast mouth of a serpent, the head of which took up the whole wall. Round which door all crowding together, while Cerberus barked, Ceres called out asking whether her lost daughter were in there, and, a voice having answered Yes, she added that she desired to have her back. But Pluto replied that he would not give her up, and invited Ceres with all the company to the nuptials that were being prepared; and the

* A Florentine cake.

invitation was accepted. Whereupon, all having entered through
that mouth, which was full of teeth, and which, being hung on
hinges, opened to each couple of men that entered, and then shut
again, they found themselves at last in a great room of a round
shape, which had no light but a very little one in the centre,
which burned so dim that they could scarcely see one another.
There, having been pushed into their seats with a great fork by a
most hideous Devil who was in the middle, beside the tables,
which were draped in black, Pluto commanded that in honour of
his nuptials the pains of Hell should cease for as long as those
guests remained there; and so it was done. Now in that room
were painted all the chasms of the regions of the damned, with
their pains and torments; and, fire being put to a match of tow,
in a flash a light was kindled at each chasm, thus revealing in the
picture in what manner and with what pains those who were in
it were tormented. The viands of that infernal supper were all
animals vile and most hideous in appearance; but nevertheless
within, under the loathly covering and the shape of the pastry,
were most delicate meats of many kinds. The skin, I say, on the
outer side, made it appear as if they were serpents, grass-snakes,
lizards large and small, tarantulas, toads, frogs, scorpions, bats,
and other suchlike animals; but within all were composed of the
choicest viands. And these were placed on the tables before every
man with a shovel, under the direction of the Devil, who was in
the middle, while a companion poured out exquisite wines from
a horn of glass, ugly and monstrous in shape, into glazed cruci-
bles, which served as drinking-glasses. These first viands finished,
which formed a sort of relish, dead men's bones were set all the
way down the table in place of fruits and sweetmeats, as if the
supper, which was scarcely begun, were finished; which reliquary
fruits were of sugar. That done, Pluto, who proclaimed that he
wished to go to his repose with his Proserpine, commanded that
the pains should return to torment the damned; and in a moment
all the lights that have been mentioned were blown out by a sort
of wind, on every side were heard rumblings, voices, and cries,
awesome and horrible, and in the middle of that darkness, with
a little light, was seen the image of Baia the bombardier, who was
one of the guests, as has been related – condemned to Hell by
Pluto for having always chosen as the subjects and inventions of
his girandole and other fireworks the seven mortal sins and the
things of Hell. While all were occupied in gazing on that spectacle

and listening to various sounds of lamentation, the mournful and funereal table was taken away, and in place of it, lights being kindled, was seen a very rich and regal feast, with splendid servants who brought the rest of the supper, which was handsome and magnificent. At the end of the supper came a ship full of various confections, and the crew of the ship, pretending to remove their merchandize, little by little brought the men of the Company into the upper rooms, where, a very rich scenic setting having been already prepared, there was performed a comedy called the Filogenia, which was much extolled; and at dawn, the play finished, every man went happily home.

Two years afterwards, it being the turn of the same man, after many feasts and comedies, to be master of the Company another time, he, in order to reprove some of that Company who had spent too much on certain feasts and banquets (only, as the saying goes, to be themselves eaten alive), had his banquet arranged in the following manner. At the Aia, where they were wont to assemble, there were first painted on the wall without the door some of those figures that are generally painted on the walls and porticoes of hospitals, such as the director of the hospital, with gestures full of charity, inviting and receiving beggars and pilgrims. This picture being uncovered late on the evening of the feast, there began to arrive the men of the Company, who, after knocking and being received at the entrance by the director of the hospital, made their way into a great room arranged in the manner of a hospital, with the beds at the sides and other such-like things. In the middle of that room, round a great fire, were Bientina, Battista dell' Ottonaio, Barlacchi, Baia, and other merry spirits, dressed after the manner of beggars, wastrels, and gallows-birds, who, pretending not to be seen by those who came in from time to time and gathered into a circle, and conversing of the men of the Company and also of themselves, said the hardest things in the world about those who had thrown away their all and spent on suppers and feasts much more than was right. Which discourse finished, when it was seen that all who were to be there had arrived, in came S. Andrew, their Patron Saint, who, leading them out of the hospital, took them into another room, magnificently furnished, where they sat down to table and had a joyous supper. Then the Saint laughingly commanded them that, in order not to be too wasteful with their superfluous expenses, so that they might keep well away from hospitals, they should be

contented with one feast, a grand and solemn affair, every year; after which he went his way. And they obeyed him, holding a most beautiful supper, with a comedy, every year over a long period of time; and thus there were performed at various times, as was related in the Life of Aristotile da San Gallo, the Calandra of M. Bernardo, Cardinal of Bibbiena, the Suppositi and the Cassaria of Ariosto, and the Clizia and Mandragola of Macchiavelli, with many others.

Francesco and Domenico Rucellai, for the feast that it fell to them to give when they were masters of the Company, performed first the Arpie of Fineo, and the second time, after a disputation of philosophers on the Trinity, they caused to be represented S. Andrew throwing open a Heaven with all the choirs of the Angels, which was in truth a very rare spectacle. And Giovanni Gaddi, with the help of Jacopo Sansovino, Andrea del Sarto, and Giovan Francesco Rustici, represented a Tantalus in Hell, who gave a feast to all the men of the Company clothed in the dress of various Gods; with all the rest of the fable, and many fanciful inventions of gardens, scenes of Paradise, fireworks, and other things, to recount which would make our story too long. A very beautiful invention, also, was that of Luigi Martelli, when, being master of the Company, he gave them supper in the house of Giuliano Scali at the Porta Pinti; for he represented Mars all smeared with blood, to signify his cruelty, in a room full of bloody human limbs; in another room he showed Mars and Venus naked in a bed, and a little farther on Vulcan, who, having covered them with the net, was calling all the Gods to see the outrage done to him by Mars and by his sorry spouse.

But it is now time – after this digression, which may perchance appear to some too long, although for many reasons it does not seem to me that this account has been given wholly out of place – that I return to the Life of Rustici. Giovan Francesco, then, not liking much to live in Florence after the expulsion of the Medici in the year 1528, left the charge of all his affairs to Niccolò Buoni, and went off with his young man Lorenzo Naldini, called Guazzetto, to France, where, having been made known to King Francis by Giovan Battista della Palla, who happened to be there then, and by Francesco di Pellegrino, his very dear friend, who had gone there a short time before, he was received very willingly, and an allowance of five hundred crowns a year was granted to him. By that King, for whom Giovan

Francesco executed some works of which nothing in particular is known, he was finally commissioned to make a horse in bronze, twice the size of life, upon which was to be placed the King himself. Whereupon, having set his hand to the work, after some models which much pleased the King, he went on with the making of the large model and the mould for casting it, in a large palace given to him for his enjoyment by the King. But, whatever may have been the reason, the King died before the work was finished; and since at the beginning of Henry's reign many persons had their allowances taken away and the expenses of the Court were cut down, it is said that Giovan Francesco, now old and not very prosperous, had nothing to live upon save the profit that he made by letting the great palace and dwelling that he had received for his own enjoyment from the liberality of King Francis. And Fortune, not content with all that the poor man had endured up to that time, gave him, in addition to all the rest, another very great shock, in that King Henry presented that palace to Signor Piero Strozzi; and Giovan Francesco would have found himself in very dire straits, if the goodness of that lord, to whom the misfortunes of Rustici were a great grief (the latter having made himself known to him), had not brought him timely aid in the hour of his greatest need. For Signor Piero, sending him to an abbey or some other place, whatever it may have been, belonging to his brother, not only succoured Giovan Francesco in his needy old age, but even had him attended and cared for, according as his great worth deserved, until the end of his life. Giovan Francesco died at the age of eighty, and his possessions fell for the most part to the above-named Signor Piero Strozzi. I must not omit to tell that it has come to my ears that while Antonio Mini, a disciple of Buonarroti, was living in France, when he was entertained and treated with much lovingness in Paris by Giovan Francesco, there came into the hands of Rustici some cartoons, designs, and models by the hand of Michelagnolo; a part of which the sculptor Benvenuto Cellini received when he was in France, and he brought them to Florence.

Giovan Francesco, as has been said, was not only without an equal in the work of casting, but also exemplary in conduct, of supreme goodness, and a great lover of the poor. Wherefore it is no marvel that he was assisted most liberally in the hour of his need by the above-mentioned Signor Piero with money and every other thing, for it is true beyond all other truths that even in this

life the good works that we do to our neighbours for the love of God are repaid a thousand-fold. Rustici drew very well, as may be seen, besides our own book, from the book of drawings of the very reverend Don Vincenzio Borghini.

The above-mentioned Lorenzo Naldini, called Guazzetto, the disciple of Rustici, has executed many works of sculpture excellently well in France, but of these I have not been able to learn any particulars, any more than of those of his master, who, it may well be believed, did not stay all those years in France as good as idle, nor always occupied with that horse of his. That Lorenzo possessed some houses beyond the Porta a San Gallo, in the suburbs that were destroyed on account of the siege of Florence, which houses were thrown to the ground together with the rest by the people. That circumstance so grieved him, that, returning in the year 1540 to revisit his country, when he was within a quarter of a mile of Florence he put the hood of his cloak over his head, covering his eyes, in order that, in entering by that gate, he might not see the suburb and his own houses all pulled down. Wherefore the guards at the gate, seeing him thus muffled up, asked him what that meant, and, having heard from him why he had so covered his face, they laughed at him. Lorenzo, after being a few months in Florence, returned to France, taking his mother with him; and there he still lives and labours.

FRA GIOVANNI AGNOLO MONTORSOLI,
Sculptor

To one Michele d' Agnolo of Poggibonzi, in the village of Montorsoli, which is three miles distant from Florence on the road to Bologna, where he had a good farm of some size, there was born a male child, to whom he gave the name of his father, Agnolo. That child, growing up, and having an inclination for design, as could be readily seen, was placed by his father, according to the advice of friends, to learn stone-cutting under some masters who worked at the quarries of Fiesole, almost opposite to Montorsoli. Agnolo continuing to ply the chisel with those masters, in company with Francesco del Tadda, who was then a lad, and with others, not many months had passed before he knew very well how to handle the tools and to execute many kinds of work in

that profession. Having then contracted a friendship by means of Francesco del Tadda with Maestro Andrea, a sculptor of Fiesole, the genius of the child so pleased that master, that he conceived an affection for him, and began to teach him; and thus he kept him in his workshop for three years. After which time, his father Michele being dead, Agnolo went off in company with other young stone-cutters to Rome, where, having been set to work on the building of S. Pietro, he carved some of those rosettes that are in the great cornices which encircle the interior of that temple, with much profit to himself and a good salary. Having then departed from Rome, I know not why, he placed himself in Perugia with a master stone-cutter, who at the end of a year left him in charge of all his works. But, recognizing that to stay at Perugia was not the life for him, and that he was not learning, he went off, when the opportunity to depart presented itself, to work on the tomb of M. Raffaello Maffei, called Il Volterrano, at Volterra; and in that work, which was being made in marble, he carved some things which showed that his genius was destined some day to achieve a good result. Which labour finished, hearing that Michelagnolo Buonarroti was setting to work at that time on the buildings of the sacristy and library of S. Lorenzo the best carvers and stone-cutters that could be found, he went off to Florence; where, having been likewise set to work, among the first things that he did were some ornaments from which Michelagnolo recognized that he was a young man of most beautiful and resolute genius, and that, moreover, he could do more in one day by himself alone than the oldest and best practised masters could do in two. Wherefore he caused to be given to him, boy as he was, the same salary as the older men were drawing.

These buildings being then suspended in the year 1527 on account of the plague and for other reasons, Agnolo, not knowing what else to do, went to Poggibonsi, from which place his father and grandfather had their origin; and there he remained for a time with M. Giovanni Norchiati, his uncle, a pious and well-lettered man, doing nothing but draw and study. But in the end, seeing the world turned topsy-turvy, a desire came to him to become a monk, and to give his attention in peace to the salvation of his soul, and he went to the Hermitage of Camaldoli. There, making trial of that life, and not being able to endure the discomforts, fastings, and abstinences, he did not stay long; but nevertheless, during the time that he was there, he became very

dear to those Fathers, for he was of an excellent disposition. And during that time his diversion was to carve heads of men and of various animals, with beautiful and fanciful inventions, on the ends of the staves, or rather, sticks, that those holy Fathers carry when they go from Camaldoli to the Hermitage or for recreation into the forest, at which time they have a dispensation from silence. Having departed from the Hermitage with the leave and good-will of the Principal, he went off to La Vernia, as one who was drawn at all costs to become a monk, and stayed there awhile, frequenting the choir and mixing with those Fathers; but that life, also, did not please him, and, after having received information about the life in many religious houses of Florence and Arezzo, he left La Vernia and went to those places. And finally, not being able to settle in any other in such a manner as to have facilities for attending both to drawing and to the salvation of his soul, he became a friar in the Ingesuati at Florence, without the Porta a Pinti, and was received by them very willingly; for they gave their attention to making windows of glass, and they hoped that he would be of great assistance and advantage to them in that work. Now those Fathers, according to the custom of their life and rule, do not say Mass, and keep for that purpose a priest to say Mass every morning; and they had at that time as their chaplain a certain Fra Martino of the Servite Order, a person of passing good judgment and character. That Fra Martino, having recognized the young man's genius, reflected that he was little able to exercise it among those Fathers, who do nothing but say Paternosters, make windows of glass, distil waters, and lay out gardens, with other suchlike pursuits, and do not study or give their attention to letters; and he contrived to say and do so much that the young man, going forth from the Ingesuati, assumed the habit among the Servite Friars of the Nunziata in Florence on the seventh day of October in the year 1530, receiving the name of Fra Giovanni Agnolo. In the next year, 1531, having learned in the meanwhile the ceremonies and offices of that Order, and studied the works of Andrea del Sarto that are in that place, he made what they call his profession; and in the year following, to the full satisfaction of those Fathers and the contentment of his relatives, he chanted his first Mass with much pomp and honour. Then, the images in wax of Leo, Clement, and others of that most noble family, which had been placed there as votive offerings, having been destroyed during the expulsion of the Medici

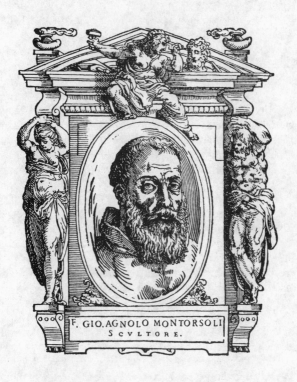

F. GIO. AGNOLO MONTORSOLI
SCVLTORE.

by some young men who were rather mad than valorous, the friars determined that these should be made again, and Fra Giovanni Agnolo, with the help of some of those men who gave their attention to the work of fashioning such images, restored some that were old and consumed by time, and made anew those of Pope Leo and Pope Clement, which are still to be seen there, and a short time afterwards those of the King of Bosnia and of the old Lord of Piombino. And in these works Fra Giovanni Agnolo made no little proficience.

Meanwhile, Michelagnolo being in Rome with Pope Clement, who desired that the work of S. Lorenzo should be continued, and had therefore had him summoned, his Holiness asked him to find a young man who might restore some ancient statues in the Belvedere, which were broken. Whereupon Buonarroti, remembering Fra Giovanni Agnolo, proposed him to the Pope, and his Holiness demanded him in a brief from the General of the Servite Order, who gave him up because he could not do otherwise, and very unwillingly. Arriving in Rome, then, the friar, labouring in the rooms of the Belvedere that were given to him by the Pope to live and work in, restored the left arm that was wanting to the Apollo and the right arm of the Laocoon, which statues are in that place, and likewise gave directions for restoring the Hercules. And, since the Pope went almost every morning to the Belvedere for recreation and to say the office, the friar made his portrait in marble, and that so well that the work brought him much praise, and the Pope conceived a very great affection for him, particularly because he saw him to be very studious of the matters of art, and heard that he used to draw all night in order to have new things every morning to show to the Pope, who much delighted in them. During that time, a canonicate having fallen vacant at S. Lorenzo, a church in Florence built and endowed by the House of Medici, Fra Giovanni Agnolo, who by that time had laid aside the friar's habit, obtained it for M. Giovanni Norchiati, his uncle, who was chaplain in the above-named church.

Finally, Pope Clement, having determined that Buonarroti should return to Florence to finish the works of the sacristy and library of S. Lorenzo, gave him orders, since many statues were wanting there, as will be told in the Life of Michelagnolo himself, that he should avail himself of the most able men that could be found, and particularly of Fra Giovanni Agnolo, employing the same methods as had been adopted by Antonio da San Gallo in

order to finish the works of the Madonna di Loreto. Having
therefore made his way with the Frate to Florence, Michelagnolo,
in executing the statues of Duke Lorenzo and Duke Giuliano,
employed the Frate much in polishing them and in executing
certain difficult undercuttings; with which occasion Fra Giovanni
Agnolo learned many things from that truly divine man, standing
with attention to watch him at work, and observing every least
thing. Now among other statues that were wanting to the com-
pletion of that work, there were lacking a S. Cosimo and a
S. Damiano that were to be one on either side of the Madonna,
and Michelagnolo gave the S. Damiano to Raffaello da Monte-
lupo to execute, and to the Frate the S. Cosimo, commanding the
latter that he should work in the same rooms where he himself
had worked and was still working. Having therefore set his hand
with the greatest zeal to that work, the Frate made a large model
of the figure, which was retouched by Buonarroti in many parts;
indeed, Michelagnolo made with his own hand the head and the
arms of clay, which are now at Arezzo, held by Vasari among his
dearest treasures in memory of that great man. There were not
wanting many envious persons who blamed Michelagnolo for his
action, saying that in allotting that statue he had shown little
judgment, and had made a bad choice; but the result afterwards
proved, as will be related, that Michelagnolo had shown excellent
judgment, and that the Frate was an able man. When Michel-
agnolo, with the assistance of Fra Giovanni Agnolo, had finished
and placed in position the statues of Duke Giuliano and Duke
Lorenzo, being summoned by the Pope, who wished that ar-
rangements should be made for executing in marble the façade
of S. Lorenzo, he went to Rome; but he had not made a long
stay there, when, Pope Clement dying, everything was left unfi-
nished. At Florence the statue of the Frate, unfinished as it was,
together with the other works, was thrown open to view, and was
very highly extolled; and in truth, whether it was his own study
and diligence, or the assistance of Michelagnolo, it proved in the
end to be an excellent figure, and the best that Fra Giovanni
Agnolo ever made among all that he executed in the whole of his
life, so that it was truly worthy to be placed where it was.

Buonarroti, being freed by the death of the Pope from his
engagements at S. Lorenzo, turned his attention to discharging
his obligations in connection with the tomb of Pope Julius II;
but, since he had need of assistance for this, he sent for the Frate.

But Fra Giovanni Agnolo did not go to Rome until he had finished entirely the image of Duke Alessandro for the Nunziata, which he executed in a manner different from the others, and very beautiful, in the form in which that lord may still be seen, clad in armour and kneeling on a Burgundian helmet, and with one hand to his breast, in the act of recommending himself to the Madonna there. That image finished, he then went to Rome, and was of great assistance to Michelagnolo in the work of the above-mentioned tomb of Julius II.

Meanwhile Cardinal Ippolito de' Medici heard that Cardinal de Tournon had to take a sculptor to France to serve the King, and he proposed to him Fra Giovanni Agnolo, who, being much exhorted with good reasons by Michelagnolo, went with that same Cardinal de Tournon to Paris. Arriving there, he was introduced to the King, who received him very willingly, and shortly afterwards assigned to him a good allowance, with the command that he should execute four large statues. Of these the Frate had not yet finished the models, when, the King being far away and occupied in fighting with the English on the borders of his kingdom, he began to be badly treated by the treasurers, not being able to draw his allowances and have whatever he desired, according as had been ordained by the King. At which feeling great disdain – for it appeared to him that in proportion as these arts and the men of the arts were esteemed by that magnanimous King, even so they were disprized and put to shame by his Ministers – he departed, notwithstanding that the treasurers, who became aware of his displeasure, paid him his overdue allowances down to the last farthing. It is true that before setting out he gave both the King and the Cardinal to know by means of letters that he wished to go away.

Having therefore gone from Paris to Lyons, and from there through Provence to Genoa, he had not been long there when, in company with some friends, he went to Venice, Padua, Verona, and Mantua, seeing with great pleasure buildings, sculptures, and pictures, and at times drawing them; but above all did the pictures of Giulio Romano in Mantua please him, some of which he drew with care. Then, having heard at Ferrara and Bologna that his fellow-friars of the Servite Order were holding a General Chapter at Budrione, he went there in order to see again many who were his friends, and in particular the Florentine Maestro Zaccheria, whom he loved most dearly. At his entreaty Fra

Giovanni Agnolo made in a day and a night two figures in clay of the size of life, a Faith and a Charity, which, made in the semblance of white marble, served to adorn a temporary fountain contrived by him with a great vessel of copper, which continued to spout water during the whole day when the Chapter was held, to his great credit and honour.

Having returned with the above-named Maestro Zaccheria from Budrione to Florence, he made in his own Servite Convent, likewise of clay, and placed in two niches of the chapter-house, two figures larger than life, Moses and S. Paul, which brought him much praise. Being then sent to Arezzo by Maestro Dionisio, the General of the Servites at that time, who was afterwards made a Cardinal by Pope Paul III, and who felt himself much indebted to Angelo, the General at Arezzo, who had brought him up and taught him the appreciation of letters, Fra Giovanni Agnolo executed for that General of Arezzo a beautiful tomb of grey sandstone in S. Piero in that city, with many carvings and some statues, and upon a sarcophagus the above-named General Angelo taken from life, and two nude little boys in the round, who are weeping and extinguishing the torches of human life, with other ornaments, which render that work very beautiful. It was not yet completely ´finished, when, being summoned to Florence by the proveditors for the festive preparations that Duke Alessandro was then causing to be made for the visit to that city of the Emperor Charles V, who was returning victorious from Tunis, the Frate was forced to depart. Having arrived in Florence, he made on the Ponte a S. Trinita, upon a great base, a figure of eight braccia, representing the River Arno lying down, which from its attitude appeared to be rejoicing with the Rhine, the Danube, the Bagradas, and the Ebro, statues executed by others, over the coming of his Majesty; which Arno was a very good and beautiful figure. On the Canto de' Carnesecchi the same master made a figure, twelve braccia high, of Jason, Leader of the Argonauts, but this, being of immoderate size, and the time short, did not prove to have the perfection of the first; nor, indeed, did the figure of August Gladness that he made on the Canto alla Cuculia. But, everyone remembering the shortness of the time in which he executed those works, they won much honour and fame for him both from the craftsmen and from all others.

Having then finished the work at Arezzo, and hearing that Girolamo Genga had a work to execute in marble at Urbino,

the Frate went to seek him out; but, not having come to any agreement, he took the road to Rome, and, after staying there but a short time, went on to Naples, in the hope that he might have to make the tomb of Jacopo Sannazzaro, a gentleman of Naples, and a truly distinguished and most rare poet. Sannazzaro had built at Margoglino, a very pleasant place with a most beautiful view at the end of the Chiaia, on the shore, a magnificent and most commodious habitation, which he enjoyed during his life-time; and, coming to his death, he left that place, which has the form of a convent, with a beautiful little church, to the Order of Servite Friars, enjoining on Signor Cesare Mormerio and the Lord Count d'Aliffe, the executors of his will, that they should erect his tomb in that church, built by himself, which was to be administered by the above-named friars. When the making of it came to be discussed, Fra Giovanni Agnolo was proposed by the friars to the above-named executors; and to him, after he had gone to Naples, as has been related, that tomb was allotted, for his models had been judged to be no little better than the many others that had been made by various sculptors, the price being a thousand crowns. Of which having received a good portion, he sent to quarry the marbles Francesco del Tadda of Fiesole, an excellent carver, whom he had commissioned to execute all the squared work and carving that had to be done in that undertaking, in order to finish it more quickly.

While the Frate was preparing himself to make that tomb, the Turkish army having entered Puglia and the people of Naples being in no little alarm on that account, orders were given that the city should be fortified, and for that purpose there were appointed four men of importance and of the best judgment. These men, wishing to make use of competent architects, turned their thoughts to the Frate; but he, having heard some rumour of this, and not considering that it was right for a man of religion, such as he was, to occupy himself with affairs of war, gave the executors to understand that he would do the work either in Carrara or in Florence, and that at the appointed time it would be finished and erected in its place. Having then made his way from Naples to Florence, he straightway received a command from the Signora Donna Maria, the mother of Duke Cosimo, that he should finish the S. Cosimo that he had previously begun under the direction of Buonarroti, for the tomb of the elder Lorenzo de' Medici, the Magnificent. Whereupon he set his

hand to it, and finished it; and, that done, since the Duke had already caused to be constructed a great part of the conduits for the great fountain of his villa at Castello, and that fountain was to have at the top, as a crowning ornament, a Hercules in the act of crushing Antæus, from whose mouth there was to issue, in place of breath, a jet of water rising to some height, the Frate was commissioned to make for this a model of considerable size; which pleasing his Excellency, it was ordained that he should execute it and should go to Carrara to quarry the marble.

To Carrara the Frate went very willingly, hoping with that opportunity to carry forward the above-mentioned tomb of Sannazzaro, and in particular a scene with figures in half-relief. While Fra Giovanni Agnolo was there, then, Cardinal Doria wrote from Genoa to Cardinal Cibo, who happened to be at Carrara, saying that, since Bandinelli had not finished the statue of Prince Doria, and would now never finish it, he should contrive to obtain for him some able man, a sculptor, who might do it, for the reason that he had the charge of pressing on that work. Which letter having been received by Cibo, who had long had knowledge of the Frate, he did his utmost to send him to Genoa; but he steadfastly declared that he could not and would not serve his most reverend Highness until he had fulfilled the promise and obligation by which he was bound to Duke Cosimo.

While these matters were being discussed, he had carried the tomb of Sannazzaro well forward, and had blocked out the marble for the Hercules; and he then went with the latter to Florence. There he brought it with much promptitude and study to such a condition, that it would have been but little toil for him to finish it completely if he had continued to work at it. But a rumour having arisen that the marble was not proving to be by any means as perfect a work as the model, and that the Frate was likely to find difficulty in fitting together the legs of the Hercules, which did not correspond with the torso, Messer Pier Francesco Riccio, the majordomo, who was paying the Frate his allowance, let himself be swayed by that more than a serious man should have done, and began to proceed very cautiously with his payments, trusting too much to Bandinelli, who was leaning with all his weight against Fra Giovanni Agnolo, in order to avenge himself for the wrong which it appeared to him that master had done to him by promising that he would make the statue of Doria when once free of his obligation to the Duke. It was also thought

that the favour of Tribolo, who was executing the ornaments of
Castello, was no advantage to the Frate. However that may have
been, perceiving himself to be badly treated by Riccio, and being
a proud and choleric man, he went off to Genoa. There he re-
ceived from Cardinal Doria and from the Prince the commission
for the statue of that Prince, which was to be placed on the
Piazza Doria; to which having set his hand, yet without altogether
neglecting the tomb of Sannazzaro, while Tadda was executing
the squared work and the carvings at Carrara, he finished it to
the great satisfaction of the Prince and the people of Genoa. But,
although that statue had been made to be placed on the Piazza
Doria, nevertheless the Genoese made so much ado, that, to the
despair of the Frate, it was placed on the Piazza della Signoria,
notwithstanding that he said that he had fashioned it to stand by
itself on a pedestal, and that therefore it could not look well or
have its proper effect against a wall. And, to tell the truth, nothing
worse can be done than to set up a work made for one place in
some other place, seeing that the craftsman accommodates him-
self in the process of his labour, with regard to the lights and
view-points, to the position in which his work, whether sculpture
or painting, is to be placed. After this the Genoese, seeing the
scenes and figures made for the tomb of Sannazzaro, and much
liking them, desired that the Frate should execute a S. John the
Evangelist for their Cathedral Church; which, when finished,
pleased them so much that it filled them with stupefaction.

Finally Fra Giovanni Agnolo departed from Genoa and went
to Naples, where he set up in the place already mentioned the
tomb of Sannazzaro, which is composed in this fashion. At
the lower corners are two pedestals, on each of which are
carved the arms of Sannazzaro, and between them is a slab of
one braccio and a half on which is carved the epitaph that Jacopo
wrote for himself, supported by two little boys. Next, on each of
the said pedestals is a seated statue of marble in the round, four
braccia in height, these being Minerva and Apollo; and between
them, set off by two ornamental consoles that are at the sides, is
a scene two braccia and a half square, in which are carved in
low-relief Fauns, Satyrs, Nymphs, and other figures that are
playing and singing, after the manner which that most excellent
man has described in the pastoral verses of his most learned
Arcadia. Above this scene is placed a sarcophagus of a very beau-
tiful shape in the round, all carved and very ornate, in which are

the remains of that poet; and upon it, on a base in the centre, is his head taken from life, with these words at the foot – ACTIUS SINCERUS; accompanied by two boys with wings in the manner of Loves, who have some books about them. And in two niches that are at the sides, in the other two walls of the chapel, there are on two bases two upright figures of marble in the round, each of three braccia or little more; these being S. James the Apostle and S. Nazzaro. When this work had been built up in the manner that has been described, the above-mentioned lords, the executors, were completely satisfied with it, and all Naples likewise.

The Frate then remembering that he had promised Prince Doria that he would return to Genoa to make his tomb for him in S. Matteo and to adorn the whole church, he departed straightway from Naples and set out for Genoa. Having arrived there, he made the models of the work that he was to execute for that lord, which pleased him vastly; and then he set his hand to it, with a good allowance of money and a good number of masters. And thus, dwelling in Genoa, the Frate made many friendships with noblemen and men of distinction, and in particular with some physicians, who were of much assistance to him; for, helping one another, they made anatomical studies of many human bodies, and gave their attention to architecture and perspective, and so Fra Giovanni Agnolo attained to the greatest excellence. Besides this, the Prince, going very often to the place where he was working, and much liking his discourse, conceived a very great affection for him. At that time, also, of two nephews that he had left in charge of Maestro Zaccheria, one, called Agnolo, was sent to him, a young man of beautiful genius and exemplary character; and shortly afterwards there was sent to him by the same Zaccheria another young man called Martino, the son of one Bartolommeo, a tailor. Of both these young men, teaching them as if they were his sons, the Frate availed himself in the work that he had in hand. And when he had finally come to the end of it, he built up the chapel, the tomb, and the other ornaments that he had made for that church, which forms a cross at the head of the central nave and three crosses down along the length of the nave, and has the high-altar standing isolated at the head and in the centre. The chapel, then, is supported at the corners by four large pilasters, which likewise uphold the great cornice that runs right round, over which curve four semicircular arches that lie in line with the pilasters. Of these arches,

three are adorned in their central space with windows of no great size; and over the arches curves a round cornice that forms four angles between one arch and another at the corners, while above it rises a vaulting in the form of a basin. After the Frate, then, had made many ornaments of marble about the altar on all four sides, he placed upon the altar a very rich and beautiful vase of marble for the most Holy Sacrament, between two Angels of the size of life, likewise of marble. Next, around the whole runs a pattern of different kinds of stone let into the marble with a beautiful and well-varied arrangement of variegated marbles and rare stones, such as serpentines, porphyries, and jaspers. And in the principal wall, at the head of the chapel, he made another pattern from the level of the floor to the height of the altar, with similar kinds of variegated marble and stone, which forms a base to four pilasters of marble that enclose three spaces. In the central space, which is larger than the others, there is in a tomb the body of I know not what Saint, and in those at the sides are two statues of marble, representing two Evangelists. Above that range of pilasters is a cornice, and above the cornice four other smaller pilasters; and these support another cornice, which is divided into compartments to hold three little tablets that correspond to the spaces below. In the central compartment, which rests upon the great cornice, is a Christ of marble rising from the dead, in full-relief, and larger than life. On the walls at the sides the same order of columns is repeated; and above that tomb, in the central space, is a Madonna in half-relief, with the Dead Christ: which Madonna is between King David and S. John the Baptist; and on the other side are S. Andrew and Jeremiah the Prophet. The lunettes of the arches above the great cornice, wherein are two windows, are in stucco-work, with two children that appear to be adorning the windows. In the angles below the tribune are four Sibyls, likewise of stucco, even as the whole vaulting is also wrought in grotesques of various manners. Beneath this chapel is built a subterranean chamber, wherein, after descending to it by a marble staircase, one sees at the head a sarcophagus of marble with two children upon it, in which was to be placed – as I believe was done after his death – the body of Signor Andrea Doria himself. And on an altar opposite to the sarcophagus, within a most beautiful vase of bronze, which was made and polished divinely well by him who cast it, whoever he may have been, is a piece of the wood of that most holy Cross upon which our

Blessed Jesus Christ was crucified; which wood was presented to Prince Doria by the Duke of Savoy. The walls of that tomb are all encrusted with marble, and the vaulting wrought in stucco and gold, with many stories of the noble deeds of Doria; and the pavement is all divided into compartments with different kinds of variegated stone, to correspond with the vaulting. Next, on the walls of the cross of the nave, at the head, are two tombs of marble with two tablets in half-relief; in one is buried Count Filippino Doria, and in the other Signor Giannettino of the same family. Against the pilasters at the beginning of the central nave are two very beautiful pulpits of marble, and at the sides of the aisles there are distributed along the walls in a fine order of architecture some chapels with columns and many other ornaments, which make that church a truly rich and magnificent edifice.

The church finished, the same Prince Doria ordained that work should be begun on his Palace, and that new additions of buildings should be made to it, with very beautiful gardens. These were executed under the direction of the Frate, who, having at the last constructed a fish-pond in front of that Palace, made a sea monster of marble in full-relief, which pours water in great abundance into that fish-pond; and after the likeness of that monster he made for those lords another, which was sent into Spain to Granvela. He also executed a great Neptune in stucco, which was placed on a pedestal in the garden of the Prince; and he made in marble two portraits of the same Prince and two of Charles V, which were taken by Covos to Spain.

Much the friends of the Frate, while he was living in Genoa, were Messer Cipriano Pallavicino, who, being a man of great judgment in the matters of our arts, has always associated readily with the most excellent craftsmen, and has shown them every favour; the Lord Abbot Negro, Messer Giovanni da Montepulciano, the Lord Prior of S. Matteo, and, in a word, all the first lords and gentlemen of that city, in which he acquired both fame and riches.

Having finished the works described above, Fra Giovanni Agnolo departed from Genoa and went to Rome to visit Buonarroti, whom he had not seen for many years past, and to try if he could by some means pick up again the thread of his connection with the Duke of Florence and return to complete the Hercules that he had left unfinished. But, after arriving in Rome, where he bought himself the title of Chevalier of S. Pietro, he heard by letters received from Florence that Bandinelli, pretending to be

in want of marble, and giving out that the above-named Hercules was a piece of marble spoiled, had broken it up, with the leave of Riccio the majordomo, and had used it to make cornices for the tomb of Signor Giovanni, on which he was then at work; and at this he felt such disdain, that for the time being he would not on any account return to visit Florence, since it appeared to him that the presumption, arrogance, and insolence of that man were too easily endured.

While the Frate was thus passing his time in Rome, the people of Messina, having determined to erect on the Piazza of their Duomo a fountain with a very great enrichment of statues, had sent men to Rome to seek out some excellent sculptor. These men had secured Raffaello da Montelupo, but he fell ill at the very moment when he was about to depart with them for Messina, so that they made another choice and took the Frate, who had sought with all insistence, and even with some interest, to obtain that work. Having therefore apprenticed as a carpenter in Rome his nephew Agnolo, who had proved to be less gifted than he had expected, he set out with Martino, and they arrived in Messina in the month of September, 1547. There, having been provided with rooms, he set his hand to making the conduit for the waters, which come from a distance, and to having marble sent from Carrara; and with great promptitude, assisted by many stone-cutters and carvers, he finished that fountain, which is made in the following manner. The fountain, I say, has eight sides – namely, four large, the principal sides, and four smaller. The principal sides are divided, and two of these, projecting outwards, form an angle in the middle, and two, receding inwards, join a straight face that belongs to the four smaller sides, so that in all there are eight. The four angular sides, which jut outwards, making a projection, give space for the four straight sides, which recede inwards; and in each enclosed space is a basin of some size, which receives water in great abundance from one of four River Gods of marble that are placed on the edge of the basin of the whole fountain, so as to command all the eight sides already described. The fountain stands on a base of four steps, which form twelve sides; eight longer sides, which contain the angles, and four smaller sides, where the basins are, under the four River Gods. The borders of the fountain are five palms high, and at each of the corners (which in all cover twenty sides) there is a terminal figure as an ornament. The circumference of the first

basin with eight sides is one hundred and two palms, and the diameter is thirty-four; and in each of the above-named twenty sides is a little scene of marble in low-relief, with poetical subjects appropriate to water and fountains, such as the horse Pegasus creating the Castalian Fount, Europa passing over the sea, Icarus flying and falling into the same, Arethusa transformed into a fount, Jason crossing the sea with the Golden Fleece, Narcissus changed into a fount, and Diana in the water and transforming Actæon into a stag, with other suchlike stories. At the eight angles that divide the projections of the steps of the fountain, which rises two steps towards the basins and River Gods, and four towards the angular sides, are eight Sea Monsters, lying on certain dados, with their front paws resting on some masks that pour water into some vases. The River Gods which are on the border, and which rest within the basin on dados so high that they appear as if sitting in the water, are the Nile with seven little boys, the Tiber surrounded by an infinite number of palms and trophies, the Ebro with many victories of Charles V, and the River Cumano, near Messina, from which the waters for the fountain are taken; with some stories and Nymphs executed with beautiful conceptions. Up to this level of ten palms there are sixteen jets of water, very abundant; eight come from the masks already mentioned, four from the River Gods, and four from some fishes seven palms high, which, standing upright in the basin, with their heads out, spout water towards the larger sides. In the centre of the octagonal basin, on a pedestal four palms high, are Sirens with wings in place of arms, one at each corner; and above these Sirens, which are twined together in the centre, are four Tritons eight palms high, which likewise have their tails twined together, and with their arms they support a great tazza, into which water is poured by four masks superbly carved. From the centre of that tazza rises a round shaft that supports two most hideous masks, representing Scylla and Charybdis, which are trodden under foot by three nude Nymphs, each six palms high, above whom is placed the last tazza, which is upheld by them with their arms. In that tazza four Dolphins, with their heads down and their tails raised on high, forming a base, support a ball, from the centre of which, through four heads, there issues water that spouts upwards, and so also from the Dolphins, upon which are mounted four naked little boys. On the top-most summit, finally, is a figure in armour representing the

constellation of Orion, which has on the shield the arms of the city of Messina, of which Orion is said, or rather is fabled, to have been the founder.

Such, then, is that fountain of Messina, although it is not so easy to describe it in words as it would be to picture it in drawing. And since it much pleased the people of Messina, they caused him to make another on the shore, where the Customs-house is; which also proved to be beautiful and very rich. Now, although that fountain has in like manner eight sides, it is nevertheless different from that described above; for it has four straight sides that rise three steps, and four others, smaller, that are semicircular, and upon these stands the fountain with its eight sides. The borders of the great basin on the lowest level have at each angle a carved pedestal of an equal height, and in the centre of four of them, on the front face, is another pedestal. On each side where the steps are semicircular there is an elliptical basin of marble, into which water pours in great abundance through two masks that are on the parapet below the carved border. In the centre of the great basin of the fountain is a pedestal high in proportion, on which are the arms of Charles V; at each angle of that pedestal is a Sea-horse, which spouts water on high from between its feet; and in the frieze of the same, beneath the upper cornice, are eight great masks that pour jets of water downwards. And on the summit is a Neptune of five braccia, who holds the trident in his hand, and has the right leg planted beside a Dolphin. At the sides, also, upon two other pedestals, are Scylla and Charybdis in the forms of two monsters, fashioned very well, with heads of Dogs and Furies about them.

That work, likewise, when finished, much pleased the people of Messina, who, having found a man to their liking, made a beginning, when the fountains were completed, with the façade of the Duomo, and carried it to some extent forward. And then they ordained that twelve chapels in the Corinthian Order should be made in that Duomo, six on either side, with the twelve Apostles in marble, each of five braccia. Of these chapels only four were finished by the Frate, who also made with his own hand a S. Peter and a S. Paul, which were two large and very good figures. He was also commissioned to make a Christ of marble for the head of the principal chapel, with a very rich ornament all around, and a scene in low-relief beneath each of the statues of the Apostles; but at that time he did nothing more. On the

Piazza of the same Duomo he directed the building of the Temple of S. Lorenzo, in a beautiful manner of architecture, which won him much praise; and on the shore there was built under his direction the Beacon-tower. And while these works were being carried forward, he caused a chapel to be erected for the Captain Cicala in S. Domenico, for which he made a Madonna of marble as large as life; and for the chapel of Signor Agnolo Borsa, in the cloister of the same church, he executed a scene of marble in low-relief, which was held to be beautiful, and was wrought with much diligence. He also caused water to be conducted by way of the wall of S. Agnolo for a fountain, and made for it with his own hand a large boy of marble, which pours water into a vase that is very ornate and beautifully contrived; which was held to be a lovely work. At the Wall of the Virgin he made another fountain, with a Virgin by his own hand, which pours water into a basin; and for that which is erected at the Palace of Signor Don Filippo Laroca, he made a boy larger than life, of a kind of stone that is used at Messina, which boy, surrounded by certain monsters and other products of the sea, pours water into a vase. And he made a statue in marble of four braccia, a very beautiful figure of S. Catharine the Martyr, which was sent to Taormina, a place twenty-four miles distant from Messina.

Friends of Fra Giovanni Agnolo, while he was living at Messina, were the above-named Signor Don Filippo Laroca, and Don Francesco of the same family; Messer Bardo Corsi, Giovan Francesco Scali, and M. Lorenzo Borghini, all three Florentine gentlemen then in Messina; Serafino da Fermo, and the Grand Master of Rhodes, which last many times sought to draw him to Malta and to make him a Knight; but he answered that he did not wish to confine himself in that island, besides which, feeling that he was doing ill not to be wearing the habit of his Order, he thought at times of going back to it. And, in truth, I know that even if he had not been in a manner forced to do it, he was determined to resume the habit and to go back to live like a good Churchman. When, therefore, in the time of Pope Paul IV, in the year 1557, all the apostates, or rather, friars who had thrown off the habit, were constrained to return to their Orders under threat of the severest penalties, Fra Giovanni Agnolo abandoned the works that he had in hand, leaving his disciple Martino in his place, and went in the month of May from Messina to Naples, intending to return to his Servite Monastery in Florence.

But before doing any other thing, wishing to devote himself entirely to God, he set about thinking how he might dispose of his great gains most suitably. And so, after having given in marriage certain nieces who were poor girls, and others from his native country and from Montorsoli, he ordained that a thousand crowns should be given to his nephew Agnolo, of whom mention has been already made, in Rome, and that a knighthood of the Lily should be bought for him. To each of two hospitals in Naples he gave a good sum of money in alms. To his own Servite Convent he left a thousand crowns to buy a farm, and also that at Montorsoli which had belonged to his forefathers, on the condition that twenty-five crowns should be paid to each of two nephews of his own, friars of the same Order, every year during their lifetime, together with other charges that will be mentioned later. All these matters being arranged, he showed himself in Rome and resumed the habit, with much joy to himself and to his fellow-friars, and particularly to Maestro Zaccheria. Then, having gone to Florence, he was received and welcomed by his relatives and friends with incredible pleasure and gladness. But, although the Frate had determined that he would spend the rest of his life in the service of our Lord God and the salvation of his soul, and live in peace and quietness, enjoying a knighthood that he had reserved for himself, he did not succeed in this so easily. For he was summoned to Bologna with great insistence by Maestro Giulio Bovio, the uncle of Vascone Bovio, to the end that he might make the high-altar in the Church of the Servites, which was to be all of marble and isolated, and in addition a tomb with figures, richly decorated with variegated stone and incrustations of marble; and he was not able to refuse him, particularly because that work was to be executed in a church of his Order. Having therefore gone to Bologna, he set his hand to the work and executed it in twenty-eight months, making that altar, which shuts off the choir of the friars from one pilaster to the other, all of marble both within and without, with a nude Christ of two braccia and a half in the centre, and with some other statues at the sides. That work is truly beautiful in architecture, well designed and distributed, and so well put together, that nothing better could be done; the pavement, also, wherein there is the tomb of Bovio on the level of the ground, is wrought in a beautifully ordered pattern; certain candelabra of marble, with some little figures and scenes, are passing well contrived; and every part

is rich in carving. But the figures, besides that they are small, on account of the difficulty that is found in conveying large pieces of marble to Bologna, are not equal to the architecture, nor much worthy to be praised.

While Fra Giovanni Agnolo was executing that work in Bologna, he was ever pondering, as one who was not yet firmly resolved in the matter, in what place, among those of his Order, he might be able most conveniently to spend his last years; when Maestro Zaccheria, his very dear friend, who was then Prior of the Nunziata in Florence, desiring to attract him to that place and to settle him there, spoke of him to Duke Cosimo, recalling to his memory the excellence of the Frate, and praying that he should deign to make use of him. To which the Duke having answered graciously, saying that he would avail himself of the Frate as soon as he had returned from Bologna, Maestro Zaccheria wrote to him of the whole matter, and then sent him a letter of Cardinal Giovanni de' Medici, in which that lord exhorted him that he should return to his own country to execute some important work with his own hand. Having received these letters, the Frate, remembering that Messer Pier Francesco Riccio, after having been mad many years, had died, and that Bandinelli also had left the world, which men had seemed to be little his friends, wrote back that he would not fail to return as soon as he might be able, in order to serve his most illustrious Excellency, and to execute under his protection not profane things, but some sacred work, since he had a mind wholly turned to the service of God and of His Saints.

Finally, then, having returned to Florence in the year 1561, he went off with Maestro Zaccheria to Pisa, where the Lord Duke and the Cardinal were, to do reverence to their most illustrious lordships; and after he had been received with much kindness and favour by those lords, and informed by the Duke that after his return to Florence he would be given a work of importance to execute, he went back. Then, having obtained leave from his fellow-friars of the Nunziata by means of Maestro Zaccheria, he erected in the centre of the chapter-house of that convent, where many years before he had made the Moses and S. Paul of stucco, as has been related above, a very beautiful tomb for himself and for all such men of the arts of design, painters, sculptors, and architects, as had not a place of their own in which to be buried; intending to arrange by a contract, as he did, that those friars, in

return for the property that he was to leave to them, should be obliged to say Mass on some feast-days and ordinary days in that chapter-house, and that every year, on the day of the most Holy Trinity, a solemn festival should be held there, and on the following day an office of the dead for the souls of those buried in that place.

This design having then been imparted by Fra Giovanni Agnolo and Maestro Zaccheria to Giorgio Vasari, who was very much their friend, they discoursed together on the affairs of the Company of Design, which had been created in the time of Giotto, and had a home in S. Maria Nuova in Florence, which it had possessed from that time down to our own, as may still be seen at the present day from a record at the high-altar of that Hospital; and they thought with this occasion to revive it and set it up again. For that Company had been removed from the above-mentioned high-altar, as has been related in the Life of Jacopo di Casentino, to a place under the vaulting of the same Hospital at the corner of the Via della Pergola, and finally had been removed and driven from that place also by Don Isidoro Montaguti, the Director of the Hospital, so that it was almost entirely dispersed, and no longer assembled. Now, after Fra Giovanni Agnolo, Maestro Zaccheria, and Giorgio had thus discoursed at some length of the condition of that Company, and the Frate had spoken of it with Bronzino, Francesco da San Gallo, Ammanati, Vincenzio de' Rossi, Michele di Ridolfo, and many other sculptors and painters of the first rank, and had declared his mind to them, when the morning of the most Holy Trinity came, all the most noble and excellent craftsmen of the arts of design, to the number of forty-eight, were assembled in the above-named chapter-house, where a most beautiful festival had been prepared, and where the tomb was already finished, and the altar so far advanced that there were wanting only some figures of marble that were going into it. There, after a most solemn Mass had been said, a beautiful oration was made by one of those fathers in praise of Fra Giovanni Agnolo, and of the magnificent liberality that he was showing to the Company by presenting to them that chapter-house, that tomb, and that chapel, in order to take possession of which, he said in conclusion, it had been already arranged that the body of Pontormo, which had been placed in a vault in the first little cloister of the Nunziata, should be laid in the new tomb before any other. When, therefore, the Mass and

the oration were finished, they all went into the church, where there were on a bier the remains of that Pontormo; and then, having placed the bier on the shoulders of the younger men, with a taper for each and also some torches, they passed around the Piazza and carried it into the chapter-house, which, previously draped with cloth of gold, they found all black and covered with painted corpses and other suchlike things; and thus was Pontormo laid in the new tomb.

The Company then dispersing, the first meeting was ordained for the next Sunday, when, besides settling the constitution of the Company, they were to make a selection of the best and create an Academy, with the assistance of which those without knowledge might learn, and those with knowledge, spurred by honourable and praiseworthy emulation, might proceed to make greater proficience. Giorgio, meanwhile, had spoken of these matters with the Duke, and had besought him that he should favour the study of these noble arts, even as he had favoured the study of letters by reopening the University of Pisa, creating a college for scholars, and making a beginning with the Florentine Academy; and he found him as ready to assist and favour that enterprise as he could have desired. After these things, the Servite Friars, having thought better over the matter, came to a resolution, which they made known to the Company, that they would not have their chapter-house used by them save for holding festivals, offices, and burials, and would not have their convent disturbed by the Company's meetings and assemblies, or in any other way. Of which Giorgio having spoken with the Duke, demanding some place from him, his Excellency said that he had thought of providing them with one wherein they might not only be able to erect a building for the Company, but also have room enough to work and demonstrate their worth. And shortly afterwards he wrote through M. Lelio Torelli to the Prior and Monks of the Angeli, giving them to understand that they were to accommodate the above-named Company in the temple that had been begun in their monastery by Filippo Scolari, called Lo Spano. The monks obeyed, and the Company was provided with certain rooms, in which they assembled many times with the gracious leave of those fathers, who received them sometimes even in their own chapter-house with much courtesy. But the Duke having been informed afterwards that some of those monks were not altogether content that the Company's building should be erected

in their precincts, because the monastery would be encumbered
thereby, and the above-named temple, which the craftsmen said
that they wished to fill with their works, would do very well as it
was, so far as they were concerned, his Excellency made it known
to the men of the Academy, which had already made a beginning
and had held the festival of S. Luke in that temple, that the
monks, so he understood, were not very willing to have them in
their house, and that therefore he would not fail to provide them
with another place. The same Lord Duke also said, like the truly
magnanimous Prince that he is, that he wished not only always
to favour that Academy, but also to be himself its chief, guide,
and protector, and that for that reason he would appoint year
by year a Lieutenant who might be present in his stead at all
their meetings. Acting on this promise, he chose as the first the
reverend Don Vincenzio Borghini, the Director of the Hospital
of the Innocenti; and for these favours and courtesies shown
by the Lord Duke to his new Academy, he was thanked by ten
of the oldest and most excellent of its members. But since the
reformation of the Company and the rules of the Academy are
described at great length in the statutes that were drawn up by
the men elected and deputed for that purpose as reformers by the
whole body (who were Fra Giovanni Agnolo, Francesco da San
Gallo, Agnolo Bronzino, Giorgio Vasari, Michele di Ridolfo, and
Pier Francesco di Jacopo di Sandro), in the presence of the
said Lieutenant, and with the approval of his Excellency, I shall
say no more about it in this place. I must mention, however,
that since the old seal and arms, or rather, device of the Com-
pany, which was a winged ox lying down, the animal of S. Luke
the Evangelist, displeased many of them, it was ordained that
each one should give in words his suggestion for a new one, or
show it in a drawing, and then there were seen the most beau-
tiful inventions and the most lovely and extravagant fantasies
that could be imagined. But for all that it is not yet completely
determined which of them is to be accepted.

Meanwhile Martino, the disciple of the Frate, having come
from Messina to Florence, died in a few days, and was buried in
the above-named tomb that had been made by his master. And
not long afterwards, in 1564, the good father himself, Fra Gio-
vanni Agnolo, who had been so excellent a sculptor, was buried
in the same tomb with most honourable obsequies, a very beau-
tiful oration being delivered in his praise in the Temple of the

Nunziata by the very reverend and most learned Maestro Michelagnolo. Truly great is the debt that our arts for many reasons owe to Fra Giovanni Agnolo, in that he bore infinite love to them and likewise to their craftsmen; and of what great service has been and still is that Academy, which may be said to have received its origin from him in the manner that has been described, and which is now under the protection of the Lord Duke Cosimo, and assembles by his command in the new sacristy of S. Lorenzo, where there are so many works in sculpture by Michelagnolo, may be recognized from this, that not only in the obsequies of that Buonarroti (which, thanks to our craftsmen and to the assistance of the Prince, were not merely magnificent, but little less than regal, and which will be described in his Life), but also in many other undertakings, the same men, from emulation, and from a desire not to be unworthy of their Academy, have achieved marvellous things, and particularly in the nuptials of the most illustrious Lord, Don Francesco de' Medici, Prince of Florence and Siena, and of her Serene Highness, Queen Joanna of Austria, which have been described fully and in due order by others, and will be described again by us at great length in a more convenient place.

And since not only in this good father, but also in many others of whom we have spoken above, it has been seen, as it still continues to be, that good Churchmen are useful and serviceable to the world in the arts and in the other more noble exercises no less than in letters, in public instruction, and in sacred councils, and that they have no reason to fear comparison in this respect with others, it may be said that there is probably no truth whatever in that which certain persons, influenced more by anger or by some private spite than by reason and love of truth, declare so freely of them – namely, that they devote themselves to such a life because from poverty of spirit they have not, like other men, the power to make a livelihood; for which may God forgive them. Fra Giovanni Agnolo lived fifty-six years, and died on the last day of August, 1563.

FRANCESCO SALVIATI, Painter of Florence

THE father of Francesco Salviati, whose Life we are now about to write, and who was born in the year 1510, was a good man

called Michelagnolo de' Rossi, a weaver of velvets; and he, having not only this child but also many others, both male and female, and being therefore in need of assistance, had determined in his own mind that he would at all costs make Francesco devote himself to his own calling of weaving velvets. But the boy, who had turned his mind to other things, and did not like the pursuit of that trade, although in the past it had been practised by persons, I will not say noble, but passing rich and prosperous, followed his father's wishes in that matter with no good-will. Indeed, associating in the Via de' Servi, where his father had a house, with the children of Domenico Naldini, their neighbour and an honoured citizen, he showed himself all given to gentle and honourable ways, and much inclined to design. In which matter he received no little assistance for a time from a cousin of his own called Diacceto, a young goldsmith, who had a passing good knowledge of design, in that he not only taught him all that he knew, but also furnished him with many drawings by various able men, over which, without telling his father, Francesco practised day and night with extraordinary zeal. And Domenico Naldini, having become aware of this, first examined the boy well, and then prevailed upon his father, Michelagnolo, to place him in his uncle's shop to learn the goldsmith's art; by reason of which opportunity for design Francesco in a few months made so much proficience, that everyone was astonished.

In those days a company of young goldsmiths and painters used to assemble together at times and go throughout Florence on feast-days drawing the most famous works, and not one of them laboured more or with greater love than did Francesco. The young men of that company were Nanni di Prospero delle Corniole, the goldsmith Francesco di Girolamo dal Prato, Nannoccio da San Giorgio, and many other lads who afterwards became able men in their professions.

At this time Francesco and Giorgio Vasari, both being still boys, became fast friends, and in the following manner. In the year 1523, Silvio Passerini, Cardinal of Cortona, passing through Arezzo as the Legate of Pope Clement VII, Antonio Vasari, his kinsman, took Giorgio, his eldest son, to make his reverence to the Cardinal. And the Cardinal, finding that the boy, who at that time was not more than nine years of age, had been so well grounded in his first letters by the diligence of M. Antonio da Saccone and of Messer Giovanni Pollastra, an excellent poet of

Arezzo, that he knew by heart a great part of the *Æneid* of Virgil, which he was pleased to hear him recite, and that he had learned to draw from Guglielmo da Marcilla, the French painter – the Cardinal, I say, ordained that Antonio should himself take the boy to Florence. There Giorgio was settled in the house of M. Niccolò Vespucci, Knight of Rhodes, who lived on the abutment of the Ponte Vecchio, above the Church of the Sepolcro, and was placed with Michelagnolo Buonarroti; and this circumstance came to the knowledge of Francesco, who was then living in the Chiasso di Messer Bivigliano, where his father rented a great house that faced on the Vaccereccia, employing many workmen. Whereupon, since like always draws to like, he so contrived that he became the friend of Giorgio, by means of M. Marco da Lodi, a gentleman of the above-named Cardinal of Cortona, who showed to Giorgio a portrait, which much pleased him, by the hand of Francesco, who a short time before had been placed to learn painting with Giuliano Bugiardini. Meanwhile Vasari, not neglecting the study of letters, by order of the Cardinal spent two hours every day with Ippolito and Alessandro de' Medici, under their master Pierio, an able man. And this friendship, contracted as described above between Vasari and Francesco, became such that it never ceased to bind them together, although, by reason of their rivalry and a certain somewhat haughty manner of speech that Francesco had, some persons thought otherwise.

When Vasari had been some months with Michelagnolo, that excellent man was summoned to Rome by Pope Clement, to receive instructions for beginning the Library of S. Lorenzo; and he was placed by him, before he departed, with Andrea del Sarto. And devoting himself under him to design, Giorgio was continually lending his master's drawings in secret to Francesco, who had no greater desire than to obtain and study them, as he did day and night. Afterwards Giorgio was placed by the Magnificent Ippolito with Baccio Bandinelli, who was pleased to have the boy with him and to teach him; and Vasari contrived to obtain Francesco as his companion, with great advantage to them both, for the reason that while working together they learned more and made greater progress in one month than they had done in two years while drawing by themselves. And the same did another young man who was likewise working under Bandinelli at that time, called Nannoccio of the Costa San Giorgio, of whom mention was made not long ago.

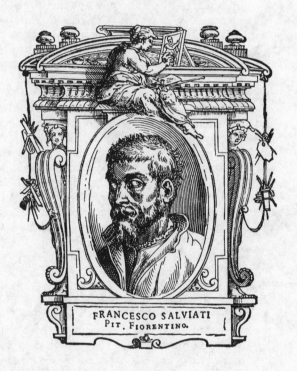

FRANCESCO SALVIATI
PIT. FIORENTINO.

In the year 1527, the Medici being expelled from Florence, there was a fight for the Palace of the Signoria, and a bench was thrown down from on high so as to fall upon those who were assaulting the door; but, as fate would have it, that bench hit an arm of the David in marble by Buonarroti, which is beside the door on the Ringhiera, and broke it into three pieces. These pieces having remained on the ground for three days, without being picked up by anyone, Francesco went to the Ponte Vecchio to find Giorgio, and told him his intention; and then, children as they were, they went to the Piazza, and, without thinking of any danger, in the midst of the soldiers of the guard, they took the pieces of that arm and carried them to the house of Michelagnolo, the father of Francesco, in the Chiasso di M. Bivigliano. From which house having afterwards recovered them, Duke Cosimo in time caused them to be restored to their places with pegs of copper.

After this, the Medici being in exile, and with them the above-mentioned Cardinal of Cortona, Antonio Vasari took his son back to Arezzo, to the no little regret of Giorgio and Francesco, who loved one another as brothers. But they did not long remain separated from each other, for the reason that after the plague, which came in the following August, had killed Giorgio's father and the best part of his family, he was so pressed with letters by Francesco, who also came very near dying of plague, that he returned to Florence. There, working with incredible zeal for a period of two years, being driven by necessity and by the desire to learn, they made marvellous proficience, having recourse, together with the above-named Nannoccio da San Giorgio, to the workshop of the painter Raffaello da Brescia, under whom Francesco, being the one who had most need to provide himself with the means to live, executed many little pictures.

Having come to the year 1529, since it did not appear to Francesco that staying in Brescia's workshop was doing him much good, he and Nannoccio went to work with Andrea del Sarto, and stayed with him all the time that the siege lasted, but in such discomfort, that they repented that they had not followed Giorgio, who spent that year in Pisa with the goldsmith Manno, giving his attention for four months to the goldsmith's craft to occupy himself. Vasari having then gone to Bologna, at the time when the Emperor Charles V was crowned there by Clement VII, Francesco, who had remained in Florence, executed on a little

panel a votive picture for a soldier who had been murderously
attacked in bed by certain other soldiers during the siege; and
although it was a paltry thing, he studied it and executed it to
perfection. That votive picture fell not many years ago into the
hands of Giorgio Vasari, who presented it to the reverend Don
Vincenzio Borghini, the Director of the Hospital of the Innocenti,
who holds it dear. For the Black Friars of the Badia Francesco
painted three little scenes on a Tabernacle of the Sacrament made
by the carver Tasso in the manner of a triumphal arch. In one of
these is the Sacrifice of Abraham, in the second the Manna, and
in the third the Hebrews eating the Paschal Lamb on their depar-
ture from Egypt; and the work was such that it gave an earnest
of the success that he has since achieved. He then painted in a
picture for Francesco Sertini, who sent it to France, a Dalilah
who was cutting off the locks of Samson, and in the distance
Samson embracing the columns of the temple and bringing it
down upon the Philistines; which picture made Francesco known
as the most excellent of the young painters that were then in
Florence.

Not long afterwards the elder Cardinal Salviati having re-
quested Benvenuto della Volpaia, a master of clock-making, who
was in Rome at that time, to find for him a young painter who
might live with him and paint some pictures for his delight, Ben-
venuto proposed to him Francesco, who was his friend, and
whom he knew to be the most competent of all the young pain-
ters of his acquaintance; which he did all the more willingly be-
cause the Cardinal had promised that he would give the young
man every facility and all assistance to enable him to study. The
Cardinal, then, liking the young Francesco's qualities, said to Ben-
venuto that he should send for him, and gave him money for that
purpose. And so, when Francesco had arrived in Rome, the
Cardinal, being pleased with his method of working, his ways,
and his manners, ordained that he should have rooms in the
Borgo Vecchio, and four crowns a month, with a place at the
table of his gentlemen. The first works that Francesco (to whom
it appeared that he had been very fortunate) executed for the
Cardinal were a picture of Our Lady, which was held to be very
beautiful, and a canvas of a French nobleman who is running in
chase of a hind, which, flying from him, takes refuge in the
Temple of Diana: of which work I keep the design, drawn by his
hand, in my book, in memory of him. That canvas finished, the

Cardinal caused him to portray in a very beautiful picture of Our Lady a niece of his own, married to Signor Cagnino Gonzaga, and likewise that lord himself.

Now, while Francesco was living in Rome, with no greater desire than to see his friend Giorgio Vasari in that city, Fortune was favourable to his wishes in that respect, and even more to Vasari. For, Cardinal Ippolito having parted in great anger from Pope Clement for reasons that were discussed at the time, but returning not long afterwards to Rome accompanied by Baccio Valori, in passing through Arezzo he found Giorgio, who had been left without a father and was occupying himself as best he could; wherefore, desiring that he should make some proficience in art, and wishing to have him near his person, he commanded Tommaso de' Nerli, who was Commissary there, that he should send him to Rome as soon as he should have finished a chapel that he was painting in fresco for the Monks of S. Bernardo, of the Order of Monte Oliveto, in that city. That commission Nerli executed immediately, and Giorgio, having thus arrived in Rome, went straightway to find Francesco, who joyfully described to him in what favour he was with his lord the Cardinal, and how he was in a place where he could satisfy his hunger for study; adding, also: 'Not only do I enjoy the present, but I hope for even better things, for, besides seeing you in Rome, with whom, as the young friend nearest to my heart, I shall be able to study and discuss the matters of art, I also live in hope of entering the service of Cardinal Ippolito de' Medici, from whose liberality, as well as from the favour of the Pope, I may look for greater things than I have at present; and this will happen without a doubt if a certain young man, who is expected from abroad, does not arrive.' Giorgio, although he knew that the young man who was expected was himself, and that the place was being kept for him, yet would not reveal himself, because of a certain doubt that had entered his mind as to whether the Cardinal might not have another in view, and also from a wish not to declare a circumstance that might afterwards fall out differently. Giorgio had brought a letter from the above-named Commissary Nerli to the Cardinal, which, after having been five days in Rome, he had not yet presented. Finally Giorgio and Francesco went to the Palace and found in what is now the Hall of Kings Messer Marco da Lodi, who had formerly been with the Cardinal of Cortona, as was related above, but was then in the service of Medici. To him

Giorgio presented himself, saying that he had a letter from the Commissary of Arezzo that was to be delivered to the Cardinal, and praying that he should give it to him; which Messer Marco was promising to do immediately, when at that very moment the Cardinal himself appeared there. Whereupon Giorgio, coming forward before him, presented the letter and kissed his hands; and he was received graciously, and shortly afterwards given into the charge of Jacopone da Bibbiena, the master of the household, who was commanded to provide him with rooms and with a place at the table of the pages. It appeared a strange thing to Francesco that Giorgio should not have confided the matter to him; but he was persuaded that he had done it for the best and with a good intention.

When the above-named Jacopone, therefore, had given Giorgio some rooms behind S. Spirito, near Francesco, the two devoted themselves in company all that winter to the study of art, with much profit, leaving no noteworthy work, either in the Palace or in any other part of Rome, that they did not draw. And since, when the Pope was in the Palace, they were not able to stay there drawing at their ease, as soon as his Holiness had ridden forth to the Magliana, as he often did, they would gain admittance by means of friends into those apartments to draw, and would stay there from morning till night without eating anything but a little bread, and almost freezing with cold. Cardinal Salviati having then commanded Francesco that he should paint in fresco in the chapel of his Palace, where he heard Mass every morning, some stories of the life of S. John the Baptist, Francesco set himself to study nudes from life, and Giorgio with him, in a bath-house near there; and afterwards they made some anatomical studies in the Campo Santo.

The spring having then come, Cardinal Ippolito, being sent by the Pope to Hungary, ordained that Giorgio should be sent to Florence, and should there execute some pictures and portraits that he had to despatch to Rome. But in the July following, what with the fatigues of the past winter and the heat of summer, Giorgio fell ill and was carried by litter to Arezzo, to the great sorrow of Francesco, who also fell sick and was like to die. However, being restored to health, Francesco was commissioned by Maestro Filippo da Siena, at the instance of Antonio L'Abacco, a master-worker in wood, to paint in fresco in a niche over the door at the back of S. Maria della Pace, a Christ speaking with

S. Filippo, and in two angles the Virgin and the Angel of the Annunciation; which pictures, much pleasing Maestro Filippo, were the reason that he caused him to paint the Assumption of Our Lady in the same place, in a large square space that was not yet painted in one of the eight sides of that temple. Whereupon Francesco, reflecting that he had to execute that work not merely in a public place, but in a place where there were pictures by the rarest masters – Raffaello da Urbino, Rosso, Baldassarre da Siena, and others – put all possible study and diligence into executing it in oils on the wall, so that it proved to be a beautiful picture, and was much extolled; and excellent among other figures is held to be the portrait that he painted there of the above-named Maestro Filippo with the hands clasped. And since Francesco lived, as has been told, with Cardinal Salviati, and was known as his protégé, he began to be called and known by no other name but Cecchino Salviati, and he kept that name to the day of his death.

Pope Clement VII being dead and Paul III elected, M. Bindo Altoviti caused Francesco to paint on the façade of his house at the Ponte S. Agnolo the arms of the new Pontiff, with some large nude figures, which gave infinite satisfaction. About the same time he made a portrait of that Messer Bindo, which was a very good figure and a beautiful portrait; and this was afterwards sent to his villa of S. Mizzano in the Valdarno, where it still is. He then painted for the Church of S. Francesco a Ripa a very beautiful altar-picture of the Annunciation in oils, which was executed with the greatest diligence. For the coming of Charles V to Rome in the year 1535, he painted for Antonio da San Gallo some scenes in chiaroscuro, which were placed on the arch that was made at S. Marco; and these pictures, as has been said in another place, were the best that there were in all those festive decorations.

Afterwards Signor Pier Luigi Farnese, who had been made Lord of Nepi at that time, wishing to adorn that city with new buildings and pictures, took Francesco into his service, giving him rooms in the Belvedere; and there Francesco painted for him on large canvases some scenes in gouache of the actions of Alexander the Great, which were afterwards carried into execution and woven into tapestries in Flanders. For the same Lord of Nepi he decorated a large and very beautiful bathroom with many scenes and figures executed in fresco. Then, the same lord having been created Duke of Castro, for his first entry rich and most

beautiful decorations were made in that city under the direction of Francesco, and at the gate an arch all covered with scenes, figures, and statues, executed with much judgment by able men, and in particular by Alessandro, called Scherano, a sculptor of Settignano. Another arch, in the form of a façade, was made at the Petrone, and yet another on the Piazza, which arches, with regard to the woodwork, were executed by Battista Botticelli; and in these festive preparations, among other things, Francesco made a beautiful perspective-scene for a comedy that was performed.

About the same time, Giulio Camillo, who was then in Rome, having made a book of his compositions in order to send it to King Francis of France, had it all illustrated by Francesco Salviati, who put into it all the diligence that it is possible to devote to such a work. Cardinal Salviati, having a desire to possess a picture in tinted woods (that is, in tarsia) by the hand of Fra Damiano da Bergamo, a lay-brother of S. Domenico at Bologna, sent him a design done in red chalk by the hand of Francesco, as a pattern for its execution; which design, representing King David being anointed by Samuel, was the best thing that Cecchino Salviati ever drew, and truly most rare. After this, Giovanni da Cepperello and Battista Gobbo of San Gallo – who had caused the Florentine painter Jacopo del Conte, then a young man, to paint in the Florentine Company of the Misericordia in S. Giovanni Decollato, under the Campidoglio at Rome, namely, in the second church where they hold their assemblies, a story of that same S. John the Baptist, showing the Angel appearing to Zacharias in the Temple – commissioned Francesco to paint below that scene another story of the same Saint, namely, the Visitation of Our Lady to S. Elizabeth. That work, which was finished in the year 1538, he executed in fresco in such a manner, that it is worthy to be numbered among the most graceful and best conceived pictures that Francesco ever painted, in the invention, in the composition of the scene, in the method and the attention to rules for the gradation of the figures, in the perspective and the architecture of the buildings, in the nudes, in the draped figures, in the grace of the heads, and, in short, in every part; wherefore it is no marvel if all Rome was struck with astonishment by it. Around a window he executed some bizarre fantasies in imitation of marble, and some little scenes that have marvellous grace. And since Francesco never wasted any time, while he was engaged on

that work he executed many other things, and also drawings, and he coloured a Phaëthon with the Horses of the Sun, which Michelagnolo had drawn. All these things Salviati showed to Giorgio, who after the death of Duke Alessandro had gone to Rome for two months; saying to him that, once he had finished a picture of a young S. John that he was painting for his master Cardinal Salviati, a Passion of Christ on canvas that was to be sent to Spain, and a picture of Our Lady that he was painting for Raffaello Acciaiuoli, he wished to turn his steps to Florence in order to revisit his native place, his relatives, and his friends, for his father and mother were still alive, to whom he was always of the greatest assistance, and particularly in settling two sisters, one of whom was married, and the other is a nun in the Convent of Monte Domini.

Coming thus to Florence, where he was received with much rejoicing by his relatives and friends, it chanced that he arrived there at the very moment when the festive preparations were being made for the nuptials of Duke Cosimo and the Lady Donna Leonora di Toledo. Wherefore he was commissioned to paint one of the already mentioned scenes that were executed in the courtyard, which he accepted very willingly; and that was the one in which the Emperor was placing the Ducal crown on the head of Duke Cosimo. But being seized, before he had finished it, with a desire to go to Venice, Francesco left it to Carlo Portelli of Loro, who finished it after Francesco's design; which design, with many others by the same hand, is in our book.

Having departed from Florence and made his way to Bologna, Francesco found there Giorgio Vasari, who had returned two days before from Camaldoli, where he had finished the two altarpieces that are in the tramezzo* of the church, and had begun that of the high-altar; and Vasari was arranging to paint three great panel-pictures for the refectory of the Fathers of S. Michele in Bosco, where he kept Francesco with him for two days. During that time, some of his friends made efforts to obtain for him the commission for an altar-piece that was to be allotted by the men of the Della Morte Hospital. But, although Salviati made a most beautiful design, those men, having little understanding, were not able to recognize the opportunity that Messer Domeneddio†

* See note on p. 90, Vol. I.
† A method of alluding to the Deity, which, in its playful simplicity, is quite impossible in English.

had sent them of obtaining for Bologna a work by the hand of an able master. Wherefore Francesco went away in some disdain, leaving some very beautiful designs in the hands of Girolamo Fagiuoli, to the end that he might engrave them on copper and have them printed.

Having arrived in Venice, he was received courteously by the Patriarch Grimani and his brother Messer Vettorio, who showed him a thousand favours. For that Patriarch, after a few days, he painted in oils, in an octagon of four braccia, a most beautiful Psyche to whom, as to a Goddess, on account of her beauty, incense and votive offerings are presented; which octagon was placed in a hall in the house of that lord, wherein is a ceiling in the centre of which there curve some festoons executed by Camillo Mantovano, an excellent painter in representing landscapes, flowers, leaves, fruits, and other suchlike things. That octagon, I say, was placed in the midst of four pictures each two braccia and a half square, executed with stories of the same Psyche, as was related in the Life of Genga, by Francesco da Forlì; and the octagon is not only beyond all comparison more beautiful than those four pictures, but even the most beautiful work of painting that there is in all Venice. After that, in a chamber wherein Giovanni Ricamatori of Udine had executed many works in stucco, he painted some little figures in fresco, both nude and draped, which are full of grace. In like manner, in an altar-piece that he executed for the Nuns of the Corpus Domini at Venice, he painted with much diligence a Dead Christ with the Maries, and in the air an Angel who has the Mysteries of the Passion in the hands. He made the portrait of M. Pietro Aretino, which, as a rare work, was sent by that poet to King Francis, with some verses in praise of him who had painted it. And for the Nuns of S. Cristina in Bologna, of the Order of Camaldoli, the same Salviati, at the entreaty of Don Giovan Francesco da Bagno, their Confessor, painted an altar-piece with many figures, a truly beautiful picture, which is in the church of that convent.

Then, having grown weary of the life in Venice, as one who remembered that of Rome, and considering that it was no place for men of design, Francesco departed in order to return to Rome. And so, making a détour by Verona and Mantua, in the first of which places he saw the many antiquities that are there, and in the other the works of Giulio Romano, he made his way back to Rome by the road through Romagna, and arrived there

in the year 1541. There, having rested a little, the first works that
he made were the portrait of Messer Giovanni Gaddi and that of
Messer Annibale Caro, who were much his friends. Those
finished, he painted a very beautiful altar-piece for the Chapel of
the Clerks of the Chamber in the Pope's Palace. And in the
Church of the Germans he began a chapel in fresco for a mer-
chant of that nation, painting on the vault above the Apostles
receiving the Holy Spirit, and in a picture that is half-way up the
wall Jesus Christ rising from the dead, with the soldiers sleeping
round the Sepulchre in various attitudes, foreshortened in a bold
and beautiful manner. On one side he painted S. Stephen, and on
the other side S. George, in two niches; and at the foot he
painted S. Giovanni Limosinario, who is giving alms to a naked
beggar, with a Charity on one side of him, and on the other side
S. Alberto, the Carmelite Friar, between Logic and Prudence.
And in the great altar-picture, finally, he painted in fresco the
Dead Christ with the Maries.

Having formed a friendship with Piero di Marcone, a Floren-
tine goldsmith, and having become his gossip, Francesco made
to Piero's wife, who was also his gossip, after her delivery, a
present of a very beautiful design, which was to be painted on
one of those round baskets in which food is brought to a newly-
delivered woman. In that design there was the life of man, in a
number of square compartments containing very beautiful
figures, both on one side and on the other; namely, all the ages
of human life, each of which rested on a different festoon appro-
priate to the particular age and the season. In that bizarre com-
position were included, in two long ovals, figures of the sun and
moon, and between them Sais, a city of Egypt, standing before
the Temple of the Goddess Pallas and praying for wisdom, as if
to signify that on behalf of new-born children one should pray
before any other thing for wisdom and goodness. That design
Piero held ever afterwards as dear as if it had been, as indeed it
was, a most beautiful jewel.

Not long afterwards, the above-named Piero and other friends
having written to Francesco that he would do well to return to
his native place, for the reason that it was held to be certain that
he would be employed by the Lord Duke Cosimo, who had no
masters about him save such as were slow and irresolute, he
finally determined (trusting much, also, in the favour of M. Ala-
manno, the brother of the Cardinal and uncle of the Duke) to

return to Florence. Having arrived, therefore, before attempting any other thing, he painted for the above-named M. Alamanno Salviati a very beautiful picture of Our Lady, which he executed in a room in the Office of Works of S. Maria del Fiore that was occupied by Francesco dal Prato, who at that time, from being a goldsmith and a master of tausia,* had set himself to casting little figures in bronze and to painting, with much profit and honour. In that same place, then, which that master held as the official in charge of the woodwork of the Office of Works, Francesco made portraits of his friend Piero di Marcone and of Avveduto del Cegia, the dresser of minever-furs, who was also much his friend; which Avveduto, besides many other things by the hand of Francesco that he possesses, has a portrait of Francesco himself, executed in oils with his own hand, and very life-like.

The above-mentioned picture of Our Lady, being, after it was finished, in the shop of the wood-carver Tasso, who was then architect of the Palace, was seen by many persons and vastly extolled; but what caused it even more to be considered a rare picture was that Tasso, who was accustomed to censure almost everything, praised it to the skies. And, what was more, he said to M. Pier Francesco, the major-domo, that it would be an excellent thing for the Duke to give Francesco some work of importance to execute; whereupon M. Pier Francesco and Cristofano Rinieri, who had the ear of the Duke, played their part in such a way, that M. Alamanno spoke to his Excellency, saying to him that Francesco desired to be commissioned to paint the Hall of Audience, which is in front of the Chapel of the Ducal Palace, and that he cared nothing about payment; and the Duke was content that this should be granted to him. Whereupon Francesco, having made small designs of the Triumph of Furius Camillus and of many stories of his life, set himself to contrive the division of that hall according to the spaces left by the windows and doors, some of which are high and some low; and there was no little difficulty in making that division in such a way that it might be well-ordered and might not disturb the sequence of the stories. In the wall where there is the door by which one enters into the hall, there were two large spaces, divided by the door. Opposite to that, where there are the three windows that look out over the Piazza, there were four spaces, but not wider than

* Damascening.

about three braccia each. In the end-wall that is on the right hand as one enters, wherein are two windows that likewise look out on the Piazza, but in another direction, there were three similar spaces, each about three braccia wide; and in the end-wall that is on the left hand, opposite to the other, what with the marble door that leads into the chapel, and a window with a grating of bronze, there remained only one space large enough to contain a work of importance. On the wall of the chapel, then – within an ornament of Corinthian columns that support an architrave, which has below it a recess, wherein hang two very rich festoons, and two pendants of various fruits, counterfeited very well, while upon it sits a naked little boy who is holding the Ducal arms, namely, those of the Houses of Medici and Toledo – he painted two scenes; on the right hand Camillus, who is commanding that the schoolmaster shall be given up to the vengeance of his young scholars, and on the other the same Camillus, while the army is in combat and fire is burning the stockades and tents of the camp, is routing the Gauls. And beside that, where the same range of pilasters continues, he painted a figure of Opportunity, large as life, who has seized Fortune by the locks, and some devices of his Excellency, with many ornaments executed with marvellous grace. On the main wall, where there are two great spaces divided by the principal door, he painted two large and very beautiful scenes. In the first are the Gauls, who, weighing the gold of the tribute, add to it a sword, to the end that the weight may be the greater, and Camillus, full of rage, delivers himself from the tribute by force of arms; which scene is very beautiful, and crowded with figures, landscapes, antiquities, and vases counterfeited very well and in various manners in imitation of gold and silver. In the other scene, beside the first, is Camillus in the triumphal chariot, drawn by four horses; and on high is Fame, who is crowning him. Before the chariot are priests very richly apparelled, with the statue of the Goddess Juno, and holding vases in their hands, and with some trophies and spoils of great beauty. About the chariot are innumerable prisoners in various attitudes, and behind it the soldiers of the army in their armour, among whom Francesco made a portrait of himself, which is so good that it seems as if alive. In the distance, where the triumphal procession is passing, is a very beautiful picture of Rome, and above the door is a figure of Peace in chiaroscuro, who is burning the arms, with some prisoners; all which was

executed by Francesco with such diligence and study, that there is no more beautiful work to be seen.

On the wall towards the west he painted in a niche in one of the larger spaces, in the centre, a Mars in armour, and below that a nude figure representing a Gaul,* with a crest on the head similar to that of a cock; and in another niche a Diana with a skin about her waist, who is drawing an arrow from her quiver, with a dog. In the two corners next the other two walls are two figures of Time, one adjusting weights in a balance, and the other tempering the liquid in two vases by pouring one into the other. On the last wall, which is opposite to the chapel and faces towards the north, in a corner on the right hand, is the Sun figured in the manner wherein the Egyptians represent him, and in the other corner the Moon in the same manner. In the middle is Favour, represented as a nude young man on the summit of the wheel, with Envy, Hatred, and Malice on one side, and on the other side Honours, Pleasure, and all the other things described by Lucian. Above the windows is a frieze all full of most beautiful nudes, as large as life, and in various forms and attitudes; with some scenes likewise from the life of Camillus. And opposite to the Peace that is burning the arms is the River Arno, who, holding a most abundant horn of plenty, raises with one hand a curtain and reveals Florence and the greatness of her Pontiffs and the heroes of the House of Medici. He painted there, besides all that, a base that runs round below those scenes, and niches with some terminal figures of women that support festoons; and in the centre are certain ovals with scenes of people adorning a Sphinx and the River Arno.

Francesco put into the execution of that work all the diligence and study that are possible; and, although he had many contradictions, he carried it to a happy conclusion, desiring to leave in his native city a work worthy of himself and of so great a Prince. Francesco was by nature melancholy, and for the most part he did not care to have anyone about him when he was at work. But nevertheless, when he first began that undertaking, almost doing violence to his nature and affecting an open heart, with great cordiality he allowed Tasso and others of his friends, who had done him some service, to stand and watch him at work, showing them every courtesy that he was able. But when he had gained a

* A play on the word Gallo, which means both Gaul and cock.

footing at Court, as the saying goes, and it seemed to him that
he was in good favour, returning to his choleric and biting nature,
he paid them no attention. Nay, what was worse, he used the
most bitter words according to his wont (which served as an
excuse to his adversaries), censuring and decrying the works of
others, and praising himself and his own works to the skies.
These methods, which displeased most people and likewise cer-
tain craftsmen, brought upon him such odium, that Tasso and
many others, who from being his friends had become his
enemies, began to give him cause for thought and for action. For,
although they praised the excellence of the art that was in him,
and the facility and rapidity with which he executed his works so
well and with such unity, they were not at a loss, on the other
hand, for something to censure. And since, if they had allowed
him to gain a firm footing and to settle his affairs, they would not
have been able afterwards to hinder or hurt him, they began in
good time to give him trouble and to molest him. Whereupon
many of the craftsmen and others, banding themselves together
and forming a faction, began to disseminate among the people of
importance a rumour that Salviati's work was not succeeding, and
that he was labouring by mere skill of hand, and devoting no
study to anything that he did. In which, in truth, they accused
him wrongly, for, although he never toiled over the execution of
his works, as they themselves did, yet that did not mean that he
did not study them and that his works had not infinite grace and
invention, or that they were not carried out excellently well. Not
being able to surpass his excellence with their works, those ad-
versaries wished to overwhelm it with such words and re-
proaches; but in the end truth and excellence have too much
force. At first Francesco made light of such rumours, but later,
perceiving that they were growing beyond all reason, he com-
plained of it many times to the Duke. But, since it began to be
seen that the Duke, to all appearance, was not showing him such
favours as he would have liked, and it seemed that his Excellency
cared nothing for those complaints, Francesco began to fall from
his position in such a manner, that his adversaries, taking courage
from that, sent forth a rumour that his scenes in the hall were to
be thrown to the ground, because they did not give satisfaction
and had in them no particle of excellence. All these calumnies,
which were pressed against him with incredible envy and malice
by his adversaries, had reduced Francesco to such a state, that, if

it had not been for the goodness of Messer Lelio Torelli, Messer Pasquino Bertini, and others of his friends, he would have re-treated before them, which was exactly what they desired. But the above-named friends, exhorting him continually to finish the work of the hall and others that he had in hand, restrained him, even as was done by many other friends not in Florence, to whom he wrote of these persecutions. And Giorgio Vasari, among others, answering a letter that Salviati wrote to him on the matter, exhorted him always to have patience, because excellence is refined by persecution as gold by fire; adding that a time was about to come when his art and his genius would be recognized, and that he should complain of no one but himself, in that he did not yet know men's humours, and how the people and the craftsmen of his own country were made. Thus, notwithstanding all these contradictions and persecutions that poor Francesco suffered, he finished that hall – namely, the work that he had undertaken to execute in fresco on the walls, for the reason that on the ceiling, or rather, soffit, there was no need for him to do any painting, since it was so richly carved and all overlaid with gold, that among works of that kind there is none more beautiful to be seen. And as a finish to the whole the Duke caused two new windows of glass to be made, with his devices and arms and those of Charles V; and nothing could be better in that kind of work than the manner in which they were executed by Battista del Borro, an Aretine painter excellent in that field of art.

After that, Francesco painted for his Excellency the ceiling of the hall where he dines in winter, with many devices and little figures in distemper; and a most beautiful study which opens out over the Green Chamber. He made portraits, likewise, of some of the Duke's children; and one year, for the Carnival, he ex-ecuted in the Great Hall the scenery and prospect-view for a comedy that was performed, and that with such beauty and in a manner so different from those that had been done in Florence up to that time, that they were judged to be superior to them all. Nor is this to be marvelled at, since it is very certain that Francesco was always in all his works full of judgment, and well-varied and fertile in invention, and, what is more, he had a perfect knowledge of design, and had a more beautiful manner than any other painter in Florence at that time, and handled colours with great skill and delicacy. He also made a head, or rather, a portrait, of Signor Giovanni de' Medici, the father of Duke Cosimo,

which was very beautiful; and it is now in the guardaroba of the same Lord Duke. For Cristofano Rinieri, who was much his friend, he painted a most beautiful picture of Our Lady, which is now in the Udienza della Decima. For Ridolfo Landi he executed a picture of Charity, which could not be more lovely than it is; and for Simone Corsi, likewise, he painted a picture of Our Lady, which was much extolled. For M. Donato Acciaiuoli, a knight of Rhodes, with whom he always maintained a particular intimacy, he executed certain little pictures that are very beautiful. And he also painted in an altar-piece Christ showing to S. Thomas, who would not believe that He had newly risen from the dead, the marks of the blows and wounds that He had received from the Jews; which altar-piece was taken by Tommaso Guadagni into France, and placed in the Chapel of the Florentines in a church at Lyons.

Francesco also depicted at the request of the above-named Cristofano Rinieri and of Maestro Giovanni Rosto, the Flemish master of tapestry, the whole story of Tarquinius and the Roman Lucretia in many cartoons, which, being afterwards put into execution in tapestries woven in silk, floss-silk, and gold, proved to be a marvellous work. Which hearing, the Duke, who was at that time having similar tapestries, all in silk and gold, made in Florence by the same Maestro Giovanni for the Sala de' Dugento, and had caused cartoons with the stories of the Hebrew Joseph to be executed by Bronzino and Pontormo, as has been related, commanded that Francesco also should make a cartoon, which was that with the interpretation of the dream of the seven fat and seven lean kine. Into that cartoon Francesco put all the diligence that could possibly be devoted to such a work, and that is required for pictures that are to be woven; for there must be fantastic inventions and variety of composition in the figures, and these must stand out one from another, so that they may have strong relief, and they must come out bright in colouring and rich in the costumes and vestments. That piece of tapestry and the others having turned out well, his Excellency resolved to establish the art in Florence, and caused it to be taught to some boys, who, having grown to be men, are now executing most excellent works for the Duke.

Francesco also executed a most beautiful picture of Our Lady, likewise in oils, which is now in the chamber of Messer Alessandro, the son of M. Ottaviano de' Medici. For the above-named

M. Pasquino Bertini he painted on canvas yet another picture of
Our Lady, with Christ and S. John as little children, who are
smiling over a parrot that they have in their hands; which was a
very pleasing and fanciful work. And for the same man he made
a most beautiful design of a Crucifix, about one braccio high,
with a Magdalene at the foot, in a manner so new and so pleasing
that it is a marvel; which design M. Salvestro Bertini lent to
Girolamo Razzi, his very dear friend, who is now Don Silvano,
and two pictures were painted from it by Carlo of Loro, who has
since executed many others, which are dispersed about Florence.

Giovanni and Piero d'Agostino Dini had erected in S. Croce,
on the right hand as one enters by the central door, a very rich
chapel of grey sandstone and a tomb for Agostino and others of
their family; and they gave the commission for the altar-piece of
that chapel to Francesco, who painted in it Christ taken down
from the Cross by Joseph of Arimathæa and Nicodemus, and at
the foot the Madonna in a swoon, with Mary Magdalene, S. John,
and the other Maries. That altar-piece was executed by Francesco
with so much art and study, that not only the nude Christ is very
beautiful, but all the other figures likewise are well disposed and
coloured with relief and force; and although at first the picture
was censured by Francesco's adversaries, nevertheless it won him
a great name with men in general, and those who have painted
others after him out of emulation have not surpassed him. The
same Francesco, before he departed from Florence, painted the
portrait of the above-mentioned M. Lelio Torelli, and some other
works of no great importance, of which I know not the particu-
lars. But, among other things, he brought to completion a design
of the Conversion of S. Paul that he had drawn long before in
Rome, which is very beautiful; and he had it engraved on copper
in Florence by Enea Vico of Parma, and the Duke was content
to retain him in Florence until that should be done, with his usual
salary and allowances. During that time, which was in the year
1548, Giorgio Vasari being at Rimini in order to execute in fresco
and in oils the works of which we have spoken in another place,
Francesco wrote him a long letter, informing him in exact detail
how his affairs were passing in Florence, and, in particular, that
he had made a design for the principal chapel of S. Lorenzo,
which was to be painted by order of the Lord Duke, but that
with regard to that work infinite mischief had been done against
him with his Excellency, and, among other things, that he held it

almost as certain that M. Pier Francesco, the major-domo, had not presented his design, so that the work had been allotted to Pontormo. And finally he said that for these reasons he was returning to Rome, much dissatisfied with the men and the craftsmen of his native country.

Having thus returned to Rome, he bought a house near the Palace of Cardinal Farnese, and, while he was occupying himself with executing some works of no great importance, he received from that Cardinal, through M. Annibale Caro and Don Giulio Clovio, the commission to paint the Chapel of the Palace of S. Giorgio, in which he executed an ornament of most beautiful compartments in stucco, and a vaulting in fresco with stories of S. Laurence and many figures, full of grace, and on a panel of stone, in oils, the Nativity of Christ, introducing into that work, which was very beautiful, the portrait of the above-named Cardinal. Then, having another work allotted to him in the above-mentioned Company of the Misericordia (where Jacopo del Conte had painted the Preaching and the Baptism of S. John, in which, although he had not surpassed Francesco, he had acquitted himself very well, and where some other works had been executed by the Venetian Battista Franco and by Pirro Ligorio), Francesco painted, on that part that is exactly beside his own picture of the Visitation, the Nativity of S. John, which, although he executed it excellently well, was nevertheless not equal to the first. At the head of that Company, likewise, he painted for M. Bartolommeo Bussotti two very beautiful figures in fresco – S. Andrew and S. Bartholomew, the Apostles – which are one on either side of the altar-piece, wherein is a Deposition from the Cross by the hand of the same Jacopo del Conte, which is a very good picture and the best work that he had ever done up to that time.

In the year 1550, Julius III having been elected Supreme Pontiff, Francesco painted some very beautiful scenes in chiaroscuro for the arch that was erected above the steps of S. Pietro, among the festive preparations for the coronation. And then, in the same year, a sepulchre with many steps and ranges of columns having been made in the Minerva by the Company of the Sacrament, Francesco painted upon it some scenes and figures in terretta, which were held to be very beautiful. In a chapel of S. Lorenzo in Damaso he executed two Angels in fresco that are holding a canopy, the design of one of which is in our book. In the refectory of S. Salvatore del Lauro at Monte Giordano, on the

principal wall, he painted in fresco, with a great number of figures, the Marriage of Cana in Galilee, at which Jesus Christ turned water into wine; and at the sides some Saints, with Pope Eugenius IV, who belonged to that Order, and other founders. Above the door of that refectory, on the inner side, he painted a picture in oils of S. George killing the Dragon, and he executed that whole work with much mastery, finish, and charm of colouring. About the same time he sent to Florence, for M. Alamanno Salviati, a large picture in which are Adam and Eve beside the Tree of Life in the Earthly Paradise, eating the Forbidden Fruit, which is a very beautiful work. For Signor Ranuccio, Cardinal Sant' Agnolo, of the House of Farnese, Francesco painted with most beautiful fantasy two walls in the hall that is in front of the great hall in the Farnese Palace. On one wall he depicted Signor Ranuccio the Elder receiving from Eugenius IV his baton as Captain-General of Holy Church, with some Virtues, and on the other Pope Paul III, of the Farnese family, who is giving the baton of the Church to Signor Pier Luigi, while there is seen approaching from a distance the Emperor Charles V, accompanied by Cardinal Alessandro Farnese and by other lords portrayed from life; and on that wall, besides the things described above and many others, he painted a Fame and a number of other figures, which are executed very well. It is true, indeed, that the work received its final completion, not from him, but from Taddeo Zucchero of Sant' Agnolo, as will be related in the proper place. He gave completion and proportion to the Chapel of the Popolo, which Fra Sebastiano Viniziano had formerly begun for Agostino Chigi, but had not finished; and Francesco finished it, as has been described in the Life of Fra Sebastiano. For Cardinal Riccio of Montepulciano he painted a most beautiful hall in his Palace in the Strada Giulia, where he executed in fresco various pictures with many stories of David; and, among others, one of Bathsheba bathing herself in a bath, with many other women, while David stands gazing at her, is a scene very well composed and full of grace, and as rich in invention as any other that there is to be seen. In another picture is the Death of Uriah, in a third the Ark, before which go many musical instruments, and finally, after some others, a battle that is being fought between David and his enemies, very well composed. And, to put it briefly, the work of that hall is all full of grace, of most beautiful fantasies, and of many fanciful and ingenious inventions; the distribution

of the parts is done with much consideration, and the colouring is very pleasing. To tell the truth, Francesco, feeling himself bold and fertile in invention, and having a hand obedient to his brain, would have liked always to have on his hands works large and out of the ordinary. And for no other reason was he strange in his dealings with his friends, save only for this, that, being variable and in certain things not very stable, what pleased him one day he hated the next; and he did few works of importance without having in the end to contend about the price, on which account he was avoided by many.

After these works, Andrea Tassini, having to send a painter to the King of France, in the year 1554 sought out Giorgio Vasari, but in vain, for he said that not for any salary, however great, or promises, or expectations, would he leave the service of his lord, Duke Cosimo; and finally Andrea came to terms with Francesco and took him to France, undertaking to recompense him in Rome if he were not satisfied in France. Before Francesco departed from Rome, as if he thought that he would never return, he sold his house, his furniture, and every other thing, excepting the offices that he held. But the venture did not succeed as he had expected, for the reason that, on arriving in Paris, where he was received kindly and with many courtesies by M. Francesco Primaticcio, painter and architect to the King, and Abbot of S. Martin, he was straightway recognized, so it is said, as the strange sort of man that he was, for he saw no work either by Rosso or by any other master that he did not censure either openly or in some subtle way. Everyone therefore expecting some great work from him, he was set by the Cardinal of Lorraine, who had sent for him, to execute some pictures in his Palace at Dampierre. Whereupon, after making many designs, finally he set his hand to the work, and executed some pictures with scenes in fresco over the cornices of chimney-pieces, and a little study full of scenes, which are said to have shown great mastery; but, whatever may have been the reason, these works did not win him much praise. Besides that, Francesco was never much liked there, because he had a nature altogether opposed to that of the men of that country, where, even as those merry and jovial men are liked and held dear who live a free life and take part gladly in assemblies and banquets, so those are, I do not say shunned, but less liked and welcomed, who are by nature, as Francesco was, melancholy, abstinent, sickly, and cross-grained. For some things he might

have deserved to be excused, since his habit of body would not allow him to mix himself up with banquets and with eating and drinking too much, if only he could have been more agreeable in conversation. And, what was worse, whereas it was his duty, according to the custom of that country and that Court, to show himself and pay court to others, he would have liked, and thought that he deserved, to be himself courted by everyone.

In the end, the King being occupied with matters of war, and likewise the Cardinal, and himself being disappointed of his salary and promised benefits, Francesco, after having been there twenty months, resolved to return to Italy. And so he made his way to Milan, where he was courteously received by the Chevalier Leone Aretino in the house that he has built for himself, very ornate and all filled with statues ancient and modern, and with figures cast in gesso from rare works, as will be told in another place; and after having stayed there a fortnight and rested himself, he went on to Florence. There he found Giorgio Vasari and told him how well he had done not to go to France, giving him an account that would have driven the desire to go there, no matter how great, out of anyone. From Florence he returned to Rome, and there entered an action against those who had guaranteed his allowances from the Cardinal of Lorraine, and compelled them to pay him in full; and when he had received the money he bought some offices, in addition to others that he held before, with a firm resolve to look after his own life, knowing that he was not in good health and that he had wholly ruined his constitution. Notwithstanding that, he would have liked to be employed in great works; but in this he did not succeed so readily, and he occupied himself for a time with executing pictures and portraits.

Pope Paul IV having died, Pius was elected, likewise the Fourth of that name, who, much delighting in building, availed himself of Pirro Ligorio in matters of architecture; and his Holiness ordained that Cardinals Alessandro Farnese and Emulio should cause the Great Hall, called the Hall of Kings, to be finished by Daniello da Volterra, who had begun it. That very reverend Farnese did his utmost to obtain the half of that work for Francesco, and in consequence there was a long contention between Daniello and Francesco, particularly because Michelagnolo Buonarroti exerted himself in favour of Daniello, and for a time they arrived at no conclusion. Meanwhile, Vasari having

gone with Cardinal Giovanni de' Medici, the son of Duke Cosimo, to Rome, Francesco related to him his many difficulties, and in particular that in which, for the reasons just given, he then found himself; and Giorgio, who much loved the excellence of the man, showed him that up to that time he had managed his affairs very badly, and that for the future he should let him (Vasari) manage them, for he would so contrive that in one way or another the half of that Hall of Kings would fall to him to execute, which Daniello was not able to finish by himself, being a slow and irresolute person, and almost certainly not as able and versatile as Francesco. Matters standing thus, and nothing more being done for the moment, not many days afterwards Giorgio himself was requested by the Pope to paint part of that Hall, but he answered that he had one three times larger to paint in the Palace of his master, Duke Cosimo, and, in addition, that he had been so badly treated by Pope Julius III, for whom he had executed many labours in the Vigna on the Monte and elsewhere, that he no longer knew what to expect from certain kinds of men; adding that he had painted for the Palace of the same Pontiff, without being paid, an altar-piece of Christ calling Peter and Andrew from their nets on the Sea of Tiberias (which had been taken away by Pope Paul IV from a chapel that Julius had built over the corridor of the Belvedere, and which was to be sent to Milan), and that his Holiness should cause it to be either paid for or restored to him. To which the Pope said in answer – and whether it was true or not, I do not know – that he knew nothing of that altar-piece, but wished to see it; whereupon it was sent for, and, after his Holiness had seen it, but in a bad light, he was content that it should be restored.

The discussion about the Hall being then resumed, Giorgio told the Pope frankly that Francesco was the first and best painter in Rome, that his Holiness would do well to employ him, since no one could serve him better, and that, although Buonarroti and the Cardinal of Carpi favoured Daniello, they did so more from the motive of friendship, and perhaps out of animosity, than for any other reason. But to return to the altar-piece; Giorgio had no sooner left the Pope than he sent it to the house of Francesco, who afterwards had it taken to Arezzo, where, as we have related in another place, it has been deposited by Vasari with a rich, costly, and handsome ornament, in the Pieve of that city. The affairs of the Hall of Kings remaining in the condition

that has been described above, when Duke Cosimo departed
from Siena in order to go to Rome, Vasari, who had gone as far
as that with his Excellency, recommended Salviati warmly to him,
beseeching him to make interest on his behalf with the Pope, and
to Francesco he wrote as to all that he was to do when the Duke
had arrived in Rome. In all which Francesco departed in no way
from the advice given him by Giorgio, for he went to do rev-
erence to the Duke, and was welcomed by his Excellency with an
aspect full of kindness, and shortly afterwards so much was said
to his Holiness on his behalf, that the half of the above-men-
tioned Hall was allotted to him. Setting his hand to the work,
before doing any other thing he threw to the ground a scene that
had been begun by Daniello; on which account there were after-
wards many contentions between them. The Pontiff was served
in matters of architecture, as has been already related, by Pirro
Ligorio, who at first had much favoured Francesco, and would
have continued to favour him; but Francesco paying no more
attention either to Pirro or to any other after he had begun to
work, this was the reason that Ligorio, from being his friend,
became in a certain sort his adversary, and of this very manifest
signs were seen, for Pirro began to say to the Pope that since
there were many young painters of ability in Rome, and he
wished to have that Hall off his hands, it would be a good thing
to allot one scene to each of them, and thus to see it finished
once and for all. These proceedings of Pirro's, to which it was
evident that the Pope was favourable, so displeased Francesco,
that in great disdain he retired from the work and all the conten-
tions, considering that he was held in little estimation. And so,
mounting his horse and not saying a word to anyone, he went off
to Florence, where, like the strange creature that he was, without
giving a thought to any of the friends that he had there, he took
up his abode in an inn, as if he did not belong to the place and
had no acquaintance there nor anyone who cared for him in any
way. Afterwards, having kissed the hands of the Duke, he was
received with such kindness, that he might well have looked for
some good result, if only he had been different in nature and had
adhered to the advice of Giorgio, who urged him to sell the
offices that he had in Rome and to settle in Florence, so as to
enjoy his native place with his friends and to avoid the danger of
losing, together with his life, all the fruits of his toil and grievous
labours. But Francesco, moved by sensitiveness and anger, and

by his desire to avenge himself, resolved that he would at all costs return to Rome in a few days. Meanwhile, moving from that inn at the entreaty of his friends, he retired to the house of M. Marco Finale, the Prior of S. Apostolo, where he executed a Pietà in colours on cloth of silver for M. Jacopo Salviati, as it were to pass the time, with the Madonna and the other Maries, which was a very beautiful work. He renewed in colours a medallion with the Ducal arms, which he had made on a former occasion and placed over a door in the Palace of Messer Alamanno. And for the above-named M. Jacopo he made a most beautiful book of bizarre costumes and various head-dresses of men and horses for masquerades, for which he received innumerable courtesies from the liberality of that lord, who lamented the strange and eccentric nature of Francesco, whom he was never able to attract into his house on this occasion, as he had done at other times.

Finally, Francesco being about to set out for Rome, Giorgio, as his friend, reminded him that, being rich, advanced in years, weak in health, and little fitted for more fatigues, he should think of living in peace and shun strife and contention, which he would have been able to do with ease, having acquired honour and property in plenty, if he had not been too avaricious and desirous of gain. He exhorted him, in addition, to sell the greater part of the offices that he possessed and to arrange his affairs in such a manner, that in any emergency or any misfortune that might happen he might be able to remember his friends and those who had given him faithful and loving service. Francesco promised that he would do right both in word and deed, and confessed that Giorgio had spoken the truth; but, as happens to most of the men who think that time will last for ever, he did nothing more in the matter. Having arrived in Rome, Francesco found that Cardinal Emulio had distributed the scenes of the Hall, giving two of them to Taddeo Zucchero of Sant' Agnolo, one to Livio da Forlì, another to Orazio da Bologna, yet another to Girolamo da Sermoneta, and the rest to others. Which being reported by Francesco to Giorgio, whom he asked whether it would be well for him to continue the work that he had begun, he received the answer that it would be a good thing, after making so many little designs and large cartoons, to finish at least one picture, notwithstanding that the greater part of the work had been allotted to so many others, all much inferior to him, and that he should make an effort to approach as near as possible in his work to the

pictures by Buonarroti on the walls and vaulting of the Sistine Chapel, and to those of the Pauline; for the reason that after his work was seen, the others would be thrown to the ground, and all, to his great glory, would be allotted to him. And Giorgio warned him to give no thought to profit or money, or to any vexation that he might suffer from those in charge of the work, telling him that the honour was much more important than any other thing. Of all these letters and of the replies, the originals, as well as copies, are among those that we ourselves treasure in memory of so great a man, who was our dearest friend, and among those by our own hand that must have been found among his possessions.

After these things Francesco was living in an angry mood, in no way certain as to what he wished to do, afflicted in mind, feeble in body, and weakened by everlasting medicines, when finally he fell ill with the illness of death, which carried him in a short time to the last extremity, without having given him time to make a complete disposal of his possessions. To a disciple called Annibale, the son of Nanni di Baccio Bigio, he left sixty crowns a year on the Monte delle Farine, fourteen pictures, and all his designs and other art possessions. The rest of his property he left to Suor Gabriella, his sister, a nun, although I understand that she did not receive, as the saying goes, even the 'cord of the sack.' However, there must have come into her hands a picture painted on cloth of silver, with embroidery around it, which he had executed for the King of Portugal or of Poland, whichever it was, and left to her to the end that she might keep it in memory of him. All his other possessions, such as the offices that he had bought after unspeakable fatigues, all were lost.

Francesco died on S. Martin's Day, the 11th of November, in the year 1563, and was buried in S. Gieronimo, a church near the house where he lived. The death of Francesco was a very great loss to art, seeing that, although he was fifty-four years of age and weak in health, he was continually studying and working, cost what it might; and at the very last he had set himself to work in mosaic. It is evident that he was capricious, and would have liked to do many things; and if he had found a Prince who could have recognized his humour and could have given him works after his fancy, he would have achieved marvellous things, for, as we have said, he was rich, fertile, and most exuberant in every kind of invention, and a master in every field of painting. He gave great

beauty and grace to every kind of head, and he understood the
nude as well as any other painter of his time. He had a very
graceful and delicate manner in painting draperies, arranging them
in such a way that the nude could always be perceived in the parts
where that was required, and clothing his figures in new fashions
of dress; and he showed fancy and variety in head-dresses, foot-
wear, and every other kind of ornament. He handled colours in
oils, in distemper, and in fresco in such a manner, that it may be
affirmed that he was one of the most able, resolute, bold, and
diligent craftsmen of our age, and to this we, who associated with
him for so many years, are well able to bear testimony. And al-
though there was always between us a certain proper emulation,
by reason of the desire that good craftsmen have to surpass one
another, none the less, with regard to the claims of friendship,
there was never any lack of love and affection between us, al-
though each of us worked in competition in the most famous
places in Italy, as may be seen from a vast number of letters that
are in my possession, as I have said, written by the hand of
Francesco. Salviati was affectionate by nature, but suspicious,
acute, subtle, and penetrative, and yet ready to believe anything;
and when he set himself to speak of some of the men of our arts,
either in jest or in earnest, he was likely to give offence, and at
times touched them to the quick. It pleased him to mix with men
of learning and great persons, and he always held plebeian crafts-
men in detestation, even though they might be able in some field
of art. He avoided such persons as always speak evil, and when
the conversation turned on them he would tear them to pieces
without mercy. But most of all he abhorred the knaveries that
craftsmen sometimes commit, of which, having been in France,
and having heard something of them, he was only too well able
to speak. At times, in order to be less weighed down by his mel-
ancholy, he used to mingle with his friends and force himself to
be cheerful. But in the end his strange nature, so irresolute, suspi-
cious, and solitary, did harm to no one but himself.

His dearest friend was Manno, a Florentine goldsmith in
Rome, a man rare in his profession and excellent in character and
goodness of heart. Manno is burdened with a family, and if
Francesco had been able to dispose of his property, and had not
spent all the fruits of his labours on offices, only to leave them
to the Pope, he would have left a great part of them to that
worthy man and excellent craftsman. Very dear to him, likewise,

was the above-mentioned Avveduto dell' Avveduto, a dresser of minever-furs, who was the most loving and most faithful friend that Francesco ever had; and if he had been in Rome when Francesco died, Salviati would probably have arranged certain of his affairs with better judgment than he did.

His disciple, also, was the Spaniard Roviale, who executed many works in company with him, and by himself an altar-piece containing the Conversion of S. Paul for the Church of S. Spirito in Rome. And Salviati was very well disposed towards Francesco di Girolamo dal Prato, in company with whom, as has been related above, he studied design while still a child; which Francesco was a man of most beautiful genius, and drew better than any other goldsmith of his time; and he was not inferior to his father Girolamo, who executed every kind of work with plates of silver better than any of his rivals. It is said that Girolamo succeeded with ease in any kind of work; thus, having beaten the plate of silver with certain hammers, he placed it on a piece of plank, and between the two a layer of wax, tallow and pitch, producing in that way a material midway between soft and hard, and then, beating it with iron instruments both inwards and outwards, he caused it to come out in whatever shapes he desired – heads, breasts, arms, legs, backs, and any other thing that he wished or was demanded from him by those who caused votive offerings to be made, in order to attach them to those holy images that were to be found in any place where they had received favours or had been heard in their prayers. Francesco, then, not attending only to the making of votive offerings, as his father did, worked also at tausia and at inlaying steel with gold and silver after the manner of damascening, making foliage, figures, and any other kind of work that he wished; in which manner of inlaid work he made a complete suit of armour for a foot-soldier, of great beauty, for Duke Alessandro de' Medici. Among many medals that the same man made, those were by his hand, and very beautiful, which were placed in the foundations of the fortifications at the Porta a Faenza, with the head of the above-named Duke Alessandro; together with others in which there was on one side the head of Pope Clement VII, and on the other a nude Christ with the scourges of His Passion. Francesco also delighted in the work of sculpture, and cast some little figures in bronze, full of grace, which came into the possession of Duke Alessandro. And the same master polished and carried to great perfection four similar

figures, made by Baccio Bandinelli – namely, a Leda, a Venus, a Hercules, and an Apollo – which were given to the same Duke. Being dissatisfied, then, with the goldsmith's craft, and not being able to give his attention to sculpture, which calls for too many resources, Francesco, having a good knowledge of design, devoted himself to painting; and since he was a person who mixed little with others, and did not care to have it known more than was inevitable that he was giving his attention to painting, he executed many works by himself. Meanwhile, as was related at the beginning, Francesco Salviati came to Florence, and he worked at the picture for M. Alamanno in the rooms that the other Francesco occupied in the Office of Works of S. Maria del Fiore; wherefore with that opportunity, seeing Salviati's method of working, he applied himself to painting with much more zeal than he had done up to that time, and executed a very beautiful picture of the Conversion of S. Paul, which is now in the possession of Guglielmo del Tovaglia. And after that, in a picture of the same size, he painted the Serpents raining down on the Hebrew people, and in another he painted Jesus Christ delivering the Holy Fathers from the Limbo of Hell; which two last-named pictures, both very beautiful, now belong to Filippo Spini, a gentleman who much delights in our arts. Besides many other little works that Francesco dal Prato executed, he drew much and well, as may be seen from some designs by his hand that are in our book of drawings. He died in the year 1562, and his death much grieved the whole Academy, because, besides his having been an able master in art, there was never a more excellent man than Francesco.

Another pupil of Francesco Salviati was Giuseppe Porta of Castelnuovo della Garfagnana, who, out of respect for his master, was also called Giuseppe Salviati. This Giuseppe, having been taken to Rome as a boy, in the year 1535, by an uncle, the secretary of Monsignor Onofrio Bartolini, Archbishop of Pisa, was placed with Salviati, under whom he learned in a short time not only to draw very finely, but also to use colour excellently well. He then went with his master to Venice, where he formed so many connections with noble persons, that, being left there by Francesco, he made up his mind that he would choose that city as his home; and so, having taken a wife there, he has lived there ever since, and he has worked in few other places but Venice. He painted long ago the façade of the house of the Loredani on the

Campo di S. Stefano, with scenes very pleasingly coloured in fresco and executed in a beautiful manner. He painted, likewise, that of the Bernardi at S. Polo, and another behind S. Rocco, which is a very good work. Three other façades he has painted in chiaroscuro, very large and covered with various scenes – one at S. Moisè, the second at S. Cassiano, and the third at S. Maria Zebenigo. He has also painted in fresco, at a place called Treville, near Treviso, the whole of the Palace of the Priuli, a rich and vast building, both within and without; of which building there will be a long account in the Life of Sansovino; and at Pieve di Sacco he has painted a very beautiful façade. At Bagnuolo, a seat of the Friars of S. Spirito at Venice, he has executed an altar-piece in oils; and for the same fathers he has painted the ceiling, or rather, soffit of the refectory in the Convent of S. Spirito, with a number of compartments filled with painted pictures, and a most beautiful Last Supper on the principal wall. For the Hall of the Doge, in the Palace of S. Marco, he has painted the Sibyls, the Prophets, the Cardinal Virtues, and Christ with the Maries, which have won him vast praise; and in the above-mentioned Library of S. Marco he painted two large scenes, in competition with the other painters of Venice of whom mention has been made above. Being summoned to Rome by Cardinal Emulio after the death of Francesco, he finished one of the larger scenes that are in the Hall of Kings, and began another; and then, Pope Pius IV having died, he returned to Venice, where the Signoria commissioned him to paint a ceiling with pictures in oils, which is at the head of the new staircase in the Palace.

The same master has painted six very beautiful altar-pieces in oils, one of which is on the altar of the Madonna in S. Francesco della Vigna, the second on the high-altar in the Church of the Servites, the third is with the Friars Minors, the fourth in the Madonna dell' Orto, the fifth at S. Zaccheria, and the sixth at S. Moisè; and he has painted two at Murano, which are beautiful and executed with much diligence and in a lovely manner. But of this Giuseppe, who is still alive and is becoming a very excellent master, I say no more for the present, save that, in addition to his painting, he devotes much study to geometry. By his hand is the Volute of the Ionic Capital that is to be seen in print at the present day, showing how it should be turned after the ancient measure; and there is to appear soon a work that he has composed on the subject of geometry.

A disciple of Francesco, also, was one Domenico Romano, who was of great assistance to him in the hall that he painted in Florence, and in other works. Domenico engaged himself in the year 1550 to Signor Giuliano Cesarino, and he does not work on his own account.

DANIELLO RICCIARELLI,
Painter and Sculptor of Volterra

DANIELLO, when he was a lad, learned to draw a little from Giovanni Antonio Sodoma, who went at that time to execute certain works in the city of Volterra; and when Sodoma had gone away he made much greater and better proficience under Baldassarre Peruzzi than he had done under the discipline of the other. But to tell the truth, for all that, he achieved no great success at that time, for the reason that in proportion as he devoted great effort and study to seeking to learn, being urged by a strong desire, even so, on the other hand, did his brain and hand fail him. Wherefore in his first works, which he executed at Volterra, there is evidence of very great, nay, infinite labour, but not yet any promise of a grand or beautiful manner, nor any grace, charm, or invention, such as have been seen at an early hour in many others who have been born to be painters, and who, even in their first beginnings, have shown facility, boldness, and some indication of a good manner. His first works, indeed, seem in truth as if done by a melancholic, being full of effort and executed with much patience and expenditure of time.

But let us come to his works, leaving aside those that are not worthy of attention; in his youth he painted in fresco at Volterra the façade of M. Mario Maffei, in chiaroscuro, which gave him a good name and won him much credit. But after he had finished it, perceiving that he had there no competition that might spur him to seek to rise to greater heights, and that there were no works in that city, either ancient or modern, from which he could learn much, he determined at all costs to go to Rome, where he heard that there were not at that time many who were engaged in painting, excepting Perino del Vaga. Before departing, he resolved that he would take some finished work that might make him known; and so, having painted a canvas in oils of Christ

Scourged at the Column, with many figures, to which he devoted all possible diligence, availing himself of models and portraits from life, he took it with him. And, having arrived in Rome, he had not been long there before he contrived by means of friends to show that picture to Cardinal Triulzi, whom it satisfied in such a manner that he not only bought it, but also conceived a very great affection for Daniello; and a short time afterwards he sent him to work in a village without Rome belonging to himself, called Salone, where he had built a very large house, which he was having adorned with fountains, stucco-work, and paintings, and in which at that very time Gian Maria da Milano and others were decorating certain rooms with stucco and grotesques. Arriving there, then, Daniello, both out of emulation and from a desire to serve that lord, from whom he could hope to win much honour and profit, painted various things in many rooms and loggie in company with the others, and in particular executed many grotesques, full of various little figures of women. But the work that proved to be more beautiful than all the rest was a story of Phaëthon, executed in fresco with figures of the size of life, and a very large River God that he painted there, which is a very good figure; and all these works, since the above-named Cardinal went often to see them, and took with him now one and now another of the Cardinals, were the reason that Daniello formed a friendship and bonds of service with many of them.

Afterwards, Perino del Vaga, who at that time was painting the Chapel of M. Agnolo de' Massimi in the Trinità, having need of a young man who might help him, Daniello, desiring to make proficience, and drawn by his promises, went to work with him and assisted him to execute certain things in the work of that chapel, which he carried to completion with much diligence. Now, before the sack of Rome Perino had painted on the vaulting of the Chapel of the Crocifisso in S. Marcello, as has been related, the Creation of Adam and Eve in figures of the size of life, and in much larger figures two Evangelists, S. John and S. Mark, which were not yet completely finished, since the figure of S. John was wanting from the middle upwards; and the men of that Company resolved, when the affairs of Rome had finally become settled again, that the same Perino should finish the work. But he, having other work to do, made the cartoons and had it finished by Daniello, who completed the S. John that had been left unfinished, painted all by himself the two other

Evangelists, S. Luke and S. Matthew, between them two little boys that are holding a candelabrum, and, on the arch of the wall that contains the window, two Angels standing poised on their wings in the act of flight, who are holding in their hands the Mysteries of the Passion of Jesus Christ; and he adorned the arch richly with grotesques and little naked figures of great beauty. In short, he acquitted himself marvellously well in all that work, although he took a considerable time over it.

The same Perino having then caused Daniello to execute a frieze in the hall of the Palace of M. Agnolo Massimi, with many divisions in stucco and other ornaments, and stories of the actions of Fabius Maximus, he bore himself so well, that Signora Elena Orsina, having seen that work and hearing the ability of Daniello much extolled, commissioned him to paint her chapel in the Church of the Trinità in Rome, on the hill, where the Friars of S. Francesco di Paola have their seat. Wherefore Daniello, putting forth all possible effort and diligence, in order to produce a rare work which might make him known as an excellent painter, did not shrink from devoting to it the labour of many years. From the name of that lady, the title given to the chapel being that of the Cross of Christ Our Saviour, the subject chosen was that of the actions of S. Helen; and so in the principal altarpiece Daniello painted Jesus Christ taken down from the Cross by Joseph, Nicodemus, and other disciples, and the Virgin Mary in a swoon, supported on the arms of the Magdalene and the other Maries, in all which he showed very great judgment, and gave proof of very rare ability, for the reason that, besides the composition of the figures, which has a very rich effect, the figure of Christ is very fine and most beautifully foreshortened, with the feet coming forward and the rest backwards. Very beautiful and difficult, likewise, are the foreshortenings in the figures of those who, having removed Him from the Cross, support Him with some bands, standing on some ladders and revealing in certain parts the nude flesh, executed with much grace. Around that altar-piece he made an ornament in stucco-work of great beauty and variety, full of carvings, with two figures that support the pediment with their heads, while with one hand they hold the capital, and with the other they seek to place the column, which stands at the foot on the base, below the capital to support it; which work is done with extraordinary care. In the arch above the altar-piece he painted two Sibyls in fresco, which are the best

figures in the whole work; and those Sibyls are one on either side of the window, which is above the centre of the altar-piece, giving light to the whole chapel. The vaulting of the chapel is divided into four compartments by bizarre, well varied, and beautiful partitions of stucco-work and grotesques made with new fantasies of masks and festoons; and in those compartments are four stories of the Cross and of S. Helen, the mother of Constantine. In the first is the scene when, before the Passion of the Saviour, three Crosses are constructed; in the second, S. Helen commanding certain Hebrews to reveal those Crosses to her; in the third, the Hebrews not consenting to reveal them, she causes to be cast into a well him who knows where they are; and in the fourth he reveals the place where all three are buried. Those four scenes are beautiful beyond belief, and executed with great care. On the side-walls are four other scenes, two to each wall, and each is divided off by the cornice that forms the impost of the arch upon which rests the groined vaulting of the chapel. In one is S. Helen causing the Holy Cross and the two others to be drawn up from a well; and in the second is that of the Saviour healing a sick man. Of the pictures below, in that on the right hand is the same S. Helen recognizing the Cross of Christ because it restores to life a corpse upon which it is laid; to the nude flesh of which corpse Daniello devoted extraordinary pains, searching out all the muscles and seeking to render correctly all the parts of the body, as he also did in those who are placing the Cross upon it, and in the bystanders, who are all struck with amazement by the sight of that miracle. And, in addition, there is a bier of bizarre shape painted with much diligence, with a skeleton embracing it, executed with great care and with beautiful invention. In the other picture, which is opposite to the first, he painted the Emperor Heraclius walking barefoot and in his shirt, and carrying the Cross of Christ through the gate of Rome, with men, women, and children kneeling, who are adoring it, many lords in his train, and a groom who is holding his horse. Below each scene, forming a kind of base, are two most beautiful women in chiaroscuro, painted in imitation of marble, who appear to be supporting those scenes. And under the first arch, on the front side, he painted on the flat surface, standing upright, two figures as large as life, a S. Francesco di Paola, the head of the Order that administers the above-named church, and a S. Jerome robed as a Cardinal, which are two very good figures,

even as are those of the whole work, which Daniello executed in seven years, with incalculable labour and study.

But, since pictures that are executed in that way have always a certain hard and laboured quality, the work is wanting in the grace and facility that give most pleasure to the eye. Wherefore Daniello, himself confessing the fatigue that he had endured in the work, and fearing the fate that did come upon him (namely, that he would be censured), made below the feet of those two Saints, to please himself, and as it were in his own defence, two little scenes of stucco in low-relief, in which he sought to show that, although he worked slowly and with effort, nevertheless, since Michelagnolo Buonarroti and Fra Sebastiano del Piombo were his friends, and he was always imitating their works and observing their precepts, his imitation of those two men should be enough to defend him from the biting words of envious and malignant persons, whose evil nature must perforce be revealed, although they may not think it. In one of these scenes, then, he made many figures of Satyrs that are weighing legs, arms, and other members of figures with a steelyard, in order to put on one side those that are correct in weight and satisfactory, and to give those that are bad to Michelagnolo and Fra Sebastiano, who are holding conference over them; and in the other is Michelagnolo looking at himself in a mirror, the significance of which is clear enough. At two angles of the arch, likewise, on the outer side, he painted two nudes in chiaroscuro, which are of the same excellence as the other figures in that work. When it was all uncovered, which was after a very long time, it was much extolled, and held to be a very beautiful work and a triumph over difficulties, and the painter a most excellent master.

After that chapel, Cardinal Alessandro Farnese caused him to execute in a room in his Palace – namely, at the corner, under one of those very rich ceilings made under the direction of Maestro Antonio da San Gallo for three large chambers that are in a line – a very beautiful frieze in painting, with a scene full of figures on each wall, the scenes being a very beautiful triumph of Bacchus, a Hunt, and others of that kind. These much pleased the Cardinal, who caused him to paint, in addition, in several parts of that frieze, the Unicorn in various forms in the lap of a Virgin, which is the device of that most illustrious family. Which work was the reason that that lord, who has ever been the friend of all talented and distinguished men, always favoured him, and even

more would he have done it, if Daniello had not been so dilatory over his work; but for that Daniello was not to blame, seeing that such was his nature and genius, and he was content to do little well rather than much not so well. Now, in addition to the affection that the Cardinal bore him, Signor Annibale Caro worked on his behalf in such a manner with his patrons, the Farnesi, that they always assisted him. And for Madama Margherita of Austria, the daughter of Charles V, he painted in eight spaces in the study of which mention has been made in the Life of Indaco, in the Palace of the Medici on the Piazza Navona, eight little stories of the actions and illustrious deeds of the above-named Emperor Charles V, with such diligence and excellence, that it would be almost impossible to do better in that kind of work.

In the year 1547 Perino del Vaga died, leaving unfinished the Hall of Kings, which, as has been related, is in the Papal Palace, in front of the Sistine and Pauline Chapels; and by the mediation of many friends and lords, and in particular of Michelagnolo Buonarroti, Daniello was set in his place by Pope Paul III, with the same salary that Perino had received, and was commanded to make a beginning with the ornaments of the walls that were to be executed in stucco, with many nudes in the round over certain pediments. Now, since the walls of that Hall are broken by six large doors in variegated marble, and only one wall is left unbroken, Daniello made over each door what is almost a tabernacle in stucco, of great beauty. In each of these he intended to execute in painting one of those Kings who have defended the Apostolic Church, and then to continue on the walls with stories of those Kings who have benefited the Church with tributes or victories, so that in all there were to be six stories and six niches. After those niches, or rather, tabernacles, Daniello with the aid of many assistants executed all the other very rich decorations in stucco that are to be seen in that Hall, studying at the same time over the cartoons for all that he had proposed to do in that place in the way of painting. Which done, he made a beginning with one of the stories, but he did not paint more than about two braccia of it, and two of the Kings in the tabernacles of stucco over the doors. For, although he was pressed by Cardinal Farnese and by the Pope, not reflecting that death very often spoils the designs of men, he carried on the work so slowly that when in the year 1549 the death of the Pope took place, there was nothing done save what has been described; and then, the Conclave

having to be held in the Hall, which was full of scaffolding and wood-work, it became necessary to throw everything to the ground and uncover the work. The whole being thus seen by everyone, the works in stucco were vastly extolled, as they deserved, but not so the two Kings in painting, for it was thought that they were not equal in excellence to the work at the Trinità, and that with all those fine allowances and advantages he had gone rather backward than forward.

Julius III having been created Pontiff in the year 1550, Daniello put himself forward by means of friends and interests, hoping to obtain the same salary and to continue the work of that Hall, but the Pope, not having any inclination in his favour, always put him off; indeed, sending for Giorgio Vasari, who had been his servant from the time when he was Archbishop of Siponto, he made use of him in all matters concerned with design. Nevertheless, his Holiness having determined to make a fountain at the head of the corridor of the Belvedere, and not liking a design by Michelagnolo (in which was Moses striking the rock and causing water to flow from it) because it was a thing that could not be carried out without a great expenditure of time, since Michelagnolo wished to make it of marble; his Holiness, I say, preferring the advice of Giorgio, which was that the Cleopatra, a divine figure made by the Greeks, should be set up in that place, the charge of that work was given by means of Buonarroti to Daniello, with orders that he should make in the above-named place a grotto in stucco-work, within which that Cleopatra was to be placed. Daniello, then, having set his hand to that work, pursued it so slowly, although he was much pressed, that he finished only the stucco-work and the paintings in that room, but as for the many other things that the Pope wished to have done, seeing them delayed longer than he had expected, he lost all desire for them, so that nothing more was done and everything was left in the condition that is still to be seen.

In a chapel in the Church of S. Agostino Daniello painted in fresco, with figures of the size of life, S. Helen causing the Cross to be found, and in two niches at the sides S. Cecilia and S. Lucia, which work was painted partly by him and partly, after his designs, by the young men who worked with him, so that it did not prove as perfect as his others. At this same time there was allotted to him by Signora Lucrezia della Rovere a chapel in the Trinità, opposite to that of Signora Elena Orsina. In that chapel,

having divided it into compartments with stucco-work, he had the vaulting painted with stories of the Virgin, after his own cartoons, by Marco da Siena and Pellegrino da Bologna; on one of the walls he caused the Nativity of the Virgin to be painted by the Spaniard Bizzerra, and on the other, by Giovan Paolo Rossetti of Volterra, his disciple, the Presentation of Jesus Christ to Simeon; and he caused the same Giovan Paolo to execute two scenes that are on the arches above, Gabriel bringing the Annunciation to the Virgin and the Nativity of Christ. On the outer side, at the angles, he painted two large figures, and on the pilasters, at the foot, two Prophets. On the altar-front Daniello painted with his own hand the Madonna ascending the steps of the Temple, and on the principal wall the same Virgin ascending into Heaven, borne by many most beautiful Angels in the forms of little boys, and the twelve Apostles below, gazing on her as she ascends. And since the place would not hold so many figures, and he desired to use a new invention in the work, he made it appear as if the altar of that chapel were the sepulchre, and placed the Apostles around it, making their feet rest on the floor of the chapel, where the altar begins; which method of Daniello's has pleased some, but others, who form the greater and better part, not at all. And although Daniello toiled fourteen years over executing that work, it is not a whit better than the first. On the last wall of the chapel that remained to be finished, on which there was to be painted the Massacre of the Innocents, having himself made the cartoons, he had the whole executed by the Florentine Michele Alberti, his disciple.

The Florentine Monsignor M. Giovanni della Casa, a man of great learning (to which his most pleasing and learned works, both in Latin and in the vulgar tongue, bear witness), having begun to write a treatise on the matters of painting, and wishing to enlighten himself as to certain minute particulars with the help of men of the profession, commissioned Daniello to make with all possible care a finished model of a David in clay. And then he caused him to paint, or rather, to copy in a picture, the same David, which is very beautiful, from either side, both the front and the back, which was a fanciful notion; and that picture now belongs to M. Annibale Rucellai. For the same M. Giovanni he executed a Dead Christ with the Maries; and, on a canvas that was to be sent to France, Æneas disrobing in order to go to sleep with Dido, and interrupted by Mercury, who is represented as

speaking to him in the manner that may be read in the verses of Virgil. And he painted for the same man in another picture, likewise in oils, a most beautiful S. John in Penitence, of the size of life, which was held very dear by that lord as long as he lived; and also a S. Jerome, beautiful to a marvel.

Pope Julius III having died, and Paul IV having been elected Supreme Pontiff, the Cardinal of Carpi sought to persuade his Holiness to give the above-mentioned Hall of Kings to Daniello to finish, but that Pope, not delighting in pictures, answered that it was much better to fortify Rome than to spend money on painting it. And so he caused a beginning to be made with the great portal of the Castle, after the design of Salustio, the son of Baldassarre Peruzzi of Siena and his architect, and ordained that in that work, which was being executed all in travertine, after the manner of a sumptuous and magnificent triumphal arch, there should be placed in niches five statues, each of four braccia and a half; whereupon Daniello was commissioned to make an Angel Michael, the other statues having been allotted to other craftsmen. Meanwhile Monsignor Giovanni Riccio, Cardinal of Montepulciano, resolved to erect a chapel in S. Pietro a Montorio, opposite to that which Pope Julius had caused to be built under the direction of Giorgio Vasari, and he allotted the altar-piece, the scenes in fresco and the statues of marble that were going into it, to Daniello; and Daniello, by that time completely determined that he would abandon painting and devote himself to sculpture, went off to Carrara to have the marble quarried both for the S. Michael and for the statues that he was to make for the chapel in S. Pietro a Montorio. With that occasion, coming to see Florence and the works that Vasari was executing in the Palace for the Duke, and the other works in that city, he received many courtesies from his innumerable friends, and in particular from Vasari himself, to whom Buonarroti had recommended him by letter. Abiding in Florence, then, and perceiving how much the Lord Duke delighted in all the arts of design, Daniello was seized with a desire to attach himself to the service of his most illustrious Excellency. Many means being therefore employed, the Lord Duke replied to those who were recommending him that he should be introduced by Vasari, and so it was done; and Daniello offering himself as the servant of his Excellency, the Duke answered graciously that he accepted him most willingly, and that after he had fulfilled the engagements that he had in

Rome, he should come when he pleased, and he would be received very gladly.

Daniello stayed all that summer in Florence, where Giorgio lodged him in the house of Simon Botti, who was much his friend. There, during that time, he cast in gesso nearly all the figures of marble by the hand of Michelagnolo that are in the new sacristy of S. Lorenzo; and for the Fleming Michael Fugger he made a Leda, which was a very beautiful figure. He then went to Carrara, and from there, having sent the marble that he desired in the direction of Rome, he returned once again to Florence, for the following reason. Daniello had brought with him, when he first came from Rome to Florence, a young disciple of his own called Orazio Pianetti, a talented and very gentle youth; but no sooner had he arrived in Florence, whatever may have been the reason, than he died. At which feeling infinite grief and sorrow, Daniello, as one who much loved the young man for his fine qualities, and was not able to show his affection for him in any other way, returning that last time to Florence, made a portrait of him in marble from the breast upwards, which he copied excellently well from one moulded from his dead body. And when it was finished, he placed it with an epitaph in the Church of S. Michele Berteldi on the Piazza degli Antinori; in which Daniello proved himself, by that truly loving office, to be a man of rare goodness, and a different sort of friend to his friends from the kind that is generally seen at the present day, when there are very few to be found who value anything in friendship beyond their own profit and convenience.

After these things, it being a long time since he had been in his native city of Volterra, he went there before returning to Rome, and was warmly welcomed by his relatives and friends. Being besought to leave some memorial of himself in his native place, he executed the story of the Innocents in a small panel with little figures, which was held to be a very beautiful work, and placed it in the Church of S. Piero. Then, thinking that he would never return, he sold the little that he possessed there by way of patrimony to Leonardo Ricciarelli, his nephew, who, having been with him in Rome, and having learned very well how to work in stucco, afterwards served Giorgio Vasari for three years, in company with many others, in the works that were executed at that time in the Palace of the Duke.

When Daniello had finally returned to Rome, Pope Paul IV having a desire to throw to the ground the Judgment of Michelagnolo on account of the nudes, which seemed to him to display the parts of shame in an unseemly manner, it was said by the Cardinals and by men of judgment that it would be a great sin to spoil them, and they found a way out of it, which was that Daniello should paint some light garments to cover them; and the business was afterwards finished in the time of Pius IV by repainting the S. Catherine and the S. Biagio, which were thought to be unseemly.

In the meantime he began the statues for the Chapel of the above-named Cardinal of Montepulciano, and the S. Michael for the great portal; but none the less, being a man who was always going from one notion to another, he did not work with the promptitude that he could and should have used. About this time, after King Henry of France had been killed in a tournament, Signor Ruberto Strozzi being about to come to Italy and to Rome, Queen Caterina de' Medici, having been left Regent in that kingdom, and wishing to erect some honourable memorial to her dead husband, commanded the said Ruberto to confer with Buonarroti and to contrive to have her desire in that matter fulfilled. Wherefore, having arrived in Rome, he spoke long of the matter with Michelagnolo, who, not being able, because he was old, to accept that undertaking himself, advised Signor Ruberto to give it to Daniello, saying that he would not fail to give him all the counsel and assistance that he could. To that offer Strozzi attached great importance, and, after they had considered with much deliberation what should be done, it was resolved that Daniello should make a horse of bronze all in one piece, twenty palms high from the head to the feet, and about forty in length, and that upon it there should then be placed the statue of King Henry in armour, likewise of bronze. Daniello having then made a little model of clay after the advice and judgment of Michelagnolo, which much pleased Signor Ruberto, an account of everything was written to France, and in the end an agreement was made between him and Daniello as to the method of executing that work, the time, the price, and every other thing. Whereupon Daniello, setting to work with much study on the horse, made it in clay exactly as it was to be, without ever doing any other work; and then, having made the mould, he was proceeding to prepare to cast it, and, the work being of such

importance, was taking advice from many founders as to the method that he ought to pursue, to the end that it might come out well, when Pius IV, who had been elected Pontiff after the death of Paul, gave Daniello to understand that he desired, as has been related in the Life of Salviati, that the work of the Hall of Kings should be finished, and that therefore every other thing was to be put on one side. To which Daniello answered that he was fully occupied and pledged to the Queen of France, but would make the cartoons and have the work carried forward by his young men, and, in addition, would also do his own part in it. The Pope, not liking that answer, began to think of allotting the whole to Salviati; wherefore Daniello, seized with jealousy, so went to work with the help of the Cardinal of Carpi and Michelagnolo, that the half of that Hall was given to him to paint, and the other half, as we have related, to Salviati, although Daniello did his utmost to obtain the whole, in order to proceed with it at his leisure and convenience, without competition. But in the end the matter of that work was handled in such a manner, that Daniello did not do there one thing more than what he had done before, and Salviati did not finish the little that he had begun, and even that little was thrown to the ground for him by certain malicious persons.

Finally, after four years, Daniello was ready, so far as concerned him, to cast the above-mentioned horse, but he was obliged to wait many months more than he would otherwise have done, for want of the supplies of iron instruments, metal, and other materials that Signor Ruberto was to give him. But in the end, all these things having been provided, Daniello embedded the mould, which was a vast mass, between two furnaces for founding in a very suitable room that he had at Monte Cavallo. The material being melted and the orifices unstopped, for a time the metal ran well enough, but at length the weight of the metal burst the mould of the body of the horse, and all the molten material flowed in a wrong direction. At first this much troubled the mind of Daniello, but none the less, having thought well over everything, he found a way to remedy that great misfortune; and so after two months, casting it a second time, his ability prevailed over the impediments of Fortune, so that he executed the casting of that horse (which is a sixth, or more, larger than that of Antoninus which is on the Campidoglio) perfectly uniform and equally delicate throughout, and it is a marvellous thing that

a work so large should not weigh more than twenty thousand (libbre).

But such were the discomforts and fatigues that were endured in the work by Daniello, who was rather feeble in constitution and melancholy than otherwise, that not long afterwards there came upon him a cruel catarrh, which much reduced him; indeed, whereas Daniello should have been happy at having surmounted innumerable difficulties in so rare a casting, it seemed that he never smiled again, no matter what good fortune might befall him, and no long time passed before that catarrh, after an illness of two days, robbed him of his life, on the 4th of April, 1566. But before that, having foreseen his death, he confessed very devoutly, and demanded all the Sacraments of the Church; and then, making his will, he directed that his body should be buried in the new church that had been begun at the Baths by Pius IV for the Carthusian Monks, ordaining also that at his tomb, in that place, there should be set up the statue of the Angel that he had formerly begun for the great portal of the Castle. And of all this he gave the charge to the Florentine Michele degli Alberti and to Feliciano of San Vito in the district of Rome, making them executors of his will in those matters, and leaving them two hundred crowns for the purpose. Which last wishes of Daniello's the two of them executed with diligence and love, giving him honourable burial in that place, according as he had directed. To the same men he left all his property pertaining to art, moulds in gesso, models, designs, and all the other materials and implements of his work; wherefore they offered themselves to the Ambassador of France, saying that they would deliver completely finished, within a fixed time, the work of the horse and the figure of the King that was to go upon it. And, in truth, both of them having practised many years under the instruction and discipline of Daniello, the greatest things may be expected from them.

Disciples of Daniello, likewise, have been Biagio da Carigliano of Pistoia, and Giovan Paolo Rossetti of Volterra, who is a very diligent person and of most beautiful genius; which Giovan Paolo, having retired to Volterra many years ago, has executed, as he still does, works worthy of much praise. Another who also worked with Daniello, and made much proficience, was Marco da Siena, who, having made his way to Naples and chosen that city as his home, lives there and is constantly at work. And Giulio Mazzoni of Piacenza has likewise been a disciple of Daniello;

which Giulio received his first instruction from Vasari, when
Giorgio was executing in Florence an altar-piece for M. Biagio Mei,
which was sent to Lucca and placed in S. Piero Cigoli, and when
the same Giorgio was painting the altar-piece of the high-altar and
a great work in the refectory of Monte Oliveto at Naples, besides
the Sacristy of S. Giovanni Carbonaro and the doors of the organ
in the Piscopio, with other altar-pieces and pictures. Giulio, having
afterwards learned from Daniello to work in stucco, in which he
equalled his master, has adorned with his own hand all the interior
of the Palace of Cardinal Capodiferro, executing there marvellous
works not only in stucco, but also of scenes in fresco and in oils,
which have won him infinite praise, and that rightly. The same
master has made a head of Francesco del Nero in marble, copying
it so well from the life, that I do not believe that it is possible to do
better; wherefore it may be hoped that he is destined to achieve a
very fine result, and to attain to the greatest excellence and perfec-
tion that a man can reach in these our arts.

 Daniello was an orderly and excellent man, but so intent on
the studies of art, that he gave little thought to the other circum-
stances of his life. He was a melancholy person, and very solitary;
and he died at about the age of fifty-seven. A request for his
portrait was made to those disciples of his, who had taken it in
gesso, and when I was in Rome last year they promised it to me;
but, for all the messages and letters that I have sent to them, they
have refused to give it, thus showing little affection for their dead
master. However, I have been unwilling to be hindered by that
ingratitude on their part, seeing that Daniello was my friend, and
I have included the portrait given above, which, although it
is little like him, must serve as a proof of my diligence and
of the little care and lovingness of Michele degli Alberti and
Feliciano da San Vito.

TADDEO ZUCCHERO,
Painter of Sant' Agnolo in Vado

FRANCESCO MARIA being Duke of Urbino, there was born in
the township of Sant' Agnolo in Vado, a place in that State, on
the 1st of September in the year 1529, to the painter Ottaviano
Zucchero, a male child to whom he gave the name of Taddeo;

which boy having learned by the age of ten to read and write
passing well, his father took him under his own discipline and
taught him something of design. But, perceiving that his son had
a very beautiful genius and was likely to become a better master
in painting than he believed himself to be, Ottaviano placed him
with Pompeo da Fano, who was very much his friend, but a
commonplace painter. Pompeo's works not pleasing Taddeo, and
likewise his ways, he returned to Sant' Agnolo, and there, as well
as in other places, assisted his father to the best of his power and
knowledge. Finally, being well grown in years and in judgment,
and perceiving that he could not make much progress under the
discipline of his father, who was burdened with seven sons and
one daughter, and also that with his own little knowledge he
could not be of as much assistance to his father as he might wish,
he went off all alone, at the age of fourteen, to Rome. There, at
first, not being known by anyone, and himself knowing no one,
he suffered some hardships; and, if he did know one or two
persons, he was treated worse by them than by the others. Thus,
having approached Francesco, called Sant' Agnolo, who was
working by the day at grotesques under Perino del Vaga, he
commended himself to him with all humility, praying him that,
being his kinsman, he should consent to help him; but no good
came of it, for Francesco, as certain kinds of kinsmen often do,
not only did not assist him by word or deed, but reproved and
repelled him harshly. But for all that, not losing heart and not
being dismayed, the poor boy contrived to maintain himself (or
we should rather say, to starve himself) for many months in
Rome by grinding colours for a small price, now in one shop and
now in another, at times also drawing something, as best he
could. And although in the end he placed himself as an assistant
with one Giovan Piero Calavrese, he did not gain much profit
from that, for the reason that his master, together with his wife,
a shrew of a woman, not only made him grind colours all day
and all night, but even, among other things, kept him in want of
bread, which, lest he should be able to have enough or to take it
at his pleasure, they used to keep in a basket hung from the
ceiling, with some little bells, which would ring at the least touch
of a hand on the basket, and thus give the alarm. But this would
have caused little annoyance to Taddeo, if only he had had any
opportunity of drawing some designs by the hand of Raffaello da
Urbino that his pig of a master possessed.

On account of these and many other strange ways Taddeo left Giovan Piero, and resolved to live by himself and to have recourse to the workshops of Rome, where he was by that time known, spending a part of the week in doing work for a livelihood, and the rest in drawing, particularly the works by the hand of Raffaello that were in the house of Agostino Chigi and in other places in Rome. And since very often, when the evening came on, he had no place wherein to sleep, many a night he took refuge under the loggie of the above-named Chigi's house and in other suchlike places; which hardships did something to ruin his constitution, and, if his youth had not helped him, they would have killed him altogether. As it was, falling ill, and not being assisted by his kinsman Francesco Sant' Agnolo any more than he had been before, he returned to his father's house at Sant' Agnolo, in order not to finish his life in such misery as that in which he had been living.

However, not to waste any more time on matters that are not of the first importance, now that I have shown at sufficient length with what difficulties and hardships he made his proficience, let me relate that Taddeo, at length restored to health and once more in Rome, resumed his usual studies, but with more care of himself than he had taken in the past, and learned so much under a certain Jacopone, that he came into some credit. Wherefore the above-mentioned Francesco, his kinsman, who had behaved so cruelly toward him, perceiving that he had become an able master, and wishing to make use of him, became reconciled with him; and they began to work together, Taddeo, who was of a kindly nature, having forgotten all his wrongs. And so, Taddeo making the designs, and both together executing many friezes in fresco in chambers and loggie, they went on assisting one another.

Meanwhile the painter Daniello da Parma, who had formerly been many years with Antonio da Correggio, and had associated with Francesco Mazzuoli of Parma, having undertaken to paint a church in fresco for the Office of Works of S. Maria at Vitto,* beyond Sora, on the borders of the Abruzzi, called Taddeo to his assistance and took him to Vitto. In which work, although Daniello was not the best painter in the world, nevertheless, on account of his age, and from his having seen the methods of

* Alvito.

Correggio and Parmigiano, and with what softness they executed
their paintings, he had such experience that, imparting it to Tad-
deo and teaching him, he was of the greatest assistance to him
with his words; no less, indeed, than another might have been by
working before him. In that work, which was on a groined vault-
ing, Taddeo painted the four Evangelists, two Sibyls, two
Prophets, and four not very large stories of Jesus Christ and of
the Virgin His Mother.

He then returned to Rome, where, M. Jacopo Mattei, a
Roman gentleman, discoursing with Francesco Sant' Agnolo of
his desire to have the façade of his house painted in chiaroscuro,
Francesco proposed Taddeo to him; but he appeared to that
gentleman to be too young, wherefore Francesco said to him
that he should make trial of Taddeo in two scenes, which, if they
were not successful, could be thrown to the ground, and, if suc-
cessful, could be continued. Taddeo having then set his hand to
the work, the two first scenes proved to be such, that M. Jacopo
was not only satisfied with them, but astonished. In the year
1548, therefore, when Taddeo had finished that work, he was
vastly extolled by all Rome, and that with good reason, because
after Polidoro, Maturino, Vincenzio da San Gimignano, and Bal-
dassarre da Siena, no one had attained in works of that kind to
the standard that Taddeo had reached, who was then a young
man only eighteen years of age. The stories of the work may be
understood from these inscriptions, of the deeds of Furius
Camillus, one of which is below each scene.

The first, then, runs thus —

TUSCULANI, PACE CONSTANTI, VIM ROMANAM ARCENT.

The second —
M.F.C. SIGNIFERUM SECUM IN HOSTEM RAPIT.

The third —
M.F.C. AUCTORE, INCENSA URBS RESTITUITUR.

The fourth —
M.F.C. PACTIONIBUS TURBATIS PRÆLIUM GALLIS
NUNCIAT.

The fifth —
M.F.C. PRODITOREM VINCTUM FALERIO REDUCENDUM
TRADIT.

The sixth –

MATRONALIS AURI COLLATIONE VOTUM APOLLINI
SOLVITUR.

The seventh –

M.F.C. JUNONI REGINÆ TEMPLUM IN AVENTINO DEDICAT.

The eighth –

SIGNUM JUNONIS REGINÆ A VEIIS ROMAM TRANSFERTUR.

The ninth –

M.F.C. . . . ANLIUS DICT. DECEM . . . SOCIOS CAPIT.

From that time until the year 1550, when Julius III was elected
Pope, Taddeo occupied himself with works of no great import-
ance, yet with considerable profits. In which year of 1550, the
year of the Jubilee, Ottaviano, the father of Taddeo, with his
mother and another of their sons, went to Rome to take part in
that most holy Jubilee, and partly, also, to see their son. After
they had been there some weeks with Taddeo, on departing they
left with him the boy that they had brought with them, who was
called Federigo, to the end that he might cause him to study
letters. But Taddeo judged him to be more fitted for painting, as
indeed Federigo has since been seen to be from the excellent
result that he has achieved; and so, after he had learned his first
letters, Taddeo began to make him give his attention to design,
with better fortune and support than he himself had enjoyed.
Meanwhile Taddeo painted in the Church of S. Ambrogio de'
Milanesi, on the wall of the high-altar, four stories of the life of
that Saint, coloured in fresco and not very large, with a frieze of
little boys, and women after the manner of terminal figures;
which was a work of no little beauty. That finished, he painted a
façade full of stories of Alexander the Great, beside S. Lucia della
Tinta, near the Orso, beginning from his birth and continuing
with five stories of the most noteworthy actions of that famous
man; which work won him much praise, although it had to bear
comparison with another façade near it by the hand of Polidoro.

About that time Guidobaldo, Duke of Urbino, having heard
the fame of the young man, who was his vassal, and desiring to
give completion to the walls of the chapel in the Duomo of
Urbino, wherein Battista Franco, as has been related, had painted
the vaulting in fresco, caused Taddeo to be summoned to Urbi-
no. And he, leaving Federigo in Rome, under the care of persons

who might make him give his attention to his studies, and like-
wise another of his brothers, whom he placed with some friends
to learn the goldsmith's art, went off to Urbino, where many
attentions were paid him by that Duke; and then orders were
given to him as to all that he was to design in the matter of the
chapel and other works. But in the meantime the Duke, as
General to the Signori of Venice, had to visit Verona and the
other fortified places of that dominion, and he took with him
Taddeo, who copied for him the picture by the hand of Raffaello
da Urbino which, as has been related in another place, is in the
house of the noble Counts of Canossa. And he afterwards began,
also for his Excellency, a large canvas with the Conversion of
S. Paul, which, unfinished as he left it, is still in the possession
of his father Ottaviano at Sant' Agnolo.

Then, having returned to Urbino, he occupied himself for a
time with continuing the designs for the above-mentioned chapel,
which were of the life of Our Lady, as may be seen from some
of them that are in the possession of his brother Federigo, drawn
in chiaroscuro with the pen. But, whether it was that the Duke
had not made up his mind or considered Taddeo to be too
young, or for some other reason, Taddeo remained with him two
years without doing anything but some pictures in a little study
at Pesaro, a large coat of arms in fresco on the façade of the
Palace, and a picture with a life-size portrait of the Duke, which
were all beautiful works. Finally the Duke, having to depart for
Rome to receive from Pope Julius III his baton as General of
Holy Church, left directions that Taddeo was to proceed with the
above-named chapel, and that he was to be provided with all that
he required for that purpose. But the Duke's ministers, keeping
him, as such men generally do, in want of everything, brought it
about that Taddeo, after having lost two years of his time, had
to go off to Rome, where, having found the Duke, he excused
himself adroitly, without blaming anyone, and promised that he
would not fail to do the work when the time came.

In the year 1551, Stefano Veltroni, of Monte Sansovino –
having received orders from the Pope and from Vasari to have
adorned with grotesques the apartments of the villa on the hill
without the Porta del Popolo, which had belonged to Cardinal
Poggio – summoned Taddeo, and caused him to paint in the
central picture a figure of Opportunity, who, having seized For-
tune by the locks, appears to be about to cut them with her

shears (the device of that Pope); in which Taddeo acquitted himself very well. Then, Vasari having made before any of the others the designs for the court and the fountain at the foot of the new Palace, which were afterwards carried on by Vignuola and Ammanati and built by Baronino, Prospero Fontana, in painting many pictures there, as will be related hereafter, availed himself not a little of Taddeo in many things. And these were the cause of even greater benefits for him, for the Pope, liking his method of working, commissioned him to paint in some apartments, above the corridor of the Belvedere, some little figures in colour that served as friezes for those apartments; and in an open loggia, behind those that faced towards Rome, he painted in chiaroscuro on the wall, with figures as large as life, all the Labours of Hercules, which were destroyed in the time of Pope Paul IV, when other apartments and a chapel were built there. At the Vigna of Pope Julius, in the first apartments of the Palace, he executed some scenes in colour, and in particular one of Mount Parnassus, in the centre of the ceilings, and in the court of the same he painted in chiaroscuro two scenes of the history of the Sabines, which are one on either side of the principal door of variegated marble that leads into the loggia, whence one descends to the fountain of the Acqua Vergine; all which works were much commended and extolled.

Now Federigo, while Taddeo was in Rome with the Duke, had returned to Urbino, and he had lived there and at Pesaro ever since; but Taddeo, after the works described above, caused him to return to Rome, in order to make use of him in executing a great frieze in a hall, with others in other rooms, of the house of the Giambeccari on the Piazza di S. Apostolo, and in other friezes that he painted in the house of M. Antonio Portatore at the Obelisk of S. Mauro, all full of figures and other things, which were held to be very beautiful. Maestro Mattivolo, the Master of the Post, bought in the time of Pope Julius a site on the Campo Marzio, and built there a large and very commodious house, and then commissioned Taddeo to paint the façade in chiaroscuro; which Taddeo executed there three stories of Mercury, the Messenger of the Gods, which were very beautiful, and the rest he caused to be painted by others after designs by his own hand. Meanwhile M. Jacopo Mattei, having caused a chapel to be built in the Church of the Consolazione below the Campidoglio, allotted it to Taddeo to paint, knowing already how able

he was; and he willingly undertook to do it, and for a small price, in order to show to certain persons, who went about saying that he could do nothing save façades and other works in chiaroscuro, that he could also paint in colour. Having then set his hand to that work, Taddeo would only touch it when he was in the mood and vein to do well, spending the rest of his time on works that did not weigh upon him so much in the matter of honour; and so he executed it at his leisure in four years. On the vaulting he painted in fresco four scenes of the Passion of Christ, of no great size, with most beautiful fantasies, and all so well executed in invention, design, and colouring, that he surpassed his own self; which scenes are the Last Supper with the Apostles, the Washing of Feet, the Prayer in the Garden, and Christ taken and kissed by Judas. On one of the walls at the sides he painted in figures large as life Christ Scourged at the Column, and on the other Pilate showing Him after the scourging to the Jews, saying 'Ecce Homo'; above this last, in an arch, is the same Pilate washing his hands, and in the other arch, opposite to that, Christ led before Annas. On the altar-wall he painted the same Christ Crucified, and the Maries at the foot of the Cross, with Our Lady in a swoon; on either side of her is a Prophet, and in the arch above the ornament of stucco he painted two Sibyls; which four figures are discoursing of the Passion of Christ. And on the vaulting, about certain ornaments in stucco, are four half-length figures representing the Four Evangelists, which are very beautiful. The whole work, which was uncovered in the year 1556, when Taddeo was not more than twenty-six years of age, was held, as it still is, to be extraordinary, and he was judged by the craftsmen at that time to be an excellent painter.

That work finished, M. Mario Frangipane allotted to him his chapel in the Church of S. Marcello, in which Taddeo made use, as he also did in many other works, of the young strangers who are always to be found in Rome, and who go about working by the day in order to learn and to gain their bread; but none the less for the time being he did not finish it completely. The same master painted in fresco in the Pope's Palace, in the time of Paul IV, some rooms where Cardinal Caraffa lived, in the great tower above the Guard of Halberdiers; and two little pictures in oils of the Nativity of Christ and the Virgin flying with Joseph into Egypt, which were sent to Portugal by the Ambassador of that Kingdom. The Cardinal of Mantua, wishing to have painted with

the greatest possible rapidity the whole interior of his Palace beside the Arco di Portogallo, allotted that work to Taddeo for a proper price; and Taddeo, beginning it with the help of a good number of men, in a short time carried it to completion, showing that he had very great judgment in being able to employ so many different brains harmoniously in so great a work, and in managing the various manners in such a way, that the work appears as if all by the same hand. In short, Taddeo satisfied in that undertaking, with great profit to himself, the Cardinal and all who saw it, disappointing the expectations of those who could not believe that he was likely to succeed amid the perplexities of such a great work.

In like manner, he painted some scenes with figures in fresco for M. Alessandro Mattei in some recesses in the apartments of his Palace near the Botteghe Scure, and some others he caused to be executed by his brother Federigo, to the end that he might become accustomed to the work. Which Federigo, having taken courage, afterwards executed by himself a Mount Parnassus in the recess of a ceiling in the house of a Roman gentleman called Stefano Margani, below the steps of the Araceli. Whereupon Taddeo, seeing Federigo confident and working by himself from his own designs, without being assisted more than was reasonable by anyone, contrived to have a chapel allotted to him by the men of S. Maria dell' Orto a Ripa, making it almost appear that he intended to do it himself, for the reason that it would never have been given to Federigo alone, who was still a mere lad. Taddeo, then, in order to satisfy these men, painted there the Nativity of Christ, and Federigo afterwards executed all the rest, acquitting himself in such a manner that there could be seen the beginning of that excellence which is now made manifest in him.

In those same times the Duke of Guise, who was then in Rome, desiring to take an able and practised painter to paint his Palace in France, Taddeo was proposed to him; whereupon, having seen some of his works, and liking his manner, he agreed to give him a salary of six hundred crowns a year, on condition that Taddeo, after finishing the work that he had in hand, should go to France to serve him. And so Taddeo would have done, the money for his preparations having been deposited in a bank, if it had not been for the wars that broke out in France at that time, and shortly afterwards the death of that Duke. Taddeo then went back to finish the work for Frangipane in S. Marcello, but he was not able to work for long without being interrupted, for, the

Emperor Charles V having died, preparations were made for giv-
ing him most honourable obsequies in Rome, fit for an Emperor
of the Romans, and to Taddeo were allotted many scenes from
the life of that Emperor, and also many trophies and other orna-
ments, which were made by him of pasteboard in a very sump-
tuous and magnificent manner; and he finished the whole in
twenty-five days. For his labours, therefore, and those of Fede-
rigo and others who had assisted him, six hundred crowns of
gold were paid to him.

Shortly afterwards he painted two great chambers at Bracciano
for Signor Paolo Giordano Orsini, which were very beautiful and
richly adorned with stucco-work and gold; in one the stories of
Cupid and Psyche, and in the second, which had been begun
previously by others, some stories of Alexander the Great; and
others that remained for him to paint, continuing the history of
the same Alexander, he caused to be executed by his brother
Federigo, who acquitted himself very well. And then he painted
in fresco for M. Stefano del Bufalo, in his garden near the foun-
tain of Trevi, the Muses around the Castalian Fount and Mount
Parnassus, which was held to be a beautiful work.

The Wardens of Works of the Madonna of Orvieto, as has
been related in the Life of Simone Mosca, had caused some
chapels with ornaments of marble and stucco to be built in the
aisles of their church, and had also had some altar-pieces ex-
ecuted by Girolamo Mosciano of Brescia; and, having heard the
fame of Taddeo by means of friends, they sent a summons to
him, and he went to Orvieto, taking with him Federigo. There,
settling to work, he executed two great figures on the wall of one
of those chapels, one representing the Active Life, and the other
the Contemplative, which were despatched with a very sure fa-
cility of hand, in the manner wherein he executed works to which
he gave little study; and while Taddeo was painting those figures,
Federigo painted three little stories of S. Paul in the recess of the
same chapel. At the end of which, both having fallen ill, they
went away, promising to return in September. Taddeo returned
to Rome, and Federigo to Sant' Agnolo with a slight fever; which
having passed, at the end of two months he also returned to
Rome. There, Holy Week being close at hand, the two together
set to work in the Florentine Company of S. Agata, which is
behind the Banchi, and painted in four days on the vaulting and
the recess of that oratory, for a rich festival that was prepared for

Holy Thursday and Good Friday, scenes in chiaroscuro of the whole Passion of Christ, with some Prophets and other pictures, which caused all who saw them to marvel.

After that, Cardinal Alessandro Farnese, having brought very near completion his Palace of Caprarola, with Vignuola as architect, of whom there will be an account in a short time, gave the charge of painting it all to Taddeo, on these conditions: that, since Taddeo did not wish to abandon his other works in Rome, he should be obliged to make all the cartoons, designs, divisions, and arrangements for the works in painting and in stucco that were to be executed in that place; that the men who were to carry them into execution should be chosen by Taddeo, but paid by the Cardinal; and that Taddeo should be obliged to work there himself for two or three months in the year, and to go there as many times as it might be necessary to see how things were progressing, and to retouch all that was not to his satisfaction. And for all these labours the Cardinal promised him a salary of two hundred crowns a year. Whereupon Taddeo, having so honourable an appointment and the support of so great a lord, determined that he would give himself some peace of mind, and would no longer accept any mean work in Rome, as he had done up to that time; desiring, above all, to avoid the censure that many men of art laid upon him, saying that from a certain grasping avarice he would accept any kind of work, in order to gain with the arms of others that which would have been to many of them an honest means to enable them to study, as he himself had done in his early youth. Against which reproaches Taddeo used to defend himself by saying that he did it on account of Federigo and the other brothers that he had on his shoulders, desiring that they should learn with his assistance.

Having thus resolved to serve Farnese and also to finish the chapel in S. Marcello, he obtained for Federigo from M. Tizio da Spoleti, the master of the household to the above-named Cardinal, the commission to paint the façade of a house that he had on the Piazza della Dogana, near S. Eustachio; which was very welcome to Federigo, for he had never desired anything so much as to have some work altogether for himself. On one part of the façade, therefore, he painted in colours the scene of S. Eustachio causing himself to be baptized with his wife and children, which was a very good work; and on the centre of the façade he painted the same Saint, when, while hunting, he sees Jesus Christ on the

Cross between the horns of a stag. Now since Federigo, when he executed that work, was not more than twenty-eight* years of age, Taddeo, who reflected that the work was in a public place, and that it was of great importance to the credit of Federigo, not only went sometimes to see him at his painting, but also at times insisted on retouching and improving some part. Wherefore Federigo, after having had patience for a time, finally, carried away on one occasion by the anger natural in one who would have preferred to work by himself, seized a mason's hammer and dashed to the ground something (I know not what) that Taddeo had painted; and in his rage he stayed some days without going back to the house. Which being heard by the friends of both the one and the other of them, they so went to work that the two were reconciled, on the understanding that Taddeo should be able to set his hand on the designs and cartoons of Federigo and correct them at his pleasure, but never the works that he might execute in fresco, in oils, or in any other medium.

Federigo having then finished the work of that house, it was universally extolled, and won him the name of an able painter. After that, Taddeo was ordered to repaint in the Sala de' Palafrenieri those Apostles which Raffaello had formerly executed there in terretta, and which had been thrown to the ground by Paul IV; and he, having painted one, caused all the others to be executed by his brother Federigo, who acquitted himself very well. Next, they painted together a frieze in fresco-colours in one of the halls of the Palace of the Araceli. Then, a proposal being discussed, about the same time that they were working at the Araceli, to give to Signor Federigo Borromeo as a wife the Lady Donna Virginia, the daughter of Duke Guidobaldo of Urbino, Taddeo was sent to take her portrait, which he did excellently well; and before he departed from Urbino he made all the designs for a credence, which that Duke afterwards caused to be made in clay at Castel Durante, for sending to King Philip of Spain. Having returned to Rome, Taddeo presented to the Pope that portrait, which pleased him well enough; but such was the discourtesy of that Pontiff, or of his ministers, that the poor painter was not recompensed even for his expenses.

In the year 1560 the Pope expected in Rome the Lord Duke Cosimo and the Lady Duchess Leonora, his consort, and

* An error of the copyist or printer for eighteen.

proposed to lodge their Excellencies in the apartments formerly built by Innocent VIII, which look out upon the first court of the Palace and that of S. Pietro, and have in front of them loggie that look out on the piazza where the Benediction is given; and Taddeo received the charge of painting the pictures and some friezes that were to be executed there, and of overlaying with gold the new ceilings that had been made in place of the old ones, which had been consumed by time. In that work, which was certainly a great and important undertaking, Federigo, to whom his brother Taddeo gave the charge of almost the whole, acquitted himself very well; but he incurred a great danger, for, as he was painting grotesques in those loggie, he fell from a staging that rested on the main part of the scaffolding, and was near coming to an evil end.

No long time passed before Cardinal Emulio, to whom the Pope had given the charge of the matter, commissioned many young men, to the end that the work might be finished quickly, to paint the little palace that is in the wood of the Belvedere, which was begun in the time of Pope Paul IV with a most beautiful fountain and many ancient statues as ornaments, after an architectural design by Pirro Ligorio. The young men who worked (with great credit to themselves) in that place, were Federigo Barocci of Urbino, a youth of great promise, and Leonardo Cungi and Durante del Nero, both of Borgo San Sepolcro, who executed the apartments of the first floor. At the head of the staircase, which was made in a spiral shape, the first room was painted by Santi Titi, a painter of Florence, who acquitted himself very well; the larger room, which is beside the first, was painted by the above-named Federigo Zucchero, the brother of Taddeo; and the Sclavonian Giovanni dal Carso, a passing good master of grotesques, executed another room beyond it. But, although each of the men named above acquitted himself very well, nevertheless Federigo surpassed all the others in some stories of Christ that he painted there, such as the Transfiguration, the Marriage of Cana in Galilee, and the Centurion kneeling before Christ. And of two that were still wanting, one was painted by Orazio Sammacchini, a Bolognese painter, and the other by a certain Lorenzo Costa of Mantua. The same Federigo Zucchero painted in that place the little loggia that looks out over the fish-pond. And then he painted a frieze in the principal hall of the Belvedere (to which one ascends by the spiral staircase), with stories of Moses and

Pharaoh, beautiful to a marvel; the design for which work, drawn and coloured with his own hand in a most beautiful drawing, Federigo himself gave not long since to the Reverend Don Vincenzio Borghini, who holds it very dear as a drawing by the hand of an excellent painter. In the same place, also, Federigo painted the Angel slaying the first-born in Egypt, availing himself, in order to finish it the quicker, of the help of many of his young men. But when those works came to be valued by certain persons, the labours of Federigo and the others were not rewarded as they should have been, because there are among our craftsmen in Rome, as well as in Florence and everywhere else, some most malignant spirits who, blinded by prejudice and envy, are not able or not willing to recognize the merits of the works of others and the deficiency of their own; and such persons are very often the reason that the young men of fine genius, becoming dismayed, grow cold in their studies and their work. After these works, Federigo painted in the Office of the Ruota, about an escutcheon of Pope Pius IV, two figures larger than life, Justice and Equity, which were much extolled; thus giving time to Taddeo, meanwhile, to attend to the work of Caprarola and the chapel in S. Marcello.

In the meantime his Holiness, wishing at all costs to finish the Hall of Kings, after the many contentions that had taken place between Daniello and Salviati, as has been related, gave orders to the Bishop of Forlì as to all that he wished him to do in the matter. Wherefore the Bishop wrote to Vasari (on the 3rd of September in the year 1561), that the Pope, wishing to finish the work of the Hall of Kings, had given him the charge of finding men who might once and for all take it off his hands, and that therefore, moved by their ancient friendship and by other reasons, he besought Giorgio to consent to go to Rome in order to execute that work, with the good pleasure and leave of his master the Duke, for the reason that, while giving satisfaction to his Holiness, he would win much honour and profit for himself; praying him to answer as soon as possible. Replying to which letter, Vasari said that, finding himself very well placed in the service of the Duke, and remunerated for his labours with rewards different from those that he had received from other Pontiffs in Rome, he intended to remain in the service of his Excellency, for whom he was at that very time to set his hand to a hall much greater than the Hall of Kings; and that there was

no want in Rome of men who might be employed in that work. The above-named Bishop having received that answer from Vasari, and having conferred with his Holiness of the whole matter, Cardinal Emulio, immediately after receiving from the Pontiff the charge of having that Hall finished, divided the work, as has been related, among many young men, some of whom were already in Rome, and others were summoned from other places. To Giuseppe Porta of Castelnuovo della Garfagnana, a disciple of Salviati, were given two of the largest scenes in the Hall; to Girolamo Siciolante of Sermoneta, one of the large scenes and one of the small; to Orazio Sammacchini of Bologna one of the small scenes, to Livio da Forlì a similar one, and to Giovan Battista Fiorini of Bologna yet another of the small scenes. Which hearing, Taddeo perceived that he had been excluded because it had been said to the above-named Cardinal Emulio that he was a person who gave more attention to gain than to glory and working well; and he did his utmost with Cardinal Farnese to obtain a part of that work. But the Cardinal, not wishing to move in the matter, answered him that his labours at Caprarola should content him, and that it did not seem to him right that his own works should be neglected by reason of the rivalry and emulation between the craftsmen; adding also that, when a master does well, it is the works that give a name to the place, and not the place to the works. Notwithstanding this, Taddeo so went to work by other means with Emulio, that finally he was commissioned to execute one of the smaller scenes over a door, not being able, either by prayers or by any other means, to obtain the commission for one of the large scenes; and, in truth, it is said that Emulio was acting with caution in the matter, for the reason that, hoping that Giuseppe Salviati would surpass all the others, he was minded to give him the rest, and perchance to throw to the ground all that might have been done by the others. Now, after all the men named above had carried their works well forward, the Pope desired to see them all; and so, everything being uncovered, he recognized (and all the Cardinals and the best craftsmen were of the same opinion) that Taddeo had acquitted himself better than any of the others, although all had done passing well. His Holiness, therefore, commanded Signor Agabrio that he should cause Cardinal Emulio to commission him to execute one of the larger scenes; whereupon the head-wall was allotted to him, wherein is the door of the Pauline Chapel. And

there he made a beginning with the work, but he did not carry it any farther, for, the death of the Pope supervening, everything was uncovered for the holding of the Conclave, although many of those scenes had not been finished. Of the scene that Taddeo began in that place, we have the design by his hand, sent to us by him, in the book of drawings that we have so often mentioned.

Taddeo painted at the same time, besides some other little things, a picture with a very beautiful Christ, which was to be sent to Caprarola for Cardinal Farnese; which work is now in the possession of his brother Federigo, who says that he desires it for himself as long as he lives. The picture receives its light from some weeping Angels, who are holding torches. But since the works that Taddeo executed at Caprarola will be described at some length in a little time, in discoursing of Vignuola, who built that fabric, for the present I shall say nothing more of them.

Federigo was meanwhile summoned to Venice, and made an agreement with the Patriarch Grimani to finish for him the chapel in S. Francesco della Vigna, which had remained incomplete, as has been related, on account of the death of the Venetian Battista Franco. But, before he began that chapel, he adorned for that Patriarch the staircase of his Palace in Venice, with little figures placed with much grace in certain ornaments of stucco; and then he executed in fresco, in the above-named chapel, the two stories of Lazarus and the Conversion of the Magdalene, the design of which, by the hand of Federigo, is in our book. Afterwards, in the altar-piece of the same chapel, Federigo painted the story of the Magi in oils. And then he painted some pictures in a loggia, which are much extolled, at the villa of M. Giovan Battista Pellegrini, between Chioggia and Monselice, where Andrea Schiavone and the Flemings, Lamberto and Gualtieri, have executed many works.

After the departure of Federigo, Taddeo continued to work in fresco all that summer in the chapel of S. Marcello; and for that chapel, finally, he painted in the altar-piece the Conversion of S. Paul. In that picture may be seen, executed in a beautiful manner, the Saint fallen from his horse and all dazed by the splendour and voice of Jesus Christ, whom he depicted amid a Glory of Angels, in the act, so it appears, of saying, 'Saul, Saul, why persecutest thou Me?' His followers, who are about him, are likewise struck with awe, and stand as if bereft of their senses. On the

vaulting, within certain ornaments of stucco, he painted in fresco three stories of the same Saint. In one he is being taken as a prisoner to Rome, and disembarks on the Island of Malta; and there may be seen how, on the kindling of the fire, a viper strikes at his hand to bite it, while some mariners, almost naked, stand in various attitudes about the barque; in another is the scene when a young man, having fallen from a window, is brought to S. Paul, who by the power of God restores him to life; and in the third is the Beheading and Death of the Saint. On the walls below are two large scenes, likewise in fresco; in one is S. Paul healing a man crippled in the legs, and in the other a disputation, wherein he causes a magician to be struck with blindness; and both the one and the other are truly most beautiful. But that work having been left incomplete by reason of his death, Federigo has finished it this year, and it has been thrown open to view with great credit to him. At this same time Federigo executed some pictures in oils, which were sent to France by the Ambassador of that kingdom.

The little hall in the Farnese Palace having remained unfinished on account of the death of Salviati (wanting two scenes, namely, at the entrance, opposite to the great window), Cardinal Sant' Agnolo, of the Farnese family, gave them to Taddeo to execute, and he carried them to completion very well. But nevertheless he did not surpass or even equal Francesco in the works executed by him in the same apartment, as certain envious and malignant spirits went about saying throughout Rome, in order to diminish the glory of Salviati by their foul calumnies; and although Taddeo used to defend himself by saying that he had caused the whole to be executed by his assistants, and that there was nothing in that work by his hand save the design and a few other things, such excuses were not accepted, for the reason that a man who wishes to surpass another in any competition, must not entrust the credit of his art to the keeping of feeble persons, for that is clearly the way to perdition. Thus Cardinal Sant' Agnolo, a man of truly supreme judgment in all things, and of surpassing goodness, recognized how much he had lost by the death of Salviati; for, although he was proud and even arrogant, and ill-tempered, in matters of painting he was truly most excellent. However, since the best craftsmen had disappeared from Rome, that lord, for want of others, resolved to entrust the painting of the Great Hall in that Palace to Taddeo, who accepted it

willingly, in the hope of being able to prove by means of every effort how great were his ability and knowledge.

The Florentine Lorenzo Pucci, Cardinal Santiquattro, had formerly caused a chapel to be built in the Trinità, and all the vaulting to be painted by Perino del Vaga, with certain Prophets on the outer side, and two little boys holding the arms of that Cardinal. But the chapel remaining unfinished, with three walls still to be painted, when the Cardinal died, those fathers, without any regard for what was just and reasonable, sold that chapel to the Archbishop of Corfu; and it was afterwards given by that Archbishop to Taddeo to paint. Now although, out of respect for the church and from other reasons, it may have been well to find means of finishing the chapel, at least they should not have allowed the arms of the Cardinal to be removed from the part that was finished, only in order to place there those of the above-named Archbishop, which they could have set up in another place, instead of offering so manifest an affront to the memory of that good Cardinal. Having thus so many works on his hands, Taddeo was every day urging Federigo to return from Venice. That Federigo, after having finished the chapel for the Patriarch, was negotiating to undertake to paint the principal wall of the Great Hall of the Council, where Antonio Viniziano had formerly painted; but the rivalry and the contentions that he suffered from the Venetian painters were the reason that neither they, with all their interest, nor he, likewise, obtained it.

Meanwhile Taddeo, having a desire to see Florence and the many works which, so he heard, Duke Cosimo had carried out and was still carrying out, and the beginning that his friend Giorgio Vasari was making in the Great Hall; Taddeo, I say, pretending one day to go to Caprarola in connection with the work that he was doing there, went off to Florence for the Festival of S. John, in company with Tiberio Calcagni, a young Florentine sculptor and architect. There, to say nothing of the city, he found vast pleasure in the works of the many excellent sculptors and painters, ancient as well as modern; and if he had not had so many charges and so many works on his hands, he would gladly have stayed there some months. Thus he saw the preparations of Vasari for the above-named Hall – namely, forty-four great pictures, of four, six, seven, or ten braccia each – in which he was executing figures for the most part of six or eight braccia, with the assistance only of the Fleming Giovanni Strada and Jacopo

Zucchi, his disciples, and Battista Naldini, in all which he took the greatest pleasure, and, hearing that all had been executed in less than a year, it gave him great courage. Wherefore, having returned to Rome, he set his hand to the above-named chapel in the Trinità, with the resolve that he would surpass himself in the stories of Our Lady that were to be painted there, as will be related presently.

Now Federigo, although he was pressed to return from Venice, was not able to refuse to stay in that city for the Carnival in company with the architect Andrea Palladio. And Andrea, having made for the gentlemen of the Company of the Calza a theatre in wood after the manner of a Colosseum, in which a tragedy was to be performed, caused Federigo to execute for the decoration of the same twelve large scenes, each seven feet and a half square, with innumerable other stories of the actions of Hyrcanus, King of Jerusalem, after the subject of the tragedy; in which work Federigo gained much honour, from its excellence and from the rapidity with which he executed it. Next, Palladio going to Friuli to found the Palace of Civitale, of which he had previously made the model, Federigo went with him in order to see that country; and there he drew many things that pleased him. Then, after having seen many things in Verona and in many other cities of Lombardy, he finally made his way to Florence, at the very time when festive preparations, rich and marvellous, were being made for the coming of Queen Joanna of Austria. Having arrived there, he executed, after the desire of the Lord Duke, a most beautiful and fanciful Hunt in colours on a vast canvas that covered the stage at the end of the Hall, and some scenes in chiaroscuro for an arch; all which gave infinite satisfaction. From Florence he went to Sant' Agnolo, to revisit his relatives and friends, and finally he arrived in Rome on the 16th of the January following; but he was of little assistance to Taddeo at that time, for the reason that the death of Pope Pius IV, followed by that of Cardinal Sant' Agnolo, interrupted the work of the Hall of Kings and that of the Farnese Palace. Whereupon Taddeo, who had finished another apartment of rooms at Caprarola, and had carried almost to completion the chapel in S. Marcello, proceeded to give his attention to the work of the Trinità, much at his leisure, and to execute the Passing of Our Lady, with the Apostles standing about the bier.

In the meantime, also, Taddeo had obtained for Federigo a

chapel to be painted in fresco in the Church of the Reformed
Priests of Jesus at the Obelisk of S. Mauro; and to that Federigo
straightway set his hand. Taddeo, feigning to be angry because
Federigo had delayed too long to return, appeared to care little
for his arrival; but in truth he welcomed it greatly, as was after-
wards seen from the result. For he was much annoyed by having
to provide for his house (of which annoyance Federigo had been
accustomed to relieve him), and by the anxious care of that
brother who was employed as a goldsmith; but when Federigo
came they put many inconveniences to rights, in order to be able
to attend to their work with a quiet mind. The friends of Taddeo
were seeking meanwhile to give him a wife, but he, being one
who was accustomed to living free, and fearing that which gener-
ally happens (namely, that he would bring into his house,
together with the wife, a thousand vexatious cares and annoy-
ances), could never make up his mind to it. Nay, attending to his
work in the Trinità, he proceeded to make the cartoon of the
principal wall, on which there was going the Ascension of Our
Lady into Heaven; while Federigo painted a picture of S. Peter in
Prison for the Lord Duke of Urbino; another, wherein is a Ma-
donna in Heaven with some Angels about her, which was to be
sent to Milan; and a third with a figure of Opportunity, which
was sent to Perugia.

The Cardinal of Ferrara had kept many painters and masters in
stucco at work at the very beautiful villa that he has at Tivoli, and
finally he sent Federigo there to paint two rooms, one of which
is dedicated to Nobility, and the other to Glory; in which Federigo
acquitted himself very well, executing there beautiful and fantastic
inventions. That finished, he returned to the work of the above-
mentioned chapel in Rome, which he has carried to completion,
painting in it a choir of many Angels and various Glories, with
God the Father sending down the Holy Spirit upon the Madonna,
who is receiving the Annunciation from the Angel Gabriel, while
about her are six Prophets, larger than life and very beautiful.
Taddeo, meanwhile, continuing to paint the Assumption of the
Madonna in fresco in the Trinità, appeared to be driven by nature
to do in that work, as his last, the utmost in his power. And in
truth it proved to be his last, for, having fallen ill of a sickness
which at first appeared to be slight enough, and caused by the
great heat that there was that year, and which afterwards became
very grave, he died in the month of September in the year 1566;

having first, like a good Christian, received the Sacraments of the
Church, and seen the greater part of his friends, and leaving in
his place his brother Federigo, who was also ill at that time. And
so in a short time, Buonarroti, Salviati, Daniello, and Taddeo
having been taken from the world, our arts have suffered a very
great loss, and particularly the art of painting.

Taddeo was very bold in his work, and had a manner passing
soft and pastose, and very far removed from the hardness often
seen. He was very abundant in his compositions, and he made
his heads, hands, and nudes very beautiful, keeping them free of
the many crudities over which certain painters labour beyond all
reason, in order to make it appear that they understand anatomy
and art; to which kind of men there often happens that which
befell him who, from his seeking to be in his speech more Athe-
nian than the Athenians, was recognized by a woman of the
people to be no Athenian. Taddeo also handled colours with
much delicacy, and he had great facility of manner, for he
was much assisted by nature; but at times he sought to make too
much use of it. He was so desirous of having something of his
own, that he continued for a time to accept any sort of work for
the sake of gain; but for all that he executed many, nay, innumer-
able works worthy of great praise. He kept a number of assistants
in order to finish his works, for the reason that it is not possible
to do otherwise. He was sanguine, hasty, and quick to take offence,
and, in addition, much given to the pleasures of love; but never-
theless, although he was strongly inclined by nature to such plea-
sures, he contrived to conduct his affairs with a certain degree of
decency, and very secretly. He was loving with his friends, and
whenever he could help them he never spared himself.

At his death he left the work in the Trinità not yet uncovered,
and the Great Hall in the Farnese Palace unfinished, and so also
the works of Caprarola, but nevertheless these all remained in the
hands of his brother Federigo, whom the patrons of the works
are content to allow to give them completion, as he will do; and,
in truth, Federigo will be heir to the talents of Taddeo no less
than to his property. Taddeo was given burial by Federigo in the
Ritonda of Rome, near the tabernacle where Raffaello da Urbino,
his fellow-countryman, is buried; and certainly they are well
placed, one beside the other, for the reason that even as Raffaello
died at the age of thirty-seven and on the same day that he was
born, which was Good Friday, so Taddeo was born on the first

day of September, 1529, and died on the second day of the same month in the year 1566. Federigo is minded, if it should be granted to him, to restore the other tabernacle in the Ritonda, and to make some memorial in that place to his loving brother, to whom he knows himself to be deeply indebted.

Now, since mention has been made above of Jacopo Barozzi of Vignuola, saying that after his architectural designs and directions the most illustrious Cardinal Farnese has built his rich and even regal villa of Caprarola, let me relate that the same Jacopo Barozzi of Vignuola, a Bolognese painter and architect, who is now fifty-eight years of age, was placed in his childhood and youth to learn the art of painting in Bologna, but did not make much proficience, because he did not receive good guidance at the beginning. And also, to tell the truth, he had by nature much more inclination for architecture than for painting, as was clearly manifest even at that time from his designs and from the few works of painting that he executed, for there were always to be seen in them pieces of architecture and perspective; and so strong and potent in him was that inclination of nature, that he may be said to have learned almost by himself, in a short time, both the first principles and also the greatest difficulties, and that very well. Wherefore, almost before he was known, various designs with most beautiful and imaginative fantasies were seen to issue from his hand, executed for the most part at the request of M. Francesco Guicciardini, at that time Governor of Bologna, and for others of his friends; which designs were afterwards put into execution in tinted woods inlaid after the manner of tarsia, by Fra Damiano da Bergamo, of the Order of S. Domenico in Bologna. Vignuola then went to Rome to work at painting, and to obtain from that art the means to assist his poor family; and at first he was employed at the Belvedere with Jacopo Melighini of Ferrara, the architect of Pope Paul III, drawing some architectural designs for him. But afterwards, there being in Rome at that time an academy of most noble lords and gentlemen who occupied themselves in reading Vitruvius (among whom were M. Marcello Cervini, who afterwards became Pope, Monsignor Maffei, M. Alessandro Manzuoli, and others), Vignuola set himself in their service to take complete measurements of all the antiquities of Rome, and to execute certain works after their fancy; which circumstance was of the greatest assistance to him both for learning and for profit. Meanwhile Francesco Primaticcio, the Bolognese

painter, of whom there will be an account in another place, had arrived in Rome, and he made much use of Vignuola in making moulds of a great part of the antiques in Rome, in order to take those moulds into France, and then to cast from them statues in bronze similar to the antiques; which work having been despatched, Primaticcio, in going to France, took Vignuola with him, in order to make use of him in matters of architecture and to have his assistance in casting in bronze the above-mentioned statues of which they had made the moulds; which things, both the one and the other, he did with much diligence and judgment. After two years had passed, he returned to Bologna, according to the promise made by him to Count Filippo Pepoli, in order to attend to the building of S. Petronio. In that place he consumed several years in discussions and disputes with certain others who were his competitors in the affairs there, without doing anything but design and cause to be constructed after his plans the canal that brings vessels into Bologna, whereas before that they could not come within three miles; than which work none better or more useful was ever executed, although Vignuola, the originator of an enterprise so useful and so praiseworthy, was poorly rewarded for it.

Pope Julius III having been elected in the year 1550, by means of Vasari Vignuola was appointed architect to his Holiness, and there was given to him the particular charge of conducting the Acqua Vergine and of superintending the works at the Vigna of Pope Julius, who took Vignuola into his service most willingly, because he had come to know him when he was Legate in Bologna. In that building, and in other works that he executed for that Pontiff, he endured much labour, but was badly rewarded for it. Finally Cardinal Alessandro Farnese, having recognized the genius of Vignuola, to whom he always showed much favour, desired, in carrying out the building of his Palace at Caprarola, that the whole work should spring from the fanciful design and invention of Vignuola. And, in truth, the judgment of that lord in making choice of so excellent an architect was no less than the greatness of his mind in setting his hand to an edifice so noble and grand, which, although it is in a place where it can be enjoyed but little by men in general, being out of the way, yet is none the less marvellous in its site, and very suitable for one who wishes at times to withdraw from the vexations and tumult of the city. This edifice, then, has the form of a pentagon, and is divided into

four sets of apartments, without counting the front part, where the principal door is; in which front part is a loggia forty palms in breadth and eighty in length. On one side there curves in a round form a spiral staircase, ten palms wide across the steps, and twenty palms across the space in the centre, which gives light to the staircase, which curves from the base to the third or upper-most story; and these steps are all supported by double columns with cornices, which curve in a round in accordance with the staircase. The whole is a rich and well-varied work, beginning with the Doric Order, and continuing in the Ionic, the Corin-thian, and the Composite, with a wealth of balusters, niches, and other fanciful ornaments, which make it a rare thing, and most beautiful. Opposite to this staircase – namely, at the other of the corners that are one on either side of the above-mentioned loggia of the entrance – there is a suite of rooms that begins in a circular vestibule equal in breadth to the staircase, and leads to a great hall on the ground floor, eighty palms long and forty broad. This hall is wrought in stucco and painted with stories of Jove – namely, his birth, his being nursed by the Goat Amaltheia, and her coronation, with two other stories on either side of the last-named, showing her being placed in the heavens among the forty-eight Heavenly Signs, and another similar story of the same Goat, which alludes, as also do the others, to the name of Capra-rola. On the walls of this hall are perspective-views of buildings drawn by Vignuola and coloured by his son-in-law, which are very beautiful and make the room seem larger than it is. Beside this hall is a smaller hall of forty palms, which comes exactly at the next corner, and in it, besides the works in stucco, are painted things that are all significant of Spring. Continuing from this little hall towards the other angle (that is, towards the point of the pentagon, where a tower has been begun), one goes into three chambers, each forty palms broad and thirty long. In the first of these are various inventions executed in stucco and painting, rep-resenting Summer, to which season this first chamber is dedi-cated. In that which follows there is painted and wrought in the same manner the season of Autumn; and in the last, which is sheltered from the north, and decorated likewise in the same manner, there is represented in a similar kind of work the season of Winter.

So far we have spoken (with regard to the floor that is over the underground rooms of the basement, cut out of the tufa,

where there are rooms for the servants, kitchens, larders, and wine-cellars) of the half of this pentagonal edifice – namely, of the part on the right hand. Opposite to that part, on the left hand, there are rooms exactly equal in number and of the same size. Within the five angles of the pentagon Vignuola has made a circular court, into which all the apartments of the edifice open with their doors; which doors, I mean, all open into the circular loggia surrounding the court, which is eighteen palms in breadth, while the diameter of the remaining space in the court is ninety-five palms and five inches. The pilasters of the loggia (which is divided up by niches), supporting the arches and the vaulting, are in couples, with a niche in the centre, and twenty in number; and each couple covers a breadth of fifteen palms, which is also the breadth of the space of the arches. Around the loggia, at the angles that form the shape of the round, are four spiral staircases, which lead from the basement of the palace up to the top, for the convenience of the edifice and of the rooms. And there are reservoirs that collect the rain-water, which feed a very large and beautiful cistern in the centre; to say nothing of the windows and innumerable other conveniences, which make this building appear to be, as indeed it is, a rare and most beautiful fabric. And, besides having the site and form of a fortress, it is furnished on the outer side with an oval flight of steps, with ditches all around, and with drawbridges made with beautiful invention and in a novel manner, which lead into gardens full of rich and well-varied fountains, graceful parterres of verdure, and, in short, all that is required for a truly regal villa.

Now, ascending by the great spiral staircase from the level of the court to the other apartment above, one finds already finished, over the part of which we have spoken, an equal number of rooms, and also the chapel, which is opposite to the principal round staircase on this floor. In the hall that is exactly above that of Jove, and of equal size, there are painted by the hands of Taddeo and his young men, with very rich and beautiful ornaments of stucco, the actions of the illustrious men of the House of Farnese. On the vaulting are compartments with six scenes, four square and two round, which follow right round the cornice of this hall, and in the centre are three ovals, accompanied along their length by two smaller and rectangular pictures, in one of which is painted Fame, and in the other Bellona. In the first of the three ovals is Peace, in the central oval the ancient arms of the House of Farnese, with the helmet-crest, above

which is the Unicorn, and in the last is Religion. In the first of
the six above-mentioned scenes, which is a round, is Guido
Farnese, with many persons, all well executed, about him, and
with this inscription below:

GUIDO FARNESIUS, URBIS VETERIS PRINCIPATUM CIVIBUS
IPSIS DEFERENTIBUS ADEPTUS, LABORANTI INTESTINIS
DISCORDIIS CIVITATI, SEDITIOSA FACTIONE EJECTA, PACEM
ET TRANQUILLITATEM RESTITUIT, ANNO 1323.

In an oblong picture is Pietro Niccolò Farnese, who is deliver-
ing Bologna, with this inscription below:

PETRUS NICOLAUS, SEDIS ROMANÆ POTENTISSIMIS HOSTIBUS
MEMORABILI PRÆLIO SUPERATIS, IMMINENTI OBSIDIONIS
PERICULO BONONIAM LIBERAT, ANNO SALUTIS 1361.

In the rectangular picture next to this is Pietro Farnese,
elected Captain of the Florentines, with this inscription:

PETRUS FARNESIUS, REIP. FLORENTINÆ IMPERATOR, MAGNIS
PISANORUM COPIIS...URBEM FLORENTIAM TRIUMPHANS
INGREDITUR, ANNO 1362.

In the other round picture, which is opposite to that described
above, is another Pietro Farnese, who routs the enemies of the
Roman Church at Orbatello, with his inscription.

In one of the two other rectangular pictures, which are of
equal size, is Signor Ranieri Farnese, elected General of the
Florentines in place of the above-named Signor Pietro, his
brother, with this inscription:

RAINERIUS FARNESIUS A FLORENTINIS DIFFICILI REIP.
TEMPORE IN PETRI FRATRIS MORTUI LOCUM COPIARUM
OMNIUM DUX DELIGITUR, ANNO 1362.

In the last picture is Ranuccio Farnese, chosen by Eugenius
III as General of the Church, with this inscription:

RANUTIUS FARNESIUS, PAULI TERTII PAPÆ AVUS, EUGENIO
TERTIO P.M. ROSÆ AUREÆ MUNERE INSIGNITUS,
PONTIFICII EXERCITUS IMPERATOR CONSTITUITUR,
ANNO CHRISTI 1435.

In short, there are on this vaulting vast numbers of most
beautiful figures, besides the stucco-work and other ornaments
overlaid with gold.

On the walls are eight scenes, two to each wall. On the first, in a scene on the right hand as one enters, is Pope Julius III confirming Duke Ottavio and the Prince his son in the possession of Parma and Piacenza, in the presence of Cardinal Farnese, Sant' Agnolo his brother, the Camarlingo Santa Fiore, the elder Salviati, Chieti, Carpi, Polo, and Morone, all being portraits from life; with this inscription:

JULIUS III, P.M., ALEXANDRO FARNESIO AUCTORE, OCTAVIO
FARNESIO, EJUS FRATRI, PARMAM AMISSAM RESTITUIT, ANNO
SALUTIS 1550.

In the second scene is Cardinal Farnese going to Worms as Legate to the Emperor Charles V, and his Majesty and the Prince, his son, are coming forth to meet him, with a vast multitude of Barons, and among them the King of the Romans; with the proper inscription. On the wall on the left hand as one enters, in the first scene, is the war fought against the Lutherans in Germany, where Duke Ottavio Farnese was Legate, in the year 1546, with the inscription; and in the second are the above-named Cardinal Farnese and the Emperor with his sons, who are all four under a baldachin carried by various persons portrayed from life, among whom is Taddeo, the master of the work, with a company of many lords all around. On one of the head-walls, or rather, ends, are two scenes, and between them an oval, in which is the portrait of King Philip, with this inscription:

PHILIPPO HISPANIARUM REGI MAXIMO, OB EXIMIA IN
DOMUM FARNESIAM MERITA.

In one of the scenes is Duke Ottavio taking Madama Margherita of Austria as his wife, with Pope Paul III in the centre, and portraits of Cardinal Farnese the younger, the Cardinal of Carpi, Duke Pier Luigi, M. Durante, Eurialo da Cingoli, M. Giovanni Riccio of Montepulciano, the Bishop of Como, Signora Livia Colonna, Claudia Mancina, Settimia, and Donna Maria di Mendoza. In the other is Duke Orazio taking as his wife the daughter of King Henry of France, with this inscription:

HENRICUS II, VALESIUS, GALLORUM REX, HORATIO
FARNESIO CASTRI DUCI DIANAM FILIAM IN MATRIMONIUM
COLLOCAT, ANNO SALUTIS 1552.

In which scene, besides the portrait of Diana herself with the

royal mantle, and that of her husband Duke Orazio, are portraits of Caterina de' Medici, Queen of France, Marguerite, the sister of the King, the King of Navarre, the Constable, the Duke of Guise, the Duke of Nemours, the Admiral Prince of Condé, the younger Cardinal of Lorraine, Guise not yet a Cardinal, Signor Piero Strozzi, Madame de Montpensier, and Mademoiselle de Rohan.

On the other head-wall, opposite to that already described, are likewise two other scenes, with the oval in the centre, in which is the portrait of King Henry of France, with this inscription:

HENRICO FRANCORUM REGI MAX. FAMILIÆ FARNESIÆ
CONSERVATORI.

In one of the scenes (namely, in that which is on the right hand) Pope Paul III is investing Duke Orazio, who is kneeling, with a priestly robe, and making him Prefect of Rome, with Duke Pier Luigi close at hand, and other lords around; and with these words:

PAULUS III P.M. HORATIUM FARNESIUM NEPOTEM, SUMMÆ
SPEI ADOLESCENTEM, PRÆFECTUM URBIS CREAT, ANNO. SAL.
1549.

And in this scene are portraits of the Cardinal of Paris, Viseo, Morone, Badia, Trento, Sfondrato, and Ardinghelli. In the other scene, beside the last-named, the same Pope is giving the General's baton to Pier Luigi and his sons, who were not yet Cardinals; with portraits of the Pope, Pier Luigi Farnese, the Camarlingo, Duke Ottavio, Orazio, the Cardinal of Capua, Simonetta, Jacobaccio, San Jacopo, Ferrara, Signor Ranuccio Farnese as a young man, Giovio, Molza, Marcello Cervini, who afterwards became Pope, the Marquis of Marignano, Signor Giovan Battista Castaldo, Signor Alessandro Vitelli, and Signor Giovan Battista Savelli.

Coming now to the little hall which is beside the hall just described, and which is above the Hall of Spring, in the vaulting, which is adorned with a vast and rich decoration in stucco and gold, in the recess in the centre, there is the Coronation of Pope Paul III, with four spaces that form a cruciform inscription, with these words:

PAULUS III FARNESIUS, PONTIFEX MAXIMUS, DEO ET
HOMINIBUS APPROBANTIBUS, SACRA TIARA SOLEMNI RITU
CORONATUR, ANNO SALUTIS 1534, III NON. NOVEMB.

Then follow four scenes above the cornice – namely, one over every wall. In the first the Pope is blessing the galleys at Città Vecchia, when about to send them to Tunis in Barbary in the year 1535. In the next the same Pope is excommunicating the King of England in the year 1537; with the proper inscription. In the third is a fleet of galleys which the Emperor and the Venetians fitted out against the Turk, with the authority and assistance of the Pontiff, in the year 1538. In the fourth, Perugia having rebelled against the Church, the people of that city go to seek pardon in the year 1540. On the walls of the same little hall are four large scenes, one to each wall, with windows and doors between. In the first large scene the Emperor Charles V, having returned victorious from Tunis, is kissing the feet of Pope Paul, of the Farnese family, in Rome, in the year 1535. In the next, which is above the door on the left hand, is the story of the peace that Pope Paul III brought about at Busseto between the Emperor Charles V and Francis I of France, in the year 1538; in which scene are these portraits – the elder Bourbon, King Francis, King Henry, the elder Lorenzo, Tournon, the younger Lorenzo, the younger Bourbon, and two sons of King Francis. In the third the same Pope is making Cardinal di Monte his Legate at the Council of Trent; and there are innumerable portraits. In the last, which is between two windows, the same Pontiff is creating many Cardinals in preparation for the Council, among whom there are four who became Popes in succession after him – Julius III, Marcello Cervini, Paul IV, and Pius IV. To put it briefly, this little hall is very richly adorned with all that is required in such a place.

In the first chamber next to the little hall, which is dedicated to Dress, and likewise richly wrought in stucco and gold, there is in the centre a Sacrifice, with three nude figures, among which is an armed figure of Alexander the Great, who is casting some garments of skin upon the fire; and in many other scenes that are in the same place, one sees how men discovered the way to make garments from plants and other wild products; but it would take too long to seek to describe the whole in full. From this chamber one enters into a second, dedicated to Sleep, for which, when Taddeo had to paint it, he received the inventions given below from the Commendatore Annibale Caro, at the commission of the Cardinal; and, to the end that the whole may be the better understood, we shall write here the advice of Caro in his own words, which are these –

'The subjects that the Cardinal has commanded me to give you for the pictures in the Palace of Caprarola, it is not enough for them to be explained by word of mouth, because, besides the invention, we must look to the disposition of the figures, the attitudes, the colours, and a number of other considerations, all in accordance with the descriptions that I find of the things that appear to me to be suitable; wherefore I shall put down on paper all that occurs to me in the matter, as briefly and as distinctly as I shall be able. And first with regard to the chamber with the flat vaulting – for of any other, up to the present, he has not given me the charge – it appears to me that since it is destined to contain the bed for the person of his most illustrious lordship, there must be executed there things in keeping with the place and out of the common both in the invention and in the workman-ship. Now, to declare my conception first in general, I would have a Night painted there, because, besides that it would be appropriate to sleep, it would be a subject not very customary and different from those of the other rooms, and would give you an occasion of executing rare and beautiful works in your art, since the strong lights and dark shadows that go into such a subject are wont to give no little grace and relief to the figures; and it would please me to have the time of this Night close upon the dawn, to the end that the things represented there may be visible without improbability. And to come to the details and to their disposition, it is necessary that we come to an understanding first about the situation and the distribution of the chamber. Let us say, then, that it is divided, as indeed it is, into vaulting and walls, or façades, as we wish to call them. The vaulting has a sunk oval in the centre and four great spandrels at the corners, which, drawing together little by little and continuing one with the other along the façades, embrace the above-mentioned oval. The walls, also, are four, and between the spandrels they form four lunettes.

'Now, let us give names to all these parts, with the divisions that we shall make in the whole chamber, and we shall thus be able to distinguish each part on every side, all the way round. Dividing it into five sections, then, the first shall be the "head"; and this I presume to be next to the garden. The second, which must be that opposite to the first, we shall call the "foot"; the third, on the right hand, we shall call the "right"; the fourth, on the left hand, the "left"; and the fifth, situated in the midst of the others, shall be named the "centre." Thus, distinguishing all the

parts with these names, we shall speak, for example, of the lunette at the head, the façade at the foot, the concavity on the left, the horn on the right, and so with any other part that it may be necessary to name; and to the spandrels that are at the corners, each between two of these boundaries, we shall give the name both of the one and of the other. And thus, also, we shall determine on the pavement below the situation of the bed, which, in my opinion, must be along the façade at the foot, with the head turned to the left-hand façade.

'Now, all the parts having received a name, let us turn to give a form to them all in general, and then to each by itself. First of all, the concavity of the vaulting, or rather, the oval, shall be represented – so the Cardinal has judiciously determined – as being all heaven. The rest of the vaulting, comprising the four spandrels together with the border that we have already mentioned as enclosing the oval all around, shall be made to appear as the unbroken surface within the chamber, and as resting upon the façades, with some beautiful architectural design of your own devising. The four lunettes I would have counterfeited as likewise concave; and, whereas the oval above represents a heaven, these must represent heaven, earth, and sea, as if without the chamber, in accordance with the various figures and scenes that shall be there. And since, the vaulting being very flat, the lunettes are so low that they will not hold any but little figures, I would divide each lunette into three parts along its length, and, leaving the ends in a line with the height of the spandrels, I would deepen the centre part below that line, in such a manner that it may be like a great high window and show the exterior of the room, as it were, with figures and scenes proportionate in size to the others. And the two extremities that remain on either side, like horns to the lunette – and horns henceforward they will be called – shall be left low, of the height that they are above that line, and in each of them must be painted a figure seated or recumbent, and seeming to be either within or without the room, whichever you please, for you must choose what looks best; and what I say of one lunette I say of all four.

'To return to the interior of the chamber as a whole, it appears to me that it should be in itself all in darkness, save in so far as the concavities both of the oval above and of the large windows at the sides may give it a certain degree of light, partly from the heaven, with its celestial lights, and partly from the earth with

fires that must be painted there, as will be described later. At the same time, from the centre of the room to the lower end, I would have it that the nearer one may approach to the foot, where the Night is to be, the greater shall be the darkness, and that in like manner in the other half, from the centre to the upper end, in proportion as one approaches step by step to the head, where Aurora is to be, it shall grow continually lighter.

'Having thus disposed of the chamber as a whole, let us proceed to distribute the subjects, giving to each part its own. In the oval that is in the vaulting, you must paint at the head, as we have said, a figure of Aurora. This figure, I find, may be made in several ways, but of all these I shall choose that which in my opinion can be done with the greatest grace in painting. You must paint, then, a maiden of such beauty as the poets strive to express with words, composing her of roses, gold, purple, dew, and other suchlike graces; and so much for the colours and flesh-tints of her person. As for her dress, composing out of many one that appears most suitable, we must reflect that, even as she has three stages, and three distinct colours, so she has three names – Alba, Vermiglia, and Rancia;* and for this reason I would make her down to the girdle a garment delicate in texture, as it were transparent, and white; from the girdle down to the knees an outer garment of scarlet, with certain pinkings and tassels in imitation of the reflections seen on the clouds when she is vermilion, and from the knees down to the feet of the colour of gold, in order to represent her when she is orange, taking heed that this dress must be slit from the thighs downwards, in order to show the bare legs; and both the under garment and the outer must be blown by the wind, so as to flutter in folds. The arms, also, must be naked and of a rosy flesh-tint; on the shoulders you must make her wings of various colours, and on the head a crown of roses; and in her hands you must place a lamp or a lighted torch, or rather, there must go before her a Cupid who is carrying a torch, and after her another who with another torch awakens Tithonus. She must be seated on a gilded throne in a chariot likewise gilded, drawn by a winged Pegasus or by two horses, for she is depicted both in the one way and in the other. As for the colours of the horses, one must be shining white and the other shining red, in order to denote them according to the names that

* White, vermilion, and orange.

Homer gives them of Lampus and Phaëthon. You must make her rising from a tranquil sea, which should appear rippled, luminous, and glancing. On the wall behind, upon the right-hand horn, you must paint her husband Tithonus, and on the left her lover Cephalus. Tithonus should be an old man white as snow, on an orange-coloured bed, or rather, in a cradle, according to those who make him, on account of his great age, once more a child; and he should be shown in the act of holding her back, or gazing on her with amorous eyes, or sighing after her, as if her departure grieved him. Cephalus must be a most beautiful young man dressed in a doublet girt at the waist, with his buskins on his feet, with the spear, which must have the iron head gilded, in his hand, and with a dog at his side, in the act of entering into a wood, as if caring nothing for her by reason of the love that he bears to his Procris. Between Cephalus and Tithonus, in the space with the great window, behind the Aurora, there must shoot upwards some few rays of the sun, of a splendour more vivid than that of the Aurora; but these must be cut off, so as not to be seen, by a large figure of a woman who must appear before them. This woman shall be Vigilance, and she must be so painted that it may appear that she is illumined from behind by the rising sun, and that, in order to forestall him, she is entering into the chamber by the great window that has been mentioned. Let her form be that of a tall, valorous, and splendid woman, with the eyes well open and the brows well arched; dressed down to the feet in a transparent veil, which is girt at the waist; leaning with one hand on a lance, and with the other gathering together a fold of her gown. Let her stand firmly on the right foot, and, holding the left foot suspended, appear from one side to be rooted to the ground, and from the other to be ready to step out. Let her raise her head in order to gaze at Aurora, and appear to be angry that she has risen before her; and let her have on the head a helmet with a cock upon it, which shall be in the act of beating its wings and crowing. All this must be behind the Aurora; and in front of her, in the heaven of the concave oval, I would make certain little figures of girls one behind another, some more bright and some less bright, according as they are more or less near to the light of the Aurora, in order to represent the Hours which go before her and the sun. These Hours shall be painted with the vestments, garlands, and head-dresses of virgins, and winged, with the hands full of flowers, as if they were scattering these about.

'On the opposite side, at the foot of the oval, there shall be Night, and even as Aurora is rising, Night shall be sinking; as the one shows her front, the other shall turn her back; as the first is issuing from a tranquil sea, the second shall be plunging into a sea that is troubled and dark; the horses of the first come with the breast forward, those of the second shall show their croups; and so, also, the person of Night shall be altogether different from that of Aurora. Her flesh-tint shall be dark, dark her mantle, dark her hair, and dark her wings; and these shall be open, as if she were flying. She shall hold her hands on high, and in one a white babe that is sleeping, to represent Sleep, and in the other a black babe that appears to be sleeping, to represent Death; for of both these she is said to be the mother. She shall appear to be sinking with the head downwards and wrapped in thicker shadow, and the heaven about her shall be of a deeper blue and dotted with many stars. Her car shall be of bronze, with the wheels divided into four spaces, to denote her four watches. Then, on the façade opposite (namely, at the foot), even as Aurora has on either side Tithonus and Cephalus, Night shall have Oceanus and Atlas. Oceanus shall be painted on the right, a great figure of a man with the beard and hair dripping and dishevelled, and both from the beard and from the hair there shall issue here and there some heads of dolphins. He shall be depicted as resting on a car drawn by whales, with the Tritons all around in front of him, with their trumpets, and also the Nymphs, and behind him some beasts of the sea; or, if not with all these things, at least with some of them, according to the space that you will have, which to me appears little for so much matter. For Atlas, on the left hand, there shall be painted a mountain with the breast, arms, and all the upper parts of a robust man, bearded and muscular, in the act of upholding the heavens, as his figure is generally shown. Lower down, likewise, over against the Vigilance that we have placed opposite to Aurora, there should be placed a figure of Sleep; but, since it appears to me better, for several reasons, that Sleep should be over the bed, we must place in his stead a figure of Repose. As for this Repose, I find, indeed, that she was worshipped, and that temples were dedicated to her; but I can by no means find how she was figured, unless her figure was that of Security, which I do not believe, because security is a thing of the mind and repose of the body. We must therefore figure a Repose of our own devising, in this manner: a young maiden of pleasing

aspect, who, being weary, yet does not lie down, but sleeps seated with the head resting on the left arm. She shall have a spear with the head lying against her shoulder and the foot fixed in the ground, and shall let one arm hang limply down it, and have one leg crossed over it, in the attitude of resting for the restoration of her strength, and not from indolence. She shall have a crown of poppies, and a sceptre laid on one side, but not so far distant that she cannot readily take it up again; and whereas Vigilance has upon her head a cock crowing, so to her we may give a sitting hen, in order to signify that even when resting she is active.

'Within the same oval, on the right hand, you shall paint a Moon. Her figure shall be that of a maiden of about eighteen years, tall and virginal in aspect, after the likeness of Apollo, with long tresses, thick and somewhat waved, or wearing on the head one of those caps that are called Phrygian, wide at the foot and pointed and twisted at the top, like the Doge's hat, with two wings over the brow that must hang down and cover the ears, and with two little horns jutting from the head, as of the crescent moon; or, after Apuleius, with a flat disk, polished and shining in the manner of a mirror, on the centre of the brow, which must have on either side of it some serpents and over it some few ears of corn, and on the head a crown of dittany, after the Greeks, or of various flowers, after Marcian, or of helichrysum, after certain others. Her dress some would have reaching down to the feet, others only to the knees, girt under the breasts and crossed below the navel after the fashion of a nymph, with a little mantle on the shoulder clasped over the muscle on the right side, and on the feet buskins wrought in a pleasing pattern. Pausanias, alluding, I believe, to Diana, makes her dressed in deerskin; Apuleius, taking her perchance for Isis, gives her a vestment of the finest veiling in various colours, white, yellow, and red, and another garment all black, but bright and shining, dotted with many stars and with a moon in the centre, and all around it a border with ornaments of fruits and flowers hanging down after the manner of tassels. Of these vestments, take whichever looks best. The arms you must make bare, with the sleeves broad; with the right hand she must hold a lighted torch, and with the left an unbent bow, which, according to Claudian, is of horn, and, according to Ovid, of gold. Make it as seems best to you, and attach the quiver to her shoulders. She is found in Pausanias with two serpents in the left hand, and in Apuleius she has a gilded vase

with a serpent as a handle, which appears as if swollen with poison, the foot of the vase being adorned with palm leaves; but by this I believe that he means to indicate Isis, and I have therefore resolved that you shall represent her with the bow, as described above. She shall ride on a car drawn by horses, one black and the other white, or, if you desire variety, by a mule, after Festus Pompeius, or by bullocks, after Claudian and Ausonius; and if you choose bullocks, they must have the horns very small and a white patch on the right flank. The attitude of the Moon must be that of looking down from the heaven in the oval towards the horn of the façade that looks out over the garden, where you must place her lover Endymion, and she shall lean down from the car to kiss him, and, not being able by reason of the interposition of the border, she shall gaze lovingly upon him and illumine him with her radiance. For Endymion you must make a beautiful young shepherd, asleep at the foot of Mount Latmus. In the horn on the other side there shall be Pan, the God of Shepherds, who was enamoured of the Moon; his figure is very well known. Round his neck place his pipes, and with both hands he shall hold out towards the Moon a skein of white wool, with which he is fabled to have won her love; and with that present he must appear to be persuading her to come down to live with him. In the rest of the space of the same great window you must paint a scene, and that shall be the scene of the sacrifices to the Lemures, which men used to hold at night in order to drive evil spirits from their houses. The ritual of these sacrifices was to go about, with the hands washed and the feet bare, scattering black beans; first rolling them about in the mouth, and then throwing them over the shoulder; and among the company were some who made a noise by sounding basins and suchlike instruments of copper.

'On the left side of the oval you must paint Mercury in the ordinary manner, with the little winged cap, with the winged sandals on the feet, with the Caduceus in the left hand, and with the purse in the right; altogether nude, save for his little mantle on the shoulder; a most beautiful youth, but with a natural beauty, without any artifice; of a cheerful countenance, spirited eyes, beardless, or with the first down, with reddish hair, and narrow in the shoulders. Some place wings over his ears, and make certain golden feathers coming out of his hair. The attitude you may make as you please, provided only that it shows him gliding down from Heaven in order to infuse sleep, and, turning

towards the side of the bed, about to touch the tester with his wand. On the left-hand façade, in the horn next to the façade at the foot, we might have the Lares, his two sons, who were the tutelary spirits of private houses; namely, two young men dressed in the skins of dogs, with certain garments girt up and thrown over the left shoulder in such a way that they may come out under the right, in order to signify that they are unencumbered and ready to guard the house. They shall sit one beside the other, each holding a spear in the right hand, and between them, in the centre, there shall be a dog, and above them a small head of Vulcan, wearing a little cap, with a smith's pincers beside it. In the other horn, next to the façade at the head, you must paint a Battus being converted into stone for having revealed the cattle stolen by Mercury. Let him be an old shepherd seated, showing with the forefinger of the right arm the place where the cattle were hidden, and leaning with the left arm on a stick or rod, the herdsman's staff; and from the waist downwards he must be of black stone of the colour of basanite, into which stone he was converted. Then in the rest of the great window you must paint the scene of the sacrifice that the ancients used to offer to Mercury to the end that their sleep might not be interrupted; and to represent this it is necessary to make an altar with his statue upon it, at the foot of that a fire, and all around persons who are throwing into it pieces of wood for burning, and who, having in their hands cups full of wine, are sprinkling part of the wine and drinking the rest.

'In the centre of the oval, in order to fill up all the space of the heaven, I would paint Twilight, as being the mean between Aurora and Night. To represent him, I find that one must paint a young man wholly naked, sometimes with wings and sometimes without, and with two lighted torches, one of which we must show being kindled at that of Aurora, and the other held out towards Night. Some represent this young man, with the same two torches, as riding on one of the horses of the Sun or of Aurora, but this would not be a composition suitable for our purpose; wherefore we shall make him as described above, turned towards Night, and place behind him, between his legs, a great star, which shall be that of Venus, because Venus, Phosphorus, Hesperus, and Twilight seem to be regarded as one and the same thing. And with the exception of this star, see to it that all the lesser stars near the Aurora shall have disappeared.

'Now, having by this time filled up all the exterior of the chamber both above in the oval and on the sides and façades, it remains for us to come to the interior, the four spandrels of the vaulting. Beginning with that over the bed, which is between the left-hand façade and that at the foot, you must paint Sleep there; and in order to figure him, you must first figure his home. Ovid places it in Lemnos and among the Cimmerii, Homer in the Ægean Sea, Statius among the Ethiopians, and Ariosto in Arabia. Wherever it may be, it is enough to depict a mountain, such an one as may be imagined where there is always darkness and never any sun; at the foot of it a deep hollow, through which water shall pass, as still as death, in order to signify that it makes no murmur, and this water must be of a sombre hue, because they make it a branch of Lethe. Within this hollow shall be a bed, which, being fabled to be of ebony, shall be black in colour and covered with black draperies. In this bed shall be placed Sleep, a young man of perfect beauty, for they make him surpassing beautiful and serene; nude, according to some, and according to others clothed in two garments, one black below and another white over it, with wings on the shoulders, and, according to Statius, also at the top of the head. Under his arm he shall hold a horn, which shall appear to be spilling a liquid of a livid hue over the bed, in order to denote Oblivion; although others make the horn full of fruits. In one hand he shall hold the wand, and in the other three poppy-heads. He shall be sleeping like one sick, with the head and the limbs hanging limp, as if wholly relaxed in slumber. About his head shall be seen Morpheus, Icelus, and Phantasus, and a great number of Dreams, all which are his children. The Dreams shall be little figures, some of a beautiful aspect and others hideous, as being things that partly please and partly terrify. Let them, likewise, have wings, and also twisted feet, as being unstable and uncertain things, and let them hover and whirl about him, making a kind of dramatic spectacle by transforming themselves into things possible and impossible. Morpheus is called by Ovid the creator and fashioner of figures, and I would therefore make him in the act of fashioning various masks with grotesque faces and placing some of them on feet. Icelus, they say, transforms himself into many shapes, and him I would figure in such a way that as a whole he may have the appearance of a man, and yet may have parts of a wild beast, of a bird, and of a serpent, as the same Ovid describes him. Phantasus, they have it,

transforms himself into various inanimate things, and him, also, we may represent, after the words of Ovid, partly of stone, partly of water, and partly of wood. You must feign that in this place there are two gates, one of ivory, whence there issue the false dreams, and one of horn, whence the true dreams come; the true shall be more distinct in colour, more luminous, and better executed, and the false shall be confused, sombre, and imperfect.

'In the next spandrel, between the façade at the foot and that on the right hand, you shall place Brizo, the Goddess of prophecy and the interpretress of dreams. For her I cannot find the vestments, but I would make her in the manner of a Sibyl, seated at the foot of the elm described by Virgil, under the branches of which are placed innumerable images, which, falling from those branches, must be shown flying about her in the forms that we have given them; as has been related, some lighter and some darker, some broken and some indistinct, and others almost wholly invisible; in order to represent by these the dreams, the visions, the oracles, the phantasms, and the vain things that are seen in sleep (for into these five kinds Macrobius appears to divide them); and she shall be as it were lost in thought, interpreting them, and shall have about her persons offering to her baskets filled with all manner of things, excepting only fishes.

'In the spandrel between the right-hand façade and that at the head it will be well to place Harpocrates, the God of Silence, because this, presenting itself at the first glance before those who enter by the door that leads from the great painted chamber, will warn them as they enter that they must not make any noise. His figure is that of a young man, or rather, of a boy, black in colour, from his being God of the Egyptians, and with his finger to his mouth in the act of commanding silence. He shall carry in his hand a branch of a peach-tree, and, if you think it well, a garland of the leaves of the same tree. They feign that he was born weak in the legs, and that, having been killed, his mother Isis restored him to life; and for this reason some make him stretched out on the ground, and others in the lap of his mother, with the feet joined together. But, for the sake of harmony with the other figures, I would make him standing, supported in some way, or rather, seated, like that of the most illustrious Cardinal Sant' Agnolo, which is likewise winged and holds a horn of plenty. He shall have about him persons offering to him, as was the custom, first-fruits of lentils and other vegetables, and also of peaches, as

mentioned above. Others used to make for this same God a figure without a face, with a little cap on the head, and about him a wolf's skin, all covered with eyes and ears. Take which of these two you please.

'In the last spandrel, between the façade at the head and that on the left, it will be well to place Angerona, the Goddess of Secrecy, which figure, coming within the same door of entrance, will admonish those who come out of the chamber to keep secret all that they have seen and heard, as is the duty of the servants of noblemen. The figure is that of a woman placed upon an altar, with the mouth bound and sealed. I know not with what vestments she used to be depicted, but I would envelop her in a long gown covering her whole person, and would represent her as shrugging her shoulders. Around her there must be painted some priests, by whom sacrifices used to be offered to her before the gate in the Curia, to the end that it might be unlawful for any person to reveal to the prejudice of the Republic any matter that might be discussed there.

'The space within the spandrels being filled up, it now only remains to say that around all this work it seems to me that there should be a frieze to encircle it on every side, and in this I would make either grotesques or small scenes with little figures. The matter of these I would have in harmony with the subjects already given above, each in accord with that nearest to it; and if you paint little scenes, it would please me to have them representing the actions that men and also animals do at the hour that we have fixed there. Now, beginning at the head, I would paint in the frieze of that façade, as things appropriate to the Dawn, artisans, workmen, and persons of various kinds who, having risen, are returning to the labours of their pursuits – as smiths to the forge, men of letters to their studies, huntsmen to the open country, and muleteers to the road, and above all would I like to have the poor old woman from Petrarca rising from her spinning and lighting the fire, with her feet bare and her clothes dishevelled. And if you think fit to make grotesques of animals there, make them of birds singing, geese going forth to their pasture, cocks announcing the day, and similar fancies. In the frieze on the façade at the foot, in accord with the darkness there, I would make persons going fowling by night, spies, adulterers, climbers of windows, and other suchlike things; and for grotesques, porcupines, hedgehogs, badgers, a peacock with the tail spread,

signifying the night of stars, owls large and small, bats, and such-like animals. In the frieze on the right-hand façade you must paint things in keeping with the Moon, such as fishers of the night, mariners navigating with the compass, necromancers, witches, and the like; for grotesques, a beacon-tower in the distance, nets, weir-baskets with some fishes in them, crabs feeding by the light of the moon, and, if there be space enough, an elephant kneeling in adoration of her. And, finally, in the frieze on the left-hand façade, mathematicians with their instruments for measuring, thieves, false-coiners, robbers of buried treasure, shepherds with their folds still closed, lying around their fires, and the like; and for animals I would make there wolves, foxes, apes, weasels, and any other treacherous animals that lie in wait for other creatures.

'In this part I have placed these phantasies thus at random in order to suggest what kinds of inventions could be painted there; but, since they are not things that need to be described, I leave you to imagine them in your own manner, knowing that painters are by their nature full of resource and grace in inventing such bizarre fantasies. And now, having filled in all the parts of the work both within and without the chamber, there is no occasion for us to say any more, save that you must discuss the whole matter with the most illustrious Monsignore, and, according to his taste, adding or taking away whatever may be necessary, you must strive on your part to do yourself honour. Fare you well.'

Now, although all these beautiful inventions of Caro's were very ingenious, fanciful, and worthy of praise, nevertheless Taddeo was not able to carry into execution more than the place would contain; but those that he painted there were the greater part, and they were executed by him with much grace and in a most beautiful manner. Next to this chamber, in the last of the three, which is dedicated to Solitude, Taddeo, with the help of his assistants, painted Christ preaching to the Apostles in the desert and in the woods, with a S. John on the right hand that is very well executed. In another scene, which is opposite to the first, are painted many figures of men who are living in the forest in order to avoid the conversation of mankind; and these certain others are seeking to disturb, throwing stones at them, while some are plucking out their own eyes so as not to see. And in this scene, likewise, is painted the Emperor Charles V, portrayed from life, with this inscription –

POST INNUMEROS LABORES OCIOSAM QUIETAMQUE VITAM
TRADUXIT.

Opposite to Charles is the portrait of the last Grand Turk, who
much delighted in solitude, with these words –

ANIMUM A NEGOCIO AD OCIUM REVOCAVIT.

Near him is Aristotle, who has beneath him these words –

ANIMA FIT SEDENDO ET QUIESCENDO PRUDENTIOR.

Opposite to him, beneath another figure by the hand of Taddeo,
is written this –

QUEMADMODUM NEGOCII, SIC ET OCII RATIO HABENDA.

Beneath another may be read –

OCIUM CUM DIGNITATE, NEGOCIUM SINE PERICULO.

And opposite to that, under another figure, is this motto –

VIRTUTIS ET LIBERÆ VITÆ OPTIMA MAGISTRA SOLITUDO.

Beneath another –

PLUS AGUNT QUI NIHIL AGERE VIDENTUR.

And under the last –

QUI AGIT PLURIMA, PLURIMUM PECCAT.

To put it briefly, this room is very ornate with beautiful
figures, and likewise very rich in stucco and gold. But to return
to Vignuola; how excellent he is in matters of architecture, the
works that he has written and published and still continues to
write, in addition to his marvellous buildings, bear ample testi-
mony, and in the Life of Michelagnolo we shall say all that it may
be expedient for us to say in this connection.

Taddeo, in addition to the works described above, executed
many others of which there is no need to make mention; but in
particular a chapel in the Church of the Goldsmiths in the Strada
Giulia, a façade in chiaroscuro at S. Gieronimo, and the Chapel
of the High-altar in S. Sabina. And his brother Federigo is paint-
ing for the Chapel of S. Lorenzo, which is all wrought in stucco,
in S. Lorenzo in Damaso, an altar-piece with that Saint on the
gridiron and Paradise all open; which altar-piece is expected to

prove a very beautiful work. And, in order not to omit anything that may be useful, pleasing, or helpful to anyone who may read these my labours, I shall add this as well. While Taddeo was working, as has been related, at the Vigna of Pope Julius and at the façade of Mattiuolo, the Master of the Post, he executed for Monsignor Innocenzio, the most reverend and illustrious Cardinal di Monte, two painted pictures of no great size; and one of them, which is beautiful enough, is now in the guardaroba of that Cardinal (who has given the other away), in company with a vast number of things ancient and modern, all truly of the rarest, among which, I must not omit to mention, there is a painted picture as fantastic as any work of which we have spoken hitherto. In this picture, which is about two braccia and a half in height, there is nothing to be seen by him who looks at it from the ordinary point of view, from the front, save some letters on a flesh-coloured ground, and in the centre the Moon, which goes gradually increasing or diminishing according to the lines of the writing. And yet, if you go below the picture and look in a sphere or mirror that is placed over the picture in the manner of a little baldachin, you see in that mirror, which receives the image from the picture, a most life-like portrait in painting of King Henry II of France, somewhat larger than life, with these words about it – HENRY II, ROY DE FRANCE. You can see the same portrait by lowering the picture, placing your brow on the upper part of the frame, and looking down; but it is true that whoever looks at it in that manner, sees it turned the other way from what it is in the mirror. That portrait, I say, cannot be seen save by looking at it as described above, because it is painted on twenty-eight ridges, too low to be perceived, which are between the lines of the words given below, in which, besides the ordinary meaning, there may be read, by looking at both ends of the lines and in the centre, certain letters somewhat larger than the others, which run thus –

HENRICUS VALESIUS DEI GRATIA GALLORUM REX INVICTISSIMUS.

It is true, indeed, that the Roman M. Alessandro Taddei, the secretary of that Cardinal, and Don Silvano Razzi, my dearest friend, who have given me information about this picture and about many other things, do not know by whose hand it is, but only that it was presented by the above-named King Henry to Cardinal Caraffa, when he was in France, and then by Caraffa to

the most illustrious Cardinal di Monte, who treasured it as a very rare thing, which in truth it is. The words painted in the picture, which alone are to be seen by him who looks at it from the ordinary point of view, as one looks at other pictures, are these –

HEus tu quid	viDes nil ut	reoR
Nisi lunam	crEscentem	et E
Regione	posItam quæ	eX
Intervallo	GRadatim	utI
Crescit	nos Admonet	ut iN
Una spe fide	eT charitate	tV
Simul et ego	Illuminat	I
Verbo dei	crescAmus,	donecC
Ab ejusdem	Gratia	fiaT
Lux in nobis	Amplissima	quI
Est æternus	iLLe dator	luciS
In quo et a	quO mortales	omneS
Veram lucem	Recipere	sI
Speramus in	vanUM non	sperabiMUS

In the same guardaroba is a most beautiful portrait of Signora Sofonisba Anguisciuola by her own hand, once presented by her to Pope Julius III. And there is another thing of great value, a very ancient book with the Bucolics, the Georgics, and the Æneid of Virgil, in characters so old, that it has been judged by many men of learning in Rome and in other places that it was written in the very time of Cæsar Augustus, or little after; wherefore it is no marvel that it should be held by the Cardinal in the greatest veneration.

And let this be the end of the Life of the painter Taddeo Zucchero.

MICHELAGNOLO BUONARROTI,
Painter, Sculptor, and Architect of Florence

WHILE the most noble and industrious spirits were striving, by the light of the famous Giotto and of his followers, to give to the world a proof of the ability that the benign influence of the stars and the proportionate admixture of humours had given to their intellects, and while, desirous to imitate with the excellence of their art the grandeur of Nature in order to approach as near as possible to that supreme knowledge that many call under-standing, they were universally toiling, although in vain, the most benign Ruler of Heaven in His clemency turned His eyes to the earth, and, having perceived the infinite vanity of all those la-bours, the ardent studies without any fruit, and the presumptuous self-sufficiency of men, which is even further removed from truth than is darkness from light, and desiring to deliver us from such great errors, became minded to send down to earth a spirit with universal ability in every art and every profession, who might be able, working by himself alone, to show what manner of thing is the perfection of the art of design in executing the lines, con-tours, shadows, and high lights, so as to give relief to works of painting, and what it is to work with correct judgment in sculp-ture, and how in architecture it is possible to render habitations secure and commodious, healthy and cheerful, well-proportioned, and rich with varied ornaments. He was pleased, in addition, to endow him with the true moral philosophy and with the orna-ment of sweet poesy, to the end that the world might choose him and admire him as its highest exemplar in the life, works, saintli-ness of character, and every action of human creatures, and that he might be acclaimed by us as a being rather divine than human. And since He saw that in the practice of these rare exercises and arts – namely, in painting, in sculpture, and in architecture – the Tuscan intellects have always been exalted and raised high above all others, from their being diligent in the labours and studies of every faculty beyond no matter what other people of Italy, He chose to give him Florence, as worthy beyond all other cities, for his country, in order to bring all the talents to their highest per-fection in her, as was her due, in the person of one of her citizens.

There was born a son, then, in the Casentino, in the year 1474,

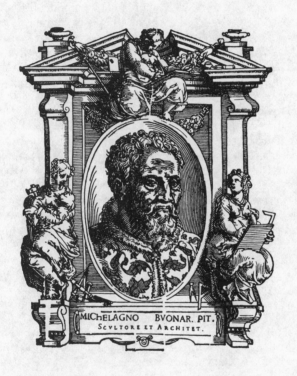

MICheLAGNO BVONAR. PIT.
SCVLTORE ET ARCHITET.

under a fateful and happy star, from an excellent and noble mother, to Lodovico di Leonardo Buonarroti Simoni, a descendant, so it is said, of the most noble and most ancient family of the Counts of Canossa. To that Lodovico, I say, who was in that year Podestà of the township of Chiusi and Caprese, near the Sasso della Vernia, where S. Francis received the Stigmata, in the Diocese of Arezzo, a son was born on the 6th of March, a Sunday, about the eighth hour of the night, to which son he gave the name Michelagnolo, because, inspired by some influence from above, and giving it no more thought, he wished to suggest that he was something celestial and divine beyond the use of mortals, as was afterwards seen from the figures of his horoscope, he having had Mercury and Venus in the second house of Jupiter, with happy augury, which showed that from the art of his brain and of his hand there would be seen to issue forth works marvellous and stupendous. Having finished his office as Podestà, Lodovico returned to Florence and settled in the village of Settignano, at a distance of three miles from the city, where he had a farm that had belonged to his forefathers; which place abounds with stone and is all full of quarries of grey-stone, which is constantly being worked by stone-cutters and sculptors, who for the most part are born in the place. Michelagnolo was put out to nurse by Lodovico in that village with the wife of a stone-cutter: wherefore the same Michelagnolo, discoursing once with Vasari, said to him jestingly, 'Giorgio, if I have anything of the good in my brain, it has come from my being born in the pure air of your country of Arezzo, even as I also sucked in with my nurse's milk the chisels and hammer with which I make my figures.' In time Lodovico's family increased, and, being in poor circumstances, with slender revenues, he set about apprenticing his sons to the Guilds of Silk and Wool. Michelagnolo, who by that time was well grown, was placed to be schooled in grammar with Maestro Francesco da Urbino; but, since his genius drew him to delight in design, all the time that he could snatch he would spend in drawing in secret, being scolded for this by his father and his other elders, and at times beaten, they perchance considering that to give attention to that art, which was not known by them, was a mean thing and not worthy of their ancient house.

At this time Michelagnolo had formed a friendship with Francesco Granacci, who, likewise a lad, had placed himself

with Domenico Ghirlandajo in order to learn the art of painting; wherefore Granacci, loving Michelagnolo, and perceiving that he was much inclined to design, supplied him daily with drawings by Ghirlandajo, who at that time was reputed to be one of the best masters that there were not only in Florence, but throughout all Italy. Whereupon, the desire to work at art growing greater every day in Michelagnolo, Lodovico, perceiving that he could not divert the boy from giving his attention to design, and that there was no help for it, and wishing to derive some advantage from it and to enable him to learn that art, resolved on the advice of friends to apprentice him with Domenico Ghirlandajo. Michelagnolo, when he was placed with Domenico Ghirlandajo, was fourteen years of age. Now he who wrote his life after the year 1550, when I wrote these Lives the first time, has said that some persons, through not having associated with him, have related things that never happened, and have left out many that are worthy to be recorded, and has touched on this circumstance in particular, taxing Domenico with jealousy and saying that he never offered any assistance to Michelagnolo; which is clearly false, as may be seen from an entry by the hand of Lodovico, the father of Michelagnolo, written in one of Domenico's books, which book is now in the possession of his heirs. That entry runs thus: '1488, I record, this first day of April, that I, Lodovico di Leonardo di Buonarrota, placed Michelagnolo my son with Domenico and David di Tommaso di Currado for the three years next to come, on these terms and conditions, that the said Michelagnolo shall remain with the above-named persons for the said period of time, in order to learn to paint and to exercise that vocation; that the said persons shall have command over him; and that the same Domenico and David shall be bound to give him in those three years twenty-four florins of full weight, the first year six florins, the second year eight florins, and the third ten florins; in all, the sum of ninety-six lire.' And next, below this, is another record, or rather, entry, also written in the hand of Lodovico: 'The aforesaid Michelagnolo has received of that sum, this sixteenth day of April, two gold florins in gold. I, Lodovico di Leonardo, his father, have received twelve lire and twelve soldi as cash due to him.' These entries I have copied from the book itself, in order to prove that all that was written at that time, as well as all that is about to be written, is the truth; nor do I know that anyone has been more associated with him than I have been,

or has been a more faithful friend and servant to him, as can be proved even to one who knows not the facts, neither do I believe that there is anyone who can show a greater number of letters written by his own hand, or any written with greater affection than he has expressed to me. I have made this digression for the sake of truth, and it must suffice for all the rest of his Life. Let us now return to our story.

When the ability as well as the person of Michelagnolo had grown in such a manner, that Domenico, seeing him execute some works beyond the scope of a boy, was astonished, since it seemed to him that he not only surpassed the other disciples, of whom he had a great number, but very often equalled the things done by himself as master, it happened that one of the young men who were learning under Domenico copied with the pen some draped figures of women from works by Ghirlandajo; whereupon Michelagnolo took that drawing and with a thicker pen outlined one of those women with new lineaments, in the manner that it should have been in order to be perfect. And it is a marvellous thing to see the difference between the two manners, and the judgment and excellence of a mere lad who was so spirited and bold, that he had the courage to correct the work of his master. That sheet is now in my possession, treasured as a relic; and I received it from Granacci to put in my book of drawings together with others by the same hand, which I received from Michelagnolo. In the year 1550, when Giorgio was in Rome, he showed it to Michelagnolo, who recognized it and was pleased to see it again, saying modestly that he knew more of the art when he was a boy than he did at that time, when he was an old man.

Now it happened that when Domenico was at work on the great chapel of S. Maria Novella, one day that he was out Michelagnolo set himself to draw the staging from the reality, with some desks and all the appliances of art, and some of the young men who were working there. Whereupon, when Domenico had returned and seen Michelagnolo's drawing, he said, 'This boy knows more about it than I do;' and he was struck with amazement at the novel manner and the novel method of imitation that a mere boy of such tender age displayed by reason of the judgment bestowed upon him by Heaven, for these, in truth, were as marvellous as could have been looked for in the workmanship of a craftsman who had laboured for many years. And this was

because all the power and knowledge of the gracious gifts of his nature were exercised by study and by the practice of art, wherefore these gifts produced every day fruits more divine in Michelagnolo, as began to be made clearly manifest in the copy that he executed of a printed sheet by the German Martino, which gave him a very great name. For there had come to Florence at that time a scene by the above-named Martino, of the Devils beating S. Anthony, engraved on copper, and Michelagnolo copied it with the pen in such a manner that it could not be detected, and then painted that same sheet in colours, going at times, in order to counterfeit certain strange forms of devils, to buy fishes that had scales bizarre in colouring; and in that work he showed so much ability, that he acquired thereby credit and fame. He also counterfeited sheets by the hands of various old masters, making them so similar that they could not be detected, for, tinting them and giving them the appearance of age with smoke and various other materials, he made them so dark that they looked old, and, when compared with the originals, one could not be distinguished from the other. Nor did he do this with any other purpose but to obtain the originals from the hands of their owners by giving them the copies, for he admired them for the excellence of their art and sought to surpass them in his own practice; on which account he acquired a very great name.

At that time the Magnificent Lorenzo de' Medici kept the sculptor Bertoldo in his garden on the Piazza di S. Marco, not so much as custodian or guardian of the many beautiful antiques that he had collected and gathered together at great expense in that place, as because, desiring very earnestly to create a school of excellent painters and sculptors, he wished that these should have as their chief and guide the above-named Bertoldo, who was a disciple of Donato. Bertoldo, although he was so old that he was not able to work, was nevertheless a well-practised master and in much repute, not only because he had polished with great diligence the pulpits cast by his master Donato, but also on account of many castings in bronze that he had executed himself, of battles and certain other small works, in the execution of which there was no one to be found in Florence at that time who surpassed him. Now Lorenzo, who bore a very great love to painting and to sculpture, was grieved that there were not to be found in his time sculptors noble and famous enough to equal the many painters of the highest merit and reputation, and he

determined, as I have said, to found a school. To this end he besought Domenico Ghirlandajo that, if he had among the young men in his workshop any that were inclined to sculpture, he might send them to his garden, where he wished to train and form them in such a manner as might do honour to himself, to Domenico, and to the whole city. Whereupon there were given to him by Domenico as the best of his young men, among others, Michelagnolo and Francesco Granacci; and they, going to the garden, found there that Torrigiano, a young man of the Torrigiani family, was executing in clay some figures in the round that had been given to him by Bertoldo. Michelagnolo, seeing this, made some out of emulation; wherefore Lorenzo, seeing his fine spirit, always regarded him with much expectation. And he, thus encouraged, after some days set himself to counterfeit from a piece of marble an antique head of a Faun that was there, old and wrinkled, which had the nose injured and the mouth laughing. Michelagnolo, who had never yet touched marble or chisels, succeeded so well in counterfeiting it, that the Magnificent Lorenzo was astonished; and then, perceiving that, departing from the form of the antique head, he had opened out the mouth after his own fancy and had made a tongue, with all the teeth showing, that lord, jesting pleasantly, as was his wont, said to him, 'Surely you should have known that old folks never have all their teeth, and that some are always wanting.' It appeared to Michelagnolo, in his simplicity, both fearing and loving that lord, that he had spoken the truth; and no sooner had Lorenzo departed than he straightway broke one of the teeth and hollowed out the gum, in such a manner, that it seemed as if the tooth had dropped out. And then he awaited with eagerness the return of the Magnificent Lorenzo, who, when he had come and had seen the simplicity and excellence of Michelagnolo, laughed at it more than once, relating it as a miracle to his friends. Moreover, having made a resolve to assist and favour Michelagnolo, he sent for his father Lodovico and asked for the boy from him, saying that he wished to maintain him as one of his own children; and Lodovico gave him up willingly. Thereupon the Magnificent Lorenzo granted him a chamber in his own house and had him attended, and he ate always at his table with his own children and with other persons of quality and of noble blood who lived with that lord, by whom he was much honoured. This was in the year after he had been placed with Domenico, when Michelagnolo was about

fifteen or sixteen years of age; and he lived in that house four
years, which was until the death of the Magnificent Lorenzo in
1492. During that time, then, Michelagnolo had five ducats a
month from that lord as an allowance and also to help his father;
and for his particular gratification Lorenzo gave him a violet
cloak, and to his father an office in the Customs. Truth to tell,
all the young men in the garden were salaried, some little and
some much, by the liberality of that magnificent and most noble
citizen, and rewarded by him as long as he lived.

At this time, at the advice of Poliziano, a man eminent in
letters, Michelagnolo executed from a piece of marble given to
him by that lord the Battle of Hercules with the Centaurs, which
was so beautiful that now, to those who study it from time
to time, it appears as if by the hand not of a youth but of a
master of repute, perfected by study and well practised in that
art. It is now in his house, treasured in memory of him by his
nephew Leonardo as a rare thing, which indeed it is. That
Leonardo, not many years since, had in his house in memory of
his uncle a Madonna of marble in low-relief by the hand of
Michelagnolo, little more than one braccio in height, in which
when a lad, at this same time, wishing to counterfeit the manner
of Donatello, he acquitted himself so well that it seems as if by
Donatello's hand, save that there may be seen in it more
grace and more design. That work Leonardo afterwards gave to
Duke Cosimo de' Medici, who treasures it as a unique thing, for
we have no other low-relief in sculpture by his hand save
that one.

Now, returning to the garden of the Magnificent Lorenzo;
that garden was full of antiques and richly adorned with excellent
pictures, all gathered together in that place for their beauty, for
study, and for pleasure. Michelagnolo always had the keys, and
he was much more earnest than the others in his every action,
and showed himself always alert, bold, and resolute. He drew for
many months from the pictures of Masaccio in the Carmine,
where he copied those works with so much judgment, that the
craftsmen and all other men were astonished, in such sort that
envy grew against him together with his fame. It is said
that Torrigiano, after contracting a friendship with him, mocked
him, being moved by envy at seeing him more honoured than
himself and more able in art, and struck him a blow of the fist
on the nose with such force, that he broke and crushed it very

grievously and marked him for life; on which account Torrigiano was banished from Florence, as has been related in another place.

When the Magnificent Lorenzo died, Michelagnolo returned to his father's house in infinite sorrow at the death of so great a man, the friend of every talent. There he bought a great piece of marble, and from it carved a Hercules of four braccia, which stood for many years in the Palace of the Strozzi; this was esteemed an admirable work, and afterwards, in the year of the siege, it was sent into France to King Francis by Giovan Battista della Palla. It is said that Piero de' Medici, who had been left heir to his father Lorenzo, having long been intimate with Michelagnolo, used often to send for him when he wished to buy antiques, such as cameos and other carved stones. One winter, when much snow fell in Florence, he caused him to make in his courtyard a statue of snow, which was very beautiful; and he honoured Michelagnolo on account of his talents in such a manner, that his father, beginning to see that he was esteemed among the great, clothed him much more honourably than he had been wont to do.

For the Church of S. Spirito in the city of Florence Michelagnolo made a Crucifix of wood, which was placed, as it still is, above the lunette of the high-altar; doing this to please the Prior, who placed rooms at his disposal, in which he was constantly flaying dead bodies, in order to study the secrets of anatomy, thus beginning to give perfection to the great knowledge of design that he afterwards acquired. It came about that the Medici were driven out of Florence, and a few weeks before that Michelagnolo had gone to Bologna, and then to Venice, fearing, as he saw the insolence and bad government of Piero de' Medici, lest some evil thing might befall him from his being the servant of that family; but, not having found any means of living in Venice, he returned to Bologna. There he had the misfortune to neglect, through lack of thought, when entering by the gate, to learn the countersign for going out again, a command having been issued at that time, as a precaution, at the desire of Messer Giovanni Bentivogli, that all strangers who had not the countersign should be fined fifty Bolognese lire; and having fallen into such a predicament, nor having the means to pay, Michelagnolo by chance was seen by Messer Giovan Francesco Aldovrandi, one of the Sixteen of the Government, who had compassion on him, and, having made him tell his story, liberated him, and then kept him

in his house for more than a year. One day Aldovrandi took
him to see the tomb of S. Dominic, made, as has been related,
by Giovanni Pisano and then by Maestro Niccolò dell' Arca,
sculptors of olden days. In that work there were wanting a
S. Petronio and an Angel holding a candelabrum, figures of about
one braccio, and Aldovrandi asked him if he felt himself able to
make them; and he answered Yes. Whereupon he had the marble
given to him, and Michelagnolo executed them in such a man-
ner, that they are the best figures that are there; and Messer
Francesco Aldovrandi caused thirty ducats to be given to him
for the two. Michelagnolo stayed a little more than a year in
Bologna, and he would have stayed there even longer, in order
to repay the courtesy of Aldovrandi, who loved him both for his
design and because, liking Michelagnolo's Tuscan pronunciation
in reading, he was pleased to hear from his lips the works of
Dante, Petrarca, Boccaccio, and other Tuscan poets. But, since
he knew that he was wasting his time, he was glad to return to
Florence.

There he made for Lorenzo di Pier Francesco de' Medici a
S. Giovannino of marble, and then set himself to make from
another piece of marble a Cupid that was sleeping, of the size of
life. This, when finished, was shown by means of Baldassarre del
Milanese to Lorenzo di Pier Francesco as a beautiful thing, and
he, having pronounced the same judgment, said to Michelagnolo:
'If you were to bury it under ground and then sent it to Rome
treated in such a manner as to make it look old, I am certain that
it would pass for an antique, and you would thus obtain much
more for it than by selling it here.' It is said that Michelagnolo
handled it in such a manner as to make it appear an antique; nor
is there any reason to marvel at that, seeing that he had genius
enough to do it, and even more. Others maintain that Milanese
took it to Rome and buried it in a vineyard that he had there,
and then sold it as an antique to Cardinal San Giorgio for two
hundred ducats. Others, again, say that Milanese sold to the
Cardinal one that Michelagnolo had made for him, and that he
wrote to Lorenzo di Pier Francesco that he should cause thirty
crowns to be given to Michelagnolo, saying that he had not re-
ceived more for the Cupid, and thus deceiving the Cardinal,
Lorenzo di Pier Francesco, and Michelagnolo; but afterwards,
having received information from one who had seen that the boy
was fashioned in Florence, the Cardinal contrived to learn the

truth by means of a messenger, and so went to work that Milanese's agent had to restore the money and take back the Cupid. That work, having come into the possession of Duke Valentino, was presented by him to the Marchioness of Mantua, who took it to her own country, where it is still to be seen at the present day. This affair did not happen without some censure attaching to Cardinal San Giorgio, in that he did not recognize the value of the work, which consisted in its perfection; for modern works, if only they be excellent, are as good as the ancient. What greater vanity is there than that of those who concern themselves more with the name than the fact? But of that kind of men, who pay more attention to the appearance than to the reality, there are some to be found at any time.

Now this event brought so much reputation to Michelagnolo, that he was straightway summoned to Rome and engaged by Cardinal San Giorgio, with whom he stayed nearly a year, although, as one little conversant with our arts, he did not commission Michelagnolo to do anything. At that time a barber of the Cardinal, who had been a painter, and could paint with great diligence in distemper-colours, but knew nothing of design, formed a friendship with Michelagnolo, who made for him a cartoon of S. Francis receiving the Stigmata. That cartoon was painted very carefully in colours by the barber on a little panel; and the picture is now to be seen in S. Pietro a Montorio in the first chapel on the left hand as one enters the church. The talent of Michelagnolo was then clearly recognized by a Roman gentleman named Messer Jacopo Galli, an ingenious person, who caused him to make a Cupid of marble as large as life, and then a figure of a Bacchus ten palms high, who has a cup in the right hand, and in the left hand the skin of a tiger, with a bunch of grapes at which a little satyr is trying to nibble. In that figure it may be seen that he sought to achieve a certain fusion in the members that is marvellous, and in particular that he gave it both the youthful slenderness of the male and the fullness and roundness of the female – a thing so admirable, that he proved himself excellent in statuary beyond any other modern that had worked up to that time. On which account, during his stay in Rome, he made so much proficience in the studies of art, that it was a thing incredible to see his exalted thoughts and the difficulties of the manner exercised by him with such supreme facility; to the amazement not only of those who were not accustomed to see

such things, but also of those familiar with good work, for the reason that all the works executed up to that time appeared as nothing in comparison with his. These things awakened in Cardinal di San Dionigi, called Cardinal de Rohan, a Frenchman, a desire to leave in a city so famous some worthy memorial of himself by the hand of so rare a craftsman; and he caused him to make a Pietà of marble in the round, which, when finished, was placed in the Chapel of the Vergine Maria della Febbre in S. Pietro, where the Temple of Mars used to be. To this work let no sculptor, however rare a craftsman, ever think to be able to approach in design or in grace, or ever to be able with all the pains in the world to attain to such delicacy and smoothness or to perforate the marble with such art as Michelagnolo did therein, for in it may be seen all the power and worth of art. Among the lovely things to be seen in the work, to say nothing of the divinely beautiful draperies, is the body of Christ; nor let anyone think to see greater beauty of members or more mastery of art in any body, or a nude with more detail in the muscles, veins, and nerves over the framework of the bones, nor yet a corpse more similar than this to a real corpse. Here is perfect sweetness in the expression of the head, harmony in the joints and attachments of the arms, legs, and trunk, and the pulses and veins so wrought, that in truth Wonder herself must marvel that the hand of a craftsman should have been able to execute so divinely and so perfectly, in so short a time, a work so admirable; and it is certainly a miracle that a stone without any shape at the beginning should ever have been reduced to such perfection as Nature is scarcely able to create in the flesh. Such were Michelagnolo's love and zeal together in this work, that he left his name – a thing that he never did again in any other work – written across a girdle that encircles the bosom of Our Lady. And the reason was that one day Michelagnolo, entering the place where it was set up, found there a great number of strangers from Lombardy, who were praising it highly, and one of them asked one of the others who had done it, and he answered, 'Our Gobbo from Milan.' Michelagnolo stood silent, but thought it something strange that his labours should be attributed to another; and one night he shut himself in there, and, having brought a little light and his chisels, carved his name upon it. And truly the work is such, that an exalted spirit has said, as to a real and living figure –

Bellezza ed Onestate
E Doglia e Pietà in vivo marmo morte,
Deh, come voi pur fate,
Non piangete si forte,
Che anzi tempo risveglisi da morte;
E pur mal grado suo
Nostro Signore, e tuo
Sposo, Figliuolo, e Padre,
Unica Sposa sua, Figliuola, e Madre.

From this work he acquired very great fame, and although certain persons, rather fools than otherwise, say that he has made Our Lady too young, are these so ignorant as not to know that unspotted virgins maintain and preserve their freshness of countenance a long time without any mark, and that persons afflicted as Christ was do the contrary? That circumstance, therefore, won an even greater increase of glory and fame for his genius than all his previous works.

Letters were written to him from Florence by some of his friends, saying that he should return, because it was not unlikely that he might obtain the spoiled block of marble lying in the Office of Works, which Piero Soderini, who at that time had been made Gonfalonier of the city for life, had very often talked of having executed by Leonardo da Vinci, and was then arranging to give to Maestro Andrea Contucci of Monte Sansovino, an excellent sculptor, who was seeking to obtain it. Now, however difficult it might be to carve a complete figure out of it without adding pieces (for which work of finishing it without adding pieces none of the others, save Buonarroti alone, had courage enough), Michelagnolo had felt a desire for it for many years back; and, having come to Florence, he sought to obtain it. This block of marble was nine braccia high, and from it, unluckily, one Maestro Simone da Fiesole had begun a giant, and he had managed to work so ill, that he had hacked a hole between the legs, and it was altogether misshapen and reduced to ruin, insomuch that the Wardens of Works of S. Maria del Fiore, who had the charge of the undertaking, had placed it on one side without troubling to have it finished; and so it had remained for many years past, and was likely to remain. Michelagnolo measured it all anew, considering whether he might be able to carve a reasonable figure from that block by accommodating himself as to the attitude to the marble as it had been left all misshapen by Maestro

Simone; and he resolved to ask for it from Soderini and the Wardens, by whom it was granted to him as a thing of no value, they thinking that whatever he might make of it would be better than the state in which it was at that time, seeing that neither in pieces nor in that condition could it be of any use to their building. Whereupon Michelagnolo made a model of wax, fashioning in it, as a device for the Palace, a young David with a sling in his hand, to the end that, even as he had defended his people and governed them with justice, so those governing that city might defend her valiantly and govern her justly. And he began it in the Office of Works of S. Maria del Fiore, in which he made an enclosure of planks and masonry, thus surrounding the marble; and, working at it continuously without anyone seeing it, he carried it to perfect completion. The marble had already been spoilt and distorted by Maestro Simone, and in some places it was not enough to satisfy the wishes of Michelagnolo for what he would have liked to do with it; and he therefore suffered certain of the first marks of Maestro Simone's chisel to remain on the extremity of the marble, some of which are still to be seen. And truly it was a miracle on the part of Michelagnolo to restore to life a thing that was dead.

This statue, when finished, was of such a kind that many disputes took place as to how to transport it to the Piazza della Signoria. Whereupon Giuliano da San Gallo and his brother Antonio made a very strong framework of wood and suspended the figure from it with ropes, to the end that it might not hit against the wood and break to pieces, but might rather keep rocking gently; and they drew it with windlasses over flat beams laid upon the ground, and then set it in place. On the rope which held the figure suspended he made a slip-knot which was very easy to undo but tightened as the weight increased, which is a most beautiful and ingenious thing; and I have in my book a drawing of it by his own hand – an admirable, secure, and strong contrivance for suspending weights.

It happened at this time that Piero Soderini, having seen it in place, was well pleased with it, but said to Michelagnolo, at a moment when he was retouching it in certain parts, that it seemed to him that the nose of the figure was too thick. Michelagnolo noticed that the Gonfalonier was beneath the Giant, and that his point of view prevented him from seeing it properly; but in order to satisfy him he climbed upon the staging, which was

against the shoulders, and quickly took up a chisel in his left hand, with a little of the marble-dust that lay upon the planks of the staging, and then, beginning to strike lightly with the chisel, let fall the dust little by little, nor changed the nose a whit from what it was before. Then, looking down at the Gonfalonier, who stood watching him, he said, 'Look at it now.' 'I like it better,' said the Gonfalonier, 'you have given it life.' And so Michelagnolo came down, laughing to himself at having satisfied that lord, for he had compassion on those who, in order to appear full of knowledge, talk about things of which they know nothing.

When it was built up, and all was finished, he uncovered it, and it cannot be denied that this work has carried off the palm from all other statues, modern or ancient, Greek or Latin; and it may be said that neither the Marforio at Rome, nor the Tiber and the Nile of the Belvedere, nor the Giants of Monte Cavallo, are equal to it in any respect, with such just proportion, beauty and excellence did Michelagnolo finish it. For in it may be seen most beautiful contours of legs, with attachments of limbs and slender outlines of flanks that are divine; nor has there ever been seen a pose so easy, or any grace to equal that in this work, or feet, hands and head so well in accord, one member with another, in harmony, design, and excellence of artistry. And, of a truth, whoever has seen this work need not trouble to see any other work executed in sculpture, either in our own or in other times, by no matter what craftsman. Michelagnolo received from Piero Soderini in payment for it four hundred crowns; and it was set in place in the year 1504. In consequence of the fame that he thereby won as a sculptor, he made for the above-named Gonfalonier a most beautiful David of bronze, which Soderini sent to France; and at this time, also, he began, but did not finish, two medallions of marble – one for Taddeo Taddei, which is now in his house, and another that he began for Bartolommeo Pitti, which was presented by Fra Miniato Pitti of Monte Oliveto, a man with a rare knowledge in cosmography and many other sciences, and particularly in painting, to Luigi Guicciardini, who was much his friend. These works were held to be admirable in their excellence; and at this same time, also, he blocked out a statue of S. Matthew in marble in the Office of Works of S. Maria del Fiore, which statue, rough as it is, reveals its full perfection and teaches sculptors in what manner figures can be carved out of marble without their coming out misshapen, so that it may be possible to go on

ever improving them by removing more of the marble with judgment, and also to draw back and change some part, according as the necessity may arise. He also made a medallion in bronze of a Madonna, which he cast in bronze at the request of certain Flemish merchants of the Moscheroni family, persons of high nobility in their own country, who paid him a hundred crowns for it, and intended to send it to Flanders.

There came to Agnolo Doni, a Florentine citizen and a friend of Michelagnolo, who much delighted to have beautiful things both by ancient and by modern craftsmen, a desire to possess some work by Michelagnolo; wherefore that master began for him a round picture containing a Madonna, who, kneeling on both knees, has an Infant in her arms and presents Him to Joseph, who receives Him. Here Michelagnolo expresses in the turn of the head of the Mother of Christ and in the gaze of her eyes, which she keeps fixed on the supreme beauty of her Son, her marvellous contentment and her lovingness in sharing it with that saintly old man, who receives Him with equal affection, tenderness, and reverence, as may be seen very readily in his countenance, without considering it long. Nor was this enough for Michelagnolo, who, the better to show how great was his art, made in the background of his work a number of nudes, some leaning, some standing, and some seated; and with such diligence and finish he executed this work, that without a doubt, of his pictures on panel, which indeed are but few, it is held to be the most finished and the most beautiful work that there is to be found. When it was completed, he sent it covered up to Agnolo's house by a messenger, with a note demanding seventy ducats in payment. It seemed strange to Agnolo, who was a careful person, to spend so much on a picture, although he knew that it was worth more, and he said to the messenger that forty was enough, which he gave to him. Thereupon Michelagnolo sent them back to him, with a message to say that he should send back either one hundred ducats or the picture. Then Agnolo, who liked the work, said, 'I will give him these seventy,' but he was not content; indeed, angered by Agnolo's breach of faith, he demanded the double of what he had asked the first time, so that, if Agnolo wanted the picture, he was forced to send him a hundred and forty.

It happened that while Leonardo da Vinci, that rare painter, was painting in the Great Council Hall, as has been related in his

Life, Piero Soderini, who was then Gonfalonier, moved by the great ability that he saw in Michelagnolo, caused a part of that Hall to be allotted to him; which was the reason that he executed the other façade in competition with Leonardo, taking as his subject the War of Pisa. To this end Michelagnolo was given a room in the Hospital of the Dyers at S. Onofrio, and there he began a vast cartoon, but would never consent that anyone should see it. And this he filled with naked men that were bathing in the River Arno on account of the heat, when suddenly the alarm sounded in the camp, announcing that the enemy were attacking; and, as the soldiers were springing out of the water to dress themselves, there could be seen, depicted by the divine hands of Michelagnolo, some hastening to arm themselves in order to give assistance to their companions, others buckling on their cuirasses, many fastening other armour on their bodies, and a vast number beginning the fray and fighting on horseback. There was, among other figures, an old man who had a garland of ivy on his head to shade it, and he, having sat down in order to put on his hose, into which his legs would not go because they were wet with water, and hearing the cries and tumult of the soldiers and the uproar of the drummers, was struggling to draw on one stocking by force; and, besides that all the muscles and nerves of his figure could be perceived, his mouth was so distorted as to show clearly how he was straining and struggling even to the very tips of his toes. There were also drummers, and figures with their clothes in their arms running to the combat; and there were to be seen the most extravagant attitudes, some standing, some kneeling or bent double, others stretched horizontally and struggling in mid-air, and all with masterly foreshortenings. There were also many figures in groups, all sketched in various manners, some outlined with charcoal, some drawn with strokes, others stumped in and heightened with lead-white, Michelagnolo desiring to show how much he knew in his profession. Wherefore the craftsmen were seized with admiration and astonishment, seeing the perfection of art revealed to them in that drawing by Michelagnolo; and some who saw them, after beholding figures so divine, declare that there has never been seen any work, either by his hand or by the hands of others, no matter how great their genius, that can equal it in divine beauty of art. And, in truth, it is likely enough, for the reason that since the time when it was finished and carried to the Sala del Papa

with great acclamation from the world of art and extraordinary glory for Michelagnolo, all those who studied from that cartoon and drew those figures – as was afterwards the custom in Florence for many years both for strangers and for natives – became persons eminent in art, as we have since seen. For among those who studied the cartoon were Aristotile da San Gallo, the friend of Michelagnolo, Ridolfo Ghirlandajo, Raffaello Sanzio of Urbino, Francesco Granacci, Baccio Bandinelli, and the Spaniard Alonzo Berughetta, and then there followed Andrea del Sarto, Franciabigio, Jacopo Sansovino, Rosso, Maturino, Lorenzetto, Tribolo, who was then a boy, Jacopo da Pontormo, and Perino del Vaga; and all these became excellent Florentine masters. The cartoon having thus become a school for craftsmen, it was taken into the Great Upper Hall in the house of the Medici; and this was the reason that it was left with too little caution in the hands of the craftsmen, insomuch that during the illness of Duke Giuliano, while no one was expecting such a thing, it was torn up and divided into many pieces, as has been related elsewhere, and scattered over various places, to which some pieces bear witness that are still to be seen in Mantua, in the house of M. Uberto Strozzi, a gentleman of that city, where they are treasured with great reverence; and, indeed, they seem to the eye things rather divine than human.

The name of Michelagnolo, by reason of the Pietà that he had made, the Giant in Florence, and the cartoon, had become so famous, that in the year 1503, Pope Alexander VI having died and Julius II having been elected, at which time Michelagnolo was about twenty-nine years of age, he was summoned with much graciousness by Julius II, who wished to set him to make his tomb; and for the expenses of the journey a hundred crowns were paid to him by the Pope's representatives. Having made his way to Rome, he spent many months there before he was made to set his hand to any work. But finally the Pope's choice fell on a design that he had made for that tomb, an excellent testimony to the genius of Michelagnolo, which in beauty and magnificence, abundance of ornamentation and richness of statuary, surpassed every ancient or imperial tomb. Whereupon Pope Julius took courage, and thus resolved to set his hand to make anew the Church of S. Pietro in Rome, in order to erect the tomb in it, as has been related in another place. And so Michelagnolo set to work with high hopes; and, in order to make a beginning, he

went to Carrara to excavate all the marble, with two assistants, receiving a thousand crowns on that account from Alamanno Salviati in Florence. There, in those mountains, he spent eight months without other moneys or supplies; and he had many fantastic ideas of carving great statues in those quarries, in order to leave memorials of himself, as the ancients had done before him, being invited by those masses of stone. Then, having picked out the due quantity of marbles, he caused them to be loaded on board ship at the coast and then conveyed to Rome, where they filled half the Piazza di S. Pietro, round about S. Caterina, and between the church and the corridor that goes to the Castello. In that place Michelagnolo had prepared his room for executing the figures and the rest of the tomb; and, to the end that the Pope might be able to come at his convenience to see him at work, he had caused a drawbridge to be constructed between the corridor and that room, which led to a great intimacy between them. But in time these favours brought much annoyance and even persecution upon him, and stirred up much envy against him among his fellow-craftsmen.

Of this work Michelagnolo executed during the lifetime and after the death of Julius four statues completely finished and eight only blocked out, as will be related in the proper place; and since the work was designed with extraordinary invention, we will describe here below the plan that he adopted. In order to produce an effect of supreme grandeur, he decided that it should be wholly isolated, so as to be seen from all four sides, each side in one direction being twelve braccia and each in the other eighteen, so that the proportions were a square and a half. It had a range of niches running right round the outer side, which were divided one from another by terminal figures clothed from the middle upwards, which with their heads supported the first cornice, and each terminal figure had bound to it, in a strange and bizarre attitude, a naked captive, whose feet rested on a projection of the base. These captives were all provinces subjugated by that Pontiff and rendered obedient to the Apostolic Church; and there were various other statues, likewise bound, of all the noble arts and sciences, which were thus shown to be subject to death no less than was that Pontiff, who made such honourable use of them. On the corners of the first cornice were to go four large figures, the Active and the Contemplative Life, S. Paul, and Moses. The structure rose above the cornice in steps gradually diminishing,

with a frieze of scenes in bronze, and with other figures, children
and ornaments all around, and at the summit, as a crown to the
work, were two figures, one of which was Heaven, who, smiling,
was supporting a bier on her shoulder, together with Cybele, the
Goddess of Earth, who appeared to be grieving that she was left
in a world robbed of all virtue by the death of such a man; and
Heaven appeared to be smiling with gladness that his soul had
passed to celestial glory. The work was so arranged that one
might enter and come out again by the ends of the quadrangular
structure, between the niches, and the interior curved in the form
of an oval after the manner of a temple, in the centre of which
was the sarcophagus wherein was to be laid the dead body of that
Pope. And, finally, there were to be in this whole work forty
statues of marble, without counting the other scenes, children,
and ornaments, the carvings covering the cornices, and the other
architectural members of the work. Michelagnolo ordained, to
expedite the labour, that a part of the marbles should be con-
veyed to Florence, where he intended at times to spend the sum-
mer months in order to avoid the malaria of Rome; and there he
executed one side of the work in many pieces, complete in every
detail. In Rome he finished entirely with his own hand two of the
captives, figures divinely beautiful, and other statues, than which
none better have ever been seen; but in the end they were never
placed in position, and those captives were presented by him to
S. Ruberto Strozzi, when Michelagnolo happened to be lying ill
in his house; which captives were afterwards sent as presents to
King Francis, and they are now at Ecouen in France. Eight
statues, likewise, he blocked out in Rome, and in Florence he
blocked out five and finished a Victory with a captive beneath,
which are now in the possession of Duke Cosimo, having been
presented by Michelagnolo's nephew, Leonardo, to his Excel-
lency, who has placed the Victory in the Great Hall of his Palace,
which was painted by Vasari.

He finished the Moses, a statue in marble of five braccia,
which no modern work will ever equal in beauty; and of the
ancient statues, also, the same may be said. For, seated in an
attitude of great dignity, he rests one arm on the Tables, which
he holds with one hand, and with the other he holds his beard,
which is long and waving, and carved in the marble in such sort,
that the hairs – in which the sculptor finds such difficulty – are
wrought with the greatest delicacy, soft, feathery, and detailed in

such a manner, that one cannot but believe that his chisel was changed into a pencil. To say nothing of the beauty of the face, which has all the air of a true Saint and most dread Prince, you seem, while you gaze upon it, to wish to demand from him the veil wherewith to cover that face, so resplendent and so dazzling it appears to you, and so well has Michelagnolo expressed the divinity that God infused in that most holy countenance. In addition, there are draperies carved out and finished with most beautiful curves of the borders; while the arms with their muscles, and the hands with their bones and nerves, are carried to such a pitch of beauty and perfection, and the legs, knees, and feet are covered with buskins so beautifully fashioned, and every part of the work is so finished, that Moses may be called now more than ever the friend of God, seeing that He has deigned to assemble together and prepare his body for the Resurrection before that of any other, by the hands of Michelagnolo. Well may the Hebrews continue to go there, as they do every Sabbath, both men and women, like flocks of starlings, to visit and adore that statue; for they will be adoring a thing not human but divine.

Finally all the agreements for this work were made, and the end came into view; and of the four sides one of the smaller ones was afterwards erected in S. Pietro in Vincola. It is said that while Michelagnolo was executing the work, there came to the Ripa all the rest of the marbles for the tomb that had remained at Carrara, which were conveyed to the Piazza di S. Pietro, where the others were; and, since it was necessary to pay those who had conveyed them, Michelagnolo went, as was his custom, to the Pope. But, his Holiness having on his hands that day some important business concerning Bologna, he returned to his house and paid for those marbles out of his own purse, thinking to have the order for them straightway from his Holiness. He returned another day to speak of them to the Pope, but found difficulty in entering, for one of the grooms told him that he had orders not to admit him, and that he must have patience. A Bishop then said to the groom, 'Perhaps you do not know this man?' 'Only too well do I know him,' answered the groom; 'but I am here to do as I am commanded by my superiors and by the Pope.' This action displeased Michelagnolo, and, considering that it was contrary to what he had experienced before, he said to the Pope's groom that he should tell his Holiness that from that time forward, when he should want him, it would be found that he had gone elsewhere;

and then, having returned to his house, at the second hour of the night he set out on post-horses, leaving two servants to sell all the furniture of his house to the Jews and to follow him to Florence, whither he was bound. Having arrived at Poggibonzi, a place in the Florentine territory, and therefore safe, he stopped; and almost immediately five couriers arrived with letters from the Pope to bring him back. Despite their entreaties and also the letters, which ordered him to return to Rome under threat of punishment, he would not listen to a word; but finally the prayers of the couriers induced him to write a few words in reply to his Holiness, asking for pardon, but saying that he would never again return to his presence, since he had caused him to be driven away like a criminal, that his faithful service had not deserved such treatment, and that his Holiness should look elsewhere for some-one to serve him.

After arriving at Florence, Michelagnolo devoted himself dur-ing the three months that he stayed there to finishing the cartoon for the Great Hall, which Piero Soderini, the Gonfalonier, desired that he should carry into execution. During that time there came to the Signoria three Briefs commanding them to send Michel-agnolo back to Rome: wherefore he, perceiving this vehemence on the part of the Pope, and not trusting him, conceived the idea, so it is said, of going to Constantinople to serve the Grand Turk, who desired to secure him, by means of certain Friars of S. Francis, to build a bridge crossing from Constantinople to Pera. However, he was persuaded by Piero Soderini, although very unwilling, to go to meet the Pope as a person of public importance with the title of Ambassador of the city, to reassure him; and finally the Gonfalonier recommended him to his brother Cardinal Soderini for presentation to the Pope, and sent him off to Bologna, where his Holiness had already arrived from Rome. His departure from Rome is also explained in another way – namely, that the Pope became angered against Michelagnolo, who would not allow any of his works to be seen; that Michel-agnolo suspected his own men, doubting (as happened more than once) that the Pope disguised himself and saw what he was doing on certain occasions when he himself was not at home or at work; and that on one occasion, when the Pope had bribed his assistants to admit him to see the chapel of his uncle Sixtus, which, as was related a little time back, he caused Buonarroti to paint, Michelagnolo, having waited in hiding because he

suspected the treachery of his assistants, threw planks down at the Pope when he entered the chapel, not considering who it might be, and drove him forth in a fury. It is enough for us to know that in the one way or the other he fell out with the Pope and then became afraid, so that he had to fly from his presence.

Now, having arrived in Bologna, he had scarcely drawn off his riding-boots when he was conducted by the Pope's servants to his Holiness, who was in the Palazzo de' Sedici; and he was accompanied by a Bishop sent by Cardinal Soderini, because the Cardinal, being ill, was not able to go himself. Having come into the presence of the Pope, Michelagnolo knelt down, but his Holiness looked askance at him, as if in anger, and said to him, 'Instead of coming yourself to meet us, you have waited for us to come to meet you!' meaning to infer that Bologna is nearer to Florence than Rome. Michelagnolo, with a courtly gesture of the hands, but in a firm voice, humbly begged for pardon, saying in excuse that he had acted as he had done in anger, not being able to endure to be driven away so abruptly, but that, if he had erred, his Holiness should once more forgive him. The Bishop who had presented Michelagnolo to his Holiness, making excuse for him, said to the Pope that such men were ignorant creatures, that they were worth nothing save in their own art, and that he should freely pardon him. The Pope, seized with anger, belaboured the Bishop with a staff that he had in his hand, saying to him, 'It is you that are ignorant, who level insults at him that we ourselves do not think of uttering;' and then the Bishop was driven out by the groom with fisticuffs. When he had gone, the Pope, having discharged his anger upon him, gave Michelagnolo his benediction; and the master was detained in Bologna with gifts and promises, until finally his Holiness commanded him that he should make a statue of bronze in the likeness of Pope Julius, five braccia in height. In this work he showed most beautiful art in the attitude, which had an effect of much majesty and grandeur, and displayed richness and magnificence in the draperies, and in the countenance, spirit, force, resolution, and stern dignity; and it was placed in a niche over the door of S. Petronio. It is said that while Michelagnolo was working at it, he received a visit from Francia, a most excellent goldsmith and painter, who wished to see it, having heard so much praise and fame of him and of his works, and not having seen any of them, so that agents had been set to work to enable him to see it, and he had obtained

permission. Whereupon, seeing the artistry of Michelagnolo, he was amazed: and then, being asked by Michelagnolo what he thought of that figure, Francia answered that it was a most beautiful casting and a fine material. Wherefore Michelagnolo, considering that he had praised the bronze rather than the workmanship, said to him, 'I owe the same obligation to Pope Julius, who has given it to me, that you owe to the apothecaries who give you your colours for painting;' and in his anger, in the presence of all the gentlemen there, he declared that Francia was a fool. In the same connection, when a son of Francia's came before him and was announced as a very beautiful youth, Michelagnolo said to him, 'Your father's living figures are finer than those that he paints.' Among the same gentlemen was one, whose name I know not, who asked Michelagnolo which he thought was the larger, the statue of the Pope or a pair of oxen; and he answered, 'That depends on the oxen. If they are these Bolognese oxen, then without a doubt our Florentine oxen are not so big.'

Michelagnolo had the statue finished in clay before the Pope departed from Bologna for Rome, and his Holiness, having gone to see it, but not knowing what was to be placed in the left hand, and seeing the right hand raised in a proud gesture, asked whether it was pronouncing a benediction or a curse. Michelagnolo answered that it was admonishing the people of Bologna to mind their behaviour, and asked his Holiness to decide whether he should place a book in the left hand; and he said, 'Put a sword there, for I know nothing of letters.' The Pope left a thousand crowns in the bank of M. Anton Maria da Lignano for the completion of the statue, and at the end of the sixteen months that Michelagnolo toiled over the work it was placed on the frontispiece in the façade of the Church of S. Petronio, as has been related; and we have also spoken of its size. This statue was destroyed by the Bentivogli, and the bronze was sold to Duke Alfonso of Ferrara, who made with it a piece of artillery called La Giulia; saving only the head, which is to be found in his guardaroba.

When the Pope had returned to Rome and Michelagnolo was at work on the statue, Bramante, the friend and relative of Raffaello da Urbino, and for that reason little the friend of Michelagnolo, perceiving that the Pope held in great favour and estimation the works that he executed in sculpture, was constantly planning with Raffaello in Michelagnolo's absence to remove

from the mind of his Holiness the idea of causing Michelagnolo, after his return, to devote himself to finishing his tomb; saying that for a man to prepare himself a tomb during his own lifetime was an evil augury and a hurrying on of his death. And they persuaded his Holiness that on the return of Michelagnolo, he should cause him to paint in memory of his uncle Sixtus the vaulting of the chapel that he had built in the Palace. In this manner it seemed possible to Bramante and other rivals of Michelagnolo to draw him away from sculpture, in which they saw him to be perfect, and to plunge him into despair, they thinking that if they compelled him to paint, he would do work less worthy of praise, since he had no experience of colours in fresco, and that he would prove inferior to Raffaello, and, even if he did succeed in the work, in any case it would make him angry against the Pope; so that in either event they would achieve their object of getting rid of him. And so, when Michelagnolo returned to Rome, the Pope was not disposed at that time to finish his tomb, and requested him to paint the vaulting of the chapel. Michelagnolo, who desired to finish the tomb, believing the vaulting of that chapel to be a great and difficult labour, and considering his own want of practice in colours, sought by every means to shake such a burden from his shoulders, and proposed Raffaello for the work. But the more he refused, the greater grew the desire of the Pope, who was headstrong in his undertakings, and, in addition, was being spurred on anew by the rivals of Michelagnolo, and especially by Bramante; so that his Holiness, who was quick-tempered, was on the point of becoming enraged with Michelagnolo. Whereupon Michelagnolo, perceiving that his Holiness was determined in the matter, resolved to do it; and the Pope commanded Bramante to erect the scaffolding from which the vaulting might be painted. Bramante made it all supported by ropes, piercing the vaulting; which having perceived, Michelagnolo inquired of Bramante how he was to proceed to fill up the holes when he had finished painting it, and he replied that he would think of that afterwards, and that it could not be done otherwise. Michelagnolo recognized that Bramante was either not very competent for such a work or else little his friend, and he went to the Pope and said to him that the scaffolding was not satisfactory, and that Bramante had not known how to make it; and the Pope answered, in the presence of Bramante, that he should make it after his own fashion. And so he commanded that it should be erected upon

props so as not to touch the walls, a method of making scaffold-
ings for vaults that he taught afterwards to Bramante and others,
whereby many fine works have been executed. Thus he enabled
a poor creature of a carpenter, who rebuilt the scaffolding, to
dispense with so many of the ropes, that, after selling them (for
Michelagnolo gave them to him), he made up a dowry for his
daughter.

He then set his hand to making the cartoons for that vaulting;
and the Pope decided, also, that the walls which the masters
before him in the time of Sixtus had painted should be scraped
clean, and decreed that he should have fifteen thousand ducats
for the whole cost of the work; which price was fixed through
Giuliano da San Gallo. Thereupon, forced by the magnitude of
the undertaking to resign himself to obtaining assistance, Michel-
agnolo sent for men to Florence; and he determined to demon-
strate in such a work that those who had painted there before
him were destined to be vanquished by his labours, and also
resolved to show to the modern craftsmen how to draw and
paint. Having begun the cartoons, he finished them; and the
circumstances of the work spurred him to soar to great heights,
both for his own fame and for the welfare of art. And then,
desiring to paint it in fresco-colours, and not having any experi-
ence of them, there came from Florence to Rome certain of his
friends who were painters, to the end that they might give him
assistance in such a work, and also that he might learn from them
the method of working in fresco, in which some of them were
well-practised; and among these were Granaccio, Giuliano Bu-
giardini, Jacopo di Sandro, the elder Indaco, Agnolo di Donnino,
and Aristotile. Having made a commencement with the work, he
caused them to begin some things as specimens; but, perceiving
that their efforts were very far from what he desired, and not
being satisfied with them, he resolved one morning to throw to
the ground everything that they had done. Then, shutting himself
up in the chapel, he would never open to them, nor even allowed
himself to be seen by them when he was at home. And so, when
the jest appeared to them to be going too far, they resigned
themselves to it and returned in shame to Florence. Thereupon
Michelagnolo, having made arrangements to paint the whole
work by himself, carried it well on the way to completion with
the utmost solicitude, labour, and study; nor would he ever let
himself be seen, lest he should given any occasion to compel him

to show it, so that the desire in the minds of everyone to see it grew greater every day.

Pope Julius was always very desirous to see any undertakings that he was having carried out, and therefore became more eager than ever to see this one, which was hidden from him. And so one day he resolved to go to see it, but was not admitted, for Michelagnolo would never have consented to show it to him; out of which affair arose the quarrel that has been described, when he had to depart from Rome because he would not show his work to the Pope. Now, when a third of the work was finished (as I ascertained from him in order to clear up all doubts), it began to throw out certain spots of mould, one winter that the north wind was blowing. The reason of this was that the Roman lime, which is made of travertine and white in colour, does not dry very readily, and, when mixed with pozzolana, which is of a tawny colour, makes a dark mixture which, when soft, is very watery; and when the wall has been well soaked, it often breaks out into an efflorescence in the drying; and thus this salt efflorescence of moisture came out in many places, but in time the air consumed it. Michelagnolo was in despair over this, and was unwilling to continue the work, asking the Pope to excuse him, since he was not succeeding; but his Holiness sent Giuliano da San Gallo to see him, and he, having told him whence the defect arose and taught him how to remove the spots of mould, encouraged him to persevere.

Now, when he had finished half of it, the Pope, who had subsequently gone to see it several times (mounting certain ladders with the assistance of Michelagnolo), insisted that it should be thrown open, for he was hasty and impatient by nature, and could not wait for it to be completely finished and to receive, as the saying is, the final touch. No sooner was it thrown open than all Rome was drawn to see it, and the Pope was the first, not having the patience to wait until the dust caused by the dismantling of the scaffolding had settled. Thereupon Raffaello da Urbino, who was very excellent in imitation, after seeing it straightway changed his manner, and without losing any time, in order to display his ability, painted the Prophets and Sibyls in the work of the Pace; and at the same time Bramante sought to have the other half of the chapel entrusted by the Pope to Raffaello. Which hearing, Michelagnolo complained of Bramante, and revealed to the Pope without any reserve many faults both in his

life and in his architectural works; of which last, in the building
of S. Pietro, as was seen afterwards, Michelagnolo became the
corrector. But the Pope, recognizing more clearly every day the
ability of Michelagnolo, desired that he should continue the work,
judging, after he had seen it uncovered, that he could make the
second half considerably better; and so in twenty months he
carried that work to perfect completion by himself alone, without
the assistance even of anyone to grind his colours. Michelagnolo
complained at times that on account of the haste that the Pope
imposed on him he was not able to finish it in his own fashion,
as he would have liked; for his Holiness was always asking him
importunately when he would finish it. On one occasion, among
others, he replied, 'It will be finished when I shall have satisfied
myself in the matter of art.' 'But it is our pleasure,' answered the
Pope, 'that you should satisfy us in our desire to have it done
quickly;' and he added, finally, that if Michelagnolo did not finish
the work quickly he would have him thrown down from the
scaffolding. Whereupon Michelagnolo, who feared and had good
reason to fear the anger of the Pope, straightway finished all that
was wanting, without losing any time, and, after taking down the
rest of the scaffolding, threw it open to view on the morning of
All Saints' Day, when the Pope went into the chapel to sing Mass,
to the great satisfaction of the whole city. Michelagnolo desired
to retouch some parts 'a secco,' as the old masters had done on
the scenes below, painting backgrounds, draperies, and skies in
ultramarine, and ornaments in gold in certain places, to the end
that this might produce greater richness and a more striking
effect; and the Pope, having learned that this ornamentation was
wanting, and hearing the work praised so much by all who had
seen it, wished him to finish it; but, since it would have been too
long a labour for Michelagnolo to rebuild the scaffolding, it was
left as it was. His Holiness, often seeing Michelagnolo, would say
to him that the chapel should be enriched with colours and gold,
since it looked poor. And Michelagnolo would answer familiarly,
'Holy Father, in those times men did not bedeck themselves with
gold, and those that are painted there were never very rich, but
rather holy men, on which account they despised riches.'

For this work Michelagnolo was paid by the Pope three thou-
sand crowns on several occasions, of which he had to spend
twenty-five on colours. The work was executed with very great
discomfort to himself, from his having to labour with his face

upwards, which so impaired his sight that for a time, which was not less than several months, he was not able to read letters or look at drawings save with his head backwards. And to this I can bear witness, having painted five vaulted chambers in the great apartments in the Palace of Duke Cosimo, when, if I had not made a chair on which I could rest my head and lie down at my work, I would never have finished it; even so, it has so ruined my sight and injured my head, that I still feel the effects, and I am astonished that Michelagnolo endured all that discomfort so well. But in truth, becoming more and more kindled every day by his fervour in the work, and encouraged by the proficience and improvement that he made, he felt no fatigue and cared nothing for discomfort.

The distribution of this work is contrived with six pendentives on either side, with one in the centre of the walls at the foot and at the head, and on these he painted Sibyls and Prophets, six braccia in height; in the centre of the vault the history of the world from the Creation down to the Deluge and the Drunkenness of Noah, and in the lunettes all the Genealogy of Christ. In these compartments he used no rule of perspectives in foreshortening, nor is there any fixed point of view, but he accommodated the compartments to the figures rather than the figures to the compartments, being satisfied to execute those figures, both the nude and the draped, with the perfection of design, so that another such work has never been and never can be done, and it is scarcely possible even to imitate his achievement. This work, in truth, has been and still is the lamp of our art, and has bestowed such benefits and shed so much light on the art of painting, that it has served to illuminate a world that had lain in darkness for so many hundreds of years. And it is certain that no man who is a painter need think any more to see new inventions, attitudes, and draperies for the clothing of figures, novel manners of expression, and things painted with greater variety and force, because he gave to this work all the perfection that can be given to any work executed in such a field of art. And at the present day everyone is amazed who is able to perceive in it the excellence of the figures, the perfection of the foreshortenings, and the extraordinary roundness of the contours, which have in them slenderness and grace, being drawn with the beauty of proportion that is seen in beautiful nudes; and these, in order to display the supreme perfection of art, he made of all ages, different in

expression and in form, in countenance and in outline, some more slender and some fuller in the members; as may also be seen in the beautiful attitudes, which are all different, some seated, some moving, and others upholding certain festoons of oak-leaves and acorns, placed there as the arms and device of Pope Julius, and signifying that at that time and under his government was the age of gold; for Italy was not then in the travail and misery that she has since suffered. Between them, also, they hold some medallions containing stories in relief in imitation of bronze and gold, taken from the Book of Kings.

Besides this, in order to display the perfection of art and also the greatness of God, he painted in a scene God dividing Light from Darkness, wherein may be seen His Majesty as He rests self-sustained with the arms outstretched, and reveals both love and power. In the second scene he depicted with most beautiful judgment and genius God creating the Sun and Moon, in which He is supported by many little Angels, in an attitude sublime and terrible by reason of the foreshortenings in the arms and legs. In the same scene Michelagnolo depicted Him after the Blessing of the Earth and the Creation of the Animals, when He is seen on that vaulting as a figure flying in foreshortening; and wherever you go throughout the chapel, it turns constantly and faces in every direction. So, also, in the next scene, where He is dividing the Water from the Earth; and both these are very beautiful figures and refinements of genius such as could be produced only by the divine hands of Michelagnolo. He then went on, beyond that scene, to the Creation of Adam, wherein he figured God as borne by a group of nude Angels of tender age, which appear to be supporting not one figure only, but the whole weight of the world; this effect being produced by the venerable majesty of His form and by the manner of the movement with which He embraces some of the little Angels with one arm, as if to support Himself, and with the other extends the right hand towards Adam, a figure of such a kind in its beauty, in the attitude, and in the outlines, that it appears as if newly fashioned by the first and supreme Creator rather than by the brush and design of a mortal man. Beyond this, in another scene, he made God taking our mother Eve from Adam's side, in which may be seen those two nude figures, one as it were dead from his being the thrall of sleep, and the other become alive and filled with animation by the blessing of God. Very clearly do we see from the brush of

this most gifted craftsman the difference that there is between sleep and wakefulness, and how firm and stable, speaking humanly, the Divine Majesty may appear.

Next to this there follows the scene when Adam, at the persuasion of a figure half woman and half serpent, brings death upon himself and upon us by the Forbidden Fruit; and there, also, are seen Adam and Eve driven from Paradise. In the figure of the Angel is shown with nobility and grandeur the execution of the mandate of a wrathful Lord, and in the attitude of Adam the sorrow for his sin together with the fear of death, as likewise in the woman may be seen shame, abasement, and the desire to implore pardon, as she presses the arms to the breast, clasps the hands palm to palm, and sinks the neck into the bosom, and also turns the head towards the Angel, having more fear of the justice of God than hope in His mercy. Nor is there less beauty in the story of the sacrifice of Cain and Abel, wherein are some who are bringing up the wood, some who are bent down and blowing at the fire, and others who are cutting the throat of the victim; which certainly is all executed with not less consideration and attention than the others. He showed the same art and the same judgment in the story of the Deluge, wherein are seen various deaths of men, who, terrified by the horror of those days, are striving their utmost in different ways to save their lives. For in the faces of those figures may be seen life a prey to death, not less than fear, terror, and disregard of everything; and compassion is visible in many that are assisting one another to climb to the summit of a rock in search of safety, among them one who, having embraced one half dead, is striving his utmost to save him, than which Nature herself could show nothing better. Nor can I tell how well expressed is the story of Noah, who, drunk with wine, is sleeping naked, and has before him one son who is laughing at him and two who are covering him up – a scene incomparable in the beauty of the artistry, and not to be surpassed save by himself alone.

Then, as if his genius had taken courage from what it had achieved up to that time, it soared upwards and proved itself even greater in the five Sibyls and seven Prophets that are painted there, each five braccia or more in height. In all these are well-varied attitudes, beautiful draperies, and different vestments; and all, in a word, are wrought with marvellous invention and judgment, and to him who can distinguish their expressions they

appear divine. Jeremiah is seen with the legs crossed, holding one hand to the beard, and resting that elbow on the knee; the other hand rests in his lap, and he has the head bowed in a manner that clearly demonstrates the melancholy, cogitation, anxious thought and bitterness of soul that his people cause him. Equally fine, also, are two little children that are behind him, and likewise the first Sibyl, beyond him in the direction of the door, in which figure, wishing to depict old age, in addition to enveloping her in draperies, he sought to show that her blood is already frozen by time; besides which, since her sight has become feeble, he has made her as she reads bring the book very close to her eyes. Beyond this figure follows the Prophet Ezekiel, an old man, who has a grace and a movement that are most beautiful, and is much enveloped in draperies, while with one hand he holds a roll of prophecies, and with the other uplifted, turning his head, he appears to be about to utter great and lofty words; and behind him he has two boys who hold his books. Next to him follows a Sibyl, who is doing the contrary to the Erythræan Sibyl that we described above, for, holding her book away from her, she seeks to turn a page, while with one knee over the other she sits sunk within herself, pondering gravely over what she is to write; and then a boy who is behind her, blowing on a burning brand, lights her lamp. This figure is of extraordinary beauty in the expression of the face, in the head-dress, and in the arrangement of the draperies; besides which she has the arms nude, which are equal to the other parts. Beyond this Sibyl he painted the Prophet Joel, who, sunk within himself, has taken a scroll and reads it with great attention and appreciation: and from his aspect it is so clearly evident that he is satisfied with that which he finds written there, that he looks like a living person who has applied his thoughts intently to some matter. Over the door of the chapel, likewise, he placed the aged Zaccharias, who, seeking through his written book for something that he cannot find, stands with one leg on high and the other low; and, while the ardour of the search after something that he cannot find causes him to stand thus, he takes no notice of the discomfort that he suffers in such a posture. This figure is very beautiful in its aspect of old age, and somewhat full in form, and has draperies with few folds, which are most beautiful. In addition, there is another Sibyl, who is next in the direction of the altar on the other side, displaying certain writings, and, with her boys in attendance, is no less worthy of

praise than are the others. Beyond her is the Prophet Isaiah, who, wholly absorbed in his own thoughts, has the legs crossed over one another, and, holding one hand in his book to mark the place where he was reading, has placed the elbow of the other arm upon the book, with the cheek pressed against the hand; and, being called by one of the boys that he has behind him, he turns only the head, without disturbing himself otherwise. Whoever shall consider his countenance, shall see touches truly taken from Nature herself, the true mother of art, and a figure which, when well studied in every part, can teach in liberal measure all the precepts of the good painter. Beyond this Prophet is an aged Sibyl of great beauty, who, as she sits, studies from a book in an attitude of extraordinary grace, not to speak of the beautiful attitudes of the two boys that are about her. Nor may any man think with all his imaginings to be able to attain to the excellence of the figure of a youth representing Daniel, who, writing in a great book, is taking certain things from other writings and copying them with extraordinary attention; and as a support for the weight of the book Michelagnolo painted a boy between his legs, who is upholding it while he writes, all which no brush held by a human hand, however skilful, will ever be able to equal. And so, also, with the beautiful figure of the Libyan Sibyl, who, having written a great volume drawn from many books, is in an attitude of womanly grace, as if about to rise to her feet; and in one and the same movement she makes as if to rise and to close the book – a thing most difficult, not to say impossible, for any other but the master of the work.

And what can be said of the four scenes at the corners, on the spandrels of that vaulting; in one of which David, with all the boyish strength that he can exert in the conquest of a giant, is cutting off his head, bringing marvel to the faces of some soldiers who are about the camp. And so, also, do men marvel at the beautiful attitudes that Michelagnolo depicted in the story of Judith, at the opposite corner, in which may be seen the trunk of Holofernes, robbed of life but still quivering, while Judith is plac-ing the lifeless head in a basket on the head of her old serving-woman, who, being tall in stature, is stooping to the end that Judith may be able to reach up to her and adjust the weight well; and the servant, while upholding the burden with her hands, seeks to conceal it, and, turning her head towards the trunk, which, although dead, draws up an arm and a leg and makes a

noise in the tent, she shows in her expression fear of the camp and terror of the dead body – a picture truly full of thought. But more beautiful and more divine than this or any of the others is the story of the Serpents of Moses, which is above the left-hand corner of the altar; for the reason that in it is seen the havoc wrought by death, the rain of serpents, their stings and their bites, and there may also be perceived the serpent of brass that Moses placed upon a pole. In this scene are shown vividly the various deaths that those die who are robbed of all hope by the bite of the serpents, and one sees the deadly venom causing vast numbers to die in terror and convulsions, to say nothing of the rigid legs and twisted arms of those who remain in the attitudes in which they were struck down, unable to move, and the marvellous heads that are shrieking and thrown backwards in despair. Not less beautiful than all these are those who, having looked upon the serpent, and feeling their pains alleviated by the sight of it, are gazing on it with profound emotion; and among them is a woman who is supported by another figure in such a manner that the assistance rendered to her by him who upholds her is no less manifest than her pressing need in such sudden alarm and hurt. In the next scene, likewise, in which Ahasuerus, reclining in a bed, is reading his chronicles, are figures of great beauty, and among them three figures eating at a table, which represent the council that was held for the deliverance of the Jewish people and the hanging of Haman. The figure of Haman was executed by Michelagnolo in an extraordinary manner of foreshortening, for he counterfeited the trunk that supports his person, and that arm which comes forward, not as painted things but as real and natural, standing out in relief, and so also that leg which he stretches outwards and other parts that bend inwards: which figure, among all that are beautiful and difficult, is certainly the most beautiful and the most difficult.

It would take too long to describe all the beautiful fantasies in the different actions in the part where there is all the Genealogy of the Fathers, beginning with the sons of Noah, to demonstrate the Genealogy of Jesus Christ, in which figures is a variety of things that it is not possible to enumerate, such as draperies, expressions of heads, and an infinite number of novel and extraordinary fancies, all most beautifully considered. Nothing there but is carried into execution with genius: all the figures there are masterly and most beautifully foreshortened, and everything that

you look at is divine and beyond praise. And who will not be struck dumb with admiration at the sight of the sublime force of Jonas, the last figure in the chapel, wherein by the power of art the vaulting, which in fact springs forward in accord with the curve of the masonry, yet, being in appearance pushed back by that figure, which bends inwards, seems as if straight, and, vanquished by the art of design with its lights and shades, even appears in truth to recede inwards? Oh, truly happy age of ours, and truly blessed craftsmen! Well may you be called so, seeing that in our time you have been able to illumine anew in such a fount of light the darkened sight of your eyes, and to see all that was difficult made smooth by a master so marvellous and so unrivalled! Certainly the glory of his labours makes you known and honoured, in that he has stripped from you that veil which you had over the eyes of your minds, which were so full of darkness, and has delivered the truth from the falsehood that overshadowed your intellects. Thank Heaven, therefore, for this, and strive to imitate Michelagnolo in everything.

When the work was thrown open, the whole world could be heard running up to see it, and, indeed, it was such as to make everyone astonished and dumb. Wherefore the Pope, having been magnified by such a result and encouraged in his heart to undertake even greater enterprises, rewarded Michelagnolo liberally with money and rich gifts: and Michelagnolo would say at times of the extraordinary favours that the Pope conferred upon him, that they showed that he fully recognized his worth, and that, if by way of proving his friendliness he sometimes played him strange tricks, he would heal the wound with signal gifts and favours. As when, Michelagnolo once demanding from him leave to go to Florence for the festival of S. John, and asking money for that purpose, the Pope said, 'Well, but when will you have this chapel finished?' 'As soon as I can, Holy Father.' The Pope, who had a staff in his hand, struck Michelagnolo, saying, 'As soon as I can! As soon as I can! I will soon make you finish it!' Whereupon Michelagnolo went back to his house to get ready to go to Florence; but the Pope straightway sent Cursio, his Chamberlain, to Michelagnolo with five hundred crowns to pacify him, fearing lest he might commit one of his caprices, and Cursio made excuse for the Pope, saying that such things were favours and marks of affection. And Michelagnolo, who knew the Pope's nature and, after all, loved him, laughed over it all, for he saw

that in the end everything turned to his profit and advantage, and that the Pontiff would do anything to keep a man such as himself as his friend.

When the chapel was finished, before the Pope was overtaken by death, his Holiness commanded Cardinal Santiquattro and Cardinal Aginense, his nephew, in the event of his death, that they should cause his tomb to be finished, but on a smaller scale than before. To this work Michelagnolo set himself once again, and so made a beginning gladly with the tomb, hoping to carry it once and for all to completion without so many impediments; but he had from it ever afterwards vexations, annoyances, and travails, more than from any other work that he did in all his life, and it brought upon him for a long time, in a certain sense, the accusation of being ungrateful to that Pope, who had so loved and favoured him. Thus, when he had returned to the tomb, and was working at it continually, and also at times preparing designs from which he might be able to execute the façades of the chapel, envious Fortune decreed that that memorial, which had been begun with such perfection, should be left unfinished. For at that time there took place the death of Pope Julius, and the work was abandoned on account of the election of Pope Leo X, who, being no less splendid than Julius in mind and spirit, had a desire to leave in his native city (of which he was the first Pope), in memory of himself and of a divine craftsman who was his fellow-citizen, such marvels as only a mighty Prince like himself could undertake. Wherefore he gave orders that the façade of S. Lorenzo, a church built by the Medici family in Florence, should be erected for him, which was the reason that the work of the tomb of Julius was left unfinished; and he demanded advice and designs from Michelagnolo, and desired that he should be the head of that work. Michelagnolo made all the resistance that he could, pleading that he was pledged in the matter of the tomb to Santiquattro and Aginense, but the Pope answered him that he was not to think of that, and that he himself had already seen to it and contrived that Michelagnolo should be released by them; promising, also, that he should be able to work in Florence, as he had already begun to do, at the figures for that tomb. All this was displeasing to the Cardinals, and also to Michelagnolo, who went off in tears.

Many and various were the discussions that arose on this subject, on the ground that such a work as that façade should have

been distributed among several persons, and in the matter of the architecture many craftsmen flocked to Rome to see the Pope, and made designs; Baccio d'Agnolo, Antonio da San Gallo, Andrea Sansovino and Jacopo Sansovino, and the gracious Raffaello da Urbino, who was afterwards summoned to Florence for that purpose at the time of the Pope's visit. Thereupon Michelagnolo resolved to make a model and not to accept anyone beyond himself as his guide or superior in the architecture of such a work; but this refusal of assistance was the reason that neither he nor any other executed the work, and that those masters returned in despair to their customary pursuits. Michelagnolo, going to Carrara, had an order authorizing that a thousand crowns should be paid to him by Jacopo Salviati; but on his arrival Jacopo was shut up in his room on business with some citizens, and Michelagnolo, refusing to wait for an audience, departed without saying a word and went straightway to Carrara. Jacopo heard of Michelagnolo's arrival, and, not finding him in Florence, sent him a thousand crowns to Carrara. The messenger demanded that Michelagnolo should write him a receipt, to which he answered that the money was for the expenses of the Pope and not for his own interest, and that the messenger might take it back, but that he was not accustomed to write out quittances or receipts for others; whereupon the other returned in alarm to Jacopo without a receipt.

While Michelagnolo was at Carrara and was having marble quarried for the tomb of Julius, thinking at length to finish it, no less than for the façade, a letter was written to him saying that Pope Leo had heard that in the mountains of Pietrasanta near Seravezza, in the Florentine dominion, at the summit of the highest mountain, which is called Monte Altissimo, there were marbles of the same excellence and beauty as those of Carrara. This Michelagnolo already knew, but it seems that he would not take advantage of it because of his friendship with the Marchese Alberigo, Lord of Carrara, and, in order to do him a good service, chose to quarry those of Carrara rather than those of Seravezza; or it may have been that he judged it to be a long undertaking and likely to waste much time, as indeed it did. However, he was forced to go to Seravezza, although he pleaded in protest that it would be more difficult and costly, as in truth it was, especially at the beginning, and, moreover, that the report about the marble was perhaps not true; but for all that the Pope would not hear a

word of objection. Thereupon it was decided to make a road for several miles through the mountains, breaking down rocks with hammers and pickaxes to obtain a level, and sinking piles in the marshy places; and there Michelagnolo spent many years in executing the wishes of the Pope. Finally five columns of the proper size were excavated, one of which is on the Piazza di S. Lorenzo in Florence, and the others are on the sea-shore. And for this reason the Marchese Alberigo, who saw his business ruined, became the bitter enemy of Michelagnolo, who was not to blame. Michelagnolo, in addition to these columns, excavated many other marbles there, which are still in the quarries, abandoned there for more than thirty years. But at the present day Duke Cosimo has given orders for the road to be finished, of which there are still two miles to make over very difficult ground, for the transportation of these marbles, and also a road from another quarry of excellent marble that was discovered at that time by Michelagnolo, in order to be able to finish many beautiful undertakings. In the same district of Seravezza he discovered a mountain of variegated marble that is very hard and very beautiful, below Stazema, a village in those mountains; where the same Duke Cosimo has caused a paved road of more than four miles to be made, for conveying the marble to the sea.

But to return to Michelagnolo: having gone back to Florence, he lost much time now in one thing and now in another. And he made at that time for the Palace of the Medici a model for the knee-shaped windows of those rooms that are at the corner, where Giovanni da Udine adorned the chamber in stucco and painting, which is a much extolled work; and he caused to be made for them by the goldsmith Piloto, but under his own direction, those jalousies of perforated copper, which are certainly admirable things. Michelagnolo consumed many years in quarrying marbles, although it is true that while they were being excavated he made models of wax and other things for the work. But this undertaking was delayed so long, that the money assigned by the Pope for the purpose was spent on the war in Lombardy; and at the death of Leo the work was left unfinished, nothing being accomplished save the laying of a foundation in front to support it, and the transportation of a large column of marble from Carrara to the Piazza di S. Lorenzo.

The death of Leo completely dismayed the craftsmen and the arts both in Rome and in Florence; and while Adrian VI was alive

Michelagnolo gave his attention in Florence to the tomb of Julius. But after the death of Adrian Clement VII was elected, who was no less desirous than Leo and his other predecessors to leave his fame established by the arts of architecture, sculpture, and painting. At this time, which was the year 1525, Giorgio Vasari was taken as a little boy to Florence by the Cardinal of Cortona, and placed with Michelagnolo to learn art. But Michelagnolo was then summoned to Rome by Pope Clement VII, who had made a beginning with the library of S. Lorenzo and also the new sacristy, in which he proposed to place the marble tombs that he was having made for his forefathers; and he resolved that Vasari should go to work with Andrea del Sarto until he should himself be free again, and went in person to Andrea's workshop to present him.

Michelagnolo departed for Rome in haste, harassed once again by Francesco Maria, Duke of Urbino, the nephew of Pope Julius, who complained of him, saying that he had received sixteen thousand crowns for the above-named tomb, yet was living a life of pleasure in Florence; and he threatened in his anger that, if Michelagnolo did not give his attention to the work, he would make him rue it. Having arrived in Rome, Pope Clement, who wished to make use of him, advised him to draw up his accounts with the agents of the Duke, believing that after all that he had done he must be their creditor rather than their debtor; and so the matter rested. After discussing many things together, they resolved to finish completely the library and new sacristy of S. Lorenzo in Florence. Michelagnolo therefore departed from Rome, and raised the cupola that is now to be seen, causing it to be wrought in various orders of composition; and he had a ball with seventy-two faces made by the goldsmith Piloto, which is very beautiful. It happened, while Michelagnolo was raising the cupola, that he was asked by some friends, 'Should you not make your lantern very different from that of Filippo Brunelleschi?' And he answered them, 'Different it can be made with ease, but better, no.' He made four tombs in that sacristy, to adorn the walls and to contain the bodies of the fathers of the two Popes, the elder Lorenzo and his brother Giuliano, and those of Giuliano, the brother of Leo, and of Duke Lorenzo, his nephew. And since he wished to execute the work in imitation of the old sacristy that Filippo Brunelleschi had built, but with another manner of ornamentation, he made in it an ornamentation in a composite

order, in a more varied and more original manner than any other master at any time, whether ancient or modern, had been able to achieve, for in the novelty of the beautiful cornices, capitals, bases, doors, tabernacles, and tombs, he departed not a little from the work regulated by measure, order, and rule, which other men did according to a common use and after Vitruvius and the antiquities, to which he would not conform. That licence has done much to give courage to those who have seen his methods to set themselves to imitate him, and new fantasies have since been seen which have more of the grotesque than of reason or rule in their ornamentation. Wherefore the craftsmen owe him an infinite and everlasting obligation, he having broken the bonds and chains by reason of which they had always followed a beaten path in the execution of their works. And even more did he demonstrate and seek to make known such a method afterwards in the library of S. Lorenzo, at the same place; in the beautiful distribution of the windows, in the pattern of the ceiling, and in the marvellous entrance of the vestibule. Nor was there ever seen a more resolute grace, both in the whole and in the parts, as in the consoles, tabernacles, and cornices, nor any staircase more commodious; in which last he made such bizarre breaks in the outlines of the steps, and departed so much from the common use of others, that everyone was amazed.

At this time he sent his disciple Pietro Urbano of Pistoia to Rome to carry to completion a nude Christ holding the Cross, a most admirable figure, which was placed beside the principal chapel of the Minerva, at the commission of Messer Antonio Metelli. About the same time there took place the sack of Rome and the expulsion of the Medici from Florence; by reason of which upheaval those who governed the city of Florence resolved to rebuild the fortifications, and therefore made Michelagnolo Commissary General over all that work. Whereupon he made designs and caused fortifications to be built for several parts of the city, and finally encircled the hill of San Miniato with bastions, which he made not with sods of earth, wood, and bundles of brushwood, as is generally done, but with a stout base of chestnut, oak, and other good materials interwoven, and in place of sods he took unbaked bricks made with tow and the dung of cattle, squared with very great diligence. And for this reason he was sent by the Signoria of Florence to Ferrara, to inspect the fortifications of Duke Alfonso I, and so also his artillery and

munitions; where he received many courtesies from that lord, who besought him that he should do something for him with his own hand at his leisure, and Michelagnolo promised that he would. After his return, he was continually engaged in fortifying the city, but, although he was thus occupied, nevertheless he kept working at a picture of a Leda for that Duke, painted with his own hand in distemper-colours, which was a divine thing, as will be related in the proper place; also continuing the statues for the tombs of S. Lorenzo, but in secret. At this time Michelagnolo spent some six months on the hill of San Miniato in order to press on the fortification of that hill, because if the enemy became master of it, the city was lost; and so he pursued these undertakings with the utmost diligence.

At this same time he continued the work in the above-mentioned sacristy, in which were seven statues that were left partly finished and partly not. With these, and with the architectural inventions of the tombs, it must be confessed that he surpassed every man in these three professions; to which testimony is borne by the statues of marble, blocked out and finished by him, which are to be seen in that place. One is Our Lady, who is in a sitting attitude, with the right leg crossed over the left and one knee placed upon the other, and the Child, with the thighs astride the leg that is uppermost, turns in a most beautiful attitude towards His Mother, hungry for her milk, and she, while holding Him with one hand and supporting herself with the other, bends forward to give it to Him; and although the figure is not equal in every part, and it was left rough and showing the marks of the gradine, yet with all its imperfections there may be recognized in it the full perfection of the work. Even more did he cause everyone to marvel by the circumstance that in making the tombs of Duke Giuliano and Duke Lorenzo de' Medici he considered that earth alone was not enough to give them honourable burial in their greatness, and desired that all the phases of the world should be there, and that their sepulchres should be surrounded and covered by four statues; wherefore he gave to one Night and Day, and to the other Dawn and Twilight; which statues, most beautifully wrought in form, in attitude, and in the masterly treatment of the muscles, would suffice, if that art were lost, to restore her to her pristine lustre. There, among the other statues, are the two Captains, armed; one the pensive Duke Lorenzo, the very presentment of wisdom, with legs so beautiful and so well

wrought, that there is nothing better to be seen by mortal eye; and the other is Duke Giuliano, so proud a figure, with the head, the throat, the setting of the eyes, the profile of the nose, the opening of the mouth, and the hair all so divine, to say nothing of the hands, arms, knees, feet, and, in short, every other thing that he carved therein, that the eye can never be weary or have its fill of gazing at them; and, of a truth, whoever studies the beauty of the buskins and the cuirass, believes it to be celestial rather than mortal. But what shall I say of the Dawn, a nude woman, who is such as to awaken melancholy in the soul and to render impotent the style of sculpture? In her attitude may be seen her effort, as she rises, heavy with sleep, and raises herself from her downy bed; and it seems that in awakening she has found the eyes of that great Duke closed in death, so that she is agonized with bitter grief, weeping in her own unchangeable beauty in token of her great sorrow. And what can I say of the Night, a statue not rare only, but unique? Who is there who has ever seen in that art in any age, ancient or modern, statues of such a kind? For in her may be seen not only the stillness of one sleeping, but the grief and melancholy of one who has lost a great and honoured possession; and we must believe that this is that night of darkness that obscures all those who thought for some time, I will not say to surpass, but to equal Michelagnolo in sculpture and design. In that statue is infused all the somnolence that is seen in sleeping forms; wherefore many verses in Latin and rhymes in the vulgar tongue were written in her praise by persons of great learning, such as these, of which the author is not known —

> La Notte che tu vedi in si dolci atti
> > Dormire, fu da un Angelo scolpita
> > In questo sasso; e perche dorme, ha vita.
> > Destala, se no 'l credi, e parleratti.

To which Michelagnolo, speaking in the person of Night, answered thus —

> Grato mi è il sonno, e più l' esser di sasso;
> > Mentre che il danno e la vergogna dura,
> > Non veder' non sentir' m' è gran ventura.
> > Però non mi destar'; deh parla basso.

Truly, if the enmity that there is between Fortune and Genius,

between the envy of the one and the excellence of the other, had not prevented such a work from being carried to completion, Art was like to prove to Nature that she surpassed her by a great measure in every conception.

While Michelagnolo was labouring with the greatest solicitude and love at these works, there came in 1529 the siege of Florence, which hindered their completion only too effectually, and was the reason that he did little or no more work upon them, the citizens having laid upon him the charge of fortifying not only the hill of S. Miniato, but also the city, as we have related. And thus, having lent a thousand crowns to that Republic, and being elected one of the Nine, a military Council appointed for the war, he turned all his mind and soul to perfecting those fortifications. But in the end, when the enemy had closed round the city, and all hope of assistance was failing little by little, and the difficulties of maintaining the defence were increasing, and it appeared to Michelagnolo that he was in a sorry pass with regard to his personal safety, he determined to leave Florence and make his way to Venice, without making himself known to anyone on the road. He set out secretly, therefore, by way of the hill of S. Miniato, without anyone knowing of it, taking with him Antonio Mini, his disciple, and the goldsmith Piloto, his faithful friend; and each of them carried a number of crowns on his person, sewn into his quilted doublet. Having arrived in Ferrara, they rested there; and it happened that on account of the alarm caused by the war and the league of the Emperor and the Pope, who were besieging Florence, Duke Alfonso d'Este was keeping strict watch in Ferrara, and required to be secretly informed by the hosts who gave lodging to travellers of the names of all those who lodged with them from one day to another; and he caused a list of all foreigners, with their nationality, to be brought to him every day. It came to pass, then, that when Michelagnolo had dismounted with his companions, intending to stay there without revealing himself, this became known in that way to the Duke, who was very glad, because he had already become his friend. That Prince was a man of lofty mind, delighting constantly in persons of ability all his life long, and he straightway sent some of the first men of his Court with orders to conduct him in the name of his Excellency to the Palace, where the Duke was, to remove thither his horses and all his baggage, and to give him a handsome lodging in that Palace. Michelagnolo, finding himself in the power of another,

was constrained to obey and to make the best of a bad business, and he went with those courtiers to the Duke, but without removing his baggage from the inn. Thereupon the Duke, after first complaining of his reserve, gave him a great reception; and then, making him rich and honourable presents, he sought to detain him in Ferrara with the promise of a fine salary. He, having his mind set on something else, would not consent to remain; but the Duke again made him a free offer of all that was in his power, praying him that he should at least not depart as long as the war continued. Whereupon Michelagnolo, not wishing to be outdone in courtesy, thanked him warmly, and, turning towards his two companions, said that he had brought twelve thousand crowns to Ferrara, and that, if the Duke had need of them, they were at his disposal, together with himself. The Duke then took him through the Palace to divert him, as he had done on another occasion, and showed him all the beautiful things that he had there, including a portrait of himself by Tiziano, which was much commended by Michelagnolo. However, his Excellency was not able to keep him in the Palace, for he insisted on returning to the inn; wherefore the host who was lodging him received from the Duke a great abundance of things wherewith to do him honour, and also orders that at his departure he should not accept anything for his lodging. From Ferrara he made his way to Venice, where many gentlemen sought to become known to him; but he, who always had a very poor opinion of their knowledge of his profession, departed from the Giudecca, where he had his lodging. There, so it is said, he made for that city at that time, at the request of the Doge Gritti, a design for the bridge of the Rialto, which was very rare in invention and in ornamentation.

Michelagnolo was invited with great insistence to go back to his native country, being urgently requested not to abandon his undertaking there, and receiving a safe-conduct; and finally, vanquished by love of her, he returned, but not without danger to his life. At this time he finished the Leda that he was painting, as has been related, at the request of Duke Alfonso; and it was afterwards taken to France by Antonio Mini, his disciple. And at this same time he saved the campanile of S. Miniato, a tower which sorely harassed the enemy's forces with its two pieces of artillery, so that their artillerists, having set to work to batter it with heavy cannon, had half ruined it, and were like to destroy it completely, when Michelagnolo protected it so well with bales of

wool and stout mattresses suspended by cords, that it is still standing. It is said, also, that at the time of the siege there came to him an opportunity to acquire, according to a desire that he had long had, a block of marble of nine braccia which had come from Carrara, and which Pope Clement, after much rivalry and contention between him and Baccio Bandinelli, had given to Baccio. But Michelagnolo, now that such a matter was in the hands of the Commonwealth, asked for it from the Gonfalonier, who gave it to him that he might likewise try his hand upon it, although Baccio had already made a model and hacked away much of the stone in blocking it out. Thereupon Michelagnolo made a model, which was held to be a marvellous and very beautiful thing; but on the return of the Medici the marble was restored to Baccio.

When peace had been made, Baccio Valori, the Pope's Commissioner, received orders to have some of the most partisan citizens arrested and imprisoned in the Bargello, and the same tribunal sought out Michelagnolo at his house; but he, fearing that, had fled secretly to the house of one who was much his friend, where he remained hidden many days. Finally, when the first fury had abated, Pope Clement, remembering the ability of Michelagnolo, caused a diligent search to be made for him, with orders that nothing should be said to him, but rather that his former appointments should be restored to him, and that he should attend to the work of S. Lorenzo, over which he placed as proveditor M. Giovan Battista Figiovanni, the old servant of the Medici family and Prior of S. Lorenzo. Thus reassured, Michelagnolo, in order to make Baccio Valori his friend, began a figure of three braccia in marble, which was an Apollo drawing an arrow from his quiver, and carried it almost to completion. It is now in the apartment of the Prince of Florence, and is a very rare work, although it is not completely finished.

At this time a certain gentleman was sent to Michelagnolo by Duke Alfonso of Ferrara, who, having heard that the master had made some rare work for him with his own hand, did not wish to lose such a jewel. Having arrived in Florence and found Michelagnolo, the envoy presented to him letters of recommendation from that lord; whereupon Michelagnolo, receiving him courteously, showed him the Leda embracing the Swan that he had painted, with Castor and Pollux issuing from the Egg, in a large picture executed in distemper, as it were with the breath.

The Duke's envoy, thinking from the praise that he heard every-where of Michelagnolo that he should have done something great, and not recognizing the excellence and artistry of that figure, said to Michelagnolo: 'Oh, this is but a trifle.' Michelagnolo, knowing that no one is better able to pronounce judgment on works than those who have had long practice in them, asked him what was his vocation. And he answered, with a sneer, 'I am a merchant'; believing that he had not been recognized by Michelagnolo as a gentleman, and as it were making fun of such a question, and at the same time affecting to despise the industry of the Florentines. Michelagnolo, who had understood perfectly the meaning of his words, at once replied: 'You will find you have made a bad bargain this time for your master. Get you gone out of my sight.'

Now in those days Antonio Mini, his disciple, who had two sisters waiting to be married, asked him for the Leda, and he gave it to him willingly, with the greater part of the designs and car-toons that he had made, which were divine things, and also two chests full of models, with a great number of finished cartoons for making pictures, and some of works that had been painted. When Antonio took it into his head to go to France, he carried all these with him; the Leda he sold to King Francis by means of some merchants, and it is now at Fontainebleau, but the cartoons and designs were lost, for he died there in a short time, and some were stolen; and so our country was deprived of all these valuable labours, which was an incalculable loss. The cartoon of the Leda has since come back to Florence, and Bernardo Vecchietti has it; and so also four pieces of the cartoons for the chapel, with nudes and Prophets, brought back by the sculptor Benvenuto Cellini, and now in the possession of the heirs of Girolamo degli Albizzi.

It became necessary for Michelagnolo to go to Rome to see Pope Clement, who, although angry with him, yet, as the friend of every talent, forgave him everything, and gave him orders that he should return to Florence and have the library and sacristy of S. Lorenzo completely finished; and, in order to shorten that work, a vast number of statues that were to be included in it were distributed among other masters. Two he allotted to Tribolo, one to Raffaello da Montelupo, and one to Fra Giovanni Agnolo, the Servite friar, all sculptors; and he gave them assistance in these, making rough models in clay for each of them. Whereupon they all worked valiantly, and he, also, caused work to be pursued on

the library, and thus the ceiling was finished in carved woodwork, which was executed after his models by the hands of the Florentines Carota and Tasso, excellent carvers and also masters of carpentry; and likewise the shelves for the books, which were executed at that time by Battista del Cinque and his friend Ciappino, good masters in that profession. And in order to give the work its final perfection there was summoned to Florence the divine Giovanni da Udine, who, together with others his assistants and also some Florentine masters, decorated the tribune with stucco; and they all sought with great solicitude to give completion to that vast undertaking.

Now, just as Michelagnolo was about to have the statues carried into execution, at that very time the Pope took it into his head to have him near his person, being desirous to have the walls of the Chapel of Sixtus painted, where Michelagnolo had painted the vaulting for Julius II, his nephew. On the principal wall, where the altar is, Clement wished him to paint the Universal Judgment, to the end that he might display in that scene all that the art of design could achieve, and opposite to it, on the other wall, over the principal door, he had commanded that he should depict the scene when Lucifer was expelled for his pride from Heaven, and all those Angels who sinned with him were hurled after him into the centre of Hell: of which inventions it was found that Michelagnolo many years before had made various sketches and designs, one of which was afterwards carried into execution in the Church of the Trinità at Rome by a Sicilian painter, who stayed many months with Michelagnolo, to serve him and to grind his colours. This work, painted in fresco, is in the Chapel of S. Gregorio, in the cross of the church, and, although it is executed badly, there is a certain variety and terrible force in the attitudes and groups of those nudes that are raining down from Heaven, and of the others who, having fallen into the centre of the earth, are changed into various forms of Devils, very horrible and bizarre; and it is certainly an extraordinary fantasy. While Michelagnolo was directing the preparation of the designs and cartoons of the Last Judgment on the first wall, he never ceased for a single day to be at strife with the agents of the Duke of Urbino, by whom he was accused of having received sixteen thousand crowns from Julius II for the tomb. This accusation was more than he could bear, and he desired to finish the work some day, although he was already an old man, and he

would have willingly stayed in Rome to finish it, now that he had found, without seeking it, such a pretext for not returning any more to Florence, since he had a great fear of Duke Alessandro de' Medici, whom he regarded as little his friend; for, when the Duke had given him to understand through Signor Alessandro Vitelli that he should select the best site for the building of the castle and citadel of Florence, he answered that he would not go save at the command of Pope Clement.

Finally an agreement was formed in the matter of the tomb, that it should be finished in the following manner: there was no longer to be an isolated tomb in a rectangular shape, but only one of the original façades, in the manner that best pleased Michelagnolo, and he was to be obliged to place in it six statues by his own hand. In this contract that was made with the Duke of Urbino, his Excellency consented that Michelagnolo should be at the disposal of Pope Clement for four months in the year, either in Florence or wherever he might think fit to employ him. But, although it seemed to Michelagnolo that at last he had obtained some peace, he was not to be quit of it so easily, for Pope Clement, desiring to see the final proof of the force of his art, kept him occupied with the cartoon of the Judgment. However, contriving to convince the Pope that he was thus engaged, at the same time he kept working in secret, never relaxing his efforts, at the statues that were going into the above-named tomb.

In the year 1533* came the death of Pope Clement, where-upon the work of the library and sacristy in Florence, which had remained unfinished in spite of all the efforts made to finish it, was stopped. Then, at length, Michelagnolo thought to be truly free and able to give his attention to finishing the tomb of Julius II. But Paul III, not long after his election, had him summoned to his presence, and, besides paying him compliments and making him offers, requested him to enter his service and remain near his person. Michelagnolo refused, saying that he was not able to do it, being bound by contract to the Duke of Urbino until the tomb of Julius should be finished. The Pope flew into a rage and said: 'I have had this desire for thirty years, and now that I am Pope do you think I shall not satisfy it? I shall tear up the contract, for I am determined to have you serve me, come what may.' Michelagnolo, hearing this resolution, was tempted to leave

* 1534.

Rome and in some way find means to give completion to the tomb; however, fearing, like a wise man, the power of the Pope, he resolved to try to keep him pacified with words, seeing that he was so old, until something should happen. The Pope, who wished to have some extraordinary work executed by Michelagnolo, went one day with ten Cardinals to visit him at his house, where he demanded to see all the statues for the tomb of Julius, which appeared to him marvellous, and particularly the Moses, which figure alone was said by the Cardinal of Mantua to be enough to do honour to Pope Julius. And after seeing the designs and cartoons that he was preparing for the wall of the chapel, which appeared to the Pope to be stupendous, he again besought Michelagnolo with great insistence that he should enter his service, promising that he would persuade the Duke of Urbino to content himself with three statues, and that the others should be given to other excellent masters to execute after his models. Whereupon, his Holiness having arranged this with the agents of the Duke, a new contract was made, which was confirmed by the Duke; and Michelagnolo of his own free will bound himself to pay for the other three statues and to have the tomb erected, depositing for this purpose in the bank of the Strozzi one thousand five hundred and eighty ducats. This he might have avoided, and it seemed to him that he had truly done enough to be free of such a long and troublesome undertaking; and afterwards he caused the tomb to be erected in S. Pietro in Vincola in the following manner. He erected the lower base, which was all carved, with four pedestals which projected outwards as much as was necessary to give space for the captive that was originally intended to stand on each of them, instead of which there was left a terminal figure; and since the lower part had thus a poor effect, he placed at the feet of each terminal figure a reversed console resting on the pedestal. Those four terminal figures had between them three niches, two of which (those at the sides) were round, and were to have contained the Victories. Instead of the Victories, he placed in one Leah, the daughter of Laban, to represent the Active Life, with a mirror in her hand to signify the consideration that we should give to our actions, and in the other hand a garland of flowers, to denote the virtues that adorn our life during its duration, and make it glorious after death; and the other figure was her sister Rachel, representing the Contemplative Life, with the hands clasped and one knee bent, and on the

countenance a look as of ecstasy of spirit. These statues Michelagnolo executed with his own hand in less than a year. In the centre is the other niche, rectangular in shape, which in the original design was to have been one of the doors that were to lead into the little oval temple of the rectangular tomb; this having become a niche, there is placed in it, upon a dado of marble, the gigantic and most beautiful statue of Moses, of which we have already said enough. Above the heads of the terminal figures, which form capitals, are architrave, frieze, and cornice, which project beyond those figures and are carved with rich ornaments, foliage, ovoli, dentils, and other rich members, distributed over the whole work. Over that cornice rises another course, smooth and without carvings, but with different terminal figures standing directly above those below, after the manner of pilasters, with a variety of cornice-members; and since this course accompanies that below and resembles it in every part, there is in it a space similar to the other, forming a niche like that in which there is now the Moses, and in the niche, resting on projections of the cornice, is a sarcophagus of marble with the recumbent statue of Pope Julius, executed by the sculptor Maso dal Bosco, while in that niche, also, there stands a Madonna who is holding her Son in her arms, wrought by the sculptor Scherano da Settignano from a model by Michelagnolo; which statues are passing good. In two other rectangular niches, above the Active and the Contemplative Life, are two larger statues, a Prophet and a Sibyl seated, which were both executed by Raffaello da Montelupo, as has been related in the Life of his father Baccio, but little to the satisfaction of Michelagnolo. For its crowning completion this work had a different cornice, which, like those below, projected over the whole work; and above the terminal figures, as a finish, were candelabra of marble, with the arms of Pope Julius in the centre. Above the Prophet and the Sibyl, in the recess of each niche, he made a window for the convenience of the friars who officiate in that church, the choir having been made behind; which windows serve to send their voices into the church when they say the divine office, and permit the celebration to be seen. Truly this whole work has turned out very well, but not by a great measure as it had been planned in the original design.

Michelagnolo resolved, since he could not do otherwise, to serve Pope Paul, who allowed him to continue the work as

ordered by Clement, without changing anything in the inventions and the general conception that had been laid before him, thus showing respect for the genius of that great man, for whom he felt such reverence and love that he sought to do nothing but what pleased him; of which a proof was soon seen. His Holiness desired to place his own arms beneath the Jonas in the chapel, where those of Pope Julius II had previously been put; but Michelagnolo, being asked to do this, and not wishing to do a wrong to Julius and Clement, would not place them there, saying that they would not look well; and the Pope, in order not to displease him, was content to have it so, having recognized very well the excellence of such a man, and how he always followed what was just and honourable without any adulation or respect of persons – a thing that the great are wont to experience very seldom. Michelagnolo, then, caused a projection of well baked and chosen bricks to be carefully built on the wall of the above-named chapel (a thing which was not there before), and contrived that it should overhang half a braccio from above, so that neither dust nor any other dirt might be able to settle upon it. But I will not go into the particulars of the invention and composition of this scene, because so many copies of it, both large and small, have been printed, that it does not seem necessary to lose time in describing it. It is enough for us to perceive that the intention of this extraordinary man has been to refuse to paint anything but the human body in its best proportioned and most perfect forms and in the greatest variety of attitudes, and not this only, but likewise the play of the passions and contentments of the soul, being satisfied with justifying himself in that field in which he was superior to all his fellow-craftsmen, and to lay open the way of the grand manner in the painting of nudes, and his great knowledge in the difficulties of design; and, finally, he opened out the way to facility in this art in its principal province, which is the human body, and, attending to this single object, he left on one side the charms of colouring and the caprices and new fantasies of certain minute and delicate refinements which many other painters, perhaps not without some show of reason, have not entirely neglected. For some, not so well grounded in design, have sought with variety of tints and shades of colouring, with various new and bizarre inventions, and, in short, with the other method, to win themselves a place among the first masters; but Michelagnolo, standing always firmly rooted in his profound

knowledge of art, has shown to those who know enough how they should attain to perfection.

But to return to the story: Michelagnolo had already carried to completion more than three-fourths of the work, when Pope Paul went to see it. And Messer Biagio da Cesena, the master of ceremonies, a person of great propriety, who was in the chapel with the Pope, being asked what he thought of it, said that it was a very disgraceful thing to have made in so honourable a place all those nude figures showing their nakedness so shamelessly, and that it was a work not for the chapel of a Pope, but for a bagnio or tavern. Michelagnolo was displeased at this, and, wishing to revenge himself, as soon as Biagio had departed he portrayed him from life, without having him before his eyes at all, in the figure of Minos with a great serpent twisted round the legs, among a heap of Devils in Hell; nor was Messer Biagio's pleading with the Pope and with Michelagnolo to have it removed of any avail, for it was left there in memory of the occasion, and it is still to be seen at the present day.

It happened at this time that Michelagnolo fell no small distance from the staging of this work, and hurt his leg; and in his pain and anger he would not be treated by anyone. Now there was living at this same time the Florentine Maestro Baccio Rontini, his friend, an ingenious physician, who had a great affection for his genius; and he, taking compassion on him, went one day to knock at his door. Receiving no answer either from the neighbours or from him, he so contrived to climb by certain secret ways from one room to another, that he came to Michelagnolo, who was in a desperate state. And then Maestro Baccio would never abandon him or take himself off until he was cured.

Having recovered from this injury, he returned to his labour, and, working at it continually, he carried it to perfect completion in a few months, giving such force to the paintings in the work, that he justified the words of Dante –

Morti li morti, i vivi parean vivi.

And here, also, may be seen the misery of the damned and the joy of the blessed. Wherefore, when this Judgment was thrown open to view, it proved that he had not only vanquished all the earlier masters who had worked there, but had sought to surpass the vaulting that he himself had made so famous, excelling it by a great measure and outstripping his own self. For he imagined

to himself the terror of those days, and depicted, for the greater pain of all who have not lived well, the whole Passion of Christ, causing various naked figures in the air to carry the Cross, the Column, the Lance, the Sponge, the Nails, and the Crown of Thorns, all in different attitudes, executed to perfection in a triumph of facility over their difficulties. In that scene is Christ seated, with a countenance proud and terrible, turning towards the damned and cursing them; not without great fear in Our Lady, who, hearing and beholding that vast havoc, draws her mantle close around her. There are innumerable figures, Prophets and Apostles, that form a circle about Him, and in particular Adam and S. Peter, who are believed to have been placed there, one as the first parent of those thus brought to judgment, and the other as having been the first foundation of the Christian Church; and at His feet is a most beautiful S. Bartholomew, who is displaying his flayed skin. There is likewise a nude figure of S. Laurence; besides which, there are multitudes of Saints without number, both male and female, and other figures, men and women, around Him, near or distant, who embrace one another and make rejoicing, having received eternal blessedness by the grace of God and as the reward of their works. Beneath the feet of Christ are the Seven Angels with the Seven Trumpets described by S. John the Evangelist, who, as they sound the call to judgment, cause the hair of all who behold them to stand on end at the terrible wrath that their countenances reveal. Among others are two Angels that have each the Book of Life in the hands: and near them, on one side, not without beautiful consideration, are seen the Seven Mortal Sins in the forms of Devils, assailing and striving to drag down to Hell the souls that are flying towards Heaven, all with very beautiful attitudes and most admirable foreshortenings. Nor did he hesitate to show to the world, in the resurrection of the dead, how they take to themselves flesh and bones once more from the same earth, and how, assisted by others already alive, they go soaring towards Heaven, whence succour is brought to them by certain souls already blessed; not without evidence of all those marks of consideration that could be thought to be required in so great a work. For studies and labours of every kind were executed by him, which may be recognized throughout the whole work without exception; and this is manifested with particular clearness in the barque of Charon, who, in an attitude of fury, strikes with his oars at the souls dragged down by the

Devils into the barque, after the likeness of the picture that the master's best-beloved poet, Dante, described when he said –

> Caron demonio con occhi di bragia,
> Loro accennando, tutte le raccoglie,
> Batte col remo qualunque si adagia.

Nor would it be possible to imagine how much variety there is in the heads of those Devils, which are truly monsters from Hell. In the sinners may be seen sin and the fear of eternal damnation; and, to say nothing of the beauty of every detail, it is extraordinary to see so great a work executed with such harmony of painting, that it appears as if done in one day, and with such finish as was never achieved in any miniature. And, of a truth, the terrible force and grandeur of the work, with the multitude of figures, are such that it is not possible to describe it, for it is filled with all the passions known to human creatures, and all expressed in the most marvellous manner. For the proud, the envious, the avaricious, the wanton, and all the other suchlike sinners can be distinguished with ease by any man of fine perception, because in figuring them Michelagnolo observed every rule of Nature in the expressions, in the attitudes, and in every other natural circumstance; a thing which, although great and marvellous, was not impossible to such a man, for the reason that he was always observant and shrewd and had seen men in plenty, and had acquired by commerce with the world that knowledge that philosophers gain from cogitation and from writings. Wherefore he who has judgment and understanding in painting perceives there the most terrible force of art, and sees in those figures such thoughts and passions as were never painted by any other but Michelagnolo. So, also, he may see there how the variety of innumerable attitudes is accomplished, in the strange and diverse gestures of young and old, male and female; and who is there who does not recognize in these the terrible power of his art, together with the grace that he had from Nature, since they move the hearts not only of those who have knowledge in that profession, but even of those who have none? There are foreshortenings that appear as if in relief, a harmony of painting that gives great softness, and fineness in the parts painted by him with delicacy, all showing in truth how pictures executed by good and true painters should be; and in the outlines of the forms turned by him in such a way as could not have been achieved by any

other but Michelagnolo, may be seen the true Judgment and the
true Damnation and Resurrection. This is for our art the exem-
plar and the grand manner of painting sent down to men on
earth by God, to the end that they may see how Destiny works
when intellects descend from the heights of Heaven to earth, and
have infused in them divine grace and knowledge. This work
leads after it bound in chains those who persuade themselves that
they have mastered art; and at the sight of the strokes drawn by
him in the outlines of no matter what figure, every sublime spirit,
however mighty in design, trembles and is afraid. And while the
eyes gaze at his labours in this work, the senses are numbed at
the mere thought of what manner of things all other pictures,
those painted and those still unpainted, would appear if placed in
comparison with such perfection. Truly blessed may he be called,
and blessed his memories, who has seen this truly stupendous
marvel of our age! Most happy and most fortunate Paul III, in
that God granted that under thy protection should be acquired
the renown that the pens of writers shall give to his memory and
thine! How highly are thy merits enhanced by his genius! And
what good fortune have the craftsmen had in this age from his
birth, in that they have seen the veil of every difficulty torn away,
and have beheld in the pictures, sculptures, and architectural
works executed by him all that can be imagined and achieved!

He toiled eight years over executing this work, and threw it
open to view in the year 1541, I believe, on Christmas day, to the
marvel and amazement of all Rome, nay, of the whole world; and
I, who was that year in Venice, and went to Rome to see it, was
struck dumb by its beauty.

Pope Paul, as has been related, had caused a chapel called the
Pauline to be erected on the same floor by Antonio da San Gallo,
in imitation of that of Nicholas V; and in this he resolved that
Michelagnolo should paint two great pictures with two large
scenes. In one he painted the Conversion of S. Paul, with Jesus
Christ in the air and a multitude of nude Angels making most
beautiful movements, and below, all dazed and terrified, Paul
fallen from his horse to the level of the ground, with his soldiers
about him, some striving to raise him up, and others, struck with
awe by the voice and splendour of Christ, are flying in beautiful
attitudes and marvellous movements of panic, while the horse,
taking to flight, appears to be carrying away in its headlong
course him who seeks to hold it back; and this whole scene is

executed with extraordinary design and art. In the other picture
is the Crucifixion of S. Peter, who is fixed, a nude figure of rare
beauty, upon the cross; showing the ministers of the crucifixion,
after they have made a hole in the ground, seeking to raise the
cross on high, to the end that he may remain crucified with his
feet in the air; and there are many remarkable and beautiful con-
siderations. Michelagnolo, as has been said elsewhere, gave his
attention only to the perfection of art, and therefore there are no
landscapes to be seen there, nor trees, nor buildings, nor any
other distracting graces of art, for to these he never applied him-
self, as one, perchance, who would not abase his great genius to
such things. These, executed by him at the age of seventy-five,
were his last pictures, and, as he used himself to tell me, they cost
him much fatigue, for the reason that painting, and particularly
working in fresco, is no art for men who have passed a certain
age. Michelagnolo arranged that Perino del Vaga, a very excellent
painter, should decorate the vaulting with stucco and with many
things in painting, after his designs, and such, also, was the wish
of Pope Paul III; but the work was afterwards delayed, and noth-
ing more was done, even as many undertakings are left unfi-
nished, partly by the fault of want of resolution in the craftsmen,
and partly by that of Princes little zealous in urging them on.

Pope Paul had made a beginning with the fortifying of the
Borgo, and had summoned many gentlemen, together with Anto-
nio da San Gallo, to a conference; but he wished that Michel-
agnolo also should have a part in this, knowing that the
fortifications about the hill of S. Miniato in Florence had been
constructed under his direction. After much discussion, Michel-
agnolo was asked what he thought; and he, having opinions con-
trary to San Gallo and many others, declared them freely.
Whereupon San Gallo said to him that his arts were sculpture
and painting, and not fortification. Michelagnolo replied that of
sculpture and painting he knew little, but of fortification, what
with the thought that he had devoted to it for a long time, and
his experience in what he had done, it appeared to him that he
knew more than either Antonio or any of his family; showing him
in the presence of the company that he had made many errors in
that art. Words rising high on either side, the Pope had to com-
mand silence; but no long time passed before Michelagnolo
brought a design for all the fortifications of the Borgo, which laid
open the way for all that has since been ordained and executed;

and this was the reason that the great gate of S. Spirito, which was approaching completion under the direction of San Gallo, was left unfinished.

The spirit and genius of Michelagnolo could not rest without doing something; and, since he was not able to paint, he set to work on a piece of marble, intending to carve from it four figures in the round and larger than life, including a Dead Christ, for his own delight and to pass the time, and because, as he used to say, the exercise of the hammer kept him healthy in body. This Christ, taken down from the Cross, is supported by Our Lady, by Nicodemus, who bends down and assists her, planted firmly on his feet in a forceful attitude, and by one of the Maries, who also gives her aid, perceiving that the Mother, overcome by grief, is failing in strength and not able to uphold Him. Nor is there anywhere to be seen a dead form equal to that of Christ, who, sinking with the limbs hanging limp, lies in an attitude wholly different, not only from that of any other work by Michelagnolo, but from that of any other figure that was ever made. A laborious work is this, a rare achievement in a single stone, and truly divine; but, as will be related hereafter, it remained unfinished, and suffered many misfortunes, although Michelagnolo had intended that it should serve to adorn his own tomb, at the foot of that altar where he thought to place it.

It happened in the year 1546 that Antonio da San Gallo died; whereupon, there being now no one to direct the building of S. Pietro, many suggestions were made by the superintendents to the Pope as to who should have it. Finally his Holiness, inspired, I believe, by God, resolved to send for Michelagnolo. But he, when asked to take Antonio's place, refused it, saying, in order to avoid such a burden, that architecture was not his proper art; and in the end, entreaties not availing, the Pope commanded that he should accept it, whereupon, to his great displeasure and against his wish, he was forced to undertake that enterprise. And one day among others that he went to S. Pietro to see the wooden model that San Gallo had made, and to examine the building, he found there the whole San Gallo faction, who, crowding before Michelagnolo, said to him in the best terms at their command that they rejoiced that the charge of the building was to be his, and that the model was a field where there would never be any want of pasture. 'You speak the truth,' answered Michelagnolo, meaning to infer, as he declared to a friend, that it

was good for sheep and oxen, who knew nothing of art. And afterwards he used to say publicly that San Gallo had made it wanting in lights, that it had on the exterior too many ranges of columns one above another, and that, with its innumerable projections, pinnacles, and subdivisions of members, it was more akin to the German manner than to the good method of the ancients or to the gladsome and beautiful modern manner; and, in addition to this, that it was possible to save fifty years of time and more than three hundred thousand crowns of money in finishing the building, and to execute it with more majesty, grandeur, and facility, greater beauty and convenience, and better ordered design. This he afterwards proved by a model that he made, in order to bring it to the form in which the work is now seen constructed; and thus he demonstrated that what he said was nothing but the truth. This model cost him twenty-five crowns, and was made in a fortnight; that of San Gallo, as has been related, cost four thousand, and took many years to finish. From this and other circumstances it became evident that that fabric was but a shop and a business for making money, and that it would be continually delayed, with the intention of never finishing it, by those who had undertaken it as a means of profit.

Such methods did not please our upright Michelagnolo, and in order to get rid of all these people, while the Pope was forcing him to accept the office of architect to the work, he said to them openly one day that they should use all the assistance of their friends and do all that they could to prevent him from entering on that office, because, if he were to undertake such a charge, he would not have one of them about the building. Which words, spoken in public, were taken very ill, as may be believed, and were the reason that they conceived a great hatred against him, which increased every day as they saw the whole design being changed, both within and without, so that they would scarcely let him live, seeking out daily new and various devices to harass him, as will be related in the proper place. Finally the Pope issued a Motu-proprio creating him head of that fabric, with full authority, and giving him power to do or undo whatever he chose, and to add, take away, or vary anything at his pleasure; and he decreed that all the officials employed in the work should be subservient to his will. Whereupon Michelagnolo, seeing the great confidence and trust that the Pope placed in him, desired, in order to prove his generosity, that it should be declared in the Motu-proprio that

he was serving in the fabric for the love of God and without any reward. It is true that the Pope had formerly granted to him the ferry over the river at Parma,* which yielded him about six hundred crowns; but he lost it at the death of Duke Pier Luigi Farnese, and in exchange for it he was given a Chancellery at Rimini, a post of less value. About that he showed no concern; and, although the Pope sent him money several times by way of salary, he would never accept it, to which witness is borne by Messer Alessandro Ruffini, Chamberlain to the Pope at that time, and by M. Pier Giovanni Aliotti, Bishop of Forlì. Finally the model that had been made by Michelagnolo was approved by the Pope; which model diminished S. Pietro in size, but gave it greater grandeur, to the satisfaction of all those who have judgment, although some who profess to be good judges, which in fact they are not, do not approve of it. He found that the four principal piers built by Bramante, and left by Antonio da San Gallo, which had to support the weight of the tribune, were weak; and these he partly filled up, and beside them he made two winding or spiral staircases, in which is an ascent so easy that the beasts of burden can climb them, carrying all the materials to the very top, and men on horseback, likewise, can go up to the uppermost level of the arches. The first cornice above the arches he constructed of travertine, curving in a round, which is an admirable and graceful thing, and very different from any other; nor could anything better of that kind be done. He also made a beginning with the two great recesses of the transepts; and whereas formerly, under the direction of Bramante, Baldassarre, and Raffaello, as has been related, eight tabernacles were being made on the side towards the Camposanto, and that plan was afterwards followed by San Gallo, Michelagnolo reduced these to three, with three chapels in the interior, and above them a vaulting of travertine, and a range of windows giving a brilliant light, which are varied in form and of a sublime grandeur. But, since these things are in existence, and are also to be seen in engraving, not only those of Michelagnolo, but those of San Gallo as well, I will not set myself to describe them, for it is in no way necessary. Let it suffice to say that he set himself, with all possible diligence, to cause the work to be carried on in those parts where the fabric was to be changed in design, to the end that it might remain so solid and

* Piacenza.

stable that it might never be changed by another; which was the wise provision of a shrewd and prudent intellect, because it is not enough to do good work, if further precautions be not taken, seeing that the boldness and presumption of those who might be supposed to have knowledge if credit were placed rather in their words than in their deeds, and at times the favour of such as know nothing, may give rise to many misfortunes.

The Roman people, with the sanction of that Pope, had a desire to give some useful, commodious, and beautiful form to the Campidoglio, and to furnish it with colonnades, ascents, and inclined approaches with and without steps, and also with the further adornment of the ancient statues that were already there, in order to embellish that place. For this purpose they sought the advice of Michelagnolo, who made them a most beautiful and very rich design, in which, on the side where the Senatore stands, towards the east, he arranged a façade of travertine, and a flight of steps that ascends from two sides to meet on a level space, from which one enters into the centre of the hall of that Palace, with rich curving wings adorned with balusters that serve as supports and parapets. And there, to enrich that part, he caused to be placed on certain bases the two ancient figures in marble of recumbent River Gods, each of nine braccia, and of rare workmanship, one of which is the Tiber and the other the Nile; and between them, in a niche, is to go a Jove. On the southern side, where there is the Palace of the Conservatori, in order that it might be made rectangular, there followed a rich and well varied façade, with a loggia at the foot full of columns and niches, where many ancient statues are to go; and all around are various ornaments, doors, windows, and the like, of which some are already in place. On the other side from this, towards the north, below the Araceli, there is to follow another similar façade; and before it, towards the west, is to be an ascent of baston-like steps, which will be almost level, with a border and parapet of balusters; here will be the principal entrance, with a colonnade, and bases on which will be placed all that wealth of noble statues in which the Campidoglio is now so rich. In the middle of the Piazza, on a base in the form of an oval, is placed the famous bronze horse on which is the statue of Marcus Aurelius, which the same Pope Paul caused to be removed from the Piazza di Laterano, where Sixtus IV had placed it. This edifice is now being made so beautiful that it is worthy to be numbered among the finest works that

Michelagnolo has executed, and it is being carried to completion at the present day under the direction of M. Tommaso de' Cavalieri, a Roman gentleman who was, and still is, one of the greatest friends that Michelagnolo ever had, as will be related hereafter.

Pope Paul III had caused San Gallo, while he was alive, to carry forward the Palace of the Farnese family, but the great upper cornice, to finish the roof on the outer side, had still to be constructed, and his Holiness desired that Michelagnolo should execute it from his own designs and directions. Michelagnolo, not being able to refuse the Pope, who so esteemed and favoured him, caused a model of wood to be made, six braccia in length, and of the size that it was to be; and this he placed on one of the corners of the Palace, so that it might show what effect the finished work would have. It pleased his Holiness and all Rome, and that part of it has since been carried to completion which is now to be seen, proving to be the most varied and the most beautiful of all that have ever been known, whether ancient or modern. On this account, after San Gallo was dead, the Pope desired that Michelagnolo should have charge of the whole fabric as well; and there he made the great marble window with the beautiful columns of variegated marble, which is over the principal door of the Palace, with a large escutcheon of great beauty and variety, in marble, of Pope Paul III, the founder of that Palace. Within the Palace he continued, above the first range of the court, the two other ranges, with the most varied, graceful, and beautiful windows, ornaments and upper cornice that have ever been seen, so that, through the labours and the genius of that man that court has now become the most handsome in Europe. He widened and enlarged the Great Hall, and set in order the front vestibule, and caused the vaulting of that vestibule to be constructed in a new variety of curve, in the form of a half oval.

Now in that year there was found at the Baths of Antoninus a mass of marble seven braccia in every direction, in which there had been carved by the ancients a Hercules standing upon a mound, who was holding the Bull by the horns, with another figure assisting him, and around that mound various figures of Shepherds, Nymphs, and different animals – a work of truly extraordinary beauty, showing figures so perfect in one single block without any added pieces, which was judged to have been intended for a fountain. Michelagnolo advised that it should be

conveyed into the second court, and there restored so as to make it spout water in the original manner; all which advice was approved, and the work is still being restored at the present day with great diligence, by order of the Farnese family, for that purpose. At that time, also, Michelagnolo made a design for the building of a bridge across the River Tiber in a straight line with the Farnese Palace, to the end that it might be possible to go from that palace to another palace and gardens that they possessed in the Trastevere, and also to see at one glance in a straight line from the principal door which faces the Campo di Fiore, the court, the fountain, the Strada Giulia, the bridge, and the beauties of the other garden, even to the other door which opened on the Strada di Trastevere – a rare work, worthy of that Pontiff and of the judgment, design, and art of Michelagnolo.

In the year 1547 died Sebastiano Viniziano, the Friar of the Piombo; and, Pope Paul proposing that the ancient statues of his Palace should be restored, Michelagnolo willingly favoured the Milanese sculptor Guglielmo della Porta, a young man of promise, who had been recommended by the above-named Fra Sebastiano to Michelagnolo, who, liking his work, presented him to Pope Paul for the restoration of those statues. And the matter went so far forward that Michelagnolo obtained for him the office of the Piombo, and he then set to work on restoring the statues, some of which are to be seen in that Palace at the present day. But Guglielmo, forgetting the benefits that he had received from Michelagnolo, afterwards became one of his opponents.

In the year 1549 there took place the death of Pope Paul III; whereupon, after the election of Pope Julius III, Cardinal Farnese gave orders for a grand tomb to be made for his kinsman Pope Paul by the hand of Fra Guglielmo, who arranged to erect it in S. Pietro, below the first arch of the new church, beneath the tribune, which obstructed the floor of the church, and was, in truth, not the proper place. Michelagnolo advised, most judiciously, that it could not and should not stand there, and the Frate, believing that he was doing this out of envy, became filled with hatred against him; but afterwards he recognized that Michelagnolo had spoken the truth, and that the fault was his, in that he had had the opportunity and had not finished the work, as will be related in another place. And to this I can bear witness, for the reason that in the year 1550 I had gone by order of Pope

Julius III to Rome to serve him (and very willingly, for love of Michelagnolo), and I took part in that discussion. Michelagnolo desired that the tomb should be erected in one of the niches, where there is now the Column of the Possessed, which was the proper place, and I had so gone to work that Julius III was resolving to have his own tomb made in the other niche with the same design as that of Pope Paul, in order to balance that work; but the Frate, who set himself against this, brought it about that his own was never finished after all, and that the tomb of the other Pontiff was also not made; which had all been predicted by Michelagnolo.

In the same year Pope Julius turned his attention to having a chapel of marble with two tombs constructed in the Church of S. Pietro a Montorio for Cardinal Antonio di Monte, his uncle, and Messer Fabiano, his grandfather, the first founder of the greatness of that illustrious house. For this work Vasari having made designs and models, Pope Julius, who always esteemed the genius of Michelagnolo and loved Vasari, desired that Michelagnolo should fix the price between them; and Vasari besought the Pope that he should prevail upon him to take it under his protection. Now Vasari had proposed Simone Mosca for the carvings of this work, and Raffaello da Montelupo for the statues; but Michelagnolo advised that no carvings of foliage should be made in it, not even in the architectural parts of the work, saying that where there are to be figures of marble there must not be any other thing. On which account Vasari feared that the work should be abandoned, because it would look poor; but in fact, when he saw it finished, he confessed that Michelagnolo had shown great judgment. Michelagnolo would not have Montelupo make the statues, remembering how badly he had acquitted himself in those of his own tomb of Julius II, and he was content, rather, that they should be entrusted to Bartolommeo Ammanati, whom Vasari had proposed, although Buonarroti had something of a private grievance against him, as also against Nanni di Baccio Bigio, caused by a reason which, if one considers it well, seems slight enough; for when they were very young, moved rather by love of art than by a desire to do wrong, they had entered with great pains into his house, and had taken from Antonio Mini, the disciple of Michelagnolo, many sheets with drawings; but these were afterwards all restored to him by order of the Tribunal of Eight, and, at the intercession of his friend Messer Giovanni

Norchiati, Canon of S. Lorenzo, he would not have any other punishment inflicted on them. Vasari, when Michelagnolo spoke to him of this matter, said to him, laughing, that it did not seem to him that they deserved any blame, and that he himself, if he had ever been able, would have not taken a few drawings only, but robbed him of everything by his hand that he might have been able to seize, merely for the sake of learning art. One must look kindly, he said, on those who seek after excellence, and also reward them, and therefore such men must not be treated like those who go about stealing money, household property, and other things of value; and so the matter was turned into a jest. This was the reason that a beginning was made with the work of the Montorio, and that in the same year Vasari and Ammanati went to have the marble conveyed from Carrara to Rome for the execution of that work.

At that time Vasari was with Michelagnolo every day; and one morning the Pope in his kindness gave them both leave that they might visit the Seven Churches on horseback (for it was Holy Year), and receive the Pardon in company. Whereupon, while going from one church to another, they had many useful and beautiful conversations on art and every industry, and out of these Vasari composed a dialogue, which will be published at some more favourable opportunity, together with other things concerning art. In that year Pope Julius III confirmed the Motu-proprio of Pope Paul III with regard to the building of S. Pietro; and although much evil was spoken to him of Michelagnolo by the friends of the San Gallo faction, in the matter of that fabric of S. Pietro, at that time the Pope would not listen to a word, for Vasari had demonstrated to him (as was the truth) that Michelagnolo had given life to the building, and also persuaded his Holiness that he should do nothing concerned with design without the advice of Michelagnolo. This promise the Pope kept ever afterwards, for neither at the Vigna Julia did he do anything without his counsel, nor at the Belvedere, where there was built the staircase that is there now, in place of the semicircular staircase that came forward, ascending in eight steps, and turned inwards in eight more steps, erected in former times by Bramante in the great recess in the centre of the Belvedere. And Michelagnolo designed and caused to be built the very beautiful quadrangular staircase, with balusters of peperino-stone, which is there at the present day.

Vasari had finished in that year the printing of his work, the Lives of the Painters, Sculptors, and Architects, in Florence. Now he had not written the Life of any living master, although some who were old were still alive, save only of Michelagnolo; and in the book were many records of circumstances that Vasari had received from his lips, his age and his judgment being the greatest among all the craftsmen. Giorgio therefore presented the work to him, and he received it very gladly; and not long afterwards, having read it, Michelagnolo sent to him the following sonnet, written by himself, which I am pleased to include in this place in memory of his loving-kindness:

> Se con lo stile o co' colori havete
> Alla Natura pareggiato l'Arte,
> Anzi a quella scemato il pregio in parte,
> Che 'l bel di lei più bello a noi rendete,
> Poichè con dotta man posto vi siete
> A più degno lavoro, a vergar carte,
> Quel che vi manca a lei di pregio in parte,
> Nel dar vita ad altrui tutto togliete.
> Che se secolo alcuno omai contese
> In far bell' opre, almen cedale, poi
> Che convien', ch' al prescritto fine arrive.
> Or le memorie altrui già spente accese
> Tornando fate, or che sien quelle, e voi,
> Mal grado d' esse, eternalmente vive.

Vasari departed for Florence, and left to Michelagnolo the charge of having the work founded in the Montorio. Now Messer Bindo Altoviti, the Consul of the Florentine colony at that time, was much the friend of Vasari, and on this occasion Giorgio said to him that it would be well to have this work erected in the Church of S. Giovanni de' Fiorentini, and that he had already spoken of it with Michelagnolo, who would favour the enterprise; and that this would be a means of giving completion to that church. This proposal pleased Messer Bindo, and, being very intimate with the Pope, he urged it warmly upon him, demonstrating that it would be well that the chapel and the tombs which his Holiness was having executed for the Montorio should be placed in the Church of S. Giovanni de' Fiorentini; adding that the result would be that with this occasion and this spur the Florentine colony would undertake such expenditure that the church would receive its completion, and, if his Holiness were to

build the principal chapel, the other merchants would build six chapels, and then little by little all the rest. Whereupon the Pope changed his mind, and, although the model for the work was already made and the price arranged, went to the Montorio and sent for Michelagnolo, to whom Vasari was writing every day, receiving answers from him according to the opportunities presented in the course of affairs. Michelagnolo then wrote to Vasari, on the first day of August in 1550, of the change that the Pope had made; and these are his words, written in his own hand:

ROME.

'MY DEAR MESSER GIORGIO,

'With regard to the founding of the work at S. Pietro a Montorio, and how the Pope would not listen to a word, I wrote you nothing, knowing that you are kept informed by your man here. Now I must tell you what has happened, which is as follows. Yesterday morning the Pope, having gone to the said Montorio, sent for me. I met him on the bridge, on his way back, and had a long conversation with him about the tombs allotted to you; and in the end he told me that he was resolved that he would not place those tombs on that mount, but in the Church of the Florentines. He sought from me my opinion and also designs, and I encouraged him not a little, considering that by this means the said church would be finished. Respecting your three letters received, I have no pen wherewith to answer to such exalted matters, but if I should rejoice to be in some sort what you make me, I should rejoice for no other reason save that you might have a servant who might be worth something. But I do not marvel that you, who restore dead men to life, should lengthen the life of the living, or rather, that you should steal from death for an unlimited period those barely alive. To cut this short, such as I am, I am wholly yours,

'MICHELAGNOLO BUONARROTI.'

While these matters were being discussed, and the Florentine colony was seeking to raise money, certain difficulties arose, on account of which they came to no decision, and the affair grew cold. Meanwhile, Vasari and Ammanati having by this time had all the marbles quarried at Carrara, a great part of them were sent to Rome, and with them Ammanati, through whom Vasari wrote to Buonarroti that he should ascertain from the Pope where he wanted the tomb, and, after receiving his orders, should have the

work begun. The moment that Michelagnolo received the letter, he spoke to his Holiness; and with his own hand he wrote the following resolution to Vasari:

'*13th of October*, 1550.

'MY DEAR MESSER GIORGIO,

'The instant that Bartolommeo arrived here, I went to speak to the Pope, and, having perceived that he wished to begin the work once more at the Montorio, in the matter of the tombs, I looked for a mason from S. Pietro. "Tantecose"* heard this, and insisted on sending one of his choosing, and I, to avoid contending with a man who commands the winds, have retired from the matter, because, he being a light-minded person, I would not care to be drawn into any entanglement. Enough that in my opinion there is no more thought to be given to the Church of the Florentines. Fare you well, and come back soon. Nothing else occurs to me.'

Michelagnolo used to call Monsignor di Forlì 'Tantecose,' because he insisted on doing everything himself. Being Chamberlain to the Pope, he had charge of the medals, jewels, cameos, little figures in bronze, pictures, and drawings, and desired that everything should depend on him. Michelagnolo was always anxious to avoid the man, because he had been constantly working against the master's interests, and therefore Buonarroti feared lest he might be drawn into some entanglement by the intrigues of such a man. In short, the Florentine colony lost a very fine opportunity for that church, and God knows when they will have such another; and to me it was an indescribable grief. I have desired not to omit to make this brief record, to the end that it may be seen that our Michelagnolo always sought to help his fellow-countrymen and his friends, and also art.

Vasari had scarcely returned to Rome, when, before the beginning of the year 1551, the San Gallo faction arranged a conspiracy against Michelagnolo, whereby the Pope was to hold an assembly in S. Pietro, and to summon together the superintendents and all those who had the charge of the work, in order to show to the Pope, by means of false calumnies, that Michelagnolo had ruined that fabric, because, he having already built the apse

* Busybody, or Jack-of-all-Trades.

of the King, where there are the three chapels, and having ex-
ecuted these with the three windows above, they, not knowing
what was to be done with the vaulting, with feeble judgment had
given the elder Cardinal Salviati and Marcello Cervini, who after-
wards became Pope, to understand that S. Pietro was being left
with little light. Whereupon, all being assembled, the Pope said
to Michelagnolo that the deputies declared that the apse would
give little light, and he answered: 'I would like to hear these
deputies speak in person.' Cardinal Marcello replied: 'We are
here.' Then Michelagnolo said to him: 'Monsignore, above these
windows, in the vaulting, which is to be made of travertine, there
are to be three others.' 'You have never told us that,' said the
Cardinal. And Michelagnolo answered: 'I am not obliged, nor do
I intend to be obliged, to say either to your Highness or to any
other person what I am bound or desirous to do. Your office is
to obtain the money and to guard it from thieves, and the charge
of the design for the building you must leave to me.' And then,
turning to the Pope, he said: 'Holy Father, you see what my gains
are, and that if these fatigues that I endure do not profit me in
my mind, I am wasting my time and my work.' The Pope, who
loved him, laid his hands on his shoulders, and said: 'You shall
profit both in mind and in body; do not doubt it.' Michelagnolo
having thus been able to get rid of those persons, the Pope came
to love him even more; and he commanded him and Vasari that
on the day following they should both present themselves at the
Vigna Julia, in which place his Holiness had many discussions
with him, and they carried that work almost to the condition of
perfect beauty in which it now is; nor did the Pope discuss or do
anything in the matter of design without Michelagnolo's advice
and judgment. And, among other things, since Michelagnolo
went often with Vasari to visit him, the Pope insisted, once when
he was at the fountain of the Acqua Vergine with twelve Cardi-
nals, after Buonarroti had come up; the Pope, I say, insisted very
strongly that he should sit beside him, although he sought most
humbly to excuse himself; thus always honouring his genius as
much as lay in his power.

The Pope caused him to make the model of a façade for a
palace that his Holiness desired to build beside S. Rocco, intend-
ing to avail himself of the Mausoleum of Augustus for the rest
of the masonry; and, as a design for a façade, there is nothing to
be seen that is more varied, more ornate, or more novel in

manner and arrangement, for the reason that, as has been seen in all his works, he never consented to be bound by any law, whether ancient or modern, in matters of architecture, as one who had a brain always able to discover things new and well-varied, and in no way less beautiful. That model is now in the possession of Duke Cosimo de' Medici, who had it as a present from Pope Pius IV when he went to Rome; and he holds it among his dearest treasures. That Pope had such respect for Michelagnolo, that he was constantly taking up his defence against Cardinals and others who sought to calumniate him, and he desired that other crafts-men, however able and renowned they might be, should always go to seek him at his house; such, indeed, were the regard and reverence that he felt for him, that his Holiness did not venture, lest he might annoy him, to call upon Michelagnolo for many works which, although he was old, he could have executed.

As far back as the time of Paul III Michelagnolo had made a beginning with the work of refounding, under his own direction, the Ponte S. Maria at Rome, which had been weakened by the constant flow of water and by age, and was falling into ruin. The refounding was contrived by Michelagnolo by means of caissons, and by making stout reinforcements against the piers; and already he had carried a great part of it to completion, and had spent large sums on wood and travertine on behalf of the work, when, in the time of Julius III, an assembly was held by the Clerks of the Chamber with a view to making an end of it, and a proposal was made among them by the architect Nanni di Baccio Bigio, saying that if it were allotted by contract to him it would be finished in a short time and without much expense; and this they suggested on the pretext, as it were, of doing a favour to Mich-elagnolo and relieving him of a burden, because he was old, alleging that he gave no thought to it, and that if matters re-mained as they were the end would never be seen. The Pope, who little liked being troubled, not thinking what the result might be, gave authority to the Clerks of the Chamber that they should have charge of the work, as a thing pertaining to them; and then, without Michelagnolo hearing another word about it, they gave it with all those materials, without any conditions, to Nanni, who gave no attention to the reinforcements, which were necessary for the refounding, but relieved the bridge of some weight, in consequence of having seen a great quantity of travertine where-with it had been flanked and faced in ancient times, the result of

which was to give weight to the bridge and to make it stouter, stronger, and more secure. In place of that he used gravel and other materials cast with cement, in such a manner that no defect could be seen in the inner part of the work, and on the outer side he made parapets and other things, insomuch that to the eye it appeared as if made altogether new; but it was made lighter all over and weakened throughout. Five years afterwards, when the flood of the year 1557 came down, it happened that the bridge collapsed in such a manner as to make known the little judgment of the Clerks of the Chamber and the loss that Rome suffered by departing from the counsel of Michelagnolo, who predicted the ruin of the bridge many times to me and to his other friends. Thus I remember that he said to me, when we were passing there together on horseback, 'Giorgio, this bridge is shaking under us; let us spur our horses, or it may fall while we are upon it.'

But to return to the narrative interrupted above; when the work of the Montorio was finished, and that much to my satisfaction, I returned to Florence to re-enter the service of Duke Cosimo, which was in the year 1554. The departure of Vasari grieved Michelagnolo, and likewise Giorgio, for the reason that Michelagnolo's adversaries kept harassing him every day, now in one way and now in another; wherefore they did not fail to write to one another daily. And in April of the same year, Vasari giving him the news that Leonardo, the nephew of Michelagnolo, had had a male child, that they had accompanied him to baptism with an honourable company of most noble ladies, and that they had revived the name of Buonarroto, Michelagnolo answered in a letter to Vasari in these words:

'DEAR FRIEND GIORGIO,

'I have had the greatest pleasure from your letter, seeing that you still remember the poor old man, and even more because you were present at the triumph which, as you write, you witnessed in the birth of another Buonarroto; for which intelligence I thank you with all my heart and soul. But so much pomp does not please me, for man should not be laughing when all the world is weeping. It seems to me that Leonardo should not make so much rejoicing over a new birth, with all that gladness which should be reserved for the death of one who has lived well. Do not marvel if I delay to answer; I do it so as not to appear a merchant. As for the many praises that you send me in

your letter, I tell you that if I deserved a single one of them, it would appear to me that in giving myself to you body and soul, I had truly given you something, and had discharged some infinitesimal part of the debt that I owe you; whereas I recognize you every hour as my creditor for more than I can repay, and, since I am an old man, I can now never hope to be able to square the account in this life, but perhaps in the next. Wherefore I pray you have patience, and remain wholly yours. Things here are much as usual.'

Already, in the time of Paul III, Duke Cosimo had sent Tribolo to Rome to see if he might be able to persuade Michelagnolo to return to Florence, in order to give completion to the Sacristy of S. Lorenzo. But Michelagnolo excused himself because, having grown old, he could not support the burden of such fatigues, and demonstrated to him with many reasons that he could not leave Rome. Whereupon Tribolo finally asked him about the staircase of the library of S. Lorenzo, for which Michelagnolo had caused many stones to be prepared, but there was no model of it nor any certainty as to the exact form, and, although there were some marks on a pavement and some other sketches in clay, the true and final design could not be found. However, no matter how much Tribolo might beseech him and invoke the name of the Duke, Michelagnolo would never answer a word save that he remembered nothing of it. Orders were given to Vasari by Duke Cosimo that he should write to Michelagnolo, requesting him to write saying what final form that staircase was to have; in the hope that through the friendship and love that he bore to Vasari, he would say something that might lead to some solution and to the completion of the work. Vasari wrote to Michelagnolo the mind of the Duke, saying that the execution of all that was to be done would fall to him; which he would do with that fidelity and care with which, as Michelagnolo knew, he was wont to treat such of his works as he had in charge. Wherefore Michelagnolo sent the directions for making the above-named staircase in a letter by his own hand on the 28th of September, 1555.

'MESSER GIORGIO, DEAR FRIEND,
 'Concerning the staircase for the library, of which so much has been said to me, you may believe that if I could remember

how I had designed it, I would not need to be entreated. There does, indeed, come back to my mind, like a dream, a certain staircase; but I do not believe that it is exactly the one which I conceived at that time, because it comes out so stupid. However, I will describe it here. Take a quantity of oval boxes, each one palm in depth, but not of equal length and breadth. The first and largest place on the pavement at such a distance from the wall of the door as may make the staircase easy or steep, according to your pleasure. Upon this place another, which must be so much smaller in every direction as to leave on the first one below as much space as the foot requires in ascending; diminishing and drawing back the steps one after another towards the door, in accord with the ascent. And the diminution of the last step must reduce it to the proportion of the space of the door. The said part of the staircase with the oval steps must have two wings, one on one side and one on the other, with corresponding steps but not oval. Of these the central flight shall serve as the principal staircase, and from the centre of the staircase to the top the curves of the said wings shall meet the wall; but from the centre down to the pavement they shall stand, together with the whole staircase, at a distance of about three palms from the wall, in such a manner that the basement of the vestibule shall not be obstructed in any part, and every face shall be left free. I am writing nonsense; but I know well that you will find something to your purpose.'

Michelagnolo also wrote to Vasari in those days that Julius III being dead, and Marcellus elected, the faction that was against him, in consequence of the election of the new Pontiff, had again begun to harass him. Which hearing, and not liking these ways, the Duke caused Giorgio to write and tell him that he should leave Rome and come to live in Florence, where the Duke did not desire more than his advice and designs at times for his buildings, and that he would receive from that lord all that he might desire, without doing anything with his own hand. Again, there were carried to him by M. Leonardo Marinozzi, the private Chamberlain of Duke Cosimo, letters written by his Excellency; and so also by Vasari. But then, Marcellus being dead, and Paul IV having been elected, by whom once again numerous offers had been made to him from the very beginning, when he went to kiss his feet, the desire to finish the fabric of S. Pietro, and the

obligation by which he thought himself bound to that task, kept him back; and, employing certain excuses, he wrote to the Duke that for the time being he was not able to serve him, and to Vasari a letter in these very words:

'MESSER GIORGIO, MY DEAR FRIEND,

'I call God to witness how it was against my will and under the strongest compulsion that I was set to the building of S. Pietro in Rome by Pope Paul III, ten years ago. Had they continued to work at that fabric up to the present day, as they were doing then, I would now have reached such a point in the undertaking that I might be thinking of returning home; but for want of money it has been much retarded, and is still being retarded at the time when it has reached the most laborious and difficult stage, insomuch that to abandon it now would be nothing short of the greatest possible disgrace and sin, losing the reward of the labours that I have endured in those ten years for the love of God. I have made you this discourse in answer to your letter, and also because I have a letter from the Duke that has made me marvel much that his Excellency should have deigned to write so graciously; for which I thank God and his Excellency to the best of my power and knowledge. I wander from the subject, because I have lost my memory and my wits, and writing is a great affliction to me, for it is not my art. The conclusion is this: to make you understand what would be the result if I were to abandon the fabric and depart from Rome; firstly, I would please a number of thieves, and secondly, I would be the cause of its ruin, and perhaps, also, of its being suspended for ever.'

Continuing to write to Giorgio, Michelagnolo said to him, to excuse himself with the Duke, that he had a house and many convenient things at his disposal in Rome, which were worth thousands of crowns, in addition to being in danger of his life from disease of the kidneys, colic, and the stone, as happens to every old person, and as could be proved by Maestro Realdo, his physician, from whom he congratulated himself on having his life, after God; that for these reasons he was not able to leave Rome, and, finally, that he had no heart for anything but death. He besought Vasari, as he did in several other letters that Giorgio has by his hand, that he should recommend him to the Duke for pardon, in addition to what he wrote to the Duke, as I have said,

to excuse himself. If Michelagnolo had been able to ride, he would have gone straightway to Florence, whence, I believe, he would never have consented to depart in order to return to Rome, so much was he influenced by the tenderness and love that he felt for the Duke; but meanwhile he gave his attention to working at many parts of the above-named fabric, in order so to fix the form that it might never again be changed. During this time certain persons had informed him that Pope Paul IV was minded to make him alter the façade of the chapel where the Last Judgment is, because, he said, those figures showed their nakedness too shamelessly. When, therefore, the mind of the Pope was made known to Michelagnolo, he answered: 'Tell the Pope that it is no great affair, and that it can be altered with ease. Let him put the world right, and every picture will be put right in a moment.' The office of the Chancellery of Rimini was taken away from Michelagnolo, but he would never speak of this to the Pope, who did not know it; and it was taken away from him by the Pope's Cupbearer, who sought to have a hundred crowns a month given to him in respect of the fabric of S. Pietro, and caused a month's payment to be taken to his house, but Michelagnolo would not accept it. In the same year took place the death of Urbino, his servant, or rather, as he may be called, and as he had been, his companion. This man came to live with Michelagnolo in Florence in the year 1530, after the siege was finished, when his disciple Antonio Mini went to France; and he rendered very faithful service to Michelagnolo, insomuch that in twenty-six years that faithful and intimate service brought it about that Michelagnolo made him rich and so loved him, that in this, Urbino's last illness, old as he was, he nursed him and slept in his clothes at night to watch over him. Wherefore, after he was dead, Vasari wrote to Michelagnolo to console him, and he answered in these words:

'MY DEAR MESSER GIORGIO,

'I am scarce able to write, but, in reply to your letter, I shall say something. You know how Urbino died, wherein God has shown me very great grace, although it is also a grave loss and an infinite grief to me. This grace is that whereas when living he kept me alive, dying he has taught me to die not with regret, but with a desire for death. I have had him twenty-six years, and have found him a very rare and faithful servant; and now, when I had made him rich and was looking to him as the staff and repose of

my old age, he has flown from me, nor is any hope left to me but to see him again in Paradise. And of this God has granted a sign in the happy death that he died, in that dying grieved him much less than leaving me in this traitorous world with so many afflictions; although the greater part of me is gone with him, and nothing is left me but infinite misery. I commend myself to you.'

Michelagnolo was employed in the time of Pope Paul IV on many parts of the fortifications of Rome, and also by Salustio Peruzzi, to whom that Pope, as has been related elsewhere, had given the charge of executing the great portal of the Castello di S. Angelo, which is now half ruined; and he occupied himself in distributing the statues of that work, examining the models of the sculptors, and correcting them. At that time the French army approached near to Rome, and Michelagnolo thought that he was like to come to an evil end together with that city; whereupon he resolved to fly from Rome with Antonio Franzese of Castel Durante, whom Urbino at his death had left in his house as his servant, and went secretly to the mountains of Spoleto, where he visited certain seats of hermits. Meanwhile Vasari wrote to him, sending him a little work that Carlo Lenzoni, a citizen of Florence, had left at his death to Messer Cosimo Bartoli, who was to have it printed and dedicated to Michelagnolo; which, when it was finished, Vasari sent in those days to Michelagnolo, and he, having received it, answered thus:

September 18, 1556.

'MESSER GIORGIO, DEAR FRIEND,

'I have received Messer Cosimo's little book, which you send to me, and this shall be a letter of thanks. I pray you to give them to him, and send him my compliments.

'I have had in these days great discomfort and expense, but also great pleasure, in visiting the hermits in the mountains of Spoleto, insomuch that less than half of me has returned to Rome, seeing that in truth there is no peace to be found save in the woods. I have nothing more to tell you. I am glad that you are well and happy, and I commend myself to you.'

Michelagnolo used to work almost every day, as a pastime, at that block with the four figures of which we have already spoken; which block he broke into pieces at this time for these reasons, either because it was hard and full of emery, and the chisel often

struck sparks from it, or it may have been that the judgment of
the man was so great that he was never content with anything
that he did. A proof that this is true is that there are few finished
statues to be seen out of all that he executed in the prime of his
manhood, and that those completely finished were executed by
him in his youth, such as the Bacchus, the Pietà in S. Maria della
Febbre, the Giant of Florence, and the Christ of the Minerva,
which it would not be possible to increase or diminish by as little
as a grain of millet without spoiling them; and the others, with
the exception of the Dukes Giuliano and Lorenzo, Night, Dawn,
and Moses, with the other two, the whole number of these
statues not amounting in all to eleven, the others, I say, were all
left unfinished, and, moreover, they are many, Michelagnolo hav-
ing been wont to say that if he had had to satisfy himself in what
he did, he would have sent out few, nay, not one. For he had
gone so far with his art and judgment, that, when he had laid bare
a figure and had perceived in it the slightest degree of error, he
would set it aside and run to lay his hand on another block of
marble, trusting that the same would not happen to the new
block; and he often said that this was the reason that he gave for
having executed so few statues and pictures. This Pietà, when it
was broken, he presented to Francesco Bandini. Now at this time
Tiberio Calcagni, a Florentine sculptor, had become much the
friend of Michelagnolo by means of Francesco Bandini and
Messer Donato Giannotti; and being one day in Michelagnolo's
house, where there was the Pietà, all broken, after a long conver-
sation he asked him for what reason he had broken it up and
destroyed labours so marvellous, and he answered that the reason
was the importunity of his servant Urbino, who kept urging him
every day to finish it, besides which, among other things, a piece
of one of the elbows of the Madonna had been broken off, and
even before that he had taken an aversion to it, and had had
many misfortunes with it by reason of a flaw that was in the
marble, so that he lost his patience and began to break it up; and
he would have broken it altogether into pieces if his servant
Antonio had not besought him that he should present it to him
as it was. Whereupon Tiberio, having heard this, spoke to Ban-
dini, who desired to have something by the hand of Michel-
agnolo, and Bandini contrived that Tiberio should promise to
Antonio two hundred crowns of gold, and prayed Michelagnolo
to consent that Tiberio should finish it for Bandini with the

assistance of models by his hand, urging that thus his labour would not be thrown away. Michelagnolo was satisfied, and then made them a present of it. The work was carried away immediately, and then put together again and reconstructed with I know not what new pieces by Tiberio; but it was left unfinished by reason of the death of Bandini, Michelagnolo, and Tiberio. At the present day it is in the possession of Pier Antonio Bandini, the son of Francesco, at his villa on Monte Cavallo. But to return to Michelagnolo; it became necessary to find some work in marble on which he might be able to pass some time every day with the chisel, and another piece of marble was put before him, from which another Pietà had been already blocked out, different from the first and much smaller.

There had entered into the service of Paul IV, and also into the charge of the fabric of S. Pietro, the architect Pirro Ligorio, and he was now once more harassing Michelagnolo, going about saying that he had sunk into his second childhood. Wherefore, angered by such treatment, he would willingly have returned to Florence, and, having delayed to return, he was again urged in letters by Giorgio, but he knew that he was too old, having now reached the age of eighty-one. Writing at that time to Vasari by his courier, and sending him various spiritual sonnets, he said that he was come to the end of his life, that he must be careful where he directed his thoughts, that by reading he would see that he was at his last hour, and that there arose in his mind no thought upon which was not graved the image of death; and in one letter he said:

'It is God's will, Vasari, that I should continue to live in misery for some years. I know that you will tell me that I am an old fool to wish to write sonnets, but since many say that I am in my second childhood, I have sought to act accordingly. By your letter I see the love that you bear me, and you may take it as certain that I would be glad to lay these feeble bones of mine beside those of my father, as you beg me to do; but by departing from here I would be the cause of the utter ruin of the fabric of S. Pietro, which would be a great disgrace and a very grievous sin. However, when it is so firmly established that it can never be changed, I hope to do all that you ask me, if it be not a sin to keep in anxious expectation certain gluttons that await my immediate departure.'

With this letter was the following sonnet, also written in his own hand:

> Giunto è già'l corso della vita mia
> Con tempestoso mar' per fragil barca
> Al comun porto, ov' a render' si varca
> Conto e ragion' d'ogni opra trista e pia.
> Onde l'affetuosa fantasia,
> Che l'arte mi fece idolo e monarca,
> Conosco or' ben' quant' era d'error' carca,
> E quel ch' a mal suo grado ognun' desia.
> Gli amorosi pensier' già vani e lieti
> Che sien' or', s' a due morti mi avvicino?
> D'una so certo, e l'altra mi minaccia.
> Nè pinger' nè scolpir' sia più che quieti
> L'anima volta a quello Amor Divino
> Ch' aperse a prender' noi in Croce le braccia.

Whereby it was evident that he was drawing towards God, abandoning the cares of art on account of the persecution of his malignant fellow-craftsmen, and also through the fault of certain overseers of the fabric, who would have liked, as he used to say, to dip their hands in the chest. By order of Duke Cosimo, a reply was written to Michelagnolo by Vasari in a letter of few words, exhorting him to repatriate himself, with a sonnet corresponding in the rhymes. Michelagnolo would willingly have left Rome, but he was so weary and aged, that although, as will be told below, he was determined to go back, while the spirit was willing the flesh was weak, and that kept him in Rome. It happened in June of the year 1557, he having made a model for the vault that was to cover the apse, which was being built of travertine in the Chapel of the King, that, from his not being able to go there as he had been wont, an error arose, in that the capomaestro took the measurements over the whole body of the vault with one single centre, whereas there should have been a great number; and Michelagnolo, as the friend and confidant of Vasari, sent him designs by his own hand, with these words written at the foot of two of them:

'The centre marked with red was used by the capomaestro over the body of the whole vault; then, when he began to pass to the half-circle, which is at the summit of the vault, he became aware of the error which that centre was producing, as may be

seen here in the design, marked in black. With this error the vault has gone so far forward, that we have to displace a great number of stones, for in that vault there is being placed no brick-work, but all travertine, and the diameter of the circle, without the cornice that borders it, is twenty-two palms. This error, after I had made an exact model, as I do of everything, has been caused by my not being able, on account of my old age, to go there often; so that, whereas I believed that the vault was now finished, it will not be finished all this winter, and, if it were possible to die of shame and grief, I should not be alive now. I pray you account to the Duke for my not being at this moment in Florence.'

And continuing in the other design, where he had drawn the plan, he said this:

'MESSER GIORGIO,
 'To the end that it may be easier to understand the difficulty of the vault by observing its rise from the level of the ground, let me explain that I have been forced to divide it into three vaults, corresponding to the windows below divided by pilasters; and you see that they go pyramidally into the centre of the summit of the vault, as also do the base and sides of the same. It was necessary to regulate them with an infinite number of centres, and there are in them so many changes in various directions, from point to point, that no fixed rule can be maintained. And the circles and squares that come in the middle of their deepest parts have to diminish and increase in so many directions, and to go to so many points, that it is a difficult thing to find the true method. Nevertheless, having the model, such as I make for everything, they should never have committed so great an error as to seek to regulate with one single centre all those three shells; whence it has come about that we have been obliged with shame and loss to pull down, as we are still doing, a great number of stones. The vault, with its sections and hewn stone-work, is all of travertine, like all the rest below; a thing not customary in Rome.'

Michelagnolo was excused by Duke Cosimo, hearing of these misfortunes, from coming to Florence; the Duke saying to him that his contentment and the continuation of S. Pietro were more dear to him than anything in the world, and that he should rest

in peace. Whereupon Michelagnolo wrote to Vasari, on the same sheet in which he thanked the Duke to the best of his power and knowledge for such kindness, saying, 'God give me grace that I may be able to serve him with this my poor person, for my memory and my brain are gone to await him elsewhere.' The date of this letter was August in the year 1557. Thus, then, Michelagnolo learned that the Duke esteemed his life and his honour more than he did himself, who so revered him. All these things, and many more that it is not necessary to mention, we have in our possession, written in his hand.

Michelagnolo by this time was reduced to a feeble condition, and it was evident that little was being done in S. Pietro, now that he had carried on a great part of the frieze of the windows within, and of the double columns without, which curve above the great round cornice* where the cupola is to be placed, as will be related; and he was exhorted and urged by his greatest friends, such as the Cardinal of Carpi, Messer Donato Giannotti, Francesco Bandini, Tommaso de' Cavalieri, and Lottino that, since he saw the delay in the raising of the cupola, he should at least make a model of it. He stayed many months without making up his mind to this, but in the end he made a beginning, and then little by little constructed a small model in clay, from which, as an exemplar, and from the plans and profiles that he had drawn, it might be possible afterwards to make a larger one of wood. This, having made a beginning with it, he caused to be constructed in little more than a year by Maestro Giovanni Franzese, with much study and pains; and he made it on such a scale that the smaller proportions of the model, measured by the old Roman palm, corresponded with complete exactness to those of the large work, he having fashioned with diligence in that model all the members of columns, bases, capitals, doors, windows, cornices, projections, and likewise every least thing, knowing that in such a work no less should be done, for in all Christendom, nay, in all the world, there is not to be found or seen any fabric more ornate or more grand. And I cannot but think that, if we have given up time to noting smaller things, it is even more useful, and also our duty, to describe this manner of design for building the structure of this tribune with the form, order, and method that Michelagnolo thought to give it; wherefore with such brevity as we may we will

* Drum.

give a simple description of it, to the end that, if it should ever be the fate of this work, which God forbid, to be disturbed by the envy and malice of presumptuous persons after the death of Michelagnolo, even as we have seen it disturbed up to the present during his lifetime, these my writings, such as they may be, may be able to assist the faithful who are to be the executors of the mind of that rare man, and also to restrain the malignant desires of those who may seek to alter it, and so at one and the same time assist, delight, and open the minds of those beautiful intellects that are the friends of this profession and regard it as their joy.

I must begin by saying that according to this model, made under the direction of Michelagnolo, I find that in the great work the whole space within the tribune will be one hundred and eighty-six palms, speaking of its width from wall to wall above the great cornice of travertine that curves in a round in the interior, resting on the four great double piers that rise from the ground with their capitals carved in the Corinthian Order, accompanied by their architrave, frieze, and cornice, likewise of travertine; which great cornice, curving right round over the great niches, rests supported upon the four great arches of the three niches and of the entrance, which form the cross of the building. Then there begins to spring the first part of the tribune, the rise of which commences in a basement of travertine with a platform six palms broad, where one can walk; and this basement curves in a round in the manner of a well, and its thickness is thirty-three palms and eleven inches, the height to the cornice eleven palms and ten inches, the cornice over it about eight palms, and its projection six and a half palms. Into this basement you enter, in order to ascend the tribune, by four entrances that are over the arches of the niches, and the thickness of the basement is divided into three parts; that on the inner side is fifteen palms, that on the outer side is eleven palms, and that in the centre is seven palms and eleven inches, which make up the thickness of thirty-three palms and eleven inches. The space in the centre is hollow and serves as a passage, which is two squares in height and curves in a continuous round, with a barrel-shaped vault; and in line with the four entrances are eight doors, each of which rises in four steps, one of them leading to the level platform of the cornice of the first basement, six palms and a half in breadth, and another leading to the inner cornice that curves round the tribune, eight palms and three-quarters broad, on

which platforms, by each door, you can walk conveniently both within and without the edifice, and from one entrance to another in a curve of two hundred and one palms, so that, the sections being four, the whole circuit comes to be eight hundred and four palms. We now have to ascend from the level of this basement, upon which rest the columns and pilasters, and which forms the frieze of the windows within all the way round, being fourteen palms and one inch in height, and around it, on the outer side, there is at the foot a short order of cornice work, and so also at the top, which does not project more than ten inches, and all of travertine; and so in the thickness of the third part, above that on the inner side, which we have described as fifteen palms thick, there is made in every quarter-section a staircase, one half of which ascends in one direction and the second half in another, the width being four palms and a quarter; and this staircase leads to the level of the columns. Above this level there begin to rise, in line with the solid parts of the basement, eighteen large piers all of travertine, each adorned with two columns on the outer side and pilasters on the inner, as will be described below, and between the piers are left the spaces where there are to be all the windows that are to give light to the tribune. These piers, on the sides pointing towards the central point of the tribune, are thirty-six palms in extent, and on the front sides nineteen and a half. Each of them, on the outer side, has two columns, the lowest dado of which is eight palms and three-quarters broad and one palm and a half high, the base five palms and eight inches broad and palms and eleven inches high, the shaft of the column forty-three and a half palms high, five palms and six inches thick at the foot and four palms and nine inches at the top, the Corinthian capital six palms and a half high, with the crown of mouldings nine palms. Of these columns three quarters are to be seen, and the other quarter is merged into the corner, with the accompaniment of the half of a pilaster that makes a salient angle on the inner side, and this is accompanied in the central inner space by the opening of an arched door, five palms wide and thirteen palms and five inches high, from the summit of which to the capitals of the pilasters and columns there is a filling of solid masonry, serving as a connection with two other pilasters that are similar to those that form a salient angle beside the columns. These two pilasters correspond to the others, and adorn the sides of sixteen windows that go right round the tribune, each with a

light twelve palms and a half wide and about twenty-two palms
high. These windows are to be adorned on the outer side with
varied architraves two palms and three-quarters high, and on the
inner side they are to be adorned with orders likewise varied, with
pediments and quarter-rounds; and they are wide without and
more narrow within, and so, also, they are sloped away at the foot
of the inner side, so that they may give light over the frieze and
cornice. Each of them is bordered by two flat pilasters that corres-
pond in height to the columns without, so that there come to
be thirty-six columns without and thirty-six pilasters within; over
which pilasters is the architrave, which is four palms and three-
quarters in height, the frieze four and a half, and the cornice four
and two-thirds, with a projection of five palms; and above this is
to go a range of balusters, so that one may be able to walk all
the way round there with safety. And in order that it may be
possible to climb conveniently from the level where the columns
begin, another staircase ascends in the same line within the thick-
ness of the part that is fifteen palms wide, in the same manner
and of the same width, with two branches or ascents, all the way
up to the summit of the columns, with their capitals, architraves,
friezes, and cornices; insomuch that, without obstructing the light
of the windows, these stairs pass at the top into a spiral stair-
case of the same breadth, which finally reaches the level where
the turning of the tribune is to begin.

All this order, distribution, and ornamentation is so well var-
ied, commodious, rich, durable, and strong, and serves so well to
support the two vaults of the cupola that is to be turned upon it,
that it is a very ingenious thing, and it is all so well considered
and then executed in masonry, that there is nothing to be seen
by the eyes of one who has knowledge and understanding that is
more pleasing, more beautiful, or wrought with greater mastery,
both on account of the binding together and mortising of the
stones and because it has in it in every part strength and eternal
life, and also because of the great judgment wherewith he
contrived to carry away the rain-water by many hidden channels,
and, finally, because he brought it to such perfection, that all
other fabrics that have been built and seen up to the present
day appear as nothing in comparison with the grandeur of this
one. And it has been a very great loss that those whose duty it
was did not put all their power into the undertaking, for the
reason that, before death took away from us that rare man, we

should have seen that beautiful and terrible structure already raised.

Up to this point has Michelagnolo carried the masonry of the work; and it only remains to make a beginning with the vaulting of the tribune, of which, since the model has come down to us, we shall proceed to describe the design that he has left to the end that it may be carried out. He turned the curve of this vault on three points that make a triangle, in this manner:

<p style="text-align:center">A B
C</p>

The point C, which is the lowest, is the principal one, wherewith he turned the first half-circle of the tribune, with which he gave the form, height and breadth of this vault, which he ordered to be built entirely of bricks well baked and fired, laid herring-bone fashion. This shell he makes four palms and a half thick, and as thick at the top as at the foot, and leaving beside it, in the centre, a space four palms and a half wide at the foot, which is to serve for the ascent of the stairs that are to lead to the lantern, rising from the platform of the cornice where there are balusters. The arch of the interior of the other shell, which is to be wider at the foot and narrower at the top, is turned on the point marked B, and the thickness of the shell at the foot is four palms and a half. And the last arch, which is to be turned in order to make the exterior of the cupola, wider at the foot and narrowing towards the top, is to be raised on the point marked A, which arch turned, there remains at the top all the hollow space of the interior for the ascent of the stairs, which are eight palms high, so that one may climb them upright; and the thickness of that shell comes to diminish little by little, insomuch that, being as before four palms and a half at the foot, it decreases at the top to three palms and a half. And the outer shell comes to be so well bound to the inner shell with bonds and with the stairs, that the one supports the other; while of the eight parts into which the fabric is divided at the base, the four over the arches are left hollow, in order to put less weight upon the arches, and the other four are bound and chained together with bonds upon the piers, so that the structure may have everlasting life.

The stairs in the centre between one shell and the other are constructed in this form; from the level where the springing of the vault begins they rise in each of the four sections, and each

ascends from two entrances, the stairs intersecting one another in the form of an X, until they have covered the half of the arch marked C, on the upper side of the shell, when, having ascended straight up the half of that arch, the remaining space is then easily climbed circle after circle and step after step in a direct line, until finally one arrives at the eye of the cupola, where the rise of the lantern begins, around which, in accord with the diminution of the compartments that spring above the piers, there is a smaller range of double pilasters and windows similar to those that are constructed in the interior, as will be described below.

Over the first great cornice within the tribune there begin at the foot the compartments for the recesses that are in the vault of the tribune, which are formed by sixteen projecting ribs. These at the foot are as broad as the breadth of the two pilasters which at the lower end border each window below the vault of the tribune, and they rise, diminishing pyramidally, as far as the eye of the lantern; at the foot they rest on pedestals of the same breadth and twelve palms high, and these pedestals rest on the level platform of the cornice which goes in a circle right round the tribune. Above this, in the recessed spaces between the ribs, there are eight large ovals, each twenty-nine palms high, and over them a number of straight-sided compartments that are wider at the foot and narrower at the top, and twenty-four palms high, and then, the ribs drawing together, there comes above each straight-sided compartment a round fourteen palms high; so that there come to be eight ovals, eight straight-sided compartments, and eight rounds, each range forming recesses that grow more shallow in succession. The ground of all these displays extraordinary richness, for Michelagnolo intended to make the ribs and the ornaments of the said ovals, straight-sided compartments, and rounds, all corniced in travertine.

It remains for us to make mention of the surface and adornment of the arch on that side of the vault where the roofing is to go, which begins to rise from a base twenty-five palms and a half high, which has at the foot a basement that has a projection of two palms, as have the crowning mouldings at the top. The covering or roofing with which he proposed to cover it is of lead, such as covers the roof of the old S. Pietro at the present day, and is divided into sixteen sections from one solid base to another, each base beginning where the two columns end, which are one on either side of it. In each of these sections, in the

centre, he made two windows to give light to the inner space where the ascent of the stairs is, between the two shells, so that in all they are thirty-two. These, by means of brackets that support a quarter-round, he made projecting from the roof in such a manner as to protect the lofty and novel view-point from the rain. In a line with the centre of the solid base between each two columns, above which was the crowning cornice, sprang a rib, one to each, wider at the foot and narrowing at the top; in all sixteen ribs, five palms broad, in the centre of each of which was a quadrangular channel one palm and a half wide, within which is formed an ascent of steps about one palm high, by which to ascend or descend between the platform at the foot and the summit where the lantern begins. These are to be built of travertine and constructed with mortisings, to the end that the joins may be protected against water and ice during times of rain.

The design for the lantern is reduced in the same proportion as all the rest of the work, so that, taking lines round the circumference, everything comes to diminish in exact accord, and with proportionate measurements it rises as a simple temple with round columns two by two, like those on the solid bases below. These have pilasters to correspond to them, and one can walk all the way round and see from the central spaces between the pilasters, where the windows are, the interior of the tribune and the church. Above this, architrave, frieze, and cornice curve in a round, projecting over each pair of columns; and over these columns, in a line with them, spring some caulicoles, which, together with some niches that divide them, rise to find the end of the lantern, which, beginning to draw together, grows gradually narrower for a third of its height, in the manner of a round pyramid, until it reaches the ball, upon which, as the final crown of the structure, goes the cross. Many particulars and minute details I might have mentioned, such as air-holes for protection against earthquakes, water-conduits, the various lights, and other conveniences, but I omit them because the work is not yet come to completion, being content to have touched on the principal parts as well as I have been able. For, since every part is in existence and can be seen, it is enough to have made this brief sketch, which is a great light to him who has no knowledge of the structure.

The completion of this model caused the greatest satisfaction not only to all his friends, but to all Rome, the form of the fabric

having been thus settled and established. It then came to pass that Paul IV died, and after him was elected Pius IV, who, while causing the building of the little palace in the wood of the Belvedere to be continued by Pirro Ligorio, who remained architect to the Palace, made many gracious offers and advances to Michelagnolo. The Motu-proprio originally received by Michelagnolo from Paul III, and then from Julius III and Paul IV, in respect of the fabric of S. Pietro, he confirmed in his favour, and he restored to him a part of the revenues and allowances taken away by Paul IV, employing him in many of his works of building; and in his time he caused the fabric of S. Pietro to be carried on vigorously. He made use of Michelagnolo, in particular, in preparing a design for the tomb of the Marchese Marignano, his brother, which, destined to be erected in the Duomo of Milan, was allotted by his Holiness to the Chevalier Leone Lioni of Arezzo, a most excellent sculptor and much the friend of Michelagnolo; the form of which tomb will be described in the proper place.

At this time the Chevalier Leone made a very lively portrait of Michelagnolo in a medal, and to please him he fashioned on the reverse a blind man led by a dog, with these letters around:

DOCEBO INIQUOS VIAS TUAS,
ET IMPII AD TE CONVERTENTUR.

And Michelagnolo, since it pleased him much, presented him a model in wax of Hercules crushing Antæus, by his own hand, with certain of his designs. Of Michelagnolo we have no other portraits but two in painting, one by the hand of Bugiardini and the other by Jacopo del Conte, one in bronze executed in full-relief by Daniello Ricciarelli, and this one by the Chevalier Leone; from which portraits so many copies have been made, that I have seen a good number in many places in Italy and in foreign parts.

The same year Cardinal Giovanni de' Medici, the son of Duke Cosimo, went to Rome to receive the hat from Pius IV, and it fell to Vasari, as his servant and familiar friend, to go with him; which Vasari went there willingly and stayed about a month, in order to enjoy Michelagnolo, who received him with great affection and was always with him. Vasari had taken with him, by order of his Excellency, a model in wood of the whole Ducal Palace of Florence, together with designs of the new apartments that had been built and painted by him; which Michelagnolo

desired to see both in the model and in the designs, since, being old, he was not able to see the works themselves. These works, which were abundant and well varied, with different inventions and fancies, began with the Castration of Uranus and continued in stories of Saturn, Ops, Ceres, Jove, Juno, and Hercules, each room having one of these names, with the stories in various compartments; even as the other chambers and halls, which were beneath these, had the names of the heroes of the House of Medici, beginning with the elder Cosimo, and continuing with Lorenzo, Leo X, Clement VII, Signor Giovanni, Duke Alessandro, and Duke Cosimo, in each of which were not only the stories of their actions, but also portraits of them, of their children, and of all the ancients renowned in statesmanship, in arms, and in letters, taken from the life. Of these Vasari had written a Dialogue in which he explained all the stories, the end of the whole invention, and how the fables above harmonized with the stories below; which was read to Michelagnolo by Annibale Caro, and he took the greatest pleasure in it. This Dialogue, when Vasari shall have more time, will be published.

The result of all this was as follows. Vasari was desirous of setting his hand to the Great Hall, and since, as has been said elsewhere, the ceiling was low, making it stunted and wanting in lights, he had a desire to raise that ceiling. Now the Duke would not make up his mind to give him leave that it should be raised; not that the Duke feared the cost, as was seen afterwards, but rather the danger of raising the beams of the roof thirteen braccia. However, like a man of judgment, his Excellency consented that the advice of Michelagnolo should be taken, and Michelagnolo, having seen in that model the Hall as it then was, and afterwards, all the beams having been removed and replaced by other beams with a new invention in the ceiling and walls, the same Hall as it has since been made, with the invention of the stories likewise designed therein, liked it and straightway became not a judge but a supporter, and the rather as he saw the facile method of raising the beams and the roof, and the plan for executing the whole work in a short time. Wherefore, on Vasari's return, he wrote to the Duke that he should carry out that undertaking, since it was worthy of his greatness.

The same year Duke Cosimo went to Rome with the Lady Duchess Leonora, his consort, and Michelagnolo, after the

Duke's arrival, went straightway to see him. The Duke, after receiving him with many endearments, caused him, out of respect for his great genius, to sit by his side, and with much familiarity talked to him of all that he had caused to be done in painting and sculpture at Florence, and also of all that he was minded to have done, and in particular of the Hall; and Michelagnolo again encouraged and reassured him in that matter, lamenting, since he loved that Lord, that he was not young enough to be able to serve him. His Excellency said that he had discovered the way to work porphyry, a thing which Michelagnolo could not believe, and the Duke therefore sent him, as has been related in the first chapter of the Treatise on Theory, the head of Christ wrought by the sculptor Francesco del Tadda, at which he was astonished; and he visited the Duke several times the while that he stayed in Rome, to his vast satisfaction. He did the same a short time afterwards when the most Illustrious Don Francesco de' Medici, the Duke's son, went there, in whom Michelagnolo took much delight from the marks of regard and affection shown to him by his most Illustrious Excellency, who spoke with him always cap in hand, having infinite reverence for so rare a man; and Michelagnolo wrote to Vasari that it vexed him to be old and infirm, for he would have liked to do something for that Lord, but he was going about trying to buy some beautiful antique to send to him in Florence.

Being requested at this time by the Pope for a design for the Porta Pia, Michelagnolo made three, all fantastic and most beautiful, of which the Pope chose the least costly for putting into execution; and it is now to be seen erected there, with much credit to him. Perceiving the inclination of the Pope, and hoping that he would restore the other gates of Rome, he made many other designs for him; and he did the like, at the request of the same Pontiff, in the matter of the new Church of S. Maria degli Angeli in the Baths of Diocletian, in order to convert them into a temple for the use of Christians. A design by his hand prevailed over many others made by excellent architects, being executed with such beautiful considerations for the convenience of the Carthusian Friars, who have now carried it almost to completion, that it caused his Holiness and all the prelates and lords of the Court to marvel at the judgment of the lovely conceptions that he had drawn, availing himself of all the skeleton of those baths, out of which was seen formed a most beautiful temple, with an

entrance surpassing the expectations of all the architects; from which he acquired infinite praise and honour. For that place, also, he designed for his Holiness a Ciborium of the Sacrament in bronze, cast for the most part by Maestro Jacopo Ciciliano, an excellent bronze-caster, who makes his works come out very delicate and fine, without any roughness, so that they can be polished with little labour; in which field he is a rare master, and gave much satisfaction to Michelagnolo.

The Florentine colony had often talked among themselves of giving a good beginning to the Church of S. Giovanni in the Strada Giulia. Finally, all the heads of the richest houses having assembled together, they each promised to contribute in due proportion according to their means towards that fabric, insomuch that they contrived to collect a good sum of money; and then it was discussed among them whether it were better to follow the old lines or to have something new and finer. It was determined that something new should be erected upon the old foundations, and finally they elected three men to have the charge of the fabric, who were Francesco Bandini, Uberto Ubaldini, and Tommaso de' Bardi; and these requested Michelagnolo for a design, recommending themselves to him on the ground that it was a disgrace to their colony to have thrown away so much money without any kind of profit, and that, if his genius did not avail to finish the work, they had no other resource. He promised them to do it, with as much lovingness as he had ever shown in any work in the past, because in this his old age he readily gave his attention to sacred things, such as might redound to the honour of God, and also from affection for his fellow-Florentines, whom he loved always. Michelagnolo had with him at this conference the Florentine sculptor Tiberio Calcagni, a young man very ardent to learn art, who, after going to Rome, had turned his mind to the study of architecture. Loving him, Michelagnolo had given him to finish, as has been related, the Pietà in marble that he had broken, and, in addition, a head of Brutus in marble with the breast, considerably larger than life, to the end that he might finish it. Of this the head alone was carved, with certain most minute gradines, and he had taken it from a portrait of Brutus cut in a very ancient cornelian that was in the possession of Signor Giuliano Cesarino; which Michelagnolo was doing for Cardinal Ridolfi at the entreaty of Messer Donato Giannotti, his very dear friend, and it is a rare work. Michelagnolo, then, in

matters of architecture, not being able by reason of old age to draw any more or to make accurate lines, was making use of Tiberio, because he was very gentle and discreet; and thus, desiring to avail himself of him in such an undertaking, he laid on him the charge of tracing the plan of the site of the above-named church. That plan having been traced and carried straightway to Michelagnolo, at a time when it was not thought that he was doing anything, he gave them to understand through Tiberio that he had carried out their wishes, and finally showed them five most beautiful ground-plans of temples; which having seen, they marvelled. He said to them that they should choose one that pleased them, and they, not wishing to do it, left the matter to his judgment, but he insisted that they should decide of their own free will; wherefore they all with one accord chose the richest. This having been adopted, Michelagnolo said to them that if they carried such a design to completion, neither the Greeks nor the Romans ever in their times executed such a work; words that neither before nor afterwards ever issued from the mouth of Michelagnolo, for he was very modest. Finally it was agreed that the direction should be left entirely to Michelagnolo, and that the labour of executing that work should fall to Tiberio; with all which they were content, Buonarroti promising them that Tiberio would serve them excellently well. And so, having given the ground-plan to Tiberio to be drawn accurately and with correct measurements, he drew for him the profiles both within and without, and bade him make a model of clay, teaching him the way to execute it so that it might stand firm. In ten days Tiberio executed a model of eight palms, which much pleased the whole Florentine colony, so that afterwards they caused to be made from it a model of wood, which is now in the residence of the Consuls of that colony; a thing as rare in its beauty, richness, and great variety, as any temple that has ever been seen. A beginning was made with the building, and five thousand crowns were spent; but the funds for the fabric failed, and so it was abandoned, at which Michelagnolo felt very great displeasure. He obtained for Tiberio the commission to finish under his direction, at S. Maria Maggiore, a chapel begun for Cardinal Santa Fiore; but it was left unfinished, on account of the death of the Cardinal, of Michelagnolo, and of Tiberio himself, the death of which young man was a very great loss.

Michelagnolo had been seventeen years in the fabric of

S. Pietro, and several times the deputies had tried to remove him from that position, but they had not succeeded, and they were seeking to oppose him in every matter now with one vexatious pretext and now with another, hoping that out of weariness, being now so old that he could do no more, he would retire before them. It happened in those days that Cesare da Castel Durante, who had been the overseer, died, and Michelagnolo, to the end that the fabric might not suffer, sent there Luigi Gaeta, who was too young but very competent, until he should find a man after his desire. The deputies (some of whom had many times made efforts to place there Nanni di Baccio Bigio, who was always urging them and promising great things), in order to be able to disturb the affairs of the fabric at their pleasure, sent Luigi Gaeta away, which having heard, Michelagnolo, as in anger, would no longer show himself at the fabric; whereupon they began to give out that he could do no more, that it was necessary to give him a substitute, and that he himself had said that he did not wish to be embroiled any longer with S. Pietro. All this came to the ears of Michelagnolo, who sent Daniello Ricciarelli of Volterra to Bishop Ferratino, one of the superintendents, who had said to the Cardinal of Carpi that Michelagnolo had told one of his servants that he did not wish to be mixed up with the fabric any longer; and Daniello said that this was by no means Michelagnolo's desire. Ferratino complained that Michelagnolo would not make his conception known, adding that it would be well for him to provide a substitute, and that he would have gladly accepted Daniello; and with this Michelagnolo appeared to be content. Thereupon Ferratino, having had the deputies informed in the name of Michelagnolo that they now had a substitute, presented not Daniello, but in his place Nanni di Baccio Bigio, who came in and was accepted by the superintendents. Before very long he gave orders to make a scaffolding of wood from the side of the Pope's stables, where the hill is, to rise above the great recess that is turned towards that side, and caused some stout beams of fir to be cut, saying that too many ropes were consumed in drawing up the materials, and that it was better to raise them by his method. Which having heard, Michelagnolo went straight to the Pope, who was on the Piazza di Campidoglio, and made so much noise that his Holiness made him go at once into a room, where he said: 'Holy Father, there has been appointed as my substitute by the deputies a man of whom I

know nothing; but if they are convinced, and also your Holiness, that I am no longer the proper man, I will return to rest in Florence, where I will enjoy the favours of that great Duke who has so long desired me, and will finish my life in my own house; I therefore beg your gracious leave.' The Pope was vexed at this, and, consoling him with kind words, ordained that he should come to speak with him on the following day at the Araceli. There, having caused the deputies of the fabric to be assembled together, he desired to be informed of the reasons of what had happened: whereupon their answer was that the fabric was going to ruin, and that errors were being made in it. Which having heard not to be the truth, the Pope commanded Signor Gabrio Scerbellone that he should go to see the fabric for himself, and that Nanni, who was making these assertions, should show it to him. This was carried out, and Signor Gabrio found that the whole story was a malicious slander, and not the truth; wherefore Nanni was dismissed from that fabric with no very flattering words in the presence of many lords, being also reproached that by his fault the bridge of Santa Maria fell into ruin, and that at Ancona, seeking to do great things at little cost in the matter of cleaning out the harbour, he filled it up more in one day than the sea had done in ten years. Such was the end of Nanni in the fabric of S. Pietro. For that work Michelagnolo for seventeen years attended constantly to nothing but to establishing it securely with directions, doubting on account of those envious persecutions lest it might come to be changed after his death; so that at the present day it is strong enough to allow the vaulting to be raised with perfect security. Thus it has been seen that God, who is the protector of the good, defended him as long as he lived, and worked for the benefit of the fabric and for the defence of the master until his death. Moreover, Pius IV, living after him, commanded the superintendents of the fabric that nothing of what Michelagnolo had directed should be changed; and with even greater authority his successor, Pius V, caused it to be carried out, who, lest disorder should arise, insisted that the designs made by Michelagnolo should be carried into execution with the utmost fidelity, so that, when the architects Pirro Ligorio and Jacopo Vignuola were in charge of it, and Pirro wished presumptuously to disturb and alter those directions, he was removed with little honour from that fabric, and only Vignuola remained. Finally, that Pontiff being full of zeal no less for the honour of

the fabric of S. Pietro than for the Christian religion, in the year 1565, when Vasari went to kiss the feet of his Holiness, and in the year 1566, when he was again summoned, nothing was discussed save the means to ensure the observing of the designs left by Michelagnolo; and his Holiness, in order to obviate all chance of disorder, commanded Vasari that he should go with Messer Guglielmo Sangalletti, the private treasurer of his Holiness, to seek out Bishop Ferratino, the head of the superintendents of S. Pietro, with orders from the Pontiff that he should listen to all the suggestions and records of importance that Vasari might impart to him, to the end that no words of any malignant and presumptuous person might ever cause to be disturbed any line or order left by the excellent genius of Michelagnolo of happy memory; and at that interview was present Messer Giovan Battista Altoviti, who was much the friend of Vasari and of these arts. And Ferratino, having heard a discourse that Vasari made to him, readily accepted every record, and promised to observe and to cause to be observed with the utmost fidelity in that fabric every order and design that Michelagnolo had left for that purpose, and, in addition, to be the protector, defender, and preserver of the labours of that great man.

But to return to Michelagnolo: I must relate that about a year before his death, Vasari secretly prevailed upon Duke Cosimo de' Medici to persuade the Pope by means of Messer Averardo Serristori, his Ambassador, that, since Michelagnolo was much reduced, a diligent watch should be kept on those who were about him to take care of him, or who visited him at his house, and that, in the event of some sudden accident happening to him, such as might well happen to an old man, he should make arrangements for his property, designs, cartoons, models, money, and all his other possessions at the time of his death, to be set down in an inventory and placed in security, for the sake of the fabric of S. Pietro, so that, if there were things pertaining to that fabric, and also to the sacristy, library, and façade of S. Lorenzo, they might not be taken away, as is often wont to happen; and in the end, all this being duly carried out, such diligence had its reward. Leonardo, the nephew of Michelagnolo, was desirous to go during the coming Lent to Rome, as one who guessed that he was now come to the end of his life; and at this Michelagnolo was content. When, therefore, he fell sick of a slow fever, he straightway caused Daniello to write to Leonardo that

he should come; but the illness grew worse, although Messer Federigo Donati, his physician, and his other attendants were about him, and with perfect consciousness he made his will in three sentences, leaving his soul in the hands of God, his body to the earth, and his substance to his nearest relatives, and enjoining on his friends that, at his passing from this life, they should recall to him the agony of Jesus Christ. And so at the twenty-third hour of the seventeenth day of February, in the year 1563 (after the Florentine reckoning, which according to the Roman would be 1564), he breathed his last, to go to a better life.

Michelagnolo was much inclined to the labours of art, seeing that everything, however difficult, succeeded with him, he having had from nature a genius very apt and ardent in these most noble arts of design. Moreover, in order to be entirely perfect, innumerable times he made anatomical studies, dissecting men's bodies in order to see the principles of their construction and the concatenation of the bones, muscles, veins, and nerves, the various movements and all the postures of the human body; and not of men only, but also of animals, and particularly of horses, which last he much delighted to keep. Of all these he desired to learn the principles and laws in so far as touched his art, and this knowledge he so demonstrated in the works that fell to him to handle, that those who attend to no other study than this do not know more. He so executed his works, whether with the brush or with the chisel, that they are almost inimitable, and he gave to his labours, as has been said, such art and grace, and a loveliness of such a kind, that (be it said without offence to any) he surpassed and vanquished the ancients; having been able to wrest things out of the greatest difficulties with such facility, that they do not appear wrought with effort, although whoever draws his works after him finds enough in imitating them.

The genius of Michelagnolo was recognized in his lifetime, and not, as happens to many, after death, for it has been seen that Julius II, Leo X, Clement VII, Paul III, Julius III, Paul IV, and Pius IV, all supreme Pontiffs, always wished to have him near them, and also, as is known, Suleiman, Emperor of the Turks, Francis of Valois, King of France, the Emperor Charles V, the Signoria of Venice, and finally, as has been related, Duke Cosimo de' Medici; all offering him honourable salaries, for no other reason but to avail themselves of his great genius. This does not happen save to men of great worth, such as he was; and it is

evident and well known that all these three arts were so perfected in him, that it is not found that among persons ancient or modern, in all the many years that the sun has been whirling round, God has granted this to any other but Michelagnolo. He had imagination of such a kind, and so perfect, and the things conceived by him in idea were such, that often, through not being able to express with the hands conceptions so terrible and grand, he abandoned his works – nay, destroyed many of them; and I know that a little before he died he burned a great number of designs, sketches, and cartoons made with his own hand, to the end that no one might see the labours endured by him and his methods of trying his genius, and that he might not appear less than perfect. Of such I have some by his hand, found in Florence, and placed in my book of drawings; from which, although the greatness of that brain is seen in them, it is evident that when he wished to bring forth Minerva from the head of Jove, he had to use Vulcan's hammer. Thus he used to make his figures in the proportion of nine, ten, and even twelve heads, seeking nought else but that in putting them all together there should be a certain harmony of grace in the whole, which nature does not present; saying that it was necessary to have the compasses in the eyes and not in the hand, because the hands work and the eye judges; which method he used also in architecture.

No one should think it strange that Michelagnolo delighted in solitude, he having been one who was enamoured of his art, which claims a man, with all his thoughts, for herself alone; moreover, it is necessary that he who wishes to attend to her studies should shun society, and, while attending to the considerations of art, he is never alone or without thoughts. And those who attributed it to caprice and eccentricity are wrong, because he who wishes to work well must withdraw himself from all cares and vexations, since art demands contemplation, solitude, and ease of life, and will not suffer the mind to wander. For all this, he prized the friendship of many great persons and of learned and ingenious men, at convenient times; and these he maintained. Thus the great Cardinal Ippolito de' Medici loved him greatly, and, having heard that a Turkish horse that he possessed pleased Michelagnolo because of its beauty, it was sent as a present to him by the liberality of that lord, with ten mules laden with fodder, and a serving-man to attend to it; and Michelagnolo accepted it willingly. The illustrious Cardinal Pole was much his

friend, Michelagnolo being enamoured of his goodness and his talents; also Cardinal Farnese, and Santa Croce, which latter afterwards became Pope Marcellus, Cardinal Ridolfi, Cardinal Maffeo, Monsignor Bembo, Carpi, and many other Cardinals, Bishops, and Prelates, whom it is not necessary to name. Others were Monsignor Claudio Tolomei, the Magnificent Messer Ottaviano de' Medici, his gossip, whose son he held at baptism, and Messer Bindo Altoviti, to whom he presented that cartoon of the Chapel in which Noah, drunk with wine, is derided by one of his sons, and his nakedness is covered by the two others; M. Lorenzo Ridolfi, M. Annibale Caro, and M. Giovan Francesco Lottini of Volterra. But infinitely more than any of the others he loved M. Tommaso de' Cavalieri, a Roman gentleman, for whom, being a young man and much inclined to these arts, he made, to the end that he might learn to draw, many most superb drawings of divinely beautiful heads, designed in black and red chalk; and then he drew for him a Ganymede rapt to Heaven by Jove's Eagle, a Tityus with the Vulture devouring his heart, the Chariot of the Sun falling with Phaëthon into the Po, and a Bacchanal of children, which are all in themselves most rare things, and drawings the like of which have never been seen. Michelagnolo made a life-size portrait of Messer Tommaso in a cartoon, and neither before nor afterwards did he take the portrait of anyone, because he abhorred executing a resemblance to the living subject, unless it were of extraordinary beauty. These drawings, on account of the great delight that M. Tommaso took in them, were the reason that he afterwards obtained a good number, miraculous things, which Michelagnolo once drew for Fra Sebastiano Viniziano, who carried them into execution; and in truth he rightly treasures them as reliques, and he has courteously given craftsmen access to them. Of a truth Michelagnolo always placed his affections with persons noble, deserving, and worthy of them, for he had true judgment and taste in all things.

M. Tommaso afterwards caused Michelagnolo to make many designs for friends, such as that of the picture for Cardinal di Cesis, wherein is Our Lady receiving the Annunciation from the Angel, a novel thing, which was afterwards executed in colours by Marcello Mantovano and placed in the marble chapel which that Cardinal caused to be built in the Church of the Pace at Rome. So, also, with another Annunciation coloured likewise by the hand of Marcello in a picture in the Church of S. Giovanni

Laterano, the design of which belongs to Duke Cosimo de' Medici, having been presented after Michelagnolo's death by his nephew Leonardo Buonarroti to his Excellency, who cherishes it as a jewel, together with a Christ praying in the Garden and many other designs, sketches, and cartoons by the hand of Michelagnolo, and likewise the statue of Victory with a captive beneath, five braccia in height, and four captives in the rough which serve to teach us how to carve figures from the marble by a method secure from any chance of spoiling the stone; which method is as follows. You take a figure in wax or some other solid material, and lay it horizontally in a vessel of water, which water being by its nature flat and level at the surface, as you raise the said figure little by little from the level, so it comes about that the more salient parts are revealed, while the lower parts – those, namely, on the under side of the figure – remain hidden, until in the end it all comes into view. In the same manner must figures be carved out of marble with the chisel, first laying bare the more salient parts, and then little by little the lower parts; and this method may be seen to have been followed by Michelagnolo in the above-mentioned captives, which his Excellency wishes to be used as exemplars for his Academicians.

Michelagnolo loved his fellow-craftsmen, and held intercourse with them, as with Jacopo Sansovino, Rosso, Pontormo, Daniello da Volterra, and Giorgio Vasari of Arezzo, to which last he showed innumerable kindnesses; and he was the reason that Giorgio gave his attention to architecture, intending to make use of him some day, and he readily conferred and discussed matters of art with him. Those who say that he was not willing to teach are wrong, because he was always willing with his intimates and with anyone who asked him for counsel; and I have been present on many such occasions, but of these, out of consideration, I say nothing, not wishing to reveal the deficiencies of others. It may be urged that he had bad fortune with those who lived with him in his house, which was because he hit upon natures little able to imitate him. Thus, Pietro Urbano of Pistoia, his pupil, was a man of parts, but would never exert himself. Antonio Mini was willing, but had no aptitude of brain; and when the wax is hard it does not readily take an impression. Ascanio dalla Ripa Transone took great pains, but of this no fruits were ever seen either in designs or in finished works, and he toiled several years over a picture for which Michelagnolo had given him a cartoon. In the

end, all the good expectation in which he was held vanished in smoke; and I remember that Michelagnolo would be seized with compassion for his toil, and would assist him with his own hand, but this profited him little. If he had found a nature after his heart, as he told me several times, in spite of his age he would often have made anatomical studies, and would have written upon them, for the benefit of his fellow-craftsmen; for he was disappointed by several. But he did not trust himself, through not being able to express himself in writing as he would have liked, because he was not practised in diction, although in the prose of his letters he explained his conceptions very well in a few words. He much delighted in readings of the poets in the vulgar tongue, and particularly of Dante, whom he much admired, imitating him in his conceptions and inventions; and so with Petrarca, having delighted to make madrigals and sonnets of great weight, upon which commentaries have been written. M. Benedetto Varchi gave a lecture in the Florentine Academy upon that sonnet which begins –

> Non ha l' ottimo artista alcun concetto
> Ch' un marmo solo in se non circonscriva.

Michelagnolo sent a vast number by his own hand – receiving answers in rhyme and in prose – to the most illustrious Marchioness of Pescara, of whose virtues he was enamoured, and she likewise of his; and she went many times to Rome from Viterbo to visit him, and Michelagnolo designed for her a Dead Christ in the lap of Our Lady, with two little Angels, all most admirable, and a Christ fixed on the Cross, who, with the head uplifted, is recommending His Spirit to the Father, a divine work; and also a Christ with the Woman of Samaria at the well. He much delighted in the sacred Scriptures, like the excellent Christian that he was; and he held in great veneration the works written by Fra Girolamo Savonarola, because he had heard the voice of that friar in the pulpit. He greatly loved human beauty for the sake of imitation in art, being able to select from the beautiful the most beautiful, for without this imitation no perfect work can be done; but not with lascivious and disgraceful thoughts, as he proved by his way of life, which was very frugal. Thus, when he was young, all intent on his work, he contented himself with a little bread and wine, and this he continued when old until the time when he was painting the Judgment in the Chapel, taking his refreshment

in the evening when he had finished the day's work, but always very frugally. And, although he was rich, he lived like a poor man, nor did any friend ever eat at his table, or rarely; and he would not accept presents from anyone, because it appeared to him that if anyone gave him something, he would be bound to him for ever. This sober life kept him very active and in want of very little sleep, and often during the night, not being able to sleep, he would rise to labour with the chisel; having made a cap of thick paper, and over the centre of his head he kept a lighted candle, which in this way threw light over where he was working without encumbering his hands. Vasari, who had seen the cap several times, reflecting that he did not use wax, but candles of pure goat's tallow, which are excellent, sent him four bundles of these, which weighed forty libbre. And his servant with all courtesy carried them to him at the second hour of the evening, and presented them to him; but Michelagnolo refused them, declaring that he did not want them; and then the servant said: 'They have broken my arms on the way between the bridge and here, and I shall not carry them back to the house. Now here in front of your door there is a solid heap of mud; they will stand in it beautifully, and I will set them all alight.' Michelagnolo said to him: 'Put them down here, for I will not have you playing pranks at my door.'

He told me that often in his youth he slept in his clothes, being weary with labour and not caring to take them off only to have to put them on again later. There are some who have taxed him with being avaricious, but they are mistaken, for both with works of art and with his substance he proved the contrary. Of works of art, as has been seen and related, he presented to M. Tommaso de' Cavalieri, to Messer Bindo, and to Fra Sebastiano, designs of considerable value; and to Antonio Mini, his pupil, all his designs, all his cartoons, and the picture of the Leda, and all the models in clay and wax that he ever made, which, as has been related, were all left in France. To Gherardo Perini, a Florentine gentleman who was very much his friend, he gave three sheets with some divine heads in black chalk, which since Perini's death have come into the hands of the most illustrious Don Francesco, Prince of Florence, who treasures them as jewels, as indeed they are; for Bartolommeo Bettini he made a cartoon, which he presented to him, of a Venus with a Cupid that is kissing her, a divine thing, which is now in the possession of Bettini's heirs in Florence, and for the Marchese del Vasto he

made a cartoon of a 'Noli me Tangere,' a rare thing; and these two last were painted excellently well by Pontormo, as has been related. He presented the two Captives to Signor Ruberto Strozzi, and the Pietà in marble, which he broke, to Antonio, his servant, and to Francesco Bandini. I know not, therefore, how this man can be taxed with avarice, he having given away so many things for which he could have obtained thousands of crowns. What better proof can I give than this, that I know from personal experience that he made many designs and went to see many pictures and buildings, without demanding any payment? But let us come to the money earned by him by the sweat of his brow, not from revenues, not from traffickings, but from his own study and labour. Can he be called avaricious who succoured many poor persons, as he did, and secretly married off a good number of girls, and enriched those who served him and assisted him in his works, as with his servant Urbino, whom he made a very rich man? This Urbino was his man of all work, and had served him a long time; and Michelagnolo said to him: 'If I die, what will you do?' And he answered: 'I will serve another master.' 'You poor creature,' said Michelagnolo, 'I will save you from such misery'; and presented two thousand crowns to him in one sum, an act such as is generally left to Cæsars and Pontiffs. To his nephew, moreover, he gave three and four thousand crowns at a time, and at the end he left him ten thousand crowns, besides the property in Rome.

Michelagnolo was a man of tenacious and profound memory, so that, on seeing the works of others only once, he remembered them perfectly, and could avail himself of them in such a manner, that scarcely anyone has ever noticed it; nor did he ever do anything that resembled another thing by his hand, because he remembered everything that he had done. In his youth, being once with his painter-friends, they played for a supper for him who should make a figure most completely wanting in design and clumsy, after the likeness of the puppet-figures which those make who know nothing, scrawling upon walls; and in this he availed himself of his memory, for he remembered having seen one of those absurdities on a wall, and drew it exactly as if he had had it before him, and thus surpassed all those painters – a thing difficult for a man so steeped in design, and accustomed to choice works, to come out of with credit. He was full of disdain, and rightly, against anyone who did him an injury, but he was never seen to run to take revenge; nay, rather, he was most

patient, modest in all his ways, very prudent and wise in his speech, with answers full of weight, and at times sayings most ingenious, amusing, and acute. He said many things that have been written down by me, of which I shall include only a few, because it would take too long to give them all. A friend having spoken to him of death, saying that it must grieve him much, because he had lived in continual labour in matters of art, and had never had any repose, he answered that all that was nothing, because, if life is a pleasure to us, death, being likewise by the hand of one and the same master, should not displease us. To a citizen who found him by Orsanmichele in Florence, where he had stopped to gaze at Donato's statue of S. Mark, and who asked him what he thought of that figure, Michelagnolo answered that he had never seen a figure that had more of the air of a good man than that one, and that, if S. Mark was like that, one could give credence to what he had written. Being shown the drawing of a boy then beginning to learn to draw, who was recommended to him, some persons excusing him because it was not long since he had applied himself to art, he replied: 'That is evident.' He said a similar thing to a painter who had painted a Pietà, and had not acquitted himself well: 'It is indeed a pitiful thing to see.' Having heard that Sebastiano Viniziano had to paint a friar in the chapel of S. Pietro a Montorio, he said that this would spoil the work for him; and being asked why he said that, he answered: 'Since they have spoiled the world, which is so large, it would not be surprising if they were to spoil such a small thing as that chapel.' A painter had executed a work with very great pains, toiling over it a long time; but when it was given to view he had made a considerable profit. Michelagnolo was asked what he thought of the craftsman, and he answered: 'As long as this man strives to be rich, he will always remain a poor creature.' One of his friends who was a churchman, and used formerly to say Mass, having arrived in Rome all covered with points and silk, saluted Michelagnolo; but he pretended not to see him, so that the friend was forced to declare his name to him. Michelagnolo expressed marvel that he should be in that habit, and then added, as it were to congratulate him: 'Oh, but you are magnificent! If you were as fine within as I see you to be without, it would be well with your soul.' The same man had recommended a friend to Michelagnolo (who had given him a statue to execute), praying him that he should have something more given to him, which Michelagnolo

graciously did; but the envy of the friend, who had made the request to Michelagnolo only in the belief that he would not grant it, brought it about that, perceiving that the master had granted it after all, he complained of it. This matter was reported to Michelagnolo, and he answered that he did not like men made like sewers, using a metaphor from architecture, and meaning that it is difficult to have dealings with men who have two mouths. Being asked by a friend what he thought of one who had counterfeited in marble some of the most celebrated antique figures, and boasted that in his imitations he had surpassed the antiques by a great measure, Michelagnolo replied: 'He who goes behind others can never go in front of them, and he who is not able to work well for himself cannot make good use of the works of others.' A certain painter, I know not who, had executed a work wherein was an ox, which looked better than any other part; and Michelagnolo, being asked why the painter had made the ox more lifelike than the rest, said: 'Any painter can make a good portrait of himself.' Passing by S. Giovanni in Florence, he was asked his opinion of those doors, and he answered: 'They are so beautiful that they would do well at the gates of Paradise.' While serving a Prince who kept changing plans every day, and would never stand firm, Michelagnolo said to a friend: 'This lord has a brain like a weather-cock, which turns round with every wind that blows on it.' He went to see a work of sculpture which was about to be sent out because it was finished, and the sculptor was taking much trouble to arrange the lights from the windows, to the end that it might show up well; whereupon Michelagnolo said to him: 'Do not trouble yourself; the important thing will be the light of the Piazza'; meaning to infer that when works are in public places, the people must judge whether they are good or bad. There was a great Prince in Rome who had a notion to play the architect, and he had caused certain niches to be built in which to place figures, each three squares high, with a ring at the top; and having tried to place various statues within these niches, which did not turn out well, he asked Michelagnolo what he should place in them, and he answered: 'Hang bunches of eels from those rings.' There was appointed to the government of the fabric of S. Pietro a gentleman who professed to understand Vitruvius, and to be a critic of the work done. Michelagnolo was told, 'You have obtained for the fabric one who has a great intelligence'; and he answered, 'That is true, but he has a bad judgment.' A painter

had executed a scene, and had copied many things from various other works, both drawings and pictures, nor was there anything in that work that was not copied. It was shown to Michelagnolo, who, having seen it, was asked by a very dear friend what he thought of it, and he replied: 'He has done well, but I know not what this scene will do on the day of Judgment, when all bodies shall recover their members, for there will be nothing left of it' – a warning to those who practise art, that they should make a habit of working by themselves. Passing through Modena, he saw many beautiful figures by the hand of Maestro Antonio Bigarino,* a sculptor of Modena, made of terracotta and coloured in imitation of marble, which appeared to him to be excellent works; and, since that sculptor did not know how to work marble, Michelagnolo said: 'If this clay were to become marble, woe to the ancient statues.' Michelagnolo was told that he should show resentment against Nanni di Baccio Bigio, who was seeking every day to compete with him; but he answered: 'He who contends with men of no account never gains a victory.' A priest, his friend, said to him: 'It is a pity that you have not taken a wife, so that you might have had many children and left them all your honourable labours.' And Michelagnolo replied: 'I have only too much of a wife in this art of mine, who has always kept me in tribulation, and my children shall be the works that I may leave, which, even if they are naught, will live a while. Woe to Lorenzo di Bartoluccio Ghiberti, if he had not made the gates of S. Giovanni, for his children and grandchildren sold or squandered all that he left, but the gates are still standing.' Vasari, sent by Julius III to Michelagnolo's house for a design at the first hour of the night, found him working at the Pietà in marble that he broke. Michelagnolo, recognizing him by the knock at the door, left his work and took a lamp with his hand by the handle; Vasari explained what he wanted, whereupon Michelagnolo sent Urbino upstairs for the design, and then they entered into another conversation. Meanwhile Vasari turned his eyes to examine a leg of the Christ at which he was working, seeking to change it; and, in order to prevent Vasari from seeing it, he let the lamp fall from his hand, and they were left in darkness. He called to Urbino to bring a light, and meanwhile came forth from the enclosure where the work was, and said: 'I am so old that death often pulls

* Begarelli.

me by the cloak, that I may go with him, and one day this body of mine will fall like the lamp, and the light of my life will be spent.'

For all this, he took pleasure in certain kinds of men after his taste, such as Menighella, a commonplace and clownish painter of Valdarno, who was a most diverting person. He would come at times to Michelagnolo, that he might make for him a design of S. Rocco or S. Anthony, to be painted for peasants; and Michelagnolo, who was with difficulty persuaded to work for Kings, would deign to set aside all his other work and make him simple designs suited to his manner and his wishes, as Menighella himself used to say. Among other things, Menighella persuaded him to make a model of a Crucifix, which was very beautiful; of this he made a mould, from which he formed copies in pasteboard and other materials, and these he went about selling throughout the countryside. Michelagnolo would burst out laughing at him, particularly because he used to meet with fine adventures, as with a countryman who commissioned him to paint a S. Francis, and was displeased because Menighella had made the vestment grey, whereas he would have liked it of a finer colour; whereupon Menighella painted over the Saint's shoulders a pluvial of brocade, and so contented him.

He loved, likewise, the stonecutter Topolino, who had a notion of being an able sculptor, but was in truth very feeble. This man spent many years in the mountains of Carrara, sending marble to Michelagnolo; nor would he ever send a boatload without adding to it three or four little figures blocked out with his own hand, at which Michelagnolo would die of laughing. Finally Topolino returned, and, having blocked out a Mercury from a piece of marble, he set himself to finish it; and one day, when there was little left to do, he desired that Michelagnolo should see it, and straitly besought him that he should tell him his opinion. 'You are a madman to try to make figures, Topolino,' said Michelagnolo. 'Do you not see that your Mercury is more than a third of a braccio too short between the knees and the feet, and that you have made him a dwarf and all misshapen?' 'Oh, that is nothing! If there is nothing else wrong, I will put it right; leave it to me.' Michelagnolo laughed once more at his simplicity; and when he was gone, Topolino took a piece of marble, and, having cut the Mercury a quarter of a braccio below the knees, he let it into the new piece of marble and joined it neatly together, making

a pair of buskins for the Mercury, the tops of which were above the joins; and so he added the length required. Then he invited Michelagnolo to come, and showed him his work once again; and the master laughed, marvelling that such simpletons, when driven by necessity, form resolutions of which able men are not capable.

While Michelagnolo was having the tomb of Julius II finished, he caused a marble-hewer to execute a terminal figure for placing in the tomb in S. Pietro in Vincula, saying to him, 'Cut away this to-day,' 'Level that,' 'Polish here'; insomuch that, without the other noticing it, he enabled him to make a figure. Wherefore, when it was finished, the man gazed at it marvelling; and Michelagnolo said: 'What do you think of it?' 'I think it fine,' he answered, 'and I am much obliged to you.' 'Why so?' asked Michelagnolo. 'Because by your means I have discovered a talent that I did not know I possessed.'

Now, to be brief, I must record that the master's constitution was very sound, for he was lean and well knit together with nerves, and although as a boy he was delicate, and as a man he had two serious illnesses, he could always endure any fatigue and had no infirmity, save that in his old age he suffered from dysuria and from gravel, which in the end developed into the stone; wherefore for many years he was syringed by the hand of Maestro Realdo Colombo, his very dear friend, who treated him with great diligence. He was of middle stature, broad in the shoulders, but well proportioned in all the rest of the body. In his latter years he wore buskins of dogskin on the legs, next to the skin, constantly for whole months together, so that afterwards, when he sought to take them off, on drawing them off the skin often came away with them. Over the stockings he wore boots of cordwain fastened on the inside, as a protection against damp. His face was round, the brow square and spacious, with seven straight lines, and the temples projected considerably beyond the ears; which ears were somewhat on the large side, and stood out from the cheeks. The body was in proportion to the face, or rather on the large side; the nose somewhat flattened, as was said in the Life of Torrigiano, who broke it for him with his fist; the eyes rather on the small side, of the colour of horn, spotted with blueish and yellowish gleams; the eyebrows with few hairs, the lips thin, with the lower lip rather thicker and projecting a little, the chin well shaped and in proportion with the rest, the hair black, but mingled with white hairs,

like the beard, which was not very long, forked, and not very thick.

Truly his coming was to the world, as I said at the beginning, an exemplar sent by God to the men of our arts, to the end that they might learn from his life the nature of noble character, and from his works what true and excellent craftsmen ought to be. And I, who have to praise God for infinite blessings, as is seldom wont to happen with men of our profession, count it among the greatest blessings that I was born at the time when Michelagnolo was alive, that I was thought worthy to have him as my master, and that he was so much my friend and intimate, as everyone knows, and as the letters written by him to me, now in my possession, bear witness; and out of love for truth, and also from the obligation that I feel to his loving kindness, I have contrived to write many things of him, and all true, which many others have not been able to do. Another blessing he used to point out to me himself: 'You should thank God, Giorgio, who has caused you to serve Duke Cosimo, who, in his contentment that you should build and paint and carry into execution his conceptions and designs, has grudged no expense; and you will remember, if you consider it, that the others whose Lives you have written did not have such advantages.'

With most honourable obsequies, and with a concourse of all the craftsmen, all his friends, and all the Florentine colony, Michelagnolo was given burial in a sepulchre at S. Apostolo, in the sight of all Rome; his Holiness having intended to make him some particular memorial and tomb in S. Pietro at Rome. Leonardo, his nephew, arrived when all was over, although he travelled post. When Duke Cosimo was informed of the event, he confirmed his resolve that since he had not been able to have him and honour him alive, he would have him brought to Florence and not hesitate to honour him with all manner of pomp after death; and the body was sent secretly in a bale, under the title of merchandise, which method was adopted lest there might be a tumult in Rome, and lest perchance the body of Michelagnolo might be detained and prevented from leaving Rome for Florence. But before the body arrived, the news of the death having been heard, the principal painters, sculptors, and architects were assembled together at the summons of the Lieutenant of their Academy, and they were reminded by that Lieutenant, who at that time was the Reverend Don Vincenzio Borghini, that they were obliged by virtue of their statutes to

pay due honour to the death of any of their brethren, and that, they having done this so lovingly and with such universal satisfaction in the obsequies of Fra Giovanni Agnolo Montorsoli, who had been the first to die after the creation of the Academy, they should look well to what it might be proper for them to do in honour of Buonarroti, who had been elected by an unanimous vote of the whole body of the Company as the first Academician and the head of them all. To which proposal they all replied, as men most deeply indebted and affected to the genius of so great a man, that at all costs pains should be taken to do him honour in the best and finest ways available to them. This done, in order not to have to assemble so many persons together every day, to their great inconvenience, and to the end that matters might proceed more quietly, four men were elected as heads of the obsequies and the funeral pomp that were to be held; the painters Agnolo Bronzino and Giorgio Vasari, and the sculptors Benvenuto Cellini and Bartolommeo Ammanati, all men of illustrious name and eminent ability in their arts; to the end, I say, that they might consult and determine between themselves and the Lieutenant what was to be done in each particular, and in what way, with authority and power to dispose of the whole body of the Company and Academy. This charge they accepted all the more willingly because all the members, young and old, each in his own profession, offered their services for the execution of such pictures and statues as had to be done for that funeral pomp. They then ordained that the Lieutenant, in pursuance of his office, and the Consuls, in the name of the Company and Academy, should lay the whole matter before the Lord Duke, and beseech him for all the aids and favours that might be necessary, and especially for permission to have those obsequies held in S. Lorenzo, the church of the most illustrious House of Medici; wherein are the greater part of the works by the hand of Michelagnolo that there are to be seen in Florence; and, in addition, that his Excellency should allow Messer Benedetto Varchi to compose and deliver the funeral oration, to the end that the excellent genius of Michelagnolo might be extolled by the rare eloquence of a man so great as was Varchi, who, being in the particular service of his Excellency, would not have undertaken such a charge without a word from him, although they were very certain that, as one most loving by nature and deeply affected to the memory of Michelagnolo, of himself he would never have refused. This done, and the Academicians dismissed, the

above-named Lieutenant wrote to the Lord Duke a letter of this precise tenor:

'The Academy and Company of Painters and Sculptors having resolved among themselves, if it should please your most illustrious Excellency, to do honour in some sort to the memory of Michelagnolo Buonarroti, both from the general obligation due from their profession to the extraordinary genius of one who was perhaps the greatest craftsman who has ever lived, and from their particular obligation through their belonging to a common country, and also because of the great advantage that these professions have received from the perfection of his works and inventions, insomuch that they hold themselves obliged to prove their affection to his genius in whatever way they are able, they have laid this their desire before your illustrious Excellency in a letter, and have besought you, as their peculiar refuge, for a certain measure of assistance. I, entreated by them, and being, as I think, obliged because your most illustrious Excellency has been content that I should be again this year in their Company with the title of your Lieutenant, with the added reason that the proposal is a generous one and worthy of virtuous and grateful minds, and, above all, knowing how your most illustrious Excellency is the patron of talent, and as it were a haven and unique protector for ingenious persons in this age, even surpassing in this respect your forefathers, who bestowed extraordinary favours on those excellent in these professions, as, by order of the Magnificent Lorenzo, Giotto, already so long dead, received a statue in the principal church, and Fra Filippo a most beautiful tomb of marble at his expense, while many others obtained the greatest benefits and honours on various occasions; moved, I say, by all these reasons, I have taken it upon myself to recommend to your most illustrious Excellency the petition of this Academy, that they may be able to do honour to the genius of Michelagnolo, the particular nursling and pupil of the school of the Magnificent Lorenzo, which will be an extraordinary pleasure to them, a vast satisfaction to men in general, no small incitement to the professors of these arts, and to all Italy a proof of the lofty mind and overflowing goodness of your most illustrious Excellency, whom may God long preserve in happiness for the benefit of your people and the support of every talent.'

To which letter the above-named Lord Duke answered thus:

'REVEREND AND WELL-BELOVED FRIEND,

'The zeal that this Academy has displayed, and continues to display, to honour the memory of Michelagnolo Buonarroti, who has passed from this to a better life, has given us much consolation for the loss of a man so extraordinary; and we wish not only to satisfy them in all that they have demanded in their memorial, but also to have his remains brought to Florence, which, according as we are informed, was his own desire. All this we are writing to the aforesaid Academy, to encourage them to celebrate by every possible means the genius of that great man. May God content you in your desire.'

Of the letter, or rather, memorial, of which mention has been made above, addressed by the Academy to the Lord Duke, the tenor was as follows:

'MOST ILLUSTRIOUS, ETC.

'The Academy and the Men of the Company of Design, created by the grace and favour of your most illustrious Excellency, knowing with what solicitude and affection you caused the body of Michelagnolo Buonarroti to be brought to Florence by means of your representative in Rome, have assembled together and have unanimously determined that they shall celebrate his obsequies in the best manner in their power and knowledge. Wherefore they, knowing that your most illustrious Excellency was revered by him as much as you yourself loved him, beseech you that you should deign in your infinite goodness and liberality to grant to them, first, that they may be allowed to celebrate the said obsequies in the Church of S. Lorenzo, a church built by your ancestors, in which are so many beautiful works wrought by his hand, both in architecture and in sculpture, and near which you are minded to have erected a place that shall be as it were a nest and an abiding school of architecture, sculpture, and painting, for the above-named Academy and Company of Design. Secondly, they pray you that you should consent to grant a commission to Messer Benedetto Varchi that he shall not only compose the funeral oration, but also deliver it with his own mouth, as he has promised most freely that he would do, when besought by us, in the event of your most illustrious Excellency consenting. In the third place, they entreat and pray you that you should deign, in the same goodness and liberality of your heart,

to supply them with all that may be necessary for them in celebrating the above-mentioned obsequies, over and above their own resources, which are very small. All these matters, and each singly, have been discussed and determined in the presence and with the consent of the most Magnificent and Reverend Monsignor, Messer Vincenzio Borghini, Prior of the Innocenti and Lieutenant of your most illustrious Excellency in the aforesaid Academy and Company of Design, which, etc.'

To which letter of the Academy the Duke made this reply:

'WELL-BELOVED ACADEMICIANS,

'We are well content to give full satisfaction to your petitions, so great is the affection that we have always borne to the rare genius of Michelagnolo Buonarroti, and that we still bear to all your profession; do not hesitate, therefore, to carry out all that you have proposed to do in his obsequies, for we will not fail to supply whatever you need. Meanwhile, we have written to Messer Benedetto Varchi in the matter of the oration, and to the Director of the Hospital with regard to anything more that may be necessary in this undertaking. Fare you well.

'PISA.'

The letter to Varchi was as follows:

'MESSER BENEDETTO, OUR WELL-BELOVED,

'The affection that we bear to the rare genius of Michelagnolo Buonarroti makes us desire that his memory should be honoured and celebrated in every possible way. It will be pleasing to us, therefore, that you for love of us shall undertake the charge of composing the oration that is to be delivered at his obsequies, according to the arrangements made by the deputies of the Academy; and still more pleasing that it should be delivered by your own lips. Fare you well.'

Messer Bernardino Grazzini, also, wrote to the above-named deputies that they could not have expected in the Duke any desire in that matter more ardent than that which he had shown, and that they might be assured of every aid and favour from his most illustrious Excellency.

While these matters were being discussed in Florence,

Leonardo Buonarroti, Michelagnolo's nephew (who, when informed of his uncle's illness, had made his way to Rome by post, but had not found him alive), having heard from Daniello da Volterra, who had been the very familiar friend of Michelagnolo, and also from others who had been about the person of that saintly old man, that he had requested and prayed that his body should be carried to Florence, that most noble city of his birth, of which he was always a most tender lover; Leonardo, I say, with prompt and therefore good resolution, removed the body cautiously from Rome and sent it off to Florence in a bale, as if it had been a piece of merchandise. And here I must not omit to say that this final resolution of Michelagnolo's proved a thing against the opinion of certain persons, but nevertheless very true, namely, that his absence for so many years from Florence had been caused by no other thing but the nature of the air, for the reason that experience had taught him that the air of Florence, being sharp and subtle, was very injurious to his constitution, while that of Rome, softer and more temperate, had kept him in perfect health up to his ninetieth year, with all the senses as lively and sound as they had ever been, and with such strength, for his age, that up to the last day he had never ceased to work at something.

Since, then, the coming of the bale was so sudden and so unexpected that for the time being it was not possible to do what was done afterwards, the body of Michelagnolo, on arriving in Florence, was placed with the coffin, at the desire of the deputies, on the same day that it arrived in the city (namely, on the 11th of March, which was a Saturday), in the Company of the Assumption, which is under the high-altar of S. Pietro Maggiore, beneath the steps at the back; but it was not touched in any way whatever. The next day, which was Sunday of the second week in Lent, all the painters, sculptors, and architects assembled as quietly as possible round S. Pietro, whither they had brought nothing but a pall of velvet, all bordered and embroidered in gold, which covered the coffin and the whole bier; upon which coffin was an image of Christ Crucified. Then, about the middle hour of the night, all having gathered around the body, all at once the oldest and most eminent craftsmen laid their hands on a great quantity of torches that had been carried there, and the younger men took up the bier with such eagerness, that blessed was he who could approach it and place his shoulders under it, believing as it were that in the time to come they would be able to claim

the glory of having borne the remains of the greatest man that there had ever been in their arts. The sight of a certain number of persons assembled about S. Pietro had caused, as always happens in such cases, many others to stop there, and the rather as it had been trumpeted abroad that the body of Michelagnolo had arrived, and was to be carried to S. Croce. And although, as I have said, every precaution had been taken that the matter should not become known, lest the report might spread through the city, and there might flock thither such a multitude that it would not be possible to avoid a certain degree of tumult and confusion, and also because they desired that the little which they wished to do at that time should be done with more quiet than pomp, reserving the rest for a more convenient time with greater leisure; nevertheless, both the one thing and the other took a contrary course, for with regard to the multitude, the news, as has been related, passing from lip to lip, in the twinkling of an eye the church was so filled, that in the end it was with the greatest difficulty that the body was carried from the church to the sacristy, in order to take it out of the bale and then place it in the sepulchre. With regard to the question of honour, although it cannot be denied that to see in funeral pomps a great show of priests, a large quantity of wax tapers, and a great number of mourners dressed in black, is a thing of grand and magnificent appearance, it does not follow that it was not also a great thing to see thus assembled in a small company, without preparation, all those eminent men who are now in such repute, and who will be even more in the future, honouring that body with such loving and affectionate offices. And, in truth, the number of such craftsmen in Florence – and they were all there – has always been very great, for the reason that these arts have always flourished in Florence in such a manner, that I believe that it may be said without prejudice to other cities that their principal and true nest and domicile is Florence, not otherwise than Athens once was of the sciences. In addition to that number of craftsmen, there were so many citizens following them, and so many at the sides of the streets where the procession passed, that there was no place for any more; and, what is an even greater thing, there was nothing heard but praises in every man's mouth of the merits of Michelagnolo, all saying that true genius has such force that, after all expectation of such honour and profit as can be obtained from a gifted man has failed, nevertheless, by its own nature and peculiar merits, it remains honoured and beloved. For

these reasons that demonstration was more vivid in effect and more precious than any pomp of gold and trappings that could have been contrived.

The body having been carried with so beautiful a train into S. Croce, after the friars had finished the ceremonies that were customary for the dead, it was borne – not without very great difficulty, as has been related, by reason of the concourse of people – into the sacristy, where the above-named Lieutenant, who had been present in virtue of his office, thinking to do a thing pleasing to many, and also (as he afterwards confessed) desiring to see in death one whom he had not seen in life, or had seen at such an early age that he had lost all memory of him, then resolved to have the coffin opened. This done, when he and all the rest of us present thought to find the body already marred and putrefied, because Michelagnolo had been dead twenty-five days and twenty-two in the coffin, we found it so perfect in every part, and so free from any noisome odour, that we were ready to believe that it was rather at rest in a sweet and most peaceful sleep; and, besides that the features of the face were exactly as in life (except that there was something of the colour of death), it had no member that was marred or revealed any corruption, and the head and cheeks were not otherwise to the touch than as if he had passed away but a few hours before.

When the tumult of the people had abated, arrangements were made to place the body in a sepulchre in the church, beside the altar of the Cavalcanti, by the door that leads into the cloister of the chapter-house. Meanwhile the news had spread through the city, and such a multitude of young people flocked thither to see the corpse, that there was great difficulty in contriving to close the tomb; and if it had been day, instead of night, we would have been forced to leave it open many hours in order to satisfy the public. The following morning, while the painters and sculptors were commencing to make arrangements for the memorial of honour, many choice spirits, such as have always abounded in Florence, began to attach above the aforesaid sepulchre verses both Latin and in the vulgar tongue, and so it was continued for some time; but those compositions that were printed at that time were but a small part with respect to the many that were written.

Now to come to the obsequies, which were not held the day after the day of S. John, as had been intended, but were postponed until the 14th of July. The three deputies (for Benvenuto

Cellini, having felt somewhat indisposed from the beginning, had never taken any part in the matter), having appointed the sculptor Zanobi Lastricati as their proveditor, resolved that they would do something ingenious and worthy of their arts rather than costly and full of pomp. And, in truth, since honour was to be paid (said those deputies and their proveditor) to such a man as Michelagnolo, and by men of the profession that he had practised, men rich rather in talents than in excess of means, that must be done not with regal pomp or superfluous vanities, but with inventions and works abounding in spirit and loveliness, such as issue from the knowledge and readiness of hand of our craftsmen; thus honouring art with art. For although, they said, we may expect from his Excellency the Lord Duke any sum of money that may be necessary, and we have already received such amounts as we have demanded, nevertheless we must hold it as certain that from us there is expected something ingenious and pleasing in invention and art, rather than rich through vast expense or grand by reason of superb appurtenances. But, notwithstanding this, it was seen in the end that the work was equal in magnificence to any that ever issued from the hands of those Academicians, and that this memorial of honour was no less truly magnificent than it was ingenious and full of fanciful and praiseworthy inventions.

Finally, then, it was arranged that in the central nave of S. Lorenzo, between the two lateral doors, of which one leads out of the church and the other into the cloister, there should be erected, as was done, a catafalque of a rectangular form, twenty-eight braccia high, eleven braccia long, and nine broad, with a figure of Fame on the summit. On the base of the catafalque, which rose two braccia from the ground, on the part looking towards the principal door of the church, there were placed two most beautiful recumbent figures of Rivers, one representing the Arno and the other the Tiber. Arno had a horn of plenty, full of flowers and fruits, signifying thereby the fruits that have come to these professions from the city of Florence, which have been of such a kind and so many that they have filled the world, and particularly Rome, with extraordinary beauty. This was demonstrated excellently well by the other River, representing, as has been said, the Tiber, in that, extending one arm, it had the hands full of flowers and fruits received from the horn of plenty of the Arno, which lay beside it, face to face; and it served also to demonstrate, by enjoying the fruits of Arno, that Michelagnolo

had lived a great part of his life in Rome, and had executed there those marvels that cause amazement to the world. Arno had for a sign the Lion, and Tiber the She-Wolf, with the infants Romulus and Remus; and they were both colossal Wgures of extraordinary grandeur and beauty, in the likeness of marble. One, the Tiber, was by the hand of Giovanni di Benedetto of Castello, a pupil of Bandinelli, and the other by Battista di Benedetto, a pupil of Ammanati; both excellent young men of the highest promise.

From this level rose façades of five braccia and a half, with the proper cornices above and below, and also at the corners, leaving space for four pictures, one in the centre of each. In the first of these, which was on the façade where the two Rivers were, there was painted in chiaroscuro (as were also all the other pictures of this structure) the Magnificent Lorenzo de' Medici, the Elder, receiving Michelagnolo as a boy in his garden, of which there has been an account in another place, after he had seen certain specimens of his handiwork, which foreshadowed, as early flowers, the fruits that afterwards issued in abundance from the living force and grandeur of his genius. Such, then, was the story contained in that picture, which was painted by Mirabello and Girolamo del Crocifissaio, so called, who, as very dear friends and companions, undertook to do the work together. In it were animated and lively attitudes, and there could be seen the above-named Magnificent Lorenzo, portrayed from nature, graciously receiving Michelagnolo, a boy all full of reverence, into his garden, and, after an examination, handing him over to some masters who should teach him.

In the second scene, which came, continuing the same order, to face towards the lateral door that leads out of the church, was figured Pope Clement, who, contrary to the expectation of the public, which thought that his Holiness felt disdain against Michelagnolo on account of his actions in the siege of Florence, not only assures his safety and shows himself lovingly disposed towards him, but sets him to work on the new sacristy and the library of S. Lorenzo, in which places how divinely well he worked has been already told. In this picture, then, there was painted by the hand of Federigo Fiammingo, called Del Padovano, with much dexterity and great sweetness of manner, Michelagnolo showing to the Pope the ground-plan of that sacristy, and behind him were borne, partly by little Angels and partly by other figures, the models of the library and sacristy and of the statues

that are there, finished, at the present day; which was all very well composed and executed with diligence.

In the third picture, which stood on the first level, like the others described above, and looked towards the high-altar, was a great Latin epitaph composed by the most learned M. Pier Vettori, the sense of which was in the Florentine speech as follows:

'The Academy of Painters, Sculptors, and Architects, with the favour and assistance of Duke Cosimo de' Medici, their head and the supreme protector of these arts, admiring the extraordinary genius of Michelagnolo Buonarroti, and seeking to acknowledge in part the benefits received from his divine works, has dedicated this memorial, born from their own hands and from all the affection of their hearts, to the excellence and genius of the greatest painter, sculptor, and architect that there has ever been.'

The Latin words were these:

COLLEGIUM PICTORUM, STATUARIORUM, ARCHITECTORUM, AUSPICIO OPEQUE SIBI PROMPTA COSIMI DUCIS AUCTORIS SUORUM COMMODORUM, SUSPICIENS SINGULAREM VIRTUTEM MICHAELIS ANGELI BONARROTÆ, INTELLIGENSQUE QUANTO SIBI AUXILIO SEMPER FUERINT PRÆCLARA IPSIUS OPERA, STUDUIT SE GRATUM ERGA ILLUM OSTENDERE, SUMMUM OMNIUM QUI UNQUAM FUERINT P.S.A., IDEOQUE MONUMENTUM HOC SUIS MANIBUS EXTRUCTUM MAGNO ANIMI ARDORE IPSIUS MEMORIÆ DEDICAVIT.

This epitaph was supported by two little Angels, who, with weeping faces, and extinguishing each a torch, appeared to be lamenting that a genius so great and so rare was now spent.

Next, in the picture which came to face towards the door that leads into the cloister, was Michelagnolo making, on account of the siege of Florence, the fortifications of the hill of San Miniato, which were held to be impregnable and a marvellous work. This was by the hand of Lorenzo Sciorini, a pupil of Bronzino and a young man of excellent promise.

This lowest part, or, so to speak, the base of the whole structure, had at every corner a pedestal that projected, and upon every pedestal was a statue larger than life, which had beneath it another, as it were subjugated and vanquished, of similar size, but each constrained in a different and extravagant attitude. The first,

on the right hand going towards the high-altar, was a young man, slender and the very presentment of pure spirit, and of a most lively beauty, representing Genius, with two little wings over the temples, in the guise wherein at times Mercury is painted; and beneath this young man, wrought with incredible diligence, was a marvellous figure with asses' ears, representing Ignorance, the mortal enemy of Genius. These two statues were by the hand of Vincenzio Danti of Perugia, of whom and of his works, which are renowned among the young modern sculptors, we shall speak at greater length in another place.

Upon the next pedestal, which, being on the right hand of the approach towards the high-altar, looked towards the new sacristy, was a woman representing Christian Piety, which, being composed of religion and every other excellence, is nothing less than an aggregate of all those virtues that we have called the Theological, and of those that were named by the Gentiles the Moral; wherefore it was right that, since the genius of a Christian, adorned by most saintly character, was being celebrated by Christians, a seemly and honourable place should be given to this Piety, which is concerned with the law of God and the salvation of souls, seeing that all other ornaments of body and mind, where she is lacking, are to be held in little estimation, or rather, none. This figure, who had beneath her, prostrate and trampled under foot by her, Vice, or rather, Impiety, was by the hand of Valerio Cioli, who is a young man of ability and fine spirit, and deserves the name of a very judicious and diligent sculptor. Opposite to this, on the side towards the old sacristy, was another similar figure made with much judgment to represent Minerva, or rather, Art; for the reason that it may be said with truth that after excellence of character and life, which must always hold the first place among the good, it was Art that gave to this man not only honour and profit, but also so much glory, that he may be said to have enjoyed in his lifetime such fruits as able and illustrious men have great difficulty in wresting even after death from the grasp of Fame, by means of their finest works; and, what is more, that he so vanquished envy, that by common consent, without any contradiction, he has obtained the rank and fame of the best and highest excellence. And for this reason this figure had beneath her feet Envy, who was an old woman lean and withered, with the eyes of a viper; in short, with features that all breathed out venom and poison, besides which she was girt with serpents,

and had a viper in her hand. These two statues were by the hand of a boy of very tender years, called Lazzaro Calamech of Carrara, who at the present day, although still a mere lad, has given in some works of painting and sculpture convincing proofs of a beautiful and most lively genius. By the hand of Andrea Calamech, the uncle of the above-mentioned Lazzaro, and pupil of Ammanati, were the two statues placed upon the fourth pedestal, which was opposite to the organ and looked towards the principal doors of the church. The first of these was made to represent Study, for the reason that those who exert themselves little and sluggishly can never acquire repute, as Michelagnolo did, who from his early boyhood, from fifteen to ninety years of age, as has been seen above, never ceased to labour. This statue of Study, which was well in keeping with that great man, was a bold and vigorous youth, who had at the end of the arms, just above the joint of the hands, two little wings signifying rapidity and frequency of working; and he had prostrate beneath him, as a prisoner, Idleness or Indolence, who was a sluggish and weary woman, heavy and somnolent in her whole attitude.

These four figures, disposed in the manner that has been described, made a very handsome and magnificent composition, and had all the appearance of marble, because a coat of white had been laid over the clay, which resulted in a very beautiful effect. From this level, upon which the above-named figures rested, there rose another base, likewise rectangular and about four braccia high, but smaller in length and breadth than that below by the extent of the projection and cornice-work upon which those figures rested; and on every side this had a painted compartment six braccia and a half in length and three in height. Above this rose a platform in the same manner as that below, but smaller; and upon every corner, on the projection of a socle, sat a figure of the size of life, or rather more. These were four women, who, from the instruments that they had, were easily recognized as Painting, Sculpture, Architecture, and Poetry; placed there for reasons that have been perceived in the narration of Michelagnolo's Life.

Now, going from the principal door of the church towards the high-altar, in the first picture of the second range of the catafalque – namely, above the scene in which, as has been related, Lorenzo de' Medici is receiving Michelagnolo into his garden – there was painted in a most beautiful manner, to suggest Architecture,

Michelagnolo in the presence of Pope Pius IV, with a model in his hand of the stupendous pile of the Cupola of S. Pietro in Rome. This scene, which was much extolled, was painted by Piero Francia, a Florentine painter, with beautiful manner and invention; and the statue, or rather, image of Architecture, which was on the left hand of this scene, was by the hand of Giovanni di Benedetto of Castello, who with so much credit to himself, as has been related, executed also the Tiber, one of the two Rivers that were on the front part of the catafalque. In the second picture, continuing to go forward on the right hand towards the lateral door that leads out of the church, was seen (to suggest Painting) Michelagnolo painting that so much but never sufficiently extolled Judgment: that Judgment, I mean, which is an exemplar in foreshortenings and all the other difficulties of art. This picture, which was executed by Michele di Ridolfo's young men with much diligence and grace, had likewise, on the left hand (namely, at the corner looking towards the new sacristy), its appropriate image, a statue of Painting, wrought by Battista del Cavaliere, a young man no less excellent in sculpture than remarkable for his goodness, modesty, and character. In the third picture, facing towards the high-altar (in that, namely, which was above the epitaph already mentioned), there was to be seen, to suggest Sculpture, Michelagnolo speaking with a woman, who by many signs could be recognized as Sculpture; and it appeared that he was taking counsel with her. Michelagnolo had about him some of the most excellent works that he executed in sculpture; and the woman held a little tablet with these words of Boethius:

SIMILI SUB IMAGINE FORMANS.

Beside that picture, which was the work of Andrea del Minga, and executed by him with beautiful invention and manner, there was on the left hand the statue of Sculpture, wrought very well by the sculptor Antonio di Gino Lorenzi. In the fourth of those four scenes, which faced towards the organ, there could be seen, to suggest Poetry, Michelagnolo all intent on writing some composition, and about him the Nine Muses, marvellous in their grace and beauty and with their distinctive garments, according as they are described by the poets, and before them Apollo with the lyre in his hand, his crown of laurel on his head, and another crown in the hand, which he made as if to place on the head of Michelagnolo. Near the gladsome and beautiful composition

of this scene, painted in a very lovely manner, with most vivacious and spirited attitudes, by Giovan Maria Butteri, there was on the left hand the statue of Poetry, the work of Domenico Poggini, a man much practised not only in sculpture and in striking impressions of coins and medals with great beauty, but also in working in bronze and likewise in poetry.

Of such a kind, then, was the ornamentation of the catafalque, which so diminished from course to course that it was possible to walk round each, and it was much after the likeness of the Mausoleum of Augustus in Rome; although perchance, from being rectangular, it rather resembled the Septizonium of Severus, not that near the Campidoglio, which is commonly so called in error, but the true one, which is to be seen in stamp in the 'Nuove Rome,' near the Baths of Antoninus. Up to this point the catafalque had three levels; where the Rivers lay was the first, the second where the pairs of figures rested, and the third where the single figures had their feet. From this last level rose a base, or rather, socle, one braccio high, and much less in length and breadth than that last level; upon the projections of that base sat the above-named single figures, and around it could be read these words:

SIC ARS EXTOLLITUR ARTE.

Upon this base stood a pyramid nine braccia high, on two sides of which (namely, that which looked towards the principal door, and that which faced towards the high-altar), at the foot, were two ovals with the head of Michelagnolo portrayed from nature in relief and executed very well by Santi Buglioni. At the summit of the pyramid was a ball in due proportion with the pyramid, such as might have contained the ashes of him who was being honoured, and upon the ball was a figure of Fame, larger than life and in the likeness of marble, and in the act, as it were, of taking flight, and at the same time of causing the praises and glory of that great craftsman to resound throughout the world through a trumpet which branched into three mouths. That Fame was by the hand of Zanobi Lastricati, who, besides the labours that he had as proveditor for the whole work, desired also not to fail to show, with much honour to himself, the virtue of his hand and brain. In all, from the level of the ground to the head of the Fame, the height, as has been related, was twenty-eight braccia.

Besides the catafalque described above, the whole church was draped with black baize and serge, hung not on the columns in

the centre, as is usual, but on the chapels that are all around; and there was no space between the pilasters that enclose those chapels and correspond to the columns, that had not some adornment in painting, which, making an ingenious, pleasing, and beautiful display, caused marvel and at the same time the greatest delight.

Now, to begin with one end: in the space of the first chapel that is beside the high-altar, as you go towards the old sacristy, was a picture six braccia in height and eight in length, in which, with novel and as it were poetical invention, was Michelagnolo in the centre, already come to the Elysian fields, where, on his right hand, were figures considerably larger than life of the most famous and most highly celebrated sculptors and painters of antiquity. Each of these could be recognized by some notable sign; Praxiteles by the Satyr that is in the Vigna of Pope Julius III, Apelles by the portrait of Alexander the Great, Zeuxis by a little panel on which were figured the grapes that deceived the birds, and Parrhasius with the covering counterfeited in painting over his picture; and, even as these, so the others were known by other signs. On the left hand were those who have been illustrious in these arts in our own centuries, from Cimabue to the present day. Thus Giotto could be recognized there by a little panel on which was seen the portrait of Dante as a young man, in the manner in which he may be seen in S. Croce, painted by Giotto himself; Masaccio by his portrait from life, Donatello likewise by his portrait, and also by his Zuccone from the Campanile, which was by his side, and Filippo Brunelleschi by the representation of his Cupola of S. Maria del Fiore; and there were portrayed from life, without other signs, Fra Filippo, Taddeo Gaddi, Paolo Uccello, Fra Giovanni Agnolo, Jacopo da Pontormo, Francesco Salviati, and others. All these were about him with the same expressions of welcome as the ancients, full of love and admiration, in the same manner as Virgil was received by the other poets on his return, according to the fable of the divine poet Dante, from whom, in addition to the invention, there was taken also the verse that could be read in a scroll both above and in the hand of the River Arno, which lay at the feet of Michelagnolo, most beautiful in features and in attitude:

TUTTI L'AMMIRAN, TUTTI ONOR GLI FANNO.

This picture, by the hand of Alessandro Allori, the pupil of

Bronzino, an excellent painter and a not unworthy disciple and pupil of so great a master, was consummately extolled by all those who saw it. In the space of the Chapel of the most holy Sacrament, at the head of the transept, there was in a picture, five braccia in length and four in breadth, Michelagnolo with all the school of the arts about him, little children, boys, and young men of every age up to twenty-four, who were offering to him, as to a being sacred and divine, the firstfruits of their labours, such as pictures, sculptures, and models; and he was receiving them courteously, and was instructing them in the matters of art, while they were listening most intently and gazing upon him with expressions and attitudes truly full of beauty and grace. And, to tell the truth, the whole composition of this picture could not have been, in a certain sense, better done, nor could anything more beautiful have been desired in any of the figures, wherefore Battista, the pupil of Pontormo, who had done the work, received infinite praise for it; and the verses that were to be read at the foot of the scene, ran thus:

TU PATER, TU RERUM INVENTOR, TU PATRIA NOBIS
SUPPEDITAS PRÆCEPTA TUIS EX, INCLYTE, CHARTIS.

Going, then, from the place where was the picture described above, towards the principal doors of the church, almost at the corner and just before arriving at the organ, in a picture six braccia long and four high that was in the space of a chapel, there was depicted the extraordinary and unexampled favour that was paid to the rare genius of Michelagnolo by Pope Julius III, who, wishing to avail himself in certain buildings of the judgment of that great man, had him summoned to his presence at his villa, where, having invited him to sit by his side, they talked a good time together, while Cardinals, Bishops, and other personages of the Court, whom they had about them, remained constantly standing. This event, I say, was seen to have been depicted with such fine composition and so much relief, and with such liveliness and spirit in the figures, that perchance it might not have turned out better from the hands of an eminent, aged, and well-practised master; wherefore Jacopo Zucchi, a young man, the pupil of Giorgio Vasari, who executed the work in a beautiful manner, proved that a most honourable result could be expected from him. Not far from this, on the same side (namely, a little below the organ), Giovanni Strada, an able Flemish painter, had

depicted in a picture six braccia long and four high the story of Michelagnolo's going to Venice at the time of the siege of Florence; where, living in that quarter of that most noble city which is called the Giudecca, the Doge Andrea Gritti and the Signoria sent some gentlemen and others to visit him and make him very great offers. In representing that event the above-named painter showed great judgment and much knowledge, which did him great honour, both in the whole composition and in every part of it, for in the attitudes, the lively expressions of the faces, and the movements of every figure, were seen invention, design, and excellent grace.

Now, returning to the high-altar, and facing towards the new sacristy: in the first picture found there, which came in the space of the first chapel, there was depicted by the hand of Santi Titi, a young man of most beautiful judgment and much practised in painting both in Florence and in Rome, another signal favour paid to the genius of Michelagnolo, as I believe I mentioned above, by the most illustrious Lord, Don Francesco de' Medici, Prince of Florence, who, happening to be in Rome about three years before Michelagnolo died, and receiving a visit from him, the moment that Buonarroti entered the Prince rose to his feet, and then, in order to do honour to that great man and to his truly venerable age, with the greatest courtesy that ever young Prince showed, insisted – although Michelagnolo, who was very modest, protested against it – that he should sit in his own chair, from which he had risen, standing afterwards on his feet to hear him with the attention and reverence that children are wont to pay to a well-beloved father. At the feet of the Prince was a boy, executed with great diligence, who had in his hands a mazzocchio,* or Ducal cap, and around them were some soldiers dressed in ancient fashion, and painted with much spirit and a beautiful manner; but beyond all the rest, most beautifully wrought, most lifelike and most natural were the Prince and Michelagnolo, insomuch that it appeared as if the old man were in truth speaking, and the young man most intently listening to his words.

In another picture, nine braccia in height and twelve in length, which was opposite to the Chapel of the Sacrament, Bernardo Timante Buontalenti, a painter much beloved and favoured by the most illustrious Prince, had figured with most beautiful inven-

* See note on p. 282, Vol. I.

tion the Rivers of the three principal parts of the world, come, as it were, all grieving and sorrowful, to lament with Arno on their common loss and to console him; and these Rivers were the Nile, the Ganges, and the Po. The Nile had as a symbol a crocodile, and, to signify the fertility of his country, a garland of ears of corn; the Ganges, a gryphon-bird and a chaplet of gems; the Po, a swan and a crown of black amber. These Rivers, having been conducted into Tuscany by the Fame, who was to be seen on high, as it were in flight, were standing round Arno, who was crowned with cypress and held his vase, drained empty, uplifted with one hand, and in the other a branch of cypress, and beneath him was a lion. And, to signify that the soul of Michelagnolo had flown to the highest felicity in Heaven, the judicious painter had depicted in the air a Splendour representing the celestial light, towards which the blessed soul, in the form of a little Angel, was winging its way; with this lyric verse:

VIVENS ORBE PETO LAUDIBUS ÆTHERA.

At the sides, upon two bases, were two figures in the act of holding open a curtain within which, so it appeared, were the above-named Rivers, the soul of Michelagnolo, and the Fame; and each of those two figures had another beneath it. That which was on the right hand of the Rivers, representing Vulcan, had a torch in the hand; and the figure representing Hatred, which had the neck under Vulcan's feet in an attitude of great constraint, and as it were struggling to writhe free, had as symbol a vulture, with this verse:

SURGERE QUID PROPERAS ODIUM CRUDELE? JACETO.

And that because things superhuman, and almost divine, should in no way be regarded with envy or hatred. The other, representing Aglaia, one of the Three Graces and wife of Vulcan, to signify Proportion, had in her hand a lily, both because flowers are dedicated to the Graces, and also because the lily is held to be not inappropriate to the rites of death. The figure which was lying beneath Aglaia, and which was painted to represent Disproportion, had as symbol a monkey, or rather, ape, and above her this verse:

VIVUS ET EXTINCTUS DOCUIT SIC STERNERE TURPE.

And under the Rivers were these two other verses:

VENIMUS, ARNE, TUO CONFIXA IN VULNERE MŒSTA
FLUMINA, UT EREPTUM MUNDO PLOREMUS HONOREM.

This picture was held to be very beautiful in the invention, in the composition of the whole scene and the loveliness of the figures, and in the beauty of the verses, and because the painter honoured Michelagnolo with this his labour, not by commission, but spontaneously and with such assistance as his own merit enabled him to obtain from his courteous and honourable friends; and for this reason he deserved to be even more highly commended.

In another picture, six braccia in length and four in height, near the lateral door that leads out of the church, Tommaso da San Friano, a young painter of much ability, had painted Michelagnolo as Ambassador of his country at the Court of Pope Julius II; as we have related that he went, and for what reasons, sent by Soderini. Not far distant from the above-named picture (namely, a little below that lateral door which leads out of the church), in another picture of the same size, Stefano Pieri, a pupil of Bronzino and a young man of great diligence and industry, had painted a scene that had in truth happened several times in Rome not long before – namely, Michelagnolo seated in a room by the side of the most illustrious Lord Duke Cosimo, who stood conversing with him; of all which enough has been said above.

Over the said black draperies with which, as has been told, the whole church was hung all round, wherever there were no painted scenes or pictures, there were in each of the spaces of the chapels images of death, devices, and other suchlike things, all different from those that are generally made, and very fanciful and beautiful. Some of these, as it were lamenting that they had been forced to deprive the world of such a man, had these words in a scroll:

COEGIT DURA NECESSITAS.

And near them was a globe of the world, from which had sprung a lily, which had three flowers and was broken in the middle, executed with most beautiful fantasy and invention by the above-named Alessandro Allori. There were other Deaths, also, depicted with other inventions, but that one was most extolled upon whose neck, as she lay prostrate on the ground, Eternity, with a palm in the hand, had planted one of her feet, and, regarding her with a look of disdain, appeared to be saying to her: 'Be it necessity or

thy will, thou hast done nothing, for in spite of thee, come what may, Michelagnolo shall live.' The motto ran thus:

VICIT INCLYTA VIRTUS.

And all this was the invention of Vasari.

I will not omit to say that each of these Deaths had on either side the device of Michelagnolo, which was three crowns, or rather, three circlets, intertwined together in such a manner, that the circumference of one passed through the centre of the two others, and so with each; which sign Michelagnolo used either to suggest that the three professions of sculpture, painting, and architecture are interwoven one with another and so bound together, that each of them receives benefit and adornment from the others, and they neither can nor should be separated; or, indeed, being a man of lofty genius, he may have had a more subtle meaning. But the Academicians, considering him to have been perfect in all these three professions, and that each of these had assisted and embellished the other, changed his three circlets into three crowns intertwined together, with the motto:

TERGEMINIS TOLLIT HONORIBUS.

Which was intended to signify that in those three professions the crown of human perfection was justly due to him.

On the pulpit from which Varchi delivered the funeral oration, which was afterwards printed, there was no ornamentation, because, that work having been executed in bronze, with scenes in half-relief and low-relief, by the excellent Donatello, any adornment that might have been added to it would have been by a great measure less beautiful. But on the other, which is opposite to the first, although it had not yet been raised on the columns, there was a picture, four braccia in height and little more than two in width, wherein there was painted with beautiful invention and excellent design, to represent Fame, or rather, Honour, a young man in a most beautiful attitude, with a trumpet in the right hand, and with the feet planted on Time and Death, in order to show that fame and honour, in spite of death and time, preserve alive to all eternity those who have laboured valiantly in this life. This picture was by the hand of Vincenzio Danti, the sculptor of Perugia, of whom we have spoken, and will speak again elsewhere.

The church having been embellished in such a manner,

adorned with lights, and filled with a countless multitude, for everyone had left every other care and flocked together to such an honourable spectacle, there entered behind the above-named Lieutenant of the Academy, accompanied by the Captain and Halberdiers of the Duke's Guard, the Consuls and the Academicians, and, in short, all the painters, sculptors, and architects of Florence. After all these had sat down between the catafalque and the high-altar, where they had been awaited for a good while by an infinite number of lords and gentlemen, who had been accommodated with seats according to the rank of each, there was begun a most solemn Mass for the dead, with music and ceremonies of every kind. Which finished, Varchi mounted the above-mentioned pulpit, who had never performed such an office since he did it for the most illustrious Lady Duchess of Ferrara, the daughter of Duke Cosimo; and there, with that elegance, those modes of utterance, and that voice which were the peculiar attributes of that great man in oratory, he recounted the praises and merits, life and works of the divine Michelagnolo Buonarroti.

Of a truth, what great good fortune it was for Michelagnolo that he did not die before our Academy was created, whereby his funeral rites were celebrated with so much honour and such magnificent and honourable pomp! So, also, it must be considered most fortunate for him that it happened that he passed from this to an eternal and most blessed life before Varchi, seeing that he could not have been extolled by any more eloquent and learned man. That funeral oration by M. Benedetto Varchi was printed a short time afterwards, as was also, not long after that, another equally beautiful oration, likewise in praise of Michelagnolo and of painting, composed by the most noble and most learned M. Leonardo Salviati, at that time a young man of about twenty-two years of age, and of a rare and happy genius in all manner of compositions, both Latin and Tuscan, as is known even now, and will be better known in the future, to all the world. And what shall I say, what can I say, that would not be too little, of the capacity, goodness, and wisdom of the very reverend Lord Lieutenant, the above-named Don Vincenzio Borghini? Save that it was with him as their chief, their guide, and their counsellor, that the eminent men of the Academy and Company of Design celebrated those obsequies; for the reason that, although each of them was competent to do much more in his art than he did, nevertheless no enterprise is ever carried to a perfect and praise-

worthy end save when one single man, in the manner of an experienced pilot and captain, has authority and power over all others. And since it was not possible that the whole city should see that funeral pomp in one day, by order of the Duke it was all left standing many weeks, for the satisfaction of his people and of the strangers who came from neighbouring places to see it.

We shall not give in this place the great multitude of epitaphs and verses, both Latin and Tuscan, composed by many able men in honour of Michelagnolo; both because they would require a work to themselves, and because they have been written down and published by other writers elsewhere. But I will not omit to say in this last part, that after all the honours described above the Duke ordained that an honourable place should be given to Michelagnolo for his tomb in S. Croce, in which church he had purposed in his lifetime to be buried, because the sepulchre of his ancestors was there. And to Leonardo, the nephew of Michelagnolo, his Excellency gave all the marbles, both white and variegated, for that tomb, which was allotted to Battista Lorenzi, an able sculptor, to execute after the design of Giorgio Vasari, together with the head of Michelagnolo. And since there are to be three statues there, Painting, Sculpture, and Architecture, one of these was allotted to the above-named Battista, one to Giovanni dell' Opera, and the last to Valerio Cioli, Florentine sculptors; which statues are in process of being fashioned together with the tomb, and soon they will be seen finished and set in their places. The cost, over and above the marbles received from the Duke, has been borne by the same Leonardo Buonarroti. But his Excellency, in order not to fail in any respect in doing honour to that great man, will cause to be placed in the Duomo, as he has previously thought to do, a memorial with his name, besides the head, even as there are to be seen there the names and images of the other eminent Florentines.

FRANCESCO PRIMATICCIO, Painter and Architect of Bologna, and Abbot of S. Martin

HAVING treated hitherto of such of our craftsmen as are no longer alive among us – of those, namely, who have lived from 1200 until this year of 1567 – and having set Michelagnolo

Buonarroti in the last place for many reasons, although two or three have died later than he, I have thought that it cannot be otherwise than a praiseworthy labour to make mention likewise in this our work of many noble craftsmen who are alive, and, for their merits, most worthy to be highly extolled and to be numbered among these last masters. This I do all the more willingly because they are all very much my friends and brothers, and the three most eminent are already so far advanced in years, that, having come to the furthest limit of old age, little more can be expected from them, although they still continue by a sort of habit to occupy themselves with some work. After these I will also make brief mention of those who under their discipline have become such, that they hold the first places among the craftsmen of our own day; and of others who in like manner are advancing towards perfection in our arts.

Beginning, then, with Francesco Primaticcio, to go on afterwards to Tiziano Vecelli and Jacopo Sansovino: I have to record that the said Francesco, born in Bologna of the noble family of the Primaticci, much celebrated by Fra Leandro Alberti and by Pontano, was apprenticed in his early boyhood to commerce. But, that calling pleasing him little, not long afterwards, being exalted in mind and spirit, he set himself to practise design, to which he felt himself inclined by nature; and so, giving his attention to drawing, and at times to painting, no long time passed before he gave proof that he was likely to achieve an excellent result. Going afterwards to Mantua, where at that time Giulio Romano was working at the Palace of the Te for Duke Federigo, he employed such interest that he was set, in company with many other young men who were with Giulio, to labour at that work. There, attending to the studies of art with much industry and diligence for a period of six years, he learned very well to handle colours and to work in stucco; wherefore, among all the other young men who were labouring in the work of that Palace, Francesco came to be held one of the most excellent, and the best of all at drawing and colouring. This may be seen in a great chamber, round which he made two friezes of stucco, one above the other, with a great abundance of figures that represent the ancient Roman soldiery; and in the same Palace, likewise, he executed many works in painting that are to be seen there, after the designs of the above-named Giulio. Through these works Primaticcio came into such favour with that Duke, that, when

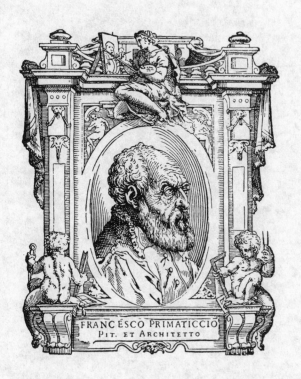

FRANCESCO PRIMATICCIO
Pit. et Architetto

King Francis of France heard with what quantity of ornaments he had caused the work of the Palace to be executed, and wrote to him that at all costs he should send him a young man able to work in painting and stucco, the Duke sent him Francesco Primaticcio, in the year 1531. And although the year before that the Florentine painter Rosso had gone into the service of the same King, as has been related, and had executed many works there, and in particular the pictures of Bacchus and Venus, Psyche and Cupid, nevertheless the first works in stucco that were done in France, and the first labours in fresco of any account, had their origin, it is said, from Primaticcio, who decorated in this manner many chambers, halls, and loggie for that King.

Liking the manner of this painter, and his procedure in every matter, the King sent him in the year 1540 to Rome, to contrive to obtain certain antique marbles; in which Primaticcio served him with such diligence, that in a short time, what with heads, torsi, and figures, he bought one hundred and twenty-five pieces. And at that same time he caused to be moulded by Jacopo Barozzi of Vignuola, and by others, the bronze horse that is on the Campidoglio, a great part of the scenes on the Column, the statue of Commodus, the Venus, the Laocoon, the Tiber, the Nile, and the statue of Cleopatra, which are in the Belvedere; to the end that they might all be cast in bronze. Rosso having meanwhile died in France, and a long gallery therefore remaining unfinished which had been begun after his designs and in great part adorned with stucco-work and pictures, Primaticcio was recalled from Rome; whereupon he took ship with the above-mentioned marbles and moulds of antique figures, and returned to France. There, before any other thing, he cast according to those moulds and forms a great part of those antique figures, which came out so well, that they might be the originals; as may be seen in the Queen's garden at Fontainebleau, where they were placed, to the vast satisfaction of that King, who made in that place, one might say, another Rome. I will not omit to say that Primaticcio, in executing those statues, employed masters so excellent in the art of casting, that those works came out not only light, but with a surface so smooth, that it was hardly necessary to polish them.

This work done, Primaticcio was commissioned to give completion to the gallery that Rosso had left unfinished; whereupon he set his hand to it, and in a short time delivered it finished with as many works in stucco and painting as have ever been executed

in any place. Wherefore the King, finding that he had been well served in the period of eight years that this master had worked for him, had him placed among the number of his chamberlains; and a short time afterwards, which was in the year 1544, he made him Abbot of S. Martin, considering that Francesco deserved no less. But for all this Francesco has never ceased to have many works in stucco and in painting executed in the service of his King and of the others who have governed that kingdom after Francis I. Among others who have assisted him in this, he has been served, to say nothing of many of his fellow-Bolognese, by Giovan Battista, the son of Bartolommeo Bagnacavallo, who has proved not less able than his father in many scenes and other works of Primaticcio's that he has carried into execution. Another who has served him for a considerable time is one Ruggieri da Bologna, who is still with him. In like manner, Prospero Fontana, a painter of Bologna, was summoned to France not long since by Primaticcio, who intended to make use of him; but, having fallen ill to the danger of his life immediately after his arrival, he returned to Bologna. To tell the truth, these two, Bagnacavallo and Fontana, are able men, and I, who have made considerable use both of the one and of the other, of the first at Rome, and of the second at Rimini and Florence, can declare this with certainty. But of all those who have assisted the Abbot Primaticcio, none has done him more honour than Niccolò da Modena, of whom mention has been made on another occasion, for by the excellence of his art this master has surpassed all the others. Thus he executed with his own hand, after the designs of the Abbot, a hall called the Ball-room, with such a vast number of figures, that it appears scarcely possible that they could be counted, and all as large as life and coloured in so bright a manner, that in the harmony of the fresco-colours they appear like work in oils. After this work he painted in the Great Gallery, likewise from the designs of the Abbot, sixty stories of the life and actions of Ulysses, but with a colouring much darker than the pictures in the Ball-room. This came about because he used no other colours but the earths in the pure state in which they are produced by Nature, without mixing with them, it may be said, any white, and so heavily loaded with darks in the deep parts, that these have extraordinary relief and force; besides which, he executed the whole work with such harmony, that it appears almost as if painted in one and the same day. Wherefore

he merits extraordinary praise, particularly because he executed it in fresco, without ever retouching it 'a secco,' as many at the present day are accustomed to do. The vaulting of this gallery, likewise, is all wrought in stucco and painting, executed with much diligence by the men mentioned above and other young painters, but still after the designs of the Abbot; as is also the old Hall, and likewise a lower gallery that is over the pond, which is most beautiful and better adorned with lovely works than any other part of that place; but to attempt to speak of it at any length would make too long a story.

At Meudon the same Abbot Primaticcio has made innumerable decorations for the Cardinal of Lorraine in a vast palace belonging to him, called the Grotto, a place so extraordinary in size, that, after the likeness of similar edifices of the ancients, it might be called the Thermæ, by reason of the vast number and grandeur of the loggie, staircases, and apartments, both public and private, that are there; and, to say nothing of other particulars, most beautiful is a room called the Pavilion, for it is all adorned with compartments and mouldings of stucco that are wrought with a view to being seen from below, and filled with a number of figures foreshortened in the same manner, which are very beautiful. Beneath this, then, is a large room with some fountains wrought in stucco, and full of figures in the round and compartments formed of shells and other products of the sea and natural objects, which are marvellous things and beautiful beyond measure; and the vaulting, likewise, is all most excellently wrought in stucco by the hand of Domenico del Barbiere, a Florentine painter, who is excellent not only in this kind of relief, but also in design, so that in some works that he has coloured he has given proofs of the rarest ability. In the same place, also, many figures of stucco in the round have been executed by a sculptor likewise of our country, called Ponzio, who has acquitted himself very well. But, since the works that have been executed in those places in the service of those lords are innumerable in their variety, I must touch only on the principal works of the Abbot, in order to show how rare he is in painting, in design, and in matters of architecture; although, in truth, it would not appear to me an excessive labour to enlarge on the particular works, if I had some true and clear information about them, as I have about works here. With regard to design, Primaticcio has been and still is most excellent, as may be seen from a drawing by his hand

painted with the signs of the heavens, which is in our book, sent to me by Francesco himself; and I, both for love of him and because it is a thing of absolute perfection, hold it very dear.

King Francis being dead, the Abbot remained in the same place and rank with King Henry, and served him as long as he lived; and afterwards he was created by King Francis II Commissary-General over all the buildings of the whole kingdom, in which office, one of great honour and much repute, there had previously acted the father of Cardinal della Bordagiera and Monseigneur de Villeroy. Since the death of Francis II, he has continued in the same office, serving the present King, by whose order and that of the Queen-Mother Primaticcio has made a beginning with the tomb of the above-named King Henry, making in the centre of a six-sided chapel the sepulchre of the King himself, and at four sides the sepulchres of his four children; while at one of the other two sides of the chapel is the altar, and at the other the door. And since there are going into this work innumerable statues in marble and bronzes and a number of scenes in low-relief, it will prove worthy of all these great Kings and of the excellence and genius of so rare a craftsman as is this Abbot of S. Martin, who in his best years has been most excellent and versatile in all things that pertain to our arts, seeing that he has occupied himself in the service of his lords not only in buildings, paintings, and stucco-work, but also in the preparations for many festivals and masquerades, with most beautiful and fantastic inventions.

He has been very liberal and most loving towards his friends and relatives, and likewise towards the craftsmen who have served him. In Bologna he has conferred many benefits on his relatives, and has bought honourable dwellings for them and made them commodious and very ornate, as is that wherein there now lives M. Antonio Anselmi, who has for wife one of the nieces of our Abbot Primaticcio, who has also given in marriage another niece, the sister of the first-named, with honour and a good dowry. Primaticcio has always lived not like a painter and craftsman, but like a nobleman, and, as I have said, he has been very loving towards our craftsmen. When, as has been related, he sent for Prospero Fontana, he despatched to him a good sum of money, to the end that he might be able to make his way to France. This sum, having fallen ill, Prospero was not able to pay back or return by means of his works and labours; wherefore I,

passing in the year 1563 through Bologna, recommended Prospero to him in this matter, and such was the courtesy of Primaticcio, that before I departed from Bologna I saw a writing by the hand of the Abbot in which he made a free gift to Prospero of all that sum of money which he had in hand for that purpose. For which reasons the affection that he has won among craftsmen is such, that they address and honour him as a father.

Now, to say something more of Prospero, I must record that he was once employed with much credit to himself in Rome, by Pope Julius III, at his Palace, at the Vigna Giulia, and at the Palace of the Campo Marzio, which at that time belonged to Signor Balduino Monti, and now belongs to the Lord Cardinal Ernando de' Medici, the son of Duke Cosimo. In Bologna the same master has executed many works in oils and in fresco, and in particular an altar-piece in oils in the Madonna del Baracane, of a S. Catherine who is disputing with philosophers and doctors in the presence of the Tyrant, which is held to be a very beautiful work. And the same Prospero has painted many pictures in fresco in the principal chapel of the Palace where the Governor lives.

Much the friend of Primaticcio, likewise, is Lorenzo Sabatini, an excellent painter; and if he had not been burdened with a wife and many children, the Abbot would have taken him to France, knowing that he has a very good manner and great mastery in all kinds of work, as may be seen from many things that he has done in Bologna. And in the year 1566 Vasari made use of him in the festive preparations that were carried out in Florence for the above-mentioned nuptials of the Prince and her serene Highness Queen Joanna of Austria, causing him to execute, in the vestibule that is between the Sala dei Dugento and the Great Hall, six figures in fresco that are very beautiful and truly worthy to be praised. But since this able painter is constantly making progress, I shall say nothing more about him, save that, attending as he does to the studies of art, a most honourable result is expected from him.

Now, in connection with the Abbot and the other Bolognese of whom mention has been made hitherto, I shall say something of Pellegrino Bolognese, a painter of the highest promise and most beautiful genius. This Pellegrino, after having attended in his early years to drawing the works by Vasari that are in the refectory of S. Michele in Bosco at Bologna, and those by other

painters of good name, went in the year 1547 to Rome, where he occupied himself until the year 1550 in drawing the most note-worthy works; executing during that time and also afterwards, in the Castello di S. Angelo, some things in connection with the works that Perino del Vaga carried out. In the centre of the vaulting of the Chapel of S. Dionigi, in the Church of S. Luigi de' Franzesi, he painted a battle-scene in fresco, in which he acquitted himself in such a manner, that, although Jacopo del Conte, a Florentine painter, and Girolamo Siciolante of Sermon-eta had executed many works in the same chapel, Pellegrino proved to be in no way inferior to them; nay, it appears to many that he acquitted himself better than they did in the boldness, grace, colouring, and design of those his pictures. By reason of this Monsignor Poggio afterwards availed himself much of Pelle-grino, for he had erected a palace on the Esquiline Hill, where he had a vineyard, without the Porta del Popolo, and he desired that Pellegrino should execute some figures for him on the façade, and then that he should paint the interior of a loggia that faces towards the Tiber, which he executed with such diligence, that it is held to be a work of much beauty and grace. In the house of Francesco Formento, between the Strada del Pellegrino and the Parione, he painted in a courtyard a façade and two figures besides. By order of the ministers of Pope Julius III, he executed a large escutcheon, with two figures, in the Belvedere; and with-out the Porta del Popolo, in the Church of S. Andrea, which that Pontiff had caused to be built, he painted a S. Peter and a S. Andrew, which two figures were much extolled, and the design of the S. Peter is in our book, together with other sheets drawn with much diligence by the same hand.

Being then sent to Bologna by Monsignor Poggio, he painted for him in his palace there many scenes in fresco, among which is one that is most beautiful, wherein from the many figures, both nude and clothed, and the lovely composition of the scene, it is evident that he surpassed himself, insomuch that he has never done any work since better than this. In S. Jacopo, in the same city, he began to paint a chapel likewise for Cardinal Poggio, which was afterwards finished by the above-mentioned Prospero Fontana. Being then taken by the Cardinal of Augsburg to the Madonna of Loreto, Pellegrino decorated for him a chapel most beautifully with stucco-work and pictures. On the vaulting, within a rich pattern of compartments in stucco, are the Nativity of

Christ and His Presentation in the arms of Simeon at the Temple; and in the centre, in particular, is the Transfiguration of the Saviour on Mount Tabor, and with Him Moses, Elias, and the Disciples. In the altar-piece that is above the altar, he painted S. John the Baptist baptizing Christ; and in this he made a portrait of the above-named Cardinal, kneeling. On one of the façades at the sides he painted S. John preaching to the multitude, and on the other the Beheading of the same Saint. In the forecourt below the church he painted stories of the Judgment, and some figures in chiaroscuro in the place where the Theatines now have their Confessional.

Being summoned not long afterwards to Ancona by Giorgio Morato, he painted for the Church of S. Agostino a large altar-piece in oils of Christ baptized by S. John, with S. Paul and other Saints on one side, and in the predella a good number of little figures, which are full of grace. For the same man he made in the Church of S. Ciriaco sul Monte a very beautiful ornament in stucco for the altar-piece of the high-altar, and within it a Christ of five braccia in full-relief, which was much extolled. In like manner, he has made in the same city a very large and very beautiful ornament of stucco for the high-altar of S. Domenico, and he would also have painted the altar-picture, but he had a difference with the patron of that work, and it was given to Tiziano Vecelli to execute, as will be related in the proper place. Finally, having undertaken to decorate in the same city of Ancona the Loggia de' Mercanti, which faces on one side over the sea-shore and on the other towards the principal street of the city, Pellegrino has adorned the vaulting, which is a new structure, with pictures and many large figures in stucco; in which work since he has exerted all the effort and study possible to him, it has turned out in truth full of beauty and grace, for the reason that, besides that all the figures are beautiful and well executed, there are some most lovely foreshortenings of nudes, in which it is evident that he has imitated with much diligence the works of Buonarroti that are in the Chapel in Rome.

Now, since there are not in those parts any architects or engineers of account, or any who know more than he does, Pellegrino has taken it upon himself to give his attention to architecture and to the fortifying of places in that province; and, as one who has recognized that painting is more difficult and perhaps less advantageous than architecture, setting his painting

somewhat on one side, he has executed many works for the
fortification of Ancona and for many other places in the States
of the Church, and particularly at Ravenna. Finally, he has made
a beginning with a palace for the Sapienza, at Pavia, for Cardinal
Borromeo. And at the present day, since he has not wholly aban-
doned painting, he is executing a scene in fresco, which will be
very beautiful, in the refectory of S. Giorgio at Ferrara, for the
Monks of Monte Oliveto; and of this Pellegrino himself not long
ago showed me the design, which is very fine. But, seeing that he
is a young man of thirty-five, and is constantly making more and
more progress and advancing towards perfection, this much
about him must suffice for the present. In like manner, I shall be
brief in speaking of Orazio Fumaccini,* a painter likewise from
Bologna, who has executed in Rome, as has been related, above
one of the doors of the Hall of Kings, a scene that is very fine,
and in Bologna many much-extolled pictures; for he also is
young, and he is acquitting himself in such a manner, that he will
not be inferior to his elders, of whom we have made mention in
these our Lives.

The men of Romagna, also, spurred by the example of the
Bolognese, their neighbours, have executed many noble works in
our arts; for, besides Jacopone da Faenza, who, as has been re-
lated, painted the tribune of S. Vitale in Ravenna, there have been
and still are many others after him who are excellent. Maestro
Luca de' Longhi of Ravenna, a man of good, quiet, and studious
nature, has painted in his native city of Ravenna and in the sur-
rounding country many very beautiful panel-pictures in oils and
portraits from nature; and of much charm, among others, are two
little altar-pieces that he was commissioned not long since to
paint for the Church of the Monks of Classi by the Reverend
Don Antonio da Pisa, then Abbot of that Monastery; to say
nothing of an infinite number of other works that this painter has
executed. And, to tell the truth, if Maestro Luca had gone forth
from Ravenna, where he has always lived and still lives with his
family, being assiduous and very diligent, and of fine judgment,
he would have become a very rare painter, because he has ex-
ecuted his works, as he still does, with patience and study; and to
this I can bear witness, who know how much proficience he
made during my sojourn of two months in Ravenna, both prac-

* Sammacchini.

tising and discussing the matters of art; nor must I omit to say
that a daughter of his, still but a little girl, called Barbara, draws
very well, and has begun to do some work in colour with no little
grace and excellence of manner.

A rival of Luca, for a time, was Livio Agresti of Forlì, who,
after he had executed for Abbot de' Grassi in the Church of the
Spirito Santo some scenes in fresco and certain other works,
departed from Ravenna and made his way to Rome. There, at-
tending with much study to design, he became a well-practised
master, as may be seen from some façades and other works in
fresco that he executed at that time; and his first works, which
are in Narni, have in them not a little of the good. In a chapel
of the Church of the Santo Spirito, in Rome, he has painted a
number of figures and scenes in fresco, which are executed with
much industry and study, so that they are rightly extolled by
everyone. That work was the reason, as has been related, that
there was allotted to him one of the smaller scenes that are over
the doors in the Hall of Kings in the Palace of the Vatican, in
which he acquitted himself so well, that it can bear comparison
with the others. The same master has executed for the Cardinal
of Augsburg seven pieces with scenes painted on cloth of silver,
which have been held to be very beautiful in Spain, where they
have been sent by that same Cardinal as presents to King Philip,
to be used as hangings in a chamber. Another picture on cloth
of silver he has painted in the same manner, which is now to be
seen in the Church of the Theatines of Forlì. Finally, having
become a good and bold draughtsman, a well-practised colourist,
fertile in the composition of scenes, and universal in his manner,
he has been invited by the above-named Cardinal with a good
salary to Augsburg, where he is constantly executing works
worthy of much praise.

But most rare among the other men of Romagna, in certain
respects, is Marco da Faenza (for only so, and not otherwise, is
he called), for the reason that he has no ordinary mastery in the
work of fresco, being bold, resolute, and of a terrible force, and
particularly in the manner and practice of making grotesques, in
which he has no equal at the present day, nor one who even
approaches his perfection. His works may be found throughout
all Rome; and in Florence there is by his hand the greater part
of the ornaments of twenty different rooms that are in the
Ducal Palace, and the friezes of the ceiling in the Great Hall of

that Palace, which was painted by Giorgio Vasari, as will be fully described in the proper place; not to mention that the decorations of the principal court of the same Palace, made in a short time for the coming of Queen Joanna, were executed in great part by the same man. And this must be enough of Marco, he being still alive and in the flower of his growth and activity.

In Parma there is at the present day in the service of the Lord Duke Ottavio Farnese, a painter called Miruolo, a native, I believe, of Romagna, who, besides some works executed in Rome, has painted many scenes in fresco in a little palace that the same Lord Duke has caused to be built in the Castle of Parma. There, also, are some fountains constructed with fine grace by Giovanni Boscoli, a sculptor of Montepulciano, who, having worked in stucco for many years under Vasari in the Palace of the above-named Lord Duke Cosimo of Florence, has finally entered the service of the above-mentioned Lord Duke of Parma, with a good salary, and has executed, as he continues constantly to do, works worthy of his rare and most beautiful genius. In the same cities and provinces, also, are many other excellent and noble craftsmen; but, since they are still young, we shall defer to a more convenient time the making of that honourable mention of them that their talents and their works may have merited.

And this is the end of the works of Abbot Primaticcio. I will add that, he having had himself portrayed in a pen-drawing by the Bolognese painter Bartolommeo Passerotto, who was very much his friend, that portrait has come into our hands, and we have it in our book of drawings by the hands of various excellent painters.

TIZIANO DA CADORE, Painter

TIZIANO was born at Cadore, a little township situated on the Piave and five miles distant from the pass of the Alps, in the year 1480, from the family of the Vecelli, one of the most noble in that place. At the age of ten, having a fine spirit and a lively intelligence, he was sent to Venice to the house of an uncle, an honoured citizen, who, perceiving the boy to be much inclined to painting, placed him with Gian Bellini, an excellent painter very famous at that time, as has been related. Under his discipline, attending to design, he soon showed that he was endowed

by nature with all the gifts of intellect and judgment that are necessary for the art of painting; and since at that time Gian Bellini and the other painters of that country, from not being able to study ancient works, were much – nay, altogether – given to copying from the life whatever work they did, and that with a dry, crude, and laboured manner, Tiziano also for a time learned that method. But having come to about the year 1507, Giorgione da Castelfranco, not altogether liking that mode of working, began to give to his pictures more softness and greater relief, with a beautiful manner; nevertheless he used to set himself before living and natural objects and counterfeit them as well as he was able with colours, and paint them broadly with tints crude or soft according as the life demanded, without doing any drawing, holding it as certain that to paint with colours only, without the study of drawing on paper, was the true and best method of working, and the true design. For he did not perceive that for him who wishes to distribute his compositions and accommodate his inventions well, it is necessary that he should first put them down on paper in several different ways, in order to see how the whole goes together, for the reason that the idea is not able to see or imagine the inventions perfectly within herself, if she does not reveal and demonstrate her conception to the eyes of the body, that these may assist her to form a good judgment. Besides which, it is necessary to give much study to the nude, if you wish to comprehend it well, which you will never do, nor is it possible, without having recourse to paper; and to keep always before you, while you paint, persons naked or draped, is no small restraint, whereas, when you have formed your hand by drawing on paper, you then come little by little with greater ease to carry your conceptions into execution, designing and painting together. And so, gaining practice in art, you make both manner and judgment perfect, doing away with the labour and effort wherewith those pictures were executed of which we have spoken above, not to mention that by drawing on paper, you come to fill the mind with beautiful conceptions, and learn to counterfeit all the objects of nature by memory, without having to keep them always before you or being obliged to conceal beneath the glamour of colouring the painful fruits of your ignorance of design, in the manner that was followed for many years by the Venetian painters, Giorgione, Palma, Pordenone, and others, who never saw Rome or any other works of absolute perfection.

Tiziano, then, having seen the method and manner of Giorgione, abandoned the manner of Gian Bellini, although he had been accustomed to it for a long time, and attached himself to that of Giorgione; coming in a short time to imitate his works so well, that his pictures at times were mistaken for works by Giorgione, as will be related below. Then, having grown in age, practice, and judgment, Tiziano executed many works in fresco, which cannot be enumerated in order, being dispersed over various places; let it suffice that they were such, that the opinion was formed by many experienced judges that he would become, as he afterwards did, a most excellent painter. At the time when he first began to follow the manner of Giorgione, not being more than eighteen years of age, he made the portrait of a gentleman of the Barberigo family, his friend, which was held to be very beautiful, the likeness of the flesh-colouring being true and natural, and all the hairs so well distinguished one from another, that they might have been counted, as also might have been the stitches in a doublet of silvered satin that he painted in that work. In short, it was held to be so well done, and with such diligence, that if Tiziano had not written his name on a dark ground, it would have been taken for the work of Giorgione.

Meanwhile Giorgione himself had executed the principal façade of the Fondaco de' Tedeschi, and by means of Barberigo there were allotted to Tiziano certain scenes on the same building, above the Merceria. After which work he painted a large picture with figures of the size of life, which is now in the hall of M. Andrea Loredano, who dwells near S. Marcuola. In that picture is painted Our Lady going into Egypt, in the midst of a great forest and certain landscapes that are very well done, because Tiziano had given his attention for many months to such things, and had kept in his house for that purpose some Germans who were excellent painters of landscapes and verdure. In the wood in that picture, likewise, he painted many animals, which he portrayed from the life; and they are truly natural, and almost alive. Next, in the house of M. Giovanni D'Anna, a Flemish gentleman and merchant, his gossip, he made his portrait, which has all the appearance of life, and also an 'Ecce Homo' with many figures, which is held by Tiziano himself and by others to be a very beautiful work. The same master painted a picture of Our Lady with other figures the size of life, of men and children, all portrayed from the life and from persons of that

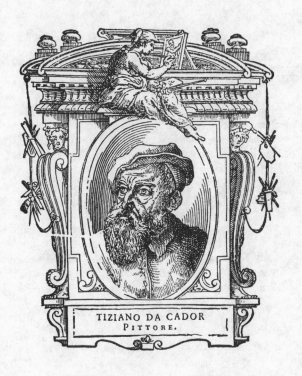

TIZIANO DA CADOR
PITTORE.

house. Then in the year 1507, while the Emperor Maximilian was making war on the Venetians, Tiziano, according to his own account, painted an Angel Raphael with Tobias and a dog in the Church of S. Marziliano, with a distant landscape, where, in a little wood, S. John the Baptist is praying on his knees to Heaven, whence comes a radiance that illumines him; and this work it is thought that he executed before he made a beginning with the façade of the Fondaco de' Tedeschi. Concerning which façade, many gentlemen, not knowing that Giorgione was not working there any more and that Tiziano was doing it, who had uncovered one part, meeting with Giorgione, congratulated him in friendly fashion, saying that he was acquitting himself better in the façade towards the Merceria than he had done in that which is over the Grand Canal. At which circumstance Giorgione felt such disdain, that until Tiziano had completely finished the work and it had become well known that the same had done that part, he would scarcely let himself be seen; and from that time onward he would never allow Tiziano to associate with him or be his friend.

In the year after, 1508, Tiziano published in wood-engraving the Triumph of Faith, with an infinity of figures; our first Parents, the Patriarchs, the Prophets, the Sibyls, the Innocents, the Martyrs, the Apostles, and Jesus Christ borne in Triumph by the four Evangelists and the four Doctors, with the Holy Confessors behind. In that work Tiziano displayed boldness, a beautiful manner, and the power to work with facility of hand; and I remember that Fra Sebastiano del Piombo, conversing of this, said to me that if Tiziano had been in Rome at that time, and had seen the works of Michelagnolo, those of Raffaello, and the ancient statues, and had studied design, he would have done things absolutely stupendous, considering the beautiful mastery that he had in colouring, and that he deserved to be celebrated as the finest and greatest imitator of Nature in the matter of colour in our times, and with the foundation of the grand method of design he might have equalled the Urbinate and Buonarroti. Afterwards, having gone to Vicenza, Tiziano painted the Judgment of Solomon in fresco, which was a beautiful work, under the little loggia where justice is administered in public audience. He then returned to Venice, and painted the façade of the Grimani. At Padua, in the Church of S. Antonio, he executed likewise in fresco some stories of the actions of that Saint, and

for that of S. Spirito he painted a little altar-piece with a S. Mark seated in the midst of certain Saints, in whose faces are some portraits from life done in oils with the greatest diligence; which picture many have believed to be by the hand of Giorgione. Then, a scene having been left unfinished in the Hall of the Great Council through the death of Giovanni Bellini, wherein Frederick Barbarossa is kneeling at the door of the Church of S. Marco before Pope Alexander IV, who places his foot on Barbarossa's neck, Tiziano finished it, changing many things, and making there many portraits from life of his friends and others; for which he was rewarded by receiving from the Senate an office in the Fondaco de' Tedeschi, called the Senseria, which yields three hundred crowns a year. That office those Signori are accustomed to give to the most excellent painter of their city, on the condition that he shall be obliged from time to time to paint the portrait of their Prince or Doge, at his election, for the price of only eight crowns, which the Prince himself pays to him; which portrait is afterwards kept, in memory of him, in a public place in the Palace of S. Marco.

In the year 1514 Duke Alfonso of Ferrara had caused a little chamber to be decorated, and had commissioned Dosso, the painter of Ferrara, to execute in certain compartments stories of Æneas, Mars, and Venus, and in a grotto Vulcan with two smiths at the forge; and he desired that there should also be there pictures by the hand of Gian Bellini. Bellini painted on another wall a vat of red wine with some Bacchanals around it, and Satyrs, musicians, and other men and women, all drunk with wine, and near them a nude and very beautiful Silenus, riding on his ass, with figures about him that have the hands full of fruits and grapes; which work was in truth executed and coloured with great diligence, insomuch that it is one of the most beautiful pictures that Gian Bellini ever painted, although in the manner of the draperies there is a certain sharpness after the German manner (nothing, indeed, of any account), because he imitated a picture by the Fleming Albrecht Dürer, which had been brought in those days to Venice and placed in the Church of S. Bartolommeo, a rare work and full of most beautiful figures painted in oils. On that vat Gian Bellini wrote these words:

JOANNES BELLINUS VENETUS, P. 1514.

That work he was not able to finish completely, because he

was old, and Tiziano, as the most excellent of all the others, was sent for to the end that he might finish it; wherefore, being desirous to acquire excellence and to make himself known, he executed with much diligence two scenes that were wanting in that little chamber. In the first is a river of red wine, about which are singers and musicians, both men and women, as it were drunk, and a naked woman who is sleeping, so beautiful that she might be alive, together with other figures; and on this picture Tiziano wrote his name. In the other, which is next to it and seen first on entering, he painted many little boys and Loves in various attitudes, which much pleased that lord, as also did the other picture; but most beautiful of all is one of those boys who is making water into a river and is reflected in the water, while the others are around a pedestal that has the form of an altar, upon which is a statue of Venus with a sea-conch in the right hand, and Grace and Beauty about her, which are very lovely figures and executed with incredible diligence. On the door of a press, likewise, Tiziano painted an image of Christ from the waist upwards, marvellous, nay, stupendous, to whom a base Hebrew is showing the coin of Cæsar; which image, and also other pictures in that little chamber, our best craftsmen declare to be the finest and best executed that Tiziano has ever done, and indeed they are most rare. Wherefore he well deserved to be most liberally recompensed and rewarded by that lord, whom he portrayed excellently well with one arm resting on a great piece of artillery; and he also made a portrait of Signora Laura, who afterwards became the wife of the Duke, which is a stupendous work. And, in truth, gifts have great potency with those who labour for the love of art, when they are uplifted by the liberality of Princes. At that time Tiziano formed a friendship with the divine Messer Lodovico Ariosto, and was recognized by him as a most excellent painter and celebrated in his Orlando Furioso:

> ... E Tizian che onora
> Non men Cador, che quei Vinezia e Urbino.

Having then returned to Venice, Tiziano painted on a canvas in oils, for the father-in-law of Giovanni da Castel Bolognese, a naked shepherd and a country-girl who is offering him some pipes, that he may play them, with a most beautiful landscape; which picture is now at Faenza, in the house of the said Giovanni. He then executed for the high-altar in the Church of the Friars

Minors, called the Cà Grande, a picture of Our Lady ascending
into Heaven, and below her the twelve Apostles, who are gazing
upon her as she ascends; but of this work, from its having been
painted on cloth, and perhaps not well kept, there is little to be
seen. For the Chapel of the Pesari family, in the same church, he
painted in an altar-piece the Madonna with the Child in her arms,
a S. Peter and a S. George, and about them the patrons of the
work, kneeling and portrayed from life; among whom are
the Bishop of Paphos and his brother, then newly returned
from the victory which that Bishop won against the Turks. For
the little Church of S. Niccolò, in the same convent, he painted
in an altar-piece S. Nicholas, S. Francis, S. Catharine, and also a
nude S. Sebastian, portrayed from life and without any artifice
that can be seen to have been used to enhance the beauty of the
limbs and trunk, there being nothing there but what he saw in
the work of nature, insomuch that it all appears as if stamped
from the life, so fleshlike it is and natural; but for all that it is
held to be beautiful, as is also very lovely the Madonna with the
Child in her arms at whom all those figures are gazing. The
subject of that picture was drawn on wood by Tiziano himself,
and then engraved by others and printed. For the Church of
S. Rocco, after the works described above, he painted a picture
of Christ with the Cross on His shoulder, and about His neck a
cord that is drawn by a Hebrew; and that figure, which many
have believed to be by the hand of Giorgione, is now the object
of the greatest devotion in Venice, and has received in alms more
crowns than Tiziano and Giorgione ever gained in all their lives.
Then he was invited to Rome by Bembo, whom he had already
portrayed, and who was at that time Secretary to Pope Leo X, to
the end that he might see Rome, Raffaello da Urbino, and others;
but Tiziano delayed that visit so long from one day to another,
that Leo died, and Raffaello in 1520, and after all he never went.
For the Church of S. Maria Maggiore he painted a picture with
S. John the Baptist in the Desert among some rocks, an Angel
that appears as if alive, and a little piece of distant landscape with
some trees upon the bank of a river, all full of grace.

He made portraits from life of the Prince Grimani and Lore-
dano, which were held to be admirable; and not long afterwards
of King Francis, when he departed from Italy in order to return
to France. And in the year when Andrea Gritti was elected Doge,
Tiziano painted his portrait, which was a very rare thing, in a

picture wherein are Our Lady, S. Mark, and S. Andrew with the countenance of that Doge; which picture, a most marvellous work, is in the Sala del Collegio. He has also painted portraits, in addition to those of the Doges named above (being obliged, as has been related, to do it), of others who have been Doges in their time; Pietro Lando, Francesco Donato, Marcantonio Trevisano, and Veniero. But by the two Doges and brothers Paoli* he has been excused recently, because of his great age, from that obligation. Before the sack of Rome there had gone to live in Venice Pietro Aretino, a most famous poet of our times, and he became very much the friend of Tiziano and Sansovino; which brought great honour and advantage to Tiziano, for the reason that the poet made him known wherever his pen reached, and especially to Princes of importance, as will be told in the proper place.

Meanwhile, to return to Tiziano's works, he painted the altarpiece for the altar of S. Piero Martire in the Church of SS. Giovanni e Polo, depicting therein that holy martyr larger than life, in a forest of very great trees, fallen to the ground and assailed by the fury of a soldier, who has wounded him so grievously in the head, that as he lies but half alive there is seen in his face the horror of death, while in another friar who runs forward in flight may be perceived the fear and terror of death. In the air are two nude Angels coming down from a flash of Heaven's lightning, which gives light to the landscape, which is most beautiful, and to the whole work besides, which is the most finished, the most celebrated, the greatest, and the best conceived and executed that Tiziano has as yet ever done in all his life. This work being seen by Gritti, who was always very much the friend of Tiziano, as also of Sansovino, he caused to be allotted to him a great scene of the rout of Chiaradadda, in the Hall of the Great Council. In it he painted a battle with soldiers in furious combat, while a terrible rain falls from Heaven; which work, wholly taken from life, is held to be the best of all the scenes that are in that Hall, and the most beautiful. And in the same Palace, at the foot of a staircase, he painted a Madonna in fresco. Having made not long afterwards for a gentleman of the Contarini family a picture of a very beautiful Christ, who is seated at table with Cleophas and Luke, it appeared to that gentleman that the work was worthy to

* Priuli.

be in a public place, as in truth it is. Wherefore having made a
present of it, like a true lover of his country and of the common-
wealth, to the Signoria, it was kept a long time in the apartments
of the Doge; but at the present day it is in a public place, where
it may be seen by everyone, in the Salotta d'Oro in front of the
Hall of the Council of Ten, over the door. About the same time,
also, he painted for the Scuola of S. Maria della Carità Our Lady
ascending the steps of the Temple, with heads of every kind
portrayed from nature; and for the Scuola of S. Fantino, likewise,
a little altar-piece of S. Jerome in Penitence, which was much
extolled by the craftsmen, but was consumed by fire two years
ago together with the whole church.

It is said that in the year 1530, the Emperor Charles V being
in Bologna, Tiziano was invited to that city by Cardinal Ippolito
de' Medici, through the agency of Pietro Aretino. There he made
a most beautiful portrait of his Majesty in full armour, which so
pleased him, that he caused a thousand crowns to be given to
Tiziano; but of these he was obliged afterwards to give the half
to the sculptor Alfonso Lombardi, who had made a model to be
reproduced in marble, as was related in his Life.

Having returned to Venice, Tiziano found that a number of
gentlemen, who had taken Pordenone into their favour, praising
much the works executed by him on the ceiling of the Sala de'
Pregai and elsewhere, had caused a little altar-piece to be allotted
to him in the Church of S. Giovanni Elemosinario, to the end
that he might paint it in competition with Tiziano, who for the
same place had painted a short time before the said S. Giovanni
Elemosinario in the habit of a Bishop. But, for all the diligence
that Pordenone devoted to that altar-piece, he was not able to
equal or even by a great measure to approach to the work of
Tiziano. Next, Tiziano executed a most beautiful altar-picture of
an Annunciation for the Church of S. Maria degli Angeli at Mu-
rano, but he who had caused it to be painted not being willing
to spend five hundred crowns upon it, which Tiziano was asking,
by the advice of Messer Pietro Aretino he sent it as a gift to the
above-named Emperor Charles V, who, liking that work vastly,
made him a present of two thousand crowns; and where that
picture was to have been placed, there was set in its stead one by
the hand of Pordenone. Nor had any long time passed when
Charles V, returning to Bologna for a conference with Pope Cle-
ment, at the time when he came with his army from Hungary,

desired to be portrayed again by Tiziano. Before departing from Bologna, Tiziano also painted a portrait of the above-named Cardinal Ippolito de' Medici in Hungarian dress, and in a smaller picture the same man in full armour; both which portraits are now in the guardaroba of Duke Cosimo. At that same time he executed a portrait of Alfonso Davalos, Marchese del Vasto, and one of the above-named Pietro Aretino, who then contrived that he should become the friend and servant of Federigo Gonzaga, Duke of Mantua, with whom Tiziano went to his States and there painted a portrait of him, which is a living likeness, and then one of the Cardinal, his brother. These finished, he painted, for the adornment of a room among those of Giulio Romano, twelve figures from the waist upwards of the twelve Cæsars, very beautiful, beneath each of which the said Giulio afterwards painted a story from their lives.

In Cadore, his native place, Tiziano has painted an altar-picture wherein are Our Lady, S. Tiziano the Bishop, and a portrait of himself kneeling. In the year when Pope Paul III went to Bologna, and from there to Ferrara, Tiziano, having gone to the Court, made a portrait of that Pope, which was a very beautiful work, and from it another for Cardinal S. Fiore; and both these portraits, for which he was very well paid by the Pope, are in Rome, one in the guardaroba of Cardinal Farnese, and the other in the possession of the heirs of the above-named Cardinal S. Fiore, and from them have been taken many copies, which are dispersed throughout Italy. At this same time, also, he made a portrait of Francesco Maria, Duke of Urbino, which was a marvellous work; wherefore M. Pietro Aretino on this account celebrated him in a sonnet that began:

> Se il chiaro Apelle con la man dell' arte
> Rassembrò d' Alessandro il volto e il petto.

There are in the guardaroba of the same Duke, by the hand of Tiziano, two most lovely heads of women, and a young recumbent Venus with flowers and certain light draperies about her, very beautiful and well finished; and, in addition, a figure of S. Mary Magdalene with the hair all loose, which is a rare work. There, likewise, are the portraits of Charles V, King Francis as a young man, Duke Guidobaldo II, Pope Sixtus IV, Pope Julius II, Paul III, the old Cardinal of Lorraine, and Suleiman Emperor of the Turks; which portraits, I say, are by the hand of Tiziano, and

most beautiful. In the same guardaroba, besides many other things, is a portrait of Hannibal the Carthaginian, cut in intaglio in an antique cornelian, and also a very beautiful head in marble by the hand of Donato.

In the year 1541 Tiziano painted for the Friars of S. Spirito, in Venice, the altar-piece of their high-altar, figuring in it the Descent of the Holy Spirit upon the Apostles, with a God depicted as of fire, and the Spirit as a Dove; which altar-piece becoming spoiled in no long time, after having many disputes with those friars he had to paint it again, and it is that which is over the altar at the present day. For the Church of S. Nazzaro in Brescia he executed the altar-piece of the high-altar in five pictures; in the central picture is Jesus Christ returning to life, with some soldiers around, and at the sides are S. Nazzaro, S. Sebastian, the Angel Gabriel, and the Virgin receiving the Annunciation. In a picture for the wall at the entrance of the Duomo of Verona, he painted an Assumption of Our Lady into Heaven, with the Apostles on the ground, which is held to be the best of the modern works in that city. In the year 1541 he made the portrait of Don Diego di Mendoza, at that time Ambassador of Charles V in Venice, a whole-length figure and standing, which was very beautiful; and from this Tiziano began what has since come into fashion, the making of certain portraits of full length. In the same manner he painted that of the Cardinal of Trento, then a young man, and for Francesco Marcolini the portrait of Messer Pietro Aretino, but this last was by no means as beautiful as one of that poet, likewise by the hand of Tiziano, which Aretino himself sent as a present to Duke Cosimo de' Medici, to whom he sent also the head of Signor Giovanni de' Medici, the father of the said Lord Duke. That head was copied from a cast taken from the face of that lord when he died at Mantua, which was in the possession of Aretino; and both these portraits are in the guardaroba of the same Lord Duke, among many other most noble pictures.

The same year, Vasari having been thirteen months in Venice to execute, as has been related, a ceiling for Messer Giovanni Cornaro, and some works for the Company of the Calza, Sansovino, who was directing the fabric of S. Spirito, had commissioned him to make designs for three large pictures in oils which were to go into the ceiling, to the end that he might execute them in painting; but, Vasari having afterwards departed, those three pictures were allotted to Tiziano, who executed them most

beautifully, from his having contrived with great art to make the figures foreshortened from below upwards. In one is Abraham sacrificing Isaac, in another David severing the neck of Goliath, and in the third Abel slain by his brother Cain. About the same time Tiziano painted a portrait of himself, in order to leave that memory of himself to his children.

The year 1546 having come, he went at the invitation of Cardinal Farnese to Rome, where he found Vasari, who, having returned from Naples, was executing the Hall of the Cancelleria for the above-named Cardinal; whereupon, Tiziano having been recommended by that lord to Vasari, Giorgio kept him company lovingly in taking him about to see the sights of Rome. And then, after Tiziano had rested for some days, rooms were given to him in the Belvedere, to the end that he might set his hand to painting once more the portrait of Pope Paul, of full length, with one of Farnese and one of Duke Ottavio, which he executed excellently well and much to the satisfaction of those lords. At their persuasion he painted, for presenting to the Pope, a picture of Christ from the waist upwards in the form of an 'Ecce Homo,' which work, whether it was that the works of Michelagnolo, Raffaello, Polidoro, and others had made him lose some force, or for some other reason, did not appear to the painters, although it was a good picture, to be of the same excellence as many others by his hand, and particularly his portraits. Michelagnolo and Vasari, going one day to visit Tiziano in the Belvedere, saw in a picture that he had executed at that time a nude woman representing Danaë, who had in her lap Jove transformed into a rain of gold; and they praised it much, as one does in the painter's presence. After they had left him, discoursing of Tiziano's method, Buonarroti commended it not a little, saying that his colouring and his manner much pleased him, but that it was a pity that in Venice men did not learn to draw well from the beginning, and that those painters did not pursue a better method in their studies. 'For,' he said, 'if this man had been in any way assisted by art and design, as he is by nature, and above all in counterfeiting the life, no one could do more or work better, for he has a fine spirit and a very beautiful and lively manner.' And in fact this is true, for the reason that he who has not drawn much nor studied the choicest ancient and modern works, cannot work well from memory by himself or improve the things that he copies from life, giving them the grace and perfection wherein art

goes beyond the scope of nature, which generally produces some parts that are not beautiful.

Tiziano, finally departing from Rome, with many gifts received from those lords, and in particular a benefice of good value for his son Pomponio, set himself on the road to return to Venice, after Orazio, his other son, had made a portrait of Messer Battista Ceciliano, an excellent player on the bass-viol, which was a very good work, and he himself had executed some other portraits for Duke Guidobaldo of Urbino. Arriving in Florence, and seeing the rare works of that city, he was amazed by them no less than he had been by those of Rome. And besides that, he visited Duke Cosimo, who was at Poggio a Caiano, offering to paint his portrait; to which his Excellency did not give much heed, perchance in order not to do a wrong to the many noble craftsmen of his city and dominion.

Then, having arrived in Venice, Tiziano finished for the Marchese del Vasto an Allocution (for so they called it) made by that lord to his soldiers; and after that he took the portrait of Charles V, that of the Catholic King, and many others. These works finished, he painted a little altar-piece of the Annunciation for the Church of S. Maria Nuova in Venice; and then, employing the assistance of his young men, he executed a Last Supper in the refectory of SS. Giovanni e Polo, and for the high-altar of the Church of S. Salvadore an altar-piece in which is a Christ Transfigured on Mount Tabor, and for another altar in the same church a Madonna receiving the Annunciation from the Angel. But these last works, although there is something of the good to be seen in them, are not much esteemed by him, and have not the perfection that his other pictures have. And since the works of Tiziano are without number, and particularly the portraits, it is almost impossible to make mention of them all; wherefore I shall speak only of the most remarkable, but without order of time, it being of little import to know which was first and which later. Several times, as has been related, he painted the portrait of Charles V, and in the end he was summoned for that purpose to the Court, where he portrayed him as he was in those his later years; and the work of Tiziano so pleased that all-conquering Emperor, that after he had once seen it he would not be portrayed by other painters. Each time that he painted him, he received a thousand crowns of gold as a present, and he was made by his Majesty a Chevalier, with a revenue of two hundred

crowns on the Chamber of Naples. In like manner, when he portrayed Philip, King of Spain, the son of Charles, he received from him a fixed allowance of two hundred crowns more; insomuch that, adding those four hundred to the three hundred that he has on the Fondaco de' Tedeschi from the Signori of Venice, he has without exerting himself a fixed income of seven hundred crowns every year. Of the same Charles V and King Philip Tiziano sent portraits to the Lord Duke Cosimo, who has them in his guardaroba. He portrayed Ferdinand, King of the Romans, who afterwards became Emperor, and both his sons, Maximilian, now Emperor, and his brother. He also portrayed Queen Maria, and, for the Emperor Charles V, the Duke of Saxony when he was a prisoner. But what a waste of time is this? There has been scarce a single lord of great name, or Prince, or great lady, who has not been portrayed by Tiziano, a painter of truly extraordinary excellence in this field of art. He painted portraits of King Francis I of France, as has been related, Francesco Sforza, Duke of Milan, the Marquis of Pescara, Antonio da Leva, Massimiano Stampa, Signor Giovan Battista Castaldo, and other lords without number.

In like manner, besides the works mentioned above, at various times he has executed many others. In Venice, by order of Charles V, he painted in a great altar-piece the Triune God enthroned, Our Lady and the Infant Christ, with the Dove over Him, and the ground all of fire, signifying Love; and the Father is surrounded by fiery Cherubim. On one side is the same Charles V, and on the other the Empress, both clothed in linen garments, with the hands clasped in the attitude of prayer, among many Saints; all which was after the command of the Emperor, who, at that time at the height of his victories, began to show that he was minded to retire from the things of this world, as he afterwards did, in order to die like a true Christian, fearing God and desirous of his own salvation. Which picture the Emperor said to Tiziano that he wished to place in the monastery wherein afterwards he finished the course of his life; and since it is a very rare work, it is expected that it may soon be published in engravings. The same Tiziano executed for Queen Maria a Prometheus who is bound to Mount Caucasus and torn by Jove's Eagle, a Sisyphus in Hell who is toiling under his stone, and Tityus devoured by the Vulture. These her Majesty received, excepting the Prometheus, and with them a Tantalus of the same size (namely, that of life), on canvas and in oils. He executed, also, a Venus

and Adonis that are marvellous, she having swooned, and the boy in the act of rising to leave her, with some dogs about him that are very natural. On a panel of the same size he represented Andromeda bound to the rock, and Perseus delivering her from the Sea-Monster, than which picture none could be more lovely; as is also another of Diana, who, bathing in a fount with her Nymphs, transforms Actæon into a stag. He also painted Europa passing over the sea on the back of the Bull. All these pictures are in the possession of the Catholic King, held very dear for the vivacity that Tiziano has given to the figures with his colours, making them natural and as if alive.

It is true, however, that the method of work which he employed in these last pictures is no little different from the method of his youth, for the reason that the early works are executed with a certain delicacy and a diligence that are incredible, and they can be seen both from near and from a distance, and these last works are executed with bold strokes and dashed off with a broad and even coarse sweep of the brush, insomuch that from near little can be seen, but from a distance they appear perfect. This method has been the reason that many, wishing to imitate him therein and to play the practised master, have painted clumsy pictures; and this happens because, although many believe that they are done without effort, in truth it is not so, and they deceive themselves, for it is known that they are painted over and over again, and that he returned to them with his colours so many times, that the labour may be perceived. And this method, so used, is judicious, beautiful, and astonishing, because it makes pictures appear alive and painted with great art, but conceals the labour.

Tiziano painted recently in a picture three braccia high and four braccia broad, Jesus Christ as an Infant in the lap of Our Lady and adored by the Magi, with a good number of figures of one braccio each, which is a very lovely work, as is also another picture that he himself copied from that one and gave to the old Cardinal of Ferrara. Another picture, in which he depicted Christ mocked by the Jews, which is most beautiful, was placed in a chapel of the Church of S. Maria delle Grazie, in Milan. For the Queen of Portugal he painted a picture of a Christ scourged by Jews at the Column, a little less than the size of life, which is very beautiful. For the high-altar of S. Domenico, at Ancona, he painted an altar-piece with Christ on the Cross, and at the foot

Our Lady, S. John, and S. Dominic, all most beautiful, and executed in his later manner with broad strokes, as has just been described above. And by the same hand, in the Church of the Crocicchieri at Venice, is the picture that is on the altar of S. Lorenzo, wherein is the martyrdom of that Saint, with a building full of figures, and S. Laurence lying half upon the gridiron, in foreshortening, with a great fire beneath him, and about it some who are kindling it. And since he counterfeited an effect of night, there are two servants with torches in their hands, which throw light where the glare of the fire below the gridiron does not reach, which is piled high and very fierce. Besides this, he depicted a lightning-flash, which, darting from Heaven and cleaving the clouds, overcomes the light of the fire and that of the torches, shining over the Saint and the other principal figures, and, in addition to those three lights, the figures that he painted in the distance at the windows of the building have the light of lamps and candles that are near them; and all, in short, is executed with beautiful art, judgment, and genius. In the Church of S. Sebastiano, on the altar of S. Niccolò, there is by the hand of the same Tiziano a little altar-piece of a S. Nicholas who appears as if alive, seated in a chair painted in the likeness of stone, with an Angel that is holding his mitre; which work he executed at the commission of Messer Niccolò Crasso, the advocate. Tiziano afterwards painted, for sending to the Catholic King, a figure of S. Mary Magdalene from the middle of the thighs upwards, all dishevelled; that is, with the hair falling over the shoulders, about the throat, and over the breast, the while that, raising the head with the eyes fixed on Heaven, she reveals remorse in the redness of the eyes, and in her tears repentance for her sins. Wherefore the picture moves mightily all who behold it; and, what is more, although she is very beautiful, it moves not to lust but to compassion. This picture, when it was finished, so pleased ... Silvio, a Venetian gentleman, that in order to have it, being one who takes supreme delight in painting, he gave Tiziano a hundred crowns: wherefore Tiziano was forced to paint another, which was not less beautiful, for sending to the above-named Catholic King.

There are also to be seen portraits from life by Tiziano of a Venetian citizen called Sinistri, who was much his friend, and of another named M. Paolo da Ponte, for whom he likewise portrayed a daughter that he had at that time, a most beautiful young woman called Signora Giulia da Ponte, a dear friend of Tiziano;

and in like manner Signora Irene, a very lovely maiden, skilled in letters and music and a student of design, who, dying about seven years ago, was celebrated by the pens of almost all the writers of Italy. He portrayed M. Francesco Filetto, an orator of happy memory, and in the same picture, before him, his son, who seems as if alive; which portrait is in the house of Messer Matteo Giustiniani, a lover of these arts, who has also had a picture painted for himself by the painter Jacopo da Bassano, which is very beautiful, as also are many other works by that Bassano which are dispersed throughout Venice, and held in great price, particularly his little works and animals of every kind. Tiziano portrayed Bembo another time (namely, after he became a Cardinal), Fracastoro, and Cardinal Accolti of Ravenna, which last portrait Duke Cosimo has in his guardaroba; and our Danese, the sculptor, has in his house at Venice a portrait by the hand of Tiziano of a gentleman of the Delfini family. There may be seen portraits by the same hand of M. Niccolò Zono, of Rossa, wife of the Grand Turk, at the age of sixteen, and of Cameria, her daughter, with most beautiful dresses and adornments. In the house of M. Francesco Sonica, an advocate and a gossip of Tiziano, is a portrait by his hand of that M. Francesco, and in a large picture Our Lady flying to Egypt, who is seen to have dismounted from the ass and to have seated herself upon a stone on the road, with S. Joseph beside her, and a little S. John who is offering to the Infant Christ some flowers picked by the hand of an Angel from the branches of a tree that is in the middle of a wood full of animals, where in the distance the ass stands grazing. That picture, which is full of grace, the said gentleman has placed at the present day in a palace that he has built for himself at Padua, near S. Giustina. In the house of a gentleman of the Pisani family, near S. Marco, there is by the hand of Tiziano the portrait of a gentlewoman, which is a marvellous thing. And having made for Monsignor Giovanni della Casa, the Florentine, who has been illustrious in our times both for nobility of blood and as a man of letters, a very beautiful portrait of a gentlewoman whom that lord loved while he was in Venice, Tiziano was rewarded by being honoured by him with the lovely sonnet that begins –

Ben vegg' io, Tiziano, in forme nuove
 L' idolo mio, che i begli occhi apre e gira (with what follows).

Finally, this excellent painter sent to the above-named Catholic King a Last Supper of Christ with the Apostles, in a picture seven braccia long, which was a work of extraordinary beauty.

In addition to the works described and many others of less merit executed by this man, which are omitted for the sake of brevity, he has in his house, sketched in and begun, the following: the Martyrdom of S. Laurence, similar to that described above, and destined by him for sending to the Catholic King; a great canvas wherein is Christ on the Cross, with the Thieves, and at the foot the ministers of the crucifixion, which he is painting for Messer Giovanni d'Anna; and a picture which was begun for the Doge Grimani, father of the Patriarch of Aquileia. And for the Hall of the Great Palace of Brescia he has made a beginning with three large pictures that are to go in the ornamentation of the ceiling, as has been related in speaking of Cristofano and his brother, painters of Brescia. He also began, many years ago, for Alfonso I, Duke of Ferrara, a picture of a nude young woman bowing before Minerva, with another figure at the side, and a sea in the centre of which, in the distance, is Neptune in his car; but through the death of that lord, after whose fancy the work was being executed, it was not finished, and remained with Tiziano. He has also carried well forward, but not finished, a picture wherein is Christ appearing to Mary Magdalene in the Garden in the form of a gardener, with figures the size of life; another, also, of equal size, in which the Madonna and the other Maries being present, the Dead Christ is laid in the Sepulchre; likewise a picture of Our Lady, which is one of the best things that are in that house, and, as has been told, a portrait of himself that was finished by him four years ago, very beautiful and natural, and finally a S. Paul who is reading, a half-length figure, which has all the appearance of the real Saint filled with the Holy Spirit.

All these works, I say, he has executed, with many others that I omit in order not to be wearisome, up to his present age of about seventy-six years. Tiziano has been very sound in health, and as fortunate as any man of his kind has ever been; and he has not received from Heaven anything save favours and blessings. In his house at Venice have been all the Princes, men of letters and persons of distinction who have gone to that city or lived there in his time, because, in addition to his excellence in art, he has shown great gentleness, beautiful breeding, and most courteous ways and manners. He has had in Venice some

competitors, but not of much worth, so that he has surpassed them easily with the excellence of his art and with his power of attaching himself and making himself dear to the men of quality. He has earned much, for he has been very well paid for his works; but it would have been well for him in these his last years not to work save as a pastime, so as not to diminish with works of less excellence the reputation gained in his best years, when his natural powers were not declining and drawing towards imperfection. When Vasari, the writer of this history, was at Venice in the year 1566, he went to visit Tiziano, as one who was much his friend, and found him at his painting with brushes in his hand, although he was very old; and he had much pleasure in seeing him and discoursing with him. He made known to Vasari Messer Gian Maria Verdezotti, a young Venetian gentleman full of talent, a friend of Tiziano and passing able in drawing and painting, as he showed in some landscapes of great beauty drawn by him. This man has by the hand of Tiziano, whom he loves and cherishes as a father, two figures painted in oils within two niches, an Apollo and a Diana.

Tiziano, then, having adorned with excellent pictures the city of Venice, nay, all Italy and other parts of the world, deserves to be loved and revered by the craftsmen, and in many things to be admired and imitated, as one who has executed and is still executing works worthy of infinite praise, which shall endure as long as the memory of illustrious men may live.

Now, although many have been with Tiziano in order to learn, yet the number of those who can truly be called his disciples is not great, for the reason that he has not taught much, and each pupil has gained more or less knowledge according as he has been able to acquire it from the works executed by Tiziano. There has been with him, among others, one Giovanni, a Fleming, who has been a much-extolled master in figures both small and large, and in portraits marvellous, as may be seen in Naples, where he lived some time, and finally died. By his hand – and this must do him honour for all time – were the designs of the anatomical studies that the most excellent Andrea Vessalio caused to be engraved and published with his work. But he who has imitated Tiziano more than any other is Paris Bordone, who, born in Treviso from a father of Treviso and a Venetian mother, was taken at the age of eight to the house of some relatives in Venice. There, having learned his grammar and become an excel-

lent musician, he went to be with Tiziano, but he did not spend many years with him, for he perceived that man to be not very ready to teach his young men, although besought by them most earnestly and invited by their patience to do his duty by them; and he resolved to leave him. He was much grieved that Giorgione should have died in those days, whose manner pleased him vastly, and even more his reputation for having taught well and willingly, and with lovingness, all that he knew; but, since there was nothing else to be done, Paris resolved in his mind that he would follow the manner of Giorgione. And so, setting himself to labour and to counterfeit the work of that master, he became such that he acquired very good credit; wherefore at the age of eighteen there was allotted to him an altar-piece that was to be painted for the Church of S. Niccolò, of the Friars Minors. Which having heard, Tiziano so went to work with various means and favours that he took it out of his hands, either to prevent him from being able to display his ability so soon, or perhaps drawn by his desire of gain.

Afterwards Paris was summoned to Vicenza, to paint a scene in fresco in the Loggia of the Piazza where justice is administered, beside that of the Judgment of Solomon which Tiziano had previously executed; and he went very willingly, and painted there a story of Noah with his sons, which was held to be a work passing good in diligence and in design, and not less beautiful than that of Tiziano, insomuch that by those who know not the truth they are considered to be both by the same hand. Having returned to Venice, Paris executed some nudes in fresco at the foot of the bridge of the Rialto; by reason of which essay he was commissioned to paint some façades of houses in Venice. Being then summoned to Treviso, he painted there likewise some façades and other works, and in particular many portraits, which gave much satisfaction; that of the Magnificent M. Alberto Unigo, that of M. Marco Seravalle, and of M. Francesco da Quer, of the Canon Rovere, and of Monsignor Alberti. For the Duomo of that city, in an altar-piece in the centre of the church, at the instance of the reverend Vicar, he painted the Nativity of Jesus Christ, and then a Resurrection. For S. Francesco he executed another altar-piece at the request of the Chevalier Rovere, another for S. Girolamo, and one for Ognissanti, with different heads of Saints both male and female, all beautiful and varied in the attitudes and in the vestments. He executed another

altar-piece for S. Lorenzo, and in S. Polo he painted three cha-
pels, in the largest of which he depicted Christ rising from the
dead, the size of life, and accompanied by a great multitude of
Angels; in the second some Saints with many Angels about them,
and in the third Jesus Christ upon a cloud, with Our Lady, who
is presenting to Him S. Dominic. All these works have made him
known as an able man and a lover of his city.

In Venice, where he has dwelt almost always, he has executed
many works at various times. But the most beautiful, the most
remarkable and the most worthy of praise that Paris ever painted,
was a scene in the Scuola of S. Marco, at SS. Giovanni e Polo,
wherein is the story of the fisherman presenting to the Signoria
of Venice the ring of S. Mark, with a very beautiful building in
perspective, about which is seated the Senate with the Doge;
among which Senators are many portraits from nature, lifelike
and well painted beyond belief. The beauty of this work, executed
so well and coloured in fresco, was the reason that he began to
be employed by many gentlemen. Thus in the great house of the
Foscari, near S. Barnaba, he executed many paintings and pic-
tures, and among them a Christ who, having descended to the
Limbo of Hell, is delivering the Holy Fathers; which is held to
be a work out of the ordinary. For the Church of S. Giobbe
in Canal Reio he painted a most beautiful altar-piece, and for
S. Giovanni in Bragola another, and the same for S. Maria della
Celeste and for S. Marina.

But, knowing that he who wishes to be employed in Venice
is obliged to endure too much servitude in paying court to one
man or another, Paris resolved, as a man of quiet nature and far
removed from certain methods of procedure, whenever an occa-
sion might present itself, to go abroad to execute such works as
Fortune might set before him, without having to go about beg-
ging. Wherefore, having made his way with a good opportunity
into France in the year 1538, to serve King Francis, he executed
for him many portraits of ladies and other pictures with various
paintings; and at the same time he painted for Monseigneur de
Guise a most beautiful church-picture, and a chamber-picture of
Venus and Cupid. For the Cardinal of Lorraine he painted a
Christ in an 'Ecce Homo,' a Jove with Io, and many other works.
He sent to the King of Poland a picture wherein was Jove with
a Nymph, which was held to be a very beautiful thing. And to
Flanders he sent two other most beautiful pictures, a S. Mary

Magdalene in the Desert accompanied by some Angels, and a Diana who is bathing with her Nymphs in a fount; which two pictures the Milanese Candiano caused him to paint, the physician of Queen Maria, as presents for her Highness. At Augsburg, in the Palace of the Fugger family, he executed many works of the greatest importance, to the value of three thousand crowns. And in the same city he painted for the Prineri, great men in that place, a large picture wherein he counterfeited in perspective all the five Orders of architecture, which was a very beautiful work; and another chamber-picture, which is in the possession of the Cardinal of Augsburg. At Crema he has executed two altar-pieces for S. Agostino, in one of which is portrayed Signor Giulio Manfrone, representing a S. George, in full armour. The same master has painted many works at Civitale di Belluno, which are extolled, and in particular an altar-piece in S. Maria and another in S. Giosef, which are very beautiful. He sent to Signor Ottaviano Grimaldo a portrait of him the size of life and most beautiful, and with it another picture, equal in size, of a very lustful woman. Having then gone to Milan, Paris painted for the Church of S. Celso an altar-piece with some figures in the air, and beneath them a very beautiful landscape, at the instance, so it is said, of Signor Carlo da Roma; and for the palace of the same lord two large pictures in oils, in one Venus and Mars under Vulcan's net, and in the other King David seeing Bathsheba being bathed by her serving-women in the fount; and also the portrait of that lord and that of Signora Paola Visconti, his consort, and some pieces of landscape not very large, but most beautiful. At this same time he painted many of Ovid's Fables for the Marchese d'Astorga, who took them with him to Spain; and for Signor Tommaso Marini, likewise, he painted many things of which there is no need to make mention.

And this much it must suffice to have said of Paris, who, being seventy-five years of age, lives quietly at home with his comforts, and works for pleasure at the request of certain Princes and others his friends, avoiding rivalries and certain vain ambitions, lest he should suffer some hurt and have his supreme tranquillity and peace disturbed by those who walk not, as he says, in truth, but by dubious ways, malignantly and without charity; whereas he is accustomed to live simply and by a certain natural goodness, and knows nothing of subtleties or astuteness in his life. He has executed recently a most beautiful picture for the Duchess of Savoy, of a Venus and Cupid that are sleeping,

guarded by a servant; all executed so well, that it is not possible to praise them enough.

But here I must not omit to say that a kind of painting which is almost discontinued in every other place, namely, mosaic, is kept alive by the most Serene Senate of Venice. Of this the benign and as it were the principal reason has been Tiziano, who, so far as it has lain in him, has always taken pains that it should be practised in Venice, and has caused honourable salaries to be given to those who have worked at it. Wherefore various works have been executed in the Church of S. Marco, all the old works have been almost renewed, and this sort of painting has been carried to such a height of excellence as is possible, and to a different condition from that in which it was in Florence and Rome at the time of Giotto, Alesso Baldovinetti, the Ghirlandajo family, and the miniaturist Gherardo. And all that has been done in Venice has come from the design of Tiziano and other excellent painters, who have made drawings and coloured cartoons to the end that the works might be carried to such perfection as may be seen in those of the portico of S. Marco, where in a very beautiful niche there is a Judgment of Solomon so lovely, that in truth it would not be possible to do more with colours. In the same place is the genealogical tree of Our Lady by the hand of Lodovico Rosso, all full of Sibyls and Prophets executed in a delicate manner and put together very well, with a relief that is passing good. But none have worked better in this art in our times than Valerio and Vincenzio Zuccheri* of Treviso, by whose hands are stories many and various that may be seen in S. Marco, and in particular that of the Apocalypse, wherein around the Throne of God are the Four Evangelists in the form of animals, the Seven Candlesticks, and many other things executed so well, that, looking at them from below, they appear as if done in oil-colours with the brush; besides that there may be seen in their hands and about them little pictures full of figures executed with the greatest diligence, insomuch that they have the appearance not of paintings only, but of miniatures, and yet they are made of stones joined together. There are also many portraits; the Emperor Charles V, Ferdinand his brother, who succeeded him in the Empire, and Maximilian, son of Ferdinand and now Emperor; likewise the head of the most illustrious Cardinal Bembo,

* Zuccati.

the glory of our age, and that of the Magnificent . . . ; all executed with such diligence and unity, and so well harmonized in the lights, flesh-colours, tints, shadows, and every other thing, that there is nothing better to be seen, nor any more beautiful work in a similar material. And it is in truth a great pity that this most excellent art of working in mosaic, with its beauty and everlasting life, is not more in use than it is, and that, by the fault of the Princes who have the power, no attention is given to it.

In addition to those named above, there has worked in mosaic at S. Marco, in competition with the Zuccheri, one Bartolommeo Bozzato, who also has acquitted himself in his works in such a manner as to deserve undying praise. But that which has been of the greatest assistance to all in this art, is the presence and advice of Tiziano; of whom, besides the men already named and many more, another disciple, helping him in many works, has been one Girolamo, whom I know by no other name than Girolamo di Tiziano.

JACOPO SANSOVINO,* Sculptor of Florence

THE while that Andrea Contucci, the sculptor of Monte Sansovino, having already acquired in Italy and Spain the name of the most excellent sculptor and architect that there was in art after Buonarroti, was living in Florence in order to execute the two figures of marble that were to be placed over that door of the Temple of S. Giovanni which faces towards the Misericordia, a young man was entrusted to him to be taught the art of sculpture, the son of Antonio di Jacopo Tatti, whom Nature had endowed with a great genius, so that he gave much grace to the things that he did in relief. Whereupon Andrea, having recognized how excellent in sculpture the young man was destined to become, did not fail to teach him with all possible care all those things which might make him known as his disciple. And so, loving him very dearly, and doing his best for him with much affection, and being loved by the young man with equal tenderness, people judged that the pupil would not only become as excellent as his master,

* After the death of Jacopo Sansovino in 1570, Vasari published a separate Life of him, containing an account of his death and other additional information. Such passages as contain information that is new or expressed differently from that of the Edition of 1568 will be found in the notes at the end of this Life.

but would by a great measure surpass him. And such were the reciprocal friendliness and love between these two, as it were between father and son, that Jacopo in those early years began to be called no longer Tatti, but Sansovino, and so he has always been, and always will be.

Now, Jacopo beginning to exercise his hand, he was so assisted by Nature in the things that he did, that, although at times he did not use much study and diligence in his work, nevertheless in what he did there could be seen facility, sweetness, grace, and a certain delicacy very pleasing to the eyes of craftsmen, insomuch that his every sketch, rough study, and model has always had a movement and a boldness that Nature is wont to give to but few sculptors. Moreover, the friendship and intercourse that Andrea del Sarto and Jacopo Sansovino had with each other in their childhood, and then in their youth, assisted not a little both the one and the other, for they followed the same manner in design and had the same grace in execution, one in painting and the other in sculpture, and, conferring together on the problems of art, and Jacopo making models of figures for Andrea, they gave one another very great assistance. And that this is true a proof is that in the altar-piece of S. Francesco, belonging to the Nuns of the Via Pentolini, there is a S. John the Evangelist which was copied from a most beautiful model in clay that Sansovino made in those days in competition with Baccio da Montelupo; for the Guild of Por Santa Maria wished to have a bronze statue of four braccia made for a niche at the corner of Orsanmichele, opposite to the Wool-Shearers, for which Jacopo made a more beautiful model in clay than Baccio, but nevertheless it was allotted to Montelupo, from his being an older master, rather than to Sansovino, although his work, young as he was, was the better. That model, which is a very beautiful thing, is now in the possession of the heirs of Nanni Unghero; for which Nanni, being then his friend, Sansovino made some models of large boys in clay, and the model for a figure of S. Nicholas of Tolentino, which were all executed of the size of life in wood, with the assistance of Sansovino, and placed in the Chapel of that Saint in the Church of S. Spirito.

Becoming known for these reasons to all the craftsmen of Florence, and being considered a young man of fine parts and excellent character, Jacopo was invited by Giuliano da San Gallo, architect to Pope Julius II, to Rome, vastly to his satisfaction; and then, taking extraordinary pleasure in the ancient statues that are

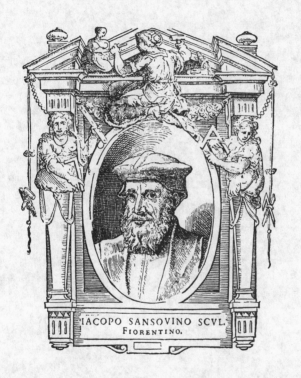

IACOPO SANSOVINO SCVL.
Fiorentino.

in the Belvedere, he set himself to draw them. Whereupon Bramante, who was likewise architect to Pope Julius, holding the first place at that time and dwelling in the Belvedere, having seen some drawings by this young man, and a nude recumbent figure of clay in full-relief, holding a vessel to contain ink, which he had made, liked them so much that he took him under his protection and ordered him that he should make a large copy in wax of the Laocoon, which he was having copied also by others, in order to take a cast in bronze – namely, by Zaccheria Zacchi of Volterra, the Spaniard Alonzo Berughetta, and Vecchio of Bologna. These, when all were finished, Bramante caused to be seen by Raffaello Sanzio of Urbino, in order to learn which of the four had acquitted himself best; whereupon it was judged by Raffaello that Sansovino, young as he was, had surpassed the others by a great measure. Then, by the advice of Cardinal Domenico Grimani, orders were given to Bramante that he should have Jacopo's copy cast in bronze; and so the mould was made, and the work, being cast in metal, came out very well. And afterwards, having been polished, it was given to the Cardinal, who held it as long as he lived not less dear than if it had been the antique; and when he came to die, he left it as a very rare thing to the most Serene Signoria of Venice, which, after having kept it many years in the press of the Hall of the Council of Ten, finally in the year 1534 presented it to the Cardinal of Lorraine, who took it to France.

While Sansovino was acquiring greater fame every day in Rome with his studies in art, being held in much consideration, Giuliano da San Gallo, who had been keeping him in his house in the Borgo Vecchio, fell ill; and when he departed from Rome in a litter, in order to go to Florence for a change of air, a room was found for Jacopo by Bramante, likewise in the Borgo Vecchio, in the Palace of Domenico della Rovere, Cardinal of San Clemente, where Pietro Perugino was also dwelling, who at that time was painting for Pope Julius the vaulting of the chamber in the Borgia Tower. Whereupon Pietro, having seen the beautiful manner of Sansovino, caused him to make many models in wax for himself, and among them a Christ taken down from the Cross in the round, with many ladders and figures, which was a very beautiful thing. This and other things of the same sort, and models of various fantasies, were all collected afterwards by M. Giovanni Gaddi, and they are now in his house on the Piazza di Madonna in Florence. And these works were the reason that

Sansovino became very intimately associated with Maestro Luca Signorelli, the painter of Cortona, with Bramantino da Milano, with Bernardino Pinturicchio, with Cesare Cesariano, who was in repute at that time for his commentaries on Vitruvius, and with many other famous and beautiful intellects of that age. Bramante, then, desiring that Sansovino should become known to Pope Julius, arranged to have some antiques restored by him; whereupon Jacopo, setting to work, displayed such diligence and so much grace in restoring them, that the Pope and all who saw them judged that nothing better could be done. These praises so spurred Sansovino to surpass himself, that, having given himself beyond measure to his studies, and being, also, somewhat delicate in constitution and suffering from some excess such as young men commit, he became so ill that he was forced for the sake of his life to return to Florence, where, profiting by his native air, by the advantage of his youth, and by the diligence and care of the physicians, in a short time he completely recovered. Now Messer Piero Pitti was arranging at that time to have a Madonna of marble made for that façade of the Mercato Nuovo in Florence where the clock is, and it appeared to him, since there were in Florence many young men of ability and also old masters, that the work should be given to that one among them who might make the best model. Whereupon one was given to Baccio da Montelupo to execute, one to Zaccheria Zacchi of Volterra, who had likewise returned to Florence the same year, another to Baccio Bandinelli, and yet another to Sansovino; and when these were placed in comparison, the honour and the work were given by Lorenzo di Credi, an excellent painter and a person of judgment and probity, and likewise by the other judges, craftsmen, and connoisseurs, to Sansovino. But, although the work was therefore allotted to him, nevertheless so much delay was caused in procuring and conveying the marble for him, by the envious machinations of Averardo da Filicaia, who greatly favoured Bandinelli and hated Sansovino, that he was ordered by certain other citizens, having perceived that delay, to make one of the large Apostles in marble that were going into the Church of S. Maria del Fiore. Wherefore, having made the model of a S. James (which model, when the work was finished, came into the possession of Messer Bindo Altoviti), he began that figure and, continuing to work at it with all diligence and study, he carried it to completion so perfectly, that it is a miraculous figure and

shows in all its parts that it was wrought with incredible study and care, the draperies, arms, and hands being undercut and executed with such art and such grace, that there is nothing better in marble to be seen. Thus, Sansovino showed in what way undercut draperies should be executed, having made these so delicate and so natural, that in some places he reduced the marble to the thickness that is seen in real folds and in the edges and hems of the borders of draperies; a difficult method, and one demanding much time and patience if you wish that it should so succeed as to display the perfection of art. That figure remained in the Office of Works from the time when it was finished by Sansovino until the year 1565, at which time, in the month of December, it was placed in the Church of S. Maria del Fiore to do honour to the coming of Queen Joanna of Austria, the wife of Don Francesco de' Medici, Prince of Florence and Siena. And there it is kept as a very rare work, together with the other Apostles, likewise in marble, executed in competition by other craftsmen, as has been related in their Lives.

At this same time he made for Messer Giovanni Gaddi a Venus of marble on a shell, of great beauty, as was also the model, which was in the house of Messer Francesco Montevarchi, a friend of these arts, but came to an evil end in the inundation of the River Arno in the year 1558. He also made a boy of tow and a swan as beautiful as could be, of marble, for the same M. Giovanni Gaddi, together with many other things, which are all in his house. For Messer Bindo Altoviti he had a chimney-piece of great cost made, all in grey-stone carved by Benedetto da Rovezzano, which was placed in his house in Florence, and Messer Bindo caused Sansovino to make a scene with little figures for placing in the frieze of that chimney-piece, with Vulcan and other Gods, which was a very rare work; but much more beautiful are two boys of marble that were above the crown of the chimney-piece, holding some arms of the Altoviti in their hands, which have been removed by Signor Don Luigi di Toledo, who inhabits the house of the above-named Messer Bindo, and placed about a fountain in his garden, behind the Servite Friars, in Florence. Two other boys of extraordinary beauty, also of marble and by the same hand, who are likewise holding an escutcheon, are in the house of Giovan Francesco Ridolfi. All these works caused Sansovino to be held by the men of art and by all Florence to be a most excellent and gracious master; on which

account Giovanni Bartolini, having caused a house to be built in his garden of Gualfonda, desired that Sansovino should make for him a young Bacchus in marble, of the size of life. Whereupon the model for this was made by Sansovino, and it pleased Giovanni so much, that he had him supplied with the marble, and Jacopo began it with such eagerness, that his hands and brain flew as he worked. This work, I say, he studied in such a manner, in order to make it perfect, that he set himself to portray from the life, although it was winter, an assistant of his called Pippo del Fabbro, making him stand naked a good part of the day. Which Pippo would have become a capable craftsman, for he was striving with every effort to imitate his master; but, whether it was the standing naked with the head uncovered at that season, or that he studied too much and suffered hardships, before the Bacchus was finished he went mad, copying the attitudes of that figure. And this he showed one day that it was raining in torrents, when, Sansovino calling out 'Pippo!' and he not answering, the master afterwards saw him mounted on the summit of a chimney on the roof, wholly naked and striking the attitude of his Bacchus. At other times, taking a sheet or other large piece of cloth, and wetting it, he would wrap it round his naked body, as if he were a model of clay or rags, and arrange the folds; and then, climbing up to some extraordinary place, and settling himself now in one attitude and now in another, as a Prophet, an Apostle, a soldier, or something else, he would have himself portrayed, standing thus for a period of two hours without speaking, not otherwise than as if he had been a motionless statue. Many other amusing follies of that kind poor Pippo played, but above all he was never able to forget the Bacchus that Sansovino had made, save only when he died, a few years afterwards.

But to return to the statue; when it was carried to completion, it was held to be the most beautiful work that had ever been executed by a modern master, seeing that in it Sansovino overcame a difficulty never yet attempted, in making an arm raised in the air and detached on every side, which holds between the fingers a cup all cut out of the same marble with such delicacy, that the attachment is very slight, besides which the attitude is so well conceived and balanced on every side, and the legs and arms are so beautiful and so well proportioned and attached to the trunk, that to the eye and to the touch the whole seems much more like living flesh; insomuch that the fame that it has from all

who see it is well deserved, and even more. This work, I say, when finished, while Giovanni was alive, was visited in that courtyard in the Gualfonda by everyone, native and stranger alike, and much extolled. But afterwards, Giovanni being dead, his brother Gherardo Bartolini presented it to Duke Cosimo, who keeps it as a rare thing in his apartments, together with other most beautiful statues of marble that he possesses. For the same Giovanni Sansovino made a very beautiful Crucifix of wood, which is in their house in company with many works by the ancients and by the hand of Michelagnolo.

In the year 1514, when festive preparations of great richness were to be made in Florence for the coming of Pope Leo X, orders were given by the Signoria and by Giuliano de' Medici that many triumphal arches of wood should be made in various parts of the city. Whereupon Sansovino not only executed the designs for many of these, but himself undertook in company with Andrea del Sarto to construct the façade of S. Maria del Fiore all of wood, with statues, scenes, and architectural orders, exactly in the manner wherein it would be well for it to be in order to remove all that there is in it of the German order of composition. Having therefore set his hand to this (to say nothing in this place of the awning of cloth that used to cover the Piazza of S. Maria del Fiore and that of S. Giovanni for the festival of S. John and for others of the greatest solemnity, since we have spoken sufficiently of this in another place), beneath that awning, I say, Sansovino constructed the said façade in the Corinthian Order, making it in the manner of a triumphal arch, and placing upon an immense base double columns on each side, and between them certain great niches filled with figures in the round that represented the Apostles. Above these were some large scenes in half-relief, made in the likeness of bronze, with stories from the Old Testament, some of which are still to be seen in the house of the Lanfredini on the bank of the Arno; and over them followed architraves, friezes, and cornices, projecting outwards, and then frontispieces of great beauty and variety; and in the angles of the arches, both in the wide parts and below, were stories painted in chiaroscuro by the hand of Andrea del Sarto, and very beautiful. In short, this work of Sansovino's was such that Pope Leo, seeing it, said that it was a pity that the real façade of that temple was not so built, which was begun by the German Arnolfo. The same Sansovino made among these festive preparations for the coming of Leo X,

besides the said façade, a horse in the round all of clay and shearings of woollen cloth, in the act of rearing, and under it a figure of nine braccia, upon a pedestal of masonry. Which work was executed with such spirit and force, that it pleased Pope Leo and was much extolled by him; wherefore Sansovino was taken by Jacopo Salviati to kiss the feet of the Pope, who showed him many marks of affection.

The Pope departed from Florence, and had a conference at Bologna with King Francis I of France; and then he resolved to return to Florence. Whereupon orders were given to Sansovino that he should make a triumphal arch at the Porta S. Gallo, and he, not falling back in any way from his own standard, executed it similar to the other works that he had done – namely, beautiful to a marvel, and full of statues and painted pictures wrought excellently well. His Holiness having then determined that the façade of S. Lorenzo should be executed in marble, the while that Raffaello da Urbino and Buonarroti were expected from Rome, Sansovino, by order of the Pope, made a design for it; which giving much satisfaction, Baccio d'Agnolo was commissioned to make a model of it in wood, which proved very beautiful. Meanwhile, Buonarroti had made another, and he and Sansovino were ordered to go to Pietrasanta; where, finding much marble, but difficult to transport, they lost so much time, that when they returned to Florence they found the Pope departed for Rome. Whereupon, both following after him with their models, each by himself, Jacopo arrived at the very moment when Buonarroti's model was being shown to his Holiness in the Torre Borgia; but he did not succeed in obtaining what he hoped, because, whereas he believed that he would at least make under Michelagnolo part of the statues that were going into that work, the Pope having spoken of it to him and Michelagnolo having given him so to understand, he perceived on arriving in Rome that Buonarroti wished to be alone in the work. Nevertheless, having made his way to Rome and not wishing to return to Florence without any result, he resolved to remain in Rome and there give his attention to sculpture and architecture. And so, having undertaken to execute for the Florentine Giovan Francesco Martelli a Madonna in marble larger than life, he made her most beautiful, with the Child in her arms; and this was placed upon an altar within the principal door of S. Agostino, on the right hand as one enters. The clay model of this statue he presented to the Priore de' Salviati, in Rome, who placed it in a chapel in his palace on the

corner of the Piazza di S. Pietro, at the beginning of the Borgo
Nuovo. After no long lapse of time he made for the altar of the
chapel that the very reverend Cardinal Alborense had caused to
be built in the Church of the Spaniards in Rome, a statue in
marble of four braccia, worthy of no ordinary measure of praise,
of a S. James, which has a movement full of grace and is executed
with judgment and perfect art, so that it won him very great
fame. And the while that he was executing these statues, he made
the ground-plan and model, and then began the building, of the
Church of S. Marcello for the Servite Friars, a work of truly great
beauty. Continuing to be employed in matters of architecture, he
built for Messer Marco Coscia a very beautiful loggia on the road
that leads to Rome, at Pontemolle on the Via Appia.* For the
Company of the Crocifisso, attached to the Church of S. Marcello,
he made a Crucifix for carrying in procession, a thing full of
grace; and for Cardinal Antonio di Monte he began a great fabric
at his villa without Rome, on the Acqua Vergine. And by the
hand of Jacopo, perhaps, is a very beautiful portrait in marble of
that elder Cardinal di Monte which is now in the Palace of Signor
Fabiano at Monte Sansovino, over the door of the principal
chamber off the hall. He directed, also, the building of the house
of Messer Luigi Leoni, a most commodious edifice, and in the
Banchi a palace beside the house of the Gaddi, which was bought
afterwards by Filippo Strozzi – certainly a commodious and most
beautiful fabric, with many ornaments.

At this time, with the favour of Pope Leo, the Florentine
colony had bestirred itself out of emulation of the Germans,
Spaniards, and Frenchmen, who had either begun or finished the
churches of their colonies in Rome, and had begun to perform
their solemn offices in those already built and adorned; and the
Florentines had sought leave likewise to build a church for them-
selves. For which the Pope having given instructions to Lodovico
Capponi, the Consul of the Florentine colony at that time, it was
determined that behind the Banchi, at the beginning of the Strada
Giulia, on the bank of the Tiber, an immense church should be
built, to be dedicated to S. John the Baptist; which might surpass
in magnificence, grandeur, cost, ornamentation, and design, the
churches of all the other colonies. There competed, then, in mak-
ing designs for this work, Raffaello da Urbino, Antonio da San

* Via Flaminia.

Gallo, Baldassarre da Siena, and Sansovino; and the Pope, when he had seen all their designs, extolled as the best that of Sansovino, because, besides other things, he had made at each of the four corners of that church a tribune, and a larger tribune in the centre, after the likeness of the plan that Sebastiano Serlio placed in his second book on Architecture. Whereupon, all the heads of the Florentine colony concurring with the will of the Pope, with much approval of Sansovino, the foundations were begun for a part of that church, altogether twenty-two canne* in length. But, there being not enough space, and yet wishing to make the façade of the church in line with the houses of the Strada Giulia, they were obliged to stretch out into the stream of the Tiber at least fifteen canne; which pleasing many of them, because the grandeur as well as the cost was increased by making the foundations in the river, work was begun on this, and they spent upon it more than forty thousand crowns, which would have been enough to build half the masonry of the church.

In the meantime Sansovino, who was the head of this fabric, while the foundations were being laid little by little, had a fall and suffered a serious injury; and after a few days he had himself carried to Florence for treatment, leaving the charge of laying the rest of the foundations, as has been related, to Antonio da San Gallo. But no long time passed before the Florentine colony, having lost by the death of Leo so great a support and so splendid a Prince, abandoned the building for the duration of the life of Pope Adrian VI. Then, Clement having been elected, it was ordained, in order to pursue the same order and design, that Sansovino should return and carry on that fabric in the same manner wherein he had first arranged it; and so a beginning was made once more with the work. Meanwhile, Sansovino undertook to make the tomb of the Cardinal of Arragon and that of Cardinal Aginense; and he had caused work to be begun on the marbles for the ornaments, and had made many models for the figures, and already Rome was in his hands, and he was executing many works of the greatest importance for all those lords, when God, in order to chastise that city and abate the pride of the inhabitants of Rome, permitted that Bourbon should come with his army on the 6th of May, 1527, and that the whole city should be sacked and put to fire and sword.

* A 'canna' is equal to about four braccia.

In that ruin, besides many other beautiful intellects that came to an evil end, Sansovino was forced to his great loss to depart from Rome and to fly to Venice, intending from there to pass into France to enter the service of the King, whither he had been already invited. But, halting in that city in order to make himself ready and provide himself with many things, for he was despoiled of everything, it was announced to the Prince Andrea Gritti, who was much the friend of every talent, that Jacopo Sansovino was there. Whereupon there came to Gritti a desire to speak with him, because at that very time Cardinal Domenico Grimani had given him to understand that Sansovino would have been the man for the cupolas of S. Marco, their principal church, which, because of age and of weak foundations, and also from their being badly secured with chains, were all opening out and threatening to fall; and so he had him summoned. After many courtesies and long discussions, he said to Sansovino that he wished, or rather, prayed him, that he should find a remedy for the ruin of those tribunes; which Sansovino promised to do, and to put it right. And so, having agreed to do the work, he caused it to be taken in hand; and, having contrived all the scaffoldings in the interior and made supports of beams after the manner of stars, he propped in the central hollow of woodwork all the timbers that sustained the vault of each tribune, and encircled them on the inner side with curtains of woodwork, going on then to bind them on the outer side with chains of iron, to flank them with new walls, and to make at the foot new foundations for the piers that supported them, insomuch that he strengthened them vastly and made them for ever secure. By doing which he caused all Venice to marvel, and not only satisfied Gritti, but also – which was far more – rendered his ability so clearly manifest to that most illustrious Senate, that when the work was finished, the Protomaster to the Lords Procurators of S. Mark being dead, which is the highest office that those lords give to their architects and engineers, they gave it to him with the usual house and a passing handsome salary. Whereupon Sansovino, having accepted it most willingly and freed his mind of all doubt, became the head of all their fabrics, with honour and advantage for himself.

First, then, he erected the public building of the Mint, which he designed and distributed in the interior with so much order and method, for the convenience and service of the many artificers, that in no place is there a Treasury ordered so well or with

greater strength than that one, which he adorned altogether in the Rustic Order, very beautifully; which method, not having been used before in Venice, caused no little marvel in the men of that city. Wherefore, having recognized that the genius of Sansovino was equal to their every need in the service of the city, they caused him to attend for many years to the fortifications of their State. Nor did any long time pass before he took in hand, by order of the Council of Ten, the very rich and beautiful fabric of the Library of S. Marco, opposite to the Palazzo della Signoria, with such a wealth of carvings, cornices, columns, capitals, and half-length figures over the whole work, that it is a marvel; and it is all done without any sparing of expense, so that up to the present day it has cost one hundred and fifty thousand ducats. And it is held in great estimation in that city, because it is full of the richest pavements, stucco-work, and stories, distributed among the halls of the building, with public stairs adorned by various pictures, as has been related in the Life of Battista Franco; besides many other beautiful appurtenances, and the rich ornaments that it has at the principal door of entrance, which give it majesty and grandeur, making manifest the ability of Sansovino. This method of building was the reason that in that city, into which up to that time there had never entered any method save that of making their houses and palaces with the same order, each one always continuing the same things with the same measure and ancient use, without varying according to the sites as they found them or according to convenience – this, I say, was the reason that buildings both public and private began to be erected with new designs and better order.

The first palace that he built was that of M. Giorgio Cornaro, a most beautiful work, erected with all proper appurtenances and ornaments at a cost of seventy thousand crowns. Moved by which, a gentleman of the Delfino family caused Sansovino to build a smaller one, at a cost of thirty thousand crowns, which was much extolled and very beautiful. Then he built that of Moro, at a cost of twenty thousand crowns, which likewise was much extolled; and afterwards many others of less cost in the city and the neighbourhood. Wherefore it may be said that at the present day that magnificent city, in the quantity and quality of her sumptuous and well-conceived edifices, shines resplendent and is in that respect what she is through the ability, industry, and art of Jacopo Sansovino, who therefore deserves the highest

praise; seeing that with those works he has been the reason that the gentlemen of Venice have introduced modern architecture into their city, in that not only has that been done there which has passed through his hands, but also many – nay, innumerable – other works which have been executed by other masters, who have gone to live there and have achieved magnificent things. Jacopo also built the fabric of the loggia in the Piazza di S. Marco, in the Corinthian Order, which is at the foot of the Campanile of the said S. Marco, with a very rich ornamentation of columns, and four niches, in which are four figures the size of life and in bronze, of supreme beauty. And that work formed, as it were, a base of great beauty to the said campanile, which at the foot has a breadth, on one of the sides, of thirty-five feet, which is about the extent of Sansovino's ornamentation; and a height from the ground to the cornice, where are the windows of the bells, of one hundred and sixty feet. From the level of that cornice to the other above it, where there is the corridor, is twenty-five feet, and the other dado above is twenty-eight feet and a half high; and from that level of the corridor to the pyramid, spire, or pinnacle, whatever it may be called, is sixty feet. At the summit of that pinnacle the little square, upon which stands the Angel, is six feet high, and the said Angel, which revolves, is ten feet high; insomuch that the whole height comes to be two hundred and ninety-two feet. He also designed and executed for the Scuola, or rather, Confraternity and Company of the Misericordia, the fabric of that place, an immense building which cost one hundred and fifty thousand crowns; and he rebuilt the Church of S. Francesco della Vigna, where the Frati de' Zoccoli have their seat, a vast work and of much importance.

Nor for all this, the while that he has been giving his attention to so many buildings, has he ever ceased from executing every day for his own delight great and beautiful works of sculpture, in marble and in bronze; and over the holy-water font of the Friars of the Cà Grande there is a statue executed in marble by his hand, representing a S. John the Baptist, very beautiful and much extolled. At Padua, in the Chapel of the Santo, there is a large scene in marble by the same hand, with very beautiful figures in half-relief, of a miracle of S. Anthony of Padua; which scene is much esteemed in that place. For the entrance of the stairs of the Palace of S. Marco he is even now executing in marble, in the form of two most beautiful giants, each of seven braccia, a

Neptune and a Mars, signifying the power that is exercised both on land and on sea by that most illustrious Republic. He made a very beautiful statue of a Hercules for the Duke of Ferrara; and for the Church of S. Marco he executed four scenes of bronze in half-relief, one braccio in height and one and a half in length, for placing around a pulpit, and containing stories of that Evangelist, which are held in great estimation for their variety. Over the door of the same S. Marco he has made a Madonna of marble, the size of life, which is held to be a very beautiful thing, and at the entrance of the sacristy in that place there is by his hand the door of bronze, divided into two most beautiful parts, with stories of Jesus Christ all in half-relief and wrought excellently well; and over the door of the Arsenal he has made a very lovely Madonna of marble, who is holding her Son in her arms. All which works not only have given lustre and adornment to that Republic, but also have caused Sansovino to become daily more known as a most excellent craftsman, and to be loved by those Signori and honoured by their magnificent liberality, and likewise by the other craftsmen; for every work of sculpture and architecture that has been executed in that city in his time has been referred to him. And in truth the excellence of Jacopo has well deserved to be held in the first rank in that city among the craftsmen of design, and his genius is rightly loved and revered by all men, both nobles and plebeians, for the reason that, besides other things, he has brought it about, as has been said, with his knowledge and judgment, that that city has been almost entirely made new and has learned the true and good manner of building.

But, if she has received from him beauty and adornment, he, on the other hand, has received many benefits from her. Thus, in addition to other things, he has lived in her, from the time when he first went there to the age of seventy-eight years, full of health and strength; and the air and that sky have done so much for him, that he does not seem, one might say, more than forty. He has had, and still has, from a most talented son – a man of letters – two grandchildren, one male and the other female, both of them pictures of health and beauty, to his supreme contentment; and, what is more, he is still alive, full of happiness and with all the greatest conveniences and comforts that any man of his profession could have. He has always loved his brother-craftsmen, and in particular he has been very much the friend of the

excellent and famous Tiziano, as he also was of M. Pietro Aretino during his lifetime. For all these reasons I have judged it well to make this honourable record of him, although he is still living, and particularly because now he is by way of doing little in sculpture.

Sansovino had many disciples in Florence: Niccolò, called Tribolo, as has been related, and Solosmeo da Settignano, who finished with the exception of the large figures the whole of the tomb in marble that is at Monte Casino, wherein is the body of Piero de' Medici, who was drowned in the River Garigliano. His disciple, likewise, was Girolamo da Ferrara, called Lombardo, of whom there has been an account in the Life of Benvenuto Garofalo of Ferrara; which Girolamo has learned his art both from the first Sansovino and from this second one in such a manner, that, besides the works at Loreto of which we have spoken, both in marble and in bronze, he has executed many works in Venice. This master, although he came under Sansovino at the age of thirty and knowing little of design, being rather a man of letters and a courtier than a sculptor, although he had previously executed some works in sculpture, nevertheless applied himself in such a manner, that in a few years he made the proficience that may be perceived in his works in half-relief that are in the fabrics of the Library and the Loggia of the Campanile of S. Marco; in which he acquitted himself so well, that he was afterwards able to make by himself alone the statues of marble and the Prophets that he executed, as has been related, at the Madonna of Loreto.

A disciple of Sansovino, also, was Jacopo Colonna, who died at Bologna thirty years ago while executing a work of importance. This Jacopo made for the Church of S. Salvadore in Venice a nude S. Jerome of marble, still to be seen in a niche near the organ, which was a beautiful figure and much extolled, and for S. Croce della Giudecca he made a Christ also nude and of marble, who is showing His Wounds, a work of beautiful artistry; and likewise for S. Giovanni Nuovo three figures, S. Dorothy, S. Lucia, and S. Catharine. In S. Marina may be seen a horse with an armed captain upon it, by his hand; and all these works can stand in comparison with any that are in Venice. In Padua, for the Church of S. Antonio, he executed in stucco the said Saint and S. Bernardino, clothed. Of the same material he made for Messer Luigi Cornaro a Minerva, a Venus, and a Diana, larger than life and in the round; in marble a Mercury, and in terra-cotta

a nude Marzio as a young man, who is drawing a thorn from his foot, or rather, showing that he has drawn it out, he holds the foot with one hand, looking at the wound, and with the other hand seems to be about to cleanse it with a cloth; which last work, because it is the best that Jacopo ever did, the said Messer Luigi intends to have cast in bronze. For the same patron he made another Mercury of stone, which was afterwards presented to Duke Federigo of Mantua.

Another disciple of Sansovino was Tiziano da Padova, a sculptor, who carved some little figures of marble in the Loggia of the Campanile of S. Marco at Venice; and in the Church of the same S. Marco there may be seen, likewise fashioned and cast in bronze by him, a large and beautiful cover for a basin in bronze, in the Chapel of S. Giovanni. This Tiziano had made a statue of S. John, with which were the four Evangelists and four stories of S. John, wrought with beautiful artistry for casting in bronze; but he died at the age of thirty-five, and the world was robbed of an excellent and valiant craftsman. And by the same hand is the vaulting of the Chapel of S. Antonio da Padova, with a very rich pattern of compartments in stucco. He had begun for the same chapel a grating of five arches in bronze, which were full of stories of that Saint, with other figures in half-relief and low-relief; but this, also, by reason of his death and of the disagreement of those who had the charge of having it done, remained unfinished. Many pieces of it had already been cast, which turned out very beautiful, and many others were made in wax, when he died, and for the said reasons the whole work was abandoned. The same Tiziano, when Vasari executed the above-described decorations for the gentlemen of the Company of the Calza in Canareio, made for that work some statues in clay and many terminal figures. And he was employed many times on ornaments for scenic settings, theatres, arches, and other suchlike things, whereby he won much honour; having executed works all full of invention, fantasy, and variety, and above all with great rapidity.

Pietro da Salò, also, was a disciple of Sansovino; and after having toiled at carving foliage up to the age of thirty, finally, assisted by Sansovino, who taught him, he set himself to make figures of marble. In which he so delighted, and studied in such a manner, that in two years he was working by himself; to which witness is borne by some passing good works by his hand that

are in the tribune of S. Marco, and the statue of a Mars larger than life that is in the façade of the Palazzo Pubblico, which statue is in company with three others by the hands of good craftsmen. He also made two figures for the apartments of the Council of Ten, one male and the other female, in company with two others executed by Danese Cattaneo, a sculptor of highest renown, who, as will be related, was likewise a disciple of Sansovino; which figures serve to adorn a chimney-piece. Pietro made, in addition, three figures that are at S. Antonio, in the round and larger than life; and these are a Justice, a Fortitude, and a statue of a Captain-General of the Venetian forces, all executed with good mastery. He also made a statue of Justice in a beautiful attitude and with good design, which was placed upon a column in the Piazza of Murano, and another in the Piazza del Rialto in Venice, as a support for that stone where public proclamations are made, which is called the Gobbo* di Rialto; and these works have made him known as a very good sculptor. For the Santo, in Padua, he made a very beautiful Thetis; and a Bacchus who is squeezing a bunch of grapes into a cup, which figure, the most difficult that he ever executed, and the best, he left at his death to his children, who have it still in their house, seeking to sell it to him who shall best recognize and reward the labour that their father endured for it.

Likewise a disciple of Jacopo was Alessandro Vittoria of Trento, a most excellent sculptor and much the friend of study, who with a very beautiful manner has shown in many works that he has executed, as well in stucco as in marble, that he has a ready brain and a lovely style, and that his labours are worthy to be held in estimation. By the hand of this Alessandro, in Venice, at the principal door of the Library of S. Marco, are two great women of stone, each ten palms high, which are full of grace and beauty and worthy to be much extolled. He has made four figures for the tomb of the Contarini in the Santo of Padua, two slaves, or rather, captives, with a Fame and a Thetis, all of stone; and an Angel ten feet high, a very beautiful statue, which has been placed upon the Campanile of the Duomo in Verona. And to Dalmatia he sent four Apostles also of stone, each five feet high, for the Cathedral of Traù. He made, also, some figures in silver for the Scuola of S. Giovanni Evangelista in Venice, which were all in

* Hunchback.

full-relief and rich in grace, and a S. Teodoro of two feet in silver, in the round. For the Chapel of the Grimani, in S. Sebastiano, he wrought two figures in marble, each three feet high; and then he made a Pietà, with two figures of stone, held to be good, which are at S. Salvadore in Venice. He made a Mercury, held to be a good figure, for the pulpit of the Palazzo di S. Marco, which looks out over the Piazza; and for S. Francesco della Vigna he made three figures large as life – S. Anthony, S. Sebastian, and S. Rocco – all of stone and full of beauty and grace, and well wrought. For the Church of the Crocicchieri he made in stucco two figures each six feet high, very beautiful, which are placed on the high-altar; and of the same material he made, as has been already told, all the ornaments that are in the vaulting of the new staircase of the Palazzo di S. Marco, with various patterns of compartments in stucco, where Battista Franco afterwards painted in the spaces the scenes, figures, and grotesques that are there. In like manner, Alessandro executed the ornaments of the staircase of the Library of S. Marco, all works of great mastery; and a chapel for the Friars Minors, and in the altar-piece of marble, which is very large and very beautiful, the Assumption of Our Lady in half-relief, with five great figures at the foot which have in them something of the grand and are made with a beautiful manner, a lovely and dignified flow of draperies, and much diligence of execution; which figures of marble – S. Jerome, S. John the Baptist, S. Peter, S. Andrew, and S. Leonardo – each six feet high, are the best of all the works that he has done up to the present. And as a crown to that chapel, on the frontispiece, are two figures likewise of marble, each eight feet high and very graceful. The same Vittoria has executed many portraits in marble and most beautiful heads, which are good likenesses, such as that of Signor Giovan Battista Feredo, placed in the Church of S. Stefano, that of Camillo Trevisano, the orator, placed in the Church of SS. Giovanni e Polo; the most illustrious Marc' Antonio Grimani, likewise placed in the Church of S. Sebastiano; and in S. Gimignano, the rector of that church. He has also portrayed Messer Andrea Loredano, M. Priano da Lagie, and two brothers of the Pellegrini family – M. Vincenzio and M. Giovan Battista – both orators. And since Vittoria is young and a willing worker, talented, amiable, desirous of acquiring name and fame, and, lastly, very gentle, we may believe that if he lives, we are destined to see most beautiful works come from him from day to day,

worthy of his name of Vittoria, and that, if his life endures, he is like to be a most excellent sculptor and to win the palm from all the others of that country.

There is also one Tommaso da Lugano, a sculptor, who likewise has been many years with Sansovino, and has made with the chisel many figures in the Library of S. Marco, very beautiful, in company with others. And then, having left Sansovino, he has made by himself a Madonna with the Child in her arms, and at her feet a little S. John, which are all three figures of such beautiful form, attitude, and manner, that they can stand among all the other beautiful modern statues that are in Venice; which work is placed in the Church of S. Bastiano. And a portrait of the Emperor Charles V, which he made from the breast upwards, of marble, has been held to be a marvellous thing, and was very dear to his Majesty. And since Tommaso has delighted to work rather in stucco than in marble or bronze, there are innumerable most beautiful figures by his hand and works executed by him in that material in the houses of various gentlemen of Venice. But it must suffice to have said this much of him.

Of the Lombards, finally, it remains for us to make record of Jacopo Bresciano, a young man of twenty-four, who has not long parted from Sansovino. He has given proof at Venice, in the many years that he has been there, of being talented and likely to prove excellent, as he has since shown in the works that he has executed in his native Brescia, and particularly in the Palazzo Pubblico, and if he lives and studies, there will be seen from his hand, also, things greater and better, for he has a fine spirit and most beautiful gifts.

Of our Tuscans, one of the disciples of Sansovino has been the Florentine Bartolommeo Ammanati, of whom record has already been made in many places in this work. This Bartolommeo, I say, worked under Sansovino in Venice; and then in Padua for Messer Marco da Mantova, a most excellent doctor of medicine, in whose house he made an immense giant from more than one piece of stone for his court, and his tomb, with many statues. Afterwards, Ammanati having gone to Rome in the year 1550, there were allotted to him by Giorgio Vasari four statues of marble, each of four braccia, for the tomb of the old Cardinal di Monte, which Pope Julius III had allotted to Giorgio himself in the Church of S. Pietro a Montorio, as will be related; which statues were held to be very beautiful. Wherefore Vasari, having

conceived an affection for him, made him known to the said Julius III, who, having ordained what he wanted done, caused him to be set to work; and so both of them, Vasari and Ammanati, worked together for a time at the Vigna. But not long afterwards, when Vasari had gone to serve Duke Cosimo in Florence, the above-named Pope being dead, Ammanati, who found himself without work and badly recompensed by that Pontiff for his labours in Rome, wrote to Vasari, praying him that, even as he had assisted him in Rome, so he should assist him in Florence with the Duke. Whereupon Vasari, occupying himself with fervour in this matter, introduced him into the service of the Duke, for whom he has executed many statues in marble and in bronze that are not yet in position. For the garden of Castello he has made two figures in bronze larger than life – namely, a Hercules who is crushing Antæus, from which Antæus, in place of his spirit, there issues from the mouth water in great abundance. Finally, Ammanati has executed in marble the colossal figure of Neptune that is in the Piazza, ten braccia and a half in height; but since the work of the fountain, in the centre of which the said Neptune is to stand, is not finished, I shall say nothing more of it. The same Ammanati, as architect, is giving his attention with much honour and praise to the fabric of the Pitti, in which work he has a great opportunity to show the worth and grandeur of his mind, and the magnificence and great spirit of Duke Cosimo. I could tell many particulars of this sculptor, but since he is my friend, and another, so I hear, is writing his history, I shall say no more, in order not to set my hand to things that may be related by another better than I perhaps might be able.

It remains for us to make mention, as the last of Sansovino's disciples, of Danese Cattaneo, the sculptor of Carrara, who was already with him in Venice when still a little boy. Parting from his master at the age of nineteen, he made by himself a boy of marble for S. Marco, and a S. Laurence for the Church of the Friars Minors; for S. Salvadore another boy in marble, and for SS. Giovanni e Polo the statue of a nude Bacchus, who is grasping a bunch of grapes from a vine which twines round a trunk that he has behind his legs, which statue is now in the house of the Mozzenighi at S. Barnaba. He has executed many figures for the Library of S. Marco and for the Loggia of the Campanile, together with others of whom there has been an account above; and, in addition to those named, the two that have been men-

tioned already as being in the apartments of the Council of Ten. He made portraits in marble of Cardinal Bembo and Contarini, the Captain-General of the Venetian forces, which are both in S. Antonio at Padua, with rich and beautiful ornaments about them. And in the same city of Padua, in S. Giovanni di Verdara, there is by the same hand the portrait of Messer Girolamo Gigante, a most learned jurist. And for S. Antonio della Giudecca, in Venice, he has made a very lifelike portrait of Giustiniano, the Lieutenant of the Grand Master of Malta, and that of Tiepolo, who was three times General; but these have not yet been set in their places. But the greatest work and the most distinguished that Danese has ever executed is a rich chapel of marble, with large figures, in S. Anastasia at Verona, for Signor Ercole Fregoso, in memory of Signor Jano, once Lord of Genoa, and then Captain-General of the Venetians, in whose service he died. This work is of the Corinthian Order, in the manner of a triumphal arch, and divided by four great columns, round and fluted, with capitals of olive-leaves, which rest upon a base of proportionate height, making the space in the centre as wide again as one of those at the sides; with an arch between the columns, above which there rest on the capitals the architrave and cornice, and in the centre, within the arch, a very beautiful decoration of pilasters, with cornice and frontispiece, and with a ground formed by a tablet of most beautiful black basanite, where there is the statue of a nude Christ, larger than life and in the round, a very good figure; which statue stands in the act of showing the Wounds, with a piece of drapery bound round the flanks and reaching between the legs to the ground. Over the angles of the arch are Signs of His Passion, and between the columns that are on the right side there stands upon a pedestal a statue in the round representing Signor Jano Fregoso, fully armed after the antique save that he shows the arms and legs nude, and he has the left hand upon the pommel of the sword at his girdle, and with the right hand he holds the general's baton; having behind him as a pendant, within the space between the columns, a Minerva in half-relief, who, poised in the air, holds with one hand a Ducal staff, such as that of the Doges of Venice, and with the other a banner containing the device of S. Mark. Between the two other columns, as the other pendant, is Military Valour in armour, on her head the helmet-crest with the house-leek upon it, and on her cuirass the device of an ermine that stands upon a

rock surrounded by mire, with letters that run – 'Potius mori quam fœdari,' and with the device of the Fregosi; and above is a Victory, with a garland of laurel and a palm in the hands. Above the columns, architrave, frieze and cornice, is another range of pilasters, upon the crowns of which stand two figures of marble in the round, and two trophies likewise in the round and of the same size as the figures. Of these two statues, one is Fame in the act of taking flight, pointing with the right hand to Heaven, and with a trumpet that she is sounding; and this figure has light and most beautiful draperies about the body, and all the rest nude. The other, representing Eternity, is clothed in heavier vestments, and stands in majesty, holding in the left hand a round on which she is gazing, and with the right hand she grasps a hem of her garment wherein are globes that signify the various ages, with the celestial sphere encircled by the serpent that seizes the tail in the mouth. In the central space above the great cornice, which forms and separates those two other spaces, are three steps upon which are seated two large nude boys, who hold a great shield with the helmet above it, containing the devices of the Fregosi; and below those steps is an epitaph of basanite with large gilded letters. That whole work is truly worthy to be extolled, for Danese executed it with great diligence, and gave beautiful proportion and grace to the composition, and made each figure with great study. And Danese is not only, as has been described, an excellent sculptor, but also a good and much extolled poet, as his works clearly demonstrate, on which account he has always had intercourse and strait friendship with the greatest men and choicest spirits of our age; and of this may serve as a proof the work described above, executed by him with much poetic feeling. By the hand of Danese is the nude statue of the Sun above the ornament of the well in the courtyard of the Mint, at Venice; in place of which those Signori desired a Justice, but Danese considered that in that place the Sun is more appropriate. This figure has a bar of gold in the left hand, and in the right hand a sceptre, at the end of which he made an eye, and about the head the rays of the sun, and above all the globe of the world encircled by the serpent that holds the tail in the mouth, with some little mounds of gold about the globe, generated by him. Danese would have liked to make two other statues, that of the Moon for silver and another for copper, with that of the Sun for gold; but it was enough for those Signori that there should be that of gold, as the most

perfect of all the metals. The same Danese has begun another work in memory of Prince Loredano, Doge of Venice, wherein it is hoped that in invention and fantasy he is to surpass by a great measure all his other labours; which work is to be placed in the Church of SS. Giovanni e Polo in Venice. But, since this master is alive and still constantly at work for the benefit of the world and of art, I shall say nothing more of him; nor of other disciples of Sansovino. I will not omit, however, to speak briefly of some other excellent craftsmen, sculptors and painters, from that dominion of Venice, taking my opportunity from those mentioned above, in order to make an end of speaking of them in this Life of Sansovino.

Vicenza, then, has likewise had at various times sculptors, painters, and architects, of some of whom record was made in the Life of Vittore Scarpaccia, and particularly of those who flourished in the time of Mantegna and learned to draw from him; and such were Bartolommeo Montagna, Francesco Verbo, and Giovanni Speranza, all painters, by whose hands are many pictures that are dispersed throughout Vicenza. Now in the same city there are many sculptures by the hand of one Giovanni, a carver and architect, which are passing good, although his proper profession has been to carve foliage and animals, as he still does excellently well, although he is old. In like manner, Girolamo Pironi of Vicenza has executed praiseworthy works of sculpture and painting in many places in his city. But among all the masters of Vicenza he who most deserves to be extolled is the architect Andrea Palladio, from his being a man of singular judgment and brain, as many works demonstrate that were executed by him in his native country and elsewhere, and in particular the Palazzo della Comunità, a building much renowned, with two porticoes composed in the Doric Order with very beautiful columns. The same Palladio has erected a palace, beautiful and grand beyond all belief, with an infinity of the richest ornaments, for Count Ottavio de' Vieri, and another like it for Count Giuseppe di Porto, which could not be more beautiful or magnificent, nor more worthy than it is of no matter how great a Prince; and another is being built even now for Count Valerio Chiericati under the direction of the same master, very similar in majesty and grandeur to the ancient buildings so much extolled. For the Counts of Valmorana, likewise, he has now carried almost to completion another most superb palace, which does not yield in

any particular to any of those mentioned above. In the same city, upon the piazza commonly called the Isola, he has built another very magnificent fabric for Signor Valerio Chiericati; and at Pugliano, a place in the Vicentino, a most beautiful house for the Chevalier, Signor Bonifazio Pugliana. In the same territory of Vicenza, at Finale, he has erected another fabric for Messer Biagio Saraceni; and one at Bagnolo for Signor Vittore Pisani, with a large and very rich court in the Doric Order with most beautiful columns. Near Vicenza, at the township of Lisiera, he has constructed for Signor Giovan Francesco Valmorana another very rich edifice, with four towers at the corners, which make a very fine effect. At Meledo, likewise, for Count Francesco Trissino and Lodovico his brother, he has begun a magnificent palace upon a hill of some eminence, with many ranges of loggie, staircases, and other appurtenances of a villa. At Campiglia, likewise in the Vicentino, he is making for Signor Mario Ropetta another similar habitation, with so many conveniences, rich apartments of rooms, loggie, staircases, and chambers dedicated to various virtues, that it will be, when once carried to completion, an abode rather for a King than for a nobleman. At Lunedo he has built another, in the manner of a villa, for Signor Girolamo de' Godi; and at Angarano another for Count Jacopo Angarano, which is truly most beautiful, although it appears a small thing to the great mind of that lord. At Quinto, also, near Vicenza, he erected not long ago another palace for Count Marc' Antonio Tiene, which has in it more of the grand and the magnificent than I could express. In short, Palladio has constructed so many vast and lovely buildings within and without Vicenza, that, even if there were no others there, they would suffice to make a very handsome city with most beautiful surroundings.

In Venice the same Palladio has begun many buildings, but one that is marvellous and most notable among them all, in imitation of the houses that the ancients used to build, in the Monastery of the Carità. The atrium of this is forty feet wide and fifty-four feet long, which are exactly the diameters of the quadrangle, the wings being one-third and a half of the length. The columns, which are Corinthian, are three feet and a half in thickness and thirty-five feet high. From the atrium one goes into the peristyle, that is, into a clauster (for thus do the friars call their courts), which on the side towards the atrium is divided into five parts, and at the flanks into seven, with three orders of columns

one above the other, of which the Doric is at the foot, and above it the Ionic and the Corinthian. Opposite to the atrium is the refectory, two squares in length, and as high as the level of the peristyle, with its officines around it, all most commodious. The stairs are spiral, in the form of an oval, and they have neither wall nor column, nor any part in the middle to support them; they are thirteen feet wide, and the steps by their position support one another, being fixed in the wall. This edifice is all built of baked stone, that is, of brick, save the bases of the columns, the capitals, the imposts of the arches, the stairs, the surface of the cornices, and the whole of the windows and doors. The same Palladio has built for the Black Friars of S. Benedict, in their Monastery of S. Giorgio Maggiore in Venice, a very large and most beautiful refectory with its vestibule in front, and has begun to found a new church, with such beautiful ordering, according as the model shows, that, if it is carried to completion, it will prove a stupendous and most lovely work. Besides this, he has begun the façade of the Church of S. Francesco della Vigna, which the very reverend Grimani, Patriarch of Aquileia, is causing to be made of Istrian stone, with a most magnificent disregard of expense; the columns are four palms thick at the foot, forty palms high, and in the Corinthian Order, and already the whole basement at the foot is built. At Gambaraie, a place seven miles distant from Venice, on the River Brenta, the same Palladio has made a very commodious habitation for M. Niccolò and M. Luigi Foscari, gentlemen of Venice. Another he has built at Marocco, a place in the Mestrino, for the Chevalier Mozzenigo; at Piombino one for M. Giorgio Cornaro, one at Montagnana for the Magnificent M. Francesco Pisani, and another at Cicogna in the territory of Padua for Count Adovardo da Tiene, a gentleman of Vicenza. At Udine, in Friuli, he has built one for Signor Floriano Antimini; at Motto, a township likewise in Friuli, one for the Magnificent M. Marco Zeno, with a most beautiful court and porticoes all the way round; and at Fratta, a township in the Polesine, a great fabric for Signor Francesco Badoaro, with some very beautiful and fantastic loggie. In like manner, near Asolo, a place in the territory of Treviso, he has erected a most commodious habitation for the very reverend S. Daniello Barbaro, Patriarch-Elect of Aquileia, who has written upon Vitruvius, and for the most illustrious M. Marc' Antonio, his brother, with such beautiful ordering, that nothing better or greater can ever be imagined. Among

other things, he has made there a fountain very similar to that
which Pope Julius caused to be made at his Vigna Giulia in
Rome; with ornaments of stucco and paintings everywhere, ex-
ecuted by excellent masters. In Genoa M. Luca Giustiniano
has erected a building with the design of Palladio, which is held
to be very beautiful, as are also all those mentioned above; but it
would have made too long a story to seek to recount the many
particulars of the strange and lovely inventions and fantasies
that are in them. But, since there is soon to come into the light
of day a work of Palladio, in which will be printed two books of
ancient edifices and one book of those that he himself has caused
to be built, I shall say nothing more of him, because this will be
enough to make him known as the excellent architect that he is
held to be by all who see his beautiful works; besides which,
being still young and attending constantly to the studies of his
art, every day greater things may be expected of him. Nor will I
omit to say that he has wedded to such gifts a nature so amiable
and gentle, that it renders him well-beloved with everyone;
wherefore he has won the honour of being accepted into the
number of the Academicians of Design in Florence, together
with Danese, Giuseppe Salviati, Tintoretto, and Battista Farinato
of Verona, as will be told in another place, speaking of the said
Academicians.

Bonifazio, a Venetian painter, of whom I have never before
received any information, is also worthy to be numbered in the
company of these many excellent craftsmen, being a well-
practised and able colourist. This master, besides many pictures
and portraits that are dispersed throughout Venice, has executed
for the altar of the Relics in the Church of the Servites, in the
same city, an altar-piece wherein is a Christ with the Apostles
about Him, and Philip who appears to be saying, 'Domine, os-
tende nobis patrem,' which is painted with a very good and beau-
tiful manner. And for the altar of the Madonna in the Church of
the Nuns of the Spirito Santo, he has executed another most
beautiful altar-picture with a vast number of men, women, and
children of every age, who in company with the Virgin are ador-
ing a God the Father who is in the air with many Angels about
Him. Another painter of passing good name in Venice is Jacopo
Fallaro, who has painted on the doors of the organ in the Church
of the Ingesuati the Blessed Giovanni Colombini receiving his
habit in the Consistory from the Pope, with a good number of

Cardinals. Another Jacopo, called Pisbolica, has executed an altar-piece for S. Maria Maggiore in Venice, wherein is Christ in the air with many Angels, and below Him Our Lady with the Apostles. And one Fabrizio Viniziano has painted on the façade of a chapel in the Church of S. Maria Sebenico the Consecration of the baptismal font, with many portraits from life executed with beautiful grace and a good manner.

NOTES.

I., line 1, p. 803.

The family of the Tatti in Florence is recorded in the books of the Commune from the year 1300, because, having come from Lucca, a very noble city of Tuscany, it was always abundant in industrious and honoured men, and they were most highly favoured by the House of Medici. Of this family was born Jacopo, of whom we are writing in this place; and he was born from Antonio, a most excellent person, and from his wife Francesca, in the month of January, 1477. In the first years of his boyhood he was set, as is usual, to learn his letters; and, after beginning to show in these vivacity of brain and readiness of spirit, not long afterwards he applied himself of his own accord to drawing, giving evidence in a certain sort that nature was inclining him much more to this kind of work than to letters, for the reason that he went very unwillingly to school and learned much against his will the scabrous rudiments of grammar. His mother, whom he resembled strongly, perceiving this and fostering his genius, gave him assistance, causing him to be taught design in secret, because she loved the thought that her son should be a sculptor, perchance in emulation of the then rising glory of Michelagnolo Buonarroti, who at that time was still quite young; and also moved by a certain fateful augury, in that Michelagnolo and this Jacopo had been born in one and the same street, called Via S. Maria, near the Via Ghibellina. Now the boy, after some time, was placed to learn the trade of a merchant; in which delighting even less than in letters, he did and said so much, that he obtained leave from his father to attend without hindrance to that towards which he was urged by nature.

There had come to Florence at that time Andrea Contucci of Monte Sansovino, a township near Arezzo, risen to great fame in our days from having been the birthplace of Pope Julius III; which Andrea, having acquired in Italy and in Spain the name of the best sculptor and architect that there was in art after Buonarroti, was staying in Florence in order to execute two figures of marble. Etc.

II., line 34, p. 812.

(And he was executing many works of the greatest importance for all those lords), having been recognized by three Pontiffs, and especially

by Pope Leo, who presented him with a Knighthood of S. Pietro, which he sold during his illness, doubting lest he might die; (when God, etc.).

III., line 37, p. 813.

Having then entered on that office, he began to occupy himself with every care, both with regard to buildings and in the management of the papers and of the books that he held by virtue of his office, acquitting himself with all possible diligence in the affairs of the Church of S. Marco, of the Commissions, which are a great number, and of the many other matters that are in the charge of those Procurators; and he showed extraordinary lovingness towards those Signori, in that, having turned his whole attention to benefiting them and to directing their affairs to the aggrandizement, embellishment, and ornamentation of the church, the city, and the public square (a thing never yet done by any other in that office), he provided them with various advantages, profits, and revenues by means of his inventions, with his ingenuity of brain and readiness of spirit, yet always with little or no expense to the Signori themselves. Among which benefits, one was this; in the year 1529 there were between the two columns in the Piazza some butchers' stalls, and also between the one column and the other many wooden cabins to accommodate persons in their natural necessities – a thing most filthy and disgraceful, both for the dignity of the Palace and of the Piazza Pubblica, and for the strangers who, coming into Venice by way of S. Giorgio, saw first of all on arrival that filthiness. Jacopo, after demonstrating to the Prince Gritti the honourable and profitable nature of his design, caused those stalls and cabins to be removed; and, placing the stalls where they now are and making certain places for the sellers of herbs, he obtained for the Procurators an additional revenue of seven hundred ducats, embellishing at the same time the Piazza and the city. Not long afterwards, having perceived that in the Merceria (on the way to the Rialto, near the Clock), by removing a house that paid a rent of twenty-six ducats, a street could be made leading into the Spadaria, whereby the rent of the houses and shops all around would be increased, he threw down that house and increased their revenues by one hundred and fifty ducats a year. Besides this, by placing on that site the hostelry of the Pellegrino and another in the Campo Rusolo, he brought them in another four hundred ducats. He obtained for them similar benefits by the buildings in the Pescaria, and, on divers other occasions, by many houses and shops and other places belonging to those Signori, at various times; insomuch that the Procurators, having gained by his care a revenue of more than two thousand ducats, have been rightly moved to love him and to hold him dear.

Not long afterwards, by order of the Procurators, he set his hand to the very rich and beautiful building of the Library opposite to the Palazzo Pubblico, with such a variety of architecture (for it is both Doric

and Corinthian), and such a wealth of carvings, cornices, columns, capitals, and half-length figures throughout the whole work, that it is a marvel; and all without any sparing of expense, since it is full of the richest pavements, stucco-work and scenes throughout the halls of that place, and public staircases adorned with various pictures, as has been related in the Life of Battista Franco, not to speak of the appurtenances and rich ornaments that it has at the principal door of entrance, which give it majesty and grandeur, demonstrating the ability of Sansovino. Which method of building was the reason that in that city, into which there had not entered up to that time any other method but that of building their houses and palaces in one and the same order, each man always continuing the same things with the same measurements and ancient use, without varying according to the sites as they found them, or according to convenience; it was the reason, I say, that buildings both public and private began to be erected with new designs and better order, and according to the ancient teaching of Vitruvius; and that work, in the opinion of those who are good judges and have seen many parts of the world, is without any equal.

He then built the Palace of Messer Giovanni Delfino, situated on the Grand Canal on the other side from the Rialto, opposite to the Riva del Ferro, at a cost of thirty thousand ducats. He built, likewise, that of Messer Leonardo Moro at S. Girolamo, a work of great cost, which has almost the appearance of a castle. And he erected the Palace of Messer Luigi de' Garzoni, wider by thirteen paces in every direction than is the Fondaco de' Tedeschi, with so many conveniences, that water runs through the whole fabric, which is adorned with four most beautiful figures by Sansovino; which palace is at Ponte Casale, in the neighbourhood of Venice. But the most beautiful is the Palace of Messer Giorgio Cornaro on the Grand Canal, which, without any doubt surpassing the others in convenience, majesty, and grandeur, is considered perhaps the finest that there is in Italy. He also built (to have done with speaking of private edifices) the Scuola or Confraternity of the Misericordia, a vast work costing one hundred and thirty thousand crowns, which, when carried to completion, will prove to be the most superb edifice in Italy. And his work, also, is the Church of S. Francesco della Vigna, where the Frati de' Zoccoli have their seat, a work of great size and importance; but the façade was by another master. The Loggia about the Campanile of S. Marco, in the Corinthian Order, was from his design, with a very rich ornament of columns, and with four niches, in which are four supremely beautiful figures in bronze, little less than the size of life, which are by his hand, together with various scenes and figures in low-relief. That work makes a most beautiful base to the said campanile, which has a thickness, on one of the sides, of thirty-five feet, which is about the extent of Sansovino's ornamentation. In height, from the ground to the cornice where are the windows of the bells, it is one

hundred and sixty feet; from the level of that cornice to the other above it, where the corridor is, twenty-five feet; and the other dado above has a height of twenty-eight feet and a half. From that level of the corridor up to the pyramid is sixty feet; at the summit of which spire, the little square, upon which rests the Angel, is six feet high, and the said Angel, which turns with every wind, is ten feet high; insomuch that the whole height comes to be two hundred and ninety-two feet.

But the finest, richest, and strongest of his edifices is the Mint of Venice, all of iron and stone, for there is not in it one single piece of wood, in order to render it absolutely safe from fire. And the interior is distributed with such order and convenience for the sake of the many artificers, that there is not in any part of the world a treasury better ordered, or with greater strength, than that one, which he built entirely in the Rustic Order and very beautiful; which method, not having been used before in that city, caused the inhabitants to marvel not a little. By his hand, also, may be seen the Church of S. Spirito on the lagoons, of a very delicate and pleasing workmanship; and in Venice there is the façade of S. Gimignano, which gives splendour to the Piazza, in the Merceria the façade of S. Giuliano, and in S. Salvadore the very rich tomb of the Prince Francesco Veniero. He also erected in the Rialto, on the Grand Canal, the new fabrics of the vaults, with such good design, that almost every day there assembles there a very convenient market of townsmen and of other persons who flock to that city. And a very marvellous thing and new was that which he did for the Tiepoli at the Misericordia, in that, they having on the canal a great palace with many regal chambers, and the whole building being badly founded in the water, so that it was likely enough that in a few years the edifice would fall to the ground, Sansovino rebuilt all the foundations in the canal below the palace with very large stones, maintaining the house on its feet with a marvellous support of props, while the owners lived in their house with perfect security.

Nor for all this, while he has given his attention to so many buildings, has he ever ceased to occupy himself every day for his own delight with vast and beautiful works of sculpture, in marble and in bronze. Over the holy-water font of the Friars of the Cà Grande there is by his hand a statue made of marble, representing S. John the Baptist, which is very beautiful and highly extolled. At Padua, in the Chapel of the Santo, there is a large scene in marble by the same hand, with very beautiful figures in half-relief, of a miracle of S. Anthony of Padua; which is much esteemed in that place. For the entrance of the stairs of the Palace of S. Marco he is even now executing in marble in the forms of two very beautiful giants, each of seven braccia, a Neptune and a Mars, signifying the power which that most illustrious Republic has on land and sea. He made a most beautiful statue of Hercules for the Duke of Ferrara; and for the Church of S. Marco he made six scenes of bronze in half-relief,

one braccio high and one and a half long, for placing on a pulpit, with stories of that Evangelist, which are held in much estimation for their variety. Over the door of the same S. Marco he made a Madonna of marble, the size of life, which is held to be a very beautiful thing; and at the entrance to the sacristy of that place there is by his hand the door of bronze divided into two most beautiful parts, with stories of Jesus Christ all in half-relief and wrought excellently well. And over the door of the Arsenal he made a very beautiful Madonna, who is holding her Son in her arms, of marble. All which works not only have given lustre and adornment to that Republic, but also have caused Sansovino to be better known every day as a most excellent craftsman, and loved and honoured by the magnificent liberality of those Signori, and likewise by the other craftsmen, every work of sculpture and architecture that has been executed in that city in his time being referred to him. And in truth the excellence of Jacopo has well deserved that he should be held in the first rank among the craftsmen of design in that city, and that his talents should be loved and revered by all without exception, both nobles and plebeians, for the reason that, besides other things, as has been told, with his judgment and knowledge he has brought it about that the city has been made almost entirely new and has learned the true and good method of building.

Three most beautiful figures in stucco by his hand, also, may be seen in the possession of his son, one a Laocoon, another a Venus standing, and the third a Madonna with many children about her; which figures are so rare, that in Venice there is seen nothing to equal them. The said son also has in drawing sixty plans of temples and churches of Sansovino's invention, which are so excellent that from the days of the ancients to our own there have been seen none better conceived or more beautiful. These I have heard that the son will publish for the benefit of the world, and already he has had some pieces engraved, accompanying them with designs of the numberless labours that have been carried into execution by Sansovino in various parts of Italy.

For all this, although occupied, as has been related, with the management of so many things both public and private, and both in the city and abroad (for strangers, also, ran to him for models and designs of buildings, for figures, or for counsel, as did the Duke of Ferrara, who obtained a Hercules in the form of a giant, the Duke of Mantua, and the Duke of Urbino), he was always very zealous in the private and particular service of each of his own Lords Procurators, who, availing themselves of him both in Venice and elsewhere, and not doing a single thing without his assistance or counsel, kept him continually at work not only for themselves, but also for their friends and relatives, without any reward, he consenting to endure any inconvenience and fatigue in order to satisfy them. But above all he was greatly loved and held in infinite price by the Prince Gritti, who delighted in beautiful intellects, by

Messer Vettorio Grimani, brother of the Cardinal, and by Messer Giovanni da Legge the Chevalier, all Procurators, and by Messer Marc' Antonio Justiniano, who became acquainted with him in Rome. For these illustrious men, exalted in spirit and truly regal in mind, being conversant with the affairs of the world and well informed in the noble and excellent arts, soon recognized his merit and how worthy he was to be cherished and esteemed, and availed themselves of him in due measure; and they used to say, in accord with the whole city, that the Procurators never had and never would have at any time another equal to him, for they knew very well how celebrated and renowned his name was with the men and princes of intellect in Florence and Rome and throughout all Italy, and every one held it as certain that not he only but also his descendants and all his posterity deserved to be endowed for ever in return for his singular genius.

Jacopo was in body of ordinary stature, without any fat, and he walked with the person upright. He was white in complexion, with the beard red; and in his youth he was very graceful and handsome, and therefore much beloved by various women of some importance. After he became old, he had a venerable presence, with a beautiful white beard, and walked like a young man, insomuch that, having come to the age of ninety-three, he was still very strong and healthy and could see every least thing, however distant it might be, without spectacles, and when writing he kept his head erect, not bending over at all as is done by others. He delighted to dress handsomely, and was always very neat in his person; and he always took pleasure in women down to extreme old age, and much loved to talk of them. In his youth, by reason of his excesses, he was not very robust; but when he had become old he never suffered any illness, insomuch that for a period of fifty years, although at times he felt indisposed, he would never avail himself of any physician; nay, having had an apoplectic stroke for the fourth time at the age of eighty-four, he recovered by staying only two months in bed in a very dark and warm place, despising medicines. He had so good a stomach, that he was not afraid of anything, making no distinction between food that might be good and food that might be harmful; and in summer he lived almost entirely on fruits, eating very often as many as three cucumbers at a time, and half a citron, in his extreme old age. As for his qualities of mind, he was very prudent and foresaw future events in the matters of the present, weighing them against the past; and he was zealous in his affairs, not considering any fatigue, and never left his business to follow pleasures. He discoursed well and with many words upon no matter what subject that he understood, giving many illustrations with much grace; on which account he was very dear both to the great and to the small, and to his friends. And in his last years he had a memory still very fresh, and remembered in detail his childhood, the sack of Rome, and many things, fortunate or unfortunate, that he

experienced in his time. He was courageous, and from his youth took delight in contending with those greater than himself, because, he used to say, by contending with the great a man advances, but against the little he lowers himself. He esteemed honour above everything in the world, wherefore in his affairs he was most loyal and a man of his word, and so pure in heart, that no offer, however great, could have corrupted him, although he was put to the test several times by his Signori, who for this and for other qualities regarded him not as their protomaster or minister, but as a father and brother, honouring him for his goodness, which was in no way feigned, but real. He was liberal with every man, and so loving towards his relatives, that he deprived himself of many comforts in order to assist them; although he lived always in repute and honour, as one who was observed by everyone. At times he let himself be overcome by anger, which was very great in him, but it soon passed; and very often with a few humble words you could make the tears come to his eyes.

He had a surpassing love for the art of sculpture; such a love, indeed, that, to the end that it might be dispersed widely in various parts, he formed many disciples, making as it were a seminary of that art in Italy. Among these, very famous were Niccolò Tribolo and Solosmeo, Florentines; Danese Cattaneo of Carrara, a Tuscan, of supreme excellence in poetry as well as in sculpture; Girolamo da Ferrara, Jacopo Colonna of Venice, Luca Lancia of Naples, Tiziano da Padova, Pietro da Salò, Bartolommeo Ammanati of Florence, at the present day sculptor and protomaster to the great Duke of Tuscany, and, finally, Alessandro Vittoria of Trento, a rare master in portraits of marble, and Jacopo de' Medici of Brescia; who, reviving the memory of the excellence of their master, have employed their talents on many honoured works in various cities.

Sansovino was much esteemed by Princes, among whom Alessandro de' Medici, Duke of Florence, sought his judgment in building the Citadel of that city. And Duke Cosimo in the year 1540, Sansovino having gone on his affairs to his native city, not only sought his counsel in the matter of that fortress, but also strove to engage him in his service, offering him a good salary; and on his return from Florence Duke Ercole of Ferrara detained him about his person and proposed various conditions to him, making every effort to keep him in Ferrara. But he, being used to Venice, and finding himself comfortable in that city, where he had lived a great part of his life, and having a singular love for the Procurators, by whom he was so much honoured, would never listen to any of them. He was also invited by Pope Paul III, who wished to advance him to the charge of S. Pietro in the place of Antonio da San Gallo, and with this Monsignor della Casa, who was then Legate in Venice, occupied himself much; but all was in vain, because he said that he was not minded to exchange the manner of life of a republic for that of living under an absolute Prince. And King Philip of Spain,

on his way to Germany, showed him much kindness at Peschiera, whither Jacopo had gone to see him.

He had an immoderate desire of glory, and by reason of that used to spend his own substance on others (not without notable harm to his descendants), in the hope that there might remain some memory of him. Good judges say that although he had to yield to Michelagnolo, yet in certain things he was his superior. Thus in the fashioning of draperies, in children, and in the expressions of women, Jacopo had no equal, for the reason that his draperies in marble were very delicate and well executed, with beautiful folds and curves that revealed the nude beneath the vestments; his children he made tender and soft, without those muscles that adults have, and with their little arms and legs as if of flesh, insomuch that they were in no way different from the life; and the expressions of his women were sweet and pleasing, and as gracious as could be, as is clearly seen from various Madonnas made by him in many places, of marble and in low-relief, and from his statues of Venus and other figures.

Now this man, having thus become celebrated in sculpture and in architecture a master without a rival, and having lived in the grace of mankind and also of God, who bestowed upon him the genius that made him illustrious, as has been related, when he had come to the age of ninety-three, feeling somewhat weary in body, took to his bed in order to rest; in which having lain without any kind of suffering, although he strove to rise and dress himself as if well, for a period of a month and a half, failing little by little, he asked for the Sacraments of the Church, which having received, while still hoping to live a few years, he sank gradually and died on the 2nd of November in the year 1570; and although in his old age he had run the whole course of nature, yet his death was a grief to all Venice. He left behind him his son Francesco, born at Rome in the year 1521, a man learned both in the law and in the humanities, from whom Jacopo saw three grandchildren born; a male child called, like his grandfather, Jacopo, and two female, one called Fiorenza, who died, to his infinite grief and sorrow, and the other Aurora. His body was borne with much honour to his chapel in S. Gimignano, where there was erected to his memory by his son the marble statue made by Jacopo himself while he was alive, with the epitaph given below in memory of his great worth:

JACOBO SANSOVINO FLORENTINO QUI ROMÆ JULIO II, LEONI X, CLEMENTI VII, PONT. MAX., MAXIME GRATUS, VENETIIS ARCHITECTURÆ SCULPTURÆQUE INTERMORTUUM DECUS PRIMUS EXCITAVIT, QUIQUE A SENATU OB EXIMIAM VIRTUTEM LIBERALITER HONESTATUS, SUMMO CIVITATIS MŒRORE DECESSIT, FRANCISCUS F. HOC MON. P. VIXIT ANN. XCIII. OB. V. CAL. DEC. MDLXX.

His obsequies were likewise celebrated publicly at the Frari by the Florentine colony, with no slight pomp, and the oration was delivered by Messer Camillo Buonpigli, an excellent man.

LEONE LIONI OF AREZZO, and other Sculptors and Architects

SINCE that which has been said above, here and there, of the Chevalier Leone, a sculptor of Arezzo, has been said incidentally, it cannot but be well to speak here in due order of his works, which are truly worthy to be celebrated and to pass into the memory of mankind. This Leone, then, having applied himself in the beginning to the goldsmith's art, and having made in his youth many beautiful works, and in particular portraits from life in dies of steel for medals, became in a few years so excellent, that he came to the knowledge of many great men and Princes, and particularly of the Emperor Charles V, by whom, having recognized his talents, he was set to works of greater importance than medals. Thus, not long after he became known to his Majesty, he made a statue of that Emperor in bronze, larger than life and in the round, which he then furnished with a very delicate suit of armour formed of two very thin shells, which can be put on and taken off with ease, and all wrought with such grace, that whoever sees the statue when covered does not notice it and can scarcely believe that it is nude below, and when it is nude no one would believe without difficulty that it could ever be so well clad in armour. This statue rests on the left leg, and with the right foot tramples on Fury, which is a recumbent figure bound in chains, with the torch beneath it and arms of various kinds. On the base of this work, which is now in Madrid, are these words:

CÆSARIS VIRTUTE FUROR DOMITUS.

After these statues Leone made a great die for striking medals of his Majesty, and on the reverse the Giants being slain by Jove with thunderbolts. For all which works the Emperor gave to Leone a pension of one hundred and fifty ducats a year on the Mint of Milan, with a very commodious house in the Contrada de' Moroni, and made him a Chevalier and of his household, besides giving him many privileges of nobility for his descend-

ants. And while Leone was with his Majesty in Brussels, he had his rooms in the palace of the Emperor himself, who at times would go for recreation to see him at work. Not long afterwards he made another statue of the Emperor, in marble, and also those of the Empress and King Philip, and a bust of the same Emperor for placing on high between two panels in bronze. He made, likewise in bronze, the head of Queen Maria, that of Ferdinand, at that time King of the Romans, that of Maximilian his son, now Emperor, and that of Queen Leonora, with many others, which were placed in the Gallery of the Palace of Binche by Queen Maria, who had caused them to be made. But they did not stay there long, because King Henry of France set fire to the building by way of revenge, leaving written there these words, 'Vela fole Maria';* I say by way of revenge, because a few years before that Queen had done the same to him. However it may have been, the work of that gallery did not proceed, and those statues are now partly in the Palace of the Catholic King at Madrid, and partly at Alicante, a sea-port, from which her Majesty intended to have them conveyed to Granada, where are the tombs of all the Kings of Spain. On returning from Spain, Leone brought with him two thousand crowns in cash, besides many other gifts and favours that were bestowed upon him by that Court.

For the Duke of Alva Leone has executed a head of the Duke, one of Charles V, and another of King Philip. For the very reverend Bishop of Arras, now Grand Cardinal, called Granvella, he has made some pieces in bronze of an oval form, each of two braccia, with rich borders, and containing half-length statues; in one is Charles V, in another King Philip, and in the third the Cardinal himself, portrayed from life, and all have bases with little figures of much grace. For Signor Vespasiano Gonzaga he has made in a great bust of bronze the portrait of Alva, which Gonzaga has placed in his house at Sabbionetto. For Signor Cesare Gonzaga he has executed, likewise in metal, a statue of four braccia, which has beneath it another figure that is entwined with a Hydra, in order to denote his father Don Ferrante, who by his worth and valour overcame the vicious envy that had sought to

* The story runs that in the year 1533 Queen Maria attacked and destroyed the Castle of Folembrai, and that in the following year King Henry of France, out of revenge, destroyed the fortress of Binche in Upper Hainault, leaving on the ruined walls the words 'Voilà Folembrai'; which in the Italian have been corrupted into 'Vela fole Maria.'

bring him into disgrace with Charles V in the matter of the government of Milan. This statue, which is clad in a toga and armed partly in the ancient and partly in the modern fashion, is to be taken to Guastalla and placed there in memory of that Don Ferrante, a most valorous captain.

The same Leone has made, as has been told in another place, the tomb of Signor Giovanni Jacopo Medici, Marquis of Marignano and brother of Pope Pius IV, which stands in the Duomo of Milan, about twenty-eight palms in length and forty in height. This tomb is all of Carrara marble, and adorned with four columns, two of them black and white, which were sent by the Pope as rare things from Rome to Milan, and two others, larger, which are of a spotted stone similar to jasper; which are all accommodated under one and the same cornice, an unusual contrivance, by the desire of that Pope, who caused the whole work to be executed after the directions of Michelagnolo, excepting only the five figures of bronze that are there, which are by the hand of Leone. The first of these, the largest of them all, is the statue of the Marquis himself, standing upright and larger than life, which has in the right hand the baton of a General, and the left hand resting on a helmet that is on a very richly adorned trunk. On the left of this is a smaller statue, representing Peace, and on the right another signifying Military Virtue; and these are seated, and in aspect all sad and sorrowing. Of the other two, which are on high, one is Providence and the other Fame; and between them, on the same level, is a most beautiful Nativity of Christ in bronze, in low-relief. At the summit of the whole work are two figures of marble, which support that lord's escutcheon of balls. For this work seven thousand and eight hundred crowns were paid, according to the agreement made in Rome by the most illustrious Cardinal Morone and Signor Agabrio Scierbellone.

The same master has made for Signor Giovan Battista Castaldo a statue likewise in bronze, which is to be placed in I know not what monastery, with some ornaments. For the above-named Catholic King he has executed a Christ in marble, more than three braccia high, with the Cross and with other Mysteries of the Passion, which is much extolled. Finally, he has in hand the statue of Signor Alfonso Davalos, the Marchese del Vasto of famous memory, which was entrusted to him by the Marchese di Pescara, his son; four braccia high, and likely to prove an excellent figure when cast, by reason of the diligence that he is devoting to its

execution, and the good fortune that Leone has always had in his castings.

Leone, in order to display the greatness of his mind, the beautiful genius that he has received from Nature, and the favour of Fortune, has built at great expense and with most beautiful architecture a house in the Contrada de' Moroni, so full of fantastic inventions, that there is perhaps no other like it in all Milan. In the distribution of the façade there are upon pilasters six captives each of six braccia and all of pietra viva, and between these, in certain niches, Fates in imitation of the antique, with little terminal figures, windows, and cornices all different from the common use and very graceful; and all the parts below correspond with beautiful order to those above, and the frieze-ornaments are all of various instruments of the arts of design. From the principal door one enters by a passage into a courtyard, in the centre of which, upon four columns, is the horse with the statue of Marcus Aurelius, cast in gesso from the original which is in the Campidoglio. By means of that statue he has intended that his house should be dedicated to Marcus Aurelius; and as for the captives, that fancy is interpreted by various persons in various ways. Besides the horse, he has in that beautiful and most commodious habitation, as has been told in another place, as many casts in gesso as he has been able to obtain of famous works in sculpture and casting, both ancient and modern.

A son of Leone, called Pompeo, who is now in the service of King Philip of Spain, is in no way inferior to his father in executing dies of steel for medals and in casting figures that are marvellous. Wherefore at that Court he has been a competitor of Giovan Paolo Poggini, a Florentine, who also works in the service of that King and has made most beautiful medals. But Pompeo, having served that King many years, intends to return to Milan in order to enjoy his Aurelian house and the other labours of his excellent father, the loving friend of every man of talent.

And now to say something of medals, and of the steel dies with which they are made. I believe that it may be affirmed with truth that our modern intellects have achieved as much as the ancient Romans once did in the excellence of the figures, and that in the lettering and in other parts they have surpassed them. Which may be seen clearly in twelve reverses – besides many others – that Pietro Paolo Galeotto has executed recently in the

medals of Duke Cosimo, and they are these; Pisa restored almost to her pristine condition by means of the Duke, he having drained the country round and dried the marshy places, and having made many other improvements; the waters conducted to Florence from various places, the ornate and magnificent building of the Magistrates erected for the public convenience, the union of the States of Florence and Siena, the building of a city and two fortresses in Elba, the column conveyed from Rome and placed on the Piazza di S. Trinita in Florence, the preservation, completion and enlargement of the Library of S. Lorenzo for the public good, the foundation of the Order of the Knights of S. Stephen, the resignation of the government to the Prince, the fortifying of the State, the militia or trained companies of his dominion, and the Pitti Palace with its gardens, waters, and buildings, a work of such regal magnificence; of which reverses I do not give here either the lettering that they have around them, or their explanation, having to treat of them in another place. All these twelve reverses are beautiful to a marvel and executed with much diligence and grace, as is also the head of the Duke, which is of perfect beauty; and medals and other works in stucco, likewise, as I have said on another occasion, are being made of absolute perfection at the present day. And recently Mario Capocaccia of Ancona has executed with coloured stucco, in little cases, heads and portraits that are truly most beautiful; such as a portrait of Pope Pius V, which I saw not long since, and that of Cardinal Alessandrino. I have seen, also, portraits of the same kind by the hands of the sons of Polidoro, a painter of Perugia, which are very beautiful.

But to return to Milan; looking again a year ago over the works of the sculptor Gobbo, of whom mention has been made in another place, I did not see anything that was otherwise than ordinary, excepting an Adam and Eve, a Judith, and a S. Helena, in marble, which are about the Duomo; with two other statues of dead persons, representing Lodovico, called Il Moro, and Beatrice his wife, which were to be placed upon a tomb by the hand of Giovan Jacomo della Porta, sculptor and architect to the Duomo of Milan, who in his youth executed many works under the said Gobbo; and those named above, which were to go on that tomb, are wrought with a high finish. The same Giovan Jacomo has executed many beautiful works for the Certosa of Pavia, and in particular on the tomb of the Conte di Virtù and

on the façade of the church. From him one his nephew learned his art, by name Guglielmo, who in Milan, about the year 1530, applied himself with much study to copying the works of Leonardo da Vinci, which gave him very great assistance. Whereupon he went with Giovan Jacomo to Genoa, when in the year 1531 the latter was invited to execute the sepulchre of S. John the Baptist, and he devoted himself with great study to design under Perino del Vaga; and, not therefore abandoning sculpture, he made one of the sixteen pedestals that are in that sepulchre, on which account, it being seen that he was acquitting himself very well, he was commissioned to make all the others. Next, he executed two Angels in marble, which are in the Company of S. Giovanni; and for the Bishop of Servega he made two portraits in marble, and a Moses larger than life, which was placed in the Church of S. Lorenzo. And then, after he had made a Ceres of marble that was placed over the door of the house of Ansaldo Grimaldi, he executed for placing over the Gate of the Cazzuola, in that city, a statue of S. Catharine of the size of life; and after that the three Graces, with four little boys, of marble, which were sent into Flanders to the Grand Equerry of the Emperor Charles V, together with another Ceres of the size of life.

Having executed these works in six years, Guglielmo in the year 1537 made his way to Rome, where he was much recommended by his uncle Giovan Jacomo to the painter Fra Sebastiano Viniziano, his friend, to the end that he might recommend him, as he did, to Michelagnolo Buonarroti. Which Michelagnolo, seeing Guglielmo to be spirited and very assiduous in labouring, began to conceive an affection for him, and, before any other thing, caused him to restore some antique things in the Farnese Palace, in which he acquitted himself in such a manner, that Michelagnolo put him into the service of the Pope. Another proof of his powers had been seen already in a tomb that he had executed at the Botteghe Scure, for the most part of metal, for Bishop Sulisse, with many figures and scenes in low-relief — namely, the Cardinal Virtues and others, wrought with much grace, and besides these the figure of the Bishop himself, which afterwards went to Salamanca in Spain. Now, while Guglielmo was engaged in restoring the statues, which are now in the loggia that is before the upper hall in the Farnese Palace, there took place in the year 1547 the death of Fra Sebastiano Viniziano, who, as has been told, had administered the office of the Piombo.

Whereupon Guglielmo, with the favour of Michelagnolo and of others, so wrought upon the Pope, that he obtained the said office of the Piombo, with the charge of executing the tomb of Pope Paul III, which was to be placed in S. Pietro. For this he availed himself in the model, with better design, of the scenes and figures of the Theological and Cardinal Virtues that he had made for the above-named Bishop Sulisse, placing at the corners four children in four partitions, and four cartouches, and making in addition a bronze statue of the said Pontiff seated, giving the benediction; which statue was seventeen palms high. But doubting, on account of the size of the casting, lest the metal might grow cold and the work therefore not succeed, he placed the metal in the vessel below, in such a way that it might be gradually sucked upwards. And with this unusual method that casting came out very well, and as clean as the wax, so that the very surface that came from the fire had no need at all to be polished, as may be seen from the statue itself, which was placed below the first arches that support the tribune of the new S. Pietro. On this tomb, which according to a design by his hand was to be isolated, were to be placed four figures, which he executed in marble with beautiful inventions according as he was directed by M. Annibale Caro, who had the charge of this from the Pope and Cardinal Farnese. One was Justice, which is a nude figure lying upon some draperies, with the belt of the sword across the breast, and the sword hidden; in one hand she has the fasces of consular jurisdiction, and in the other a flame of fire, and she is young in countenance, and has the hair plaited, the nose aquiline, and the aspect full of expression. The second was Prudence in the form of a matron, young in aspect, with a mirror in the hand, and a closed book, and partly nude, partly draped. The third was Abundance, a young woman crowned with ears of corn, with a horn of plenty in one hand and the ancient corn-measure in the other, and clothed in such a manner as to show the nude beneath the draperies. The fourth and last was Peace, who is a matron with a boy that has lost his eyes, and with the Caduceus of Mercury. He made, likewise, a scene also of metal and after the directions of the above-named Caro, which was to be placed in the work, with two River Gods, one representing a lake and the other a river that is in the domains of the Farnesi; and, besides all these things, there was to be there a mount covered with lilies, and with the rainbow of Iris. But the whole was not afterwards carried into

execution, for the reasons that have been given in the Life of Michelagnolo. It may be believed that even as these parts are in themselves beautiful and wrought with much judgment, so they would have succeeded as a whole together; and yet it is the air of the piazza* which gives the true light and enables us to form a correct judgment of a work.

The same Fra Guglielmo has executed during a period of many years fourteen stories of the life of Christ, for casting in bronze; each of which is four palms in breadth and six in height, excepting only one, which is twelve palms high and six broad, wherein is the Nativity of Jesus Christ, with most beautiful fantasies of figures. In the other thirteen are, Mary going with the Infant Christ on the ass to Jerusalem, with two figures in strong relief, and many in half-relief and low-relief; the Last Supper, with thirteen figures well composed, and a very rich building; the Washing of the Disciples' feet; the Prayer in the Garden, with five figures, and at the foot a multitude of great variety; Christ led before Annas, with six large figures, many lower down, and one in the distance; the Scourging at the Column, the Crowning with Thorns, the 'Ecce Homo,' Pilate washing his hands; Christ bearing the Cross, with fifteen figures, and others in the distance, going to Mount Calvary; Christ Crucified, with eighteen figures; and Christ taken down from the Cross. All which scenes, if they were cast, would form a very rare work, seeing that they have been wrought with much study and labour. Pope Pius IV had intended to have them executed for one of the doors of S. Pietro, but he had not time, being overtaken by death. Recently Fra Guglielmo has executed models in wax for three altars in S. Pietro; Christ taken down from the Cross, Peter receiving the Keys of the Church, and the Coming of the Holy Spirit, which would all be beautiful scenes.

In short, this man has had, and still has, the greatest opportunities to exert himself and to execute works, seeing that the office of the Piombo gives such a revenue that the holder can study and labour for glory, which he who has not such advantages is not able to do; and yet Fra Guglielmo has executed no finished work between 1547 and this year of 1567. But it is the characteristic of those who hold that office to become sluggish and indolent; and that this is true, a proof is that this Guglielmo,

* See line 28 p. 743.

before he became Friar of the Piombo, executed many heads in marble and other works, besides those that we have mentioned. It is true, indeed, that he has made four great Prophets in stucco, which are in the niches between the pilasters of the first great arch of S. Pietro. He also occupied himself much with the cars for the feast of Testaccio and other masquerades, which were held now many years ago in Rome.

A pupil of this master has been one Guglielmo Tedesco, who, among other works, has executed a very rich and beautiful ornamentation of little statues in bronze, imitated from the best antiques, for a cabinet of wood (so it is called) which the Count of Pitigliano presented to the Lord Duke Cosimo. Which little figures are these; the horse of the Campidoglio, those of Monte Cavallo, the Farnese figures of Hercules, the Antinous and the Apollo of the Belvedere, and the heads of the Twelve Emperors, with others, all well wrought and very similar to the originals.

Milan has also had another sculptor, dead this year, called Tommaso Porta, who worked marble excellently well, and in particular counterfeited antique heads in marble, which have been sold as antiques; and masks he made so well that in them no one has equalled him, of which I have one in marble by his hand, placed on the chimney-piece of my house at Arezzo, which everyone takes for an antique. This Tommaso made the heads of the Twelve Emperors in marble, the size of life, which were the rarest things. These Pope Julius III took, making him a present of an office of a hundred crowns a year in the Segnatura; and he kept the heads I know not how many months in his chamber, as choice things. But by the agency (so it is believed) of the above-named Fra Guglielmo and others who were jealous of him, such measures were taken against him, that, with no regard for the dignity of the gift bestowed upon him by that Pontiff, they were sent back to his house; where they were afterwards bought from him on better terms by merchants, and then sent to Spain. Not one of our imitators of antiques was superior to this Tommaso, of whom it has seemed to me right that record should be made, and the rather as he has passed to a better life, leaving name and fame for his ability.

Many works, likewise, have been executed in Rome by one Leonardo, a Milanese, who has made recently two statues of marble, S. Peter and S. Paul, for the Chapel of Cardinal Giovanni Riccio da Montepulciano, which are much extolled and held to

be good and beautiful figures. And the sculptors Jacopo and Tommaso Casignuola have made in the Chapel of the Caraffi, in the Church of the Minerva, the tomb of Pope Paul IV, and, besides other ornaments, a statue formed of pieces which represents that Pope, with a mantle of veined brocatello marble, and the trimming and other things of veined marbles of various colours, which render it marvellous. And so we see added to the other industries of our modern intellects this new one, and that sculptors proceed with colours in their sculpture to imitate painting. Which tomb has been executed by means of the great saintliness, goodness and gratitude of Pope Pius V, a Pontiff and Holy Father truly most saintly, most blessed, and most worthy of long life.

Of Nanni di Baccio Bigio, a Florentine sculptor, besides what has been said of him in other places, I have to record that in his youth, under Raffaello da Montelupo, he applied himself in such a manner to sculpture, that in some little things that he did in marble he gave great promise that he would prove to be an able man. And having gone to Rome, under the sculptor Lorenzetto, while he gave his attention as his father had done also to architecture, he executed the statue of Pope Clement VII, which is in the choir of the Minerva, and a Pietà of marble, copied from that of Michelagnolo, which was placed in S. Maria de Anima, the Church of the Germans, as a work that is truly very beautiful. Another like it he made not long afterwards for Luigi del Riccio, a Florentine merchant, which is now in S. Spirito at Florence, in a chapel of that Luigi, who is no less extolled for such piety towards his native city than is Nanni for having executed the statue with much diligence and love. Nanni then applied himself under Antonio da San Gallo with more study to architecture, and gave his attention, while Antonio was alive, to the fabric of S. Pietro; where, falling from a staging sixty braccia high, and shattering himself, he escaped with his life by a miracle. Nanni has erected many edifices in Rome and in the country round, and has sought to obtain even more, and greater, as has been told in the Life of Michelagnolo. His work, also, is the Palace of Cardinal Montepulciano on the Strada Giulia, and a gate at Monte Sansovino built by order of Julius III, with a reservoir for water that is not finished, and a loggia and other apartments of the palace formerly built by the old Cardinal di Monte. And a work of Nanni, likewise, is the house of the Mattei, with many other

buildings that have been erected or are still being constructed in Rome.

A famous and most celebrated architect, also, among others of the present day, is Galeazzo Alessi of Perugia, who, serving in his youth the Cardinal of Rimini, whose chamberlain he became, executed among his first works, at the desire of that lord, the rebuilding of the apartments in the Fortress of Perugia, with so many conveniences and such beauty, that for a place so small it was a marvel, and many times already they have accommodated the Pope with all his Court. Then, after many other works that he executed for the said Cardinal, he was invited by the Genoese with much honour into the service of that Republic, for which the first work that he did was to restore and fortify the port and the mole; nay rather, to make it almost entirely different from what it was before. For, reaching out over a good space into the sea, he caused to be constructed a great and most beautiful port, which lies in a semicircle, very ornate with rustic columns and with niches about them, at the extremities of which semicircle there meet two little bastions, which defend that great port. On the piazza, then, above the mole and at the back of the great port, towards the city, he made a very large portico of the Doric Order, which accommodates the Guard, and over it, comprising all the space that it covers and likewise the two bastions and the gate, there is left a platform arranged for the operations of artillery, which commands the mole in the manner of a cavalier and defends the port both within and without. And besides this, which is finished, arrangements are being made for the enlargement of the city after his design, and his model has already been approved by the Signoria; and all with much praise for Galeazzo, who in these and other works has shown himself to be a most ingenious architect. The same Galeazzo has executed the new street of Genoa, with so many palaces built in the modern manner after his designs, that many declare that in no other city of Italy is there to be found a street more magnificent and grand than that one, nor one more full of the richest palaces, all built by those Signori with the persuasion and directions of Galeazzo, to whom all confess that they owe a very great obligation, in that he has been the inventor and executor of works which render their city, with regard to edifices, incomparably more grand and magnificent than it was before. The same master has built other streets without Genoa, and among others that which starts from Ponte

Decimo on the way to Lombardy. He has restored the walls of the city towards the sea, and the fabric of the Duomo, making therein the tribune and the cupola; and he has built, also, many private edifices, such as the country palace of Messer Luca Giustiniano, that of Signor Ottaviano Grimaldi, the Palaces of two Doges, one for Signor Battista Grimaldi, and many others of which there is no need to speak.

Now I will not omit to say that he has made the lake and island of Signor Adamo Centurioni, abounding in waters and fountains contrived in various beautiful and fantastic ways, and also the fountain of the Captain Larcaro, near the city, which is a most remarkable work; but beyond all the different kinds of fountains that he has made for many persons, most beautiful is the bath that he has made in the house of Signor Giovan Battista Grimaldi at Bisagno. This bath, which in form is round, has in the centre a little basin wherein eight or ten persons can bathe without inconvenience; which basin has hot water from four heads of sea-monsters that appear as if issuing from it, and cold water from as many frogs that are over those heads of monsters. Around that basin, to which one descends by three circular steps, there curves a space wide enough for two persons to walk in comfort. The circular wall of the whole bath is divided into eight spaces, in four of which are four great niches, each of which contains a round basin that is raised a little from the ground, half being within the niche and half remaining without; and in the centre of each basin a man can bathe, hot and cold water coming from a great mask that pours it through the horns and draws it in again when necessary by the mouth. In one of the other four spaces is the door, and in the other three are windows and places to sit; and all the eight spaces are separated by terminal figures, which support the cornice upon which rests the round vaulting of the whole bath. From the centre of that vaulting hangs a great ball of crystal-glass, on which is painted the sphere of the heavens, and within it the globe of the earth, from certain parts of which, when one uses the bath at night, comes a brilliant light that renders the place as light as if it were mid-day. I forbear to speak of the anteroom, the dressing-room, and the small bath, which are full of stucco-ornaments, and of the pictures that adorn the place, so as not to be longer than is needful; let it suffice to say that they are in no way unworthy of so great a work.

In Milan, under the direction of the same Galeazzo, has been

built the Palace of Signor Tommaso Marini, Duke of Terranuova; and also, possibly, the façade of the fabric of S. Celso that is now being built, the auditorium of the Cambio, which is round in form, the already begun Church of S. Vittore, and many other edifices. He has also sent designs over all Italy and abroad, wherever he has not been able to be in person, of many edifices, palaces, and temples, of which I shall say no more; this much being enough to make him known as a talented and most excellent architect.

I will not omit – seeing that he is one of our Italians, although I do not know any particulars of his works – that in France, so I am informed, a most excellent architect, and particularly in the work of fortification, is Rocco Guerrini of Marradi, who in the recent wars of that kingdom, to his great profit and honour, has executed many ingenious and laudable works.

And so in this last part, in order not to defraud any man of the proper credit of his talent, I have discoursed of some sculptors and architects now living, of whom hitherto I had not had a convenient occasion to speak.

DON GIULIO CLOVIO, Miniaturist

There has never been, nor perhaps will there ever be for many centuries, a more rare or more excellent miniaturist, or we would rather say painter of little things, than Don Giulio Clovio, in that he has surpassed by a great measure all others who have ever been engaged in that kind of painting. This master was born in the province of Sclavonia, or rather, Croatia, at a place called Grisone, in the diocese of Madrucci, although his elders, of the family of the Clovi, had come from Macedonia; and the name given to him at baptism was Giorgio Giulio. As a child he gave his attention to letters; and then, by a natural instinct, to design. And having come to the age of eighteen, being desirous to make proficience, he came to Italy and placed himself in the service of Cardinal Marino Grimani, with whom for a period of three years he applied himself in such a manner to drawing, that he achieved a much better result than perhaps up to that time had been expected of him; as was seen in some designs of medals and their reverses that he made for that lord, drawn with the pen most

minutely, with extreme and almost incredible diligence. Whereupon, having seen that he was more assisted by nature in little things than in great, he resolved, and wisely, that he would give his attention to miniature, since his works in that field were full of grace and beautiful to a marvel; being urged to this, also, by many friends, and in particular by Giulio Romano, a painter of bright renown, who was the man who before any other taught him the method of using tints and colours in gum and in distemper.

Among the first works that Clovio coloured was a Madonna, which, as a man of ingenious and beautiful spirit, he copied from the book of the Life of the Virgin; which Madonna was printed in wood-engraving among the first sheets of Albrecht Dürer. Whereupon, having acquitted himself well in that his first work, he made his way by means of Signor Alberto da Carpi, who was then serving in Hungary, into the service of King Louis and of Queen Maria, the sister of Charles V; for which King he executed a Judgment of Paris in chiaroscuro, which much pleased him, and for the Queen the Roman Lucretia killing herself, with some other things, which were held to be very beautiful. The death of that King then ensuing, and the ruin of everything in Hungary, Giorgio Giulio was forced to return to Italy; where he had no sooner arrived than the old Cardinal Campeggio took him into his service. Thereupon, being settled to his liking, he executed a Madonna in miniature for that lord, and some other little things, and disposed himself to attend at all costs with greater study to the matters of art; and so he set himself to draw, and to seek with every effort to imitate the works of Michelagnolo. But this fine resolution was interrupted by the unhappy sack of Rome in the year 1527, when the poor man, finding himself the prisoner of the Spaniards and maltreated, in his great misery had recourse to divine assistance, making a vow that if he escaped safely from that miserable ruin and out of the hands of those new Pharisees, he would straightway become a friar. Wherefore, having escaped by the grace of God and made his way to Mantua, he became a monk in the Monastery of S. Ruffino, a seat of the Order of Canons Regular of Scopeto; having been promised, besides peace and quiet of mind and tranquil leisure in the service of God, that he would have facilities for attending at times, as it were by way of pastime, to the work of miniature. Having thus taken the habit and the name of Don Giulio, at the end of a year he made his

profession; and then for a period of three years he stayed peace-fully enough among those fathers, changing from one monastery to another according to his pleasure, as has been related else-where, and always working at something. During that time he completed a great choirbook with delicate illuminations and most beautiful borderings, making in it, among other things, a Christ appearing to the Magdalene in the form of a gardener, which was held to be a rare thing. Wherefore, growing in courage, he de-picted – but in figures much larger – the Adulterous Woman accused by the Jews before Christ, with a good number of figures; all which he copied from a picture that had been executed in those days by Tiziano Vecelli, that most excellent painter.

Not long afterwards it happened that Don Giulio, in transfer-ring himself from one monastery to another, as monks or friars do, by misfortune broke a leg. Being therefore conveyed by those fathers to the Monastery of Candiana, that he might be better attended, he lay there some time without recovering, perhaps having been wrongly treated, as is common, no less by the fathers than by the physicians. Which hearing, Cardinal Grimani, who much loved him for his excellence, obtained from the Pope the power to keep him in his service and to have him cured. Where-upon Don Giulio, having thrown off the habit, and his leg being healed, went to Perugia with the Cardinal, who was Legate there; and, setting to work, he executed for him in miniature these works; an Office of Our Lady, with four most beautiful stories, and in an Epistolar three large stories of S. Paul the Apostle, one of which was sent not long afterwards to Spain. He also made for him a very beautiful Pietà, and a Christ Crucified, which after the death of Grimani came into the hands of Messer Giovanni Gaddi, Clerk of the Chamber.

All these works caused Don Giulio to become known in Rome as an excellent craftsman, and were the reason that Cardi-nal Alessandro Farnese, who has always assisted, favoured, and desired to have about him rare and gifted men, having heard his fame and seen his works, took him into his service, in which he has remained ever since and still remains, old as he is. For that lord, I say, he has executed an infinite number of the rarest miniatures, of which I shall mention here only a part, because to mention them all is almost impossible. In a little picture he has painted Our Lady with her Son in her arms, with many Saints and figures around, and Pope Paul III kneeling, portrayed from

life so well, that for all the smallness of that miniature he seems as if alive; and all the other figures, likewise, appear to lack nothing save breath and speech. That little picture, as a thing truly of the rarest, was sent to Spain to the Emperor Charles V, who was amazed by it. After that work the Cardinal caused him to set his hand to executing in miniature the stories in an Office of Our Lady, written in lettering shaped by Monterchi, who is a rare master in such work. Whereupon Don Giulio, resolving that this work should be the highest flight of his powers, applied himself to it with so much study and diligence, that no other was ever executed with more; wherefore he has achieved with the brush things so stupendous, that it does not appear possible to go so far with the eye or with the hand. Don Giulio has divided this labour into twenty-six little scenes, each two sheets being next to one another, the figure and the prefiguration, and every little scene has around it an ornament different from the other, with figures and fantasies appropriate to the story that it represents. Nor do I wish to grudge the labour of describing them briefly, for the reason that everyone is not able to see them. On the first page, where Matins begin, is the Angel bringing the Annunciation to the Virgin Mary, and in the ornament a border full of little children that are marvellous; and in the other scene Isaiah speaking with King Ahaz. In the second, for Lauds, is the Visitation of the Virgin to Elizabeth, which has an ornament in imitation of metal; and in the opposite scene are Justice and Peace embracing one another. For Prime is the Nativity of Christ, and opposite, in the Earthly Paradise, Adam and Eve eating the Fruit; both the one and the other with ornaments full of nudes and other figures and animals, portrayed from nature. For Terce he has painted the Shepherds with the Angel appearing to them, and in the opposite scene the Tiburtine Sibyl showing to the Emperor Octavian the Virgin with Christ her Son in Heaven; both the one and the other with ornaments of various borders and figures, all coloured, and containing the portrait of Alexander the Great and of Cardinal Alessandro Farnese. For Sext there is the Circumcision of Christ, where Pope Paul III is portrayed for Simeon, and in the scene are portraits of Mancina and Settimia, gentlewomen of Rome, who were of surpassing beauty; and around it a border well adorned, which likewise encloses with the same design the other story that is beside it, wherein is S. John the Baptist baptizing Christ, a scene full of nudes. For Nones he has made there

the Magi adoring Christ, and opposite to that Solomon adored by the Queen of Sheba, both one and the other with borders rich and varied, and at the foot of this the whole Feast of Testaccio executed with figures smaller than ants, which is a marvellous thing to see, that a work so small should have been executed to perfection with the point of a brush; this is one of the greatest things that mortal hand could do or mortal eye could behold, and in it are all the liveries that Cardinal Farnese devised at that time. For Vespers there is Our Lady flying with Christ into Egypt, and opposite is the Submersion of Pharaoh in the Red Sea; with varied borders at the sides. For Complines there is the Coronation of Our Lady in Heaven, with a multitude of Angels, and in the other scene opposite is Ahasuerus crowning Esther; with appropriate borders. For the Mass of the Madonna he has placed first, in a border in imitation of cameos, the Angel Gabriel announcing the Word to the Virgin; and the two scenes are Our Lady with Jesus Christ in her arms and God the Father creating Heaven and Earth. Before the Penitential Psalms is the Battle in which Uriah the Hittite was done to death by command of King David, wherein are horses and warriors wounded or dead, all marvellous; and opposite, in the other scene, David in Penitence; with ornaments and also little grotesques. But he who would sate himself with marvelling, let him look at the Litanies, where Don Giulio has woven a maze with the letters of the names of the Saints; and there in the margin above is a Heaven filled with Angels around the most holy Trinity, and one by one the Apostles and the other Saints; and on the other side the Heaven continues with Our Lady and all the Virgin Saints. On the margin below he has depicted with the most minute figures the procession that Rome holds for the solemn office of the Corpus Christi, thronged with officers with their torches, Bishops, and Cardinals, and the most Holy Sacrament borne by the Pope, with the rest of the Court and the Guard of Halberdiers, and finally Castel S. Angelo firing artillery; all such as to cause every acutest wit to marvel with amazement. At the beginning of the Office for the Dead are two scenes; Death triumphing over all mortals, mighty rulers of States and Kingdoms and the common herd alike, and opposite, in the other scene, the Resurrection of Lazarus, and also Death in combat with some on horseback. For the Office of the Cross he has made Christ Crucified, and opposite is Moses with the rain of serpents, and the same Moses placing on high

the serpent of brass. For that of the Holy Spirit is that same Holy Spirit descending upon the Apostles, and opposite is the Building of the Tower of Nimrod.

That work was executed by Don Giulio in a period of nine years with so much study and labour, that in a manner of speaking it would never be possible to pay for the work with no matter what price; nor is one able to see any more strange and beautiful variety than there is in all the scenes, of bizarre ornaments and various movements and postures of nudes both male and female, studied and well detailed in every part, and placed appropriately all around in those borders, in order to enrich the work. Which diversity of things infuses such beauty into that whole work, that it appears a thing divine and not human, and above all because with his colours and his manner of painting he has made the figures, the buildings and the landscapes recede and fade into the distance with all those considerations that perspective requires, and with the greatest perfection that is possible, insomuch that, whether near or far, they cause everyone to marvel; not to speak of the thousand different kinds of trees, wrought so well that they appear as if grown in Paradise. In the stories and inventions may be seen design, in the composition order and variety, and richness in the vestments, which are executed with such beauty and grace of manner, that it seems impossible that they could have been fashioned by the hand of man. Wherefore we may say, as we said at the beginning, that Don Giulio has surpassed in this field both ancients and moderns, and that he has been in our times a new, if smaller, Michelagnolo.

The same master once executed a small picture with little figures for the Cardinal of Trent, so pleasing and so beautiful, that that lord made a present of it to the Emperor Charles V; and afterwards, for the same lord, he painted another of Our Lady, and with it the portrait of King Philip, which were very beautiful and therefore presented to the said Catholic King. For the above-named Cardinal Farnese he painted a little picture of Our Lady with her Son in her arms, S. Elizabeth, a young S. John, and other figures, which was sent to Ruy Gomez in Spain. In another, which the above-named Cardinal now has, he painted S. John the Baptist in the Desert, with landscapes and animals of great beauty, and another like it he executed afterwards for the same lord, for sending to King Philip; and a Pietà, which he painted with the Madonna and many other figures, was presented by the

same Farnese to Pope Paul IV, who as long as he lived would always have it beside him. And a scene in which David is cutting off the head of the giant Goliath, was presented by the same Cardinal to Madama Margherita of Austria, who sent it to King Philip, her brother, together with another which that most illustrious lady caused Don Giulio to execute as a companion to it, wherein was Judith severing the head of Holofernes.

Many years ago Don Giulio stayed many months with Duke Cosimo, and during that time executed some works for him, part of which were sent to the Emperor and other lords, and part remained with his most illustrious Excellency, who, among other things, caused him to copy a little head of Christ from one of great antiquity that his Excellency himself possesses, which once belonged to Godfrey of Bouillon, King of Jerusalem; which head, they say, is more like the true image of the Saviour than any other that there may be. Don Giulio painted for the said Lord Duke a Christ on the Cross with the Magdalene at the foot, which is a marvellous thing, and a little picture of a Pietà, of which we have the design in our book together with another, also by the hand of Don Giulio, of Our Lady standing with her Son in her arms, dressed in the Jewish manner, with a choir of Angels about her, and many nude souls in the act of commending themselves to her. But to return to the Lord Duke; he has always loved dearly the excellence of Don Giulio, and sought to obtain works by his hand; and if it had not been for the regard that he felt for Farnese, he would not have let him go when he stayed some months, as I have said, in his service in Florence. The Duke, then, besides the works mentioned, has a little picture by the hand of Don Giulio, wherein is Ganymede borne to Heaven by Jove transformed into an Eagle, copied from the one that Michelagnolo once drew, which is now in the possession of Tommaso de' Cavalieri, as has been told elsewhere. In like manner, the Duke has in his study a S. John the Baptist seated upon a rock, and some portraits by the same hand, which are admirable.

Don Giulio once executed a picture of a Pietà, with the Maries and other figures around, for the Marchioness of Pescara, and another like it in every part for Cardinal Farnese, who sent it to the Empress, who is now the wife of Maximilian and sister of King Philip; and another little picture by the same master's hand he sent to his Imperial Majesty, in which, in a most beautiful little landscape, is S. George killing the Serpent, executed with

supreme diligence. But this was surpassed in beauty and design by a larger picture that Don Giulio painted for a Spanish gentleman, in which is the Emperor Trajan as he is seen in medals with the Province of Judæa on the reverse; which picture was sent to the above-named Maximilian, now Emperor.

For the same Cardinal Farnese he has executed two other little pictures; in one is Jesus Christ nude, with the Cross in His hands, and in the other is Christ led by the Jews and accompanied by a vast multitude to Mount Calvary, with the Cross on His shoulder, and behind Him Our Lady and the other Maries in attitudes full of grace, such as might move to pity a heart of stone. And in two large sheets for a Missal, he has painted for that Cardinal Jesus Christ instructing the Apostles in the doctrine of the Holy Evangel, and the Universal Judgment – a work so beautiful, nay, so marvellous, so stupendous, that I am confounded at the thought of it; and I hold it as certain that it is not possible, I do not say to execute, but to see or even imagine anything in miniature more beautiful.

It is a notable thing that in many of these works, and particularly in the Office of the Madonna described above, Don Giulio has made some little figures not larger than very small ants, with all the members so depicted and distinguished, that more could not have been done in figures of the size of life; and that everywhere there are dispersed portraits from nature of men and women, not less like the reality than if they had been executed, large as life and very natural, by Tiziano or Bronzino. Besides which, in some ornaments of the borders there may be seen little figures both nude and in other manners, painted in the likeness of cameos, which, marvellously small as they are, resemble in those proportions the most colossal giants; such is the art and surpassing diligence that Don Giulio uses in his work. Of him I have wished to give to the world this information, to the end that those may know something of him who are not or will not be able to see any of his works, from their being almost all in the hands of great lords and personages. I say almost all, because I know that some private persons have in little cases most beautiful portraits by his hand, of various lords, their friends, or ladies loved by them. But, however that may be, it is certain that the works of men such as Don Giulio are not public, nor in places where they can be seen by everyone, like the pictures, sculptures, and buildings of the other masters of these our arts.

At the present day Don Giulio, although he is old and does not study or attend to anything save to seeking the salvation of his soul by good and holy works and by a life wholly apart from the things of the world, and is in every way an old man, yet continues constantly to work at something, there where he lives well attended and in perfect peace in the Palace of the Farnesi, where he is most courteous in showing his work with much willingness to all who go to visit and see him, as they visit the other marvels of Rome.

OF DIVERS ITALIAN CRAFTSMEN STILL LIVING

THERE is now living in Rome one who is certainly very excellent in his profession, Girolamo Siciolante of Sermoneta, of whom, although something has been said in the Life of Perino del Vaga, whose disciple he was, assisting him in the works of Castel S. Angelo and in many others, nevertheless it cannot but be well to say also here so much as his great excellence truly deserves. Among the first works, then, that this Girolamo executed by himself, was an altar-piece twelve palms high painted by him in oils at the age of twenty, which is now in the Badia of S. Stefano, near his native town of Sermoneta; wherein, large as life, are S. Peter, S. Stephen, and S. John the Baptist, with certain children. After that altar-piece, which was much extolled, he painted for the Church of S. Apostolo, in Rome, an altar-piece in oils with the Dead Christ, Our Lady, S. John, the Magdalene, and other figures, all executed with diligence. Then in the Pace, in the marble chapel that Cardinal Cesis caused to be constructed, he decorated the whole vaulting with stucco-work in a pattern of four pictures, painting therein the Nativity of Jesus Christ, the Adoration of the Magi, the Flight into Egypt, and the Massacre of the Innocents; all which was a work worthy of much praise and executed with invention, judgment, and diligence. For that same church, not long after, the same Girolamo painted an altar-piece fifteen palms high, which is beside the high-altar, of the Nativity of Jesus Christ, which was very beautiful; and then in another altar-piece in oils, for the Sacristy of the Church of S. Spirito in Rome, the Descent of the Holy Spirit upon the Apostles, which is a work full of grace. In like manner, in the

Church of S. Maria de Anima, the church of the German colony, he painted in fresco the whole of the Chapel of the Fugger family (for which Giulio Romano once executed the altar-piece), with large scenes of the Life of Our Lady. For the high-altar of S. Jacopo degli Spagnuoli he painted in a large altar-piece a very beautiful Christ on the Cross with some Angels about Him, Our Lady, and S. John, and besides this two large pictures that are one on either side of it, each nine palms high and with a single figure, S. James the Apostle and S. Alfonso the Bishop; in which pictures it is evident that he used much study and diligence. On the Piazza Giudea, in the Church of S. Tommaso, he painted in fresco the whole of a chapel that looks out over the court of the Cenci Palace, depicting there the Nativity of the Madonna, the Annunciation by the Angel, and the Birth of Our Saviour Jesus Christ. For Cardinal Capodiferro he painted a hall in his palace, which is very beautiful, with stories of the ancient Romans. And at Bologna he once executed for the Church of S. Martino the altar-piece of the high-altar, which was much commended. For Signor Pier Luigi Farnese, Duke of Parma and Piacenza, whom he served for some time, he executed many works, and in particular a picture that is in Piacenza, painted for a chapel, wherein are Our Lady, S. Joseph, S. Michael, S. John the Baptist, and an Angel, of eight palms.

After his return from Lombardy he painted in the Minerva, in the passage of the sacristy, a Christ on the Cross, and another in the church. Then he painted in oils a S. Catharine and a S. Agatha; and in S. Luigi he executed a scene in fresco in competition with Pellegrino Pellegrini of Bologna and the Florentine Jacopo del Conte. In an altar-piece in oils, sixteen palms high, executed not long since for the Church of S. Alò, opposite to the Misericordia, a Company of the Florentines, he painted Our Lady, S. James the Apostle, and the Bishops S. Alò and S. Martino; and in S. Lozenzo in Lucina, in the Chapel of the Countess of Carpi, he painted in fresco a S. Francis who is receiving the Stigmata. In the Hall of Kings, at the time of Pope Pius IV, as has been related, he executed a scene in fresco over the door of the Chapel of Sixtus; in that scene, which was much extolled, Pepin, King of the Franks, is presenting Ravenna to the Roman Church, and is leading as prisoner Astulf, King of the Lombards; and we have the design of it by Girolamo's own hand in our book, with many others by the same master. And, finally, he has now in hand the Chapel of Cardinal Cesis in S. Maria Maggiore, for which he has

already executed in a large altar-piece the Martyrdom of S. Ca-
tharine on the wheel, which is a most beautiful picture, as are the
others on which both there and elsewhere, with much study, he
is continually at work. I shall not make mention of the portraits
and other pictures and little works of Girolamo, because, besides
that they are without number, these are enough to make him
known as a valiant and excellent painter.

Having said above, in the Life of Perino del Vaga, that the
painter Marcello Mantovano worked many years under him at
pictures that gave him a great name, I have to say in this place,
coming more to particulars, that he once painted in the Church
of S. Spirito the whole Chapel of S. Giovanni Evangelista and its
altar-piece, with the portrait of a Knight Commander of the same
S. Spirito, who built that church and constructed that chapel;
which portrait is a very good likeness, and the altar-piece most
beautiful. Whereupon a Friar of the Piombo, having seen
his beautiful manner, caused him to paint in fresco in the Pace,
over the door that leads from the church into the convent, Jesus
Christ as a boy disputing with the Doctors in the Temple, which
is a very lovely work. But since he has always delighted to make
portraits and little things, abandoning larger works, he has ex-
ecuted an infinite number of these; and among them may be seen
some of Pope Paul III, which are beautiful and speaking like-
nesses. In like manner, from the designs of Michelagnolo and
from his works he has executed a vast number of things likewise
small, and among these he has depicted in one of his works the
whole façade of the Judgment, which is a rare thing and executed
excellently well; and in truth, for small paintings, it would not be
possible to do better. For which reason, finally, that most gentle
Messer Tommaso de' Cavalieri, who has always favoured him, has
caused him to paint after the design of Michelagnolo an altar-
picture of the Annunciation of the Virgin, most beautiful, for the
Church of S. Giovanni Laterano; which design by Buonarroti's
own hand, imitated by this Marcello, Leonardo Buonarroti, the
nephew of Michelagnolo, presented to the Lord Duke Cosimo
together with some others of fortifications and architecture and
other things of the rarest. And this must suffice for Marcello, who
has been attending lately to working at little things, executing them
with a truly supreme and incredible patience.

Of Jacopo del Conte, a Florentine, who like those named
above dwells in Rome, enough will have been said, what with this

and other places, after certain other particulars have been given here. This Jacopo, then, having been much inclined from his earliest youth to portraying from the life, has desired that this should be his principal profession, although on occasions he has executed altar-pictures and works in fresco in some numbers, both in Rome and without. Of his portraits – not to speak of them all, which would make a very long story – I shall say only that he has portrayed all the Pontiffs that there have been from Pope Paul III to the present day, and all the lords and ambassadors of importance who have been at that Court, and likewise the military captains and great men of the house of Colonna and of the Orsini, Signor Piero Strozzi, and an infinite number of Bishops, Cardinals, and other great prelates and lords, not to speak of many men of letters and other men of quality; all which has caused him to acquire fame, honour, and profit in Rome, so that he lives honourably and much at his ease with his family in that city. From his boyhood he drew so well that he gave promise, if he should persevere, of becoming excellent, and so in truth he would have been, but, as I have said, he turned to that to which he felt himself inclined by nature. Nevertheless, his works cannot but be praised. By his hand is a Dead Christ in an altar-piece that is in the Church of the Popolo, and in another that he has executed for the Chapel of S. Dionigi in S. Luigi, with stories, is the first-named Saint. But the most beautiful work that he ever did was in two scenes in fresco that he once painted, as has been told in another place, in the Florentine Company of the Misericordia, with an altar-picture of Christ taken down from the Cross, with the Thieves fixed on their crosses, and the Madonna in a swoon, painted in oil-colours, all beautiful and executed with diligence and with great credit to him. He has made many pictures throughout Rome, and figures in various manners, and has executed a number of full-length portraits, both nude and draped, of men and women, which have proved very beautiful, because the subjects were not otherwise. He has also portrayed, according as occasions arose, many heads of noble ladies, gentlewomen and princesses who have been in Rome; and among others, I know that he once portrayed Signora Livia Colonna, a most noble lady, incomparable in her illustrious blood, her virtue, and her beauty. And let this suffice for Jacopo del Conte, who is still living and constantly at work.

I might have made known, also, many from our Tuscany and

from other parts of Italy, their names and their works, which I have passed over lightly, because many of them, being old, have ceased to work, and others who are young are now trying their hands and will become known better by their works than by means of writings. But of Adone Doni of Assisi, because he is still living and working, although I made mention of him in the Life of Cristofano Gherardi, I shall give some particulars of his works, such as are in Perugia and throughout all Umbria, and in particular many altar-pieces in Foligno. But his best works are in S. Maria degli Angeli at Assisi, in the little chapel where S. Francis died, wherein are some stories of the life of that Saint executed in oils on the walls, which are much extolled, besides which, he has painted the Passion of Christ in fresco at the head of the refectory of that convent, in addition to many other works that have done him honour; and his gentleness and courtesy have caused him to be considered liberal and courteous.

In Orvieto there are two young men also of that same profession, one a painter called Cesare del Nebbia, and the other a sculptor, both well on the way to bringing it about that their city, which up to the present has always invited foreign masters to adorn her, will no longer be obliged, if they follow up the beginnings that they have made, to seek other masters. There is working at Orvieto, in S. Maria, the Duomo of that city, a young painter called Niccolò dalle Pomarancie, who, having executed an altar-piece wherein is Christ raising Lazarus, has given signs – not to speak of other works in fresco – of winning a name among the others named above.

And now that we are come to the end of our Italian masters still living, I shall say only that no less service has been rendered by one Lodovico, a Florentine sculptor, who, so I am told, has executed notable works in England and at Bari; but, since I have not found here either his relatives or his family name, and have not seen his works, I am not able (as I fain would) to make any other record of him than this mention of his name.

OF DIVERS FLEMINGS

Now, although in many places mention has been made of the works of certain excellent Flemish painters and of their

engravings, but without any order, I shall not withhold the names of certain others – for of their works I have not been able to obtain full information – who have been in Italy, and I have known the greater number of them, in order to learn the Italian manner; believing that no less is due to their industry and to the labour endured by them in our arts. Leaving aside, then, Martin of Holland, Jan van Eyck of Bruges, and Hubert his brother, who in 1510 invented and brought to light the method of painting in oil-colours, as has been told elsewhere, and left many works by his hand in Ghent, Ypres, and Bruges, where he lived and died in honour; after them, I say, there followed Roger van der Weyden of Brussels, who executed many works in several places, but principally in his native city, and for the Town Hall four most beautiful panel-pictures in oils, of things appertaining to Justice. A disciple of that Roger was Hans,* by whom, as has been told, we have in Florence the Passion of Christ in a little picture that is in the hands of the Duke. To him there succeeded the Fleming Louis of Louvain, Pieter Christus, Justus of Ghent, Hugo of Antwerp, and many others, who, for the reason that they never went forth from their own country, always adhered to the Flemish manner. And if Albrecht Dürer, of whom we have spoken at some length, did once come to Italy, nevertheless he kept always to one and the same manner; although he was spirited and vivacious, particularly in his heads, as is well known to all Europe.

But, leaving these, and together with them Lucas of Holland and others, I became acquainted in Rome, in 1532, with one Michael Coxie, who gave no little study to the Italian manner, and executed many works in fresco in that city, and in particular two chapels in S. Maria de Anima. Having then returned to his own country and made himself known as an able man, I hear that among other works he executed for King Philip of Spain an altar-picture copied from one by the above-named Jan van Eyck that is in Ghent; and in that copy, which was taken into Spain, is the Triumph of the Agnus Dei. There studied in Rome, not long afterwards, Martin Heemskerk, a good master of figures and landscapes, who has executed in Flanders many pictures and many designs for copper-engravings, which, as has been related elsewhere, have been engraved by Hieronymus Cock, whom I

* Hans Memling.

came to know in Rome while I was serving Cardinal Ippolito de' Medici. And all these have been most beautiful inventors of stories, and close observers of the Italian manner.

In Naples, also, in the year 1545, I came to know Johann of Calcar, a Flemish painter, who became very much my friend; a very rare craftsman, and so well practised in the Italian manner, that his works were not recognized as by the hand of a Fleming. But he died young in Naples, while great things were expected of him; and he drew for Vessalio his studies in anatomy. Before him, however, there was much in repute one Dirk of Louvain, a good master in that manner; and also Quentin of the same place, who in his figures always followed nature as well as he was able, as also did a son of his called Johann. Joost van Cleef, likewise, was a great colourist and rare in making portraits from life, for which King Francis of France employed him much in executing many portraits of various lords and ladies. Famous painters of the same province, also, have been – and some of them still are – Jan van Hemessen, Matthys Cock of Antwerp, Bernard of Brussels, Jan Cornelis of Amsterdam, Lambert of the same city, Hendrik of Dinant, Joachim Patinier of Bouvignes, and Jan Scorel, Canon of Utrecht, who carried into Flanders many new methods of painting taken from Italy. Besides these, there have been Jean Bellegambe of Douai, Dirk of Haarlem, from the same place, and Franz Mostaert, who was passing skilful in painting landscapes in oils, fantasies, bizarre inventions, dreams, and suchlike imaginings. Hieronymus Bosch and Pieter Brueghel of Breda were imitators of that Mostaert, and Lancelot Blondeel has been excellent in painting fires, nights, splendours, devils, and other things of that kind. Pieter Koeck has had much invention in stories, and has made very beautiful cartoons for tapestries and arras-hangings; with a good manner and practice in matters of architecture, on which account he has translated into the Teuton tongue the works on architecture of Sebastiano Serlio of Bologna. And Jean Gossart of Mabuse was almost the first who took from Italy into Flanders the true method of making scenes full of nude figures and poetical inventions; and by his hand is a large altar-piece in the Abbey of Middelburg in Zeeland. Of all these information has been received from Maestro Giovanni Strada of Bruges, a painter, and from Giovan Bologna of Douai, a sculptor; both Flemings and men of excellence, as we shall relate in the Treatise on the Academicians.

As for those of the same province who are still living and in repute, the first among them, both for his works in painting and for his many copper-plate engravings, is Franz Floris of Antwerp, a disciple of the above-mentioned Lambert Lombard. This Floris, who is held to be most excellent, has worked in such a manner in every field of his profession, that no one, they say there, has expressed better the emotions of the soul, sorrow, gladness, and the other passions, and all with most beautiful and bizarre inventions; insomuch that, likening him to the Urbinate, they call him the Flemish Raffaello. It is true that this is not demonstrated to us fully by the printed sheets, for the reason that the engraver, be he ever so able, never by a great measure equals the originals or the design and manner of him who has drawn them. A fellow-disciple with Floris, learning under the discipline of the same master, has been Willem Key of Breda, and also of Antwerp, a temperate, serious, and judicious man, and a close imitator of the life and the objects of nature, and in addition passing fertile in invention, and one who more than any other executes his pictures with good gradation and all full of sweetness and grace; and although he has not the facility, boldness, and terrible force of his brother-disciple Floris, for all that he is held to be truly excellent. Michael Coxie, of whom I have spoken above, saying that he carried the Italian manner into Flanders, is much celebrated among the Flemish craftsmen for being profoundly serious and making his figures such that they have in them much of the virile and severe; wherefore the Fleming Messer Domenicus Lampsonius, of whom mention will be made in the proper place, discoursing of the two masters named above and of this Michael, likens them to a fine trio in music, in which each plays his part with excellence. Much esteemed, also, among the same men, is Antonius Moor of Utrecht in Holland, painter to the Catholic King, whose colours, they say, in portraying whatever he may choose from nature, vie with the reality and deceive the eye most beautifully. The same Lampsonius writes to me that Moor, who is a man of very gentle ways and much beloved, has painted a most beautiful altar-picture of Christ rising from the dead, with two Angels, S. Peter, and S. Paul, which is a marvellous thing. Marten de Vos, who copies excellently well from nature, is held to be good in invention and colouring. But in the matter of making beautiful landscapes, none are equal to Jakob Grimmer, Hans Bol, and others, all of Antwerp and able men, of whom,

nevertheless, I have not been able to obtain particular informa-
tion. Pieter Aertsen, called Long Peter, painted in his native city
of Amsterdam an altar-picture with wing-panels, containing Our
Lady and other Saints; which whole work cost two thousand
crowns. They also celebrate as a good painter Lambert of Am-
sterdam, who dwelt many years in Venice, and had the Italian
manner very well. This Lambert was the father of Federigo, of
whom, from his being one of our Academicians, record will be
made in the proper place. Pieter Brueghel of Antwerp, likewise,
they celebrate as an excellent master, and Lambert van Noort of
Amersfort in Holland, and as a good architect Gilis Mostaert,
brother of the above-named Franz; and Pieter Pourbus, a mere
lad, has given proof that he is destined to become an excellent
painter.

Now, that we may learn something of the miniaturists of
those countries: they say that these have been excellent there,
Marinus of Zierickzee, Lucas Horebout of Ghent, Simon Bening
of Bruges, and Gerard; and likewise some women, Susanna,
sister of the said Lucas, who was invited for that work into the
service of Henry VIII, King of England, and lived there in honour
all the rest of her life; Clara Skeysers of Ghent, who at the age
of eighty died, so they say, a virgin; Anna, daughter of Meister
Seghers, a physician; Levina, daughter of the above-named
Meister Simon of Bruges, who was married by the said Henry of
England to a nobleman, and held in estimation by Queen Mary,
even as she is now by Queen Elizabeth; and likewise Catharina,
daughter of Meister Jan van Hemessen, who went to Spain into
the service of the Queen of Hungary, with a good salary. In short,
many other women in those parts have been excellent miniaturists.

In the work of glass and of making windows there have been
many able men in the same province; Arthus van Noort of Nym-
wegen, Borghese of Antwerp, Dierick Jacobsz Vellaert, Dirk van
Staren of Kampen, and Jan Haeck of Antwerp, by whom are the
windows in the Chapel of the Sacrament in the Church of
S. Gudule in Brussels. And here in Tuscany many very beautiful
windows of fired glass have been made for the Duke of Florence
by Wouter Crabeth and Giorgio, Flemings and able men, from
the designs of Vasari.

In architecture and sculpture the most celebrated Flemings are
Sebastian van Oja of Utrecht, who served Charles V in some
fortifications, and then King Philip; Willem van Antwerp, Willem

Keur of Holland, a good architect and sculptor; Jan van Dalen, sculptor, poet and architect; and Jakob Breuck, sculptor and architect, who executed many works for the Queen Regent of Hungary, and was the master of Giovan Bologna of Douai, one of our Academicians, of whom we shall speak in a short time. Jan de Mynsheere of Ghent, also, is held to be a good architect, and Matthaeus Manemaker of Antwerp, who is with the King of the Romans, an excellent sculptor; and Cornelis Floris, brother of the above-named Franz, is likewise an excellent sculptor and architect, and the first who introduced into Flanders the method of making grotesques. Others who give their attention to sculpture, with much honour to themselves, are Willem Paludanus, a very studious and diligent sculptor, brother of the above-named Heinrich; Jan der Sart of Nymwegen, Simon van Delft, and Joost Janszoon of Amsterdam. And Lambert Suavius of Liège is a very good architect and master in engraving prints with the burin, wherein he has been followed by Joris Robyn of Ypres, Dirk Volkaerts and Philip Galle, both of Haarlem, Lucas van Leyden, and many others; who have all been in Italy in order to learn and to draw the antiquities, and to return home, as for the most part they have done, excellent masters. But greater than any of those named above has been Lambert Lombard of Liège, a man great in letters, judicious in painting, and excellent in architecture, the master of Franz Floris and Willem Key; of the excellencies of which Lambert and of others I have received much information in letters from M. Domenicus Lampsonius of Liège, a man well lettered and of much judgment in everything, who was the familiar confidant of Cardinal Pole of England during his lifetime, and now is secretary to Monsignor the Prince Bishop of Liège. That gentleman, I say, once sent me the life of the said Lambert written in Latin, and he has saluted me several times in the name of many of our craftsmen from that province; and a letter that I have by his hand, dated October 30, 1564, is written in this tenor:

'For four years back I have had it constantly in mind to thank you, honoured Sir, for two very great benefits that I have received from you, although I know that this will appear to you a strange exordium from one whom you have never seen or known. And strange, indeed, it would be, if I had not known you, which has been from the time when my good fortune, or rather, our Lord God, willed that by His Grace there should come into my hands, I know not in what way, your most excellent writings

concerning the architects, painters, and sculptors. But at that time I did not know one word of Italian, whereas now, thanks be to God, for all that I have never seen Italy, by reading your writings I have gained such little knowledge as has encouraged me to write you this letter. And to this desire to learn your tongue I have been attracted by your writings, which perhaps those of no other man could have done; being drawn to seek to understand them by a natural and irresistible love that I have borne from child-hood to these three most beautiful arts, but above all to that most pleasing to every age, sex, and rank, and hurtful to none, your art of painting. In which art, although I was at that time wholly ignorant and wanting in judgment, now, by means of the fre-quently reiterated reading of your writings, I understand so much – little though it may be, and as it were nothing – as is yet enough to enable me to lead an agreeable and happy life; and this I value more than all the honours, comforts and riches of this world. By this little I mean only that I could copy with oil-colours, as with any kind of drawing-instrument, the objects of nature, and par-ticularly nudes and vestments of every sort; but I have not had courage enough to plunge deeper, as for example, to paint things more hazardous which require a hand more practised and sure, such as landscapes, trees, waters, clouds, splendours, fires, etc. And although in these things, as also in inventions, up to a cer-tain point, it is possible that in case of necessity I could show that I have made some little proficience by means of the reading I have mentioned, yet I have been content, as I have said, to confine myself to making only portraits, and the rather because the many occupations which my office necessarily involves do not permit me to do more. And in order to prove myself in some way appreciative and grateful for these benefits, that by your means I have learned a most beautiful tongue and the art of painting, I would have sent you with this letter a little portrait of my face, taken with a mirror, had I not doubted whether my letter would find you in Rome or not, since at the present mo-ment you might perchance be living in Florence or your native city of Arezzo.'

This letter contains, in addition, many other particulars that are not here to the point. In others, since, he has prayed me in the name of many honourable gentlemen of those parts, who have heard that these Lives are being reprinted, that I should add to them three treatises on sculpture, painting, and architecture,

with drawings of figures, by way of elucidation according to necessity, in order to expound the secrets of the arts, as Albrecht Dürer and Serlio have done, and Leon Battista Alberti, who has been translated by M. Cosimo Bartoli, a gentleman and Academician of Florence. Which I would have done more than willingly, but my intention has been only to describe the lives and works of our craftsmen, and not to teach the arts, with the methods of drawing the lines of painting, architecture, and sculpture; besides which, the work having grown under my hands for many reasons, it will be perchance too long, even without adding treatises. But it was not possible or right for me to do otherwise than I have done, or to defraud anyone of his due praise and honour, nor yet the world of the pleasure and profit that I hope may be derived from these labours.

OF THE ACADEMICIANS OF DESIGN, PAINTERS, SCULPTORS, AND ARCHITECTS, AND OF THEIR WORKS, AND FIRST OF BRONZINO

HAVING written hitherto of the lives and works of the most excellent painters, sculptors, and architects, from Cimabue down to the present day, who have passed to a better life, and having spoken with the opportunities that came to me of many still living, it now remains that I say something of the craftsmen of our Academy of Florence, of whom up to this point I have not had occasion to speak at sufficient length. And beginning with the oldest and most important, I shall speak first of Agnolo, called Bronzino, a Florentine painter truly most rare and worthy of all praise.

Agnolo, then, having been many years with Pontormo, as has been told, caught his manner so well, and so imitated his works, that their pictures have been taken very often one for the other, so similar they were for a time. And certainly it is a marvel how Bronzino learned the manner of Pontormo so well, for the reason that Jacopo was rather strange and shy than otherwise even with his dearest disciples, being such that he would never let anyone see his works save when completely finished. But notwithstanding this, so great were the patience and lovingness

of Agnolo towards Pontormo, that he was forced always to look kindly upon him, and to love him as a son. The first works of account that Bronzino executed, while still a young man, were in the Certosa of Florence, over a door that leads from the great cloister into the chapter-house, on two arches, one within and the other without. On that without is a Pietà, with two Angels, in fresco, and on that within is a nude S. Laurence upon the grid-iron, painted in oil-colours on the wall; which works were a good earnest of the excellence that has been seen since in the works of this painter in his mature years. In the Chapel of Lodovico Capponi, in S. Felicita at Florence, Bronzino, as has been said in another place, painted two Evangelists in two round pictures in oils, and on the vaulting he executed some figures in colour. In the Abbey of the Black Friars at Florence, in the upper cloister, he painted in fresco a story from the life of S. Benedict, when he throws himself naked on the thorns, which is a very good picture. In the garden of the Sisters called the Poverine, he painted in fresco a most beautiful tabernacle, wherein is Christ appearing to the Magdalene in the form of a gardener. And in S. Trinita, likewise in Florence, may be seen a picture in oils by the same hand, on the first pilaster at the right hand, of the Dead Christ, Our Lady, S. John, and S. Mary Magdalene, executed with much diligence and in a beautiful manner. And during that time when he executed these works, he also painted many portraits of various persons, and other pictures, which gave him a great name.

Then, the siege of Florence being ended and the settlement made, he went, as has been told elsewhere, to Pesaro, where under the protection of Guidobaldo, Duke of Urbino, besides the above-mentioned harpsichord-case full of figures, which was a rare thing, he executed the portrait of that lord and one of a daughter of Matteo Sofferoni, which was a truly beautiful picture and much extolled. He also executed at the Imperiale, a villa of the said Duke, some figures in oils on the spandrels of a vault; and more of these he would have done if he had not been recalled to Florence by his master, Jacopo Pontormo, that he might assist him to finish the Hall of Poggio a Caiano. And having arrived in Florence, he painted as it were by way of pastime, for Messer Giovanni de Statis, Auditor to Duke Alessandro, a little picture of Our Lady which was a much extolled work, and shortly afterwards, for Monsignor Giovio, his friend, the portrait of Andrea Doria; and for Bartolommeo Bettini, to fill certain lunettes

in a chamber, the portraits of Dante, Petrarca, and Boccaccio, half-length figures of great beauty. Which pictures finished, he made portraits of Bonaccorso Pinadori, Ugolino Martelli, Messer Lorenzo Lenzi, now Bishop of Fermo, and Pier Antonio Bandini and his wife, with so many others, that it would be a long work to seek to make mention of them all; let it suffice that they were all very natural, executed with incredible diligence, and finished so well, that nothing more could be desired. For Bartolommeo Panciatichi he painted two large pictures of Our Lady, with other figures, beautiful to a marvel and executed with infinite diligence, and, besides these, portraits of him and his wife, so natural that they seem truly alive, and nothing is wanting in them save breath. For the same man he has painted a picture of Christ on the Cross, which is executed with much study and pains, insomuch that it is clearly evident that he copied it from a real dead body fixed on a cross, such is the supreme excellence and perfection of every part. For Matteo Strozzi he painted in fresco, in a tabernacle at his villa of S. Casciano, a Pietà with some Angels, which was a very beautiful work. For Filippo d'Averardo Salviati he executed a Nativity of Christ in a small picture with little figures, of such beauty that it has no equal, as everyone knows, that work being now in engraving; and for Maestro Francesco Montevarchi, a most excellent physicist, he painted a very beautiful picture of Our Lady and some other little pictures full of grace. And he assisted his master Pontormo, as was said above, to execute the work of Careggi, where on the spandrels of the vaults he painted with his own hand five figures, Fortune, Fame, Peace, Justice, and Prudence, with some children, all wrought excellently well.

Duke Alessandro being then dead and Cosimo elected, Bronzino assisted the same Pontormo in the work of the Loggia of Castello. For the nuptials of the most illustrious Lady, Leonora di Toledo, the wife of Duke Cosimo, he painted two scenes in chiaroscuro in the court of the Medici Palace, and on the base that supported the horse made by Tribolo, as was related, some stories of the actions of Signor Giovanni de' Medici, in imitation of bronze; all which were the best pictures that were executed in those festive preparations. Wherefore the Duke, having recognized the ability of this man, caused him to set his hand to adorning a chapel of no great size in the Ducal Palace for the said Lady Duchess, a woman of true worth, if ever any woman was, and for her infinite merits worthy of eternal praise. In that

chapel Bronzino made on the vault some compartments with very beautiful children and four figures, each of which has the feet turned towards the walls – S. Francis, S. Jerome, S. Michelagnolo, and S. John; all executed with the greatest diligence and lovingness. And on the three walls, two of which are broken by the door and the window, he painted three stories of Moses, one on each wall. Where the door is, he painted the story of the snakes or serpents raining down upon the people, with many beautiful considerations in figures bitten by them, some of whom are dying, some are dead, and others, gazing on the Brazen Serpent, are being healed. On another wall, that of the window, is the Rain of Manna; and on the unbroken wall the Passing of the Red Sea, and the Submersion of Pharaoh; which scene has been printed in engraving at Antwerp. In a word, this work, executed as it is in fresco, has no equal, and is painted with the greatest possible diligence and study. In the altar-picture of this chapel, painted in oils, which was placed over the altar, was Christ taken down from the Cross, in the lap of His Mother; but it was removed from there by Duke Cosimo for sending as a present, as a very rare work, to Granvella, who was once the greatest man about the person of the Emperor Charles V. In place of that altar-piece the same master has painted another like it, which was set over the altar between two pictures not less beautiful than the altar-piece, in which pictures are the Angel Gabriel and the Virgin receiving from him the Annunciation; but instead of these, when the first altar-picture was removed, there were a S. John the Baptist and a S. Cosimo, which were placed in the guardaroba when the Lady Duchess, having changed her mind, caused the other two to be painted.

The Lord Duke, having seen from these and other works the excellence of this painter, and that it was his particular and peculiar field to portray from life with the greatest diligence that could be imagined, caused him to paint a portrait of himself, at that time a young man, fully clad in bright armour, and with one hand upon his helmet; in another picture the Lady Duchess, his consort, and in yet another picture the Lord Don Francesco, their son and Prince of Florence. And no long time passed before he portrayed the same Lady Duchess once again, to do her pleasure, in a different manner from the first, with the Lord Don Giovanni, her son, beside her. He also made a portrait of La Bia, a young girl, the natural daughter of the Duke; and afterwards all the

Duke's children, some for the first time and others for the second – the Lady Donna Maria, a very tall and truly beautiful girl, the Prince Don Francesco, the Lord Don Giovanni, Don Garzia, and Don Ernando, in a number of pictures which are all in the guardaroba of his Excellency, together with the portraits of Don Francesco di Toledo, Signora Maria, mother of the Duke, and Ercole II, Duke of Ferrara, with many others. About the same time, also, he executed in the Palace for the Carnival, two years in succession, two scenic settings and prospect-views for comedies, which were held to be very beautiful. And he painted a picture of singular beauty that was sent to King Francis in France, wherein was a nude Venus, with a Cupid who was kissing her, and Pleasure on one side with Play and other Loves, and on the other side Fraud and Jealousy and other passions of love. The Lord Duke had caused to be begun by Pontormo the cartoons of the tapestries in silk and gold for the Sala del Consiglio de' Dugento; and, having had two stories of the Hebrew Joseph executed by the said Pontormo, and one by Salviati, he gave orders that Bronzino should do the rest. Whereupon he executed fourteen pieces with the excellence and perfection which everyone knows who has seen them; but since this was an excessive labour for Bronzino, who was losing too much time thereby, he availed himself in the greater part of these cartoons, himself making the designs, of Raffaello dal Colle, the painter of Borgo a San Sepolcro, who acquitted himself excellently well.

Now Giovanni Zanchini had built a chapel very rich in carved stone, with his family tombs in marble, opposite to the Chapel of the Dini in S. Croce at Florence, on the front wall, on the left hand as one enters the church by the central door; and he allotted the altar-piece to Bronzino, to the end that he might paint in it Christ descended into the Limbo of Hell in order to deliver the Holy Fathers. Agnolo, then, having set his hand to it, executed that work with the utmost possible diligence that one can use who desires to acquire glory by such a labour; wherefore there are in it most beautiful nudes, men, women, and children, young and old, with different features and attitudes, and portraits of men that are very natural, among which are Jacopo da Pontormo, Giovan Battista Gello, a passing famous Academician of Florence, and the painter Bacchiacca, of whom we have spoken above. And among the women he portrayed there two noble and truly most beautiful young women of Florence, worthy of eternal

praise and memory for their incredible beauty and virtue, Madonna Costanza da Sommaia, wife of Giovan Battista Doni, who is still living, and Madonna Camilla Tedaldi del Corno, who has now passed to a better life. Not long afterwards he executed another large and very beautiful altar-picture of the Resurrection of Jesus Christ, which was placed in the Chapel of Jacopo and Filippo Guadagni beside the choir in the Church of the Servites – that is, the Nunziata. And at this same time he painted the altar-piece that was placed in the chapel of the Palace, whence there had been removed that which was sent to Granvella; which altar-piece is certainly a most beautiful picture, and worthy of that place. Bronzino then painted for Signor Alamanno Salviati a Venus with a Satyr beside her, so beautiful as to appear in truth Venus Goddess of Beauty.

Having then gone to Pisa, whither he was summoned by the Duke, he executed some portraits for his Excellency; and for Luca Martini, who was very much his friend, and not of him only, but also attached with true affection to all men of talent, he painted a very beautiful picture of Our Lady, in which he portrayed that Luca with a basket of fruits, from his having been the minister and proveditor for the said Lord Duke in the draining of the marshes and other waters that rendered unhealthy the country round Pisa, and for having made it in consequence fertile and abundant in fruits. Nor did Bronzino depart from Pisa before there was allotted to him at the instance of Martini, by Raffaello del Setaiuolo, the Warden of Works of the Duomo, the altar-picture for one of the chapels in that Duomo, wherein he painted a nude Christ with the Cross, and about Him many Saints, among whom is a S. Bartholomew flayed, which has the appearance of a true anatomical subject and of a man flayed in reality, so natural it is and imitated with such diligence from an anatomical subject. That altar-picture, which is beautiful in every part, was placed, as I have said, in a chapel from which they removed another by the hand of Benedetto da Pescia, a disciple of Giulio Romano. Bronzino then made for Duke Cosimo a full-length portrait of the dwarf Morgante, nude, and in two ways – namely, on one side of the picture the front, and on the other the back, with the bizarre and monstrous members which that dwarf has; which picture, of its kind, is beautiful and marvellous. For Ser Carlo Gherardi of Pistoia, who from his youth was a friend of Bronzino, he executed at various times, besides the

portrait of Ser Carlo himself, a very beautiful Judith placing the head of Holofernes in a basket, and on the cover that protects that picture, in the manner of a mirror, a Prudence looking at herself; and for the same man a picture of Our Lady, which is one of the most beautiful things that he has ever done, because it has extraordinary design and relief. And the same Bronzino executed the portrait of the Duke when his Excellency was come to the age of forty, and also that of the Lady Duchess, both of which are as good likenesses as could be. After Giovan Battista Cavalcanti had caused a chapel to be built in S. Spirito, at Florence, with most beautiful variegated marbles conveyed from beyond the sea at very great cost, and had laid there the remains of his father Tommaso, he had the head and bust of the father executed by Fra Giovanni Agnolo Montorsoli, and the altar-piece Bronzino painted, depicting in it Christ appearing to Mary Magdalene in the form of a gardener, and more distant two other Maries, all figures executed with incredible diligence.

Jacopo da Pontormo having left unfinished at his death the chapel in S. Lorenzo, and the Lord Duke having ordained that Bronzino should complete it, he finished in the part where the Deluge is many nudes that were wanting at the foot, and gave perfection to that part, and in the other, where at the foot of the Resurrection of the Dead many figures were wanting over a space about one braccio in height and as wide as the whole wall, he painted them all in the manner wherein they are to be seen, very beautiful; and between the windows, at the foot, in a space that remained there unpainted, he depicted a nude S. Laurence upon a gridiron, with some little Angels about him. In that whole work he demonstrated that he had executed his paintings in that place with much better judgment than his master Pontormo had shown in his pictures in the work; the portrait of which Pontormo Bronzino painted with his own hand in a corner of that chapel, on the right hand of the S. Laurence. The Duke then gave orders to Bronzino that he should execute two large altar-pictures, one containing a Deposition of Christ from the Cross with a good number of figures, for sending to Porto Ferraio in the Island of Elba, for the Convent of the Frati Zoccolanti, built by his Excellency in the city of Cosmopolis; and another altar-piece, in which Bronzino painted the Nativity of Our Lord Jesus Christ, for the new Church of the Knights of S. Stephen, which has since been built in Pisa, together with their Palace and Hospital, after the designs and

directions of Giorgio Vasari. Both these pictures have been finished with such art, diligence, design, invention, and supreme loveliness of colouring, that it would not be possible to go further; and no less, indeed, was required in a church erected by so great a Prince, who has founded and endowed that Order of Knights.

On some little panels made of sheet-tin, and all of one same size, the same Bronzino has painted all the great men of the House of Medici, beginning with Giovanni di Bicci and the elder Cosimo down to the Queen of France, in that line, and in the other from Lorenzo, the brother of the elder Cosimo, down to Duke Cosimo and his children; all which portraits are set in order behind the door of a little study that Vasari has caused to be made in the apartment of new rooms in the Ducal Palace, wherein is a great number of antique statues of marble and bronzes and little modern pictures, the rarest miniatures, and an infinity of medals in gold, silver, and bronze, arranged in very beautiful order. These portraits of the illustrious men of the House of Medici are all natural and vivacious, and most faithful likenesses.

It is a notable thing that whereas many are wont in their last years to do less well than they have done in the past, Bronzino does as well and even better now than when he was in the flower of his manhood, as the works demonstrate that he is executing every day. Not long ago he painted for Don Silvano Razzi, a Camaldolite monk in the Monastery of the Angeli at Florence, who is much his friend, a picture about one braccio and a half high of a S. Catharine, so beautiful and well executed, that it is not inferior to any other picture by the hand of this noble craftsman; insomuch that nothing seems to be wanting in her save the spirit and that voice which confounded the tyrant and confessed Christ her well-beloved spouse even to the last breath; and that father, like the truly gentle spirit that he is, has nothing that he esteems and holds in price more than that picture. Agnolo made a portrait of the Cardinal, Don Giovanni de' Medici, the son of Duke Cosimo, which was sent to the Court of the Emperor for Queen Joanna; and afterwards that of the Lord Don Francesco, Prince of Florence, which was a picture very like the reality, and executed with such diligence that it has the appearance of a miniature. For the nuptials of Queen Joanna of Austria, wife of that Prince, he painted in three large canvases which were placed at the Ponte alla Carraia, as will be described at the end, some scenes of the Nuptials of Hymen, of such beauty that they

appeared not things for a festival, but worthy to be set in some honourable place for ever, so finished they were and executed with such diligence. For the same Lord Prince he painted a few months ago a small picture with little figures which has no equal, and it may be said that it is truly a miniature. And since at this his present age of sixty-five he is no less enamoured of the matters of art than he was as a young man, he has undertaken recently, according to the wishes of the Duke, to execute two scenes in fresco on the wall beside the organ in the Church of S. Lorenzo, in which there is not a doubt that he will prove the excellent Bronzino that he has always been.

This master has delighted much, and still delights, in poetry; wherefore he has written many capitoli and sonnets, part of which have been printed. But above all, with regard to poetry, he is marvellous in the style of his capitoli after the manner of Berni, insomuch that at the present day there is no one who writes better in that kind of verse, nor things more fanciful and bizarre, as will be seen one day if all his works, as is believed and hoped, come to be printed. Bronzino has been and still is most gentle and a very courteous friend, agreeable in his conversation and in all his affairs, and much honoured; and as loving and liberal with his possessions as a noble craftsman such as he is could well be. He has been peaceful by nature, and has never done an injury to any man, and he has always loved all able men in his profession, as I know, who have maintained a strait friendship with him for three-and-forty years, that is, from 1524 down to the present year, ever since I began to know and to love him in that year of 1524, when he was working at the Certosa with Pontormo, whose works I used as a youth to go to draw in that place.

Many have been the pupils and disciples of Bronzino, but the first (to speak now of our Academicians) is Alessandro Allori, who has been loved always by his master, not as a disciple, but as his own son, and they have lived and still live together with the same love, one for another, that there is between a good father and his son. Alessandro has shown in many pictures and portraits that he has executed up to his present age of thirty, that he is a worthy disciple of so great a master, and that he is seeking by diligence and continual study to arrive at that rarest perfection which is desired by beautiful and exalted intellects. He has painted and executed all with his own hand the Chapel of the Montaguti in the Church of the Nunziata – namely, the altar-

piece in oils, and the walls and vaulting in fresco. In the altar-piece is Christ on high, and the Madonna, in the act of judging, with many figures in various attitudes and executed very well, copied from the Judgment of Michelagnolo Buonarroti. About that altar-piece, on the same wall, are four large figures in the forms of Prophets, or rather, Evangelists, two above and two below; and on the vaulting are some Sibyls and Prophets executed with great pains, study, and diligence, he having sought in the nudes to imitate Michelagnolo. On the wall which is at the left hand looking towards the altar, is Christ as a boy disputing in the midst of the Doctors in the Temple; which boy is seen in a fine attitude answering their questions, and the Doctors, and others who are there listening attentively to him, are all different in features, attitudes, and vestments, and among them are portraits from life of many of Alessandro's friends, which are good likenesses. Opposite to that, on the other wall, is Christ driving from the Temple those who with their buying and selling were making it a house of traffic and a market-place; with many things worthy of consideration and praise. Over those two scenes are some stories of the Madonna, and on the vaulting figures that are of no great size, but passing graceful; with some buildings and landscapes, which in their essence show the love that he bears to art, and how he seeks the perfection of design and invention. And opposite to the altar-piece, on high, is a story of Ezekiel, when he saw a great multitude of bones reclothe themselves with flesh and take to themselves their members; in which this young man has demonstrated how much he desires to master the anatomy of the human body, and how he has studied it and given it his attention. And, in truth, in this his first work of importance, as also in the nuptials of his Highness, with figures in relief and stories in painting, he has proved himself and given great signs and promise, as he continues to do, that he is like to become an excellent painter; and not in this only, but in some other smaller works, and recently in a small picture full of little figures in the manner of miniature, which he has executed for Don Francesco, Prince of Florence, a much-extolled work; and other pictures and portraits he has painted with great study and diligence, in order to become practised and to acquire a grand manner.

Another young man, likewise a pupil of Bronzino and one of our Academicians, called Giovan Maria Butteri, has shown good mastery and much dexterity in what he did, besides many other

smaller pictures and other works, for the obsequies of Michelagnolo and for the coming of the above-named most illustrious Queen Joanna to Florence.

And another disciple, first of Pontormo and then of Bronzino, has been Cristofano dell' Altissimo, a painter, who, after having executed in his youth many pictures in oils and some portraits, was sent by the Lord Duke Cosimo to Como, to copy many pictures of illustrious persons in the Museum of Monsignor Giovio, out of the vast number which that man, so distinguished in our times, collected in that place. Many others, also, the Lord Duke has obtained by the labours of Vasari; and of all these portraits a list* will be made in the index of this book, in order not to occupy too much space in this discourse. In the work of these portraits Cristofano has exerted himself with such diligence and pains, that those which he has copied up to the present day, and which are in three friezes in a guardaroba of the said Lord Duke, as will be described elsewhere in speaking of the decorations of that place, are more than two hundred and eighty in number, what with Pontiffs, Emperors, Kings, Princes, Captains of armies, men of letters, and, in short, all men for some reason illustrious and renowned. And, to tell the truth, we owe a great obligation to this zeal and diligence of Giovio and of the Duke, for the reason that not only the apartments of Princes, but also those of many private persons, are now being adorned with portraits of one or other of those illustrious men, according to the country, family, and particular affection of each person. Cristofano, then, having established himself in this manner of painting, which is suited to his genius, or rather, inclination, has done little else, as one who is certain to derive from it honour and profit in abundance.

Pupils of Bronzino, also, are Stefano Pieri and Lorenzo della Sciorina, who have so acquitted themselves, both the one and the other, in the obsequies of Michelagnolo and in the nuptials of his Highness, that they have been admitted among the number of our Academicians.

From the same school of Pontormo and Bronzino has issued also Battista Naldini, of whom we have spoken in another place. This Battista, after the death of Pontormo, having been some time in Rome and having applied himself with much study to art, has

* Given in the original Italian edition of 1568.

made much proficience and become a bold and well-practised painter, as many works demonstrate that he has executed for the very reverend Don Vincenzio Borghini, who has made great use of him and assisted him, together with Francesco da Poppi, a young man of great promise and one of our Academicians, who has acquitted himself well in the nuptials of his Highness, and other young men, whom Don Vincenzio is continually employing and assisting. Of this Battista, Vasari has made use for more than two years, as he still does, in the works of the Ducal Palace of Florence, where, by the emulation of many others who were working in the same place, he has made much progress, insomuch that at the present day he is equal to any other young man of our Academy; and that which much pleases those who are good judges is that he is expeditious, and does his work without effort. Battista has painted in an altar-picture in oils that is in a chapel of the Black Friars' Abbey of Florence, a Christ who is bearing the Cross, in which work are many good figures; and he has other works constantly in hand, which will make him known as an able man.

Not inferior to any of these named above in talent, art, and merit, is Maso Manzuoli, called Maso da San Friano, a young man of about thirty or thirty-two years, who had his first principles from Pier Francesco di Jacopo di Sandro, one of our Academicians, of whom we have spoken in another place. This Maso, I say, besides having shown how much he knows and how much may be expected of him in many pictures and smaller paintings, has demonstrated this recently in two altar-pictures with much honour to himself and full satisfaction to everyone, having displayed in them invention, design, manner, grace, and unity in the colouring. In one of these altar-pieces, which is in the Church of S. Apostolo at Florence, is the Nativity of Jesus Christ, and in the other, which is placed in the Church of S. Pietro Maggiore, and is as beautiful as an old and well-practised master could have made it, is the Visitation of Our Lady to S. Elizabeth, executed with judgment and with many fine considerations, insomuch that the heads, the draperies, the attitudes, the buildings, and all the other parts are full of loveliness and grace. This man acquitted himself with no ordinary excellence in the obsequies of Buonarroti, as an Academician and very loving, and then in some scenes for the nuptials of Queen Joanna.

Now, since not only in the Life of Ridolfo Ghirlandajo I have

spoken of his disciple Michele and of Carlo da Loro, but also in other places, I shall say nothing more of them here, although they are of our Academy, enough having been said of them. But I will not omit to tell that other disciples and pupils of Ghirlandajo have been Andrea del Minga, likewise one of our Academicians, who has executed many works, as he still does; Girolamo di Francesco Crocifissaio, a young man of twenty-six, and Mirabello di Salincorno, both painters, who have done and continue to do such works of painting in oils and in fresco, and also portraits, that a most honourable result may be expected from them. These two executed together, now several years ago, some pictures in fresco in the Church of the Capuchins without Florence, which are passing good; and in the obsequies of Michelagnolo and the above-mentioned nuptials, also they did themselves much honour. Mirabello has painted many portraits, and in particular that of the most illustrious Prince more than once, and many others that are in the hands of various gentlemen of Florence.

Another, also, who has done much honour to our Academy and to himself, is Federigo di Lamberto of Amsterdam, a Fleming, the son-in-law of the Paduan Cartaro, working in the said obsequies and in the festive preparations for the nuptials of the Prince, and besides this he has shown in many pictures painted in oils, both large and small, and in other works that he has executed, a good manner and good design and judgment. And if he has merited praise up to the present, he will merit even more in the future, for he is labouring constantly with much advantage in Florence, which he appears to have chosen as his country, that city being one where young men derive much benefit from competition and emulation.

A beautiful genius, also, universal and abundant in fine fantasies, has been shown by Bernardo Timante Buontalenti, who had his first principles of painting in his youth from Vasari, and then, continuing, has made so much proficiency that he has now served for many years, and still serves with much favour, the most illustrious Lord Don Francesco de' Medici, Prince of Florence. That lord has kept him continually at work; and he has executed for his Excellency many works in miniature after the manner of Don Giulio Clovio, such as many portraits and scenes with little figures, painted with much diligence. The same Bernardo has made with a beautiful architectural design, by order of the said Prince, a cabinet with compartments of ebony and columns

of heliotrope, oriental jasper, and lapis-lazuli, which have bases and capitals of chased silver; and besides this he has filled the whole surface of the work with jewels and most lovely ornaments of silver and beautiful little figures, within which ornaments are to be miniatures, and, between terminals placed in pairs, figures of silver and gold in the round, separated by other compartments of agate, jasper, heliotrope, sardonyx, cornelian, and others of the finest stones, to describe all which here would make a very long story. It is enough that in this work, which is near completion, Bernardo has displayed a most beautiful genius, equal to any work. Thus that lord makes use of him for many ingenious fantasies of his own of cords for drawing weights, of windlasses, and of lines; besides that he has discovered a method of fusing rock-crystal with ease and of purifying it, and has made with it scenes and vases of several colours; for Bernardo occupies himself with everything. This, also, will be seen in a short time in the making of vases of porcelain with all the perfection of the most ancient and most perfect; in which at the present day a most excellent master is Giulio da Urbino, who is in the service of the most illustrious Duke Alfonso II of Ferrara, and does stupendous things in the way of vases with several kinds of clay, and to those in porcelain he gives the most beautiful shapes, besides fashioning with the same earth little squares, octagons, and rounds, hard and with an extraordinary polish, for making pavements counterfeiting the appearance of variegated marbles; of all which things our Prince has the methods of making them. His Excellency has also caused a beginning to be made with the executing of a study-table with precious stones, richly adorned, as an accompaniment to another belonging to his father, Duke Cosimo. And not long ago he had one finished after the design of Vasari, which is a rare work, being of oriental alabaster all inlaid with great pieces of jasper, heliotrope, cornelian, lapis-lazuli, and agate, with other stones and jewels of price that are worth twenty thousand crowns. This study-table has been executed by Bernardino di Porfirio of Leccio in the neighbourhood of Florence, who is excellent in such work, and who made for Messer Bindo Altoviti an octagon of ebony and ivory inlaid likewise with jaspers, after the design of the same Vasari; which Bernardino is now in the service of their Excellencies. But to return to Bernardo: in painting, also, beyond the expectation of many, he showed that he is able to execute large figures no less well than the small, when he

painted for the obsequies of Michelagnolo that great canvas of which we have spoken. Bernardo was employed, also, with much credit to him, for the nuptials of his and our Prince, in certain masquerades, in the Triumph of Dreams, as will be told, and in the interludes of the comedy that was performed in the Palace, as has been described exhaustively by others. And if this man, when he was a youth (although even now he is not past thirty), had given his attention to the studies of art as he gave it to the methods of fortification, in which he spent no little time, he would be perchance now at such a height of excellence as would astonish everyone; none the less, it is believed that he is bound for all that to achieve the same end, although something later, for the reason that he is all genius and art, to which is added this also, that he is continually employed and exercised by his sovereign, and in the most honourable works.

Of our Academy, also, is Giovanni della Strada, a Fleming, who has good design, the finest fantasy, much invention, and a good manner of colouring; and, having made much proficience during the ten years that he has worked in the Palace in distemper, fresco, and oils, after the designs and directions of Giorgio Vasari, he can bear comparison with any of the many painters that the said Lord Duke has in his service. But at the present day the principal task of this man is to make cartoons for various arras-tapestries that the Duke and the Prince are having executed, likewise under the direction of Vasari, of divers kinds in accordance with the stories in painting that are on high in the rooms and chambers painted by Vasari in the Palace, for the adornment of which they are being made, to the end that the embellishment of tapestries below may correspond to the pictures above. For the chambers of Saturn, Ops, Ceres, Jove, and Hercules, he has made most lovely cartoons for about thirty pieces of tapestry; and for the upper chambers where the Princess has her habitation, which are four, dedicated to the virtues of woman, with stories of Roman, Hebrew, Greek, and Tuscan women (namely, the Sabines, Esther, Penelope, and Gualdrada), he has made, likewise, very beautiful cartoons for tapestries. In like manner, he has done the same for ten pieces of tapestry in a hall, in which is the Life of Man; and also for the five lower rooms where the Prince dwells, dedicated to David, Solomon, Cyrus, and others. And for twenty rooms in the Palace of Poggio a Caiano, for which the tapestries are even now being woven, he has made after the

inventions of the Duke cartoons of the hunting of every kind of animal, and the methods of fowling and fishing, with the strangest and most beautiful inventions in the world; in which variety of animals, birds, fishes, landscapes, and vestments, with huntsmen on foot and on horseback, fowlers in various habits, and nude fishermen, he has shown and still shows that he is a truly able man, and that he has learned well the Italian manner, being minded to live and die in Florence in the service of his most illustrious lords, in company with Vasari and the other Academicians.

Another pupil of Vasari, likewise, and also an Academician, is Jacopo di Maestro Piero Zucca, a young Florentine of twenty-five or twenty-six years, who, having assisted Vasari to execute the greater part of the works in the Palace, and in particular the ceiling of the Great Hall, has made so much proficience in design and in the handling of colours, labouring with much industry, study, and assiduity, that he can now be numbered among the first of the young painters in our Academy. And the works that he has done by himself alone in the obsequies of Michelagnolo, in the nuptials of the most illustrious Lord Prince, and at other times for various friends, in which he has shown intelligence, boldness, diligence, grace, and good judgment, have made him known as a gifted youth and an able painter; but even more will those make him known that may be expected from him in the future, doing as much honour to his country as has been done to her by any painter at any time.

In like manner, among other young painters of the Academy, Santi Titi may be called ingenious and able, who, as has been told in other places, after having practised for many years in Rome, has returned finally to enjoy Florence, which he regards as his country, although his elders are of Borgo a San Sepolcro and of a passing good family in that city. This Santi acquitted himself truly excellently in the works that he executed for the obsequies of Buonarroti and the above-mentioned nuptials of the most illustrious Princess, but even more, after great and almost incredible labours, in the scenes that he painted in the theatre which he made for the same nuptials on the Piazza di S. Lorenzo, for the most illustrious Lord Paolo Giordano Orsino, Duke of Bracciano; wherein he painted in chiaroscuro, on several immense pieces of canvas, stories of the actions of various illustrious men of the Orsini family. But how able he is can be

perceived best from two altar-pieces by his hand that are to be seen, one of which is in Ognissanti, or rather, S. Salvadore di Fiorenza (as it is now called), once the church of the Padri Umiliati, and now of the Zoccolanti, and contains the Madonna on high and at the foot S. John, S. Jerome, and other Saints; and in the other, which is in S. Giuseppe, behind S. Croce, in the Chapel of the Guardi, is a Nativity of Our Lord executed with much diligence, with many portraits from life. Not to speak of many pictures of Our Lady and various portraits that he has painted in Rome and in Florence, and pictures executed in the Vatican, as has been related above.

There are also certain other young painters of the same Academy who have been employed in the above-mentioned decorations, some of Florence and some of the Florentine States. Alessandro del Barbiere, a young Florentine of twenty-five, besides many other works, painted for the said nuptials in the Palace, after the designs and directions of Vasari, the canvases of the walls in the Great Hall, wherein were depicted the squares of all the cities in the dominion of the Lord Duke; in which he certainly acquitted himself very well, and proved himself a young man of judgment and likely to achieve any success. In like manner, Vasari has been assisted in these and other works by many other disciples and friends; Domenico Benci, Alessandro Fortori of Arezzo, his cousin Stefano Veltroni, and Orazio Porta, both of Monte Sansovino, and Tommaso del Verrocchio.

In the same Academy there are also many excellent craftsmen who are strangers, of whom we have spoken at length in various places above; and therefore it shall suffice here to make known their names, to the end that they may be numbered in this part among the other Academicians. These, then, are Federigo Zucchero; Prospero Fontana and Lorenzo Sabatini, of Bologna; Marco da Faenza, Tiziano Vecelli, Paolo Veronese, Giuseppe Salviati, Tintoretto, Alessandro Vittoria, the sculptor Danese, the painter Battista Farinato of Verona, and the architect Andrea Palladio.

Now, to say something also of the sculptors in our Academy and of their works, although I do not intend to speak of them at any length, because they are alive and for the most part most illustrious in name and fame, I say that Benvenuto Cellini, a citizen of Florence, who is now a sculptor (to begin with the oldest and most honoured), had no peer in his youth when he

was a goldsmith, nor perhaps had he for many years any equal in that profession and in making most beautiful figures in the round and in low-relief, and all the other works of that craft. He set jewels, and adorned them with marvellous collets and with little figures so well wrought, and at times so bizarre and fantastic, that it is not possible to imagine anything finer or better. And the medals that he made in his youth, of silver and gold, were executed with incredible diligence, nor can they ever be praised enough. He made in Rome for Pope Clement VII a very beautiful morse for a pluvial, setting in it excellently well a pointed diamond surrounded by some children made of gold plate, and a God the Father marvellously wrought; wherefore, besides his payment, he received as a gift from that Pope an office of mace-bearer. Being then commissioned by the same Pontiff to make a chalice of gold, the cup of which was to be supported by figures representing the Theological Virtues, he carried it near completion with most marvellous artistry. In these same times there was no one who made the medals of that Pope better than he did, among the many who essayed it, as those well know who saw his medals and possess them; and since for these reasons he received the charge of making the dies for the Mint of Rome, no more beautiful coins have ever been seen than were struck in Rome at that time. Wherefore Benvenuto, after the death of Clement, having returned to Florence, likewise made dies with the head of Duke Alessandro for the coins of the Mint of Florence, so beautiful and wrought with such diligence, that some of them are now preserved as if they were most beautiful antique medals, and that rightly, for the reason that in these he surpassed himself. Having finally given himself to sculpture and to the work of casting, Benvenuto executed in France many works in bronze, silver, and gold, while he was in the service of King Francis in that kingdom. Then, having returned to his own country and entered the service of Duke Cosimo, he was first employed in some goldsmiths' work, and in the end was given some works of sculpture; whereupon he executed in metal the statue of the Perseus that has cut off the head of Medusa, which is in the Piazza del Duca, near the door of the Ducal Palace, upon a base of marble with some very beautiful figures in bronze, each about one braccio and a third in height. This whole work was carried to perfection with the greatest possible study and diligence, and set up in the above-named place as a worthy companion to the Judith by the hand of

Donato, that famous and celebrated sculptor. And certainly it was a marvel that Benvenuto, after being occupied for so many years in making little figures, executed so great a statue with such excellence. The same master has made a Crucifix of marble, in the round and large as life, which of its kind is the rarest and most beautiful piece of sculpture that there is to be seen. Wherefore the Lord Duke keeps it, as a thing most dear to him, in the Pitti Palace, intending to place it in the chapel, or rather, little church, that he is building in that place; which little church could not have in these times anything more worthy of itself and of so great a Prince. In short, it is not possible to praise this work so much as would be sufficient. Now, although I could enlarge at much greater length on the works of Benvenuto, who has been in his every action spirited, proud, vigorous, most resolute, and truly terrible, and a person who has been only too well able to speak for himself with Princes, no less than to employ his hand and brain in matters of art, I shall say nothing more of him here, seeing that he has written of his own life and works, and a treatise on the goldsmith's arts, and on founding and casting in metal, with other things pertaining to such arts, and also of sculpture, with much more eloquence and order than I perchance would be able to use here; as for him, therefore, I must be content with this short summary of the rarest of his principal works.

Francesco di Giuliano da San Gallo, sculptor, architect, and Academician, and now a man seventy years of age, has executed many works of sculpture, as has been related in the Life of his father and elsewhere; the three figures of marble, somewhat larger than life, which are over the altar of the Church of Orsanmichele, S. Anne, the Virgin, and the Child Christ, figures which are much extolled; certain other statues, also in marble, for the tomb of Piero de' Medici at Monte Cassino; the tomb of Bishop de' Marzi, which is in the Nunziata, and that of Monsignor Giovio, the writer of the history of his own times. In architecture, likewise, the same Francesco has executed many good and beautiful works in Florence and elsewhere; and he has well deserved, both for his own good qualities and for the services of his father Giuliano, to be always favoured by the house of Medici as their protégé, on which account Duke Cosimo, after the death of Baccio d'Agnolo, gave him the place which that master had held as architect to the Duomo of Florence.

Of Ammanati, who is also among the first of our Academ-

icians, enough having been said of him in the description of the works of Jacopo Sansovino, there is no need to speak further here. But I will record that disciples of his, and also Academicians, are Andrea Calamech of Carrara, a well-practised sculptor, who executed many figures under Ammanati, and was invited to Messina after the death of the above-named Martino to take the position which Fra Giovanni Agnolo had once held, in which place he died; and Battista di Benedetto, a young man who has given promise of becoming, as he will, an excellent master, having demonstrated already by many works that he is not inferior to the above-named Andrea or to any other of the young sculptors of our Academy, in beauty of genius and judgment.

Vincenzio de' Rossi of Fiesole, likewise a sculptor, architect, and Academician of Florence, is worthy to have some record made of him in this place, in addition to what has been said of him in the Life of Baccio Bandinelli, whose disciple he was. After he had taken leave of Baccio, then, he gave a great proof of his powers in Rome, although he was young enough, in the statue that he made for the Ritonda, of a S. Joseph with Christ as a boy of ten years, both figures wrought with good mastery and a beautiful manner. He then executed two tombs in the Church of S. Maria della Pace, with the effigies of those who are within them on the sarcophagi, and on the front without some Prophets of marble in half-relief and large as life, which acquired for him the name of an excellent sculptor. Whereupon there was allotted to him by the Roman people the statue of Pope Paul IV, which was placed on the Campidoglio; and he executed it excellently well. But that work had a short life, for the reason that after the death of the Pope it was thrown to the ground and destroyed by the populace, which persecutes fiercely one day the very men whom it has exalted to the heavens the day before. After that figure Vincenzio made from one block of marble two statues a little larger than life, a Theseus, King of Athens, who has carried off Helen and holds her in his arms in the act of knowing her, with a Troy beneath his feet; than which figures it is not possible to make any with more diligence, study, labour, and grace. Wherefore when Duke Cosimo de' Medici, having journeyed to Rome, and going to see the modern works worthy to be seen no less than the antiques, saw those statues, Vincenzio himself showing them to him, he extolled them very highly, as they deserved; and then Vincenzio, who is a gentle spirit, courteously presented

them to him, and at the same time freely offered him his services. But his Excellency, having conveyed them not long afterwards to his Palace of the Pitti in Florence, paid him a good price for them; and, having taken Vincenzio himself with him, he commissioned him after no long time to execute the Labours of Hercules in figures of marble larger than life and in the round. On these Vincenzio is now spending his time, and already he has carried to completion the Slaying of Cacus and the Combat with the Centaur; which whole work, even as it is most exalted·in subject and also laborious, so it is hoped that it will prove excellent in artistry, Vincenzio being a man of very beautiful genius and much judgment, and prodigal of thought in all his works of importance.

Nor must I omit to say that under his discipline Ilarione Ruspoli, a young citizen of Florence, gives his attention with much credit to sculpture; which Ilarione, no less than his peers in our Academy, showed that he had knowledge, design, and a good mastery in the making of statues, when he had occasion together with the others in the obsequies of Michelagnolo and in the festive preparations for the nuptials named above.

Francesco Camilliani, a sculptor and Academician of Florence, who was a disciple of Baccio Bandinelli, after having given in many works proof of being a good sculptor, has consumed fifteen years in making ornaments for fountains; and of such there is one most stupendous, which the Lord Don Luigi di Toledo has caused to be executed for his garden in Florence. The ornaments about that garden are various statues of men and animals in divers manners, all rich and truly regal, and wrought without sparing of expense; and among other statues that Francesco has made for that place, two larger than life, which represent the Rivers Arno and Mugnone, are of supreme beauty, and particularly the Mugnone, which can bear comparison with no matter what statue by an excellent master. In short, all the architecture and ornamentation of that garden are the work of Francesco, who by the richness of the various fountains has made it such, that it has no equal in Florence, and perhaps not in Italy. And the principal fountain, which is even now being carried to completion, will be the richest and most sumptuous to be seen in any place, with its wealth of the richest and finest ornaments that can be imagined, and the great abundance of waters that will be there, flowing without fail at every season.

Also an Academician, and much in favour with our Princes

for his talents, is Giovan Bologna of Douai, a Flemish sculptor and a young man truly of the rarest, who has executed with most beautiful ornaments of metal the fountain that has been made recently on the Piazza di S. Petronio in Bologna, opposite to the Palazzo de' Signori, in which there are, besides other ornaments, four very beautiful Sirens at the corners, with various children all around, and masks bizarre and extraordinary. But the most notable thing is a figure that he has made and placed over the centre of that fountain, a Neptune of six braccia, which is a most beautiful casting and a statue studied and wrought to perfection. The same master – not to speak at present of all the works that he has executed in clay, terracotta, wax, and other mixtures – has made a very beautiful Venus in marble, and has carried almost to completion for the Lord Prince a Samson large as life, who is combating on foot with two Philistines. And in bronze he has made a statue of Bacchus, larger than life and in the round, and a Mercury in the act of flying, a very ingenious figure, the whole weight resting on one leg and on the point of the foot, which has been sent to the Emperor Maximilian, as a thing that is indeed most rare. But if up to the present he has executed many works, he will do many more in the future, and most beautiful, for recently the Lord Prince has had him provided with rooms in the Palace, and has commissioned him to make a statue of a Victory of five braccia, with a captive, which is going into the Great Hall, opposite another by the hand of Michelagnolo; and he will execute for that Prince large and important works, in which he will have an ample field to show his worth. Many works by his hand, and very beautiful models of various things, are in the possession of M. Bernardo Vecchietti, a gentleman of Florence, and Maestro Bernardo di Mona Mattea, builder to the Duke, who has constructed with great excellence all the fabrics designed by Vasari.

Not less than this Giovan Bologna and his friends and other sculptors of our Academy, Vincenzio Danti of Perugia, who under the protection of Duke Cosimo has adopted Florence as his country, is a young man truly rare and of fine genius. Vincenzio, when a youth, worked as a goldsmith, and executed in that profession things beyond belief; and afterwards, having applied himself to the work of casting, he had the courage at the age of twenty to cast in bronze a statue of Pope Julius III, four braccia high, seated and giving the Benediction; which statue, a very creditable work, is now in the Piazza of Perugia. Then, having

come to Florence to serve Duke Cosimo, he made a very beautiful model in wax, larger than life, of a Hercules crushing Antæus, in order to cast from it a figure in bronze, which was to be placed over the principal fountain in the garden of Castello, a villa of the said Lord Duke. But, having made the mould upon that model, in seeking to cast it in bronze it did not succeed, although he returned twice to the work; either by bad fortune, or because the metal was burnt, or for some other reason. Having then turned, in order not to subject his labours to the whim of chance, to working in marble, he executed in a short time from one single piece of marble two figures, Honour with Deceit beneath it, and with such diligence, that it seemed as if he had never done anything but handle the hammer and chisels; and on the head of Honour, which is beautiful, he made the hair curling and so well pierced through, that it seems real and natural, besides displaying a very good knowledge of the nude. That statue is now in the courtyard of the house of Signor Sforza Almeni in the Via de' Servi. And at Fiesole, for the same Signor Sforza, he made many ornaments in his garden and around certain fountains. Afterwards he executed for the Lord Duke some low-reliefs in marble and in bronze, which were held to be very beautiful, for in that manner of sculpture he is perhaps not inferior to any other master. He then cast, also in bronze, the grating of the chapel built in the new apartments of the Palace, which were painted by Giorgio Vasari, and with it a panel with many figures in low-relief, which serves to close a press wherein the Duke keeps writings of importance; and another panel one braccio and a half in height and two and a half in breadth, representing how Moses, in order to heal the Hebrew people from the bites of the serpents, placed one upon a pole. All these things are in the possession of that lord, by order of whom he made the door of the sacristy in the Pieve of Prato, and over it a sarcophagus of marble, with a Madonna three braccia and a half high, and beside her the Child nude, and two little children that are one on either side of a head in low-relief of Messer Carlo de' Medici, the natural son of the elder Cosimo, and once Provost of Prato, whose bones, after having long been in a tomb of brick, Duke Cosimo has caused to be laid in the above-named sarcophagus, thus giving him honourable sepulture; although it is true that the said Madonna and the head in low-relief (which is very beautiful), being in a bad light, do not show up by a great measure as they

should. The same Vincenzio has since made, in order to adorn the residence of the Magistrates of the Mint, on the head-wall over the loggia that is on the River Arno, an escutcheon of the Duke with two nude figures, larger than life, on either side of it, one representing Equity and the other Rigour; and from hour to hour he is expecting the marble to make the statue of the Lord Duke himself, considerably larger than life, of which he has made a model; and that statue is to be placed seated over the escutcheon, as a completion to the work, which is to be built shortly, together with the rest of the façade, which Vasari, who is the architect of that fabric, is even now superintending. He has also in hand, and has carried very near completion, a Madonna of marble larger than life, standing with Jesus, a Child of three months, in her arms; which will be a very beautiful work. All these works, together with others, he is executing in the Monastery of the Angeli in Florence, where he lives quietly in company with these monks, who are much his friends, in the rooms that were once occupied there by Messer Benedetto Varchi, of whom the same Vincenzio is making a portrait in low-relief, which will be very beautiful.

Vincenzio has a brother in the Order of Preaching Friars, called Fra Ignazio Danti, who is very excellent in matters of cosmography, and of a rare genius, insomuch that Duke Cosimo de' Medici is causing him to execute a work than which none greater or more perfect has ever been done at any time in that profession; which is as follows. His Excellency, under the direction of Vasari, has built a new hall of some size expressly as an addition to the guardaroba, on the second floor of the apartments in the Ducal Palace; and this he has furnished all around with presses seven braccia high, with rich carvings of walnut-wood, in order to deposit in them the most important, precious, and beautiful things that he possesses. Over the doors of those presses, within their ornaments, Fra Ignazio has distributed fifty-seven pictures about two braccia high and wide in proportion, in which are painted in oils on the wood with the greatest diligence, after the manner of miniatures, the Tables of Ptolemy, all measured with perfect accuracy and corrected after the most recent authorities, with exact charts of navigation and their scales for measuring and degrees, done with supreme diligence; and with these are all the names, both ancient and modern. His distribution of these pictures is on this wise. At the principal entrance of

the hall, on the transverse surfaces of the thickness of the presses, in four pictures, are four half-spheres in perspective; in the two below is the Universe of the Earth, and in the two above is the Universe of the Heavens, with its signs and celestial figures. Then as one enters, on the right hand, there is all Europe in fourteen tables and pictures, one after another, as far as the centre of the wall that is at the head, opposite to the principal door; in which centre is placed the clock with the wheels and with the spheres of the planets that every day go through their motions, which is that clock, so famous and renowned, made by the Florentine Lorenzo della Volpaia. Above these tables is Africa in eleven tables, as far as the said clock; and then, beyond that clock, Asia in the lower range, which continues likewise in fourteen tables as far as the principal door. Above these tables of Asia, in fourteen other tables, there follow the West Indies, beginning like the others from the clock, and continuing as far as the same principal door; and thus there are in all fifty-seven tables. In the base at the foot, in an equal number of pictures running right round, which will be exactly in line with those tables, are to be all the plants and all the animals copied from nature, according to the kinds that those countries produce. Over the cornice of the presses, which is the crown of the whole, there are to be some projections separating the pictures, and upon these are to be placed such of the antique heads in marble as are in existence of the Emperors and Princes who have possessed those lands; and on the plain walls up to the cornice of the ceiling, which is all of carved wood and painted in twelve great pictures, each with four celestial signs, making in all forty-eight, and little less than life-size, with their stars – there are beneath, as I have said, on those walls, three hundred portraits from life of distinguished persons for the last five hundred years or more, painted in pictures in oils (and a note will be made of them in the table of portraits, in order not to make too long a story here with their names), all of one size, and with one and the same ornament of carved walnut-wood – a very rare effect. In the two compartments in the centre of the ceiling, each four braccia wide, where there are the celestial signs, which open with ease without revealing the secret of the hiding-place, in a part after the manner of a heaven, will be accommodated two large globes, each three braccia and a half in height. In one of them will be the whole earth, marked distinctly, and this will be let down by a windlass that will

not be seen, down to the floor, and will rest on a balanced pedestal, so that, when fixed, there will be seen reflected all the tables that are right round in the pictures of the presses, and they will have a countermark in the globe wherewith to find them with ease. In the other globe will be the forty-eight celestial signs arranged in such a manner, that it will be possible with it to perform all the operations of the Astrolabe to perfection. This fanciful invention came from Duke Cosimo, who wished to put together once and for all these things both of heaven and of earth, absolutely exact and without errors, so that it might be possible to see and measure them separately and all together, according to the pleasure of those who delight in this most beautiful profession and study it; of which, as a thing worthy to be recorded, it has seemed to me my duty to make mention in this place on account of the art of Fra Ignazio and the greatness of the Prince, who holds us worthy to enjoy such honourable labours, and also to the end that it may be known throughout the whole world.

And now to return to the men of our Academy; although I have spoken in the Life of Tribolo of Antonio di Gino Lorenzi, a sculptor of Settignano, I must record here with better order, as in the proper place, that he executed under his master Tribolo the statue of Æsculapius described above, which is at Castello, and four children that are in the great fountain of that place; and since then he has made some heads and ornaments that are about the new fish-pond of Castello, which is high up there in the midst of various kinds of trees of perpetual verdure. Recently he has made in the lovely garden of the stables, near S. Marco, most beautiful ornaments for an isolated fountain, with many very fine aquatic animals of white and variegated marble; and in Pisa he once executed under the direction of the above-named Tribolo the tomb of Corte, a most excellent philosopher and physician, with his statue and two very beautiful children of marble. In addition to these, he is even now executing new works for the Duke, of animals and birds in variegated marble for fountains, works of the greatest difficulty, which make him well worthy to be in the number of these our Academicians.

In like manner, a brother of Antonio, called Stoldo di Gino Lorenzi, a young man thirty years of age, has acquitted himself in such a manner up to the present in many works of sculpture, that he may now be numbered with justice among the first of the young men in his profession, and set in the most honourable

place in their midst. At Pisa he has executed in marble a Madonna receiving the Annunciation from the Angel, which has made him known as a young man of beautiful judgment and genius; and Luca Martini caused him to make another very lovely statue in Pisa, which was presented afterwards by the Lady Duchess Leonora to the Lord Don Garzia di Toledo, her brother, who has placed it in his garden on the Chiaia at Naples. The same Stoldo has made, under the direction of Vasari, in the centre of the façade of the Palace of the Knights of S. Stephen at Pisa, over the principal door, a very large escutcheon in marble of the Lord Duke, their Grand Master, between two statues in the round, Religion and Justice, which are truly most beautiful and highly extolled by all those who are good judges. The same lord has since caused him to execute a fountain for his garden of the Pitti, after the likeness of the beautiful Triumph of Neptune that was seen in the superb masquerade which his Excellency held for the above-mentioned nuptials of the most illustrious Lord Prince. And let this suffice for Stoldo Lorenzi, who is young and is constantly working and acquiring more and more fame and honour among his companions of the Academy.

Of the same family of the Lorenzi of Settignano is Battista, called Battista del Cavaliere from his having been a disciple of the Chevalier Baccio Bandinelli; who has executed in marble three statues of the size of life, which Bastiano del Pace, a citizen of Florence, has caused him to make for the Guadagni, who live in France, and who have placed them in a garden that belongs to them. These are a nude Spring, a Summer, and a Winter, which are to be accompanied by an Autumn; which statues have been held by many who have seen them, to be beautiful and executed with no ordinary excellence. Wherefore Battista has well deserved to be chosen by the Lord Duke to make the sarcophagus, with the ornaments, and one of the three statues that are to be on the tomb of Michelagnolo Buonarroti, which his Excellency and Leonardo Buonarroti are carrying out after the design of Giorgio Vasari; which work, as may be seen, Battista is carrying to completion excellently well, with certain little boys, and the figure of Buonarroti himself from the breast upwards.

The second of these three figures that are to be on that sepulchre, which are to be Painting, Sculpture, and Architecture, has been allotted to Giovanni di Benedetto of Castello, a disciple of Baccio Bandinelli and an Academician, who is executing for

the Wardens of S. Maria del Fiore the works in low-relief that are
going round the choir, which is now near completion. In these
he is closely imitating his master, and acquitting himself in such
a manner that an excellent result is expected of him; nor will it
fall out otherwise, seeing that he is very assiduous in his work
and in the studies of his profession.

The third figure has been allotted to Valerio Cioli of Settigna-
no, a sculptor and Academician, for the reason that the other
works that he has executed up to the present have been such,
that it is thought that the said figure must prove to be so good
as to be not otherwise than worthy to be placed on the tomb of
so great a man. Valerio, who is a young man twenty-six years
of age, has restored many antique statues of marble in the gar-
den of the Cardinal of Ferrara at Monte Cavallo in Rome, making
for some of them new arms, for some new feet, and for others
other parts that were wanting; and he has since done the same
for many statues in the Pitti Palace, which the Duke has con-
veyed there for the adornment of a great hall. The Duke has
also caused the same Valerio to make a nude statue of the
dwarf Morgante in marble, which has proved so beautiful and so
like the reality, that probably there has never been seen another
monster so well wrought, nor one executed with such diligence,
lifelike and faithful to nature. In like manner, he has caused him
to execute the statue of Pietro, called Barbino, a gifted dwarf,
well-lettered and a very gentle spirit, and a favourite of our Duke.
For all these reasons, I say, Valerio has well deserved that
there should be allotted to him by his Excellency the statue that
is to adorn the tomb of Buonarroti, the one master of all these
able men of the Academy.

As for Francesco Moschino, a sculptor of Florence, enough
having been spoken of him in another place, it suffices here to
say that he also is an Academician, that under the protection of
Duke Cosimo he is constantly at work in the Duomo of Pisa, and
that among the festive preparations for the nuptials he acquitted
himself excellently well in the decorations of the principal door
of the Ducal Palace.

Of Domenico Poggini, likewise, having said above that he is
an able sculptor and that he has executed an infinity of medals
very faithful to the reality, and some works in marble and in
casting, I shall say nothing more of him here, save that he is
deservedly one of our Academicians, that for the above-named

nuptials he made some very beautiful statues, which were placed upon the Arch of Religion at the Canto della Paglia, and that recently he has executed a new medal of the Duke, very true to the life and most beautiful; and he is still continually at work.

Giovanni Fancelli, or rather, as others call him, Giovanni di Stocco, an Academician, has executed many works in marble and stone, which have proved good sculptures; among others, much extolled is an escutcheon of balls with two children and other ornaments, placed on high over the two knee-shaped windows of the façade of Ser Giovanni Conti in Florence. And the same I say of Zanobi Lastricati, who, as a good and able sculptor, has executed and is still executing many works in marble and in casting, which have made him well worthy to be in the Academy in company with those named above; and, among his works, much praised is a Mercury of bronze that is in the court of the Palace of M. Lorenzo Ridolfi, for it is a figure wrought with all the considerations that are requisite.

Finally, there have been accepted into the Academy some young sculptors who executed honourable and praiseworthy works in the above-named preparations for the nuptials of his Highness; and these were Fra Giovanni Vincenzio of the Servites, a disciple of Fra Giovanni Agnolo; Ottaviano del Collettaio, a pupil of Zanobi Lastricati, and Pompilio Lancia, the son of Baldassarre da Urbino, architect and pupil of Girolamo Genga; which Pompilio, in the masquerade called the Genealogy of the Gods, arranged for the most part, and particularly the mechanical contrivances, by the said Baldassarre, his father, acquitted himself in certain things excellently well.

In these last pages we have shown at some length what kind of men, and how many and how able, have been gathered together to form so noble an Academy, and we have touched in part on the many and honourable occasions obtained by them from their most liberal lords, wherein to display their capacity and ability. Nevertheless, to the end that this may be the better understood, although those first learned writers, in their descriptions of the arches and of the various spectacles represented in those splendid nuptials, made it very well known, yet, since there has been given into my hands the following little work, written by way of exercise by a person of leisure who delights not a little in our profession, to a dear and close friend who was not able to see those festivities, forming the most brief account

and comprising everything in one, it has seemed to me my duty, for the satisfaction of my brother-craftsmen, to insert it in this volume, adding to it a few words, to the end that it may be more easy, by thus uniting rather than separating it, to preserve an honourable record of their noble labours.

OF THE ACADEMICIANS
DESCRIPTION OF THE FESTIVE PREPARATIONS FOR THE NUPTIALS OF THE PRINCE DON FRANCESCO OF TUSCANY

DESCRIPTION OF THE PORTA AL PRATO

WE will describe, then, with the greatest clearness and brevity that may be permitted by the abundance of our material, how the intention in all these decorations was to represent by the vast number of pictures and sculptures, as if in life, all those ceremonies, effects, and pomps that appeared to be proper to the reception and the nuptials of so great a Princess, forming of them poetically and ingeniously a whole so well proportioned, that with judgment and grace it might achieve the result designed. First of all, therefore, at the Gate that is called the Porta al Prato, by which her Highness was to enter the city, there was built with dimensions truly heroic, which well showed ancient Rome risen again in her beloved daughter Florence, a vast, most ornate, and very ingeniously composed ante-port of Ionic architecture, which, surpassing by a good measure the height of the walls, which are there very lofty, presented a marvellous and most superb view not only to those entering the city, but even at a distance of several miles. And this arch was dedicated to Florence, who – standing between two figures, as it were her beloved companions, of Fidelity and Affection, virtues which she has always shown towards her Lords – in the form of a young and most beautiful woman, smiling and all adorned with flowers, had been set, as was her due, in the most important and most honourable place, nearest to the Gate, as if she sought to receive, introduce, and accompany her new Lady; having brought with her, as it were as her minister and companion, and as the symbol of those of her sons who in the art of war, among other arts, have rendered

her illustrious, Mars, their leader and master, and in a certain sense the first father of Florence herself, in that under his auspices and by martial men, who were descended from Mars, was made her first foundation. His statue, dread and terrible, could be seen on the right in the part farthest from her, sword in hand, as if he sought to use it in the service of his new Lady; he likewise having as it were brought with him to accompany his Florence, in a very large and very beautiful canvas painted in chiaroscuro that was beneath his feet (very similar to the whitest marble, as were all the other works that were in these decorations), some of the men of that invincible Martian Legion so dear to the first and second Cæsar, her first founders, and some of those born from her, who afterwards followed her discipline so gloriously. Many of these could be seen issuing full of gladness from his temple, which is now dedicated to S. John in the name of the Christian religion; and in the farthest distance were placed those who were thought to have had a name only for bodily valour, in the central space those others who had become famous by their counsel and industry, such as commissaries or proveditors (to call them by their Venetian name), and in the front part nearest to the eye, in the most honourable places, as being the most worthy of honour, were painted the captains of armies and those who had acquired illustrious renown and immortal fame by valour of the body and mind together. Among these, as the first and perhaps the most honourable, could be seen on horseback, like many others, the glorious Signor Giovanni de' Medici portrayed from life, that rare master of Italian military discipline, and the illustrious father of the great Cosimo whom we honour as our excellent and most valorous Duke; and with him Filippo Spano, terror of the barbarous Turks, and M. Farinata degli Uberti, great-hearted saviour of his native Florence. There, also, was M. Buonaguisa della Pressa, who, at the head of the valiant youth of Florence, winning the first and glorious mural crown at Damiata, acquired so great a name; and the Admiral Federigo Folchi, Knight of Rhodes, who with his two sons and eight nephews performed so many deeds of prowess against the Saracens. There were M. Nanni Strozzi, M. Manno Donati, Meo Altoviti, and Bernardo Ubaldini, called Della Carda, father of Federigo, Duke of Urbino, that most excellent captain of our times. There, likewise, was the Great Constable, M. Niccola Acciaiuoli, he who it may be said preserved for Queen Joanna and King Louis, his Sovereigns, the

troubled kingdom of Naples, and who always bore himself both there and in Sicily with such loyalty and valour. There were another Giovanni de' Medici and Giovanni Bisdomini, most illustrious in the wars with the Visconti, and the unfortunate but valorous Francesco Ferrucci; and among those more ancient were M. Forese Adimari, M. Corso Donati, M. Vieri de' Cerchi, M. Bindaccio da Ricasoli, and M. Luca da Panzano. Among the commissaries, not less faithfully portrayed from life, could be seen there Gino Capponi, with Neri his son, and Piero his grand-nephew, he who, tearing so boldly the insolent proposals of Charles VIII, King of France, to his immortal honour, caused the voice of a Capon (Cappon), as the witty poet said so well, to sound so nobly among so many Cocks (Galli). There were Bernardetto de' Medici, Luca di Maso degli Albizzi, Tommaso di M. Guido, now called Del Palagio, Piero Vettori, so celebrated in the wars with the Aragonese, and the so greatly and so rightly renowned Antonio Giacomini, with M. Antonio Ridolfi and many others of this and other orders, who would make too long a story. All these appeared to be filled with joy that they had raised their country to such a height, auguring for her, in the coming of that new Lady, increase, felicity, and greatness; which was expressed excellently well in the four verses that were to be seen written on the architrave above:

> Hanc peperere suo patriam qui sanguine nobis
> Aspice magnanimos heroas; nunc et ovantes
> Et laeti incedant, felicem terque quaterque
> Certatimque vocent tali sub Principe Floram.

Not less gladness could be seen in the beautiful statue of one of the nine Muses, which was placed as a complement opposite to that of Mars, nor less, again, in the figures of the men of science in the painted canvas that was to be seen at her feet, of the same size and likewise as the complement of the men of Mars opposite, by which it was sought to signify that even as the men of war, so also the men of learning, of whom Florence had always a great abundance and in no way less renowned (in that, as all men admit, it was there that learning began to revive), had likewise been brought by Florence under the guidance of their Muse to receive and honour the noble bride. Which Muse, clad in a womanly, graceful, and seemly habit, with a book in the right hand and a flute in the left, seemed with a certain loving express-

ion to wish to invite all beholders to apply their minds to true
virtue; and on the canvas beneath her, executed, like all the
others, in chiaroscuro, could be seen painted a great and rich
Temple of Minerva, whose statue crowned with olive, with the
shield of the Gorgon (as is customary), was placed without; and
before the temple and at the sides, within an enclosure of balus-
ters made as it were for a promenade, could be seen a great
throng of grave and solemn men, who, although all rejoicing and
making merry, yet retained in their aspect a certain something of
the venerable, and these, also, were portrayed from life. For The-
ology and Sanctity there was the famous Fra Antonino, Arch-
bishop of Florence, for whom a little Angel was holding the
episcopal mitre, and with him was seen Giovanni Domenici, first
Friar and then Cardinal; and with them Don Ambrogio, General
of Camaldoli, and M. Ruberto de' Bardi, Maestro Luigi Marsili,
Maestro Leonardo Dati, and many others. Even so, in another
part – and these were the Philosophers – were seen the Platonist
M. Marsilio Ficino, M. Francesco Cattani da Diacceto, M. Fran-
cesco Verini the elder, and M. Donato Acciaiuoli; and for
Law there were, with the great Accursio, Francesco his son,
M. Lorenzo Ridolfi, M. Dino Rossoni di Mugello, and M. Forese
da Rabatta. The Physicians, also, had their portraits; and among
them Maestro Taddeo Dino and Tommaso del Garbo, with
Maestro Torrigian Valori and Maestro Niccolò Falcucci, had the
first places. Nor did the Mathematicians, likewise, fail to be
painted there; and of these, besides the ancient Guido Bonatto,
were seen Maestro Paolo del Pozzo and the very acute, ingenious,
and noble Leon Batista Alberti, and with them Antonio Manetti
and Lorenzo della Volpaia, he by whose hand we have that
first and marvellous clock of the planets, the wonder of our age,
which is now to be seen in the guardaroba of our most excellent
Duke. For Navigation, also, there was Amerigo Vespucci, most
experienced and most fortunate of men, in that so great a part of
the world, having been discovered by him, retains because of him
the name of America. For Learning, various and elegant, there
was Messer Agnolo Poliziano, to whom how much is owed by
the Latin and Tuscan tongues, which began to revive in him, I
believe is sufficiently well known to all the world. With him were
Pietro Crinito, Giannozzo Manetti, Francesco Pucci, Bartolom-
meo Fonzio, Alessandro de' Pazzi, and Messer Marcello Vergilio
Adriani, father of the most ingenious and most learned M. Gio-

van Battista, now called Il Marcellino, who is still living and giving public lectures with so much honour in our Florentine University, and who at the commission of their illustrious Excellencies has been writing anew the History of Florence; and there were also M. Cristofano Landini, M. Coluccio Salutati, and Ser Brunetto Latini, the master of Dante. Nor were there wanting certain Poets who had written in Latin, such as Claudian, and among the more modern Carlo Marsuppini and Zanobi Strada. Of the Historians, then, were seen M. Francesco Guicciardini, Niccolò Macchiavelli, M. Leonardo Bruni, M. Poggio, Matteo Palmieri, and, among the earliest, Giovanni and Matteo Villani and the very ancient Ricordano Malespini. All these, or the greater part, for the satisfaction of all beholders, had each his name or that of his most famous works marked on the scrolls or on the covers of the books that they held, placed there as if by chance; and with all of them, as with the men of war, to demonstrate what they were come there to do, the four verses that were painted on the architrave, as with the others, made it clearly manifest, saying:

> Artibus egregiis Latiæ Graiæque Minervæ
> Florentes semper quis non miretur Etruscos?
> Sed magis hoc illos ævo florere necesse est
> Et Cosmo genitore et Cosmi prole favente.

Next, beside the statue of Mars, and somewhat nearer to that of Florence – and here it must be noted with what singular art and judgment every least thing was distributed, in that, the intention being to accompany Florence with six Deities, so to speak, for the potency of whom she could right well vaunt herself, the two hitherto described, Mars and the Muse, because other cities could perhaps no less than she lay claim to them, as being the least peculiar to her, were placed less near to her than the others; and so for the spacious vestibule or passage, as it were, formed before the gate by the four statues to follow, the two already described were used as wings or head-pieces, being placed at the entrance, one turned towards the Castle and the other towards the Arno, but the next two, which formed the beginning of the vestibule, for the reason that they are shared by her with few other cities, came to be placed somewhat nearer to her, even as the last two, because they are entirely peculiar to her and shared with no other city, or, to speak more exactly, because no other

can compare with her in them (and may this be said without offence to any other Tuscan people, which, when it shall have a Dante, a Petrarca, and a Boccaccio to put forward, may perchance be able to come into dispute with her), were placed in close proximity to her, and nearer than any of the others – now, to go back, I say that beside the statue of Mars had been placed a Ceres, Goddess of Cultivation and of the fields, not less beautiful and good to look upon than the others; which pursuit, how useful it is and how worthy of honour for a well-ordered city, was taught in ancient times by Rome, who had enrolled all her nobility among the rustic tribes, as Cato testifies, besides many others, calling it the nerve of that most puissant Republic, and as Pliny affirms no less strongly when he says that the fields had been tilled by the hands of Imperatores, and that it may be believed that earth rejoiced to be ploughed by the laureate share and by the triumphant ploughman. That Ceres was crowned, as is customary, with ears of various kinds of corn, having in the right hand a sickle and in the left a bunch of similar ears. Now, how much Florence can vaunt herself in this respect, whoever may be in any doubt of it may enlighten himself by regarding her most ornate and highly cultivated neighbourhood, for, leaving on one side the vast number of most superb and commodious palaces that may be seen dispersed over its surface, it is such that Florence, although among the most beautiful cities of which we have any knowledge she might be said to carry off the palm, yet remains by a great measure vanquished and surpassed by it, insomuch that it may rightly claim the title of the garden of Europe; not to speak of its fertility, as to which, although it is for the most part mountainous and not very large, nevertheless the diligence that is used in it is such, that it not only feeds bountifully its own vast population and the infinite multitude of strangers who flock to it, but very often gives courteous succour to other lands both near and far. In the canvas (to return to our subject) which was to be seen in like fashion beneath her statue, in the same manner and of the same size, the excellent painter had figured a most beautiful little landscape adorned with an infinite variety of trees, in the most distant part of which was seen an ancient and very ornate little temple dedicated to Ceres, in which, since it was open and raised upon colonnades, could be perceived many who were offering religious sacrifices. On the other side, in a part somewhat more solitary, Nymphs of the chase could be seen

standing about a shady and most limpid fount, gazing as it were in marvel and offering to the new bride of those pleasures and delights that are found in their pursuits, in which Tuscany is perhaps not inferior to any other part of Italy. In another part, with many countrymen bringing various animals both wild and domestic, were seen also many country-girls, young and beautiful, and adorned in a thousand rustic but graceful manners, and likewise come – weaving the while garlands of flowers and bearing various fruits – to see and honour their Lady. And the verses which were over this scene as with the others, taken from Virgil, to the great glory of Tuscany, ran thus:

> Hanc olim veteres vitam coluere Sabini,
> Hanc Remus et frater, sic fortis Etruria crevit,
> Scilicet et rerum facta est pulcherrima Flora,
> Urbs antiqua, potens armis atque ubere glebæ.

Next, opposite to the above-described statue of Ceres, was seen that of Industry; and I do not speak merely of that industry which is seen used by many in many places in matters of commerce, but of a certain particular excellence and ingenious virtue which the men of Florence employ in everything to which they deign to apply themselves, on which account many, and in particular the Poet of supreme judgment (and rightly, as is evident), give them the title of Industrious. How great a benefit this industry has been to Florence, and in what great account it has always been held by her, is seen from this, that upon it she formed her body corporate, decreeing that none could become one of her citizens who was not entered under the name of some Guild, and thus recognizing that by that industry she had risen to no small power and greatness. Now Industry was figured as a woman in a light and easy habit, holding a sceptre, at the head of which was a hand with an eye in the centre of the palm, and with two little wings, whereby with the sceptre there was achieved a certain sort of resemblance to the Caduceus of Mercury; and in the canvas that was beneath her, as with the other statues, was seen a vast and most ornate portico or forum, very similar to the place where our merchants resort to transact their business, called the Mercato Nuovo, which was made even clearer by the boy that was to be seen striking the hours on one of the walls. And on one side, their particular Gods having been ingeniously placed there (in one part, namely, the statue of Fortune seated on a wheel, and in

another part Mercury with the Caduceus and with a purse in the hand), were seen assembled many of the most noble artificers, those, namely, who exercise their arts with perhaps greater excellence in Florence than in any other place; and of such, with their wares in their hands, as if they were seeking to offer them to the incoming Princess, some were to be seen with cloth of gold or of silk, some with the finest draperies, and others with most beautiful and marvellous embroideries, and all with expressions of joy. Even so, in another part, some were seen in various costumes trafficking as they walked, and others of lower degree with various most beautiful wood-carvings and works in tarsia, and some again with balls, masks, and rattles, and other childish things, all in the same manner showing the same gladness and contentment. All which, and the advantage of these things, and the profit and glory that have come from them to Florence, was made manifest by the four verses that were placed above them, as with the others, saying:

> Quas artes pariat solertia, nutriat usus,
> Aurea monstravit quondam Florentia cunctis.
> Pandere namque acri ingenio atque enixa labore est
> Præstanti, unde paret vitam sibi quisque beatam.

Of the two last Deities or Virtues, seeing that, as we have said, by reason of the number and excellence in them of her sons they are so peculiar to Florence that she may well consider herself glorious in them beyond any other city, there was placed on the right hand, next to the statue of Ceres, that of Apollo, representing that Tuscan Apollo who infuses Tuscan verse in Tuscan poets. Under his feet, as in the other canvases, there was painted on the summit of a most lovely mountain, recognized as that of Helicon by the horse Pegasus, a very spacious and beautiful meadow, in the centre of which rose the sacred Fount of Aganippe, likewise recognized by the nine Muses, who stood around it in pleasant converse, and with them, and in the shade of the verdant laurels with which the whole mount was covered, were seen various poets in various guise seated or discoursing as they walked, or singing to the sound of the lyre, while a multitude of little Loves were playing above the laurels, some of them shooting arrows, and some appeared to be throwing down crowns of laurel. Of these poets, in the most honourable place were seen the profound Dante, the gracious Petrarca, and the fecund Boccaccio, who with smiling aspect appeared to be promising to the

incoming Lady, since a subject so noble had not fallen to them, to infuse in the intellects of Florence such virtue that they would be able to sing worthily of her; to which with the exemplar of their writings, if only there may be found one able to imitate them, they have opened a broad and easy way. Near them, as if discoursing with them, and all, like the rest, portrayed from life, were seen M. Cino da Pistoia, Montemagno, Guido Cavalcanti, Guittone d'Arezzo, and Dante da Maiano, who lived in the same age and were poets passing gracious for those times. In another part were Monsignor Giovanni della Casa, Luigi Alamanni, and Lodovico Martelli, with Vincenzio at some distance from him, and with them Messer Giovanni Rucellai, the writer of the tragedies, and Girolamo Benivieni; among whom, if he had not been living at that time, a well-merited place would have been given also to the portrait of M. Benedetto Varchi, who shortly afterwards made his way to a better life. In another part, again, were seen Franco Sacchetti, who wrote the three hundred Novelle, and other men, who, although at the present day they have no great renown, yet, because in their times they made no small advance in romances, were judged to be not unworthy of that place – Luigi Pulci, with his brothers Bernardo and Luca, and also Ceo and Altissimo. Berni, also, the inventor and father (and excellent father) of Tuscan burlesque poetry, with Burchiello, with Antonio Alamanni, and with Unico Accolti (who were standing apart), appeared to be showing no less joy than any of the others; while Arno, leaning in his usual manner on his Lion, with two children that were crowning him with laurel, and Mugnone, known by the Nymph that stood over him crowned with stars, with the moon on her brow, in allusion to the daughters of Atlas, and representing Fiesole, appeared likewise to be expressing the same gladness and contentment. All which conception described above was explained excellently well by the four verses that were placed in the architrave, as with the others, which ran thus:

> Musarum hic regnat chorus, atque Helicone virente
> Posthabito, venere tibi Florentia vates
> Eximii, quoniam celebrare hæc regia digno
> Non potuere suo et connubia carmine sacro.

Opposite to this, placed on the left hand, and perhaps not less peculiar to the Florentine genius than the last-named, was seen

the statue of Design, the father of painting, sculpture, and architecture, who, if not born in Florence, as may be seen in the past writings, may be said to have been born again there, and nourished and grown as in his own nest. He was figured by a statue wholly nude, with three similar heads for the three arts that he embraces, each holding in the hand some instrument, but without any distinction; and in the canvas that was beneath him was seen painted a vast courtyard, for the adornment of which were placed in various manners a great quantity of statues and of pictures in painting, both ancient and modern, which could be seen in process of being designed and copied by divers masters in divers ways. In one part was being prepared an anatomical study, and many could be seen observing it, and likewise drawing, very intently. Others, again, considering the fabric and rules of architecture, appeared to be seeking to measure certain things with great minuteness, the while that the divine Michelagnolo Buonarroti, prince and monarch of them all, with the three circlets in his hand (his ancient device), making signs to Andrea del Sarto, Leonardo da Vinci, Pontormo, Rosso, Perino del Vaga, Francesco Salviati, Antonio da San Gallo, and Rustici, who were gathered with great reverence about him, was pointing out with supreme gladness the pompous entrance of the noble Lady. The ancient Cimabue, standing in another part, was doing as it were the same service to certain others, at whom Giotto appeared to be smiling, having taken from him, as Dante said so well, the field of painting which he thought to hold; and Giotto had with him, besides the Gaddi, Buffalmacco and Benozzo, with many others of that age. In another part, again, placed in another fashion and all rejoicing as they conversed, were seen those who conferred such benefits on art, and to whom these new masters owed so much; the great Donatello, Filippo di Ser Brunellesco, Lorenzo Ghiberti, Fra Filippo, the excellent Masaccio, Desiderio, and Verrocchio, with many others, portrayed from life, whom, since I have spoken of them in the previous books, I will pass by without saying more about them, thus avoiding the tedium that might come upon my readers by repetition. Who they were, and what they were come thither to do, was explained, as with the others, by four verses written above them:

Non pictura satis, non possunt marmora et æra
Tuscaque non arcus testari ingentia facta,

Atque ea præcipue quæ mox ventura trahuntur;
Quis nunc Praxiteles cælet, quis pingat Apelles?

Now in the base of all these six vast and most beautiful can-
vases was seen painted a gracious throng of children, each occu-
pying himself in the profession appropriate to the canvas placed
above, who, besides the adornment, were seen to be demonstrat-
ing with great accuracy with what beginnings one arrived at the
perfection of the men painted above; even as with much judg-
ment and singular art the same canvases were also divided and
adorned by round and very tall columns and by pilasters, and by
various ornaments of trophies all in keeping with the subjects to
which they were near. But, above all, graceful and lovely in ap-
pearance were the ten devices, or, to speak more precisely, the
ten reverses (as it were) of medals, partly long established in the
city and partly newly introduced, which were painted in the com-
partments over the columns, serving to divide the statues already
described, and accompanying very appropriately their inventions;
the first of which was the Deduction of a Colony, represented by
a bull and a cow together in a yoke, and behind them the plough-
man with the head veiled, as the ancient Augurs are depicted,
with the crooked lituus in the hand, and with a motto, which said:
COL. JUL. FLORENTIA. The second – and this is very ancient in
the city, and the one wherewith public papers are generally sealed
– was Hercules with the Club and with the skin of the Nemæan
Lion, but without any motto. The third was the horse Pegasus,
which with the hind feet was smiting the urn held by Arno, in
the manner that is told of the Fount of Helicon; whence were
issuing waters in abundance, which formed a river, crystal-clear,
that was all covered with swans; but this, also, was without any
motto. So, likewise, was the fourth, which was composed of a
Mercury with the Caduceus in the hand, the purse, and the cock,
such as is seen in many ancient cornelians. But the fifth, in accord
with that Affection which, as was said at the beginning, was given
to Florence as a companion, was a young woman receiving a
crown of laurel from two figures, one on either side of her,
which, clad in the military paludament and likewise crowned with
laurel, appeared to be Consuls or Imperatores; with words that
ran: GLORIA POP. FLOREN. So also the sixth, in like manner in
accord with Fidelity, likewise the companion of Florence, was
also figured by a woman seated, with an altar near her, upon

which she was seen to be laying one of her hands, and with the other uplifted, holding the second finger raised in the manner wherein one generally sees an oath taken, she was seen to declare her intention with the inscription: FIDES. POP. FLOR. This, also, did the picture of the seventh, without any inscription; which was the two horns of plenty filled with ears of corn intertwined together. And the eighth, likewise without any inscription, did the same with the three Arts of Painting, Sculpture, and Architecture, which, after the manner of the three Graces, with hands linked to denote the interdependence of one art with another, were placed no less gracefully than the others upon a base in which was seen carved a Capricorn. And so, also, did the ninth (placed more towards the Arno), which was the usual Florence with her Lion beside her, to whom various boughs of laurel were offered by certain persons standing around her, as it were showing themselves grateful for the benefits received from her, in that there, as has been told, letters began to revive. And the tenth and last did the same with its inscription that ran thus, TRIBU SCAPTIA, written upon a shield held by a Lion; which tribe was that of Augustus, her founder, and the one in which in ancient times Florence used to be enrolled.

But the finest ornament – besides the beautiful shields on which were the arms of their Excellencies, both the one and the other, and of the most illustrious Princess, and the device of the city, and besides the great Ducal crown of gold, which Florence was in the act of presenting – was the principal device, set over all the shields, and placed there in allusion to the city; which was composed of two halcyons making their nest in the sea at the beginning of winter. This was made clear by the part of the Zodiac that was painted there, wherein the Sun was seen at the point of entering into the Sign of Capricorn, with a motto that said, HOC FIDUNT, signifying that even as the halcyons, by the grace of Nature, at the time when the Sun is entering into the said Sign of Capricorn, which renders the sea smooth and tranquil, are able to make their nests there in security (whence such days are called 'halcyon days'), so also Florence, with Capricorn in the ascendant, which is therefore the ancient and most honourable device of her excellent Duke, is able in whatever season the world may bring her to flourish in the greatest felicity and peace, as she does right well. And all this, with all the other conceptions given above, was declared in

great part by the inscription which, addressed to the exalted bride, was written appropriately in a most ornate and beautiful place, saying:

INGREDERE URBEM FELICISSIMO CONJUGIO FACTAM TUAM, AUGUSTISSIMA VIRGO, FIDE, INGENIIS, ET OMNI LAUDE PRÆSTANTEM; OPTATAQUE PRÆSENTIA TUA, ET EXIMIA VIR- TUTE, SPERATAQUE FECUNDITATE, OPTIMORUM PRINCIPUM PATERNAM ET AVITAM CLARITATEM, FIDELISSIMORUM CI- VIUM LÆTITIAM, FLORENTIS URBIS GLORIAM ET FELICITATEM AUGE.

Of the Entrance to Borg'Ognissanti.

Proceeding, then, towards Borg'Ognissanti, a street, as everyone knows, most beautiful, spacious, and straight, there were at the entrance two very large colossal figures, one repre- senting Austria, as a young woman in full armour after the an- tique, with a sceptre in the hand, signifying her military power as embodied in the Imperial dignity, which now has its residence in that nation and appears to be entirely concentrated there; and the other representing Tuscany, apparelled in religious vestments and with the sacerdotal lituus in the hand, which in like manner dem- onstrated the excellence that the Tuscan nation has always dis- played from the most ancient times in the Divine cult, insomuch that even at the present day it is seen that the Pontiffs and the Holy Roman Church have chosen to establish their principal seat in Tuscany. Each of these had at her side a nude and gracious little Angel, one of whom was seen guarding the Imperial crown, and the other the crown that the Pontiffs are wont to use; and one figure was shown offering her hand most lovingly to the other, almost as if Austria, with her most noble cities (which were depicted under various images in the vast canvas that was as an ornament and head-piece, at the entrance to that street, facing towards the Porta al Prato), wished to signify that she was come parentally to take part in the rejoicings and festivities in honour of the illustrious bridal pair, and to meet and embrace her beloved Tuscany, thus in a certain sort uniting together the two most mighty powers, the spiritual and the temporal. All which was declared excellently well in the six verses that were written in a suitable place, saying:

Augustæ en adsum sponsæ comes Austria; magni
 Cæsaris hæc nata est, Cæsaris atque soror.
Carolus est patruus, gens et fæcunda triumphis,
 Imperio fulget, regibus et proavis.
Lætitiam et pacem adferimus dulcesque Hymeneos
 Et placidam requiem, Tuscia clara, tibi.

Even as on the other side Tuscany, having yielded the first place at the first Gate to Florence, her Lady and her Queen, was seen with an aspect all full of joy at receiving so great a Princess; having likewise in company with her, in a similar painted canvas beside her, Fiesole, Pisa, Siena, and Arezzo, with the most famous of her other cities, and with the Ombrone, the Arbia, the Serchio, and the Chiana, all depicted in various forms according to custom; and expressing her contentment in the six following verses, written in a way similar to the others, and in a suitable place:

Ominibus faustis et lætor imagine rerum,
 Virginis aspectu Cæsareæque fruor.
Hæ nostræ insignes urbes, hæc oppida et agri,
 Hæc tua sunt; illis tu dare jura potes.
Audis ut resonet lætis clamoribus æther,
 Et plausu et ludis Austria cuncta fremat?

OF THE PONTE ALLA CARRAIA.

And to the end that the splendid nuptials might be celebrated with all the most favourable auspices, at the Palazzo de' Ricasoli, which, as everyone knows, is situated at the beginning of the Ponte alla Carraia, there was erected in the Doric Order of composition the third ornament, dedicated to Hymen, their God; and this consisted – in addition to a head-piece of singular beauty, on which the eyes of all who came through Borg'Ognissanti feasted with marvellous delight – of two very lofty and most magnificent portals, between which it stood, and over one of these, which gave access to those passing into the street called La Vigna, was placed with much judgment the statue of Venus Genetrix, perhaps alluding to the House of the Cæsars, which had its origin from Venus, or perchance auguring generation and fecundity for the bridal pair; with a motto taken from the Epithalamium of Theocritus, saying:

Κύπρις δὲ, θεὰ Κύπρις ἶσον ἔρασθαι ἀλλάλων.

And over the other, giving access along the bank of the Arno, through which the procession passed, was the statue of the Nurse Latona, perchance to ward off sterility or the jealous interference of Juno, and likewise with a motto that ran:

Λατὼ μὲν δοίη, Λατὼ κουροτρόφος ὑμμιν
εὐτεκνίαν.

As a complement to these, executed with singular artistry, upon a great base attached to one of the portals, there was seen on one side, as it were newly issued from the water, and in the form of a most beautiful giant with a garland of lilies, the River Arno, who, as if he wished to give an example of nuptial bliss, was locked in embrace with his Sieve, who had likewise a garland of leaves and apples; which apples, alluding to the balls of the Medici, of which they were the origin, would have been rosy, if the colour had been in keeping with the white marble. And Arno, all rejoicing, was shown speaking to his new Lady in the manner expressed by the following verses:

> In mare nunc auro flaventes Arnus arenas
> Volvam, atque argento purior unda fluet.
> Etruscos nunc invictis comitantibus armis
> Cæsareis, tollam sidera ad alta caput.
> Nunc mihi fama etiam Tibrim fulgoreque rerum
> Tantarum longe vincere fata dabunt.

And on the other side, as a complement to Arno, on a similar base attached in a similar way to the other portal (the two being turned, as it were, like wings one towards the other), and almost in the same form, were seen the Danube and the Drava likewise in a close embrace, and, even as the others had the Lion, so they had the Eagle as emblem and support; and these, crowned also with roses and with a thousand varieties of little flowers, were shown speaking to Florence, even as the others were speaking to themselves, the following verses:

> Quamvis Flora tuis celeberrima finibus errem,
> Sum septemgeminus Danubiusque ferox;
> Virginis Augustæ comes, et vestigia lustro,

Ut reor, et si quod flumina numen habent,
Conjugium faustum et fœcundum et Nestoris annos,
Tuscorum et late nuntio regna tibi.

Then at the summit of the head-piece, in the place of honour, and with a close resemblance to the whitest marble, was seen the statue of the young Hymen, with a garland of flowering marjoram and the torch and veil, and at his feet this inscription: BONI CONJUGATOR AMORIS. On one side of him was Love, who lay all languid under one of his flanks; and on the other side was Conjugal Fidelity, who was holding one arm supported under the other; which was all so pleasing, so full of charm, so beautiful, and so well distributed before the eyes of all beholders, that in truth it is not to be expressed in words. As the principal crown of that ornament – for on them all there was placed a principal crown and a principal device – there were formed in the hands of the Hymen described above two garlands of the same marjoram that crowned his head, which, as he held them, he appeared to be about to present to the happy pair. But most lovely and beautiful of all, and best executed, were the three spacious pictures, separated by double columns, into which the whole of that vast façade was divided, placed with supreme beauty at the feet of Hymen; for in them were depicted all the advantages, all the delights, and all the desirable things that are generally found in nuptials; those displeasing and vexatious being driven away from them with a certain subtle grace. And thus in one of these, that in the centre namely, were seen the Three Graces painted in the manner that is customary, all full of joy and gladness, who appeared to be singing with a certain soft harmony the verses written over them, saying:

Quæ tam præclara nascetur stirpe parentum
Inclita progenies, digna atavisque suis?
Etrusca attollet se quantis gloria rebus
Conjugio Austriacæ Mediceæque Domus?
Vivite felices; non est spes irrita, namque
Divina Charites talia voce canunt.

These had on one side, forming as it were a choir about them, and coupled becomingly together, Youth and Delight, and Beauty with Contentment in her embrace, and on the other side, in like fashion, Gladness with Play, and Fecundity with Repose, all in attitudes most graceful and in keeping with their characters, and

so well distinguished by the able painter, that they could be recognized with ease. In the picture that was on the right of that one, there were seen, besides Love and Fidelity, the same Gladness, Contentment, Delight, and Repose, with lighted torches in their hands, who were chasing from the world and banishing to the nethermost abyss Jealousy, Contention, Affliction, Sorrow, Lamentation, Deceit, Sterility, and other vexatious and displeasing things of that kind, which are wont so often to disturb the minds of human creatures. And in the other, on the left hand, were seen the same Graces in company with Juno, Venus, Concord, Love, Fecundity, Sleep, Pasithea, and Thalassius, setting the genial bed in order with those ancient religious ceremonies of torches, incense, garlands, and flowers, which were customary; of which last a number of little Loves, playing in their flight, were scattering no small quantity over the bed. Above these, then, were two other pictures distributed in very beautiful compartments, one on either side of the statue of Hymen, and somewhat smaller than those described; in one of which, in imitation of the ancient custom so well described by Catullus, was seen the illustrious Princess portrayed from life in the midst of a gracious little company of most beautiful maidens in virginal dress, all crowned with flowers, and with lighted torches in their hands, who were pointing towards the Evening Star, which was seen appearing, and, as if set in motion by them, seemed in a certain gracious manner to move and to advance towards Hymen; with the motto: O DIGNA CONJUNCTA VIRO. Even as in the other picture, on the other side, was seen the excellent Prince in the midst of many young men likewise crowned with garlands and burning with love, not less eager than the maidens in lighting the nuptial torches, and pointing no less towards the newly-appeared star, and giving signs, in advancing towards it, of equal or even greater desire; likewise with a motto that said: O TÆDIS FELICIBUS AUCTE. Above these, arranged in a very graceful manner, there was seen as the principal device, which, as has been told, was placed over all the arches, a gilded chain all composed of marriage-rings with their stones, which, hanging down from Heaven, appeared to be sustaining this terrestrial World; alluding in a certain sense to the Homeric Chain of Jove, and signifying that by virtue of nuptials, the heavenly causes being wedded with terrestrial matter, Nature and the aforesaid terrestrial World are preserved and rendered as it were eternal;

with a motto that said: NATURA SEQUITUR CUPIDE. And then a quantity of little Angels and Loves, all gracious and merry, and all set in fitting places, were seen dispersed among the bases, the pilasters, the festoons, and the other ornaments, which were without number; and all, with a certain gladness, appeared to be either scattering flowers and garlands, or sweetly singing the following ode, from among the spaces between the double columns that divided, as has been told, the great pictures and the great façade, which was arranged in a lovely and gracious manner:

Augusti soboles regia Cæsaris,
 Summo nupta viro Principi Etruriæ,
 Faustis auspiciis deseruit vagum
 Istrum regnaque patria.

Cui frater, genitor, patruus, atque avi
 Fulgent innumeri stemmate nobiles
 Præclaro Imperii, prisca ab origine
 Digno nomine Cæsares.

Ergo magnanimæ virgini et inclytæ
 Jam nunc Arne pater suppliciter manus
 Libes, et violis versicoloribus
 Pulchram Flora premas comam.

Assurgant proceres, ac velut aureum
 Et cæleste jubar rite colant eam.
 Omnes accumulent templa Deum, et piis
 Aras muneribus sacras.

Tali conjugio Pax hilaris redit,
 Fruges alma Ceres porrigit uberes,
 Saturni remeant aurea sæcula,
 Orbis lætitia fremit.

Quin diræ Eumenides monstraque Tartari
 His longe duce te finibus exulant.
 Bellorum rabies hinc abit effera,
 Mavors sanguineus fugit.

Sed jam nox ruit et sidera concidunt;
 Et nymphæ adveniunt, Junoque pronuba
 Arridet pariter, blandaque Gratia
 Nudis juncta sororibus.

Hæc cingit niveis tempora liliis,
 Hæc e purpureis serta gerit rosis,
 Huic m'lles violæ et suavis amaracus
 Nectunt virgineum caput.

Lusus, læta Quies cernitur et Decor;
 Quos circum volitat turba Cupidinum,
 Et plaudens recinit hæc Hymeneus ad
 Regalis thalami fores.

Quid statis juvenes tam genialibus
 Indulgere toris immemores? Joci
 Cessent et choreæ; ludere vos simul
 Poscunt tempora mollius.

Non vincant hederæ bracchia flexiles,
 Conchæ non superent oscula dulcia,
 Emanet pariter sudor et ossibus
 Grato murmure ab intimis.

Det summum imperium regnaque Juppiter,
 Det Latona parem progeniem patri;
 Ardorem unanimem det Venus, atque Amor
 Aspirans face mutua.

Of the Palazzo degli Spini.

And to the end that no part of either dominion might be left without being present at those happy nuptials, at the Ponte a S. Trinita and also at the Palazzo degli Spini, which is to be seen at the beginning of that bridge, there was the fourth ornament, of an architecture not less magnificent in composition, and consisting of a head-piece with three façades, one of which, turning to face towards the Ponte alla Carraia, became joined to that in the centre, which was somewhat bent and likewise attached to that which in like manner turned to face towards the Palazzo degli Spini and S. Trinita; whence it appeared to have been contrived principally for the point of view both from the one street and from the other, insomuch that both from the one and from the other it presented itself complete to the eyes of all beholders – a thing of singular artifice for him who well considers it, which rendered that street, which is in itself as imposing and

magnificent as any other that is to be found in Florence, even more imposing and more beautiful than could be believed. In the façade that came in the centre, there had been formed upon a great base two Giants, immense and most superb to behold, supported by two great monsters and by other extravagant fishes that appeared to be swimming in the sea, and accompanied by two sea-nymphs. These represented, one the great Ocean and the other the Tyrrhenian Sea, and, half reclining, they appeared to be seeking to present to the most illustrious pair, with a certain affectionate liberality, not only many most beautiful branches of coral and immense shells of mother-of-pearl, and others of their sea-riches that they held in their hands, but also new islands, new lands, and new dominions, which were seen led thither in their train. Behind them, making that whole ornament lovely and imposing, were seen rising little by little, from their socles that rested upon the base, two vast half-columns, upon which rested cornice, frieze, and architrave, leaving behind the Sea-Gods already described, almost in the form of a triumphal arch, a very spacious square; and over the two columns and the architrave rose two very well-formed pilasters covered with creepers, from which sprang two cornices, forming at the summit a superb and very bold frontispiece, at the top of which, and above the creepers of the pilasters already described, were seen placed three very large vases of gold, all filled to overflowing with thousands and thousands of different riches of the sea; and in the space that remained between the architrave and the point of the frontispiece, there was seen lying with rare dignity a masterly figure of a Nymph, representing Tethys, or Amphitrite, Goddess and Queen of the Sea, who with a very grave gesture was presenting as the principal crown of that place a rostral crown, such as was generally given to the victors in naval battles, with her motto, VINCE MARI, and as it were adding that which follows: JAM TERRA TUA EST. Even as in the picture and the façade behind the Giants, in a very large niche that had the appearance of a real and natural cavern or grotto, there was painted among many other monsters of the sea the Proteus of Virgil's Georgics, bound by Aristæus, who, pointing with his finger towards the verses written above him, appeared to wish to announce in prophecy to the well-united pair good fortune, victories, and triumphs in maritime affairs, saying:

Germana adveniet felici cum alite virgo,
 Flora, tibi, adveniet soboles Augusta, Hymenei
 Cui pulcher Juvenis jungatur fœdere certo
 Regius Italiæ columen, bona quanta sequentur
 Conjugium? Pater Arne tibi, et tibi Florida Mater,
 Gloria quanta aderit? Protheum nil postera fallunt.

And since, as has been told, this façade of the cavern stood between the two other façades, one of which was turned towards S. Trinita and the other towards the Ponte alla Carraia, both these, which were of the same size and height, were likewise bordered in a similar manner by two similar half-columns, which in like manner supported their architrave, frieze, and cornice in a quarter-round, upon which, both on the one side and on the other, were seen three statues of boys on three pedestals, who were upholding certain very rich festoons of gold, composed in a most masterly fashion of conches, shells, coral, sword-grass, and sea-weed, by which a no less graceful finish was given to the whole structure.

But to return to the space of the façade which, turning from the straight, was supported against the Palazzo degli Spini. In it was seen, painted in chiaroscuro, a Nymph all unadorned and little less than nude, placed between many new kinds of animals, who stood for the new land of Peru, with the other new West Indies, discovered and ruled for the most part under the auspices of the most fortunate House of Austria. She was turned towards a figure of Jesus Christ Our Lord, who, painted all luminous in a Cross in the air (alluding to the four exceeding bright stars which form the semblance of a Cross, newly discovered among those peoples), appeared in the manner of a Sun piercing some thick clouds with most resplendent rays, for which she seemed in a certain sense to be rendering much thanks to that house, in that by their means she was seen converted to the Divine worship and to the true Christian Religion, with the verses written below:

 Di tibi pro meritis tantis, Augusta propago,
 Præmia digna ferant, quæ vinctam mille catenis
 Heu duris solvis, quæ clarum cernere solem
 E tenebris tantis et Christum noscere donas.

Even as on the base which supported that whole façade, and which, although on a level with that of the Giants, yet did not like that one project outwards, there was seen, painted as it were

by way of allegory, the fable of Andromeda delivered by Perseus from the cruel Monster of the sea. And in that which, turning, faced towards the Arno and the Ponte alla Carraia, there was seen in like manner painted the small but famous Island of Elba, in the form of an armed warrior seated upon a great rock, with the Trident in her right hand, having on one side of her a little boy who was seen sporting playfully with a dolphin, and on the other side another like him, who was upholding an anchor, with many galleys that were shown circling about her port, which was painted there. At her feet, on her base, and corresponding in like manner to the façade painted above, was seen likewise the fable that is given by Strabo, when he relates that the Argonauts, returning from the acquisition of the Golden Fleece, and arriving with Medea in Elba, raised altars there and made sacrifice to Jove upon them; perhaps foreseeing or auguring that at another time our present glorious Duke, being as it were of their company by virtue of the Order of the Golden Fleece, was to fortify that island and to safeguard distressed mariners, thus reviving their ancient and glorious memory. Which was expressed excellently well by the four verses written there in a suitable place, saying:

> Evenere olim Heroes qui littore in isto
> Magnanimi votis petiere. En Ilva potentis
> Auspiciis Cosmi multa munita opera ac vi;
> Pacatum pelagus securi currite nautæ.

But the most beautiful effect, the most bizarre, the most fantastic, and the most ornate – besides the various devices and trophies, and Arion, who was riding pleasantly through the sea on the back of the swimming dolphin – came from an innumerable quantity of extravagant fishes of the sea, Nereids, and Tritons, which were distributed among the friezes, pedestals, and bases, and wherever a space or the beauty of the place required them. Even as at the foot of the great base of the Giants there was another gracious effect in the form of a most beautiful Siren seated upon the head of a very large fish, from whose mouth at times, at the turning of a key, not without laughter among the expectant bystanders, a rushing jet of water was seen pouring upon such as were too eager to drink the white and red wine that flowed in abundance from the breasts of the Siren into a very capacious and most ornate basin. And since the bend of the façade where Elba was painted was the first thing to strike the

eyes of those who came, as did the procession, from the Ponte alla Carraia along the Arno towards the Palazzo degli Spini, it seemed good to the inventor to hide the ugliness of the scaffolding and woodwork that were necessarily placed behind, by raising to the same height another new façade similar to the three described, which might, as it did, render that whole vista most festive and ornate. And in it, within a large oval, it appeared to him that it was well to place the principal device, embracing the whole conception of the structure; and to that end, therefore, there was seen figured a great Neptune on his usual Car, with the usual Trident, as he is described by Virgil, chasing away the troublesome winds, and using as a motto the very same words, MATURATE FUGAM; as if he wished to promise to the fortunate pair happiness, peace, and tranquillity in his realm.

OF THE COLUMN.

Opposite to the graceful Palace of the Bartolini there had been erected a short time before, as a more stable and enduring ornament, not without singular ingenuity, that ancient and immense column of oriental granite which had been taken from the Baths of Antoninus in Rome, and granted by Pius IV to our glorious Duke, and by him conveyed, although at no little expense, to Florence, and magnanimously presented to her as a courteous gift for her public adornment. Upon that column, over its beautiful capital, which had, like the base, the appearance of bronze, and which is now being made of real bronze, there was placed a statue (of clay, indeed, but in the colour of porphyry, because even so it is to be), very large and very excellent, of a woman in full armour, with a helmet on the head, and representing, by the sword in the right hand and by the scales in the left, an incorruptible and most valorous Justice.

OF THE CANTO DE' TORNAQUINCI.

The sixth ornament was erected at the Canto de' Tornaquinci; and here I must note a thing which would appear incredible to one who had not seen it – namely, that this ornament was so magnificent, so rich in pomp, and fashioned with so much art

and grandeur, that, although it was conjoined with the superb
Palace of the Strozzi, which is such as to make the greatest things
appear as nothing, and although on a site altogether disastrous by
reason of the uneven ends of the streets that run together there,
and certain other inconvenient circumstances, nevertheless such
was the excellence of the craftsman, and so well conceived the
manner of the work, that it seemed as if all those difficulties had
been brought together there for the purpose of rendering it the
more admirable and the more beautiful; that most lovely palace
being so well accompanied by the richness of the ornaments, the
height of the arches, the grandeur of the columns, all intertwined
with arms and trophies, and the great statues that towered over
the summit of the whole structure, that anyone would have
judged that neither that ornament required any other accompani-
ment than that of such a palace, nor such a palace required any
other ornament. And to the end that all may be the better under-
stood, and in order to show more clearly and distinctly in what
manner the work was constructed, it is necessary that some
measure of pardon should be granted to us by those who are not
of our arts, if for the sake of those who delight in them we
proceed, more minutely than might appear proper to the others,
to describe the nature of the sites and the forms of the arches;
and this in order to demonstrate how noble intellects accommo-
date ornaments to places and inventions to sites with grace and
beauty. We must relate, then, that since the street which runs
from the Column to the Tornaquinci is, as everyone knows, very
wide, and since it was necessary to pass from there into the street
of the Tornabuoni, which by its narrowness brought it about that
the eyes of those thus passing fell for the most part on the not
very ornate Tower of the Tornaquinci, which occupies more than
half the street, it was thought expedient, in order to obviate that
difficulty and to make the effect more pleasing, to construct in
the width of the above-named street, in a Composite Order, two
arches divided by a most ornate column, one of which gave free
passage to the procession, which proceeded through the said
street of the Tornabuoni, and the other, concealing the view of
the tower, appeared, by virtue of an ingenious prospect-scene
that was painted there, to lead into another street similar to the
said street of the Tornabuoni, wherein with most pleasing illusion
were seen not only the houses and windows adorned with
tapestries and full of men and women who were all intent on

gazing at the spectacle, but also the gracious sight of a most lovely maiden on a white palfrey, accompanied by certain grooms, who appeared to be coming from there towards those approaching, insomuch that both on the day of the procession and all the time afterwards that she remained there, she roused in more than one person, by a gracious deception, a desire either to go to meet her or to wait until she should have passed. These two arches, besides the above-mentioned column that divided them, were bordered by other columns of the same size, which supported architraves, friezes, and cornices; and over each arch was seen a lovely ornament in the form of a most beautiful picture, in which were seen painted, likewise in chiaroscuro, the stories of which we shall speak in a short time. The whole work was crowned above by an immense cornice with ornaments corresponding to the loveliness, grandeur, and magnificence of the rest, upon which, then, stood the statues, which, although they were at a height of a good twenty-five braccia from the level of the ground, nevertheless were wrought with such proportion that the height did not take away any of their grace, nor the distance any of the effect of any detail of their adornment and beauty. There stood in the same manner, as it were as wings to those two main arches, on the one side and on the other, two other arches, one of which, attached to the Palace of the Strozzi, and leading to the above-mentioned Tower of the Tornaquinci, gave passage to those who wished to turn towards the Mercato Vecchio, even as the other, placed on the other side, did the same service to those who might desire to go towards the street called La Vigna; wherefore the Via di S. Trinita, which, as has been told, is so broad, terminating thus in the four arches described, came to present such loveliness and a view so beautiful and so heroic, that it appeared impossible to afford greater satisfaction to the eyes of the spectators. And this was the front part, composed, as has been described, of four arches; of two main arches, namely, one false, and one real, which led into the Via de' Tornabuoni, and of two others at the sides, in the manner of wings, which were turned towards the two cross-streets. Now since, entering into the said street of the Tornabuoni on the left side, beside the Vigna, there debouches (as everyone knows) the Strada di S. Sisto, which likewise of necessity strikes the flank of the same Tower of the Tornaquinci, it was made to appear, in order to hide the same ugliness in a similar manner with the same illusion

of a similar prospect-scene, that that side also passed into a similar street of various houses placed in the same way, with an ingenious view of a very ornate fountain overflowing with crystal-clear waters, from which a woman with a child was represented as drawing some, so that one who was at no great distance would certainly have declared that she was real and by no means simulated. Now these four arches – to return to those in front – were supported and divided by five columns adorned in the manner described, forming as it were a rectangular piazza; and in a line with each of those columns, above the final cornice and the summit of the edifice, there was a most beautiful seat, while in the same manner four others were placed over the centre of each arch, which in all came to the number of nine. In eight of these was seen seated in each a statue of most imposing appearance, some shown in armour, some in the garb of peace, and others in the imperator's paludament, according to the characters of those who were portrayed in them; and in place of the ninth seat and the ninth statue, above the column in the centre, was seen placed an immense escutcheon, supported by two great Victories with the Imperial Crown of the House of Austria, to which that structure was dedicated; which was made manifest by a very large epitaph, which was seen placed with much grace and beauty below the escutcheon, saying:

VIRTUTI FELICITATIQUE INVICTISSIMÆ DOMUS AUSTRIÆ, MAJESTATIQUE TOT ET TANTORUM IMPERATORUM AC REGUM, QUI IN IPSA FLORUERUNT ET NUNC MAXIME FLORENT, FLORENTIA AUGUSTO CONJUGIO PARTICEPS ILLIUS FELICITATIS, GRATO PIOQUE ANIMO DICAT.

The intention had been, after bringing to those most splendid nuptials the Province of Austria, with her cities and rivers and with her ocean-sea, and after having caused her to be received by Tuscany with her cities, the Arno, and the Tyrrhenian Sea, as has been related, to bring then her great and glorious Cæsars, all magnificent in adornment and pomp, as is the general custom in taking part in nuptials; as if they, having conducted thither with them the illustrious bride, were come before to have the first meeting of kinsmen with the House of Medici, and to prove of what stock, and how glorious, was the noble virgin that they sought to present to them. And so, of the eight above-mentioned statues placed upon the eight seats, representing eight Emperors

of that august house, there was seen on the right hand of the
above-named escutcheon, over the arch through which the pro-
cession passed, that of Maximilian II, the present magnanimous
and excellent Emperor, and brother of the bride; below whom,
in a very spacious picture, there was seen painted with most
beautiful invention his marvellous assumption to the Empire,
himself being seated in the midst of the Electors, both spiritual
and temporal, the first being recognized – besides their long vest-
ments – by a Faith that was to be seen at their feet, and the
others by a Hope in a like position. In the air, also, over his head,
were seen certain little Angels that seemed to be chasing many
malign spirits out of certain thick and dark clouds; these being
intended either to suggest the hope which is felt that at some
time, in that all-conquering and most constant nation, men will
contrive to dissipate and clear away the clouds of those many
disturbances that have occurred there in matters of religion, and
restore her to her pristine purity and serenity of tranquil concord;
or rather, that in that act all dissensions had flown away, and
showing how marvellously, and with what unanimous consent of
all Germany, amid that great variety of minds and religions, that
assumption had taken place, which was explained by the words
that were placed above, saying:

MAXIMILIANUS II SALUTATUR IMP. MAGNO CONSENSU
GERMANORUM, ATQUE INGENTI LÆTITIA BONORUM OMNIUM,
ET CHRISTIANÆ PIETATIS FELICITATE.

Then, next to the statue of the said Maximilian, in a place
corresponding to the column at the corner, was seen that of the
truly invincible Charles V; even as over the arch of that wing,
which commanded the Via della Vigna, there was that of the
second Albert, a man of most resolute valour, although he
reigned but a short time. Above the column at the head was
placed that of the great Rudolph, who, the first of that name, was
also the first to introduce into that most noble house the Imperial
dignity, and the first to enrich her with the great Archduchy of
Austria; when, having reverted to the Empire for lack of a suc-
cessor, he invested with it the first Albert, his son, whence the
House of Austria has since taken its name. All which, in memory
of an event so important, was seen painted in a most beautiful
manner in the frieze above that arch, with an inscription at the
foot that said:

RODULPHUS PRIMUS EX HAC FAMILIA IMP. ALBERTUM
PRIMUM AUSTRIÆ PRINCIPATU DONAT.

But to return to the part on the left, beginning with the same
place in the centre; beside the escutcheon, and over the false arch
that covered the Tower of the Tornaquinci, was seen the statue
of the most devout Ferdinand, father of the bride, beneath whose
feet was seen painted the valorous resistance made by his efforts
in the year 1529 in the defence of Vienna against the terrible
assault of the Turks; demonstrated by the inscription written
above, which said:

FERDINANDUS PRIMUS IMP., INGENTIBUS COPIIS TURCORUM
CUM REGE IPSORUM PULSIS, VIENNAM NOBILEM URBEM
FORTISSIME FELICISSIMEQUE DEFENDIT.

Even as at the corner there was the statue of the first and
most renowned Maximilian, and over the arch that inclined to-
wards the Palace of the Strozzi that of the pacific Frederick,
father of that same Maximilian, leaning against an olive-trunk.
Above the last column, which was attached to the above-named
Palace of the Strozzi, was seen that of the first Albert mentioned
above, who, as has been told, was first invested by his father
Rudolph with the sovereignty of Austria, and gave to that most
noble house the arms that are still to be seen at the present day.
Those arms used formerly to be five little larks on a gold ground,
whereas the new arms, which, as everyone may see, are all red
with a white band that divides them, are said to have been intro-
duced by him in that form because, as was seen painted there in
a great picture beneath his feet, he found himself not otherwise
in that most bloody battle fought by him with Adolf, who had
been first deposed from the Imperial throne, when the said Al-
bert was seen to slay Adolf valorously with his own hand and to
win from him the Spolia Opima; and since, save for the middle
of his person, which was white on account of his armour, over
all the rest he found himself on that day all stained and dabbled
with blood, he ordained that in memory of that his arms should
be painted in the same manner both of form and colour, and that
they should be preserved gloriously after him by his successors
in that house; and beneath the picture, as with the others, there
was to be read a similar inscription that said:

ALBERTUS I IMP. ADOLPHUM, CUI LEGIBUS IMPERIUM

ABROGATUM FUERAT, MAGNO PRŒLIO VINCIT ET SPOLIA OPIMA REFERT.

And since each of the eight above-mentioned Emperors, besides the arms common to their whole house, also used during his lifetime arms private and peculiar to himself, for that reason, in order to make it more manifest to the beholders which Emperor each of the statues represented, there were also placed beneath their feet, on most beautiful shields, the particular arms that each, as has been told, had borne. All which, together with some pleasing and well-accommodated little scenes that were painted on the pedestals, made a magnificent, heroic, and very ornate effect; even as not less was done, on the columns and in all the parts where ornaments could be suitably placed, in addition to trophies and the arms, by the Crosses of S. Andrew, the Fusils, and the Pillars of Hercules, with the motto, PLUS ULTRA, the principal device of that arch, and many others like it used by the men of that Imperial family.

Such, then, was the principal view which presented itself to those who chose to pass by the direct way with the procession; but for those who came from the opposite direction, from the Via de' Tornabuoni towards the Tornaquinci, there appeared, with an ornamentation perhaps not less lovely, in so far as the narrowness of the street permitted, a similar spectacle arranged in due proportion. For on that side, which we will call the back, there was formed, as it were, another structure similar to that already described, save that on account of the narrowness of the street, whereas the first was seen composed of four arches, the other was of three only; one of which being joined with friezes and cornices to that upon which, as has been told, was placed the statue of the second Maximilian, now Emperor, and thus making it double, and another likewise attached to the above-described prospect-scene which concealed the tower, brought it about that the third, leaving also behind it a little quadrangular piazza, remained as the last for one coming with the procession, and appeared as the first for one approaching, on the contrary, from the street of the Tornabuoni; and upon that last, which was in the same form as those described, even as upon them were the Emperors, so upon it were seen towering, but standing on their feet, the two Kings Philip, one the father and the other the son of the great Charles V, the first Philip, namely, and also the second, so

filled with liberality and justice, whom at the present day we honour as the great and puissant King of so many most noble realms. Between him and the statue of his grandfather there was seen painted in the circumambient frieze that same Philip II seated in majesty, and standing before him a tall woman in armour, recognized by the white cross that she had on the breast as being Malta, delivered by him through the valour of the most illustrious Lord Don Garzia di Toledo, who was portrayed there, from the siege of the Turks; and she appeared to be seeking, as one grateful for that great service, to offer to him the obsidional crown of dog's grass, which was made manifest by the inscription written beneath, which said:

MELITA, EREPTA E FAUCIBUS IMMANISSIMORUM HOSTIUM
STUDIO ET AUXILIIS PIISSIMI REGIS PHILIPPI, CONSERVATOREM
SUUM CORONA GRAMINEA DONAT.

And to the end that the part turned towards the Strada della Vigna might have likewise some adornment, it was thought a fitting thing to declare the conception of the whole vast structure by a great inscription between the final cornice, where the statues stood, and the arch, which was a large space, saying:

IMPERIO LATE FULGENTES ASPICE REGES;
AUSTRIACA HOS OMNES EDIDIT ALTA DOMUS.
HIS INVICTA FUIT VIRTUS, HIS CUNCTA SUBACTA,
HIS DOMITA EST TELLUS, SERVIT ET OCEANUS.

Even as was done in the same manner and for the same reason towards the Mercato Vecchio, in another inscription, saying:

IMPERIIS GENS NATA BONIS ET NATA TRIUMPHIS,
QUAM GENUS E CŒLO DUCERE NEMO NEGET;
TUQUE NITENS GERMEN DIVINÆ STIRPIS ETRUSCIS
TRADITUM AGRIS NITIDIS, UT SOLA CULTA BEES;
SI MIHI CONTINGAT VESTRO DE SEMINE FRUCTUM
CARPERE ET IN NATIS CERNERE DETUR AVOS,
O FORTUNATAM! VERO TUNC NOMINE FLORENS
URBS FERAR, IN QUAM FORS CONGERAT OMNE BONUM.

OF THE CANTO DE' CARNESECCHI.

Now it appeared a fitting thing, having brought the triumphant Cæsars to the place described above, to bring the

magnanimous Medici, also, with all their pomp, to the corner that is called the Canto de' Carnesecchi, which is not far distant from it; as if, reverently receiving the Cæsars, as is the custom, they were come to hold high revel and to do honour to the new-come bride, so much desired. And here, no less than in some of the passages to follow, it will be necessary that I should be pardoned by those who are not of our arts for describing minutely the nature of the site and the form of the arches and other orna-ments, for the reason that it is my intention to demonstrate not less the excellence of the hands and brushes of the craftsmen who executed the works, than the fertility and acuteness of brain of him who was the author of the stories and of the whole invention; and particularly because the site in that place was per-haps more disastrous and more difficult to accommodate than any of the others described or about to be described. For there the street turns towards S. Maria del Fiore, inclining to somewhat greater breadth, and comes to form the angle that by those of our arts is called obtuse; and that was the side on the right. Opposite, and on the left-hand side, there is a little piazza into which two streets lead, one that comes from the great Piazza di S. Maria Novella, and the other likewise from another piazza called the Piazza Vecchia. In that little piazza, which is in truth very ill proportioned, there was built over all the lower part a structure in the form of an octagonal theatre, the doors of which were rectangular and in the Tuscan Order; and over each of them was seen a niche between two columns, with cornices, archi-traves, and other ornaments, rich and imposing, of Doric architecture, and then, rising higher, there was formed the third range, wherein was seen above the niches, in each space, a compart-ment with most beautiful ornaments in painting. Now it is but proper to remark that although it has been said that the doors below were rectangular and Tuscan, nevertheless the two by which the principal road entered and issued forth, and by which the procession was to pass, were made in the semblance of arches, and projected for no small distance in the manner of vestibules, one towards the entrance and the other towards the exit, both the one and the other having been made as rich and ornate on the outer façade as was required for the sake of proportion.

Having thus described the general form of the whole edifice, let us come down to the details, beginning with the front part, which presented itself first to the eyes of passers-by and was after

the manner of a triumphal arch, as has been told, in the Corinthian Order. That arch was seen bordered on the one side and on the other by two most warlike statues in armour, each of which, resting upon a graceful little door, was seen likewise coming forth from the middle of a niche placed between two well-proportioned columns. Of these statues, that which was to be seen on the right hand represented Duke Alessandro, the son-in-law of the most illustrious Charles V, a Prince spirited and bold, and of most gracious manners, holding in one hand his sword, and in the other the Ducal baton, with a motto placed at his feet, which said, on account of his untimely death: SI FATA ASPERA RUMPAS, ALEXANDER ERIS. On the left hand was seen, portrayed like all the others from life, the most valorous Signor Giovanni, with the butt of a broken lance in the hand, and likewise with his motto at his feet: ITALUM FORTISS. DUCTOR. And since over the architraves of those four columns already described there were placed very spacious friezes in due proportion, in the width covered by the niches there was seen above each of the statues a compartment between two pilasters; in that above Duke Alessandro was seen in painting the device of a rhinoceros, used by him, with the motto: NON BUELVO SIN VENCER; and above the statue of Signor Giovanni, in the same fashion, his flaming thunderbolt. Above the arch in the centre, which, being more than seven braccia in width and more than two squares in height, gave ample room for the procession to pass, and above the cornice and the frontispieces, there was seen seated in majestic beauty that of the wise and valorous Duke Cosimo, the excellent father of the fortunate bridegroom, likewise with his motto at his feet, which said: PIETATE INSIGNIS ET ARMIS; and with a She-Wolf and a Lion on either side of him, representing Siena and Florence, which, supported and regarded lovingly by him, seemed to be reposing affectionately together. That statue was seen set in the frieze, exactly in a line with the arch, and between the pictures with the devices described; and in that same width, above the crowning cornice, there rose on high another painted compartment, with pilasters in due proportion, cornice, and other embellishments, wherein with great fitness, alluding to the election of the above-named Duke Cosimo, was seen represented the story of the young David when he was anointed King by Samuel, with his motto: A DOMINO FACTUM EST ISTUD. And then, above that last cornice, which was raised a very great distance

from the ground, was seen the escutcheon of that most adventuresome family, which, large and magnificent as was fitting, was likewise supported, with the Ducal Crown, by two Victories also in imitation of marble; and over the principal entrance of the arch, in the most becoming place, was the inscription, which said:

VIRTUTI FELICITATIQUE ILLUSTRISSIMÆ MEDICEÆ FAMILIÆ, QUÆ FLOS ITALIÆ, LUMEN ETRURIÆ, DECUS PATRIÆ SEMPER FUIT, NUNC ASCITA SIBI CÆSAREA SOBOLE CIVIBUS SECURITATEM ET OMNI SUO IMPERIO DIGNITATEM AUXIT, GRATA PATRIA DICAT.

Entering within that arch, one found a kind of loggia, passing spacious and long, with the vaulting above all painted and embellished with the most bizarre and beautiful ornaments and with various devices. After which, in two pilasters over which curved an arch, through which was the entrance into the above-mentioned theatre, there were seen opposite to one another two most graceful niches, as it were conjoined with that second arch; between which niches and the arch first described there were seen on the counterfeit walls that supported the loggia two spacious painted compartments, the stories of which accompanied becomingly each its statue. Of these statues, that on the right hand was made to represent the great Cosimo, called the Elder, who, although there had been previously in the family of the Medici many men noble and distinguished in arms and in civil actions, was nevertheless the first founder of its extraordinary greatness, and as it were the root of that plant which has since grown so happily to such magnificence. In his picture was seen painted the supreme honour conferred upon him by his native Florence, when he was acclaimed by the public Senate as Pater Patriæ; which was declared excellently well in the inscription that was seen below, saying:

COSMUS MEDICES, VETERE HONESTISSIMO OMNIUM SENATUS CONSULTO RENOVATO, PARENS PATRIÆ APPELLATUR.

In the upper part of the same pilaster in which was placed the niche, there was a little picture in due proportion wherein was portrayed his son, the magnificent Piero, father of the glorious Lorenzo, likewise called the Elder, the one and true Mæcenas of his times, and the magnanimous preserver of the peace of Italy, whose statue was seen in the other above-mentioned niche,

corresponding to that of the Elder Cosimo. In the little picture, which he in like manner had over his head, was painted the portrait of his brother, the magnificent Giuliano, the father of Pope Clement; and in the large picture, corresponding to that of Cosimo, was the public council held by all the Italian Princes, wherein was seen formed, by the advice of Lorenzo, that so stable and so prudent union by which, as long as he was alive and it endured, Italy was seen brought to the height of felicity, whereas afterwards, Lorenzo dying and that union perishing, she was seen precipitated into such conflagrations, calamities, and ruin; which was demonstrated no less clearly by the inscription that was beneath, saying:

LAURENTIUS MEDICES, BELLI ET PACIS ARTIBUS EXCELLENS, DIVINO SUO CONSILIO CONJUNCTIS ANIMIS ET OPIBUS PRINCIPUM ITALORUM ET INGENTI ITALIÆ TRANQUILLITATE PARTA, PARENS OPTIMI SÆCULI APPELLATUR.

Now, coming to the little piazza in which, as has been told, was placed the octagonal theatre, as I shall call it, and beginning from that first entrance to go round on the right hand, let me say that the first part was occupied by that arch of the entrance, above which, in a frieze corresponding in height to the third and last range of the theatre, were seen in four ovals the portrait of Giovanni di Bicci, father of Cosimo the Elder, and that of his son Lorenzo, brother of the same Cosimo, from whom this fortunate branch of the Medici now reigning had its origin; with that of Pier Francesco, son of the above-named Lorenzo, and likewise that of another Giovanni, father of the warlike Signor Giovanni mentioned above. In the second façade of the octagon, which was joined to the entrance, there was seen between two most ornate columns, seated in a great niche, with the royal staff in the hand, a figure in marble, like all the other statues, of Caterina, the valorous Queen of France, with all the other ornaments that are required in architecture both lovely and heroic. And in the third range above, where, as has been said, the painted compartments came, there was figured for her scene the same Queen seated in majesty, who had before her two most beautiful women in armour, one of whom, representing France, and kneeling before her, was shown presenting to her a handsome boy adorned with a royal crown, even as the other, who was Spain, standing, was shown in like manner presenting to her a most lovely girl; the

boy being intended for the most Christian Charles IX, who is now revered as King of France, and the girl the most noble Queen of Spain, wife of the excellent King Philip. Then, about the same Caterina, were seen standing with much reverence some other smaller boys, representing her other most gracious little children, for whom a Fortune appeared to be holding sceptres, crowns, and realms. And since between that niche and the arch of the entrance, on account of the disproportion of the site, there was some space left over, caused by the desire to make the arch not ungracefully awry, but well-proportioned and straight, for that reason there was placed there, as it were in a niche, a painted picture wherein by means of a Prudence and a Liberality, who stood clasped in a close embrace, it was shown very ingeniously with what guides the House of Medici had come to such a height; having above them, painted in a little picture equal in breadth to the others of the third range, a Piety humble and devout, recognized by the stork that was beside her, round whom were seen many little Angels that were showing to her various designs and models of the many churches, monasteries, and convents built by that magnificent and religious family. Now, proceeding to the third side of the octagon, where there was the arch by which one issued from the theatre, over the frontispiece of that arch was placed, as the heart of so many noble members, the statue of the most excellent and amiable Prince and Spouse, and at his feet the motto: SPES ALTERA FLORÆ. In the frieze above – meaning, as before, that this came to the height of the third range – to correspond to the other arch, where, as has been told, four portraits had been placed, in that part, also, were four other similar portraits of his illustrious brothers, accommodated in a similar manner; those, namely, of the two very reverend Cardinals, Giovanni of revered memory and the most gracious Ferdinando, and those of the handsome Signor Don Garzia and the amiable Signor Don Pietro. Then, to go on to the fourth face, since the corner of the houses that are there, not giving room for the hollow of any recess, did not permit of the usual niche being made there, in its stead was seen accommodated with beautiful artifice, corresponding to the niches, a very large inscription that said:

HI, QUOS SACRA VIDES REDIMITOS TEMPORA MITRA
 PONTIFICES TRIPLICI, ROMAN TOTUMQUE PIORUM
 CONCILIUM REXERE PII; SED QUI PROPE FULGENT

ILLUSTRI E GENTE INSIGNES SAGULISVE TOGISVE
HEROES, CLARAM PATRIAM POPULUMQUE POTENTEM
IMPERIIS AUXERE SUIS CERTAQUE SALUTE.
NAM SEMEL ITALIAM DONARUNT AUREA SÆCLA,
CONJUGIO AUGUSTO DECORANT NUNC ET MAGE FIRMANT.

Above it, in place of scene and picture, there were painted in two ovals the two devices, one of the fortunate Duke, the Capricorn with the seven Stars and with the motto, FIDUCIA FATI; and the other of the excellent Prince, the Weasel, with the motto, AMAT VICTORIA CURAM. Then in the three niches that came in the three following façades were the statues of the three Supreme Pontiffs who have come from that family; all rejoicing, likewise, to lend their honourable presence to so great a festival, as if every favour human and divine, every excellence in arms, letters, wisdom, and religion, and every kind of sovereignty, were assembled together to view in rendering those splendid nuptials august and happy. Of those Pontiffs one was Pius IV, departed a short time before to a better life, over whose head, in his picture, was seen painted how, after the intricate disputes were ended at Trent and the sacrosanct Council was finished, the two Cardinal Legates presented to him its inviolable decrees; even as in that of Leo X was seen the conference held by him with Francis I, King of France, whereby with prudent counsel he bridled the vehemence of that bellicose and victorious Prince, so that he did not turn all Italy upside down, as he might perchance have done, and as he was certainly able to do; and in that of Clement VII was the Coronation, performed by him in Bologna, of the great Charles V. But in the last façade, which hit against the acute angle of the houses of the Carnesecchi, by which the straight line of that façade of the octagon was no little interrupted, nevertheless there was made with gracious and pleasing artifice another masterly inscription, after the likeness of the other, but curving somewhat outwards, which said:

PONTIFICES SUMMOS MEDICUM DOMUS ALTA LEONEM,
 CLEMENTEM DEINCEPS, EDIDIT INDE PIUM.
QUID TOT NUNC REFERAM INSIGNES PIETATE VEL ARMIS
 MAGNANIMOSQUE DUCES EGREGIOSQUE VIROS?
GALLORUM INTER QUOS LATE REGINA REFULGET,
 HÆC REGIS CONJUNX, HÆC EADEM GENITRIX.

Such, as a whole, was the interior of the theatre described

above; but although it may appear to have been described minutely enough, it is none the less true that an infinity of other ornaments, pictures, devices, and a thousand most bizarre and most beautiful fantasies which were placed throughout the Doric cornices and many spaces according to opportunity, making a very rich and gracious effect, have been omitted as not being essential, in order not to weary the perhaps already tired reader; and anyone who delights in such things may imagine that no part was left without being finished with supreme mastery, consummate judgment, and infinite loveliness. And a most pleasing and beautiful finish was given to the highest range by the many arms that were seen distributed there in due proportion, which were Medici and Austria for the illustrious Prince, the bridegroom, and her Highness; Medici and Toledo for the Duke, his father; Medici and Austria again, recognized by the three feathers as belonging to his predecessor Alessandro; Medici and Boulogne in Picardy for Lorenzo, Duke of Urbino; Medici and Savoy for Duke Giuliano; Medici and Orsini for the double kinship of the Elder Lorenzo and his son Piero; Medici and the Viper for the above-named Giovanni, husband of Caterina Sforza; Medici and Salviati for the glorious Signor Giovanni, his son; France and Medici for her most serene Highness the Queen; Ferrara and Medici for the Duke, with one of the sisters of the most excellent bridegroom; and Orsini and Medici for the other most gentle sister, married to the illustrious Signor Paolo Giordano, Duke of Bracciano.

It now remains for us to describe the last part of the theatre and the exit, which, corresponding in size, in proportion, and in every other respect to the entrance already described, there will be little labour, I believe, in making known to the intelligent reader; save only that the arch which formed the façade there, facing towards S. Maria del Fiore, had been constructed, as a part less important, without statues and with somewhat less magnificence, and in their stead there had been placed over that arch a very large inscription, which said:

VIRTUS RARA TIBI, STIRPS ILLUSTRISSIMA, QUONDAM
CLARUM TUSCORUM DETULIT IMPERIUM;
QUOD COSMUS FORTI PRÆFUNCTUS MUNERE MARTIS
PROTULIT ET JUSTA CUM DITIONE REGIT;
NUNC EADEM MAJOR DIVINA E GENTE JOANNAM
ALLICIT IN REGNUM CONCILIATQUE TORO.

QUÆ SI CRESCET ITEM VENTURA IN PROLE NEPOTES,
AUREA GENS TUSCIS EXORIETUR AGRIS.

In the two pilasters that were at the beginning of the passage, or vestibule, as we have called it (over which pilasters rose the arch of the exit, upon which was the statue of the illustrious bridegroom), were seen two niches, in one of which was placed the statue of the most gentle Giuliano, Duke of Nemours, the younger brother of Leo and Gonfalonier of Holy Church, who had likewise in the little picture that was above him the portrait of the magnanimous Cardinal Ippolito, his son, and, in the picture that stretched towards the exit, the scene of the Capitoline Theatre, dedicated to him by the Roman people in the year 1513, with an inscription to make this known, which said:

JULIANUS MEDICES EXIMIÆ VIRTUTIS ET PROBITATIS ERGO
SUMMIS A POP. ROM. HONORIBUS DECORATUR, RENOVATA
SPECIE ANTIQUÆ DIGNITATIS AC LÆTITIÆ.

In the other niche, corresponding to the first statue, and, like it, standing and in armour, was seen the statue of Lorenzo the Younger, Duke of Urbino, with a sword in the hand; and in the little picture above him he had the portrait of his father Piero, and in the other picture the scene when the general's baton was given to him with such happy augury by his native Florence, likewise with an inscription to explain it, which said:

LAURENTIUS MED. JUNIOR MAXIMA INVICTÆ VIRTUTIS
INDOLE, SUMMUM IN RE MILITARI IMPERIUM MAXIMO
SUORUM CIVIUM AMORE ET SPE ADIPISCITUR.

OF THE CANTO ALLA PAGLIA.

At the corner which from the straw that is constantly sold there is called the Canto alla Paglia, there was made another arch of great beauty and not less rich and imposing than any of the others. Now it may perchance appear to some, for the reason that all or the greater part of those ornaments have been extolled by us as in the highest rank of beauty and excellence of artistry, pomp, and richness, that this has been done by reason of a certain manner of writing inclined to overmuch praise and exaggeration. But everyone may take it as very certain that those

works, besides leaving a long way behind them all things of that kind as were ever executed in that city, and perhaps in any other place, were also such, and ordained with such grandeur, magnificence, and liberality by those magnanimous Lords, and executed in such a manner by the craftsmen, that they surpassed by a great measure every expectation, and took away from no matter what writer all force and power to attain with the pen to the excellence of the reality.

Now, to return, I say that in that place – in that part, namely, where the street that leads from the Archbishop's Palace into the Borgo S. Lorenzo, dividing the above-named Strada della Paglia, forms a perfect crossing of the ways, was made the ornament already mentioned, much after the likeness of the ancient four-fronted Temple of Janus; and, for the reason that from there the Cathedral Church could be seen, it was ordained by those truly religious Princes that it should be dedicated to sacrosanct Religion, in which how eminent all Tuscany, and Florence in particular, has been at all times, I do not believe that it is necessary for me to take much pains to demonstrate. And therein the intention was that since Florence had brought with her, as was told at the beginning, as her hand-maids and companions, to give the first welcome to the new bride, some of the virtues or attributes that had raised her to greatness, and in which she could well vaunt herself, the intention, I say, was to show that there also, for a no less necessary office, she had left Religion, that she, awaiting the bride, might in a certain manner introduce her into the vast and most ornate church so near at hand. That arch, then, which was in a very broad street, as has been told, was seen formed of four very ornate façades, the first of which presented itself to the eyes of one going in the direction of the Carnesecchi, and another, following the limb of the cross, faced towards S. Giovanni and the Duomo of S. Maria del Fiore, leaving two other façades on the cross-limb of the cross, one of which looked towards S. Lorenzo and the other towards the Archbishop's Palace. And now, to describe in order and with as much clearness as may be possible the composition and the beauty of the whole, I say – beginning again with the front part, to which that at the back was wholly similar in the composition of the ornaments, without failing in any point – that in the centre of the wide street was seen the very broad entrance of the arch, which rose to a beautifully proportioned height, and on either side of it were seen two immense niches bordered by two similar Corinthian columns, all

painted with sacred books, mitres, thuribles, chalices, and other
sacerdotal instruments, in place of trophies and spoils. Above
these, and above the regular cornices and friezes, which projected
somewhat further outwards than those which came over the arch
in the centre, but were exactly equal to them in height, was seen
another cornice, as of a door or window, curving between the
one column and the other in a quarter-round, which, seeming to
form a separate niche, made an effect as graceful and lovely as
could well be imagined. Above that last cornice, then, rose a
frieze of a height and magnificence in accord with the propor-
tions of so great a beginning, with certain great consoles, carved
and overlaid with gold, which came exactly in perpendicular lines
with the columns already described; and upon them rested an-
other magnificent and very ornate cornice, with four very large
candelabra likewise overlaid with gold and, like all the columns,
bases, capitals, cornices, architraves, and every other thing, picked
out with various carvings and colours, and also standing in line
with the great consoles and the columns above described. Now
in the centre, springing above the said consoles, two cornices
were seen rising, and little by little forming an angle, and finally
uniting as a frontispiece, over which, upon a very rich and beau-
tiful base, was seated an immense statue with a Cross in the hand,
representing the most holy Christian Religion, at whose feet, one
on either side of her, were seen two other similar statues which
seemed to be lying upon the cornice of the above-named fron-
tispiece, one of which, that on the right hand, with three children
about her, represented Charity, and the other Hope. Then in the
space, or, to speak more precisely, in the angle of the frontis-
piece, there was seen as the principal device of that arch
the ancient Labarum with the Cross, and with the motto, IN
HOC VINCES, sent to Constantine; beneath which was seen set
with beautiful grace a very large escutcheon of the Medici with
three Papal crowns, in keeping with the idea of Religion, for the
three Pontiffs whom she has had from that house. And on the
first level cornice, on either side, was seen a statue corresponding
to the niche already described which came between the two col-
umns; one of which, that on the right hand, was a most beautiful
young woman in full armour, with the spear and shield, such as
Minerva used to be represented in ancient times, save that in
place of the head of Medusa there was seen a great red cross on
her breast, which caused her to be recognized with ease as the

new Order of S. Stephen, founded so devoutly by our glorious
and magnanimous Duke. The other on the left hand was seen all
adorned with sacerdotal and civil vestments in place of arms, and
with a great cross in the hand in place of a spear; and these,
towering over the whole structure in most beautiful accord with
the others, made a very imposing and marvellous effect. Next,
in the frieze that came between that last cornice and the archi-
trave that rested upon the columns, where according to the order
of the composition there came three compartments, were seen
painted the three kinds of true religion that have been from the
creation of the world down to the present day. In the first of
these, which came on the right hand beneath the armed statue,
was seen painted that kind of religion which reigned in the time
of natural law, in those few who had it true and good, although
they had not a perfect knowledge of God, wherefore there was
seen figured Melchizedek offering bread and wine and other fruits
of the earth. Even so, in the picture on the left hand, which came
in like manner beneath the statue of peaceful Religion, was seen
the other religion, ordained by God through the hands of Moses,
and more perfect than the first, but all so veiled with images and
figures, that these did not permit the final and perfect clearness
of Divine worship to be fully revealed; to signify which there
were seen Moses and Aaron sacrificing the Paschal Lamb to God.
But in the central picture, which came exactly beneath the large
and above-described statues of Religion, Charity, and Hope, and
over the principal arch, and which in proportion with the greater
space was much larger, there was seen figured an altar, and upon
it a Chalice with the Host, which is the true and evangelic Sac-
rifice; about which were seen some figures kneeling, and over it
a Holy Spirit in the midst of many little Angels, who were holding
in their hands a scroll in which was written, IN SPIRITU ET
VERITATE; so that it appeared that they were repeating those
words in song, Spiritus meaning all that concerns the sacrifice
natural and corporeal, and Veritas all that appertains to the legal;
which was all by way of image and figure. Beneath the whole
scene was a most beautiful inscription, which, supported by two
other Angels, rested on the cornice of the central arch, saying:

VERÆ RELIGIONI, QUÆ VIRTUTUM OMNIUM FUNDAMENTUM,
PUBLICARUM RERUM FIRMAMENTUM, PRIVATARUM OR-
NAMENTUM, ET HUMANÆ TOTIUS VITÆ LUMEN CONTINET,

ETRURIA SEMPER DUX ET MAGISTRA ILLIUS HABITA, ET EADEM
NUNCANTIQUA ET SUA PROPRIA LAUDE MAXIME FLORENS,
LIBENTISSIME CONSECRAVIT.

But coming to the lower part, and returning to the niche
which came on the right hand, between the two columns and
beneath the armed Religion, and which, although in painting, by
reason of the chiaroscuro appeared as if in relief; there, I say, was
seen the statue of our present most pious Duke in the habit of a
Knight of S. Stephen, with the cross in his hand, and with the
following inscription, which had the appearance of real carving,
over his head and above the niche, saying:

COSMUS MEDIC. FLOREN. ET SENAR. DUX II, SACRAM D. STE-
PHANI MILITIAM CHRISTIANÆ PIETATIS ET BELLICÆ VIRTUTIS
DOMICILIUM FUNDAVIT, ANNO MDLXI.

Even as on the base of the same niche, between the two
pedestals of the columns, which were fashioned in the Corinthian
proportions, there was seen painted the Taking of Damiata,
achieved by the prowess of the valiant knights of Florence; as it
were auguring for those his new knights similar glory and valour.
And in the lunette or semicircle which came above the two col-
umns, there was seen his private and particular escutcheon of
balls, which, by the red cross that was added to it with beautiful
grace, made it clearly manifest that it was that of the Grand
Master and Chief of the Order.

Now, for the public and universal satisfaction, and in order to
revive the memory of those who, born in that city or that prov-
ince, became illustrious for integrity of character and for sanctity
of life, and founders of some revered Order, and also to kindle
the minds of all beholders to imitation of their goodness and
perfection, it was thought right and proper, since there had been
placed on the right hand, as has been related, the statue of the
Duke, founder of the holy military Order of S. Stephen, to set
on the other side that of S. Giovanni Gualberto, who was like-
wise a knight of the household, according to the custom of those
times, and the first founder and father of the Order of Vallom-
brosa. Most fittingly, even as the Duke was beneath the armed
statue, in like manner he was seen standing beneath the sacer-
dotal statue of Religion, in the habit of a knight, pardoning
his enemy; having in the frontispiece over the niche a similar

escutcheon of the Medici, with three Cardinal's hats, and on the base the story of the miracle that took place at Badia di Settimo, when the friar, by the command of the above-named S. Giovanni Gualberto, to the confusion of the heretics and simonists, passed with his benediction and with a cross in his hand through the midst of a raging fire; with the inscription likewise in a little tablet above him, which made all that manifest, saying:

JOANNES GUALBERTUS, EQUES NOBILISS. FLOREN., VALLIS
UMBROSÆ FAMILIÆ AUCTOR FUIT, ANNO MLXI.

With which was terminated that most ornate and beautiful principal façade.

Entering beneath the arch, one saw there a passing spacious loggia, or passage, or vestibule, whichever we may choose to call it; and in exactly the same manner were seen formed the three other entrances, which, being joined together at the intersection of the two streets, left in the centre a space about eight braccia square. There the four arches rose to the height of those without, and the pendentives curved in the manner of a vault as if a little cupola were to spring over them; but when these had reached the cornice curving right round, at the point where the vault of the cupola would have had to begin to rise, there sprang a gallery of gilded balusters, above which was seen a choir of most beautiful Angels, dancing most gracefully in a ring and singing in sweetest harmony; while for greater grace, and to the end that there might be light everywhere beneath the arch, in place of a cupola there was left the free and open sky. And in the spaces or spandrels, whichever they may be called, of the four angles, which of necessity, narrow at their springing, opened out as they rose nearer to the cornice in accordance with the curve of the arch, were painted with no less grace in four rounds the four beasts mystically imagined by Ezekiel and by John the Divine for the four writers of the holy Evangel. But to return to the first of those four loggie or vestibules, as we have called them; the vaults there were seen distributed with very graceful and lovely divisions, and all adorned and painted with various little scenes and with the arms and devices of those religious Orders which were above or beside them, and in whose service, principally, they were there. Thus on the façade of that first one on the right hand, which was joined to the Duke's niche, there was seen painted in a spacious picture the same Duke giving the habit to

his knights, with those observances and ceremonies that are customary with them; in the most distant part, which represented Pisa, could be perceived the noble building of their palace, church, and hospital, and on the base, in an inscription for the explanation of the scene, could be read these words:

COSMUS MED. FLOR. ET SENAR. DUX II, EQUITIBUS SUIS DI-
VINO CONSILIO CREATIS MAGNIFICE PIEQUE INSIGNIA ET
SEDEM PRÆBET LARGEQUE REBUS OMNIBUS INSTRUIT.

Even as in the other on the opposite side, attached to the niche of S. Giovanni Gualberto, was seen how that same Saint founded his first and principal monastery in the midst of the wildest forests; with an inscription likewise on the base, which said:

S. JO. GUALBERTUS IN VALLOMBROSIANO MONTE, AB INTER-
VENTORIBUS ET ILLECEBRIS OMNIBUS REMOTO LOCO, DO-
MICILIUM PONIT SACRIS SUIS SODALIBUS.

Now, having despatched the front façade, and passing to that at the back, and describing it in the same manner, the less to hinder a clear understanding, we shall say, as has also been said before, that in height, in size, in the compartments, in the columns, and, finally, in every other ornament, it corresponded completely to that already described, save that whereas the first had on the highest summit in the centre the three great statues described above, Religion, Charity, and Hope, the other had in place of these only a most beautiful altar all composed and adorned after the ancient use, upon which, even as one reads of Vesta, was seen burning a very bright flame. On the right hand, towards S. Giovanni, there was seen standing a great statue in becoming vestments and gazing intently on Heaven, representing the Contemplative Life, which came exactly in a perpendicular line over the great niche between the two columns, as has been described in the other façade; and on the other side another great statue like it, but very active, with the arms bare and with the head crowned with flowers, representing the Active Life; in which statues were comprised very fittingly all the qualities that appertain to the Christian Religion. In the frieze between the one cornice and the other, which corresponded to that of the other part, and which was likewise divided into three compartments, there were seen in the largest, which was in the centre, three men

in Roman dress presenting twelve little children to some old and venerable Tuscans, to the end that these, being instructed by them in their religion, might demonstrate in what repute the Tuscan religion was held in ancient times among the Romans and all other nations: with a motto to explain this, taken from that perfect law of Cicero, which said: ETRURIA PRINCIPES DISCI-PLINAM DOCETO. Beneath which was the inscription, similar and corresponding to that already given from the other façade, which said:

FRUGIBUS INVENTIS DOCTÆ CELEBRANTUR ATHENÆ,
 ROMA FEROX ARMIS IMPERIOQUE POTENS.
AT NOSTRA HÆC MITIS PROVINCIA ETRURIA RITU
 DIVINO ET CULTU NOBILIORE DEI,
UNAM QUAM PERHIBENT ARTES TENUISSE PIANDI
 NUMINIS, ET RITUS EDOCUISSE SACROS;
NUNC EADEM SEDES VERÆ EST PIETATIS, ET ILLI
 HOS NUMQUAM TITULOS AUFERET ULLA DIES.

In one of the two smaller pictures, that which came on the right hand, since it is thought that the ancient religion of the Gentiles (which not without reason was placed on the west) is divided into two parts, and consists, above all, of augury and sacrifice, there was seen painted according to that use an ancient priest who with marvellous solicitude was standing all intent on considering the entrails of the animals sacrificed, which were placed before him in a great basin by the ministers of the sacrifice; and in the other picture an augur like him with the crooked lituus in the hand, drawing in the sky the regions proper for taking auguries from certain birds that were shown flying above.

Now, descending lower, and coming to the niches; in that, I say, which was on the right hand, was seen S. Romualdo, who in this our country, a land set apart, as it were, by Nature for religion and sanctity, founded on the wild Apennine mountains the holy Hermitage of Camaldoli, whence that Order had its origin and name; with the inscription over the niche, which said:

ROMUALDUS IN HAC NOSTRA PLENA SANCTITATIS TERRA,
CAMALDULENSIUM ORDINEM COLLOCAVIT ANNO MXII.

And on the base the story of the sleeping hermit who saw in a dream the staircase similar to that of Jacob, which, passing

beyond the clouds, ascended even to Heaven. On the façade which was joined to the niche, and which passed, as was said of the other, under the vestibule, was seen painted the building of the above-named hermitage in that wild place, carried out with marvellous care and magnificence; with the inscription, which in explanation said:

SANCTUS ROMUALDUS IN CAMALDULENSI SYLVESTRI LOCO, DIVINITUS SIBI OSTENSO ET DIVINÆ CONTEMPLATIONI AP- TISSIMO, SUO GRAVISSIMO COLLEGIO SEDES QUIETISSIMAS EXTRUIT.

In the niche on the left hand was seen the Blessed Filippo Benizi, one of our citizens, who was little less than the founder of the Servite Order, and without a doubt its first ordinator; and he, although he was accompanied by seven other noble Floren- tines, the one niche not being large enough to contain them all, was placed therein alone, as the most worthy; with the inscription above, which said:

PHILIPPUS BENITIUS CIVIS NOSTER INSTITUIT ET REBUS OMNIBUS ORNAVIT SERVORUM FAMILIAM, ANNO MCCLXXXV.

With the story of the Annunciation, likewise, on the base, wherein was the Virgin supported by many little Angels, with one among them who was shown scattering a beautiful vase of flowers over a vast multitude that stood there in supplication; representing the in- numerable graces that are seen bestowed daily by her intercession on the faithful who with devout zeal commend themselves to her. In the other scene, in the great picture that came in the passage below, were the same S. Filippo and the seven above-mentioned noble citizens throwing off the civil habit of Florence and assuming that of the Servite Order, and shown all occupied with directing the building of their beautiful monastery, which is now to be seen in Florence, but was then without the city, and the venerable and most ornate Church of the Annunziata, so celebrated throughout the whole world for innumerable miracles, which has been ever since the head of that Order; with the inscription, which said:

SEPTEM NOBILES CIVES NOSTRI IN SACELLO NOSTRÆ URBIS, TOTO NUNC ORBE RELIGIONIS ET SANCTITATIS FAMA CLA- RISSIMO, SE TOTOS RELIGIONI DEDUNT ET SEMINA JACIUNT ORDINIS SERVORUM D. MARIÆ VIRG.

There remain the two façades which formed as it were arms, as has been told, to the straight limb of the cross. These were smaller than those already described, which was caused by the narrowness of the two streets that begin there; wherefore, since less space came to be left for the magnificence of the work, in order consequently not to depart from the due proportion of height in their much smaller size, with much judgment the arch which gave passage there had on either side not a niche but a single column; over which rose a frieze in due proportion, in the centre of which was a painted picture that crowned the ornamentation of that façade, but not without an infinity of such other embellishments, devices, and pictures as were thought to be proper in such a place. Now, that whole structure being dedicated to the glory and power of the true Religion and to the memory of her glorious victories, they chose the two most noble and most important victories, won over two most powerful and particular adversaries, human wisdom namely, under which are comprised philosophers and heretics, and worldly power: and on the part facing towards the Archbishop's Palace was seen depicted how S. Peter and S. Paul and the other Apostles, filled with the divine spirit, disputed with a great number of philosophers and many others full of human wisdom, some of whom, those most confused, were seen throwing away or tearing up the books that they held in their hands, and others, such as Dionysius the Areopagite, Justinus, Pantænus, and the like, were coming towards them, all humble and devout, in token of having recognized and accepted the Evangelic truth; with the motto in explanation of this, which said: NON EST SAPIENTIA, NON EST PRUDENTIA. In the other scene towards the Archbishop's Palace, on the other side from the first, were seen the same S. Peter and S. Paul and the others in the presence of Nero and many of his armed satellites, boldly and freely preaching the truth of the Evangel; with the motto – NON EST FORTITUDO, NON EST POTENTIA, referring to that which follows in Solomon, whence the motto is taken – CONTRA DOMINUM. Of the façades which came under the two vaults of those two arches, in one, on the side towards the Archbishop's Palace, was seen the Blessed Giovanni Colombini, an honoured citizen of Siena, making a beginning with the Company of the Ingesuati by throwing off the citizen's habit on the Campo di Siena and assuming that of a miserable beggar, and giving the same habit to many who with

great zeal were demanding it from him; with the inscription, which said:

ORIGO COLLEGII PAUPERUM, QUI AB JESU COGNOMEN
ACCEPERUNT; CUJUS ORDINIS PRINCEPS FUIT JOANNES
COLOMBINUS, DOMO SENENSIS, ANNO MCCCLI.

And in the other, on the opposite side, were seen other gentlemen, likewise of Siena, before Guido Pietramalesco, Bishop of Arezzo, to whom a commission had been given by the Pope that he should inquire into their lives; and they were all intent on making manifest to him the wish and desire that they had to create the Order of Monte Oliveto, which was seen approved by that Bishop, exhorting them to put into execution the building of that vast and most holy monastery, which they erected afterwards at Monte Oliveto in the district of Siena, and of which they were shown to have brought thither a model; with the inscription, which said:

INSTITUITUR SACER ORDO MONACORUM QUI AB OLIVETO
MONTE NOMINATUR, AUCTORIBUS NOBILIBUS CIVIBUS
SENENSIBUS, ANNO MCCCXIX.

On the side towards S. Lorenzo was seen the building of the most famous Oratory of La Vernia, at the expense in great part of the devout Counts Guidi, at that time lords of that country, and by the agency of the glorious S. Francis, who, moved by the solitude of the place, made his way thither, and was visited there by Our Lord the Crucified Jesus Christ and marked with the Stigmata; with the inscription that explained all this, saying:

ASPERRIMUM AGRI NOSTRI MONTEM DIVUS FRANCIS-
CUS ELEGIT, IN QUO SUMMO ARDORE DOMINI NOSTRI SALU-
TAREM NECEM CONTEMPLARETUR, ISQUE NOTIS
PLAGARUM IN CORPORE IPSIUS EXPRESSIS DIVINITUS
CONSERVATUR.

Even as on the opposite side was seen the Celebration held in Florence of the Council under Eugenius IV, when the Greek Church, so long at discord with the Latin, was reunited with her, and the true Faith, it may be said, was restored to her pristine clearness and purity; which was likewise made manifest by the inscription, saying:

NUMINE DEI OPTIMI MAX. ET SINGULARI CIVIUM NOS-

TRORUM RELIGIONIS STUDIO, ELIGITUR URBS NOSTRA IN QUA
GRÆCIA, AMPLISSIMUM MEMBRUM A CHRISTIANA PIETATE
DISJUNCTUM, RELIQUO ECCLESIÆ CORPORI CONJUNGERETUR.

OF S. MARIA DEL FIORE.

As for the Cathedral Church, the central Duomo of the city, although it is in itself stupendous and most ornate, nevertheless, since the new Lady was to halt there, met by all the clergy, as she did, it was thought well to embellish it with all possible pomp and show of religion, and with lights, festoons, shields, and a vast and very well distributed quantity of banners. At the principal door, in particular, there was made in the Ionic Order of composition a marvellous and most graceful ornament, in which, in addition to the rest, which was in truth excellently well conceived, rich and rare beyond all else appeared ten little stories of the actions of the glorious Mother of Our Lord Jesus Christ, executed in low-relief, which, since they were judged by all who saw them to be of admirable artistry, it is hoped that some day they may be seen in bronze in competition with the marvellous and stupendous gates of the Temple of S. Giovanni, and even, as in a more favoured age, more pleasing and more beautiful; but at that time, although of clay, they were seen all overlaid with gold, and were let in a graceful pattern of compartments into the wooden door, which likewise had the appearance of gold. Above which, besides an immense escutcheon of the Medici with the Papal Keys and Crown, supported by Operation and Grace, were seen painted in a very beautiful canvas all the tutelary Saints of the city, who, turned towards a Madonna and the Child that she was holding in her arms, appeared to be praying to her for the welfare and felicity of Florence; even as over all, as the principal device, and with most lovely invention, was seen a little ship which, with the aid of a favourable wind, appeared to be speeding with full sail towards a most tranquil port, signifying that Christian actions are in need of the divine grace, but that it is also necessary on our part to add to them, as not being passive, good disposition and activity. Which was likewise made clearly manifest by the motto, which said, Σὺν θεῷ; and even more by the very short inscription that was seen beneath, saying:

CONFIRMA HOC DEUS QUOD OPERATUS ES IN NOBIS.

OF THE HORSE.

On the Piazza di S. Pulinari, not in connection with the tribunal that was near there, but to the end that the great space between the Duomo and the next arch might not remain empty, although the street is very beautiful, there was made with marvellous artistry and subtle invention the figure of an immense, very excellent, very fiery and well-executed horse, more than nine braccia in height, which was rearing up on the hind-legs; and upon it was seen a young hero in full armour and in aspect all filled with valour, who had just wounded to death with his spear, the butt of which was seen at his feet, a vast monster that was stretched all limp beneath his horse, and already he had laid his hand on a glittering sword, as if about to smite him again, and seemed to marvel to what straits the monster had been reduced by the first blow. That hero represented the true Herculean Virtue, which, as Dante said so well, chased through every town and banished to Hell the dissipatrix of kingdoms and republics, the mother of discord, injury, rapine, and injustice, that evil power, finally, that is commonly called Vice or Fraud, hidden under the form of a woman young and fair, but with a great scorpion's tail; and, slaying her, he seemed to have restored the city to the tranquillity and peace in which she is seen at the present day, thanks to her excellent Lords, reposing and flourishing so happily. Which was demonstrated in a manner no less masterly by the device, placed fittingly on the great base, in which, in the centre of an open temple supported by many columns, upon a sacredaltar, was seen the Egyptian Ibis, which was shown tearing with the beak and with the claws some serpents that were wound round its legs; with a motto that said aptly: PRÆMIA DIGNA.

OF THE BORGO DE' GRECI.

Even so, also, at the corner of the Borgo de' Greci, to the end that in the turn that was made in going towards the Dogana, the eyes might have something on which to feast with delight, it was thought well to form a little closed arch of Doric architecture, dedicating it to Public Merriment; which was demonstrated by

the statue of a woman crowned with a garland and all joyous and smiling, which was in the principal place, with a motto in explanation, saying: HILARITAS P.P. FLORENT. Below her, in the midst of many grotesques and many graceful little stories of Bacchus, were seen two most charming little Satyrs, which with two skins that they held on their shoulders were pouring into a very beautiful fountain, as was done in the other, white and red wine; and as in the other the fish, so in this one two swans that were under the boys, played a trick on him who drank too much by means of jets of water that at times spurted with force from the vase; with a graceful motto that said: ABITE LYMPHÆ VINI PERNICIES. Above and around the large statue were seen many others, both Satyrs and Bacchanals, who, shown in a thousand pleasing ways drinking, dancing, singing, and playing all those pranks that the drunken are wont to play, seemed as if chanting the motto written above them:

NUNC EST BIBENDUM, NUNC PEDE LIBERO PULSANDA TELLUS.

OF THE ARCH OF THE DOGANA.

It appeared, among the many prerogatives, excellences, and graces with which fair Florence adorned herself, distributing them over various places, as has been shown, to receive and accompany her illustrious Princess, it appeared, I say, that the sole sovereign and head of them all, Civil Virtue or Prudence, queen and mistress of the art of ruling and governing well peoples and states, had been passed over up to this point without receiving any attention; as to which Prudence, although to the great praise and glory of Florence it could be demonstrated amply in many of her children in past times, nevertheless, having at the present time in her most excellent Lords the most recent, the most true, and without a doubt the most splendid example that has ever been seen in her up to our own day, it was thought that their magnanimous actions were best fitted to express and demonstrate that virtue. And with what good reason, and how clearly without any taint of adulation, but only by the grateful minds of the best citizens, this honour was paid to them, anyone who is not possessed by blind envy (by whose venomous bite whoever has ruled at any time has always been molested), may judge with

ease, looking not only at the pure and upright government of
their happily adventuresome State and at its preservation among
difficulties, but also at its memorable, ample, and glorious in-
crease, brought about certainly not less by the infinite fortitude,
constancy, patience, and vigilance of its most prudent Duke, than
by the benign favour of prosperous Fortune. All which came to
be expressed excellently well in the inscription set with most
beautiful grace in a fitting place, embracing the whole conception
of the whole ornament, and saying:

REBUS URBANIS CONSTITUTIS, FINIB. IMPERII PROPAGATIS,
RE MILITARI ORNATA, PACE UBIQUE PARTA, CIVITATIS
IMPERIIQUE DIGNITATE AUCTA, MEMOR TANTORUM
BENEFICIORUM PATRIA PRUDENTIÆ DUCIS OPT. DEDICAVIT.

At the entrance of the public and ducal Piazza, then, and attached
on one side to the public and ducal Palace, and on the other to
those buildings in which salt is distributed to the people, there
was dedicated well and fittingly to that same Civil Virtue or
Prudence an arch marvellous and grand beyond all the others,
similar and conforming in every part, although more lofty and
more magnificent, to that of Religion already described, which
was placed on the Canto alla Paglia. In that arch, above four vast
Corinthian columns, in the midst of which space was left for the
procession to pass, and above the usual architrave, cornice, and
frieze of projections – as was said of the other – divided into
three compartments, and upon a second great cornice that
crowned the whole work, there was seen in grave and heroic
majesty, seated in the semblance of a Queen with a sceptre in the
right hand and resting the left on a great globe, an immense
woman adorned with a royal crown, who could be recognized
with ease as being that Civil Virtue. There remained below, be-
tween one column and another, as much space as accommodated
without difficulty a deep and spacious niche, in each of which was
demonstrated very aptly of what other virtues that Civil Virtue is
composed; and, rightly giving the first place to the military vir-
tues, there was seen in the niche on the right hand, with heroic
and most beautiful composition, the statue of Fortitude, the first
principle of all magnanimous and generous actions, even as on
the left hand in like manner was seen placed that of Constancy,
who best guides and executes them. And since between the fron-
tispieces of the two niches and the cornice that went right round

there was left some space, to the end that the whole might be adorned, there were counterfeited there two rounds in the colour of bronze, in one of which was depicted with a fine fleet of galleys and other ships the diligence and solicitude of our most shrewd Duke in maritime affairs, and in the other, as is often found in ancient medals, was seen the same Duke going around on horseback to visit his fortunate States and to provide for their wants. Next, over the crowning cornice, where, as has been told, the masterly statue of Civil Prudence was seated, continuing to show of what parts she is composed, and exactly in a line with the Fortitude already described, and separated from her by some magnificent vases, was seen Vigilance, so necessary in every human action; even as above Constancy was seen in like manner Patience, and I do not speak of that patience to which meek minds, tolerating injuries, have given the name of virtue, but of that which won so much honour for the ancient Fabius Maximus, and which, awaiting opportune moments with prudence and mature reflection, and void of all rash vehemence, executes every action with reason and advantage. In the three pictures, then, into which, as was said, the frieze was divided, and which were separated by medallions and pilasters that sprang in a line with the columns and extended with supreme beauty as far as the great cornice; in that in the centre, which came above the portal of the arch and beneath the Sovereign Prudence, was seen painted the generous Duke with prudent and loving counsel handing over to the worthy Prince the whole government of his spacious States, which was expressed by a sceptre upon a stork, which he was shown offering to his son, and it was being accepted with great reverence by the obedient Prince; with a motto that said: REGET PATRIIS VIRTUTIBUS. Even as in that on the right hand was seen the same most valiant Duke with courageous resolution sending forth his people, and the first fort of Siena occupied by them – no slight cause, probably, of their victory in that war. And in that on the left hand, in like manner, was painted his joyful entry into that most noble city after the winning of the victory. But behind the great statue of Sovereign Prudence – and in this alone was that front part dissimilar to the Arch of Religion – was seen raised on high a base beautifully twined with cartouches and square, although at the foot, not without infinite grace, it was something wider than at the top; upon which, reviving the ancient use, was seen a most beautiful triumphal chariot drawn

by four marvellous coursers, not inferior, perchance, to any of the ancient in beauty and grandeur. In that chariot was seen held suspended in the air by two lovely little Angels the principal crown of the arch, composed of civic oak, and, in the likeness of that of the first Augustus, attached to two tails of Capricorns; with the same motto that was once used with it by him, saying: OB CIVES SERVATOS. And in the spaces that remained between the pictures, statues, columns, and niches, all was filled up with richness and grace by an infinite wealth of Victories, Anchors, Tortoises with the Sail, Diamonds, Capricorns, and other suchlike devices of those magnanimous Lords.

Now, passing to the part at the back, facing towards the Piazza, which we must describe as being in every way similar to the front, excepting that in place of the statue of Sovereign Prudence, there was seen in a large oval corresponding to the great pedestal that supported the great chariot described above, which, with ingenious artifice, after the passing of the procession, was turned in a moment towards the Piazza; there was seen, I say, as the principal device of the arch, a celestial Capricorn with its stars, which was shown holding with the paws a royal sceptre with an eye at the top, such as it is said that the ancient and most just Osiris used once to carry, with the ancient motto about it, saying: NULLUM NUMEN ABEST; as if adding, as the first author said: SI SIT PRUDENTIA. In the lower part, we have to relate as a beginning – because that façade was made to represent the actions of peace, which are perhaps no less necessary to the human race – that in the niche on the right hand, as with those of the other façade already described, there was seen placed a statue of a woman, representing Reward or Remuneration, and called Grace, such as wise Princes are wont to confer for meritorious works upon men of excellence and worth, even as on the left hand, in a threatening aspect, with a sword in the hand, in the figure of Nemesis, was seen Punishment, for the vicious and criminal; with which figures were comprised the two principal pillars of Justice, without both which no State ever had stability or firmness, or was anything but imperfect and maimed. In the two ovals, then, always corresponding to those of the other façade, and like them also counterfeited in bronze, in one were seen the fortifications executed with much forethought in many places by the prudent Duke, and in the other his marvellous care and diligence in achieving the common peace of Italy, as has been seen in many

of his actions, but particularly at that moment when by his agency was extinguished the terrible and so dangerous conflagration fanned with little prudence by one who should rather have assured the public welfare of the Christian people; which was represented by various Fetiales, altars, and other suchlike instruments of peace, and by the words customary in medals placed over them, saying: PAX AUGUSTA. Over these, and over the two above-described statues of the niches, similar to those of the other side, were seen on the right hand Facility and on the left Temperance or Goodness, as we would rather call her; signifying by the first an external courtesy and affability in deigning to listen and hearken and answer graciously to everyone, which keeps the people marvellously well contented, and by the other that temperate and benign nature which renders the Prince amiable and loving with his confidants and intimates, and with his subjects easy and gracious. In the frieze, corresponding to that of the front part, and like it divided into three pictures, was likewise seen in that of the centre, as the thing of most importance, the conclusion of the happy marriage contracted between the most illustrious Prince and the most serene Queen Joanna of Austria, with so much satisfaction and benefit to his fortunate people, and bringing peace and repose to everyone; with a motto saying: FAUSTO CUM SIDERE. Even as in another, on the right hand, was seen the loving Duke holding by the hand the excellent Duchess Leonora, his consort, a woman of virile and admirable worth and wisdom, with whom while she was alive he was joined by such a love, that they could well be called the bright mirror of conjugal fidelity. On the left hand was seen the same gracious Duke listening with marvellous courtesy, as he has been wont always to do, to many who were shown seeking to speak with him. And such was all that part which faced towards the Piazza.

Beneath the spacious arch and within the wide passage through which the procession passed, on one of the walls that supported the vaulting, was seen painted the glorious Duke in the midst of many venerable old men, with whom he was taking counsel, and he appeared to be giving to many various laws and statutes written on divers sheets, signifying the innumerable laws so wisely amended or newly decreed by him; with the motto: LEGIBUS EMENDES. Even as in the other, demonstrating his most useful resolve to set in order and increase his valorous militia, was seen the same valiant Duke standing upon a military

tribune and engaged in addressing a great multitude of soldiers who stood around him, as we see in many ancient medals; with a motto above him that said: ARMIS TUTERIS. And so on the great vault, which was divided into six compartments, there was seen in each of these, in place of the rosettes that are generally put there, a device, or, to speak more correctly, the reverse of a medal in keeping with the two above-described scenes of the walls. In one of these were painted various curule chairs with various consular fasces, and in another a woman with the balance, representing Equity; these two being intended to signify that just laws must always unite with the severity of the supreme power the equity of the discerning judge. The next two were concerned with military life, demonstrating the virtues of soldiers and the fidelity incumbent on them; for the first of these things there was seen painted a woman armed in the ancient fashion, and for the other many soldiers who, laying one hand upon an altar, were shown presenting the other to their captain. In the two that remained, representing the just and desired fruits of all these fatigues, namely, Victory, the whole was seen fully expressed, as is customary, by the figures of two women, one standing in one of the pictures upon a great chariot, and the other in the other picture upon a great ship's beak; and both were seen holding in one of the hands a branch of glorious palm, and in the other a verdant crown of triumphal laurel. And in the encircling frieze that ran right round the vaulting, the front and the back, there followed the third part of the motto already begun, saying: MORIBUS ORNES.

OF THE PIAZZA, AND OF THE NEPTUNE.

Next, all the most noble magistrates of the city, distributing themselves one by one over the whole circuit of the great Piazza, each with his customary devices and with very rich tapestries divided evenly by most graceful pilasters, had rendered it all magnificently imposing and ornate; and there in those days great care and diligence were devoted to hastening the erecting in its place, at the beginning of the Ringhiera, of that Giant in the finest white marble, so marvellous and so stupendous in grandeur, in beauty, and in every part, which is still to be seen there at the present day; although it had been ordained as a permanent and enduring

ornament. That Giant is known by the trident that he has in the hand, by the crown of pine, and by the Tritons that are at his feet, sounding their trumpets, to be Neptune, God of the sea; and, riding in a graceful car adorned with various products of the sea and two ascendant Signs, Capricorn for the Duke and Aries for the Prince, and drawn by four Sea-horses, he appears in the guise of a benign protector to be promising tranquillity, felicity, and victory in the affairs of the sea. At the foot of this, in order to establish it more securely and more richly, there was made at that time in a no less beautiful manner an immense and most lovely octagonal fountain, gracefully supported by some Satyrs, who, holding in their hands little baskets of various wild fruits and prickly shells of chestnuts, and divided by some little scenes in low-relief and by some festoons in which were interspersed sea-shells, crabs, and other suchlike things, seemed as they danced to be expressing great joy in their new Lady; even as with no less joy and no less grace there were seen lying on the sides of the four principal faces of the fountain, likewise with certain great shells in their hands and with some children in their arms, two nude women and two most beautiful youths, who in a certain gracious attitude, as if they were on the sea-shore, appeared to be playing and sporting gracefully with some dolphins that were there, likewise in low-relief.

OF THE DOOR OF THE PALACE.

Now, having caused the serene Princess to be received, as has been told in the beginning of this description, by Florence, accompanied by the followers of Mars, of the Muses, of Ceres, of Industry, and of Tuscan Poetry and Design, and then triumphant Austria by Tuscany, and the Drava by Arno, and Ocean by the Tyrrhenian Sea, with Hymen promising her happy and prosperous nuptials, and the parental meeting of her august and glorious Emperors with the illustrious Medici, and then all passing through the Arch of Sacrosanct Religion and fulfilling and accomplishing their vows at the Cathedral Church, and having seen Heroic Virtue in triumph over Vice, and with what public rejoicing her entry was celebrated by Civil Virtue, and how, finally, she was welcomed by the magistrates of the city, with Neptune promising her a tranquil sea, it was determined judiciously to

bring her at the last into the port of peaceful Security, who was
seen figured over the door of the Ducal Palace, in a place mar-
vellously appropriate, in the form of a very tall, most beautiful,
and most joyous woman crowned with laurel and olive, who was
shown seated in an easy attitude upon a stable pedestal and lean-
ing against a great column; demonstrating by means of her the
desired end of all human affairs, deservedly acquired for Florence,
and in consequence for the happy bride, by the sciences, arts, and
virtues of which we have spoken above, but particularly by her
most prudent and most fortunate Lords, who had prepared to
receive and accommodate her there as in a place secure beyond
all others, wherein she might enjoy unceasingly in glory and
splendour the benefits human and divine displayed before her in
the ornaments that she had passed; which was explained very
aptly both by the inscription that came with most beautiful grace
over the door, saying:

INGREDERE OPTIMIS AUSPICIIS FORTUNATAS ÆDES TUAS AU-
GUSTA VIRGO, ET PRÆSTANTISSIMI SPONSI AMORE, CLARISS.
DUCIS SAPIENTIA, CUM BONIS OMNIBUS DELICIISQUE SUMMA
ANIMI SECURITATE DIU FELIX ET LÆTA PERFRUERE, ET DIVI-
NÆ TUÆ VIRTUTIS, SUAVITATIS, FECUNDITATIS FRUCTIBUS
PUBLICAM HILARITATEM CONFIRMA.

And also by the principal device, which was seen painted in a
great oval in the highest part, over the statue of Security already
described; and this was the military Eagle of the Roman Legions
upon a laureate staff, which was shown to have been planted
firmly in the earth by the hand of the standard-bearer; with the
motto of such happy augury from Livy, from whom the whole
device is taken, saying: HIC MANEBIMUS OPTUME. The orna-
ment of the door, which was attached to the wall, was contrived
in such a manner, and conceived so well, that it would serve
excellently well if at any time, in order to adorn the simple but
magnificent roughness of past ages, it were determined to build
it in marble or some other finer stone as more stable and endur-
ing, and more in keeping with our more cultured age. Beginning
with the lowest part, I say, upon two great pedestals that rested
on the level of the ground and stood one on either side of the
true door of the Palace, were seen two immense captives, one
male, representing Fury, and one female, with vipers and horned
snakes for hair, representing Discord, his companion; which, as

it were vanquished, subjugated, and bound with chains, and held down by the Ionic capital and by the architrave, frieze, and cornice that pressed upon them from above, seemed in a certain sort to be unable to breathe by reason of the great weight, revealing only too well in their faces, which were most beautiful in their ugliness, Anger, Rage, Venom, Violence, and Fraud, their peculiar and natural passions. Above that cornice was seen formed a frontispiece, in which was placed a very rich and very large escutcheon of the Duke, bordered by the usual Fleece, with the Ducal Mazzocchio supported by two very beautiful boys. And lest this single ornament, which exactly covered the jambs of the true door, might have a poor effect in so great a palace, it was thought right to place on either side of it four half-columns set two on one side and two on the other, which, coming to the same height, and furnished with the same cornice and architrave, should form a quarter-round which the other frontispiece, pointed but rectilinear, might embrace, with its projections and with all its appurtenances set in the proper places. And above this was formed a very beautiful base, where there was seen the above-described statue of Security, set in position, as has been told, with most beautiful grace. But to return to the four half-columns below; for the sake of greater magnificence, beauty, and proportion, I say, there had been left so much space at either side, between column and column, that there was ample room for a large and beautiful picture painted there in place of a niche. In one of these, that which was placed nearest to the divine statue of the gentle David, were seen in the forms of three women, who were shown full of joy advancing to meet their desired Lady, Nature, with her towers on her head, as is customary, and with her many breasts, signifying the happy multitude of her inhabitants, and Concord with the Caduceus in her hand, even as in the third was seen figured Minerva, the inventress and mistress of the liberal arts and of civil and refined customs. In the other, which faced towards the proud statue of Hercules, was seen Amaltheia, with the usual horn of plenty, overflowing with fruits and flowers, in her arms, and at her feet the corn-measure brimming and adorned with ears of corn, signifying the abundance and fertility of the earth; there, also, was Peace crowned with flowered and fruitful olive, with a branch of the same in the hand, and finally there was seen, with an aspect grave and venerable, Majesty or Reputation; demonstrating ingeniously with all these things how in well-ordered

cities, abundant in men, copious in riches, adorned by arts, filled with sciences, and illustrious in majesty and reputation, one lives happily and in peace, quietness, and contentment. Then in line with the four half-columns already described, above the cornice and frieze of each, was seen fixed in a manner no less beautiful a socle with a pedestal in proportion, upon which rested some statues; and since the two in the centre embraced also the width of the two terminals described, upon each of these were placed two statues embracing one another – Virtue, namely, who was shown holding Fortune in a strait and loving embrace, with a motto on the base saying, VIRTUTEM FORTUNA SEQUETUR; as if to demonstrate that, whatever many may say, where virtue is fortune is never wanting; and upon the other Fatigue or Diligence, who in like manner was shown in the act of embracing Victory, with a motto at her feet saying: AMAT VICTORIA CURAM. And above the half-columns that were at the extremities, and upon which the pedestals were narrower, adorning each of them with a single statue, on one there was seen Eternity as she is figured by the ancients, with the heads of Janus in her hands, and with the motto, NEC FINES NEC TEMPORA; and on the other Fame figured in the usual manner, likewise with a motto saying: TERMINAT ASTRIS. Between one and the other of these, there was placed with ornate and beautiful composition, so as to have the above-named escutcheon of the Duke exactly in the middle, on the right hand that of the most excellent Prince and Princess, and on the other that which the city has been accustomed to use from ancient times.

OF THE COURT OF THE PALACE.

I thought, when I first resolved to write, that it would take much less work to bring me to the end of the description given above, but the abundance of the inventions, the magnificence of the things done, and the desire to satisfy the curiosity of craftsmen, for whose particular benefit, as has been told, this description is written, have in some way, I know not how, carried me to a length which might perchance appear to some to be excessive, but which is nevertheless necessary for one who proposes to render everything distinct and clear. But now that I find myself past the first part of my labours, although I hope to treat

with more brevity, and with perhaps no less pleasure for my readers, the remainder of the description of the spectacles that were held, in which, no less than the liberality of our magnanimous Lords, and no less than the lively dexterity of the ingenious inventors, there appeared rare and excellent the industry and art of the same craftsmen, yet it should not be thought a thing beside the mark or altogether unworthy of consideration, if, before going any further, we say something of the aspect of the city while the festivities for the nuptials were being prepared and after they were finished, for the reason that in the city, to the infinite entertainment of all beholders, were seen many streets redecorated both within and without, the Ducal Palace (as will be described) embellished with extraordinary rapidity, the fabric of the long corridor (which leads from that Palace to that of the Pitti) flying, as it were, with wings, the column, the fountain, and all the arches described above springing in a certain sense out of the ground, and all the other festive preparations in progress, but in particular the comedy, which was to appear first, and the two grand masquerades, which had need of most labour, and, finally, all the other things being prepared according to the time at which they were to be represented, some quickly and others more slowly; the two Lords, Duke and Prince, after the manner of the ancient Ædiles, having distributed them between themselves, and having undertaken to execute each his part in generous emulation. Nor was less solicitude or less rivalry seen among the gentlemen and ladies of the city, and among the strangers, of whom a vast number had flocked thither from all Italy, vying one with another in the pomp of vestments, and not less in their own than in the liveries of their attendants, male and female, in festivals private and public, and in the sumptuous banquets that were given in constant succession, now in one place and now in another; so that there could be seen at one and the same moment leisure, festivity, delight, spending, and pomp, and also commerce, industry, patience, labour, and grateful gain, with which all the craftsmen named above were filled, all working their effect in liberal measure.

Now, to come to the court of the Ducal Palace, into which one entered by the door already described; in order not to pass it by without saying anything about it, we must relate that, although it seemed dark and inconvenient, and almost incapable of receiving any kind of ornamentation, nevertheless with marvellous novelty and with incredible rapidity it was carried to that

perfection of beauty and loveliness in which it may be seen by
everyone at the present day. In addition to the graceful fountain
of hardest porphyry that is placed in the centre, and the lovely
boy that pours water into it from the dolphin held in his arms,
in an instant the nine columns were fluted and shaped in a most
beautiful manner in the Corinthian Order, which surround the
square court named above, and which support on one side the
encircling loggie constructed very roughly of hard-stone, accord-
ing to the custom of those times; overlaying the ground of those
columns almost entirely with gold, and filling them with most
graceful foliage over the flutings, and shaping their bases and
capitals together according to the good ancient custom. Within
the loggie, the vaults of which were all filled and adorned with
most bizarre and extravagant grotesques, there were seen repre-
sented, as in many medallions made for the same purpose, some
of the glorious deeds of the magnanimous Duke, which – if
smaller things may be compared with greater – I have considered
often in my own mind to be so similar to those of the first
Octavianus Augustus, that it would be difficult to find any greater
resemblance; for the reason that – not to mention that both the
one and the other were born under one and the same ascendant
of Capricorn, and not to mention that both were raised almost
unexpectedly to the sovereignty at the same immature age, and
not to speak of the most important victories gained both by the
one and by the other in the first days of August, and of their
having similar constitutions and natures in their private and inti-
mate lives, and of their singular affection for their wives, save that
in his children, in the election to the principality, and perhaps in
many other things, I believe that our fortunate Duke might be
esteemed more blessed than Augustus – is there not seen both in
the one and in the other a most ardent and most extraordinary
desire to build and embellish, and to contrive that others should
build and embellish? Insomuch that, if the first said that he found
Rome built of bricks and left her built of solid stone, the second
will be able to say not less truthfully that he received Florence
already of stone, indeed, ornate and beautiful, but leaves her to
his sucessors by a great measure more ornate and more beautiful,
increased and magnified by every kind of convenient, lovely, and
magnificent adornment.

To represent these matters, in each lunette of the above-
named loggie there was seen an oval accommodated with suitable

ornaments, and with singular grace; in one of which there could be seen the fortification of Porto Ferrajo in Elba, a work of such importance, with many ships and galleys that were shown lying there in safety, and the glorious building of the city in the same place, called after its founder Cosmopolis; with a motto within the oval, saying: ILVA RENASCENS; and another in the encircling scroll, which said: TUSCORUM ET LIGURUM SECURITATI. Even as in the second was seen that most useful and handsome building wherein the greater part of the most noble magistrates are to be accommodated, which is being erected by his command opposite to the Mint, and which may be seen already carried near completion; and over it stretches that long and convenient corridor of which mention has been made above, built with extraordinary rapidity in these days by order of the same Duke; likewise with a motto that said: PUBLICÆ COMMODITATI. And so, also, in the third was seen Concord, with the usual horn of plenty in the left hand, and with an ancient military ensign in the right, at whose feet a Lion and a She-Wolf, the well-known emblems of Florence and Siena, were shown lying in peaceful tranquillity; with a motto suited to the matter, and saying: ETRURIA PACATA. In the fourth was seen depicted the above-described oriental column of granite, with Justice on the summit, which under his happy sceptre may well be said to be preserved inviolate and impartial; with a motto saying: JUSTITIA VICTRIX. Even as in the fifth was seen a ferocious bull with both the horns broken, intended to signify, as has been told already of the Achelous, the straightening of the River Arno in many places, carried out with such advantage by the Duke; with the motto: IMMINUTUS CREVIT. In the sixth, then, was seen that most superb palace which was begun formerly by M. Luca Pitti with a magnificence so marvellous in a private citizen, and with truly regal spirit and grandeur, and which at the present day our most magnanimous Duke is causing with incomparable artistry and care to be not only carried to completion, but also to be increased and beautified in a glorious and marvellous manner, with architecture heroic and stupendous, and also with very large and very choice gardens full of most abundant fountains, and with a vast quantity of most noble statues, ancient and modern, which he has caused to be collected from all over the world; which was explained by the motto, saying: PULCHRIORA LATENT. In the seventh, within a great door, were seen many books arranged in various manners,

with a motto in the scroll, saying, PUBLICÆ UTILITATI; intended to signify the glorious solicitude shown by many of the Medici family, and particularly by our most liberal Duke, in collecting and preserving with such diligence a marvellous quantity of the rarest books in every tongue, recently placed in the beautiful Library of S. Lorenzo, which was begun by Clement VII and finished by his Excellency. Even as in the eighth, under the figure of two hands that appeared to become more firmly bound together the more they strove to undo a certain knot, there was denoted the abdication lovingly performed by him in favour of the most amiable Prince, and how difficult, or, we should rather say, how impossible it is for one who has once set himself to the government of a State, to disengage himself; which was explained by the motto, saying: EXPLICANDO IMPLICATUR. In the ninth was seen the above-described Fountain of the Piazza, with that rare statue of Neptune, and with the motto, OPTABILIOR QUO MELIOR; signifying not only the adornment of the immense statue and fountain named above, but also the profit and advantage that will accrue in a short time to the city from the waters that the Duke is constantly engaged in bringing to her. In the tenth, then, was seen the magnanimous creation of the new Order of S. Stephen, represented by the figure of the same Duke in armour, who was shown offering a sword with one hand over an altar to an armed knight, and with the other one of their crosses; with a motto saying: VICTOR VINCITUR. And in the eleventh, likewise under the figure of the same Duke, who was addressing many soldiers according to the ancient custom, there was represented the militia so well ordained and preserved by him in his valorous companies; with a motto that explained it, saying: RES MILITARIS CONSTITUTA. In the twelfth, with the sole words, MUNITA TUSCIA, and without any further representation, were demonstrated the many fortifications made by our most prudent Duke in the most important places in the State; adding in the scroll, with fine morality: SINE JUSTITIA IMMUNITA. Even as in the thirteenth, in like manner without any other representation, there could be read, SICCATIS MARITIMIS PALUDIBUS; as may be seen to his infinite glory in many places, but above all in the fertile country of Pisa. And in order not to pass over completely in silence the praise due to him for having brought back and restored so gloriously to his native Florence the artillery and the ensigns lost at other times, in the fourteenth and last

were seen some soldiers returning to him laden with these, all dancing and joyful; with a motto in explanation, which said: SIG-NIS RECEPTIS. And then, for the satisfaction of the strangers, and particularly the many German lords who had come thither in vast numbers in honour of her Highness, with the most excellent Duke of Bavaria, the younger, her kinsman, there were seen under the above-described lunettes, beautifully distributed in compartments and depicted with all the appearance of reality, many of the principal cities of Austria, Bohemia, Hungary, the Tyrol, and the other States subject to her august brother.

OF THE HALL, AND OF THE COMEDY.

Now, ascending by the most commodious staircase to the Great Hall, where the principal and most important festivities and the principal banquet of the nuptials were celebrated (forbearing to speak of the magnificent and stupendous ceiling, marvellous in the variety and multitude of the rare historical paintings, and marvellous also in the ingenuity of the inventions, in the richness of the partitions, and in the infinite quantity of gold with which the whole is seen to shine, but most marvellous in that it has been executed in an incredibly short time by the industry of a single painter; and treating of the other things pertaining only to this place), I must say that truly I do not believe that in these our parts we have any information of any other hall that is larger or more lofty; but to find one more beautiful, more rich, more ornate, or arranged with more convenience than that hall as it was seen on the day when the comedy was performed, that I believe would be absolutely impossible. For, in addition to the immense walls, on which with graceful partitions, and not without poetical invention, were seen portrayed from the reality the principal squares of the most noble cities of Tuscany, and in addition to the vast and most lovely canvas painted with various animals hunted and taken in various ways, which, upheld by a great cornice, and concealing the prospect-scene, served so well as one of the end-walls, that the Great Hall appeared to have its due proportions, such, in addition, and so well arranged, were the tiers of seats that ran right round, and so lovely on that day the sight of the handsome ladies who had been invited there in great numbers from among the most beautiful, the most noble, and the

richest, and of the many lords, chevaliers, and other gentlemen who had been accommodated above them and throughout the rest of the room, that without a doubt, when the fantastic lights were lit, at the fall of the canvas described above, the luminous prospect-scene being revealed, it appeared in truth as if Paradise with all the Choirs of the Angels had been thrown open at that instant; which illusion was increased marvellously by a very soft, full, and masterly concert of instruments and voices, which very soon afterwards was heard to come forth from that direction. In that prospect-scene the most distant part was made to recede most ingeniously along the line of the bridge, terminating in the end of the street that is called the Via Maggio, and in the nearest part was represented the beautiful street of S. Trinita; and when the eyes of the spectators had been allowed to sate themselves for some time with that and the many other marvellous things, the desired and welcome beginning was made with the first interlude of the comedy, which was taken, like all the others, from that touching story of Psyche and Cupid so delicately narrated by Apuleius in his Golden Ass. From it were taken the parts that appeared the most important, and these were accommodated with the greatest possible dexterity to the comedy, so that, having made, as it were, an ingenious composition from the one fable and the other, it might appear that what the Gods did in the fable of the interludes was done also by mankind in the fable of the comedy, as if constrained by a superior power. In the hollow sky of the above-named prospect-scene, which opened out all of a sudden, there was seen to appear another sky contrived with great artifice, from which was seen issuing little by little a white and very naturally counterfeited cloud, upon which, with an effect of singular beauty, a gilded and jewelled car appeared to be resting, recognized as that of Venus, because it was drawn by two snow-white swans, and in it, as its mistress and guide, could be perceived likewise that most beautiful Goddess, wholly nude and crowned with roses and myrtle, seated with great majesty and holding the reins. She had in her company the three Graces, likewise recognized by their being shown wholly nude, by their blonde tresses, which fell all loose over their shoulders, and even more by the manner in which they were standing linked hand to hand; and also the four Hours, who had the wings all painted after the likeness of butterflies, and, not without reason, were distinguished in certain particulars according to the four seasons

of the year. Thus one of them, who had the head and the buskins all adorned with various little flowers, and the dress of changing colours, was intended to represent the varied and flowering Spring; even as the second, with the garland and the buskins woven of pale ears of corn, and the yellow draperies wherewith she was adorned, was intended to signify the heat of Summer, and the third, representing Autumn, and all clothed in red draperies, signifying the maturity of fruits, was seen likewise all covered and adorned with those same fruits, vine-leaves, and grapes; and the fourth and last, who represented the white and snowy Winter, besides her dress of turquoise-blue all sprinkled with flakes of snow, had the hair and the buskins likewise covered with similar snow, hoar-frost, and ice. And all, as followers and handmaidens of Venus, being grouped around the car on the same cloud with singular artistry and most beautiful composition, were seen – leaving behind them Jove, Juno, Saturn, Mars, Mercury, and the other Gods, from whom appeared to be issuing the soft harmony described above – to sink gradually with most beautiful grace towards the earth, and by their coming to fill the scene and the whole hall with a thousand sweet and precious odours; while from another part, with an aspect no less gracious, but appearing to walk on earth, was seen to come the nude and winged Cupid, likewise accompanied by those four Passions that seem so often to be wont to disturb his unrestful kingdom; Hope, namely, all clothed in green, with a little flowering branch on the head; Fear, recognized, in addition to his pale garment, by the rabbits that he had on his hair and his buskins; Joy, likewise clothed in white and orange and a thousand glad colours, and with a plant of flowering borage on the hair, and Sorrow, all in black and in aspect all weeping and sad; of whom, as his ministers, one carried the bow, another the quiver and the arrows, another the nets, and yet another the lighted torch. And while the above-described Hours and Graces, having descended from the cloud, went slowly towards their mother's car, now arrived on earth, and, having grouped themselves reverently in a most graceful choir around the lovely Venus, seemed all intent on singing in harmony with her, she, turning towards her son with rare and infinite grace, and making manifest to him the cause of her displeasure, when those in Heaven were silent, sang the two following stanzas, the first of the ballad, saying:

A me, che fatta son negletta e sola,
 Non più gli altar nè i voti,
 Ma di Psiche devoti
 A lei sola si danno, ella gl' invola;

Dunque, se mai di me ti calse o cale,
 Figlio, l' armi tue prendi,
 E questa folle accendi
 Di vilissimo amor d' uomo mortale.

Which being finished, and each of her handmaidens having returned
to her own place, while they kept continually throwing down various
delicate and lovely garlands of flowers upon the assembled specta-
tors, the cloud and the car, as if the beautiful guide had satisfied her
desire, were seen to move slowly and to go back towards the heaven;
and when they had arrived there, and the heaven was closed again
in an instant, without a single sign remaining from which one might
have guessed by which part the cloud and so many other things had
come forth and returned, everyone, it appeared, was left all amazed
with a sort of novel and pleasing marvel. But the obedient Cupid,
while that was being done, making a sign, as it were, to his mother
that her command would be fulfilled, and crossing the stage, conti-
nued – with his companions, who were presenting him his arms,
and who, likewise singing, kept in harmony with him – the following
stanza, the last, saying:

Ecco madre, andiam noi; chi l' arco dammi?
 Chi le saette? ond' io
 Con l' alto valor mio
 Tutti i cor vinca, leghi, apra, ed infiammi.

And he, also, as he sang this, kept shooting arrows, many and
various, at those listening to him, whereby he gave reason to believe
that the lovers who were about to perform their parts, stung, as it
were, by them, were giving birth to the comedy about to follow.

SECOND INTERLUDE.

The first act being finished, and Cupid having been taken in
his own snare – at the moment when he thought to take the
lovely Psyche – by reason of her infinite beauty, it became necess-
ary to represent those mysterious voices which, as may be read
in the fable, had been intended by him to serve her; and so there

was seen to issue by one of the four passages that had been left on the stage for the use of the performers, first a little Cupid who was carrying in his arms what seemed to be a graceful swan, with which, since it concealed an excellent bass-viol, while he appeared to be diverting himself with a wand of marsh-grass that served him as a bow, he proceeded to play most sweet airs. After him, four others were seen to come at one and the same moment by the four passages of the stage already described; by one the amorous Zephyr, all merry and smiling, who had wings, garments, and buskins woven of various flowers; by another Music, known by the tuning instrument that she had on the head, by her rich dress covered with her various instruments and with various scrolls wherein were marked all her notes and all her times, and even more because she likewise was seen playing with most sweet harmony upon a great and beautiful lyra-viol; and by the other two, also, Play and Laughter were seen to appear in the form of two little Cupids, playing and laughing. After these, while they were going on their way to their destined places, four other Cupids were seen to issue by the same passages, in the same guise, and at the same time, and to proceed likewise to play most graciously on four most ornate lutes; and after them four other similar little Cupids, two of whom, with fruits in their hands, were seen playing together, and two seemed to be seeking to shoot one another in the breast with their bows and arrows, in a quaint and playful fashion. All these gathered in a graceful circle, and, singing in most harmonious concert the following madrigal, with the lutes and with many other instruments concealed within the scenery accompanying the voices, they appeared to make this whole conception manifest enough, saying:

> O altero miracolo novello!
> > Visto l' abbiam! ma chi sia che cel creda?
> > Ch' amor, d' amor ribello,
> > Di se stesso e di Psiche oggi sia preda?
> > Dunque a Psiche conceda
> > Di beltà pur la palma e di valore
> > Ogn' altra bella, ancor che pel timore
> > Ch' ha del suo prigionier dogliosa stia;
> > Ma seguiam noi l' incominciata via,
> > Andiam Gioco, andiam Riso,
> > Andiam dolce armonia di Paradiso,
> > E facciam che i tormenti
> > Suoi dolci sien co' tuoi dolci concenti.

THIRD INTERLUDE.

Not less festive was the third Interlude, because, as is narrated in the fable, Cupid being occupied with the love of his beautiful Psyche, and not caring any more to kindle the customary flames in the hearts of mortals, and using with others, as others with him, fraud and deceit, it was inevitable that among those same mortals, who were living without love, there should arise at the same time a thousand frauds and a thousand deceits. And therefore it was made to appear that the floor of the stage swelled up, and finally that it was changed into seven little mounds from which there were seen to issue, as things evil and hurtful, first seven Deceits, and then seven others, which could be recognized as such with ease, for the reason that not only the bust of each was all spotted, after the likeness of a leopard, and the thighs and legs like serpents, but their locks were seen all composed of malicious foxes in most fantastic forms and very beautiful attitudes; and in their hands, not without laughter from the bystanders, some were holding traps, some hooks, and others guileful crooks and grapnels, under which had been concealed with singular dexterity some musical serpents, for the sake of the music that they had to make. These, expressing thus the conception described above, after they had first most sweetly sung, and then sung and played, the following madrigal, went with very beautiful order (providing material for the deceptions of the comedy) their several ways along the four above-mentioned passages of the stage:

> S' amor vinto e prigion, posto in oblio
>> L' arco e l' ardente face,
>> Della madre ingannar nuovo desio
>> Lo punge, e s' a lui Psiche inganno face,
>> E se l' empia e fallace
>> Coppia d' invide suore inganno e froda
>> Sol pensa, or chi nel mondo oggi più sia
>> Che' l regno a noi non dia?
>> D' inganni dunque goda
>> Ogni saggio, e se speme altra l' invita
>> Ben la strada ha smarrita.

FOURTH INTERLUDE.

Now, deceits giving rise to affronts, and affronts to dissensions and quarrels and a thousand other suchlike evils, since Cupid, by reason of the hurt received from the cruel lamp, was not able to attend to his customary office of inflaming the hearts of living mortals, in the fourth interlude, in place of the seven mounds that had been shown on the stage the time before, there were seen to appear in this one (to give material for the disturbances of the comedy) seven little abysses, from which there first came a black smoke, and then, little by little, was seen to appear Discord with an ensign in the hand, recognized, besides her arms, by the torn and varied dress and by the tresses, and with her Rage, also recognized, besides the arms, by the buskins in the form of claws, and by the bear's head in place of a helmet, from which poured a constant stream of smoke and flame; and Cruelty, with the great scythe in her hand, known by the helmet in the likeness of a tiger's head and by the buskins after the manner of the feet of a crocodile; and Rapine, also, with the pruning-hook in her hand, with the bird of prey on the helmet, and with the feet in the likeness of an eagle; and Vengeance, with a bloody scimitar in the hand, and with buskins and helmet all woven of vipers; and two Anthropophagi, or Lestrigonians, as we would rather call them, who, sounding two trombones in the form of ordinary trumpets, appeared to be seeking with a certain bellicose movement (besides the sound) to excite the audience of bystanders to combat. Each of these was between two Furies, horrible companions, furnished with drums, whips of iron, and various arms, beneath which with the same dexterity had been hidden various musical instruments. The above-named Furies could be recognized by the wounds wherewith their whole persons were covered, from which were seen pouring flames of fire, by the serpents with which they were all encircled and bound, by the broken chains that hung from their legs and arms, and by the fire and smoke that issued from their hair. And all these, having sung the following madrigal all together with a certain fiery and warlike harmony, performed in the manner of combatants a novel, bold, and most extravagant Moorish dance; at the end of which, running here and there in confusion about the stage, they were seen finally to take themselves in a horrible and fearsome rout out of the sight of the spectators:

In bando itene, vili
 Inganni; il mondo solo ira e furore
 Sent' oggi; audaci voi, spirti gentili,
 Venite a dimostrar vostro valore;
 Che se per la lucerna or langue amore,
 Nostro convien, non che lor sia l' impero.
 Su dunque ogni più fero
 Cor surga; il nostro bellicoso carme
 Guerra, guerra sol grida, e solo arm', arme.

Fifth Interlude.

Poor simple Psyche, having (as has been hinted in the last interlude) injured her beloved spouse with the torch by her rash and eager curiosity, and being abandoned by him, and having finally fallen into the hands of angry Venus, provided most convenient material for the fifth and most sorrowful interlude, accompanying the sadness of the fourth act of the comedy; for it was feigned that she was sent by that same Venus to the infernal Proserpine, whence she should never be able to return among living creatures. And so, wrapped in despair and very sad, she was seen approaching by one of the passages, accompanied by hateful Jealousy, who had an aspect all pallid and afflicted, like her other followers, and was known by the four heads and by the dress of turquoise-blue all interwoven with eyes and ears; by Envy, known likewise by the serpents that she was devouring; by Thought, Care, or Solicitude, whichever we may choose to call her, known by the raven that she had on the head, and by the vulture that was tearing her entrails; and by Scorn, or Disdain (to make it a woman's name), who could be recognized not only by the owl that she had on the head, but also by the ill-made, ill-fitting and tattered dress. When these four, beating and goading her, had made their way near the middle of the stage, in an instant the ground opened in four places with fire and smoke, and they, as if they sought to defend themselves, seized hold of four most horrible serpents that were seen without any warning to issue from below, and struck them a thousand different blows with their thorny staves, under which were concealed four little bows, until in the end, after much terror in the bystanders, it appeared that the serpents had been torn open by them; and then, striking

again in the blood-stained bellies and entrails, all at once there was heard to issue – Psyche singing the while the madrigal given below – a mournful but most delicate and sweet harmony; for in the serpents were concealed with singular artifice four excellent bass-viols, which, accompanying (together with four trombones that sounded behind the stage) the single plaintive and gracious voice of Psyche, produced an effect at once so sad and so sweet, that there were seen drawn from the eyes of more than one person tears that were not feigned. Which finished, and each figure having taken her serpent on her shoulders, there was seen, with no less terror among the spectators, a new and very large opening appearing in the floor, from which issued a thick and continuous stream of flame and smoke, and an awful barking was heard, and there was seen to issue from the hole the infernal Cerberus with his three heads, to whom, in accordance with the fable, Psyche was seen to throw one of the two flat cakes that she had in her hand; and shortly afterwards there was seen likewise to appear, together with various monsters, old Charon with his customary barque, into which the despairing Psyche having entered, the four tormentors described above kept her unwelcome and displeasing company.

> Fuggi, speme mia, fuggi,
> E fuggi per non far più mai ritorno;
> Sola tu, che distruggi
> Ogni mia pace, a far vienne soggiorno,
> Invidia, Gelosia, Pensiero e Scorno
> Meco nel cieco Inferno
> Ove l' aspro martir mio viva eterno.

Last Interlude.

The sixth and last interlude was all joyous, for the reason that, the comedy being finished, there was seen to issue in an instant from the floor of the stage a verdant mound all adorned with laurels and different flowers, which, having on the summit the winged horse Pegasus, was soon recognized to be the Mount of Helicon, from which were seen descending one by one that most pleasing company of little Cupids already described, and with them Zephyr, Music, and Cupid, all joining hands, and Psyche also, all joyful and merry now that she was safe returned from

Hell, and that by the prayers of her husband Cupid, at the inter-
cession of Jove, after such mighty wrath in Venus, there had been
won for her grace and pardon. With these were Pan and nine
other Satyrs, with various pastoral instruments in their hands,
under which other musical instruments were concealed; and all
descending from the mound described above, they were seen
bringing with them Hymen, God of nuptials, in whose praise they
sang and played, as in the following canzonets, and performed in
the second a novel, most merry and most graceful dance, giving
a gracious conclusion to the festival:

> Dal bel monte Elicona
> Ecco Imeneo che scende,
> E già la face accende, e s' incorona;
> Di persa s' incorona,
> Odorata e soave,
> Onde il mondo ogni grave cura scaccia.
> Dunque e tu, Psiche, scaccia
> L' aspra tua fera doglia,
> E sol gioia s' accoglia entro al tuo seno.
> Amor dentro al suo seno
> Pur lieto albergo datti,
> E con mille dolci atti ti consola.
> Nè men Giove consola
> Il tuo passato pianto,
> Ma con riso e con canto al Ciel ti chiede.
> Imeneo dunque ognun chiede,
> Imeneo vago ed adorno,
> Deh che lieto e chiaro giorno,
> Imeneo, teco oggi riede!
> Imeneo, per l' alma e diva
> Sua Giovanna ogn' or si sente
> Del gran Ren ciascuna riva
> Risonar soavemente;
> E non men l' Arno lucente
> Pel gratioso, inclito e pio
> Suo Francesco aver desio
> D' Imeneo lodar si vede.
> Imeneo ecc.
> Flora lieta, Arno beato,
> Arno umil, Flora cortese,
> Deh qual più felice stato
> Mai si vide, mai s' intese?
> Fortunato almo paese,

Terra in Ciel gradita e cara,
A cui coppia così rara
Imeneo benigno diede.
 Imeneo ecc.
Lauri or dunque, olive e palme
E corone e scettri e regni
Per le due sì felici alme,
Flora, in te sol si disegni;
Tutti i vili atti ed indegni
Lungi stien; sol pace vera
E diletto e primavera
Abbia in te perpetua sede.

And all the rich vestments and all the other things, which one might think it impossible to make, were executed by the ingenious craftsmen with such dexterity, loveliness and grace, and made to appear so natural, real, and true, that it seemed that without a doubt the real action could surpass the counterfeited spectacle by but a little.

Of the Triumph of Dreams and Other Festivities.

Now after this, although every square and every street, as has been told, resounded with music and song, merriment and festivity, our magnanimous Lords, distributing everything most prudently, to the end that excessive abundance might not produce excessive satiety, had ordained that one of the principal festivals should be performed on each Sunday, and for this reason, and for the greater convenience of the spectators, they had caused the sides of the most beautiful squares of S. Croce and S. Maria Novella to be furnished after the likeness of a theatre, with very strong and very capacious tribunes. And since within these there were held games, in which the young noblemen played a greater part by their exercises than did our craftsmen by attiring them, I shall treat of them briefly, saying that on one occasion there was presented therein by our most liberal Lords, with six companies of most elegant cavaliers, eight to a company, the play of the canes and the carousel, so celebrated among the Spaniards, each of the companies, which were all resplendent in cloth of gold and silver, being distinguished from the rest, one

in the ancient habit of the Castilians, another in the Portuguese, another in the Moorish, a fourth in the Hungarian, a fifth in the Greek, and the last in the Tartar; and finally, after a perilous combat, partly with assegais and horses likewise in the Spanish manner, and partly with men on foot and dogs, some most ferocious bulls were killed. Another time, renewing the ancient pomp of the Roman chase, there was seen a beautifully ordered spectacle of certain elegant huntsmen and a good quantity of various dogs, chasing forth from a little counterfeited wood and slaying an innumerable multitude of animals, which came out in succession one kind after another, first rabbits, hares, roebucks, foxes, porcupines, and badgers, and then stags, boars, and bears, and even some savage horses all burning with love; and in the end, as the most noble and most superb chase of all, after they had sought several times by means of an immense turtle and a vast and most hideous mask of a monster, which were full of men and were made to move hither and thither with various wheels, to incite a most fierce lion to do battle with a very valiant bull; finally, since that could not be achieved, both the animals were seen struck down and slain, not without a long and bloody struggle, by the multitude of dogs and huntsmen. Besides this, every evening the noble youth of the city exercised themselves with most elegant dexterity and valour, according to their custom, at the game of football, the peculiar and particular sport of that people, with which finally there was given on one of those Sundays one of the most agreeable and most graceful spectacles that anyone could ever behold, in very rich costumes of cloth of gold in red and green colours, with all the rules, which are many and beautiful.

But since variety seems generally to enhance the pleasure of most things, another time the illustrious Prince sought with a different show to satisfy the expectant people by means of his so much desired Triumph of Dreams. The invention of this, although, since he went to Germany to see his exalted bride and to do reverence to the most august Emperor Maximilian and to his other illustrious kinsmen, it was arranged and composed by others with great learning and diligence, may yet be said to have been born in the beginning from his most noble genius, so competent in no matter how subtle and exacting a task; and with it he who afterwards executed the work, and was the composer of the song, sought to demonstrate that moral opinion expressed by Dante when he says that innumerable errors arise among living

mortals because many are set to do many things for which they do not seem to have been born fitted by nature, deviating, on the other hand, from those for which, following their natural inclination, they might be very well adapted. This he also strove to demonstrate with five companies of masks led by five of those human desires that were considered by him the greatest; by Love, namely, behind whom followed the lovers; by Beauty, figured under the form of Narcissus, and followed by those who strive too much to appear beautiful; by Fame, who had as followers those too hungry for glory; by Pluto, signifying Riches, behind whom were seen those eager and greedy for them, and by Bellona, who was followed by the men enamoured of war; contriving that the sixth company, which comprised all the five described above, and to which he wished that they should all be referred, should be guided by Madness, likewise with a good number of her followers behind her, signifying that he who sinks himself too deep and against the inclination of Nature in the above-named desires, which are in truth dreams and spectres, comes in the end to be seized and bound by Madness. And then this judgment, turning, as a thing of feast and carnival, to the amorous, announces to young women that the great father Sleep is come with all his ministers and companions in order to show to them with his matutinal dreams, which are reputed as true (comprised, as has been told, in the first five companies), that all the above-named things that are done by us against Nature, are to be considered, as has been said, as dreams and spectres; and therefore, exhorting them to pursue that to which their nature inclines them, it appears that in the end he wishes, as it were, to conclude that if they feel themselves by nature inclined to be loved, they should not seek to abstain from that natural desire; nay, despising any other counsel as something vain and mad, they should dispose themselves to follow the wise, natural, and true. And then, around the Car of Sleep and the masks that were to express this conception, were accommodated and placed as ornaments those things that are judged to be in keeping with sleep and with dreams. There was seen, therefore, after two most beautiful Sirens, who, blowing two great trumpets in place of two trumpeters, preceded all the rest, and after two extravagant masks, the guides of all the others, by which, mingling white, yellow, red, and black over their cloth of silver, were demonstrated the four humours of which bodies are composed, and after the bearer of a large red

ensign adorned with various poppies, on which was painted a great gryphon, with three verses that encircled it, saying:

Non solo aquila è questo, e non leone,
Ma l' uno e l' altro; così 'l Sonno ancora
Ed humana e divina ha condizione.

There was seen coming, I say, as has been told above, the joyous Love, figured as is customary, and accompanied on one side by ever-verdant Hope, who had a chameleon on the head, and on the other by pallid Fear, with the head likewise adorned by a timorous deer; and he was seen followed by the lovers, his captives and slaves, dressed for the most part with infinite grace and richness in draperies of flaming gold, for the flames wherewith they are ever burning, and all girt and bound with most delicate gilded chains. After these (to avoid excessive minuteness) there was seen coming, to represent Beauty, in a graceful habit of turquoise-blue all interwoven with his own flowers, the beautiful Narcissus, likewise accompanied, as was said of Love, on one side by Youth adorned with flowers and garlands, and dressed all in white, and on the other by Proportion, adorned with draperies of turquoise-blue, and recognized by the spectators by an equilateral triangle that was upon the head. After these were seen those who seek to be esteemed for the sake of their beauty, and who appeared to be following their guide Narcissus; and they, also, were of an aspect youthful and gracious, and had the same narcissus-blooms most beautifully embroidered upon the cloth of silver wherein they were robed, with their blonde and curly locks all crowned in lovely fashion with the same flowers. And after them was seen approaching Fame, who seemed to be sounding a great trumpet that had three mouths, with a globe on her head that represented the world, and with immense wings of peacock's feathers; having in her company Glory, who had a head-dress fashioned likewise of a peacock, and Reward, who in like manner carried a crowned eagle on the head; and her followers, who were divided into three companies, Emperors, Kings, and Dukes, although they were all dressed in gold with the richest embroideries and pearls, and although they all presented an aspect of singular grandeur and majesty, nevertheless were distinguished very clearly one from another by the forms of the different crowns that they wore on their heads, each in accord with his rank. Then the blind Pluto, the God (as has been told) of Riches, who followed after

these with rods of gold and silver in the hands, was seen, like the others, accompanied on either side by Avarice dressed in yellow, with a she-wolf on the head, and by Rapacity robed in red draperies, who had a falcon on the head to make her known; but it would be a difficult thing to seek to describe the quantity of gold, pearls, and other precious gems, and the various kinds of draperies with which his followers were covered and adorned. And Bellona, Goddess of War, most richly robed in many parts with cloth of silver in place of arms, and crowned with a garland of verdant laurel, with all the rest of her habit composed in a thousand rich and gracious ways, was seen likewise coming after them with a large and warlike horn in the hand, and accompanied, like the others, by Terror, known by the cuckoo in the head-dress, and by Boldness, also known by the lion's head worn in place of a cap; and with her the military men in her train were seen following her in like manner with swords and iron-shod maces in their hands, and draperies of gold and silver arranged most fancifully in the likeness of armour and helmets. These and all the others in the other companies had each, to demonstrate that they represented dreams, a large, winged, and very well fashioned bat of grey cloth of silver fitted on the shoulders, and forming a sort of little mantle; which, besides the necessary significance, gave to all the companies (which, as has been shown, were all different) the necessary unity, and also grace and beauty beyond measure. And all this left in the minds of the spectators a firm belief that there had never been seen in Florence, and perhaps elsewhere, any spectacle so rich, so gracious, and so beautiful; for, in addition to all the gold, the pearls, and the other most precious gems wherewith the embroideries, which were very fine, were made, all the dresses were executed with such diligence, design, and grace, that they seemed to be costumes fashioned not for masquerades, but enduring and permanent, and worthy to be used only by great Princes.

There followed Madness, the men of whose company alone, for the reason that she had to be shown not as a dream but as real in those who sought against the inclination of nature to pursue the things described above, were seen without the bat upon the shoulders; and she was dressed in various colours, but all put together most inharmoniously and without any manner of grace, while upon her dishevelled tresses, to demonstrate her disordered thoughts, were seen a pair of gilded spurs with the

rowels turned upwards, and on either side of her were a Satyr and a Bacchante. Her followers, then, in the semblance of lunatics and drunkards, were seen dressed most extravagantly in cloth of gold, embroidered with varied boughs of ivy and vine-leaves with their little bunches of ripe grapes. And these and all the others in the companies already described, besides a good number of grooms, likewise very richly and ingeniously dressed according to the company wherein they were serving, had horses of different colours distributed among them, a particular colour to each company, so that one had dappled horses, another sorrel, a third black, a fourth peach-coloured, another bay, and yet another of a varied coat, according as the invention required. And to the end that the above-described masques, which were composed almost entirely of the most noble lords, might not be constrained to carry the customary torches at night, forty-eight different witches – who during the day preceded in most beautiful order all those six companies, guided by Mercury and Diana, who had each three heads to signify their three powers; being themselves also divided into six companies, and each particular company being ruled by two dishevelled and barefooted priestesses – when night came, went in due order on either side of the particular company of dreams to which they were assigned, and, with the lighted torches which they and the grooms bore, rendered it abundantly luminous and clear. These witches, besides their different faces, all old and hideous, and besides the different colours of the rich draperies wherewith they were clothed, were known in particular, and one company distinguished from another, by the animals that they had upon their heads, into the shapes of which, so men say and believe, they transform themselves often by their incantations; for some had upon the cloth of silver that served as kerchief for their heads a black bird, with wings and claws outspread, and with two little phials about the head, signifying their maleficent distillations; and some had cats, others black and white dogs, and others, by their false blonde tresses and by the natural white hair that could be seen, as it were against their will, beneath them, betrayed their vain desire to appear young and beautiful to their lovers.

The immense car, drawn by six large and shaggy bears crowned with poppies, which came at the end after all that lovely train, was without a doubt the richest, the most imposing, and the most masterly in execution that has ever been seen for a long

time back. That car was guided by Silence, a figure adorned with grey draperies and with the customary shoes of felt upon the feet, who, placing a finger on the mouth, appeared to be making sign to the spectators that they should be silent; and with him were three women, representing Quiet, plump and full in countenance, and dressed in rich robes of azure-blue, and each with a tortoise upon the head, who appeared to be seeking to assist that same Silence to guide those bears. The car itself, resting upon a graceful hexagonal platform, was shaped in the form of a vast head of an elephant, within which, also, there was represented as the house of Sleep a fantastic cavern, wherein the great father Sleep was likewise seen lying at his ease, fat and ruddy, and partly nude, with a garland of poppies, and with his cheek resting upon one of his arms; having about him Morpheus, Icelus, Phantasus, and his other sons, figured in various extravagant and bizarre forms. At the summit of the same cavern was seen the white, luminous, and beautiful Dawn, with her blonde tresses all soft and moist with dew; and at the foot of the cavern, with a badger that served her for a pillow, was dark Night, who, being held to be the mother of true dreams, was thought likely to lend no little faith to the words of the dreams described above. For the adornment of the car, then, were seen some most lovely little stories, accommodated to the invention and distributed with so much diligence, delicacy, and grace, that it appeared impossible for anything more to be desired. In the first of these was seen Bacchus, the father of Sleep, upon a car wreathed in vine-leaves and drawn by two spotted tigers, with a verse to make him known, which said:

Bacco, del Sonno sei tu vero padre.

Even as in another was seen Ceres, the mother of the same Sleep, crowned with the customary ears of corn, and likewise with a verse placed there for the same reason, which said:

Cerer del dolce Sonno è dolce madre.

And in a third was seen Pasithea, wife of the same Sleep, who, seeming to fly over the earth, appeared to have infused most placid sleep in the animals that were dispersed among the trees and upon the earth; likewise with her motto which made her known, saying:

Sposa del Sonno questa è Pasitea.

On the other side was seen Mercury, president of Sleep, infusing slumber in the many-eyed Argus; also with his motto, saying:

Creare il sonno può Mercurio ancora.

And there was seen, to express the nobility and divinity of the same Sleep, an ornate little temple of Æsculapius, in which many men, emaciated and infirm, sleeping, appeared to be winning back their lost health; likewise with a verse signifying this, and saying:

Rende gl' uomini sani il dolce Sonno.

Even as in another place there was seen Mercury pointing towards some Dreams that were shown flying through the air and speaking in the ears of King Latinus, who was asleep in a cave; his verse saying:

Spesso in sogno parlar lece con Dio.

Orestes, then, spurred by the Furies, was seen alone taking some rest amid such travail by the help of the Dreams, who were shown driving away those Furies with certain bunches of poppies; with his verse that said:

Fuggon pel sonno i più crudi pensieri.

And there was the wretched Hecuba likewise dreaming in a vision that a lovely hind was rapt from her bosom and strangled by a fierce wolf; this being intended to signify the piteous fate that afterwards befell her hapless daughter; with a motto saying:

Quel ch'esser deve, il sogno scuopre e dice.

Even as in another place, with a verse that said:

Fanno gli Dei saper lor voglie in sogno,

there was seen Nestor appearing to Agamemnon, and revealing to him the will of almighty Jove. And in the seventh and last was depicted the ancient usage of making sacrifice, as to a revered deity, to Sleep in company with the Muses, represented by an animal sacrificed upon an altar; with a verse saying:

Fan sacrifizio al Sonno ed alle Muse.

All these little scenes were divided and upheld by various Satyrs, Bacchants, boys, and witches, and rendered pleasingly joyous and

ornate by divers nocturnal animals and festoons of poppies, not without a beautiful medallion set in place of a shield in the last part of the car, wherein was seen painted the story of Endymion and the Moon; everything, as has been said, being executed with such delicacy and grace, patience and design, that it would entail too much work to seek to describe every least part with its due praise. But those of whom it has been told that they were placed as the children of Sleep in such extravagant costumes upon the above-described car, singing to the favourite airs of the city the following canzonet, seemed truly, with their soft and marvellous harmony, to be seeking to infuse a most gracious and sweet sleep in their hearers, saying:

> Or che la rugiadosa
>> Alba la rondinella a pianger chiama,
>> Questi che tanto v' ama,
>> Sonno, gran padre nostro e dell' ombrosa
>> Notte figlio, pietosa
>> E sacra schiera noi
>> Di Sogni, o belle donne, mostra a voi;
> Perchè il folle pensiero
>> Uman si scorga, che seguendo fiso
>> Amor, Fama, Narciso
>> E Bellona e Ricchezza il van sentiero
>> La notte e il giorno intero
>> S' aggira, al fine insieme
>> Per frutto ha la Pazzia del suo bel seme.
> Accorte or dunque, il vostro
>> Tempo miglior spendete in ciò che chiede
>> Natura, e non mai fede
>> Aggiate all' arte, che quasi aspro mostro
>> Cinto di perle e d' ostro
>> Dolce v' invita, e pure
>> Son le promesse Sogni e Larve scure.

Of the Castle.

By way of having yet another different spectacle, there was built with singular mastery on the vast Piazza di S. Maria Novella a most beautiful castle, with all the proper appurtenances of ramparts, cavaliers, casemates, curtains, ditches and counterditches, secret and public gates, and, finally, all those considerations that are required in good and strong fortifications; and in it was placed

a good number of valorous soldiers, with one of the principal and most noble lords of the Court as their captain, a man determined on no account ever to be captured. That magnificent spectacle being divided into two days, on the first day there was seen appearing in most beautiful order from one side a fine and most ornate squadron of horsemen all in armour and in battle-array, as if about to meet real enemies in combat, and from the other side, with the aspect of a massive and well-ordered army, some companies of infantry with their baggage, waggons of munitions, and artillery, and with their pioneers and sutlers, all drawn close together, as is customary amid the dangers of real wars; these likewise having a similar lord of great experience and valour as captain, who was seen urging them on from every side, and fulfilling his office most nobly. And after the attackers had been reconnoitred several times and in various ways, with valour and artifice, by those within the castle, and various skirmishes had been fought, now by the horsemen and now by the infantry, with a great roar of musketry and artillery, and charges had been delivered and received, and several ambuscades and other suchlike stratagems of war had been planned with astuteness and ingenuity; finally the defenders were seen, as if overcome by the superior force, to begin little by little to retire, and in the end it seemed that they were constrained to shut themselves up completely within the castle. But the second day, after they had, as it were during the night, constructed their platforms and gabionade and planted their artillery, there was seen to begin a most terrible bombardment, which seemed little by little to throw a part of the walls to the ground; after which, and after the explosion of a mine, which in another part, in order to keep the attention of the defenders occupied, appeared to have made a passing wide breach in the wall, the places were reconnoitred and the cavalry drew up in most beautiful battle-array, and then was seen now one company moving up, and now another, some with ladders and some without, and many valorous and terrible assaults delivered in succession and repeated several times, and ever received by the others with skill, boldness, and obstinacy, until in the end it was seen that the defenders, weary, but not vanquished, made an honourable compact with the attackers to surrender the place to them, issuing from it, with marvellous satisfaction for the spectators, in military order, with their banners unfurled, their drums, and all their usual baggage.

The Genealogy of the Gods.

We read of Paulus Emilius, that first captain of his illustrious age, that he caused no less marvel by his wisdom and worth to the people of Greece and of many other nations who had assembled in Amphipolis to celebrate various most noble spectacles there after the victory that he had won, than by the circumstance that first, vanquishing Perseus and subjugating Macedonia, he had borne himself valiantly in the management of that war, which was in no small measure laborious and difficult; he having been wont to say that it is scarcely less the office of a good captain, requiring no less order and no less wisdom, to know how to prepare a banquet well in time of peace, than to know how to marshal an army for a deed of arms in time of war. Wherefore if our glorious Duke, born to do everything with noble worth and grandeur, displayed the same wisdom and the same order in those spectacles, and, above all, in that one which I am about to describe, I believe that he will not take it amiss that I have been unwilling to refrain from saying that he was in every part its inventor and ordinator, and in a certain sense its executor, preparing all the various things, and then representing them, with so much order, tranquillity, wisdom, and magnificence, that among his many glorious actions this one also may be numbered to his supreme glory.

Now, yielding to him who wrote of it in those days with infinite learning, before me, and referring to that work those who may seek curiously to see how every least thing in this masquerade, which had as title the Genealogy of the Gods, was figured with the authority of excellent writers, and passing over whatever I may judge to be superfluous in this place, let me say that even as we read that some of the ancient Gods were invited to the nuptials of Peleus and Thetis in order to render them auspicious and fortunate, so to the nuptials of this new and most excellent bridal pair it appeared that there had come for the same reason not some only of these same Gods, but all, and not invited, but seeking to introduce themselves and by their own wish, the good auguring them the same felicity and contentment, and the harmful assuring them that they would do them no harm. Which conception appeared gracefully expressed in the following fashion by four madrigals that were sung at various times in the

principal places by four very full choirs, even as has been told of the Triumph of Dreams; saying:

> L' alta che fino al ciel fama rimbomba
> Della leggiadra Sposa,
> Che in questa riva erbosa
> D' Arno, candida e pura, alma colomba
> Oggi lieta sen vola e dolce posa,
> Dalla celeste sede ha noi qui tratti,
> Perchè più leggiadri atti
> E bellezza più vaga e più felice
> Veder già mai non lice.

> Nè pur la tua festosa
> Vista, o Flora, e le belle alme tue dive
> Traggionne alle tue rive,
> Ma il lume e 'l sol della novella Sposa,
> Che più che mai gioiosa
> Di suo bel seggio e freno
> Al gran Tosco divin corcasi in seno.

> Da' bei lidi, che mai caldo nè gielo
> Discolora, vegnam; nè vi crediate
> Ch' altrettante beate
> Schiere e sante non abbia il Mondo e il Cielo;
> Ma vostro terren velo
> E lor soverchio lume,
> Questo e quel vi contende amico nume.

> Ha quanti il Cielo, ha quanti
> Iddii la Terra e l' Onda al parer vostro;
> Ma Dio solo è quell' un che il sommo chiostro
> Alberga in mezzo a mille Angeli santi,
> A cui sol giunte avanti
> Posan le pellegrine
> E stanche anime al fine, al fin del giorno,
> Tutto allegrando il Ciel del suo ritorno.

I believe I can affirm most surely that this masquerade – a spectacle only to be arranged by the hand of a wise, well-practised, great, and valiant Prince, and in which almost all the lords and gentlemen of the city, and many strangers, took part – was without a doubt the greatest, the most magnificent, and the most splendid which can be remembered to have been held in any place for many centuries down to our own times, for the greater part of the vestments were not only made of cloth of gold and silver and other very rich draperies, and, when the place

required it, of the finest skins, but, what is more (art surpassing the materials), composed with rare and marvellous industry, invention, and loveliness; and to the end that the eyes of the spectators, as they gazed, might be able with greater satisfaction to recognize one by one which of the Gods it was intended to represent, it was thought expedient to proceed to divide them into twenty-one distinct companies, placing at the head of each company one that should be considered as the chief, and causing each of these, for greater magnificence and grandeur, and because they are so figured by the ancient poets, to be drawn upon appropriate cars by their appropriate and particular animals. Now in these cars, which were beautiful, fantastic, and bizarre beyond belief, and most splendid with silver and gold, and in representing as real and natural the above-named animals that drew them, without a doubt the dexterity and excellence of the ingenious craftsmen were such, that not only they surpassed all things done up to that time both within and without the city, which at all times has had a reputation for rare mastery in such things, but they also (infinite marvel!) took away from everyone all hope of ever being able to see another thing so heroic or so lifelike. Beginning, then, with those Gods who were such that they were reputed to be the first causes and the first fathers of the others, we will proceed to describe each of the cars and of the companies that preceded them. And since the representation was of the Genealogy of the Gods, making a beginning with Demogorgon, the first father of them all, and with his car, we have to say that after a graceful, lovely, and laurel-crowned Shepherd, representing the ancient poet Hesiod, who, singing of the Gods in his Theogony, first wrote their genealogy, and who, as guide, carried in his hand a large, square, and ancient ensign, wherein were depicted in divers colours Heaven and the four Elements, and in the centre was painted a large Greek O, crossed with a serpent that had the head of a hawk; and after eight trumpeters who were gesticulating in a thousand graceful and sportive ways, representing those tibicines who, having been prevented from eating in the temple, fled in anger to Tibur, but were made drunk and put to sleep by deceit, and brought back with many privileges to Rome; beginning, I say, with Demogorgon, there was seen his car in the form of a dark and double cavern drawn by two awful dragons, and for Demogorgon was seen a figure of a pallid old man with the hair ruffled, all wrapped in mist and dark fog, lying

in utter sloth and negligence in the front part of the cavern, and accompanied on one side by youthful Eternity adorned (because she never grows old) with verdant draperies, and on the other side by Chaos, who had the appearance, as it were, of a mass without any shape. Beyond that cavern, which contained the three figures described, rose a graceful little mound all covered and adorned with trees and various plants, representing Mother Earth, at the back of which was seen another cavern, but darker and deeper than that already described, wherein Erebus was shown likewise lying in the guise that has been told of his father Demogorgon, and in like manner accompanied on one side by Night, the daughter of Earth, with two children in her arms, one white and the other dark, and on the other side by Æther, the child of the aforesaid Night and Erebus, who must be figured, so it appeared, as a resplendent youth with a ball of turquoise-blue in the hand. At the foot of the car, then, was seen riding Discord, who separates things confused and is therefore held by philosophers to preserve the world, and who is regarded as the first daughter of Demogorgon; and with her the three Fates, who were shown spinning various threads and then cutting them. And in the form of a youth all robed in draperies of turquoise-blue was seen Polus, who had a terrestrial globe in the hand, and over him, alluding to the fable that is related of him, many sparks appeared to have been scattered from a vase of glowing coals that was beneath him; and there was seen Python, also the son of Demogorgon, all yellow and with a mass of fire in the hand, who seemed to have come in the company of his brother Polus. After them, then, came Envy, the daughter of Erebus and Night, and with her Timidity, her brother, in the form of a pallid and trembling old man, who had the head-dress and all the other vestments made from skins of the timid deer. And after these was seen Obstinacy, who is born from the same seed, all in black, with some boughs of ivy that seemed to have taken root upon her; and with the great cube of lead that she had on the head she gave a sign of that Ignorance wherewith Obstinacy is said to be joined. She had in her company Poverty, her sister, who was seen all pale and raging, and negligently covered rather than clothed in black; and with them was Hunger, born likewise from the same father, who was seen feeding the while on roots and wild herbs. Then Complaint or Querulousness, their sister, covered with tawny draperies, and with the querulous solitary rock-thrush,

which was seen to have made her nest in her head-dress, was shown walking in profound melancholy after them, having in her company the sister common to them, called Infirmity, who by her meagreness and pallor, and by the garland and the little stalk of anemone that she held in her hand, made herself very well known to the spectators for what she was. And on her other side was the other sister, Old Age, with white hair and all draped in simple black vestments, who likewise had, not without reason, a stalk of cress in the hand. The Hydra and the Sphinx, daughters of Tartarus, in the guise wherein they are generally figured, were seen coming behind them in the same beautiful order; and after these, to return to the other daughters of Erebus and Night, was seen License, all nude and dishevelled, with a garland of vine-leaves on the head, and keeping the mouth open without any restraint, and in her company was Falsehood, her sister, all covered and wrapped in various draperies of various colours, with a magpie on the head for better recognition, and with a cuttle-fish in the hand. These had Thought walking on a level with them, represented as an old man, likewise all dressed in black, with an extravagant head-dress of peach-stones on the head, and showing beneath the vestments, which at times fluttered open with the wind, the breast and the whole person pricked and pierced by a thousand sharp thorns. Momus, then, the God of censure and of evil-speaking, was seen coming after them in the form of a bent and very loquacious old man; and with them, also, the boy Tages, all resplendent, although he was the son of Earth, figured in such a manner because he was the first inventor of the soothsayer's art, in token of which there was hung from his neck a lamb split down the middle, which showed a good part of the entrails. There was seen, likewise, in the form of an immense giant, the African Antæus, his brother, who, clothed in barbaric vestments, with a dart in the right hand, appeared to wish to give on that day manifest signs of his vaunted prowess. And following after him was seen Day, also the son of Erebus and Night, represented in like manner as a resplendent and joyous youth, all adorned with white draperies and crowned with ornithogal, in whose company was seen Fatigue, his sister, who, clothed in the skin of an ass, had made herself a cap from the head of the same animal, with the ears standing erect, not without laughter among the spectators; to which were added two wings of the crane, and in her hands were placed also the legs of the

same crane, because of the common opinion that this renders
men indefatigable against all fatigue. And Jurament, born of the
same parents, in the form of an old priest all terrified by an
avenging Jove that he held in the hand, and bringing to conclu-
sion the band attributed to the great father Demogorgon, was the
last in their company.

And here, judging that with these deities the origins of all the
other Gods had been made sufficiently manifest, the followers of
the first car were brought to an end.

SECOND CAR, OF HEAVEN.

In a second car of more pleasing appearance, which was dedi-
cated to the God Heaven, held by some to be the son of the
above-named Æther and Day, was seen that jocund and youthful
God clothed in bright-shining stars, with a crown of sapphires on
the brow, and with a vase in the hand that contained a burning
flame, and seated upon a ball of turquoise-blue all painted and
adorned with the forty-eight celestial signs; and in that car, which
was drawn by the Great and the Little Bear, the one known by
the seven and the other by the twenty-one stars with which they
were all dotted, there were seen painted, in order to render it
ornate and rich in pomp, with a most beautiful manner and a
graceful distribution, seven of the fables of that same Heaven. In
the first was figured his birth – in order to demonstrate, not
without reason, the other opinion that is held of it – which is said
to have been from Earth; even as in the second was seen his
union with the same Mother Earth, from which were born,
besides many others, Cottus, Briareus, and Gyges, who, it is be-
lieved, had each a hundred hands and fifty heads; and there were
born also the Cyclopes, so called from the single eye that they
had on the brow. In the third was seen how he imprisoned their
common children in the caverns of that same Earth, that they
might never be able to see the light; even as in the fourth their
Mother Earth, seeking to deliver them from such oppression, was
seen exhorting them to take a rightful vengeance on their cruel
father; wherefore in the fifth his genital members were cut off by
Saturn, when from their blood on one side it appeared that the
Furies and the Giants were born, and on the other, from the
foam that was shown fallen into the sea, was seen a different

birth, from which sprang the beautiful Venus. In the sixth was seen expressed the anger that he showed against the Titans, because, as has been told, they had allowed his genitals to be cut off; and in the seventh and last, likewise, was seen the same God adored by the Atlantides, with temples and altars devoutly raised to him. Now at the foot of the car (as with the other already described) was seen riding the black, old, and blindfolded Atlas, who has been reputed to have supported Heaven with his stout shoulders, on which account there had been placed in his hands a great globe of turquoise-blue, dotted with stars. After him was seen walking in the graceful habit of a huntsman the young and beautiful Hyas, his son, in whose company were his seven sisters, also called Hyades, five of whom, all resplendent in gold, were seen to have each on the head a bull's head, for the reason that they are said to form an ornament to the head of the Heavenly Bull; and the two others, as being less bright in the heavens, it was thought proper to clothe in grey cloth of silver. After these followed the seven Pleiades, daughters of the same Atlas, figured as seven other similar stars; one of whom, for the reason that she shines with little light in the heavens, it was thought right and proper to adorn only with the same grey cloth, whereas the six others, because they are resplendent and very bright, were seen in front glittering and flashing with an infinite abundance of gold, but at the back they were clothed only in vestments of pure white, that being intended to signify that even as at their first appearance the bright and luminous summer seems to have its beginning, so at their departure it is seen that they leave us dark and snowy winter; which was also expressed by the head-dress, which had the front part woven of various ears of corn, even as the back appeared to be composed of snow, ice, and hoar-frost. There followed after these the old and monstrous Titan, who had with him the proud and audacious Iapetus, his son. And Prometheus, who was born of Iapetus, was seen coming after them all grave and venerable, with a little statue of clay in one of his hands, and in the other a burning torch, denoting the fire that he is said to have stolen from Jove out of Heaven itself. And after him, as the last, to conclude the company of the second car, there were seen coming, with a Moorish habit and with a sacred elephant's head as a cap, likewise two of the Atlantides, who, as has been told, first adored Heaven; and, in addition, in token of the things that were used by them in their first sacrifices, there were

in the hands of both, in a great bundle, the ladle, the napkin, the cleaver, and the casket of incense.

THIRD CAR, OF SATURN.

Saturn, the son of Heaven, all white and old, who was shown greedily devouring some children, had the third car, no less ornate than the last, and drawn by two great black oxen; and to enhance the beauty of that car, even as in the last there were seven fables painted, so in that one it was thought proper that five of his fables should be painted. For the first, therefore, was seen this God surprised by his wife Ops as he lay taking his pleasure of the gracious and beautiful Nymph Philyra, on which account being constrained to transform himself into a horse in order not to be recognized by her, it was shown how from that union there was born afterwards the Centaur Cheiron. Even as in the second was seen his other union with the Latin Entoria, from which sprang at one and the same birth Janus, Hymnus, Felix, and Faustus, by whom the same Saturn distributed among the human race that so useful invention of planting vines and making wine; and there was seen Janus arriving in Latium and there teaching his father's invention to the ignorant people, who, drinking intemperately of the new and most pleasing liquor, and therefore sinking little by little into a most profound sleep, when finally they awakened, thinking that they had been poisoned by him, were seen rushing impiously to stone and slay him; on which account Saturn, moved to anger, chastised them with a most horrible pestilence; but in the end it was shown how he was pacified and turned to mercy by the humble prayers of the miserable people and by the temple built by them upon the Tarpeian rock. In the third, then, was seen figured how, Saturn seeking cruelly to devour his son Jove, his shrewd wife and compassionate daughters sent to him in Jove's stead the stone, which he brought up again before them, being left thereby in infinite sorrow and bitterness. Even as in the fourth was painted the same fable of which there has been an account in speaking of the above-described car of Heaven – namely, how he cut off the genitals of the above-named Heaven, from which the Giants, the Furies, and Venus had their origin. And in the last, likewise, was seen how, after he was made a prisoner by the Titans, he was

liberated by his compassionate son Jove. And then, to demonstrate the belief that is held by some, that history first began to be written in the time of Saturn, there was seen figured with the authority of an approved writer a Triton blowing a sea-conch, with the double tail as it were fixed in the earth, closing the last part of the car; at the foot of which (as has been told of the others) was seen a pure maiden, representing Pudicity, adorned with green draperies and holding a white ermine in her arms, with a gilded topaz-collar about the neck. She, with the head and face covered with a yellow veil, had in her company Truth, likewise figured in the form of a most beautiful, delicate, and pure young woman, clothed only in a few white and transparent veils; and these, walking in a manner full of grace, had between them the happy Age of Gold, also figured as a pure and gracious virgin, wholly nude, and all crowned and adorned with those first fruits produced by herself from the earth. After them followed Quiet, robed in black draperies, in the aspect of a young but very grave and venerable woman, who had as head-dress a nest composed in a most masterly manner, in which was seen lying an old and featherless stork, and she walked between two black priests, who, crowned with fig-leaves, and each with a branch of the same fig in one hand, and in the other a basin containing a flat cake of flour and honey, seemed to wish to demonstrate thereby that opinion which is held by some, that Saturn was the first discoverer of grain-crops; for which reason the Cyrenæans (and even such were the two black priests) are said to have been wont to offer him sacrifices of those things named above. These were followed by two Roman priests, who appeared likewise to be about to sacrifice to him some waxen images, as it were after the more modern use, since they were seen delivered by means of the example of Hercules, who used similar waxen images, from the impious custom of sacrificing men to Saturn, introduced into Italy by the Pelasgians. These, like the others with Quiet, had likewise between them the venerable Vesta, daughter of Saturn, who, very narrow in the shoulders and very broad and full in the flanks, after the manner of a round ball, and dressed in white, carried a lighted lamp in the hand. And after them, as the last, closing the third company, was seen coming the Centaur Cheiron, the son, as has been told, of Saturn, armed with sword, bow, and quiver; and with him another of the sons of the same Saturn, holding the crooked lituus (for the reason that he was an

augur) in the hand, and all robed in green draperies, with a bird, the woodpecker, on the head, because into such a bird, according as the fables tell, it is believed that he was transformed by Cheiron.

FOURTH CAR, OF THE SUN.

To the resplendent Sun was dedicated the fourth car, all glittering, gilded, and jewelled, which, drawn according to custom by four swift and winged coursers, was seen to have Velocity, with a head-dress of a dolphin and a sail on the head, as charioteer; and in it were painted (as has been told of the others), but with a different distribution, and as pleasing and gracious as could well be imagined, seven of his fables. For the first of these was seen the fate of the too audacious Phaëthon, who contrived so ill to guide that same car, even as for the second was seen the death of the serpent Python, and for the third the chastisement inflicted on the rash Marsyas. In the fourth was seen how the Sun deigned for a time to lead a humble pastoral life, grazing the flocks of Admetus; even as in the fifth was seen how, flying from the fury of Typhœus, he was constrained to change himself into a raven. In the sixth were likewise depicted his other transformations, first into a lion and then into a hawk; and as the last was seen his love received so ill by the timid Daphne, who finally, as is very well known, was changed by the compassion of the Gods into laurel. At the foot of the car, then, were seen riding, all winged and of different ages and colours, the Hours, the handmaids and ministers of the Sun, each of whom, in imitation of the Egyptians, carried a hippopotamus in the hand, and was crowned with flowers of the lupine; and behind them, likewise following the Egyptian custom, in the form of a young man all dressed in white, with two little horns on the head that were turned towards the ground, and with a garland of oriental palm, was seen walking the Month, carrying in the hand a calf which, not without reason, had only one horn. And after him was seen likewise walking the Year, with the head all covered with ice and snow, the arms wreathed in flowers and garlands, and the breast and stomach all adorned with ears of corn, even as the thighs and legs, also, were seen to be all wet and stained with must, while in one hand he carried, as a symbol of his circling course, a circle formed by a serpent that appeared to be seeking to devour the tail with the

mouth, and in the other hand a nail, such as the ancient Romans used, so we read, to keep count of the years in their temples. Then came rosy Aurora, all pleasing, fair, and lissom, with a little yellow mantle, and with an ancient lamp in the hand, seated with most beautiful grace upon the horse Pegasus. In her company was seen the physician Æsculapius, in the habit of a priest, with a knotted stick and a ruddy serpent in the hands, and a dog at his feet; and with them the young Phaëton, also (like Æsculapius) the child of the Sun, who, all burning, to recall the memory of his unhappy fate, appeared to wish to transform himself into even such a swan as he carried in his hand. Orpheus, next, their brother, was seen walking behind them, young and much adorned, but of a presence grave and venerable, with the tiara on his head, and seeming to play a most ornate lyre; and with him was seen the enchantress Circe, likewise the daughter of the Sun, with a band around the head, which was a sign of her sovereignty, and in the habit of a matron, and she was shown holding in the hand, in place of a sceptre, a little branch of larch and another of cedar, with the fumes of which it is said that she used to contrive the greater part of her enchantments. And the nine Muses, walking in gracious order, formed a most beautiful finish to the last part of the lovely company just described; who were seen figured in the forms of most graceful Nymphs, crowned with feathers of the magpie in remembrance of the Sirens vanquished by them, and with feathers of other kinds, and holding various musical instruments in the hands, while among the last of them, who held the most honourable place, was set Memory, mother of the Muses, adorned with rich black draperies, and holding in the hand a little black dog, signifying the marvellous memory which that animal is said to have, and with the head-dress fantastically composed of the most different things, denoting the so many and so different things that the memory is able to retain.

FIFTH CAR, OF JOVE.

The great father of mankind and of the Gods, Jove, the son of Saturn, had the fifth car, ornate and rich in pomp beyond all the others; for, besides the five fables that were seen painted there, as with the others, it was rendered rich and marvellous beyond belief by three statues that served as most imposing

partitions to those fables. By one of these was seen represented the image, such as it is believed to have been, of the young Epaphus, the son of Io and Jove, and by the second that of the lovely Helen, who was born from Leda at one birth with Castor and Pollux; even as by the last was represented that of the grandfather of the sage Ulysses, called Arcesius. For the first of the fables already mentioned was seen Jove transformed into a Bull, conveying the trusting Europa to Crete, even as for the second was seen his perilous rape as he flew to Heaven in the form of an Eagle with the Trojan Ganymede, and for the third his other transformation into fire when he wished to lie with the beautiful Ægina, daughter of Asopus. For the fourth was seen the same Jove, changed into a rain of gold, falling into the lap of his beloved Danaë; and in the fifth and last he was seen delivering his father Saturn, who, as has been told above, was unworthily held prisoner by the Titans. In such and so adorned a car, then, and upon a most beautiful throne composed of various animals and of many gilded Victories, with a little mantle woven of divers animals and plants, the above-named great father Jove was seen seated in infinite majesty, with a garland of leaves similar to those of the common olive, and in the right hand a Victory crowned with a band of white wool, and in the left hand a royal sceptre, at the head of which was shown poised the imperial Eagle. At the foot of the throne, to render it more imposing and pompous, was seen on one side Niobe, with her children, dying by the shafts of Apollo and Diana, and on the other side seven men in combat, who were seen to have in their midst a boy with the head bound with white wool, even as in another place could be seen Hercules and Theseus, who were shown in combat with the famous Amazons. And at the foot of the car, which was drawn by two very large and very naturally figured eagles, there was seen walking (as has been told of the others) Bellerophon adorned with a royal habit and a royal diadem, in allusion to whose fable there was seen over that diadem the Chimera slain by him; having in his company the young Perseus, born from Jove and Danaë, with the usual head of Medusa in his hand, and the usual knife at his flank; and with them was the above-named Epaphus, who had as a cap the head of an African elephant. Hercules, the son of Jove and Alcmena, with the customary lion's skin and the customary club, was seen coming after them; and in his company he had Scythes, his brother (although born from a different

mother), the first inventor of bow and arrows, on which account his hands and his flank were seen furnished with these. After them were seen the two gracious Twins, Castor and Pollux, riding with an air of no less beauty upon two milk-white and spirited coursers, and dressed in military habit; each having upon the helmet, one of which was dotted with eight stars and the other with ten, a brilliant little flame as helmet-crest, in allusion to that salutary light, now called S. Elmo's Fire, which is wont to appear to mariners as a sign that the tempest has passed; the stars being intended to signify how they were placed in Heaven by Jove as the sign of the Twins. Then Justice was seen coming after these, a beautiful maiden, who was beating with a stick and finally strangling a woman ugly and deformed, and in her company were four of the Gods Penates, two male and two female, these demonstrating – although in barbaric and extravagant dress, and although they had on the head a pediment which, with the base turned upwards, supported the heads of a young man and an old – by the gilded chain with a heart attached that they had about the neck, and by their long, ample, and pompous vestments, that they were persons of great weight and of great and lofty counsel; which was done with much reason, seeing that they were reputed by the ancient writers to be the counsellors of Jove. After them were seen walking the two Palici, born of Jove and Thaleia, adorned with draperies of tawny hue, and crowned with various ears of corn, and each with an altar in the hand; and in their company was Iarbas, King of Gætulia, the son of the same Jove, crowned with a white band, and with the head of a lion surmounted by a crocodile as a cap, and his other garments interwoven with leaves of cane and papyrus and various monsters, and with the sceptre and a burning flame of fire in the hands. Behind these were seen coming Xanthus, the Trojan River, likewise the son of Jove, in human form, but all yellow, all nude, and all shorn, with the overflowing vase in his hands, and Sarpedon, King of Lycia, his brother, in a most imposing garb, and in his hand a little mound covered with lions and serpents. And the last part of that great company, concluding the whole, was formed of four armed Curetes, who kept clashing their swords one against another, thus reviving the memory of Mount Ida, where Jove was saved from the voracious Saturn by their means, drowning by the clash of their arms the wailing of the tender babe; among whom, with the last couple, for greater

dignity, as Queen of all the others, winged and without feet, and with much pomp and grandeur, proud Fortune was seen haughtily approaching.

SIXTH CAR, OF MARS.

Mars, the proud and warlike God, covered with brightly-shining armour, had the sixth car, adorned with no little richness and pomp, and drawn by two ferocious wolves very similar to the reality; and therein his wife Neriene and his daughter Evadne, figured in low-relief, served to divide three of his fables, which (as has been told of the other cars) were painted there. For the first of these, he was seen slaying the hapless son of Neptune, Halirrhotius, in vengeance for the violation of Alcippe, and for the second he was seen in most amorous guise lying with Rea Silvia, and begetting by her the two great founders of Rome, Romulus and Remus; even as for the third and last he was seen miserably reduced to captivity (as happens often enough to his followers) in the hands of the impious Otus and Ephialtes. Then before the car, as the first figures, preceding it on horseback, were seen two of his priests, the Salii, with their usual shields, the Ancilia, and clad and adorned with their usual armour and vestments, and wearing on their heads, in place of helmets, two caps in the likeness of cones; and they were seen followed by the above-named Romulus and Remus in the guise of shepherds, covered in rustic fashion with skins of wolves, while, to distinguish the one from the other, Remus had six vultures placed in his head-dress, and Romulus twelve, in memory of his more happy augury. After them came Œnomaus, King of the Greek Pisa, and also the son of Mars, who held in one hand, as King, a royal sceptre, and in the other a little chariot all broken, in memory of the treachery shown against him by the charioteer Myrtilus in his combat for his daughter Hippodameia against Pelops, her lover. And after him were seen coming Ascalaphus and Ialmenus, likewise sons of Mars, adorned with a rich military habit; recalling by the ships that they had in the hand, one for each, the weighty succour brought by them with fifty ships to the besieged Trojans. These were followed by the beautiful Nymph Britona, daughter likewise of Mars, with a net in her arms, in memory of her miserable fate; and by the not less beautiful Har-

monia, who was born of the same Mars and lovely Venus, and became the wife of Theban Cadmus. To her, it is said, Vulcan once presented a most beautiful necklace, on which account she was seen with that necklace about her neck; and in the upper parts she had the semblance of a woman, but in the lower parts – denoting that she was transformed, together with her husband, into a serpent – she was seen all covered with serpent's skin. These had behind them, with a bloody knife in the hand and across the shoulders a little kid split open, and very fierce in aspect, Hyperion, born from the same father, by whom it is said that men were first taught to kill brute-animals, and with him the no less fierce Ætolus, likewise the offspring of Mars; and between them was seen walking blind Rage, adorned with a red habit all picked out with black embroidery, with foaming mouth, and with a rhinoceros on the head and a cynocephalus upon the back. After these walked Fraud, with the face of a human creature and with the other parts as they are described by Dante in the Inferno, and Menace, truly threatening in aspect with the sword and the staff that she had in the hands, covered with grey and red draperies, and with the mouth open; and they were seen to have behind them Fury, the great Minister of Mars, and Death, pallid and not less in harmony with the same Mars; the first all draped and tinted in dark red, with the hands bound behind the back, and seeming to be seated, all threatening, upon a great bundle of various arms, and the second all pallid, as has been said, and covered with black draperies, with the eyes closed, and with a presence no less awful and no less horrible. Spoils, then, in the form of a woman adorned with a lion's skin, with an ancient trophy in the hand, was seen coming after these, and she appeared as if desirous to exult over two prisoners, wounded and bound, who were on either side of her; having behind her, as the last line of so terrible a company, a woman of a very stalwart presence, with two bull's horns on the head and with an elephant in the hand, representing Force, to whom Cruelty, all red and likewise awful, killing a little child, seemed to make a true and fit companion.

SEVENTH CAR, OF VENUS.

Very different was the aspect of the charming, graceful, elegant, and gilded car of benign Venus, which was seen coming after

the last in the seventh place, drawn by two most peaceful, snow-white, and amorous doves; wherein were not wanting four scenes executed with great mastery, to render it pleasing, gladsome, and rich in pomp. For the first of these was seen the lovely Goddess transforming herself into a fish, to escape from the fury of the Giant Typhœus, and for the second, likewise, she was seen praying the great father Jove most piteously that he should deign to make an end at last of the many labours of her much-enduring son Æneas. In the third was seen the same Venus caught by her husband Vulcan with the net, while lying with her lover Mars; even as in the fourth and last she was seen, no less solicitous for her same son Æneas, coming into accord with the so inexorable Juno to unite him with the snares of love to the chaste Queen of Carthage. The beautiful Adonis, as her dearest lover, was seen walking first before the car, in the gracious habit of a huntsman, and with him appeared as his companions two charming little Loves, with painted wings and with bows and arrows. These were followed by the marital Hymeneus, young and beautiful, with the customary garland of marjoram, and in his hand the lighted torch; and by Thalassius with the spear and shield, and the little basket full of wool. And after them was seen coming Peitho, the God-dess of Persuasion, robed in the habit of a matron, with a great tongue upon the head (after the Egyptian custom) containing a bloody eye, and in the hand another similar tongue which was joined to another counterfeited hand; and with her the Trojan Paris in the habit of a shepherd, who was seen carrying in mem-ory of his fable that for him so unlucky apple. Even as Concord, in the form of a grave and beautiful woman crowned with a garland, with a cup in one hand and in the other a sceptre wreathed in flowers, could be seen following these; and with her, likewise, appeared as a companion Priapus, the God of orchards, with the usual sickle and with the lap all full of fruits; and with them, with a cube in the hand and another upon the head, Man-turna, who was always invoked most devoutly by brides on the first night that they were joined with their husbands, believing that firmness and constancy could be infused by her into incon-stant minds. Extravagantly figured, next, was Friendship, who came after these, for, although in the form of a young woman, she was seen to have the bare head crowned with leaves of pom-egranate and myrtle, wearing a rough dress, upon which could be read, MORS ET VITA; with the breast open, so that the heart

could be perceived, and there, likewise, were to be read these words written, LONGE ET PROPE; and she carried in the hand a withered elm-trunk entwined with a fresh and fertile vine. In her company was Pleasure, both the seemly and the unseemly, likewise extravagantly figured in the form of two young women that were shown attached to one another by the back; one white, and, as Dante said, cross-eyed and with the feet distorted, and the other, although black, yet of a seemly and gracious form, girt with beautiful consideration by the jewelled and gilded cestus, with a bit and a common braccio for measuring in the hands. And she was followed by the Goddess Virginensis, who used also to be invoked in ancient nuptials, that she might aid the husband to loose the virgin zone; on which account, all robed in draperies of white linen, with a crown of emeralds and a cock upon the head, she was seen walking with the above-named zone and with a little branch of agnus-castus in the hands. In her company was Beauty, desired so much and by so many, in the form of a gracious virgin wreathed in flowers, and all crowned with lilies; and with them was Hebe, the Goddess of Youth, likewise a virgin, and likewise dressed with much richness and infinite grace, and crowned with the ornament of a lovely gilded garland, and carrying in the hand a beautiful little branch of flowering almond. Finally, that most lovely company was concluded by Joy, likewise a virgin, gracious and crowned with a garland, who in similar guise carried in the hand a thyrsus all woven of garlands and various leaves and flowers.

Eighth car, of mercury.

To Mercury, who had the caduceus, the cap, and the winged sandals, was given the eighth car, drawn by two most natural storks, and likewise enriched and adorned with five of his fables. For the first of these he was seen appearing upon the new walls of Carthage, as the Messenger of Jove, to the enamoured Æneas, and commanding him that he should depart thence and set out on the way to Italy; even as for the second was seen the unhappy Agraulos converted by him into stone, and for the third he was seen likewise at the command of Jove binding the too audacious Prometheus to the rocks of Mount Caucasus. In the fourth, again, he was seen converting the ill-advised Battus into that stone that is called basanite; and in the fifth and last was his

slaying, so cunningly achieved, of the many-eyed Argus. For clearer demonstration, that same Argus was seen walking first before the car, in a pastoral habit all covered with eyes; and with him was seen as his companion Maia, the mother of the above-named Mercury and daughter of Faunus, in the very rich habit of a young woman, with a vine upon the head and a sceptre in the hand, having some serpents tame in appearance that were following her. After these was seen coming Palæstra, daughter of Mercury, in the semblance of a virgin wholly nude, but stalwart and proud to a marvel, and adorned with various leaves of olive over the whole person, with the hair cut short, to the end that when fighting, as it was her custom always to do, it might not give a grip to the enemy; and with her was Eloquence, also the daughter of Mercury, robed in the dignified and decorous habit of a matron, with a parrot upon the head, and with one of the hands open. Next were seen the three Graces, with the hands linked in the usual manner, and draped in most delicate veiling; and after them were seen coming the two Lares, dressed in the skins of dogs, with whom there appeared as their companion Art, also in the habit of a matron, with a great lever and a great flame of fire in the hands. These were followed by Autolycus, that most subtle thief, the son of Mercury and of the Nymph Chione, with shoes of felt and a closed cap that hid his face, having both his hands occupied with such a lantern as is called a thieves' lantern, various picklocks, and a rope-ladder. And finally, Hermaphroditus, the offspring of the same Mercury and of Venus, figured in the usual manner, was seen bringing up the rear of that little company.

NINTH CAR, OF THE MOON.

The ninth car, all silvered, of the Moon, drawn by two horses, one black and the other white, was seen passing in no less lovely fashion after the last; the Moon, draped, as is customary, in a white and delicate veil, guiding the silver reins with grace most gracious; and, like the others, it was seen adorned with no less beauty and pomp by four of her fables. For the first of these that most gentle Goddess, flying from the fury of Typhœus, was seen constrained to transform herself into a cat; even as in the second she was seen fondly embracing and kissing beautiful Endymion as he lay asleep, and in the third she was seen, won over by a delicate

fleece of white wool, making her way into a dark forest, there to lie with the enamoured Pan, the God of Shepherds. In the fourth was seen how the same Endymion named above, for the grace acquired with her, was given pasture for his white flock; and for a better representation of him who was so dear to the Moon, he was then seen walking first before the car, crowned with dittany, and in his company a fair-haired child, with a serpent in the hand, and also crowned with leaves of the plane, representing the Good Genius, and a great black man, awful in aspect, with the beard and hair all dishevelled and with an owl in the hand, representing the Evil Genius. These were followed by the God Vaticanus, who is believed to be able to bring succour to the wailing of little infants, robed in a handsome tawny habit, and with an infant in his arms; and with him was likewise seen coming, in a splendid and well-varied dress, with a key in the hand, the Goddess Egeria, who is also invoked in aid of pregnant women; and with them the other Goddess, Nundina, who likewise protects the names of little babes, in a venerable habit, with a branch of laurel and a sacrificial vase in the hands. Then after these Vitumnus was seen walking, who was reputed to breathe the soul into children at their birth, figured after the Egyptian custom, and with him Sentinus, who likewise was believed by the ancients to give to the newly-born the power of the senses, on which account, he himself being all white, there were seen in his head-dress the heads of those five animals that are believed to have the five senses more acute than any of the others; that of an ape, namely, that of a vulture, that of a wild-boar, that of a lynx, and that – or rather, the whole body – of a little spider. Then Edusa and Potina, who preside over the nourishment of those same infants, were seen riding in the same fashion as the others, in the habit of nymphs, but with breasts very long and very full, one holding a basin containing white bread, and the other a most beautiful vase that seemed to be full of water; and with them, concluding the last part of the company, was Fabulinus, who presides over the first speech of the same infants, robed in various colours, with the head all crowned with wagtails and singing chaffinches.

Tenth Car, of Minerva.

Minerva, clad in armour, with the spear and the shield of the Gorgon, as she is generally figured, had the tenth car, composed in a triangular form and in the colour of bronze, and drawn by two very large and most bizarre owls, of which I cannot forbear to say that although it would be possible to relate singular and even incredible marvels of all the animals that drew the cars, yet these, beyond all the others, were figured so lifelike and so natural, and their feet, wings, and necks were made to move, and even the eyes to open and shut so well, and with a resemblance so close to the reality, that I know not how I could ever be able to convince of it those who never saw them. However, ceasing to speak of these, I must relate that of the three sides of which the triangular car was composed, there was seen painted in one the miraculous birth of the Goddess from the head of Jove, even as in the second Pandora was seen adorned by her with all those countless ornaments, and in the third, likewise, she was seen converting the hair of the wretched Medusa into snakes. Then on one part of the base there was painted the contest that she had with Neptune over the name that was to be given to Athenæ (before she had such a name), when, he producing the fiery horse and she the fruitful olive, she was seen to win thereby a glorious and memorable victory; and on the other she was seen in the form of a little old woman, striving to persuade the overbold Arachne, before she had transformed her into the animal of that name, that she should consent, without putting the matter to the proof, to yield her the palm in the art of embroidery; even as in the third and last part, with a different aspect, she was seen valorously slaying the proud Typhon. Before the car was seen walking Virtue, in the form of a young and stalwart woman, with two great wings, and in an easy, chaste, and becoming habit, having as a worthy companion the venerable Honour, crowned with palm and resplendent in purple and gold, with the shield and spear in the hands, who was shown supporting two temples, into one of which (namely, that dedicated to the same Honour) it appeared impossible to pass save by way of that dedicated to Virtue; and to the end that a noble and worthy companion might be given to those masks, it seemed right that Victory, crowned with laurel and likewise with a branch of palm in the hand,

should be added to the same line. These were followed by Good
Fame, figured in the form of a young woman with two white
wings, sounding a great trumpet, and after her, with a little
white dog in her arms, came Faith, likewise all white, with a
luminous veil that was seen covering her arms, head, and face;
and with them Salvation, holding in the right hand a cup that she
seemed to be seeking to offer to a serpent, and in the other a thin
and straight wand. After these, then, was seen coming Nemesis,
the daughter of Night, who rewards the good and chastises the
wicked, virginal in aspect, and crowned with little stags and
little victories, with a spear of ash and a similar cup in the hands;
with whom appeared as her companion Peace, also a virgin, but
of a kindly aspect, with a branch of olive in the hand and a blind
boy, representing the God of riches, in the arms; and with
them, carrying in the hand a drinking-vessel in the form of a lily,
and in similar guise, was seen likewise coming ever-verdant
Hope, followed by Clemency, who was riding upon a great lion,
with a spear in one hand and in the other a thunderbolt, which
she was making as if not to hurl furiously, but to throw
away. Then were seen likewise coming Opportunity, who had a
little behind her Penitence, by whom she seemed to be
continually smitten, and Felicity, upon a commodious throne,
with a caduceus in one hand and a horn of plenty in the other.
And these were seen followed by the Goddess Pellonia,
whose office it is to keep enemies at a distance, in full armour,
with two great horns upon the head, and in the hand a vigilant
crane, who was seen poised upon one foot, as is their custom,
and holding in the other a stone; and with her, closing the
last part of the glorious company, was Science, figured in
the form of a young man, who was shown carrying in the hand a
book and upon the head a gilded tripod, to denote his constancy
and firmness.

Eleventh Car, of Vulcan.

Vulcan, the God of fire, old, ugly, and lame, with a cap of
turquoise-blue upon the head, had the eleventh car, drawn by two
great dogs; and in it was figured the Isle of Lemnos, where it is
said that Vulcan, thrown down from Heaven, was nursed by
Thetis, and began to fashion there the first thunderbolts for Jove.

Before it were seen walking, as his ministers and servants, three Cyclopes, Brontes, Steropes, and Pyracmon, of whose aid he is said to have been wont to avail himself in making those thunder-bolts. After them was seen coming Polyphemus, the lover of the beautiful Galatea and the first of all the Cyclopes, in the garb of a shepherd, with a great pipe hanging from his neck and a staff in the hand; and with him, crowned with seven stars, the de-formed but ingenious Ericthonius, born with serpent's feet from Vulcan's attempt to violate Minerva, to conceal the ugliness of which it is believed that he invented the use of chariots, on which account he walked with one of these in the hand. He was seen followed by the savage Cacus, also the son of Vulcan, spouting a stream of sparks from the mouth and nose; and by Cæculus, likewise the son of Vulcan, and likewise in pastoral garb, but adorned with the royal diadem, and in one of his hands, in mem-ory of the building of Præneste, was seen a city placed upon a hill, and in the other a ruddy and burning flame. After these was seen coming Servius Tullius, King of Rome, who is also believed to have been born of Vulcan, and upon his head, even as in the hand of Cæculus, in token of his happy augury, a similar flame was seen to form in marvellous fashion a splendid and propitious garland. Then was seen the jealous Procris, daughter of the above-named Ericthonius, and wife of Cephalus, who, in mem-ory of the ancient fable, seemed to have the breast transfixed by a javelin; and with her was seen Oreithyia, her sister, in a virginal and lovely habit, and in the centre between them was Pandion, King of Athens, born with them of the same father, adorned with the vestments of a Grecian King. After him came Procne and Philomela, his daughters, one dressed in the skin of a deer, with a spear in the hand and upon the head a little chattering swallow, and the other carrying in the same place a nightingale, and likewise having in the hand a woman's embroidered mantle, in allusion to her miserable fate; and she appeared to be following her beloved father all filled with sorrow, although adorned with a rich vestment. And with them, to conclude the last part of the company, was Caca, the sister of Cacus, adored by the ancients as a Goddess for the reason that, laying aside her love for her brother, she is said to have revealed to Hercules the secret of the stolen cattle.

Twelfth Car, of Juno.

When Vulcan had passed, Queen Juno, adorned with a rich, superb, and royal crown, and with vestments transparent and luminous, was seen coming in much majesty upon the twelfth car, which was not less pompous than any of the others, and drawn by two most lovely peacocks; and between the five little stories of her actions that were seen painted therein, were Lycorias, Beroë, and Deiopea, her most beautiful and most favoured Nymphs. For the first of these stories was seen the unhappy Callisto transformed by her into a bear, who was placed afterwards by compassionate Jove among the principal stars in the heavens; and in the second was seen how, having transformed herself into the likeness of Beroë, she persuaded the unsuspecting Semele to beseech Jove that he should deign in his grace to lie with her in the guise wherein he was wont to lie with his wife Juno; on which account the unhappy mortal, not being able to sustain the force of the celestial splendour, was consumed by fire, and Jove was seen to take Bacchus from her belly and place him in his own, preserving him for the full time of birth. In the third, likewise, she was seen praying Æolus that he should send his furious winds to scatter the fleet of Trojan Æneas; even as in the fourth she was seen in like manner, filled with jealousy, demanding from Jove the miserable Io transformed into a cow, and giving her, to the end that she might not be stolen from her by Jove, into the custody of the ever-vigilant Argus, who, as has been told elsewhere, was put to sleep and slain by Mercury; and in the fifth picture was seen Juno sending after most unhappy Io the pitiless gad-fly, to the end that he might keep her continually pricked and stung. At the foot of the car, then, were seen coming a good number of those phenomena that are formed in the air, among which could be seen as the first Iris, regarded by the ancients as the messenger of the Gods, and the daughter of Thaumas and Electra; all lissom and free, and dressed in vestments of red, yellow, blue, and green, signifying the rainbow, with two hawks' wings upon the head that denoted her swiftness. In her company, then, in a red habit, with the hair ruddy and dishevelled, was the Comet, figured as a young woman who had a large and shining star upon the brow; and with them came Clear Sky, in the aspect of a virgin, who was seen with the countenance of

turquoise-blue, and turquoise-blue all the wide and ample dress, not without a white dove likewise upon the head, to signify the sky. After these were seen Snow and Mist, coupled together; the first dressed in tawny-coloured draperies, upon which were shown lying many trunks of trees all sprinkled with snow, and the other was seen walking, as if she had no shape, as it were in the semblance of a great white mass; having with them verdant Dew, figured in that same colour, to denote the green plants upon which she is generally seen, and having a round moon upon the head, signifying that in the time of the moon's fulness, above all, dew is wont to fall from the heavens upon green herbage. Then there followed Rain, dressed in a white but somewhat soiled habit, upon whose head seven stars, partly bright and partly dim, formed a garland representing the seven Pleiades, even as the seventeen that blazed upon her breast appeared to denote the sign of rainy Orion. There followed, likewise, three virgins of different ages, attired in white draperies and also crowned with olive, representing the three classes of virgins that used to run races in the ancient games of Juno; having with them, for the last, the Goddess Populonia in the rich habit of a matron, with a garland of pomegranate and balm-mint upon the head, and with a little table in the hand, by whom the airy company above described was seen graciously concluded.

THIRTEENTH CAR, OF NEPTUNE.

Fanciful, bizarre, and beautiful beyond all the others appeared the thirteenth car, of Neptune, which was composed of an immense crab, such as the Venetians are wont to call Grancevola, which rested upon four great dolphins, having about the base, which resembled a real and natural rock, a vast number of sea-shells, sponges, and corals, which rendered it most lovely and ornate, and being drawn by two sea-horses; and upon it was seen standing Neptune, in the customary form and with the customary trident, having at his feet, as a companion, his spouse Salacia, in the form of a snow-white nymph all covered with foam. Before the car, then, was seen walking the old and bearded Glaucus, all dripping and all covered with sea-weed and moss, whose person from the waist downwards was seen in the form of a swimming

fish. About him circled many halcyon-birds, and with him was seen the much-changing and deceitful Proteus, likewise old, all dripping, and covered with sea-weed; and with them proud Phorcys, with a royal band of turquoise-blue about the head, and with beard and hair long and flowing beyond measure, and carrying in the hand the famous Pillars of Hercules, as a sign of the empire that he once had. Then followed two Tritons with the customary tails, sounding their trumpets, and in their company appeared old Æolus, likewise holding in the hands a royal sceptre and a sail, and having upon the head a burning flame of fire. And he was followed by four of his principal Winds; by young Zephyrus, with the locks and the varied wings adorned with various little flowers, by dark and parching Eurus, who had a radiant sun upon the head; by cold and snowy Boreas; and, finally, by the soft, cloudy, and proud Auster; all figured, according as they are generally painted, with swelling cheeks and with the large and swift wings that are customary. After these, in due place, were seen coming the two giants, Otus and Ephialtes, all wounded and transfixed by various arrows, in memory of their having been slain by Apollo and Diana; and with them, not less appropriately, were seen coming likewise two Harpies, with the customary maiden's face and the customary rapacious claws and most hideous belly. There was seen also the Egyptian God Canopus, in memory of the astuteness formerly used by the priest against the Chaldæans, figured as very short, round, and fat; and likewise, young and lovely, winged Zetes and Calais, the sons of Boreas, by whose valour it is related that once upon a time those foul and ravenous Harpies were driven from the world. And with them were seen, at the last, the beautiful Nymph Amymone, beloved by Neptune, with a gilded vase, and the young Greek Neleus, son of the same Neptune, who, with royal sceptre and habit, was seen to conclude the last part of the company described above.

Fourteenth Car, of Oceanus and of Tethys.

There followed in the fourteenth company, with Tethys, the great Queen of the sea, the great father Oceanus, her husband, the son of Heaven, who was figured in the form of a tall and

cerulean old man, with a great beard and long hair all wet and dishevelled, and covered all over with sea-weed and various sea-shells, with a horrible seal in the hand, while she was represented as a tall and masterful matron, resplendent, old, and white, and holding in the hand a great fish; and they were both seen upon a most fantastic car in the semblance of a rock, very strange and bizarre, drawn by two immense whales. At the foot of the car was seen walking Nereus, their son, old, venerable, and covered with foam, and with him Thetis, daughter of that Nereus and of Doris, and mother of great Achilles, who was shown riding upon a dolphin; and she was seen followed by three most beautiful Sirens figured in the usual manner, who had behind them two very beautiful, although white-haired, Nymphs of the sea, called Graeæ, likewise daughters of the Sea-God Phorcys and of the Nymph Ceto, clothed most pleasingly in various graceful draperies. Behind these, then, were seen coming the three Gorgons with their snaky locks, daughters of the same father and mother, who made use of a single eye, with which alone, lending it to one another, they were all three able to see; and there was likewise seen coming the cruel Scylla, with the face and breast of a maiden and with the rest of the person in the form of a fish, and with her the old, ugly, and voracious Charybdis, transfixed by an arrow in memory of her well-deserved punishment. And behind these, in order to leave the last part of the company more gladsome in aspect, there was seen coming for the last, all nude, the beautiful and pure-white Galatea, beloved and gracious daughter of Nereus and Doris.

FIFTEENTH CAR, OF PAN.

In the fifteenth car, which had the natural and true appearance of a shady forest counterfeited with much artifice, and was drawn by two great white he-goats, was seen coming the rubicund Pan, the God of forests and of shepherds, in the form of an old and horned Satyr, crowned with foliage of the pine, with the spotted skin of a panther across the body, and in the hands a great pipe with seven reeds and a pastoral staff. At the foot of the car were seen walking some other Satyrs and some old Sylvan Gods, crowned with fennel and lilies, and holding some boughs of cypress in memory of the beloved Cyparissus. After these, likewise,

were seen coming two Fauns crowned with laurel, and each with a cat upon the right shoulder; and behind them the wild and beautiful Syrinx, beloved by Pan, who, flying from him, is said to have been transformed by the Naiad sisters into a tremulous and musical reed. Syrinx had in her company the other Nymph, Pitys, likewise beloved by Pan; but since the wind Boreas was also and in like manner enamoured of her, it is believed that out of jealousy he hurled her over a most cruel rock, whereupon, being all shattered, it is said that out of pity she was transformed by Mother Earth into a beautiful pine, from the foliage of which her lover Pan used, as has been shown above, to make himself a gracious and well-beloved garland. Then after these was seen coming Pales, the revered custodian and protectress of flocks, dressed as a gentle shepherdess, with a great vessel of milk in the hands, and a garland of medicinal herbs; and with her the protectress of herds, by name Bubona, in a similar pastoral dress, with an ornate head of an ox that made a cap for her head; and Myiagrus, the God of flies, dressed in white, with an infinite multitude of those importunate little creatures about his head and his person, with a garland of spondyl, and with the club of Hercules in his hand; and Evander, who first taught men in Italy to make sacrifices to Pan, adorned with royal purple and the royal head-band, and with the royal sceptre in his hand, concluded with gracious pomp the last part of that pastoral, indeed, yet pleasing and most fair company.

Sixteenth Car, of Pluto and of Proserpine.

Then followed infernal Pluto with Queen Proserpine, all nude, awful, and dark, and crowned with funeral cypress, holding a little sceptre in one of his hands as a sign of his royal power, and having at his feet the great, horrible, and triple-throated Cerberus; but Proserpine, who was seen with him (accompanied by two Nymphs, one holding in the hand a round ball, and the other a great and strong key, denoting that one who has once come into that kingdom must abandon all hope of return), was shown clothed in a white and rich dress, ornate beyond belief. And both were in the usual car, drawn by four jet-black horses, whose reins were seen guided by a most hideous and infernal monster,

who had with him, as worthy companions, the three likewise infernal Furies, bloody, foul, and awful, with the hair and the whole person entwined with various venomous serpents. Behind these were seen following the two Centaurs, Nessus and Astylus, with bows and arrows, and besides these arms Astylus carried in the hand a great eagle; and with them the proud giant Briareus, who had a hundred hands armed with sword and buckler, and fifty heads, from which a stream of fire was seen spouting through the mouth and nostrils. These were followed by turbid Acheron, pouring water and sand, livid and stinking, from a great vase that he carried in his hands, and with him was seen coming the other infernal river, Cocytus, likewise pallid and dark, and likewise pouring from a similar vase a similar fetid and turbid stream; having with them the horrible and sluggish Styx, daughter of Oceanus, so much feared by all the Gods, who was dressed in a nymph's habit, but dark and foul, and carried a similar vase, and seemed to be encompassed by the other infernal river, Phlege-thon, whose whole person, with his vase and the boiling waters, was tinted with a dark and fearful redness. Then followed old Charon, with the oar, and with the eyes (as Dante said) of glow-ing coal; accompanied, to the end that not one of the infernal rivers might be absent, by the pallid, meagre, emaciated, and oblivious Lethe, in whose hand was seen a similar vase, which likewise poured from every side turbid and livid water; and fol-lowing behind them were the three great judges of Hell, Minos, Æacus, and Rhadamanthus, the first being figured in royal form and habit, and the second and third attired in dark, grave, and venerable vestments. After these was seen coming Phlegyas, the sacrilegious King of the Lapithæ, recalling, by an arrow that transfixed his breast, the memory of the burned temple of Phœbus and the chastisement received from him, and, for clearer demonstration, carrying that temple all burning in one of his hands. Next was seen the afflicted Sisyphus under the great and ponderous stone, and with him the famished and miserable Tantalus, who was shown with the fruits so vainly desired close to his mouth. And then were seen coming, but in more gracious aspect, as if setting out from the glad Elysian Fields, with the comet-like star on the brow, and wearing the imperial habit, the divine Julius and the happy Octavianus Augustus, his successor; the terrible and dreadful company being finally con-cluded in most noble fashion by the Amazon Penthesileia,

adorned with the spear, the half-moon shield, and the royal band upon the head, and by the widowed Queen Tomyris, who likewise had the hands and side adorned with the bow and barbaric arrows.

SEVENTEENTH CAR, OF CYBELE.

After these was seen coming Cybele, the great mother of the Gods, crowned with towers, and, for the reason that she is held to be Goddess of the Earth, robed in a vestment woven of various plants, with a sceptre in the hand, and seated upon a quadrangular car, which contained many other empty seats besides her own, and was drawn by two great lions; and for the adornment of the car were painted with most beautiful design four of her stories. For the first of these was seen how, when she was conveyed from Pessinus to Rome, the ship that was carrying her being stuck fast in the Tiber, she was drawn miraculously to the bank by the Vestal Claudia with only her own simple girdle, to the rare marvel of the bystanders; even as for the second she was seen taken by command of her priests to the house of Scipio Nasica, who was judged to be the best and most holy man to be found in Rome at that time. For the third, likewise, she was seen visited in Phrygia by the Goddess Ceres, after she thought to have hidden her daughter Proserpine safely in Sicily; and for the fourth and last she was seen flying from the fury of the Giants into Egypt, as the poets relate, and constrained to transform herself into a blackbird. At the foot of the car, then, were seen riding ten Corybantes, armed after the ancient fashion, who were making various extravagant gestures of head and person; after whom were seen coming two Roman matrons in Roman dress, with the head covered by a yellow veil, and with them the above-named Scipio Nasica and the Vestal Virgin Claudia, who had over the head a square white kerchief with a border all around, which was fastened under the throat. And for the last, to give a gracious conclusion to the little company, there was seen coming with an aspect of great loveliness the young and beautiful Atys, beloved most ardently, as we read, by Cybele; who, besides the rich, easy, and charming costume of a huntsman, was seen most gracefully adorned by a very beautiful gilded collar.

Eighteenth Car, of Diana.

In the eighteenth and incredibly beautiful car, drawn by two white stags, there was seen coming, with the gilded bow and gilded quiver, the huntress Diana, who was shown seated with infinite grace and loveliness upon two other stags, which with their hindquarters made for her, as it were, a most fanciful seat; the rest of the car being rendered strangely gracious, lovely, and ornate by nine of her most pleasing fables. For the first of these was seen how, moved by pity for the flying Arethusa, who was seen pursued by the enamoured Alpheus, the Goddess converted her into a fountain; even as for the second she was seen praying Æsculapius that he should consent to restore to life for her the dead but innocent Hippolytus; which being accomplished, she was then seen in the third ordaining him guardian of her temple and her sacred wood in Aricia. For the fourth she was seen chasing Cynthia, violated by Jove, from the pure waters where she used to bathe with her other virgin Nymphs; and for the fifth was seen the deceit practised by her on the above-named Alpheus, when, seeking presumptuously to obtain her as his wife, he was taken by her to see her dance, and there, having smeared her face with mire in company with the other Nymphs, she constrained him, not being able to recognize her in that guise, to depart all derided and scorned. For the sixth, then, she was seen in company with her brother Apollo, chastising proud Niobe and slaying her with all her children; and for the seventh she was seen sending the great and savage boar into the Calydonian forest, which laid all Ætolia waste, having been moved to just and righteous wrath against that people because they had discontinued her sacrifices. Even as for the eighth she was seen not less wrathfully converting the unhappy Actæon into a stag; but in the ninth and last, moved on the contrary by pity, she was seen transforming Egeria, weeping for the death of her husband, Numa Pompilius, into a fountain. At the foot of the car, then, were seen coming eight of her huntress Nymphs, with their bows and quivers, dressed in graceful, pleasing, loose, and easy garments, composed of skins of various animals as it were slain by them; and with them, as the last, concluding the small but gracious company, was young Virbius, crowned with spotted-leaf myrtle, and holding in

one hand a little broken chariot, and in the other a bunch of tresses virginal and blonde.

NINETEENTH CAR, OF CERES.

In the nineteenth car, drawn by two great dragons, coming in no less pomp than the others, was seen Ceres, the Goddess of grain-crops, in the habit of a matron, with a garland of ears of corn and with ruddy locks; and with no less pomp that car was seen adorned by nine of her fables, which had been painted there. For the first of these was seen figured the happy birth of Pluto, the God of Riches, born, as we read in certain poets, from her and from the hero Iasius; even as for the second she was seen washing with great care and feeding with her own milk the little Triptolemus, son of Eleusis and Hyona. For the third was seen the same Triptolemus flying by her advice upon one of the two dragons that had been presented to him by her, together with the car, to the end that he might go through the world piously teaching the care and cultivation of the fields; the other dragon having been killed by the impious King of the Getæ, who sought with every effort likewise to slay Triptolemus. For the fourth was seen how she hid her beloved daughter Proserpine in Sicily, foreseeing in a certain sense that which afterwards befell her; even as in the fifth, likewise, she was seen after that event, as has been told elsewhere, going to Phrygia to visit her mother Cybele; and in the sixth, as she was dwelling in that place, the same Proserpine was seen appearing to her in a dream, and demonstrating to her in what a plight she found herself from Pluto's rape of her; on which account, being all distraught, she was seen in the seventh returning in great haste to Sicily. For the eighth, likewise, was seen how, not finding her there, in her deep anguish she kindled two great torches, being moved to the resolution to seek her throughout the whole world; and in the ninth and last she was seen arriving at the well of Cyane, and there coming by chance upon the girdle of her stolen daughter, a sure proof of what had befallen her; whereupon in her great wrath, not having aught else on which to vent it, she was seen turning to break to pieces the rakes, hoes, ploughs, and other rustic implements that chanced to have been left there in the fields by the peasants. At the foot of the car, then, were seen walking figures signifying her various

sacrifices; first, for those that are called the Eleusinia, two little
virgins attired in white vestments, each with a gracious little bas-
ket in the hands, one of which was seen to be all filled with
various flowers, and the other with various ears of corn. After
which, for those sacrifices that were offered to Ceres as Goddess
of Earth, there were seen coming two boys, two women, and two
men, likewise all dressed in white, and all crowned with hyacinths,
who were leading two great oxen, as it were to sacrifice them;
and then, for those others that were offered to Ceres the Law-
giver, called by the Greeks Thesmophoros, were seen coming
two matrons only, very chaste in aspect, likewise dressed in white,
and in like manner crowned with ears of corn and agnus-castus.
And after these, in order to display in full the whole order of her
sacrifices, there were seen coming three Greek priests, likewise
attired in white draperies, two of whom carried in the hands two
lighted torches, and the other an ancient lamp, likewise lighted.
And, finally, the sacred company was concluded by the two
heroes so much beloved by Ceres, of whom mention has been
made above – Triptolemus, namely, who carried a plough in the
hand and was shown riding upon a dragon, and Iasius, whom it
was thought proper to figure in the easy, rich, and gracious habit
of a huntsman.

TWENTIETH CAR, OF BACCHUS.

Then followed the twentieth car, of Bacchus, likewise shaped
with singular artistry and with novel and truly most fanciful and
bizarre invention; and it was seen in the form of a very graceful
little ship all overlaid with silver, which was balanced in such wise
upon a great base that had the true and natural appearance of the
cerulean sea, that at the slightest movement it was seen, with
extraordinary pleasure for the spectators, to roll from side to side
in the very manner of a real ship upon the real sea. In it, besides
the merry and laughing Bacchus, attired in the usual manner and
set in the most commanding place, there were seen in company
with Maron, King of Thrace, some Bacchantes and some Satyrs
all merry and joyful, sounding various cymbals and other suchlike
instruments; and since, as it were, from a part of that happy ship
there rose an abundant fount of bright and foaming wine, they
were seen not only drinking the wine very often from various

cups, with much rejoicing, but also with the licence that wine induces inviting the bystanders to drink and sing in their company. In place of a mast, also, the little ship had a great thyrsus wreathed in vine-leaves, which supported a graceful and swelling sail, upon which, to the end that it might be gladsome and ornate, were seen painted many of those Bacchantes who, so it is said, are wont to run about, drinking and dancing and singing with much licence, over Mount Tmolus, father of the choicest wines. At the foot of the car, then, was seen walking the beautiful Syce, beloved by Bacchus, who had upon the head a garland, and in the hand a branch, of fig; and with her, likewise, was the other love of the same Bacchus, Staphyle by name, who, besides a great vine-branch with many grapes that she carried in the hand, was also seen to have made in no less lovely fashion about her head, with vine-leaves and bunches of similar grapes, a green and graceful garland. After these came the fair and youthful Cissus, also beloved by Bacchus, who, falling by misfortune, was transformed by Mother Earth into ivy, on which account he was seen in a habit all covered with ivy in every part. And behind him was seen coming old Silenus, all naked and bound upon an ass with various garlands of ivy, as if by reason of his drunkenness he were unable to support himself, and carrying attached to his girdle a great wooden cup all worn away; and with him, likewise, came the God of Banquets, called by the ancients Comus, represented in the form of a ruddy, beardless, and most beautiful youth, all crowned with roses, but in aspect so somnolent and languid, that it appeared almost as if the huntsman's boar-spear and the lighted torch that he carried in the hands might fall from them at any moment. There followed with a panther upon the back the old and likewise ruddy and laughing Drunkenness, attired in a red habit, with a great foaming vessel of wine in the hands, and with her the young and merry Laughter; and behind these were seen coming in the garb of shepherds and nymphs two men and two women, followers of Bacchus, crowned and adorned in various ways with various leaves of the vine. And Semele, the mother of Bacchus, all smoky and scorched in memory of the ancient fable, with Narcæus, the first ordinator of the sacrifices to Bacchus, who had a great he-goat upon his back, and was adorned with antique and shining arms, appeared to form a worthy, appropriate, and gracious end to that glad and festive company.

TWENTY-FIRST AND LAST CAR.

The twenty-first and last car, representing the Roman Mount Janiculum, and drawn by two great white rams, was given to the venerable Janus, figured with two heads, one young and the other old, as is the custom, and holding in the hands a great key and a thin wand, to demonstrate the power over doors and streets that is attributed to him. At the foot of the car was seen coming sacred Religion, attired in white linen vestments, with one of the hands open, and carrying in the other an ancient altar with a burning flame; and on either side of her were the Prayers, represented, as they are described by Homer, in the form of two wrinkled, lame, cross-eyed, and melancholy old women, dressed in draperies of turquoise-blue. After these were seen coming Antevorta and Postvorta, the companions of Divinity, of whom it was believed that the first had power to know whether prayers were or were not to be heard by the Gods; and the second, who rendered account only of the past, was able to say whether prayers had or had not been heard; the first being figured in the comely aspect and habit of a matron, with a lamp and a corn-sieve in the hands, and a head-dress covered with ants upon the head; and the second, clothed in front all in white, and figured with the face of an old woman, was seen to be attired at the back in heavy black draperies, and to have the hair, on the contrary, blonde, curling, and beautiful, such as is generally seen in young and love-compelling women. Then followed that Favour which we seek from the Gods, to the end that our desires may have a happy and fortunate end; and he, although shown in the aspect of a youth, blind and with wings, and with a proud and haughty presence, yet at times appeared timid and trembling because of the rolling wheel upon which he was seen standing, doubting that, as is often seen to happen, at every least turn he might come with great ease to fall from it; and with him was seen Success, or, as we would rather say, the happy end of our enterprises, figured as a gay and lovely youth, holding in one of the hands a cup, and in the other an ear of corn and a poppy. Then there followed, in the form of a virgin crowned with oriental palm, with a star upon the brow and with a branch of the same palm in the hand, Anna Perenna, revered by the ancients as a Goddess, believing that she was able to make the year fortunate, and with her were seen

coming two Fetiales with the Roman toga, adorned with garlands of verbenæ and with a sow and a stone in the hands, to denote the kind of oath that they were wont to take when they made any declaration for the Roman people. Behind these, then, following the religious ceremonies of war, was seen coming a Roman Consul in the Gabinian and purple toga, and with a spear in the hand, and with him two Roman Senators likewise in the toga, and two soldiers in full armour and with the Roman javelin. And finally, concluding that company and all the others, there followed Money, attired in draperies of yellow, white, and tawny colour, and holding in the hands various instruments for striking coins; the use of which, so it is believed, was first discovered and introduced, as a thing necessary to the human race, by Janus.

Such were the cars and companies of that marvellous masquerade, the like of which was never seen before, and, perchance, will never be seen again in our day. And about it – leaving on one side, as a burden too great for my shoulders, the vast and incomparable praises that would be due to it – there had been marshalled with much judgment six very rich masks in the guise of sergeants, or rather, captains, who, harmonizing very well with the invention of the whole, were seen, according as necessity demanded, running hither and thither and keeping all that long line, which occupied about half a mile of road, advancing in due order with decorum and grace.

Now, drawing near at length to the end of that splendid and most merry Carnival, which would have been much more merry and celebrated with much more splendour, if the inopportune death of Pius IV, which happened a short time before, had not incommoded a good number of very reverend Cardinals and other very illustrious lords from all Italy, who, invited to those most royal nuptials, had made preparations to come; and leaving on one side the rich and lovely inventions without number seen in the separate masks, thanks to the amorous young men, not only in the innumerable banquets and other suchlike entertainments, but wherever they broke a lance or tilted at the ring, now in one place and now in another, and wherever they made similar trial of their dexterity and valour in a thousand other games; and treating only of the last festival, which was seen on the last day, I shall say that although there had been seen the innumerable things, so rare, so rich, and so ingenious, of which mention has been made above, yet this festival, from the pleasing nature of

the play, from the richness, emulation and competence shown in it by our craftsmen (some of whom, as always happens, considered themselves surpassed in the things accomplished), and from a certain extravagance and variety in the inventions, some of which appeared beautiful and ingenious, and others ridiculous and clumsy, this one, I say, also displayed an extraordinary and most charming beauty, and likewise gave to the admiring people, amid all that satiety, a pleasure and a delight that were marvellous and perhaps unexpected; and it was a buffalo-race, composed of ten distinct companies, which were distributed, besides those that the Sovereign Princes took for themselves, partly among the lords of the Court and the strangers, and partly among the gentlemen of the city and the two colonies of merchants, the Spanish and the Genoese. First, then, upon the first buffalo that appeared in the appointed place, there was seen coming Wickedness, adorned with great art and judgment, who was shown being chased, goaded and beaten by six cavaliers likewise figured most ingeniously as Scourging, or rather, Scourges. After that, upon the second buffalo, which had the appearance of a lazy ass, was seen coming the old and drunken Silenus, supported by six Bacchants, who were seen striving at the same time to goad and spur the ass; even as upon the third, which had the form of a calf, there was likewise seen coming the ancient Osiris, accompanied by six of the companions or soldiers with whom, it is believed, that Deity travelled over many parts of the world and taught to the still new and barbarous races the cultivation of the fields. Upon the fourth, without any disguise, was placed as on horseback Human Life, likewise chased and goaded by six cavaliers who represented the Years; even as upon the fifth, also without any disguise, was seen coming Fame with the many mouths and with the great wings of desire that are customary, also chased by six cavaliers who resembled Virtue, or the Virtues; which Virtues, so it was said, chasing her, were aspiring to obtain the due and well-deserved reward of honour. Upon the sixth, then, was seen coming a very rich Mercury, who was shown being goaded and urged on no less than the others by six other similar figures of Mercury; and upon the seventh was seen the nurse of Romulus, Acca Laurentia, with six of her Fratres Arvales, who were not only urging her lazy animal to a run with their goads, but seemed almost to have been introduced to keep her company with much fittingness and pomp. Upon the eighth, next, was seen coming

with much grace and richness a large and very natural owl, with six cavaliers in the form of bats most natural and marvellously similar to the reality, who with most dexterous horses, goading the buffalo now from one side and now from another, were seen delivering a thousand joyous and most festive assaults. For the ninth, with singular artifice and ingenious illusion, there was seen appearing little by little a Cloud, which, after it had held the eyes of the spectators for some time in suspense, was seen in an instant as it were to part asunder, and from it issued the seafaring Misenus seated upon the buffalo, which at once was seen pursued and pricked by six Tritons adorned in a very rich and most masterly fashion. And for the tenth and last there was seen coming, almost with the same artifice, but in a different and much larger form and in a different colour, another similar Cloud, which, parting asunder in like manner at the appointed place with smoke and flame and a horrible thunder, was seen to have within it infernal Pluto, drawn in his usual car, and from it in a most gracious manner was seen to come forth in place of a buffalo a great and awful Cerberus, who was chased by six of those glorious ancient heroes who are supposed to dwell in peace in the Elysian Fields. All those companies, when they had appeared one by one upon the piazza and presented the due and gracious spectacle, and after a long breaking of lances, a great caracoling of horses, and a thousand other suchlike games, with which the fair ladies and the multitude of spectators were entertained for a good time, finally made their way to the place where the buffaloes were to be set to race. And there, the trumpet having sounded, and each company striving that its buffalo should arrive at the appointed goal before the others, and now one prevailing and now another, all of a sudden, when they were come within a certain distance of the place, all the air about them was seen filled with terror and alarm from the great and deafening fires that smote them now on one side and now on another, in a thousand strange fashions, insomuch that very often it was seen to happen that one who at the beginning had been nearest to winning the coveted prize, the timid and not very obedient animal taking fright at the noise, the smoke, and the fires above described, which, in proportion as one went ahead, became ever greater and assailed that one with ever greater vehemence, so that the animals turned in various directions, and very often took to headlong flight — it was seen many times, I say, that the first were con-

strained to return among the last; while the confusion of men, buffaloes, and horses, and the lightning-flashes, noises, and thunderings, produced a strange, novel, and incomparable pleasure and delight. And thus with that spectacle was finally contrived a splendid, although for many perhaps disturbing, conclusion of the joyous and most festive Carnival.

In the first and holy days of the following Lent, with the thought of pleasing the most devout bride, but also with truly extraordinary pleasure for the whole people, who, having been deprived of such things for many years, and part of the fragile apparatus having been lost, feared that they would never be resumed, there was held the festival, so famous and so celebrated in olden days, of S. Felice, so-called from the church where it used formerly to be represented. But this time, besides that which their Excellencies, our Lords, themselves deigned to do, it was represented at the pains and expense of four of the principal and most ingenious gentlemen of the city in the Church of S. Spirito, as a place more capacious and more beautiful, with a vast apparatus of machinery and all the old instruments and not a few newly added. In it, besides many Prophets and Sibyls who, singing in the simple ancient manner, announced the coming of Our Lord Jesus Christ, very notable – nay, marvellous, stupendous, and incomparable, from its having been contrived in those ignorant ages – was the Paradise, which, opening in an instant, was seen filled with all the hierarchies of the Angels and of the Saints both male and female, and with various movements representing its different spheres, and as it were sending down to earth the Divine Gabriel shining with infinite splendour, in the midst of eight other little Angels, to bring the Annunciation to the Glorious Virgin, who was seen waiting in her chamber, all humble and devout; all being let down (and reascending afterwards), to the rare marvel of everyone, from the highest part of the cupola of that church, where the above-described Paradise was figured, down to the floor of the chamber of the Virgin, which was not raised any great height from the ground, and all with such security and by methods so beautiful, so facile, and so ingenious, that it appeared scarcely possible that the human brain was able to go so far. And with this the festivities all arranged by our most excellent Lords for those most royal nuptials had a conclusion not only renowned and splendid, but also, as was right fitting for true Christian Princes, religious and devout.

Many things, also, could have been told of a very noble spectacle presented by the most liberal Signor Paolo Giordano Orsino, Duke of Bracciano, in a great and most heroic theatre, all suspended in the air, which was constructed by him of woodwork in those days with royal spirit and incredible expense; and in it, with very rich inventions of the Knights Challengers, of whom he was one, and of the Knights Adventurers, there was fought with various arms a combat for a barrier, and there was performed with beautifully trained horses, to the rare delight of the spectators, the graceful dance called the Battaglia. But this, being hindered by inopportune rains, was prolonged over many days; and since, seeking to treat of it at any length, it would require almost an entire work, being now weary, I believe that I may be pardoned if without saying more of it I bring this my long – I know not whether to call it tedious – labour, at length to an end.

DESCRIPTION OF THE WORKS OF GIORGIO VASARI, Painter and Architect of Arezzo

Having discoursed hitherto of the works of others, with the greatest diligence and sincerity that my brain has been able to command, I also wish at the end of these my labours to assemble together and make known to the world the works that the Divine Goodness in its grace has enabled me to execute, for the reason that, if indeed they are not of that perfection which I might wish, it will yet be seen by him who may consent to look at them with no jaundiced eye that they have been wrought by me with study, diligence, and loving labour, and are therefore worthy, if not of praise, at least of excuse; besides which, being out in the world and open to view, I cannot hide them. And since perchance at some time they might be described by some other person, it is surely better that I should confess the truth, and of myself accuse my imperfection, which I know only too well, being assured of this, that if, as I said, there may not be seen in them the perfection of excellence, there will be perceived at least an ardent desire to work well, great and indefatigable effort, and the extraordinary love that I bear to our arts. Wherefore it may come about that, according to the law, myself confessing openly my own deficiencies, I shall be in great part pardoned.

To begin, then, with my earliest years, let me say that, having spoken sufficiently of the origin of my family, of my birth and childhood, and how I was set by Antonio, my father, with all manner of lovingness on the path of the arts, and in particular that of design, to which he saw me much inclined, with good occasions in the Life of Luca Signorelli of Cortona, my kinsman, in that of Francesco Salviati, and in many other places in the present work, I shall not proceed to repeat the same things. But I must relate that after having drawn in my first years all the good pictures that are about the churches of Arezzo, the first rudiments were taught to me with some method by the Frenchman Guglielmo da Marcilla, whose life and works we have described above. Then, having been taken to Florence in the year 1524 by Silvio Passerini, Cardinal of Cortona, I gave some little attention to design under Michelagnolo, Andrea del Sarto, and others. But the Medici having been driven from Florence in the year 1527, and in particular Alessandro and Ippolito, with whom, young as I was, I had a strait attachment of service through the said Cardinal, my paternal uncle Don Antonio made me return to Arezzo, where a short time before my father had died of plague; which Don Antonio, keeping me at a distance from the city lest I might be infected by the plague, was the reason that I, to avoid idleness, went about exercising my hand throughout the district of Arezzo, near our parts, painting some things in fresco for the peasants of the countryside, although as yet I had scarcely ever touched colours; in doing which I learned that to try your hand and work by yourself is helpful and instructive, and enables you to gain excellent practice. In the year afterwards, 1528, the plague being finished, the first work that I executed was a little altar-picture for the Church of S. Piero, of the Servite Friars, at Arezzo; and in that picture, which is placed against a pilaster, are three half-length figures, S. Agatha, S. Rocco, and S. Sebastian. Being seen by Rosso, a very famous painter, who came in those days to Arezzo, it came about that he, recognizing in it something of the good taken from Nature, desired to know me, and afterwards assisted me with designs and counsel. Nor was it long before by his means M. Lorenzo Gamurrini gave me an altar-picture to execute, for which Rosso made me the design; and I then painted it with all the study, labour, and diligence that were possible to me, in order to learn and to acquire something of a name. And if my powers had equalled my good will, I would have soon

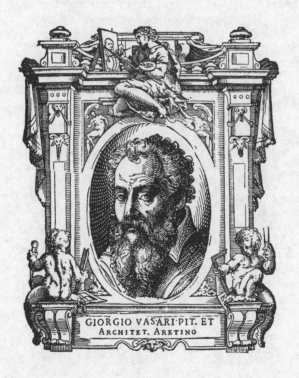

GIORGIO VASARI·PIT·ET
ARCHITET, ARETINO

become a passing good painter, so much I studied and laboured at the things of art; but I found the difficulties much greater than I had judged at the beginning.

However, not losing heart, I returned to Florence, where, perceiving that I could not save only after a long time become such as to be able to assist the three sisters and two younger brothers left to me by my father, I placed myself with a goldsmith. But not for long, because in the year 1529, the enemy having come against Florence, I went off with the goldsmith Manno, who was very much my friend, to Pisa, where, setting aside the goldsmith's craft, I painted in fresco the arch that is over the door of the old Company of the Florentines, and some pictures in oils, which were given to me to execute by means of Don Miniato Pitti, at that time Abbot of Agnano without the city of Pisa, and of Luigi Guicciardini, who was then in that city. Then, the war growing every day more general, I resolved to return to Arezzo; but, not being able to go by the direct and ordinary road, I made my way by the mountains of Modena to Bologna. There, finding that some triumphal arches were being decorated in painting for the coronation of Charles V, young as I was I obtained some work, which brought me honour and profit; and since I drew passing well, I would have found means to live and work there. But the desire that I had to revisit my family and other relatives brought it about that, having found good company, I returned to Arezzo, where, finding my affairs in a good state after the diligent care taken of them by the above-named Don Antonio, my uncle, I settled down with a quiet mind and applied myself to design, executing also some little things in oils of no great importance. Meanwhile the above-named Don Miniato Pitti was made Abbot or Prior, I know not which, of S. Anna, a monastery of Monte Oliveto in the territory of Siena, and he sent for me; and so I made for him and for Albenga, their General, some pictures and other works in painting. Then, the same man having been made Abbot of S. Bernardo in Arezzo, I painted for him two pictures in oils of Job and Moses on the balustrade of the organ. And since the work pleased those monks, they commissioned me to paint some pictures in fresco – namely, the four Evangelists – on the vaulting and walls of a portico before the principal door of the church, with God the Father on the vaulting, and some other figures large as life; in which, although as a youth of little experience I did not do all that one more practised would have done,

nevertheless I did all that I could, and work which pleased those fathers, having regard for my small experience and age. But scarcely had I finished that work when Cardinal Ippolito de' Medici, passing through Arezzo by post, took me away to Rome to serve him, as has been related in the Life of Salviati; and there, by the courtesy of that lord, I had facilities to attend for many months to the study of design. And I could say with truth that those facilities and my studies at that time were my true and principal master in my art, although before that those named above had assisted me not a little; and there had not gone from my heart the ardent desire to learn, and the untiring zeal to be always drawing night and day. There was also of great benefit to me in those days the competition of my young contemporaries and companions, who have since become for the most part very excellent in our art. Nor was it otherwise than a very sharp spur to me to have such a desire of glory, and to see many who had proved themselves very rare, and had risen to honour and rank; so that I used to say to myself at times: 'Why should it not be in my power to obtain by assiduous study and labour some of that grandeur and rank that so many others have acquired? They, also, were of flesh and bones, as I am.'

Urged on, therefore, by so many sharp spurs, and by seeing how much need my family had of me, I disposed myself never to shrink from any fatigue, discomfort, vigil, and toil, in order to achieve that end; and, having thus resolved in my mind, there remained nothing notable at that time in Rome, or afterwards in Florence, and in other places where I dwelt, that I did not draw in my youth, and not pictures only, but also sculptures and architectural works ancient and modern. And besides the proficience that I made in drawing the vaulting and chapel of Michelagnolo, there remained nothing of Raffaello, Polidoro, and Baldassarre da Siena, that I did not likewise draw in company with Francesco Salviati, as has been told already in his Life. And to the end that each of us might have drawings of everything, during the day the one would not draw the same things as the other, but different, and then at night we used to copy each other's drawings, so as to save time and extend our studies; not to mention that more often than not we ate our morning meal standing up, and little at that. After which incredible labour, the first work that issued from my hands, as from my own forge, was a great picture with figures large as life, of a Venus with the Graces adorning and

beautifying her, which Cardinal de' Medici caused me to paint; but of that picture there is no need to speak, because it was the work of a lad, nor would I touch on it, save that it is dear to me to remember still these first beginnings and many upward steps of my apprenticeship in the arts. Enough that that lord and others gave me to believe that there was in it a certain something of a good beginning and of a lively and resolute spirit. And since among other things I had made therein to please my fancy a lustful Satyr who, standing hidden amid some bushes, was rejoicing and feasting himself on the sight of Venus and the Graces nude, that so pleased the Cardinal that he had me clothed anew from head to foot, and then gave orders that I should paint in a larger picture, likewise in oils, the battle of the Satyrs with the Fauns, Sylvan Gods, and children, forming a sort of Bacchanal; whereupon, setting to work, I made the cartoon and then sketched in the canvas in colours, which was ten braccia long. Having then to depart in the direction of Hungary, the Cardinal made me known to Pope Clement and left me to the protection of his Holiness, who gave me into the charge of Signor Jeronimo Montaguto, his Chamberlain, with letters authorizing that, if I might wish to fly from the air of Rome that summer, I should be received in Florence by Duke Alessandro; which it would have been well for me to do, because, choosing after all to stay in Rome, what with the heat, the air, and my fatigue, I fell sick in such sort that in order to be restored I was forced to have myself carried by litter to Arezzo. Finally, however, being well again, about the 10th of the following December I came to Florence, where I was received by the above-named Duke with kindly mien, and shortly afterwards given into the charge of the magnificent M. Ottaviano de' Medici, who so took me under his protection, that as long as he lived he treated me always as a son; and his blessed memory I shall always remember and revere, as of a most affectionate father. Returning then to my usual studies, I received facilities by means of that lord to enter at my pleasure into the new sacristy of S. Lorenzo, where are the works of Michelagnolo, he having gone in those days to Rome; and so I studied them for some time with much diligence, just as they were on the ground. Then, setting myself to work, I painted in a picture of three braccia a Dead Christ carried to the Sepulchre by Nicodemus, Joseph, and others, and behind them the Maries weeping; which picture, when it was finished, was taken by Duke

Alessandro. And it was a good and auspicious beginning for my labours, for the reason that not only did he hold it in account as long as he lived, but it has been ever since in the chamber of Duke Cosimo, and is now in that of the most illustrious Prince, his son; and although at times I have desired to set my hand upon it again, in order to improve it in some parts, I have not been allowed. Duke Alessandro, then, having seen this my first work, ordained that I should finish the ground-floor room in the Palace of the Medici which had been left incomplete, as has been related, by Giovanni da Udine. Whereupon I painted there four stories of the actions of Cæsar; his swimming with the Commentaries in one hand and a sword in the mouth, his causing the writings of Pompeius to be burned in order not to see the works of his enemies, his revealing himself to a helmsman while tossed by fortune on the sea, and, finally, his triumph; but this last was not completely finished. During which time, although I was but little more than eighteen years of age, the Duke gave me a salary of six crowns a month, a place at table for myself and a servant, and rooms to live in, with many other conveniences. And although I knew that I was very far from deserving so much, yet I did all that I could with diligence and lovingness, nor did I shrink from asking from my elders whatever I did not know myself; wherefore on many occasions I was assisted with counsel and with work by Tribolo, Bandinelli, and others. I painted, then, in a picture three braccia high, Duke Alessandro himself in armour, portrayed from life, with a new invention in a seat formed of captives bound together, and with other fantasies. And I remember that besides the portrait, which was a good likeness, in seeking to make the burnished surface of the armour bright, shining, and natural, I was not very far from losing my wits, so much did I exert myself in copying every least thing from the reality. However, despairing to be able to approach to the truth in the work, I took Jacopo da Pontormo, whom I revered for his great ability, to see it and to advise me; and he, having seen the picture and perceived my agony, said to me lovingly: 'My son, as long as this real lustrous armour stands beside the picture, your armour will always appear to you as painted, for, although lead-white is the most brilliant pigment that art employs, the iron is yet more brilliant and lustrous. Take away the real armour, and you will then see that your counterfeit armour is not such poor stuff as you think it.'

That picture, when it was finished, I gave to the Duke, and the Duke presented it to M. Ottaviano de' Medici, in whose house it has been up to the present day, in company with the portrait of Caterina, the then young sister of the Duke, and afterwards Queen of France, and that of the Magnificent Lorenzo, the Elder. And in the same house are three pictures also by my hand and executed in my youth; in one is Abraham sacrificing Isaac, in the second Christ in the Garden, and in the third His Supper with the Apostles. Meanwhile Cardinal Ippolito died, in whom was centred the sum of all my hopes, and I began to recognize how vain generally are the hopes of this world, and that a man must trust mostly in himself and in being of some account. After these works, perceiving that the Duke was all given over to fortifications and to building, I began, the better to be able to serve him, to give attention to matters of architecture, and spent much time upon them. But meanwhile, festive preparations having to be made in Florence in the year 1536 for receiving the Emperor Charles V, the Duke, in giving orders for that, commanded the deputies charged with the care of those pomps, as has been related in the Life of Tribolo, that they should have me with them to design all the arches and other ornaments to be made for that entry. Which done, there was allotted to me for my benefit, besides the great banners of the castle and fortress, as has been told, the façade in the manner of a triumphal arch that was constructed at S. Felice in Piazza, forty braccia high and twenty wide, and then the ornamentation of the Porta a S. Piero Gattolini; works all great and beyond my strength. And, what was worse, those favours having drawn down upon me a thousand envious thoughts, about twenty men who were helping me to do the banners and the other labours left me nicely in the lurch, at the persuasion of one person or another, to the end that I might not be able to execute works so many and of such importance. But I, who had foreseen the malice of such creatures (to whom I had always sought to give assistance), partly labouring with my own hand day and night, and partly aided by painters brought in from without, who helped me secretly, attended to my business, and strove to conquer all such difficulties and treacheries by means of the works themselves. During that time Bertoldo Corsini, who was then proveditor-general to his Excellency, had reported to the Duke that I had undertaken to do so many things that it would never be possible for me to have them finished in time,

particularly because I had no men and the works were much in arrears. Whereupon the Duke sent for me, and told me what he had heard; and I answered that my works were well advanced, as his Excellency might see at his pleasure, and that the end would do credit to the whole. Then I went away, and no long time passed before he came secretly to where I was working, and, having seen everything, recognized in part the envy and malice of those who were pressing upon me without having any cause. The time having come when everything was to be in order, I had finished my works to the last detail and set them in their places, to the great satisfaction of the Duke and of all the city; whereas those of some who had thought more of my business than of their own, were set in place unfinished. When the festivities were over, besides four hundred crowns that were paid to me for my work, the Duke gave me three hundred that were taken away from those who had not carried their works to completion by the appointed time, according as had been arranged by agreement. And with those earnings and donations I married one of my sisters, and shortly afterwards settled another as a nun in the Murate at Arezzo, giving to the convent besides the dowry, or rather, alms, an altar-picture of the Annunciation by my hand, with a Tabernacle of the Sacrament accommodated in that picture, which was placed within their choir, where they perform their offices. Having then received from the Company of the Corpus Domini, at Arezzo, the commission for the altar-piece of the high-altar of S. Domenico, I painted in it Christ taken down from the Cross; and shortly afterwards I began for the Company of S. Rocco the altar-picture of their church, in Florence.

Now, while I was going on winning for myself honour, name, and wealth under the protection of Duke Alessandro, that poor lord was cruelly murdered, and there was snatched away from me all hope of that which I was promising to myself from Fortune by means of his favour; wherefore, having been robbed within a few years of Clement, Ippolito, and Alessandro, I resolved at the advice of M. Ottaviano that I would never again follow the fortune of Courts, but only art, although it would have been easy to establish myself with Signor Cosimo de' Medici, the new Duke. And so, while carrying forward in Arezzo the above-named altar-picture and the façade of S. Rocco, with the ornament, I was making preparations to go to Rome, when by means of M. Giovanni Pollastra – and by the will of God, to whom I have always

commended myself, and to whom I attribute and have always attributed my every blessing – I was invited to Camaldoli, the centre of the Camaldolese Congregation, by the fathers of that hermitage, to see that which they were designing to have done in their church. Arriving there, I found supreme pleasure in the Alpine and eternal solitude and quietness of that holy place; and although I became aware at the first moment that those fathers of venerable aspect were beside themselves at seeing me so young, I took heart and talked to them to such purpose, that they resolved that they would avail themselves of my hand in the many pictures in oils and in fresco that were to be painted in their church of Camaldoli. Now, while they wished that before any other thing I should execute the picture of the high-altar, I proved to them with good reasons that it was better to paint first one of the lesser pictures, which were going in the tramezzo,* and that, having finished it, if it should please them, I would be able to continue. Besides that, I would not make any fixed agreement with them as to money, but said that if my work, when finished, were to please them, they might pay me for it as they chose, and, if it did not please them, they might return it to me, and I would keep it for myself most willingly; which condition appearing to them only too honest and loving, they were content that I should set my hand to the work. They said to me, then, that they wished to have in it Our Lady with her Son in her arms, and S. John the Baptist and S. Jerome, who were both hermits and lived in woods and forests; and I departed from the hermitage and made my way down to their Abbey of Camaldoli, where, having made a design with great rapidity, which pleased them, I began the altar-piece, and in two months had it completely finished and set in place, to the great satisfaction of those fathers, as they gave me to understand, and of myself. And in that period of two months I proved how much more one is assisted in studies by sweet tranquillity and honest solitude than by the noises of public squares and courts; I recognized, I say, my error in having in the past placed my hopes in men and in the follies and intrigues of this world. That altar-picture finished, then, they allotted to me straightway the rest of the tramezzo* of the church – namely, the scenes and other things in fresco-work to be painted there both high and low, which I was to execute during the following

* See note on p. 90, Vol. I.

summer, for the reason that in the winter it would be scarcely possible to work in fresco at that altitude, among those mountains.

Meanwhile I returned to Arezzo and finished the altar-picture for S. Rocco, painting in it Our Lady, six Saints, and a God the Father with some thunder-bolts in the hand, representing the pestilence, which He is in the act of hurling down, but S. Rocco and other Saints make intercession for the people. And in the façade are many figures in fresco, which, like the altar-picture, are no better than they should be. Then Fra Bartolommeo Gratiani, a friar of S. Agostino in Monte Sansovino, sent to invite me to Val di Caprese, and commissioned me to execute a great altar-piece in oils for the high-altar of the Church of S. Agostino in that same Monte Sansovino. And after we had come to an agreement, I made my way to Florence to see M. Ottaviano, where, staying several days, I had much ado to prevent myself from re-entering the service of the Court, as I was minded not to do. However, by advancing good reasons I won the battle, and I resolved that by hook or by crook, before doing anything else, I would go to Rome. But in that I did not succeed until I had made for that same Messer Ottaviano a copy of the picture in which formerly Raffaello da Urbino had portrayed Pope Leo, Cardinal Giulio de' Medici, and Cardinal de' Rossi, for the Duke was claiming the original, which was then in the possession of Messer Ottaviano; and the copy that I made is now in the house of the heirs of that lord, who on my departure for Rome wrote me a letter of exchange for five hundred crowns on Giovan Battista Puccini, which he was to pay me on demand, and said to me: 'Use this money to enable you to attend to your studies, and afterwards, when you find it convenient, you can return it to me either in work or in cash, just as you please.' Arriving in Rome, then, in February of the year 1538, I stayed there until the end of June, giving my attention in company with Giovan Battista Cungi of the Borgo, my assistant, to drawing all that I had left not drawn the other times that I had been in Rome, and particularly everything that was in the underground grottoes. Nor did I leave anything either in architecture or in sculpture that I did not draw and measure, insomuch that I can say with truth that the drawings that I made in that space of time were more than three hundred; and for many years afterwards I found pleasure and advantage in examining them, refreshing the memory of the things of Rome. And how much those labours and studies

benefited me, was seen after my return to Tuscany in the altar-picture that I executed at Monte Sansovino, in which I painted with a somewhat better manner the Assumption of Our Lady, and at the foot, besides the Apostles who are about the sepulchre, S. Augustine and S. Romualdo. Having then gone to Camaldoli, according as I had promised those eremite fathers, I painted in the other altar-piece of the tramezzo* the Nativity of Jesus Christ, representing a night illumined by the Splendour of the newborn Christ, who is surrounded by some Shepherds adoring Him; in doing which, I strove to imitate with colours the rays of the sun, and copied the figures and all the other things in that work from Nature and in the proper light, to the end that they might be as similar as possible to the reality. Then, since that light could not pass above the hut, from there upwards and all around I availed myself of a light that comes from the splendour of the Angels that are in the air, singing Gloria in Excelsis Deo; not to mention that in certain places the Shepherds that are around make light with burning sheaves of straw, and also the Moon and the Star, and the Angel that is appearing to certain Shepherds. For the building, then, I made some antiquities after my own fancy, with broken statues and other things of that kind. In short, I executed that work with all my power and knowledge, and although I did not satisfy with the hand and the brush my great desire and eagerness to work supremely well, nevertheless the picture has pleased many; wherefore Messer Fausto Sabeo, a man of great learning who was then custodian of the Pope's Library, and some others after him, wrote many Latin verses in praise of that picture, moved perhaps more by affectionate feeling than by the excellence of the work. Be that as it may, if there be in it anything of the good, it was the gift of God. That altar-picture finished, those fathers resolved that I should paint in fresco on the façade the stories that were to be there, whereupon I painted over the door a picture of the hermitage, with S. Romualdo and a Doge of Venice who was a saintly man on one side, and on the other a vision which the above-named Saint had in that place where he afterwards made his hermitage; with some fantasies, grotesques, and other things that are to be seen there. Which done, they ordained that I should return in the summer of the following year to execute the picture of the high-altar.

* See note on p. 90, Vol. I.

Meanwhile the above-named Don Miniato Pitti, who was then Visitor to the Congregation of Monte Oliveto, having seen the altar-picture of Monte Sansovino and the works of Camaldoli, and finding in Bologna the Florentine Don Filippo Serragli, Abbot of S. Michele in Bosco, said to him that, since the refectory of that honoured monastery was to be painted, it appeared to him that the work should be allotted to me and not to another. Being therefore summoned to go to Bologna, I undertook to do it, although it was a great and important work; but first I desired to see all the most famous works in painting that were in that city, both by Bolognese and by others. The work of the head-wall of that refectory was divided into three pictures; in one was to be when Abraham prepared food for the Angels in the Valley of Mamre, in the second Christ in the house of Mary Magdalene and Martha, speaking with Martha, and saying to her that Mary had chosen the better part, and in the third was to be S. Gregory at table with twelve poor men, among whom he recognized one as Christ. Then, setting my hand to the work, I depicted in the last S. Gregory at table in a convent, served by White Friars of that Order, that I might be able to include those fathers therein, according to their wish. Besides that, I made in the figure of that saintly Pontiff the likeness of Pope Clement VII, and about him, among many Lords, Ambassadors, Princes, and other personages who stand there to see him eat, I portrayed Duke Alessandro de' Medici, in memory of the benefits and favours that I had received from him, and of his having been what he was, and with him many of my friends. And among those who are serving the poor men at table, I portrayed some friars of that convent with whom I was intimate, such as the strangers' attendants who waited upon me, the dispenser, the cellarer, and others of the kind; and so, also, the Abbot Serragli, the General Don Cipriano da Verona, and Bentivoglio. In like manner, I copied the vestments of that Pontiff from the reality, counterfeiting velvets, damasks, and other draperies of silk and gold of every kind; but the service of the table, vases, animals, and other things, I caused to be executed by Cristofano of the Borgo, as was told in his Life. In the second scene I sought to make the heads, draperies, and buildings not only different from the first, but in such a manner as to make as clearly evident as possible the lovingness of Christ in instructing the Magdalene, and the affection and readiness of Martha in arranging the table, and her lamentation at being left alone by her

sister in such labours and service; to say nothing of the attentive-
ness of the Apostles, and of many other things worthy of con-
sideration in that picture. As for the third scene, I painted the
three Angels – coming to do this I know not how – within a
celestial light which seems to radiate from them, while the rays
of the sun surround the cloud in which they are. Of the three
Angels the old Abraham is adoring one, although those that he
sees are three; while Sarah stands laughing and wondering how
that can come to pass which has been promised to her, and
Hagar, with Ishmael in her arms, is departing from the hospitable
shelter. The same radiance also gives light to some servants who
are preparing the table, among whom are some who, not being
able to endure that splendour, place their hands over their eyes
and seek to shade themselves. Which variety of things, since
strong shadows and brilliant lights give greater force to pictures,
caused this one to have more relief than the other two, and, the
colours being varied, they produced a very different effect. But
would I had been able to carry my conception into execution,
even as both then and afterwards, with new inventions and fan-
tasies, I was always seeking out the laborious and difficult in art.
This work, then, whatever it may be, was executed by me in eight
months, together with a frieze in fresco, architectural ornaments,
carvings, seat-backs, panels, and other adornments over the
whole work and the whole refectory; and the price of all I was
content to make two hundred crowns, as one who aspired more
to glory than to gain. Wherefore M. Andrea Alciati, my very dear
friend, who was then reading in Bologna, caused these words to
be placed at the foot:

OCTONIS MENSIBUS OPUS AB ARETINO GEORGIO PICTUM,
NON TAM PRECIO QUAM AMICORUM OBSEQUIS ET HONORIS
VOTO, ANNO 1539 PHILIPPUS SERRALIUS PON. CURAVIT.

At this same time I executed two little altar-pictures, of the
Dead Christ and of the Resurrection, which were placed by the
Abbot Don Miniato Pitti in the Church of S. Maria di Barbiano,
without San Gimignano in Valdelsa. Which works finished, I
returned straightway to Florence, for the reason that Treviso,
Maestro Biagio, and other Bolognese painters, thinking that I was
seeking to establish myself in Bologna and to take their
works and commissions out of their hands, kept molesting me
unceasingly; but they did more harm to themselves than to me, and

their envious ways moved me to laughter. In Florence, then, I copied for M. Ottaviano a large portrait of Cardinal Ippolito down to the knees, and other pictures, with which I kept myself occupied until the insupportable heat of summer. Which having come, I returned to the quiet and freshness of Camaldoli, in order to execute the above-mentioned altar-piece of the high-altar. In that work I painted a Christ taken down from the Cross, with the greatest study and labour that were within my power; and since, in the course of the work and of time, it seemed necessary to me to improve certain things, and I was not satisfied with the first sketch, I gave it another priming and repainted it all anew, as it is now to be seen, and then, attracted by the solitude and staying in that same place, I executed there a picture for the same Messer Ottaviano, in which I painted a young S. John, nude, among some rocks and crags that I copied from Nature among those mountains. And I had scarcely finished these works when there arrived in Camaldoli Messer Bindo Altoviti, who wished to arrange a transportation of great fir-trees to Rome by way of the Tiber, for the fabric of S. Pietro, from the Cella di S. Alberigo, a place belonging to those fathers; and he, seeing all the works executed by me in that place, and by my good fortune liking them, resolved, before he departed thence, that I should paint an altar-picture for his Church of S. Apostolo in Florence. Wherefore, having finished that of Camaldoli, with the façade of the chapel in fresco (wherein I made the experiment of combining work in oil-colours with the other, and succeeded passing well), I made my way to Florence, and there executed that altar-picture. Now, having to give a proof of my powers in Florence, where I had not yet executed such a work, and having many rivals, and also a desire to acquire a name, I resolved that I would do my utmost in that work and put into it all the diligence that I might find possible. And in order to be able to do that free from every vexatious thought, I first married my third sister and bought a house already begun in Arezzo, with a site for making most beautiful gardens, in the Borgo di S. Vito, in the best air of that city. In October, then, of the year 1540, I began the altar-picture for Messer Bindo, proposing to paint in it a scene that should represent the Conception of Our Lady, according to the title of the chapel; which subject presenting no little difficulty to me, Messer Bindo and I took the opinions of many common friends, men of learning, and finally I executed it in the following manner.

Having depicted the Tree of the Primal Sin in the middle of the picture, I painted at its roots Adam and Eve naked and bound, as the first transgressors of the commandment of God, and then one by one, bound to the other branches, Abraham, Isaac, Jacob, Moses, Aaron, Joshua, David, and the other Kings in succession, according to the order of time; all, I say, bound by both arms, excepting Samuel and John the Baptist, who are bound by one arm only, because they were blessed in the womb. I painted there, also, with the tail wound about the trunk of the Tree, the Ancient Serpent, who, having a human form from the middle upwards, has the hands bound behind; and upon his head, treading upon his horns, is one foot of the glorious Virgin, who has the other on a Moon, being herself all clothed with the Sun, and crowned with twelve stars. The Virgin, I say, is supported in the air, within a Splendour, by many nude little Angels, who are illumined by the rays that come from her; which rays, likewise, passing through the leaves of the Tree, shed light upon those bound to it, and appear to be loosing their bonds by means of the virtue and grace that they bring from her from whom they proceed. And in the heaven, at the top of the picture, are two children that are holding certain scrolls, in which are written these words: QUOS EVÆ CULPA DAMNAVIT, MARIÆ GRATIA SOLVIT. In short, so far as I can remember, I had not executed any work up to that time with more study or with more lovingness and labour; but all the same, while I may perhaps have satisfied others, I did not satisfy myself, although I know the time, study, and labour that I devoted to it, particularly to the nudes and heads, and, indeed, to every part.

For the labours of that picture Messer Bindo gave me three hundred crowns of gold, besides which, in the following year, he showed me so many courtesies and kindnesses in his house in Rome, where I made him a copy of the same altar-piece in a little picture, almost in miniature, that I shall always feel an obligation to his memory. At the same time that I painted that picture, which was placed, as I have said, in S. Apostolo, I executed for M. Ottaviano de' Medici a Venus and a Leda from the cartoons of Michelagnolo, and in a large picture a S. Jerome in Penitence of the size of life, who, contemplating the death of Christ, whom he has before him on the Cross, is beating his breast in order to drive from his mind the thoughts of Venus and the temptations of the flesh, which at times tormented him, although he lived in

woods and places wild and solitary, as he relates of himself at great length. To demonstrate which I made a Venus who with Love in her arms is flying from that contemplation, and holding Play by the hand, while the quiver and arrows have fallen to the ground; besides which, the shafts shot by Cupid against that Saint return to him all broken, and some that fall are brought back to him by the doves of Venus in their beaks. All these pictures, although perhaps at that time they pleased me, and were made by me as best I knew, I know not how much they please me at my present age; but, since art in herself is difficult, it is necessary to take from him who paints the best that he can do. This, indeed, I will say, because I can say it with truth, that I have always executed my pictures, inventions, and designs, whatever may be their value, I do not say only with the greatest possible rapidity, but also with incredible facility and without effort; for which let me call to witness, as I have mentioned in another place, the vast canvas that I painted in six days only, for S. Giovanni in Florence, in the year 1542, for the baptism of the Lord Don Francesco de' Medici, now Prince of Florence and Siena.

Now although I wished after these works to go to Rome, in order to satisfy Messer Bindo Altoviti, I did not succeed in doing it, because, being summoned to Venice by Messer Pietro Aretino, a poet of illustrious name at that time, and much my friend, I was forced to go there, since he much desired to see me. And, moreover, I did it willingly, in order to see on that journey the works of Tiziano and of other painters; in which purpose I succeeded, for in a few days I saw the works of Correggio at Modena and Parma, those of Giulio Romano at Mantua, and the antiquities of Verona. Having finally arrived in Venice, with two pictures painted by my hand from cartoons by Michelagnolo, I presented them to Don Diego di Mendoza, who sent me two hundred crowns of gold. Nor had I been long in Venice, when at the entreaty of Aretino I executed for the gentlemen of the Calza the scenic setting for a festival that they gave, wherein I had as my companions Battista Cungi and Cristofano Gherardi of Borgo a San Sepolcro and Bastiano Flori of Arezzo, men very able and well practised, of all which enough has been said in another place; and also the nine painted compartments in the Palace of Messer Giovanni Cornaro, which are in the soffit of a chamber in that Palace, which is by S. Benedetto. After these and other works of

no little importance that I executed in Venice at that time, I departed, although I was overwhelmed by the commissions that were coming to me, on the 16th of August in the year 1542, and returned to Tuscany. There, before consenting to put my hand to any other thing, I painted on the vaulting of a chamber that had been built by my orders in my house which I have already mentioned, all the arts that are subordinate to or depend upon design. In the centre is a Fame who is seated upon the globe of the world and sounds a golden trumpet, throwing away one of fire that represents Calumny, and about her, in due order, are all those arts with their instruments in their hands; and since I had not time to do the whole, I left eight ovals, in order to paint in them eight portraits from life of the first men in our arts. In those same days I executed in fresco for the Nuns of S. Margherita in the same city, in a chapel of their garden, a Nativity of Christ with figures the size of life. And having thus passed the rest of that summer in my own country, and part of the autumn, I went to Rome, where, having been received by the above-named Messer Bindo with many kindnesses, I painted for him in a picture in oils a Christ the size of life, taken down from the Cross and laid on the ground at the feet of His Mother; with Phœbus in the air obscuring the face of the Sun, and Diana that of the Moon. In the landscape, all darkened by that gloom, some rocky mountains, shaken by the earthquake that was caused by the Passion of the Saviour, are seen shivered into pieces, and certain dead bodies of Saints are seen rising again and issuing from their sepulchres in various manners; which picture, when finished, was not displeasing to the gracious judgment of the greatest painter, sculptor, and architect that there has been in our times, and perchance in the past. By means of that picture, also, I became known to the most illustrious Cardinal Farnese, to whom it was shown by Giovio and Messer Bindo; and at his desire I made for him, in a picture eight braccia high and four broad, a Justice who is embracing an ostrich laden with the twelve Tables, and with the sceptre that has the stork at the point, and the head covered by a helmet of iron and gold, with three feathers of three different colours, the device of the just judge. She is wholly nude from the waist upwards, and she has bound to her girdle with chains of gold, as captives, the seven Vices that are opposed to her, Corruption, Ignorance, Cruelty, Fear, Treachery, Falsehood, and Calumny. Above these, upon their shoulders, is placed Truth wholly

nude, offered by Time to Justice, with a present of two doves representing Innocence. And upon the head of that Truth Justice is placing a crown of oak, signifying fortitude of mind; which whole work I executed with all care and diligence, according to the best of my ability. At this same time I paid constant attention to Michelagnolo Buonarroti, and took his advice in all my works, and he in his goodness conceived much more affection for me; and his counsel, after he had seen some of my designs, was the reason that I gave myself anew and with better method to the study of the matters of architecture, which probably I would never have done if that most excellent man had not said to me what he did say, which out of modesty I forbear to tell.

At the next festival of S. Peter, the heat being very great in Rome, where I had spent all that winter of 1543, I returned to Florence, where in the house of Messer Ottaviano de' Medici, which I could call my own, I executed in an altar-piece for M. Biagio Mei of Lucca, his gossip, the same conception as in that of Messer Bindo in S. Apostolo, although I varied everything with the exception of the invention; and that picture, when finished, was placed in his chapel in S. Piero Cigoli at Lucca. In another of the same size – namely, seven braccia high and four broad – I painted Our Lady, S. Jerome, S. Luke, S. Cecilia, S. Martha, S. Augustine, and S. Guido the Hermit; which altar-picture was placed in the Duomo of Pisa, where there were many others by the hands of excellent masters. And I had scarcely carried that one to completion, when the Warden of Works of that Duomo commissioned me to execute another, in which, since it was to be likewise of Our Lady, in order to vary it from the other I painted the Madonna with the Dead Christ at the foot of the Cross, lying in her lap, the Thieves on high upon their crosses, and, grouped with the Maries and Nicodemus, who are standing there, the titular Saints of those chapels, all forming a good composition and rendering the scene in that picture pleasing. Having returned again to Rome in the year 1544, besides many pictures that I executed for various friends, of which there is no need to make mention, I made a picture of a Venus from a design by Michelagnolo for M. Bindo Altoviti, who took me once more into his house; and for Galeotto da Girone, a Florentine merchant, I painted an altar-picture in oils of Christ taken down from the Cross, which was placed in his chapel in the

Church of S. Agostino at Rome. In order to be able to paint that picture in comfort, together with some works that had been allotted to me by Tiberio Crispo, the Castellan of Castel S. Angelo, I had withdrawn by myself to that palace in the Trastevere which was formerly built by Bishop Adimari, below S. Onofrio, and which has since been finished by the second Salviati; but, feeling indisposed and wearied by my infinite labours, I was forced to return to Florence. There I executed some pictures, and among others one in which were Dante, Petrarca, Guido Cavalcanti, Boccaccio, Cino da Pistoia, and Guittone d'Arezzo, accurately copied from their ancient portraits; and of that picture, which afterwards belonged to Luca Martini, many copies have since been made.

In that same year of 1544 I was invited to Naples by Don Giammateo of Aversa, General of the Monks of Monte Oliveto, to the end that I might paint the refectory of a monastery built for them by King Alfonso I; but when I arrived, I was for not accepting the work, seeing that the refectory and the whole monastery were built in an ancient manner of architecture, with the vaults in pointed arches, low and poor in lights, and I doubted that I was like to win little honour thereby. However, being pressed by Don Miniato Pitti and Don Ippolito da Milano, my very dear friends, who were then Visitors to that Order, finally I accepted the undertaking. Whereupon, recognizing that I would not be able to do anything good save only with a great abundance of ornaments, dazzling the eyes of all who might see the work with a variety and multitude of figures, I resolved to have all the vaulting of the refectory wrought in stucco, in order to remove by means of rich compartments in the modern manner all the old-fashioned and clumsy appearance of those arches. In this I was much assisted by the vaults and walls, which are made, as is usual in that city, of blocks of tufa, which cut like wood, or even better, like bricks not completely baked; and thus, cutting them, I was able to sink squares, ovals, and octagons, and also to thicken them with additions of the same tufa by means of nails. Having then reduced those vaults to good proportions with that stucco-work, which was the first to be wrought in Naples in the modern manner, and in particular the façades and end-walls of that refectory, I painted there six panels in oils, seven braccia high, three to each end-wall. In three that are over the entrance of the refectory is the Manna raining down upon the Hebrew

people, in the presence of Moses and Aaron, and the people gathering it up; wherein I strove to represent a variety of attitudes and vestments in the men, women, and children, and the emotion wherewith they are gathering up and storing the Manna, rendering thanks to God. On the end-wall that is at the head is Christ at table in the house of Simon, and Mary Magdalene with tears washing His feet and drying them with her hair, showing herself all penitent for her sins; which story is divided into three pictures, in the centre the supper, on the right hand a buttery with a credence full of vases in various fantastic forms, and on the left hand a steward who is bringing up the viands. The vaulting, then, was divided into three parts; in one the subject is Faith, in the second Religion, and in the third Eternity, and each of these forms a centre with eight Virtues about it, demonstrating to the monks that in that refectory they eat what is requisite for the perfection of their lives. To enrich the spaces of the vaulting, I made them full of grotesques, which serve as ornaments in forty-eight spaces for the forty-eight celestial signs; and on six walls down the length of that refectory, under the windows, which were made larger and richly ornamented, I painted six of the Parables of Jesus Christ which are in keeping with that place; and to all those pictures and ornaments there correspond the carvings of the seats, which are wrought very richly. And then I executed for the high-altar of the church an altar-picture eight braccia high, containing the Madonna presenting the Infant Jesus Christ to Simeon in the Temple, with a new invention. It is a notable thing that since Giotto there had not been up to that time, in a city so great and noble, any masters who had done anything of importance in painting, although there had been brought there from without some things by the hands of Perugino and Raffaello. On which account I exerted myself to labour in such a manner, in so far as my little knowledge could reach, that the intellects of that country might be roused to execute great and honourable works; and, whether that or some other circumstance may have been the reason, between that time and the present day many very beautiful works have been done there, both in stucco and in painting. Besides the pictures described above, I executed in fresco on the vaulting of the strangers' apartment in the same monastery, with figures large as life, Jesus Christ with the Cross on His shoulder, and many of His Saints who have one likewise on their shoulders in imitation of Him, to demonstrate that for one who wishes

truly to follow Him it is necessary to bear with good patience the adversities that the world inflicts. For the General of that Order I executed a great picture of Christ appearing to the Apostles as they struggled with the perils of the sea, and taking S. Peter by the arm, who, having hastened towards Him through the water, was fearing to drown; and in another picture, for Abbot Capeccio, I painted the Resurrection. These works carried to completion, I painted a chapel in fresco for the Lord Don Pietro di Toledo, Viceroy of Naples, in his garden at Pozzuolo, besides executing some very delicate ornaments in stucco; and arrangements had been made to execute two great loggie for the same lord, but the undertaking was not carried into effect, for the following reason. There had been some difference between the Viceroy and the above-named monks, and the Constable went with his men to the monastery to seize the Abbot and some monks who had had some words with the Black Friars in a procession, over a matter of precedence. But the monks made some resistance, assisted by about fifteen young men who were assisting me in stucco-work and painting, and wounded some of the bailiffs; on which account it became necessary to get them out of the way, and they went off in various directions. And so I, left almost alone, was unable not only to execute the loggie at Pozzuolo, but also to paint twenty-four pictures of stories from the Old Testament and from the life of S. John the Baptist, which, not caring to remain any longer in Naples, I took to Rome to finish, whence I sent them, and they were placed about the stalls and over the presses of walnut-wood made from my architectural designs in the Sacristy of S. Giovanni Carbonaro, a convent of Eremite and Observantine Friars of S. Augustine, for whom I had painted a short time before, for a chapel without their church, a panel-picture of Christ Crucified, with a rich and varied ornament of stucco, at the request of Seripando, their General, who afterwards became a Cardinal. In like manner, half-way up the staircase of the same convent, I painted in fresco a S. John the Evangelist who stands gazing at Our Lady clothed with the sun and crowned with twelve stars, with her feet upon the moon. In the same city I painted for Messer Tommaso Cambi, a Florentine merchant and very much my friend, the times and seasons of the year on four walls in the hall of his house, with pictures of Sleep and Dreaming over a terrace where I made a fountain. And for the Duke of Gravina I painted an

altar-picture of the Magi adoring Christ, which he took to his
dominions; and for Orsanca, Secretary to the Viceroy, I executed
another altar-piece with five figures around a Christ Crucified,
and many pictures.

But, although I was regarded with favour by those lords and
was earning much, and my commissions were multiplying every
day, I judged, since my men had departed and I had executed
works in abundance in one year in that city, that it would be well
for me to return to Rome. Which having done, the first work that
I executed was for Signor Ranuccio Farnese, at that time Arch-
bishop of Naples; painting on canvas and in oils four very large
shutters for the organ of the Piscopio in Naples, on the front of
which are five Patron Saints of that city, and on the inner side
the Nativity of Jesus Christ, with the Shepherds, and King David
singing to his psaltery, DOMINUS DIXIT AD ME, etc. And I
finished likewise the twenty-four pictures mentioned above and
some for M. Tommaso Cambi, which were all sent to Naples;
which done, I painted five pictures of the Passion of Christ for
Raffaello Acciaiuoli, who took them to Spain. In the same year,
Cardinal Farnese being minded to cause the Hall of the Cancel-
leria, in the Palace of S. Giorgio, to be painted, Monsignor Gio-
vio, desiring that it should be done by my hands, commissioned
me to make many designs with various inventions, which in the
end were not carried into execution. Nevertheless the Cardinal
finally resolved that it should be painted in fresco, and with the
greatest rapidity that might be possible, so that he might be able
to use it at a certain time determined by himself. That hall is a
little more than a hundred palms in length, fifty in breadth, and
the same in height. On each end-wall, fifty palms broad, was
painted a great scene, and two on one of the long walls, but on
the other, from its being broken by windows, it was not possible
to paint scenes, and therefore there was made a pendant after the
likeness of the head-wall opposite. And not wishing to make a
base, as had been the custom up to that time with the craftsmen
in all their scenes, in order to introduce variety and do something
new I caused flights of steps to rise from the floor to a height of
at least nine palms, made in various ways, one to each scene; and
upon these, then, there begin to ascend figures that I painted in
keeping with the subject, little by little, until they come to the
level where the scene begins. It would be a long and perhaps
tedious task to describe all the particulars and minute details of

those scenes, and therefore I shall touch only on the principal things, and that briefly. In all of them, then, are stories of the actions of Pope Paul III, and in each is his portrait from life. In the first, wherein are the Dispatchings, so to speak, of the Court of Rome, may be seen upon the Tiber various embassies of various nations (with many portraits from life) that are come to seek favours from the Pope and to offer him divers tributes; and, in addition, two great figures in great niches placed over the doors, which are on either side of the scene. One of these represents Eloquence, and has above it two Victories that uphold the head of Julius Cæsar, and the other represents Justice, with two other Victories that hold the head of Alexander the Great; and in the centre are the arms of the above-named Pope, supported by Liberality and Remuneration. On the main wall is the same Pope remunerating merit, distributing salaries, knighthoods, benefices, pensions, bishoprics, and Cardinals' hats, and among those who are receiving them are Sadoleto, Polo, Bembo, Contarini, Giovio, Buonarroti, and other men of excellence, all portrayed from life, and on that wall, within a great niche, is Grace with a horn of plenty full of dignities, which she is pouring out upon the earth, and the Victories that she has above her, after the likeness of the others, support the head of the Emperor Trajan. There is also Envy, who is devouring vipers and appears to be bursting with venom; and above, at the top of the scene, are the arms of Cardinal Farnese, supported by Fame and Virtue. In the other scene the same Pope Paul is seen all intent on his buildings, and in particular on that of S. Pietro upon the Vatican, and therefore there are kneeling before the Pope Painting, Sculpture, and Architecture, who, having unfolded a design of the ground-plan of that S. Pietro, are receiving orders to execute the work and to carry it to completion. Besides these figures, there is Resolution, who, opening the breast, lays bare the heart; with Solicitude and Riches near. In a niche is Abundance, with two Victories that hold the effigy of Vespasian, and in the centre, in another niche that divides one scene from the other, is Christian Religion, with two Victories above her that hold the head of Numa Pompilius; and the arms that are above the scene are those of Cardinal San Giorgio, who built that Palace. In the other scene, which is opposite to that of the Dispatchings of the Court, is the universal peace made among Christians by the agency of Pope Paul III, and particularly between the Emperor Charles V and Francis,

King of France, who are portrayed there; wherefore there may be seen Peace burning arms, the Temple of Janus being closed, and Fury in chains. Of the two great niches that are on either side of the scene, in one is Concord, with two Victories above her that are holding the head of the Emperor Titus, and in the other is Charity with many children, while above the niche are two Victories holding the head of Augustus; and over all are the arms of Charles V, supported by Victory and Rejoicing. The whole work is full of the most beautiful inscriptions and mottoes composed by Giovio, and there is one in particular which says that those pictures were all executed in a hundred days; which, indeed, like a young man, I did do, being such that I gave no thought to anything but satisfying that lord, who, as I have said, desired to have the work finished in that time for a particular purpose. But in truth, although I exerted myself greatly in making cartoons and studying that work, I confess that I did wrong in putting it afterwards in the hands of assistants, in order to execute it more quickly, as I was obliged to do; for it would have been better to toil over it a hundred months and do it with my own hand, whereby, although I would not have done it in such a way as to satisfy my wish to please the Cardinal and to maintain my own honour, I would at least have had the satisfaction of having executed it with my own hand. However, that error was the reason that I resolved that I would never again do any work without finishing it entirely by myself over a first sketch done by the hands of assistants from designs by my hand. In that work the Spaniards, Bizzerra and Roviale, who laboured much in it in my company, gained no little practice; and also Battista da Bagnacavallo of Bologna, Bastiano Flori of Arezzo, Giovan Paolo dal Borgo, Fra Salvadore Foschi of Arezzo, and many other young men.

At that time I went often in the evening, at the end of the day's work, to see the above-named most illustrious Cardinal Farnese at supper, where there were always present, to entertain him with beautiful and honourable discourse, Molza, Annibale Caro, M. Gandolfo, M. Claudio Tolomei, M. Romolo Amaseo, Monsignor Giovio, and many other men of learning and distinction, of whom the Court of that Lord is ever full. One evening among others the conversation turned to the museum of Giovio and to the portraits of illustrious men that he had placed therein with beautiful order and inscriptions; and one thing leading to

another, as happens in conversation, Monsignor Giovio said that he had always had and still had a great desire to add to his museum and his book of Eulogies a treatise with an account of the men who had been illustrious in the art of design from Cimabue down to our own times. Enlarging on this, he showed that he had certainly great knowledge and judgment in the matters of our arts; but it is true that, being content to treat the subject in gross, he did not consider it in detail, and often, in speaking of those craftsmen, either confused their names, surnames, birthplaces, and works, or did not relate things exactly as they were, but rather, as I have said, in gross. When Giovio had finished his discourse, the Cardinal turned to me and said: 'What do you say, Giorgio? Will not that be a fine work and a noble labour?' 'Fine, indeed, most illustrious Excellency,' I answered, 'if Giovio be assisted by someone of our arts to put things in their places and relate them as they really are. That I say because, although his discourse has been marvellous, he has confused and mistaken many things one for another.' 'Then,' replied the Cardinal, being besought by Giovio, Caro, Tolomei, and the others, 'you might give him a summary and an ordered account of all those craftsmen and their works, according to the order of time; and so your arts will receive from you this benefit as well.' That undertaking, although I knew it to be beyond my powers, I promised most willingly to execute to the best of my ability; and so, having set myself down to search through my records and the notes that I had written on that subject from my earliest youth, as a sort of pastime and because of the affection that I bore to the memory of our craftsmen, every notice of whom was very dear to me, I gathered together everything that seemed to me to touch on the subject, and took the whole to Giovio. And he, after he had much praised my labour, said to me: 'Giorgio, I would rather that you should undertake this task of setting everything down in the manner in which I see that you will be excellently well able to do it, because I have not the courage, not knowing the various manners, and being ignorant of many particulars that you are likely to know; besides which, even if I were to do it, I would make at the most a little treatise like that of Pliny. Do what I tell you, Vasari, for I see by the specimen that you have given me in this account that it will prove something very fine.' And then, thinking that I was not very resolute in the matter, he caused Caro, Molza, Tolomei, and others of my dearest friends to speak to me.

Whereupon, having finally made up my mind, I set my hand to it, with the intention of giving it, when finished, to one of them, that he might revise and correct it, and then publish it under a name other than mine.

Meanwhile I departed from Rome in the month of October of the year 1546, and came to Florence, and there executed for the Nuns of the famous Convent of the Murate a picture in oils of a Last Supper for their refectory; which work was allotted to me and paid for by Pope Paul III, who had a sister-in-law, once Countess of Pitigliano, a nun in that convent. And then I painted in another picture Our Lady with the Infant Christ in her arms, who is espousing the Virgin-Martyr S. Catharine, with two other Saints; which picture M. Tommaso Cambi caused me to execute for a sister who was then Abbess of the Convent of the Bigallo, without Florence. That finished, I painted two large pictures in oils for Monsignor de' Rossi, Bishop of Pavia, of the family of the Counts of San Secondo; in one of these is a S. Jerome, and in the other a Pietà, and they were both sent to France. Then in the year 1547 I carried to completion for the Duomo of Pisa, at the instance of M. Bastiano della Seta, the Warden of Works, another altar-picture that I had begun; and afterwards, for my very dear friend Simon Corsi, a large picture in oils of Our Lady. Now, while I was executing these works, having carried nearly to completion the Book of the Lives of the Craftsmen of Design, there was scarcely anything left for me to do but to have it transcribed in a good hand, when there presented himself to me most opportunely Don Gian Matteo Faetani of Rimini, a monk of Monte Oliveto and a person of intelligence and learning, who desired that I should execute some works for him in the Church and Monastery of S. Maria di Scolca at Rimini, where he was Abbot. He, then, having promised to have it transcribed for me by one of his monks who was an excellent writer, and to correct it himself, persuaded me to go to Rimini to execute, with this occasion, the altar-picture and the high-altar of that church, which is about three miles distant from the city. In that altar-picture I painted the Magi adoring Christ, with an infinity of figures executed by me with much study in that solitary place, counterfeiting the men of the Courts of the three Kings in such a way, as well as I was able, that, although they are all mingled together, yet one may recognize by the appearance of the faces to what country each belongs and to which King he is subject,

for some have the flesh-colour white, some grey, and others dark; besides which, the diversity of their vestments and the differences in their adornments make a pleasing variety. That altar-piece has on either side of it two large pictures, in which is the rest of the Courts, with horses, elephants, and giraffes, and about the chapel, in various places, are distributed Prophets, Sibyls, and Evangelists in the act of writing. In the cupola, or rather, tribune, I painted four great figures that treat of the praises of Christ, of His Genealogy, and of the Virgin, and these are Orpheus and Homer with some Greek mottoes, Virgil with the motto, IAM REDIT ET VIRGO, etc., and Dante with these verses:

> Tu sei colei, che l' umana natura
> Nobilitasti sì, che il suo Fattore
> Non si sdegnò di farsi tua fattura.

With many other figures and inventions, of which there is no need to say any more. Then, the work of writing the above-mentioned book and carrying it to completion meanwhile continuing, I painted for the high-altar of S. Francesco, in Rimini, a large altar-picture in oils of S. Francis receiving the Stigmata from Christ on the mountain of La Vernia, copied from nature; and since that mountain is all of grey rocks and stones, and in like manner S. Francis and his companion are grey, I counterfeited a Sun within which is Christ, with a good number of Seraphim, and so the work is varied, and the Saint, with other figures, all illumined by the splendour of that Sun, and the landscape in shadow with a great variety of changing colours; all which is not displeasing to many persons, and was much extolled at that time by Cardinal Capodiferro, Legate in Romagna.

Being then summoned from Rimini to Ravenna, I executed an altar-picture, as has been told in another place, for the new church of the Abbey of Classi, of the Order of Camaldoli, painting therein a Christ taken down from the Cross and lying in the lap of Our Lady. And at this same time I executed for divers friends many designs, pictures, and other lesser works, which are so many and so varied, that it would be difficult for me to remember even a part of them, and perhaps not pleasing for my readers to hear so many particulars.

Meanwhile the building of my house at Arezzo had been finished, and I returned home, where I made designs for painting the hall, three chambers, and the façade, as it were for my own

diversion during that summer. In those designs I depicted, among other things, all the places and provinces where I had laboured, as if they were bringing tributes, to represent the gains that I had made by their means, to that house of mine. For the time being, however, I did nothing but the ceiling of the hall, which is passing rich in woodwork, with thirteen large pictures wherein are the Celestial Gods, and in four angles the four Seasons of the year nude, who are gazing at a great picture that is in the centre, in which, with figures the size of life, is Excellence, who has Envy under her feet and has seized Fortune by the hair, and is beating both the one and the other; and a thing that was much commended at the time was that as you go round the hall, Fortune being in the middle, from one side Envy seems to be over Fortune and Excellence, and from another side Excellence is over Envy and Fortune, as is seen often to happen in real life. Around the walls are Abundance, Liberality, Wisdom, Prudence, Labour, Honour, and other similar things, and below, all around, are stories of ancient painters, Apelles, Zeuxis, Parrhasius, Protogenes, and others, with various compartments and details that I omit for the sake of brevity. In a chamber, also, in a great medallion in the ceiling of carved woodwork, I painted Abraham, with God blessing his seed and promising to multiply it infinitely; and in four squares that are around that medallion, I painted Peace, Concord, Virtue, and Modesty. And since I always adored the memory and the works of the ancients, and perceived that the method of painting in distemper-colours was being abandoned, there came to me a desire to revive that mode of painting, and I executed the whole work in distemper; which method certainly does not deserve to be wholly despised or abandoned. At the entrance of the chamber, as it were in jest, I painted a bride who has in one hand a rake, with which she seems to have raked up and carried away with her from her father's house everything that she has been able, and in the hand that is stretched in front of her, entering into the house of her husband, she has a lighted torch, signifying that where she goes she carries a fire that consumes and destroys everything.

While I was passing my time thus, the year 1548 having come, Don Giovan Benedetto of Mantua, Abbot of SS. Fiore e Lucilla, a monastery of the Black Friars of Monte Cassino, who took infinite delight in matters of painting and was much my friend, prayed me that I should consent to paint a Last Supper, or some

such thing, at the head of their refectory. Whereupon I resolved to gratify his wish, and began to think of doing something out of the common use; and so I determined, in agreement with that good father, to paint for it the Nuptials of Queen Esther and King Ahasuerus, all in a picture fifteen braccia long, and in oils, but first to set it in place and then to work at it there. That method – and I can speak with authority, for I have proved it – is in truth that which should be followed by one who wishes that his pictures should have their true and proper lights, for the reason that in fact working at pictures in a place lower or other than that where they are to stand, causes changes in their lights, shadows, and many other properties. In that work, then, I strove to represent majesty and grandeur; and, although I may not judge whether I succeeded, I know well that I disposed everything in such a manner, that there may be recognized in passing good order all the manners of servants, pages, esquires, soldiers of the guard, the buttery, the credence, the musicians, a dwarf, and every other thing that is required for a magnificent and royal banquet. There may be seen, among others, the steward bringing the viands to the table, accompanied by a good number of pages dressed in livery, besides esquires and other servants; and at the ends of the table, which is oval, are lords and other great personages and courtiers, who are standing on their feet, as is the custom, to see the banquet. King Ahasuerus is seated at table, a proud and enamoured monarch, leaning upon the left arm and offering a cup of wine to the Queen, in an attitude truly dignified and regal. In short, if I were to believe what I heard said by persons at that time, and what I still hear from anyone who sees the work, I might consider that I had done something, but I know better how the matter stands, and what I would have done if my hand had followed that which I had conceived in idea. Be that as it may, I applied to it – and this I can declare freely – study and diligence. Above the work, on a spandrel of the vaulting, comes a Christ who is offering to the Queen a crown of flowers; and this was done in fresco, and placed there to denote the spiritual conception of the story, which signified that, the ancient Synagogue being repudiated, Christ was espousing the new Church of his faithful Christians.

At this same time I made the portrait of Luigi Guicciardini, brother of the Messer Francesco who wrote the History, because that Messer Luigi was very much my friend, and that year, being

Commissary of Arezzo, had caused me out of love for me to buy a very large property in land, called Frassineto, in Valdichiana, which has been the salvation and the greatest prop of my house, and will be the same for my successors, if, as I hope, they prove true to themselves. That portrait, which is in the possession of the heirs of that Messer Luigi, is said to be the best and the closest likeness of the infinite number that I have executed. But of the portraits that I have painted, which are so many, I will make no mention, because it would be a tedious thing; and, to tell the truth, I have avoided doing them to the best of my ability. That finished, I painted at the commission of Fra Mariotto da Castiglioni of Arezzo, for the Church of S. Francesco in that city, an altar-picture of Our Lady, S. Anne, S. Francis, and S. Sylvester. And at this same time I drew for Cardinal di Monte, my very good patron, who was then Legate in Bologna, and afterwards became Pope Julius III, the design and plan of a great farm which was afterwards carried into execution at the foot of Monte San-sovino, his native place, where I was several times at the orders of that lord, who much delighted in building.

Having gone, after I had finished these works, to Florence, I painted that summer on a banner for carrying in processions, belonging to the Company of S. Giovanni de' Peducci of Arezzo, that Saint on one side preaching to the multitude, and on the other the same Saint baptizing Christ. Which picture, as soon as it was finished, I sent to my house at Arezzo, that it might be delivered to the men of the above-named Company; and it happened that Monsignor Giorgio, Cardinal d'Armagnac, a Frenchman, passing through Arezzo and going to see my house for some other purpose, saw that banner, or rather, standard, and, liking it, did his utmost to obtain it for sending to the King of France, offering a large price. But I would not break faith with those who had commissioned me to paint it, for, although many said to me that I could make another, I know not whether I could have done it as well and with equal diligence. And not long afterwards I executed for Messer Annibale Caro, according as he had requested me long before in a letter, which is printed, a picture of Adonis dying in the lap of Venus, after the invention of Theocritus; which work was afterwards taken to France, almost against my will, and given to M. Albizzo del Bene, together with a Psyche gazing with a lamp at Cupid, who wakens from his sleep, a spark from the lamp having scorched him. Those figures,

all nude and large as life, were the reason that Alfonso di Tommaso Cambi, who was then a very beautiful youth, well-lettered, accomplished, and most gentle and courteous, had himself portrayed nude and at full length in the person of the huntsman Endymion beloved by the Moon, whose white form, and the fanciful landscape all around, have their light from the brightness of the moon, which in the darkness of the night makes an effect passing natural and true, for the reason that I strove with all diligence to counterfeit the peculiar colours that the pale yellow light of the moon is wont to give to the things upon which it strikes. After this, I painted two pictures for sending to Ragusa, in one Our Lady, and in the other a Pietà; and then in a great picture for Francesco Botti Our Lady with her Son in her arms, and Joseph; and that picture, which I certainly executed with the greatest diligence that I knew, he took with him to Spain. These works finished, I went in the same year to see Cardinal di Monte at Bologna, where he was Legate, and, dwelling with him for some days, besides many other conversations, he contrived to speak so well and to persuade me with such good reasons, that, being constrained by him to do a thing which up to that time I had refused to do, I resolved to take a wife, and so, by his desire, married a daughter of Francesco Bacci, a noble citizen of Arezzo. Having returned to Florence, I executed a great picture of Our Lady after a new invention of my own and with more figures, which was acquired by Messer Bindo Altoviti, who gave me a hundred crowns of gold for it and took it to Rome, where it is now in his house. Besides this, I painted many other pictures at the same time, as for Messer Bernardetto de' Medici, for Messer Bartolommeo Strada, an eminent physician, and for others of my friends, of whom there is no need to speak.

In those days, Gismondo Martelli having died in Florence, and having left instructions in his testament that an altar-picture with Our Lady and some Saints should be painted for the chapel of that noble family in S. Lorenzo, Luigi and Pandolfo Martelli, together with M. Cosimo Bartoli, all very much my friends, besought me that I should execute that picture. Having obtained leave from the Lord Duke Cosimo, the Patron and first Warden of Works of that church, I consented to do it, but on condition that I should be allowed to paint in it something after my own fancy from the life of S. Gismondo, in allusion to the name of the testator. Which agreement concluded, I remembered to have

heard that Filippo di Ser Brunellesco, the architect of that church, had given a particular form to all the chapels to the end that there might be made for each not some little altar-piece, but some large scene or picture which might fill the whole space. Wherefore, being disposed to follow in that respect the wishes and directions of Brunelleschi, and paying regard rather to honour than to the little profit that I could obtain from that commission, which contemplated the painting of a small altar-picture with few figures, I painted in an altar-piece ten braccia in breadth, and thirteen in height, the story, or rather, martyrdom, of the King S. Gismondo, when he, his wife, and his two sons were cast into a well by another King, or rather, Tyrant. I contrived that the ornamental border of that chapel, which is a semicircle, should serve as the opening of the gate of a great palace in the Rustic Order, through which there should be a view of a square court supported by pilasters and columns of the Doric Order; and I arranged that through that opening there should be seen in the centre an octagonal well with an ascent of steps around it, by which the executioners might ascend, carrying the two sons nude in order to cast them into the well. In the loggie around I painted on one side people gazing upon that horrid spectacle, and on the other side, which is the left, I made some soldiers who, having seized by force the wife of the King, are carrying her towards the well in order to put her to death. And at the principal door I made a group of soldiers that are binding S. Gismondo, who with his relaxed and patient attitude shows that he is suffering most willingly that death and martyrdom, and he stands gazing on four Angels in the air, who are showing to him palms and crowns of martyrdom for himself, his wife, and his sons, which appears to give him complete comfort and consolation. I strove, likewise, to demonstrate the cruelty and fierce anger of the impious Tyrant, who stands on the upper level of the court to behold his vengeance and the death of S. Gismondo. In short, so far as in me lay, I made every effort to give to all the figures, to the best of my ability, the proper expressions and the appropriate attitudes and spirited movements, and all that was required. How far I succeeded, that I shall leave to be judged by others; but this I must say, that I gave to it all the study, labour, and diligence in my power and knowledge.

Meanwhile, the Lord Duke Cosimo desiring that the Book of the Lives, already brought almost to completion with the greatest

diligence that I had found possible, and with the assistance of some of my friends, should be given to the printers, I gave it to Lorenzo Torrentino, printer to the Duke, and so the printing was begun. But not even the Theories had been finished, when, Pope Paul III having died, I began to doubt that I might have to depart from Florence before that book was finished printing. Going therefore out of Florence to meet Cardinal di Monte, who was passing on his way to the Conclave, I had no sooner made obeisance to him and spoken a few words, than he said: 'I go to Rome, and without a doubt I shall be Pope. Make haste, if you have anything to do, and as soon as you hear the news set out for Rome without awaiting other advice or any invitation.' Nor did that prognostication prove false, for, being at Arezzo for that Carnival, when certain festivities and masquerades were being arranged, the news came that the Cardinal had become Julius III. Whereupon I mounted straightway on horseback and went to Florence, whence, pressed by the Duke, I went to Rome, in order to be present at the coronation of the new Pontiff and to take part in the preparation of the festivities. And so, arriving in Rome and dismounting at the house of Messer Bindo, I went to do reverence to his Holiness and to kiss his feet. Which done, the first words that he spoke to me were to remind me that what he had foretold of himself had not been false. Then, after he was crowned and settled down a little, the first thing that he wished to have done was to satisfy an obligation that he had to the memory of Antonio, the first and elder Cardinal di Monte, by means of a tomb to be made in S. Pietro a Montorio; of which the designs and models having been made, it was executed in marble, as has been related fully in another place. And meanwhile I painted the altar-picture of that chapel, in which I represented the Conversion of S. Paul, but, to vary it from that which Buonarroti had executed in the Pauline Chapel, I made S. Paul young, as he himself writes, and fallen from his horse, and led blind by the soldiers to Ananias, from whom by the imposition of hands he receives the lost sight of his eyes, and is baptized; in which work, either because the space was restricted, or whatever may have been the reason, I did not satisfy myself completely, although it was perhaps not displeasing to others, and in particular to Michelagnolo. For that Pontiff, likewise, I executed another altar-picture for a chapel in the Palace; but this, for reasons given elsewhere, was afterwards taken by me to Arezzo and placed at

the high-altar of the Pieve. If, however, I had not fully satisfied either myself or others in the last-named picture or in that of S. Pietro a Montorio, it would have been no matter for surprise, because, being obliged to be continually at the beck and call of that Pontiff, I was kept always moving, or rather, occupied in making architectural designs, and particularly because I was the first who designed and prepared all the inventions of the Vigna Julia, which he caused to be erected at incredible expense. And although it was executed afterwards by others, yet it was I who always committed to drawing the caprices of the Pope, which were then given to Michelagnolo to revise and correct. Jacopo Barozzi of Vignuola finished, after many designs by his own hand, the rooms, halls, and many other ornaments of that place; but the lower fountain was made under the direction of myself and of Ammanati, who afterwards remained there and made the loggia that is over the fountain. In that work, however, it was not possible for a man to show his ability or to do anything right, because from day to day new caprices came into the head of the Pope, which had to be carried into execution according to the daily instructions given by Messer Pier Giovanni Aliotti, Bishop of Forlì.

During that time, being obliged in the year 1550 to go twice to Florence on other affairs, the first time I finished the picture of S. Gismondo, which the Duke went to see in the house of M. Ottaviano de' Medici, where I executed it; and he liked it so much, that he said to me that when I had finished my work in Rome I should come to serve him in Florence, where I would receive orders as to what was to be done. I then returned to Rome, where I gave completion to those works that I had begun, and painted a picture of the Beheading of S. John for the high-altar of the Company of the Misericordia, different not a little from those that are generally done, which I set in place in the year 1553; and then I wished to return, but I was forced to execute for Messer Bindo Altoviti, not being able to refuse him, two very large loggie in stucco-work and fresco. One of them that I painted was at his villa, made with a new method of architecture, because, the loggia being so large that it was not possible to turn the vaulting without danger, I had it made with armatures of wood, matting, and canes, over which was done the stucco-work and fresco-painting, as if the vaulting were of masonry, and even so it appears and is believed to be by all who see it; and it

is supported by many ornamental columns of variegated marble, antique and rare. The other loggia is on the ground-floor of his house on the bridge, and is covered with scenes in fresco. And after that I painted for the ceiling of an antechamber four large pictures in oils of the four Seasons of the year. These finished, I was forced to make for Andrea della Fonte, who was much my friend, a portrait from life of his wife, and with it I gave him a large picture of Christ bearing the Cross, with figures the size of life, which I had made for a kinsman of the Pope, but afterwards had not chosen to present to him. For the Bishop of Vasona I painted a Dead Christ supported by Nicodemus and by two Angels, and for Pier Antonio Bandini a Nativity of Christ, an effect of night with variety in the invention.

While I was executing these works, I was also watching to see what the Pope was intending to do, and finally I saw that there was little to be expected from him, and that it was useless to labour in his service. Wherefore, notwithstanding that I had already executed the cartoons for painting in fresco the loggia that is over the fountain of the above-named Vigna, I resolved that I would at all costs go to serve the Duke of Florence, and the rather because I was pressed to do this by M. Averardo Serristori and Bishop Ricasoli, the Ambassadors of his Excellency in Rome, and also in letters by M. Sforza Almeni, his Cupbearer and Chief Chamberlain. I transferred myself, therefore, to Arezzo, in order to make my way from there to Florence, but first I was forced to make for Monsignor Minerbetti, Bishop of Arezzo, as for my lord and most dear friend, a lifesize picture of Patience in the form that has since been used by Signor Ercole, Duke of Ferrara, as his device and as the reverse of his medal. Which work finished, I came to kiss the hand of the Lord Duke Cosimo, by whom in his kindness I was received very warmly; and while it was being considered what I should first take in hand, I caused Cristofano Gherardi of the Borgo to paint in chiaroscuro after my designs the façade of M. Sforza Almeni, in that manner and with those inventions that have been described at great length in another place. Now at that time I happened to be one of the Lords Priors of the city of Arezzo, whose office it is to govern that city, but I was summoned by letters of the Lord Duke into his service, and absolved from that duty; and, having come to Florence, I found that his Excellency had begun that year to build that apartment of his Palace which is towards the Piazza del

Grano, under the direction of the wood-carver Tasso, who was
then architect to the Palace. The roof had been placed so low
that all those rooms had little elevation, and were, indeed, al-
together dwarfed; but, since to raise the crossbeams and the
whole roof would be a long affair, I advised that a series of
timbers should be placed, by way of border, with sunk compart-
ments two braccia and a half in extent, between the crossbeams
of the roof, with a range of consoles in the perpendicular line, so
as to make a frieze of about two braccia above the timbers.
Which plan greatly pleasing his Excellency, he gave orders
straightway that so it should be done, and that Tasso should
execute the woodwork and the compartments, within which was
to be painted the Genealogy of the Gods; and that afterwards the
work should be continued in the other rooms.

While the work for those ceilings was being prepared, having
obtained leave from the Duke, I went to spend two months
between Arezzo and Cortona, partly to give completion to some
affairs of my own, and partly to finish a work in fresco begun on
the walls and vaulting of the Company of Jesus at Cortona. In
that place I painted three stories of the life of Jesus Christ, and
all the sacrifices offered to God in the Old Testament, from Cain
and Abel down to the Prophet Nehemiah; and there, during that
time, I also furnished designs and models for the fabric of the
Madonna Nuova, without the city. The work for the Company
of Jesus being finished, I returned to Florence in the year 1555
with all my family, to serve Duke Cosimo. And there I began and
finished the compartments, walls, and ceiling of the above-named
upper Hall, called the Sala degli Elementi, painting in the com-
partments, which are eleven, the Castration of Heaven in the air.
In a terrace beside that Hall I painted on the ceiling the actions
of Saturn and Ops, and then on the ceiling of another great
chamber all the story of Ceres and Proserpine; and in a still
larger chamber, which is beside the last, likewise on the ceiling,
which is very rich, stories of the Goddess Berecynthia and of
Cybele with her Triumph, and the four Seasons, and on the walls
all the twelve Months. On the ceiling of another, not so rich, I
painted the Birth of Jove and the Goat Amaltheia nursing him,
with the rest of the other most notable things related of him; in
another terrace beside the same room, much adorned with stones
and stucco-work, other things of Jove and Juno; and finally, in
the next chamber, the Birth of Hercules and all his Labours. All

that could not be included on the ceilings was placed in the friezes of each room, or has been placed in the arras-tapestries that the Lord Duke has caused to be woven for each room from my cartoons, corresponding to the pictures high up on the walls. I shall not speak of the grotesques, ornaments, and pictures of the stairs, nor of many other smaller details executed by my hand in that apartment of rooms, because, besides that I hope that a longer account may be given of them on another occasion, everyone may see them at his pleasure and judge of them.

While these upper rooms were being painted, there were built the others that are on the level of the Great Hall, and are connected in a perpendicular line with the first-named, with a very convenient system of staircases public and private that lead from the highest to the lowest quarters of the Palace. Meanwhile Tasso died, and the Duke, who had a very great desire that the Palace, which had been built at haphazard, in various stages and at various times, and more for the convenience of the officials than with any good order, should be put to rights, resolved that he would at all costs have it reconstructed in so far as that was possible, and that in time the Great Hall should be painted, and that Bandinelli should continue the Audience-chamber already begun. In order, therefore, to bring the whole Palace into accord, harmonizing the work already done with that which was to be done, he ordained that I should make several plans and designs, and finally a wooden model after some that had pleased him, the better to be able to proceed to accommodate all the apartments according to his pleasure, and to change and put straight the old stairs, which appeared to him too steep, ill-conceived, and badly made. To which work I set my hand, although it seemed to me a difficult enterprise and beyond my powers, and I executed as best I could a very large model, which is now in the possession of his Excellency; more to obey him than with any hope that I might succeed. That model, when it was finished, pleased him much, whether by his good fortune or mine, or because of the great desire that I had to give satisfaction; whereupon I set my hand to building, and little by little, doing now one thing and now another, the work has been carried to the condition wherein it may now be seen. And while the rest was being done, I decorated with very rich stucco-work in a varied pattern of compartments the first eight of the new rooms that are on a level with the Great Hall, what with saloons, chambers, and a chapel, with various

pictures and innumerable portraits from life that come in the
scenes, beginning with the elder Cosimo, and calling each room
by the name of some great and famous person descended from
him. In one, then, are the most notable actions of that Cosimo
and those virtues that were most peculiar to him, with his greatest
friends and servants and portraits of his children, all from life;
and so, also, that of the elder Lorenzo, that of his son, Pope Leo,
that of Pope Clement, that of Signor Giovanni, the father of our
great Duke, and that of the Lord Duke Cosimo himself. In the
chapel is a large and very beautiful picture by the hand of Raffaello
da Urbino, between a S. Cosimo and a S. Damiano painted by
my hand, to whom that chapel is dedicated. Then in like manner
in the upper rooms painted for the Lady Duchess Leonora,
which are four, are actions of illustrious women, Greek, Hebrew,
Latin, and Tuscan, one to each chamber. But of these, besides
that I have spoken of them elsewhere, there will be a full account
in the Dialogue which I am about to give to the world, as I have
said; for to describe everything here would have taken too long.

For all these my labours, continuous, difficult, and great as
they were, I was rewarded largely and richly by the magnanimous
liberality of the great Duke, in addition to my salaries, with do-
nations and with commodious and honourable houses both in
Florence and in the country, to the end that I might be able the
more advantageously to serve him. Besides which, he has hon-
oured me with the supreme magistracy of Gonfalonier and other
offices in my native city of Arezzo, with the right to substitute in
them one of the citizens of that place, not to mention that to my
brother Ser Piero he has given offices of profit in Florence, and
likewise extraordinary favours to my relatives in Arezzo; so that
I shall never be weary of confessing the obligation that I feel
towards that Lord for so many marks of affection.

Returning to my works, I must go on to say that my most
excellent Lord resolved to carry into execution a project that he
had had for a long time, of painting the Great Hall, a conception
worthy of his lofty and profound spirit; I know not whether, as
he said, I believe jesting with me, because he thought for certain
that I would get it off his hands, so that he would see it finished
in his lifetime, or it may have been from some other private and,
as has always been true of him, most prudent judgment. The
result, in short, was that he commissioned me to raise the cross-
beams and the whole roof thirteen braccia above the height at

that time, to make the ceiling of wood, and to overlay it with gold and paint it full of scenes in oils; a vast and most important undertaking, and, if not too much for my courage, perhaps too much for my powers. However, whether it was that the confidence of that great Lord and the good fortune that he has in his every enterprise raised me beyond what I am in myself, or that the hopes and opportunities of so fine a subject furnished me with much greater faculties, or that the grace of God – and this I was bound to place before any other thing – supplied me with strength, I undertook it, and, as has been seen, executed it in contradiction to the opinion of many persons, and not only in much less time than I had promised and the work might be considered to require, but in less than even I or his most illustrious Excellency ever thought. And I can well believe that he was astonished and well satisfied, because it came to be executed at the greatest emergency and the finest occasion that could have occurred; and this was (that the cause of so much haste may be known) that a settlement had been concluded about the marriage which was being arranged between our most illustrious Prince and the daughter of the late Emperor and sister of the present one, and I thought it my duty to make every effort that on the occasion of such festivities that Hall, which was the principal apartment of the Palace and the one wherein the most important ceremonies were to be celebrated, might be available for enjoyment. And here I will leave it to the judgment of everyone not only in our arts but also outside them, if only he has seen the greatness and variety of that work, to decide whether the extraordinary importance of the occasion should not be my excuse if in such haste I have not given complete satisfaction in so great a variety of wars on land and sea, stormings of cities, batteries, assaults, skirmishes, buildings of cities, public councils, ceremonies ancient and modern, triumphs, and so many other things, for which, not to mention anything else, the sketches, designs, and cartoons of so great a work required a very long time. I will not speak of the nude bodies, in which the perfection of our arts consists, or of the landscapes wherein all those things were painted, all which I had to copy from nature on the actual site and spot, even as I did with the many captains, generals and other chiefs, and soldiers, that were in the emprises that I painted. In short, I will venture to say that I had occasion to depict on that ceiling almost everything that human thought and imagination

can conceive; all the varieties of bodies, faces, vestments, habiliments, casques, helmets, cuirasses, various head-dresses, horses, harness, caparisons, artillery of every kind, navigations, tempests, storms of rain and snow, and so many other things, that I am not able to remember them. But anyone who sees the work may easily imagine what labours and what vigils I endured in executing with the greatest study in my power about forty large scenes, and some of them pictures ten braccia in every direction, with figures very large and in every manner. And although some of my young disciples worked with me there, they sometimes gave me assistance and sometimes not, for the reason that at times I was obliged, as they know, to repaint everything with my own hand and go over the whole picture again, to the end that all might be in one and the same manner. These stories, I say, treat of the history of Florence, from the building of the city down to the present day; the division into quarters, the cities brought to submission, the enemies vanquished, the cities subjugated, and, finally, the beginning and end of the War of Pisa on one side, and on the other likewise the beginning and end of the War of Siena, one carried on and concluded by the popular government in a period of fourteen years, and the other by the Duke in fourteen months, as may be seen; besides all the rest that is on the ceiling and will be on the walls, each eighty braccia in length and twenty in height, which I am even now painting in fresco, and hope likewise to discuss later in the above-mentioned Dialogue. And all this that I have sought to say hitherto has been for no other cause but to show with what diligence I have applied myself and still apply myself to matters of art, and with what good reasons I could excuse myself if in some cases (which I believe, indeed, are many) I have failed.

I will add, also, that about the same time I received orders to design all the arches to be shown to his Excellency for the purpose of determining the whole arrangement of the numerous festive preparations already described, executed in Florence for the nuptials of the most illustrious Lord Prince, of which I had then to carry into execution and finish a great part; to cause to be painted after my designs, in ten pictures each fourteen braccia high and eleven broad, all the squares of the principal cities of the dominion, drawn in perspective with their original builders and their devices; also, to have finished the head-wall of the above-named Hall, begun by Bandinelli, and to have a scene

made for the other, the greatest and richest that was ever made by anyone; and, finally, to execute the principal stairs of that Palace, with their vestibules, the court and the columns, in the manner that everyone knows and that has been described above, with fifteen cities of the Empire and of the Tyrol depicted from the reality in as many pictures. Not little, also, has been the time that I have spent in those same days in pushing forward the construction, from the time when I first began it, of the loggia and the vast fabric of the Magistrates, facing towards the River Arno, than which I have never had built anything more difficult or more dangerous, from its being founded over the river, and even, one might say, in the air. But it was necessary, besides other reasons, in order to attach to it, as has been done, the great corridor which crosses the river and goes from the Ducal Palace to the Palace and Garden of the Pitti; which corridor was built under my direction and after my design in five months, although it is a work that one might think impossible to finish in less than five years. In addition, it was also my task to cause to be reconstructed and increased for the same nuptials, in the great tribune of S. Spirito, the new machinery for the festival that used to be held in S. Felice in Piazza; which was all reduced to the greatest possible perfection, so that there are no longer any of those dangers that used to be incurred in that festival. And under my charge, likewise, have been the works of the Palace and Church of the Knights of S. Stephen at Pisa, and the tribune, or rather, cupola, of the Madonna dell' Umiltà in Pistoia, which is a work of the greatest importance. For all which, without excusing my imperfection, which I know only too well, if I have achieved anything of the good, I render infinite thanks to God, from whom I still hope to have such help that I may see finished, whenever that may be, the terrible undertaking of the walls in the Hall, to the full satisfaction of my Lords, who already for a period of thirteen years have given me opportunities to execute vast works with honour and profit for myself; after which, weary, aged, and outworn, I may be at rest. And if for various reasons I have executed the works described for the most part with something of rapidity and haste, this I hope to do at my leisure, seeing that the Lord Duke is content that I should not press it, but should do it at my ease, granting me all the repose and recreation that I myself could desire. Thus, last year, being tired by the many works described above, he gave me leave that I might go about

for some months to divert myself, and so, setting out to travel, I passed over little less than the whole of Italy, seeing again innumerable friends and patrons and the works of various excellent craftsmen, as I have related above in another connection. Finally, being in Rome on my way to return to Florence, I went to kiss the feet of the most holy and most blessed Pope Pius V, and he commissioned me to execute for him in Florence an altar-picture for sending to his Convent and Church of Bosco, which he was then having built in his native place, near Alessandria della Paglia.

Having then returned to Florence, remembering the command that his Holiness had laid upon me and the many marks of affection that he had shown, I painted for him, as he had commissioned me, an altar-picture of the Adoration of the Magi; and when he heard that it had been carried by me to completion, he sent me a message that to please him, and that he might confer with me over some thoughts in his mind, I should go with that picture to Rome, but particularly for the purpose of discussing the fabric of S. Pietro, which he showed himself to have very much at heart. Having therefore made preparations with a hundred crowns that he sent me for that purpose, and having sent the picture before me, I went to Rome; and after I had been there a month and had had many conversations with his Holiness, and had advised him not to permit any alterations to be made in the arrangements of Buonarroti for the fabric of S. Pietro, and had executed some designs, he commanded me to make for the high-altar of that Church of Bosco not an altar-picture such as is customary, but an immense structure almost in the manner of a triumphal arch, with two large panels, one in front and the other behind, and in smaller pictures about thirty scenes filled with many figures; all which have been carried very near completion.

At that time I obtained the gracious leave of his Holiness, who with infinite lovingness and condescension sent me the Bulls expedited free of charge, to erect in the Pieve of Arezzo a chapel and decanate, which is the principal chapel of that Pieve, under the patronage of myself and of my house, endowed by me and painted by my hand, and offered to the Divine Goodness as an acknowledgment (although but a trifle) of the great obligation that I feel to the Divine Majesty for the innumerable graces and benefits that He has deigned to bestow upon me. The altar-picture of that chapel is in form very similar to that described above, which has been in part the reason that it has been brought back

to my memory, for it is isolated and consists likewise of two pictures, one in front, already mentioned above, and one at the back with the story of S. George, with pictures of certain Saints on either side, and at the foot smaller pictures with their stories; those Saints whose bodies are in a most beautiful tomb below the altar, with other principal reliques of the city. In the centre comes a tabernacle passing well arranged for the Sacrament, because it serves for both the one altar and the other, and it is embellished with stories of the Old Testament and the New all in keeping with that Mystery, as has been told in part elsewhere.

I had forgotten to say, also, that the year before, when I went the first time to kiss the Pope's feet, I took the road by Perugia in order to set in place three large altar-pieces executed for a refectory of the Black Friars of S. Piero in that city. In one, that in the centre, is the Marriage of Cana in Galilee, at which Christ performed the Miracle of converting water into wine. In the second, on the right hand, is Elisha the Prophet sweetening with meal the bitter pot, the food of which, spoilt by colocynths, his prophets were not able to eat. And in the third is S. Benedict, to whom a lay-brother announces at a time of very great dearth, and at the very moment when his monks were lacking food, that some camels laden with meal have arrived at his door, and he sees that the Angels of God are miraculously bringing to him a vast quantity of meal.

For Signora Gentilina, mother of Signor Chiappino and Signor Paolo Vitelli, I painted in Florence and sent from there to Città di Castello a great altar-picture in which is the Coronation of Our Lady, on high a Dance of Angels, and at the foot many figures larger than life; which picture was placed in S. Francesco in that city. For the Church of Poggio a Caiano, a villa of the Lord Duke, I painted in an altar-picture the Dead Christ in the lap of His Mother, S. Cosimo and S. Damiano contemplating Him, and in the air an Angel who, weeping, displays the Mysteries of the Passion of Our Saviour; and in the Church of the Carmine at Florence, in the Chapel of Matteo and Simon Botti, my very dear friends, there was placed about this same time an altar-picture by my hand wherein is Christ Crucified, with Our Lady, S. John and the Magdalene weeping. Then I executed two great pictures for Jacopo Capponi, for sending to France, in one of which is Spring and in the other Autumn, with large figures and new inventions; and in another and even larger picture a

Dead Christ supported by two Angels, with God the Father on high. To the Nuns of S. Maria Novella of Arezzo I sent likewise in those days, or a little before, an altar-picture in which is the Virgin receiving the Annunciation from the Angel, and at the sides two Saints; and for the Nuns of Luco in the Mugello, of the Order of Camaldoli, another altar-piece that is in the inner choir, containing Christ Crucified, Our Lady, S. John, and Mary Magdalene. For Luca Torrigiani, who is very much my intimate and friend, and who desired to have among the many things that he possesses of our art a picture by my own hand, in order to keep it near him, I painted in a large picture a nude Venus with the three Graces about her, one of whom is attiring her head, another holds her mirror, and the third is pouring water into a vessel to bathe her; which picture I strove to execute with the greatest study and diligence that I was able, in order to satisfy my own mind no less than that of so sweet and dear a friend. I also executed for Antonio de' Nobili, Treasurer-General to his Excellency and my affectionate friend, besides his portrait, being forced to do it against my inclination, a head of Jesus Christ taken from the words in which Lentulus writes of His effigy, both of which were done with diligence; and likewise another somewhat larger, but similar to that named above, for Signor Mandragone, now the first person in the service of Don Francesco de' Medici, Prince of Florence and Siena, which I presented to his lordship because he is much affected towards our arts and every talent, to the end that he might remember from the sight of it that I love him and am his friend. I have also in hand, and hope to finish soon, a large picture, a most fanciful work, which is intended for Signor Antonio Montalvo, Lord of Sassetta, who is deservedly the First Chamberlain and the most trusted companion of our Duke, and so sweet and loving an intimate and friend, not to say a superior, to me, that, if my hand shall accomplish the desire that I have to leave to him a proof by that hand of the affection that I bear him, it will be recognized how much I honour him and how dearly I wish that the memory of a lord so honoured and so loyal, and beloved by me, shall live among posterity, seeing that he exerts himself willingly in favouring all the beautiful intellects that labour in our profession or take delight in design.

For the Lord Prince, Don Francesco, I have executed recently two pictures that he has sent to Toledo in Spain, to a sister of

the Lady Duchess Leonora, his mother; and for himself a little picture in the manner of a miniature, with forty figures, what with great and small, according to a very beautiful invention of his own. For Filippo Salviati I finished not long since an altar-picture that is going to the Sisters of S. Vincenzio at Prato, wherein on high is Our Lady arrived in Heaven and crowned, and at the foot the Apostles around the Sepulchre. For the Black Friars of the Badia of Florence, likewise, I am painting an altar-piece of the Assumption of Our Lady, which is near completion, with the Apostles in figures larger than life, and other figures at the sides, and around it stories and ornaments accommodated in a novel manner. And since the Lord Duke, so truly excellent in every-thing, takes pleasure not only in the building of palaces, cities, fortresses, harbours, loggie, public squares, gardens, fountains, villas, and other suchlike things, beautiful, magnificent, and most useful, for the benefit of his people, but also particularly in build-ing anew and reducing to better form and greater beauty, as a truly Catholic Prince, the temples and sacred churches of God, in imitation of the great King Solomon, recently he has caused me to remove the tramezzo* of the Church of S. Maria Novella, which had robbed it of all its beauty, and a new and very rich choir was made behind the high-altar, in order to remove that occupying a great part of the centre of that church; which makes it appear a new church and most beautiful, as indeed it is. And because things that have not order and proportion among them-selves can never be entirely beautiful, he has ordained that there shall be made in the side-aisles, between column and column, in such a manner as to correspond to the centres of the arches, rich ornaments of stone in a novel form, which are to serve as chapels with altars in the centre, and are all to be in one of two manners; and that then in the altar-pictures that are to go within these ornaments, seven braccia in height and five in breadth, there shall be executed paintings after the will and pleasure of the patrons of the chapels. Within one of those ornaments of stone, made from my design, I have executed for the very reverend Mon-signor Alessandro Strozzi, Bishop of Volterra, my old and most loving patron, a Christ Crucified according to the Vision of S. Anselm – namely, with the Seven Virtues, without which we cannot ascend the Seven Steps to Jesus Christ – and with other

* See note on p. 90, Vol. I.

considerations by the same Saint. And in the same church, within another of those ornaments, I have painted for the excellent Maestro Andrea Pasquali, physician to the Lord Duke, a Resurrection of Jesus Christ in the manner that God has inspired me, to please that Maestro Andrea, who is much my friend. And a similar work our great Duke has desired to have done in the immense Church of S. Croce in Florence; — namely, that the tramezzo* should be removed and that the choir should be made behind the high-altar, bringing that altar somewhat forward and placing upon it a new and rich tabernacle for the most holy Sacrament, all adorned with gold, figures, and scenes; and, in addition, that in the same manner that has been told of S. Maria Novella there should be made there fourteen chapels against the walls, with greater expense and ornamentation than those described above, because that church is much larger than the other. In the altar-pieces, to accompany the two by Salviati and Bronzino, are to be all the principal Mysteries of the Saviour, from the beginning of His Passion to the Sending of the Holy Spirit upon the Apostles; which picture of the Sending of the Holy Spirit, having made the design of the chapels and ornaments of stone, I have in hand for M. Agnolo Biffoli, Treasurer-General to our Lords, and my particular friend, and I finished, not long since, two large pictures that are in the Magistracy of the Nine Conservadori, beside S. Piero Scheraggio; in one is the head of Christ, and in the other a Madonna.

But since I should take too long if I sought to recount in detail the many other pictures, designs without number, models, and masquerades that I have executed, and because this much is enough and more than enough, I shall say nothing more of myself, save that however great and important have been the things that I have continually suggested to Duke Cosimo, I have never been able to equal, much less to surpass, the greatness of his mind. And this will be seen clearly in a third sacristy that he wishes to build beside S. Lorenzo, large and similar to that which Michelagnolo built in the past, but all of variegated marbles and mosaics, in order to deposit there, in tombs most honourable and worthy of his power and grandeur, the remains of his dead children, of his father and mother, of the magnanimous Duchess Leonora, his consort, and of himself; for which I have already made

* See p. 90, Vol. I.

a model after his taste and according to the orders received from him by me, which, when carried into execution, will cause it to be a novel, most magnificent, and truly regal Mausoleum.

This much, then, it must suffice to have said of myself, who am now come after so many labours to the age of fifty-five years, and look to live so long as it shall please God, honouring Him, ever at the service of my friends, and working in so far as my strength shall allow for the benefit and advantage of these most noble arts.

THE AUTHOR TO THE CRAFTSMEN OF DESIGN

HONOURED and noble craftsmen, for whose profit and advantage, chiefly, I set myself a second time to so long a labour, I now find that by the favour and assistance of the Divine Grace I have accomplished in full that which at the beginning of this my present task I promised myself to do. For which result rendering thanks first to God and afterwards to my lords, who have granted me the facilities whereby I have been able to do this advantageously, I must then give repose to my weary pen and brain, which I shall do as soon as I shall have made some brief observations. If, then, it should appear to anyone that in my writing I have been at times rather long and even somewhat prolix, let him put it down to this, that I have sought as much as I have been able to be clear, and before any other thing to set down my story in such a manner that what has not been understood the first time, or not expressed satisfactorily by me, might be made manifest at any cost. And if what has been said once has been at times repeated in another place, the reasons for this have been two – first, that the matter that I was treating required it, and then that during the time when I rewrote and reprinted the work I broke off my writing more than once for a period not of days merely but of months, either for journeys or because of a superabundance of labours, works of painting, designs, and buildings; besides which, for a man like myself (I confess it freely) it is almost impossible to avoid every error. To those to whom it might appear that I have overpraised any craftsmen, whether old or modern, and who, comparing the old with those of the present age, might laugh at them, I know not what else to answer save

that my intention has always been to praise not absolutely but, as the saying is, relatively, having regard to place, time, and other similar circumstances; and in truth, although Giotto, for example, was much extolled in his day, I know not what would have been said of him, as of other old masters, if he had lived in the time of Buonarroti, whereas the men of this age, which is at the topmost height of perfection, would not be in the position that they are if those others had not first been such as they were before us. In short, let it be believed that what I have done in praising or censuring I have done not with any ulterior object, but only to speak the truth or what I have believed to be the truth. But one cannot always have the goldsmith's balance in the hand, and he who has experienced what writing is, and particularly when one has to make comparisons, which are by their very nature odious, or to pronounce judgments, will hold me excused; and I know only too well how great have been the labours, hardships, and moneys that I have devoted over many years to this work. Such, indeed, and so many, have been the difficulties that I have experienced therein, that many a time I would have abandoned it in despair, if the succour of many true and good friends, to whom I shall always be deeply indebted, had not given me courage and persuaded me to persevere, they lending me all the loving aids that have been in their power, of notices, advices, and comparisons of various things, about which, although I had seen them, I was not a little perplexed and dubious. Those aids, indeed, have been such, that I have been able to lay bare the pure truth and bring this work into the light of day, in order to revive the memory of so many rare and extraordinary intellects, which was almost entirely buried, for the benefit of those who shall come after us. In doing which I have found no little assistance, as has been told elsewhere, in the writings of Lorenzo Ghiberti, Domenico Ghirlandajo, and Raffaello da Urbino; but although I have lent them willing faith, nevertheless I have always sought to verify their statements by a sight of the works, for the reason that long practice teaches a diligent painter to be able to recognize the various manners of craftsmen not otherwise than a learned and well-practised chancellor knows the various and diverse writings of his equals, or anyone the characters of his nearest and most familiar friends and relatives.

Now, if I have achieved the end that I have desired, which has been to benefit and at the same time to delight, that will be

a supreme satisfaction to me, and, even if it be otherwise, it will be a contentment for me, or at least an alleviation of pain, to have endured fatigue in an honourable work such as should make me worthy of pity among all choice spirits, if not of pardon. But to come at last to the end of this long discourse; I have written as a painter and with the best order and method that I have been able, and, as for language, in that which I speak, whether it be Florentine or Tuscan, and in the most easy and facile manner at my command, leaving the long and ornate periods, choice words, and other ornaments of learned speech and writing, to such as have not, as I have, a hand rather for brushes than for the pen, and a head rather for designs than for writing. And if I have scattered throughout the work many terms peculiar to our arts, of which perchance it has not occurred to the brightest and greatest lights of our language to avail themselves, I have done this because I could do no less and in order to be understood by you, my craftsmen, for whom, chiefly, as I have said, I set myself to this labour. For the rest, then, I having done all that I have been able, accept it willingly, and expect not from me what I know not and what is not in my power; satisfying yourselves of my good intention, which is and ever will be to benefit and please others.

DIE 25 AUGUSTI, 1567.

CONCEDIMUS LICENTIAM ET FACULTATEM IMPUNE ET SINE ULLO PRÆJUDICIO IMPRIMENDI FLORENTIÆ VITAS PICTORUM, SCULPTORUM, ET ARCHITECTORUM, TANQUAM A FIDE ET RELIGIONE NULLO PACTO ALIENAS, SED POTIUS VALDE CON-SONAS. IN QUORUM FIDEM ETC.

GUIDO SERVIDIUS, PRÆPOSITUS ET VICARIUS GENERALIS FLORENT.

NOTES

These notes, which do not claim to be complete, are principally concerned with the current locations of works of art referred to by Vasari. The term *in situ* is employed to refer to works which have remained in the same building; it does not necessarily imply that a painting or statue may not have moved within a church or palace. Furthermore, some churches have been completely rebuilt since the Renaissance – St Peter's in Rome is an obvious example – but *in situ* still seems the most convenient way to refer to the works they contain.

p. 25 Magi (in Duomo) – Still *in situ*.

p. 65 Silver casket (Cassetta Farnese) – Now in Capodimonte, Naples.

p. 69 Crystal casket – Now in the Uffizi, Florence.

p. 119 St Margaret – Now in the Louvre, Paris.

p. 123 Assumption – Now in the Pinacoteca Vaticana, Rome.
 Madonna with the Cat – Now in Capodimonte, Naples.
 Christ at the Column – Still *in situ*.

pp. 123–4 St Stephen – In S. Stefano, Genoa.

p. 124 Fugger Altarpiece – Still *in situ*.

p. 129 Daedalus and Icarus drawing – Now in the Louvre, Paris.

pp. 132–3 Nativity – Now in the Louvre, Paris.

p. 133 Virgin washing Christ child – Now in the Gemäldegalerie, Dresden.
 Lovers – Now in the Hermitage, St Petersburg.
 Alexander the Great – Now in the Musée d'Art et d'Histoire, Geneva.

p. 138 Peter and Andrew cartoon – Now in the Louvre, Paris.

p. 141 San Giovanni Crisostomo – Still *in situ*.

p. 142 Viterbo Pietà – Still *in situ*.

pp. 143–4 Raising of Lazarus – Now in the National Gallery, London.

p. 145 Visitation – The remaining fragments are in the collection of the Duke of Northumberland, Alnwick Castle.

p. 146 Virgin – Now in Capodimonte, Naples.
 Pope Clement – The larger picture in Capodimonte, Naples.
 Albizzi – Probably the picture in the Museum of Fine

pp. 260–61 Ugolino in wax – Now in the Ashmolean Museum, Oxford.

p. 262 Samson and Philistine – Now in the courtyard of the Palazzo Vecchio, Florence.

Pisa restored – Now in the Pinacoteca Vaticana, Rome.

pp. 267–8 Leda cartoon – A related painting was formerly in a Private Collection in Rome.

p. 271 Orpheus – Now in the Palazzo Medici-Riccardi, Florence.

p. 273 Bandinelli Laocoon – Now in the Uffizi, Florence.

p. 275 Hercules and Cacus – In the Piazza della Signoria, Florence.

p. 279 Hercules, Venus, Apollo, Leda – All in the Bargello, Florence.

Prince Doria as Neptune – Now in the Piazza del Duomo, Carrara.

p. 295 Cathedral reliefs – Now in the Museo dell' Opera del Duomo, Florence.

p. 296 Adam and Eve – Now in the Bargello, Florence.

p. 302 Dead Christ – Still in Santissima Annunziata, and by Baccio, not Clemente.

p. 303 Pitti Palace paintings – Still *in situ*.

p. 311 Dead Christ – Now in the Pitti Palace, Florence, but generally attributed to Fra Bartolommeo alone.

Rape of Dinah – Now in the Kunsthistorisches Museum, Vienna.

Virgin and two Saints – Now in the Pinacoteca Nazionale, Bologna.

p. 312 St Catherine – Still *in situ*.

Michelangelo – Formerly in the Bossi Collection, Genoa. Present whereabouts unknown.

p. 347 Veronica, and Virgin and Saints – Still *in situ*.

p. 349 S. Michele Visdomini – Still *in situ*.

St Michael and St John the Evangelist – Now in the Museo della Collegiata, Empoli.

St Quentin – Now in the Pinacoteca Communale, Borgo San Sepolcro.

p. 351 Joseph scenes – Now in the National Gallery, London.

p. 353 Adoration of the Magi – Now in the Pitti Palace, Florence.

Cosimo Portrait – Now in the Uffizi, Florence.

Virgin – Now in the Pinacoteca Nazionale, Ferrara.

Lazarus – Now in the Pinacoteca Nazionale, Ferrara.

pp. 448–9 Massacre of the Innocents – Now in the Pinacoteca Nazionale, Ferrara.

p. 449 S. Francesco Altarpiece – Probably the Nativity in the Pinacoteca Nazionale, Ferrara.

St Helen – Now in the Pinacoteca Nazionale, Ferrara.

Agony in the Garden – Now in the Pinacoteca Nazionale, Ferrara.

Annunciation – Now in the Brera, Milan.

Nativity – Now in the Gemäldegalerie, Dresden.

Ascension – Now in the Pinacoteca Provinciale, Bari.

Adoration of the Magi – Now in the Pinacoteca Nazionale, Ferrara.

p. 450 Resurrection – Now in the Kunsthistorisches Museum, Vienna.

Old and New Testaments – Now in the Pinacoteca Nazionale, Ferrara.

Triumph of Bacchus – Now in the Gemäldegalerie, Dresden.

Calumny of Apelles – Recently on the London art market.

p. 452 Noli me tangere – Now in the Prado, Madrid.

Mystic Marriage of St Catherine – Now in the Louvre, Paris.

St Peter Martyr and St Sebastian Altarpieces – Both now in the Gemäldegalerie, Dresden.

p. 453 St Joseph (Madonna della Scodella) – Now in the Pinacoteca Nazionale, Parma.

p. 454 S. Salvadore Altarpiece – Still *in situ*.

Bacchanal – Sometimes identified as the picture in the National Gallery, London.

p. 455 Virgin and Angels – Now in the National Gallery of Art, Washington.

Pentecost – Still *in situ*.

Adoration of the Magi – Still *in situ*.

Opportunity – Now in the Gemäldegalerie, Dresden.

p. 456 Virgin – Correggio's original is in the National Gallery, London.

p. 458 Niccolò dell' Abbote Beheading – Formerly in the Gemäldegalerie, Dresden. Presumed destroyed in 1945.

p. 560 Baptist frescoes – Still in the Palazzo della Cancelleria, Rome.

p. 561 Annunciation – Still *in situ*.

p. 562 S. Giovanni Decollato – Still *in situ*.

p. 564 Dead Christ – Now in the Beata Vergine del Rosario, Viggiù.

S. Cristina – Still *in situ*.

S. Maria dell' Anima ('the German church') – Still *in situ*.

pp. 566–7 Camillus – Still *in situ* in the Palazzo Vecchio, Florence.

p. 571 Charity – Now in the Uffizi, Florence.

Christ and Thomas – Now in the Louvre, Paris.

p. 572 Virgin and Child with Parrot – Now in the Prado, Madrid.

Deposition – Still *in situ*.

p. 573 Misericordia – Still *in situ* at S. Giovanni Decollato, Rome.

S. Lorenzo in Damaso – Actually a Madonna flanked by two Angels still *in situ*.

p. 574 Adam and Eve – Now in the Galleria Colonna, Rome.

Palazzo Farnese, S. Maria del Popolo – Still *in situ*.

Cardinal Riccio – Still *in situ* in Palazzo Sacchetti.

p. 586 S. Marcello – Still *in situ*.

p. 587 Deposition – Still *in situ*.

pp. 592–3 Aeneas – Known from photographs, but its present whereabouts are unknown.

p. 593 S. Pietro in Montorio – Still *in situ*.

p. 594 Massacre of the Innocents – Now in the Uffizi, Florence.

p. 604 Parnassus – Still *in situ* in the Villa Giulia, Rome.

pp. 604–5 S. Maria della Consolazione and S. Marcello (p. 605) – Still *in situ*.

p. 613 Christ – Presumably the picture now in the Galleria Nazionale delle Marche, Urbino.

p. 648 Battle of the Centaurs, Madonna – Both in the Casa Buonarotti, Florence.

p. 649 Crucifix – Now in the Casa Buonarotti, Florence.

p. 650 St Petronius, Angel – Together with a St Proculus still *in situ* in S. Domenico, Bologna.

p. 651 Bacchus – Now in the Bargello, Florence.

p. 652 Pietà – Still in St Peter's, Rome.

p.654 David – Now in the Accademia, Florence.

p.655 Taddei Tondo – Now in the Royal Academy, London.
Pitti Tondo – Now in the Bargello, Florence.
St Matthew – Now in the Accademia, Florence.

p.656 Doni Tondo – Now in the Uffizi, Florence.

p.657 War of Pisa – Battle of Cascina: a painting by Aristotele da Sangello after Michelangelo is at Holkham Hall, Norfolk.

pp.658ff. Julius Tomb – In S. Pietro in Vincoli, Rome.

p.660 Captives – Now in the Louvre, Paris.
Victory – Now in the Palazzo Vecchio, Florence.

p.680 Christ carrying the Cross – Now in S. Maria sopra Minerva, Rome.

p.685 Apollo – Actually a David, and in the Bargello, Florence.

p.697 Pietà – Now in the Duomo, Florence.

pp.701–2 Hercules – Known as the Farnese Bull, this group is now in the Museo Nazionale, Naples.

pp.716–17 Pietà – The Rondanini Pietà, now in the Castello Sforzesco, Milan.

p.737 Ganymede – Now in the Fogg Art Museum, Cambridge (Mass.).
Vulture (Tityus) – Now in the Royal Library, Windsor.
Chariot (Phaeton) – Now in the Royal Library, Windsor.
Children's Bacchanal – Now in the Royal Library, Windsor.

pp.737–8 Two Annunciations – One is in the Uffizi, Florence; the other in the Pierpont Museum Library, New York.

p.738 Agony in the Garden – Now in the Uffizi, Florence.

p.739 Pietà – Now in the Isabella Stewart Gardner Museum, Boston.
Christ on Cross – Now in the British Museum, London.
Christ and Woman of Samaria – A preparatory drawing is in the Bodmer Foundation, Geneva.

p.740 Perini sheets – All three are in the Uffizi, Florence. They represent three Heads; Fury; and Venus, Mars and Cupid.

p.773 Ponzio – Ponce Jacquiot was French.

p.775 St Catherine – Still *in situ*. A preparatory drawing by

Vasari himself is in a Private Collection.

p. 777 Ancona Baptism – Now in S. Francesco alle Scale there.

p. 779 Marco da Faenza – Marco Machetti.

p. 780 Miruolo – Girolamo Mirola. The frescoes are still *in situ* in the Palazzo del Giardino, Parma.

p. 782 Ecce Homo – Now in the Kunsthistorisches Museum, Vienna.

p. 783 S. Marziliano – In S. Marziale.

pp. 783–4 S. Antonio – Titian painted three frescoes, which are still *in situ*.

p. 784 St Mark – Now in the Salute, Venice.

Bellini – Now in the National Gallery of Art, Washington.

Dürer – The Feast of the Rose-Garlands, now in the Narodnygalerie, Prague.

p. 785 Bacchanal and Cupids – Both in the Prado, Madrid.

Christ – Now in the Gemäldegalerie, Dresden.

p. 786 Assumption; Pesaro Altarpiece – Both still *in situ* in the Frari, Venice.

S. Niccolò – Now in the Pinacoteca Vaticana, Rome.

Christ – Now in the Scuola di S. Rocco, Venice.

Baptist – Now in the Accademia, Venice.

François Premier – Now in the Louvre, Paris.

p. 788 S. Maria della Carità – *In situ* in the Accademia, Venice.

Charles V – Now in the Prado, Madrid.

S. Giovanni Elemosinario – Still *in situ*.

p. 789 Ippolito de' Medici in Hungarian dress – Now in the Pitti Palace, Florence.

Davalos – The Allegory, now in the Louvre, Paris.

Aretino – Now in the Pitti Palace, Florence.

Virgin and St Tiziano (and St Andrew) – In the Chiesa arcidiaconale, Pieve di Cadore.

Paul III – Now in Capodimonte, Naples.

Venus of Urbino – Now in the Uffizi, Florence.

Magdalene – Now in the Pitti Palace, Florence.

p. 790 Pentecost – Now in the Salute, Venice.

S. Nazzaro (e Celso) – Still *in situ*.

Aretino – Perhaps the portrait now in the Frick Collection, New York.

pp. 790–91 S. Spirito Ceiling – Now in the Salute, Venice.

p. 791 Danaë – Now in Capodimonte, Naples.

p.792 Marquis del Vasto – Now in the Prado, Madrid.
S. Salvadore Transfiguration and Annunciation – Both still *in situ*.

p.793 Trinity – Now in the Prado, Madrid.

pp.793–4 Venus and Adonis – Now in the Prado, Madrid.

p.794 Perseus and Andromeda – Now in the Wallace Collection, London.
Diana – Now in the National Gallery of Scotland, Edinburgh.
Europa – Now in the Isabella Stewart Gardner Museum, Boston.
Magi – Presumably the picture in the Escorial.
Christ Mocked – Now in the Louvre, Paris.

pp.794–5 Crucifixion – Still *in situ*.

p.795 St Laurence – *In situ* in the Chiesa dei Gesuiti.
St Nicholas – Still *in situ*.

p.797 Last Supper and St Lawrence – Both in the Escorial.
Naked Maiden – Possibly the picture now in Palazzo Doria, Rome.

p.800 Fisherman presenting Ring – Now in the Accademia, Venice.
Jove and Io – Now in the Museum in Gothenburg.

p.801 David and Bathsheba – Now in the Wallraf-Richartz Museum, Cologne.

p.804 St John – In the Madonna of the Harpies now in the Uffizi.

pp.806–7 St James – Still *in situ*.

p.808 Bacchus – Now in the Bargello, Florence.

pp.810–11 Madonna and Child; St James – both still *in situ*.

p.837 Bronze Charles V – Now in the Prado, Madrid.

p.839 Medici Tomb – Still *in situ*.

p.857 S. Stefano Madonna with St Peter, St Stephen and St John the Baptist – Now in the Castello Caetani, Sermoneta.
Pietà – Now in the Museum at Poznan.

p.858 King Pepin – The fresco is still *in situ* in the Sala Regia; the drawing is probably the *modello* in the Louvre, Paris.

p.859 St Catherine – Still *in situ*.
Annunciation – Still *in situ*. The drawing is in the Uffizi, Florence.

p. 862 Martin of Holland – Martin Schongauer.
 Lucas of Holland – Lucas van Leyden.

p. 863 Dirk of Louvain – Dirk Bouts.
 Quentin – Quentyn Massys.
 Bernard of Brussels – Bernard van Orley.
 Lambert of Amsterdam – Lambert Lombard.
 Hendrik of Dinant – Herri met de Bles, also called Civetta.
 Giovanni Strada of Bruges – Jan van der Straet, called
 Stradanus.
 Giovan Bologna – Giambologna.

p. 865 Gerard – Gerard Horebout.
 Susanna – Susanna Bening.

pp. 1023–4 Dead Christ – Now in the Casa Vasari, Arezzo.

p. 1024 Alessandro – Now in the Uffizi, Florence.

p. 1025 Lorenzo – Now in the Uffizi, Florence.

p. 1026 Deposition – Now in SS. Annunziata, Arezzo.
 S. Rocco, Arezzo – Now in the Museo Statale there.

p. 1027 Camaldoli Altarpiece – In the Chiesa dei Santi Donato
 e Ilariano there.

p. 1028 San Savino Assumption – Still *in situ*.

p. 1029 Nativity – In the Chiesa dei Santa Donato e Ilariano
 there.

p. 1030 S. Michele in Bosco – The St Gregory is in the
 Pinacoteca Nazionale, Bologna; the other two pictures
 are still *in situ*.

p. 1032 Deposition – Still *in situ*.
 Immaculate Conception – Still *in situ*.

p. 1033 St Jerome – Now in the Pitti Palace, Florence.

p. 1035 Deposition – A version of this composition is now in
 the Chigi Saracini Collection, Siena.

pp. 1035–6 Justice – Now in Capodimonte, Naples.

p. 1037 Six Tuscan Poets – Now in the Institute of Art,
 Minneapolis.

p. 1039 Christ Crucified – Still *in situ*.

p. 1040 S. Giorgio – The Sala dei Cento Giorni; still *in situ*.

p. 1044 Last Supper – Formerly in the Museo at S. Croce,
 Florence. Present whereabouts unknown.
 Magi – Still *in situ* at S. Fortunato.

p. 1045 St Francis – Still *in situ*.
 Deposition – Now in the Galleria dell' Accademia,
 Ravenna.

GENERAL INDEX OF NAMES

OF THE CRAFTSMEN MENTIONED IN VOLUME 2

NOTE.—*To bring this Index within as reasonable a compass as possible cross-references, such as* Agnolo Bronzino. See Bronzino, Agnolo, *are printed* Agnolo *Bronzino, the italics indicating the name under which the page-numbers will be found.*

This book is set in GARAMOND, the first typeface in
the ambitious programme of matrix production
undertaken by the Monotype Corporation
under the guidance of Stanley Morrison
in 1922. Although named after the
great French royal typographer,
Claude Garamond (1499–
1561), it owes much to
Jean Jannon of Sedan
(1580–1658).